A History of Western Art

FIFTH EDITION

LAURIE SCHNEIDER ADAMS

John Jay College and the Graduate Center
City University of New York

Connect
Learn
Succeed™

To John, Alexa, Caroline, and Arnie

The McGraw-Hill Companies

Connect
Learn
Succeed™

Published by McGraw-Hill, an imprint of The McGraw-Hill Companies, Inc., 1221 Avenue of the Americas, New York, NY 10020. Copyright © 2011, 2008, 2005, 2001, 1997, 1994 by Laurie Schneider Adams. All rights reserved. No part of this publication may be reproduced or distributed in any form or by any means, or stored in a database or retrieval system, without the prior written consent of The McGraw-Hill Companies, Inc., including, but not limited to, in any network or other electronic storage or transmission, or broadcast for distance learning.

This book is printed on acid-free paper.

2 3 4 5 6 7 8 9 0 DOW/DOW 2

ISBN: 978-0-07-337922-7
MHID: 0-07-337922-0

Vice President Editorial: *Michael Ryan*
Editorial Director: *William R. Glass*
Publisher: *Chris Freitag*
Sponsoring Editor: *Betty Chen*
Marketing Manager: *Pamela Cooper*
Developmental Editor: *Arthur Pomponio*
Director of Development: *Rhona Robbin*
Production Editor: *Christina Gimlin*
Production Service: *Marquand Books, Inc.: Keryn Means, Sara Billups, and Jeremy Linden*
Layout Artist and Manuscript Editor: *Marie Weiler*
Proofreader: *Carrie Wicks*
Indexer: *Candace Hyatt*
Design Manager and Cover Designer: *Andrei Pasternak*
Photo Research: *Alexandra Ambrose and Robin Sand*
Buyer II: *Tandra Jorgensen*
Composition: *9/11.5 Versailles and Gill Sans by Marie Weiler*
Image Separations: *iocolor*
Printing: *70# Sterling Ultra Web Dull by RR Donnelley & Sons, Willard, Ohio*

www.mhhe.com

Front cover: Vincent Van Gogh, *Wheatfield with Sheaves*, 1888, Musée Rodin, Paris. Oil on canvas, 28¾ × 21¼ in. (73 × 54 cm). Musée Rodin, Paris, France/Flammarion/The Bridgeman Art Library International. *This work is typical of van Gogh's interest in the theme of reaping in the wheatfields. The thick, visible brushstrokes, which are characteristic of his style, animate the painting's surface and evoke a strong tactile response from the viewer. In the background, the steam-powered train and factory chimneys reflect the changing times, juxtaposing industry with peasant labor.*

Back cover: Christo and Jeanne-Claude, *Wrapped Reichstag*, Berlin 1971–95. Photo: Wolfgang Volz. ©1995 Christo. *Christo and Jeanne-Claude spent twenty-four years trying to obtain permission from the German parliament to wrap the Reichstag. Permission was finally granted six years after the dismantling of the Berlin Wall. Designed in 1894, the building was destroyed by fire in 1933 after Hitler came to power, and was bombed in 1945 during the Battle of Berlin. Visible in this photo are the some of the thousands of visitors who viewed the remarkable feat of wrapping, which was carried out by 90 climbers and 120 installers. Fourteen days after the installation, the Reichstag was unwrapped and all the materials were recycled.*

Credits: The credits section for this book begins on page 599 and is considered an extension of the copyright page.

Library of Congress Cataloging-in-Publication Data
Adams, Laurie.
 A history of western art / Laurie Schneider Adams. — 5th ed.
 p. cm.
 Includes bibliographical references and index.
 ISBN-13: 978-0-07-337922-7 (alk. paper)
 ISBN-10: 0-07-337922-0 (alk. paper)
 1. Art—History. I. Title.
N5300.A33 2010
709—dc22

 2010031468

Contents

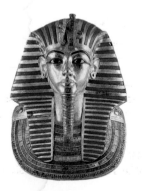

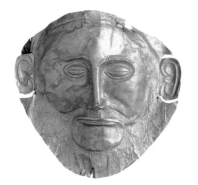

6 The Aegean 70

7 The Art of Ancient Greece 83

8 The Art of the Etruscans 117

9 Ancient Rome 125

10 Early Christian and Byzantine Art 153

16 The High Renaissance in Italy 279

17 Mannerism and the Later Sixteenth Century in Italy 306

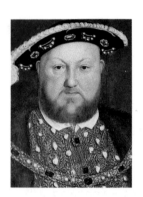

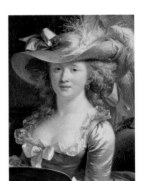

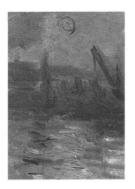

24 Nineteenth-Century Impressionism 433

Context and Style 433
SOCIETY AND CULTURE *Urban Renewal during the Second Empire* 433

Painting in France 433
Édouard Manet: 1880s 433 Pierre-Auguste Renoir 435
Edgar Degas 436 Mary Cassatt 438 Berthe Morisot 438
Claude Monet 439 Views of Paris: Renoir and Pissarro 442

Beyond the West
Japanese Woodblock Prints 444

French Sculpture: Auguste Rodin 446

American Painting at the Turn of the Century 448
Winslow Homer 448 John Singer Sargent 448

"Art for Art's Sake" 450
Whistler versus Ruskin 450

25 Post-Impressionism and the Late Nineteenth Century 452

Post-Impressionist Painting 452
Henri de Toulouse-Lautrec 452 Paul Cézanne 453
SYMBOLISM *An Apple a Day . . .* 454 Georges Seurat 456
Vincent van Gogh 457
PRIMARY SOURCE *"Dear Theo"—The Letters of Vincent van Gogh* 459
Paul Gauguin 460

Beyond the West
Gauguin and Oceania 462

Symbolism 463
SOCIETY AND CULTURE *The Symbolist Movement* 463
Gustave Moreau 463 Edvard Munch 464

Naïve Painting: Henri Rousseau 464
HISTORY *Freud on the Mechanisms of Dreaming* 466

26 The Early Twentieth Century: Picasso, Fauvism, Expressionism, and Matisse 467

Culture and Context 467

Pablo Picasso and Henri Matisse 467

Symbolism: Picasso's Blue Period 468
LITERATURE *Wallace Stevens: "The Man with the Blue Guitar"* 468

Beyond the West
African Art and the European Avant-Garde 469

Maps

Preface

We are bombarded with images from birth and we tend to assume that we know what they mean. But the paradoxical fact is that, although children understand pictures before they read words, pictures can be more complex than words—hence the saying "a picture is worth a thousand words." Through the ages, people have expressed the complexity of life through various kinds of artistic imagery, from paintings, sculptures, and buildings to digital, performance, and environmental art.

Why I Wrote A History of Western Art

All art history books attempt to help readers appreciate artistic expression, the meaning of images, and the development of style. While A History of Western Art achieves these goals, it also accomplishes something else. The book provides active learning tools to support the needs of college students, especially those who have little previous exposure to art history, as they embark on this long, sometimes challenging, journey. These tools include a carefully designed **art program,** a **strong narrative** that unifies the story of Western art, and **pedagogy** designed to foster critical thinking and visual analysis.

A History of Western Art contains numerous images without being encyclopedic. This choice is intentional because I believe it is more valuable, even in an introductory survey, for students to interact with important artworks as well as to learn to identify them. By including large-scale and multiple views of architecture and sculpture and enlarged details of paintings, I invite students to become acquainted with important works from different perspectives and in greater depth.

A History of Western Art presents students with an accessible narrative of art history. I have refined this narrative over five editions, based on comments from instructors and students throughout the United States. Art history comes alive when the narrative helps students understand the importance of a work of art, its context, and its connections to other works. I have tried to present the history of art as a dynamic narrative grounded in scholarship—a narrative that is a dialogue between today's viewers and their past.

The **context** within which to understand a work of art is an area of particular interest for me—for works of art lose much of their meaning if separated from the time and place in which they were created. Additional contextual considerations include the makers of the works—the artists—and those who commission the works—the patrons. The issue of style is a central focus of this text, for the history of art includes the history of style. Reflecting the cultural contexts of works are the titles of the early chapters, such as "The Ancient Near East," "Ancient Egypt," "The Art of Ancient Greece," "The Art of the Etruscans," "Ancient Rome," and so forth. Later chapters tend to emphasize stylistic categories—for example, Baroque, Rococo, Neoclassical, Realism, and, in the twentieth century, Expressionism, Cubism, Pop Art, Minimalism, and Conceptualism, and new media such as video.

The richness of the visual arts has led to different ways of interpreting images. Unique to A History of Western Art, therefore, is a brief survey in the Introduction of the modern methodologies of art-historical interpretation. These include formalism, Marxism, feminism, iconography, semiotics, biography and autobiography, and psychoanalysis.

As you will discover in the following sections, I have revised both the content of A History of Western Art and the pedagogy in an effort to enhance students' engagement with, and understanding of, the history of art.

Key Features

Setting the Stage: "Why Do We Study the History of Art?"

A History of Western Art begins by introducing readers to the discipline of art history by first asking and then answering the question "Why do we study the history of art?" I describe the human impulse to create art and consider why people the world over have made art for thousands of years. The Introduction surveys various ways art is valued—for example, religious, political, economic, psychological, and aesthetic values. In addition to presenting key methodologies, I survey the **formal elements** of art, such as composition, plane, balance, line, shape, space, light and color, and include new thumbnails within Chapter 2 to illustrate each of these formal points.

Lavish Illustration Program: A Closer Look

Reviewers and adopters of A History of Western Art routinely note that the illustration program is of the highest quality. Images are reproduced in a large format, which encourages careful looking, and all the paintings are reproduced in color. In fact, there are more color images in the fifth edition than ever before. For black-and-white images, two shades of black are used, resulting in greater tonal density.

More often than in previous editions, **multiple views** of sculptures are provided to give readers a sense of their three-dimensional reality. Some buildings are shown from the front, sides, and back; interiors, plans, and elevations

are designed to give students a sense of scale and space. Examples include the façade, dromos, and interior of the "Treasury of Atreus" (Chapter 6); the New York *Kouros* (front, side, and back views) (Chapter 7); *Sleeping Eros* (front and back) (Chapter 7); an aerial view of the exterior of Sainte-Foy at Conques, along with a plan of the interior, a view of the west entrance, a detail of the west portal and tympanum, and a view of the tribune and nave vaults (Chapter 12); Masaccio's Brancacci chapel is shown as a whole, as well as with a view of one wall (Chapter 15).

Another feature of the illustration program valued by instructors and students alike is the placement of **Connections**—small repeated images—to show thematic continuity in the arts. Thus, for example, the Egyptian statue of Menkaure is reproduced with the New York *Kouros* (Chapter 7), Polykleitos's *Spear Bearer* with the Roman *Augustus of Prima Porta* (Chapter 9), the Taj Mahal with the Royal Pavilion at Brighton (Chapter 22), and Giorgione's *Sleeping Venus* and Titian's *Venus of Urbino* with Manet's *Olympia* (Chapter 23).

Diagrams include the Mesopotamian cone mosaic technique, the Greek lost-wax method, lithography, and cantilever. Many of the illustration **captions** include anecdotes and biographical information about the artists, which are intended to encourage readers to identify with them. **Maps** define geographic context and indicate changing national boundaries.

Beyond the West

Sections titled "Beyond the West" provide brief introductions to the art of non-Western cultures without altering the Western focus of the text. An Australian cave painting, for example, is compared with Lascaux. A Mughal miniature of the seventeenth century illustrates the presence of Western ambassadors at the court of India. The influence of Japanese woodblock prints on Impressionism and Post-Impressionism is also treated in a box, as are Gauguin's fascination with Oceania and the influence of African art on twentieth-century avant-garde artists. These boxes provide a sense of the range of world art and remind readers that Western art is only one of many historical narratives.

Boxes: Extending the Narrative

Within chapters, readers will find boxes that encapsulate background information necessary for the study of art. These boxes take students aside, without interrupting the flow of the text, to explain a variety of topics such as media and technique, theories and philosophies of art, and myth and religion. Significant works of literature related to the cultural context of the arts are also discussed. Thus *The Epic of Gilgamesh* appears in the Ancient Near East chapter, the *Iliad* and the *Odyssey* in the Greek chapter, the *Aeneid* in the Roman chapter, and *Beowulf* in the Early Medieval chapter. Since nineteenth-century Romanticism was as much a literary as an artistic movement, boxed excerpts

of Romantic poetry are included. Certain social and political phenomena such as feudalism, medieval guilds, and the pilgrimage roads also appear in boxes.

New to this edition is the categorization of the boxes through the use of titles, such as Media and Technique, Theory, Society and Culture, Philosophy, Architecture, and so forth.

Picture Captions

The main purpose of a caption is to identify the artist, title, date, medium, dimensions, and location of a work. In this text, extended captions provide additional information about the image as well as biographical information on the artist. Sometimes quotes by critics and artists are also included.

Learning the Language of Art History

It is essential for students to retain a working art history vocabulary. The first time an art-historical term appears in the text, it is **boldfaced** to indicate that it is defined in the **glossary** at the back of the book.

Because words, as well as objects, have a history, I have included the etymology of art-historical terms in the text. This reinforces the meanings of words and reveals their continuity through time. In the chapter on ancient Greece, transcriptions of terms and proper names are given according to Greek spelling, with certain exceptions in deference to convention: Acropolis, Euclid, Socrates, and Laocoön, all of which would be spelled with a "k" rather than a "c" in Greek. Likewise, Roman names and terms are given according to Latin transcription.

Maps, Time Lines, Glossary, and Bibliography

Maps are integrated into the chapters to reinforce the sense of geographic location as well as historical time. Places mentioned in the text are included in the maps. Time lines appear at the end of each chapter. Words that are **boldfaced** in the text are listed and defined in the glossary at the end of the book. A bibliography is provided for further reading and research. These pedagogical tools are intended to emphasize the context of works of art as well as to familiarize students with the range of art-historical texts.

New to the Fifth Edition

I revise each edition of *A History of Western Art* in accordance with suggestions from adopters and reviewers, and the fifth edition is no exception.

A significant new feature is the addition of several *drawing studies* for important works of art so that students can see the process of the artist. Examples include studies for Rubens's *Raising of the Cross* (Chapter 19), for

Géricault's *Raft of the Medusa* (Chapter 22), for Van Gogh's *Self-Portrait* (Chapter 25), and for Picasso's *Demoiselles d'Avignon* (Chapter 27).

In the architectural plans and diagrams, color has been added to the leaders that link labels to what they represent. The labels themselves have also been improved for readability.

A selection of artworks that are new to the fifth edition include the following:

- Achaemenid drinking vessel (Chapter 4)
- Mask of Tutankhamon and Tomb of Nefertari (Chapter 5)
- Mycenaean Dagger with Lion Hunt (Chapter 6)
- Head of Alexander, from Pergamon (Chapter 7)
- *Wounded Chimera* (Chapter 8)
- First Style mosaic, *Soothsayers* (Chapter 9)
- Equestrian statuette of Charlemagne; Odo of Metz, interior of Charlemagne's palace chapel, along with a restored plan and a reconstruction drawing (Chapter 11)
- Reliquary statue of Sainte-Foy (Chapter 12)
- *King David Looks Down Upon Bathsheba Bathing and Up to God,* St. Louis Psalter (Chapter 13)
- Cologne Cathedral, exterior, with plan and view of the nave (Chapter 13)
- Duccio's *Rucellai Madonna* (Chapter 14)
- Giorgione's *Fête Champêtre* (Chapter 16)
- El Greco's *Burial of the Count of Orgaz* (Chapter 17)
- Lucas Cranach the Elder's *Crucifixion* and *Martin Luther* (Chapter 18)
- Rembrandt's *Belshazzar's Feast* (Chapter 19)
- Juan Sánchez Cotán's *Still Life with Quince, Cabbage, Melon, and Cucumber* (Chapter 19)
- Francesco de Zurburán's *Saint Serapion* (Chapter 19)
- Angelica Kauffmann's *Cornelia Pointing to Her Children as Her Treasures* (Chapter 20)
- Jacques-Louis David's *Napoleon at Saint Bernard Pass* (Chapter 21)
- Albert Bierstadt's *Sunrise, Yosemite Valley* (Chapter 22)
- Katsushika Hokusai's *Great Wave at Kanagawa* (Chapter 24, "Beyond the West")
- Winslow Homer's *The Army of the Potomac— A Sharpshooter on Picket Duty* (Chapter 24)
- Henri Matisse's *Joy of Life* (Chapter 26)
- Vassily Kandinksy's *Several Circles, No. 323* (Chapter 26)
- Franz Marc's *Small Yellow Horses* (Chapter 26)
- Jean Arp's *Collage Arranged According to the Laws of Chance* (Chapter 28)
- Frida Kahlo's *Thinking about Death* (Chapter 28)
- Jasper Johns's *Painted Bronze (Ale Cans)* (Chapter 30)
- Robert Rauschenberg's *Black Market* (Chapter 30)
- Joseph Kosuth's *Art as Idea as Idea* (Chapter 30)
- Sol LeWitt's *Serial Project, 1 (ABCD)* and *Wall Drawing No. 681 C* (Chapter 30)
- Andy Goldsworthy's *Icicles* (Chapter 31)
- Bob Thompson's *Crucifixion* (Chapter 31)
- Yasumasa Morimura's *Self-Portrait (Actress)/ White Marilyn* (Chapter 31)

More women artists have been added, including Caterina van Hemessen (*Self-Portrait,* Chapter 18), Adélaïde Labille-Guiard (*Self-Portrait with Two Pupils,* Chapter 20), Zaha Hadid (*IBA Housing Complex,* Chapter 31), Elizabeth Murray (*The Lowdown,* Chapter 31), Kara Walker (*Slavery! Slavery!,* Chapter 31), and Shirin Neshat (*Fervor,* Chapter 31).

Chapter 31 has been expanded with a new section on race and gender, including the addition of Romare Bearden's *Empress of the Blues.*

End-of-chapter time lines have been streamlined.

Supplements

An updated Online Learning Center (http://www.mhhe .com/westernart5e) offers a wealth of additional teaching and learning resources, including student quizzes, book-specific activities for MyArtStudio, an expanded Instructor Manual, new PowerPoint lecture highlights, and an updated Test Bank.

Connect Image Bank allows instructors to search high-resolution images within the text and download them for use in classroom presentations. Contact your McGraw-Hill representative for details.

To purchase an eBook version of this title, visit www .CourseSmart.com (ISBN 0-07-744899-5).

Acknowledgments

Many people have been extremely generous with their time and expertise during the preparation of this text. John Adams has helped on all phases of the book's development. Marlene Park was especially helpful during the formative stages of the First Edition. Others who offered useful comments and saved me from egregious errors include Paul Barolsky, Hugh Baron, James Beck, George Corbin, Allison Coudert, Jack Flam, Sidney Geist, Mona Hadler, Arnold Jacobs, Donna and Carroll Janis, Carla Lord, Maria Grazia Pernis, Catherine Roehrig, Elizabeth Simpson, and Rose-Carol Washton Long. Larissa Bonfante, Ellen Davis, Carol Lewine, Oscar White Muscarella, Mark Zucker, and Ann Sutherland Harris reviewed selected chapters in their areas of expertise.

For assistance with illustrations, I have to thank, among others, ACA Galleries, Margaret Aspinwall, Christo and Jeanne-Claude, Anita Duquette, Michael Findlay, Georgia de Havenon, the Flavin Institute, the estate of Duane Hanson, M. Knoedler and Co. Inc., Carroll Janis, Christopher Rothko, Irving Sandler, Lee Seldes, Robert Miller Gallery, Pace Gallery, and Allan Stone Gallery.

For assistance in developing the Fifth Edition, I would like to thank Arthur Pomponio and, at McGraw-Hill, Betty

Chen, Christina Gimlin, Rhona Robbin, Elena Mackawgy, and Pamela Cooper. Robin Sand, as always, did an excellent job of researching the photographs. The effective layout is due to the skill of Marie Weiler. Thanks go to Sara Billups, Jeremy Linden, and Keryn Means, at Marquand Books, for facilitating the image proofing, and to the team at iocolor for image separations of new photography. The work of proofreader Carrie Wicks and indexer Candace Hyatt is also greatly appreciated.

Reviewers

The revision of a major textbook such as *A History of Western Art* requires the help of many art historians. We would like to thank the following people for their thoughtful contributions to the development of this textbook.

Frances Altvater, *Hillyer College—University of Hartford*
Michaël J. Amy, *Rochester Institute of Technology*
Rozmeri Basic, *University of Oklahoma*
Sinclair Bell, *University of Manitoba*
Anne Bolin, *Sacred Heart University*
Eric A. Brown, *Southern Utah University*
Kara K. Burns, *University of Southern Alabama*
Gillian Cannell, *University of Pittsburgh*
Paula Carabell, *Florida Atlantic University*
Jill Carrington, *Stephen F. Austin State University*
Daniela Cunico Dal Pra, *University of North Carolina—Charlotte*
Amy Evans, *Walter State Community College*
Dan Ewing, *Barry University*
Jennifer Feltman, *Florida State University*
Brian Fencl, *West Liberty State College*
Phyllis Floyd, *Michigan State University*
Tom Folk, *Saint Peter's College*
Bradley Fratello, *St. Louis Community College*
Don Hall, *San Joaquin Delta College*
Tana Harvey, *Fairleigh Dickinson University*
Deana Hight, *California State University, Northridge*
Paul E. Ivey, *University of Arizona*
Lynn Jacobs, *University of Arkansas*
Robert P. Jenkins
Heather Belnap Jensen, *Brigham Young University*
Moritz Kellerman, *Northeastern Illinois University*
David Kroft, *Concordia University*
Dr. Issa Lampe, *American University*
Daniel Lowery, *Southwestern Illinois College*
Annika Marie, *Columbia College—Chicago*

Virginia H. Marquardt, *Marist College*
Michael J. McAuliffe, *New York City College of Technology—CUNY*
Susan Mellender, *College of Alameda*
Joan Messenger, *Miramar College*
Emily Morgan, *University of Arizona*
Jean Cooper Neumann, *Western Illinois University*
James T. Olsen, *Dana College*
E. Suzanne Owens, *Lorain County Community College*
Allison Lee Palmer, *University of Oklahoma*
Charles Phillips, *Georgia Perimeter College*
Ron Rarick, *Ball State University*
Lynne N. Reno, *Edinboro University*
William Sanders, *Surry Community College*
Wendy Schaller, *Ashland University*
Christine Schoettler, *Inver Hills Community College*
Debra Shingledecker, *Butler County Community College*
Janice Simon, *University of Georgia*
Wendy Slatkin, *California State Polytechnic University—Pomona*
David Soren, *University of Arizona*
Julie J. Tysver, *Greenville Technical College*
Michelle Vangen, *Kingsborough Community College*
Marc Vincent, *Baldwin Wallace College*
Sigrid W. Weltge, *Philadelphia College of Textiles & Science*
Jane K. Whitehead, *Central Connecticut State University*

About the Author

Laurie Schneider Adams received a Ph.D. in art history from Columbia University. She is Professor of Art History at John Jay College, City University of New York, and at the Graduate Center. Her other books include the survey text *Art across Time* (now in its fourth edition), *Key Monuments of the Italian Renaissance, Key Monuments of the Baroque, Italian Renaissance Art, Looking at Art, World Views: Topics in Non-Western Art, The Methodologies of Art* (now in its second edition), *Art and Psychoanalysis,* and *Art on Trial.* With Maria Grazia Pernis, she coauthored *Federico da Montefeltro and Sigismondo Malatesta: The Eagle and the Elephant* and *Lucrezia Tornabuoni de Medici and the Medici Family in the Fifteenth Century.* With Allison Coudert, she coauthored five children's books. She is also the editor of *Giotto in Perspective* in the *Artists in Perspective* series and of the quarterly journal *Source: Notes in the History of Art.*

1

Why Do We Study the History of Art?

We study the arts and their history because they teach us about our own creative expressions and those of our past. In the West, the major visual arts fall into three broad categories: pictures, sculpture, and architecture. Pictures (from the Latin word *pingo*, meaning "I paint") are two-dimensional images (from the Latin word *imago*, meaning "likeness") with height and width and are usually flat. Pictures are not only paintings, however: they include mosaics, stained glass, tapestries, drawings, prints, and photographs.

Sculptures (from the Latin word *sculpere*, meaning "to carve") are three-dimensional: in addition to height and width, they have depth. Sculptures have traditionally been made of stone, metal, wood, or clay. More modern materials include glass, plastics, cloth, string, wire, television monitors, and even animal carcasses.

Architecture, which literally means "high *(archi)* building *(tecture),*" is the most utilitarian of the three categories. Buildings enclose and organize space for specific purposes. They often contain pictures and sculptures, as well as other forms of visual art.

The Artistic Impulse

Art is a vital and persistent aspect of human experience. But where does the artistic impulse originate? We can see that it is inborn by observing children, who make pictures and sculptures, and model buildings before learning to read or write. Children trace images in dirt, build snowmen and sandcastles, and decorate just about anything—from their own faces to the walls of their houses. All these activities are efforts to impose order on disorder and to create form from formlessness. Although it may be difficult to relate an Egyptian pyramid or a Greek temple to a child's sandcastle or toy tower, all express the natural impulse to build.

One powerful motive for making art is the wish to leave behind, after death, something of value by which to be remembered. A work of art symbolically prolongs the artist's existence. This parallels the pervasive feeling that by having children one is ensuring genealogical continuity. Several artists have made such a connection. In an anecdote

about Giotto, the fourteenth-century Italian artist, the poet Dante asks why Giotto's children are so ugly and his paintings so beautiful; Giotto replies that he paints by daylight but reproduces in the darkness of night. The twentieth-century Swiss artist Paul Klee referred to his pictures as children and equated making art with procreation. His German contemporary Josef Albers cited this traditional connection between creation and procreation in relation to color: he described a mixed color (see Chapter 2) as the offspring of two original colors and compared the mixture to a child who combines the genes of two parents.

Related to the role of art as a memorial is the wish to preserve one's likeness after death—hence the term **portraiture**, meaning the likeness of a specific person. "Painting makes absent men present and the dead seem alive," wrote Leon Battista Alberti, the fifteenth-century Italian humanist. "I paint to preserve the likeness of men after their death," wrote Albrecht Dürer in sixteenth-century Germany. In Neolithic Jericho, around 8000 to 7000 B.C. (see Box), human skulls were modeled into faces with plaster, and shells were inserted into the eye sockets. In ancient Egypt, a pharaoh's features were painted on the outside of

Chronology

The Christian calendar, traditionally used in the West, is followed throughout this book. Other religions, such as Hinduism, Buddhism, Islam, and Judaism, have different dating systems.

Dates before the birth of Jesus are followed by the letters B.C., an abbreviation for "before Christ." Dates after his birth are denoted by the letters A.D., from the Latin phrase *anno Domini*, meaning "in the year of our Lord." The newer terms B.C.E. ("before the common era," equivalent to B.C.) and C.E. ("common era," equivalent to A.D.) are considered more religiously neutral, but they are less historical. There is no year 0, so A.D. 1 immediately follows 1 B.C. If neither B.C. nor A.D. accompanies a date, A.D. is understood. When dates are approximate or tentative, they are preceded by "c.," an abbreviation for the Latin *circa*, meaning "around."

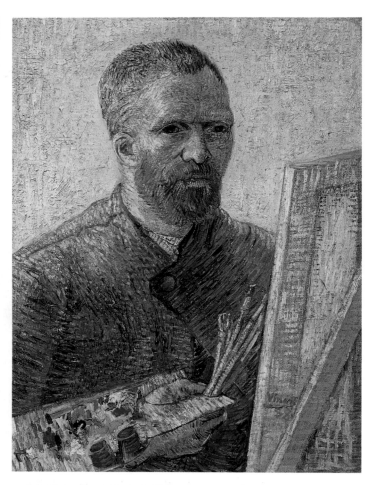

1.1 Vincent van Gogh, *Self-Portrait before His Easel*, 1888. Oil on canvas, 25¾ × 19⅞ in. (65.5 × 50.5 cm). Van Gogh Museum Amsterdam, Netherlands (Vincent van Gogh Foundation).

his mummy case so that his *ka* (soul), could recognize him. The Mycenaeans made gold death masks of their kings, and the Romans preserved the images of their ancestors by carving marble portraits from wax death masks.

Artists also make **self-portraits,** which are likenesses of themselves. The self-portraits of van Gogh are explicitly autobiographical, revealing his intense character and passion for line and color. In figure **1.1** he depicts himself behind a painting that we do not see—but we might suspect that it, too, is a self-portrait, for there are several elements in the visible painting that assert the artist's presence. Van Gogh's self-image predominates; he holds a set of brushes and a **palette** containing the same colors used in the picture. At the center of the palette is a vibrant orange, the distinctive color of van Gogh's beard, as well as of his name (Vincent) and the date ('88), with which he simultaneously signs both the painting we see and the painting we do not see.

It is not only the features of an individual that are valued as an extension of self after death. A **patron,** someone who commissions works of art, often orders more monumental

tributes. For example, Egyptian pharaohs commissioned pyramids to guarantee their existence in the afterlife as well as to assert their power on earth (see fig. 5.5). In Renaissance Italy, wealthy families spent enormous amounts of money on art to adorn public spaces, churches, private chapels, and palaces. And in the seventeenth century, Louis XIV, king of France, built a magnificent palace at Versailles as a monument to his political power, to his reign, and to the glory of France.

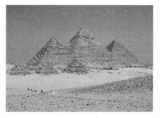

See figure 5.5. Pyramids at Giza, Egypt, 2551–2472 B.C.

Why Do We Value Art?

Works of art are valued not only by artists and patrons but also by entire cultures. In fact, the periods of history that we tend to identify as the high points of human achievement are those in which art was most valued. In the fifth century B.C., the Athenians built the Parthenon (see fig. **7.17**) to house the colossal gold and ivory statue of their patron goddess, Athena. During the Gothic era in Europe (c. 1200–1400/1500), a significant part of the economic activity of every cathedral town revolved around the construction of its cathedral, the production of sculpture, and the manufacture of stained-glass windows (see fig. **13.20**).

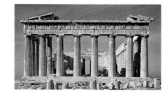

See figure 7.17. East end of the Parthenon, Athens, 447–438 B.C.

Today there is a flourishing art market throughout the world. More people than ever before invest in art, which has become an international business. Art theft is also international in scale, and the usual motive is money. Well-known

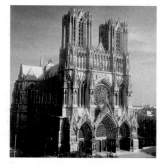

See figure 13.20. West façade, Reims Cathedral, France, begun 1211.

stolen works may be difficult to fence and are often held for ransom. The outrage that a community feels when certain works of art disappear (or are vandalized) reflects their cultural value.

Material Value

Works of art may be valued because they are made of precious material. Gold, for example, was used in Egyptian art to represent divinity and the sun. These associations recur in Christian art, which reserved gold for the background

Brancusi's *Bird:* Manufactured Metal or a Work of Art?

A trial held in New York City in 1927 illustrates just how hard it can be to agree on what constitutes "art." Edward Steichen, a prominent American photographer, purchased a bronze sculpture titled *Bird in Space* (fig. **1.2**) from the Romanian artist Constantin Brancusi, who was living in France. Steichen imported the sculpture to the United States, whose laws do not require customs duty on original works of art as long as they are declared on entering the country. But when the customs official saw the *Bird,* he balked. It was not art, he said: it was "manufactured metal." Steichen's protests fell on deaf ears. The sculpture was admitted into the United States under the category of "Kitchen Utensils and Hospital Supplies," which meant that Steichen had to pay $600 in import duty.

Later, with the financial backing of Gertrude Vanderbilt Whitney, an American sculptor and patron of the arts, Steichen appealed the ruling of the customs official. The ensuing trial received a great deal of publicity. Witnesses discussed whether the *Bird* was a bird at all, whether the artist could make it a bird by calling it one, whether it could be said to have characteristics of "birdness," and so on. The conservative witnesses refused to accept the work as a bird because it lacked certain biological attributes such as wings and tail feathers. The more progressive witnesses pointed out that it had birdlike qualities: upward movement and a sense of spatial freedom. The court decided in favor of the plaintiff. The *Bird* was declared a work of art, and Steichen got his money back. In today's market, a Brancusi *Bird* would sell for millions of dollars.

1.2 Constantin Brancusi, *Bird in Space,* 1928. Bronze, unique cast, 54 × 8½ × 6½ in. (137.2 × 21.6 × 16.5 cm). Museum of Modern Art, New York. Given anonymously. Brancusi objected to the view of his work as abstract. In a statement published shortly after his death in 1957, he declared: "They are imbeciles who call my work abstract; that which they call abstract is the most realist, because what is real is not the exterior form but the idea, the essence of things."

value of their materials. Even the monumental cult statue of Athena in the Parthenon disappeared without a trace, presumably because of the value of the gold and ivory from which it was made.

Intrinsic Value

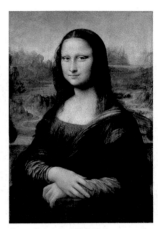

See figure 16.13. Leonardo da Vinci, *Mona Lisa,* c. 1503–5.

Intrinsic value depends on the general assessment of an artist and the aesthetic character of his or her work. The *Mona Lisa* (see fig. **16.13**), for example, is made of relatively modest materials—paint and wood—but it is a priceless object nonetheless, and arguably the Western world's most famous image. Leonardo da Vinci, who began painting it around 1503 in Italy, was acknowledged as a genius in his own day, and his work has stood the test of time. The works of van Gogh have also endured, although he was ignored in his lifetime. Intrinsic value is not always immediately apparent; it varies in different times and places, as we can see in the changing assessment of van Gogh's works. "Is it art?" is a familiar question that expresses the difficulty of defining "art" and recognizing the aesthetic value of an object (see Box).

In Europe, art collecting for the intrinsic value of the works began in Hellenistic Greece (323–31 B.C.). Romans plundered and copied Greek art, which was widely collected, especially by emperors. In the Middle Ages, the Christian Church was the main collector of art in Europe.

Interest in collecting ancient art revived in the West during the Renaissance and continued in royal families for several centuries. Some of these royal collections became the bases for major national museums. By the nineteenth century more and more private individuals were collecting art, and since then dealers, auction houses, museums, the media, and the Internet have contributed to the expansion of collecting.

Religious Value

of religious icons (the word **icon** is derived from the Greek word *eikon,* meaning "image") and for **halos** on divine figures. During the Middle Ages in Europe, ancient Greek bronze statues were not valued for their **aesthetic** character (their beauty), but rather for the fact that they could be melted down and made into weapons. Through the centuries art objects have been stolen and plundered, in disregard of their cultural, religious, or artistic significance, because of the

One of the traditional ways in which art has been valued is for its religious significance. Depictions of gods and goddesses make their images accessible. Such buildings as the Mesopotamian **ziggurat** (stepped tower) (see fig. **4.4**), temples, and churches have served as symbolic dwellings of the gods, relating worshipers to their deities. Tombs express belief in an afterlife. Medieval art served an educational function, communicating Bible stories and legends of the saints to a largely illiterate

population. Beyond its didactic (teaching) function, the religious significance of a work of art may be so great that entire groups of people identify with the object.

Nationalistic Value

Works of art have nationalistic value inasmuch as they express the pride and accomplishments of a culture. Today, as in the past, statues of national heroes decorate parks and public squares throughout the world.

See figure 4.4. The remains of the White Temple on top of its ziggurat, Uruk, c. 3500–3000 B.C.

Sometimes the nationalistic value of art is related to its religious value. In such cases, rulers take advantage of the patriotism of their subjects to impose new religious systems and to enhance their appeal through the arts. In the fourth century, under the Roman emperor Constantine, art was used to reinforce the establishment of Christianity as well as imperial power.

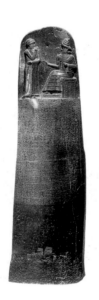

See figure 4.16. Stele inscribed with the law code of Hammurabi, c. 1792–1750 B.C.

The nationalistic value of certain works of art has made them spoils of war. When ancient Babylon was defeated by the Elamites in 1170 B.C., the victors stole the statue of Marduk, the chief Babylonian god, together with the law code of Hammurabi (see fig. **4.16**). In the early nineteenth century, when Napoleon's armies overran Europe, they plundered thousands of works of art that are now part of the French national art collection in the Musée du Louvre, in Paris.

The nationalistic value of art can be so great that countries whose works have been taken go to considerable lengths to recover them. Thus, at the end of World War II, the Allied Army assigned a special division, known as the Monuments Men, to recover the vast number of artworks stolen by the Nazis. A United States Army task force discovered Hermann Goering's two personal hoards of stolen art in Bavaria, one in a medieval castle and the other in a bombproof tunnel in a nearby mountain. The task force arrived just in time, for Goering had equipped an "art train" with thermostatic temperature controls to take "his" collection to safety. At the Nuremberg war trials, Goering claimed that his intentions had been purely honorable: he was protecting the art from air raids.

Another example of the nationalistic value of art is the case of the Elgin Marbles. In the early nineteenth century,

when Athens was under Turkish rule, Thomas Bruce, seventh earl of Elgin, obtained permission from Turkey to remove sculptures from the Parthenon and other buildings on the Acropolis. At huge personal expense (£75,000), Lord Elgin sent the sculptures by boat to England. The first shipment sank, but the remainder of the works reached their destination in 1816, and the British Museum in London purchased the sculptures for only £35,000. The Elgin Marbles, also known as the Parthenon Marbles, are still in the British Museum, where they are a tourist attraction and are studied by scholars (see fig. **7.24**). For years, the Greeks have been urging the return of the sculptures, but the British have refused. This kind of situation is a product of historical circumstance. Although Lord Elgin broke no laws, he is seen by many Greeks as having looted their cultural heritage.

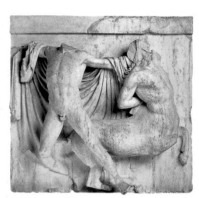

See figure 7.24. *Lapith and Centaur,* from South Metope XXVII of the Parthenon.

Modern legislation in some countries is designed to avoid similar problems by restricting or banning the export of national treasures. International cooperation agreements attempt to protect cultural property and archaeological treasures worldwide.

Psychological Value

Another symbolic value of art is psychological. Our reactions to art span virtually the entire range of human emotion. They include pleasure, fright, amusement, avoidance, and outrage. People can become attached to a work of art, as Leonardo was to his *Mona Lisa.* Instead of delivering it to the patron, Leonardo kept the painting until his death. Conversely, one may wish to destroy certain works because they arouse anger. In London in the early twentieth century, a suffragist slashed Velázquez's *Rokeby Venus* (see fig. **19.37**) because she was offended by what she considered to be its sexist representation of a woman. During the French Revolution of 1789, mobs protesting the injustices of the royal family destroyed statues and paintings of earlier kings and queens. In 1989 and 1990, when Eastern Europe began to rebel against communism, protesters tore down statues of their former leaders. And in 2001, the fundamentalist Muslim Taliban regime in Afghanistan destroyed

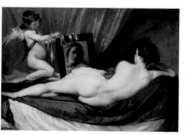

See figure 19.37. Diego Velázquez, *Venus with a Mirror (Rokeby Venus),* c. 1648.

two huge statues of Buddha because they were seen as an offense to Islam.

As societies have become increasingly technological, traditional imagery seems to have lost some of its magic power. But art still engages us. A peaceful **landscape** painting, for example, provides a respite from everyday tensions as we contemplate its rolling hills or distant horizon. A **still life** depicting fruit reminds us of the beauty inherent in objects we take for granted. And it remains true that abstract works of art containing no recognizable objects or figures can involve us in the rhythms of their shapes, the movements of their lines, and the moods of their colors. Large public sculptures, many of which are **nonrepresentational**, mark our social spaces and humanize them. Architecture, too, defines and enriches our environment. In addition, contemporary images, many in electronic media, exert power over us in both obvious and subtle ways by drawing on our image-making traditions. Movies and television affect our tastes and aesthetic judgments. Advertising images influence our decisions—what we buy and which candidates we vote for. Computer-based art is one of the fastest-growing art fields. Such modern media use certain traditional techniques of image-making to convey their messages.

Art and Illusion

Before considering illusion and the arts, it is necessary to point out that when we think of illusion in connection with an image, we usually assume that the image is true to life, or **naturalistic**. This is often, but not always, the case. With certain exceptions, Western art was mainly representational until the twentieth century. **Representational**, or **figurative**, art depicts recognizable natural forms or created objects. When the subjects of representational pictures and sculptures are so convincingly portrayed that they may be mistaken for the real thing, they are said to be **illusionistic**. Where the artist's purpose is to fool the eye, the effect is described by the French term *trompe l'oeil*.

The nature of pictorial illusion was simply but eloquently stated by the Belgian Surrealist painter René Magritte in *The Betrayal of Images* (see Box). This work is a convincing (although not a *trompe l'oeil*) rendition of a pipe. Directly below the image, Magritte reminds the viewer that in fact it is not a pipe at all—"Ceci n'est pas une pipe." ("This is not a pipe."). To the extent that observers are convinced by the image, they have been betrayed. Even though Magritte was right about illusion falling short of reality, the observer nevertheless enjoys having been fooled. The pleasure conveyed by illusion is embedded in the term itself; it comes from the Latin word *ludere*, meaning "to play" as well as "to mimic" and "to deceive."

The pleasure produced by illusionism and *trompe l'oeil* is reflected in many anecdotes, perhaps not literally true but illustrating underlying truths. For example, the ancient Greek artist Zeuxis was said to have painted grapes so

Images and Words

Artists express themselves through a visual language that has pictorial, sculptural, and architectural rather than verbal elements. As a result, no amount of description can replace the direct experience of viewing art. The artist's language consists of formal elements—line, shape, space, color, light, dark, and so forth (see Chapter 2)—whereas discussion about art is in words. Imagine, for example, if the words in Magritte's *The Betrayal of Images* (fig. **1.3**) read "This is a pipe" (*Ceci est une pipe*) instead of "This is not a pipe" (*Ceci n'est pas une pipe*), or just "Pipe." Although we might receive the same meaning of "pipeness" from both the word and the image, our experience of the verbal description would be quite different from our experience of the image of the pipe.

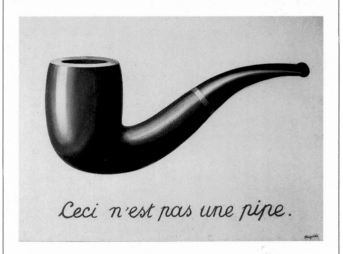

1.3 René Magritte, *The Betrayal of Images* ("This is not a pipe."), 1928. Oil on canvas, 23½ × 28½ in. (55 × 72 cm). Los Angeles County Museum of Art, California.

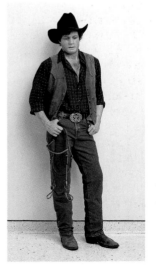

See figure 31.3. Duane Hanson, *The Cowboy*, 1995.

realistically that birds pecked at them. In the Renaissance, a favorite story was that the painter Cimabue was so deceived by Giotto's realism, he tried to brush off a fly Giotto had painted on the nose of a painted figure. The twentieth-century American sculptor Duane Hanson was a master of *trompe l'oeil*. He used synthetic materials to create such lifelike statues that it is not unusual for people to approach and speak to them (see fig. **31.3**).

In these examples of illusion and *trompe l'oeil*, artists produce

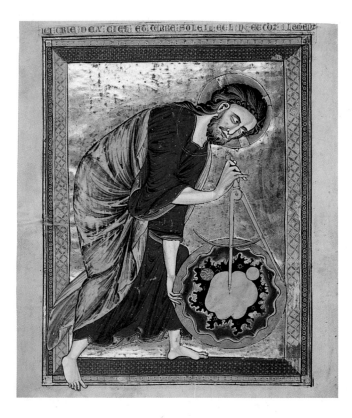

1.4 *God as Architect (God Drawing the Universe with a Compass),* from the *Bible moralisée,* Reims, France, fol. 1v, mid-13th century. Illumination, 8⅜ in. (21.2 cm) wide. Österreichische National-bibliothek, Vienna, Austria.

angelo "divine," a reflection of the notion of divine inspiration. And the nineteenth-century American painter James Abbott McNeill Whistler declared that artists are "chosen by the gods."

For centuries, artists have been compared to gods, and gods have been represented as artists. In ancient Babylonian texts, God is described as the architect of the world. In the Middle Ages, God is sometimes depicted as an architect drawing the universe with a compass (fig. **1.4**). In the **Apocrypha** (unofficial books of the Bible), Christ is portrayed as a sculptor who made clay birds and breathed life into them. Such legends are in the tradition of the supreme, omnipotent male artist-as-genius, and they reflect the fact that the original meaning of *genius* is "divinity."

The association of artists with gods, especially when artists make lifelike works, has inspired legends of rivalry between these two types of creator. Even when a work is not lifelike, the artist may incur divine anger. For example, the Old Testament account of the Tower of Babel illustrates the dangers of building too high and rivaling God by invading the heavens. God reacted by confounding the speech of the builders so that they seemed to each other to be "babbling" incomprehensibly. They scattered across the earth, forming different language groups. In the sixteenth-century painting by the Netherlandish artist Pieter Bruegel the Elder (fig. **1.5**), the Tower of Babel seems about to cave in from within, although it does not actually do so. Bruegel's tower is thus a metaphor for the collapsed ambition of the builders.

only a temporary deception. But the Latin poet Ovid relates the myth of the sculptor Pygmalion, who was not sure whether one of his own statues was real. Disillusioned by the infidelities of women, Pygmalion turned to art and fashioned a beautiful girl, Galatea, out of ivory. He dressed her, brought her jewels and flowers, undressed her and took her to bed. During the feast of Venus (the Roman goddess of love and beauty), Pygmalion prayed for a wife as lovely as his Galatea. Venus granted his wish by bringing the statue to life—something that only the gods can do. Human artists have to be satisfied with illusion.

Traditions Equating Artists with Gods

The fine line between reality and illusion, and the fact that gods are said to create nature, whereas artists create illusion, have given rise to traditions equating artists with gods. Both are seen as creators, the former making replicas of nature and the latter making nature itself. Alberti referred to the artist as an *alter deus,* Latin for "other god," and Dürer said that artists create as God did. Leonardo believed that artists are God's grandsons. Giorgio Vasari, the Italian Renaissance biographer of artists, called Michel-

Art and Identification

Reflections and Shadows: Legends of How Art Began

Belief in the power of images extends beyond the work of human hands. In many societies, not only certain works of art but also reflections and shadows are thought to embody the spirit of an animal or the soul of a person. Ancient traditions trace the origin of image-making to drawing a line around a reflected image or shadow. Alberti recalled the myth of Narcissus—a Greek youth who fell in love with his own image in a pool of water—and compared the art of painting to the reflection. The Roman writer Quintilian identified the first painting as a line traced around a shadow. A Greek legend attributes the origin of portraiture to a young woman of Corinth who traced the shadow of her lover's face cast on the wall by lamplight. Her father, a potter, filled in the outline with clay, which he then fired. In this case the work of art is inspired not only by the impulse to create form, but also by the discovery or recognition of forms that already exist and by the wish to capture and preserve them.

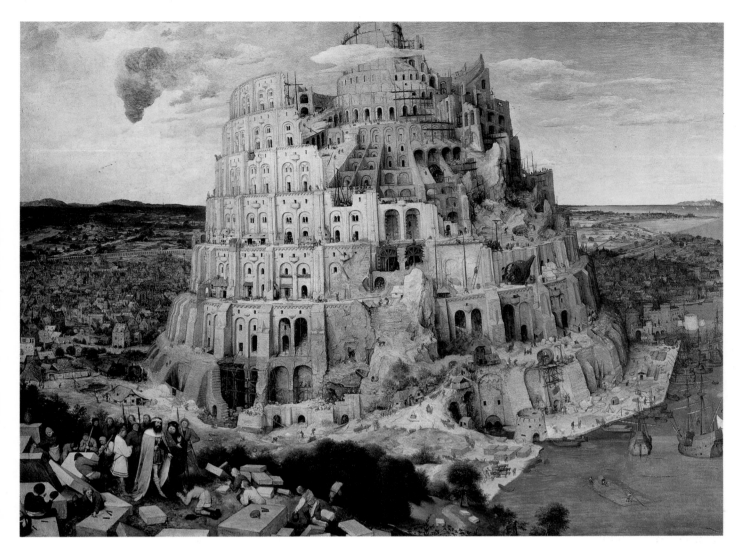

1.5 Pieter Bruegel the Elder, *The Tower of Babel*, 1563. Tempera on panel, 3 ft. 9 in. × 5 ft. 1 in. (1.14 × 1.55 m). Kunsthistorisches Museum, Vienna, Austria.

Image Magic

People in many cultures believe that harm done to an image of someone will hurt the actual person. In sixteenth-century England, Elizabeth I's advisers summoned a famous astrologer to counteract witchcraft when they discovered a wax effigy of the queen stuck through with pins.

Sometimes, usually in cultures without a strong tradition of figural art, people fear that pictures of themselves may embody—and snatch away—their souls. Even with media images permeating so much of the globe, people in remote areas may resist being photographed for fear of losing themselves. In fact, the very language we use to describe photography reflects this phenomenon: we "take" pictures and "capture" our subjects on film.

Portraits can also create a very strong impression. The nineteenth-century English art critic John Ruskin fell in love with an image on two separate occasions. He became so enamored of a marble tomb effigy of Ilaria del Caretto in Lucca, Italy, that he wrote letters home to his parents describing the statue as if it were a living girl. Later, when Ruskin was in a delusional state, he became convinced that

an image of Saint Ursula by the sixteenth-century artist Carpaccio was his former fiancée, Rose la Touche. A less extreme form of identifying a person with a picture was Whistler's famous **portrait** of his mother (fig. **1.6**, p. 8). "Yes," he replied when complimented on the work. "One does like to make one's mummy just as nice as possible."

The ability to identify with images, and the sense that a replica may actually contain the soul of what it represents, has sometimes led to an avoidance of images. Certain religions prohibit making pictures and statues of their gods or of human figures in sacred contexts. In Judaism, figurative images are expressly forbidden in the second commandment: "Thou shalt not make unto thee any graven image, or any likeness of any thing that is in heaven above, or that is in the earth beneath, or that is in the water under the earth" (Exodus 20:4).

In Islam, as in Judaism, the human figure is generally avoided in religious art. The founder of Islam, the prophet Muhammad, condemned those who would dare to imitate God's work by making figurative art. As a result, Islamic art developed an emphasis on complex patterns.

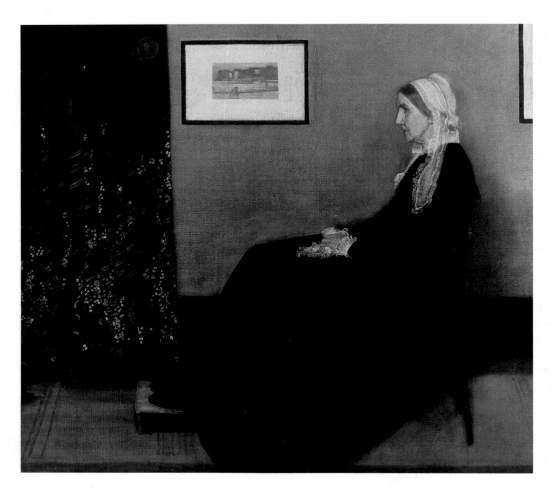

1.6 James Abbott McNeill Whistler, *Arrangement in Black and Gray (Portrait of the Artist's Mother)*, 1871. Oil on canvas, 4 ft. 9 in. × 5 ft. 4½ in. (1.45 × 1.64 m). Musée d'Orsay, Paris, France.

Architecture

As is true of pictures and sculptures, architecture evokes a response by identification. A building may seem inviting or forbidding, gracious or imposing. One might think of a country cottage as welcoming and picturesque, or of a haunted house as endowed with the spirits of former inhabitants who inflict mischief on trespassers.

Architecture is more functional, or utilitarian, than pictures and sculptures. The criteria for a successful building are not only whether it looks good, but also whether it fulfills its function well. A hospital, for example, may be aesthetically pleasing, but its ultimate test is whether it serves the patients and medical staff adequately. A medieval castle was not only a place to live, but also a fortress requiring defensive features such as a moat, towers, small windows, and thick walls.

Beyond function, the next most important consideration in architecture is its use of space. The scale (size) of buildings and the fact that, with very few exceptions, they can enclose us make our response to them significantly different from our reactions to pictures and sculptures. Pictures convey only the illusion of space. Sculptures occupy actual, three-dimensional space, but the observer generally remains on the outside of that space looking in. Our response to architecture, by contrast, is incomplete until

we have experienced it physically. Because such an experience involves time and motion as well as vision, it is particularly challenging to describe architecture through words and pictures.

The experience of architectural space appears in everyday language. We speak of "insiders" and "outsiders," of being "in on" something, and of being "out of it." The significance of "in" and "out" recurs in certain traditional architectural arrangements. Generally the innermost room of a temple, its sanctuary, is the most sacred space, the "holy of holies," which only a high priest or priestess can enter. Likewise, an appointment with a VIP is often held in an inner room, which may be closed to the public at large. Access is typically through a series of doors so that in popular speech we say of people who have influence that they can "open doors."

Our identification with the experience of being inside begins before birth. Unborn children exist in the enclosed space of the mother's womb, where they are provided with protection, nourishment, and warmth. This biological reality has resulted in a traditional association between women and architecture. The intuitive relationship between motherhood and architecture gave rise to a popular Christian metaphor equating the Virgin Mary (as the mother of Jesus) with the church building. This metaphor is given

visual form in Jan van Eyck's fifteenth-century painting *The Virgin in a Church* (fig. **1.7**). Mary is enlarged in relation to the architecture, and this identifies her with the Church as the House of God. Van Eyck portrays an intimacy between the Virgin and Jesus that evokes both the natural closeness of mother and child and the spiritual union between the human and the divine.

This union is an important aspect of the sense of space in religious architecture. Gothic cathedrals, such as the one in van Eyck's picture, contain several references to it. The vast interior spaces of such buildings are awe-inspiring, making worshipers feel small compared with an all-encompassing God. The upward movement of the interior space, together with the tall towers and spires on either side of the entrance, echoes the Christian belief that paradise is above, in the heavens. The rounded spaces of certain other places of worship, such as the domed ceilings of some mosques, likewise symbolize the dome of heaven. In a sense, then, these religious buildings stand as a transitional space between earth and sky, between our limited time on earth and our beliefs about infinite time, or eternity.

Just as we respond emotionally and physically to the open and closed spaces of architecture, so our metaphors indicate our concern for the structural security of our buildings. "A house of cards" and "a castle in the air" denote instability and irrational thinking. Since buildings are constructed from the bottom up, a house built on a "firm foundation" can symbolize stability, even rational thinking, forethought, and advance planning. In the initial stages of a building's conception, the architect makes a plan called a **ground plan,** or floor plan. This is a detailed drawing of each story of the structure indicating where walls and other architec-

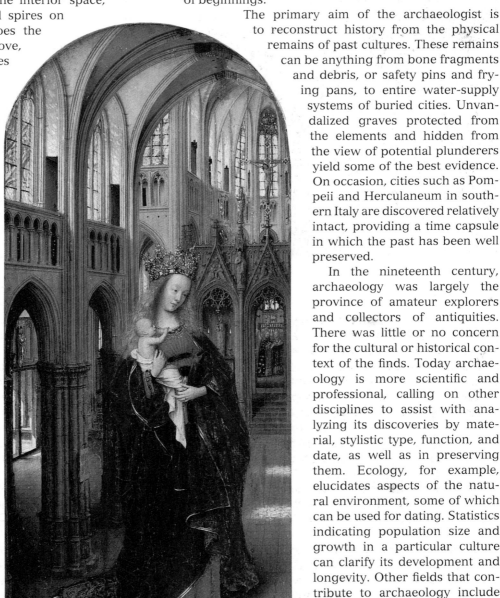

1.7 Jan van Eyck, *The Virgin in a Church*, c. 1410–25. Oil on panel, 12¼ × 5½ in. (31 × 14 cm). Gemälde-galerie, Staatliche Museen, Berlin, Germany. Given the narrowness of this picture, it may originally have been part of a **diptych**—a work of art consisting of two panels. If so, the other section is lost.

tural elements are located. Although in everyday speech we use the term *to plan* in a figurative sense, unless the architect constructs a literal and well-thought-out plan, the building, like a weak argument, will not stand up.

Archaeology and Art History

The works of art illustrated in this book are the subject of two academic fields: archaeology and art history. Archaeology (from the Greek words *archaios*, meaning "old" or "beginning," and *logos*, meaning "word") is literally a study of beginnings.

The primary aim of the archaeologist is to reconstruct history from the physical remains of past cultures. These remains can be anything from bone fragments and debris, or safety pins and frying pans, to entire water-supply systems of buried cities. Unvandalized graves protected from the elements and hidden from the view of potential plunderers yield some of the best evidence. On occasion, cities such as Pompeii and Herculaneum in southern Italy are discovered relatively intact, providing a time capsule in which the past has been well preserved.

In the nineteenth century, archaeology was largely the province of amateur explorers and collectors of antiquities. There was little or no concern for the cultural or historical context of the finds. Today archaeology is more scientific and professional, calling on other disciplines to assist with analyzing its discoveries by material, stylistic type, function, and date, as well as in preserving them. Ecology, for example, elucidates aspects of the natural environment, some of which can be used for dating. Statistics indicating population size and growth in a particular culture can clarify its development and longevity. Other fields that contribute to archaeology include chemistry, physics, computer science, linguistics (where there is evidence of writing), sociology, anthropology, and art history.

1.8 Meret Oppenheim, *Fur-Covered Cup, Saucer, and Spoon* (*Le Déjeuner en Fourrure*), 1936. Cup 4⅜ in. (10.9 cm) diameter; saucer 9⅜ in. (23.7 cm) diameter; spoon 8 in. (20.2 cm) long; overall height 2⅞ in. (7.3 cm). Museum of Modern Art, New York.

Art history is the study of the history of the visual arts. It should be distinguished from art appreciation, which is primarily about **aesthetics.** Philosophers have discussed the nature of aesthetics since antiquity, but art history did not become an academic discipline in the West until the nineteenth century. It has traditionally dealt with the analysis of individual works of art and their grouping into larger categories of style. Art history is used by archaeologists as well as other scholars studying everyday life, religious practices, means of warfare, and so forth. Stylistic analysis of works of art helps archaeologists date layers of cultures and is of great importance to cultural and economic historians in determining patterns of trade.

Methodologies of Art History

The complexity of images has led to the development of various interpretative approaches to the visual arts. Principal among these so-called methodologies of art-historical analysis are formalism, iconography and iconology, Marxism, feminism, biography and autobiography, semiology and deconstruction, and psychoanalysis. Generally, art historians approach works using some combination of these methods.

Formalism

Formalism grew out of the nineteenth-century aesthetic of "Art for Art's Sake"—art as an end in itself. Adherents of pure formalism view a work of art independently of its context, function, and content. They respond to formal elements and their aesthetic effect.

In order to grasp the effect of formal elements, let us take as an example Brancusi's *Bird in Space* (see fig. **1.2**). Imagine how different it would look lying in a horizontal plane. A large part of the effect of the work depends on its verticality. But it also has curved outlines, sleek proportions, and a highly reflective bronze surface. Its golden color might remind one of the sun and thus reinforce the association with birds and sky.

What if the texture of Brancusi's *Bird* were soft and feathery instead of hard and smooth? Consider the *Fur-Covered Cup, Saucer, and Spoon* of 1936 (fig. **1.8**) by the Swiss artist Meret Oppenheim (1913–85). When we experience the formal qualities of texture in these two sculptures, we respond to the *Bird* from a distance, as if it were suspended in space, as the title indicates. But the *Cup* evokes an immediate tactile response because we think of drinking from it, of touching it to our lips, and its furry texture repels us. At the same time, however, the *Cup* amuses us because of its contradictory nature. Whereas our line of vision soars vertically with the *Bird,* we instinctively withdraw from the *Cup.*

Iconography and Iconology

The **iconographic** method emphasizes the content of art. The term denotes the "writing" (*graphe* in Greek) of an image (from the Greek word *eikon*) and implies that a written text underlies an image. In Bruegel's *Tower of Babel* (see fig. **1.5**) the biblical text is Genesis 11:6, in which God becomes alarmed at the height of the tower. He fears that the builders will invade his territory and threaten his authority. The iconographic elements of Bruegel's picture include the tower as well as the figures and other objects depicted. The tower referred to in the Bible was probably a ziggurat commissioned by King Nebuchadnezzar of ancient Babylon, who is depicted with his entourage at the lower left of the picture. He has apparently come to review the progress of the work, which—according to the text—is about to stop. Bruegel shows this by the downward pull at the center of the tower that makes it seem about to cave in. He also refers to God's fear that the tower will reach into the heavens by painting a small white cloud overlapping the top of the tower. The cloud heightens dramatic tension by referring to the divine retribution that will follow. Recognizing the symbolic importance of this iconographic detail enriches our understanding of the work.

Iconology is the interpretation of the rationale behind a group of works, called a **program.** In a Gothic cathedral, for example, an iconographic approach would consider the textual basis for a single statue or scene in a **stained-glass** window. Iconology, on the other hand, would consider the choice and arrangement of subjects represented in the entire cathedral and explore their interrelationships.

Marxism

The Marxist approach to art derives from the writings of Karl Marx, the nineteenth-century German social scientist and philosopher whose ideas were developed into

the political doctrines of socialism and communism. Marx himself, influenced by the Industrial Revolution, was interested in the process of making art and its exploitation by the ruling classes. He contrasted the workers (proletariat) who create art with the property-owning classes (the bourgeoisie) who exploit the workers, and he believed that this distinction led to an alienation of artists from their own productions. Marxist art historians, and those influenced by Marxism, study the relationship of art to economic factors (e.g., cost and availability of materials) within its social context. They analyze patronage in relation to political and economic systems. Marxists study form and content not for their own sake, but for the social messages they convey and for evidence of the manipulation of art by the ruling class to enhance its own power.

A Marxist reading of Bruegel's *Tower* might associate the builders with the proletariat and Nebuchadnezzar with the bourgeoisie. Bruegel emphasizes the greater status of Nebuchadnezzar in relation to the workers by his larger size, his upright stance, and his royal following. Not only are the workers much smaller, but some kneel before the king.

Feminism

Feminist methodology assumes that the making of art, as well as its iconography and its reception by viewers, is influenced by gender. Feminists are opposed to pure formalism on the grounds that it ignores content. Feminist art historians have pointed out ways in which women have been discriminated against by the male-dominated art world. They have noted that before the 1970s the leading art-history textbooks did not include female artists. They have also researched women's contributions to art history as both artists and patrons, rescuing significant figures from obscurity as well as broadening our sense of the role of art in society. Feminists take issue with traditional definitions of art and notions of artistic genius, both of which have historically tended to exclude women. The fact that traditionally it has been difficult for women to receive the same training in art as men, owing in part to family obligations and the demands of motherhood and in part to social taboos, is an issue that feminists have done much to illuminate.

Taking the example of this introductory chapter, a feminist might point out that of eight illustrations of works of art only one is by a woman (fig. **1.8**). Furthermore, its subject is related to the woman's traditional role as the maker and server of food in the household. At the same time, the work is a visual joke constructed by a woman that combines female sexuality with the oral activity of eating and drinking. The "household" character of the *Fur-Covered Cup* contrasts with the "divine" character of *God as Architect (God Drawing the Universe with a Compass)* (see fig. **1.4**). As depicted by the illustrations in this chapter, the male figures are gods, kings, soldiers, and workers, whereas the female figures are mothers.

Biography and Autobiography

Biographical and autobiographical approaches to art interpret works as expressions of the artists' lives and personalities. These methods have the longest history, beginning with the mythic associations of gods and artists described above. Epic heroes such as Gilgamesh and Aeneas are credited with the architectural activity of building walls and founding cities. The anecdotes of Pliny the Elder about ancient Greek artists have a more historical character, which was revived in fourteenth-century Italy. Vasari's *Lives of the Artists,* written in the sixteenth century, covers artists from the late thirteenth century up to his own time and concludes with his own autobiography. From the fifteenth century on, the genre of biography and autobiography of artists has expanded into various literary forms—for example, sonnets (Michelangelo), memoirs (Vigée-Lebrun), journals (Delacroix), letters (van Gogh), and, more recently, films and taped interviews.

The biographical method emphasizes authorship and can be applied to iconography by using the artist's life as an underlying "text." This being said, there are certain conventions of artists' biographies and autobiographies that are remarkably consistent and that appear in quite divergent social and historical contexts. These conventions draw a parallel between artists and gods, especially in the ability to create illusion. They also include episodes in which an older artist recognizes talent in a child destined to become great, the renunciation of one's art (or even suicide) when confronted with the work of superior artists, sibling rivalry between artists, artists who are rescued from danger by their talent, and women as muses for (male) artists.

Whistler's portrait of his mother (see fig. **1.6**) obviously has autobiographical meaning. By placing his own etchings on the wall beside her, he relates her dour personality to his black-and-white drawings and etchings rather than to his more colorful paintings. Vincent van Gogh's *Self-Portrait before His Easel* (see fig. **1.1**) is one of many self-portraits that reflect the artist's inner conflicts through the dynamic tension of line and color.

Semiology

Semiology—the science of signs—takes issue with the biographical method and with much of formalism. It includes structuralism, poststructuralism, and deconstruction. Structuralism developed from structural linguistics in the late nineteenth and early twentieth centuries as an attempt to identify universal and meaningful patterns in various cultural expressions. There are several structuralist approaches to art, but in general they diverge from the equation of artists with gods, from the Platonic notion of art as *mimesis* (making exact copies of nature), and from the view that the meaning of a work is conveyed exclusively by its author.

In the structural linguistics of the Swiss scholar Ferdinand de Saussure, a "sign" is composed of "signifier" and

"signified." The former is the sound or written element (such as the four letters *p-i-p-e*), and the latter is the concept of what the sign refers to (in this case a pipe). A central feature of this theory is that the relation between signifier and signified is entirely arbitrary. Saussure insists on that point specifically to counter the conviction that there is an ideal essence of a thing, a "linguistic equivalent." The notion of linguistic equivalents derived from the belief that in the original language spoken by Adam and Eve, words naturally matched the essence of what they referred to, so that signifier and signified were naturally related to each other. Even before Adam and Eve, the logocentric (word-centered) Judaic God had created the world through language: "Let there be light" made light, and "Let there be darkness" made darkness. The New Testament **Gospel** of John (1:1) takes up this view again, opening with "In the beginning was the Word."

For certain semioticians, however, some relation between signifier and signified is allowed. These would agree that Magritte's painted pipe is closer to the idea of pipeness than the four letters *p-i-p-e*. But most semioticians prefer to base stylistic categories on signs rather than on formal elements. For example, Magritte's pipe and Oppenheim's cup do not resemble each other formally, yet both have been related to Dada and Surrealism. Their similarities lie not in shared formal elements but rather in their ability to evoke surprise by disrupting expectations. We do not expect to read a denial of the "pipeness" of a convincing image of a pipe written by the very artist who painted it. Nor do we expect fur-covered cups and spoons, because the fur interferes with their function. The unexpected—and humorous—qualities of the pipe and the cup could be considered signs of certain twentieth-century developments in imagery. Another element shared by these two works is the twentieth-century primacy of everyday objects, which can also be considered a sign.

Deconstruction

The analytical method known as deconstruction is most often associated with Jacques Derrida, a French poststructuralist philosopher who discusses art as well as written texts. Derrida opens up meanings, rather than fixing them within structural patterns. But he shares with the structuralists the notion that a work has no ultimate meaning conferred by its author.

Derrida's technique for opening up meanings is to question assumptions about works. Whistler's mother (see fig. **1.6**), for example, seems to be sitting for her portrait, but we have no proof from the painting itself that she ever did so. Whistler could have painted her from a photograph or from memory, in which case our initial assumption about the circumstances of the work's creation would be basically untrue, even though the portrait is a remarkably "truthful" rendering of a puritanical woman.

Derrida also opens up the Western tendency to binary pairing: right/left, positive/negative, male/female, and so

forth. He notes that one of a pair evokes its other half and plays on the relationship between presence and absence. Since a pair of parents is a biological given, where, a Derridean might ask, is Whistler's father? In the pairing of father and mother, the present parent evokes the absent parent. There is, in Whistler's painting, no reference to his father—only to himself, in the etchings hanging on the wall. The absent father, the present mother, the etchings of the son—the combination invites speculation about their relationships: for example, was the son trying to displace the father? Such psychological considerations lead us to the psychoanalytic methodologies.

Psychoanalysis

The branch of psychology known as psychoanalysis was originated by the Austrian neurologist Sigmund Freud in the late nineteenth century. Like art history, psychoanalysis deals with imagery, history, and creativity. Like archaeology, it reconstructs the past and interprets the relevance of the past to the present. The imagery examined by psychoanalysts is found in dreams, jokes, slips of the tongue, and neurotic symptoms, and it reveals the unconscious mind (which, like a buried city, is a repository of the past). In a work of art, personal imagery is reworked into a new form that "speaks" to a cultural audience. It thus becomes part of a history of style (and, for semioticians, of signs).

Psychoanalysis has been applied to art in different ways. In 1910 Freud published the first psychobiography of an artist, in which he explored the personality of Leonardo da Vinci through the artist's writings, iconography, and working methods. For Freud, the cornerstone of psychoanalysis was the Oedipus complex, which can be applied to Whistler's painting of his mother. An oedipal reading of that work is enriched by the fact that it contains an **underpainting** of a baby. An oedipal reading of Brancusi's *Bird* would have to consider the artist's relationship to his peasant father, an ignorant and abusive man who would have preferred his son to have been born a girl. In that light, the sculpture has been interpreted as a phallic self-image, declaring its triumph over gravity and outshining the sun. With *Bird in Space,* Brancusi symbolically "defeats" his father and "stands up" for himself as a creator (see fig. **1.2**).

According to classical psychoanalysis, works of art are "sublimations of instinct" through which instinctual energy is transformed by work and talent into aesthetic form. The ability to sublimate is one of the main differences between humans and animals, and it is necessary for creative development in any field. Because art is **expressive**, it reveals aspects of the artist who creates it, of the patron who funds it, and of the culture in which it is produced.

Chapter 2 considers the visual elements used by artists to communicate the complex layers of meaning in imagery. A review of these elements will facilitate the exploration of art history and archaeology.

2
The Language of Art

The visual arts have their own language, and the artist thinks in terms of that language, just as a musician thinks in sounds and a mathematician thinks in numbers. The basic visual vocabulary consists of **formal elements,** which include line, shape, space, color, light, and dark. When artists combine these elements in a characteristic way, they are said to have a **style.** In order to describe and analyze a work of art, it is essential to be familiar with the artist's formal vocabulary.

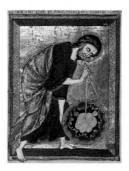

See figure 1.2. Constantin Brancusi, *Bird in Space,* 1928.

Composition

The **composition** of a work of art is its overall plan or structure. Composition denotes the relationship among component parts and involves balance and harmony, the relationships of parts to each other and to the whole work, and the effect on the viewer. The composition of a work depends on how the formal elements are arranged and is distinct from subject matter, content, or theme.

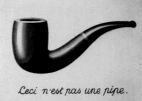

See figure 1.3. René Magritte, *The Betrayal of Images* ("This is not a pipe."), 1928.

Plane

A **plane** is a flat surface having a direction in space. Brancusi's *Bird* (see fig. **1.2**) rises in a vertical plane, Magritte's pipe (see fig. **1.3**) lies in a horizontal plane, and the figure of God in *God as Architect* (see fig. **1.4**) bends over to create two diagonal planes.

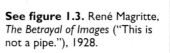

See figure 1.4. *God as Architect (God Drawing the Universe with a Compass),* mid-13th century.

Balance

In a successful composition, the harmonious blending of formal elements creates **balance.** The simplest form of balance is **symmetry,** in which there is an exact correspondence of parts on either side of a central axis—the left side of a work is a mirror image of the right side. The human body is an example of symmetry, as shown in Leonardo's *Vitruvian Man* (see fig. **16.1**).

See figure 16.1. Leonardo da Vinci, *Vitruvian Man,* c. 1485–90.

Balance can also be achieved by nonequivalent elements. In Bernini's *David* (see fig. **19.13**), the weight of the figure is not evenly distributed on either side of the central axis. However, although the parts are not arranged symmetrically, there is an equilibrium between them that produces an aesthetically satisfying result. This is known as **asymmetrical balance**.

See figure 19.13.
Gianlorenzo Bernini, *David*, 1623.

Line

A line is the path traced by a moving point. For the artist, the moving point is the tip of whatever instrument is used to create an image on a surface. In geometry, a line has no width or volume; it has only length and direction. In the language of art, however, a line can have many qualities, depending on how it is drawn (fig. **2.1**). A vertical line seems to stand stiffly at attention, a horizontal line lies down, and a diagonal seems to be falling over. Zigzags have an aggressive, sharp quality, whereas a wavy line is more graceful and, like a curve, more naturally associated with the outline of the human body. Parallel lines are balanced and harmonious, implying an endless, continuous movement. Perpendicular, converging, and intersecting lines meet and create a sense of force and counterforce. In figure **2.1**, the thin line (a) seems delicate, unassertive, even weak. The thick one (b) seems aggressive, forceful, and strong. The flat line (c) suggests calmness, like the surface of a quiet sea, whereas the wavy line (d) implies the reverse. The angular line (e) climbs upward like the edge of a rocky mountain. (Westerners understand (e) as going up and (f) as going down because we read from left to right.)

Expressive Qualities of Line

Many of the lines in figure **2.1** are familiar from geometry and can be described formally. But the formal qualities of line also convey an expressive character because we identify them with our bodies and our experience of nature. In math, for instance, a straight line is the shortest distance between two points; similarly, a person who follows a straight, clear line in thought or action is believed to have a sense of purpose. "Straight" is associated with rightness, honesty, and truth, while "crooked"—whether referring to a line or a person's character—denotes the opposite. When a baseball player hits a line drive, the bat connects firmly with the ball; and a "hard-liner" is a person who takes a strong position on an issue.

In the configuration of the face, it is especially easy to see the expressive impact of lines (fig. **2.2**). In (a), the upward curves create a happy face, and in (b) the downward curves create a sad one. These characteristics of upward and downward curves actually correspond to the emotions as expressed in natural physiognomy. They are

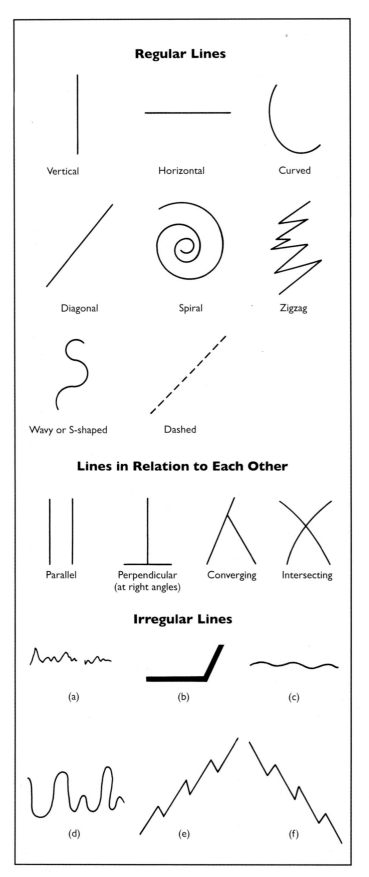

2.1 Lines.

2.2 Lines used to create facial expressions.

reflected in language when we speak of people having "ups and downs" or of events being "uppers" or "downers." The face in (c) is inscrutable.

Alexander Calder's (1898–1976) *Cat* (fig. **2.3**) merges the **linear** quality of the written word with the pictorial quality of what the word represents. The curve of the *c* outlines the

2.3 Alexander Calder, *Cat* (detail from *Children's Page*), 1943, 22 × 30 in. (55.9 × 76.2 cm).

face, a dot stands for the eye, and a slight diagonal of white in the curve suggests the mouth. The large *A* comprises the body, feet, and tail, while the tiny *t* completes the word, without interfering with reading the ensemble as a cat. The figure seems to be walking, because the left diagonal of the *A* is lower than the right one, and the short horizontals at the base of the *A* suggest feet. Not only is this cat a self-image—*C A* are the artist's initials reversed—but it defies the semiotic argument that signifier *(c-a-t)* and signified (the mental image of a cat) have no natural relation to each other.

The importance of line in the artist's vocabulary is illustrated by the account of two ancient Greek painters, Apelles, who was Alexander the Great's personal artist, and his contemporary Protogenes. Apelles traveled to Rhodes to see Protogenes' work, but when he arrived at the studio, Protogenes was away. An old woman in charge of the studio asked Apelles to leave his name. Instead, Apelles took up a brush and painted a line of color on a panel prepared for painting. "Say it was this person," he instructed the woman.

When Protogenes returned and saw the line, he immediately recognized that only Apelles could have painted it so perfectly. In response, Protogenes painted a second, and finer, line on top of it. Apelles returned and added a third line of color, leaving no more room on the original line. When Protogenes returned a second time, he admitted defeat and went to look for Apelles.

Protogenes decided to leave the panel to posterity as something for artists to marvel at. Later it was exhibited in Rome, where its nearly invisible lines on a vast surface impressed viewers. To many artists, the panel seemed a blank space, and because of that it was esteemed over other famous works. After his encounter with Protogenes, it was said that Apelles never let a day go by without drawing at least one line. His experience was the origin of an ancient proverb, "No day without a line."

Lines Used for Modeling

Even though drawn lines have only two dimensions—height and width—they can be used by an artist to make an object appear **three-dimensional** (fig. 2.4).

The parallel **modeling** lines on the front surface of the cube are called **hatching**. If they intersect other parallel lines, as in the cylinder and the oblique surface of the cube, they are known as **crosshatching**. The closer the lines are to each other, the darker their surface. They suggest shade or **shading**, which is a gradual transition from light to dark. Shading appears on the side of the object that is turned away from the light source. A **shadow** is seen as dark and denotes the absence of light; it is cast onto a surface when the source of light is blocked by an object.

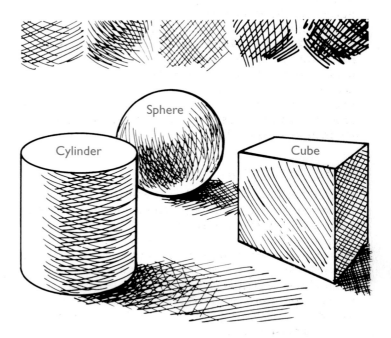

2.4 The lines on the sphere, cube, and cylinder create the illusion that these objects are solid. They also suggest that there is a source of light coming from the upper left and shining down on the objects. Such lines are called modeling lines.

The Illusion of Depth

Techniques for creating an illusion of three dimensions in a two-dimensional image include:

- Using modeling lines to simulate three-dimensionality (see fig. **2.4**).
- Making a nearer object overlap a more distant one.
- Depicting a nearer object as larger than a more distant one.
- Making the base of the nearer object closer to the lower edge of the picture.

Note that in figure **2.4** the cylinder appears closer to us than the sphere, because the cylinder is larger and nearer the lower edge of the picture. It also overlaps part of the sphere.

Perspective

Artists have also developed mathematical systems, known as **perspective**, to aid them in creating the illusion of depth. The simplest system is **one-point perspective** (fig. **2.5**). Imagine a person standing in the middle of a straight road. As the road vanishes into the distance, it seems to the viewer to narrow, even though in reality its width is constant. The illusion of depth is enhanced by the fact that equal-sized and equally spaced objects along the side of the road seem to become smaller, and the spaces between them become shorter (**foreshortened**), as their distance from the viewer increases.

In early-fifteenth-century Italy (see Chapter 15), a system was developed to provide artists with a method for depicting figures and objects as if located at increasing distances from the viewer. The **picture plane** (the surface of a painting or relief sculpture) is conceived of as a window whose frame conforms to the frame of the painting. The edges of **rectilinear** objects in the picture are extended along imaginary "lines of sight." These lines, called **orthogonals** (from two Greek words—*orthos,* meaning "right" or "straight," and *gonia,* meaning "angle"), are perpendicular to the picture plane and parallel to each other. Although parallel lines never meet in reality, the orthogonals seem to converge at a point known as the **vanishing point**. In the simplest form of this method, the vanishing point is on the horizon, at the eye level of the viewer, but it can be anywhere inside the composition or even outside it. This system focuses attention on a single vanishing point and assumes that the viewer is standing at a single fixed spot. In figure **2.5** the vanishing point is at the center of the horizon line, where the sides of the road (the orthogonals) meet.

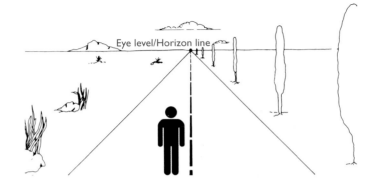

2.5 One-point perspective.

Space

In a picture, depth is an illusion. But in sculptures and buildings, depth is real, and that makes it more difficult to perceive the nature of these works in two-dimensional reproductions. In this text, therefore, sculptures are sometimes shown from two viewpoints. Buildings are diagrammed axonometrically, and their plans are illustrated.

A plan is a diagram of a building from just above ground level, indicating where the structural parts meet the ground. Taking the simple example of figure **2.4,** a plan of the cube would be a square; a plan of the cylinder would be a circle; and a plan of the sphere would be a point where the object makes contact with the surface on which it stands. **Axonometric** drawings are more complex; they diagram all the parts of a building as if it is turned at an oblique angle to the flat drawing surface. An example can be seen in Chapter 10, where an axonometric drawing of the Byzantine church of Hagia Sophia (see fig. **10.14**) shows its plan, its walls, its interior, and its dome.

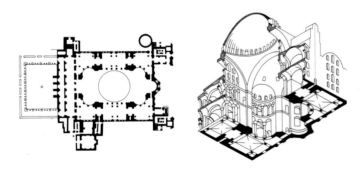

See figure 10.14a, b. Plan and axonometric projection of Hagia Sophia.

Shape

When lines enclose a space, they create a shape, and the line that outlines the shape is called its **contour**.

Types of Shapes

Regular shapes are **geometric** and have specific names. Irregular shapes are also called "biomorphs" or **biomorphic** (from the Greek words *bios,* meaning "life," and *morphe,* meaning "shape") because they seem to move like living **organic** matter. Shapes can be two-dimensional (fig. **2.6**) or three-dimensional, in which case they are solid or have volume (see fig. **2.4**).

Expressive Qualities of Shape

Like lines, shapes can be used by artists to convey ideas and emotions. Open shapes create a greater sense of movement than closed ones (fig. **2.6**). Similarly, we speak of open and closed minds. An open mind allows for a flow of ideas, flexibility, and willingness to entertain new possibilities. A closed mind, on the other hand, is inaccessible to new ideas.

Specific shapes can evoke associations with everyday experience. The square, for example, is a symbol of reliability, stability, and symmetry. If something is "all square," a certain equity or evenness is implied; a "square meal" is satisfying in both amount and content. But too much rectangularity can imply dullness or monotony—to call someone "a square" suggests overconservatism or conventionality.

The circle has had a special significance for artists since the Neolithic era. In the Roman period, the circle was considered a divine shape and thus most suitable for temples. This view of the circle persisted in the Middle Ages and the Renaissance, when ideal church plans were also circular and the ideal city was designed according to a centralized plan.

Light and Color

The technical definition of light is electromagnetic energy of certain wavelengths, which produces visual sensations when it strikes the retina of the eye. The opposite, or the absence, of light is darkness. Color, one of the most powerful elements at the artist's disposal, is derived from light. Rays of light emanating from the sun are composed of waves with various wavelengths (i.e., they vibrate at various frequencies), and these are perceived by the human brain as different colors. This can be demonstrated by passing a beam of light through a prism (a triangular block of glass), which breaks the light down into its constituent **hues** (colors) (fig. **2.7**). This is the same phenomenon as a rainbow, in which rays of light from the sun are refracted through falling raindrops.

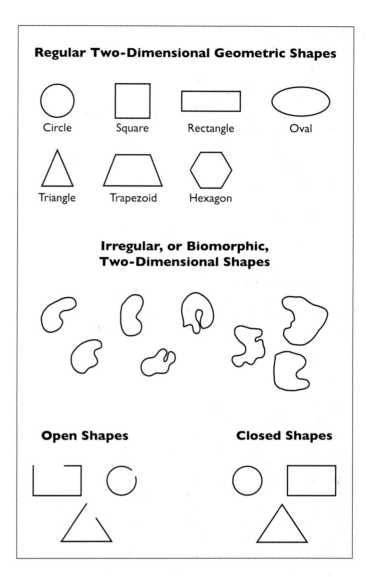

2.6 Shapes.

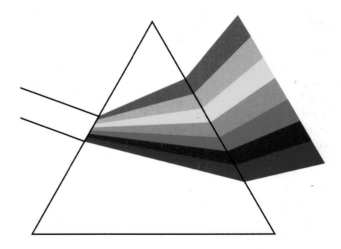

2.7 The **visible spectrum** has seven principal colors—red, orange, yellow, green, blue, indigo (or blue-violet), and violet—that blend together in a continuum. Beyond the ends is a range of other colors, starting with infrared and ultraviolet, which are invisible to the human eye. If all the colors of the spectrum are recombined, white light is again produced.

Physical Properties of Color

There are seven principal colors in the spectrum. Each of the seven has many variations, which depend on the three physical properties of color: **hue**, **value**, and **intensity.**

Hue Hue is synonymous with color. Red is one hue, yellow is another. Each has a different wavelength. Mixing one color with another changes its wavelength and hence its hue. Red plus yellow, for example, produces orange; adding more red makes a reddish orange, and adding yellow makes a yellowish orange.

Red, yellow, and blue are **primary colors;** they cannot be produced by combining any other colors. However, all of the other colors can be created by mixing the primary colors either in pairs or all together. A mixture of two primary colors produces a **secondary color:** yellow and blue produce green, blue and red produce violet, red and yellow produce orange. A **tertiary** or **intermediate color** can be formed by combining a primary with an associated secondary color.

Hues containing a common color, although in different proportions, are known as **analogous hues,** and their combination produces a feeling of color harmony in a work of art. If only a single hue is used, the work is said to be **monochromatic** (from the Greek words *monos,* meaning "single," and *chroma,* meaning "color").

The conventional **color wheel** (fig. **2.8**) illustrates the relationships between colors. The farther hues are from each other, the less they have in common and the higher their contrast. Hues directly opposite each other (red and green, for example) are the most contrasting and are known as **complementary colors.** They are often juxtaposed when a strong, eye-catching contrast is desired. Mixing two complementary hues, on the other hand, has a neutralizing effect and lessens the intensity of each. This can be seen in figure **2.8** as you look across the wheel from red to green. Red's intensity decreases, and the gray circle in the center represents a "standoff" between all the complementary colors.

Value The relative lightness or darkness of an image is its value, also called brightness, shade, or tone. An object's value is a function of the amount of light reflected from its surface. Gray, for example, reflects more light than black but less than white, which makes gray lighter than black and darker than white. The **value scale** in figure **2.9** provides an absolute value for different shades.

Value is characteristic of both **achromatic** works of art—those with no color, consisting of black, white, and shades of gray—and **chromatic** ones. On a scale of color values (fig. **2.10**), yellow reflects a relatively large amount of light, approximately equivalent to "high light" on the **neutral** scale, whereas blue is equivalent to "high dark." The normal value of each color indicates the amount of light it reflects at its maximum intensity. The addition of white or black would alter its value (i.e., make it lighter or darker) but not its hue. The addition of one color to another would change not only the values of the two colors but also their hues.

Intensity In total darkness, colors are invisible; in dim light they are muted and difficult to distinguish; in bright light, color is at its most intense. Intensity (also known as **saturation**) refers to the brightness or dullness of a color. There are four methods of changing the intensity of colors. The first is to add white. Adding white to pure red creates light red or pink, which is lighter in value and less intense. If black is added, the result is darker in value and less intense. If gray of the same value as the red is added, the result is less intense but retains the same value. The fourth way of changing a color's intensity is to add its complementary hue. This makes the mixed color less intense and more neutral than the original.

Expressive Qualities of Color

Just as lines and shapes have expressive qualities, so too do colors. Bright or warm colors convey a feeling of gaiety and happiness. Red, orange, and yellow are generally considered warm, perhaps because of their association with fire and the sun. It has been verified by psychological tests that the color red tends to produce feelings of happiness. Blue, and any other hue containing blue—green, violet, blue-green—is considered cool, possibly because of

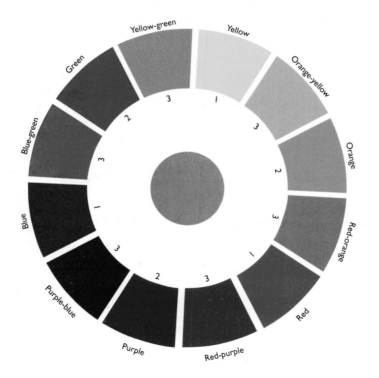

2.8 The color wheel. Note that the three primary (1) colors—red, yellow, and blue—are equally spaced around the circumference. They are separated by their secondary (2) colors. Between each primary and its two secondaries are their related tertiaries (3), giving a total of twelve hues on the rim of the wheel.

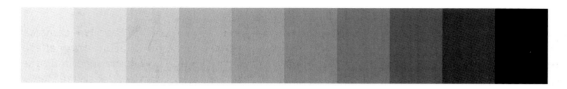

2.9 This ten-step value scale breaks the various shades from white to black into ten gradations. The choice of ten is somewhat arbitrary because there are many more values between pure white and pure black. Nevertheless, it illustrates the principle of value gradations.

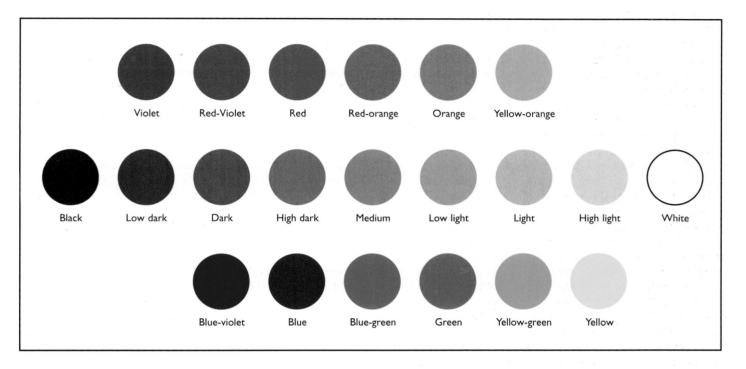

2.10 A color-value scale. The central row contains a range of neutrals from black to white; the rows above and below match the twelve colors from the color wheel with the neutrals in terms of the amount of light reflected by each.

its association with the sky and water. If we look at figure 2.2 with colors added (fig. **2.11**), we see that the orange brightens the happy face and that blue reinforces the sad face. The impassive face remains the same.

Colors can also have symbolic significance. Red, for example, can symbolize danger, as when one waves a red flag in front of a bull. But to "roll out the red carpet" means to welcome someone in an extravagant way, and we speak of a "red-letter day" when something particularly exciting has occurred. Yellow can be associated with cowardice, white with purity, and purple with luxury, wealth, and roy-alty. We might call people "green with envy," "purple with rage," or, if they are quietly gloomy, "in a brown study."

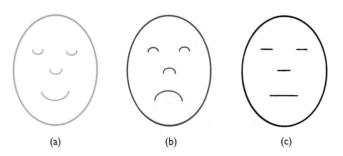

2.11 Color reinforcing the expressive quality of line.

Texture

Texture (from the Latin word *texo,* meaning "I weave") refers to the surface characteristics of an object. These are usually described by adjectives such as rough or polished, hard or soft, firm or fluffy, coarse or fine, cold (like steel) or warm (like wood), shiny or matte, stiff or pliable.

Texture is associated with the tactile sense (the sense of touch) and indirectly with vision. By touching or feeling an object, we experience its texture directly. But as soon as we see something, we either recognize its texture from experience or make an assumption based on how it looks. When we explore art, the senses of sight and touch interact.

It is necessary to distinguish between actual texture and simulated (or implied) texture. Actual texture is the surface quality of a real object. Van Gogh's jacket in figure **1.1** appears coarse; it is thus an example of simulated texture. But Oppenheim's *Fur-Covered Cup* (see fig. **1.8**) has an actual furry texture.

Until the mid-nineteenth century, it was customary for painters to create illusions of texture. During the past 150 years, however, certain painters have incorporated the medium itself into the work's impact. Brushstrokes have intentionally been made visible so as to arouse the viewer's sense of touch. Since the late 1940s, many artists have emphasized the medium to the point where its literal tactile character is a central aspect of the image.

Stylistic Terminology

Subject matter refers to what is represented in a work of art. **Content** refers to themes, values, or ideas, as distinct from **form**. The following terms describe representational, or figurative, works of art, which depict recognizable subject matter:

- **Naturalistic:** depicting figures and objects more or less as we see them (see fig. **15.36**).

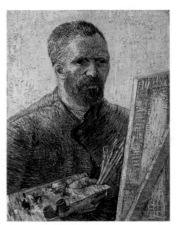

See figure 1.1. Vincent van Gogh, *Self-Portrait before His Easel,* 1888.

See figure 15.36. Jan van Eyck, *Man in a Red Turban,* 1433.

- **Realistic:** depicting figures and objects to resemble their actual appearances, rather than in a distorted or abstract way (see fig. **1.3**).

See figure 1.8. Meret Oppenheim, *Fur-Covered Cup, Saucer, and Spoon (Le Déjeuner en Fourrure),* 1936.

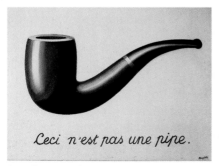

See figure 1.3. René Magritte, *The Betrayal of Images* ("This is not a pipe."), 1928.

- **Illusionistic:** depicting figures, objects, and the space they occupy so convincingly that an appearance of reality is achieved (see fig. **31.3**).

See figure 31.3. Duane Hanson, *The Cowboy*, 1995.

If an image is representational but not especially faithful to its subject, it may be described as follows:

- **Idealized:** depicting an object according to an accepted standard of beauty (see fig. **7.14**).

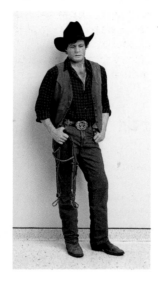

See figure 7.14. Polykleitos, *Doryphoros (Spear Bearer)*, c. 440 B.C.

- **Stylized:** depicting certain features as nonorganic surface elements rather than naturalistically or realistically (see fig. **4.12**).

See figure 4.12. Head of Gudea, c. 2100 B.C.

- **Romanticized:** depicting its subject in a nostalgic, emotional, fanciful, or mysterious way (see fig. **22.12**).

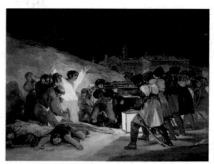

See figure 22.12. Francisco de Goya y Lucientes, *The Executions of the Third of May, 1808,* 1814.

If the subject matter of a work has little or no relation to observable reality, it may be described as follows:

- **Nonrepresentational** or **nonfigurative:** the opposite of representational or figurative, implying that the work does not depict (or claim to depict) figures or objects (see fig. **29.5a**).

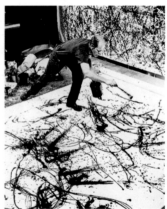

See figure 29.5a. Hans Namuth, *Jackson Pollock*, 1950.

- **Abstract:** describes forms that do not accurately depict real objects. The artist may be attempting to convey the essence of an object rather than its actual appearance. Note that the subject matter may be recognizable (making the work representational) but in a nonnaturalistic form (see fig. **1.2**).

See figure 1.2. Constantin Brancusi, *Bird in Space*, 1928.

2.12a Theo van Doesburg, *Study 1 for Composition (The Cow)*, 1916. Pencil on paper, 4⅝ × 6¼ in. (11.7 × 15.9 cm). Museum of Modern Art, New York. Purchase.

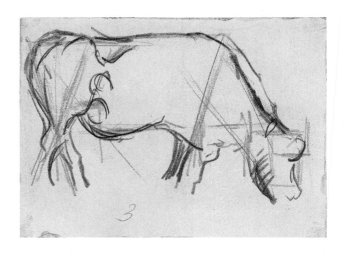

2.12b Theo van Doesburg, *Study 2 for Composition (The Cow)*, 1917. Pencil on paper, 4⅝ × 6¼ in. (11.7 × 15.9 cm). Museum of Modern Art, New York. Purchase.

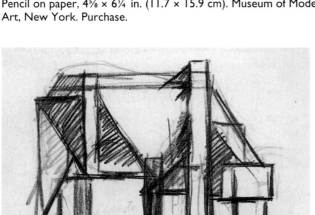

2.12c Theo van Doesburg, *Study 3 for Composition (The Cow)*, 1917. Pencil on paper, 4⅝ × 6¼ in. (11.7 × 15.9 cm). Museum of Modern Art, New York. Gift of Nelly van Doesburg.

2.12d Theo van Doesburg, *Study for Composition (The Cow)*, c. 1917; dated 1916. Tempera, oil, and charcoal on paper, 15⅝ × 22¾ in. (39.7 × 57.8 cm). Museum of Modern Art, New York. Purchase.

2.12e Theo van Doesburg, *Study for Composition (The Cow)*, c. 1917. Oil on canvas, 14¾ × 25 in. (37.5 × 63.5 cm). Museum of Modern Art, New York. Purchase.

A transition from naturalism to geometric abstraction is demonstrated by the early-twentieth-century Dutch artist Theo van Doesburg in figure **2.12**. His drawing of a cow evolved from image (a), which could be called naturalistic, figurative, or representational, to the abstract arrangement of flat squares and rectangles in (e). In (a) and (b), the form is recognizable as that of a cow—it is composed of curved outlines and a shaded surface that create an illusion of three dimensions. In (c), the cow is still recognizable, but it is no longer naturalistic. It is now devoid of curves but is still shaded—it has become a series of solid geometric shapes. Even in (d), the general form of the cow is recognizable in terms of squares, rectangles, and triangles, but there is no longer any shading. As a result, each distinct color area is flat. Finally, in image (e) the shapes can no longer be related to the original natural form. It is thus a pure abstraction, which is also nonfigurative, even though it represents a cow.

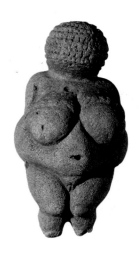

3

Prehistoric Western Europe

W ho are we? Where do we come from? Where are we going? These are three of the most universal questions we ask ourselves. They are about time and the nature of the human condition.

Works of art help us to answer these questions. We will begin our exploration of the arts by going back in time to early periods of human history, to the study of prehistory. Prehistory refers to a time before the invention of writing, although objects and images are historical records as well. The challenge lies in discovering how to read and interpret them.

The Stone Age

To organize the vast time span of prehistory, scholars divide the Stone Age in Western Europe into three periods. Paleolithic (from the Greek words *palaios,* meaning "old," and *lithos,* meaning "stone") is the earliest and the longest. It lasted from c. 1,500,000 to c. 8000 B.C. The Mesolithic ("middle stone") period extended from around 8000 to 6000 B.C. in southeastern Europe and c. 8000 to c. 4000 B.C. in the rest of Europe. The Neolithic ("new stone") period dates from c. 6000/4000 B.C. to c. 3000 B.C. and continued for another thousand years in northwestern Europe.

The designation of these periods as Stone Age derives from the use of stone tools and weapons. As technology developed, metal replaced stone for many purposes. Then, as now, technological and social change went hand in hand, bringing the Stone Age to a gradual close.

Paleolithic (c. 1,500,000–c. 8000 B.C.)

By around 50,000 B.C. in Europe, our own subspecies, *Homo sapiens sapiens* (literally "wise wise man"), had supplanted *Homo sapiens,* who had developed complex cultures. We can gain some understanding of Paleolithic society by interpreting the physical record. But because ideas cannot be fossilized, there is much that will never be known.

Inferences about Paleolithic religion have been drawn from ritual burial practices. Red ocher—possibly symbol-

Prehistoric sites in Europe.

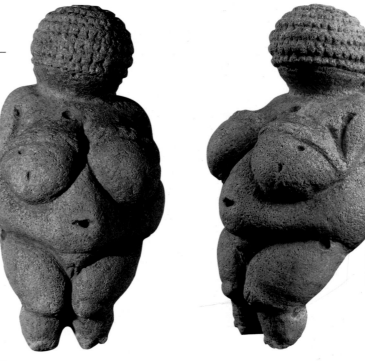

izing blood—was sprinkled on corpses, and objects of personal adornment (such as necklaces) were buried with them. Bodies were arranged in the fetal position, often oriented toward the rising sun, which must have seemed reborn with each new day. Such practices suggest a belief in life after death and offer some insight into the way Paleolithic people answered the third question posed at the start of this chapter: Where are we going?

Paleolithic people were nomadic hunters and gatherers, who lived communally. They built shelters at cave entrances, under rocky overhangs. Their tents were made of animal skins and their huts of mud, plant fibers, stone, and bone. Fire had been in use for some 600,000 years, and there is evidence of hearths in Paleolithic homes.

Although the invention of writing was still far off, people made symbolic marks on hard surfaces, such as bone and stone, possibly to keep track of time. The sophistication of Paleolithic art suggests that language —the ability to communicate with words and tell stories— had also developed, and language in itself requires a sense of sequence and time.

The earliest surviving works of Western art correspond roughly to the final stages of the Ice Age in Europe and date back to about 30,000 B.C. Before that time, objects were made primarily for utilitarian purposes, although many have aesthetic qualities. It is important to remember, however, that our modern Western concept of "art" would almost certainly have been alien in the Stone Age, when an object's aesthetic value was inseparable from its function.

Sculpture

Perhaps the most famous Paleolithic sculpture is the so-called *Venus of Willendorf* (fig. **3.1**), a striking figure carved out of limestone and variously dated from 25,000 B.C. to 21,000 B.C. Although this figure can be held in the palm of one's hand, it is a **monumental** object with a sense of organic form. The term *monumental* can mean literally "very big" or, as is the case here, "having the quality of appearing big." The rhythmic arrangement of bulbous oval shapes emphasizes the head, breasts, torso, and thighs. The scale of these elements in relation to the whole is quite large, while the facial features, neck, and lower legs are

3.1a, b *Venus of Willendorf* (front and side views), from Willendorf, Austria, c. 25,000–21,000 B.C. Limestone, 4⅜ in. (11.5 cm) high. Naturhistorisches Museum, Vienna, Austria.

virtually eliminated. The arms, resting on the breasts, are so undeveloped as to be hardly noticeable. What, we might ask, did she mean to the artist who carved her? And what was her function in her cultural context?

In the absence of written records, we can only speculate. Clearly, the artist emphasized those parts of the body related to reproduction and nursing. Furthermore, comparison of the front with the side and back shows that, although the *Venus* is a sculpture in the round (see Box), more attention has been lavished on the front. The exaggeration of the breasts and pelvis has led some scholars to conclude that the *Venus of Willendorf* represented a fertility goddess. Reinforcing this reading are traces of red **pigment** that may have been associated with childbirth.

This is one of a number of prehistoric female **figurines** (small figures) that scholars have nicknamed *Venus* (after the much later Roman goddess of love and beauty),

TECHNIQUE
Carving

Carving is a subtractive technique in which a sculptor uses a sharp instrument such as a knife, gouge, or chisel to remove material from a hard substance such as bone, wood, or stone. After an image is shaped, it can be sanded, filed, or polished. The *Venus of Willendorf* was not polished, although some Paleolithic sculptures were. It is made of limestone, which does not polish as well as other types of stone.

TECHNIQUE
Modeling

Modeling, unlike carving, is an additive process, and its materials (such as clay) are pliable rather than hard. The primary tools are the artist's hands, especially the thumbs, although various other tools can be used. Until the material dries and hardens, the work can still be reshaped.

Clay that has been heated **(fired)** in a **kiln** (a special oven) is more durable and waterproof than clay that has not been so treated. A Paleolithic kiln for firing clay statues of women and animals has been found in Eastern Europe, and a variety of finely crafted, decorated clay vessels were made in Western Europe during the Neolithic period (see page 29).

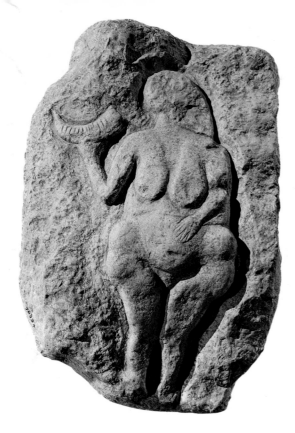

3.2 *Venus of Laussel*, from Laussel, Dordogne, France, c. 25,000–23,000 B.C. Limestone, 17⅜ in. (44 cm) high. Fouilles Lalanne, Musée d'Aquitaine, Bordeaux, France.

Most prehistoric sculptures are in the round, but Paleolithic artists also made **relief** sculpture (see Box). A good example of relief is the *Venus of Laussel* (fig. **3.2**), which also has traces of red ocher pigment (see Box). The pelvis and breasts are exaggerated, although the arms are slightly more prominent than those of the *Venus of Willendorf*. In her right hand, the *Venus of Laussel* holds an animal horn decorated with **incised** lines.

In addition to female figurines, Paleolithic artists produced small sculptures of animals. Most often found are horses, bison, and oxen; less frequently found are deer, mammoths, antelope, boar, rhinoceroses, foxes, wolves, bears, and an occasional fish or bird. These, like the paintings of animals, reflect the naturalism of Paleolithic animal art.

Painting

The surviving European Paleolithic paintings are concentrated in caves located in northern Spain, especially the Pyrenees Mountains, and the Périgord and Dordogne regions of France. The well-preserved state of these cave paintings when they were first discovered was due mainly to the fact that most of the caves are limestone and had been sealed up for thousands of years. After exposure to the modern atmosphere, the paintings began to deteriorate so rapidly that some caves have been closed to the public.

The paintings are primarily located deep within caves, in interiors that are difficult to reach and uninhabitable. They seem to have served as sanctuaries where fertility, initiation, and hunting rituals were performed and seasonal

although there is no evidence as to whom, if anyone, the figurines were meant to represent. They all exaggerate the breasts and hips, suggesting a cultural preoccupation with fertility, on which the survival of the species depends.

TECHNIQUE
Categories of Sculpture

Sculpture in the round and **sculpture in relief** are the two most basic categories of sculpture. Sculpture in the round is any sculpture completely detached from its original material so that it can be seen from all sides, such as the *Venus of Willendorf* (see fig. **3.1a, b**). The *Venus of Laussel* (see fig. **3.2**) remains partly attached to its original material, in this case limestone, so that it is shown in relief—that is, there is at least one angle from which the image cannot be seen. Sculpture in relief is more pictorial than sculpture in the round because some of the original material remains and forms a background plane.

There are different degrees of relief. In **high relief,** the image stands out relatively far from the background plane. In **low relief,** also called **bas-relief** (*bas* means "low" in French), the surface of the image is closer to the background plane. When light strikes a relief image from an angle, it casts a stronger shadow on high relief than on low relief and thus defines the image more sharply. Reliefs can also be **sunken,** or **incised,** in which case the image or its outline is slightly recessed into the surface plane, as in much ancient Egyptian carving (Chapter 5).

MEDIA
Pigment

Pigment (from the Latin word *pingere,* meaning "to paint") is the basis of color, which is the most eye-catching aspect of most painting. Pigments are colored powders made from organic substances, such as plant and animal matter, or inorganic substances, such as minerals and semiprecious stones. Cave artists either applied powdered mineral colors directly to damp walls or mixed their pigments with a liquid, the **medium** or **binder,** to make them adhere to dry walls.

Technically, the medium is a liquid in which pigments are suspended (but not dissolved). The term **vehicle** is often used interchangeably with the term *medium.* If the liquid binds the pigment particles together, it is referred to as the binder or binding medium. Binders help paint adhere to surfaces, increasing the durability of images. Cave painters used animal fats, vegetable juices, water, or blood as their binding media.

Pigment is applied to the surface of a painting, called its **support.** Supports vary widely in Western art—paper, canvas, pottery, even faces and the surface of one's body. For the cave artist, the walls of the cave were the support.

changes recorded. The predominance of animal represen-
tations is in part a reflection of the importance of hunting.
But the animals most often depicted do not coincide with
those that were most hunted, suggesting that these images
had other meanings as well.

The Chauvet Cave In 1994, three speleologists (cave
explorers) found the entrance to an underground cave
complex in the Ardèche Valley, in southeast France. They
came upon an interior chamber, later named for Jean-
Marie Chauvet, a member of the team. The cave proved to
be the largest so far known in this region; it contains over
three hundred wall paintings, engravings, Paleolithic bear
skeletons and a bear's skull set on a rock, evidence of fires,
and footprints. Radiocarbon analysis indicates a very early
date, around 30,000 B.C., for some of the paintings, which
are generally outlined in red or black pigment. They repre-
sent mainly animals along with some signs—especially red
dots and handprints. The animal images are unusual, how-
ever, in that there are many rhinoceroses and large felines.
All together thirty-four images of mammoths were found
at Chauvet, of which twenty-one are engraved into the rock
and thirteen are painted. The so-called Lion Panel, part of
which is shown in figure **3.3**, represents various species
of animals proceeding across a niche in the wall. Visible
here, deep within the cave, are three large lions and numer-
ous smaller but more densely painted rhinoceroses, several
of which are shaded. One faces a group that seems to be
moving toward it. It is not clear whether this is a coherent
scene or a ritual repetition. Some of the animals are super-
imposed—those at the top—while the others are spread
across the surface of the wall. Under the lions, traces of red
pigment can be seen, as well as the outline of a deer.

The Lascaux Cave The famous wall paintings at Las-
caux, in the Dordogne region of France (figs. **3.4–3.6**), are
nearly fifteen hundred years later than the Chauvet paint-
ings. They include a wide range of animal species and a few
human stick figures painted with earth-colored pigments
—brown, black, yellow, and red. These pigments were
ground from ocher, hematite, and manganese and applied
to the natural white limestone surfaces of the walls. The
Lascaux artists created their figures by drawing an outline
and filling it in with pigment. The pigment was stored in
hollow bones plugged at one end, which may also have
been used to blow the pigment onto the walls. Some of
these bone tubes, still bearing traces of pigment, have
been found in the caves. Such finds, and their interpreta-
tion, exemplify how deductions are made about the use of
objects in a prehistoric society. Perhaps if the bones con-
taining pigment had been found out of context—that is, far
from the paintings—different conclusions about their use
might have been drawn.

The Lascaux animals are among the best examples of the
Paleolithic artists' ability to create an illusion of motion and
capture the essence of certain species by slightly exaggerat-
ing characteristic features. The diagonal planes of the long
white bulls in figure **3.4** create the impression that they
are going uphill. Since many Lascaux animals are superim-
posed, they have been read as examples of image-magic.
According to this theory, the act of making the image was
an end in itself, possibly a symbolic capture of the animal
by fixing its likeness on the cave wall.

One Lascaux painting that has given rise to different
interpretations is the so-called Chinese Horse (fig. **3.6**),
whose sagging body suggests pregnancy. The two diago-
nal forms in this detail, one almost parallel to the horse's
neck and the other overlapping its lower outline, have been
variously identified as plants and arrows. The sign above
the horse has been interpreted as signifying a female. It is
not known why signs were juxtaposed with animals, but
the elusive character of such images illustrates the diffi-
culty in reading works pro-
duced by prehistoric artists.

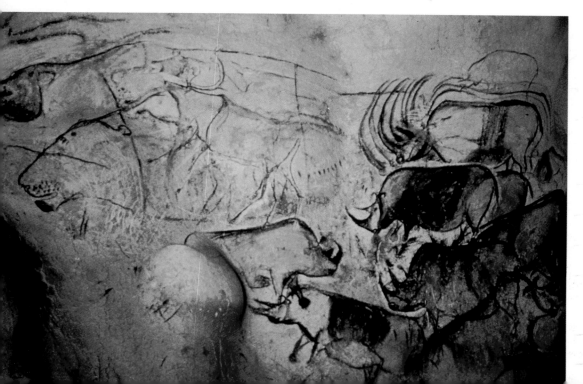

3.3 Left section of the "Lion
Panel," Chauvet Cave, Ardèche
Valley, France, c. 30,000 B.C.
Black pigment on limestone wall.
Courtesy of the French Ministry
of Culture and Communication,
Regional Direction for Cultural
Affairs–Rhône-Alpes, Regional
Department of Archaeology.

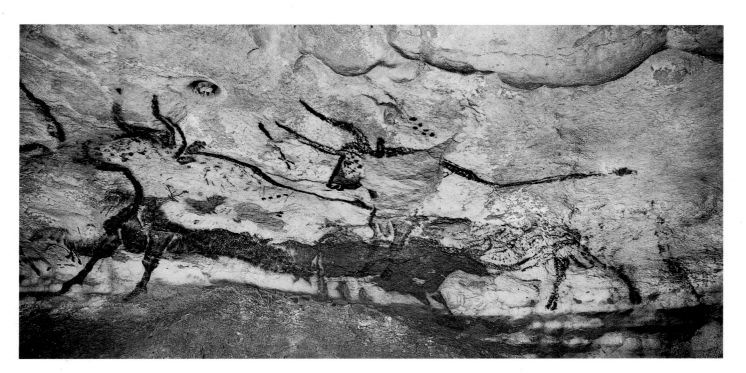

3.4 Hall of Running Bulls, Lascaux, Dordogne, France, c. 15,000–13,000 B.C. Paint on limestone rock, individual bulls 13–16 ft. (3.96–4.88 m) long. Note that the white bulls are superimposed over other animals. Cave artists did not always cover up previous representations before adding new ones.

3.5 Lascaux cave system (based on a diagram by the Service de l'Architecture, Paris).

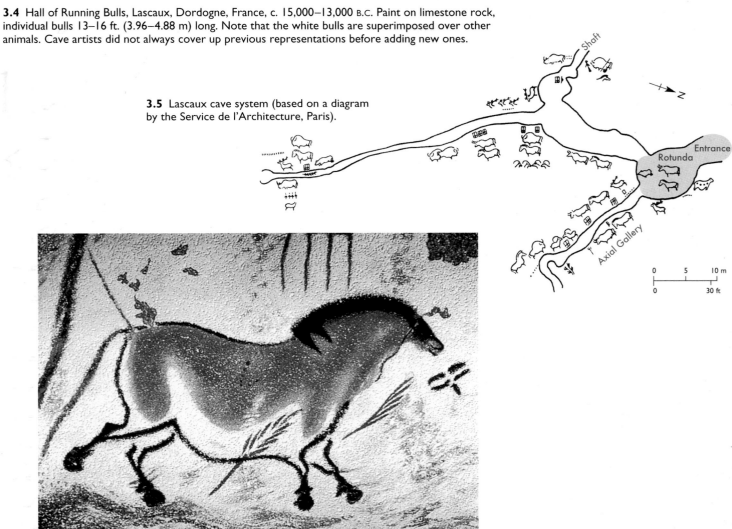

3.6 "Chinese Horse," Lascaux, Dordogne, France, c. 15,000–13,000 B.C. Paint on limestone rock, horse 5 ft. 6 in. (1.42 m) long. The animal acquired its nickname because it resembles Chinese **ceramic** horses of the Han Dynasty.

Rock Paintings of Australia
c. 75,000/50,000 B.C.–Present

Rock paintings, carvings, and other works of art have continued to be produced since the Stone Age by certain cultures around the world. A few of these societies that have persisted into our own era appear to have something in common with Paleolithic Western Europe. There is uncertainty in dating works created by such cultures and in pinning down the antiquity of their mythological traditions. Nevertheless, these "modern Stone Age" societies may provide valuable clues to the way art functioned in prehistoric Europe. Such comparisons must be made with caution, but they can suggest alternative ways of thinking about ancient art.

In the outback of Australia, Aboriginal hunting-and-gathering societies have had an unusually long history. Revolutionary archaeological finds in 1996 in a remote part of northwestern Australia at the site of Jinmium challenged basic assumptions about when and where humans evolved. Stone tools and other objects from this site suggest that Australia was inhabited as long ago as 174,000 B.C. Carved and painted rocks discovered there may be roughly 75,000 years old. If accepted, these dates are far earlier than scholars had previously believed possible. Australia is a continent that was relatively isolated from the rest of the world until the eighteenth century. Nevertheless, there are remarkable similarities between European Paleolithic and Aboriginal rock paintings, including naturalistic animals and hunting scenes.

The kangaroo, which is indigenous only to Australia and adjacent islands, is a frequent subject of Aboriginal rock art. Kangaroos have been hunted for thousands of years, probably as a source of food. Those represented in figure **3.7** are trying to escape from a group of hunters. That the kangaroos are hopping is clear from their poses: the one to the right has just landed and tilts slightly back on its feet; the one at the left leans forward as if to regain its balance. In paintings such as this, Aboriginal artists used two relatively different styles—naturalistic for animals and schematic for humans. This distinction is also characteristic of the Lascaux paintings.

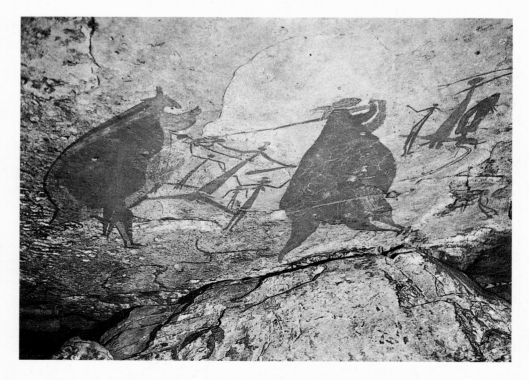

3.7 Men and women hunting kangaroos, Unbalanya Hill, Arnhem Land, Northern Territory, Australia. Rock painting.

Mesolithic (c. 8000–c. 6000/4000 B.C.)

The Mesolithic era in Western Europe was a period of transition more noteworthy for its cultural and environmental changes than for its art. It followed the end of the Ice Age and the development of a more temperate climate in about 11,000 B.C. With the retreat of the glaciers, forests expanded. Animals that had been hunted in the Paleolithic era died out or migrated, and people began to congregate around bodies of water, where fishing became a major source of food. By the end of the Mesolithic period many nomadic hunter-gatherer societies were becoming settled agricultural communities.

Neolithic (c. 6000/4000–c. 2000 B.C.)

In Western Europe the revolutionary shift from hunting and gathering to farming contributed to the development of a new art form: monumental stone architecture. As had been true of earlier art, the character of Neolithic stone structures was largely determined by religious beliefs. These buildings are referred to as **megaliths** ("made of big stones") and are assembled without the use of mortar.

Among the Neolithic megaliths of Ireland, Britain, France, Spain, and Italy, three distinctive types regularly occur: the **menhir, dolmen,** and **cromlech**—terms that are Celtic in origin. These megaliths are not only visually impressive, mysterious reminders of the ancient past but are also imbued with fascinating symbolic associations. For megalith builders, stone as a material was an integral part of cults honoring dead ancestors. Whereas Neolithic dwellings in Western Europe were made of impermanent material such as wood, the tombs—or "houses of the dead"—were of stone so that they would outlast mortal time. Even today we associate durability and stability with stone. For example, we speak of something being "written in stone" when we mean that it is unchanging and enduring, and to "stonewall" means to block a decision for as long as possible. Someone who is "stoned" is unable to move because of excessive consumption of alcohol or other drugs.

Menhirs

Menhirs (from two Celtic words: *men*, meaning "stone," and *hir*, meaning "long") are unhewn or slightly shaped single stones **(monoliths)**, usually standing upright in the ground. They were erected individually, in clusters, or in rows as at Carnac (fig. **3.8**) in Brittany (in northern France), probably an important Neolithic religious center. Menhirs have been interpreted as representing phallic fertilizers of Mother Earth.

Dolmens

Dolmens (from the Celtic word *dol*, meaning "table") are chambers or enclosures consisting of two or more vertical stones supporting a large single stone, much as legs support a table (fig. **3.9**). The earliest dolmens were tombs. Later additions turned them into passageways. Some interior dolmen walls were decorated with carvings; others were painted. Occasionally a pillar stood at the center of a burial chamber. Dolmens, like menhirs, were imbued by Neolithic people with symbolic associations. In contrast to the impermanence of houses built for the living, stone burial monuments functioned as a link between present and eternal time.

Cromlechs

Cromlechs (from the Celtic word for a circular place) are megalithic structures in which groups of menhirs form circles or semicircles. By far the greatest number of Neolithic stone circles are in Britain. Although their function and symbolism have not been determined, cromlechs clearly marked sacred spaces.

The most famous Neolithic cromlech in Western Europe is Stonehenge (fig. **3.10**), which was built in several stages from roughly 2800 to 1500 B.C. Rising dramatically from

3.8 Alignment of menhirs, Carnac, Brittany, France, c. 4000 B.C. Stone, 6–15 ft. (1.83–4.57 m) high. The Carnac menhirs, numbering almost three thousand, are arranged in parallel rows nearly 13,000 ft. (4,000 m) long. A small village has grown up around the menhirs.

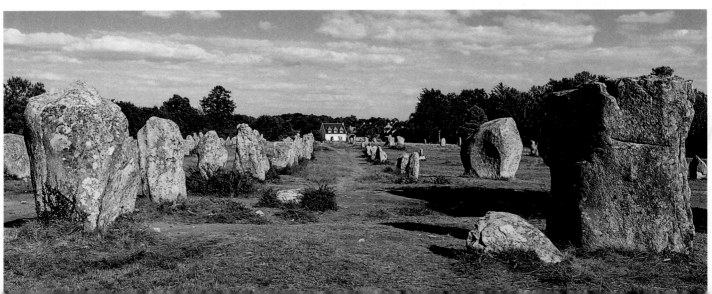

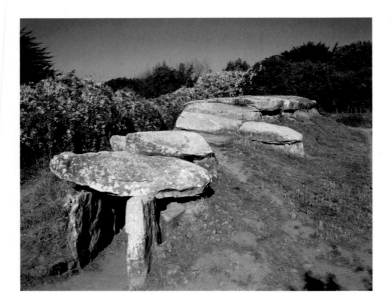

3.9 Dolmen, Carnac, Brittany, France, c. 4000 B.C.

Salisbury Plain in southwestern England, Stonehenge has fascinated visitors for centuries. The plan in figure **3.11** indicates all stages of construction, with the solid dark sections showing the megalithic circles as they stand today. Many of the original stones have now fallen. The aerial view in figure **3.10** shows the present disposition of the remaining stones.

This circular area of land on a gradually sloping ridge had been a sacred site before 3000 B.C. Originally, barrows (burial mounds) containing individual graves were sur-

rounded by a ditch roughly 350 feet (107 m) in diameter. A mile-long "avenue" hollowed out of the earth ran in an east-west direction. Fifty-six pits (known as Aubrey Holes after their seventeenth-century discoverer) were added inside the circular ditch and filled with rubble or cremated human bones. Around the same period, the Heel Stone, a block of sarsen (a local sandstone) 16 feet (4.88 m) high, was set in place outside the ditch in the entrance causeway to the northeast. The first stone circle, consisting of smaller stones called bluestones, imported from Wales (over 100 miles, or 160 km, away), was constructed around 2500 B.C.

Over the next four hundred years, a new group of people settled in Western Europe and was assimilated into the native population. The origin of these Beaker People, so called after their beaker-shaped pottery, is still a matter of debate. They brought with them a knowledge of metalworking, new building techniques, and pottery. Partly as a consequence of new technology, the Stone Age gave way to the Bronze Age. Nevertheless, before the total disappearance of the Stone Age in Western Europe, its most famous architectural monument was completed, apparently by the Beaker People themselves. In the final stages of construction at Stonehenge, huge sarsen blocks were brought to the site from Marlborough Downs, a distance of some 20 miles (32 km). From these larger monoliths, the outer circle and inner U-shape were constructed.

The cromlech at Stonehenge is a series of concentric circles and horseshoe- or U-shaped curves. The outer circle is **post-and-lintel construction** (fig. **3.12;** see Box). Each post is a sarsen block 13 feet (3.96 m) high, rougher on the outside than on the inside, bulging at its center, and then gradually tapering at the top. Projecting above each post

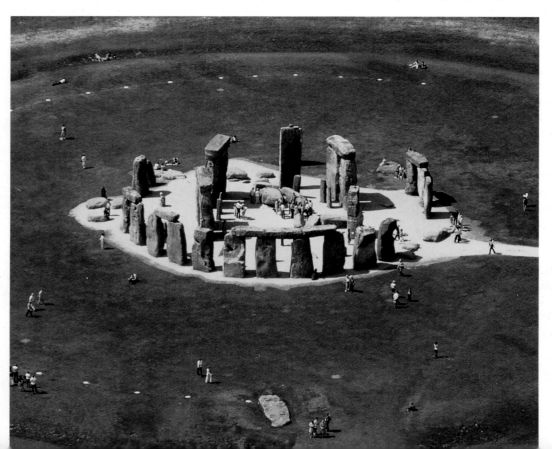

3.10 Stonehenge, Salisbury Plain, England, c. 2800–1500 B.C. Diameter of circle 97 ft. (29.57 m), height approx. 13 ft. 6 in. (4 m). Stonehenge possibly served as a kind of giant sundial used to predict seasonal changes and astronomical phenomena. It was almost certainly a ritual site.

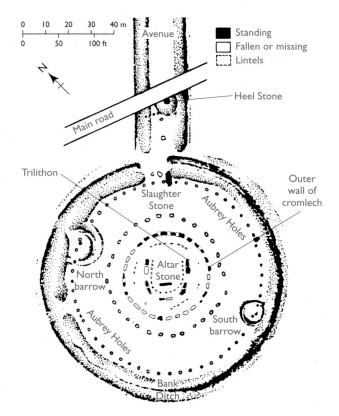

0 10 20 30 40 m
0 50 100 ft

N

Avenue

■ Standing
□ Fallen or missing
⬚ Lintels

Heel Stone

Main road

Trilithon

Slaughter
Stone

Outer
wall of
cromlech

Aubrey Holes

North
barrow

Altar
Stone

Aubrey Holes

South
barrow

Bank
Ditch

3.11 Plan of Stonehenge.

ARCHITECTURE
Post-and-Lintel Construction

In this system of construction, vertical uprights (posts) support a horizontal element (the lintel). Figure **3.12** is a diagram of the most basic single post-and-lintel form. In later eras, this simple system was elaborated into highly complex structures.

1 Lintel
2 Post

3.12 Post-and-lintel construction.

was a **tenon,** which fitted into a hollow carved out of the lintel (fig. **3.13**). For the outer wall, the lintels were slightly curved to create a circle when attached end to end.

From the inside ring (fig. **3.14**), one can see part of the outer ring and several individual posts and lintels. A second, inner circle consists entirely of single upright bluestones. Inside those are five very large **trilithons** (a pair of sarsen posts supporting a single lintel) arranged in a U-shape. An even smaller U-shape of bluestones parallels the arrangement of the five posts and lintels. We do not know how bluestones weighing up to 40 tons (40,640 kg) and sarsens weighing up to 50 tons (50,800 kg) were transported, or how the lintels were raised above the posts. Within the U of bluestones, one stone lies horizontally on the ground. This is referred to as the "altar stone," although there is no evidence that it was ever used for sacrifices.

Although continuing archaeological activity steadily increases our knowledge of Stonehenge, we still cannot identify its function. Clearly, the presence of circular stone rings throughout Western Europe points to a common purpose. Some scholars think that rites, processions, and sacred dances were held in and around the megalithic structures, celebrating the resurgence of life in spring and summer. These practices correlate with what we know of early agricultural societies, for which the timing of seasonal changes was of crucial importance.

Also consistent with agricultural concerns are interpretations of Stonehenge and other megalithic structures as

astronomical observatories, used to predict lunar eclipses and to keep track of time. At Stonehenge, for example, the absence of a roof reinforces the relationship of the structure with the sky and celestial phenomena. Carnac (see fig. **3.8**) has been described as an observatory in which each menhir functions as a point on a landscape graph. Elsewhere, direct evidence of astronomical markings on carved stones has been found. The circular monuments in particular are aligned according to the positions of the sun and moon at critical times of year. Earlier cromlechs were oriented toward sunrise at the winter solstice, and later ones at the

1 Lintel
2 Upright
3 Mortice
4 Raised to fit hollow in top
 of upright
5 Tenon
6 Dished slightly

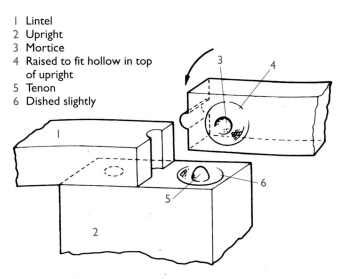

3.13 Lintel and tenon.

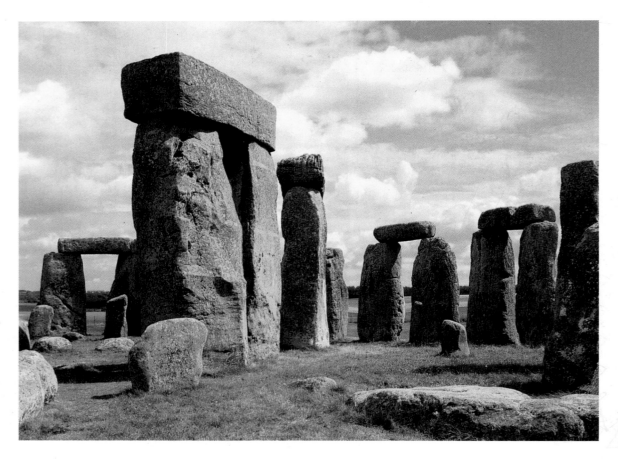

3.14 Inside ring of Stonehenge.

summer solstice. At Stonehenge, the avenue is aligned with the rising summer sun. An observer standing in the middle of the circle about 1800 B.C. would have seen the sun rise over the Heel Stone (see fig. **3.11**) on June 21, the summer solstice. Other stones are aligned with the northernmost and southernmost points of moonrise.

The greatest megalithic monument of the Neolithic era in Western Europe was also among the last. Around 2000 B.C., as the use of metal increased, the construction of large stone monuments declined.

40,000 B.C.	30,000 B.C.	20,000 B.C.	10,000 B.C.	1000 B.C.

AUSTRALIA	PALEOLITHIC IN WESTERN EUROPE		MESOLITHIC	NEOLITHIC
c. 75,000–30,000 B.C.	c. 50,000–10,000 B.C.		c. 8000–4000 B.C.	c. 6000–1800 B.C.

Hunting and gathering; stone tools

Last Ice Age (18,000–15,000 B.C.)

Bow and arrow invented (c. 10,000 B.C.)

Wheat and barley cultivated (c. 9,000 B.C.)

Australian rock paintings (75,000 B.C.–)

Chauvet Cave (25,000–17,000 B.C.)

Lascaux Cave (15,000–13,000 B.C.)

Stonehenge (c. 1800–1500 B.C.)

(3.7)

(3.1)
Venus of Willendorf (c. 25,000–21,000 B.C.)

(3.3)

(3.4)

(3.14)

4

The Ancient Near East

It was in the ancient Near East that people first invented writing—a momentous development in human history. Writing enabled people to keep documents and create a body of literature. The Near East produced the first known epic poetry, written history, religious texts, and economic records. These were based on earlier traditions, and they provide insights into the origins of human thought and civilization. They also shed light on the artistic products of ancient Near Eastern civilization in a way that is not possible for preliterate times. Before exploring the invention of writing and its relation to art history, however, we consider the rise of Neolithic cultures in this part of the world.

The Neolithic Era

Neolithic culture developed some four thousand years earlier in the Near East than in Europe. As with Neolithic Western Europe, the Near East made the transition from nomadic hunting and gathering to a more settled life centered on agriculture and animal herding. Droughts and floods made it difficult to grow crops or establish permanent communities in certain areas. In response, people learned how to manage water supplies with large-scale irrigation systems. The social structures that made this possible—organized labor and stabilized political power—contributed to the rise of increasingly complex urban cultures.

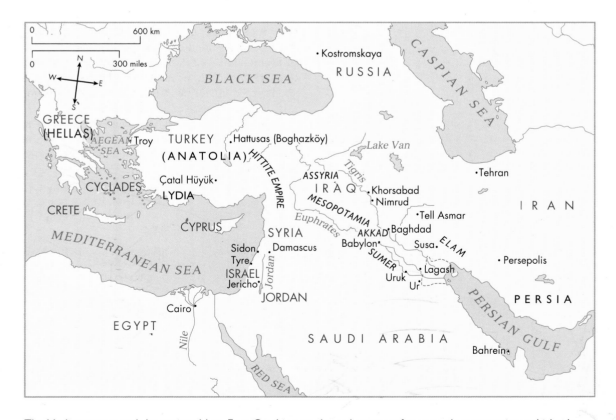

The Mediterranean and the ancient Near East. On this map the red names refer to modern countries and islands. Names in uppercase black denote ancient areas or countries, and names in lowercase black denote cities.

33

Agricultural rituals celebrated fertility and the vegetation cycles of birth-death-rebirth. Perhaps the most constant artistic and religious presence in the Neolithic religions of the Near East was a female deity and her male counterpart. Neolithic architecture reflects increasingly elaborate concepts of sacred space in which religious buildings symbolize the cosmic world of the gods. Archaeologists have also excavated mud-brick fortification walls and found evidence of town planning.

Jericho

The Neolithic settlement of Jericho, located in the West Bank, is one of the world's oldest fortified sites. It was originally built c. 8000–7000 B.C., when it was surrounded by a ditch and walls 5 to 12 feet (1.52 to 3.65 m) thick, from which rose a tower some 30 feet (more than 9 m) high. Jericho's walls protected a city of rectangular houses and mud-brick public buildings on stone foundations. The walls of the brick houses were plastered and painted. In addition to providing shelter for the living, dwellings in Jericho housed the dead. Corpses buried under the floors indicate an ancestor cult, a conclusion reinforced by one of the most intriguing archaeological finds, the so-called Jericho skulls (fig. **4.1**). These uncanny skull "portraits" are almost literal renderings of the transition between life and death. The dead person's detached skull presumably served as a kind of **armature** on which to rebuild the face and thus preserve the memory of the deceased.

4.1 Neolithic plastered skull, from Jericho, c. 7000 B.C. Life-size. Archaeological Museum, Amman, Jordan. Skulls such as this reflect an attempt to reconstitute the image of the dead person by modeling features in plaster. The hair was painted and cowrie shells were embedded in the eye sockets.

Çatal Hüyük

Similar burials in houses were found at the site of Çatal Hüyük in Anatolia (modern Turkey). Dating from c. 6500–5500 B.C., this is the largest Neolithic site so far discovered in the ancient Near East.

Archaeologists found evidence of a culture in which agriculture and trade were well established. The layout of the town suggests that it was planned without streets. Instead, as shown in figure **4.2**, one-story mud-brick houses were connected to each other by their rooftops, and scholars assume that ladders provided access from ground level. Windows were small, but a ventilation shaft allowed smoke from ovens and hearths to escape. The interiors of the houses were furnished with built-in clay benches used as seats and beds. Skeletons were buried under floors and benches. Some of the skeletons were coated with red ocher, and deposits of jewelry and weapons were buried with them.

Little is known of the religious beliefs at Çatal Hüyük since it was a preliterate culture. However, archaeologists have identified elaborately decorated chambers that may have functioned as shrines. One **motif** that was particularly prevalent among the decorations is the bull, which was widely worshiped in the ancient world, as it apparently was at Çatal Hüyük.

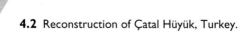

4.2 Reconstruction of Çatal Hüyük, Turkey.

Mesopotamia

Mesopotamia (in modern Iraq) was the center of ancient Near Eastern civilization. Its name is derived from the Greek words *mesos* (middle) and *potamos* (river). Mesopotamia is literally the "land between the rivers"—the Tigris and the Euphrates. The Mesopotamian climate was harsh, and its inhabitants learned irrigation to make the land fertile. The southern terrain was open and without natural protection; as a result, Mesopotamian cities were vulnerable to invasion but also accessible to trade.

The Neolithic period in Mesopotamia ended c. 4500–4000 B.C. It was followed by urbanization and the construction of the first known monumental temples. These were oriented with their corners toward the four cardinal points of the compass, suggesting religious beliefs relating sacred architecture to earth and sky.

The Uruk Period (c. 3500–3100 B.C.)

The city of Uruk (known as Erech in the Bible and Warka in present-day Iraq) has given its name to a period sometimes known as Protoliterate, when the earliest known writing developed.

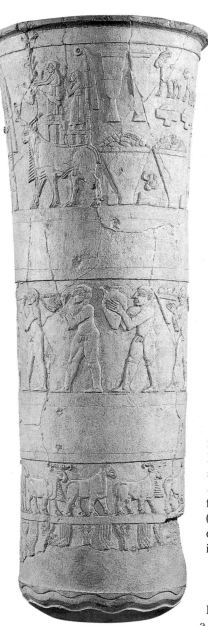

4.3 Sculptured vase, from Uruk, c. 3500–3000 B.C. Alabaster, 3 ft. (91.4 cm) high. Iraq Museum, Baghdad. The abundance of vegetation in the iconography of this vase reinforces its relationship to festivals of seasonal renewal and rebirth. The association of these rites with Inanna, the goddess of love and fertility, is almost certainly derived from the role of the Neolithic mother goddess.

It is possible that the New Year festival in honor of the goddess Inanna (see Box) is the subject of the impressive alabaster vase (fig. **4.3**) found at Uruk. It is 3 feet (91.4 cm) in height and decorated with four horizontal low-relief bands, or **registers**. In the top register a goddess (not visible here), possibly Inanna herself, receives a figure with a basket of fruit. In the next register nude men walk from right to left, also bearing offerings. In the third register rams alternating with ewes march around the vase in the opposite direction. Barley stalks alternate with date palms below. The abundance of vegetal iconography on this vase suggests its association with agricultural festivals of renewal and rebirth.

Several **conventions**—generally recognized features of representation—evident here remain characteristic of ancient Near Eastern art. Although the figures are stocky and modeled three-dimensionally, they occupy a flat space, which is partly defined by their poses. Legs and heads are in profile, the torsos turn slightly, and the eyes are frontal, creating a composite or synthesized view of the human form. There is no indication of space extending back behind the figures, who walk as if on a thin ledge. In the top register, figures and objects seem suspended in midair.

4.4 The remains of the White Temple on top of its ziggurat, Uruk, c. 3500–3000 B.C. Stone and polished brick; temple approx. 80 × 60 ft. (24.38 × 18.29 m); ziggurat approx. 140 × 150 ft. (42.7 × 45.7 m) at its base and 30 ft. (9.1 m) high. It was called the "White Temple" because of the white paint on its outer walls.

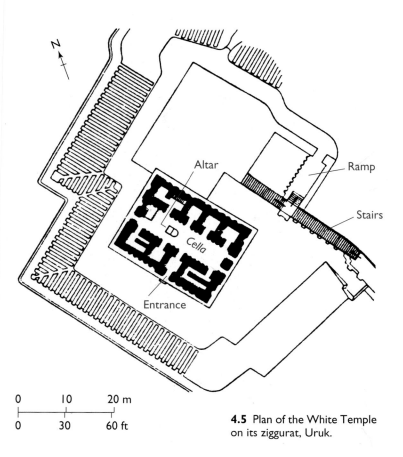

4.5 Plan of the White Temple on its ziggurat, Uruk.

<div style="border:1px solid black">

RELIGION
Mesopotamian Gods

In ancient Mesopotamian religion, the bull was worshiped as the supreme male god Anu. He was also the sky god, and his roar was thunder. Ninhursag, the great mother goddess, was the Lady of the Mountain. Enlil was the god of the air; Ea (or Enki), the water god; Nanna (or Sin), the moon goddess; Utu (later Shamash), the sun god; and Inanna (later Ishtar and Astarte), the goddess of love, fertility, and war.

</div>

Ziggurats

The **ziggurat**—the term is derived from the Assyrian word for "raised up" or "high"—is a uniquely Mesopotamian architectural form. Mesopotamians believed that each city was under the protection of a god to whom the inhabitants owed service, and they built imitation mountains, or ziggurats, as platforms for the god. Mountains were believed to embody the immanent powers of nature: they were sources of the life-giving water that flowed into the plains and made agriculture possible. The goddess Ninhursag, a source of nourishment, was also the Lady of the Mountain. As a symbolic mountain, therefore, the ziggurat satisfied one of the basic requirements of sacred architecture: the creation of a transitional space between people and their gods.

Ziggurats are examples of **load-bearing construction,** a system of building that began in the Neolithic period. Their massive walls had small openings or none at all. They were usually solid, stepped structures, tapering toward the top, with a wide base supporting the entire weight of the ziggurat.

At Uruk the earliest surviving ziggurat (fig. **4.4**) dates from between 3500 and 3000 B.C. It was a solid clay structure reinforced with brick and asphalt. White pottery jars were embedded in the walls, their rims creating a surface pattern of white circles framing the dark round spaces of their interiors. Ziggurats remained characteristic structures throughout Mesopotamian history and became increasingly elaborate as belief systems and technology evolved.

The ziggurat at Uruk supported a shrine, the "White Temple," which was accessible by a stairway and oriented toward the four cardinal points. Figure **4.5** shows the plan of the rectangular White Temple, possibly dedicated to Anu, the sky god. It was divided into several rooms off a main corridor, or *cella,* which probably contained the **altar**.

4.6 Cylinder seal and impression from Uruk, c. 3500–3000 B.C. Greenish black serpentine, 1³⁄₁₆ in. (29.5 mm) high, 1 in. (25 mm) diameter. The Pierpont Morgan Library, New York. The scene shown has been interpreted as a leather shop (note the man carrying an animal hide).

Cylinder Seals

The earliest examples of **cylinder seals**, which are examples of **glyptic art** (from the Greek word *glyptos*, meaning "carved"), were produced during the Uruk period. The seal in figure **4.6** is a small stone cylinder into which an image has been carved. In a process known as **intaglio** printing, the seal's hard, incised surface would have been pressed against a soft surface, leaving a raised impression in reverse. When a cylinder seal was rolled across a clay tablet or the closure on a container, it created a repetitive band of images. Seal impressions were used originally to designate ownership and to keep inventories and accounts, and later to legalize documents. They offer a rich view of Mesopotamian iconography and the development of pictorial style over a three-thousand-year period.

From Pictures to Words

The use of seal impressions to designate ownership contributed to the development of writing. During the Uruk period, around 3500 to 3000 B.C., abstract wedge-shaped characters began to appear on clay and stone tablets (fig. **4.7**). The earliest-known written language comes from Sumer, in southern Mesopotamia, and persisted as the language of the priestly and intellectual classes throughout Mesopotamian history. Its script is called **cuneiform,** from the Latin word *cuneus,* meaning "wedge" (see fig. **4.13**). After c. 2300 B.C. a Semitic language, Akkadian, belonging to a people who may have come from the west, became more prevalent than Sumerian. The Sumerian and Akkadian cultures coexisted for many centuries, and their languages roughly correspond to the two main geographical divisions of Mesopotamia: Sumer and Akkad. Both lie between the Tigris and Euphrates rivers, Sumer in the south and Akkad in the north.

Some time after the invention of writing, a Mesopotamian literature developed. The written word, which had originated in response to a practical need for daily record-keeping, became a tool of creative expression. Much epic poetry of Mesopotamia (see Box, p. 38) deals with the origins of gods and humans, the history of kingship, the founding of cities, and the development of civilization. According to Sumerian tradition, a great flood occurred shortly before the invention of writing, separating preliterate Mesopotamia from its literate, historical era.

4.7 Clay tablet with the pictographic text that preceded cuneiform, probably from Jemdet Nasr, Iraq, c. 3000 B.C. 3¼ × 3¼ in. (8 × 8 cm). British Museum, London, England. This tablet is covered with inscriptions made by pressing a stylus (writing implement) into the surface. In addition to the written word, Sumerians used a numerical system with a base of 60, as well as a decimal system.

LITERATURE
Gilgamesh

The *Epic of Gilgamesh,* the oldest surviving epic poem, is preserved on cuneiform tablets from the second millennium B.C. It recounts Gilgamesh's search for immortality as he undertakes perilous journeys through forests and the underworld, encountering gods and struggling with moral conflict. The opening lines introduce Gilgamesh as a hero who saw and revealed the mysteries of life:

> The one who saw the abyss . . .
> . . . he who knew everything, Gilgamesh,
> who saw things secret, opened the place hidden,
> and carried back word of the time before the Flood.[2]

Gilgamesh finally attains immortality as the builder of Uruk's walls. He establishes urban civilization and lays the foundations of historical progress. The poem also refers to his having "cut his works into a stone tablet." Just as the megalithic builders of Neolithic Europe revered stone as a permanent material, so Gilgamesh founded a city of stone walls and ensured that the record of his achievements was written in stone. This is consistent with the historical fact that the earliest writing was actually inscribed on stone or clay tablets. The works of Gilgamesh were thus literally as well as figuratively "carved in stone."

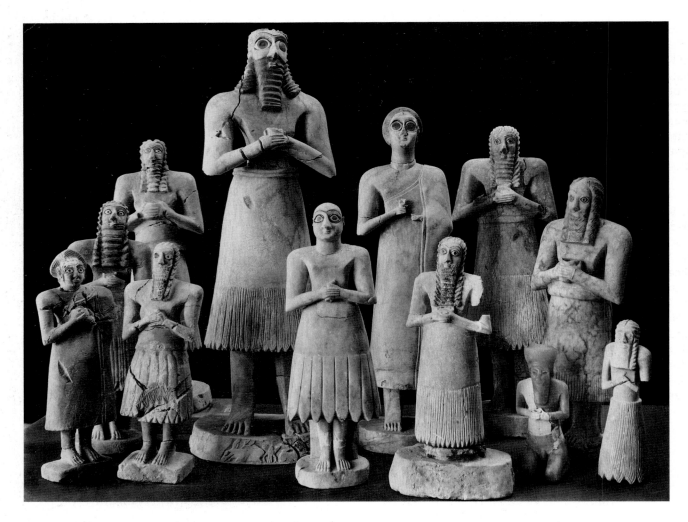

4.8 Statues from the Abu Temple at Tell Asmar, c. 2700–2500 B.C. Limestone, alabaster, and gypsum, tallest figure approx. 30 in. (76.3 cm) high. Iraq Museum, Baghdad, and Oriental Institute, University of Chicago.

Sumer: Early Dynastic Period

(c. 2800–2300 B.C.)

Tell Asmar Many small cult figures were produced during the Early Dynastic period, such as those from **Tell Asmar** (fig. **4.8**), a Sumerian site about 50 miles (80 km) northeast of modern Baghdad, in Iraq. It is not known whether these figures were originally a unified group, but most hold a cup. The men are bare-chested, and the women wear robes over one shoulder. All the figures are made of pale stone, with their features emphasized in black pitch. The eyes are shells, and the pupils are inlaid with black limestone. The largest male statue is thought to represent an important person dedicating himself to the god Abu. Probably the statues represent worshipers of varying status, and the size of a statue was determined by the amount of money its donor paid for it. Thus these figures are rendered with so-called **hierarchical proportions**, a convention equating size with status.

The statues are cylindrical, reflecting the Mesopotamian preference for rounded sculptural shapes. Also characteristic is the combination of stylization—visible here in the horizontal ridges of the males' hair and beards—with suggestions of organic form in the cheeks and chin. The frontal poses and vertical planes of these figures endow them with an air of imposing solemnity. Their frontality is emphasized by the prominence of large, wide-open eyes, indicating awe in the presence of divinity.

Ur At the Sumerian site of Ur, the English archaeologist Sir Leonard Woolley (1880–1960) discovered the so-called royal cemetery. The gold objects found in the burials included chariots, harps, sculptures, headdresses, and jewelry. The restored, elegant lyre soundbox (fig. **4.9**) from Ur indicates not only the enjoyment of music and the use of musical instruments, but also the superb craftsmanship of early Sumerian artists. The significance of the gold bearded bull's head and the inlay decoration at the front of the box is uncertain, but it is likely that they served a ritual purpose and had mythological meaning. The head was combined with a stylized human beard of semiprecious, dark blue **lapis lazuli**, illustrating the ancient Near Eastern taste for combinations of species.

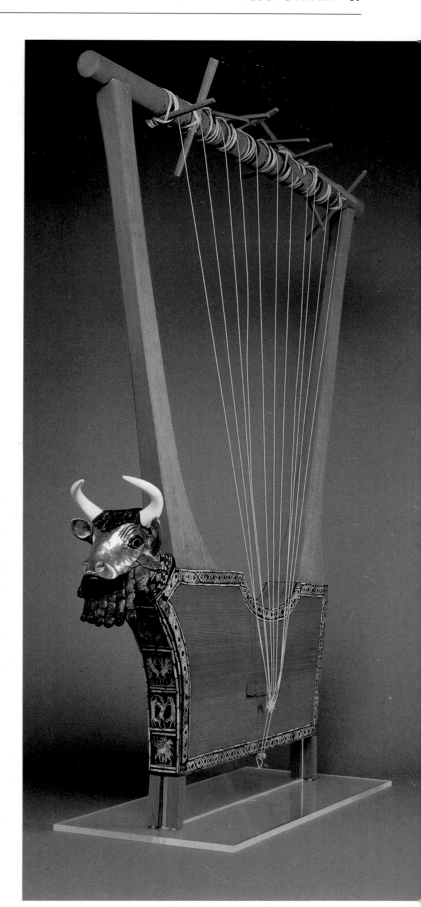

4.9 Restoration of a Sumerian lyre, Ur, c. 2600 B.C. Wood, gold leaf, and inlay, height of bull's head approx. 12 in. (30 cm). British Museum, London, England. The box is hollow to improve the quality of the sound.

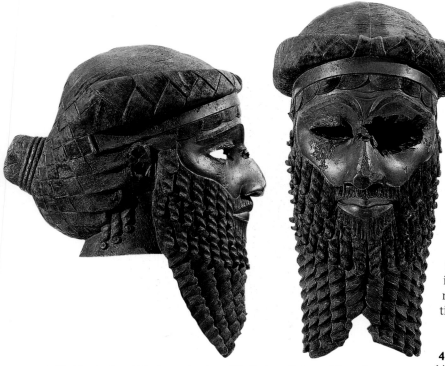

4.10 Head of an Akkadian ruler (possibly Sargon I), from Nineveh, Iraq, c. 2250 B.C. Bronze, 12 in. (30 cm) high. Museum of Antiquities, Baghdad, Iraq. This head, found on a trash heap, is what remains of a full-length statue.

Akkad (c. 2300–2100 B.C.)

Sargon I The founder of the Akkadian dynasty, Sargon I, reigned for over half a century, from c. 2300 to 2250 B.C. (see Box), gaining control of most of Mesopotamia and the lands beyond the Tigris and Euphrates rivers. A nearly life-size bronze head (fig. **4.10**) may be his portrait.

The power of this work is in the self-confident facial features emerging from a framework of stylized hair. The eye sockets would originally have been inlaid with precious stones, which have since been gouged out—perhaps for their intrinsic value or perhaps to destroy the power of the image. At the back of the head, the hair is bound in a bun and is elaborately designed in a regular arrangement of surface patterns. Large curved eyebrows meet on the bridge of the assertive nose. A striking V-shape frames the lower

face in the form of a beard made of spiraling curls. In this head, the energy and rhythm of the stylizations combine with an organic facial structure to produce an air of regal determination.

Naram-Sin Sargon I's grandson, Naram-Sin, recorded his victory over a mountain people, the Lullubians, in a commemorative **stele** (fig. **4.11**)—an upright stone marker. This form of record keeping used inscriptions and relief images to memorialize important events.

The stele of Naram-Sin proclaims the military, political, and religious authority of Naram-Sin. He is identified as a god by the horned cap, and he dominates the scene by his large size and prominent position. His long beard is a conventional sign of virility

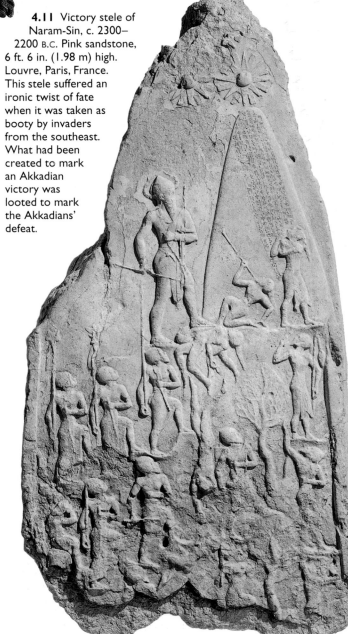

4.11 Victory stele of Naram-Sin, c. 2300–2200 B.C. Pink sandstone, 6 ft. 6 in. (1.98 m) high. Louvre, Paris, France. This stele suffered an ironic twist of fate when it was taken as booty by invaders from the southeast. What had been created to mark an Akkadian victory was looted to mark the Akkadians' defeat.

SOCIETY AND CULTURE
Sargon of Akkad

With Sargon, we encounter another "first" in Western history—the legendary birth story of one who is destined for greatness. These tales typically link humble origins to later fame. Sargon's story, inscribed on a tablet, recounts his lowly illegitimate birth. His mother sends him down a river in a basket (which resonates with the biblical account of Moses in the bulrushes). A man named Akki, who is drawing water, finds Sargon and raises him as his own son. Later Sargon rules in the city of Agade, or Akkad, whose inhabitants are called Akkadians.

and, therefore, of his potency as both man and ruler. He wears a necklace with a protective bead. Also exerting a protective force are the stars shining prominently over him. Together with the landscape details, they reflect the Akkadian taste for depicting nature.

Two defeated enemies are before the ruler, one praying for mercy and the other trying to pull a spear from his neck. Naram-Sin and his victorious followers march unhindered up the mountain while the defeated soldiers fall. This opposition exemplifies a convention in which going up denotes success and downward movement denotes failure or death. In a related convention, Naram-Sin steps on a defeated foe, indicating triumph. The nudity of Naram-Sin's victims shows that they are dead.

To the degree that Naram-Sin's own body is exposed, the artist was displaying an image of physical perfection that was a sign of his inherent "goodness," or "rightness," as a ruler. He is intentionally portrayed with his right side most visible to the viewer, in keeping with a Mesopotamian belief that a ruler's right side—including his right arm and right ear—had to be both intact and well formed for his state to prosper.

Neo-Sumerian (c. 2100–1800 B.C.)

After flourishing for about a century, the Akkadian dynasty was defeated. Following a period of turmoil, there was a revival of Sumerian culture.

Gudea is the best-known king of Lagash, a thriving Neo-Sumerian city-state. His extensive building programs were made possible by his ability to maintain peace in his own territory, despite continual political upheavals surrounding Lagash. Gudea embodied the transition between gods and humans. Just as the ziggurats linked earth with the heavens, so Mesopotamian rulers were viewed as the gods' chosen intermediaries on earth. Such ideas form the basis for the continuing belief in the divine right of kings.

Gudea's image is familiar from a series of similar statues made of **diorite,** a hard black stone that had to be imported. He either stands or sits, usually with hands folded in an attitude of prayer (figs. **4.12** and **4.13**). Whether standing or seated, Gudea wears a robe over his left shoulder, leaving his right shoulder bare; the bottom of the robe flares out slightly into a bell curve. In figure **4.12** he wears a round cap decorated with rows of small circles formed by incised spiral lines.

The seated Gudea (fig. **4.13**) is compact; there is no space between the arms and the body, and the neck is short

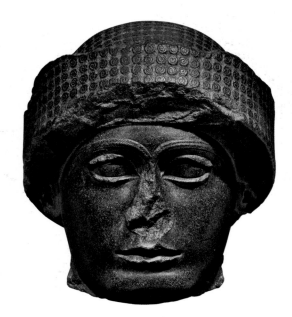

4.12 (Above) Head of Gudea, from Lagash, Iraq, c. 2100 B.C. Diorite, 9 in. (22.9 cm) high. Museum of Fine Arts, Boston (Francis Bartlett Donation of 1912).

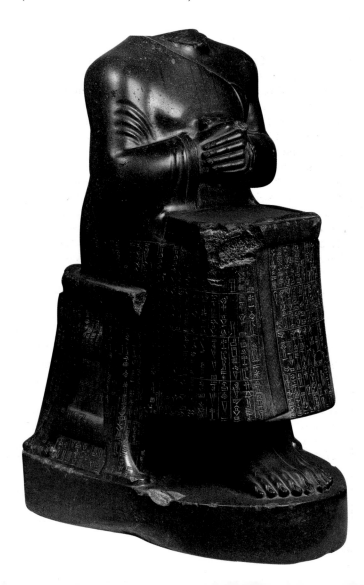

4.13 Gudea with temple plan, from Lagash, Iraq, c. 2100 B.C. Diorite, 29 in. (73.7 cm) high. Louvre, Paris, France. Gudea's affinity with the Sumerian gods is revealed in his account of a dream in which a god instructed him to restore a temple. In the dream, Gudea saw the radiant, joyful image of the god Ningirsu wearing a crown and flanked by lions. He was accompanied by a black storm bird, while a storm raged beneath him. Ningirsu told Gudea to build his house; but Gudea did not understand until a second god, Nindub, appeared with the plan of a temple on a lapis lazuli tablet. Note that Gudea's skirt is covered with incised cuneiform inscriptions.

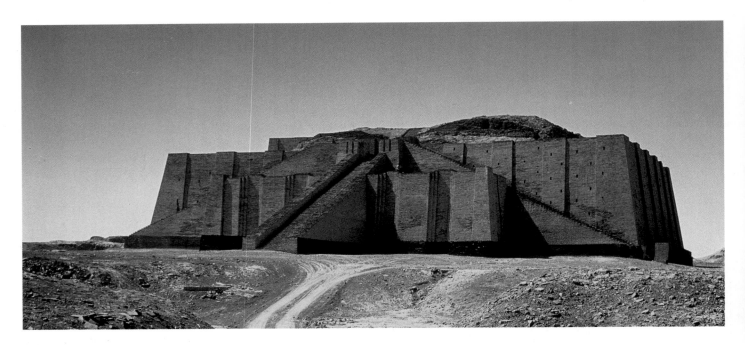

4.14 Nanna ziggurat, Ur, c. 2100–2050 B.C.

and thick. This contraction of space contributes to Gudea's monumentality, as does his controlled, dignified pose. The typical Mesopotamian combination of organic form with surface stylization can be seen in the juxtaposition of the incised eyebrows with the more naturalistically modeled nose, cheeks, and chin (fig. **4.12**). In figure **4.13** the temple plan on his lap identifies him as a patron of architecture. His gesture of prayer establishes his relation with the gods and their divine patronage as revealed in his dream (see caption).

The Ziggurat of Ur

The Neo-Sumerian period reached a peak under Ur-Nammu, the first king of its last important dynasty, the Third Dynasty of Ur. He supervised the construction of the great ziggurat at Ur (figs. **4.14** and **4.15**), which is more complex than the one in Uruk. Three stages were constructed around a mud-brick core and culminated in a shrine, which was accessible by a short stairway on the northeast side. The mud brick was faced with baked brick embedded in mortar made of bitumen (a type of asphalt). Leading to a vertical gate, which provided the only point of entry to the upper levels, were three long stairways, each composed of one hundred steps. The ziggurat walls curve gradually outward while sloping toward the center of the structure, which functioned aesthetically to reduce the rigidity of straight walls. The ancient Near Eastern preference for rounded sculptural shapes thus carried over into architectural design.

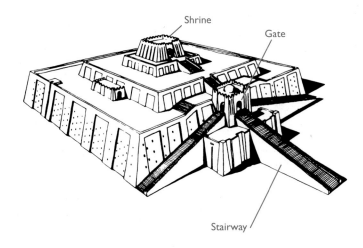

4.15 Reconstruction drawing of the ziggurat, Ur.

Babylon (c. 1900–539 B.C.)

Continuing warfare between Mesopotamian city-states led to the frequent rise and fall of different civilizations. Some two centuries into the second millennium B.C., the first dynasty of Babylon was established.

Old Babylonian Period (c. 1830–1550 B.C.) Under the rule of King Hammurabi (c. 1792–1750 B.C.), Babylon gained control of Mesopotamia. Today, Hammurabi is best known for his law code, inscribed on a black basalt stele (fig. **4.16**; see Box). The law code of Hammurabi stands as an important marker of legal history and the relationship of law to the fabric of society. Its cultural importance is reflected in its value as booty—Hammurabi's stele, as well as Naram-Sin's, was carried off to Susa by invading Elamite armies.

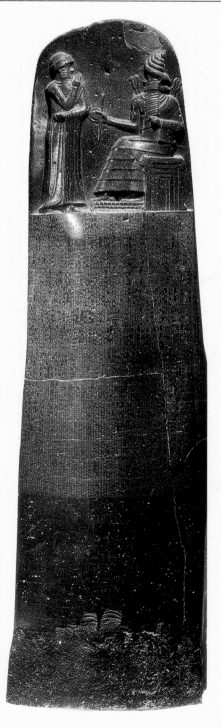

SOCIETY AND CULTURE
The Law Code of Hammurabi

The text of Hammurabi's law code, comprising three hundred statutes, is written in Akkadian in fifty-one cuneiform columns. It provides a unique glimpse into the social and legal structure of ancient Mesopotamia. Although the stated purpose of Hammurabi's laws was to protect the weak from the strong, they also maintained traditional class distinctions: the lower classes were more severely punished for crimes committed against the upper classes than vice versa. There was no intent to create social equality in the protection of the weak or in the expressed concern for orphans and widows; rather, this was meant to maintain social continuity and stability.

Three types of punishment stand out in the law code of Hammurabi. The Talion Law—the equivalent of the biblical "eye for an eye"—operated in the provision calling for the death of a builder whose house collapsed and killed the owner. In some cases, the punishment fit the crime; for example, if a surgical patient died, the doctor's hand was cut off. Perhaps the most illogical punishment was the ordeal in which the guilt or innocence of an alleged adulteress depended on whether she sank or floated when thrown into water.

Hammurabi stands before the Akkadian sun god, Shamash, who is enthroned on a symbolic mountain. Shamash wears the horned cap of divinity and an ankle-length robe. He holds the ring and rod of divine power and justice, and rays emanate from his shoulders. Here the conventional pose of the god in relief sculpture serves a dual purpose. The torso's frontality communicates with the observer, while the profile head and legs turn to Hammurabi. Hammurabi receives Shamash's blessing on the law code, which is inscribed on the remainder of the stele. The god's power over Hammurabi is evident in his greater size; were Shamash to stand, he would tower over the mortal ruler.

4.16 Stele inscribed with the law code of Hammurabi, c. 1792–1750 B.C. Basalt, height of stele approx. 7 ft. (2.13 m), height of relief 28 in. (71.1 cm). Louvre, Paris, France.

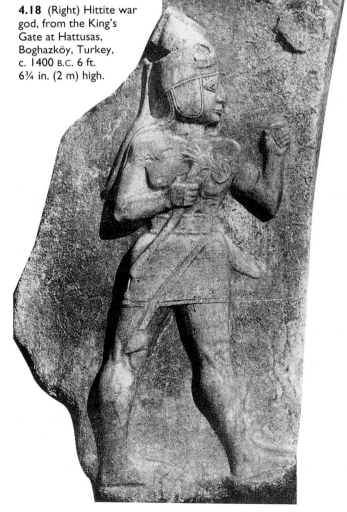

4.17 Lion Gate (Royal Gate), Hattusas, Boghazköy, Turkey, c. 1400 B.C. Stone, lions approx. 7 ft. (2.13 m) high. The lions face the visitor approaching the citadel. The direct confrontation, combined with the open, roaring mouths, served as a warning and symbolically protected the inhabitants against evil.

4.18 (Right) Hittite war god, from the King's Gate at Hattusas, Boghazköy, Turkey, c. 1400 B.C. 6 ft. 6¾ in. (2 m) high.

Anatolia: The Hittites

(c. 1450–1200 B.C.)

The Hittites were an Anatolian people whose capital city, Hattusas, was located in modern Boghazköy, in central Turkey. Like the Mesopotamians, the Hittites kept records in cuneiform on clay tablets, which were stored on shelves, systematically catalogued and labeled as in a modern library. These archives, comprising thousands of tablets, are the first known records in an Indo-European language. Because they have survived, the cultural and artistic achievements of the Hittites are fairly well documented.

The western entrance to the **citadel** (an elevated, fortified city) of Hattusas (fig. **4.17**) is a good example of the monumental walls constructed by the Hittites. The guardian lions are a traditional motif in ancient art because of the belief that lions never sleep. Here they project forward as if emerging from the natural rock. Their heads and chests are in high relief, while some details, such as the mane, fur, and eyes, are incised.

The most distinctive Hittite sculptures are usually carved on the lower levels of city walls. Figure **4.18** represents a Hittite war god. He is armed and helmeted and wears a short tunic. Conforming to ancient Near Eastern convention, his head and legs are depicted in profile with his torso in front view. As in the art of Mesopotamia, the Hittite sculptor has achieved a **synthesis** of stylization (the eye and kneecaps) with organic form. Like the stele of Naram-Sin, this relief projects an image of power.

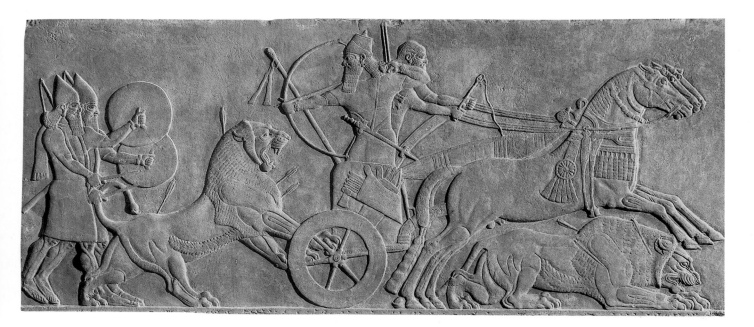

Assyria (c. 1300–612 B.C.)

A northern Assyrian city-state emerged as the next unifying force in Mesopotamia. Located along the Tigris in modern Syria, its capital city was named for Ashur, the chief Assyrian deity. At the end of Hammurabi's reign, c. 1750 B.C., Ashur had become a prominent fortified city. By 1300 B.C. its rulers were in communication with the leaders of Egypt, indicating that the Assyrians had achieved international status.

The Assyrian state is particularly well documented through both its texts and the remains of architectural and sculptural projects undertaken to reflect the might and glory of its kings. The region in and around Assyria had a great deal more stone available than the rest of Mesopotamia. As a result, the Assyrians' determination to memorialize their accomplishments could be satisfied by using local stone.

Under Assurnasirpal II (reigned 883–859 B.C.), Assyria became a formidable military force. Assurnasirpal's records are filled with boastful claims detailing his cruelty. He says that he dyed the mountains red, like wool cloth, with the blood of his slaughtered enemies. From the heads of his decapitated enemies he erected a pillar, and he covered the city walls with their skins.

The king's might is the theme of alabaster reliefs that lined the walls of his palace in present-day Nimrud, in Iraq. Figure **4.19** shows Assurnasirpal at the back of a horse-drawn chariot, his bow and arrow aimed at a rearing lion. The king's dominance over lions, a favorite subject in Assyrian art, was a metaphor for the subjugation of his enemies. The dynamic energy of the scene is reinforced by opposing diagonal planes and muscular tension. The overlapping of the horses creates an illusion of three-dimensional space.

Also symbolizing the king's power were stone *lamassu* (fig. **4.20**), monumental divine genii who guard palace entrances. *Lamassu* combine animal and human features—in this case, a bull's body and legs with a human head. The hair, beard, and eyebrows are stylized, and the figure wears a cylindrical three-horned crown of divinity.

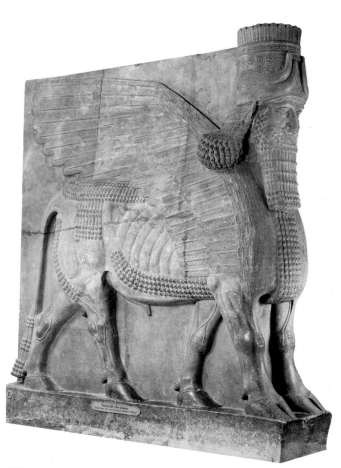

4.20 *Lamassu*, from the gateway, Dur Sharrukin (now Khorsabad, Iraq), c. 720 B.C. Limestone, 14 ft. (4.26 m) high. Louvre, Paris, France. These came from the palace of Sargon II (reigned 721–705 B.C.). An ancient visitor to the palace would experience the *lamassu* first as standing and then as walking. The *lamassu* stands as the observer faces him and walks as he passes by, all the while seeming to keep an eye out for the king's protection.

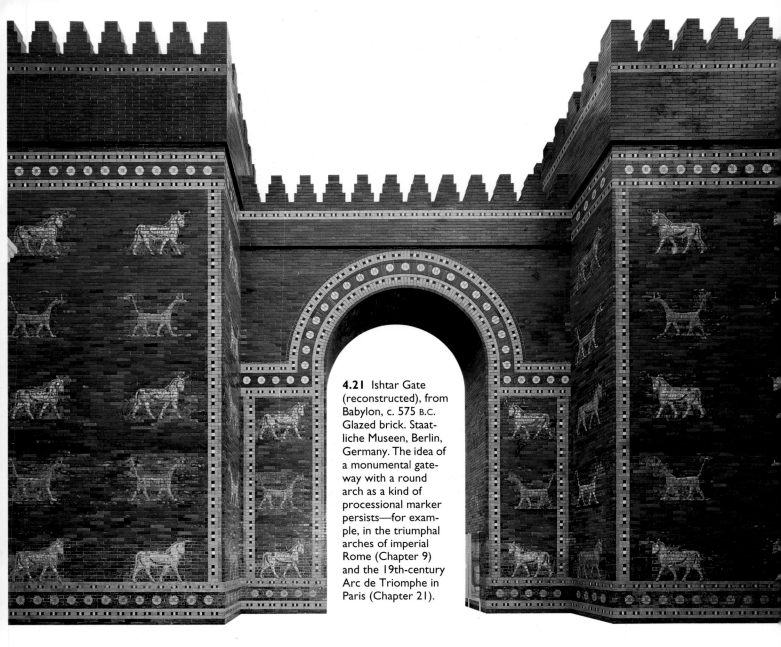

4.21 Ishtar Gate (reconstructed), from Babylon, c. 575 B.C. Glazed brick. Staatliche Museen, Berlin, Germany. The idea of a monumental gateway with a round arch as a kind of processional marker persists—for example, in the triumphal arches of imperial Rome (Chapter 9) and the 19th-century Arc de Triomphe in Paris (Chapter 21).

The relief aspect of the lamassu is more evident from the side than from the front. The figure combines organic quality in the suggestion of bone and muscle under the skin with several stylized surface patterns in the body hair. Rising from above the foreleg in a sweeping curve is a wing, which fills up the limestone block. The wing draws the eye to the side view of the lamassu, a transition further unified by the "reuse" of the foreleg in the side view. In this unique arrangement, the lamassu conform to the architectural function of an entrance, which is to mark a point of access—they face the approaching visitor and seem to stride past as one enters.

The Neo-Babylonian Empire

(612–539 B.C.)

By about 850 B.C., the Assyrians had taken control of Babylon. They ruled until the early seventh century B.C., when Nebuchadnezzar restored some of its former splendor.

The only extant example of monumental architecture from the reign of Nebuchadnezzar (605–562 B.C.) is the Ishtar Gate (fig. 4.21), one of eight gateways with round arches (see Box) located inside Babylon. Named after the goddess of love and fertility, the Ishtar Gate covered a processional route through the city. It was **faced** with

TECHNIQUE
Glazing

Glazing is a technique for adding a durable, water-resistant finish to clay objects. **Glazes** can be clear, white, or colored and are typically made with ground mineral pigments mixed with water. The minerals become vitreous (glasslike) and fuse with the clay bodies of the objects when fired at high temperatures in a kiln.

ARCHITECTURE
Round Arches

An **arch** may be thought of as a curved lintel connecting two vertical supports, or posts. The round arch, as used in the Ishtar Gate, is semicircular and stronger than a horizontal lintel. This is because a round arch carries the **thrust** of the weight onto the two vertical supports rather than having all the stress rest on the horizontal.

blue-glazed (see Box) **enamel** bricks and edged with white and gold geometric designs. Set off against the blue background are rows of bulls and dragons depicted in relief. They proceed in a horizontal plane either toward or away from the arched opening.

Iran (c. 5000–331 B.C.)

To the east of Mesopotamia lay ancient Iran, named after the Indo-European Aryans, who may have entered the Near East from the steppes of present-day Russia.

By the fifth millennium B.C. a distinctive pottery style had emerged in ancient Iran. A large painted pottery beaker from Susa, the capital of Elam in the southwest, exemplifies the artistic sophistication of the early Iranians (fig. **4.22**). It combines elegant form with a preference for animal subjects, which are characteristic of Iranian art. The central image is a stylized ibex (wild goat), whose body is composed of two curved triangles; its head is a small triangle, with individual lines comprising the beard and tail. The two large curved horns are particularly striking. They occupy two-thirds of the framed space and encircle a stylized plant form.

The ibex stands upright in contrast to the dogs, whose outstretched forelegs create an illusion of motion around

4.22 Beaker, from Susa, capital of Elam (now in Iran), c. 5000–4000 B.C. Painted pottery, 11¼ in. (28.6 cm) high. Louvre, Paris. The images painted on the beaker are consistent with the fact that the viewer is more aware of its circularity at the rim and base than on the broader surface in between.

the upper part of the beaker. A sense of slower movement is conveyed by the repeated long-necked birds, which seem to be parading along the top register in the opposite direction. By using the largest visible surface of the beaker for the standing ibexes (there is a second one on the other side), and the top two registers for the repeated animals, the artist harmonizes the painted images with the three-dimensional form of the object.

An unusual sculpture dating from c. 3000 B.C. merges the form of a bull with a human pose (fig. **4.23**; see Box). The figure wears a patterned skirt and kneels as if before a deity. Extended forward between the hooves is a spouted vessel that may have been an offering. Small limestone pebbles inside the figure suggest that it was used as a rattle or cult instrument. Its shiny surface and compact tension contribute to its curious combination of elegance and monumentality. Because this figure is unique in ancient art and because its original context is unknown, its significance has so far eluded researchers.

SOCIETY AND CULTURE
Destroying the Archaeological Record

Objects such as the Kneeling Bull in figure **4.23** create significant problems for archaeologists and raise questions about the plunder of archaeological sites. This particular work, like many others from ancient civilizations around the world, is certainly authentic (i.e., not a modern forgery), but it has no **provenience**. That is, it appeared on the art market without any record of its place of origin. Presumably because it is one of thousands of objects plundered for profit, the circumstances of its removal from the ground are unknown. It can be identified as Proto-Elamite on the basis of stylistic and iconographic analysis through comparison with related works excavated in known circumstances. But it cannot be assigned a specific context. We do not know what city it is from or whether it was found in a house, a palace, or a temple; its function is also unknown. Once the archaeological record of such an object is destroyed, a piece of history is lost forever. As a work of art, from a purely aesthetic point of view, the figure is immensely satisfying and reflects high-quality workmanship. As a visual document and an expression of a time and place, it remains a mystery.

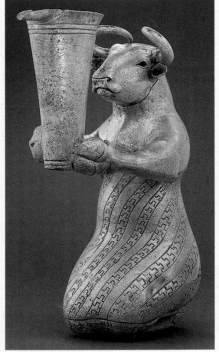

4.23 Kneeling Bull, southwest Iran, Proto-Elamite, 3100–2999 B.C. Silver, 6⁷⁄₁₆ in. (16.3 cm) high, 2½ in. (6.3 cm) wide. Metropolitan Museum of Art, New York. Purchase, Joseph Pulitzer Bequest, 1966.

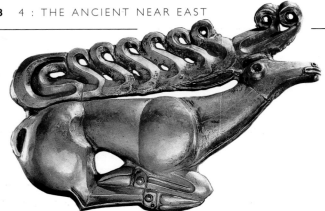

4.24 Stag, from Kostromskaya, Russia, 7th century B.C. Chased gold, 12½ in. (31.7 cm) long. State Hermitage Museum, Saint Petersburg, Russia. As with the Paleolithic cave paintings and carvings of Western Europe, this Scythian work is the product of artists familiar with the animals around them.

The Scythians

(8th–4th century B.C.)

The influence of early Iranian art persists in the much later animal art of the Scythians from southern Russia. Because the Scythians were nomadic, their art was portable. It is characterized by vivid forms and a high degree of technical skill. A stag from the seventh century B.C. (fig. **4.24**) is a typical Scythian gold object. The artist has captured a naturalistic likeness of the animal, while at the same time forming its antlers into an abstract series of curves and turning its legs into birds. Such visual metaphors, in which forms of one animal are transformed into those of another, are characteristic of Scythian animal art. They also enhance the illusion of motion; although it is clear from the folded, bird-shaped legs that the stag is not moving, there is a sense of movement in the **curvilinear** patterning.

Achaemenid Persia

(539–331 B.C.)

By the late seventh century B.C., the Babylonians and the Medes had united against the Assyrians. Cyrus the Great led the Persians against Lydia, in Anatolia, in 546 B.C. and against Babylon in 539 B.C. Under Cyrus, the Medes and the Persians united, and the Persians rose to dominance in the Near East. They created an empire that was even larger and more powerful than that of the Assyrians. The Assyrians influenced the Persians in several ways, most notably in their determination to celebrate kingship on a grand scale.

Both the culture and the style of the Persians are called Achaemenid, or Achaemenian, after Achemenes, the founder of the dynasty. There were no Achaemenid temples —religious rituals were held outdoors, where fires burned on altars. The Persians followed Zoroaster, who taught that the world's two central forces were light and dark.

The most elaborate Achaemenid architectural works were palaces. The best example is at Persepolis (Greek for "city of the Persians"). Started in about 520 B.C. by Darius I, work continued over many years under his successors, especially Xerxes and Artaxerxes I. Persepolis was built on a stone platform and consisted of multistructured rooms. The most important structure was the Apadana, or Audience Hall (fig. **4.25**), a columned chamber where the king received foreign delegations (see Box). The capitals were constructed in the form of double bulls facing in opposite directions (fig. **4.26**). With their legs tucked under the body, the bulls shown here have a dynamic, organic quality despite the stylized details. The choice of a bull as the capital parallels the animal's and the king's connotations of power and fertility. The bull is also an architectural metaphor for the position of the king as head of state.

4.25 Apadana (Audience Hall) of Darius and stairway, Persepolis (in modern Iran), c. 500 B.C. Approx. 250 ft.² (23.2 m²). The Apadana was decorated with a hundred columns 40 feet (12.2 m) high. Originally painted, the shafts show influences from other cultures, including Egypt (Chapter 5) and Greece (Chapter 7), but the bull capitals were unique to Persia.

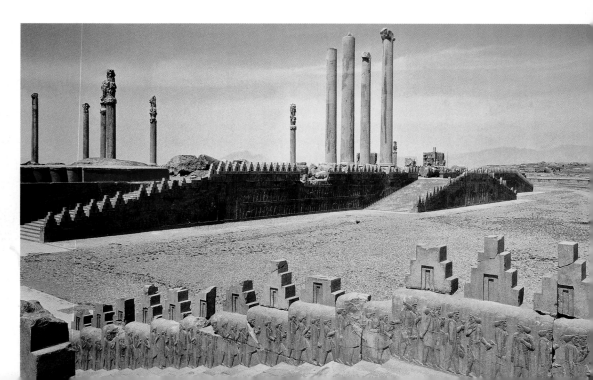

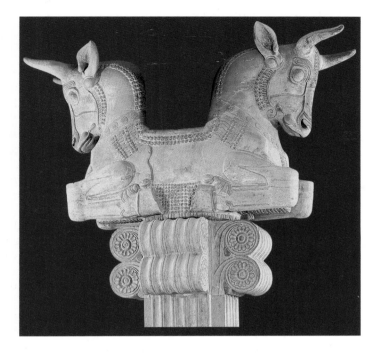

4.26 Bull capital, Persepolis, c. 500 B.C.

Further emphasizing the king's grandeur are the reliefs lining the walls and stairways of the palace at Persepolis. In contrast to the aggressive military scenes on Assyrian reliefs, Persian reliefs depict tributes and offerings presented to the ruler. This distinction is consistent with the political styles of the two civilizations—unlike the cruelly repressive Assyrian Empire, the Persian Empire was generally administered in an orderly and tolerant way. At Persepolis, sculptured groups of delegates to the palace proceed solemnly around the walls. The wall in figure 4.27, for example, shows members of the royal guard, whose broad, slightly curved drapery folds contribute to the sense of slow, ceremonial movement. The stylizations, particularly the curls of hair and beard, are classically Achaemenid. Vast numbers of such figures, like the repeated columns and their bull capitals, focus attention—both formal and iconographic—on the centrality and greatness of the king. The motif of the lion attacking the bull on either side of the royal guard is characteristic of Achaemenid art.

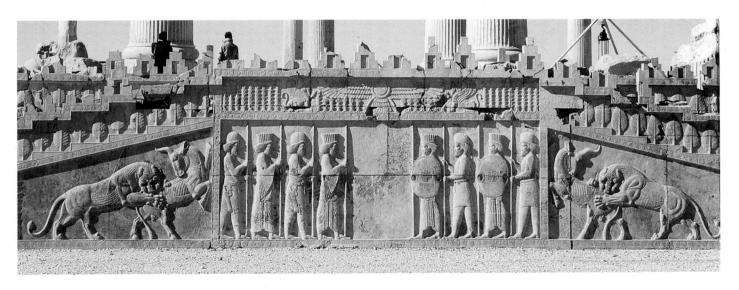

4.27 Royal guards, relief on the stairway to the Audience Hall of Darius, Persepolis, c. 500 B.C. Photo: R. Ottria.

Achaemenid artists were expert in metalwork. The gold lion drinking vessel in figure **4.28** is clearly an object fit for a king. Not only the intrinsic value of its material, but also the complexity of its design and structure, suggest that it comes from a royal workshop. It is formed from several pieces of gold, but their sophisticated fusion makes it difficult to locate the joints. Thin gold threads were used— altogether over 144 feet (44 m) of them—for the cup itself. Like the bulls on the Persepolis capital, the gold lion conveys a sense of compressed space and muscular tension. Its combination of stylized elements—such as the horseshoe-shaped leg muscle, the bulges on either side of the nose, the wing feathers and body hair—with convincing organic form is typical of much ancient Near Eastern art. So is the metamorphosing of the work from one form (the lion) into another (the drinking vessel). But the specific nature of the stylizations and the merging of elegance with monumental power are characteristic of the Achaemenid aesthetic.

Persian domination of the Near East came to an end nearly two hundred years after Darius I began the palace at Persepolis. In 331 B.C., Alexander the Great of Macedonia conquered the Persians and went on to create the largest empire the Western world had ever known.

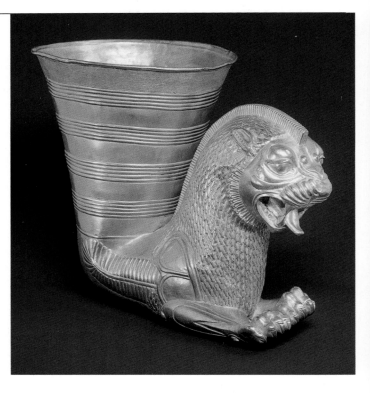

4.28 Achaemenid drinking vessel, Persian, 5th century B.C. Gold, 6¾ × 9 in. (17.1 × 22.9 cm). Metropolitan Museum of Art, New York. Fletcher Fund, 1954 (54.3.3).

6000 B.C.	3000 B.C.	1500 B.C.	300 B.C.

NEOLITHIC ERA **THE ANCIENT NEAR EAST**

c. 9000–4500 B.C.

(4.1)

Agriculture
(6000 B.C.)

First cities
(5000–4000 B.C.)

Copper
smelting
(4500 B.C.)

Bronze
casting
(4000 B.C.)

URUK
c. 3500–
3100 B.C.

(4.7)

Cuneiform
script

SUMERIAN
c. 2800–
2100 B.C.

(4.8)

*The Epic
of Gilgamesh*

AKKADIAN
c. 2300–
2100 B.C.

(4.10)

NEOSUMERIAN
c. 2100–
1800 B.C.

(4.12)

**OLD
BABYLONIAN**
c. 1800–
1600 B.C.

(4.16)

ASSYRIAN
c. 1300–
612 B.C.

(4.20)

Beginning
of Judaism
(c. 1200 B.C.)

NEOBABYLONIAN
612–539 B.C.

(4.21)

Reign of
Nebuchadnezzar
(604–562 B.C.)

HITTITE
c. 1450–
1200 B.C.

(4.17)

SCYTHIAN
c. 700–
300 B.C.

(4.24)

**ACHAEMENID
PERSIA**
539–331 B.C.

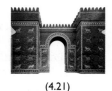

(4.28)

Birth of Buddha
(c. 563 B.C.)

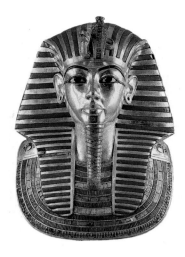

5
Ancient Egypt

The Gift of the Nile

Egypt, in northeast Africa, was the home of one of the most powerful and longest-lasting civilizations of the ancient world. In the Neolithic period, before about 7000 B.C., farming communities had settled along the banks of the Nile. They used stone tools and made ivory and bone objects and pottery. Until its unification around 3100 B.C., ancient Egypt had been divided into Upper Egypt in the south and Lower Egypt in the north. Egypt was defined by its most important geographical feature, the Nile, the world's longest river. Because annual floods kept the land fertile, Egypt was called "the gift of the Nile."

The Pharaohs

From approximately 3100 B.C., Egypt was ruled by pharaohs, or kings, whose control of the land and its people was virtually absolute. Egyptian monumental art on a vast scale begins with pharaonic rule, originating when King Menes united Upper and Lower Egypt.

Modern scholars have divided Egyptian history into the Predynastic and Early Dynastic periods, followed by the Old, Middle, and New Kingdoms and the Late Dynastic period. These were punctuated by so-called Intermediate periods of anarchy or central political decline, as well as by periods of foreign domination (see Box).

Between the Middle and New Kingdoms there was a period of more than one hundred years during which Semitic rulers in the northeastern Delta controlled Lower Egypt. Known as the Hyksos, from the Egyptian word *heqau-khasut* (meaning "princes of foreign countries"), these rulers are thought to have introduced the horse-drawn chariot to Egypt. During the New Kingdom, some important changes occurred. Hatshepsut, the first queen to assume pharaonic status and preside over an artistic revival, co-ruled Egypt with Thutmose III from c. 1479 to 1458 B.C., and later, during the Amarna period, the pharaoh Akhenaten (ruled c. 1349–1336 B.C.) made important changes in the hierarchy of gods.

From the end of the New Kingdom, Egypt was weakened by infiltration from other states. During the Late Dynastic period, Egypt twice fell under Persian rule—from 525 to 404 B.C. and again in 343 B.C. In 332 B.C. the Persians were defeated by Alexander the Great, who annexed Egypt to his empire. After his death in 323 B.C., control of Egypt passed to the Macedonian general Ptolemy, whose successors ruled until the Roman conquest in 31 B.C.

The Egyptian Concept of Kingship

As in Mesopotamia (Chapter 4), kings mediated between their people and the gods. In Egypt, however, the kings were considered gods. They ruled according to the principle of *maat*, divinely established order (personified by Maat, the goddess of truth and orderly conduct). From the Third Dynasty, the god Ra, in the guise of the reigning pharaoh, was believed to impregnate the queen with a son who

Chronology: Egyptian Kings (all dates before 664 B.C. are approximate)		
Predynastic period		5450–3100 B.C.
Early Dynastic period	Dynasties 1–2	3100–2649 B.C.
Old Kingdom	Dynasties 3–6	2649–2150 B.C.
First Intermediate period	Dynasties 7–11	2143–1991 B.C.
Middle Kingdom	Dynasties 12–14	1991–1700 B.C.
Second Intermediate period	Dynasties 15–17 (including the Hyksos period)	1699–1641 B.C. 1640–1550 B.C.
New Kingdom	Dynasties 18–20	1550–1070 B.C.
Third Intermediate period	Dynasties 21–25	1070–660 B.C.
Late Dynastic period	Dynasties 26–30	688–343 B.C.
	Persian kings	343–323 B.C.
Ptolemaic period	Macedonian kings	323–31 B.C.

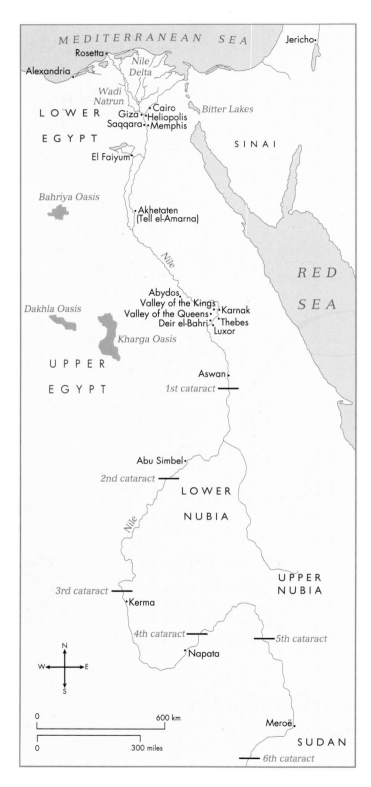

Ancient Egypt and Nubia.

ambiguous position of the queen by comparison with that of the pharaoh reflects her complementary role. Certain exceptions notwithstanding, Egyptian kingship was not for women. The queen was the king's means of renewal, providing him with male heirs to the throne or with daughters for creating alliances through advantageous marriages.

In entering into incestuous marriages, the king, like the gods, was distinct from the general population. The royal family thus modeled its behavior on that of the gods, separating itself from those it ruled. Egyptian kings maintained power not by setting an example to the public at large, but rather by their distinction from it. In the transfer of kingship from father to son or to some substitute for a son, Egypt created another avenue of identification with the gods.

The Palette of Narmer

The links between divine and earthly power can be seen in an important ritual object, namely the Palette of Narmer (figs. **5.1** and **5.2**); it dates from the beginning of pharaonic rule and is designed to project the ruler's power. On both sides, the palette is decorated in low relief. The large scene in figure **5.1** is depicted according to certain conventions that lasted for over two thousand years in Egypt. King Narmer (thought to be Menes, the first pharaoh) is the biggest figure—his size and central position denote his importance. His composite pose, in which the head and legs are rendered in profile view with the eye and upper torso in frontal view, is an Egyptian convention. This is a conceptual, rather than a naturalistic, approach to the human figure, for the body parts are arranged as they are individually understood, and not as they are seen in nature. The entire figure is flat, as is the kilt, with certain details such as the kneecaps rendered as stylizations, rather than as underlying organic structure.

Narmer wears the tall white conical crown of Upper Egypt (the *hedjet*) and threatens a kneeling enemy with a mace. He holds this enemy by the hair, symbolizing conquest and domination. Two additional enemies who are already dead occupy the lowest register of the palette. Behind Narmer on a suspended horizontal strip is a servant whose small size identifies him as much less important than the king. The servant holds Narmer's sandals indicating that the king is on holy ground. In front of Narmer, at the level of his head, is Horus, the falcon god of the sky and kingship, who holds a captive human-headed creature at the end of a rope. From the back of this figure rise six **papyrus** plants, which represent Lower Egypt. The image of Horus dominating symbols of Lower Egypt parallels Narmer, crowned as the king of Upper Egypt and subduing an enemy.

At the top center of each side of the palette is a rectangle known as a **serekh**. A *serekh* contained a king's name in **hieroglyphs** (pictures, symbolizing words, that were the earliest Egyptian writing system) and was a flattened representation of the royal palace. Flanking the *serekh* are frontal

would be heir to the throne. This divine conception was part of each pharaoh's official iconography. A queen could be either the king's mother or his principal wife. Marriages occasionally took place between a pharaoh and his sister, half-sister, or daughter when this was politically useful. The

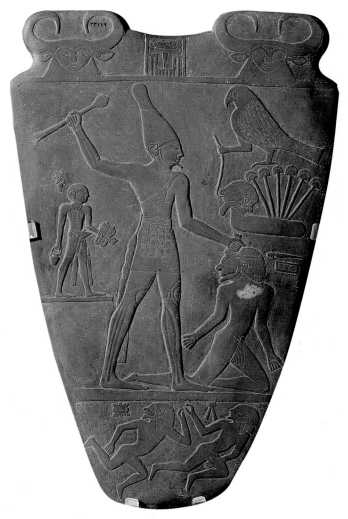

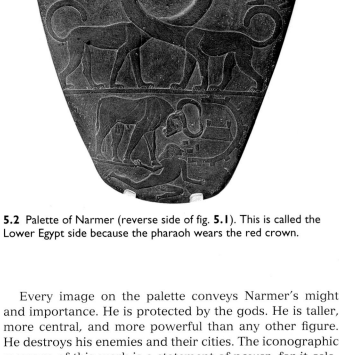

5.1 Palette of Narmer, from Hierakonpolis, c. 3100 B.C. Slate, 25 in. (63.5 cm) high. Egyptian Museum, Cairo. This is called the Upper Egypt side because Narmer wears the white crown.

5.2 Palette of Narmer (reverse side of fig. **5.1**). This is called the Lower Egypt side because the pharaoh wears the red crown.

heads of the horned cow goddess Hathor, who guards the king.

The other side of the palette (fig. **5.2**) has three registers below the Hathor heads and the pharaoh's name. In the upper register, Narmer wears the red crown of Lower Egypt (the *deshret*). His sandal-bearer is behind him, and he is preceded by standard-bearers. At the far right, ten decapitated enemies lie with their heads between their feet. These figures are meant to be read from above, as a row of bodies lying side by side. Such shifting viewpoints are characteristic of Egyptian pictorial style.

Two felines, roped by bearded men, occupy the central register. Their elongated necks frame an indented circle similar to those that held liquid for mixing eye makeup on smaller palettes. This one, however, was found as a dedication in a temple and is larger than those used in everyday life. It was most likely a ceremonial, rather than a practical, object. The meaning of the felines, called *serpopards*, is uncertain, but their intertwined necks could refer to Narmer's unification of Egypt (signified by his two crowns). In the lowest register, a bull—probably a manifestation of Narmer himself—dominates a fallen enemy.

Every image on the palette conveys Narmer's might and importance. He is protected by the gods. He is taller, more central, and more powerful than any other figure. He destroys his enemies and their cities. The iconographic message of this work is a statement of power, for it celebrates the king's divine right to rule and illustrates his ability to do so.

The Old Kingdom

(2649–2150 B.C.)

Pyramids

The most monumental architectural expression of the Egyptian pharaoh's power was the pyramid, his burial place and zone of passage into the afterlife. Pyramids had been preceded by smaller **mastabas,** single-story trapezoidal structures; the term derives from the Arabic word for "bench" (fig. **5.3**). These were originally made of mud-brick and later were faced with cut stones.

53

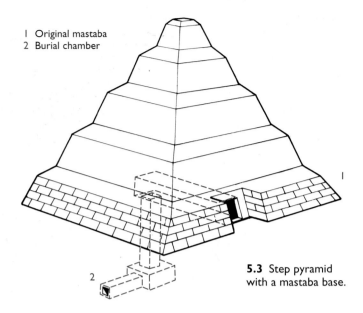

1 Original mastaba
2 Burial chamber

5.3 Step pyramid with a mastaba base.

From 2630 to 2611 B.C., King Zoser's architect Imhotep constructed a colossal structure within a sacred architectural precinct at Saqqara, on the west bank of the Nile about 30 miles (48 km) south of Cairo. Five mastabas of decreasing size, one on top of the other, resulted in a "step pyramid" (fig. **5.4**). Inside, a vertical shaft some 90 feet (27.4 m) long led to the burial chamber. The exterior was faced with limestone, most of which has now disappeared.

The next major development in pyramid design was the purely geometric type. Four triangular sides slant inward from a square base so that the apexes of the triangles meet over the center of the square. Originally, the sides were smooth and faced with polished limestone, and the four corners of the plan were oriented to the cardinal points. A capstone, probably gilded, reflected the sun, signifying the pharaoh's divinity and identification with the sun. The most impressive pyramids were built for three Old Kingdom pharaohs of the Fourth Dynasty: the pyramid of Khufu (the largest, known as the Great Pyramid); the pyramid of his son Khafre; and the pyramid of Khafre's son Menkaure (fig. **5.5**). All three are near Cairo at Giza, on the west bank of the Nile, facing the direction of sunset (symbolizing death).

Each pyramid was connected by a causeway (an elevated road) to its own valley temple at the edge of the original flood plain of the Nile. When the king died, his body was transported across the Nile by boat to the valley temple. It was then carried along the causeway to its own funerary temple, where it was presented with offerings of food and drink, and the Opening of the Mouth ceremony was performed (see fig. **5.19**).

The pyramid was a resting place for the king's body, and burial chambers were constructed either in the rock under the pyramid or in the pyramid itself. In Khufu's case (fig. **5.6**), the burial chamber is located in the middle of the pyramid. There were also smaller chambers, possibly for the body of the queen, the organs of the deceased, and worldly goods for the journey to the afterlife. The chambers were connected by a maze of passages, including dead ends designed to foil grave robbers. In this objective the builders failed; during the Middle Kingdom a succession of thieves plundered all of the Giza pyramids.

From the pyramid of Khafre, a processional road led to his valley temple, guarded by the Great Sphinx (fig. **5.7**), a colossal human-headed creature with a lion's body, carved out of sandstone. The location of the **sphinx** suggests that it represented Khafre himself. Surrounding the sphinx's head is the trapezoidal pharaonic headcloth (the *Nemes* headdress), which fills up the open space above the shoulders and enhances the sculpture's monumentality.

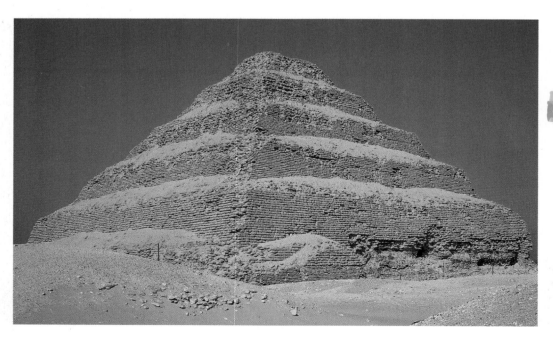

5.4 Step pyramid, funerary complex of King Zoser, Saqqara, Egypt, 2630–2611 B.C. Limestone, 200 ft. (61 m) high. Its architect, Imhotep, was a priest at Heliopolis and is reputed to have been the first Egyptian to build monumental stone structures. His name is inscribed inside the pyramid, where he is designated "First after the King of Upper and Lower Egypt." He became a legendary figure in ancient Egypt, revered for his wisdom as a magician, astronomer, and healer, and was worshiped as a god.

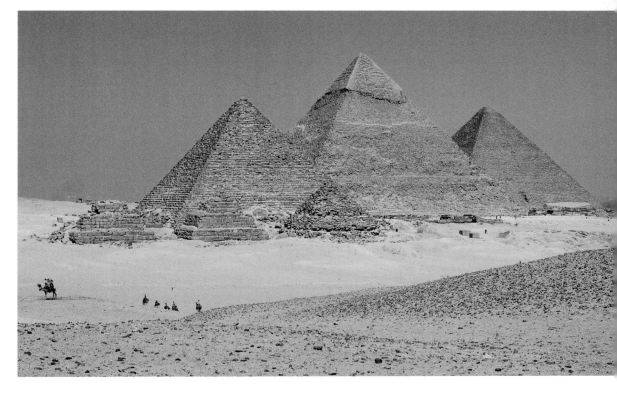

5.5 Pyramids at Giza, Egypt, 2551–2472 B.C. Limestone: pyramid of Khufu approx. 480 ft. (146 m) high; base of each side 755 ft. (230 m) long. The Giza pyramids were built for three Old Kingdom pharaohs of the 4th Dynasty: Khufu (c. 2551–2528 B.C.), Khafre (c. 2520–2494 B.C.), and Menkaure (c. 2490–2472 B.C.). Khufu's pyramid—the largest of the three—was over twice as high as Zoser's step pyramid at Saqqara.

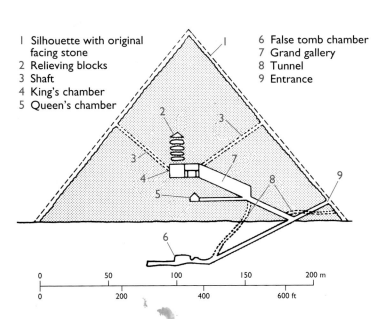

1 Silhouette with original facing stone
2 Relieving blocks
3 Shaft
4 King's chamber
5 Queen's chamber
6 False tomb chamber
7 Grand gallery
8 Tunnel
9 Entrance

5.6 (Above) Cross section of the pyramid of Khufu.

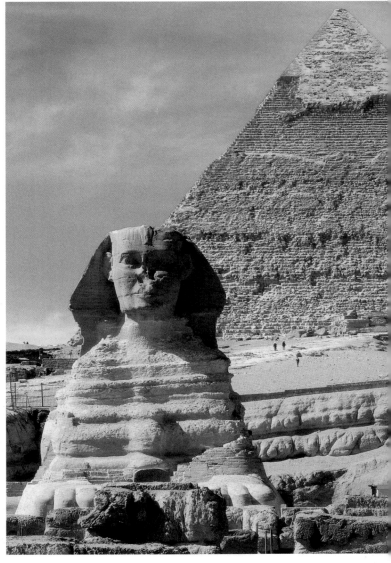

5.7 Colossal statue of Khafre, known as the Great Sphinx, Giza, c. 2520–2494 B.C. Limestone, 66 ft. (20.12 m) high, 240 ft. (73.15 m) long. In Egypt, as elsewhere in the Near East, lions guarded entrances, especially to temples and palaces. In addition to the tradition that lions never sleep, they were associated with the sun as the eye of heaven.

RELIGION
Egyptian Gods

The Egyptians, like their Near Eastern neighbors, were polytheists. Gods were manifest in every aspect of nature; they influenced human lives and ordered the universe, and they could appear in human or animal form or as various human and animal combinations. The result of this belief system was a pantheon of enormous complexity. Over time the number was increased by the introduction of foreign gods into Egypt. Like most polytheists, the Egyptians did not find the religious ideas of other cultures incompatible with their own, and they incorporated new deities either singly or in combination. This process of fusion is known as syncretism. A few of the principal gods of ancient Egypt in their most typical guises are listed here.[1]

Amon	Great god of Thebes; identified with Ra as Amon-Ra; sacred animals—the ram and goose.
Anubis	Jackal god, patron of embalmers; god of the **necropolis** who ritually "opens the mouth" of the dead.
Aten	God of the sun disk; worshiped as the great creator god by Akhenaten.
Bes	Helper of women in childbirth, protector against snakes and other dangers; depicted as a dwarf with features of a lion.
Hapy	God of the Nile in flood; depicted as a man with pendulous breasts, a clump of papyrus (or a lotus) on his head, and bearing tables laden with offerings.
Hathor	Goddess with many functions and attributes; often depicted as a cow, or a woman with a cow's head or horned headdress; mother, wife, and daughter of Ra; protector of the royal palace; domestic fertility goddess.
Horus	Falcon god, originally the sky god; identified with the king during his lifetime; the son of Osiris and Isis.
Imhotep	Chief minister of Zoser and architect of his step pyramid; deified and worshiped in the Late Dynastic period as god of learning and medicine.
Isis	Divine mother, wife of Osiris and mother of Horus; one of four protector goddesses, guarding coffins and **canopic** jars.
Maat	Goddess of truth, right, and orderly conduct; depicted as a woman with an ostrich feather on her head.
Mut	Wife of Amon; originally a vulture goddess, later depicted as a woman.
Osiris	God of the underworld, identified as the dead king; depicted as a mummified king.
Ptah	Creator god of Memphis, patron god of craftsmen; depicted as a mummy-shaped man.
Ra (Re)	Falcon-headed sun god of Heliopolis, supreme judge; often linked with other gods whose cults aspire to universality (e.g., Amon-Ra).
Serapis	Ptolemaic period; with characteristics of Egyptian (Osiris) and Greek (Zeus) gods.
Seth	God of storms and violence; brother and murderer of Osiris; rival of Horus; depicted as pig, ass, hippopotamus, or other animal.
Thoth	God of of writing and wisdom; often shown with the head of an ibis; Egyptian scribes prayed to him when preparing a text.

Mummification

For the ancient Egyptians, death was a transition to a similar existence on another plane. To ensure a good afterlife, the deceased had to be physically preserved along with earthly possessions and other reminders of daily activities. This was first achieved by simple burial in the dry desert sands. Later, coffins insulated the body and artificial means of preservation were used. But in case the body of the deceased did not last, an image could serve as a substitute. The dead person's *ka,* or soul, was believed able to enter the surrogate before journeying to the next world.

Procedures such as mummification highlight the ancient Egyptian's preoccupation with a continued material existence in the afterlife. Enormous resources were devoted to providing for the dead, both on an individual level and, in the case of the royal family and its court, on a grand scale involving the whole society. Much of the art and writings that have survived are funerary, preserved in the dry desert climate for thousands of years.

The seventy-two-day process of embalming corpses began with the removal of internal organs, except for the heart, which was believed to be the seat of understanding and was therefore left intact. The body was then packed in dry natron (a natural compound of sodium carbonate and sodium bicarbonate found in Egypt), which dehydrated the cadaver and dissolved its body fats. Then the corpse was washed, treated with oils and ointments, and bandaged with up to twenty layers of linen. The substances applied to its skin caused the body to turn black; later travelers took this to mean that the body had been preserved with pitch, for which the Arabic term is *mumiya*—hence the English terms "mummy" and "mummification."

The organs were embalmed and placed in four canopic jars, but the brain was discarded as useless. Each jar held a particular organ and was under the protection of one of Horus's four sons.

Sculpture

Egyptian artists followed certain conventions for sculptures in the round and in relief. The more important the personage represented, the more rigorously the conventions were observed.

An over-life-size diorite statue of Khafre (fig. 5.8) illustrates the conventional representation of a seated pharaoh. Khafre sits in an erect, regal posture, both hands on his lap, his right fist clenched and his left hand lying flat above his knee. The sculptor began with a rectangular block of stone to which the planes of the figure conform. Khafre's throne and its base are a stepped arrangement with two verticals (corresponding to the king's torso, upper arms, and calves) meeting three horizontals (his forearms, thighs, and feet) at right angles. Spaces between body and throne are eliminated because the original diorite remains, reflecting the symbolic identification of the king and his throne.

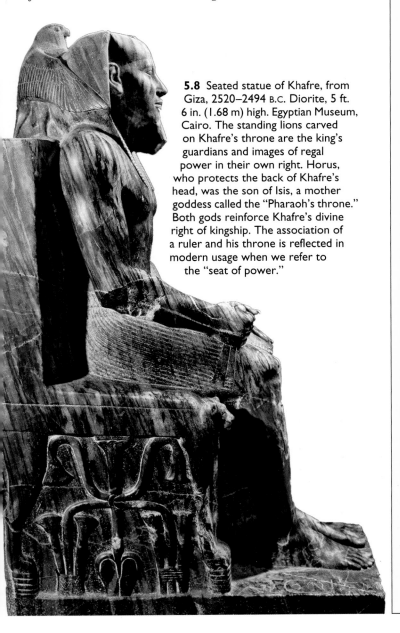

5.8 Seated statue of Khafre, from Giza, 2520–2494 B.C. Diorite, 5 ft. 6 in. (1.68 m) high. Egyptian Museum, Cairo. The standing lions carved on Khafre's throne are the king's guardians and images of regal power in their own right. Horus, who protects the back of Khafre's head, was the son of Isis, a mother goddess called the "Pharaoh's throne." Both gods reinforce Khafre's divine right of kingship. The association of a ruler and his throne is reflected in modern usage when we refer to the "seat of power."

TECHNIQUE
The Egyptian Canon of Proportion

Canons of **proportion** are commonly accepted guidelines for depicting the ideal human figure by specifying the relationships of the parts of the body to one another and to the whole. They vary from culture to culture and have evolved over time. The canons followed by Egyptian artists changed only slightly from the Old to the New Kingdom, a reflection of the unusual stability of ancient Egypt. The illustration here (fig. 5.9) is based on the Old Kingdom canon as it was used at Saqqara during the reign of Zoser.

The surface of a relief or a painting is divided into a grid of squares, each equivalent to the width of the figure's fist. The distance from the hairline to the ground is 18 fists, from the base of the nose to the shoulder 1 fist, and from the fingers of a clenched fist to the elbow 4½ fists. The length of a foot (heel to toe) is 3½ fists.

Note the characteristic way of depicting the human body: the shoulders and the one visible eye are frontal; the head, arms, and legs are in profile; the waist is nearly in profile but is turned to show the navel. One purpose of this system was to arrive at a conventional, instantly recognizable image. The persistence of such canons contributed to the continuity of Egyptian style over a two-thousand-year period.

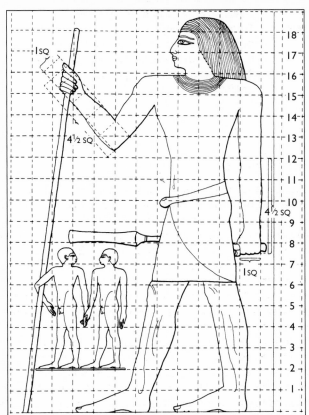

5.9 Egyptian canon of proportion.

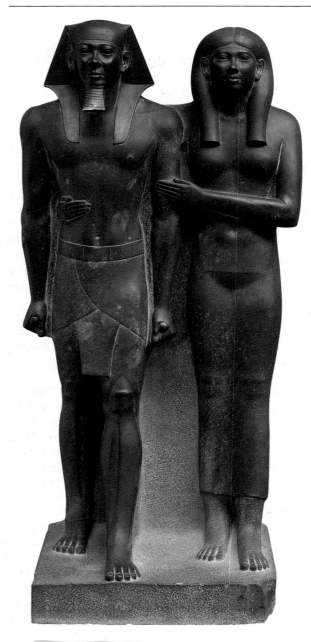

5.10 Menkaure and Queen Khamerernebty, from Giza, 2490–2472 B.C. Slate, 4 ft. 6½ in. (1.39 m) high. Courtesy Museum of Fine Arts, Boston.

A good example of standing figures from the Old Kingdom is the statue of Khafre's son Menkaure and Queen Khamerernebty (fig. **5.10**). The original upright rectangular block remains visible in the base, between the figures, and at the back. Menkaure is frontal and stands as if at attention, arms at his sides and fists clenched. His left leg extends forward in an assertive stance signifying his power. The *Nemes* headdress closes up the space around the head, as in the sphinx at Giza. Both the kneecap and the ceremonial beard are rectangular.

A comparison of Menkaure with Khamerernebty illustrates certain conventional differences between males and females in Egyptian art. Within the rigorous social hierarchy of ancient Egypt, a queen was below a king in rank, a position indicated not only by her slightly smaller size but also by her stance. Her left foot does not extend as far forward as the king's, nor are her arms as rigidly positioned. In addition, her arms are bent, the right one reaching around the king's waist and the left one bent at the elbow and holding the king's left arm. Her open hands lack the tension of the king's clenched fists. Her garment, in contrast to Menkaure's, outlines the form of her body and, like her wig, is more curvilinear. The less imposing, more naturalistic, and less formal portrayal of the queen in comparison with the king is a function of her lower rank.

The statues of Khafre and of Menkaure and Khamerernebty were originally found in their valley temples. Their function was to embody the *ka* of the royal personages they depicted and to receive food and drink brought by worshipers. Priests were believed to have the magic power to transform the images into real people who could eat the offerings.

Compared with the royal figures, the seated scribe in figure **5.11** is less monumental though no less impressive. He sits cross-legged, a pose that was conventional for scribes. A papyrus **scroll** extends across his lap, and his right hand is poised to write. In contrast to statues of pharaohs, the lower rank of the scribe meant that the sculptor could convey a more individual character. The sculptor has also cut away the limestone between the arms and body as well as around the head and neck, thereby reducing the monumentality of this statue as compared with that of Khafre. The depiction of the scribe is also more personalized than that of Khafre—he has a roll of fat around his torso, a potbelly, and sagging breasts. This particular scribe must have been of high status because he had his own tomb.

5.11 Seated scribe, from Saqqara, Egypt, c. 2551–2528 B.C. Limestone, 21 in. (53.3 cm) high. Louvre, Paris, France. The scribe retains his original paint, which makes his eyes seem lifelike. In ancient Egypt, scribes were among the most educated people, having to study law, mathematics, and religion, as well as reading and writing.

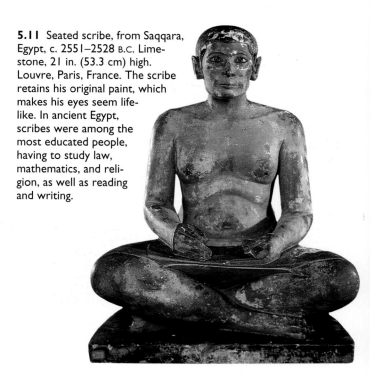

5.12 Senusret III, c. 1878–1841 B.C. Quartzite, 6½ in. (16.5 cm) high. Metropolitan Museum of Art, New York. Gift of Edward S. Harkness, 1926.

The Middle Kingdom

(c. 1991–1700 B.C.)

Monumental architecture continued in the Middle Kingdom, though much of it was destroyed by New Kingdom pharaohs for use in their own colossal building projects. Besides pyramids, a new form of tomb was introduced. This was rock-cut architecture, in which the sides of cliffs were excavated to create artificial cave chambers. Rock-cut tombs became popular with aristocrats and high-level bureaucrats in the Eleventh and Twelfth dynasties, and in the New Kingdom with the pharaohs. Thutmose I (reigned c. 1504–1492 B.C.) was the first Egyptian pharaoh buried in a rock-cut tomb in the Valley of the Kings, which is across the Nile from Luxor and Karnak.

Middle Kingdom sculpture is often somewhat more naturalistic than Old Kingdom sculpture. Forms tend to be more rounded, and faces show occasional hints of an expression.

The political turbulence and invasions of the First Intermediate period that preceded the Middle Kingdom disrupted confidence in the pharaoh's absolute divine power. Although pharaonic rule quickly reasserted itself, certain works of art reflect a new national mood. The portrait of Senusret III (fig. **5.12**) exemplifies the new approach to royal representation in the Middle Kingdom. He referred to himself as the shepherd of his people, and his portrait seems to show concern. Lines of worry crease the surface of his face, and his forehead forms a slight frown. There are bags under his eyes, and his cheeks are fleshy. This is no longer solely an image of divine, royal power. Instead, it departs from earlier conventions of royal representation, and a specific personality emerges.

The New Kingdom

(c. 1550–1070 B.C.)

Temples

The first known Egyptian temples in the Neolithic period had been in the form of huts preceded by a forecourt. From the beginning of the dynastic period, a courtyard, hallway, and inner **sanctuary** were added. The columned hallway, called a **hypostyle**, was constructed in the post-and-lintel system of elevation. Its two rows of tall central columns were flanked by rows of shorter columns.

The standard Egyptian temple, called a **pylon** temple after the two massive sloping towers (pylons) flanking the entrance, was designed symmetrically along a single axis.

Temple of Amon-Mut-Khonsu The plan of the New Kingdom temple of Amon-Mut-Khonsu at Luxor in figure **5.13** shows the spaces through which worshipers moved from the bright outdoors to the dark inner sanctuary. When they arrived at the entrance, they confronted two rows of gods in animal form facing each other. At the end of the row were two **obelisks** (tall, tapering, four-sided pillars ending in a pointed tip, or **pyramidion**) and two colossal statues of pharaohs (fig. **5.14**).

From the courtyards (2, 3, and 4 on the plan), the worshipers entered the hypostyle hall (5 on the plan), its massive columns casting shadows and creating an awe-inspiring atmosphere. The upper **(clerestory)** windows let in a small amount of light that enhanced the effect of the shadows. Most people never entered the temples, but watched from the outside the processions for which the temples were planned. The elite were allowed to enter the courtyards, while the priests carried images of the gods in and out of the innermost sanctuaries in boat-shaped shrines called barks. The transitional quality of this architecture is carefully designed to evoke the feeling of a mysterious

5.13 Plan of the temple of Amon-Mut-Khonsu, Luxor, Egypt, begun c. 1390 B.C. Reading the plan from right to left, number 1 refers to the pylons flanking the entrance. From the entrance, one proceeded through three open-air colonnaded courtyards (2, 3, 4). Then the worshiper was plunged into the darkened and mysterious realm of the hypostyle hall (5), beyond which lay the sanctuary complex (6).

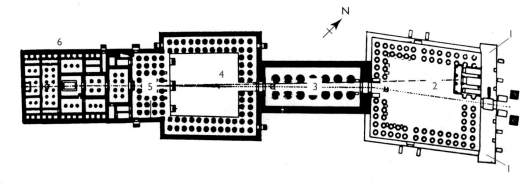

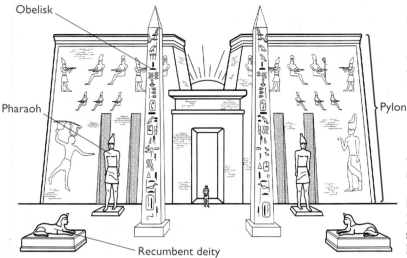

Obelisk

Pharaoh

Pylon

Recumbent deity

5.14 Diagram of a pylon façade. The obelisks were derived from the sacred benben stone worshiped as a manifestation of Amon at Heliopolis. At dawn, the rays of the rising sun caught the benben stone before anything else, and the stone was thus believed to be the god's dwelling place. The obelisks flanking the pylon entrance were arranged in relation to positions of the sun and moon and, like the pyramids, were capped with gold.

ceiling was painted blue and decorated with birds and stars, denoting its symbolic role as the heavenly realm.

Hatshepsut's Mortuary Temple and Sculpture The Eighteenth Dynasty is notable for its female pharaoh, Hatshepsut (reigned 1473–1458 B.C.). She was the wife and half-sister of Thutmose I's son, Thutmose II. When Thutmose II died, Thutmose III, *his* son by a minor queen, was underage. Around 1479 B.C. Hatshepsut became regent for her stepson-nephew, but she exerted her right to succeed her father and was crowned king of Egypt in 1473 B.C. Although female rulers of Egypt were not unprecedented, Hatshepsut's assumption of the title of king was a departure from tradition. Despite her successor's attempts to obliterate her monuments, many of them survive to document her productive reign.

It is not known why Hatshepsut became king or why Thutmose III tolerated it. Hatshepsut's strong character and political acumen must have contributed to her success. She claimed that her father had chosen her as king, and she used the institution of co-regency to maintain her power without having to eliminate her rival. Above all, she selected her officials wisely, particularly Senenmut, who was her daughter's guardian, her first minister, and her chief architect.

Hatshepsut, like other pharaohs, assumed royal titles and iconography and had her own divine conception depicted

enclosure, a space implicitly accessible only to priests, pharaohs, and gods.

The temple of Amon-Mut-Khonsu (fig. 5.15) is dedicated to a triad of gods worshiped at the New Kingdom capital city of Thebes. The view in the illustration shows the hypostyle columns and a pylon **façade** in the background. At the far end was the sanctuary—the "holy of holies"—a small central room with four columns.

Like all ancient Egyptian temples, this one was considered a microcosm of the universe and as such contained both earthly and celestial symbolism. Column designs were derived from the vegetation of Egypt—in this case papyrus —and represented the fertility of the earth. The original

5.15 Court and pylon of Ramses II and colonnade and court of Amenhotep III, temple of Amon-Mut-Khonsu, Luxor, Egypt, 19th Dynasty, c. 1279–1212 B.C.

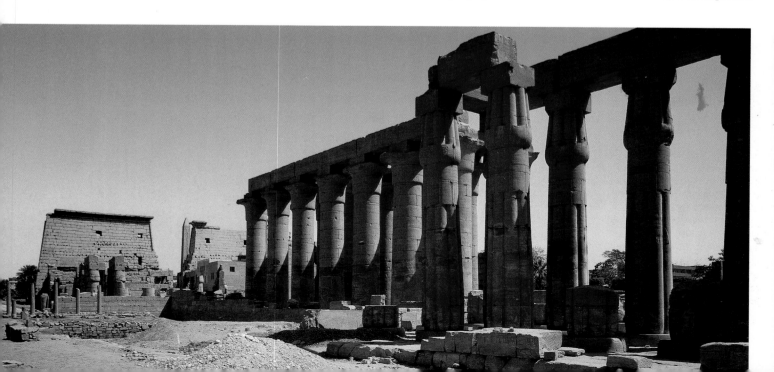

in her temple reliefs. In keeping with the conventional scene, the compound god Amon-Ra was shown handing the *ankh* symbol (♀), hieroglyph for "life," to her mother, Queen Ahmose. In this imagery, Hatshepsut proclaimed her divine right to rule Egypt as a king. She also referred to herself in texts as the female Horus, evoking the traditional parallel between pharaohs and gods.

Despite acknowledging her gender, Hatshepsut chose to be represented as a man in many of her statues. The example in figure **5.16** depicts her in the traditional assertive pose of standing pharaohs, wearing a ceremonial headdress and beard. Instead of the clenched fists of Old Kingdom pharaohs such as Menkaure (see fig. **5.10**), Hatshepsut extends her arms forward and lays her hands flat on her trapezoidal garment.

The main architectural innovation of Hatshepsut's reign was the terraced mortuary temple at Deir el-Bahri (fig. **5.17**). The primary function of the Egyptian mortuary temple, usually constructed from a pylon plan, was twofold: first, to worship the king's patron deity during his lifetime; and, second, to worship the king himself after his death. As a mortuary temple for both Hatshepsut and her father, the Deir el-Bahri complex reinforced her image as his successor. At the same time, the major deities Amon, Hathor, and Anubis were worshiped in shrines within the temple. On the exterior, terraces with rectangular supports and polygonal columns blended impressively with the vast rocky site.

At the end of Hatshepsut's reign, Thutmose III, then in his late twenties, assumed sole power (c. 1458 B.C.). He demolished the images of Hatshepsut and emphasized his own role as his father's successor. Whereas Hatshepsut's reign had been notable for diplomatic missions, Thutmose III became a great conqueror, gaining control of Nubia and invading the Near East. Reflecting his interest in foreign alliances were his marriages to three women with Syrian names.

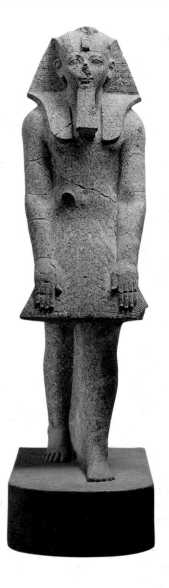

5.16 Statue of Hatshepsut as pharaoh, 18th Dynasty, c. 1473–1458 B.C. Granite, 7 ft. 11 in. (2.41 m) high. Metropolitan Museum of Art, New York. Hatshepsut was the second known queen to rule Egypt as pharaoh. The earlier queen, Sobekneferu, ruled in the 12th Dynasty but, unlike Hatshepsut, did not preside over an artistic revival.

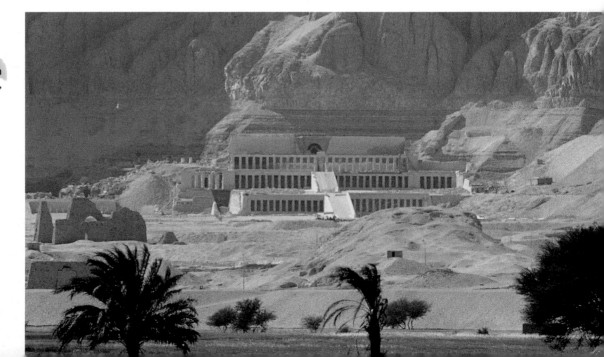

5.17 Funerary temple of Queen Hatshepsut, Deir el-Bahri, Egypt, 18th Dynasty. Sandstone and rock. Construction of this temple began in the reign of Thutmose I (1504–1496 B.C.) and continued during the reign of his daughter Hatshepsut (reigned 1473–1458 B.C.). Most of the projecting colonnades have been restored after being vandalized during the reign of Thutmose III. They adorn the three large terraces, which are connected to each other by ramps. The inner sanctuary is located inside the cliff.

5.18 Nebamun hunting birds, from the tomb of Nebamun, Thebes, Egypt, c. 1390–1352 B.C. Fragment of a painting on gypsum plaster. British Museum, London, England.

Papyrus A New Kingdom painting on papyrus from the *Book of the Dead* (fig. **5.19**) illustrates the Opening of the Mouth ceremony, which ritually "opened the mouth" of the deceased and restored the ability to breathe, feel, hear, see, and speak. In this scene, described in the rows of hieroglyphics at the top, the ritual is performed on the Nineteenth Dynasty mummy of the scribe Hunefer. Reading the image from left to right, we see a priest in a leopard skin, an altar, and two priests in white garments with upraised ritual objects—a hook, a bull's leg, and a knife. Two mourning women are directly in front of the upright mummy. Their lighter skin tones, in comparison with the men's, had been a convention of Egyptian art since the Old Kingdom.

Behind the mummy is Anubis, the jackal-headed mortuary god. The two forms behind him are a stele, covered with hieroglyphs and surmounted by a representation of Hunefer appearing before a god, and a stylized tomb façade with a pyramid on top. Note the similarity between the iconography of the power-revealing scene at the top of the stele and that on the law code of Hammurabi (see fig. **4.16**). In both, the seated god combines a frontal and profile pose, while the smaller mortal—as if commanding less space—is more nearly in profile.

The Tomb of Nefertari One of the best-preserved groups of New Kingdom paintings was found in the tomb of Nefertari, the favorite consort of the nineteenth-dynasty pharaoh Ramses II (see p. 67). Discovered in 1904 in the Valley of the Queens, not far from Hatshepsut's temple, the tomb is rarely open to the public. All the colors have been restored entirely from original pigments found inside the tomb. The ancient Egyptian artists applied plaster layers to the limestone walls and then carved scenes in low relief to assist Nefertari on the perilous path to the afterlife. Once the plaster carvings had dried, a layer of gypsum was applied and brightly painted.

The detail in figure **5.20** reveals the extraordinary richness of color and the complexity of Egyptian royal burials. It shows Nefertari wearing her characteristic long white dress and vulture cap with twin plumes. She pays homage to the seated, ibis-headed scribal god, Thoth. Between them is a small table supporting a vessel that holds Thoth's writing tablet. A magic object in the form of a frog perches

Painting

In the use of color, ancient Egypt was a great innovator and the first civilization to use synthetic pigments. Egyptian artists added many new colors to the earth tones used by prehistoric cave painters. Especially striking are Egyptian blues (ground from lapis lazuli), greens (from malachite), and golden yellows (from arsenic trisulfide—known as opriment). The variety of supports also increased to include wooden and stone statues, panels, and papyrus (for which ink was invented). As we see from the following three examples, a wider range of color was used for depicting landscape and nature than for religious painting, which was restricted to six colors that could not be mixed.

Gypsum Plaster A New Kingdom painting on gypsum plaster from the tomb of Nebamun, a Theban official (fig. **5.18**), shows him hunting birds. He is accompanied by his wife and daughter and is surrounded by animals and a landscape—note the abundant use of pale blue, the pigment made from lapis lazuli. Following the conventional Egyptian pose, Nebamun's head and legs are in profile, and his torso and eye are frontal. He wears a flattened trapezoidal kilt. His wife and daughter are small and curvilinear by comparison, continuing the Old Kingdom tradition of increasing naturalism for decreasing rank. In general, paintings of this period were slightly more naturalistic than those of the Old Kingdom. The birds turn more freely in space than the human figures, and on the fish there is evidence of shading, which conveys a sense of volume.

CONNECTIONS

See figure 4.16. Stele inscribed with the law code of Hammurabi, c. 1792–1750 B.C.

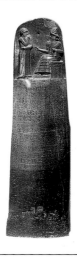

5.19 (Above) Opening of the Mouth ceremony, from the *Book of the Dead* of Hunefer, New Kingdom, 19th Dynasty, c. 1295–1186 B.C. Pigment on papyrus. British Museum, London, England.

5.20 Queen Nefertari before the Divine Scribe Thoth, from the tomb of Nefertari, north wall, Valley of the Queens, Egypt, New Kingdom, 19th Dynasty, 1290–1224 B.C.

on the table. The hieroglyphs in the background are from Spell 94 of the *Book of the Dead:*

> O you great one who see your father, keeper of the book of Thoths, see, I have come spiritualised, besouled, mighty and equipped with the writings of Thoth. Bring me the messenger of the earth-god who is with Seth, bring me a water-pot and palette from the writing-kit of Thoth and the mysteries which are in them.

In spite of the remarkable social, political, and artistic continuity of ancient Egypt, it is clear from figures **5.18–5.20** that certain changes had occurred in the two thousand years between the beginning of the Old Kingdom and the New Kingdom. The most important cultural change, however, took place from around 1353 B.C., when a revolutionary pharaoh, Amenhotep IV, came to power.

The Amarna Period (c. 1349–1336 B.C.)

Generations of scholars have tried to answer the questions surrounding Amenhotep IV, the Eighteenth Dynasty king who challenged the entrenched religious cults of ancient Egypt. In their place he adopted a new, and unpopular, religious system that was monotheistic.

Amenhotep worshiped the Aten, represented as the sun disk, and accordingly he changed his name to Akhenaten (meaning "servant of the Aten"). He effaced the names and images of the other gods and moved his capital north from the major cult center of Thebes to Akhetaten (now known as Tell el-Amarna, from which the term for this period is derived). Akhenaten chose the site and name for his new capital because the sun rising over the horizon at that point resembled the hieroglyph for sunrise.

Nothing is known of the origin of his ideas, which influenced artistic style during his reign. Statues of Akhenaten and his family differ dramatically from those of traditional pharaohs. The monumental example in figure **5.21** is from early in his reign, before he moved to Amarna. His age and his idiosyncrasies are already evident, and he looks as if he had unusual, if not deformed, physical features. At the same time, however, Akhenaten holds the crook and flail, which are attributes of Osiris and of Egyptian royalty. He also wears the combined *hedjet* and *deshret* crowns of Upper and Lower Egypt. **Cartouches** (rectangles with curved ends framing the name of the king) appear on blocks on either side of his beard, on his wrist bracelet, and on his waist. They are also incised along the top of his tunic.

5.21 Akhenaten, from Karnak, Egypt, 1353–1350 B.C. Sandstone, approx. 13 ft. (3.96 m) high. Egyptian Museum, Cairo. Akhenaten was the son of Amenhotep III and his principal wife, Tiy. Amenhotep III ruled Egypt for thirty-eight years. During Tiy's lifetime, he married a Mittani (from Mesopotamia) and two Babylonian princesses, and then made one of his daughters his principal wife.

The best-known sculpture from the Amarna period is the painted limestone bust of Akhenaten's wife, Nefertiti (fig. **5.22**). It was discovered in Akhetaten in the workshop of an artist possibly named Thutmose, but it is not known who actually made the sculpture. The well-preserved paint adds to the naturalistic impression, which is enhanced by the organically modeled features. We have the impression that taut muscles lie beneath the surface of the neck, and the open space created by the long curves at the sides of the neck enhance the elegance of the work. Instead of wearing the queen's traditional headdress, Nefertiti's hair is hidden by her tall crown, creating an elegant upward motion. The two diagonal planes of the sculpture create a new dynamic tension not seen in traditional pharaonic imagery.

A small relief in which Akhenaten and Nefertiti play with their daughters illustrates some of the stylistic and iconographic changes under Akhenaten (fig. **5.23**). The king and queen are rendered with a naturalism unprecedented for Egyptian royal figures. Their fluid, curved outlines—repeated in their drapery patterns—add a new sense of individual motion within three-dimensional space, which is enhanced by the flowing bands of material behind their heads. There is also a sense that figures turn slightly in space; this is suggested by the lines incised at the waists of Akhenaten and two of the children.

Although the daughters are represented as miniature adults, their behavior and relative freedom of movement endow them with a childlike character. The girl on Nefertiti's lap points eagerly toward her father, while the other one, perched on her mother's shoulder, pulls on her earring. Akhenaten holds a third child, whom he kisses. The intimacy of a scene such as this reflects the new humanity of the Amarna style.

Hieroglyphs are carved at the top of the scene and include many cartouches. At the center of the hieroglyphs is the sun disk Aten, with rays of light that end in hands. Some hold the *ankh,* symbol of life. Unlike earlier representations of gods in Egyptian art, this one embodies the Aten in the pure shape of the circle rather than in human or animal form.

Akhenaten's new cult posed a danger to the established priesthood and its traditions. At the close of his seventeen-year reign, despite certain innovations, Egypt reverted to its previous beliefs, reinstated the priestly hierarchy, and revived traditional artistic style. Akhenaten's tomb has been identified, but his mummy has never been located. Subsequent Egyptian rulers did their best to eradicate all traces of his religion and its expression in art.

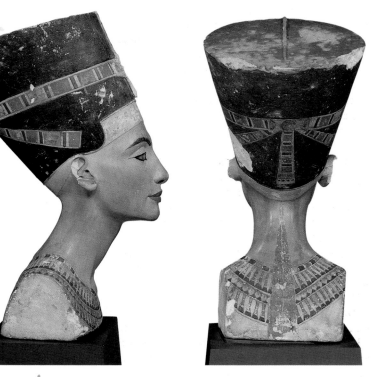

5.22 a, b Bust of Nefertiti (side and back views), Amarna period, 1349–1336 B.C. Painted limestone, approx. 19 in. (48.3 cm) high. Ägyptisches Museum, Staatliche Museen, Berlin, Germany. Nefertiti was Akhenaten's principal wife, even though, presumably for diplomatic reasons, he also had Mittani and Babylonian wives. Nefertiti was given artistic prominence and was important in Akhenaten's sun cult. The blue crown in this sculpture is unique to her.

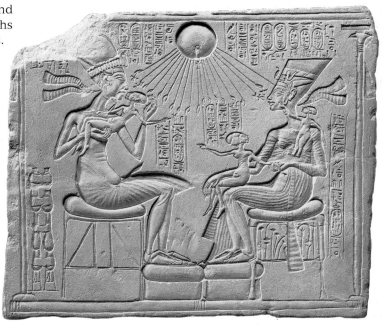

5.23 Akhenaten and Nefertiti and their daughters, Amarna period, 1349–1336 B.C. Limestone relief, 13 × 15 in. (33.0 × 38.1 cm). Staatliche Museen, Berlin, Germany.

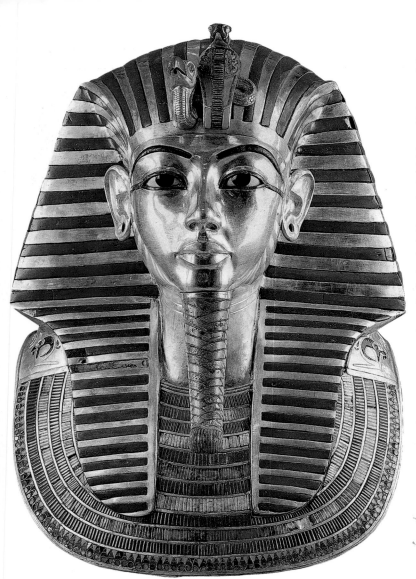

as Osiris. Each was made of beaten gold, decorated with inlaid colored glass and semiprecious stones.

A comparison of Tutankhamon's effigy with the images produced under Akhenaten shows that the rigid, frontal pose has returned. The natural spaces are closed—for example, around the head and neck by the *Nemes* head-dress and around the body by virtue of the crossed arms and tight drapery—thus restoring the conventional iconography of kingship. Like Akhenaten, Tutankhamon holds the crook and flail. Protecting his head are two goddesses, Wadjet the cobra and Nekhbet the vulture. The wings wrapped around Tutankhamon's upper body belong to the deities on his forehead, and their claws hold the sign for infinity.

More than forty years after Carter's discovery, the contents of Tutankhamon's tomb became one of the world's most popular and widely traveled museum exhibitions, appearing in Paris, London, Russia, and the United States. But Lord Carnarvon did not live to see it. Just five months after Tutankhamon's tomb was opened, Carter's patron died of an infection, which the popular press attributed to the mummy's curse.

Tutankhamon's Tomb

After Akhenaten's death, the young pharaoh Tutankhamon (reigned c. 1336–1327 B.C.), returned to the worship of Amon, as his name indicates. He died at age eighteen, and his main claim to historical significance is the fact that his tomb, with its four burial chambers, was discovered intact. In 1922 the English Egyptologist Howard Carter was excavating in the Valley of the Kings. He found one tomb whose burial chamber and treasury room had not yet been plundered. It yielded some five thousand works of art and other objects, including the mummified body of the king.

Tutankhamon's mummy wore a solid-gold portrait mask (fig. **5.24**). It was inlaid with blue glass, lapis lazuli, and other colored materials. Three coffins, one inside the other, protected the mummy. The two outer coffins were made of gilded wood; the innermost coffin was made of solid gold and weighed 243 pounds (110 kg). The mummy and its three coffins rested inside a large rectangular stone **sarcophagus.** The canopic coffinette in figure **5.25** is one of four that contained the pharaoh's organs. These small coffins were housed in a wooden shrine that was placed in another room of the tomb. Their shape conforms to that of the large coffins, and they also show Tutankhamon

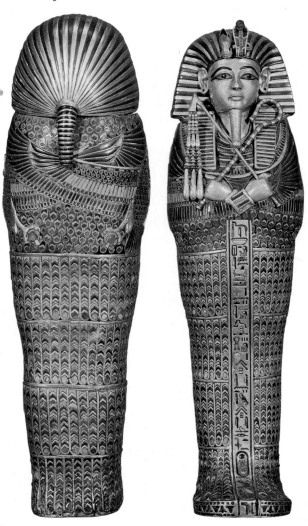

5.25 Canopic coffinette of Tutankhamon, c. 1327 B.C. Gold inlaid with enamel and semiprecious stones, 15¾ in. (39 cm) high. Egyptian Museum, Cairo.

Egypt and Nubia

The land south of the Nile's first cataract (now southernmost Egypt and the Sudan) was called Nubia by the Romans. To the Egyptians, it was the Land of the Bow (after the Nubians' standard weapon), the Land of the South, and Kush. As in Egypt, the Nile's floods were crucial to the development of Nubian culture, which was enhanced by the wealth of its natural resources—gold, copper, and semiprecious gems—and its location along a major African trade route.

During the Old Kingdom, Egypt raided Nubia for natural resources and slaves. By the Twelfth Dynasty, pharaohs invaded the region with a view to mining copper and gold and taking control of the trade route. Their successes were reinforced by the construction of massive fortresses and a highly organized communications system.

A Nineteenth Dynasty fresco fragment from Thebes depicts Nubians with gifts for the Egyptian pharaoh (fig. **5.26**). The man at the left carries interlocked gold rings that illustrate some of the natural resources of Nubia. He is followed by another man with ebony logs and giraffe tails. A baboon perches on the third figure, who holds a leopard skin and carries a basket of fruit. Behind him the arms of a fourth man leading a blue monkey on a leash are visible.

The Rock-Cut Temple of Ramses II

In the Eighteenth and Nineteenth dynasties, the Egyptians built their most imposing temples in Nubia. Figure **5.27** shows the façade of Ramses II's rock-cut temple at Abu

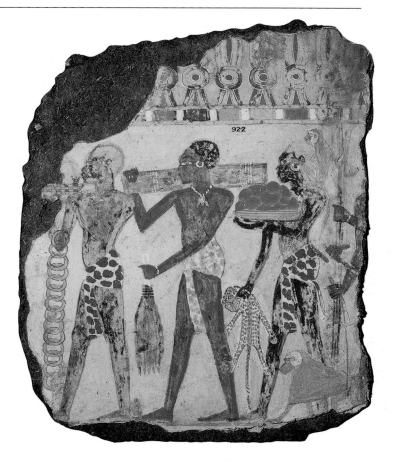

5.26 (Above) Nubians bringing offerings to Egypt, Thebes, 19th dynasty, c. 1295–1186 B.C. Fresco. British Museum, London, England.

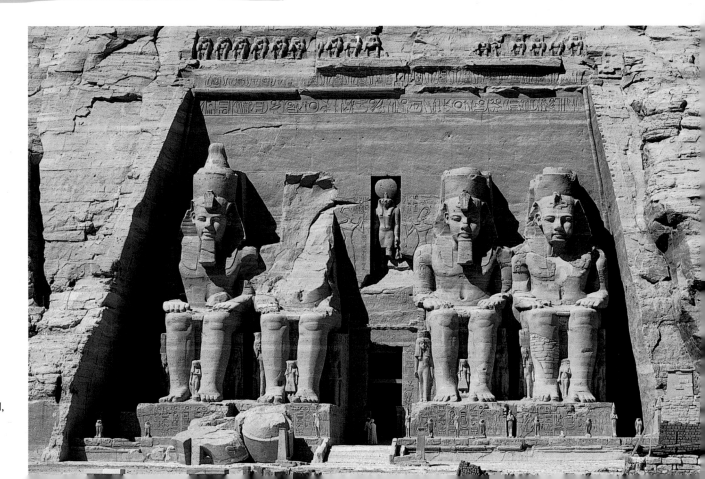

5.27 Temple of Ramses II, Abu Simbel, Nubia, 1279–1213 B.C.

Simbel, one of a series of six colossal structures south of Aswan. Four huge seated statues of Ramses II represent him in a traditional royal pose, wearing the ceremonial beard and headdress. Ramses' purpose in constructing such works in Nubia was to proclaim to the Nubians his identification with the gods Amon and Ra as well as to emphasize Egyptian domination over Nubia. During the last hundred years of the New Kingdom (c. 1170–1070 B.C.), Egypt and Nubia declined. But by the third century B.C., a new stage of Nubian cultural development can be identified. The economic and artistic high point of this period is called Meroitic, after the site of Meroë, south of Napata.

Meroë

Archaeological exploration of Meroë is still incomplete, but its significance in antiquity is clear from Classical accounts. In about 430 B.C., the Greek historian Herodotos (*History*, II, 29) described the arduous journey by ship, followed by forty days on foot and another boat journey, from Aswan to Meroë.

The most impressive buildings from Meroë are the pyramids. They are derived from Egyptian pyramids but rise more steeply than those at Giza and have flat, rather than pointed, caps. Scholars believe that these flat tops may each have supported a sun disk, indicating worship of a sun god. Burial chambers were underground, and the

deceased, as in Egypt, were mummified. The outer stone blocks, and the structures themselves, are smaller than Old Kingdom Egyptian royal pyramids. They are closer in form to New Kingdom examples built for private individuals, even though those at Meroë were royal tombs.

In 1820–21, a French traveler, F. Cailliaud, accompanied the Egyptian army into the Sudan and made drawings of the pyramids at Meroë. The pyramid in figure **5.28** belonged to Queen Amanishakheto (first century B.C.) and was discovered in a relatively good state of preservation. According to Cailliaud's drawing, the entrance, inspired by Egyptian temple pylons, was decorated with reliefs illustrating the ruler's triumph over Meroë's enemies.

Excavations of the interior of the pyramid were carried out some thirteen years later by the Italian physician Giuseppe Ferlini. His account of the excavation reflects the careless and unscientific procedures current in nineteenth-century archaeology, including the destruction of some objects and the removal of others from the site.

Among the goldwork from Amanishakheto's tomb were nine so-called shield rings, of which figure **5.29** is a typical example. The god Amon is depicted in the guise of a naturalistic ram's head under a sun disk. Behind the disk stands a chapel façade with smaller circles flanked by *uraei*. Blue glass is fused into the circle, which is soldered onto its gold background. The red glass on top of the sun disk was glued into the gold circle. It is not certain what purpose

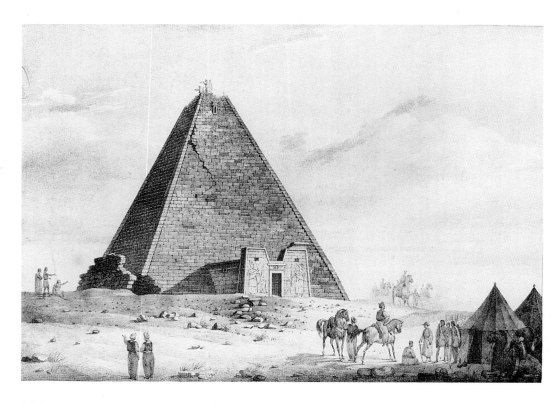

5.28 Tomb of Amanishakheto, Meroë, Nubia, late 1st century B.C. Drawing from F. Cailliaud, *Voyage à Méroé* (Paris, 1823–1827), plate XLI.

was served by the shield rings, but it is possible that they were pendants similar to the decorative pieces worn by Nubian women of today on their foreheads.

The excavation of Amanishakheto's tomb confirms Meroë's artistic independence from Egypt as well as its absorption of Egyptian forms. Amanishakheto's tomb has also contributed to our knowledge of local society, the position of women, and the organization of the royal family in this part of sub-Saharan Africa. The king's mother, who was given the title Kandake, was below the king in the royal hierarchy, but in certain cases, such as Amanishakheto's, the Kandake herself ruled. This is reflected in a New Testament text referring to a eunuch "under Candace [Kandake], queen of the Ethiopians" (Acts 8:27).

After the first century of the Christian era, Nubian civilization declined. Egypt itself underwent a series of conquests—by the Assyrians (c. 673–657 B.C.), by the Persians in 525 B.C., and by Alexander the Great in 332 B.C. The Romans invaded Egypt in 58 B.C. and annexed it in 30 B.C. Since the early seventh century, Egypt has been part of the Islamic world.

5.29 Shield ring with Amon as a ram, Meroë, Nubia, c. 200 B.C. Gold, fused glass, and carnelian, 2½ in. (5.6 cm) high. Staatliche Sammlung Ägyptischer Kunst, Munich, Germany.

3500 B.C.	3000 B.C.		2000 B.C.		1000 B.C.
PREDYNASTIC	EARLY DYNASTIC	OLD KINGDOM	MIDDLE KINGDOM	NEW KINGDOM	

c. 3100–2649 B.C. c. 2649–2150 B.C. c. 1991–1700 B.C. c. 1550–1070 B.C.

AMARNA PERIOD
c. 1349–1346 B.C.

(5.1) (5.5) (5.12) (5.16) (5.22) (5.24)

Unification of Egypt (3100 B.C.)

Hieroglyphic writing appears (c. 3100 B.C.)

Egyptian conquest of Nubia (2600 B.C.)

Use of papyrus (c. 2500 B.C.)

Nile floods used for irrigation purposes (c. 2000–1500 B.C.)

Hyksos expelled (1550 B.C.)

Akhenaten's monotheism (1353–1336 B.C.)

Tutankhamon (1336–1327 B.C.)

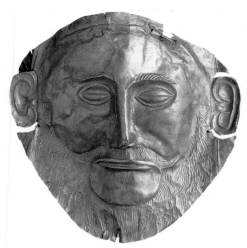

6
The Aegean

From about 3000 to 1100 B.C., three distinct cultures—Cycladic, Minoan, and Mycenaean—flourished on the islands in the Aegean Sea and on mainland Greece. These cultures chronologically overlapped the Old, Middle, and New Kingdoms of ancient Egypt (see Chapter 5), and there is evidence of contact between them. Before the late nineteenth century, however, Aegean culture was remembered only in myths and legends—most of the works of art discussed in this chapter have been discovered since 1870. Because Minoan script has not been deciphered, much less is known of the Aegean cultures than of those in Egypt and the ancient Near East.

Cycladic Civilization

(c. 3000–11th Century B.C.)

The Cyclades, so named because they form a circle (*kuklos* in Greek), are a group of islands in the southern part of the Aegean Sea. Like many island populations, the inhabitants of the Cyclades were accomplished sailors, fishermen, and traders. They also hunted and farmed, and farming required permanent village settlements. Cycladic culture had no writing system, and its earliest surviving artistic legacy dates from the Bronze Age.

The most impressive examples of early Bronze Age Cycladic art are human figures made of marble. They range in height from nearly 5 feet (1.5 m) (figs. **6.1** and **6.2**) to only a few inches. Today they are called idols because they are thought to have been objects of worship. Most were found lying in graves.

Figures of females are much more numerous than those of males. Their purpose is unknown, but it is assumed that they were carried in religious processions, for they are unable to stand on their own. The large female in figure **6.1** has long, thin proportions, with the breasts and pubic triangle accentuated. The view from the side (fig. **6.2**) shows that the idol forms a narrow vertical, extending at the back from the top of the head to the buttocks. Legs and feet fall into three slight zigzag planes, and the angle of the feet makes it impossible for them to support the statue.

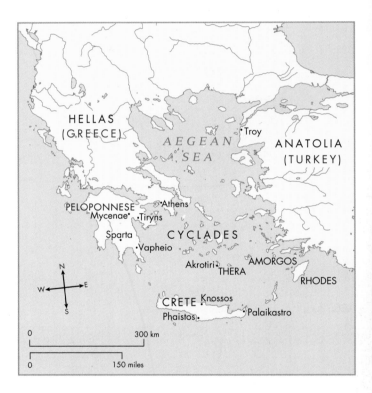

The ancient Aegean world, showing the Greek mainland, the Cycladic Islands, Crete, and western Anatolia.

Seen from the front, the figure is composed mainly of geometric sections. The head is a slightly curving rectangle—its only articulated feature is the long, pyramidal nose, but originally eyes and mouth were painted on. The neck is cylindrical, and the torso is divided into two squares by the horizontals of the lower arms. The right angles of the elbows create a three-sided frame around the upper torso. Although the overriding impression of the shapes is geometric, certain features, such as the breasts and knees, have a convincing organic quality. They seem to protrude naturally from beneath the exterior surface of the body.

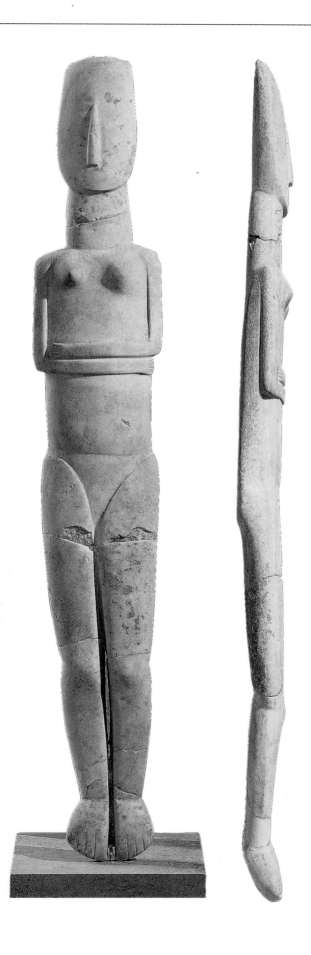

6.1 (Left) Female Cycladic idol, from Amorgos, 2700–2300 B.C. Marble, 4 ft. 10½ in. (1.49 m) high. National Archaeological Museum, Athens, Greece.

6.2 (Right) Female Cycladic idol (side view of fig. **6.1**).

Minoan Civilization

(c. 3000–1100 B.C.)

The modern Greek island of Crete, to the south of the Cyclades and northwest of the Nile delta, was the home of the most important Bronze Age culture. Many sites were destroyed by an earthquake in 1700 B.C. and again, two or three centuries later, by an invasion from the Greek mainland. The culture that flourished on Crete was all but forgotten until the early twentieth century, when the British archaeologist Sir Arthur Evans (1851–1941) excavated the site of Knossos. Inspired by his knowledge of later Greek myths about the pre-Greek Aegean, Evans established a historical basis for the myths.

In Greek mythology, Crete was the home of the tyrant King Minos, son of Zeus, and the mortal woman Europa. Minos broke an oath to Poseidon, god of the sea, who had guaranteed his kingship. In revenge, Poseidon caused Minos's wife to fall in love with a bull. The offspring of their unnatural union was the Minotaur, a monstrous creature, part man and part bull, who lived at the center of a labyrinth (maze) in the Palace of Minos at Knossos. Every year the Minotaur killed seven girls and seven boys sent to Minos as tribute from Athens. Eventually, the Athenian hero Theseus killed the Minotaur and was rescued from the labyrinth by Minos's daughter Ariadne.

The Palace at Knossos

Evans called the culture he discovered Minoan, after the legendary King Minos. "Minos" may be either a generic term for a ruler, like the designations "king" and "pharaoh," or the name of a particular ruler. The major Minoan site was Knossos, which had been inhabited since early Neolithic times. Its palace (see fig. **6.3**) was the traditional residence of Minos and the largest of several palaces on Crete. In fact, there is no royal iconography known from Minoan Crete. But the structure called the "Palace at Knossos" resembles known palaces in the ancient Near East.

In Greek mythology the palace was called a "labyrinth," which Evans believed originally meant "house of the double axe." The latter was a cult object in the Minoan era, and it is represented in paintings and reliefs throughout the palace at Knossos. Double axes may have been used to sacrifice bulls, which were sacred animals in ancient Crete. The later Greek meaning of *labyrinth* as a complex, mazelike structure, may have resulted from the asymmetrical, meandering arrangement of rooms, corridors, and staircases in

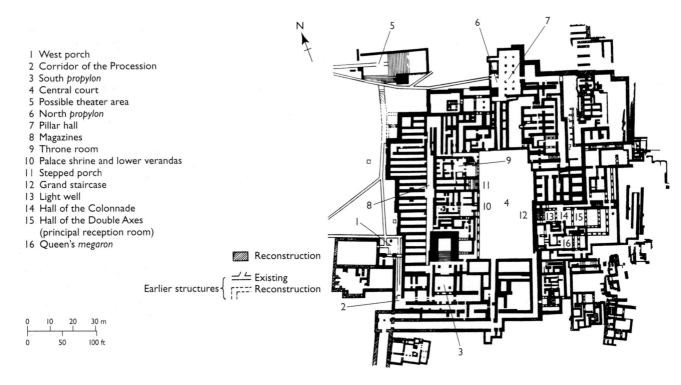

1 West porch
2 Corridor of the Procession
3 South *propylon*
4 Central court
5 Possible theater area
6 North *propylon*
7 Pillar hall
8 Magazines
9 Throne room
10 Palace shrine and lower verandas
11 Stepped porch
12 Grand staircase
13 Light well
14 Hall of the Colonnade
15 Hall of the Double Axes
 (principal reception room)
16 Queen's *megaron*

Reconstruction

Earlier structures { Existing
Reconstruction

0 10 20 30 m
0 50 100 ft

6.3 Plan of the Palace of Minos, Knossos, Crete, 1600–1400 B.C. Area approx. 4 acres (1.6 hectares). The rooms listed here were originally assigned by Sir Arthur Evans and are not necessarily archaeologically correct.

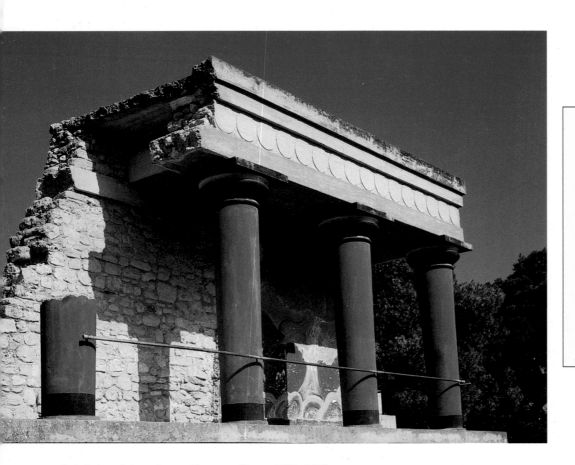

6.4 Ruins of the palace at Knossos, Crete, 1600–1400 B.C.

MEDIA AND TECHNIQUE
Minoan Fresco

Minoan wall paintings were **buon** (true) **fresco**—pigments were mixed with lime water and applied to damp lime (calcium-based) plaster. As the plaster dried, the coloring bonded to the fabric of the wall. Minoan artists painted additional details over the true fresco after it was dry. This technique was used for all Aegean wall painting.

the Palace of Minos (see fig. **6.3**). Greek coins of Knossos minted in the later historical period generally contained maze patterns.

The building complex known as the palace (fig. **6.4**) was not fortified, for the fact that Crete is an island was a natural protection against invasion. Like other Aegean and Near Eastern palaces, Knossos served as a commercial and religious center. Industry, trade, and justice were administered from the palace, which had a well-organized system for receiving and distributing local agricultural products and imported luxury goods. Much of this wealth was stored in large **terra-cotta** (literally "cooked earth") jars.

The palace at Knossos used post-and-lintel construction with low ceilings, stone masonry walls, and short, wooden columns that taper downward, as humans do. As such, Minoan columns are unique in the ancient world. Those visible in figure **6.4** have been reconstructed on the basis of depictions in fresco paintings (see Box).

The so-called *Toreador* or *Leaping Bull Fresco* (fig. **6.5**) is the best-known wall painting from Knossos. It represents a charging bull, two girls, and one boy. The girl at the left grasps the bull's horns, the boy somersaults over its back, and the girl at the right stands ready to catch him. Given the sacred character of the bull and the myth of the Minotaur, it is believed that this fresco depicts a ritual sport, possibly involving the sacrifice of the bull and the death of the athletes. As in Egyptian paintings, females are depicted with lighter skin color than males, and a profile head is combined with a frontal eye. In other ways, however, the Minoan paintings differ from those of Egypt—primarily in the predominance of curvilinear form and movement of the figures in space. Although three different human figures are represented in the *Toreador Fresco,* their poses suggest a sequence of movements that could be made by a single figure. Such dynamic depictions are more characteristic of Minoan art than Egyptian art. The extended legs of the bull are not naturalistic; they are a device known as the "flying gallop," used to create an illusion of speed and energy. The border designs simulate colored stones.

Religion

Little is known of Minoan religious beliefs. We have only archaeological evidence to shed light on Minoan religion because scholars have been unable to decipher the Minoan language (see Box). Shrines were located on mountaintops and inside palaces, which played an important role in religious ceremonies. Images of what seem to be priests and

6.5 *Toreador Fresco* (also called *The Leaping Bull Fresco*), from Knossos, Crete, c. 1500 B.C. Reconstructed fresco, 32 in. (81.3 cm) high (including border). Archaeological Museum, Herakleion, Crete, Greece. This wall painting was discovered in a fragmentary condition and has been pieced back together. The darker areas belong to the original mural; the lighter sections are a modern restoration.

SOCIETY AND CULTURE
Minoan Scripts

In the Aegean two kinds of script, Linear A and Linear B, are preserved on clay tablets. Linear A, the written Minoan script and language, developed about 2000 B.C. and remains undeciphered. Linear B came into use by about 1400 B.C. Linear B adapted the Minoan script used to write early Greek after the Mycenaean domination of Crete. Since it was used mainly for inventory lists and palace records, Linear B provides evidence of Mycenaean administration but reveals little about religion and social practices.

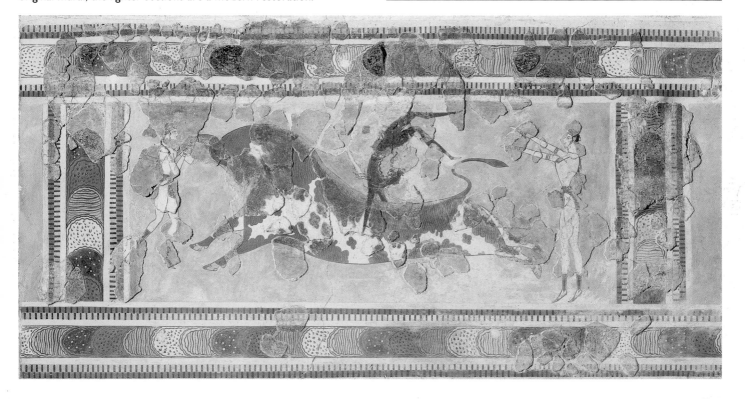

priestesses, of bulls, double axes, trees, columns, and outdoor shrines occur in scenes of religious ceremonies. Trees and pillars were venerated in rites celebrating the coming of spring and the harvest.

Another recurring motif in Minoan art is a goddess or priestess holding snakes. The precise significance of the small statue of the so-called *Snake Goddess* (fig. **6.6**) is not known. However, the motif of a male or female deity dominating animals, referred to as the "Master" or "Mistress of Beasts," occurs earlier in the ancient Near East and later in Greek art. As creatures of the earth, snakes were associated with fertility and agriculture, and did not have the evil connotations with which they later became endowed in the West.

Pottery

Minoan pottery is typically decorated with energetic designs. A Kamares ware spouted jar, dating to c. 1800 B.C. (fig. **6.7**), from the older palace at Knossos, is covered with lively geometric patterns that suggest organic forms. (The term *Kamares* is from the Kamares Cave, in the mountain above Phaistos, where examples of this type of pottery were first discovered.) Compared with Egyptian imagery, the Kamares example is freer and more curvilinear. The abstract pattern formed by white on the characteristic blue-black ground suggests a floral design, with its undulating motion and whirling,

6.6 *Snake Goddess*, from Knossos, Crete, c. 1600 B.C. Faïence, 13½ in. (34.3 cm) high. Archaeological Museum, Herakleion, Crete, Greece. This frontal figure has a thin, round waist and wears a conical flounced skirt. Her breasts are exposed, and a cat perches on top of her headdress.

Faïence is a technique for glazing earthenware and other ceramic vessels by using a glass paste, which, after firing, produces bright colors and a lustrous sheen.

circular arrangement of shapes. A few details are enhanced with orange, which contrasts with the dark blue and adds to the vibrant quality of the design. Kamares ware is an art of shape and color in which patterns are integrated in a balanced, organic manner with the form of the vessel.

The Octopus Vase (fig. **6.8**) from Palaikastro, like the Kamares jar, is enlivened by a vigorous surface design related to natural forms. Although images of an octopus and other forms of sea life are discernible on the vase, the artist obviously delighted in the ornamental character of the swirling tentacles with little round suction cups. These, in turn, are repeated formally in the large oval eyes of the octopus, which echo the holes made by the handles and seem to stare directly at the viewer. The iconography of this object reflects the Minoans' love of the sea. Later history suggests that, in their heyday, they controlled the Aegean.

6.7 Spouted jar, c. 1800 B.C. Kamares ware. Archaeological Museum, Herakleion, Crete, Greece.

6.8 Octopus Vase, from Palaikastro, Crete, c. 1500 B.C. 11 in. (27.9 cm) high. Archaeological Museum, Herakleion, Crete, Greece.

Discoveries at Thera

In the 1960s the volcanic island of Thera, now known as San-torini, in the southern Cyclades, began to yield exciting new archaeological material. The Greek archaeologist Spyridon Marinatos began to excavate near the modern town of Akrotiri, on the south coast of the island, facing Crete.

His excavations through thick layers of ash and pumice confirmed that an enormous volcanic eruption had buried a rich culture with a well-developed artistic tradition. The date of this disaster has been placed as late as 1500 B.C. or as early as around 1700 B.C.—in either case it occurred during the height of Minoan civilization. The absence of human remains in the ashes suggests that the inhabitants had evacuated the island before the volcano erupted.

The geographical location of Thera, north of Crete, places it squarely within the trading and seafaring routes between the Aegean Sea, Egypt, Syria, and Palestine. To date, archaeologists have uncovered large portions of an affluent ancient town. The paved, winding streets and houses of stone and mud-brick indicate a high standard of living. Homes had basements for storage, workroom space, and upper-story living quarters. Mills attached to houses reflect an active farming as well as seafaring economy. Walls, as in Crete, were reinforced with timber and straw for flexibility in the event of earthquakes. Interior baths and toilets were connected by clay pipes to an extensive drain-age and sewage system under the streets. Such elaborate attention to comfortable living conditions would not be found again in the West until the beginning of the Roman Empire, over a thousand years later (see Chapter 9).

The Frescoes

Equally remarkable was the attention paid to art in Theran culture. The walls of public buildings as well as of private houses were decorated with frescoes, which constitute an important new group of paintings. They represent a wide range of subjects: landscapes, animals, sports, ritu-als, boats, and battles. When first discovered, most of the frescoes were covered with volcanic ash, which had to be carefully removed by brush. The paintings had fallen from the walls and were restored piece by piece to their original locations.

The most significant painting discovered on Thera is the large *Ship Fresco;* part of the left section is reproduced in figure 6.9. It was painted in a long horizontal strip, or **frieze,** that extended over windows and doorways. The scene includes harbors, boats, cities and villages, human figures, landscape, sea life, and land animals, all of which provide information about the culture of ancient Thera. Some of the houses, for example, have several stories, the boats are propelled by paddles and sails, and the style of dress is distinctively Theran.

Various interpretations of the *Ship Fresco* have been proposed, from the straightforward return of a fleet to the depiction of a ceremonial rite. Although there is some overlapping to show depth, the landscape is rendered with no sense of spatial diminution and appears to "frame" the city. Distance is indicated by proximity to the top of the fresco—boats below, buildings on land, and hills, trees, and animals at the horizon.

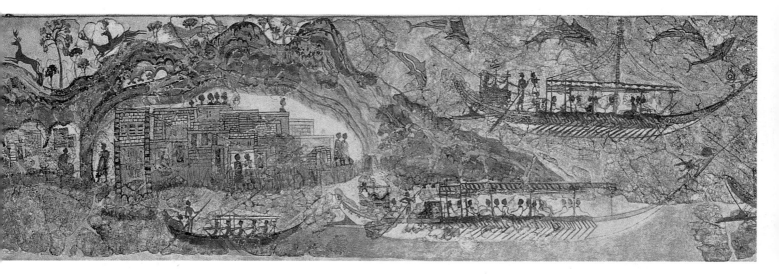

6.9 *Ship Fresco* (left section), from Akrotiri, Thera, c. 1650–1500 B.C. 15¾ in. (40 cm) high. National Archaeological Museum, Athens, Greece.

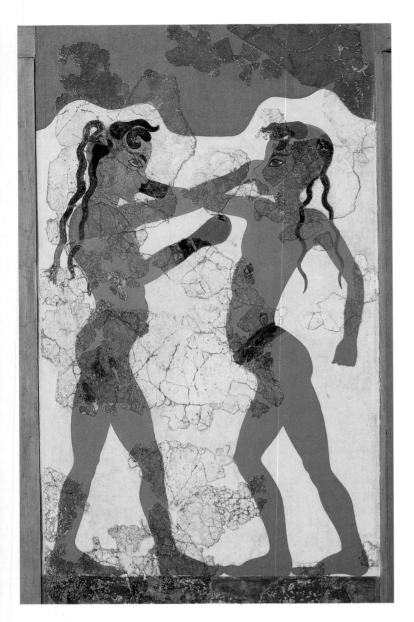

6.10 *Boxing Children*, from Akrotiri, Thera, c. 1650–1500 B.C. Fresco, 9 ft. × 3 ft. 1 in. (2.74 × 0.94 m) high. National Archaeological Museum, Athens, Greece.

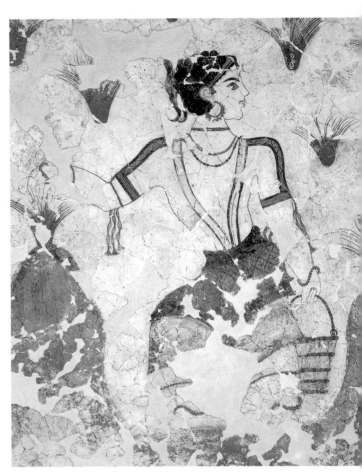

6.11 *Crocus Gatherer*, from Thera, before 1500 B.C. Fresco, approx. 35 × 32 in. (89 × 81 cm). National Archaeological Museum, Athens, Greece.

The fresco of *Boxing Children* (fig. **6.10**) is a large-scale depiction of human figures. As is true of painted figures from Egypt and Crete, these stand on a flat ground rather than in a naturalistic space. They also retain the convention of a frontal eye in a profile face. As in Minoan figures—and in contrast to Egyptian figures—the curved contours and shifting planes of movement convey vigorous, sprightly energy. The significance of these boxers remains controversial, but it is likely that they are engaged in a coming-of-age ritual. The boy on the left wears jewelry and is receiving a blow from the boy on the right. His paler face and upwardly turned eye suggest that he has been hit by his opponent and is in pain. The emphasis on him indicates that he is the initiate.

In contrast to the boxers, the *Crocus Gatherer* (fig. **6.11**) has white skin, following the convention of Minoan representation of females. She holds a basket in her left hand and reaches for a crocus with her right. Although her body is frontal—she is in a squatting position—she turns her head to speak to a companion. Her curly black hair, whose ringlets echo the lines of her ear, is held in place by a blue headband. She wears a large earring, three necklaces, a short-sleeved dress, and a flounced overskirt. The stylized outline of her eye is reminiscent of ancient Near Eastern eye outlines, although her physiognomy is more specific. Again—as in Minoan rather than Egyptian painting—she is set in a spacious landscape amid mountains and rocks. The iconography of this fresco is based on religious ritual. Crocuses are the source of saffron, which was considered valuable for medicinal as well as for ritual purposes. The girl depicted here is collecting saffron for presentation to a nature goddess.

When hitherto unknown cultures such as that on Thera are uncovered for the first time, modern views of history are modified. The precise role of Thera in the Minoan era remains to be determined. Some believe it is the source of the story of the lost Atlantis, described by Plato in his *Timaeus* and *Kritias*; others strongly disagree. In any case, new archaeological finds reveal the dynamic, ever-changing nature of history.

Mycenaean Civilization

(c. 1600–1100 B.C.)

In the late 1860s, Heinrich Schliemann, a successful young German businessman, became an archaeologist. Convinced that certain Greek myths were based on historical events, he decided to search for the truth of the Trojan War (see Box). In 1870 Schliemann first excavated the site of Troy on the west coast of Turkey. Years later he excavated Mycenae, the legendary city of Agamemnon, in the northeast of the Peloponnese, on the Greek mainland. Subsequent excavations of similar Greek sites have revealed that a powerful Greek civilization flourished between 1600 and 1100 B.C. After the eruption of Thera, the Aegean was dominated by the Mycenaeans, who began their supremacy by conquering Crete and ruling from Knossos.

Also called Late Helladic after "Hellas," the historical Greek name for Greece (*Graecia* was the name used by the Romans), Mycenaean culture takes its name from its foremost site at Mycenae. Here, as elsewhere, the citadel was built on a hilltop and fortified with massive stone walls. The major feature of the palace was a rectangular structure called the **megaron** ("large room" in Greek). One entered the *megaron* through a front porch supported by two columns and continued through an antechamber into the throne room, in which four columns surrounded a circular hearth (fig. **6.12**). The king presided in the *megaron,* his throne centered and facing the hearth. This arrangement had pre-Mycenaean antecedents on the Greek mainland, and it would be elaborated in later Greek temple architecture.

Figure **6.13** shows a reconstruction of the *megaron* at Mycenae. The walls and floors were covered with paintings. Like the Minoans, the Mycenaeans apparently had no temples separate from their palaces. Shrines have been found within the palaces, which were lavishly decorated and furnished with precious objects and painted pottery.

SOCIETY AND CULTURE
The Legend of Agamemnon

Mycenae was the legendary home of King Agamemnon, who led the Greek army against King Priam of Troy in the Trojan War. Agamemnon's brother, King Menelaus of Sparta, had married Helen, known to history as the beautiful and notorious Helen of Troy. Priam's son Paris abducted Helen, and Agamemnon was pledged to avenge this offense against his family. But as soon as the Greek fleet was ready to sail, the winds refused to blow because Agamemnon had killed a stag sacred to the moon goddess Artemis. As recompense for the stag, and in return for allowing the winds to blow, Artemis exacted the sacrifice of Agamemnon's daughter Iphigenia.

Ten years later the war ended and Agamemnon returned to Mycenae, bringing with him the Trojan seer Cassandra. He was murdered by his wife Klytemnestra, who had not forgiven him for Iphigenia's death, and her lover, Aegisthos. Agamemnon's children, Orestes and Elektra, killed Klytemnestra and Aegisthos to avenge their father's death.

These tales were well known to the historical Greeks: the Trojan War from *The Iliad,* written in the eighth century B.C. and attributed to Homer; and the tragedy of Agamemnon's family from plays of Aeschylos, Sophokles, and Euripides (fifth century B.C.).

6.12 (Above) Generic plan of the Mycenaean *megaron.* Within a rectangular structure, the throne room had four columns (1) enclosing a circular hearth (2) in the center. Access to the throne room was through an antechamber (3) and a front porch (4) with two columns.

6.13 Reconstruction drawing of the Mycenaean *megaron,* showing the front porch with two columns and the interior hearth surrounded by four columns.

The best-preserved fresco from Mycenae has similarities to Minoan fresco style. The so-called Mycenaean Goddess (fig. **6.14**) was discovered in the cult center of the citadel. Her face is rendered in profile with a frontal eye, but her naturalism is enhanced by curvilinear contours. She smiles slightly and seems to contemplate a necklace held in her right hand. The thin black lines framing her torso, outlining her eye, and defining her eyebrow recall those of the Theran *Crocus Gatherer* (see fig. **6.11**). Her elaborate jewelry and coiffure indicate that she was a personage of high status or possibly a goddess.

In contrast to the nobility, most of the citizens lived in small stone and mud-brick houses below the citadel. In times of siege, they sought refuge within its walls. The defensive fortifications of the Mycenaean cities reflect a society more involved in war than the Minoans, and thus more concerned with protection from invaders. These fortifications included thick, monumental walls constructed of large, rough-cut, irregular blocks of stone such as those visible in figure **6.15**. Because of the enormous weight of such stones, the later Greeks called the walls Cyclopean. **Cyclopean masonry** is named for the mythical race of one-eyed giants, the Cyclopes, who were believed to be strong enough to lift the huge stone blocks found at Mycenaean sites.

The Lion Gate crowned the entrance to the citadel of Mycenae (fig. **6.15**), which was centered authoritatively at the end of a long approachway. Its opening is framed by a post-and-lintel structure, and the triangular section over the lintel is called a relieving triangle because it reduces the weight on the lintel. This was formed by **corbeling**, or arranging layers, called **courses**, of stones so that each level projects beyond the lower one. When the stones meet at the top, they create an arch. Filling in the triangle is a relief of different stone showing two lions with their paws on a concave Minoan altar. They flank a Minoan-style column, which symbolized the nature goddess. Thus the relief image depicts the lions as obedient to the goddess, the "Mistress of Beasts." The heads of the lions are missing. Originally they were carved separately to project frontally and display their power as guardians of the entrance.

The most dramatic surviving structures at Mycenae are the monumental royal *tholos* (Greek for "round building") tombs. The largest (figs. **6.16**, **6.17**, and **6.18**) has been called both the "Treasury of Atreus" and the "Tomb of Agamemnon" (the son of Atreus). In fact, however, it is not known who was buried there. Like the entrance to the citadel, the *tholos* was preceded by a *dromos*, or roadway, 118 feet (36 m) long, whose walls were of Cyclopean masonry. Above the entrance, which was designed like the

6.14 "Goddess," from the citadel of Mycenae. Fresco, c. 1200 B.C. National Archaeological Museum, Athens, Greece.

6.15 Lion Gate, Mycenae, 13th century B.C. Limestone, approx. 9 ft. 6 in. (2.9 m) high. The presence of the Minoan-style column on the Lion Gate is evidence of contact between the Minoan and Mycenaean cultures.

6.16 Façade and dromos of the "Treasury of Atreus," Mycenae, 13th century B.C. Originally the door was framed by half-columns made of gypsum.

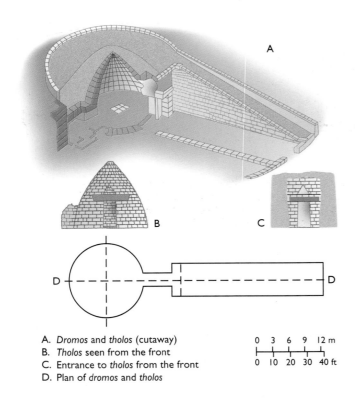

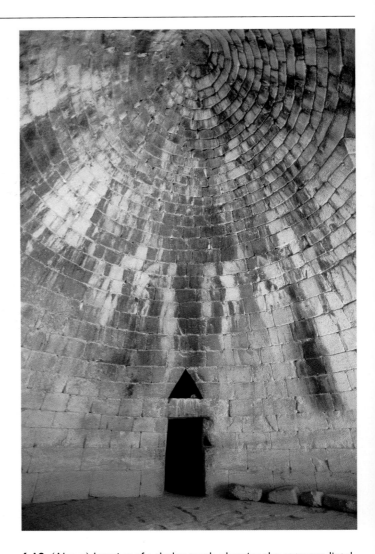

A. *Dromos* and *tholos* (cutaway)
B. *Tholos* seen from the front
C. Entrance to *tholos* from the front
D. Plan of *dromos* and *tholos*

0 3 6 9 12 m

0 10 20 30 40 ft

6.17 Plan and sections of a *tholos*.

Lion Gate, was an enormous lintel weighing over 100 tons. It also had a relieving triangle above it and was filled in with carved stone blocks.

The interior view in figure **6.18** shows the corbeled courses, which diminish in diameter as they approach the top of the chamber. This is crowned by a round capstone at the center of a huge dome. Most likely, the construction of such large tombs had been influenced by the design of smaller *tholoi* used earlier for communal burials on Crete. There is also some connection between the later *tholoi* and earlier Mycenaean shaft graves. One such grave circle inside the citadel itself can be seen in the reconstructed aerial view in figure **6.19**. The reconstruction shows the massive Cyclopean masonry walls and the disposition of the graves within them.

Once the dead body had been placed inside the *tholos,* the door was closed and the entrance was walled up with stones until it had to be reopened for later burials. All that would have been visible from the exterior was the mound of earth covering the tomb and the *dromos*. Unfortunately, the "Treasury of Atreus" was plundered before its modern excavation. However, excavations of unplundered *tholoi* have yielded remarkable objects.

6.18 (Above) Interior of a tholos tomb, showing the entrance lintel and a door to the side chamber. "Treasury of Atreus," Mycenae, 13th century B.C. Diameter of interior 43 ft. (13 m), height 40 ft. (12 m); doorway 17 ft. 8 in. × 8 ft. 10 in. (5.4 × 2.7 m).

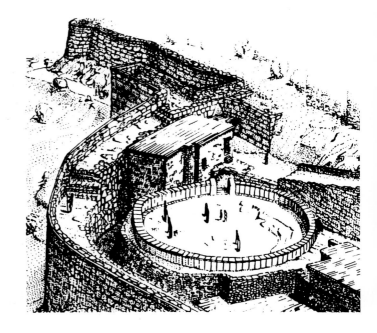

6.19 Reconstruction drawing of Grave Circle A, Mycenae, as it was in the late 13th century B.C.

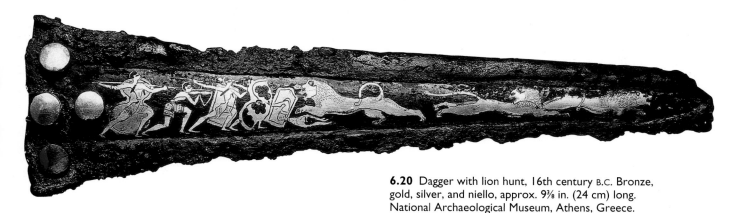

6.20 Dagger with lion hunt, 16th century B.C. Bronze, gold, silver, and niello, approx. 9⅜ in. (24 cm) long. National Archaeological Museum, Athens, Greece. Archaeological Receipts Fund (TAP).

Another object from a Mycenaean tomb that reflects the wealth of the royal burials is the bronze dagger in figure **6.20**. It is inlaid with gold and silver with details added in niello (an alloy of sulfur and silver) and depicts a lion hunt. Four hunters armed with spears, shields, and a bow confront a charging lion, which appears to have killed a fifth hunter lying below him. At the right, two more lions run from the hunters in a flying gallop pose. The dynamic energy of the scene, like the Lion Gate column, indicates Minoan influence.

The mask in figure **6.21**, the so-called Mask of Agamemnon, is a good example of the goldwork found in royal Mycenaean graves, although the gold itself was imported. The mask covered the face of a ruler once thought to have been Agamemnon, but in fact his identity is unknown. Despite stylizations such as the scroll-shaped ears, the more distinctive features—the thin lips and curved mustache—seem to be those of a particular person.

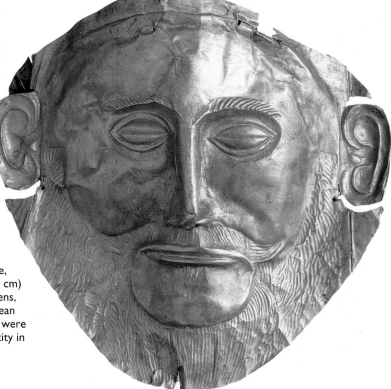

6.21 "Mask of Agamemnon," from Mycenae, c. 1500 B.C. Beaten gold, approx. 12 in. (30.5 cm) high. National Archaeological Museum, Athens, Greece. Although little is known of Mycenaean religion, it is thought that such death masks were intended to guarantee a dead person's identity in the afterlife.

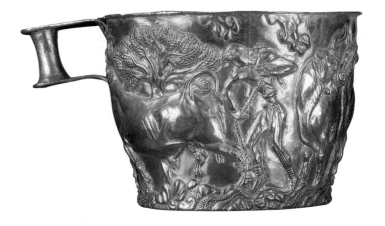
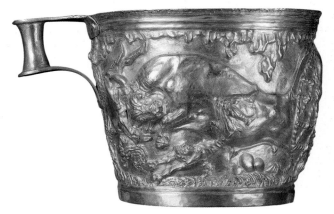

6.22 Minoan and Mycenaean cups from Vapheio, near Sparta, c. 16th century B.C. Gold, 3½ in. (8.9 cm) high. National Archaeological Museum, Athens, Greece.

Two gold cups from an intact *tholos* tomb at the site of Vapheio, in the region around Sparta (fig. **6.22**), were also buried with a king. There is some controversy over the origin of the two cups, but the one on the left seems to be the work of a Minoan artist, while the one on the right is Mycenaean. The scene on the left cup shows a man tying up a bull, possibly for the ritual Minoan bull sport. Landscape forms—trees, earth, and clouds—are depicted with considerable naturalism. Also reflecting a concern for naturalism is the sense of time, noted above in the *Toreador Fresco* (see fig. **6.5**); here the bull first sniffs the ground and then is enticed by a cow. The man's thin waist and flowing curvilinear outlines recall the slender figures in Minoan painting.

The cup on the right is Mycenaean in execution, but its iconography is Minoan. It is cruder than the Minoan cup and stresses the violence of the struggling bull caught in a net rather than landscape forms. The style of the Mycenaean cup is more powerful, and its forms are generally more abstract. The relief on both cups was made using the **repoussé** technique (from the French word *pousser*, mean-

ing "to push"), in which an artist hammers out the scenes from the inside of the cup. Final details were added on the outside and a smooth lining of gold was attached to the inside.

The rediscovery of the Minoan-Mycenaean civilizations in the late nineteenth and early twentieth centuries, and the more recent finds at Thera, have restored some missing links of Western history. Minoan and Mycenaean cultures came to light as a result of the conviction of a few scholars—notably Sir Arthur Evans, Heinrich Schliemann, and Spyridon Marinatos—that certain old legends and myths had a basis in fact. Much remains to be learned, and archaeologists continue to probe the earth for clues to the past. Although the fall of Mycenae was followed by several hundred years of a so-called Dark Age, about which we have archaeological but no literary information, the Aegean cultures provide a transition from Egypt and the ancient Near East to the later art and culture of historical Greece, which is the subject of Chapter 7.

c. 3000 B.C. **c. 1100 B.C.**

THE AEGEAN			
CYCLADIC	**MINOAN**	**THERAN**	**MYCENAEAN**
c. 3000–1200 B.C.	c. 3000–1100 B.C.	c. 1650–1100 B.C.	c. 1600–1100 B.C.

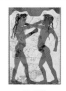

				Linear B used in Crete and Greece (c. 1400 B.C.)	
(6.1)	(6.5)	(6.10)			(6.21)

| Pyramids in Egypt (2500 B.C.) | Linear A used in Crete (c. 2000 B.C.) | Earthquake destroys Crete (c. 1700 B.C.) | Earthquake destroys Thera (modern Santorini) (c. 1628–1500 B.C.) | Beginning of decline of Mycenaean power (c. 1200 B.C.) | Trojan War; sack of Troy (c. 1180 B.C.) |

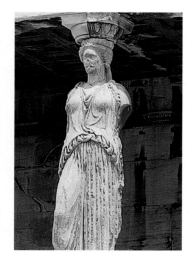

7

The Art of Ancient Greece

he Aegean civilizations were known only in myth and legend until the late nineteenth and early twentieth centuries. But ancient Greece made an immediate and lasting impact on Western culture. The decline of Mycenae and other Aegean civilizations after 1200 B.C. was followed by some four hundred years of relative obscurity in Greek history that is gradually coming to light as more and more research explores that period. On mainland Greece, shifts in population occurred, with new migrations from northern and eastern Europe.

Writing was revived, and the Greek language has persisted relatively unchanged to the present day. The Greek alphabet was an adaptation of Phoenician, a Near Eastern Semitic script. The English word *alphabet,* in fact, combines

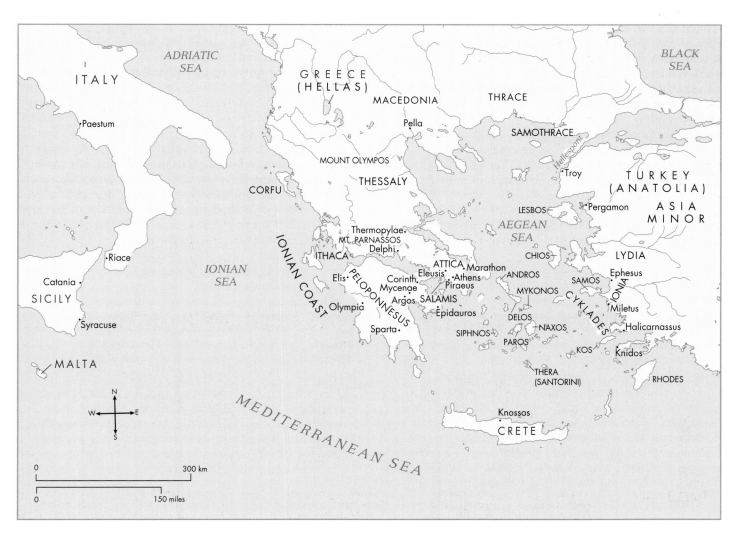

Ancient Greece and the eastern Mediterranean.

the first two letters of the Greek alphabet—*alpha* and *beta,* equivalent to the Semitic *aleph* and *beth,* and to the modern English *A* and *B.*

The exact origins of the Hellenes, as the Greeks called themselves, are unknown. By about 800 B.C., two related Greek-speaking peoples had settled in Greece, which the Greeks called Hellas—the Dorians inhabited the mainland, and the Ionians occupied the easternmost strip of the mainland (including Athens), the Aegean Islands, and the west coast of Anatolia (modern Turkey). Later, the Greeks established colonies in southern Italy, Sicily, France, and Spain. As such colonizing activity suggests, the Greeks were accomplished sailors, and their economy depended to some degree on maritime trade. They were also successful in cultivating their rocky terrain and in manufacturing pottery and metal objects.

Cultural Identity

Greece was not unified by a strong sense of its identity as a nation until the invasions of 490 and 480 B.C. by the Persians, who were long-standing enemies of the Greeks. But after defeating the Persians, the Greeks thought of themselves as the most civilized culture in the world, a view reflected in their sense of being a single people, superior to all others. The modern meaning of the word *barbarian* is "uncivilized" or "primitive," but for the ancient Greeks any foreigner was a barbarian *(barbaros)* and anyone who spoke a foreign language—unintelligible words sounding like "bar-bar"—was uncivilized.

PHILOSOPHY
Plato on Artists

Great philosopher though he was, Plato did not have much use for artists. In Book X of *The Republic,* he proposes banishing them from his ideal state. For Plato, art had no reality except as technique *(techne)* and as imitation *(mimesis)* of nature. But nature itself, he argued, is only a mere shadow of the essential truth, which he called the "Good and Beautiful" *(kalos k'agathos);* and it is the philosopher, rather than the poet or artist, who is capable of interpreting it.

The original creator, according to Plato, is God, who creates in relation to the philosophical essence. Craftsmen and artisans are below God, for they make useful objects that, like nature, only reflect the essential. The painter, who makes an image of the object, is lower still and therefore even further from the truth.

Poets do not fare much better than artists in Plato's ideal state, for, in his view, they appeal to passion rather than to truth. Although Plato loved Homer, he recommended banishing Homer's works along with those of the artists, and admitting only hymns to God and poetry praising famous men.

Not only was Greece the most civilized country in its own estimation, it was also the most central. The site of the sacred oracle at Delphi, where the future was foretold, omens read, and dreams interpreted, was called the *omphalos,* or navel, of the world. The oracle, actually a priest or priestess believed to be divinely inspired, advised on political as well as private matters. As a result, the Delphic oracle drew emissaries from all over the Mediterranean world and became an established center of international influence. Inscribed in stone at Delphi was the prescription "Know thyself," which expressed a new emphasis on individual psychology and insight.

There was also a new perception of history. Rather than marking the passage of time in terms of kings and dynasties, as the Egyptians and the Mesopotamians had done, the Greeks reckoned time in Olympiads—four-year periods beginning with the first Olympic Games, held in 776 B.C. The Games (called Panhellenic, meaning "all the Greeks") were restricted to Greek-speaking competitors and reinforced the Greek sense of cultural unity. The Olympic Games were so important that all wars on Greek territory were halted so that athletes could travel safely to Olympia to participate.

Government and Philosophy

The Athenians of the fifth century B.C. abhorred the rule of autocratic kings and pharaohs that characterized many other Mediterranean cultures. This marked a significant change from earlier periods, when Greece was ruled by tyrants. The aversion to tyranny led to the establishment of independent city-states. Each city-state, or *polis,* required male citizens to participate in its government. Even though the Greeks, like most ancient Mediterranean cultures, kept slaves and did not allow women to engage in politics (see Box), the *polis* was an important foundation of modern democracy. It inspired Thomas Jefferson when he wrote the Declaration of Independence and framed the American Constitution in the late eighteenth century. The very term *democracy* is derived from two Greek words, *demos* (people) and *kratos* (power).

Greek philosophers discussed the nature of government at length. Foremost among them was Plato (c. 427–347 B.C.). His writings include *The Republic* and *The Laws,* which describe an ideal state. Plato's spokesman and teacher, Socrates, developed a new method of teaching known as Socratic dialogue—a process of question and answer through which the truth of an argument is elicited from the student. Demanding close observation of nature and human character, the Socratic method reflects the Greek interest in the centrality of man in relation to the natural world, which is consistent with Greek artists' pursuit of naturalism and study of anatomy.

Aristotle (384–322 B.C.)—Plato's most distinguished student, who became the tutor of Alexander the Great, stands out among the ancient Greek philosophers for the diversity

In the period of Greek history depicted by Homer, aristocratic women led lives of relative independence, as did the women of Sparta from the sixth century B.C. onward. However, in Athens and other parts of Greece during the Classical period (fifth century B.C.), women lived under severe constraints. They ventured outside the house mainly for religious processions and festivals restricted to women, and they could not vote or hold public office. In the words of Aristotle: "The deliberative faculty is not present at all in the slave, in the female it is inoperative, in the child undeveloped."

In the private sphere, women occupied segregated quarters of the house, and marriages were monogamous. As in all ancient cultures, marriage was an economic transaction arranged by the parents of the couple, generally within a circle of relatives so as to preserve property within the family. The woman was usually much younger than the man, and they often had no previous acquaintance. If an unmarried woman had no brothers, she was obliged upon the death of her father to marry his closest relative in order to carry on the family.

Once married, a woman became her husband's responsibility. She had no independent status, and her life was devoted to childbearing and looking after the family and household. The Athenian general Perikles is quoted by the Greek historian Thucydides (c. 460–400 B.C.) as having said that a woman should "be spoken of as little as possible among men, whether for good or ill." Women could own nothing apart from personal possessions and could not be party to any transaction worth more than a nominal amount. A man could divorce his wife by declaration before witnesses; a wife could divorce her husband only by taking him to court and proving serious offenses.

Athenian men were required by law to marry daughters of Athenian citizens. As a result, some men developed relationships outside marriage with *hetairai*, or courtesans. *Hetairai* generally came from Ionia and were more intellectual and better educated than Athenian women. The best-known *hetaira* of the fifth century B.C. is the Milesian Aspasia, who was the companion of Perikles. He eventually divorced his wife to marry her.

Ideas about female emancipation begin to appear in literature from the end of the fifth century B.C., and some of the most memorable characters in Greek plays are females, although they were acted by young males. From the fourth century onward—and increasingly so in the Hellenistic period (third to first century B.C.)—education was accessible to certain women.

The Roman historian Pliny the Elder mentions by name one Iaia of Kyzikos, who lived in the early first century B.C. Her "hand," he wrote, "was quicker than that of any other painter, and her artistry was of such high quality that she commanded much higher prices than the most celebrated painters of the same period."

Sappho, the most famous woman poet in antiquity, lived at the turn of the seventh century B.C. and was much admired by Plato and other writers. Little is known of her life except that she was born on the island of Lesbos (from which comes the term "lesbian"). Her poems, inspired by Aphrodite, tell of her love for girls as well as boys and were accompanied by the music of the lyre. Today her work survives only in fragments, but she is known to have written nine books of odes, elegies, and *epithalamia* (lyric odes to a bride and bridegroom). She composed in various meters—the Sapphic meter is believed to have been her invention.

of his interests. In addition to natural sciences such as botany, physics, and physiology, Aristotle wrote on philosophy, metaphysics, ethics, politics, logic, rhetoric, and poetry. His *Poetics* established the basis for subsequent discussions of tragedy, comedy, and epic poetry in Western literary criticism. Aristotle did not discuss the visual arts as specifically as Plato did, but his views on aesthetics have had a substantial influence on Western philosophy.

Literature and Drama

The literary legacy of Greece is one of the most remarkable in Western civilization. *The Iliad,* attributed to Homer, is the account of the Trojan War and its heroes, and *The Odyssey* is the story of Odysseus's ten-year journey home to Ithaca after the war. These epic poems were originally recited and then were written down sometime between the eighth and sixth centuries B.C. They are noteworthy for their literary style and their new emphasis on the power and psychology of human heroes. The same is true of the tragedies of Aeschylos, Sophokles, and Euripides, and the comedies of Aristophanes, which laid the foundation of Western theater. Aeschylos's trilogy *The Oresteia,* written during the

fifth century B.C., dramatized the tragedy of Agamemnon's family after his return to Mycenae from the Trojan War (see p. 77). And it was Sophokles who gave the world the Oedipus plays, from which Freud recognized that poets had understood human psychology long before the development of psychoanalysis. The events and characters of Greek literature were often illustrated by artists, whose interest in psychology paralleled that of the writers and philosophers.

"Man Is the Measure of All Things"

The ancient Greek contributions to Western civilization are inextricably linked to this saying, which set Greece apart from other ancient Mediterranean cultures. In Greek religion, gods not only were **anthropomorphic** (human in form), but had human personalities and conflicts (see Box, p. 86). They participated in human events, such as the Trojan War, and tried to influence the outcome. The gods are referred to as the Olympians because they lived on Mount Olympos after having overthrown their primitive, cannibalistic forebears, the so-called Titans.

Greek God	Function/Subject	Attribute	Roman Counterpart
Zeus (husband and brother of **Hera**)	King of the gods, sky	Thunderbolt, eagle	**Jupiter**
Hera (wife and sister of **Zeus**)	Queen of the gods, women, marriage, maternity	Veil, cuckoo, pomegranate, peacock	**Juno**
Athena (daughter of **Zeus**)	War in its strategic aspects, wisdom, weaving, protector of Athens	Armor, shield, Gorgoneion, Nike	**Minerva**
Ares (son of **Zeus** and **Hera**)	War, carnage, strife, blind courage	Armor	**Mars**
Aphrodite	Love, beauty	**Eros** (her son)	**Venus**
Apollo (son of **Zeus** and **Leto**)	Solar light, reason, prophecy, medicine, music	Lyre, bow, quiver	**Phoebus**
Helios (later identified with **Apollo**)	Sun		**Phoebus**
Artemis (daughter of **Zeus** and **Leto**)	Lunar light, hunting, childbirth	Bow and arrow, dogs	**Diana**
Selene (later identified with **Artemis**)	Moon	Crescent moon	
Hermes (son of **Zeus** and **Maia**)	Male messenger of the gods, trickster and thief; good luck, wealth, travel, dreams, eloquence	Winged sandals, winged cap, *caduceus* (winged staff entwined with two serpents)	**Mercury**
Hades (brother of **Zeus**, husband of **Persephone**)	Ruler of the underworld	**Cerberus** (a multi-headed dog)	**Pluto**
Dionysos (son of **Zeus** and **Semele**)	Wine, theater, grapes, panther skin	*Thyrsos* (staff), wine cup	**Bacchus**
Hephaestos (son of **Hera**)	Fire, the art of the blacksmith, crafts	Hammer, tongs, lameness	**Vulcan**
Hestia (sister of **Zeus**)	Hearth, domestic fire, the family	Hearth	**Vesta**
Demeter (sister of **Zeus**)	Agriculture, grain	Ears of wheat, torch	**Ceres**
Poseidon (brother of **Zeus**)	Sea, earthquakes	Trident, horse	**Neptune**
Herakles (son of **Zeus** and a mortal woman; the only hero admitted by the gods to Mount Olympos and granted immortality)	Strength	Lion skin, club, bow and quiver	**Hercules**
Eros (son of **Aphrodite**)	Love	Bow and arrow, wings	**Amor/Cupid**
Iris	Female messenger of the gods (especially of **Hera**), rainbow	Wings	
Hebe (daughter of **Zeus** and **Hera**)	Cupbearer of the gods, youth	Cup	
Nike	Victory	Wings	**Victoria**
Persephone (daughter of **Zeus** and **Demeter**, wife of **Hades**)	The underworld	Scepter, pomegranate	

Greece also differed from other Mediterranean cultures, especially Egypt, in its views of death and rituals for the dead. Rather than engage in elaborate efforts to preserve the physical body from decay (as in Egypt), the Greeks erected grave markers, which were memorials to the deceased rather than offerings to the gods.

The surviving works of art from ancient Greece emphasize the individual above all. In contrast to the continuity of Egyptian art, Greek art evolved rapidly from stylization to naturalism. The treatment of nature and humanity's place in it—ideal as well as actual—differentiated the Greek canons of proportion from those used by the Egyptians (see p. 57). In Greek art, measurements were in relation to human scale and organic form.

The Greek attitude toward artists indicates a new interest in the relationship of creators to their work. As far as one

can tell, the Greeks were the first Westerners who regularly signed their works. For the first time in the history of the West, artists became famous, and their achievements were recorded by prominent authors. The Greeks thus gave their artists a new status consistent with their cultural view that man, rather than gods, is the "measure of all things."

Painting and Pottery

The earliest Greek style, called **Geometric** (c. 1000–700 B.C.), is known only from pottery and small-scale sculpture. The Orientalizing style (c. 700–600 B.C.) shows influences from Eastern art, and, around the same time, monumental sculptures began to develop. The broad stylistic categories of Greek art following Orientalizing are Archaic, Classical, and Hellenistic.

Geometric Style (c. 1000–700 B.C.)

The lively, rectilinear **meander patterns** circling the body of the **amphora** (two-handled storage jar) in figure **7.1** are typical of Geometric pottery design. Each pattern is framed by circular horizontal borders that emphasize the shape of the pot, and two rows of stylized animals seem to proceed slowly around the neck. Because the amphora was a grave marker, its main scene is a *prothesis* (lying-in-state of the dead). The deceased lies on a horizontal bier, held up and flanked by rows of figures who create a sense of motion through ritual gestures of mourning. Their torsos are composed of flat black triangles, and their heads are rounded. Typical of Geometric vase painting are the flat two-dimensional renderings and the lively, stylized forms painted in a dark glaze (actually a **slip,** which is refined clay) over a light surface.

Orientalizing Style (c. 700–600 B.C.)

In the eighth century B.C., influences from the Near East and Egypt entered Greek art in a recognizable way. In the Orientalizing amphora shown in figure **7.2,** dated c. 675– 650 B.C., the shapes have become larger and more curvilinear than those of the Geometric style, and the geometric patterns are relegated to borders of the main image. The scene on the

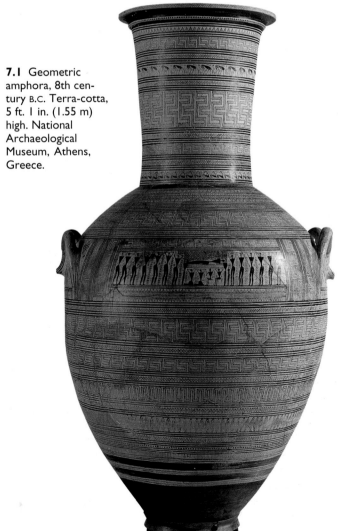

7.1 Geometric amphora, 8th century B.C. Terra-cotta, 5 ft. 1 in. (1.55 m) high. National Archaeological Museum, Athens, Greece.

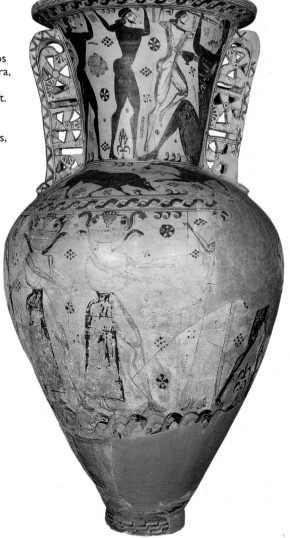

7.2 Polyphemos Painter, amphora, 675–650 B.C. Terra-cotta, 4 ft. 8 in. (1.42 m) high. Eleusis Museum, Eleusis, Greece.

neck illustrates Odysseus and his men driving a stake into the eye of the Cyclops Polyphemos, who had eaten some of Odysseus's sailors. The poses of Odysseus and his companion show similarities with earlier Aegean painting, particularly the nearly frontal shoulder, profile legs and head, and frontal eye. As in Minoan and Theran nudes (see fig. **6.10**), there is a hint of a turn at the waist to account for the spatial discrepancy between torso and legs.

MEDIA AND TECHNIQUE
Greek Vases

Greek vases were made of terra-cotta. **Black-figure** artists painted the figures in black silhouette with a slip made of clay and water. Details were added with a sharp tool by incising lines through the painted surface and exposing the orange clay below. The vase was then fired (baked in a kiln) in three stages. The final result was an oxidization process that turned the surface of the vase reddish-orange and the painted areas black.

For **red-figure** vases, the process was reversed. Figures were left in red against a painted black background, and details were painted in black.

On **white-ground** vases, a wash of white clay formed the background. Figures were then applied in black, and additional colors were sometimes added after the firing.

As early as the Archaic period, certain shapes of vases became associated with specific uses (fig. **7.3**).

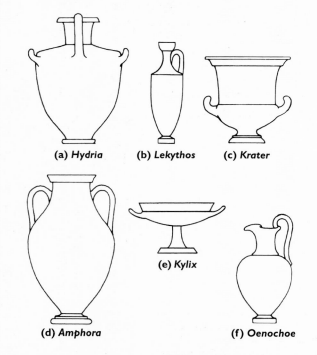

(a) Hydria **(b) Lekythos** **(c) Krater**

(e) Kylix

(d) Amphora **(f) Oenochoe**

7.3 Greek vase shapes include (a) the **hydria,** a water jar with three handles; (b) the **lekythos,** a flask for storing and pouring oil; (c) the **krater,** a bowl for mixing wine and water (the Greeks drank their wine diluted); (d) the **amphora,** a vessel for storing honey, olive oil, water, or wine; (e) the **kylix,** a drinking cup; and (f) the **oenochoe,** a jug for pouring wine.

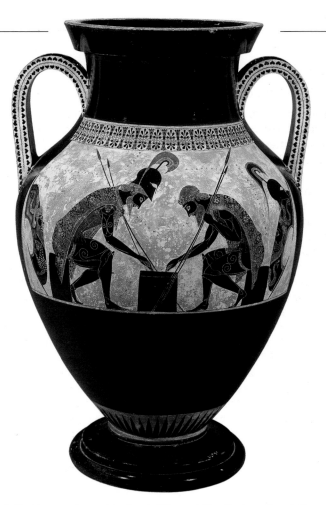

7.4 Exekias, amphora showing *Achilles and Ajax Playing a Board Game,* 540–530 B.C. Terra-cotta, whole vessel 24 in. (61 cm) high. Musei Vaticani, Rome, Italy. This amphora was signed by Exekias as both potter and painter. He integrates form with characterization to convey the impression that Achilles, the younger warrior on the left, will win the game. On the right, Ajax leans farther forward than his opponent so that the level of his head is slightly lower, and he has removed his helmet. Achilles' helmet and tall crest indicate his dominance.

Archaic Style (c. 600–480 B.C.)

The painting technique used during the Archaic period is known as black-figure (c. 600–480 B.C.) (see Box). The amphora showing *Achilles and Ajax Playing a Board Game* is a good example (fig. **7.4**). Patterning still functions as a border device, and, as in Orientalizing, the central image is a narrative scene. Exekias, the most dramatic black-figure artist known to us, invented new subjects. In this scene, he transforms the personal rivalry between the two Greek heroes of the Trojan War into a board game. He emphasizes the intense concentration of Homer's protagonists by the combined diagonals of their spears and their gazes, focusing our attention on the game board. Ajax and Achilles are identified by inscriptions. They wear elaborately patterned cloaks, arm and thigh armor enlivened with elegant spiral designs, and greaves (shin protectors). The stylized frontal eye persists from Mesopotamian, Egyptian, and Aegean art, but here the postures are rendered more three-dimensionally.

Late Archaic to Classical Style

(c. 530–400 B.C.)

The red-figure painting technique was introduced in the late Archaic period and continued until the fourth century B.C. It permitted freer painting and the representation of more natural forms than had been possible in black-figure. Furthermore, the orange clay used for skin tones was closer than black to the actual skin color of the Greeks.

In addition to increased organic form, the Greek painters of the mid-fifth century B.C. began to set figures in nature and depict elements of landscape. The kalyx krater by the Niobid Painter, depicting the *Death of the Children of Niobe* (the Niobids) (fig. **7.5**), has a rudimentary tree and sloping terrain. The decorative surface patterns have decreased in comparison with those of black-figure, and the painted lines are more flexible.

Niobe was a mortal woman who boasted that, because she had fourteen children, she was greater than Leto. Apollo (the son of Zeus and Leto) and his twin sister, Artemis, who were expert archers, killed all of Niobe's children. Here, Artemis removes an arrow from her quiver, and Apollo takes aim at his next victim. The gods' power is emphasized by the fact that they tower over the mortals, two of whom lie dead, draped over the rocky landscape in the **foreground.**

Classical to Hellenistic Style

(c. 450–323 B.C.)

During the late fifth century B.C., white-ground painting became popular on lekythoi, which were used as grave dedications. The example in figure **7.6**, from c. 410 B.C., shows a warrior sitting by a grave. He is rendered as if in a three-dimensional space—his body moves naturally, bending slightly at the waist, and his head inclines as if in meditation or mourning. The drapery falls over his legs as it would in reality, and his left leg and shield are foreshortened (that is, they are shown in perspective).

The Greek interest in naturalism led to a delight in illusionism and *trompe l'oeil* (see p. 5). Zeuxis, for example, was reputed to have painted grapes that fooled birds into believing they were real. By the late fifth century, Zeuxis was painting from live models and, therefore, directly from nature. One anecdote relates that he painted Helen of Troy as a courtesan and charged admission when the picture was exhibited; another story claims that he died laughing while staring at his own painting of an old woman.

During the fourth century B.C., Apelles reputedly painted such realistic horses that live horses neighed when they saw them. He became Alexander the Great's court painter; one of his portraits depicted Alexander with a thunderbolt so realistically that the fingers seemed to stand out from the picture plane. Apelles also painted Alexander's mistress, Pankaspe, and fell in love with her. As a measure of his esteem for Apelles, Alexander gave Pankaspe to him.

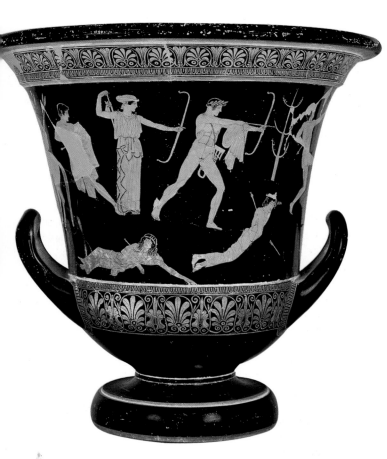

7.5 Niobid Painter, kalyx krater, side showing the *Death of the Children of Niobe*, c. 455–450 B.C. 21¼ in. (54 cm) high. Louvre, Paris, France.

7.6 Reed Painter, *Warrior by a Grave* (detail of white-ground lekythos), c. 410 B.C. Terra-cotta, 18⅞ in. (48 cm) high. National Archaeological Museum, Athens, Greece. The use of foreshortening, which depicts the round shield as an oval because it is partly turned, indicates the Greek artist's interest in rendering forms as they appear in natural, three-dimensional space.

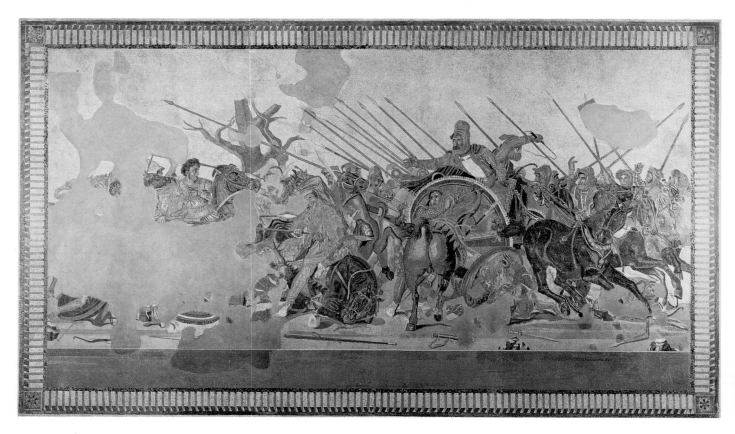

7.7 *Battle of Issos*, from the House of the Faun, Pompeii, c. 80 B.C., Roman copy after an original Greek fresco of c. 300 B.C. Mosaic, 106¾ × 201½ in. (271 × 512 cm). Museo Archeologico Nazionale, Naples, Italy. Also known as the "Alexander Mosaic," this work is made of **tesserae,** little colored tiles arranged by color to create a picture. They are arranged in gradual curves called *opus vermiculatum* ("wormwork"), because they seem to replicate the slow motion of a crawling worm. Note also the illusionistic pattern of the frame. Monumental mosaics such as this one were found on the floors of houses belonging to wealthy Romans.

The best-preserved examples of large-scale Greek pictorial style are **mosaics** (see caption, fig. **7.7**) from the Hellenistic period (c. 323–31 B.C.). This example is a Roman copy of a Greek fresco of around 300 B.C. It depicts Alexander the Great defeating the Persian king Darius II at the Battle of Issos in 333 B.C. Radical foreshortening—as in the central horse seen from the rear—and the use of shading to convey a sense of mass and volume enhance the naturalistic effect of the scene. Repeated diagonal spears, clashing metal, and the crowding of men and horses evoke the din of battle. At the same time, action is arrested by dramatic details such as the fallen horse and the Persian soldier in the foreground who watches a reflection of himself dying on a shield. Alexander sweeps into battle at the left, his wavy hair typical of royal portraiture as established in Greek art of the fourth century B.C. He focuses his gaze on the Persian leader, who turns toward Alexander. But the chariot driver whips the horses in the opposite direction as he tries to escape.

Sculpture

Archaic Style (c. 600–480 B.C.)

Monumental sculpture of human figures first appears in Greece during the Archaic period. It is not known why the Greeks began making such works when they did, but it is clear that the early Archaic artists were influenced by Egyptian techniques and conventions.

In creating life-size human figures, the Greeks learned from the Egyptians how to carve blocks of stone but adapted the technique to suit their own tastes. A comparison of the statue of a *kouros* (fig. **7.8**) of around 600 B.C. with the statue of Menkaure (see fig. **5.10**) highlights the similarities and differences between Egyptian and Greek life-size statues of standing males. The *kouros* maintains the standard Egyptian frontal pose. His left leg extends forward, with no bend at the knee, hips, or waist, and his arms are at his sides. The fists are clenched, and the elbows are turned back. Nevertheless, the sculptor has made changes to emphasize human anatomy. The *kouros* is cut away from the original block of marble, leaving open spaces between the arms and body and between

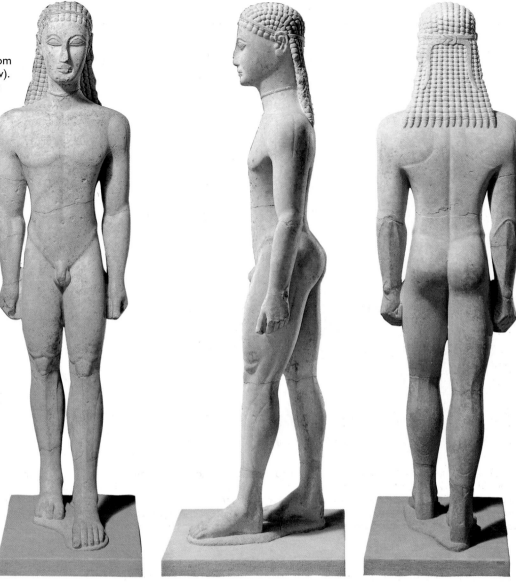

7.8a (Left) Statue of a *Kouros*, from Attica, c. 590–580 B.C. (front view). Naxian marble, H. without plinth: 76 in. (193.04 cm). Metropolitan Museum of Art, New York, Fletcher Fund, 1932. *Kouros* (*kouroi*, plural), Greek for "boy," is used to denote a type of standing male figure, typically carved from marble and usually commemorative in nature. Generally the *kouroi* either were grave markers or represented individuals honored in religious sanctuaries. Since this *kouros* appeared on the antiquities market with no provenience and has no identifying inscription, it is named for its present location. It is the earliest known life-size sculpture of a standing male from the Archaic period.

7.8b (Center) Statue of a *Kouros* (side view of fig. **7.8a**).

7.8c (Right) Statue of a *Kouros* (back view of fig. **7.8a**).

the legs. This openness and the muscularity increase the tension and liveliness of the *kouros* when compared with Menkaure.

Both figures are rendered with characteristic stylizations. In contrast to the rectangularity of Egyptian convention, various features of the *kouros* are curved—the round kneecaps surmounted by two arcs and the lower outline of the rib cage. The hair consists of small circles arranged in parallel rows that end in cone shapes. It falls over the back of the shoulders, but does not fill up as much space as Menkaure's wig does.

The most obvious difference between the figure of Menkaure and the *kouros* is the nudity of the latter. The Greek convention of nudity for male statues signals an interest in human form, although statues of females were clothed for reasons of propriety.

Archaic sculptures of standing women are referred to as *korai* (singular **kore,** Greek for "girl"). They generally represent votive figures of girls who serve Athena. The

CONNECTIONS

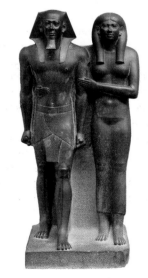

See figure 5.10. Menkaure and Queen Khamerernebty, from Giza, 2490–2472 B.C.

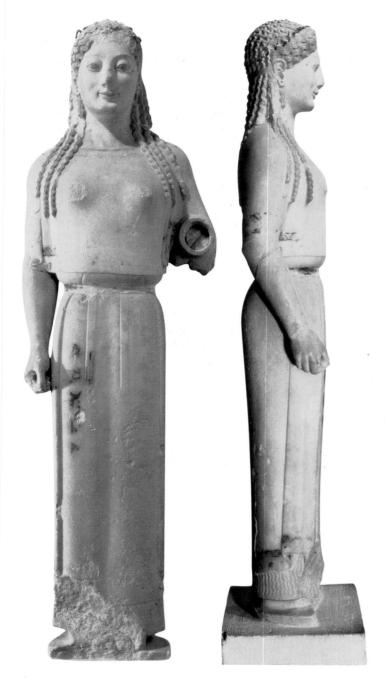

Peplos Kore (fig. **7.9**) was found on the Acropolis (see p. 97) in Athens and is named for her *peplos* (a woolen dress, pinned at the shoulders). Her pose is slightly less rigid than that of the earlier *kouros,* as she bends her left arm forward. The drapery of the upper body reveals the contours of her breasts and arms. She also has the so-called Archaic smile, which accentuates the fact of being alive, and the artist has handled the smile organically by curving the lips upward and raising the cheekbones in response.

Early Classical Style (c. 480–450 B.C.)

From 499 to 494 B.C., Athens aided the Ionian cities in their unsuccessful revolt against Persia. This provoked Darius the Great to invade mainland Greece in 490 B.C., only to be defeated by the Athenians at the Battle of Marathon. Another invasion, in 480 B.C. by Darius's son Xerxes, was repelled in 479 B.C.; this marked the end of Persia's efforts to conquer Greece. A change in artistic style seems to have coincided with the Persians' final departure from Greek soil. The Early Classical style, sometimes called Severe (because the smile has disappeared and the forms are simpler) or Transitional (because it bridges the gap between Archaic and Classical), produced radical changes in the approach to the human figure.

The best example of the new developments can be seen in the marble *Kritios Boy,* attributed to the sculptor Kritios (fig. **7.10**). It is not known whether the *Kritios Boy* was made

7.9a (Above left) *Peplos Kore,* c. 530 B.C. Parian marble, from Paros, 3 ft. 11⅝ in. (1.21 m) high. Acropolis Museum, Athens, Greece. The *Peplos Kore* still retains traces of paint on her dress and in her eyes, reminding us that Greek artists originally used color to enliven the appearance of their white marble figures.

7.9b (Above right) *Peplos Kore* (side view of fig. **7.9a**). Some recent research indicates that the *Peplos Kore* is a representation of Athena, but traces of paint on her *peplos* that have been read as animal friezes would suggest that she may be Artemis, goddess of the hunt and the moon.

7.10a, b The *Kritios Boy,* from the Acropolis, Athens, c. 480 B.C. Parian marble, 33⅞ in. (86 cm) high. Acropolis Museum, Athens, Greece.

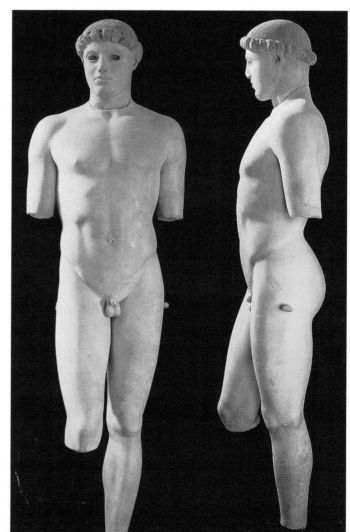

before or after the Persian Wars, but this sculpture reflects a moment of self-awareness in Greek history that is marked by the change from Archaic to Early Classical. Stylization has decreased, remaining primarily in the smooth, wavy hair and the circle of curls around the head. The flesh now seems to cover an organic structure of bone and muscle. The Archaic smile has disappeared, and the face, like the body, has become idealized; the expression is neutral. But perhaps the most important development is that the head is turned slightly and the right leg bends forward at the knee so that the left leg appears to hold the body's weight. The torso shifts, and the right hip and shoulder are lowered, a pose referred to as **contrapposto** (from the Latin words *positus,* "positioned," and *contra,* "against"). For the first time, a contrast between rigid and relaxed elements allows the viewer to feel the inner workings of the human body.

Another Early Classical development was the widespread change from marble to bronze for large-scale sculpture. Hollow statues were **cast** by the "lost-wax" process (see Box, p. 94). This liberated the figure from the block and enabled it to project more freely into space. Solid bronze casting had been used since the Aegean period. Of the few Greek over-life-size bronzes that have survived, the statue representing a god—either Zeus hurling his thunderbolt or Poseidon his trident (fig. **7.11**)—is one of the most impressive. By virtue of the pose, the god seems to command space. He focuses his aim, tenses his body, and positions himself as if ready to shift his weight, perfectly balanced between the ball of his right foot and his left heel. His slightly bent knees create the impression that he will spring at any moment. The intensity of his concentration and the force of an imminent thrust extend the viewer's experience of the sculpture toward the weapon's unseen destination.

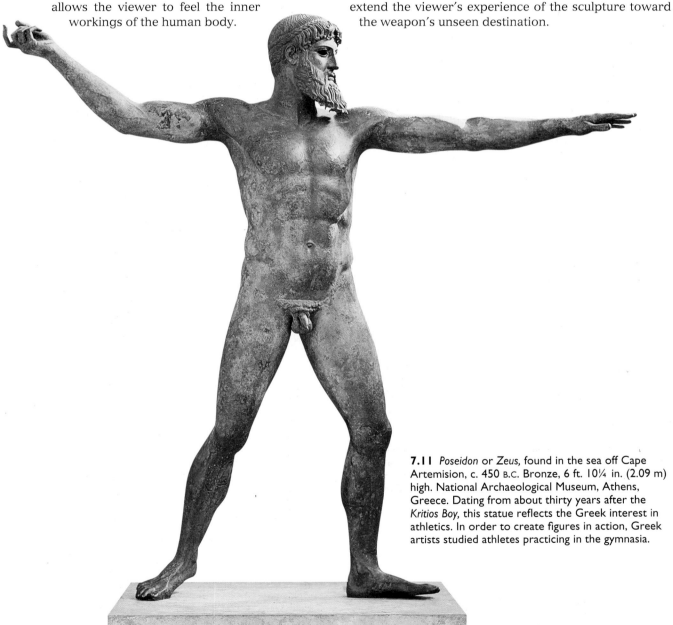

7.11 *Poseidon* or *Zeus,* found in the sea off Cape Artemision, c. 450 B.C. Bronze, 6 ft. 10¼ in. (2.09 m) high. National Archaeological Museum, Athens, Greece. Dating from about thirty years after the *Kritios Boy,* this statue reflects the Greek interest in athletics. In order to create figures in action, Greek artists studied athletes practicing in the gymnasia.

MEDIA AND TECHNIQUE
The Lost-Wax Process

In casting bronze by the **lost-wax** method (also known by the French term *cire-perdue*), the artist begins by molding a soft, pliable material such as clay or plaster into the desired shape and covering it with wax. A second coat of soft material is superimposed on the wax and attached with pins or other supports. The wax is then melted and allowed to flow away, leaving a hollow space between the two layers of soft material. The artist pours molten bronze into the mold, the bronze hardens as it cools, and the mold is removed. The bronze is now in the shape originally formed by the "lost" wax. It is ready for tooling, polishing, and the addition of features such as glass or stone eyes and ivory teeth to heighten its lifelike appearance.

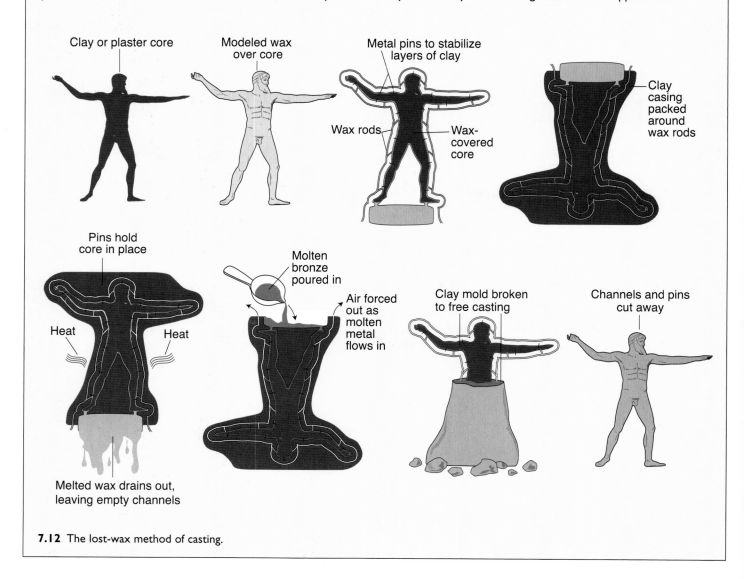

7.12 The lost-wax method of casting.

In 1972 a pair of original Greek bronzes known as the *Warriors from Riace* were discovered in the sea off the southern coast of Italy near Riace. The figure illustrated here (fig. **7.13**) is in a remarkably good state of preservation after extensive restoration work. Inlaid eyes (made of bone and glass-paste); copper eyelashes, lips, and nipples; and silver teeth create a vivid, lifelike impression. Most scholars assign a date of about 450 B.C. to this work, placing it at the end of Early Classical and the beginning of Classical. The dome-shaped head and flat, curvilinear stylizations of the hair are familiar Early Classical elements, whereas the self-confident, dynamic pose and organic form are consistent with Classical.

Classical Style (c. 450–400 B.C.)

The fifty-year span of Greek history from c. 450 to 400 B.C. is called the Classical, or High Classical, period and corresponds to the high point, or "golden age," of Greek art.

The modern term *classical,* which has multiple meanings, including "traditional," "lasting," and "of high quality," referred originally to the Greek accomplishments of the second half of the fifth century B.C. Not only do the works of art produced in this period reflect the cultural and intellectual achievements of Greece itself; they also have had a far-reaching influence on subsequent Western art and culture. It is virtually impossible to understand any aspect of Western culture fully without some familiarity with the achievements of Classical Greece.

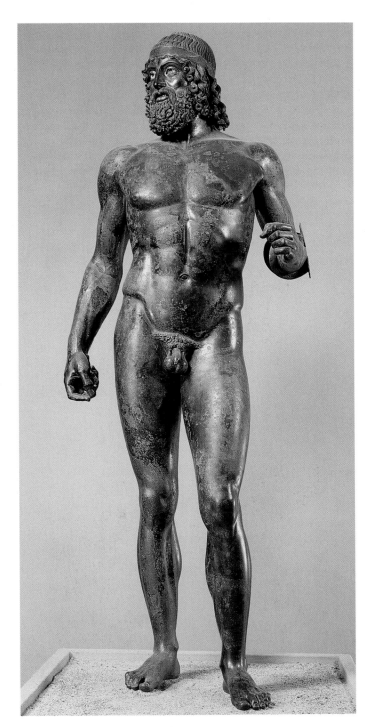

7.13 *Warrior from Riace,* c. 450 B.C. Bronze with bone, glass paste, and copper inlay, 6 ft. 6¾ in. (2 m) high. Museo Nazionale, Reggio Calabria, Italy.

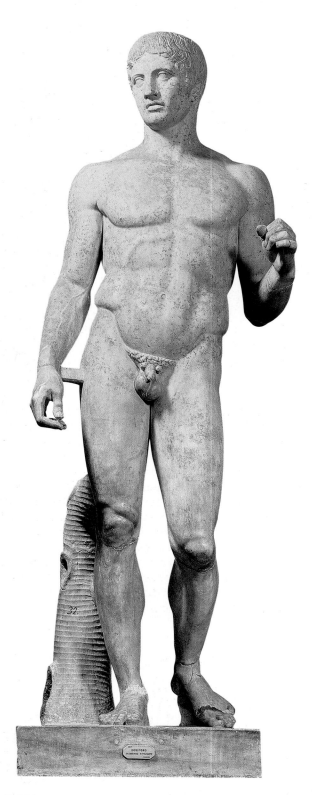

7.14 Polykleitos, *Doryphoros (Spear Bearer)*, c. 440 B.C. Marble copy of bronze original, 6 ft. 11½ in. (2.12 m) high. Museo Nazionale Archeologico, Naples, Italy. Typical of Roman copies is the "tree trunk" supporting the back of the right leg, and the block of marble connecting the hip with the right wrist. Since bronze is a stronger material than marble, it can stand on its own and needs no such additional supports.

Polykleitos of Argos Polykleitos of Argos was admired by his contemporaries, and his work is still thought of as the embodiment of Classical style. He created a canon, which is no longer extant. Most of his sculpture was cast in bronze and is known today only through later Roman copies in marble. Ancient records document the fact that the *Doryphoros (Spear Bearer)* was originally bronze (fig. **7.14**). The figure held a spear in his left hand and stands like the *Kritios Boy* (see fig. **7.10**), although with a slight increase in *contrapposto* and in the inclination of the head. The gradual S-motion of the body is more pronounced, and there is a greater sense of conviction in the body's underlying organic structure—notably the bulging knee-caps, the rib cage, and the veins in the arms. The head is dome-shaped, as in the *Kritios Boy,* but the circle of curls has been eliminated and the short, wavy hair lies flat on the surface of the head and face. The result is a figure with a sense of organic animation.

Classical artists idealized the human form. Figures are usually young, with no trace of physical defect. They are nicely proportioned and symmetrical in form (though not necessarily in pose), but they lack personality and expression.

Classical Architecture: The Athenian Acropolis

The Greeks, like all ancient peoples, thought of temples as houses for the gods. In Greece, the temple plan was derived from the *megaron* found in Mycenaean palaces (see p. 77), but the Greeks embellished it with an exterior colonnade. This reduced the inert outer wall to its structural parts—the supports and the weight they bear. This device is analogous to *contrapposto;* it animates the forces at work in the building and enables the viewer to understand them.

The god's cult statue was housed in the main room (the **naos**) and looked toward the east to an outdoor altar where sacrifices were performed. The main rituals inside the temple involved the care of the statue itself, usually ceremonial dressing and cleaning. Temple interiors were also sanctuaries for fugitives.

In the second half of the fifth century B.C., Athens was the site of the full flowering of the Classical style in the arts. The culmination was embodied in the buildings on the Acropolis (figs. **7.15** and **7.16**), particularly the Parthenon. The Acropolis (from the Greek words *akros,* meaning "high" or "upper," and *polis,* meaning "city") is an elevated rock supporting several temples, precincts, and other buildings. During the Mycenaean period, it had been a fortified citadel, and its steep walls made it difficult for invaders to scale.

The Classical period in Athens is also called the Age of Perikles, after the Greek general and statesman (c. 500–429 B.C.) who initiated the architectural projects for the Acropolis. He planned a vast rebuilding campaign

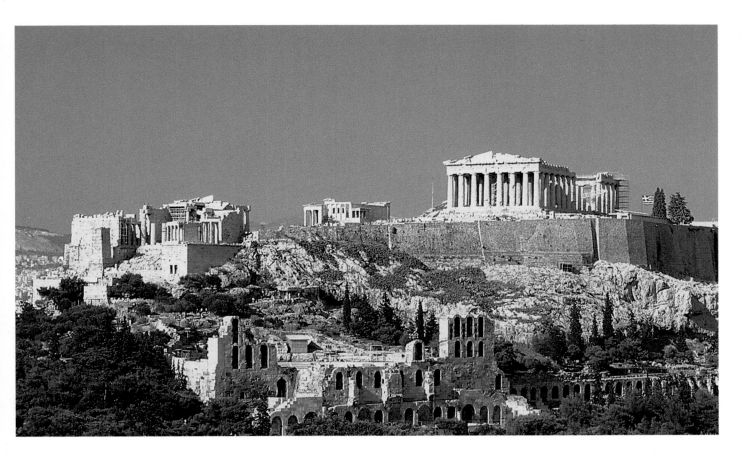

7.15 View of the Acropolis, Athens.

to celebrate Athenian art and civilization. This included the Parthenon (448–432 B.C.), the Nike Temple (427–424 B.C.), the Erechtheum (421–405 B.C.), and the Propylaea (entranceway).

Financing for Perikles' building program had come from the Delian League. Because of its sea power, Athens was able to force the rest of Greece to buy its protection against the Persian invaders. The funds housed in Apollo's sanctuary on the island of Delos were transferred from the island of Delos to the Athenian Acropolis in 454 B.C.

Athenian political rhetoric, which claimed that Athens protected other Greek cities in the league, informs the iconography of the buildings on the Acropolis. It was also Perikles' justification for spending the war chest on art and architecture in Athens. His political enemies in the assembly accused him of disgracing their city by taking the league's money. "Surely," they argued, "Hellas is insulted with a dire insult and manifestly subjected to tyranny when she sees that with her own enforced contributions for the war [against the Persians], we are gilding and bedizening our city, which, for all the world like a wanton woman, adds to her wardrobe precious stones and costly statues and temples worth their millions."[1]

Perikles replied that, as long as Athens waged war for its allies "and kept off the Barbarians," it alone deserved the money. "Not a horse, not a hoplite [a heavily armed Greek foot soldier], but money simply" was, according to Perikles, the only contribution of the other Greek cities. And furthermore, he argued, once Athens had sufficiently equipped itself for war, it was only natural that the city "should apply [its] abundance to such works as, by their completion, will bring [it] everlasting glory." This, he added, would also provide employment for many workers.

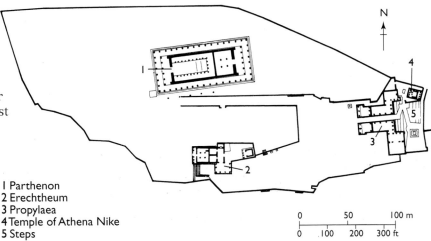

7.16 Plan of the Acropolis. This plan includes only the four Classical buildings that were rebuilt after the destruction of the Acropolis at the end of the Persian Wars (c. 480 B.C.). Like most Greek temples, they were made of marble, which was quarried from the local mountain, Pentelikos.

1 Parthenon
2 Erechtheum
3 Propylaea
4 Temple of Athena Nike
5 Steps

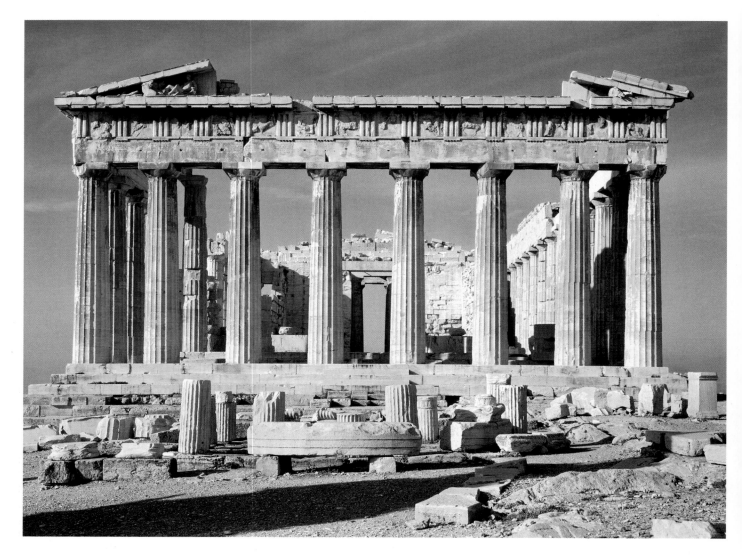

7.17 East end of the Parthenon, Athens, 447–438 B.C. Pentelic marble, 111 × 237 ft. (33.8 × 72.2 m). Once through the Propylaea at the western edge of the Acropolis, the visitor emerges, facing east. Ahead and a little to the right are the remains of the western façade of the Parthenon. Its damaged state reflects centuries of neglect and misuse. In the 5th century A.D. the Parthenon became a Christian church, and in the 15th century the Turks conquered Athens and converted the temple into a mosque. They stored gunpowder in the building! When it was shelled by artillery in 1687, most of the interior and many sculptures were destroyed. Centuries of vandalism and looting, plus modern air pollution, have further contributed to the deterioration of the Parthenon.

The Parthenon (448–432 B.C.)

The Parthenon was designed by the architects Iktinos and Kallikrates. Phidias, a leading Athenian artist of his generation and a friend of Perikles, supervised the sculptural decorations. Completed in 432 B.C. as a temple to Athena, the patron goddess of Athens, the Parthenon celebrates Athena in her aspect as a virgin goddess. (*Parthenos* is Greek for "virgin.")

No earlier Greek temple expresses Classical balance, proportion, and unity to the same extent as the Parthenon (figs. **7.17, 7.18, 7.19**). Its exceptional aesthetic impact is enhanced by its so-called refinements, which are slight architectural adjustments to improve the visual impression of the building. For example, lines that appear horizontal actually curve upward toward the middle, thereby correcting the tendency of the human eye to perceive a long horizontal as curving downward in the middle. Other refinements involve the columns, all of which tilt slightly inward; those toward the corners of the building are placed closer together, creating a sense of stability and of an organic relationship of parts to the whole.

The Parthenon sculptures were integrated harmoniously with the architecture. Their narrative content proclaimed the greatness of Classical Athens.

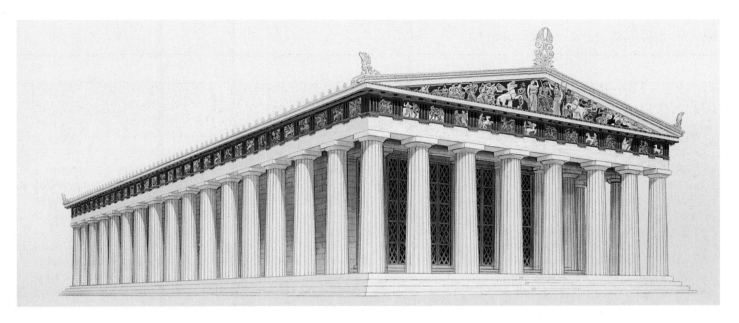

7.18 Reconstruction of the Parthenon, Athens. View of the east façade and south wall. The metopes and pediment sculptures are also reconstructed to show that they were originally painted.

ARCHITECTURE
Plan of the Parthenon

The Parthenon is constructed as a rectangle, which is divided into two smaller rectangular rooms. A front and back porch and a **peristyle (colonnade),** supported by the three steps of the Doric Order, complete the structure. The temple was made entirely of marble blocks cut and fitted without the use of mortar.

The three lines on the perimeter of the plan represent the steps. The black circles indicate columns—those of the peristyle number eight on the short sides (east and west) and seventeen on the long sides (north and south), counting the corner columns twice. Each corner column serves a short and a long side, making a smooth visual transition between them.

The inside wall of the Parthenon, supported by two steps, consists of six columns on a front and back porch, leading to a solid wall with a doorway to an inner room. The solid walls are indicated by thick black lines.

The western entrance leads to the smaller room, which served as a treasury. The eastern entrance leads to the *naos*, or inner sanctuary. It was originally dominated by a monumental **chryselephantine** (gold and ivory) statue of Athena—its base is indicated on the plan by the rectangle inside the *naos*. An inner rectangle of Doric columns repeats the shape of the room and surrounds the statue on three sides.

Although constructed primarily in the Doric Order, the Parthenon had two features that were Ionic. First, there were four Ionic columns inside the treasury. And second, a continuous Ionic frieze, which cannot be seen on the plan, ran around the top of the outside of the inside wall. The inclusion of Ionic elements in the Parthenon expressed the Athenians' interest in harmonizing the architectural and sculptural achievements of both eastern and western Greece.

1 *Naos*
2 *Pronaos*
3 *Opisthodomos*
4 Treasury
5 Base of Athena's statue
6 Peristyle columns
7 Solid wall
8 Steps (stereobate and stylobate)

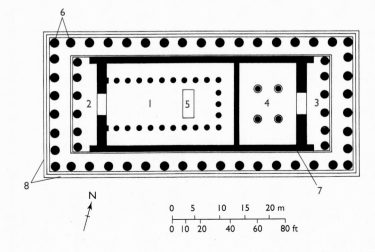

7.19 Plan of the Parthenon, Athens.

ARCHITECTURE
The Greek Orders

The Doric and Ionic **Orders** of Greek architecture (fig. **7.20**) had been established by about 600 B.C. and were an elaboration of the post-and-lintel system of elevation (see p. 31). Ancient Greek buildings, like Greek sculptures, were more human in scale and proportion than those in Egypt. And unlike the animal-based forms of ancient Iran, the Greek Orders were composed of geometric sections, each with its own individual meaning and logic. Each part was related to the others and to the whole structure in a harmonious, unified way.

The oldest Order, the Doric, is named for the Dorians, who lived on the mainland. Ionic—after Ionia, which includes the Ionian Islands and the coast of Anatolia—is an Eastern Order. Its greater elegance results from taller, thinner, curvilinear elements and surface decoration. The Corinthian capital is most easily distinguished by its **acanthus**-leaf design.

Doric Order The Doric Order begins with a base of three steps. Its shaft rises directly from the top step (the **stylobate**), generally to a height about five-and-a-half times its diameter at the foot. The **shaft** is composed of individual sections—**drums**—cut horizontally and held together in the middle by a metal dowel (peg) encased in lead. Shallow, concave grooves known as **flutes** are carved out of the exterior of the shaft. Doric shafts do not stand in an exact vertical plane but taper slightly from about a quarter of the way up. The resulting bulge, or *entasis* (Greek for "stretching"), indicates that the Classical Greeks thought of their architecture as having an inner organic structure, with a capacity for muscular tension.

At the top of the shaft, three elements make up the Doric capital, which forms both the head of the column and the transition to the horizontal lintel. The **necking** is a snug band

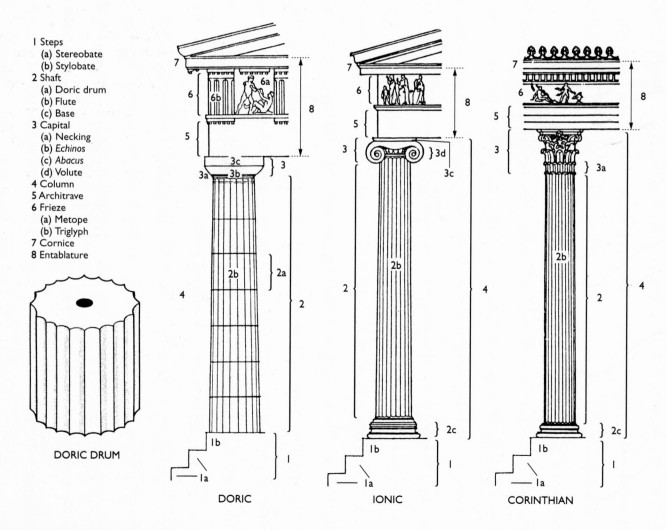

1 Steps
 (a) Stereobate
 (b) Stylobate
2 Shaft
 (a) Doric drum
 (b) Flute
 (c) Base
3 Capital
 (a) Necking
 (b) *Echinos*
 (c) *Abacus*
 (d) *Volute*
4 Column
5 Architrave
6 Frieze
 (a) Metope
 (b) Triglyph
7 Cornice
8 Entablature

DORIC DRUM

DORIC

IONIC

CORINTHIAN

7.20 Doric, Ionic, and Corinthian Orders.

at the top of the shaft. Above it is the *echinos* (Greek for "hedgehog" or "sea urchin")—a flat, curved element, like a plate, with rounded sides. The *echinos* forms a transition between the curved shaft and the flat, square *abacus* (Greek for "tablet") above. The *abacus* in turn creates a transition to the **architrave**—literally, a "high beam."

The architrave is the first element of the **entablature** (note the *tabl*, related to "table"), which forms the lintel of this complex post-and-lintel system. The **frieze,** above the architrave, is divided into alternating sections—square **metopes** and sets of three vertical grooves, or **triglyphs** (Greek *tri*, "three," and *glyphos*, "carving"). Finally, projecting over the frieze is the top element of the entablature—the thin, horizontal **cornice.** In Classical architecture, a triangular element known as a **pediment** (see fig. **7.25**) rested on the cornice, crowning the front and back of the building.

The harmonious relationship between the parts of the Doric Order is achieved by formal repetitions and logical transitions. The steps, sides of the *abacus*, architrave, metopes, frieze, and cornice are rectangles lying in a horizontal plane. The columns, spaces between columns, flutes, and triglyphs are all vertical. The outline of the three steps, the *echinos*, and each individual drum is a trapezoid (a quadrilateral with only two parallel sides).

Groups of three predominate: three steps; a capital consisting of necking, *echinos*, and *abacus*; triglyphs; and the entablature, which is made up of architrave, frieze, and cornice. The sudden shift from the horizontal steps to the vertical shaft is followed by a gradual transition via the capital to the entablature. The pediment may be read as a logical, triangular crown completing the trapezoid formed by the outline of the steps.

Ionic Order The more graceful Ionic Order has a round base with an alternating convex and concave profile. The shaft is taller in relation to its diameter (height is about nine times the diameter at the foot). The fluting is narrower and deeper. Elegant **volutes,** or **scroll** shapes, replace the Doric *echinos* at each corner and virtually eclipse the thin *abacus*. In the Ionic frieze, the absence of triglyphs and metopes permits a continuous narrative extending its entire length.

Corinthian Order There is no evidence of the existence of the Corinthian Order earlier than the latter part of the fifth century B.C. The origin of the term *Corinthian* is obscure, but it suggests that the acanthus-leaf capital was first designed by the metalworkers of Corinth and later transferred to marble. Unlike Doric and Ionic columns, Corinthian columns were used mainly in interiors by the Greeks—they were associated with luxury and, therefore, with "feminine" character.

The Parthenon Pediments The two pediments of the Parthenon represented mythological events from the life of Athena. On the west pediment (not illustrated) she was shown contesting Poseidon for patronage of the city. For the east pediment (fig. **7.21**), Phidias invented a unique composition in which Athena's birth is dramatized. It begins at the center of the pediment and spreads to the corners as the gods gradually respond. Those facing away from the center have not yet heard the news of the goddess's birth. Figure **7.21** is a reconstruction drawing of the east pediment; the center sculptures have disappeared. Those that survive are shown in figures **7.22** and **7.23**.

The three goddesses on the left side of the east pediment (fig. **7.22**)—possibly Iris or Hebe, and Demeter and Persephone, reading from the viewer's right to left—are posed so that they fit logically into the triangular space. Their repeated diagonal planes relate to the two diagonals of the pediment, while the graceful curves of their garments harmonize with the architectural curves of the Doric Order below. The reclining male nude to the left could be either Herakles or Dionysos. His limbs, like those of the goddesses, form a series of zigzag planes. His torso forms a gentle curve, repeated in the domed head and organic musculature. Despite the naturalism of the pose and the organic form, however, this figure is idealized like those of Polykleitos—there is no facial expression or individual personality.

On the right side of the east pediment (fig. **7.23**), balancing the two seated females and the reclining male on the left, is another group of three goddesses. Their identity has been disputed by scholars because they have no attributes. Though posed slightly differently, the groups on the right and left otherwise match each other closely. The reclining goddess relates to Dionysos/Herakles, and the two seated figures balance those of Demeter and Persephone in their poses and in the curvilinear garments outlining their bodies.

The most striking correspondence between the two sides of the east pediment occurs at the angles. On the far left are the marble remnants of Helios's horses, pulling the chariot of the sun. They rise, beginning their daily journey across the sky. On the far right, a single horse's head descends, echoing the triangular corner of the pediment. This horse, from the chariot of the moon goddess Selene, shows Phidias's understanding of anatomy, which he transformed into the Classical aesthetic. He creates the illusion of a triangular cheek plate with one curved side, blood vessels, and muscles pushing against the inside of the skin. The right eye seems to bulge from its socket, and the ear and mane emerge convincingly from beneath the surface. The open mouth forms another triangular space, echoing the head, the cheek plate, and the pediment itself. By indicating the rising and descending chariots of the sun and moon, the artist expands the scene beyond the pediment into cosmic time. The implication is that Athena's birth ushers in the dawn of a new day along with a new order of civilization.

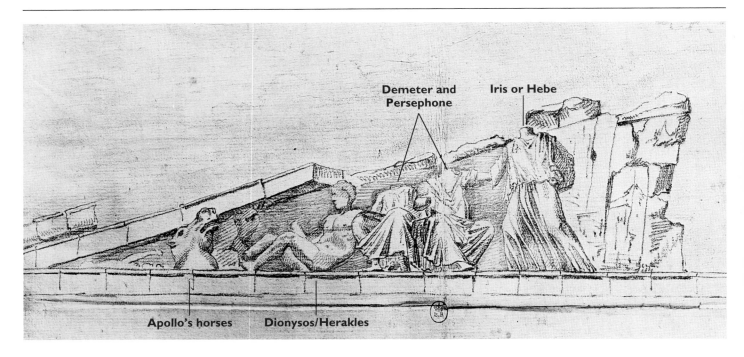

7.21 (Above and facing page, above) East pediment of the Parthenon in 1674, from a drawing by Jacques Carrey. Sculptures finished by 432 B.C. Bibliothèque Nationale, Paris, France. Greek temple sculptures and their background areas were originally painted. The sculptures in the broken center section of this pediment used to represent Athena's birth on Mount Olympos: Zeus was in the middle, and a Nike crowned Athena with a laurel wreath. According to the myth, Hephaestos struck Zeus on the head with an ax, and Athena was born fully grown and armed. As the goddess of wisdom and of war and weaving, she appeared like an idea from the head of the supreme god.

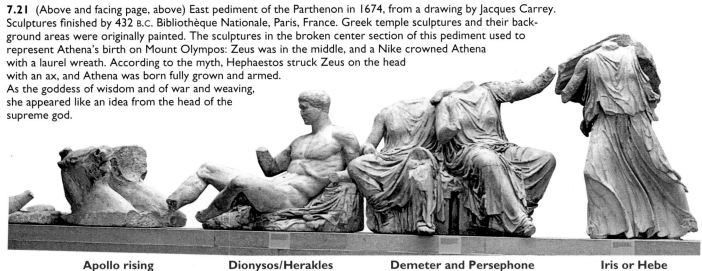

7.22 Sculptures from the left side of the east pediment of the Parthenon, finished by 432 B.C. Pentelic marble, left figure 5 ft. 8 in. (1.73 m) high. British Museum, London, England. The pediments are almost 100 feet (30.5 m) wide at the base and 11 feet (3.35 m) high at the central peak. The depth of the pediment bases is, however, only 36 inches (91.4 cm), thus restricting the space available for the sculptures. Since the sides of the pediments slope toward the corner angles, Phidias had to solve the problem of fitting the sculptures into a diminishing triangular space.

The Doric Metopes Four mythological battles are illustrated in the Parthenon metopes. The best preserved, originally on the south frieze, represent the battle between Lapiths (Greek tribesmen) and Centaurs (fig. **7.24**). The backward thrust of the Centaur's *contrapposto* suggests his struggle and defeat. Phidias has liberated the Lapith so that his head, feet, and right arm project from the block.

The other three metope battles depicted Greeks against Amazons on the west, the Trojan War on the north, and Olympians overthrowing Titans on the east. Each set of metopes expressed an aspect of the Greek sense of superiority. The Lapiths and Centaurs symbolized the universal human conflict between animal instinct or lust—exemplified by the half-horse, half-human Centaurs who became drunk at a Lapith wedding—and rational self-control, embodied by the Lapiths. The victory over the Amazons symbolized the triumph of Greek warriors over female warriors from the east. In the Trojan War, West again triumphed over East, and in the clash between Titans and Olympians the more human Greek gods wrested control of the universe from their primitive, cannibalistic predecessors. The sculptural program of the Parthenon represented mythological battles as a way of alluding to recent, and historical, victories. The political subtext of the battles on the Parthenon metopes is thus the Athenian triumph over the Persians.

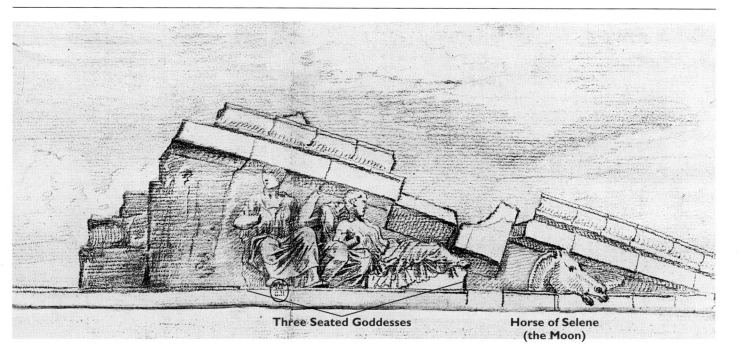

Three Seated Goddesses

**Horse of Selene
(the Moon)**

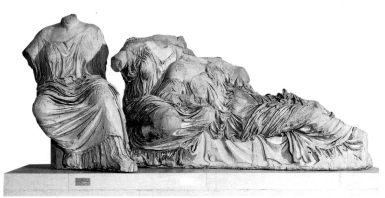

Three Seated Goddesses

Horse of Selene (the Moon)

7.23 (Above) Sculptures from the right side of the east pediment of the Parthenon. Pentelic marble, left figure 4 ft. 5 in. (1.35 m) high. British Museum, London, England. At the left corner of the whole pediment, Helios's horses mark the rising of the sun because Athena was born in the east at dawn. The horse of the moon descends at the right corner. The location of the scene on this pediment also corresponds to the sunrise in the east. Thus, in this arrangement, the artist has formally integrated sculpture and architecture with iconography, time, and place.

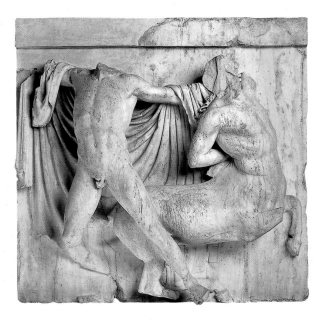

7.24 *Lapith and Centaur,* from South Metope XXVII of the Parthenon. Pentelic marble, 4 ft. 5 in. (1.35 m) high. British Museum, London, England. Each metope is approximately 4 feet square (1.22 m²) and contains high-relief sculpture. There were fourteen metopes on the short east and west sides, and thirty-two on the long north and south sides. Most are scenes of single combat.

1 Continuous Ionic frieze
2 Doric metope
3 Pediment
4 Triglyphs
5 Architrave

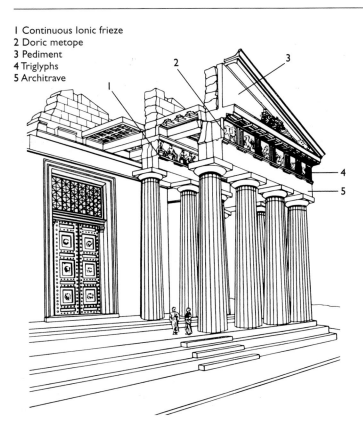

7.25 (Above) Cutaway perspective drawing of the Parthenon, showing the Doric and Ionic friezes and a pediment (after G. Niemann).

The Ionic Frieze Over the outside of the inner (*naos*) wall of the Parthenon (fig. **7.25**), an Ionic frieze 525 feet (160 m) long illustrates the Greater Panathenaic procession (fig. **7.26**). This festival was held every four years, and the entire city participated in presenting a new **peplos** to Athena on her birthday. The continuous nature of the Ionic frieze, uninterrupted by triglyphs, is consistent with its content. Thus the shape of the frieze corresponds with the form of a procession. In order to maintain the horizontal plane of the figures, Phidias adopted a sculptural convention of **isocephaly** (from the Greek words *isos*, "equal" or "level," and *kephale*, "head"). When a work is isocephalic, all the heads are set at approximately the same level.

The *Naos* The *naos* contained Phidias's cult statue of Athena towering over, and reflected in, a pool of water. In the reconstruction in figure **7.27**, she is armed and represented in her aspect as the goddess of war. She stands and confronts her viewers directly, wearing Medusa's head (see Box) on her leather aegis and holding a statue of Nike (goddess of victory) in her right hand and a shield in her left. Both the shield and pedestal were decorated with reliefs by Phidias. The colossal scale of this statue was unprecedented and embodied Athena's importance as the patron goddess of Athens. The richness of the statue's materials was a sign of the wealth transferred from Delos to Athens. Athena's central position in the Parthenon pediments and the offering of the *peplos* in the Ionic frieze signified her wisdom and power as well as the Athenians' devotion to her.

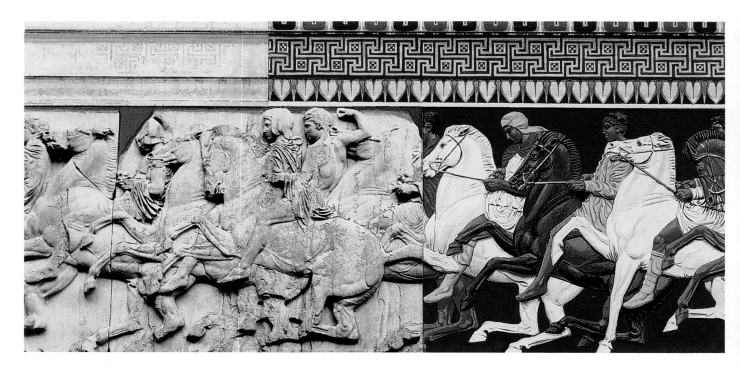

7.26 Equestrian group from the north frieze of the Parthenon, c. 442–439 B.C. Pentelic marble, 3 ft. 5¾ in. (1.06 m) high. British Museum, London, England. This illustrates Phidias's device of making the horses small in relation to the riders. He carved the horses' legs in higher relief than their bodies and heads. The effect is to cast heavier shadows on the lower part of the frieze, which, together with the multiple zigzags, increases the illusion of movement. This illustration shows the frieze partially restored, based on surviving paint traces.

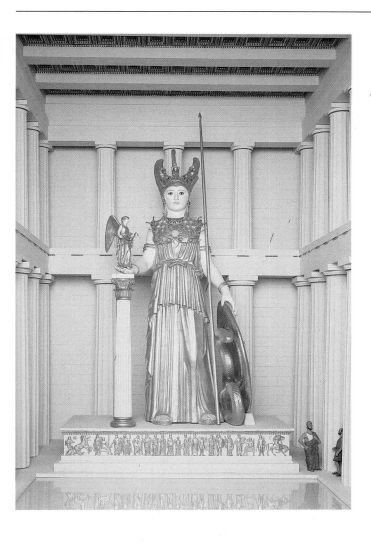

7.27 Neda Leipen and Sylvia Hahn, reconstruction of Phidias's *Athena,* from the *naos* of the Parthenon. Original dedicated 438 B.C. Wood covered with gold and ivory plating, model approx. 4 ft. (1.22 m) high. Royal Ontario Museum, Toronto, Canada. Like many cult statues, that of Athena was over-life-size, standing 40 feet (12 m) high on a pedestal. Phidias constructed the statue around a wooden frame, covering the skin area with ivory and the armor and drapery with gold. The original statue has long since disappeared; it has been reconstructed from descriptions, small copies, and images on coins.

The Temple of Athena Nike

Athena was honored as the goddess of victory in the small marble Ionic temple of Athena Nike, which crowns the southern edge of the Acropolis (fig. **7.28**). It has a square *naos* and a front porch, with four Ionic columns and four steps at the front and back. This repetition reflects the Classical insistence on unifying the parts with the whole. The small size and graceful Ionic Order of the Nike temple contrast with the heavier proportions of the Doric columns in the Parthenon.

MYTH
Medusa

Medusa, the only mortal of the three Gorgon sisters, turned to stone any man who looked at her. She had snaky hair, glaring eyes, and fanged teeth, and she emitted a loud roar. Following the wise advice of Athena to look at her only in the reflection of his shield, Perseus decapitated Medusa. He took her head to Athena, who adopted it as her shield device. The Medusa head, or *Gorgoneion,* subsequently became a popular armor decoration in the West, symbolically petrifying—that is, killing—one's enemies.

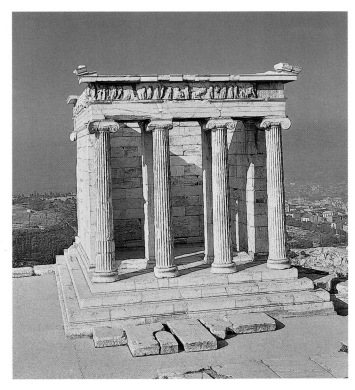

7.28 Temple of Athena Nike from the east, Acropolis, Athens, 427–424 B.C. Pentelic marble.

7.29 *Nike Adjusting Her Sandal,* from the balustrade of the temple of Athena Nike, 410–409 B.C. Pentelic marble, 3 ft. 5¾ in. (1.06 m) high. Acropolis Museum, Athens, Greece.

The Nike temple, like the Parthenon, celebrated a military victory, but it is not known which one. The issue is complicated by the fact that it was designed before the Parthenon but finished later. Gold statues of Nike that were once housed in the temple have disappeared. The best surviving sculpture from the Nike temple is the relief titled *Nike Adjusting Her Sandal* (fig. **7.29**), which was originally located on a **balustrade** of the parapet. This figure is a *tour de force* of marble carving, her deeply cut folds projecting from the surface. The helplessness of the off-balance Nike, her chiton falling down, introduces a new eroticism to Classical art. The sheer, almost transparent drapery (called "wet drapery" because it appears to cling to the body) falls in a pattern of elegant, repeated folds. Behind the Nike are the remains of her open wings. Their smooth surfaces contrast with the folds of the drapery and, at the same time, echo and frame the torso's curve.

The Erechtheum

The Erechtheum (fig. **7.30**) is on the northern side of the Acropolis, opposite the Parthenon. It replaced an old temple to Athena that housed an Archaic wooden statue of the goddess. The temple was destroyed by the Persians, but the Athenians decided to display the ruins to remind citizens of the sacrilegious act of sacking the Acropolis. A more complex Ionic building than the Nike temple, the Erechtheum is built on an uneven site. The eastern room was dedicated to Athena Polias—Athena in her aspect as patron of the city.

The small southern porch (fig. **7.31**) is distinctive for its six **caryatids**, each standing in a relaxed *contrapposto* pose. The drapery defines the ideal female body, characteristic of the Classical style. In this ensemble, a perfect symmetry is maintained so that each set of three, right and left, is a mirror image of the other. The two corner caryatids, like the corner columns of the Parthenon, are perceived as being aligned with the front figures when viewed from the front and with the side figures when viewed from the sides, thus creating a smooth visual transition between front and side.

In the metaphorical transformation of columns into human form, several features are necessarily adapted. For example, the vertical drapery folds covering the support leg resemble the flutes of columns. In the capital over the caryatid's head, the volute is omitted, but the *echinos* has been retained in the headdress, which creates a transition from the head to the *abacus*. At the same time, the headdress is an abstract geometric form, related to organic human form only by its proximity to the head. Whereas the Doric *echinos* effects a transition from vertical to horizontal and from curved elements to straight ones, the headdress satisfies the additional transition from human form to geometric form. These caryatids thus illustrate the harmonious metaphorical relationship between ideal and organic, human and abstract, that characterizes Classical style.

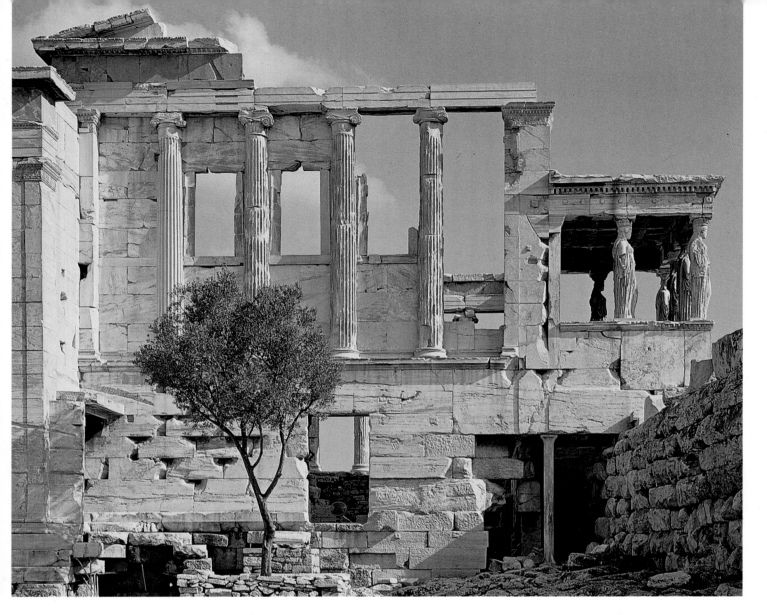

7.30 (Above) The Erechtheum, west side, Acropolis, Athens, 421–405 B.C. Porch figures approx. 8 ft. (2.44 m) high. This temple was named for Erechtheus, a legendary king of Athens who was worshiped with Athena and various other gods and ancestors. As a result of the large number of dedicatees, the building itself is unusually complex for a Classical Greek temple.

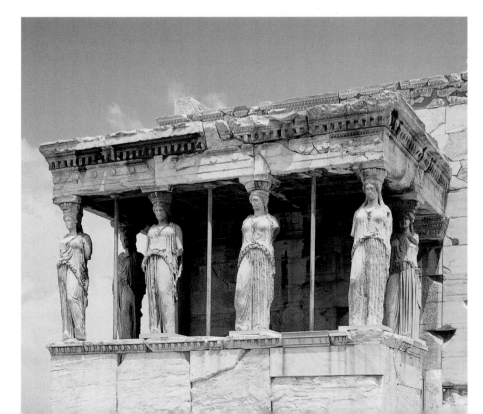

7.31 The caryatid porch of the Erechtheum, south side.

Late Classical Style

(c. 400–323 B.C.)

By the end of the fifth century B.C., Athens had lost its political supremacy. Other Greek city-states, especially Sparta, began to exert political and military power over Greece. In the fourth century B.C., Philip II of Macedon, in northeastern Greece, conquered the Greek mainland, and his son Alexander the Great extended his empire. Nevertheless, the intellectual leaders of that period, notably Plato and Aristotle, continued to flourish in Athens.

The Greek Theater

The outdoor theater came into its own as an architectural form after the fifth century B.C. (see Box). The best-preserved example is the theater at Epidauros on the eastern edge of the Peloponnesus (figs. **7.32** and **7.33**). The design is famous for its acoustics, which are based on scientific knowledge of how sound travels. It had a slightly more than semicircular seating area, with radiating stair-

> ### ARCHITECTURE
> ## Greek Theater
>
> Greek theater grew out of rituals performed in honor of the wine god, Dionysos. The early theaters were hollow spaces in hills, and in the fifth century B.C. these were developed to incorporate wooden benches arranged around an opening in a rock. Virtually embedded in nature, these theaters integrated drama with landscape. It was in such theaters—one was located below the Acropolis in Athens—that the great dramas by Aeschylos, Sophokles, and Euripides were performed. Greek theater began with a chorus of actors who sang and danced; gradually, individual roles performed by separate players emerged.

ways and a walkway a little more than halfway up—not unlike a modern sports arena. The auditorium was built around the **orchestra** (a place for dancing), which was a round space for the chorus where the action of the play unfolded. This was about 80 feet (24.5 m) in diameter and contained an altar dedicated to Dionysos.

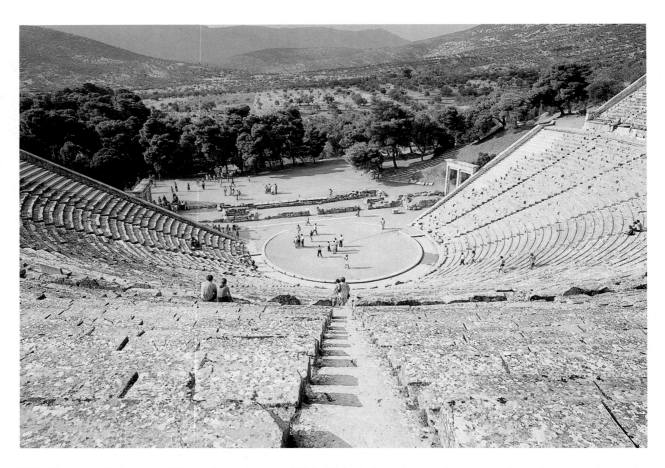

7.32 Theater at Epidauros, c. 350 B.C. Stone, diameter 373 ft. (114 m). Curved rows of stone seats formed an inverted conical space in these impressive structures. Behind the orchestra was the rectangular stone backdrop, or *skene* (from which the modern English word *scene* is derived), and actors entered from the sides.

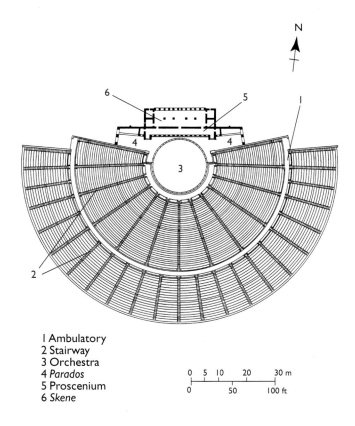

N

1 Ambulatory
2 Stairway
3 Orchestra
4 *Parados*
5 *Proscenium*
6 *Skene*

7.33 Plan of the theater at Epidauros.

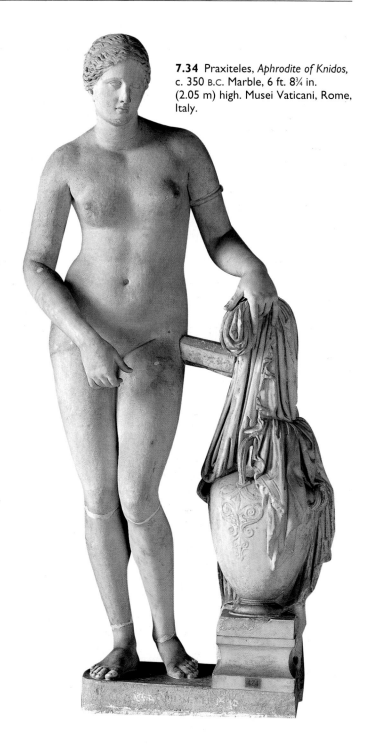

7.34 Praxiteles, *Aphrodite of Knidos*, c. 350 B.C. Marble, 6 ft. 8¾ in. (2.05 m) high. Musei Vaticani, Rome, Italy.

Sculpture

The leading Athenian sculptor of the Late Classical style was Praxiteles. A gentle S-shape, sometimes called the "Praxitelean curve," outlines the stance of his most famous statue, the *Aphrodite of Knidos* (fig. **7.34**), which is known only from Roman copies. The eastern Greek city of Kos originally commissioned the *Aphrodite* but rejected the finished work because it was shocked by its nudity. The statue was then accepted by another eastern Greek city, Knidos. It represents the goddess standing next to a water jar (hydria) after her bath. She picks up her garment with her left hand, and while the gesture of her right hand implies modesty, at the same time it calls attention to her nudity. Compared with Classical sculptures, the *Aphrodite* has slightly fleshier proportions and a heavier, fuller face.

More than any earlier Greek sculptor, Praxiteles celebrated the female nude. In fact, it was with this work that the female entered the canon of beauty in Greek art, which previously had been restricted to the male nude. The

Aphrodite was celebrated by the Knidians, who exhibited it in such a way that viewers could completely encircle it. Later anecdotes emphasized the erotic qualities and realism of the statue. One story tells of the goddess emerging from the waves off the coast of Anatolia to see her likeness. So astonished was she by its accuracy that she cried out "Where did Praxiteles see me naked?"

The "Hermes of Praxiteles"

Sometimes the stylistic categories of canonical Western art history are thrown into doubt when new discoveries are made. The so-called *Hermes of Praxiteles* is a case in point. For generations, art historians identified this sculpture (fig. **7.35**) as an original work by Praxiteles (c. 70–330 B.C.). It has the slightly fleshy proportions of the Late Classical style, and the *contrapposto* creates the S-shaped curve associated with him. The pose seems to fit comfortably between the Classical and Hellenistic styles. But when the sandals were studied in relation to the known shoe styles of ancient Greece, it was discovered that they did not belong to the fourth century. As a result, scholars have concluded that the work must belong to a later period. It may be a Roman copy of Praxiteles' original figure.

7.35 Attributed to Praxiteles, *Hermes and the Infant Dionysos*, c. 340 B.C. Marble, with vestiges of red paint on lips and hair, 7 ft. 1 in. (2.16 m) high. Archaeological Museum, Olympia, Greece.

Lysippos of Sikyon (near Corinth), who was famous for his portrayals of athletes and his portraits of great men, was among the important Greek sculptors of the fourth century B.C. whose work survives mainly in Roman copies. He introduced a new, more naturalistic approach to representing the human figure. In so doing, he became the key artist in the transition from Late Classical to Hellenistic style. His genius brought him to the attention of Alexander the Great, who made him his court sculptor.

The Roman author Pliny the Elder distinguished between the canon of Polykleitos, exemplified by the *Doryphoros* (see fig. **7.14**), and the newer style of Lysippos. Polykleitos's figures were idealized youths; but according to Pliny, Lysippos preferred thinner bodies, smaller heads, more detailed hair, and an increase in surface movement. The result was a taller, lighter appearance and a livelier stance. This, in Pliny's view, changed external form in the direction of greater emotional accuracy. It also took into account the position of the viewer in relation to the sculpture by opening up the space around its central axis. One effect of Lysippos's canon can be seen in the *Apoxyomenos* (literally, in Greek, "one scraping himself")—originally a bronze and now known only in Roman marble copies (fig. **7.36**). It represents a victorious athlete scraping oil off his arm with a strigil.

The two views of the *Apoxyomenos* show the turn in the athlete's body compared with the relaxed *Doryphoros,* who stands within a single vertical axis. Here there is more movement away from the center because of the wider opening between the legs and the outstretched arms. The athlete seems to swivel, which draws observers into his space and engages them with his action.

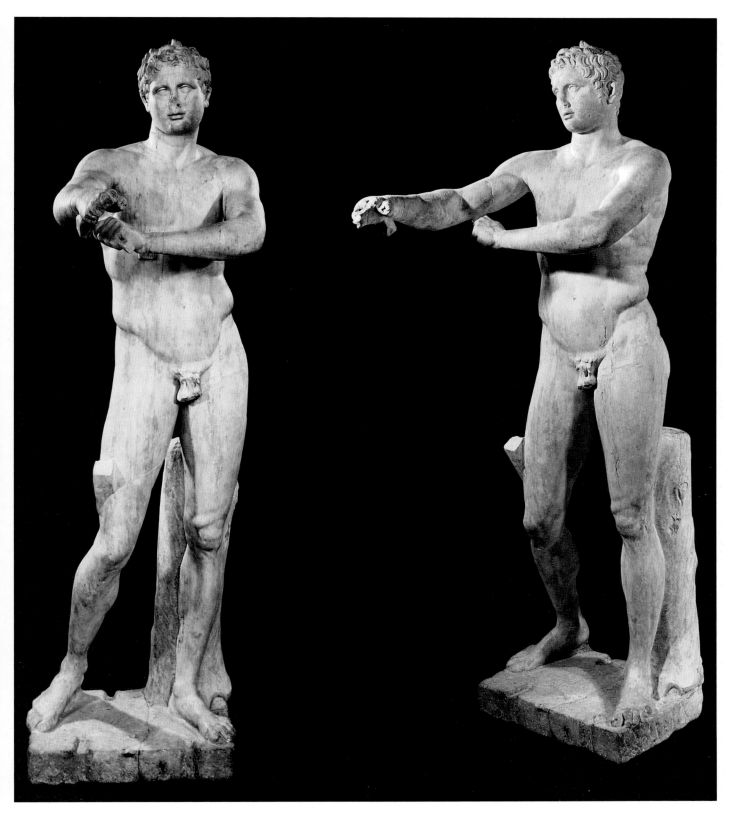

7.36a, b Lysippos, *Apoxyomenos (Athlete with a Strigil),* Roman copy of a bronze original of c. 320 B.C. Marble, 6 ft. 9 in. (2.05 m) high. Musei Vaticani, Rome, Italy. According to Pliny, this sculpture was particularly admired by the Roman emperor Tiberius, who had it moved from the public baths to his bedroom but returned it after the Roman citizens protested their loss.

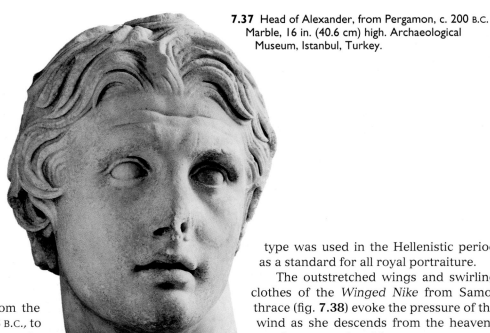

7.37 Head of Alexander, from Pergamon, c. 200 B.C. Marble, 16 in. (40.6 cm) high. Archaeological Museum, Istanbul, Turkey.

Hellenistic Period

(323–31 B.C.)

The Hellenistic period extended from the death of Alexander the Great, in 323 B.C., to the beginning of the Roman Empire under Augustus, who assumed power in 31 B.C. and became emperor four years later (see Chapter 9). The term *Hellenistic* refers to the spread of Greek culture beyond Greece—especially to the East—as a result of Alexander's conquests.

Sculpture

Hellenistic style continues the developments introduced by Lysippos and further expands the diversity of sculpture formally and iconographically as well as psychologically. There is an increase in portrait types; children and old people are represented; theatricality and melodrama express extremes of emotion; and the inner character of figures is conveyed through an emphasis on formal realism.

Lysippos established the official royal image of Alexander, but none of those portraits survives. Nevertheless, the type he created is known from descriptions and posthumous portraits of Alexander by later artists. One such example from the site of Pergamon in western Turkey shows Alexander's slightly tilted head, as if he is gazing toward the heavens, with dreamy eyes, parted lips, fleshy facial texture, and a furrowed brow (fig. **7.37**). The wavy hair, brushed upward at the center of his forehead, became characteristic of Alexander's portraits, and the general

type was used in the Hellenistic period as a standard for all royal portraiture.

The outstretched wings and swirling clothes of the *Winged Nike* from Samothrace (fig. **7.38**) evoke the pressure of the wind as she descends from the heavens on the prow of a ship to commemorate a naval victory. The wind whips her garment with a sense of movement more activated than in Classical sculpture, and her wings are outspread in triumph. The forward diagonal of her torso seems forced against the elements, and the position of her wings suggests that they have not yet settled. Adding to the sense of movement are the drapery masses sweeping across the front of the body, which are contrasted with the seemingly transparent drapery at the torso. The more deeply cut folds also increase the areas of shadow in the skirt swirling around her legs, making it appear darker as well as heavier than the drapery covering the torso. From the side, the diagonal planes of the body and the outspread wings come into view.

Hellenistic sculptors also explored the nature of childhood. In *Sleeping Eros* (fig. **7.39a**), for example, the god is depicted as a naturalistic toddler with baby fat and childlike proportions. He is shown in a state of sleep, relaxed and unaware of the waking world. His weight lies heavily on a slanted surface, and his arm hangs limply in response to the force of gravity.

The back view of the Eros (fig. **7.39b**) shows the artist's attention to the elegant curls and wing-feather patterns. Here, the weight of the child as he rests on the rock is revealed by the slight bulge of the buttock.

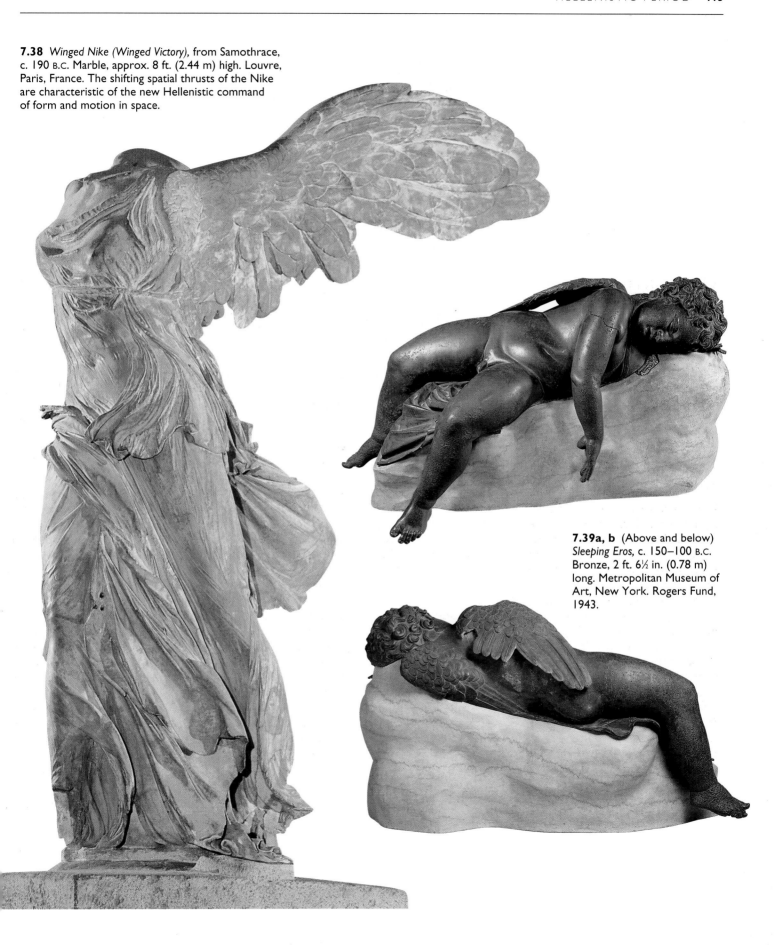

7.38 *Winged Nike (Winged Victory),* from Samothrace, c. 190 B.C. Marble, approx. 8 ft. (2.44 m) high. Louvre, Paris, France. The shifting spatial thrusts of the Nike are characteristic of the new Hellenistic command of form and motion in space.

7.39a, b (Above and below) *Sleeping Eros,* c. 150–100 B.C. Bronze, 2 ft. 6½ in. (0.78 m) long. Metropolitan Museum of Art, New York. Rogers Fund, 1943.

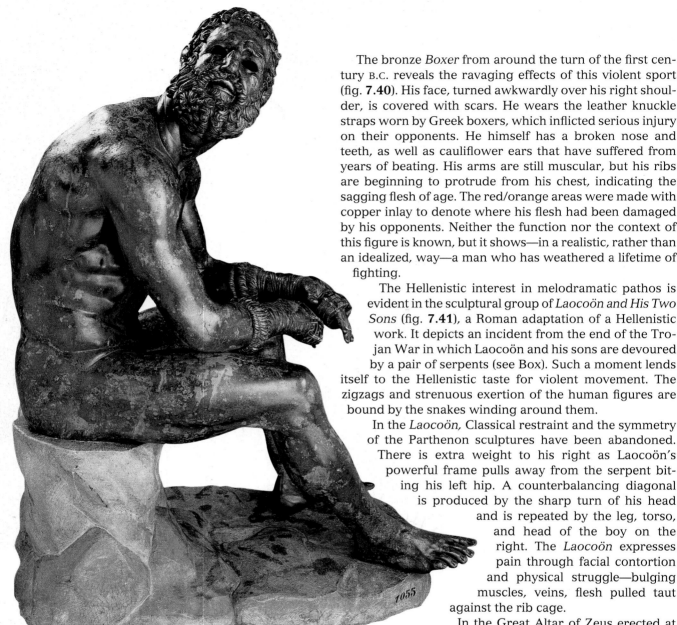

7.40 *Boxer*, 2nd or early 1st century B.C.
Bronze, 4 ft. 2½ in. (1.28 m) high. Museo
delle Terme, Rome, Italy.

The bronze *Boxer* from around the turn of the first century B.C. reveals the ravaging effects of this violent sport (fig. **7.40**). His face, turned awkwardly over his right shoulder, is covered with scars. He wears the leather knuckle straps worn by Greek boxers, which inflicted serious injury on their opponents. He himself has a broken nose and teeth, as well as cauliflower ears that have suffered from years of beating. His arms are still muscular, but his ribs are beginning to protrude from his chest, indicating the sagging flesh of age. The red/orange areas were made with copper inlay to denote where his flesh had been damaged by his opponents. Neither the function nor the context of this figure is known, but it shows—in a realistic, rather than an idealized, way—a man who has weathered a lifetime of fighting.

The Hellenistic interest in melodramatic pathos is evident in the sculptural group of *Laocoön and His Two Sons* (fig. **7.41**), a Roman adaptation of a Hellenistic work. It depicts an incident from the end of the Trojan War in which Laocoön and his sons are devoured by a pair of serpents (see Box). Such a moment lends itself to the Hellenistic taste for violent movement. The zigzags and strenuous exertion of the human figures are bound by the snakes winding around them.

In the *Laocoön,* Classical restraint and the symmetry of the Parthenon sculptures have been abandoned. There is extra weight to his right as Laocoön's powerful frame pulls away from the serpent biting his left hip. A counterbalancing diagonal is produced by the sharp turn of his head and is repeated by the leg, torso, and head of the boy on the right. The *Laocoön* expresses pain through facial contortion and physical struggle—bulging muscles, veins, flesh pulled taut against the rib cage.

In the Great Altar of Zeus erected at Pergamon (fig. **7.42**), the Hellenistic taste for emotion, energetic movement, and exaggerated musculature is expressed in relief sculpture. The two friezes on the altar celebrated the city and its superiority over the Gauls, who were a constant threat to the Pergamenes. Inside the structure, a small frieze depicted the legendary founding of Pergamon.

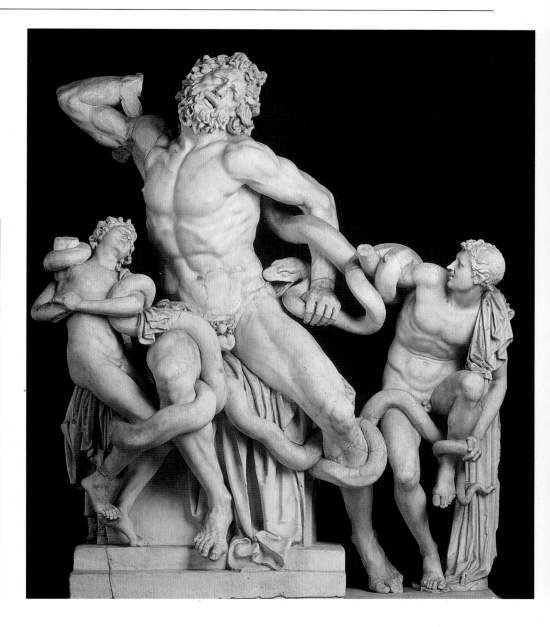

7.41 *Laocoön and His Two Sons.* Marble, 7 ft. (2.13 m) high. Musei Vaticani, Rome, Italy. The figures of Laocoön and his son on the viewer's left are Roman copies (from the 1st century A.D.) of a Hellenistic statue. The boy on our right is a Roman addition to the group.

MYTH
The Trojan Horse

According to a lost Homeric epic, the Greeks constructed a colossal wooden horse and filled it with armed soldiers. They tricked the Trojans into believing it was an offering to Athena that they should take inside their city walls. Laocoön, a Trojan seer, warned the Trojans that he did not trust the Greeks, "even bearing gifts." Thereupon, Athena sent two serpents to kill the seer and his children. The Trojans took this as a sign that Laocoön was not to be believed and accordingly opened their gates and pulled in the horse. The Greek soldiers emerged, let in the rest of the Greek army, and sacked Troy. References to the story are also found in *The Odyssey* (IV.271, VIII.492, XI.523) and the *Aeneid* (II) (see page 126).

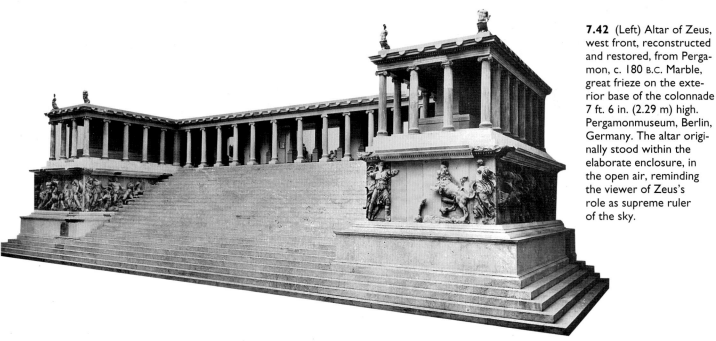

7.42 (Left) Altar of Zeus, west front, reconstructed and restored, from Pergamon, c. 180 B.C. Marble, great frieze on the exterior base of the colonnade 7 ft. 6 in. (2.29 m) high. Pergamonmuseum, Berlin, Germany. The altar originally stood within the elaborate enclosure, in the open air, reminding the viewer of Zeus's role as supreme ruler of the sky.

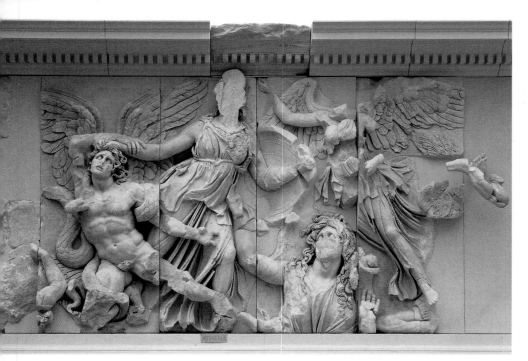

7.43 *Athena Battling with Alkyoneus*, from the great frieze of the Pergamon Altar, east section, c. 180 B.C. Marble, 7 ft. 6 in. (2.29 m) high. Antikensammlung, Staatliche Museen, Berlin, Germany.

to proclaim the victory of Greek civilization over the barbarians. Greece tried to reassert its superiority, as Athens had done in building the Parthenon following the Persian Wars. But Hellenistic art, especially in its late phase, reflects the uncertainty and turmoil of the period. By the end of the first century B.C., the Romans were in control of the Mediterranean world, and, with the ascendancy of Augustus in 31 B.C., the scene was set for the beginning of the Roman Empire.

Outside, the traditional depiction of the gods fighting the Titans was transformed. In a detail illustrating Athena's destruction of Alkyoneus (fig. **7.43**), a son of the Titan earth goddess Gaia (Apollo's predecessor at Delphi) (see p. 84), the energy inherent in the juxtaposed diagonal planes seems barely contained. This mythical battle between pre-Greek Titans and Greek Olympians recurs in Hellenistic art partly as a result of renewed political threats to Greek supremacy. But unlike the Classical version on the Parthenon metopes, that at Pergamon is full of melodrama, frenzy, and pathos.

King Attalus I defeated the powerful Gauls, who invaded Pergamon in 238 B.C. This victory made Pergamon a major political force. Later, under the rule of Eumenes II (197– c. 160 B.C.), the monumental altar dedicated to Zeus was built

Compared with the art of the other Mediterranean cultures that we have surveyed, Greek art stands out for expressing what is human. This is equally reflected in the science, philosophy, government, literature, theater, and religion of ancient Greece. As far as one can tell from surviving texts, the Greeks were the first in the West to write historically about art and artists. Of the Greek styles covered in this chapter, it is the Classical style that has had the most lasting impact on Western art and thought. The very notion of "Classical" has set a standard to which Western artists have responded in various ways. Subsequent styles, as well as individual artists, can be seen as both continuing the Classical tradition and rebelling against it. In either case, indifference to the Classical achievements was—and remains—virtually impossible.

1000 B.C. 500 B.C. 31 B.C.

THE ART OF ANCIENT GREECE

GEOMETRIC c. 1000–700 B.C.	ORIENTALIZING c. 700–600 B.C.	ARCHAIC c. 600–480 B.C.	CLASSICAL c. 480–323 B.C.		HELLENISTIC 323–1st century B.C.

8th century B.C. amphora (7.1)

7th century B.C. amphora (7.2)

Early Classical (c. 480–450 B.C.)

Late Classical (c. 400–300 B.C.)

(7.4) Black-figure vases

(7.5) Red-figure vases

(7.6) White-ground pottery begins (c. 420 B.C.)

(7.32)

(7.7)

First Olympic Games (776 B.C.)

Near Eastern influence in Greece

(7.8)

(7.10)

(7.17)

(7.34)

(7.37)

Greek alphabet adapted from Phoenician c. 9th century B.C.

Pythagoras (c. 581– 497 B.C.)

Democracy in Athens (510 B.C.)

Persian Wars (c. 499– 441 B.C.)

Socrates (c. 470– 449 B.C.)

Aeschylos, *Oresteia* (c. 458 B.C.)

Peloponnesian War (404–371 B.C.)

Death of Alexander the Great (323 B.C.)

8

The Art of the Etruscans

Etruscan civilization flourished between c. 1000 and 100 B.C. and was contemporary with the Greek culture discussed in Chapter 7. In the Iron Age (Villanovan period, named for the site near modern Bologna in northern Italy), the Etruscans had elaborate burials that included iron, bronze, and ivory objects. Etruscan culture is important in Western history in its own right and because of its relationship to Greece and Rome. The Etruscan homeland, Etruria (modern Tuscany), occupied the west-central part of the Italian peninsula. It was bordered on the south by the Tiber River, which runs through Rome, and on the north by the Arno River (see map).

The Greeks called the Etruscans Tyrrhenians, and the Romans called them Tusci or Etrusci. Like the Greeks, the Etruscans never formed a single nation but coexisted as separate city-states with their own rulers. Unlike the Romans, they never established an empire.

Although Herodotos thought the Etruscans had come from Lydia, in modern Turkey, many scholars now believe they were indigenous to, or at least developed their civilization in, Italy. From the seventh to the fifth century B.C.—the period of their greatest power—the Etruscan fleet controlled the western Mediterranean, and Etruria was an important trading nation. The Etruscans established commercial trade routes throughout the Aegean, the Near East, and North Africa. At the same time, they were largely responsible for extending Greek influence to northern Italy and Spain.

The Etruscan language resembles none other that is presently known, and its origin is uncertain; but, like Phoenician, from which the Greek alphabet was derived, Etruscan is written from right to left. The Etruscans adapted the Greek alphabet to their own language and literature. Unfortunately, all Etruscan literature—which, according to Roman sources, was rich and extensive—has disappeared. The writing that has survived is mainly in the form of religious texts and epitaphs on graves. Only a few Etruscan words, mostly names and inscriptions, have been deciphered.

Our major source of information about the Etruscans and their art comes from buried tombs and *necropoleis* (cities of the dead), which the Romans left undisturbed. Most of these were carved out of rocky ground, especially in the south. Very few Etruscan buildings have survived, partly because of the nature of the materials used— wood, mud, and **tufa** (a soft, porous volcanic rock that is easy to work). There are some remains of fortifications and urban organization, with streets arranged in a grid pattern.

Etruscan and Roman Italy. The purple area indicates the mainland region of Etruscan art and civilization.

Architecture

Greece was the inspiration for large-scale architecture in Etruria. The idea of erecting temples within open-air sanctuaries and sacred precincts came from Greece, and remains of temple foundations indicate that the plans were based on Greek prototypes. Late Archaic Etruscan temples, however, are distinct from the Greek in having gabled porches but not pediments. Etruscan architects used **wattle-and-daub** construction for the superstructure by reinforcing branches (wattle) with clay and mud (daub). Stone was used only for the podium. Roofs were tiled, and decorative sculpture was made of terracotta. Greek Archaic architecture, as well as the aristocratic social order, was favored in Etruria and lasted into the fifth century, long after Greece had evolved its Classical style and society.

The temple of Apollo at Veii (fig. **8.1**) has been reconstructed according to Etruscan temple proportions described by Vitruvius (30 B.C.–A.D. 14), a Roman architect and engineer of the Augustan period. In addition to the plan, the Etruscans incorporated the Greek wooden roof and *pronaos*. In contrast to those in Greek temples, however, these are set on a high podium rather than on steps, and the side walls are solid. This arrangement emphasizes the entrance wall as being at the front of the temple, whereas the Greeks' use of colonnaded walls minimizes the distinction between front and sides. It also gives Etruscan temples a heavier, more massive quality than their Greek counterparts.

Pottery and Sculpture

The Etruscans adopted—and adapted—certain Greek social customs, such as the *symposium* (drinking party), and the practice of banqueting in a reclining position. For these functions they imported thousands of Greek vases, which became a source of Greek pictorial style in Italy. Scenes and characters from Greek mythology liberally populate Etruscan imagery.

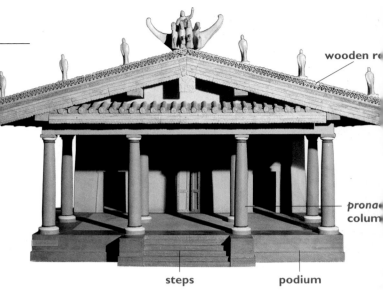

8.1 Reconstruction of the temple of Apollo at Veii, c. 515–490 B.C.

The few surviving examples of Etruscan sculpture indicate a thriving industry in bronze. As was true of architecture, Greece inspired large-scale sculpture in Etruria. Like the Greeks, Etruscan artists cast bronze by the lost-wax method. The statue of a she-wolf of around 500 B.C., the so-called *Capitoline Wolf*, captures the aggressive anger of a mother protecting her cubs (fig. **8.2**). She turns and becomes tense, as if suddenly startled, and bares her teeth at an unseen intruder. The stylized patterns of fur, especially around the neck, have affinities with Greek Archaic style.

The bronze *Wounded Chimera* from the fourth century B.C. also contains Archaic stylization patterns. It depicts the mythological monster with a lion's body, a serpent's tail, and a goat's head—here emerging from the back (fig. **8.3**). Its pose convincingly indicates a readiness to spring toward an adversary. The hair along the spine literally stands on end; fear is suggested through the open mouth, turned head, and raised eyebrows.

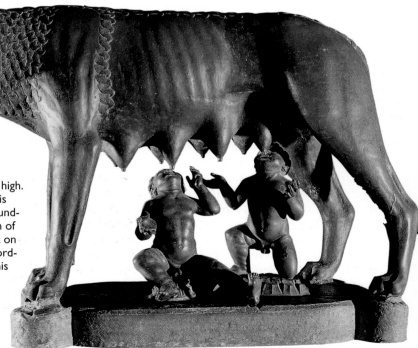

8.2 *Capitoline Wolf*, c. 500 B.C. Bronze, 2 ft. 9½ in. (85.1 cm) high. Museo Capitolino, Rome, Italy. The popular association of this statue with the tale of Romulus and Remus, the legendary founders of Rome (see p. 127), prompted the Renaissance addition of the human twins seen here. In ancient Rome, a live wolf kept on the Capitoline Hill reminded citizens of the legend. And, according to the orator and statesman Cicero, a statue similar to this one was also displayed in antiquity, but it was destroyed by lightning. The image of a wolf nursing Romulus and Remus remains the symbol of Rome. In the context of Etruscan art, the wolf was probably intended as a protective guardian.

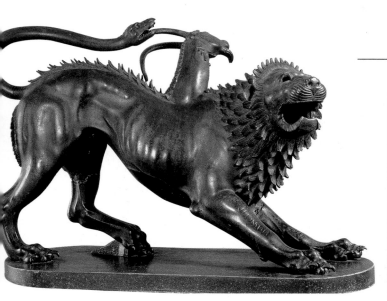

8.3 *Wounded Chimera*, from Arezzo, second quarter of the 4th century B.C. Bronze, approx. 31½ in. (80.0 cm) high. Museo Archeologico, Florence, Italy. In addition to Archaic Greek influence, note the similarity of the whiskers to the Achaemenid gold lion drinking cup in figure **4.28**.

--- **CONNECTIONS** ---

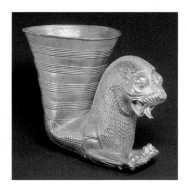

See figure 4.28. Achaemenid drinking vessel, 5th century B.C.

8.4 *Apollo of Veii*, from Veii, c. 515–490 B.C. Painted terra-cotta, approx. 5 ft. 10 in. (1.78 m) high. Museo Nazionale di Villa Giulia, Rome, Italy. Terra-cotta was a favorite Etruscan material for sculpture. It was modeled while still wet, and the smaller details were added with hand tools. In this statue, Apollo's energetic forward stride reflects the Etruscans' interest in gesture, motion, and posture.

To a considerable extent, the development of Etruscan art paralleled that of Greek art, and the same terms are used to designate stylistic categories—Archaic, Classical, and Hellenistic—even though the Etruscan dates are only roughly contemporaneous with their Greek counterparts. The Archaic style, for example, continued in Etruria for a short time after it had been abandoned in Greece. This can be seen in the life-size terra-cotta *Apollo of Veii* (fig. **8.4**), which originally decorated the roof of the temple (see fig. **8.1**). It corresponds to the Greek Late Archaic in style but slightly overlaps Greek Early Classical in time.

The *Apollo* has some organic form around the chest, but the curvilinear stylizations and flat surface patterns of the drapery folds are more characteristic of Archaic. The same is true of the diagonal calf muscles fanning out from below the knees, with the lines on top of the feet suggesting that the toes continue to the ankles. The stylized hair, arranged in long locks, and the smile also belong to Greek Archaic convention. Despite Greek influence, however, the sharp clarity of the *Apollo's* forms and stylizations, as well as its determined stride, is characteristic of the forcefulness of early Etruscan art.

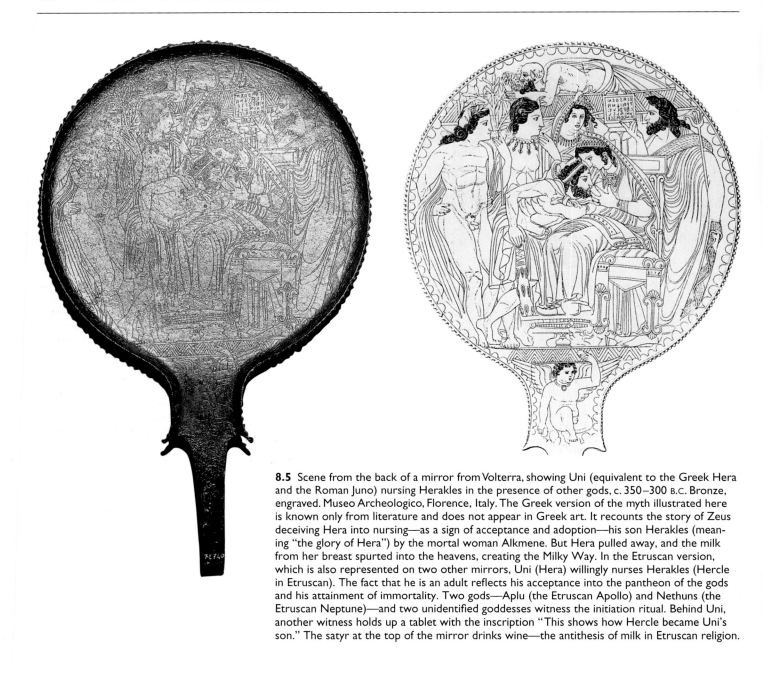

8.5 Scene from the back of a mirror from Volterra, showing Uni (equivalent to the Greek Hera and the Roman Juno) nursing Herakles in the presence of other gods, c. 350–300 B.C. Bronze, engraved. Museo Archeologico, Florence, Italy. The Greek version of the myth illustrated here is known only from literature and does not appear in Greek art. It recounts the story of Zeus deceiving Hera into nursing—as a sign of acceptance and adoption—his son Herakles (meaning "the glory of Hera") by the mortal woman Alkmene. But Hera pulled away, and the milk from her breast spurted into the heavens, creating the Milky Way. In the Etruscan version, which is also represented on two other mirrors, Uni (Hera) willingly nurses Herakles (Hercle in Etruscan). The fact that he is an adult reflects his acceptance into the pantheon of the gods and his attainment of immortality. Two gods—Aplu (the Etruscan Apollo) and Nethuns (the Etruscan Neptune)—and two unidentified goddesses witness the initiation ritual. Behind Uni, another witness holds up a tablet with the inscription "This shows how Hercle became Uni's son." The satyr at the top of the mirror drinks wine—the antithesis of milk in Etruscan religion.

Women in Etruscan Art

The Etruscans differed significantly from the Greeks in their attitude toward women. Judging from Etruscan art, Etruscan women participated more in public life with their husbands and held higher positions than women in ancient Greece—a state of affairs of which the male-centered Greeks heartily disapproved. Wives participated with their husbands in banquets, which took the place of the male-only Greek *symposia*. Wealthy Etruscan women were unusually fashion-conscious and wore elaborate jewelry commensurate with their rank.

The bronze mirrors that have been excavated from Etruria were used only by women (fig. **8.5**). They were typically decorated with mythological scenes, and their inscriptions indicate that the women to whom they belonged were literate. The greater emphasis on women in Etruscan society is consistent with the prominence in the arts of figures of the mother goddess and other female deities well beyond the Bronze Age. Etruscan artists frequently depicted myths in which women dominate men by being older, more powerful, or higher in divine status. The scene illustrated here shows the adult Herakles being breast-fed by the goddess Uni (the Etruscan Hera) in the presence of male and female divinities.

Funerary Art

The Etruscans clearly believed in an afterlife that was closer to the Egyptian concept than to the Greek, but it is not known what their specific view of the afterlife was. It seems to have been as materialistic as in ancient Egypt since items used in real life—such as mirrors, jewelry, weapons, and banquet ware—accompanied the deceased.

Cinerary Containers

In the seventh century B.C. and earlier, many Etruscans cremated their dead. They buried the ashes in individual tombs or cinerary urns, which often had a lid in the form of a human head. The vessels themselves sometimes had body markings to indicate whether the remains were those of a male or female. In figure **8.6** both the urn and the wide-backed chair on which it stands are made of bronze, but the head is terra-cotta. In spite of what seem like individualized features, the intention was to convey only a generalized likeness of the deceased.

Much later in date is an unusual limestone cinerary statue of a monumental female with a swaddled child lying across her lap (fig. **8.7**). The downcast expression characteristic of Greek Early Classical style is appropriate for this Etruscan funerary figure. On either side of the chair or throne is a sphinx, which testifies to the importance of the figure—probably a goddess, perhaps a protector of mothers who died in childbirth.

8.6 Cinerary urn, from Chiusi, 7th century B.C. Hammered bronze and terra-cotta, approx. 33 in. (83.8 cm) high. Museo Etrusco, Chiusi, Italy. The metaphorical nature of this object, in which the body, base, and handles of the urn are equated with the corresponding human anatomy, implies a religious significance. The container of the ashes was probably intended to symbolize a reversal of the process of cremation, as if to keep the dead person alive through his or her image.

8.7 *Mater Matuta*, from Chianciano, near Chiusi, 460–440 B.C. Limestone, life-size. Museo Archeologico, Florence, Italy. This figure corresponds chronologically to the beginning of the Greek Classical style. Although the woman is sculptured organically and the drapery outlines her body, she nonetheless retains the stylized hair of the Early Classical style.

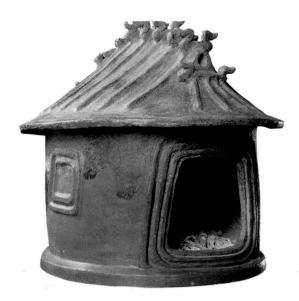

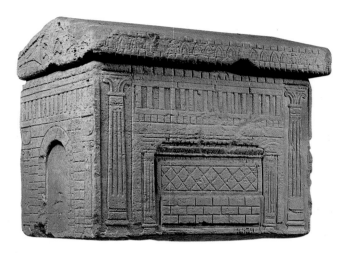

8.8 Urn in the shape of a hut, from Tarquinia, 9th–8th century B.C. Museo Archeologico, Tarquinia, Italy.

8.9 Cinerary urn in the form of a house, from Chiusi, c. 400 B.C. Museo Archeologico, Florence, Italy.

Many cinerary urns took the form of houses and thus provide a glimpse of Etruscan domestic architecture. An Iron Age urn from the Villanovan civilization, for example, is in the form of a circular hut, the first-known house type in central Italy (fig. **8.8**). It consists of a single room enclosed by a circular wall and has a thatched roof supported by interior vertical posts. A later example (fig. **8.9**) of a house-shaped cinerary urn probably represented an upper-class house or palace, for it has an elegant, symmetrical façade with an arched doorway, and a second-story gallery. At the corners of the urn, **pilasters** (square columns) reinforce the structure. The lid of the urn corresponds to the roof, with a curved gable over the entrance and a palmette relief in the center.

Architectural urns provide clues to the development of Etruscan building styles. The human-headed urns reflect both a wish to preserve the likeness of the deceased and the importance of ancestors who were considered divine in the afterlife. Urns-as-houses explicitly express the metaphor in which a tomb or burial place is a "house for the dead."

Sarcophagi

Etruscan artists developed a new funerary iconography, which they translated into monumental sculpture in the sarcophagi of wealthy individuals. For example, a painted terra-cotta sarcophagus of around 520 B.C. from Cerveteri is in the form of a dining couch (fig. **8.10**). Like the urns, it was made to contain cremated remains rather than the bodies of the deceased. The figures represent a married couple—the family unit was an important element in Etruscan art and society. The wife and husband are given similar status, reflecting the position of women in ancient Etruria. They are rendered with Archaic features—long stylized

hair, a smile with corresponding raised cheekbones and upwardly slanting eyes. The elegance of their curves and the soft areas of their bodies, their finely pleated drapery, and their almond-shaped eyes indicate influences from Greek Ionia. In contrast to Greek sculpture, however, these figures have no sense of skeletal structure and "stop" abruptly at the waist, indicating the Etruscans' preference for stylistic effects over anatomical accuracy. The sharp bend at the waists and the animated gestures create an illusion of lively, sociable dinner companions, reclining in the banqueting style adopted from Greece. The couple seem very much alive, as if to deny the fact of their death. They were made to be seen from the front in the flickering light of the tomb.

Tomb Paintings

Etruscans used pictures as well as architecture and sculpture in the service of the dead. Hundreds of paintings have been discovered in the underground tombs of Tarquinia, a site northwest of Rome. Tomb paintings were usually frescoes. Similar paintings probably adorned public and private buildings, although there are few surviving examples. Until the fourth century B.C., the subjects represented most frequently in Etruscan tomb paintings were funeral rites or optimistic scenes of aristocratic pleasures—banquets, sports, dances, and music-making. Yet hints of death do appear, even in the sixth century B.C., as in a painting from the Tomb of the Augurs, in Tarquinia, representing two mourners (fig. **8.11**). The figures stand on a horizontal ground line flanking the closed door leading to the underworld, and there is little indication of depth. Plant stems rise directly from the ground line and are the same brownish color. Aside from the blue leaves, the colors of the costumes

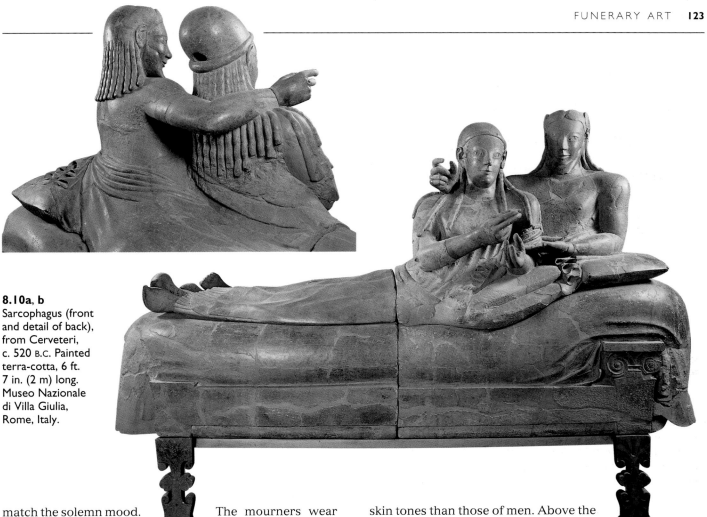

8.10a, b
Sarcophagus (front and detail of back), from Cerveteri, c. 520 B.C. Painted terra-cotta, 6 ft. 7 in. (2 m) long. Museo Nazionale di Villa Giulia, Rome, Italy.

match the solemn mood. a simple, light yellow falls to about midcalf, outer garment is black, as The mourners wear inner garment that but their shorter are their boots. Their gestures are the traditional stylized gestures of mourning and have a ritualistic quality. They direct our attention to the closed door that leads to the next life.

A fresco in the Tomb of the Leopards shows men and women reclining on banqueting couches; the standing figures are servants (fig. **8.12**). The banqueters gesture in the same animated way as the couple on the Cerveteri sarcophagus (see fig. **8.10**), but their heads are in profile. Colors are mainly terra-cotta tones of brown on an ocher background, with drapery patterns, wreaths, plants, and other details in blues, greens, and yellows.

As in Egyptian, Minoan, and Greek painting, Etruscan women are rendered with lighter skin tones than those of men. Above the banqueting scene, two leopards flank a stylized plant and symbolically protect the tomb from evil influences. The wall to the right depicts musicians and a man holding a wine cup. Compared with paintings in Greece, Etruscan paintings disregard anatomical accuracy and naturalistic movement in space, and the overall impression is of spontaneity.

8.11 *Mourners at the Door of the Other World*, Tomb of the Augurs, Tarquinia, c. 540 B.C. Note that the boots worn by the mourners resemble those of the war god in the Hittite relief from Boghazköy (see fig. **4.18**). Pointed boots are typically worn by mountain people and are another example of influence from the Greek Ionian cities and Asia Minor. The scene at the right shows two wrestlers and the gold and bronze bowls for which they are competing.

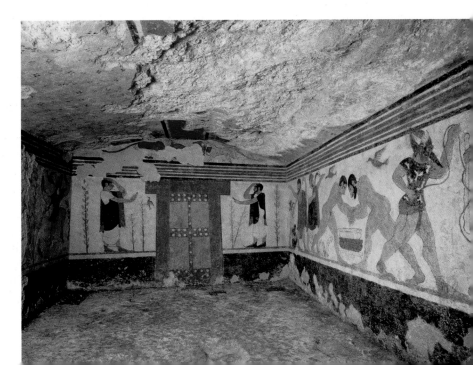

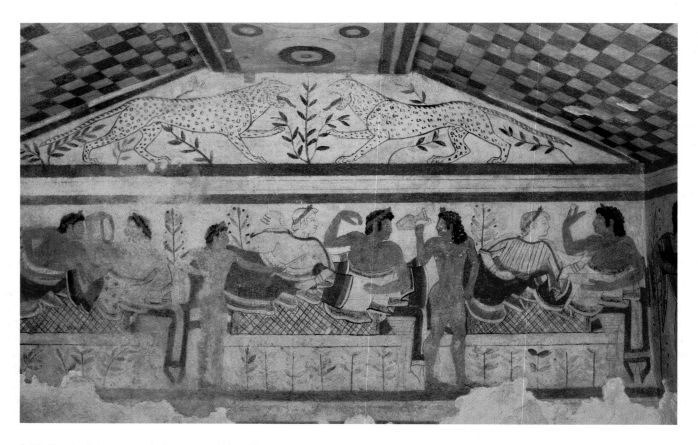

8.12 Tomb of the Leopards, Tarquinia, 480–470 B.C. Fresco. Here the conventions of Egyptian and Aegean painting are quite evident. Women are lighter skinned than men, profile heads contain a frontal eye, and figures are outlined in black and dark brown.

The Etruscans remained a culturally distinct group, retaining their own language, religion, and customs for nearly a millennium. Occupying a large section of Italy for much of the period of the Roman Republic, the Etruscans were independent of the Romans in language and religious beliefs. Yet they taught the Romans a great deal about engineering, building, drainage, irrigation, and the art of augury—how to read the will of the gods and foretell the future from the entrails of animals and the flight of birds. In matters of fashion and jewelry, the Etruscans were the envy of Greek and Roman women alike. Their technical skill and craftsmanship were remarkable; they excelled in many areas, including divination, bronze casting, jewelry decorated with gold granulation, and dentistry. Etruscans also made bridges and dentures that enhanced health as well as being cosmetically pleasing.

Etruscan kings ruled Rome until the establishment of the Republic in 509 B.C. By the early third century B.C., Etruria had become part of Rome's political organization, and two centuries later it succumbed to full Romanization.

1000 B.C. 500 B.C. 100 B.C.

THE ART OF THE ETRUSCANS

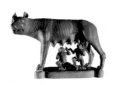

(8.2)

Legendary founding
of Rome
(753 B.C.)

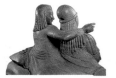

(8.10b)

Last Etruscan
king, Tarquin
the Proud, expelled
(509 B.C.)

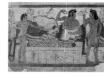

(8.12)

Rome becomes
a republic
(509 B.C.)

(8.9)

Death of
Alexander
the Great
(323 B.C.)

Etruscans
become subject
to Rome
(295 B.C.)

First Punic War
between
Rome and Carthage
(264–241 B.C.)

9

Ancient Rome

The political supremacy of Athens lasted only about fifty years; Rome's endured for nearly five hundred. Greece had been unified culturally, but the city of Rome, as well as the Roman Empire, was a melting pot. Greece had a deep cultural identity but never achieved long-term political unity. The political genius of Rome lay in its ability to encompass, govern, and assimilate cultures very different from its own. As time went on, Roman law made it increasingly easy for people from distant regions to attain citizenship, even if they had never been to Rome. Nevertheless, there was no doubt that the city itself was the center of a great empire. Rome's designation as *caput mundi* ("head" or "capital of the world") signified its position as the hub of world power.

After the death of Alexander the Great in 323 B.C., Rome began its rise to power in the Mediterranean. By the first century A.D., the Roman Empire extended from Armenia and Mesopotamia in the east to the Iberian Peninsula (modern Spain and Portugal) in the west, from Egypt in the south to the British Isles in the north (see map). Everywhere the Roman legions went, they took their culture with them, particularly their laws, their religion, and the Latin language. Greece and the Hellenized world kept Greek, rather than Latin, as the official language.

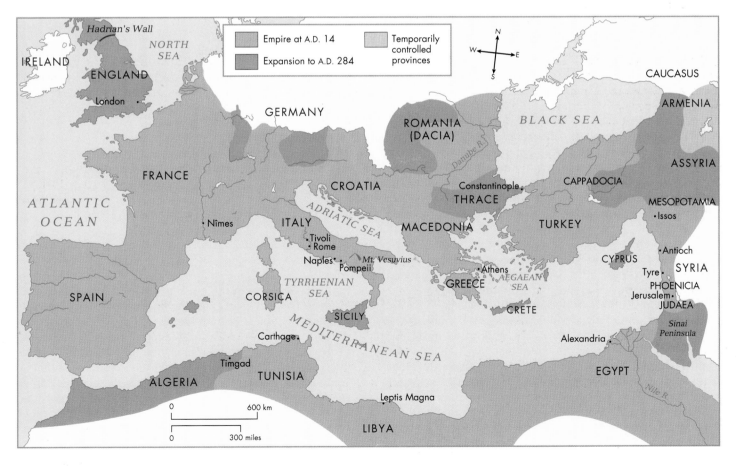

The Roman Empire, A.D. 14–284.

During the reign of Rome's first emperor, Augustus, Virgil wrote the *Aeneid*, a Latin epic to celebrate Aeneas as the legendary founder of Rome. Composed in twelve books, it opens with the fall of Troy. Aeneas, son of the goddess Venus, is a Trojan hero who carries his aged father, Anchises, and the household gods (**Lares** and **Penates**) as he leads his young son Ascanius from the burning city of Troy. Like Odysseus (see fig. **7.2**) and Gilgamesh (see p. 38) before him, Aeneas travels far and wide, even visiting the underworld. Virgil's frequent references to "pius Aeneas" evoke his hero's sense of duty and destiny. They also imply a comparison with Augustus and create an image of him as a predestined second founder of Rome—that is, as the ruler of a great empire under divine guidance. The connotations of this epic for the readers of first-century Augustan Rome were that the founding of their city and Roman domination of the world had been willed by the gods.

In the *Aeneid*, Virgil defines the Romans' view of their relationship to Greece and to Greek art by emphasizing that Rome's destiny was political rather than artistic:

> Others will cast more tenderly in bronze
> Their breathing figures, I can well believe,
> And bring more lifelike portraits out of marble;
> Argue more eloquently, use the pointer
> To trace the paths of heaven accurately
> And accurately foretell the rising stars.
> Roman, remember by your strength to rule
> Earth's peoples—for your arts are to be these:
> To pacify, to impose the rule of law,
> To spare the conquered, battle down the proud.[1]

Chronology: Roman Periods

Early Kings
Rule by kings and a senate

Late Kings
Etruscan rulers. Ends 509 B.C.

Republic (509–27 B.C.)
Rule by Senate and patrician citizens
Punic Wars (264–146 B.C.)

Transition to Empire
Julius Caesar (46–44 B.C.)
Octavian/Augustus (27 B.C.–A.D. 14)

Early Empire
Julio-Claudian Dynasty (14–68)
 Tiberius (14–37)
 Caligula (37–41)
 Claudius (41–54)
 Nero (54–68)
Flavian Dynasty (69–96)
 Vespasian (69–79)
 Titus (79–81)
 Domitian (81–96)
So-called Good Emperors (96–180)
 Nerva (96–98)
 Trajan (98–117)
 Hadrian (117–138)
 Antoninus Pius (138–161)
 Marcus Aurelius (161–180)

Beginning of Decline
Commodus (180–192)
Political unrest and economic decline

Severan Dynasty (193–235)
Septimius Severus (193–211)
Caracalla (211–217)
Alexander Severus (222–235)

Anarchy (235–284)

Period of Tetrarchs (284–306)
Diocletian (284–305) institutes four co-rulers in an unsuccessful effort to restore stability to the empire.

Late Empire
Constantine I (306–337)

There were important differences between the Greek and Roman approaches to history, which, in some sense, parallel the differences in their views of art. Greek art was a model throughout the Mediterranean and provided a Classical ideal. In Rome, art had its local styles, but the Romans continued to be influenced by Greek sculpture, painting, and architecture. They identified their own gods with Greek gods and adopted Greek iconography. Roman artists copied Greek art, and Roman collectors imported Greek works by the thousands. Although Greek monumental paintings have survived only in fragments, they, too, influenced Roman painters, especially in the Hellenistic period.

Greek art tended toward idealization, but Roman art was typically commemorative, narrative, and based on history rather than myth. As in the Hellenistic style, Roman portraitists sought to preserve the features of their subjects. They went even further in the pursuit of specific likenesses, making wax death masks and copying them in marble.

The purpose of Roman portraiture was genealogical, connecting present with past, just as Aeneas connected the origin of Rome with the fall of Troy and, through his mother, Venus, with the gods (see Box, p. 86). The Roman interest in preserving family lineage also extended to names. The typical Roman family was grouped into a clan, called a *gens,* by which individuals traced their descent. Portraits, whether sculptures or paintings, thus had a two-fold function: they both preserved the person's image and contributed to the history of the family. Similarly, Roman reliefs usually depicted historical events, commemorating the actions of a particular individual. Most commemorative reliefs adorned architectural works, and it was in architecture that the Romans were most innovative.

According to Roman legend, Rome was founded on April 21, 753 B.C., by Romulus and Remus, twin foundlings who had been nursed by a she-wolf on the banks of the Tiber River. According to Greek myth, on the other hand, Rome was founded by the Trojan hero Aeneas, fleeing the destruction of Troy, soon after 1200 B.C. These two stories, Greek and Roman, were eventually made to agree, and according to official history Aeneas was the ancestor of the twins. The Trojan War was a myth accepted as part of Greek "prehistory" throughout the Mediterranean, and it was taken up by Virgil. In many areas, including their art, the Romans inherited a dual tradition: their own native, Italic culture and the more sophisticated Greek Classical tradition.

Romulus later killed Remus, built Rome on the Palatine Hill, and became its first king. He ruled until the late eighth century B.C. and was followed by six kings, some of whom were Etruscan. With the Etruscan kings, legend approaches history. In 509 B.C. the last king was overthrown and the Republic was established. For the next five centuries Rome was ruled by two consuls, a senate, and an assembly. The consuls were elected every year and shared the military and judicial authority of the former kings. The senate was composed of former magistrates; the assembly consisted of citizens.

The Republic lasted until 27 B.C., when Octavian, who later took the title "Augustus," became the first emperor. The term *Augustus* was originally a religious title meaning "revered," but it came to mean "he who is supreme." For the next three hundred years, Rome was ruled by a succession of emperors. In A.D. 330 Constantine established an Eastern capital of the Roman Empire in Byzantium, which he renamed Constantinople (now Istanbul, in modern Turkey). After this period the Western Empire, which had kept Rome as its capital, declined and was finally overrun by the Goths in 476.

ARCHITECTURE
Arches, Domes, and Vaults

Just as the Romans recognized the potential of concrete, which had been invented in the ancient Near East, so too they developed the arch and the **vault** (fig. **9.1**), which had previously been used in the ancient Near East and Etruria.

The round arch may be thought of as a curved lintel used to span an opening. A true arch is constructed of tapered (wedge-shaped) bricks or stones, called **voussoirs**, with a **keystone** at the center. The point at which the arch begins to curve from its vertical support is called the **springing**, because it seems to spring away from it. The arch creates an outward pressure, or thrust, which must be countered by a supporting **buttress** of masonry.

The arch is the basis of the vault—an arched roof made by a continuous series of arches forming a passageway. A row of round arches produces a **barrel** or **tunnel vault,** so called because it looks like the inside of half a barrel or the curved roof of a tunnel. It requires continuous buttressing and is a difficult structure in which to make openings for windows. Vaults formed by a right-angled intersection of two identical barrel vaults are called **groin** or **cross vaults.**

Arches and vaults have to be supported during the process of construction. This is usually done by building over wooden frames known as **centerings,** which are removed when the keystone is in place and the mortar has set.

A **dome** is made by rotating a round arch through 180 degrees on its **axis.** In its most basic form, it is a hemisphere. As is true of arches and vaults, domes must be buttressed, and, since their thrust is equally dispersed in all directions, the buttressing must be from all sides. Domes can be erected on circular or square bases. Ancient Roman domes, such as the one on the Pantheon (see fig. **9.16**), were generally set on round bases. Domes on square bases are discussed in Chapter 10.

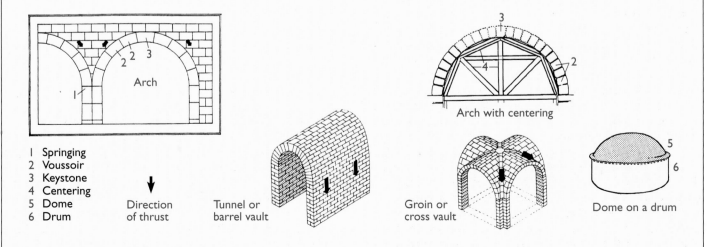

1 Springing
2 Voussoir
3 Keystone
4 Centering
5 Dome
6 Drum

Direction of thrust

Arch

Arch with centering

Tunnel or barrel vault

Groin or cross vault

Dome on a drum

9.1 Arch, arch with centering, tunnel or barrel vault, groin or cross vault, and a dome on a drum.

Architectural Types

The Romans carried out extensive building programs, partly to accommodate their expanding territory and its growing population, and partly to glorify the state and the emperor. In so doing, the Romans assimilated and developed building and engineering techniques from the Near East, Greece, and Etruria. They also recognized the potential of certain building materials, particularly concrete, which allowed them to construct the monumental public buildings that are an important part of the Roman legacy.

Domestic Architecture

The Roman interest in material comfort led to the development of sophisticated domestic architecture. Many examples have been preserved as a result of the eruption of Mount Vesuvius in A.D. 79. Volcanic ash covered Pompeii (near modern Naples), the seaside resort of Herculaneum, and several other towns.

Both Pompeii and Herculaneum were forgotten until 1592, when a Roman architect digging a canal discovered some ancient ruins. Serious archaeological excavations of the buried cities did not begin until the eighteenth century, and they are still continuing today.

Roman domestic (from the Latin word *domus,* meaning "house") architecture was derived from Etruscan and Greek antecedents but developed characteristics of its own. The main feature of the Roman *domus* was the atrium (figs. **9.2** and **9.3**), a large hall entered through a corridor from

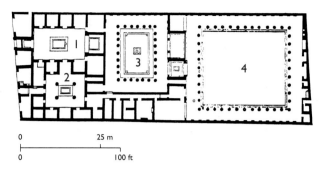

9.2 Plan of the House of the Faun, Pompeii, 2nd century B.C. 1: Atrium; 2: *Atrium tetrastylum;* 3 and 4: courtyards surrounded by peristyles.

the street. The atrium roof usually sloped inward, and a rectangular opening, the *compluvium,* allowed rainwater to collect in an *impluvium* (a sunken basin in the floor), from which it was channeled into a separate cistern. The *compluvium* was also the primary source of light in the *domus.* By the end of the first century B.C., however, the peristyle, with its colonnade, had become the **focal point** of the *domus,* and the atrium was little more than a foyer, or entrance hall. Additional rooms surrounding the peristyle included *cubicula* (bedrooms), slave quarters, wine cellars, and storage space.

These houses had plain exteriors without windows. Rooms fronting on the street functioned as shops, or *tabernae* (from which we get the English word *tavern*). Behind the unassuming façades were interiors that were often quite luxurious—decorated with floor and wall mosaics, paintings, and sculptures. The typical professional or upper-class Roman house also had running water and sewage pipes.

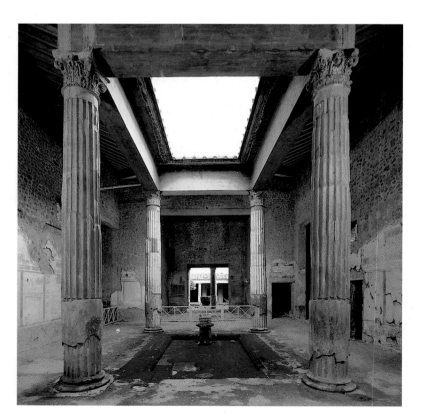

9.3 Atrium and peristyle, House of the Silver Wedding, Pompeii, early 1st century A.D. Standing with our backs to the entrance, we can see the *compluvium* in the roof, which is supported by four Corinthian columns. The *impluvium* is in the center of the floor. Visible on the other side of the atrium is the *tablinium,* probably used for entertaining and for storing family documents and images of ancestors.

For the middle and lower classes, especially in cities, the Romans built concrete apartment blocks or tenements, called **insulae** (the Latin word for "islands")—as in figure **9.4.** According to Roman building codes, the *insulae* could be as high as five stories. On the ground floor, shops and other commercial premises opened onto the street. The upper floors were occupied by families, who lived separately but shared certain facilities such as the kitchen. As early as the first century A.D., most of Rome's urban population lived in such *insulae.* Their blocklike construction conformed to the typical town plan of the empire. Such plans were organized like a military camp **(castrum),** in which a square was divided into quarters by two streets intersecting in the middle at right angles. The **cardo** ran from north to south and the **decumanus** from east to west. Each quarter was then subdivided into square or rectangular blocks of buildings, such as domestic houses and *insulae.*

In addition to urban domestic architecture, the Romans invented the country **villa** as an escape from the city. Villas varied according to the tastes and means of their owners, and naturally the most elaborate belonged to the emperors. Hadrian's Villa, built from A.D. 118 to 138 near Tivoli, 15 miles (24 km) outside modern Rome, consisted of so many buildings—including libraries containing works in Greek and Latin, baths, courtyards, temples, plazas, and a theater—that it occupied more than half a square mile (1.3 km²).

9.4 *Insula*, reconstruction, Ostia, 2nd century A.D. Brick and concrete.

When Hadrian traveled, he collected ideas for his villa, and later he had monuments reproduced on its grounds. When visiting Alexandria, Hadrian admired the **Sera-paeum,** a temple dedicated to Serapis—the Egyptian god who combined features of Osiris, Zeus, and Hades and was worshiped as ruler of the universe. Hadrian constructed his own canal and temple, and named them after the Egyptian town of Canopus and the original Serapaeum. He used Ionic columns in the Serapaeum and Corinthian columns at the far end of the Canopus (fig. **9.5**) to support a structure of round arches alternating with lintels.

9.5 Canopus, Hadrian's Villa, Tivoli, c. A.D. 123–135.

Public Buildings

As life in Rome and its provinces became increasingly complex, the need for public spaces and public buildings grew. This led to the development of two characteristic architectural types, the **forum** and the **basilica.**

The Forum The forum was typically a square or rectangular open space bounded on three sides by colonnades and on the fourth by a basilica (see below). Originally the forum was a marketplace like the Greek *agora.* In contrast to the random development of the *agora,* however, the Roman forum was given a focus by a temple placed at one end. In Rome, the first known forum, the *Forum Romanum,* dates from the sixth century B.C., and it was this particular urban space that was conceived of as *caput mundi.* In the first century B.C., the *Forum Julium* became the prototype for all later imperial forums. Planned by Julius Caesar (see Box) and completed by Augustus, it must have presented a magnificent architectural spectacle, but is now in ruins. The plan in figure **9.6** indicates the complex variety of forms and the degree to which the Romans added to the basic rectangular conception of the forum.

As a commercial center, the forum was a regular feature of most Roman towns. Gradually, however, its shops were transferred elsewhere, and the forum remained a focal point for civic and social activity. It was a more or less enclosed space, usually restricted to pedestrian traffic. Important temples and meeting places for the town council *(curia)* and the popular assembly *(comitium)* were integrated into the forum.

1 Trajan's Column
2 Libraries
3 Basilica Ulpia
4 Forum of Trajan
5 Trajan's Markets
6 Forum of Augustus
7 Forum of Julius Caesar
8 Curia Julia
9 Temple of Vespasian
10 Temple of Concord
11 Temple of Saturn
12 Basilica Julia
13 Roman Forum
14 Temple of Castor
15 Temple of Divus
 Julius
16 Basilica Aemilia
17 Forum of Nerva
18 Temple of Peace

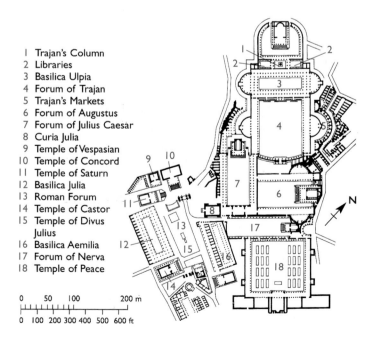

9.6 Plan of the Roman and imperial forums, Rome. When Roman civic leaders wished to address the populace, they entered the forum. Today, *forum* means an opportunity for addressing groups of people; candidates for political office are said to have a forum for their views if they can arrange a time and place for the voters to hear them speak.

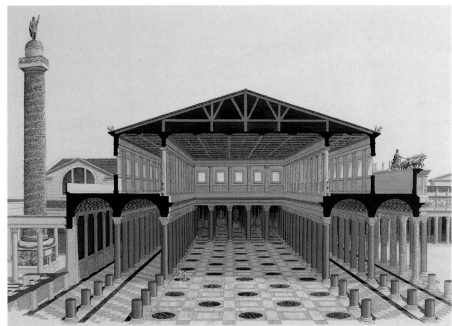

9.7 Reconstructed cross section of the Basilica Ulpia, Forum of Trajan, A.D. 98–117.

The Basilica A basilica (from the Greek word *basilikos,* meaning "royal") was a huge roofed building, usually at one end of a forum. It was used for commercial transactions and also served as a municipal hall and law court. Basilicas were typically divided into three **aisles:** a large central aisle was flanked by smaller ones on either side, separated from one another by one or two rows of columns. The extra height of the center aisle, or **nave** (from the Latin word *navis,* meaning "ship," and derived from the idea of an inverted boat), permitted the construction of a second-story wall above the colonnades separating the nave from the aisles. Clerestory windows were built into the additional wall space to admit light into the building.

Trajan's Forum adjoins the Basilica Ulpia (the name "Ulpia" comes from the *gens* to which Trajan belonged), which is rectangular in plan with an **apse** (curved section) at each end (figs. **9.7** and **9.8**). The apses contained statues of gods or emperors, provided space for legal proceedings, and often included a throne occupied by a statue of the emperor. Colonnades on either side of the nave provided an articulated space for socializing, people awaiting trial, and for those transacting business. Roofing was made of timber and covered with tiles, and the interior was adorned with marble and bronze.

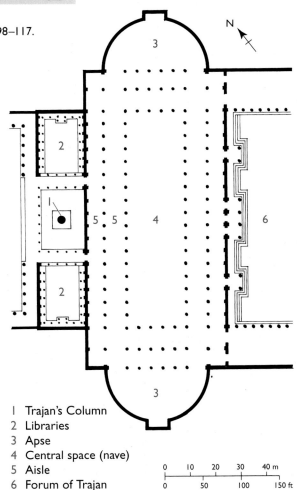

1 Trajan's Column
2 Libraries
3 Apse
4 Central space (nave)
5 Aisle
6 Forum of Trajan

9.8 Plan of the Basilica Ulpia.

The Markets of Trajan Trajan's markets, at the south-east end of his basilica (see number 5 in fig. **9.6**), were distinctive for their innovative engineering and architecture (fig. **9.9**). Their concrete core was faced with brick, with a few details in wood and stone. They were conceived as part of a total urban renovation that included Trajan's Forum (which was faced with marble). The original area is unknown, but the markets probably contained more than 200 rooms (evidence of 127 survives today) rising from the forum along the incline of the Quirinal Hill.

The view from the west in figure **9.9** gives some idea of the imposing quality and architectural variety of Trajan's markets. They form a series of tiered, apsidal spaces with barrel-vaulted ceilings. Groin vaults were used for the main hall. In the upper levels, clerestory windows, as in the basilica, provided a source of interior lighting. The rooms housed offices and more than 150 shops linked by a complex system of stairways and arcades. Shifting axes, flowing masses and spaces, and patterns of light and shadow created a dynamic interplay of solid forms with voids. As a totality, the markets served a social and commercial function and were also aesthetically pleasing.

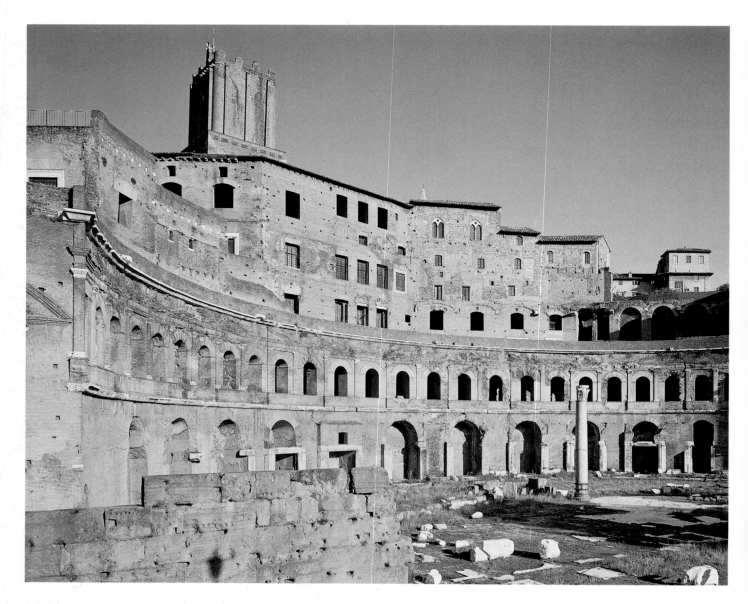

9.9 Remains of Trajan's markets, seen from the west.

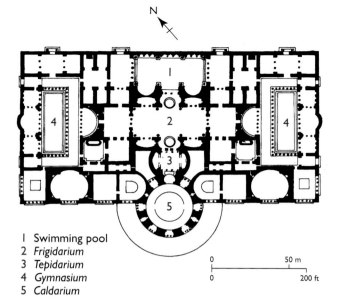

N

9.10 Plan of the Baths of Caracalla, Rome, A.D. 211–217. The total complex occupied approximately 35 acres (130,000 m²).

1 Swimming pool
2 *Frigidarium*
3 *Tepidarium*
4 *Gymnasium*
5 *Caldarium*

0 50 m
0 200 ft

Public Baths The Roman public bath was a cultural center, a place for socializing, bathing, and swimming. It also provided facilities for playing ball, running, and wrestling. Amenities included a cold room *(frigidarium),* a warm room *(tepidarium),* a hot room *(caldarium),* steam rooms, changing rooms, libraries, gardens, and a museum.

Although every Roman city in the empire had baths, Rome had 952 of them by the middle of the fourth century. Particularly magnificent were the baths of the emperor Caracalla, who ruled from A.D. 211 to 217 (figs. **9.10** and **9.11**). The plan was constructed on two axes with the *frigidarium* at their intersection. As in a typical basilica, light entered the baths through the upper clerestory windows and illuminated the myriad surface patterns created by marble, glass, painted decoration, and water.

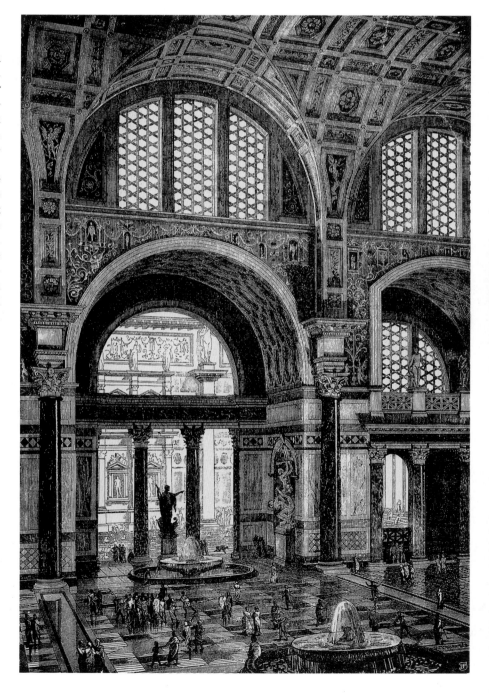

9.11 Restoration drawing of the Baths of Caracalla. Note the enormous Corinthian columns that supported the groin vaults of the ceiling and the large clerestory windows.

The Colosseum The Colosseum (begun in A.D. 72 under Vespasian and inaugurated in A.D. 80 by his son Titus) was primarily for public spectacles (figs. **9.12** and **9.13**). Its Greek antecedent was the outdoor theater (see fig. **7.32**). Similar to a modern sports arena, the Colosseum in Rome is actually a massive **amphitheater** (from the Greek words *amphi*, meaning "around" or "both," and *theatron*, meaning "theater"), a type of building invented by the Romans.

The exterior consists of **arcades** (rows of arches) with three stories of round arches framed by entablatures and **engaged columns.** The ground-floor columns are Tuscan (a later development of Doric); the second-floor columns are Ionic; and those on the third floor are Corinthian. On the fourth floor are small windows and engaged rectangular Corinthian pilasters. This system, in which the columns are arranged in order of visual as well as structural strength, with the "heaviest" Doric type at the bottom, was regularly followed in Roman architecture. The surface of the outer wall also becomes flatter as it rises, which carries the viewer's eye upward, while the repeated round arches of the circular arcades direct the eye around the building. The projecting cornice at the very top serves aesthetically to crown the structure.

The Colosseum was built around a concrete core, with an extensive system of halls and stairways for easy access. Two types of vault were used in the corridor ceilings—the simpler barrel vault and the groin vault (also called a cross vault). The upper wall was fitted with sockets, into

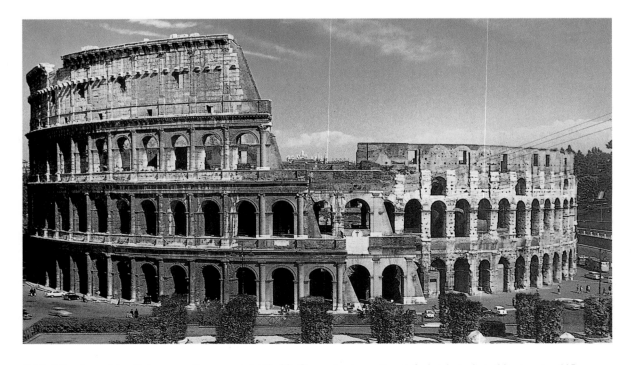

9.12 Side view of the Colosseum, Rome, c. A.D. 72–80. Concrete, travertine, tufa, brick, and marble, approx. 615 × 510 ft. (187.5 × 155.5 m). The term *colosseum* comes from a colossal statue of Nero. Construction of the Colosseum started c. A.D. 72 under the emperor Vespasian, who had come to power in A.D. 69. It was inaugurated in A.D. 80, a year after his death. More than 50,000 spectators proceeded along corridors and stairways through numbered gates to their seats. The concrete foundations were 25 feet (7.6 m) deep. Travertine (much of it dismantled and reused in the Middle Ages) was used for the framework of the piers, and tufa and brick-faced concrete were used for the walls between the piers. Originally there was marble on the interior, but it has completely disappeared.

which poles were inserted as supports for canvas coverings; these were stretched by sailors across the open top of the **arena** to protect spectators from the hot sun and rain. The Colosseum was designed for gladiatorial contests and combats between men and animals, or between animals alone. Because it was located over a pond formerly on Nero's property, it was possible to construct a built-in drainage system for washing away the blood and gore of combat and subterranean passages for animals. The Colosseum remains a monument to the political acumen of imperial Rome, providing violent spectacles as well as creature comforts for its citizens.

MEDIA
Roman Building Materials

Marble had been the favorite building material of the Greeks but was less readily available and, therefore, a luxury, to the Romans. They used it mainly as a decorative facing, or outer layer, over a core of other material. Suetonius, the Roman lawyer and author of the *Lives of the Twelve Caesars* (c. A.D. 121), wrote that Augustus found Rome a city of brick and left it a city of marble. Today, much ancient Roman marble facing has disappeared because of subsequent looting, leaving visible the inner core of the structure.

The Romans also used **travertine**—a hard, durable limestone that mellows to a golden yellow—and the soft, easily carved tufa, which had been popular with the Etruscans (see p. 117). Above all, the Romans built with concrete, a suitable material for large-scale public structures. Their concrete was a rough mixture of mortar, gravel, rubble, and water. It was shaped by wooden frames, and often wedge-shaped stones, bricks, or tiles were inserted into it for reinforcement and decoration before it had hardened. Alternatively, a facing of plaster, **stucco**, marble, or other stone was added.

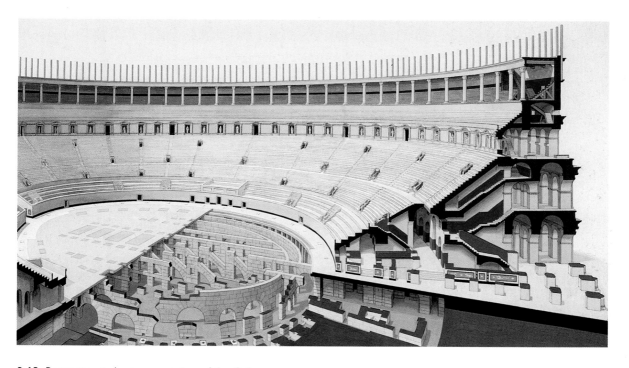

9.13 Reconstructed cutaway section of the Colosseum.

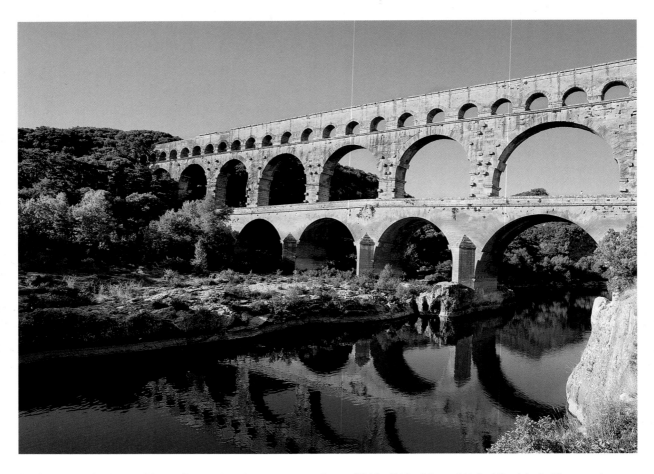

9.14 Pont du Gard, near Nîmes, France, late 1st century B.C. Stone, 854 ft. (260 m) long, 162 ft. (49 m) high. The aqueduct system maintains a constant decline of 1 in 3,000, resulting in a total drop of only 54 feet (16.5 m) over its whole length of 30 miles (48 km).

Aqueducts An example of Roman practicality and engineering ability was the development of the bridge and **aqueduct** (a conductor of water, from the Latin words *ducere,* meaning "to lead," and *aqua,* meaning "water"). The most impressive example of a section of a Roman aqueduct is the Pont du Gard (fig. **9.14**), located in modern Nîmes in the south of France. Between 20 and 16 B.C. Marcus Agrippa (son-in-law and adviser to Augustus) commissioned an aqueduct system to bring water to Nîmes from natural springs some 30 miles (48 km) away. Much of the aqueduct was built below ground or on a low wall; but when it had to cross the gorge of the Gardon River, a stone bridge was necessary.

The Pont du Gard was constructed in three tiers, each with narrow barrel vaults. Those on the first two tiers are the same size, while the third-story vaults, which carried the channel containing the water, are smaller. The voussoirs (see p. 127) that make up the arches weigh as much as 6 tons (6,096 kg) each. They were precisely cut to standard measurements, **dressed** (shaped and smoothed), and then fitted into place without mortar or clamps. The top vaults and the larger ones are in a ratio of 1:4.

The vault system of construction was well suited to a massive engineering project such as the Pont du Gard bridge and aqueduct. With the tunnel vaults arranged in a continuous series side by side, the lateral thrust of each vault is counteracted by its neighbor so that only the end vaults need buttressing. The placement of larger vaults below and smaller ones above serves both a structural purpose —support—and an aesthetic one. The repeated arches and their rhythmic proportions not only carry water, but also formally carry one's gaze across the river.

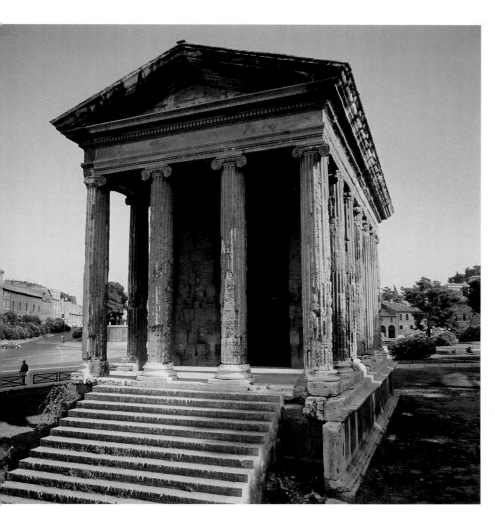

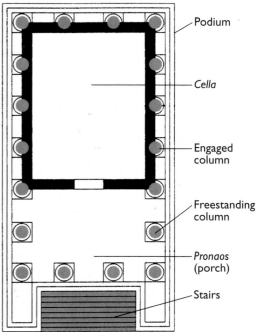

9.15a (Left) Temple of Portunus (formerly known as the Temple of Fortuna Virilis), Rome, late 2nd century B.C. Stone.

Podium

Cella

Engaged column

Freestanding column

Pronaos (porch)

Stairs

9.15b (Above) Plan of the Temple of Portunus.

Religious Architecture

Temples Roman temples were derived from Greek and Etruscan precedents. From the Etruscan type came the podium (base) and the frontality of the temple. From Greece came the columns, the *cella* (central room), the porch *(pronaos),* the Orders, and the pediment. Many Greek architects worked in Rome and its provinces following the Roman conquest of Greece in 146 B.C. Their activity led to an infusion of Greek elements and a shift toward the use of marble rather than local stone.

The Temple of Portunus (fig. **9.15**) shows Greek influence in the entablature, which is supported on all four sides by slender Ionic columns. The corner columns, as in the Parthenon (see fig. **7.18**), serve both the long and the short sides. Etruscan influence is apparent in the deeper porch, raised podium, and steps, which are restricted to the front porch and thus give the temple a well-defined frontal aspect. Later, during the empire, the frontality of the temple, raised on its podium, seemed to preside over the ritual space of the forum and was seen as a metaphor for the emperor's authority.

One aspect in which the Roman temple differs from the Greek is in the relation of the columns to the wall. Here the Romans followed the Italic, Etruscan tradition of frontality. Whereas Greek temples are typically **peripteral**

─────────────── **CONNECTIONS** ───────────────

See figure 7.18. Reconstruction of the Parthenon, Athens.

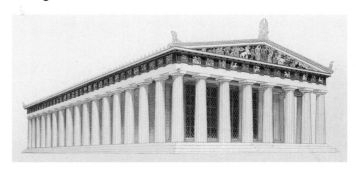

(surrounded by a colonnade of freestanding columns), the columns of the Temple of Portunus are freestanding only on the porch. The other columns are engaged in the back and side walls of the *cella*—hence the term *pseudo-peripteral* (literally, "false peripteral"). The Romans had thus moved beyond the Greek use of the column as the primary means of support and the colonnade as the organizing principle of architectural space. In the Temple of Portunus, the wall, made of rubble-faced concrete, is the supporting element, and the engaged columns, which originally were faced with travertine, have a purely decorative function.

137

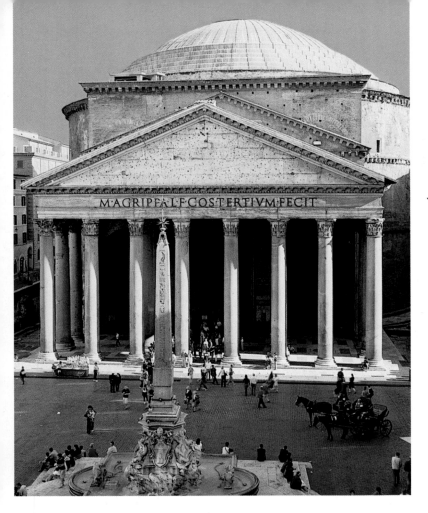

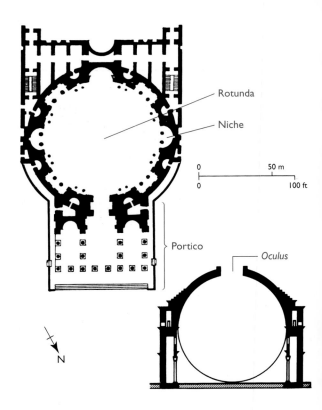

9.17 Plan and section of the Pantheon. The section shows the thickness of the dome tapering toward the top, from approximately 20 to 6 feet (6.09–1.83 m). Note the stepped buttresses on the lower half of the dome.

9.16 Exterior view of the Pantheon, Rome, A.D. 117–125. Marble, brick, and concrete.

9.18 Reconstruction of the Pantheon with a cutaway of the dome. Originally, the coffers were painted blue—not red as shown here—to resemble the sky.

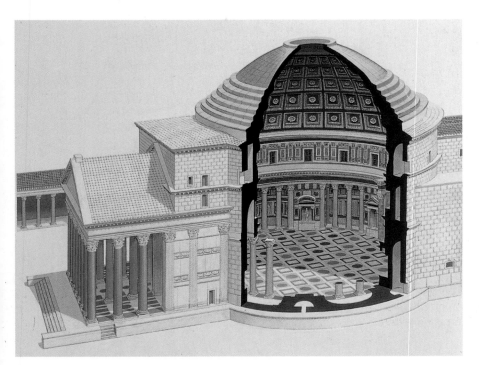

The Pantheon The Pantheon (figs. **9.16–9.19**), the most innovative ancient Roman temple, was built during the reign of Hadrian and dedicated to the five planetary gods known in the second century—Jupiter, Mars, Mercury, Saturn, and Venus (and possibly also to the sun and moon). It consists of two main parts: a traditional rectangular **portico**, supported by massive granite Corinthian columns, and a huge concrete **rotunda** (round structure), faced on the exterior with brick. To the visitor approaching the building, the Pantheon resembled a Greek temple, whereas the enormous round interior space was a Roman conception. By this combination, the tension between native tradition and Greek culture was resolved. Inscribed on the pediment of the portico is the name Marcus Agrippa, who had dedicated an earlier temple on the same site. The entire Pantheon stands on a podium with steps leading to the portico entrance. The building was originally approached through a colonnaded forecourt, which has since been destroyed.

Once inside the rotunda, the visitor is confronted by a vast domed space illuminated only by the open **oculus** (Latin for "eye") in the center of the dome (fig. **9.19**). The dome and the drum are in perfect proportion, the distance from the top of the dome to the floor being identical with the diameter of the drum. The marble

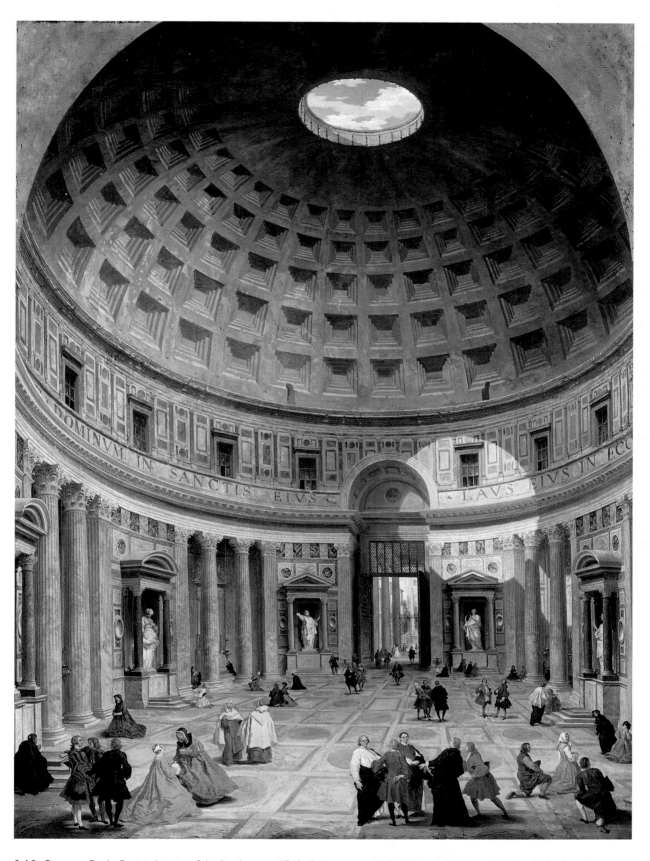

9.19 Giovanni Paolo Panini, *Interior of the Pantheon,* c. 1740. Oil on canvas, 4 ft. 2½ in. × 3 ft. 3 in. (1.28 × 0.99 m). National Gallery of Art, Washington, D.C. Samuel H. Kress Collection.

floor consists of patterns of circles and squares, and the walls contain niches (each one for a different deity) with Corinthian columns supporting alternating triangular and rounded pediments. Between each niche is a recess with two huge columns flanked by two corner pilasters. A circular entablature forms the base of a short "second story." This, in turn, bears the whole weight of the dome, which is channeled down to the eight piers.

The dome has five **coffered** bands (rows of recessed rectangles in the ceiling). These reduce the weight of the structure and also create an optical illusion of greater height. The coffers were originally painted blue, and each had a gold rosette in the middle, enhancing the dome's role as a symbol of the sky, or the dome of heaven. The blue paint repeated the blue sky visible through the oculus, which cast a circle of light inside the building. The illuminated circle reminded ancient Roman visitors of the symbolic equation between the sun and the eye of Jupiter, the supreme celestial deity of Rome.

Commemorative Architecture

An important category of Roman architecture was developed to commemorate the actions of individuals, usually emperors or generals.

The Ara Pacis One of the most symbolic marble monuments of Augustus's reign was the Ara Pacis (Altar of Peace; fig. **9.20**), located on the exercise ground, the Campus Martius (literally the "field dedicated to Mars," god of war). Its purpose was to celebrate the *pax Augusta,* or "Peace of Augustus," after the emperor had made peace with the Gauls and returned to Rome. Like the later Pantheon, the Ara Pacis resolves the conflict between native tradition and Greek culture.

The actual altar (visible here through an opening in the enclosure), which was originally not covered, stood on a podium. While the altar recalled the primitive open-air altars of early Roman times, the reliefs on the exterior of the marble frame were executed in Classical Greek style. They depict Greek motifs, such as the processional frieze, but the subjects of the reliefs are Roman.

Elegant vine-scroll **traceries**, indicating peace and fertility under Augustus, are represented on the lower half of the frame, while the upper half illustrates the actual procession that took place at the founding of the altar. On the north side, senators and other officials, some with wives and children, are shown proceeding to the entrance. The south side represents members of the imperial family (fig. **9.21**). Not seen in this illustration, the figure of Augustus has his head draped in

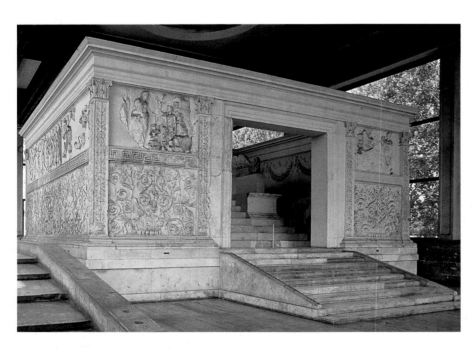

9.20 West side of the Ara Pacis (Altar of Peace), Rome, 13–9 B.C. Marble, outer wall approx. 34 ft. 5 in. × 38 ft. × 23 ft. (10.5 × 11.6 × 7 m).

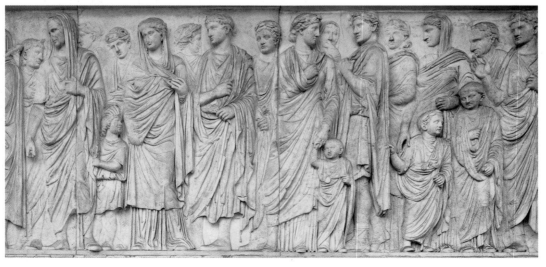

9.21 South side of the Ara Pacis, showing part of an imperial procession. Marble relief, approx. 5 ft. 3 in. (1.6 m) high.

the manner of the *Pontifex Maximus,* the title denoting his role as the state's religious leader. Visible at the left are his wife, Livia, and Agrippa, whose covered head indicates that he is carrying out a religious rite. The presence of children (fig. **9.22**) refers to the dynastic aims of Augustus, who hoped to found a stable system of political succession. He also wanted to encourage aristocrats to reproduce, and he granted tax relief for large families.

In contrast to the Parthenon frieze, which illustrated the Panathenaic procession that took place every four years, the Ara Pacis commemorates a onetime event and portrays it with almost journalistic precision. The Ara Pacis frieze includes portraits of individuals (priests and others) who participated in the ritual.

Techniques of carving also differ, for the Ara Pacis is in higher relief than the Panathenaic procession, satisfying the Roman taste for spatial illusionism. Higher relief is reserved for the more prominent foreground figures, whose feet project from the base.

Visitors approached the altar by a stairway located on the western side. Each year, magistrates, priests, and vestal virgins (virgins consecrated to the service of Vesta, goddess of the hearth) made sacrifices on it. They ascended the stairs, entered the sacred space, and performed the sacrifices while facing east, toward the sunrise.

Trajan's Column Single, freestanding, colossal columns had been used as commemorative monuments from the Hellenistic period onward. The unique Roman contribution was the addition of a ribbonlike documentary narrative frieze, first used and best exemplified in Trajan's Column (fig. **9.23**), which was completed by A.D. 113. It was erected in honor of his victories over the Dacians, the inhabitants of modern-day Romania. There were originally two libraries flanking the column, one for Greek texts and the other for Latin.

9.22 (Left) Ara Pacis, showing a detail of a child tugging at an adult's toga. Note the artist's careful observation of human nature in the child's dimpled elbows and knees and the chubby rolls around his ankles. He is tired of walking and wants to be picked up and carried. Such accurate psychological characterization of specific age-related behavior is consistent with the Roman interest in portraiture.

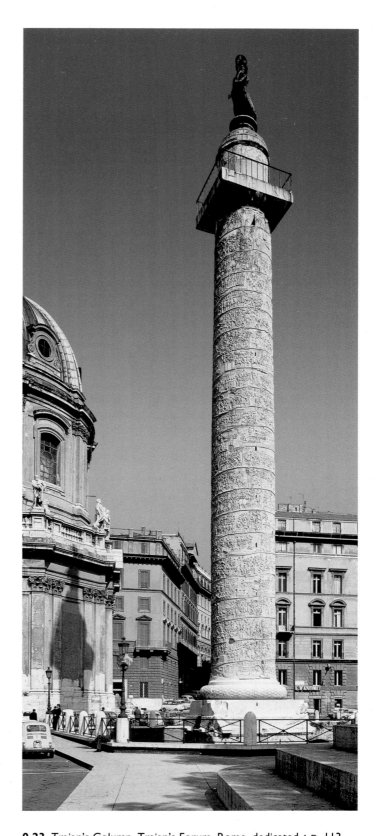

9.23 Trajan's Column, Trajan's Forum, Rome, dedicated A.D. 113. Marble, 125 ft. (38 m) high, including base; frieze 625 ft. (190 m) long. Although the upper scenes could not have been seen from the ground, they would have been visible from the balconies of nearby buildings. A gilded bronze statue of Trajan, since destroyed, originally stood at the top of the column. It has been replaced by a statue of Saint Peter.

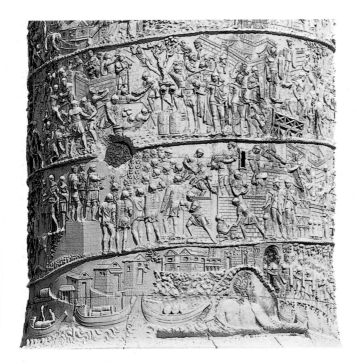

The column consists of marble drums cut horizontally and imperceptibly joined together. Supporting it is a podium decorated with sculptures illustrating the spoils of war and containing a repository for Trajan's ashes. Inside the column shaft, a spiral staircase was illuminated by openings cut into the marble. The exterior shaft is covered with a continuous low-relief spiral sculpture over 625 feet (190 m) long and containing some 2,500 figures. In the first four bands of the spiral, at the beginning of the narrative (fig. **9.24**), the Roman army prepares its campaign. On the first level, a giant bearded river god personifies the Danube. He watches as Trajan leads the Roman army out of a walled city. Boats and soldiers fill the river. The second level contains army camps, war councils, reconnaissance missions, and the capture of a spy. Background figures are raised above foreground figures, virtually eliminating any unfilled space. Zigzagging buildings faced with brickwork patterns and the diagonals of the boats enhance the sense of surface movement. The formal crowding conveys the bustling activity of armies preparing for war. In addition to its power as a commemorative statement, the frieze on Trajan's Column is an informative historical record of life in the Roman army.

The Triumphal Arch

The triumphal arch was another Roman innovation that commemorated the military exploits of a victorious general or emperor. It marked a place of ritual passage into a city at the head of an army. These symbolic triumphal arches stood alone and were different from arches cut into city walls, which served as entrances for the populace. The earliest surviving examples of the triumphal arch precede the reign of Augustus by a century. They typically consisted of a rectangular block enclosing one or more round arches, and a short barrel vault like those on the Pont du Gard (see fig. **9.14**). Most had either one or three openings, with two being quite rare. Pilasters framed the openings and supported an entablature, which was surmounted by a rectangular **attic**. This usually bore an inscription and supported sculptures of chariots drawn by horses or, occasionally, by elephants (of which none are extant). Elephants, in ancient Rome, were imported from Africa and owned only by emperors. Because of their bulk, strength, and long life, they were symbolic of the emperor's power and immortality.

The Arch of Titus (fig. **9.25**), erected in A.D. 81 to commemorate Titus's capture of Jerusalem and his suppression of a Jewish rebellion in A.D. 70–71, has a single opening.

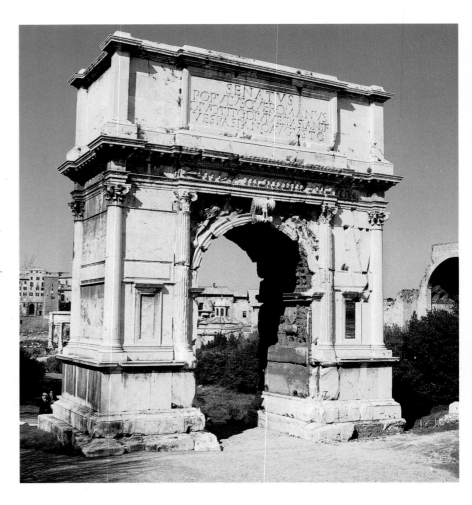

9.25 Arch of Titus, Rome, A.D. 81. Marble over concrete core, approx. 50 ft. (15 m) high, approx. 40 ft. (12 m) wide. The arch stands on the Via Sacra (Sacred Way) leading into the forum in Rome. The Latin inscription on the attic proclaims that "the senate and people of Rome (SPQR) [dedicate the arch] to divine Titus, Vespasian Augustus, son of divine Vespasian."

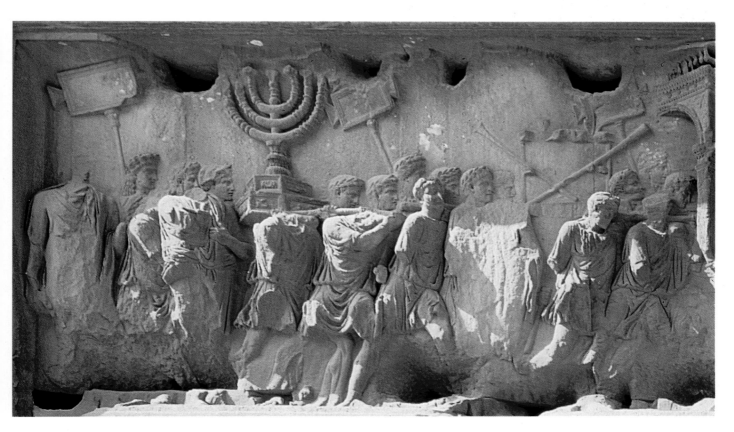

9.26 Relief from the Arch of Titus, detail showing *The Spoils of the Temple of Jerusalem Exhibited in Rome.* Marble, 6 ft. 7 in. (2 m) high.

Its columns are of the Composite Order, a Roman Order combining elements of Ionic and Corinthian. On the curved triangular spaces between the arch and the frame, winged Victories hold laurel wreaths. Reliefs on either side of the **piers** (large rectangular supports) forming the passageway depict Titus's triumphs.

A relief on the inner wall (fig. **9.26**) shows Titus's soldiers carrying off their booty from the Jewish Wars (see Box). As in the frieze of the Ara Pacis, the figures project illusionistically from the surface of the relief. Soldiers raise the menorah (the sacred Jewish candelabrum with seven candlesticks), whose weight and prominence reflect its importance for the Jews and hence its role as a symbol of the Roman victory. The base of the menorah and the arch are carved in perspective, reflecting the Roman taste for spatial effects and optical illusion.

PRIMARY SOURCE
Josephus and the Jewish Wars

Josephus (A.D. c. 37–100), a Jewish soldier and historian, wrote a history of the Jewish Wars that describes the capture of Jerusalem by Antiochus Epiphanes in 170 B.C. and Titus's seizure of Jerusalem in A.D. 70 (which he witnessed). Under the Flavian emperors (Vespasian, Titus, and Domitian, who together ruled from A.D. 69 to 96), Josephus was granted Roman citizenship, and he favored cooperation with the Romans.

Josephus's history includes a description of the triumphal procession celebrating the victory of Vespasian (ruled A.D. 69–79) and his son Titus (ruled A.D. 79–81) after the sack of Jerusalem. His account reflects the Romans' love of material splendor and its role in projecting an image of imperial power.

He was struck by the abundance of gold and silver objects, which flowed "like a river," by the Babylonian tapestries, and by the jeweled crowns. "The most interesting of all," he wrote:

> were the spoils seized from the temple of Jerusalem: a gold table weighing many talents, and a lampstand, also made of gold. . . . There was a central shaft fastened to the base; then spandrels extended from this in an arrangement which rather resembled the shape of a trident, and on the end of each of these spandrels a lamp was forged. There were seven of these, emphasizing the honor accorded to the number seven among the Jews.[2]

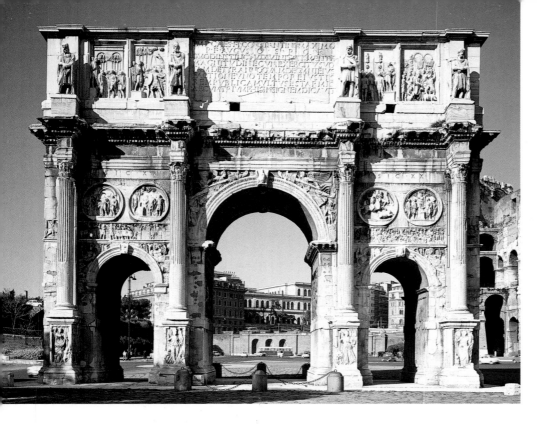

9.27 Arch of Constantine, Rome, c. A.D. 313. Marble, 70 ft. (21.3 m) high, 85 ft. 8 in. (26.1 m) wide.

More than two hundred years after the dedication of the Arch of Titus, the emperor Constantine the Great (ruled A.D. 306–337) erected the largest triumphal arch in Rome, near the Colosseum (fig. **9.27**). It commemorated his assumption of sole imperial power in 312, after defeating his rival Maxentius at the Battle of the Milvian Bridge, at which time Christianity was first recognized. This elaborate arch with three openings is decorated both with original reliefs and with *spolia,* which are reliefs removed from earlier monuments in honor of other emperors (Trajan, Hadrian, and Marcus Aurelius).

Sculptural Types

The Sarcophagus

The Romans produced three basic types of funerary art. Like the Etruscans, they used cinerary urns for cremation. Graves were marked in the Greek style by stelae or tombstones with inscriptions, reliefs, or both. But the most typical item of funerary art for the Romans was the sarcophagus, which had been used by the Etruscans and became an expression of status under Hadrian.

The early third-century sarcophagus in figure **9.28** reflects the symbolic use of Greek iconography in Roman art. Four standing nude males representing the seasons occupy poses reminiscent of the *Doryphoros* (see fig. **7.14**), but these are somewhat more self-consciously affected, and the anatomy is differently proportioned. At the center, Bacchus sits astride a panther and holds a *thyrsos* (a phallic staff surmounted by a pine cone). The other figures are traditional participants in Bacchic rites—satyrs, goats, Cupids, and maenads (frenzied female followers of Bacchus). Foliage motifs refer to vines and Bacchus's role as the god of wine.

9.28 Bacchus and the Four Seasons (the so-called Badminton Sarcophagus, named for the residence of its former owners in Great Britain), c. A.D. 220. Marble, 3 ft. 3 in. (99.1 cm) high. Metropolitan Museum of Art, New York (Joseph Pulitzer Bequest).

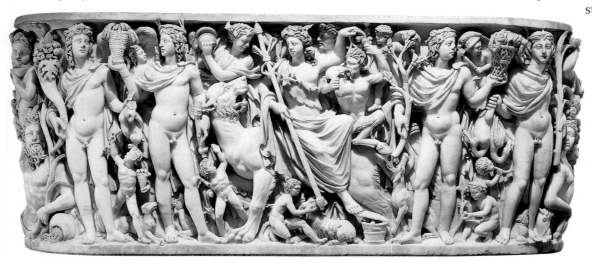

MEDIA
Color Symbolism in Roman Marble

The Roman interest in marble is evidenced by Augustus' reputation for having turned Rome from a city of concrete into a city of marble buildings. But sculptors as well as architects used marble, which was quarried throughout the Mediterranean —in Greece, Libya, Egypt, and Asia Minor—and imported by Rome. Different geological conditions produced marble in various colors. For example, a heavy concentration of iron in the earth produced red marble, and colliding plates of earth produced green serpentine; yellow marble is found in North Africa, white marble in Greece, and veined marble *(pavonazzetto)* in Phrygia.

Over time, Roman artists associated the nature and color of marble with specific types of figures and certain symbolic meanings. Red porphyry (the origin of the word *purple*) was the marble of choice for emperors and monumental cult statues. White was used for skin color and nudes. But in some imperial portraits, the skin is black, as it is in statues of Nubians. Figure **9.29** shows a third-century-A.D. bust of the emperor Caracalla wearing red porphyry; his head and

neck are of white *(lunense)* marble. The barbarian in figure **9.30**, in contrast, has black skin and a costume carved from *pavonazzetto* (white with purple veins). This represents a captive Near Easterner, possibly a Parthian, a member of the culture defeated by Augustus in A.D. 20. The figure has been reconstructed as one support of a tripod; he kneels to show his submission to the Roman emperor. The veined marble reflects the ancient Western view of Easterners as given to luxury and elegant dress—the term *pavonazzetto* means "peacocklike."

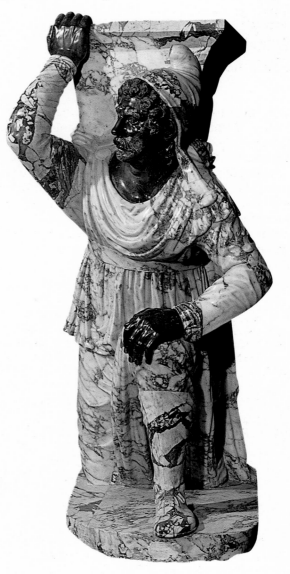

9.29 *Caracalla,* 3rd century A.D. Marble, 2 ft. 4½ in. (72 cm) high. Sala degli Imperatori, Museo Capitolino, Rome, Italy.

9.30 *Unknown Barbarian (Parthian?),* Augustan period. Marble, 5 ft. 3¾ in. (1.62 m) high. Museo Archeologico Nazionale, Naples, Italy.

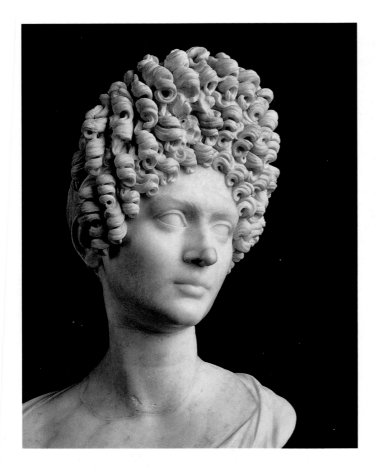

9.31a *A Young Flavian Woman*, c. 90 B.C. Marble, 25 in. (63.5 cm) high. Museo Capitolino, Rome, Italy.

9.31b Back view of **9.31a.**

Portraits

Just as earlier tomb effigies were a metaphorical way of making the dead seem alive, so portraiture is often intended as a means of keeping the deceased alive in memory.

One of the portrait types most characteristic of Rome was the head detached from the body, or **bust.** It had never been part of Greek tradition, but it was common among the Etruscans. Busts were usually carved in marble, often from a wax death mask, so that even the most specific physiognomic details were preserved.

Portraits of upper-class Roman women became popular in the first century A.D. The one illustrated here (fig. **9.31**) wears the elaborate, fashionable coiffure of a young Flavian lady. Curls frame the face and rise upward. Deep carving creates strong oppositions of light and dark that add to the sense of mass supported by the delicate, smoothly carved surfaces of the face and neck.

One of the most important subjects of Roman sculpture in the round was naturally the emperor himself. In the *Augustus of Prima Porta* (fig. **9.32**), the emperor is portrayed as a general addressing his troops. Even though the head is a like-

ness, it is idealized. Augustus was seventy-six when he died after a long reign, but this statue represents a self-confident, dominating, and above all youthful figure. A possible source for this idealization is the *Doryphoros* of Polykleitos (fig. **7.14**). The similar stance suggests that the artist who made *Augustus* was familiar with the Greek statue—probably from Roman copies, if not from the original.

The iconography of this statue again emphasizes the power of Rome embodied in Augustus as emperor. By his right leg, Cupid (Venus's son) rides a dolphin and serves as a reminder that Augustus traced his lineage to Aeneas (also a son of Venus) and was thus descended from the gods. Among the little reliefs carved on Augustus's armor is Mother Earth with a **cornucopia.** This refers to the emperor's identification with the land as a source of plenty and divine favor that has conferred power on Rome, giving it dominion over the earth. The association of Augustus with the earth also alludes to Roman territorial conquests. Another scene depicts a Parthian returning a military standard looted from the Romans. The canopy spread out by a sky god at the top of the breastplate indicates that the sky gods protect Rome.

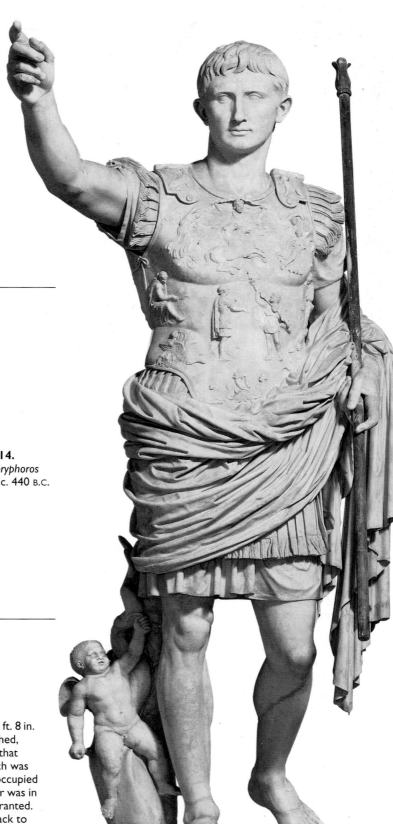

── CONNECTIONS ──

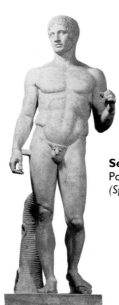

See figure 7.14.
Polykleitos, *Doryphoros*
(Spear Bearer), c. 440 B.C.

9.32 *Augustus of Prima Porta,* early 1st century A.D. Marble, 6 ft. 8 in. (2.03 m) high. Musei Vaticani, Rome, Italy. The back is unfinished, indicating that the statue was intended for a niche. The fact that Augustus is barefoot may be a reference to his divinity, which was not official during his lifetime, and indicates that the statue occupied a private space (the home of his wife, Livia, at Prima Porta) or was in an Eastern city, where the divinity of a ruler was taken for granted. The Romans' deification of Augustus after his death harks back to the traditional equation of god and ruler that persisted throughout the ancient Mediterranean world.

A type of imperial portrait invented by the Romans is the equestrian monument. The most impressive surviving example is an equestrian bronze statue of the emperor Marcus Aurelius (reigned A.D. 161–180) (fig. **9.33**; see Box). His beard reflects the Greek fashion set by Hadrian and indicates that he is a philosopher. Also suggesting Greek influence is the artist's representation of convincing organic form in both emperor and horse. Veins, muscles, and skin folds of the horse are visible as he raises his right foreleg, turns his head, and lifts his left hind leg so that only the toe of his hoof touches the ground. His apparent eagerness to set out is controlled and counteracted by the more sedate emperor, who originally held reins that have since disappeared.

Later, in the fourth century, the emperor Constantine was depicted in a colossal marble statue. The head, over 8 feet (almost 3 m) high, is detached from the body (fig. **9.34**). It is clearly a

9.33 (Above) Equestrian statue of Marcus Aurelius (before restoration), A.D. 164–166. Bronze, 11 ft. 6 in. (3.5 m) high. Piazza del Campidoglio, Rome. In this statue the emperor is unarmed, and his right arm is extended in the conventional gesture of an orator. But domination and conquest are implied by equestrian iconography. Documents indicate that a conquered enemy originally cowered under the horse's raised foreleg.

9.34 Monumental head of Constantine, from the Basilica of Constantine, Rome, A.D. 313. Marble, 8 ft. 6 in. (2.59 m) high. Palazzo dei Conservatori, Rome, Italy. The statue's original location on the throne in the apse of the basilica reflected the emperor's power over the Roman people and the empire.

portrait, as evidenced by such features as the long nose, cleft chin, clean-shaven cheeks, and thick neck. But the predominant impression left by this sculpture is derived from its monumental size, the staring geometric eyes, and the stylized hair. The restrained Classical character of earlier imperial sculptures has disappeared, giving way to a new style, which expresses the emperor's power and makes him seem aloof from his subjects.

Pictorial Style

Painting and Mosaic

Roman **murals** are among the most significant legacies of the eruption of Mount Vesuvius in A.D. 79. Hundreds of wall paintings and mosaics have been discovered among the ruins of Pompeii and Herculaneum. They provide the greatest evidence of Greek Hellenistic painting, most of which no longer survives.

Roman mural paintings were executed in *buon fresco,* but with small amounts of wax added to increase the surface shine. As a result of the durability of this technique, as well as the covering of volcanic ash, many murals from Pompeii and Herculaneum have survived in relatively good condition, and they provide a remarkable panorama of Roman painting.

Scholars have divided the wall decorations of Pompeian houses into four styles, which are more or less chronological, although there is some overlap. The First Style is found during the period of the Republic (B.C.) and typically simulates the architecture of the wall itself. The Second Style begins under the Republic and continues into the early empire. The Third and Fourth Styles are imperial, ending with the eruption of Vesuvius. Each house was painted according to a particular style, depending on its chronology.

As a result, the context of the house is necessary in order to determine the style of its wall paintings.

The First Style mosaic in figure **9.35** was created during the Roman Republic. As with the Issos mosaic (see fig. **7.7**), this was made of small colored stones and tiles embedded into a grout surface and polished when dry. It illustrates a figure at the right consulting three soothsayers (witches) about the future. Their theatrical quality—this may be a scene from a comedy—and exaggerated expressions are characteristic of the Hellenistic style that influenced Roman art in this period. Such mosaics were popular decorations in private houses as well as in public buildings.

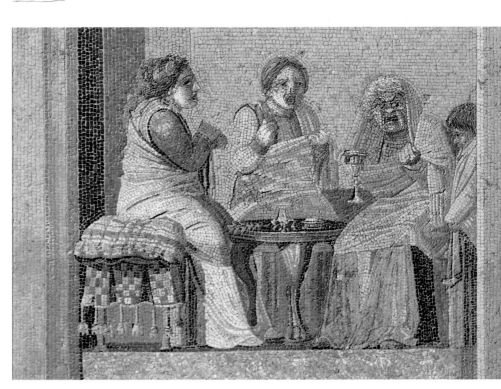

9.35 *Soothsayers,* from Villa of Cicero, Pompeii, Period of the Republic. First Style mosaic, 14 × 17 in. (35 × 42 cm). Museo Archeologico Nazionale, Naples, Italy.

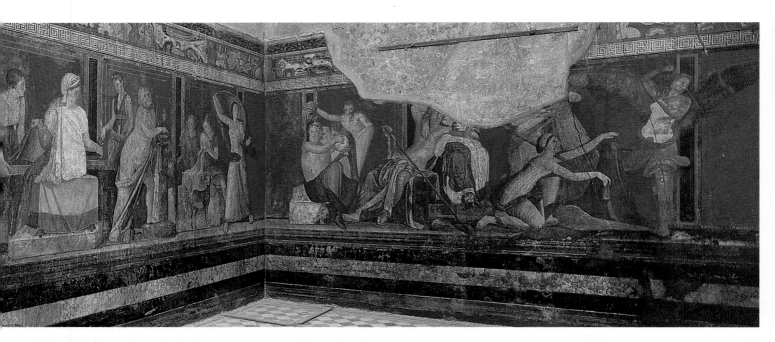

9.36 Second Style frescoes, Villa of the Mysteries, near Pompeii, c. 65–50 B.C.

The best examples of Second Style paintings are found in the country villa near Pompeii known as the Villa of the Mysteries (fig. **9.36**). In the southwest corner, painted pilasters separate each section (*oecus*) of a long narrative illustrating what is thought to be a mystery rite in honor of Bacchus. The wine god is represented on the back wall together with his wife, Ariadne; the preparation of a bride for her wedding appears on the adjacent wall. Above the pilasters is an intricate meander pattern with panels imitating marble graining. Nearly life-size figures enact the ritual on a shallow, stagelike floor, which projects illusionistically beyond the surface of the wall. The vivid red background, known as Pompeian red, was made of pigment ground from cinnabar, which was expensive and had to be imported from Spain. The narrative continues around the walls of the room, uninterrupted by shifts in the actual architecture.

Although neither the exact meaning of these scenes nor their narrative order is agreed upon by scholars, it is clear that some kind of sacred ritual is taking place. Its mysterious character is enhanced by the inconsistent sources of light and the absence of cast shadows, which are at odds with the naturalism of the figures and the perspectival space.

Figure **9.37** is a good example of the Third Style, which creates an illusion of a framed painting on a flat wall. The artist focuses on thin, delicate ornamentation and sets a miniature arrangement of trees, architecture, and human figures against a monochrome background.

In the still life in figure **9.38** of around A.D. 50, objects are placed on steps or shelves in the foreground. Spatial projection is indicated by abrupt shifts from light to dark. The spherical shape of the peaches is indicated by their gradually shaded surfaces. Patches of white on the glass jar suggest light bouncing off a shiny, transparent surface. There is a further implication that the source of light is at the left, since the jar and peaches cast shadows to the right. The **highlights**, together with the shading, create an illusion of volume, which is characteristic of the Fourth Style.

A more complex narrative mural painting, from the House of the Vettii in Pompeii, represents the Greek myth in which the infant Hercules strangles a pair of snakes (fig. **9.39**). Hercules was the son of Jupiter and the mortal Alkmene. Juno was jealous of her husband's infidelity and tried to kill the infant by sending two snakes to his nursery. Her plot failed when Hercules killed the snakes instead.

In this painting, the toddler-age Hercules is the focus of attention. At the right, Alkmene's mortal husband, Amphitryon (who believes himself to be Hercules' father), watches in amazement. Alkmene's reaction to her son, however, is more ambivalent. Her pose takes her away from the event, as she seems to be running out of the picture. But she turns to stare at Hercules, her riveted gaze enhanced by her wide-eyed expression. The shading of Hercules and Amphitryon defines the natural structure of their bodies as well as their positions in space. The figure at the left is rendered from the back, as if he, like the observer, has just happened on the scene.

The architectural elements within the picture (such as the slightly receding row of Ionic columns) add to the illusion of depth. The floor of the room is horizontal, enabling the viewer to determine the spatial locations of figures and objects. Amphitryon's footstool and the altar behind Hercules are placed at oblique angles to the picture plane. By darkening one side of the altar, the artist creates the illusion that both sides recede.

Although the painting represents a Greek myth, certain iconographic details refer to the imperial concerns of Rome. Amphitryon is clearly a ruler, wearing a laurel wreath, enthroned, and holding a scepter. Perched on the altar is the eagle, which is a reference to both Jupiter and the Roman army. Likewise, the divine origins of Hercules recall the Roman legends tracing the origins of Rome to Aeneas and through him to the Greek gods. Hercules' formal similarity to the Hellenistic sculpture *Laocoön* (see fig. **7.41**) relates the image, like Aeneas on the Ara Pacis, to the fall of Troy.

9.37 (Above) Columns and pediment with pavilion, from villa at Boscotrecase, near Pompeii, late 1st century B.C. Third Style fresco, 7 ft. 11in. × 4 ft. (2.41 × 1.22 m). Metropolitan Museum of Art, New York (Rogers Fund, 1920).

9.38 *Still Life*, from Herculaneum, c. A.D. 50. Early Fourth Style fresco, 14 × 13½ in. (35.6 × 34.3 cm). Museo Nazionale Archeologico, Naples, Italy.

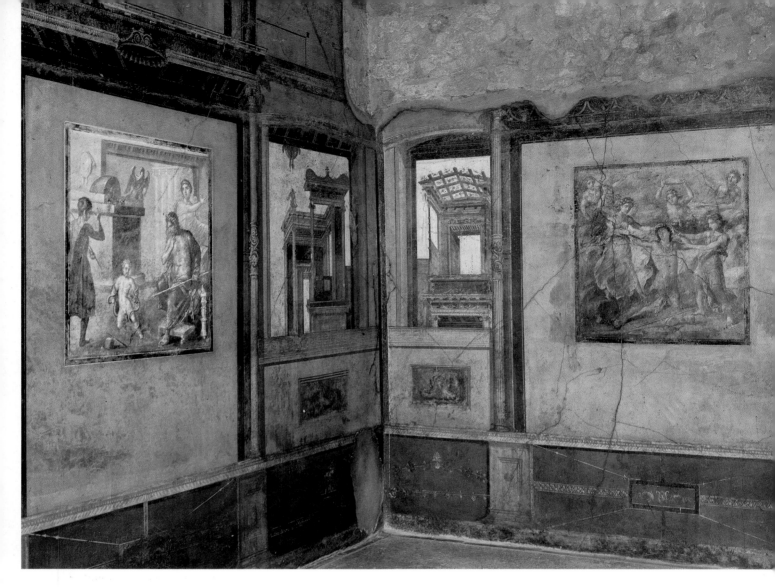

9.39 *Hercules Strangling the Serpents*, House of the Vettii, Pompeii, A.D. 63–79.

The painting is shown in situ—that is, in its original context. Like the architectural paintings in the room, *Hercules Strangling the Serpents* has the effect of a window cut into the wall. The scene at the right illustrates the death of Pentheus, a Greek ruler torn apart by Maenads because he rejected the rites of Bacchus.

During the course of the Roman Empire, a new religion was born. Christianity was legally sanctioned by Constantine the Great in A.D. 313. According to Constantine's biographer Eusebius, bishop of Caesarea (in Samaria, now Israel) and the first historian of the Christian Church, the emperor was himself baptized. For well over the next thousand years, Christianity was to dominate Western art and culture, and new conventions of style would develop to express its new message.

300 B.C. **A.D. 1** **A.D. 476**

ROMAN REPUBLIC
509 B.C.–27 B.C.

ROMAN EMPIRE
27 B.C.–A.D. 476

(9.15a) (9.4) (9.38) (9.12) (9.33)

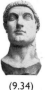

(9.27) (9.34)

First Punic War between Rome and Carthage (264–241 B.C.)

Caesar conquers Gaul (58–50 B.C.)

Caesar assassinated (44 B.C.)

Augustus becomes first emperor (27 B.C.)

Virgil, *Aeneid* (30–19 B.C.)

Crucifixion of Jesus (A.D. 33)

Edict of Milan (A.D. 313)

Fall of the Roman Empire (A.D. 476)

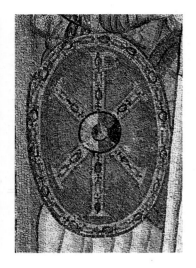

10

Early Christian and Byzantine Art

A New Religion

Jesus Christ died in about A.D. 33, during the reign of the emperor Tiberius, who ruled from A.D. 14 to 37. He was crucified outside the city of Jerusalem, then part of the vast Roman Empire. The teachings of Jesus and his followers led to the establishment of the Christian religion, whose impact on Western art after the fall of Rome cannot be overestimated.

Christianity began as one of many Eastern cults in the Mediterranean world and in Rome itself during the first century after Christ. The roots of Christianity were in Judaism since Jesus himself was a Jew. Like Judaism, Christianity was founded on written texts, was monotheistic, and taught a code of ethics. Like certain other cults, Christianity offered a promise of eternal salvation for the faithful. But it differed from these cults in two crucial respects.

First, Christian rituals did not include animal or blood sacrifices except in symbolic form. Jesus's own sacrifice was symbolically prefigured in the Last Supper, when the bread stood for his body and red wine for his blood. This celebration was originally performed by Jesus and his followers as part of the Jewish Passover, shortly before his death. He asked his followers to repeat it in his memory, and at first they did so in private dining rooms. It consisted of breaking bread, drinking wine, singing hymns, praying, and reading from the Bible. By the third century, this re-creation of the Last Supper had become established as the liturgy of the Mass. In the performance of the Mass, also called Holy Communion, the Lord's Supper, or the **Eucharist** (Greek for "thanksgiving"), bread and wine are believed to become literally the body and blood of Christ.

Second, Christians differed from followers of other Eastern religions by refusing to worship the emperor as the embodiment of the state. Christian monotheism rejected the Roman and Greek pantheons and the Near Eastern and Egyptian gods. These attitudes set Christianity at odds with the imperial Roman establishment and made its followers subject to persecution by Rome. As a result, despite the rapid growth of Christianity, its special appeal to the lower classes of society, and the fervor of its adherents, it remained an underground movement for nearly the first

three hundred years of its existence. Rome was not entirely safe for Christians before A.D. 313. In that year, Constantine issued the Edict of Milan, which granted tolerance to all religions, including Christianity.

Constantine and Christianity

Although Constantine's precise relationship to Christianity is not known, he clearly took a personal interest in the new religion. He established a new capital at Byzantium at least in part because the eastern regions of the Roman Empire were gaining in political importance. But it was also there that Christianity had established the firmest foundations by the early fourth century.

Apart from Constantine's letters, his edicts, and what can be surmised from his actions, the primary source for his life is the biography by the historian Eusebius (A.D. 265–340), who describes Constantine's defeat of his pagan rival, Maxentius, at the Milvian Bridge in Rome. According to Eusebius, Constantine saw two visions before the battle. In one, the Cross appeared against a light with the words "In this sign you conquer." In the other, he was told to place the *Chi-Rho*—the first two letters of Christ's Greek name—on the shields of his soldiers. It was after this victory that Constantine issued the Edict of Milan because, according to Eusebius, he recognized the power of the Cross and of the Christian God. Eusebius is also the source for Constantine's baptism as a Christian. However, since Eusebius was the bishop of Caesarea (in modern Israel), his account may be biased.

The Divergence of East and West

These events and the controversies surrounding them reflect the political and religious turmoil following the birth of Jesus. The title of this chapter is also a reflection of those uncertain times. The term *Early Christian* is a historical more than a stylistic designation. It refers roughly

Scriptures are literally "what has been written." For Judaism and Christianity, the most authoritative scriptures are collected in the Bible (which is derived from the Greek *biblos,* "book"). The Jewish Bible consists of the Old Testament, to which Christians have added the New Testament. The Apocrypha (Greek for "secret" or "hidden") are Old and New Testament writings whose authenticity is questioned.

Established by the fourth century, the New Testament was organized into three sections: the Gospels and Acts, the Epistles, and the **Apocalypse** (or Revelation). The four Gospels are essentially biographies of Jesus, written in about A.D. 70 to 80 by Saints Matthew, Mark, Luke, and John. The authors are called the four Evangelists (from the Greek *euangelistes,* meaning "bearer of good news"). The Acts relate the works of Jesus's **apostles** in spreading his teachings. The Epistles (or Letters), most of which were written by Saint Paul, contain further doctrine and advice on how to live as a Christian. The Apocalypse describes the end of the world and Christ's Second Coming as the final judge. When Jesus was resurrected three days after his death, he became the Christ.

The most important figures in Christian art are the Holy Family, saints, and martyrs. The Holy Family consists of Mary (Jesus's mother), Joseph (her husband), and Jesus. A saint is any person noted for piety and faith who has been sanctified by the Catholic Church. Martyr, from the Greek word *martus,* originally meant "witness" and, in a Christian context, a witness to Jesus's works. Subsequently, *martyr* came to mean one who testifies to a belief with his or her life—in this case, the belief is Christianity. In Western art, saints, martyrs, and members of the Holy Family are usually depicted with a halo—a circle of light around their heads—to indicate their holiness.

Christians developed a method of historical revision called **typology** (from the Greek *tupos,* "example" or "figure"), which paired figures and events from the Old Testament (the Old Dispensation) with those of the New Testament (the New Dispensation). The purpose of typology was to reveal that history before Jesus had foreshadowed or prefigured the Christian era. Jesus, for example, calls himself greater than Solomon, the Old Testament king known for his wise judgments and temple-building. Jesus is referred to as the new Adam, together with Mary, the new Eve. Solomon and Adam are thus types for Jesus, and Eve is a type for Mary. As Christianity developed, this typological view of history was expanded to include pagan antiquity and contemporary events as well as the Old and New Testaments.

to the first four centuries A.D. and to Christian works of art made during that period. "Byzantine," derived from the city of Byzantium, is the name of a style that originated in the Eastern Roman Empire. It is also used to include works made in Italy, Greece, and the Balkans under Byzantine influence. As Rome and the Western Empire were overrun by northern European tribes, and as the East rose to prominence under Justinian, the distinction between the Eastern and Western empires became more pronounced, and Early Christian and Byzantine diverged.

The geographical separation and political divergence of East and West were paralleled by a schism within the Church itself. In Rome and the Western Empire, the pope was the undisputed head of the Church. The Eastern branch of the Church was led by a patriarch, whose power was bestowed on him by the Byzantine emperor.

Corresponding to the East–West division were the predominant artistic styles produced by each branch of the Church. The Byzantine style persisted in the East but also infiltrated the West—especially Italy—and continued to influence artists there until the late thirteenth century. Just as republican and imperial Rome had been able to assimilate other cultures, so Christianity and Christian art absorbed aspects of previous religions and their artistic expression. Greek and Roman myths were endowed with Christian meaning and interpreted in a Christian light.

Christ means the "Anointed," "Messiah," "Savior," and "Deliverer." It is written in Greek as ΧΡΙΣΤΟΣ. The two letters *X* and *P* (*Chi* and *Rho*) are equivalent to the English *Chr* and, as Constantine's symbol, were superimposed and written as

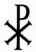

Ichthus, the Greek word for "fish," is an acronym for "Jesus Christ, Son of God, Savior." The *I* is the Greek equivalent of the English *J* (for "Jesus"), *Ch* stands for "Christ," *Th* for *theou* (Greek for "of God"), *U* for *[h]uios* (Greek for "son"), and *S* for *soter* (Greek for "savior"). The *ichthus* and other cryptic signs and symbols were used by Christians to maintain secrecy during the Roman persecutions. Much of Early Christian imagery is symbolic in nature and often takes the form of pictorial puzzles known as **rebuses.** Even after Christianity had become the official religion of Rome and secrecy was no longer necessary, images such as the fish, the Cross, the Lamb of God, and the Good Shepherd continued to have symbolic importance in art and liturgy.

Early Christian Art

Sarcophagi

A good example of continuing Roman imagery in Early Christian art can be seen on a marble sarcophagus in the Church of S. Maria Antiqua in Rome (fig. **10.1**). The side visible here includes Old and New Testament scenes as well as figures combining Roman with Christian meaning. Reading from left to right, the first character is the Old Testament Jonah, who has emerged from the whale. Jonah's form is based on the idealized Classical nude, while the whale is represented as a fantastic fish. This story was well suited to a Christian sarcophagus since Christians interpreted it as a typological prefiguration of Christ's Resurrection. Just as Jonah spent three days inside the whale, so Jesus was entombed for three days before his Resurrection. An Early Christian viewer would have recognized the implications of this iconography as a metaphor for the salvation of the person buried in the sarcophagus.

To the right of Jonah are Christian transformations of a Greco-Roman poet and his muse. The seated poet wears a Roman toga but is shown as a Christian poring over a religious text. The muse is also in Classical dress. She stands with her arms raised in a gesture that combines prayer and mourning with a visual reference to Jesus's Cross.

Spreading out from behind her palms are leafy branches of a tree—a reminder that the Cross was made of wood. Indeed, trees have replaced columns as architectural dividers between scenes. Because of their relationship to the wood of the Cross, trees were to become a central motif in Christian art.

Next on the right is a shepherd carrying a sheep on his shoulders. This figure was one of many antique images assimilated into the Christian repertoire, depicting Christ as the Good Shepherd (see fig. **10.2**). On the far right, a large, bearded John the Baptist stands on the banks of the River Jordan—indicated by wavy lines—and baptizes a small, nude Christ. In the upper left corner of the scene hovers the dove of the Holy Spirit, a traditional feature of Christ's Baptism. This is another appropriate scene for a sarcophagus because baptism signifies rebirth into the Christian faith and, thus, salvation.

The opposition of the Baptism on the right of the sarcophagus and Jonah and the whale on the left demonstrates what was to become a traditional pairing of left and right. This associates the old, or pre-Christian, era with the left, and the new, Christian era with the right. Such pairing extended beyond the Old and New Testaments to include good and evil, light and dark, and so forth. (The negative implications of the Latin word *sinister,* meaning "left," survive in English.)

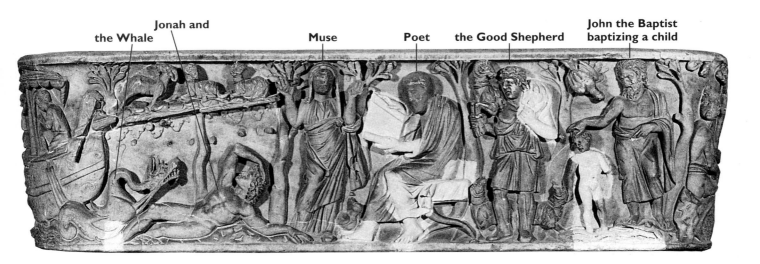

the Whale | **Jonah and** | **Muse** | **Poet** | **the Good Shepherd** | **John the Baptist baptizing a child**

10.1 Early Christian sarcophagus, S. Maria Antiqua, Rome, 4th century. Marble. Although the Christians continued to decorate their sarcophagi with relief sculptures, as the Greeks, Etruscans, and Romans had done, they omitted the effigy of the deceased from the cover of the tomb. They also eliminated cremation because they believed in bodily resurrection.

Christians as well as Jews were relatively safe from Roman persecution when hiding or performing funerary rites in the **catacombs,** which were underground cemeteries. According to Roman law, burial grounds were sacrosanct, so the Romans rarely pursued Christians into the catacombs, where some of the earliest examples of Christian art can be found.

Figure **10.2** shows a fresco depicting *Christ as the Good Shepherd* from the catacomb of Priscilla, dating from the late second or early third century. Christ carries a goat on his shoulders, with a second goat, a sheep, and a tree on either side of him. Each tree is surmounted by a bird. The motif of the Good Shepherd, which had been popular in Roman garden statuary and in the literary bucolic (related to the countryside) tradition, was assimilated by Early Christian artists as a symbol of compassion. Christ as the Good Shepherd was also incorporated into Christian liturgy, with the priest being paralleled with Jesus and the congregation with his flock.

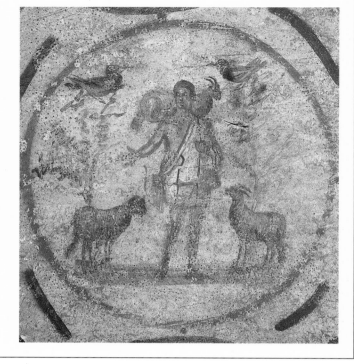

10.2 *Christ as the Good Shepherd,* catacomb of Priscilla, Rome, 2nd–3rd century. Fresco.

Basilicas

Christians worshiped in private homes until the early fourth century. But when Constantine issued the Edict of Milan in A.D. 313, they were free to construct places of worship. From that point on, Christianity was legally protected from persecution, and it soon became the official religion of the Roman Empire. New buildings were needed to accommodate the large and ever-growing Christian community. Unlike Greek and Roman temples, whose main purpose was to house the statue of a god, Christian churches were built so that crowds of believers could gather together for worship. With the active support of Constantine, many churches were constructed in very few years—in Constantinople (the new name Constantine gave to Byzantium; it is now known as Istanbul), in Italy, in the Holy Land, and elsewhere in the Roman Empire. Churches were modeled on the architectural design of the Roman basilica, which was able to hold large numbers of people and could be adapted for Christian worship. The Early Christian basilica was to become the basis for church architecture throughout western Europe.

Old St. Peter's None of the Early Christian basilicas have survived in their original form, but an accurate floor plan of Old St. Peter's Basilica (figs. **10.3** and **10.4**) has been reconstructed by archaeologists. The architectural design of the Christian basilica was adapted to the requirements of Christian ritual; the **altar,** where the Mass was performed, was its focal point. The movable communion table used in

Christian meeting places before A.D. 313 was replaced by a fixed altar that was both visible and accessible to worshipers. Both altar and apse were usually at the eastern end, and the **narthex** (vestibule) at the western entrance became standard in later churches.

The altar's location at the eastern end of the basilica was symbolic as well as practical. It generally supported a crucifix with the image of Jesus on the Cross turned to

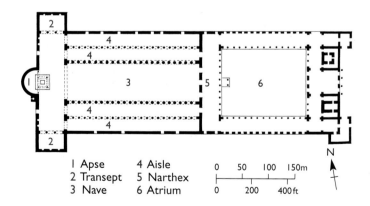

1 Apse	4 Aisle
2 Transept	5 Narthex
3 Nave	6 Atrium

10.3 Plan of Old St. Peter's Basilica, Rome, A.D. 333–390. Interior approx. 368 ft. (112 m) long. Old St. Peter's was the largest Constantinian church and became the prototype for later churches. Besides being a place of worship, it was the saint's **martyrium** (a building over the grave of a martyr)—his grave was under a marble canopy in the apse.

RELIGION
Saint Peter

Saint Peter was Jesus's first apostle. In Matthew 16:13–20, Jesus gives Peter the keys to heaven with the words "On this rock will I build my Church." That statement became the basis for the pope's authority, although it is unclear grammatically whether "rock" refers to Peter or to his faith. The name *Peter* comes from the Greek *petros* (meaning "rock"), from which comes the English word "petrify," meaning "turn to stone." Rock is also a metaphor for something strong and lasting, as in "solid as a rock" or "Rock of Ages," and here denotes the solid and enduring character of faith.

Saint Peter was the first bishop of Rome. Since all popes are also bishops of Rome, Peter is considered to have been the first pope. The basilica of Old St. Peter's became the prototypical papal church, although it was in fact an exception to the traditional Christian orientation of churches toward the east. During the Renaissance, St. Peter's was rebuilt by several architects (see p. 281), and it is still the seat of papal power today.

face the congregation. Just as the Crucifixion took place in the East (in Jerusalem), so the Early Christian basilica and most later churches are oriented with the altar in the East. According to tradition, Jesus was crucified facing west; therefore, the altar cross usually faces the western entrance of the church.

Another symbolic aspect of church design was the new use of the apse. In Roman basilicas, apses had often contained statues of the emperors, and they were also the location of legal proceedings. In Early Christian apses, therefore, the image of Christ as Judge was particularly appropriate. It referred both to the Roman law courts and to the Christian belief in a Last Judgment.

An important new feature in Old St. Peter's was the addition of a **transept** to the Roman basilica. It consisted of a transverse space, or cross-arm, placed at right angles to the nave, and it separated the apse from the nave. The transept, which contained a canopy marking Peter's grave, isolated the clergy from the main body of the church. With the transept, the building forms the shape of a cross—hence the adjective **cruciform** to describe basilicas with this feature.

The altar and apse at Old St. Peter's were framed by a huge triumphal arch—a regular architectural element of Early Christian basilicas. The architects thus assimilated the Roman triumphal arch and transformed its meaning to refer to the triumph of Christ rather than of the emperor.

The exterior of Old St. Peter's, and of similar churches, was plain brick. The interior, on the other hand, was richly decorated with mosaics, frescoes, and marble columns. Their purpose was not only to exalt God, but also to teach and inspire the worshipers.

1 Clerestory
2 Apse
3 Nave
4 Aisle

10.4 Reconstruction diagram of the nave of Old St. Peter's basilica. Old St. Peter's is similar to the pagan or secular basilica of pre-Christian Rome in having a long nave flanked by side aisles, clerestory windows on each side, an apse, and a wooden **gable** roof. Unlike pagan basilicas, which typically had an apse at each end, Old St. Peter's had a single one opposite the entrance. The building was demolished in the 16th century when work on the New St. Peter's began.

CONNECTIONS

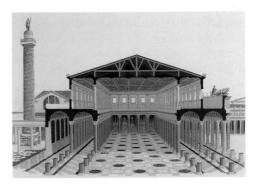

See figure 9.7. Reconstructed cross section of the Basilica Ulpia A.D. 98–117.

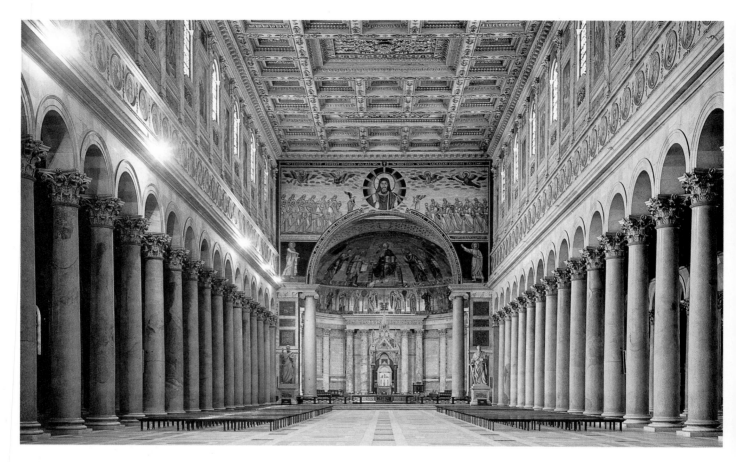

10.5 St. Paul Outside the Walls, Rome, begun A.D. 385.

St. Paul Outside the Walls The interior of St. Paul Outside the Walls (fig. **10.5**) gives some idea of the original appearance of Early Christian churches. Wooden beams in the ceiling have been replaced by coffers, but the vast basilica-like space remains. Like Old St. Peter's it retains the wide nave, aisles, clerestory windows, and apse of the Roman basilica. The triumphal arch has become a chancel arch, which is supported by Ionic columns, whereas those separating the nave from the aisles are Corinthian. The rich mosaic decoration, its iconography, and the predominance of gold contribute to the impressive effect of the interior.

Centrally Planned Churches

Another type of Early Christian structure was the **centrally planned** round or polygonal building. It radiated from a central point and was surmounted by a dome, and it was often attached to a larger structure. Such buildings were used mainly as martyria, **baptisteries** (for performing baptisms), or **mausolea** (large architectural tombs). Centrally planned churches included a central altar or tomb and a cylindrical core with clerestory windows. A circular barrel-vaulted passage, or **ambulatory** (from the Latin *ambulare,* "to walk"), ran between the central space and the exterior walls.

Justinian and the Byzantine Style

During the fifth century, the western part of the Roman Empire was overrun by Germanic tribes from northern Europe. The Ostrogoths occupied the strategic Italian city of Ravenna until it was recaptured during the reign of the Byzantine emperor Justinian in A.D. 540. Under Justinian, the Eastern Empire rose to political and artistic prominence.

San Vitale

Situated on the Adriatic coast, Ravenna was an essential port for controlling trade between the East and the West. Because of its strategic location, it became the Italian center of Justinian's empire and the focus of his artistic patronage in Italy. He was striving to restore unity to Christendom, and one expression of that effort can be seen in his building programs. Ravenna was the site of interesting developments in the centrally planned church during the sixth century. The city's most important Justinian church (figs. **10.6–10.12**) was dedicated to Saint Vitalis—San Vitale in Italian. He was a Roman slave and Christian martyr who became the object of a growing cult from the end of the fourth century.

The exterior of San Vitale (fig. **10.6**) is faced with plain brick, unbroken except by buttresses and windows, and the interior is richly decorated with mosaics and marble. In both respects, it is like the Early Christian basilica. In

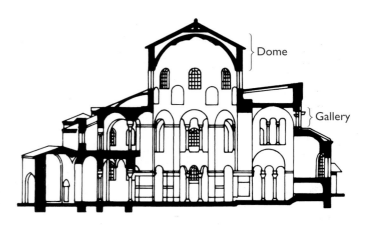

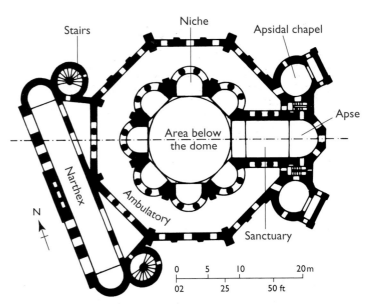

10.7a, b The domed central core and octagonal plan of San Vitale diverge from the architecture of Western Christendom. Instead of having an east-west orientation along a longitudinal axis with the altar in the east and the entrance in the west, San Vitale is centrally planned. The narthex is placed on the western side of San Vitale at an angle to the axis of the apse. The circular central space is equivalent to the nave of Western churches and is ringed by eight large piers supporting eight arches. Beyond the arches are seven semicircular niches and the cross vault containing the altar. Each niche is surrounded by an ambulatory on the floor level and a **gallery** (perhaps reserved for women) on the second story. All three levels —ground, gallery, and clerestory—have arched windows that admit light into the church.

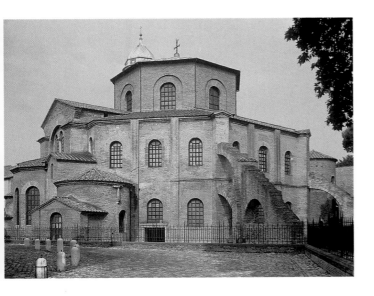

10.6 Exterior of San Vitale, Ravenna, A.D. 540–547. Brick facing.

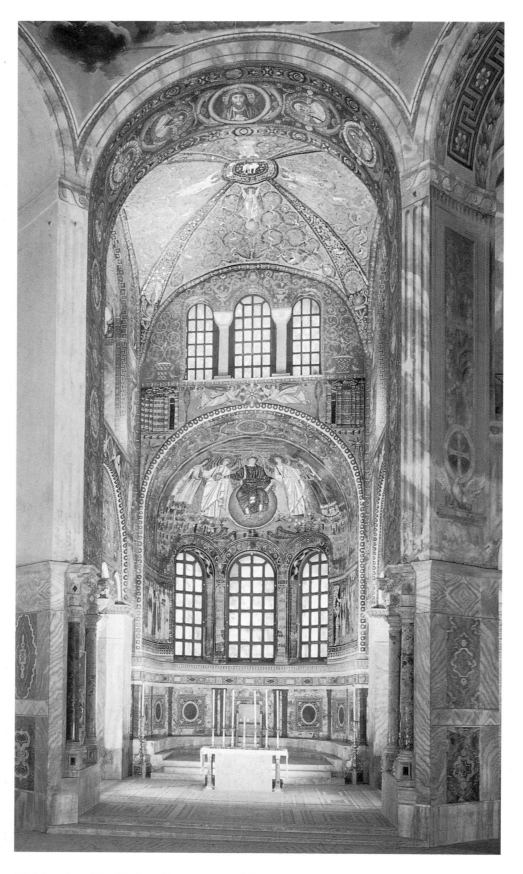

10.8 Interior of San Vitale looking east toward the apse, A.D. 540–547.

figure **10.8**—looking east toward the apse and the altar—the large rectangular piers that support the main arches and the columns at the base of the smaller arches are visible. The interior is suffused with a glow of yellow light, resulting from the prevalence of gold mosaic decoration (see Box, p. 163).

San Vitale's large apse mosaic (fig. **10.9**) depicts a young, beardless Christ, based on Western Apollonian prototypes. His halo contains an image of the Cross, and he wears the purple robe of royalty. He sits on a globe, flanked by two angels, and hands a jeweled crown to San Vitale. On the right, Bishop Ecclesius holds up a model of the church. Although there are still traces of Hellenistic and Roman naturalism—for example, in the landscape and suggestions of shading in figures and draperies—the representation is more conceptual than natural. The draperies do not convey a sense of organic bodily movement in space, and the figures are essentially, if not exactly, frontal. The absence of perspective is evident in Christ's seated pose—he is not logically supported by the globe and hovers as if in midair.

On the two side walls of the apse are mosaics representing the court of Justinian and his empress, Theodora. On

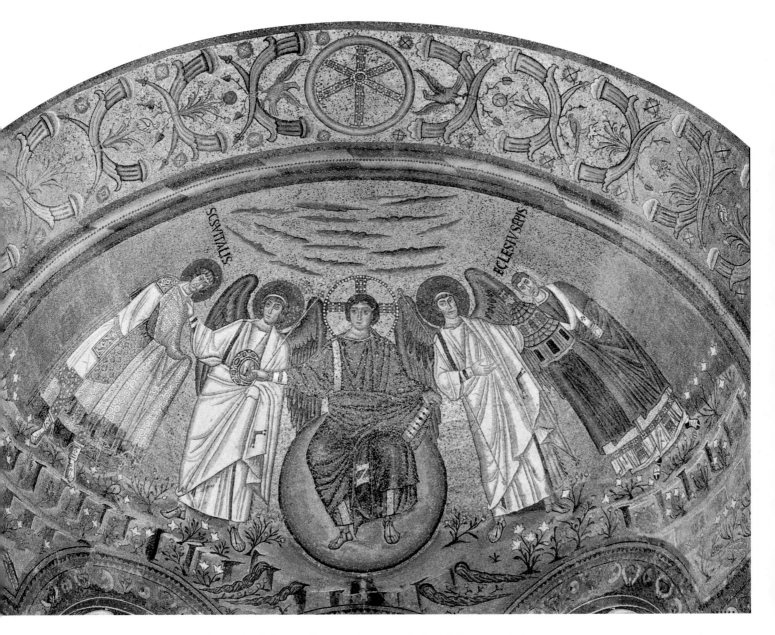

10.9 Apse mosaic showing Christ with San Vitale, Bishop Ecclesius, and two angels, San Vitale, c. A.D. 547.

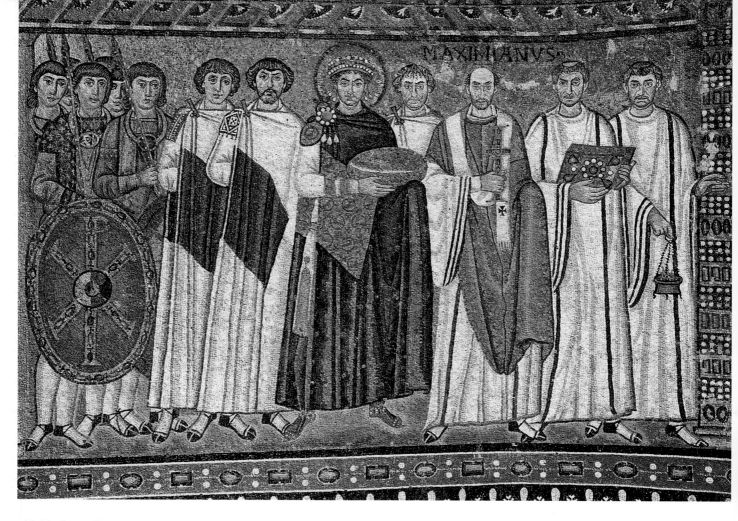

10.10 *Court of Justinian*, apse mosaic, San Vitale, c. A.D. 547. 8 ft. 8 in. × 12 ft. (2.64 × 3.65 m).

the viewer's left, and Christ's right, is Justinian's mosaic (fig. **10.10**). The central figure, the emperor, wears the same royal purple as Christ in the apse. On Justinian's left (the viewer's right), Archbishop Maximian wears a gold cloak and holds a jeweled cross. He is identified by an inscription and surrounded by three other members of the clergy. On Justinian's right are two court officials and his military guard. The large green shield is decorated with Constantine's *Chi-Rho*. The intention of this mosaic was clearly to depict Justinian as Christ's representative on earth and to show him as a worthy successor to Constantine—to express his power as head of both church and state.

Opposite Justinian's mosaic, Theodora stands in an abbreviated apse with her court ladies on the right and two churchmen on the left (figs. **10.11** and **10.12**). Like her husband, she wears a royal purple robe, and her head is framed by a halo. She offers a golden chalice, and her gesture is echoed by the three Kings bearing gifts that are embroidered in gold at the bottom of her robe. The figures in this mosaic, like those in Justinian's, stand in vertical, frontal poses. Their diagonal feet indicate that they are not naturally supported by a horizontal, three-dimensional floor. An illusion of movement is created by repetition and elaborate, colorful patterns, rather than by figures turning in space. A good example of this typical Byzantine disregard of perspective appears in the baptismal fountain on top of a Corinthian column at the left of the scene. The

bowl tilts forward; in a natural setting, this would cause the water to spill out, but here the water forms an oval, creating some degree of three-dimensional illusion. In contrast, Theodora's completely flat halo is a perfect circle.

The importance of light in Christian art is expressed in Byzantine mosaics such as these by the predominance of gold backgrounds and the reflective surfaces of the tesserae. Christ as "light of the world" provided the textual basis for such light symbolism in Christian art. The concept echoes various Eastern sun cults of earlier periods. Constantine, too, used the designation *Sol Invictus,* or Invincible Sun, for himself. So when the Byzantine artist depicted Justinian and Theodora with halos, it was to emphasize their combined roles as earthly and spiritual leaders.

The style of Justinian's and Theodora's heads is far removed from the type of Roman portraiture that preserved the features of its subjects. However, the stylistic distinction and positioning of figures according to their status have been retained. For example, the prominent position of Theodora's mosaic is a function of her status as co-regent with her husband. It is subordinate to Justinian's by virtue of being on Christ's left—traditionally a less exalted position than his right, and Theodora herself is placed farther back in the picture space than Justinian. As a result, her image is less imposing. The emphasis on rank and hierarchy rather than on personality or portraiture reflects the highly structured nature of Byzantine society.

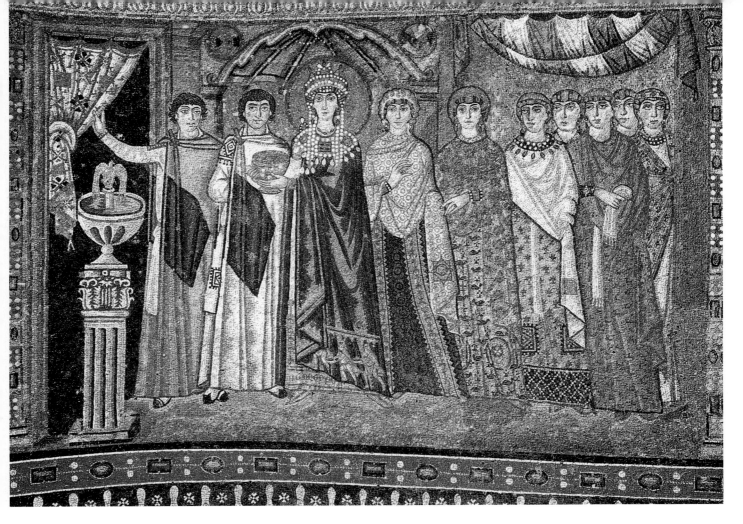

10.11 *Court of Theodora,* apse mosaic, San Vitale, c. A.D. 547. 8 ft. 8 in. × 12 ft. (2.64 × 3.65 m).

Theodora had lived a dissolute life as a courtesan before her notorious romance with Justinian. They were married in A.D. 523 and became co-regents of the Eastern Empire four years later. Theodora was a woman of great intelligence. Once in power, she devoted herself to a campaign of moral reform and advised Justinian on political and religious policy.

The symbolic character of these images is evident not only in their style and iconography but also in the virtual absence of any reference to the biographies of the emperor and empress. Since Justinian had never been to Ravenna, his mosaic had great political importance. It served both as his substitute and as a visual reminder of his power. At the same time, the flat gold background removes the scene from natural space and transports the figures into a spiritual realm. In so doing, the image also signifies Justinian's connection with God.

Note that in figure **10.12** there is still an attempt at shading on the side of the nose and under the chin. Removing the image from the illusion of naturalism, however, is the black outline. The tilted, irregular placement of the tesserae creates thousands of small, shifting planes, which reflect the outdoor light entering the church.

MEDIA AND TECHNIQUE
Mosaics

Unlike Hellenistic mosaic, made by arranging pebbles on the floor, Christian mosaic was made by adapting the Roman method of embedding tesserae in wet cement or plaster. Tesserae (from a Greek word meaning "squares" or "groupings of four") are more or less regular small squares and rectangles cut from colored stone or glass. Sometimes rounded shapes were used. The gold tesserae of the Byzantine style were made by pressing a square of gold leaf between two pieces of cut glass.

The term *mosaic* comes from the same word stem as *museum,* a place to house works of art, and *muse,* someone —usually a woman—who inspires an artist to create. When we muse about something, we ponder it in order to open our minds to new sources of inspiration. *Music,* another art form, is from the same stem as *mosaic.*

10.12 Detail of fig. **10.11.**

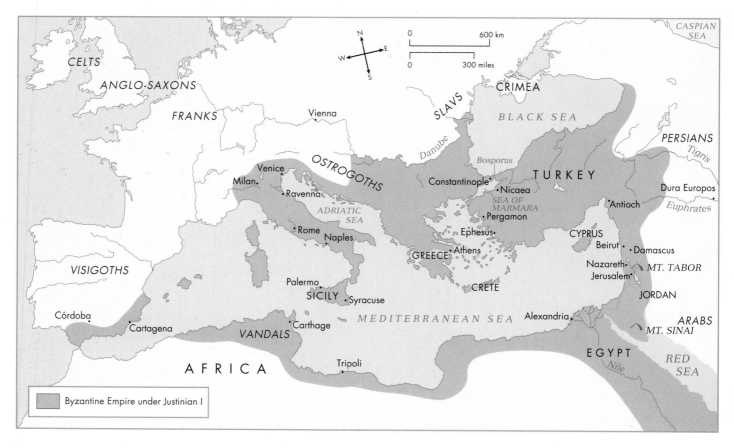

The Byzantine Empire under Justinian I, A.D. 565. Cultural groups are shown in red.

Hagia Sophia

The undisputed architectural masterpiece of Justinian's reign is the centrally planned church of Hagia Sophia (fig. **10.13**) in Constantinople. It was dedicated to Christ as the personification of Holy *(hagia)* Wisdom *(sophia)*. As part of a massive rebuilding campaign following the suppression of a revolt in A.D. 532, Justinian commissioned two Greek mathematicians, Anthemius of Tralles and Isidorus of Miletus, to plan Hagia Sophia. In their design they successfully combined elements of the basilica with enormous rising vaults (figs. **10.13** and **10.14**).

The central dome is placed above four arches at right angles to each other. The arches are supported by four huge piers, which are barely noticeable from the inside because the arches meet at the corners. Whereas in Roman buildings domes were placed on drums (see fig. **9.1**), the dome of Hagia Sophia rests on four **pendentives**—triangular segments with concave sides. Their appearance of suspension or hanging gives them their name (from the Latin word *pendere,* meaning "to hang"). They provide a transition from a square or polygonal plan to the round base of a dome or intervening drum, and they allow the architect to design larger and lighter domes. Pendentives are the principal Byzantine contribution to monumental architecture, and the central dome of Hagia Sophia is the earliest example of their use on such a grand scale. Hagia Sophia's dome was constructed of a single layer of brick—a relatively thin shell that minimized the weight borne by the pendentives. Nevertheless, the very size of the dome demanded buttressing. The exterior view (fig. **10.13**) shows that each of the forty small windows at the base of the dome is flanked by a small buttress, strengthening from the outside the interior juncture of dome and pendentives.

At the eastern and western ends of the square, two semicircles are topped by smaller half-domes. Surrounding each half-dome are three semicircular apses with open arcades surmounted by even smaller half-domes. Running from east to west along the axis are colonnaded side aisles on the first level and colonnaded galleries on the second level. Both are covered by groin vaults. Were it not for the central square, Hagia Sophia would resemble a typical centrally planned church, albeit on a massive scale. Note the impressive effect created by the open space of the nave, the high central dome, and the smaller half-domes.

On the north and south sides of the nave there are walls below the arches. As their load-bearing function has been assumed by the four piers, they can be pierced with arcades and windows (fig. **10.15**). (Nonsupporting walls, which usually have large expanses of windows or other openings, are called **screen walls.**) The extensive use of windows and arcades in Hagia Sophia creates an overwhelming impression of light and space. At the floor level, five arches connect the side aisles with the

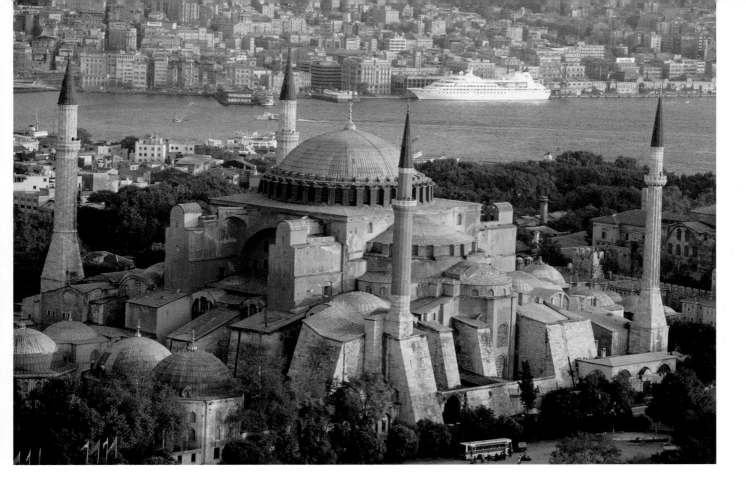

10.13 (Above) Hagia Sophia, Constantinople (now Istanbul, Turkey), completed A.D. 537. The four tall slender towers, **minarets,** were added when the Turks captured Constantinople in 1453 and Hagia Sophia was converted to a mosque. The Christian mosaics in the interior were largely covered over and replaced by Islamic decorations. Today, Hagia Sophia is a state museum.

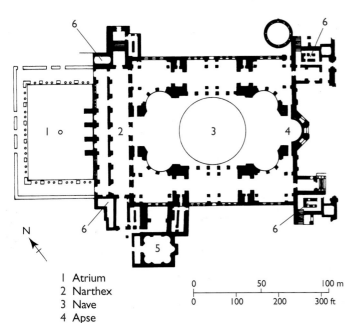

1 Atrium
2 Narthex
3 Nave
4 Apse
5 Baptistery
6 Minaret (added after 1453)
7 Dome over the nave
8 Pendentive
9 Lunette
10 Gallery

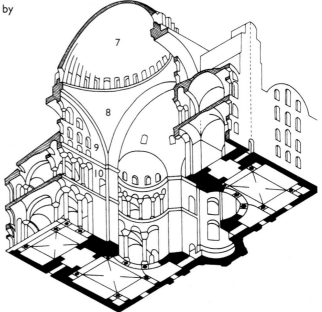

10.14a, b Plan and **axonometric projection** of Hagia Sophia. In the 6th century, one entered Hagia Sophia from the west, through an atrium that no longer survives (1 on the plan). The double narthex (2) was covered by a row of nine groin vaults. Passing through the narthex, one stood opposite the apse at the far eastern end. The path from narthex to apse, along a longitudinal axis, is reminiscent of an Early Christian basilica. However, instead of a long, symmetrical nave surmounted by a gable roof, Hagia Sophia has a huge central square supporting an enormous dome (3).

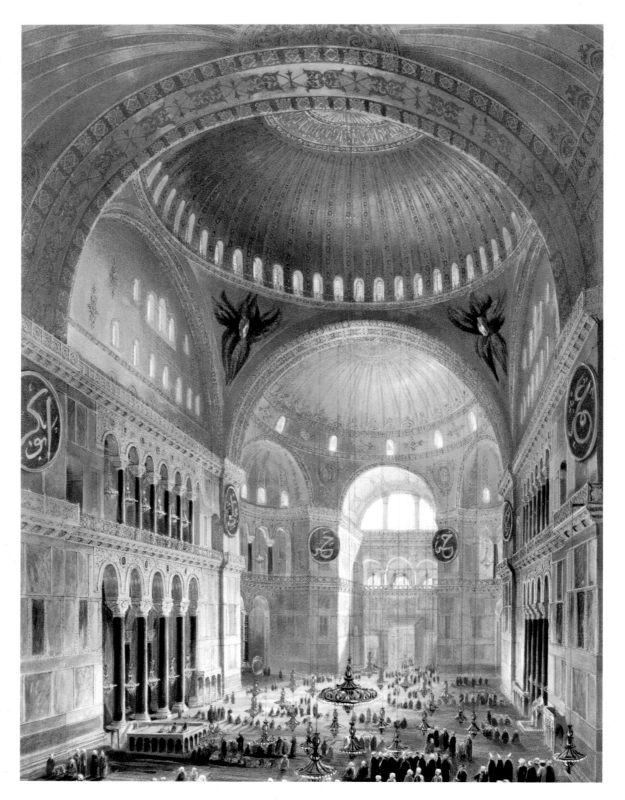

10.15 View of the interior of Hagia Sophia after its conversion to a mosque. Color lithograph by Louis Haghe, from an original drawing by Chevalier Caspar Fussati. This shows the dazzling effect of the mosaic decoration, which produced color and reflected light. Justinian's court historian described the dome as "a sphere of gold suspended in the sky."

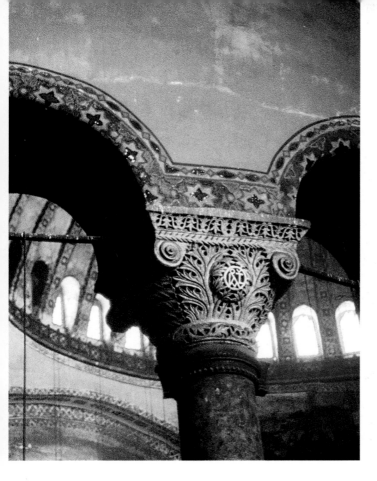

10.16 Detail of arcade spandrels and capital, Hagia Sophia.

CONNECTIONS

See figure 7.20. Diagram of an Ionic capital and the architrave.

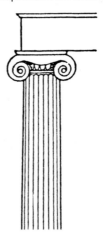

nave. Supporting these arches are large columns with intricately patterned capitals (fig. **10.16**), reminiscent of interlace. The small volutes reflect the persistence of Classical elements, although in rudimentary form. Here they have been overtaken by dazzling Byzantine patterns. At the second level, the galleries contain seven arches. The **lunettes**—the semicircular wall surfaces just below the top of the arches—have two rows of windows, five over seven. In each of the half-domes, there are five windows. Finally, a series of small windows encircling the bottom edge of the dome permits rays of light to enter from all directions.

Hagia Sophia was essentially an imperial building. Unlike San Vitale, it was the personal church of the emperor and his court, rather than a place of worship for the whole community. The clergy occupied one-half of the central space and the emperor and his attendants the other. Despite differences between San Vitale and Hagia Sophia, however, both buildings served Justinian's desire to unite Christendom under his leadership, to build churches, and to commission works of art that would express his mission as Christ's representative on earth.

The Codex

Toward the end of the first century, a new method of transmitting **miniature** imagery accompanying written texts came into use. This was the **codex**, the ancestor of the modern book. The Egyptians, Greeks, and Romans had used the papyrus scroll (*rotulus*) for texts and their illustrations. On average, a *rotulus* measured some 30 to 33 feet (9 to 10 m) in length when unrolled. The codex was more practical and easier to manage. Its pages were flat sheets of **parchment** (see Box) and of relatively sturdy **vellum** (calfskin). They were bound together on one side and covered like a book, which made the codex easier to preserve than the *rotulus*. It was also possible to illustrate ("illuminate") the pages with richer colors. The Latin poet Martial called the codex the "book with many folded skins," and he praised it because it held the complete works of Virgil in a single volume.

MEDIA
Parchment

Parchment is a writing surface prepared from the skin of a sheep or goat. The term is from the Greek *pergamina*, after the city of Pergamon in Asia Minor, where the monumental Hellenistic Altar of Zeus was located (see figs. **7.42** and **7.43**). It was at Pergamon that parchment was first used as a substitute for papyrus.

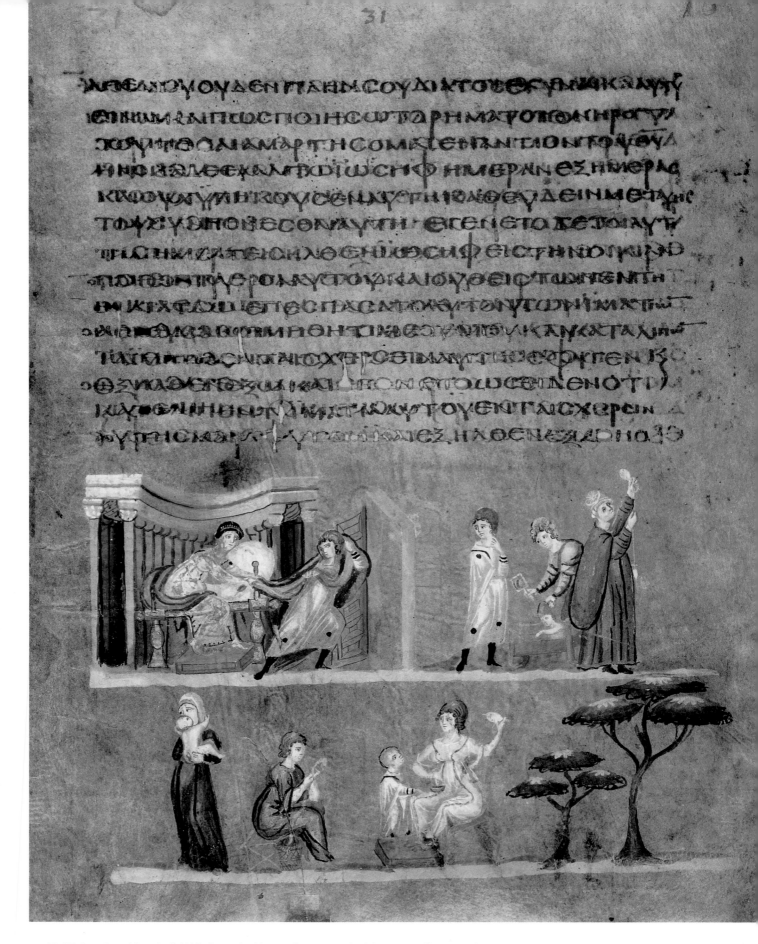

10.17 *Joseph and Potiphar's Wife,* from the Vienna Genesis, early 6th century. Illuminated manuscript. Nationalbibliothek, Vienna, Austria. It is not known where the Vienna Genesis was made, although it is believed to have originated in the Near East.

The Vienna Genesis

Among the earliest codices to illustrate scenes from the Bible is the Vienna Genesis (its name is derived from its current location, the Nationalbibliothek in Vienna). The codex originally had ninety-six folios (leaves, or pages), of which twenty-four survive; these have forty-eight miniature illustrations. Each sheet is purple, which points to an imperial patron, while the gold and silver script is characteristically Byzantine. Most of the page contains text, relegating the images to the bottom. Usually, as in figure **10.17**, more than one event is depicted on a page. The narrative is continuous, without frames or dividers between scenes, and it has been suggested that such narratives are related to the continuous spiral of scenes on Trajan's Column (see fig. **9.23**).

Figure **10.17** depicts events from the life of Joseph, recorded in Genesis. At the upper left, Potiphar's wife reclines in a colonnaded bedroom. She tries to lure Joseph, who turns to leave. To the right, continuing from the bedroom, Joseph gazes back toward the scene of the temptation he has resisted. An astrologer wearing a starry cape holds up a spindle. Between him and Joseph, Potiphar's wife tends a baby. In the lower register, identified as outdoors by the trees, one woman holds a baby while two others spin.

Later Byzantine Developments

The Byzantine style continued in Eastern and Western Christendom for several centuries following the age of Justinian. In the eighth and ninth centuries, the very nature of imagery became a subject of dispute. This is referred to as the Iconoclastic Controversy, in which the virtues and dangers of religious imagery were hotly debated. The Iconoclasts ("breakers of images"), centered in Eastern Christendom, followed the biblical injunction against worshiping graven images, and many of them destroyed works of art. They argued that images of holy figures in human form would lead to idolatry—worship of the image itself rather than what it represented. According to the Iconoclasts, it was permissible for religious art to depict designs, patterns, and animal or vegetable forms, but not human figures. The Iconophiles (those in favor of images) were centered in the West. They pointed to the tradition that Saint Luke had painted an image of the Virgin and Child (see fig. **15.40**). In 726 the Iconoclasts gained the support of Emperor Leo III and in 730 succeeded in having an edict issued against graven images, which contributed to the relatively minor role of sculpture in Byzantine art.

An icon (usually a panel painting), as opposed to a work with iconic quality, is an image whose purpose is purely devotional. A good example is the icon of Saint Peter from the monastery of Saint Catherine on the Sinai peninsula (fig. **10.18**). It shows the bearded saint with a halo, a long

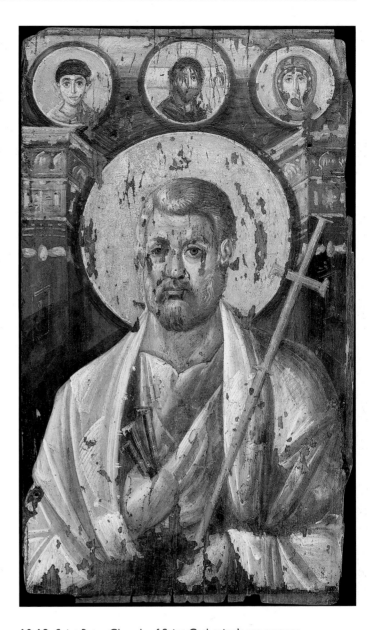

10.18 *Saint Peter*, Church of Saint Catherine's monastery, Mount Sinai, Egypt, 6th or 7th century.

cross, and his traditional attribute of the keys to heaven. The degree to which Early Christian icons absorbed elements from pagan styles is reflected in the Roman drapery with shaded folds and in the relatively naturalistic treatment of the face and neck. The halo is flat, but the buildings behind the figure recede in perspective.

When the edict was eventually lifted in 843, the Iconophile victory led to a revival of image-making and renewed artistic activity in the Byzantine world. Mosaics and paintings were now officially encouraged, but sculpture—because it is three-dimensional—remained unacceptable to the Eastern Church.

A mosaic detail of the thirteenth century from Hagia Sophia (fig. **10.19**) reflects late developments in Byzantine style. Compared with the mosaics of Justinian and Theodora at San Vitale, this image of Christ reveals a revived interest in the organic forms of Classical art. Whereas Justinian and Theodora were portrayed frontally, outlined in black, and without personality, this Christ turns his head slightly and has a facial expression. At the same time, however, the mosaic retains Byzantine elements. Although the drapery folds on the right are somewhat shaded, those on the left are rendered by dark blue lines. The background is gold and the halo is entirely flat. The letters *IC* on the left and *XC* on the right stand for "Jesus Christ."

This image illustrates both the persistence of artistic style and its accessibility to change. Although created in the Eastern Empire and located in the world's greatest Byzantine church, it contains elements of pre-Christian, Hellenistic, and Roman styles. The Eastern and Western traditions would continue to exist side by side in the West for several centuries, but eventually Greco-Roman influences would triumph.

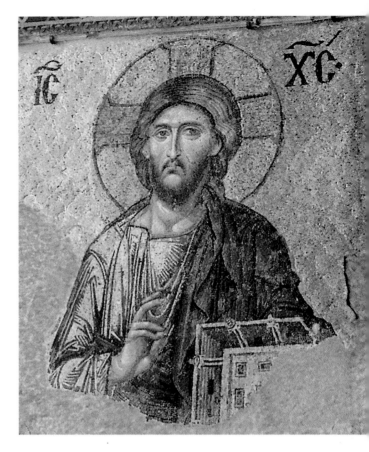

10.19 *Christ*, detail of a **Deësis** mosaic, showing Christ flanked by the Virgin and John the Baptist, Hagia Sophia, 13th century. Shading is evident in the cheeks, neck, and right hand. The edges of Christ's form are indicated by slight shading rather than a black outline. The deep eye sockets, the bags under the eyes, and the downward curve around the mouth endow him with a rather melancholy character.

300 **500** **1600**

JEWISH AND EARLY CHRISTIAN		BYZANTINE	
c. A.D. 100–500		c. 500–1600	
			LATER BYZANTINE

 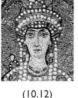 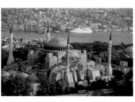 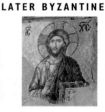

(10.2) (10.5) (10.10) (10.12) (10.13) (10.19)

| Catacombs in Rome (c. 100) | Constantine rules as Roman emperor (306–337) | Edict of Milan (313) | Old St. Peter's (4th century) | Augustine's *City of God* (426) | Justinian rules as Byzantine emperor (527–565) | Iconoclastic Controversy (726) | First Crusade (1095) | Andrei Rublev (1370–1430) | Turks capture Constantinople (Byzantium) (1453) | Ivan IV (The Terrible) tsar of Russia (1547) |

11

The Early Middle Ages

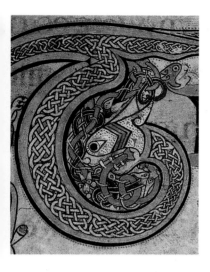

In Western Europe, the term *Middle Ages* generally designates the period following the decline of the Roman Empire through the thirteenth century. Early Middle Ages, as used here, covers the time from the seventh to the end of the tenth century.

As the Roman Empire declined, Germanic tribes overran Western Europe, affecting artistic developments and producing radical changes in social and political organization. In addition to the Germanic invasions, a powerful new influence from the Middle East entered Europe—Islam.

Spain had been part of the Roman Empire until A.D. 414, when it was overrun by the Visigoths. They ruled until 711, the date of the invasion of the Moors, who came from the Roman province of Mauretania in northwest Africa. The Moors had in turn been conquered during the seventh century by Arabs, who converted them to Islam. The Moorish occupation of Spain lasted until the thirteenth century, by which time Christians had reclaimed all but the kingdom of Granada. The final unification of Spain under Christian rule took place in 1492.

Islamic Art

Muhammad's teaching forbade idolatry, and the Koran condemns the figurative representation of Allah or his prophets. Islamic religious painting thus consists mainly of abstract geometric and floral patterns. Sculpture was considered the work of Satan and is virtually nonexistent in Islamic art. Monumental architecture and architectural decoration, on the other hand, flourished under Islam.

The primary architectural expression of Islam is the **mosque,** where Muslims pray, kneeling and facing Mecca. In the early days of Islam, the faithful prayed in any available building or space, provided it was oriented toward Mecca. The main features that all mosques have in common are a **sahn,** or enclosed courtyard, and a **qibla,** or prayer wall. The *qibla* frequently has a **mihrab** (small niche) set into it, indicating the direction of Mecca. By the end of the seventh century, Muslim rulers were beginning to build larger and more elaborate structures. The exterior of a typical mosque includes tall minarets, such as those

added to Hagia Sophia when it was changed from a church to a mosque (see fig. **10.13**). From these towers, a *muezzin* (crier) calls the faithful to prayer at certain times each day (see Box).

The Great Mosque, Córdoba

As Islam spread to the West, new mosques were needed. In the eighth century, the first Muslim ruler of Spain, Abdar-Rahma-n I, had a mosque built in his capital at Córdoba. This mosque is one of the most striking examples of Islamic architecture in the Western style. After its original construction, it was enlarged several times (fig. **11.1**). In the thirteenth century, Christians turned it into a church.

The system of double arches devised by the mosque's original architect is unique, and it was used in each later addition. Filling the interior are numerous columns either derived or salvaged from Roman and Early Christian buildings (fig. **11.2**). These columns were relatively short—just 9 feet 9 inches (3 m) high. If they had supported the arches and vaults at that height, the interior illumination would have been inadequate. Therefore, the architect constructed a series of horseshoe-shaped red-and-white-striped arches (using voussoirs of alternating red and white stone bricks). To this he added a second series of arches springing from piers and also supported by the Roman columns. A wooden roof rested on the second set of arches. (It was replaced by vaulting in the sixteenth century.) The vast numbers of columns have been likened to a forest, and the colored arches create an impression of continual motion that enlivens the interior.

As part of the second expansion phase in 961, the caliph ruling at Córdoba built a magnificent *mihrab* marking the *qibla* wall. To its north is an area reserved for the caliph and his retinue. This consists of three domed chambers entered through three tiers of lobed arches (fig. **11.3**). They crisscross each other to form an interlaced screen. The domes are built in an intricate geometric pattern on eight intersecting arches or **ribs**. The central dome and the *qibla* wall have elaborate Byzantine-inspired mosaics with gold backgrounds (fig. **11.4**).

In the thirteenth century, Christians gained control of the mosque. Three centuries later it was badly damaged when they built a **cathedral** inside it. King Charles I of Spain had consented to its construction but expressed displeasure when he saw the result. However, enough of the original mosque survives to convey the magnificence of its design and the beauty of its original ornamentation.

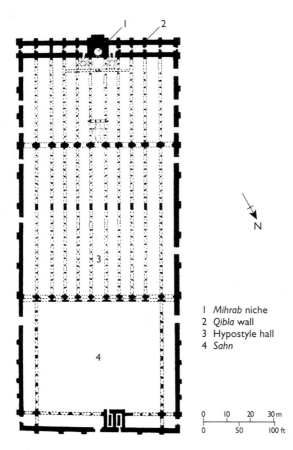

1 *Mihrab* niche
2 *Qibla* wall
3 Hypostyle hall
4 *Sahn*

11.1 Plan of the Great Mosque, Córdoba, Spain, originally built 786–787; additions 832–848 and 961. The additions of 832 to 848 and 961 are shown, but not the final enlargement of 987. The mosque is a rectangular enclosure with its main axis pointing south, toward Mecca. Because Spain lies west of Mecca, this orientation is symbolic rather than exact.

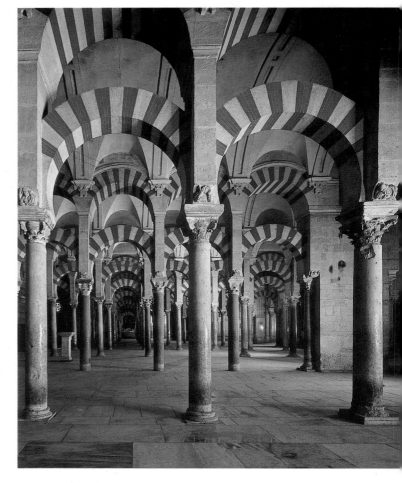

11.2 Arches of the Great Mosque, Córdoba, Spain, begun 785–786. Columns 9 ft. 9 in. (2.97 m) high. The large interior space is at present bigger than any other Christian church.

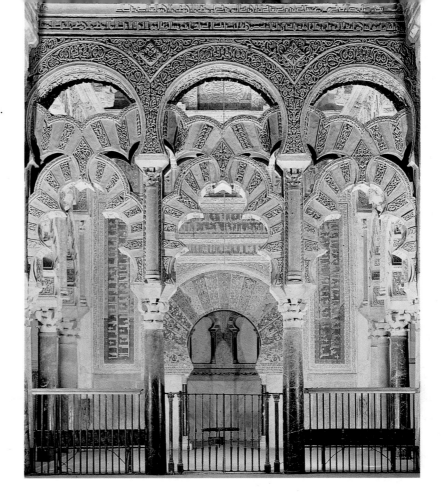

11.3 *Mihrab* bay in the Great Mosque, Córdoba, Spain.

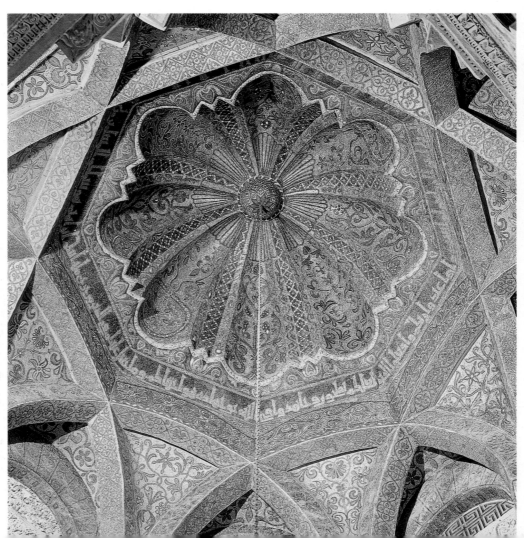

11.4 Dome in front of the *mihrab*,
Great Mosque, Córdoba, Spain,
c. A.D. 961–976. Mosaic.

Northern European Art

The early medieval Islamic influence on Western Europe and its art remained in the south, for the Frankish ruler Charles Martel halted the Muslim invasion of Europe at Tours, in central France. The north became a new focus of political and artistic activity. It was influenced more by the Germanic tribes than by either Islam or the Hellenistic-Roman tradition. The Germanic Angles and Saxons had invaded the British Isles in the fifth century A.D., and the Franks had invaded Gaul (hence the name France). Because of these continual waves of invasion, no monumental architecture, painting, or sculpture was produced. Instead, a new craft-based art developed that was inspired by the designs and techniques of the metalwork brought by the invaders.

Anglo-Saxon Metalwork

A good example of Anglo-Saxon metalwork is the seventh-century cover of a purse, originally containing gold coins, from Sutton Hoo in East Anglia on the southeast coast of England (fig. **11.5**). It was discovered among the treasures of a pagan ship burial—a practice indicating the belief that boats carried the souls of the dead to the afterlife. The circumstances of the burial suggest that the deceased was a royal personage, for the ship contained an abundance of treasures. The Anglo-Saxon epic *Beowulf* describes the lavish burials of kings with armor and other valuable objects (see Box).

The purse cover's decoration is of gold, **cloisonné enamel**, and dark red garnets. It combines Early Christian **interlace** designs and those of Germanic crafts with aspects of the Scythian animal style (see fig. **4.24**) and other ancient Near Eastern motifs. The taste for flat, crowded interlace patterns became an undercurrent in Western Europe that continued through the Middle Ages. Organic form was largely eliminated.

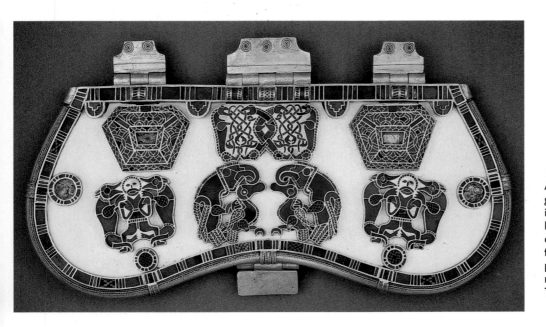

11.5 Sutton Hoo purse cover, from East Anglia, England, c. A.D. **630**. Gold with garnets and cloisonné enamel, originally on ivory or bone (since lost), 8 in. (20.3 cm) long. British Museum, London. In the cloisonné technique, liquid enamel of different colors is poured into *cloisons*, compartments formed by a network of thin metal strips, to create surface decoration. The top of the metal remains exposed.

11.6 *Lion Symbol of Saint John,* from the Book of Durrow, fol. 191v, after A.D. 650. Illuminated manuscript, 9⅝ × 5¾ in. (24.5 × 14.5 cm). Library of Trinity College, Dublin, Ireland. This manuscript originally came from either Ireland or Northumbria in England. The folio represents Saint John the Evangelist as a lion surrounded by a rectangular border filled with interlace. Later, Saint John's symbol was changed to an eagle.

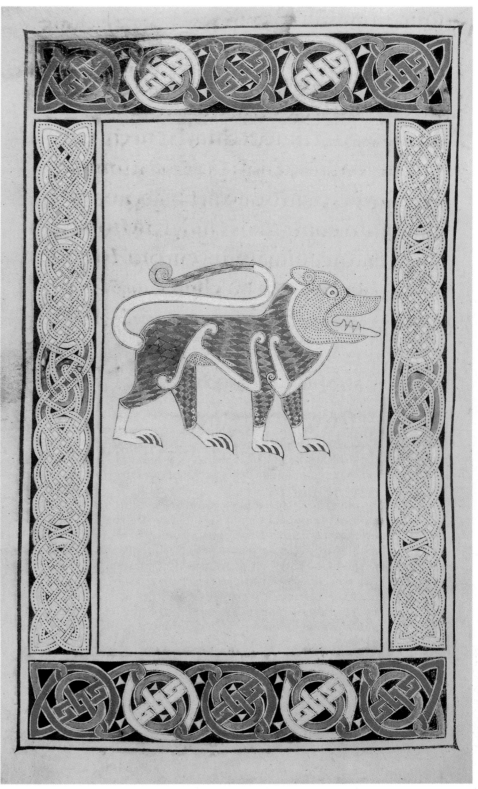

The decoration on the purse cover is symmetrical. At the top, two geometric shapes filled with gold tracery flank a centerpiece containing two fighting animals whose legs and jaws are extended into a tracery of intertwined ribbons. This technique, in which animals merge into a design or into each other, is also characteristic of the much earlier Scythian gold objects. Below, in the center of the purse cover, are two sets of animals. An eagle and a duck face each other and are symmetrically framed by a pair of frontal men flanked by animals in profile. This latter motif derives from ancient Near Eastern iconography. Such merging animal forms suggest that waves of invaders from the fifth century onward brought their artistic styles with them.

Hiberno-Saxon Art

Because of its remote location, Ireland escaped occupation by the Romans in the first and second centuries and invasion by the Germanic hordes in the fifth century. Saint Patrick (c. 387–463) introduced Christianity into Ireland in the first half of the fifth century, and for the following 250 years Irish **monasteries** provided a haven for European scholars, becoming centers of Classical and theological studies. In the early Middle Ages, missionaries from Ireland were partly responsible for the spread of the Christian faith in Europe. Among them was the Irish abbot Saint Columba, who established an outpost on the island of Iona from 563 to 597 and converted Scotland to Christianity.

During this period there was an expansion of Christian art in Ireland, on various other islands off the coasts of northern Britain, and at centers on the British mainland. Its style has been called Insular and Hiberno-Saxon (*Hibernia* is Latin for "Ireland").

Manuscript Illumination A typical use of pagan interlace in Christian art occurs in the illuminated **manuscripts** produced by monks in Irish and English monasteries. The main impetus for their style may have originated in Ireland; from there it infiltrated England and other parts of Western Europe.

The page in figure **11.6** is a relatively early example of medieval manuscript illumination. The lion is in profile, its mouth open and teeth bared as if it is growling or roaring. Note the dense patterning of the surface of its body with

red and green diamond shapes. They are accentuated by a yellow outline that merges into stylized muscle, yellow feet, and a tail. These colors, as well as the dot pattern on the face, are repeated in the interlace inside the border, creating a strict unity of color and form. On the border, the reds are reserved for the upper and lower sections, thereby repeating the horizontal of the lion's body as well as its color arrangement. The edges are crisp and clear, the colors contrasting, and the surfaces flat. Design-driven optical illusions are created in the interlace, as if a ribbon had been threaded and rethreaded through itself. This kind of illusory mazelike play was to become more complex in the course of the Middle Ages. Such early medieval illuminated manuscripts from northern Europe create a world of images that seems totally independent of the humanistic tastes of Greco-Roman tradition (see Box).

Perhaps the most famous medieval Hiberno-Saxon illuminated manuscript is the Book of Kells, from the late eighth or early ninth century. Its text consists of the four Gospels, written in Latin in 680 pages. The color and form of the illuminations have become more complex, and figures literally emit letters and shapes from their mouths (fig. **11.7**). In the *T* of *Tunc,* for example, the two arms of the letter stretch into the legs and claws of a lion or dragon. Its head is part of the left border, and its gaping jaws eject a series of colorful ribbonlike forms—probably a stylized representation of flames. The inside of the curve of the *T* contains additional interlacing—notably fishlike creatures with prominent eyes. The large white fish emerging from the lower curl of the *T* bites the thick red interlace. This in turn metamorphoses into the ears of the little green fish at the upper right. Human forms have also been added. Three sets of small human heads appear in rectangular spaces, two on the right of the page and one on the left. The attention that this artist has given to the painting—especially to the open mouths of the lion or dragon and the white fish—is actually quite common in manuscript illumination. It was to continue in border imagery throughout the Middle Ages.

Besides the obvious visual pleasure these designs gave to their artists as well as their viewers, their purpose was to illuminate the "Word of God." Since the fish was an early symbol of Christ, its presence on a page of text describing the Crucifixion denotes Christ's role as the Savior. The text, which states that Christ was crucified with two thieves, is fitted within a large *Chi* (written as *X*). This repeats the beginning of Christ's Greek name and is also a visual reference to the Cross. The formal interlacing that characterizes these manuscripts is thus echoed in the integration of the iconography into text.

The Carolingian Period

The era of the Book of Kells corresponds to an important historical landmark in Western Europe. On December 25,

MEDIA AND TECHNIQUE
Manuscript Illumination

Illuminated manuscripts are hand-decorated pages of text. Great numbers of these texts were needed because of the importance of the Bible, especially the Gospels, for the study and spread of Christianity. Most were made during the Middle Ages in Western Europe, before the invention of the printing press. (The Chinese are thought to have used movable type as early as the eleventh century, but printing was not known in Europe before the fifteenth century.) Medieval manuscripts were copied in monastery **scriptoria** (Latin for "writing places"). Medieval scribes had to know Latin, have good penmanship and excellent eyesight, and be able to read the writing of other scribes whose manuscripts they were copying.

It is not known what tools the scribes had for illuminating manuscripts, although it is obvious that compasses and rulers were used for the geometric designs. The magnifying glass had not yet been invented. Pigments consisted of minerals and animal or vegetable extracts, which were mixed with water and bound with egg whites to thicken the consistency. The paint was applied to vellum (as in the early codex), which is high-quality calfskin, specially prepared and dried for manuscripts.

800, the pope crowned Charlemagne (Charles the Great) Roman emperor at St. Peter's in Rome. When Charlemagne came to power, he ruled a large part of Western Europe, including France, Germany, Switzerland, Belgium, Holland, northern Spain, and Italy to the south of Rome. Until the nineteenth century, this territory was to be the subject of extensive political and religious controversy between the popes in Rome and the German emperors. It was named the Holy Roman Empire in the thirteenth century and lasted as such for more than six hundred years (see map). Charlemagne was also king of the Franks from 771 to 814.

He created a cultural revival to enhance his imperial image in the tradition of ancient Rome. The term used to describe this period—*Carolingian*—derives from the name of Charlemagne's grandfather, Charles Martel (*Carolus* is Latin for "Charles"), who defeated the Muslim invasion at Tours. Under Charlemagne, monasteries expanded the

11.7 (Opposite) *Tunc Crucifixerant XPI,* from the Book of Kells, fol. 124r, late 8th or early 9th century. Illuminated manuscript, 9½ × 13 in. (24 × 33 cm). Library of Trinity College, Dublin, Ireland. This is a page from the Gospel of Matthew (27:38). The scribe has written, "Tunc crucifixerant *XPI* cum eo duo latrones" ("Then they crucified Christ and, with him, two thieves").

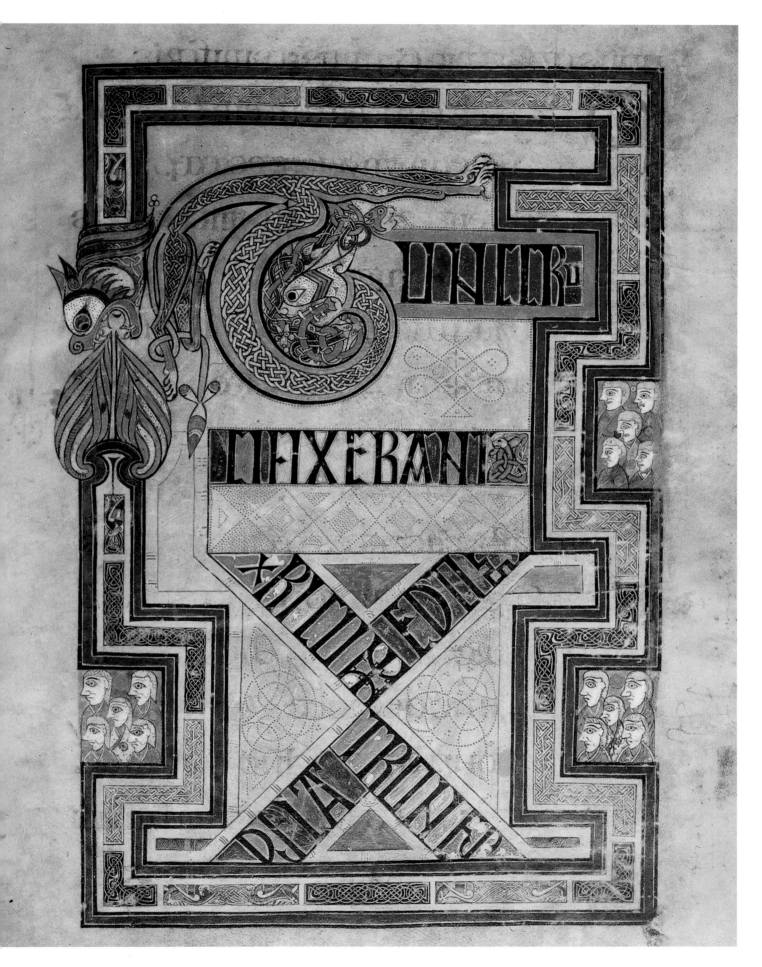

network of learning throughout Europe in which Latin, as the language of the manuscript texts, was kept alive. In addition to the Latin language, Charlemagne wanted to revive other aspects of the Roman past. He established a political organization based on that of ancient Rome and a unified code of laws, created libraries, and pursued a program of educational reform. His identification with Rome and its emperors can also be seen in his adoption of the equestrian portrait in figure **11.8**.

To improve education in his empire, Charlemagne hired the English scholar Alcuin of York and invited him to his court at Aachen. Alcuin organized cathedral and monastic schools to promote Latin culture and language. He adopted a Roman curriculum and grammar book that set the standard in Western European schools until the end of the Middle Ages. The curriculum was divided into two sets of disciplines based on the Seven Liberal Arts. The *trivium* consisted of grammar, rhetoric, and dialectic, and the *quadrivium* of geometry, arithmetic, astronomy, and music.

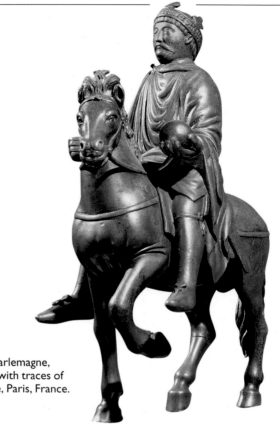

11.8 Equestrian statuette of Charlemagne, from Metz, 9th century. Bronze with traces of gilt, 9½ in. (24.1 cm) high. Louvre, Paris, France.

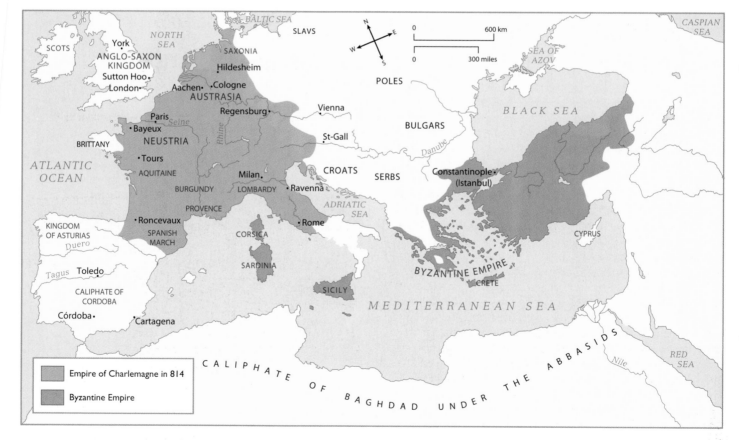

The Holy Roman Empire under Charlemagne in 814 and the Byzantine Empire.

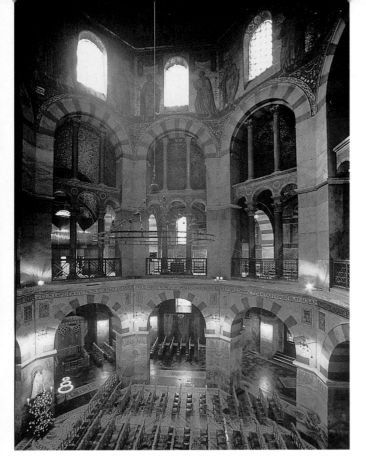

11.9 Odo of Metz, interior of Charlemagne's palace chapel, Aachen, 792–805.

The Palace Chapel

In the last decade of the eighth century, Charlemagne moved his capital and his court to Aachen (Aix-la-Chapelle in French), 45 miles (72 km) southwest of Cologne, near the modern Belgian–Dutch border. There he constructed a palace, together with offices, workshops, and other buildings. Of particular architectural importance was the palace chapel, which doubled as Charlemagne's personal chapel and a place of worship for the imperial court (figs. **11.9–11.11**).

The palace chapel has certain features in common with the Church of San Vitale in Ravenna (see p. 159). Both are large, sturdy, centrally planned buildings; San Vitale is octagonal, and the palace chapel has a sixteen-sided outer wall and an octagonal central core surrounded by an ambulatory supporting a gallery. The gallery opens onto the central area through a series of arches, which allowed Charlemagne and his entourage to observe the celebration of the Mass. At the third level, the central core rises to a clerestory. To the front of the palace chapel, a square entrance flanked by round towers was added, with tower stairs leading to a throne room at the level of the gallery. Originally the chapel also had a walled courtyard around the entrance. From here visitors could catch a glimpse of the emperor at a window in the second level of the façade. This appearance of the ruler was an old royal tradition dating back to ancient Egypt and equating the ruler with the Sun.

Like Justinian, Charlemagne used the arts to enhance his political image. His architect, Odo of Metz, revived the massive piers and round arches of ancient Rome, which reinforced Charlemagne's claim to the Holy Roman Empire. As in the Colosseum (see fig. **9.12**), the supports of the palace chapel decrease in size as they rise, creating a sense of greater weight at ground level. In the gallery, triple arches are aligned with single round arches, and two central columns with Corinthian capitals stand between each set of piers. The result is a combination of the Justianic central plan with the monumental symmetry and order of the Roman buildings.

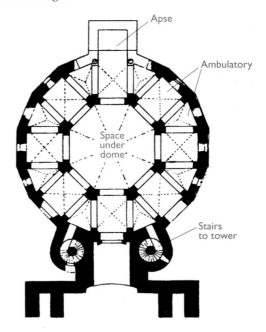

11.10 (Above) Plan (restored) of Charlemagne's palace chapel, Aachen.

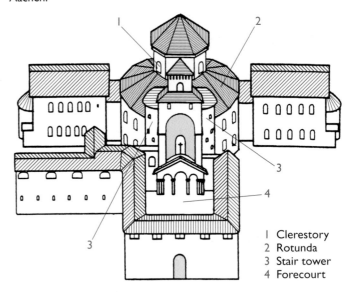

1 Clerestory
2 Rotunda
3 Stair tower
4 Forecourt

11.11 Reconstruction drawing of Charlemagne's palace chapel, Aachen.

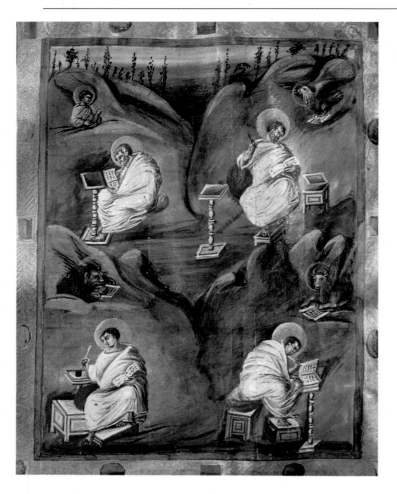

11.12 *Four Evangelists*, from a Carolingian Gospel book, Palace Chapel school, Aachen, early 9th century.

Manuscripts

Since education was an important aspect of Charlemagne's Roman revival, manuscripts played a significant role in his efforts to restore the culture of antiquity. Charlemagne's court at Aachen was the hub of his empire, but manuscripts were portable and thus a practical form of artistic and educational communication.

The *Four Evangelists* (see Box), from a Carolingian Gospel book illustrated in figure **11.12**, include the saints' symbols set in a landscape indicated by rolling hills. The oblique writing desks and stools define three-dimensional space, while the draperies define the forms and natural movement of the figures. The artist probably came from Constantinople, where the Hellenistic traditions had persisted most strongly.

After Charlemagne's death, a more apocalyptic approach to manuscript painting became the norm in French monasteries. At Tours, in central France, the Vivian Bible, named for the lay abbot Count Vivian, was dedicated to Charles the Bald around 845 to 846. The frontispiece to the Gospels, showing Christ in Majesty with the four Evangelists (fig. **11.13**), reflects a divergence from the Classical style as Charlemagne's revival of Roman antiquity waned.

The space is flatter, and the figures are connected by geometric designs rather than by landscape. In Christ's swirling drapery, the artist departs from the more Classical drapery of the Carolingian Gospels. The Vivian Christ is suspended weightlessly on a flat circle representing the globe, and he is frontal. Although the Evangelists turn in space and their footstools are rendered obliquely, their poses are exaggerated. Saint Mark, in particular, twists his neck unnaturally. Compared with the manuscript paintings produced under Charlemagne, this and other later examples have a frenzied, agitated quality.

Monasteries

Of all the institutions in Western Europe during the Middle Ages, the monastery was particularly important to Charlemagne's plan for controlling conquered territory and directing reforms in art and education. Each monastery included a school, creating a network through which artists and scholars could communicate. The monastery was also a religious and administrative center, and it performed an economic function through agricultural production. Monasticism is a way of religious life in which the

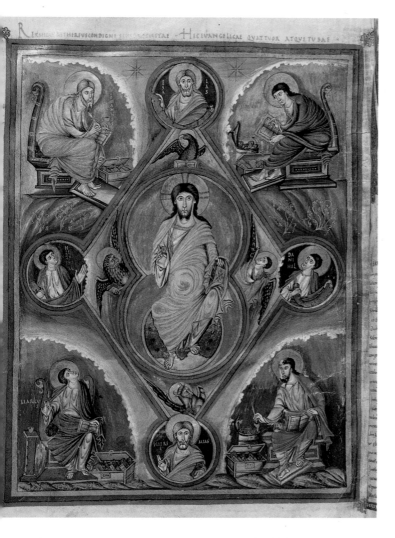

11.13 *Christ in Majesty*, Vivian Bible frontispiece, fol. 329v, c. 845–846. Bibliothèque Nationale, Paris, France.

individual takes vows of chastity, obedience, and poverty, and serves God in relative seclusion. Monasticism began in the pre-Christian era among Middle Eastern Jews. The first Christian monks date from the third century. Some chose to live as hermits, isolating themselves individually from society and devoting themselves to prayer. Others withdrew into communal groups that formed the basis of the monastic tradition.

Many monks became expert in a particular art or craft, and the monasteries played an important role in medieval cultural life and education. Works of literature, science, and philosophy, in addition to religious texts, have survived in copies handwritten in the scriptoria of monasteries.

Charlemagne decided that monasteries should follow the Benedictine Rule, a series of regulations devised by Saint Benedict of Nursia in the sixth century. According to Benedict's Rule, monks should live communally under the supervision of an abbot, devoting themselves to a strict routine of work, study, and prayer. In 816–817, Charlemagne convened a council of abbots at Aachen to discuss the Rule and draw up a standard plan for Benedictine abbeys. The council sent this plan to the abbot who was rebuilding the St. Gall monastery in Switzerland (fig. **11.14**).

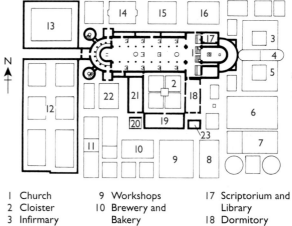

1	Church	9	Workshops	17	Scriptorium and
2	Cloister	10	Brewery and		Library
3	Infirmary		Bakery	18	Dormitory
4	Chapel	11	Stables	19	Refectory
5	Novitiate/	12	Animal pens	20	Kitchens
	Infirmary	13	Hostel	21	Cellars
6	Orchard/	14	Guesthouse	22	Hospice for the
	Cemetery	15	School		poor
7	Garden	16	Abbot's house	23	Baths and latrines
8	Barn				

11.14 Plan of the monastery of St. Gall, Switzerland, c. 820. This plan was drawn from a tracing on five pieces of parchment, itself taken from an earlier document, from which scholars have reached various conclusions about monastic life and architectural practice during the Carolingian period. The design of the monastery placed the church at the center and the buildings adjacent to it in approximate order of importance. The library and scriptorium were attached to the church, not far from the main altar. To the north were the abbot's house (connected to the transept by a private passage), a guesthouse, and a school. The school fulfilled Charlemagne's mandate that monasteries should provide education even for those not intending to take holy orders.

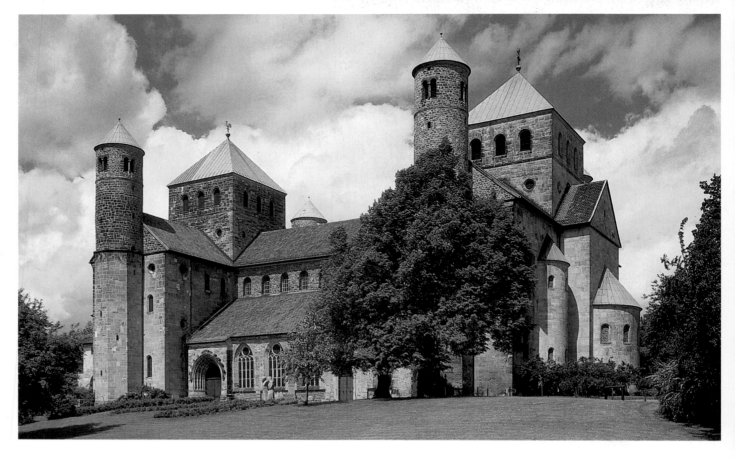

11.15 Restored abbey church of St. Michael's, Hildesheim, c. 1001–31. The building was destroyed during World War II.

Ottonian Period

Charlemagne's grandsons were ineffective rulers, and by the end of the ninth century Europe again fell prey to invaders. Vikings took over Normandy (in northern France), and Saxons resumed control of Germany. The Saxon emperor Otto I the Great (936–973) was crowned by the pope in 962. Otto I continued Charlemagne's revival of Classical antiquity as a way of reinforcing his own imperial position.

"Ottonian" refers to the three rulers named Otto who stabilized the Holy Roman Empire after disruptions following Charlemagne's death. Their empire included only Germany and parts of northern Italy and was therefore smaller than Charlemagne's. The major architectural work of this period was the Benedictine abbey church of St. Michael's at Hildesheim (figs. **11.15** and **11.16**). It was commissioned by Bernward, bishop of Hildesheim (c. 960–1022), who had been the tutor of Otto III. Both visited Rome, where they studied ancient ruins.

The metalwork at Hildesheim may show the impact of Roman influence on Bernward and Otto. An impressive surviving example, commissioned before 1015, is the pair of bronze doors originally at the entrance (fig. **11.17**), the first large-scale works cast in one piece since antiquity. The emphasis on typology is apparent in the left-right pairing of Old and New Testament scenes, which the medieval viewer would have understood as meaning that the former prefigured the latter (see p. 154). The scenes, depicted in relatively high relief, are characterized by thin, lively figures.

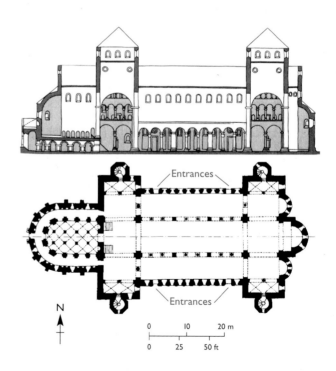

11.16 Section and plan of St. Michael's, Hildesheim.

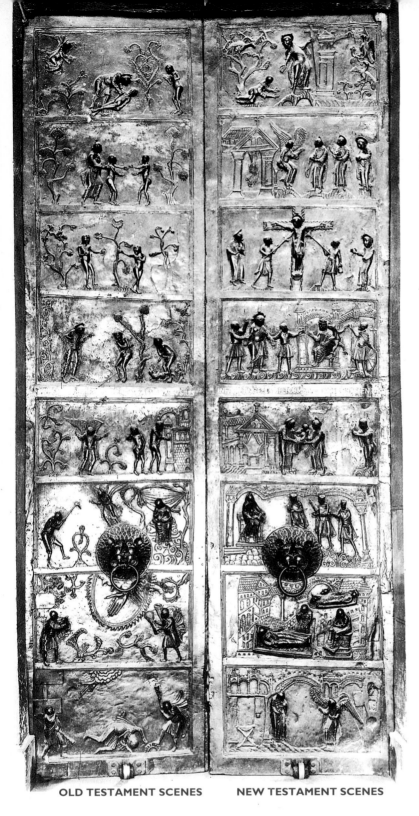

OLD TESTAMENT SCENES **NEW TESTAMENT SCENES**

11.17 Bronze doors, St. Michael's, Hildesheim, completed 1015. 16 ft. 6 in. (5.02 m) high. According to a contemporary biographer, Bishop Bernward was himself an expert goldsmith and bronze caster. He stayed with Otto III at his palace in Rome.

500 1000

THE EARLY MIDDLE AGES

Events described in *Beowulf* (6th century)

(11.5)
Death of Muhammad (632)

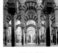
(11.4)
The Venerable Bede (673–735)

(11.2)
Dome of the Rock (late 7th century)
Moors conquer Spain (711–715)

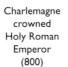
Charlemagne crowned Holy Roman Emperor (800)

Vikings invade England (c. 866)

(11.7)
Beginning of Ottonian rule (936)

(11.15)
Bishop Bernward (c. 960–1022)

12

Romanesque Art

The term *Romanesque* ("Roman-like") refers to a broad range of styles, embracing the regional variants that flourished in Western Europe in the eleventh and twelfth centuries. It is a stylistic rather than a historical term, intended to describe medieval art that shares with ancient Roman architecture such features as round arches, stone vaults, thick walls, and exterior relief sculpture. Since Europe at this time was a patchwork of regions, rather than of nations with centralized political administrations, scholars identify the various styles by the name of the relevant region—for example, Norman Romanesque (from Normandy).

Reflecting the relative stability and prosperity of the Christian Church, there was an enormous surge in building activity, especially of cathedrals, churches, and monasteries. Monasteries owned significant tracts of land, which enhanced their political and economic power. This contributed to a revival of architectural sculpture and the ornamentation of Christian buildings. Hundreds of examples of Romanesque art survive, especially in France, where the most innovative works were created.

Economic and Political Developments

During the late ninth century the Muslims continued their expansion in the South, and from the East the Magyars (an Eastern European tribe whose language is related to Finnish) advanced in search of a permanent home. From the north came the Vikings, who occupied Normandy, in northwest France. By the second half of the eleventh century, the threat of invasion had decreased largely because many pagans had converted to Christianity. The Magyars had settled in present-day Hungary. The Vikings had also become Christians, and their leaders were recognized as dukes by the French king. In 1066 William of Normandy (better known as William the Conqueror) invaded England, becoming its first Norman king and establishing feudalism as the pervasive social system in England (see Box). In the early twelfth century, the Normans, who were descended

from the Vikings, expelled the Arabs from Sicily and wrested control of much of southern Italy from the Byzantines. In Spain, Muslim dominance had declined, and the Christians, maintaining their resistance from the mountains in the north, were poised to recapture most of the Iberian Peninsula (modern Spain and Portugal).

The social structure of Western Europe was based on the feudal system, with the economic and political core centered in manorial estates. Kings, dukes, and counts, to whom lesser barons and lords owed their allegiance, ruled these manors. But there was no centralized political order, and the main unifying authority was the pope in Rome. The Church played a vital role in secular life, owning a large amount of landed property—close to a third in France—and claiming the same temporal authority as the kings and nobles.

SOCIETY AND CULTURE
Feudalism

Feudalism (from the Latin word *foedus*, meaning "oath") was the prevailing socioeconomic system of the Middle Ages. Under the feudal system, the nobility had hereditary tenure of the land. In theory, all land belonged to the emperor, who granted the use of certain portions of it to a king in return for an oath of loyalty and other obligations. The king, in turn, granted the use of land (including the right to levy taxes and administer justice locally) to a nobleman. He granted an even smaller portion to a local lord, for whom unpaid serfs, or peasants, worked the land. At each level of dependency, the vassal owed loyalty to his lord and had to render military service on demand. In practice, however, these obligations were fulfilled only when the king or lord had the power to enforce them. The principal unit of feudalism was the manor. In exchange for their services, the serfs were allowed to cultivate a part of the lord's land for their own benefit.

Feudalism and serfdom declined from the thirteenth century onward partly because of a growing cash economy and partly because of peasant revolts. In France, however, these social systems lingered on until the Revolution of 1789. In Russia and certain other European countries, feudalism continued well into the nineteenth century.

Despite conflicts among social classes engendered by feudalism and the manorial system, however, a degree of military and political equilibrium was achieved. This led to economic growth, especially in Italy, where Mediterranean trade routes were opened and several seaports (such as Naples, Pisa, Genoa, and Venice) became centers of renewed commercial activity. Manufacturing and banking flourished, and new groups of craftsmen and merchants arose. Cities and towns that had declined during the early Middle Ages revived, and new ones were founded. Gradually, towns began to assert their independence from their lords and the Church. They demanded—and received—charters setting out their legal rights and obligations. Some even established republican governments.

journeys to these cities, especially Jerusalem, could be dangerous. A third choice, which became popular in the eleventh century, was the shrine of Saint James (Santiago in Spanish) at Compostela, Galicia (in northwest Spain). Saint James was the first martyred apostle and according to Spanish tradition was buried in Compostela—the center of Christian resistance to the Muslim occupation of Spain.

Pilgrims followed four main routes across France to the Pyrenees and then westward to Compostela. Along these roads, an extensive network of churches, hospices (lodging places), and monasteries was constructed. Their design and location were a direct response to the ever-growing crowds of pilgrims.

Pilgrimage Roads

By the first half of the eleventh century, Christianity was in the ascendant in Western Europe. The spirit of religious vitality affected almost all aspects of life and manifested itself particularly in the Crusades—a series of military campaigns from 1095 to the fifteenth century to recover the Holy Land from the Muslims.

Earlier in the Middle Ages, it was primarily penitent Christians who made pilgrimages to atone for their sins (see map). From the eleventh century, however, it became customary for devout Christians to undertake pilgrimages, particularly to churches with sacred relics. These might be the physical remains of saints, remnants of their clothing, or other objects associated with them. Relics were often housed in elaborate **reliquaries** (containers for relics) of various shapes, depending on the nature of the relic.

The two most sacred pilgrimage sites were Jerusalem and Rome, but

Main pilgrimage roads from French cities to Santiago de Compostela, Spain.

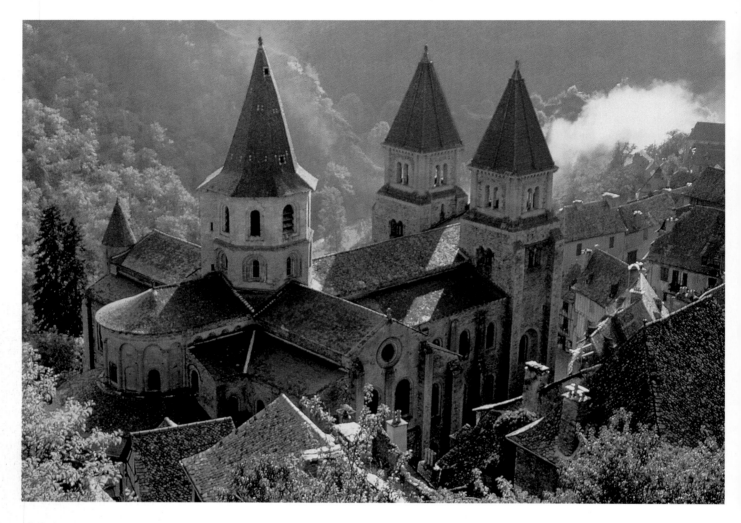

12.1 Aerial view of Sainte-Foy, Conques, Auvergne, France, c. 1050–1120. Apart from two 19th-century towers on the west façade, Sainte-Foy stands today as it did in the 12th century. It has a relatively short nave, side aisles built to the full height of the nave (so that there is no clerestory lighting), and a transept. The **belfry**, or bell tower, rises above the roof of the **crossing**.

Architecture

In addition to accommodating the Rule of an Order, Romanesque architects had to construct churches big enough for the influx of pilgrims. Churches had to be structurally sound and adequately illuminated. The availability of materials often presented problems because of the great increase in building activity. More subjective considerations, such as aesthetic appeal, also had to be taken into account. These might be influenced by the wishes of a local religious Order or a wealthy patron.

Sainte-Foy at Conques

Communication along the pilgrimage routes was continual, with pilgrims, masons, and other craftsmen moving back and forth. It is thus not surprising that many Romanesque churches had similar features. The earliest surviving example of a pilgrimage church (fig. **12.1**) is dedicated to Sainte Foy, a third-century virgin martyr known in English as Saint Faith. She was martyred in 303 while still a child because she refused to worship pagan gods. The church, which belonged to the Benedictine Order (see p. 181), was erected over her tomb in Conques, a remote village on the pilgrimage route from Le Puy in southeastern France.

The single most important attraction for pilgrims to this church was the saint's relics. They were contained in a gold reliquary statue (fig. **12.2**), the head of which is believed to have been formed around the saint's skull. Its large size—it is a late antique mask that has been reused—accentuates the impression of aloof power conveyed by the statue. The figure is made of gold repoussé, with several sheets of gold placed over a wooden core for stability. The saint sits frontally as if enthroned, wearing a martyr's crown and a rich, gold robe covered with gems. She opens her arms as if to welcome pilgrims to her church.

The builders of Sainte-Foy, and of all pilgrimage churches, had to accommodate large crowds without interfering with the duties of the clergy. The plan in figure **12.3** shows how the traditional Latin-cross basilica was modified by extending the side aisles around the transept and the apse to form

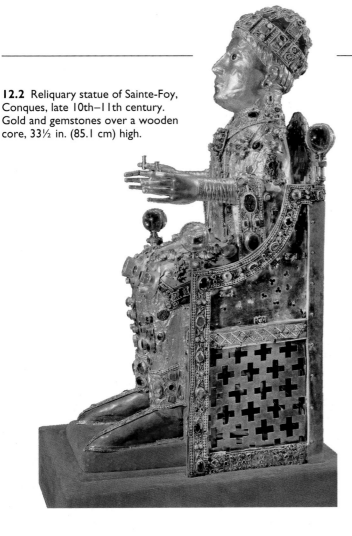

12.2 Reliquary statue of Sainte-Foy, Conques, late 10th–11th century. Gold and gemstones over a wooden core, 33½ in. (85.1 cm) high.

an ambulatory. This permitted lay visitors to circulate freely, leaving the monks undisturbed access to the main altar in the **choir.** Three smaller apses, or **radiating chapels,** protrude from the main apse, and two chapels of unequal size have been added at the east side of the transept arms. Essentially, such architectural arrangements integrated two temporal systems. One was based on the social world of the laity, while the other provided an architectural space for those whose daily lives followed another "order" of business and a liturgical calendar.

An important new architectural development in Romanesque churches was the replacement of wooden roofs with stone barrel vaults (fig. **12.4**), which lessened the risk of fire and improved acoustics. Music, particularly Gregorian chant, was an integral feature of the Christian liturgy. The

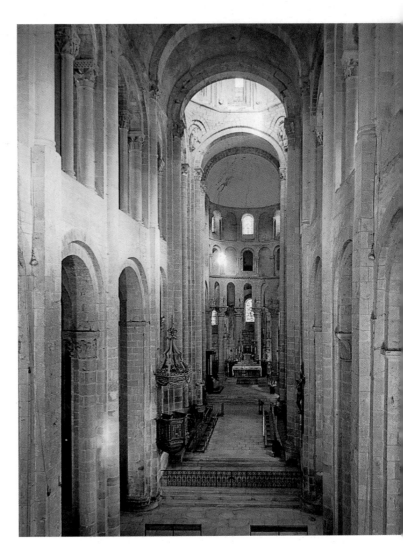

12.4 Tribune and nave vaults, Sainte-Foy, Conques, c. 1050–1120. Romanesque builders solved the problem of supporting the extra weight of the stone by constructing a second-story gallery, or tribune, over the side aisles as an **abutment.** Structurally, the gallery diverted the thrust from the side walls back onto the piers of the nave. It also provided extra space for pilgrims.

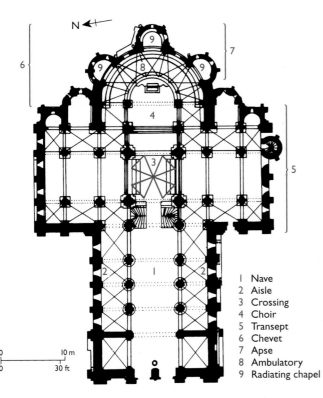

1 Nave
2 Aisle
3 Crossing
4 Choir
5 Transept
6 Chevet
7 Apse
8 Ambulatory
9 Radiating chapel

0 10 m
0 30 ft

12.3 Plan of Sainte-Foy, Conques, c. 1050–1120.

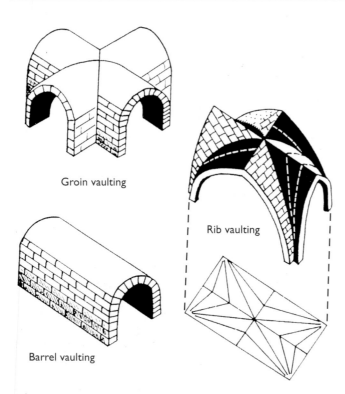

Groin vaulting

Rib vaulting

Barrel vaulting

12.5 Diagram of the three main Romanesque vaulting systems: barrel vaulting, groin vaulting, and rib vaulting.

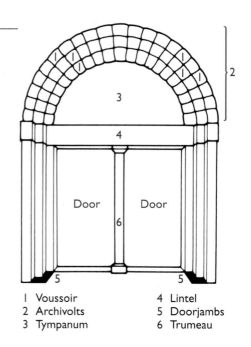

1 Voussoir 4 Lintel
2 Archivolts 5 Doorjambs
3 Tympanum 6 Trumeau

12.6 Diagram of a Romanesque portal.

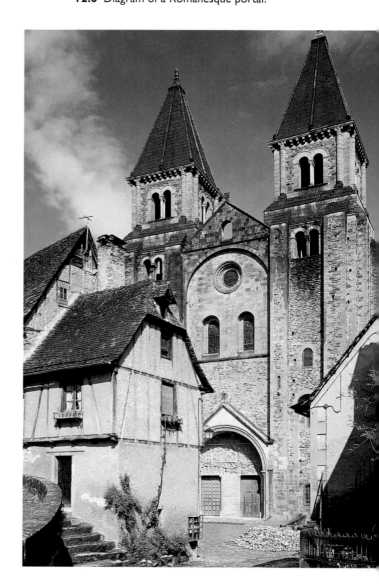

stone vaults required extra buttressing to counteract the lateral thrust, or sideways force, they exerted against the walls. At Sainte-Foy, **transverse ribs** cross the underside of the **quadrant**—that is, the **half-barrel vaults** of the nave ceiling. They are supported by **cluster piers**. The piers accent the corners of the groin-vaulted wall sections, or **bays**, of the side aisles. Figure **12.5** shows the three main vaulting systems used in Romanesque churches—barrel vaulting, as at Conques, groin vaulting, and rib vaulting.

Romanesque churches were often decorated with sculpture, painting, and wall hangings, through which a largely illiterate population could "read" the Bible stories and events portrayed in other texts. Tapestries, most of which are now lost, were hung along the aisles, adding color and warmth to the church interiors.

Most pilgrimage churches had relief sculptures at the main entrance. The area immediately around the doorways, or **portals**, would have contained the first images encountered, and the reliefs were therefore intended to attract the attention of the worshiper approaching the church. The general layout of medieval church portals is fairly consistent (fig. **12.6**); what varies from building to building is the **program**, or arrangement and meaning, of the subjects depicted on each section.

At Conques, the relief sculpture on the western portal (fig. **12.7**) is confined to the **tympanum** and the lintel.

12.7 West entrance wall, Sainte-Foy, Conques, c. 1130.

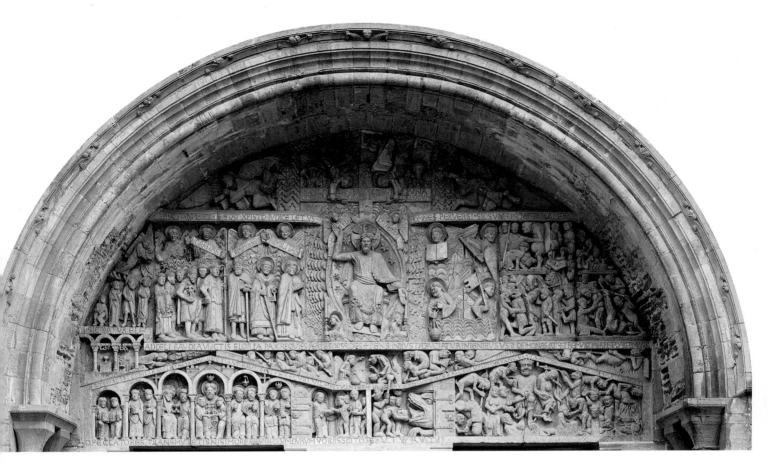

12.8 *Last Judgment,* tympanum of west portal, Sainte-Foy, Conques. Christ is the central and largest figure. He is surrounded by a **mandorla,** an oval of light (a Far Eastern motif), and his halo contains the Cross. He raises his right hand, reminding the viewer that the souls on his right will be received into heaven—a visual rendition of the advantages of being "on the right hand of God."

The scene is the *Last Judgment* (fig. **12.8**), in which Christ the Judge determines whether souls will spend eternity in heaven or in hell. It conforms to the iconographic norm in its overall arrangement. The figures on Christ's right (the viewer's left) and on his level are saints and churchmen. Above them, angels hold scrolls that form arches. Below, also on Christ's right, are figures framed by semicircular arches. Christ's left hand is lowered toward hell. His gesture directs the viewer to the damned souls falling and being tortured by devils. In the center of hell, on the viewer's right, is the crowned figure of Satan. He and his company of devils, together with the damned, are entwined by snakes. They are opposite the figures under semicircular arches on the left side of the lintel. Note that the saved souls on Christ's right are neatly arranged under framing devices, whereas the damned, on Christ's left, appear jumbled and disordered.

At the center of the lintel, directly below Christ, the traditional right-left Christian pairing is maintained. Two individual scenes are divided by a vertical. On Christ's right, angels welcome saved souls into heaven. On his left, a grotesque devil with spiked hair and a long nose brandishes a club at a damned soul. The latter bends over as if to enter the gaping jaws of a monster, which pokes its head through a doorway. This image thus conflates the Christian metaphors of the "gate of hell" and the "jaws of death."

Depictions of heaven and hell vary as Christian art develops. The basic arrangement of the *Last Judgment,* however, is fairly constant. It is intended to act as a reminder of the passage of time and of the belief that the unrighteous will be condemned to "eternal punishment, but the righteous will enter eternal life" (Matthew 25:46).

12.9 Gislebertus, capital depicting the *Flight into Egypt*, Cathedral of Saint-Lazare, Autun, Burgundy, c. 1130.

Developments at Autun

New Romanesque developments in capital decoration are reflected at Autun Cathedral in Burgundy. Its sculptural decoration was carved by Gislebertus, who signed his name on the tympanum. A capital representing the *Flight into Egypt* (fig. **12.9**) shows the Holy Family fleeing the edict of King Herod, which decreed the death of all male children under the age of two. Joseph leads a lively, high-stepping donkey carrying Mary and Christ out of Bethlehem into Egypt. The capital exemplifies a taste for elegant surface design characteristic of Romanesque sculpture. Decorative foliage is relegated to the background, and design-filled circles support the figures. Open and closed circle designs are repeated in the borders of the draperies, on Joseph's hat, on the halos, and in the donkey's trappings. Also typical are the repeated curves representing folds, which are carved into the draperies more for their patterned effect than to define organic quality. On Joseph's tunic, the surface curves enhance the impression of backward motion, as if the cloth had been blown by a sudden gust of wind. The Romanesque artist's disregard of gravity is evident in the figure of Christ. He faces front, with his right hand resting on a sphere held by Mary. He is suspended between her knees, with no indication of support for his weight. He is depicted

12.10 (Below) Gislebertus, *Last Judgment*, tympanum of west portal, Cathedral of Saint-Lazare, Autun, Burgundy, c. 1120–35. Gislebertus was the only sculptor to inscribe his name on the tympanum of a Romanesque church. Little is known about him, but his distinctive artistic personality influenced other sculptors considerably.

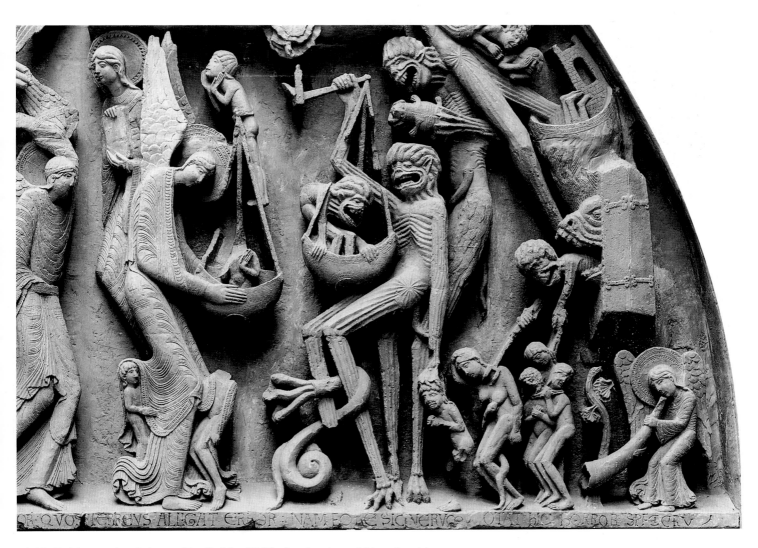

12.11 Gislebertus, *Last Judgment* (detail of fig. **12.10,** showing the weighing of souls).

as a *homunculus* ("little man"), babylike only in size, having neither the physique nor the personality of an infant. This depiction of Christ as a child-man, partly a reference to his miraculous character, is a convention of Christian art before 1300.

A similar taste for flat patterns and weightlessness characterizes the monumental tympanum at Autun (fig. **12.10**). It represents a large, imposing figure of Christ appearing in majestic light at the Last Judgment. Surrounded by a mandorla supported by four angels, Christ sits frontally on a throne and spreads out his arms in a broad gesture proclaiming his divine presence and welcoming worshipers to the cathedral. His drapery forms a pattern of flattened curves that correspond to the curved arms. Zigzags repeat the animated poses of the other figures as well as the diagonals of Christ's legs. On either side of Christ are two tiers of angels and souls—the saved

at his right and the damned at his left. Christ's left hand indicates the weighing of the souls on the lower tier (fig.**12.11**). The archangel Michael bends to the left of the scale and weighs a soul in human form, while two little souls huddle under his robe for protection. To the right of the scale, two grotesque devils weigh a tiny monstrous creature, clearly one of the damned. At the extreme right, several more damned souls fall downward, denoting their future in hell. In this detail, Gislebertus plays on the theme of physical weight and weightlessness as a metaphor for spirituality and salvation. The irony of his image is that the saved human soul seems to weigh more, for he pulls down the scale, and the damned soul weighs less. Since the damned are destined to "go down," their lesser "substance" is shown by the scale. The saved, on the other hand, "go up," but actually weigh more because of their greater spiritual substance.

The Stavelot Reliquary Triptych

In northern Europe, the Abbot Wiebald of the imperial Benedictine abbey at Stavelot, located in the Meuse River region in modern Belgium, commissioned a spectacular reliquary to house relics of the Cross (fig. **12.12**). Designed in the form of a **triptych** (an **altarpiece** with three sections), the Stavelot reliquary depicts scenes from the popular medieval Legend of the True Cross—the Cross of Jesus, as opposed to the crosses of the two thieves crucified with him. Wiebald's commission dates to the 1150s, and it enhanced the attraction of Stavelot as a pilgrimage site.

The scenes on the wings are shown in enamel inlay on a gold ground and are framed by circles, which could denote the unending, universal Church. The wings themselves contain Corinthian columns supporting round, Romanesque arches.

In the central panel are two small triptychs. The larger depicts the Cross with standing figures of Constantine and his mother, Saint Helena. Two archangels are above the arms of the Cross, and on the inside of the open wings are four saints.

The smaller triptych shows a Crucifixion flanked by the Virgin and the apostle John with a sun and moon over the Cross. A recess inside the Crucifixion contained a small silk pouch with fragments of the True Cross, the Holy Sepulcher, the Virgin's dress, and the head of a nail allegedly used in the Crucifixion.

The main wings depict three Constantine scenes (on the left), and three Helena scenes (on the right). They focus on Constantine's conversion to Christianity and Helena's discovery of the True Cross. On the left, reading from the bottom upward, are Constantine's Vision, his Victory over Maxentius, and his Baptism. On the right, the lowest scene shows Helena searching for the Cross in Jerusalem. In the middle scene, she is on Calvary as three crosses are excavated from the ground. At the top, the miracle of the True

12.12 The Stavelot Triptych, open, c. 1156–58. Gold, cloisonné enamel, inlay, 19¹⁄₁₆ in. (48.4 cm) high, 26 in. (66 cm) wide when open. The Pierpont Morgan Library, New York.

Cross is enacted. To discover which of the three crosses was Christ's, Helena had each in turn held over the body of a dead boy, whose funeral procession happened by. The True Cross restored him to life.

These scenes conveyed to the medieval pilgrim a message about the power of the Cross and its role in establishing Christianity as the official religion of Rome. The Vision of Constantine, here represented as a dream, set in motion this sequence of events. An angel holding the inscription "In this you conquer" points to a cross in the sky.

The pairing of Constantine and Helena also pairs Rome (on the left) with Jerusalem (on the right). When pilgrims traveled to Stavelot, they reinforced their identification with these sites.

Manuscripts

Some of the greatest achievements of Romanesque art were the illuminated manuscripts (see p. 176) produced in the scriptoria of monasteries. Romanesque manuscript illumination is characterized by flattened space and lively patterns. The Saint Matthew in figure **12.13** is frontal and relatively symmetrical. His feet are flat and vertical so that he has no rational support. The patterned semicircle below the feet echoes the halo and the round arch above. On the initial *L* to the left of Matthew, the intertwined human, animal, and floral forms are typical Romanesque manuscript motifs.

Also characteristic is the contrast between the animated letter and the more static, iconic quality of the saint. The medieval artist's imagination was permitted more freedom of expression in marginal areas—as in Last Judgment scenes of hell—than in the central image. Here, the interlace forms are reminiscent of Anglo-Saxon metalwork and possibly also of Islamic design. In contrast to the Muslim artist, however, the Romanesque artist is not prohibited from combining figuration with abstraction.

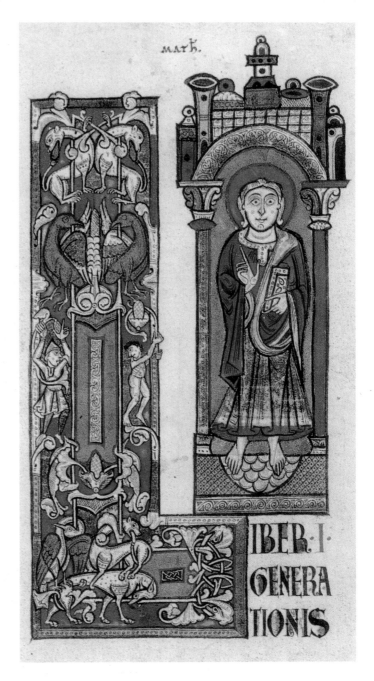

12.13 New Testament initial *L* and *Saint Matthew*, region of Agen-Moissac, c. 1100. 7½ × 4 in. (19 × 10.2 cm). Ms. Lat. 254, fol. 10. Bibliothèque Nationale, Paris, France.

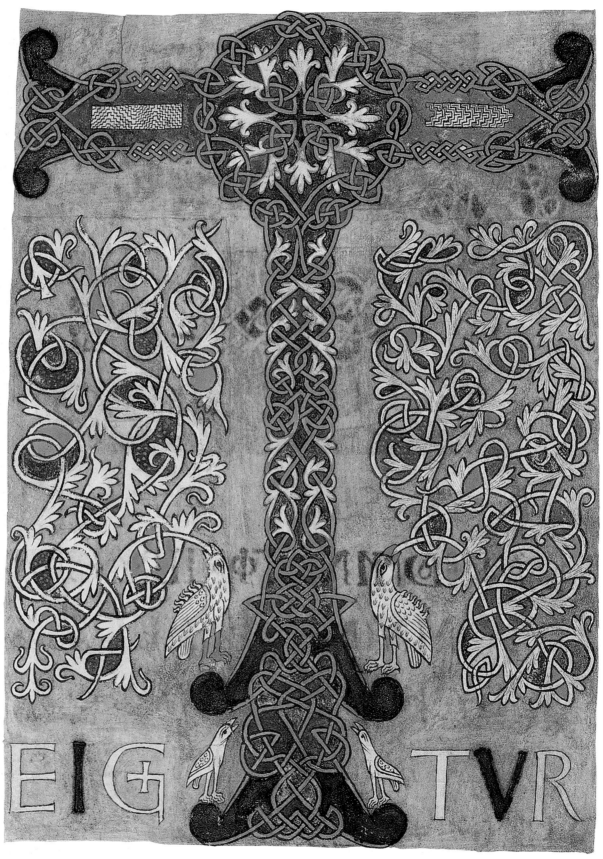

12.14 Initial *T* from the sacramentary of Saint-Saveur de Figeac, 11th century. Ms. Lat. 2293, fol. 19v. Bibliothèque Nationale, Paris, France.

A particularly exuberant Romanesque interlace appears in an eleventh-century manuscript page illustrating the initial *T* (fig. **12.14**). Its energy is conveyed by the dynamic movement of intertwined forms. And because of their dynamism, they have an organic character that borders on the figural, despite being geometric. The transition between nature and abstraction is enhanced by the interlaces flanking the *T,* which emerge from the mouths of birds.

Mural Painting

In addition to illuminating manuscripts, Romanesque artists painted monumental murals on the walls of churches and chapels. As is true of Romanesque sculpture, the paintings had both a decorative and a didactic, or teaching, function.

Documents indicate that Romanesque artists traveled from place to place. Often, more than one painter at a time would work on a particular series of murals. An art-ist's style might respond to various influences, including his personal training, the style of his co-workers, and the demands of a patron. Preliminary drawings were made in *buon fresco,* consisting of outlines and details. A compass was often used for repeated curvilinear designs. The painting itself was usually **fresco secco,** possibly redampened so that the plaster would absorb the paint. Generally, the darker areas were painted before the highlights. In the final stage, the artist outlined the forms in black or brown. As in Byzantine mosaics (Chapter 10), this technique emphasized the figures but decreased the natural relation of the figures to three-dimensional space.

The Romanesque chapel in Castel Appiano, in northern Italy, illustrates the use of rich colors—blues, greens, browns, and yellows—and lively forms (fig. **12.15**). These would have been even more striking before they were damaged. In the detail of the semidome in the central apse, Mary and Christ are enthroned between two angels. A floral border frames the scene. It is interrupted by the jeweled

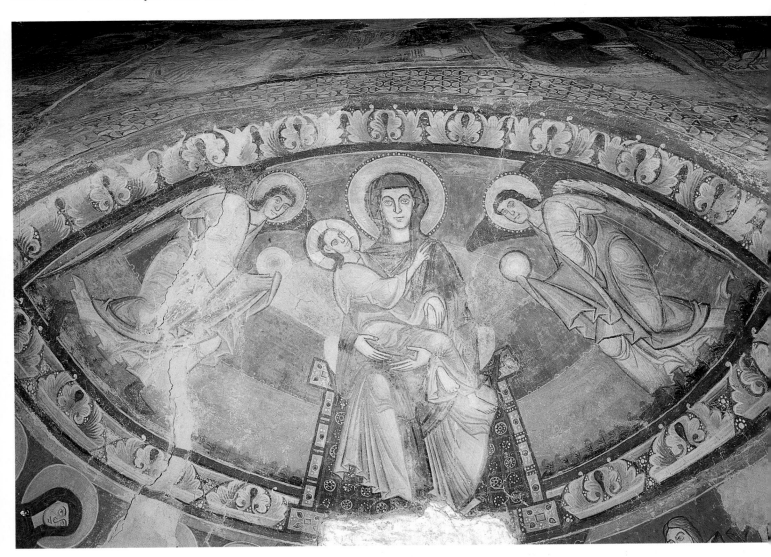

12.15 *Mary and Christ with Two Angels,* detail of the apse, chapel of Castel Appiano, c. 1200. Fresco.

golden throne, which suggests Byzantine influence. Formal unity is created, as the background green repeats the shape of the border, while the blue repeats the pointed oval of the apse itself. Mary is frontal, staring directly at the viewer. Her draperies echo the background blue and green, and her flat halo repeats the color and beaded designs of the throne. The draperies also reflect a taste for elegant, curvilinear surface patterns that are unrelated to organic form. As in the Autun *Flight,* although differing in proportions, Christ is a small man held in Mary's lap. His right hand is extended in a gesture of benediction.

The "Bayeux Tapestry"

One of the most intriguing Romanesque works of art is the so-called Bayeux Tapestry (figs. **12.16** and **12.17**), which depicts the Norman invasion of England in 1066. It is over 230 feet (70 m) long and contains 626 human figures, 731 animals, 376 boats, and 70 buildings and trees. Such an undertaking probably involved several artists, technicians, and a general designer working together with a historian. Although invariably called a tapestry, the work is actually an embroidery, made by stitching colored wool onto bleached linen. We have no records of who the artists were, but most medieval embroidery was done by women, especially at the courts.

The "tapestry" is thought by some scholars to have been created for the Cathedral of Bayeux in Normandy, near the northern coast of France. It may have been commissioned by Bishop Odo of Bayeux, half brother of William the Conqueror. The events it depicts unfold from left to right and are accompanied by Latin inscriptions. The detail in figure **12.16** shows William the Conqueror leading a group of Norman nobles, including Odo, on galloping horses against the English. This scene takes place on Saturday morning, October 14, 1066, when William's army departed from Hastings to fight Harold, the Saxon king of England.

All the riders are helmeted and armed, and their chain mail is indicated by circular patterns. Odo brandishes a mace, while the nobles carry banners, shields, and lances. The weapons, held on a diagonal, increase the illusion of movement, carrying the narrative forward. At the same time, however, the movement is arrested as Odo clashes with an enemy riding against him. The ground is indicated by a wavy line on a horizontal plane, but, aside from the overlapping of certain groups of figures, there is little attempt to depict three-dimensional space. Above and below the main narrative are borders containing human figures (note the decapitated figure below), natural and fantastic animals, and stylized plant forms.

The Viking longboats from William's fleet (fig. **12.17**) reflect the Scandinavian origins of the Normans. Ready to set sail for England, the boats are propelled by oars and

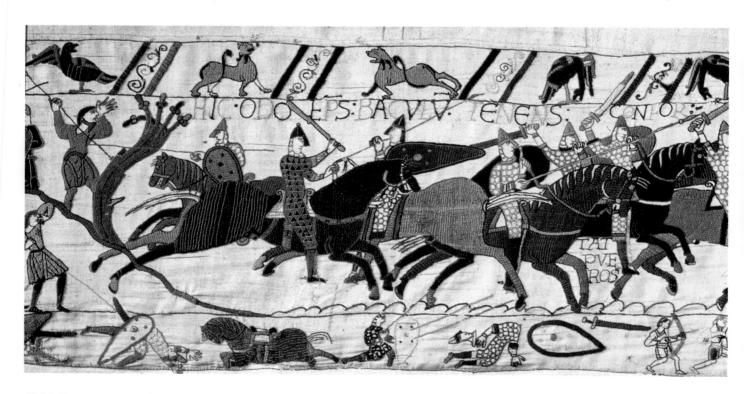

12.16 Detail of battle scene showing Bishop Odo with a mace, from the "Bayeux Tapestry," c. 1070–80. Wool embroidery on linen, 20 in. (50.8 cm) high. Tapisserie de Bayeux, by special permission of the City of Bayeux, France. Note that the smooth texture of the linen contrasts with the rough texture of the raised woolen threads. Single threads were used for waves, ropes, strands of hair on the horses' foreheads, and the outlines of each section of color.

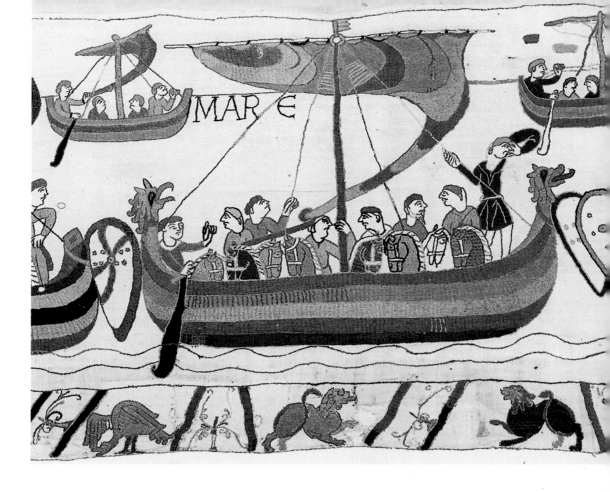

12.17 Detail of Viking longboats, from the "Bayeux Tapestry." "MARE" is Latin for "sea."

a sail. The man at the far left steers by means of the fixed, rotating rudder characteristic of Viking ships. The prows are decorated with carved dragon heads. Two shields are attached to the bow, and these are believed to have been antiramming devices.

Unlike the other Romanesque works of art discussed in this chapter, the "Bayeux Tapestry" is secular in subject. The events depicted in it are primarily historical, and they are shown from the Norman point of view. While the embroidered Latin text helps to explain the images, much of the narrative is transmitted through the pictures themselves, and many of the details remain puzzling.

The sculptural decoration of Romanesque architecture, like mural and manuscript painting, continues the medieval taste for flat space, inorganic figures, and lively, decorative stylization. Beginning in the late twelfth century, Gothic architects would expand the scale of the cathedrals, and a new trend toward naturalism would develop in painting and sculpture. But Gothic architecture did not emerge suddenly or without precedent. Precursors of Gothic can be found in Romanesque buildings as early as the late eleventh century, particularly in northern France and England. Examples of this early evolution within Romanesque of what came to typify Gothic are discussed in Chapter 13.

c. 1000 c. 1200

ROMANESQUE ART

(12.2)
Feudalism

(12.13)
Normans invade England (1066)

(12.17)
Bayeux Tapestry (c. 1070–1080)

(12.7)
Pilgrimage Roads, Crusades (1095–1204)

Song of Roland (c. 1100)

(12.14)
Peter Abelard (d. 1142)

(12.15)
Saint Francis founds Franciscan Order (1209)

Dominican Order founded (1216)

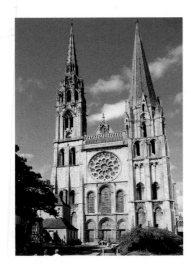

13

Gothic Art

Gothic cathedrals are among the greatest and most elaborate monuments in stone. The term *Gothic* is applied primarily to the art produced in Western Europe from about the middle of the twelfth century in France to the sixteenth century in other parts of Europe. The term was first used by Italians in the sixteenth century to denigrate the pre-Renaissance style. Literally, *Gothic* refers to the Germanic tribes who invaded Greece and Italy and sacked Rome in A.D. 410. The Goths were blamed for destroying what remained of the Classical style. In fact, however, the origins of Gothic art had nothing to do with what had happened several hundred years earlier. By the nineteenth century, when scholars realized the source of the confusion, it was too late. Gothic remains the accepted name of the style discussed in this chapter.

Origins of the Gothic Style in France

The time and place in which the Gothic style emerged can be identified with unusual precision. It dates from 1137–44, and it originated in the Île-de-France, the region in northern France that was the personal domain of the French royal family. Credit for the invention of Gothic goes to Abbot Suger of the French royal monastery at Saint-Denis, about 6 miles (10 km) north of Paris.

Suger was born in 1081 and educated in the monastery school of Saint-Denis along with the future French king Louis VI. Suger later became a close political and religious adviser to both Louis VI and Louis VII, and he remained a successful mediator between the Church and the royal family. While Louis VII was away on the Second Crusade (1147–49), Suger was appointed regent of France.

In 1122 Suger was named abbot of Saint-Denis, which had a special place in French history. Not only was Denis, the first bishop of Paris and the patron saint of France, buried there, but it was also the burial place of the French royal family. Suger decided to rebuild and enlarge the eighth-century Carolingian church of Saint-Denis, making it the spiritual center of France. To this end, he searched for a new kind of architecture to reinforce the divine right of the king's authority and enhance the spirituality of his church. The rebuilding program did not start until 1137, and in the meantime Suger made extensive preparations. He studied the biblical account of the construction of Solomon's Temple and immersed himself in what he thought were the writings of Saint Denis. (Scholars now believe that Suger was reading the works of Dionysius, a sixth-century mystic theologian.)

Suger was inspired by the author's emphasis on the mathematical harmony that should exist between the parts of a building and on the miraculous, mystical effect of light. This was elaborated into a theory based on musical ratios; the result was a system that expressed complex symbolism based on mathematical ratios. The fact that these theories were attributed to Saint Denis made them all the more appealing to Abbot Suger. In his preoccupation with light, Suger was thinking in a traditional Christian framework, for the formal qualities of light had been associated with Christ and divinity since the Early Christian period. In his reconstruction of the church, Suger rearranged the elements of medieval architecture to express the relationship between light and God's presence in a distinctive way. None of the individual architectural devices that Suger and his builders used was new; it was the way in which he synthesized elements of existing styles that was revolutionary. *The Book of Suger, Abbot of Saint-Denis* describes the beginning of the work on Saint-Denis (see Box) as follows:

> The first work on this church which we began under the inspiration of God [was this]: because of the age of the old walls and their impending ruin in some places, we summoned the best painters I could find from different regions, and reverently caused these [walls] to be repaired and becomingly painted with gold and precious colors. I completed this all the more gladly because I had wished to do it, if ever I should have an opportunity, even while I was a pupil in school.[1]

Early Gothic Architecture: Saint-Denis

Suger's additions to Saint-Denis consisted of a new narthex and west façade with twin towers and three portals. Most of the original sculptural decoration on the portals has been lost. Inside, Suger retained the basic elements of the Romanesque pilgrimage choir. A semicircular ambulatory in the apse permitted the public to circulate freely, while the clergy remained in the radiating chapels. But Suger combined these elements in an original way (figs. **13.2** and **13.3**).

Under Suger's revision, the arrangement of the chapels is a formal echo of the ambulatory, which creates a new sense of architectural unity. Suger's **chevet** (the east end of the church, comprising the choir, ambulatory, and apse) also emphasized the integration of light with lightness, because the entire area was covered with **rib vaults** (fig. **13.4**) supported by pointed arches. (The Romanesque builders, in contrast, had restricted the lighter vaulting to the ambulatory.) The arches, in turn, were supported by slender columns, which further enhanced the impression of lightness. On the exterior, thin buttresses were placed between the chapels (fig. **13.3**) to strengthen the walls. Suger's new architectural approach attracted immediate attention because the effect was so different from the dark interiors and thick, massive walls of Romanesque architecture. He describes his changes in the verses of the consecration inscription:

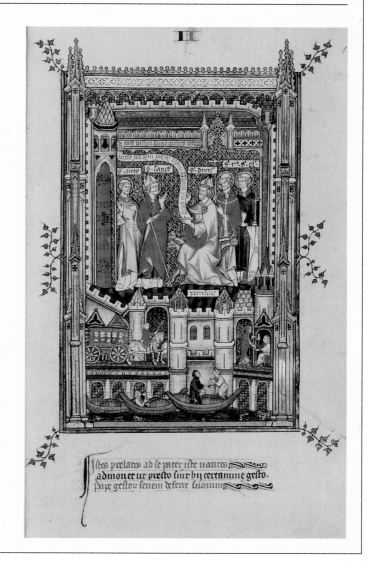

The hierarchical organizing principle of Gothic manuscript illumination can be seen in the early-fourteenth-century manuscript page from the *Life of Saint Denis* (fig. **13.1**). Saints and members of the clergy occupy the larger top section, while lay people and secular architecture are represented in the smaller section below. The elaborate architectural frame is Late Gothic. The vines transform it into a metaphor for the church building by reference to Christ's statement "I am the vine." At the top, Saint Denis is the largest figure; this denotes his importance. His lion throne connects him typologically with King Solomon and his church, therefore, with Solomon's Temple. The abbreviated cathedral entrance over his head emphasizes his position as archbishop of France and his association with the Heavenly City. His scroll winds around and forms a lintel-like horizontal under the clerestory windows.

The scene below depicts everyday life in the Earthly City—in this case, fourteenth-century France. A coach enters the gate at the upper left, a doctor checks his patient's urine sample on the right, and commercial boats carry a wine taster and two men completing a transaction. Travel, medicine, and trade are among the transient activities of daily life, while the saints above are engaged in the loftier pursuit of preserving the name and memory of Saint Denis through his image and biography.

13.1 Manuscript page from the *Life of Saint Denis,* completed 1317. Ms.Fr.2091, v. II, fol. 125. Bibliothèque Nationale, Paris, France. This manuscript was commissioned during the reign of Philip IV the Fair. It contains twenty-seven illuminations that narrate the life of Saint Denis. In this scene, the saint asks two others to write his biography.

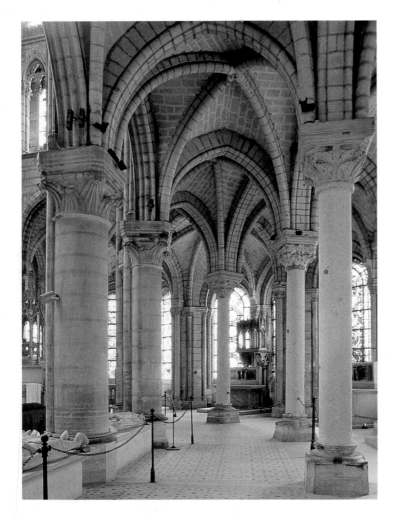

13.2 Interior of Saint-Denis. Each chapel bay has a pair of large stained-glass windows, delicate columns, and rib vaults. The ambulatory and chapels have merged to form a series of spaces illuminated by large windows supported by a masonry frame. Suger described the new effect as "a circular string of chapels, by virtue of which the whole [sanctuary] would shine with the miraculous and uninterrupted light of the most luminous windows."

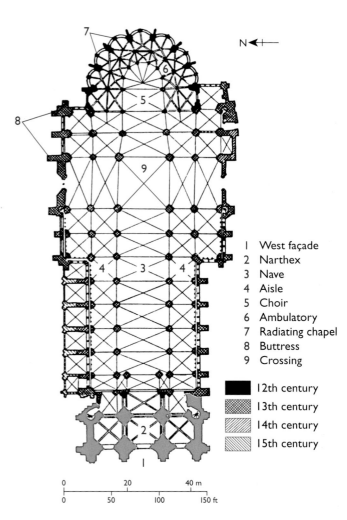

1	West façade
2	Narthex
3	Nave
4	Aisle
5	Choir
6	Ambulatory
7	Radiating chapel
8	Buttress
9	Crossing

- ■ 12th century
- ▨ 13th century
- ▨ 14th century
- ▨ 15th century

13.3 Plan of Saint-Denis, 1140–44. The chapels of the apse are connected shallow bays, which form a second ambulatory parallel to the first. This arrangement creates seven wedge-shaped compartments radiating out from the apse. Each wedge is a trapezoidal unit (in the area of the traditional ambulatory) and a pentagonal unit (in the radiating chapel). The old nave and the choir were rebuilt in the High Gothic style between 1231 and 1281.

Once the new rear part is joined to the part
 in front,
The church shines with its middle part brightened.
For bright is that which is brightly coupled with
 the bright,
And bright is the noble edifice which is pervaded
 by the new light;
Which stands enlarged in our time,
I, who was Suger, being the leader while it was
 being accomplished.[2]

The new style was particularly popular in northern and central France, where royal influence was strongest. From the 1230s to 1250, French architects built over eighty Gothic cathedrals. Notwithstanding the close association of Gothic with France (it was soon dubbed *opus francigenum,* or "French work"), the style migrated north to England, south to Spain, and east to Germany and Austria. There was also an Italian Gothic style, although Italy was the region that welcomed the style least and rejected it soonest.

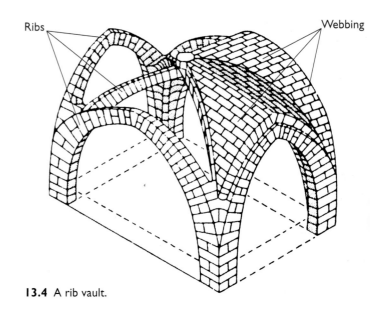

13.4 A rib vault.

Elements of Gothic Architecture

Rib Vaults

In Gothic architecture, the rib vault (fig. **13.4**) replaces the earlier barrel vaults of Romanesque. The rib vault requires less buttressing than the barrel vault, which exerts pressure along its entire length and thus needs strong buttressing. Since the weight of the rib vault is concentrated only at the corners of the bay, the structure can be buttressed at intervals, freeing more space for windows. The ribs could be built before the intervening space (usually triangular or rectangular) was filled in. Adding ribs also enabled Gothic builders to reinforce the ceiling vaults and to distribute their weight more efficiently. Because of the weight-bearing capacity of the ribs, the vault's surfaces (the **web** or infilling) could be made of lighter material.

Piers

As the vaults became more complex, so did their supports. One such support is the cluster or **compound pier** (see fig. **13.18**). These are the large columnar supports on either side of the nave to which clusters of **colonnettes** are attached. Although compound piers had been used in Romanesque buildings, they became a standard Gothic feature. The ribs of the vaults formed a series of lines that were continued down to the floor by colonnettes resting on compound piers.

With this system of support, the Gothic builders created a vertical unity leading the observer's gaze to the clerestory windows. The pier supports, with their attached colonnettes branching off into arches and vaults, have been likened to the upward growth of a tree.

Flying Buttresses

In Romanesque architecture, thick walls performed the function of buttressing. This decreased the amount of available window space, limiting the interior light. In the Gothic period, builders developed the **flying buttress**, an exterior structure composed of thin half-arches, or **flyers**. This buttress supported the wall at the point where the thrust of an interior arch or vault was greatest (fig. **13.5**).

Pointed Arches

The pointed arch, which is a characteristic and essential feature of Gothic architecture, can be thought of as the intersection of two arcs of nonconcentric circles. Examples are found in Romanesque buildings but in a much more tentative form. The piers channel the downward thrust of the pointed arch, minimizing the lateral, or sideways, thrust against the wall. Unlike round arches, pointed arches can

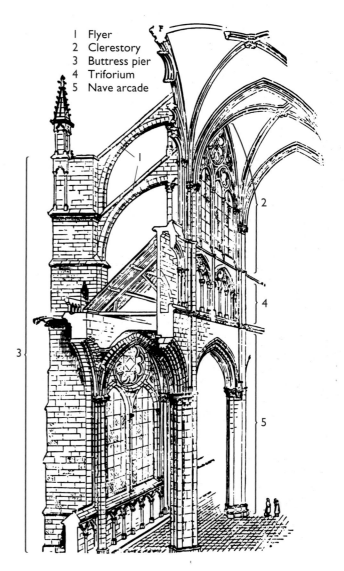

1 Flyer
2 Clerestory
3 Buttress pier
4 Triforium
5 Nave arcade

13.5 Section diagram of a Gothic cathedral (after E. Viollet-le-Duc). The **elevation** of the Gothic cathedral illustrates the flyers, which transfer interior thrusts to a pier of the exterior buttress. Since the wall spaces between the buttresses were no longer necessary for structural support, they could be pierced by large windows to achieve the desired increase in light.

theoretically be raised to any height regardless of the distance between their supports. The pointed arch is thus a more flexible building element, with more potential for increased height. Dynamically and visually, the thrust is far more vertical than that of a round arch.

The Skeleton

The features described above combined to form what is called a "skeletal" structure. The main architectural supports (buttresses, piers, ribs) form a "skeleton" to which nonsupporting elements, such as walls, are attached. The Gothic builders had, in effect, invented a structure that

biologists would describe as exoskeletal. An exoskeletal creature is one, such as a crab or a lobster, whose skeleton is on the outside of its body.

Stained-Glass Windows

Finally, the light that had so inspired Abbot Suger required an architectural solution. That solution was Suger's special use of the stained-glass window, which filtered light through colored fragments of glass. Light and color were diffused throughout the interior of the cathedral. The predominant colors of Gothic stained glass tend to be blue and red, in contrast to the golds that characterize most Byzantine mosaics.

Stained glass is translucent colored glass cut to form a window design. Compositions are made from pieces of colored glass formed by mixing metallic oxides with molten glass or fusing colored glass with clear glass. The artist cuts the individual pieces as closely as possible to the shape of a face or whatever individual feature is to be represented. The pieces are then fitted to a model drawn on wood or paper, and details are added in black enamel.

The dark pigments are hardened and fused with the glass through firing, or baking in a kiln. The pieces of fired glass are then arranged on the model and joined by strips of lead. Figure **13.6** is a detail of a stained-glass window from Chartres Cathedral (see figs. **13.10–13.19**). The blue background is broken up, seemingly at random, into numerous sections. Once the pieces of stained glass are joined together, the units are framed by an iron armature and fastened within the tracery, or ornamental stonework, of the window.

Stained-glass windows were made occasionally for Early Christian and Byzantine churches and more often in the Romanesque period. In the Gothic period, stained glass became an integral part of religious architecture and a more prominent artistic medium. The use of stained glass in Saint-Denis reflects Suger's intention to convey God's presence through a dazzling display of light and color.

13.6 Carpenters' Guild signature window, detail of a stained-glass window, Chartres Cathedral, early 13th century. This signature scene depicts two members of the guild stripping a plank of wood lying across three sawhorses.

Romanesque Precursors of Gothic

One of the buildings that show how elements of Gothic style evolved from Romanesque precursors is the abbey church of Saint-Étienne at Caen, in Normandy (figs. **13.7** and **13.8**). It was begun in 1067 by William the Conqueror (see p. 196), and the nave was completed in 1087. The organization of the façade into three distinct sections—a central rectangle surmounted by a gable and flanked by towers—became characteristic of Gothic façades. (The later spires date from the Gothic period.)

A few years after the completion of Saint-Étienne's nave, the first European cathedral with rib vaults and pointed arches was planned at Durham, in the northeast of England (fig. **13.9**). Construction began in 1093 under the supervision of its French bishop, William of Calais. The nave, finished in 1130, reflects some of the advantages of combining the pointed arch with a second transverse rib. This divided the vault into six sections and allowed for increased height, while relieving the massiveness of the Romanesque walls. It also made larger clerestory windows possible, which opened up the wall space and admitted more light.

The aesthetic effect of these structural developments was an impression of upward movement toward the source of light. This is consistent with the symbolic role of light as a divine presence in Christian churches. The success of the vaulting at Durham inspired the builders of Saint-Étienne at Caen to change the original flat roof into sexpartite (six-part) vaulting (see fig. **13.8**). This new approach to vaulting, like the three-part façade, influenced Early Gothic architecture in the Île-de-France.

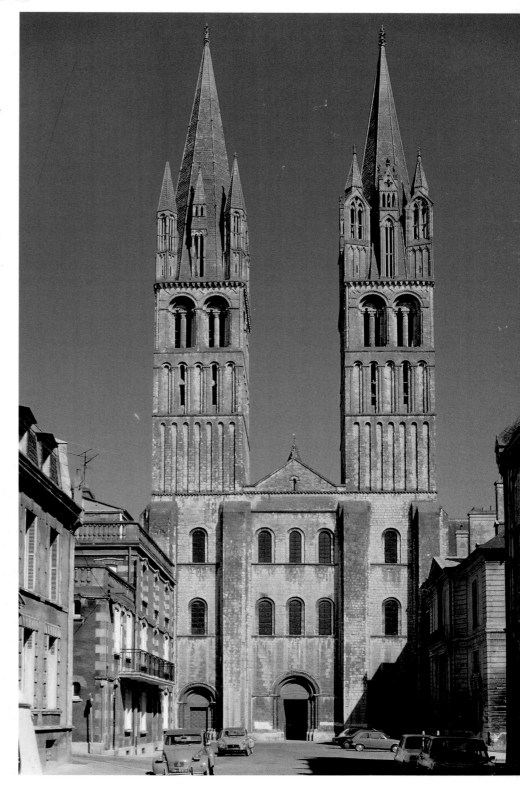

13.7 West façade, Saint-Étienne, Caen, Normandy, France, 1067–87.

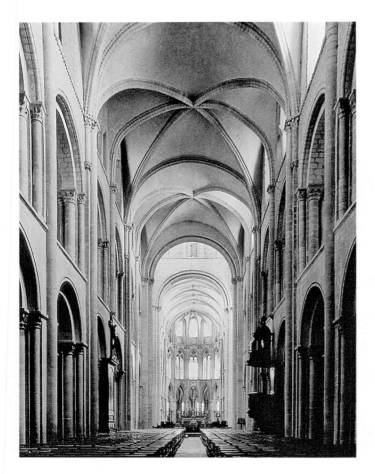

13.8 Nave, Saint-Étienne, Caen. The vaults date from c. 1115–20.

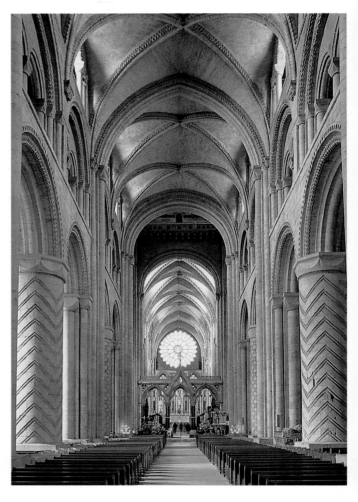

13.9 Nave, Durham Cathedral.

The Age of Cathedrals

By the time the choir and west façade of Saint-Denis were completed, in about 1144, and even before Abbot Suger turned his attention to the rest of the church, other towns in northern France had been competing to build cathedrals in the new Gothic style. A cathedral is, by definition, the seat of a bishop (the term is from the Greek word *kathedra*, meaning "seat" or "throne") and belongs to the city or town in which it is located. In contrast to rural churches, such as Sainte-Foy (see p. 186), cathedrals required an urban setting. Also consistent with increased urbanization in the twelfth century was the development of cathedral schools and universities. Their growing educational importance encroached on the relatively isolated monasteries that had proliferated in the earlier Middle Ages.

The construction of a cathedral was the largest single economic enterprise of the Gothic era. It had a significant effect on neighboring communities as well as on the city or town itself. Jobs were created for hundreds of masons, carpenters, sculptors, stonecutters, and other craftsmen. When a cathedral was finished, it attracted thousands of pilgrims and other visitors, and this continual traffic stimulated the local economy. Cathedrals also provided a focus for community activities, secular as well as religious. Above all, they generated an enormous sense of civic pride among the townspeople.

The cult of the Virgin Mary expanded during the Gothic period. Most of the great French cathedrals were dedicated to "Notre Dame" ("Our Lady"), the Virgin. To avoid confusion, therefore, it is customary to refer to the cathedrals by the towns in which they are located. At Chartres, the importance of Mary's cult was reinforced by the tradition that a pagan statue of a virgin and child, worshiped in a nearby cave, had prefigured the coming of Jesus and the Virgin Birth.

Chartres

The town of Chartres is approximately 40 miles (64 km) southwest of Paris. Its cathedral (fig. **13.10**) combines the best-preserved Early Gothic architecture with High Gothic, as well as demonstrating the transitional developments in between. For a town like Chartres, with only about ten thousand inhabitants in the thirteenth century, the building of a cathedral dominated the economy just as the structure itself dominated the landscape. At Chartres, the construction continued off and on from around 1134 to 1220. The most intensive work, however, followed a fire in 1194, when the nave and choir had to be rebuilt.

The bishop and chapter (governing body) of the cathedral were in charge of contracting out the work, but the funds came from a much broader cross section of medieval French society. The Church itself usually contributed by setting aside revenues from its estates. At Chartres, the canons (resident clergy) agreed in 1194 to give up their stipends (salaries) for three years so that the rebuilding program could begin. When the royal family or members of the nobility had a connection with a particular project, they also helped. At Chartres, Blanche, the mother of Louis IX, paid for the entire north transept façade, including the sculptures and windows. The duke of Brittany contributed to the southern transept. Other wealthy families of the region gave windows, and their donations

were recorded by depicting their coats of arms in the stained glass.

Guilds representing specific groups of craftsmen and tradesmen donated windows illustrating their professional activities (see fig. **13.6**). Pilgrims and less wealthy local inhabitants gave money in proportion to their means, often by buying relics or in gratitude for answered prayers. These donations went toward general costs rather than to a designated use. There were thus economic and social distinctions, not only in the size and nature of the contributions, but also in the degree to which they were publicly recognized.

Exterior Architecture of Chartres

Chartres was constructed on an elevated site to enhance its visibility. The vertical towers seem to reach toward the sky, while the horizontal thrust of the side walls (fig. **13.10**) carries one's gaze east toward the apse. The view in figure **13.13** shows the west façade, whose towers illustrate the dynamic, changing nature of Gothic style. The southern tower, on the right, dates from before 1194 and reflects the transition from Late Romanesque to Early Gothic. The northern tower, begun in 1507, which is taller, thinner, and more elaborate than the southern tower, is Late Gothic. Its greater height reflects advances in structural technology, as well as Suger's theological emphasis on verticality and light as expressions of God's presence.

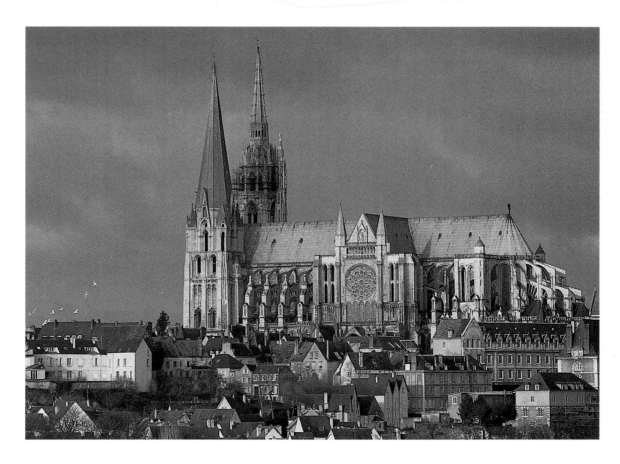

13.10 South wall of Chartres Cathedral, 13th century.

The tripartite organization of the west façade is characteristic of most Gothic cathedrals. Like Saint-Étienne at Caen (see fig. **13.7**), it is divided into three sections. Towers with a belfry flank the central rectangle, which is further subdivided. The three portals consist of the same elements as the Romanesque abbey church at Conques (see fig. **12.7**); above each portal is a tall, arched, stained-glass **lancet** window. Embedded in the rectangle over the lancets is the round **rose window**, a feature of almost all Gothic cathedral entrance walls. Above the rose window, a gallery of niche figures representing Old Testament kings stretches between the two towers. Finally, the gallery is surmounted by a triangular gable with a niche containing a statue of the Virgin and the infant Christ. The repetition of triple elements—portals, lancets, three horizontal divisions, and the triangular gable—suggests a numerical association with the Trinity (Father, Son, and Holy Spirit).

In the rose window, too, there is symbolic Christian significance in the arrangement of the geometric shapes. Three groups of twelve elements surround the small central circle. These refer to Christ's twelve apostles. The very fact that the rose window is a circle could symbolize Christ, God, and the universal aspect of the Church itself.

Proceeding counterclockwise around the southern tower, the visitor confronts the view in figure **13.10**. This is one of two long, horizontal sides of the cathedral, parts of which are labeled on the plan in figure **13.11**. Visible in the photograph are the roof (10 in fig. **13.12**), the buttresses (8) between the tower and the south transept entrance, and the flying buttresses, or flyers (9), over the buttresses and, at the east end, behind the apse. The entrance wall of the south transept has five lancet windows, a larger rose window than that of the west façade, and a similar gallery and triangular gable with niche statues.

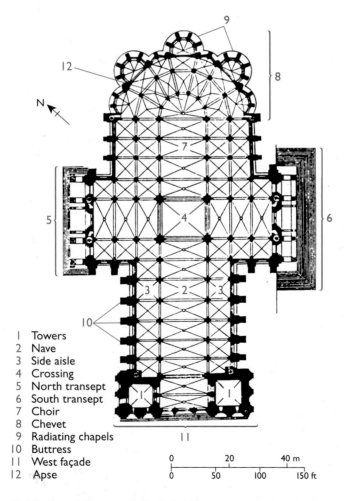

I	Towers
2	Nave
3	Side aisle
4	Crossing
5	North transept
6	South transept
7	Choir
8	Chevet
9	Radiating chapels
10	Buttress
11	West façade
12	Apse

13.11 Plan of Chartres Cathedral. Although the plan is quite symmetrical, the number of steps leading to each of the three entrances increases from west to north and from north to south. This increase parallels the building sequence, for Gothic architecture became more detailed and complex as the style developed. The Xs on the plan indicate the vaults.

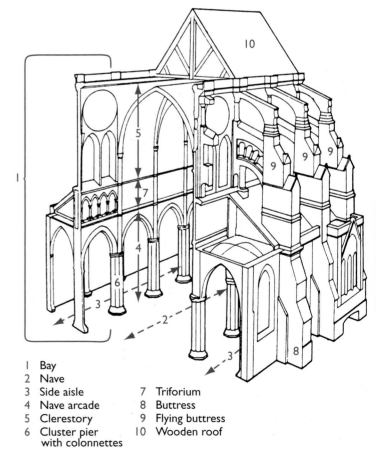

I	Bay		
2	Nave		
3	Side aisle	7	Triorium
4	Nave arcade	8	Buttress
5	Clerestory	9	Flying buttress
6	Cluster pier with colonnettes	10	Wooden roof

13.12 Perspective diagram and cross section of Chartres Cathedral.

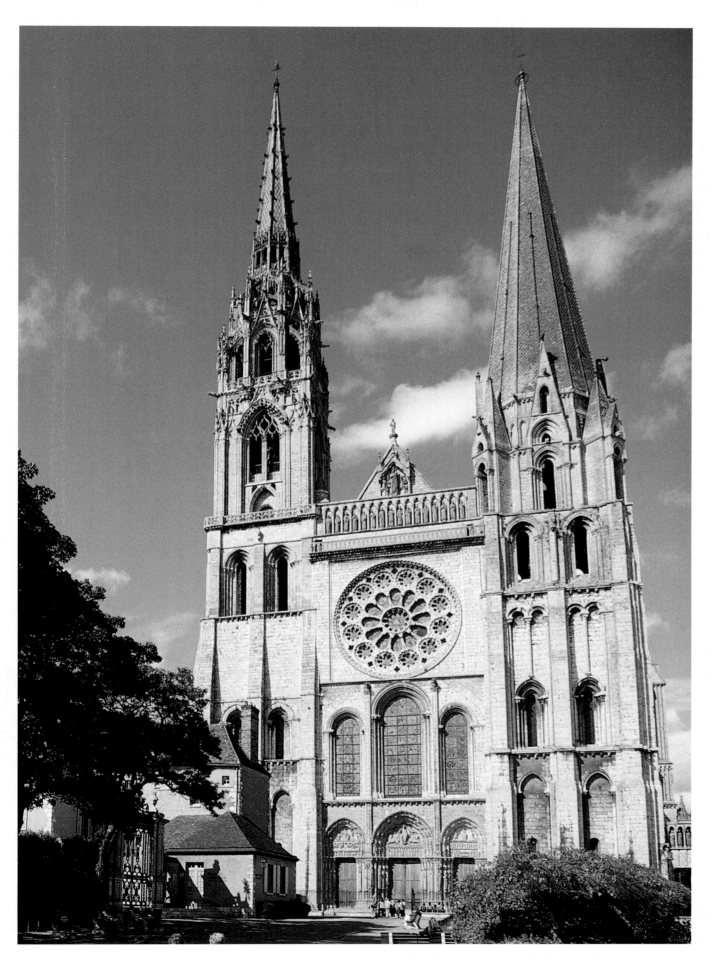

13.13 West façade, Chartres Cathedral, c. 1140–50. Symmetry in the Classical sense was not a requirement of the Gothic designers. Gothic cathedrals are structurally, but not formally, symmetrical. That is, a tower is opposite a tower, but the towers need not be identical in size or shape.

Exterior Sculpture of Chartres

On the exterior of Chartres there are so many sculptural details that it would take several volumes to consider them thoroughly. We shall, therefore, concentrate on a few of the most characteristic examples on the west and south sides of the cathedral.

Royal Portal (West Façade) There are three doors, together known as the Royal Portal, on the western entrance of Chartres (fig. **13.14**), the central door being slightly larger than the other two. This arrangement was derived from the Roman triumphal arch, which marked an entryway into a city. The derivation of the cathedral portal from the Roman arch highlights the symbolic parallel between the interior of the church and the heavenly city of Jerusalem. Throughout the Middle Ages, entering a church was thought of as an earthly prefiguration of one's ultimate entry into heaven.

In the most general sense, the Royal Portal exemplifies the typological view of history. The right, or southern, portal contains scenes of Christ's Nativity and childhood on a double lintel. An enthroned Virgin and Christ occupy the tympanum, which is surrounded by the Seven Liberal Arts in the **archivolts.** The Liberal Arts as depicted here correspond to the *trivium* (grammar, rhetoric, and dialectic) and the *quadrivium* (arithmetic, geometry, astronomy, and music) adopted from Donatus by Alcuin of York under Charlemagne (see p. 176). This curriculum reflects the importance of learning and the high status of the cathedral school as well as Mary's designation as one who "perfectly possessed" the Liberal Arts. On the left, or northern, tympanum and lintel are scenes of the Ascension. The archivolts contain signs of the zodiac and symbols of the seasonal labors of the twelve calendar months.

The central portal juxtaposes Old Testament kings and queens on the door **jambs** with the apocalyptic vision

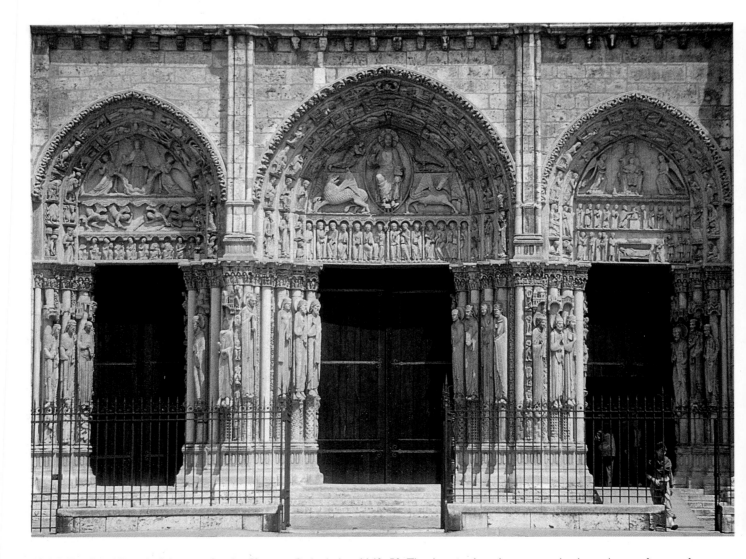

13.14 The Royal Portal of the west façade, Chartres Cathedral, c. 1140–50. The door jamb sculptures are slender, columnar figures of Old Testament kings and queens, hence the name "Royal Portal." Many of these statues were destroyed during the French Revolution (1789) by rioting crowds that mistook the biblical figures for kings and queens of France.

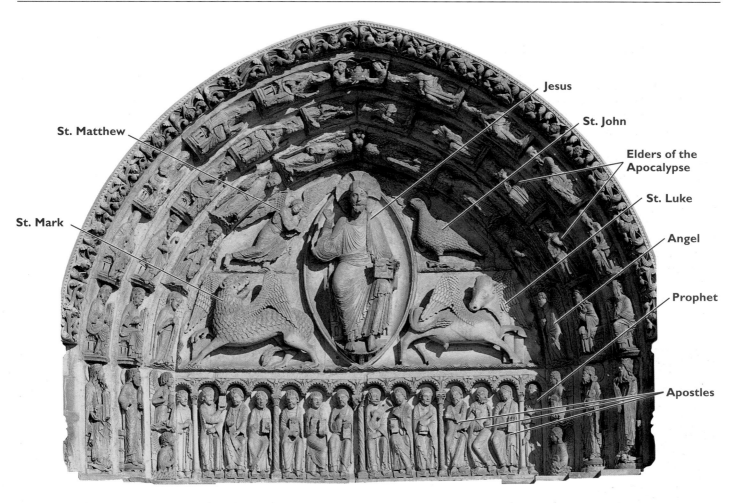

13.15 Tympanum, lintel, and archivolts of the central portal, west façade, Chartres Cathedral, c. 1145–70. The scene on the tympanum represents the Second Coming of Christ, with the four apocalyptic symbols of the Evangelists: the angel stands for Matthew, the lion for Mark, the eagle for John, and the bull for Luke. The surface patterns on all the tympanum figures are stylized—for example, Christ's drapery folds and the wings, drapery, feathers, and fur of the Evangelists' symbols. Christ is frontal, directly facing the visitors to the cathedral, as if reminding them of their destiny.

of Saint John the Divine above the door. The door jamb statues, dating from around 1145–70, are the oldest surviving examples of Early Gothic sculptural style. Each figure is slim and vertical, echoing the shape of the colonnette behind. Separating each statue and each colonnette is a space, decorated with floral relief patterns, which acts as a framing device.

As in Early Christian and Byzantine mosaics, the Old Testament kings and queens are frontal. Their arms are contained within their vertical planes and their halos are flat. Their feet slant downward on a diagonal, indicating that they are not naturally supported. The drapery folds reveal the artist's delight in surface patterns—for example, the repeated zigzags along the hems and circles at the elbows, as well as the stylized hair and beards.

The New Testament event represented over the central door (fig. **13.15**) is the Second Coming of Christ, described by John the Divine in the Book of Revelation. On the tym-

panum, a seated Christ is surrounded by an oval mandorla and the four apocalyptic symbols of the Evangelists. Beneath the tympanum on the lintel, the twelve apostles are arranged in four groups of three. Each group is separated by a colonnette supporting round arches that resemble halos. At either end of the lintel stands a single prophet, holding a scroll. Of the three archivolts, the outer two contain the twenty-four elders of the Apocalypse. The inner archivolt contains twelve angels; the two in the center hold a crown over Christ's head, proclaiming his role as King of Heaven.

Considered as an iconographic totality, the Royal Portal of Chartres offers the visitor a Christian view of history. The beginning and end of Christ's earthly life are placed over the right and left doors, respectively. The Old Testament kings and queens on the door jambs are typological precursors of Christ and Mary, while the Second Coming of Christ dominates the central portal.

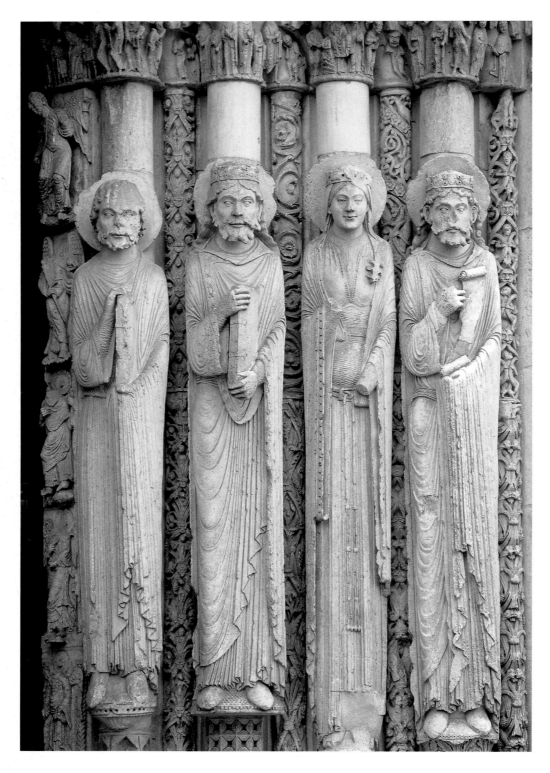

13.16 Door jamb statues, west façade, Chartres Cathedral, c. 1145–70.

A comparison of the door jamb statues from the central doorway of the Royal Portal (fig. **13.16**) with those from the south transept entrance (fig. **13.17**) illustrates the stylistic transition from Early Gothic to the beginning of High Gothic.

South Transept Façade The saints who decorate the left doorway of the entrance portal on the south transept of Chartres (fig. **13.17**) conform less strictly to their colonnettes than do the figures on the Royal Portal, and their feet rest naturally on a horizontal plane. They are no longer strictly frontal, they have facial expressions, and they are of different heights. The heads turn slightly, and there is more variety in their poses, gestures, and costumes. In the figure of Saint Theodore at the far left, for example, the right hip swings out slightly in response to the relaxation of the stance. The diagonal of the belt, apparently weighed down at the saint's left by a heavy sword, conveys a slight suggestion of movement in three-dimensional space.

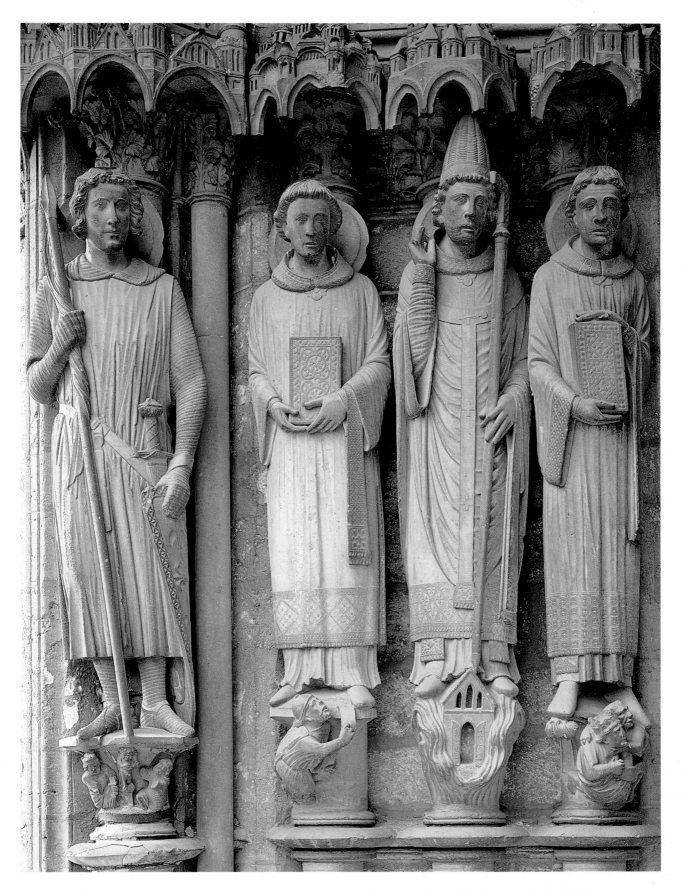

13.17 Saints Theodore, Stephen, Clement, and Lawrence, door jamb statues, south transept, Chartres Cathedral, 13th century.

This general increase in the sense of depth is enhanced by the more deeply carved folds and facial features, as well as by the projecting, crownlike architectural elements over the figures' heads. The proportions of the figures have also changed in comparison with those on the west door jambs. They are wider and seem as if they might step down from their supports into the real world of the observer. Such changes from Early to High Gothic reflect a new, fledgling interest in human form and emotion that would continue to develop in the Late Gothic era.

Interior of Chartres

The overwhelming sensation on entering Chartres Cathedral from the western entrance is height. Its nave is the earliest example of High Gothic architectural style. The view in figure **13.18** looks from the nave toward the curved apse at the east end of the building. The ceiling vaults rise nearly 120 feet (37 m) but are only about 45 feet (14 m) wide.

The new height achieved by Gothic builders was made possible by the buttressing system, whose effect can be seen in the clerestory (see fig. **13.12**). The latter is supported at two points by flyers, allowing more of the wall to be replaced by windows. In each bay, the clerestory windows consist of two lancets under a small round window. At the far end, in the apse, the clerestory lancets are taller, but there are no round windows.

Proceeding down the nave, from west to east, one arrives at the crossing (see fig. **13.11**) and the two transept entrances. Figure **13.19** shows the north rose window illuminated by outside light filtering through the stained glass. Dominating the interior entrance walls, these window arrangements are like colossal paintings in light. Their intensity varies according to weather conditions and time of day. At the center of the rose window, a small circle contains an image of Mary and the infant Christ, surrounded by twelve even smaller circles.

Each series of geometric shapes around the center of the rose window numbers twelve—a reference to the twelve apostles. The first series after the tiny circles contains four doves and eight angels. Twelve Old Testament kings, typological precursors of Christ, occupy the squares. The twelve quatrefoils contain gold lilies on a blue field, symbols of the French kings. The outer semicircles represent twelve Old Testament prophets, who are types for the New Testament apostles.

The central lancet depicts Saint Anne with the infant Mary. At the left are the high priest Melchizedek and King David, and on the right are King Solomon and the priest Aaron—all Old Testament figures. In these windows, as in the west façade sculptures, the lower images act as visual and symbolic supports for the upper images. Here, the additional genealogical link between Christ and Saint Anne is arranged vertically, with Mary as an infant in the lancet below and as the Virgin Mother above, at the center of the rose window.

Wherever possible and appropriate, Gothic artists integrated Christian dogma into the cathedrals. Such buildings were designed as supreme monuments to the glory of God. They also expressed the skills of builders, sculptors, and other craftsmen, as well as the generosity and religious devotion of the patrons.

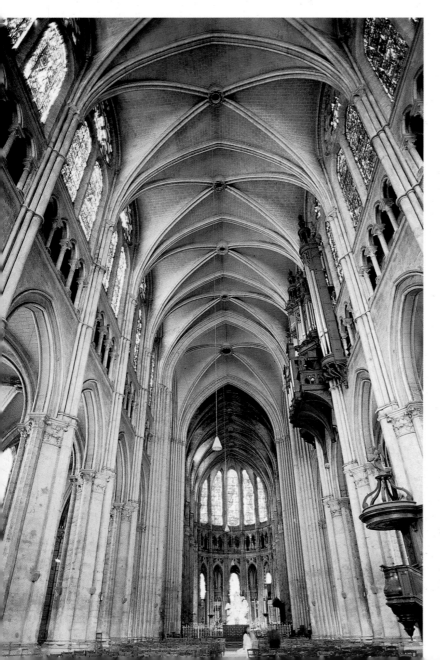

13.18 Nave, Chartres Cathedral, looking east. The three stories of Gothic elevation rise on either side of the nave. The lowest story, or nave arcade, is defined by a series of large arches on heavy piers. These separate the nave from the side aisles (see fig. **13.12**). The second story, or **triforium,** is a narrow passageway above the side aisle. At the top is the clerestory, whose windows are the main source of light in the nave.

13.19 Rose window and lancets, north transept, Chartres Cathedral, 13th century. Note that the north windows are larger and more elaborate than the earlier west façade windows. The north lancets are taller and thinner than those on the west. The north rose window is larger and contains a greater variety of geometric shapes. Additional windows have also been inserted between the lancets and rose window. The rose window measures over 42 feet (12.8 m) in diameter. The windows between the rose window and lancets are decorated with royal coats of arms, which proclaim the divine right of French kings. They also serve as a signature, recording the donation of the north transept by Blanche, the queen mother.

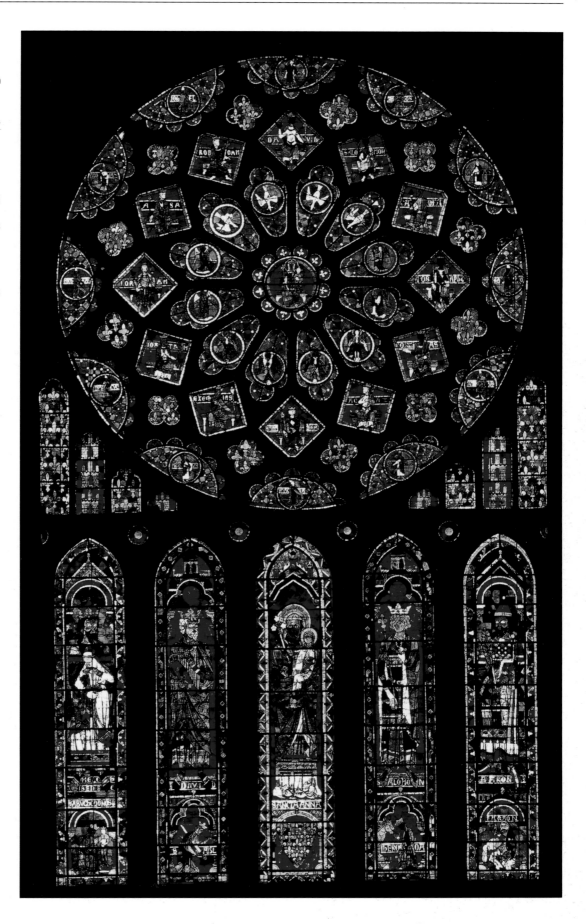

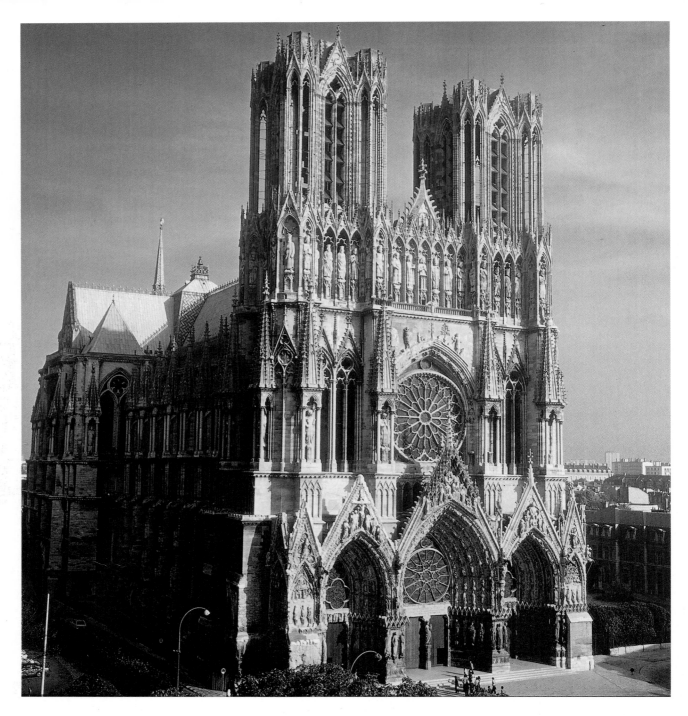

13.20 West façade, Reims Cathedral, France, begun 1211. The window space has been dramatically increased at Reims as a result of continual improvements in the buttressing system. The tympanums on the façade, for example, are filled with glass rather than stone. At Reims the portals are no longer recessed into the façade but are built outward from it.

Later Developments of the French Gothic Style

Completed in 1220, Chartres set the standard for other great French cathedrals in the High Gothic style. Height and luminosity were the criteria by which they were measured. The cathedral at Reims, northeast of Paris, was the next to be built, from 1211 to about 1290. Its nave was 125 feet (38.1 m) high.

Reims

The west façade of Reims (fig. **13.20**) and the interior view of the nave (fig. **13.21**) show the extent to which cathedral designs were becoming progressively elongated, with an increasingly vertical thrust. The proportions of the arches at Reims are taller and thinner than those at Chartres, and the plan (fig. **13.22**) is longer and thinner. The radiating chapels are deeper than at Chartres, and the transepts are somewhat stubby, appearing to merge into the choir with little or no break.

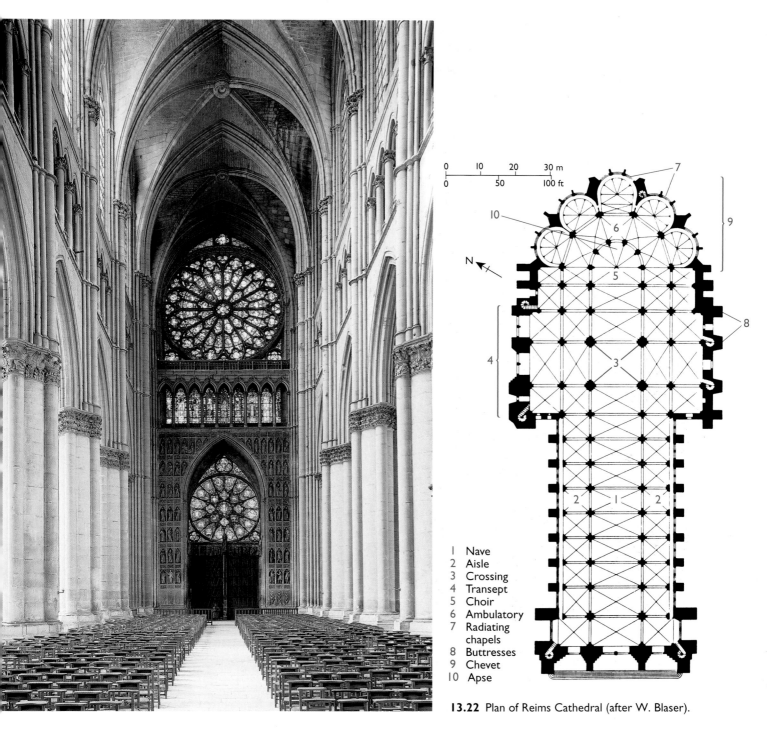

13.21 Nave, Reims Cathedral, 1211–c. 1290. 125 ft. (38.1 m) high.

1 Nave
2 Aisle
3 Crossing
4 Transept
5 Choir
6 Ambulatory
7 Radiating
 chapels
8 Buttresses
9 Chevet
10 Apse

13.22 Plan of Reims Cathedral (after W. Blaser).

The exterior surfaces at Reims are filled with a greater number of sculptures than at Chartres. In contrast to the increased verticality of the architecture, the sculptures have become more naturalistic, as can be seen in the door jamb statues on the west façade at Reims (fig. **13.23**). Rather than being vertically aligned and facing the viewer, as at Chartres, the Reims figures turn to face each other, inter-acting in a dramatic narrative and engaging the spaces between them. The drapery folds suggest human anatomy, poses, and gestures in a more pronounced way than even at the south transept of Chartres. This is one of the earli-est examples in the monumental Christian art of Western Europe of an interest in the relationship between drapery and the human form it covers.

13.23 *Annunciation and Visitation,* door jamb statues, Reims Cathedral, c. 1225–45.

The two figures on the left are the angel Gabriel and Mary. They enact the scene of the Annunciation, in which Gabriel announces Jesus's impending birth to Mary. On the right, in the Visitation scene, Mary visits her cousin Elizabeth and tells her that she is three months pregnant. Elizabeth informs Mary that she herself is six months pregnant. Her son will be John the Baptist, Christ's second cousin and childhood playmate. Note the different drapery styles in each scene. The folds in the Annunciation figures are broader and flatter than those in the Visitation, indicating that the scenes were carved by different artists.

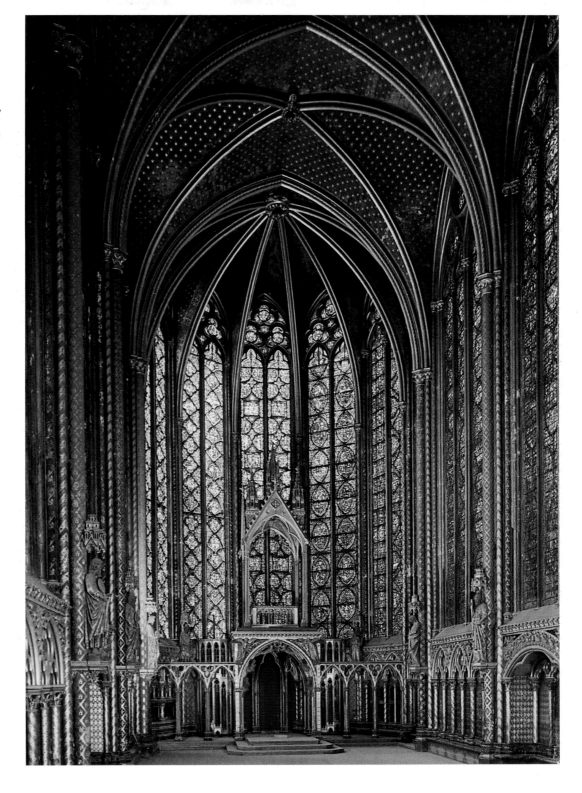

13.24 Nave, Sainte-Chapelle, Paris, 1243–48. 32 ft. × 99 ft. 6 in. (9.75 × 30.3 m). Thomas de Cormont designed Sainte-Chapelle, which was the chapel of the French kings. It was located on the Île-de-la-Cité and attached to the palace.

Paris: Reliquary Chapel of Sainte-Chapelle

The transcendent quality of Gothic light is nowhere more evident than in the reliquary chapel of Sainte-Chapelle in Paris (fig. **13.24**). It was commissioned by King Louis IX, who ruled from 1226 to 1270 and was canonized in 1297, and epitomizes the *rayonnant* style. Here the walls literally become glass as the stone supports diminish. There is no transept, and this allows the tall, thin colonnettes to rise uninterrupted from a short, dimly lit first story. This distinction between the lower darkness and the upper light is an architectural mirror of traditional Christian juxtapositions associating darkness with the lower regions of hell, the Earthly City, and the pre-Christian era. Light, in this context, evokes the Heavenly City and the New Dispensation. These metaphors are reinforced by the ceiling vaults, which are painted blue and decorated with gold stars in the form of **fleurs-de-lis**—the emblem of the French kings.

217

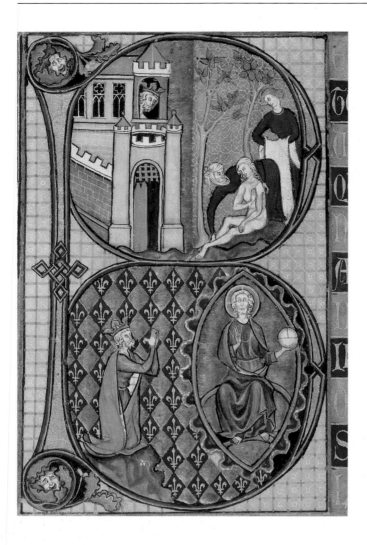

13.25 *King David Looks Down at Bathsheba Bathing and Up to God,* from the Saint Louis Psalter, Paris, c. 1260. Illumination on parchment, 5 × 3½ in. (12.7 × 8.9 cm). Bibliothèque Nationale, Paris, France.

English Gothic

Within a generation of the new choir at Saint-Denis, the Gothic style had spread beyond France. Among the first to adopt the style was England. Since its defeat by the Normans in 1066, there had been commercial, cultural, and political contacts between the two countries.

Salisbury Cathedral

English Gothic was typically more varied than French Gothic. The best example of Early Gothic style in England is Salisbury Cathedral, located in the southwest, not far from Stonehenge (fig. **3.10**). Salisbury Cathedral (fig. **13.26**) was built from 1220 onward in a relatively homogeneous style. It has a cloister (7 in fig. **13.27**), a feature of monastic communities that the English adopted as part of their cathedral plans. In contrast to French cathedrals, Salisbury has a double transept and a square apse. Its **chapter house** (8 in fig. **13.27**) is octagonal, another feature that distinguishes English from French Gothic. As is characteristic of English cathedrals, Salisbury is set in a cathedral **close,** a precinct of lawns and trees. Whereas French cathedrals usually rise directly from the streets and squares of a town, emphasizing their verticality, Salisbury is integrated into the landscape, with horizontal planar thrusts. It has fewer stained-glass windows than most French Gothic cathedrals and, therefore, less need for exterior buttressing.

The large square on the plan represents a **cloister** attached to the south side of the cathedral. Apart from the cloister and a small porch on the north side of the nave, the plan is relatively symmetrical. The double transept and the square apse differ from the corresponding parts of a typical French Gothic cathedral.

The view of the chapter-house ceiling (fig. **13.28**) shows a fan vault, so called because the central pier fans upward and outward toward the ceiling. The fan ribs join those of the vault and resemble the spokes of an inverted umbrella.

The Saint Louis Psalter

The dichotomy between earthly and heavenly vision that characterizes King Louis IX's conception of Sainte-Chapelle recurs in a page from his **psalter,** as shown in figure **13.25**. It illustrates the initial *B* of the first psalm and shows King David above, staring down at the nude Bathsheba bathing before his castle. His gaze is reinforced by those of the two females attending Bathsheba. Juxtaposed with this scene is a more spiritual kind of looking in which David—who is also symbolically King Louis—prays before a heavenly vision of Christ seated within a mandorla and removed from the earthly plane of existence. As at Sainte-Chapelle, the pattern of *fleurs-de-lys* identified Louis IX with the works of art he commissioned.

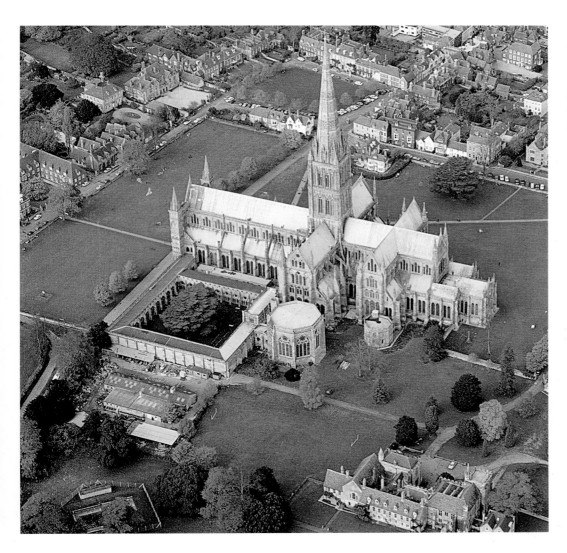

13.26 Salisbury Cathedral, England, begun 1220. The tower and spire were added in the 14th century.

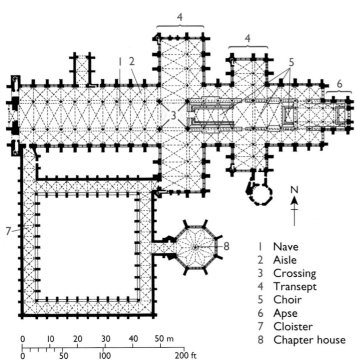

1 Nave
2 Aisle
3 Crossing
4 Transept
5 Choir
6 Apse
7 Cloister
8 Chapter house

N

13.27 Plan of Salisbury Cathedral.

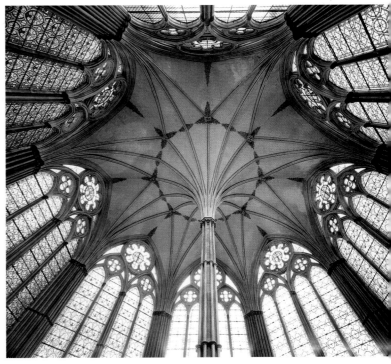

13.28 Vault, chapter house, Salisbury Cathedral, 1263–84.

German Gothic

Cologne Cathedral

The Gothic style also spread to Germany, where one of its most elaborate expressions is Cologne Cathedral (figs. **13.29–13.31**). Begun in 1248, Cologne is the biggest cathedral in Germany, with two aisles on each side of the nave for increased support (see plan). Double flying buttresses on the exterior also reinforce the exterior walls. The towers, which are 515 feet (157 m) high and were completed in 1350, exemplify the late Gothic taste for ornate tracery on the spires, slender vertical thrusts, and animated surfaces that overwhelm the portals. The view of the nave in figure **13.31** shows the dramatic upward movement of the interior as well as the elegant patterns created by the vertical regularity of piers, vaults, and windows. The repetition of statues on the piers creates a horizontal alignment that leads our gaze toward the apse. Until 1890, Cologne Cathedral was the world's tallest building, and it contains the largest reliquary in the West—namely, the Shrine of the Three Kings.

The Gothic style spread throughout Europe, lasting in some areas well into the fifteenth century. In Italy, however, Gothic was relatively shortlived, and by the early fourteenth century the new Renaissance style was beginning to emerge. Later, in the nineteenth century, a Gothic revival style would appear in England and the United States.

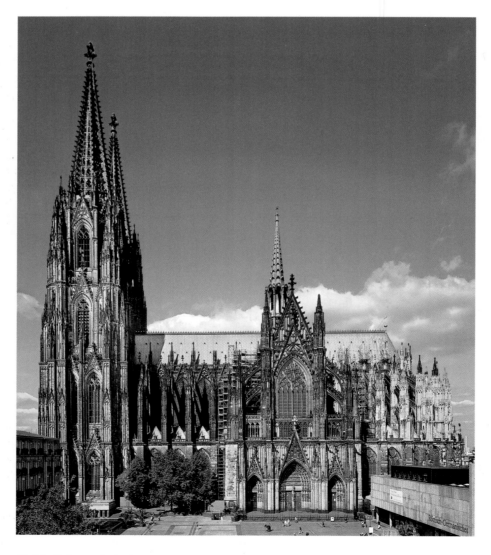

13.29 Cologne Cathedral, begun 1248. Towers completed 1350.

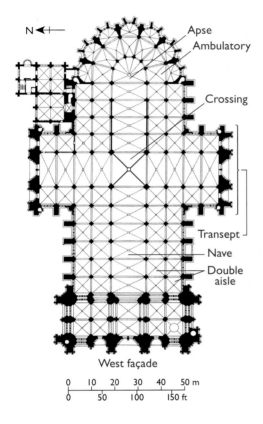

N ←|—

Apse
Ambulatory

Crossing

Transept

Nave

Double
aisle

West façade

0 10 20 30 40 50 m
0 50 100 150 ft

13.30 Plan of Cologne Cathedral.

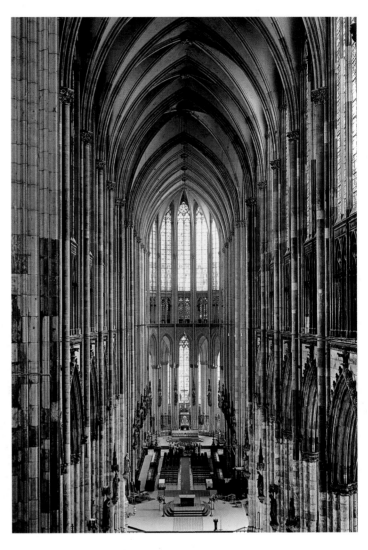

13.31 Nave of Cologne Cathedral.

1137

1500

GOTHIC ART

(13.2)

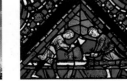
(13.13)

(13.6)

(13.25)

(13.17)

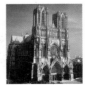
(13.19)

(13.20)

(13.26)

Suger
named abbot
of Saint-Denis
(1122)

University of
Paris founded
(1150)

Arabic numerals
in Europe
(late 1200s)

Jacopo da Voragine
publishes
The Golden Legend
(1266–1283)

Thomas Aquinas
writes
Summa Theologiae
(1273)

Fall of Acre;
end of Christian
rule in the East
(1291)

Chaucer,
*Canterbury
Tales*
(c. 1387)

14
Precursors of the Renaissance

Thirteenth-Century Italy

During the eleventh and twelfth centuries, Italy remained accessible to Byzantine influences, particularly through the eastern port cities of Venice and Ravenna. Around the turn of the thirteenth century, however, developments in Italy, inspired by Roman traditions, led to a major shift in Western European art.

The name given to the period of Italian history from the fourteenth through the sixteenth centuries is Renaissance—the French word for "rebirth" (*rinascimento* in Italian). Dating the beginning of Renaissance style remains an issue of debate, and some would consider the works in this chapter to be Late Gothic. But the term *Renaissance* denotes a self-conscious revival of interest in ancient Greek and Roman texts and culture, which began in fourteenth-century Italy. Even as early as the late thirteenth century, precursors of the Renaissance begin to appear in the visual arts. Italy was the logical place for such a revival since the model of Rome was part of its own history and territory.

Nicola Pisano

Around 1260 the sculptor Nicola Pisano (active 1258–before 1284) carved a marble **pulpit** for the baptistery in Pisa. The figure of Mary in Pisano's *Nativity* (fig. **14.1**) is a good example of Roman heritage in Italian medieval art. Her monumentality and central position evoke her connections with the earth goddesses of antiquity. Despite the Christian subject, the forms are reminiscent of imperial Roman reliefs. Most clearly related to the Roman past are the draperies, which define the organic movement of figures in space.

Nicola Pisano had been exposed to Classical art at the court of the Holy Roman Emperor,

Frederick II. During the first half of the thirteenth century, Frederick controlled territories in southern Italy, and his patronage brought French and German artists, as well as Italians, to his court at Capua, just north of Naples. Like many rulers before and after him, Frederick used the revival of Classical antiquity for his own political purposes, relating his accomplishments to those of imperial Rome. In Pisa as well, Nicola also had direct contact with Roman sculpture.

Training an Artist

In the Middle Ages and Renaissance, artists learned their trade by undertaking a prolonged period of technical training in the shop of a master artist. Young men became apprentices in their early teens either because they had already shown talent or because their families wanted them to be artists. Artists usually came from the artisan class, often from families of artists. Quite a few married into such families and went into business with their in-laws.

14.1 Nicola Pisano, relief including *Annunciation to Mary* at the upper left, *Annunciation to the Shepherds* at the upper right, *Nativity* in the center, and *Washing of the Infant Christ* at the lower center, c. 1260. Marble, approx. 34 in. (86.4 cm) high. Pisa Baptistery.

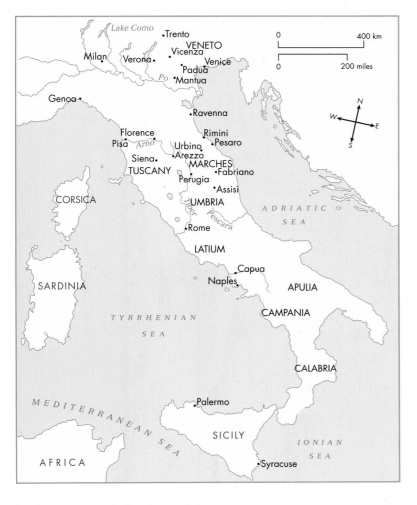

Leading art centers in Renaissance Italy.

The term of apprenticeship varied, but apprentices began learning their trade at the most menial level. They mixed paints, prepared pigments and painting surfaces, and occasionally worked on less important border areas or painted the minor figures of a master's composition. By the time an apprentice was ready to start his own shop, he had a thorough grounding in techniques and media. He would probably also have assimilated elements of his master's style.

Fourteenth-Century Italy

The early fourteenth century in Italy witnessed the development of the humanist movement, which began with a revival of ancient Greek and Latin texts. The rise of humanism reflected, but also significantly extended, the High Gothic interest in nature. Humanists began to establish libraries of Classical as well as Christian texts. Artists began to study the forms of antiquity by observing Roman ruins. And gradually a new synthesis emerged in which nature—including human nature and human form—became the ideal pursued during the Renaissance. Awareness of the Classical revival is reflected in the works of Dante (see Box), Petrarch, and Boccaccio, who discussed art and artists in a new way.

Literacy among the general population increased, and literature dealt more and more with art and the personalities of artists. Another important feature of the Renaissance in Italy was a new attitude to individual fame. Most medieval artists had remained anonymous, but artists of the Renaissance frequently signed their works. The very fact that the names of many more Italian artists of the thirteenth and fourteenth centuries are documented than were recorded in the Early Christian and medieval periods in Europe attests to the artists' intention to record their identity and to preserve it for posterity.

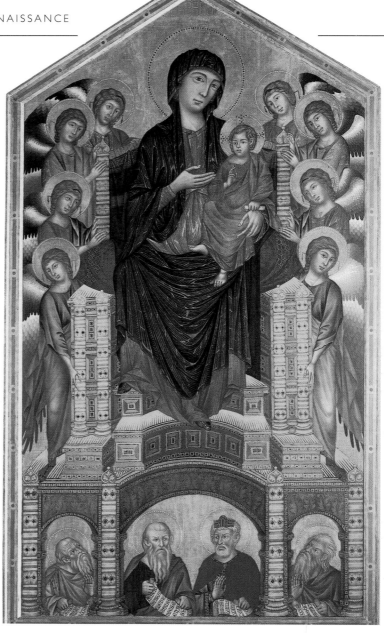

14.2 Cimabue, *Madonna Enthroned*, c. 1280–90. Tempera on wood, 12 ft. 7 in. × 7 ft. 4 in. (3.84 × 2.24 m). Galleria degli Uffizi, Florence, Italy.

Cimabue

Byzantine influence in Italy can be seen in Cimabue's (active 1272–1302) monumental *Madonna Enthroned* (fig. **14.2**). The gold background, the lines of gold in Mary's drapery, and the long, thin figures are characteristic of Byzantine style. The elaborate throne has no visible support at the back but seems instead to rise upward, disregarding the material reality of its weight. As in Byzantine and medieval art, the Christ Child is depicted with the proportions and gestures of an adult. The four prophets at the foot of the throne embody the Old Dispensation as the foundation of the New.

Giotto

The artist who most exemplified, and in large part created, the new style was Giotto di Bondone (c. 1267–1337). He was born in the Mugello Valley near Florence and lived mainly in that city, which was to be the center of the new Renaissance culture. His fame was such that he was summoned throughout Italy, and possibly also to France, on various commissions.

Boccaccio, an ardent admirer of ancient Rome, described Giotto as having brought the art of painting out of medieval darkness into daylight. He compared Giotto to the Greek Classical painter Apelles as a master of illusionism. Petrarch, who was an avid collector of Classical texts and had written extensively about the benefits of nature, owned a painting by Giotto. "The beauty of this painting," wrote Petrarch around 1361, "the ignorant cannot comprehend, but masters of the art marvel at it."[1] Petrarch thus shared Boccaccio's view that Giotto appealed to the intellectually and artistically enlightened. Ignorance, by implication, was associated with the "darkness" of the Middle Ages.

Giotto became the subject of a growing number of anecdotes about artists that were popular from the fourteenth

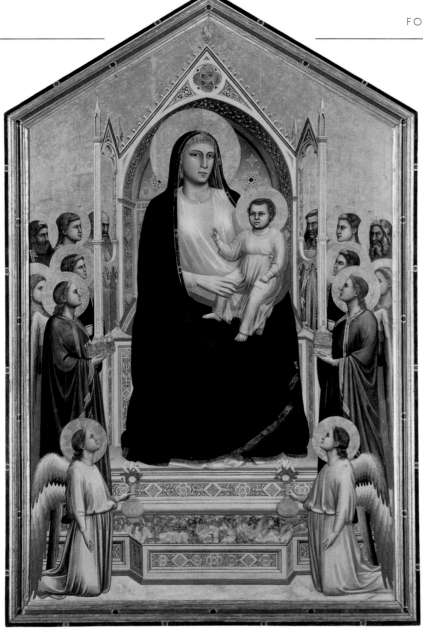

14.3 Giotto, *Madonna Enthroned* (Ognissanti Madonna), c. 1310. Tempera on wood, 10 ft. 8 in. × 6 ft. 8 in. (3.25 × 2.03 m). Galleria degli Uffizi, Florence, Italy. Despite Giotto's fame, few of his works are undisputed. This is the only panel painting unanimously attributed to him. It was commissioned for the Church of Ognissanti (All Saints) in Florence.

century onward. The anecdotal tradition is itself indicative of the Classical revival and derives from accounts of Classical Greek painters who were renowned for their illusionistic skill.

In Dante's *Purgatory,* Giotto and Cimabue are juxtaposed as a lesson in the transience of earthly fame:

> O empty glory of human powers! How short the time its green endures at its peak, if it be not overtaken by crude ages! Cimabue thought to hold the field in painting, and now Giotto has the cry, so that the fame of the former is obscured.[2]

A comparison of Giotto's *Madonna Enthroned* (fig. **14.3**) of c. 1310 with Cimabue's (see fig. **14.2**) illustrates their different approaches to space and to the relationship between space and form. Both pictures are **tempera** on panel (see Box, p. 226) and may have been intended as altarpieces (see Box, p. 226). Each has an elaborate throne (Giotto's with

Gothic pointed arches), a Byzantine gold background, and flat, round halos that do not turn with the heads. Whereas Cimabue's throne rises in an unknowable space (there is no floor), Giotto's is on a horizontal support approached by steps. In contrast to Cimabue's long, thin, elegant figures, Giotto's are bulky, with draperies that correspond convincingly to organic form and obey the law of gravity. Giotto has thus created an illusion of three-dimensional space—his figures seem to turn and move as in nature.

Whereas Cimabue uses lines of gold to emphasize folds in drapery, Giotto's folds are rendered by shading. Giotto's V-shaped folds between Mary's knees identify both their solidity and the void between them, while the curving folds above the waist impart a suggestion of *contrapposto* and also direct the viewer's attention to Jesus.

A comparison of the two figures of Jesus reveals at once that Giotto was more interested than Cimabue in the reality of childhood. Cimabue's Jesus retains aspects of the

Examples of tempera painting are found as early as ancient Egypt. From the medieval period through the fifteenth century, however, it was the preferred medium for wooden panel paintings, especially in Italy, lending itself to precise details and clear edges.

For large panels, such as those illustrated in figures 14.2 and 14.3, elaborate preparations were required before painting could begin. Generally, a carpenter made the panel from poplar, which was glued and braced on the back with strips of wood. He also made and attached the frame. Apprentices then prepared the panel, under the artist's supervision, by sanding the wood until it was smooth. They sealed it with several layers of **size**, a glutinous material used to fill in the pores of the panel and to make a stable surface for later layers. Strips of linen reinforced the wood to prevent warping. The last step in the preparation of the panel was the addition of several layers

of **gesso**, a water-based **ground** thickened with chalk and size to help smooth the surface. Once each layer of gesso had dried, the surface was again sanded, smoothed, and scraped. The gesso thus became the support for the work.

At this point, painting could begin. Using a brush, the artist lightly outlined the forms in charcoal and reinforced the outline with ink or incised it with a **stylus**. The decorative gold designs, halos, and gold background were applied next and were polished so they would glow in the dark churches.

Apprentices made paint by grinding to a paste pigments from mineral or vegetable extracts and suspending them in a mixture of water and egg. The artist then applied the paint with small brushes made of animal hair. Once the artist had completed the finishing touches, the painting was left to dry—a year was the recommended time—and then it was varnished.

medieval *homunculus*. He has a small head and thin proportions, and he is not logically supported on Mary's lap. Giotto's Jesus, on the other hand, has chubby proportions and rolls of baby fat around his neck and wrists; he sits firmly on the horizontal surface of Mary's leg. Although Giotto's Christ Child is regal and his right hand is raised in a gesture of blessing, his proportions are more natural than those of Cimabue's Child. It was precisely in the rendition of nature that Giotto seemed to his contemporaries to have surpassed Cimabue and to have revived the forms of antiquity, heralding the emergence of a new generation of artists.

An altarpiece is a devotional image (usually a panel painting of tempera on wood), which was originally located behind an altar, visible only to the clergy. After 1215, the priest was moved to the front of the altar, with his back to the congregation. This freed up the rear of the altar for an image. One purpose of the altarpiece was to engage viewers in the sacred drama of the Mass. From the fourteenth century, altarpieces typically had a fixed base (the **predella**), surmounted by one or more large panel paintings. In most cases the large panels contain the more iconic images—such as an enthroned Virgin and Christ, or individual saints—and the predellas contain smaller narrative scenes related to the larger figures. In northern Europe, **wings** (side panels) would usually have been attached with hinges. These wings would then be "closed" when the altarpiece was not on display or being used for a service. In Italy the wings were typically fixed (not movable).

The Arena Chapel

The best-preserved example of Giotto's work is the **fresco** cycle in the Arena Chapel in Padua, located about 25 miles (40 km) southwest of Venice. In the second half of the thirteenth century, under a republican form of government, a group of Paduan lawyers developed an interest in Roman law, which led to an enthusiasm for Classical thought and literature. Roman theater was revived, along with Classical poetry and rhetoric. As the site of an old and distinguished university, Padua was a natural center for the development of humanism, which acknowledged the primacy of individual intellect, character, and talent. Giotto, more than any other artist, transformed these ideals into painting.

The Arena Chapel (named for the old Roman arena adjacent to it) was founded by Enrico Scrovegni, Padua's wealthiest citizen—hence its alternative designation as the Scrovegni Chapel. Having inherited a fortune from his father, Reginaldo Scrovegni (whom Dante had consigned to the seventh circle of hell for usury), Enrico commissioned the chapel and its decoration as an act of atonement. The building itself is a simple barrel-vaulted, rectangular structure, faced on the exterior with brick. The interior is decorated with one of the most remarkable fresco cycles in Western art (fig. **14.4**). Architectural elements are kept to a minimum: the south wall has six windows while the north wall is solid, making it an ideal surface for fresco painting (see Box, p. 228). The west wall, which has one window divided into three lancets, is covered with an enormous *Last Judgment* (see fig. **14.6**).

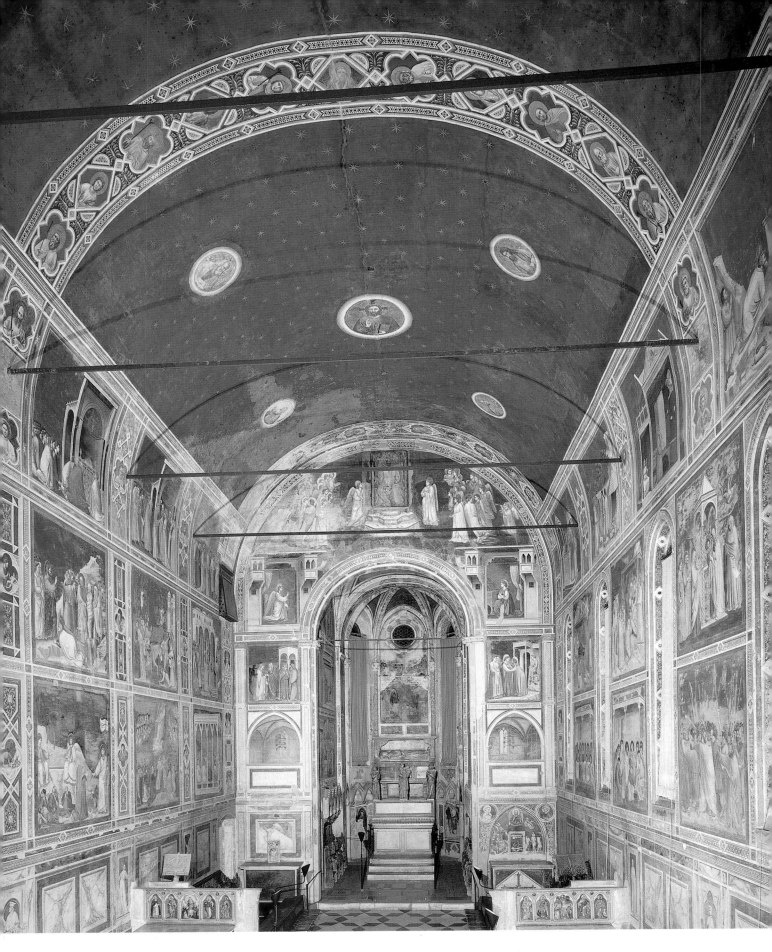

14.4 Interior view, looking east, Arena Chapel, Padua, c. 1305. At the top of the round chancel arch, there is a tempera panel set into the plaster wall, depicting God the Father enthroned. He summons the angel Gabriel and entrusts him with the Annunciation of Jesus's birth to Mary.

227

MEDIA AND TECHNIQUE
Fresco

From the thirteenth to the sixteenth century, there was a significant increase in the number of monumental fresco cycles, especially in Italy.

Fresco cycles were typically located on plaster walls in churches, public buildings, or private palaces, and large scaffolds were erected for such projects. First, the wall was covered with a layer of coarse plaster, called the **arriccio,** which was rough enough to hold the final layer of plaster. When the first layer had dried, the artist found his bearings by establishing the exact center of the surface to be painted and by locating the vertical and horizontal axes. He blocked out the composition with charcoal and made a brush drawing in red ocher pigment mixed with water. These drawings are called **sinopie (sinopia** in the singular) after Sinope, a town on the Black Sea known for the red color of its earth.

Once the artist had completed the *sinopia,* he added the final layer of smooth plaster, or **intonaco,** to the walls one patch at a time. The artist applied the colors to the *intonaco* while it was still damp and able to absorb them. Thus, when the plaster dried and hardened, the colors became integrated with it. Each patch was what the artist planned to paint in a single day—hence the term **giornata,** the Italian word for a day's work. Because each *giornata* had to be painted in a day, fresco technique encouraged advance planning, speed of execution, broad brushstrokes, and monumental forms. Sometimes small details were added in tempera, and certain colors, such as blue, were applied *secco* (dry). These have been largely lost or turned black by chemical reaction.

On the north and south walls, three levels of rectangular scenes illustrate the lives of Mary, her parents Anna and Joachim, and Jesus. Below the narrative scenes on the north and south walls are Virtues and Vices, disposed according to traditional left-right symbolism. As the viewer enters the chapel, the Virtues are on the right and the Vices on the left. Facing the observer is the chancel arch, containing *Gabriel's Mission* at the top, two other events from Jesus's life (the *Betrayal of Judas* on the left and the *Visitation* on the right), and two illusionistic chapels.

Immediately below *Gabriel's Mission,* separated into two images on either side of the arch, is the *Annunciation.* The setting is a rectangular architectural space with balconies that seem to project outward. Equally illusionistic are the pieces of cloth, which appear to hang on poles attached to the balconies and swing in toward the windows.

Illusion is an important aspect of theater, and in the Arena Chapel the space in which the sacred drama unfolds has been compared to a stage. A comparison of Giotto's *Nativity* (fig. **14.5**) with that of Nicola Pisano on the Pisa pulpit (see fig. **14.1**) illustrates Giotto's reduction of form and content to its dramatic essence. Giotto's fresco combines two rather than four events in a single space—the *Annunciation to the Shepherds* at the right with the *Nativity* at the left. Both artists use simple, massive draperies that outline the human form and monumentalize the figures. But Nicola's composition is more crowded, and the dramatic relationships between figures do not have the power of Giotto's version.

Giotto's shepherds are rendered in back view, riveted to the angel's announcement. In the *Nativity,* the human figures are reduced to four: Mary, Jesus, Joseph, and a midwife. A single foreshortened angel above the shed gazes down at the scene, interrupting the left-to-right flow of the other angels toward the shepherds and focusing the viewer's attention onto the Nativity. Another iconographic play on the gaze appears in the convention of the ox, who sees the important event taking place—a fact emphasized by the prominence of his eye. The ass, on the other hand, fails to see and thus became associated with the unenlightened and the ignorant.

A sculpturesque Joseph dozes in the foreground, withdrawing from the intimate relationship between mother and infant. Giotto accentuates this by the power of a gaze between mother and child that excludes a third party. Nicola's Mary, on the other hand, stares forward while Jesus lies in the manger behind her. Rather than emphasize the dramatic impact of the mother's first view of her son, Nicola monumentalizes Mary as an individual maternal image and, in the *Nativity,* places Jesus in the background.

Chronologically, the last scene in the chapel is the *Last Judgment* (fig. **14.6**), which fulfills the prophecy of Christ's Second Coming. The finality of that event corresponds to its location on the west wall of the Arena Chapel, where it is the last image to confront viewers on their way out. The host of heaven, consisting of military angels, is assembled on either side of the window. Above the angels, two figures roll up the sky and reveal the golden vaults of heaven.

Below the window, Christ is enthroned in a circle of light, surrounded by angels. Seated on a curved horizontal platform on either side of Christ are the twelve apostles. Christ's right hand summons the saved souls, while his left rejects the damned. He inclines his head to the lower left of

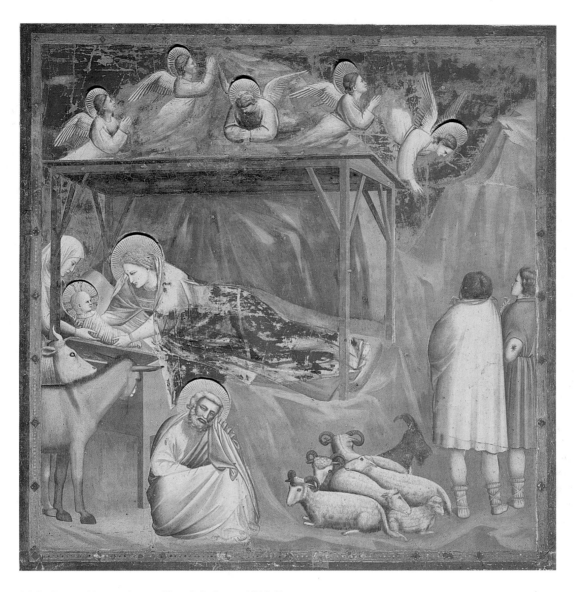

14.5 Giotto, *Nativity*, Arena Chapel, Padua, c. 1305. Fresco.

the fresco (his right), where two levels of saved souls rise upward. At the head of the upper group stands the Virgin Mary, who appears in her role as intercessor with Christ on behalf of humanity.

Giotto's hell, conventionally placed below heaven and on Christ's left, is the most medieval aspect of the Arena Chapel frescoes. It is surrounded by flames emanating from the circle around Christ. In contrast to the orderly rows of saved souls, those in hell are disordered—as in the Romanesque example from Conques (see fig. **12.8**). The elaborate visual descriptions of the tortures inflicted on the damned by the blue and red devils, and their contorted poses, are reminiscent of medieval border figures, whether on manuscripts or church sculptures.

The large, blue-gray Satan in the depths of hell is typical of medieval taste for monstrous forms merging with each other. Satan swallows one soul while serpentine creatures that emerge from his ears bite into other souls, an image of oral aggression that appears in many medieval manuscripts. Dragons on either side of Satan's rear also swallow souls, and from the ear of one of the dragons rises a ratlike creature biting into a soul, who falls back in despair. The falling and tumbling figures emphasize the Christian concept of hell as disordered, violent, and located in the lowest realms of the universe.

Directly below Christ, two angels hold the Cross, which divides the lower section of the fresco into the areas populated by the saved and the damned. Giotto's reputation for

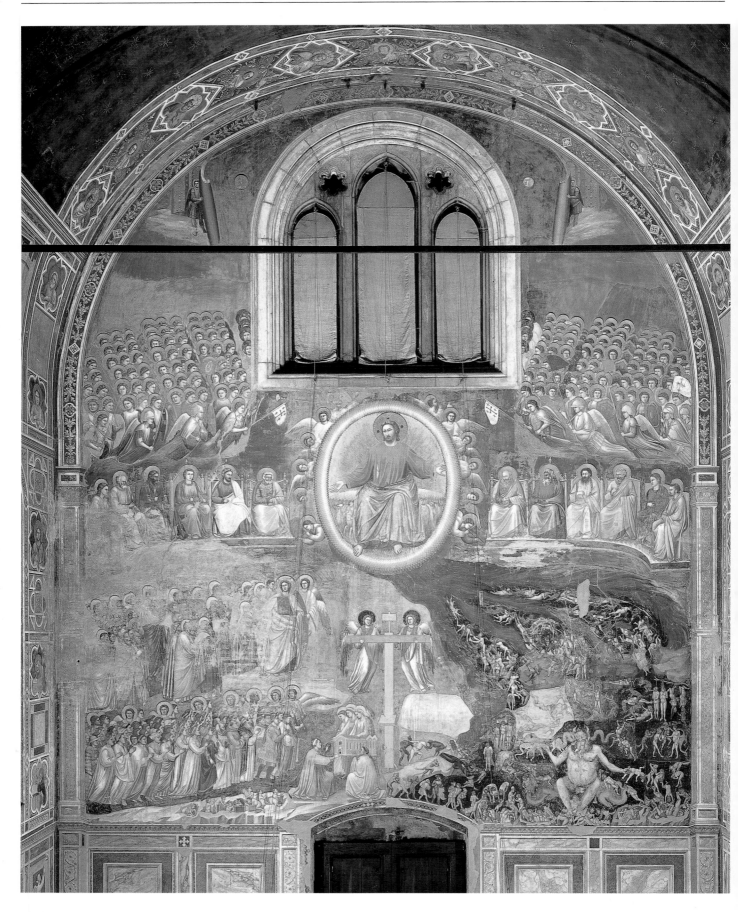

14.6 Giotto, *Last Judgment*, Arena Chapel, Padua, c. 1305. Fresco, approx. 33 ft. × 27 ft. ¾ in. (10.1 × 8.4 m).

Before leaving the Arena Chapel, we consider the Virtue of *Justice* (fig. **14.8**), which reflects the contemporary humanist concern with government. Two forms of government prevailed in Italy as the Renaissance dawned. Popes and princes ruled the relatively authoritarian states, while republics and communes (preferred by the humanists) were more democratic. Although the latter were, in practice, more often oligarchies (governments controlled by a few aristocrats) than democracies in the modern sense, the concept of a republican government was based on the ancient Roman republic and Athenian *polis* (see Chapter 7).

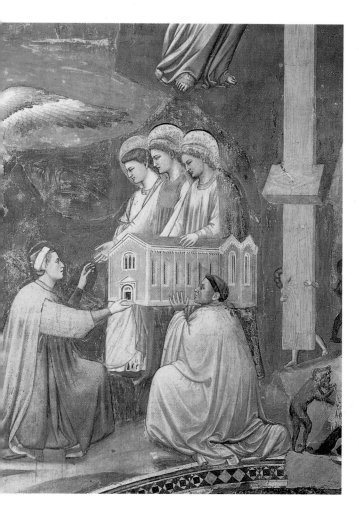

14.7 Giotto, *Last Judgment* (detail of fig. **14.6**), Arena Chapel, Padua, c. 1305. Enrico Scrovegni, assisted by a monk, lifts up a model of the Arena Chapel and presents it to the Virgin and two other figures. Scrovegni faces the exterior of the entrance wall, the interior of which contains the *Last Judgment*.

humor is exemplified in the little soul behind the Cross who is trying to sneak over to the side of the saved. Toward the bottom of hell, a mitered bishop is approached by a damned soul holding a bag of money, possibly hoping to buy an indulgence. Besides being a criticism of corruption in the Church, this detail may refer to Reginaldo Scrovegni's financial sin, for which his son tried to atone through his patronage of the Arena Chapel. Not surprisingly, Enrico is placed on the side of the saved (fig. **14.7**). Such a portrayal of the donor within a work of art was to become characteristic of the Renaissance. The drapery of the monk assisting him falls onto the ground in soft folds, indicating the weight of the fabric. It appears to fall out of the picture over the actual arch above the door, exemplifying the illusionism for which Giotto was celebrated.

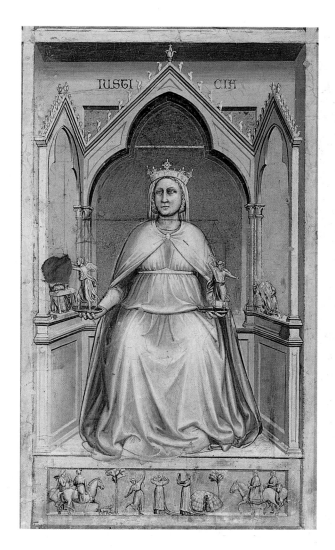

14.8 Giotto, *Justice*, Arena Chapel, Padua, c. 1305. Fresco. Justice is personified as an enthroned queen in a Gothic architectural setting. She holds a Nike in her right hand, as did Phidias's Athena in the Parthenon *naos* (fig. **7.27**), indicating that justice brings victory. Justice also leads to good government and a well-run state, with all the benefits that this implies. Painted as an imitation relief in the rectangle at the bottom of the picture are images of dancing, travel (men on horseback), and agriculture.

Painting in Siena

The leading early-fourteenth-century artists in Siena, Florence's rival city and a major artistic center, worked in a style that was influenced by Byzantine tradition. Siena was ruled by a group known as the Nine, which was in charge of public commissions. The Nine were particularly devoted to the Virgin and her cult was a significant feature of Sienese culture. She was the city's patron saint; Siena called itself "the Virgin's ancient city" (*vetusta civitas virginis*).

Duccio's *Rucellai Madonna*

In 1285 the prominent Sienese painter Duccio di Buoninsegna (active 1278–1318) was commissioned to paint an important large altarpiece for a Dominican lay confraternity devoted to the cult of the Virgin (fig. **14.9**). Compared with altarpieces by Cimabue and Giotto (see figs. **14.2** and **14.3**), Duccio's is more three-dimensional than the former but less so than the latter. The throne rests on a solid horizontal, but it rises at the back at an oblique angle, and four of the angels are suspended in a flat gold space. Duccio has emphasized vivid color, an abundance of gold, and elaborate architectural details to enhance the glory of Jesus and his mother. The tension between naturalism and flat patterning is a formal echo of the shift between the material and the spiritual worlds embodied by the life, death, and resurrection of Christ. In this painting, as in the Cimabue and the Giotto, Mary is the Queen of Heaven and her son is its future king.

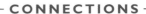

CONNECTIONS

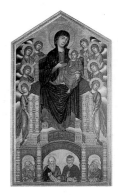

See figure 14.2.
Cimabue, *Madonna Enthroned,* c. 1280–90.

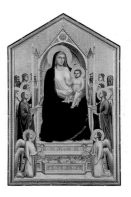

See figure 14.3.
Giotto, *Madonna Enthroned,* c. 1310.

14.9 Duccio, *Rucellai Madonna,* 1285. Panel, 14 ft. 9⅞ in. × 9 ft. 6⁵⁄₁₆ in. (4.52 × 2.90 m). Galleria degli Uffizi, Florence, Italy.

The *Maestà*

From 1308 to 1311, Duccio worked on a monumental altarpiece for the high altar of Siena Cathedral to honor the Virgin, whose image is the largest in the work. The completed altarpiece was two-sided and originally consisted of more than fifty panels, several of which have been lost. The front exalts the Virgin in her aspect as Queen of Heaven—*maestà* means "majesty." She occupies the large horizontal panel (fig. **14.10**), the sides of her throne opening up as if to welcome the viewer. In the crowd surrounding Mary appear John the Evangelist and Peter. The other ten apostles are the smaller figures under the round arches.

The influence of Giotto—and of the Roman revival—is evident in the sense that the figures obey the laws of gravity and that shading, rather than gold lines, is used to define form. As with Giotto's monk assisting Enrico Scrovegni in the *Last Judgment,* the draperies of the four saints in the foreground fall illusionistically over the edge of the painted floor. In contrast to Giotto, however, Duccio was drawn to rich color and crowded compositions. His figures are more elegant than Giotto's blocklike sculptural forms.

The iconography of the *Maestà* covers the full range of the Virgin's majesty and of her maternity. She is both the mother of Jesus and the patron of the citizens of Siena. In 1311, when Duccio had completed the *Maestà,* it was carried in a triumphal procession from his studio to the cathedral.

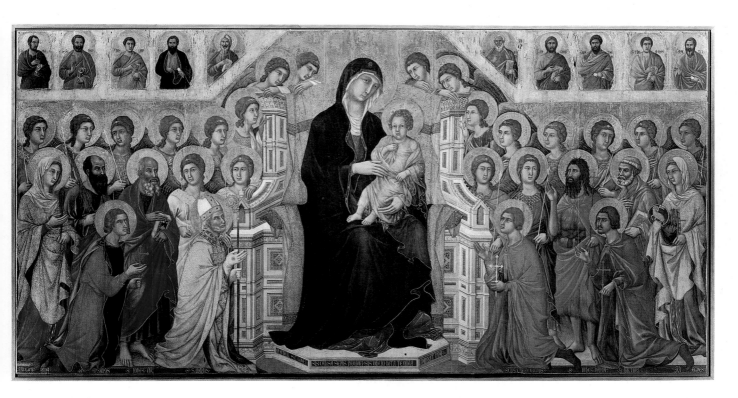

14.10 Duccio, *Maestà,* from Siena Cathedral, 1308–11. Tempera and gold on panel, 7 ft. × 13 ft. 6¼ in. (2.13 × 4.12 m). Museo dell'Opera del Duomo, Siena, Italy.

The *Kiss of Judas*

Duccio and Giotto exemplify two significant currents in early-fourteenth-century Italian painting. Duccio was more closely tied to the Byzantine tradition, whereas Giotto was steeped in the revival of Classical antiquity. This can be seen by comparing their respective versions of the *Kiss of Judas* (figs. **14.11** and **14.12**). Both represent the moment when Judas identifies Jesus to the Romans with a kiss.

In Duccio's panel (fig. **14.11**), Jesus is nearly frontal and Judas leans over in a sweeping curved plane to embrace him. Their heads connect, but Judas's lips do not actually touch Jesus's face. The scene is densely packed with figures, but this is somewhat relieved by the landscape background. The subtle shading of the drapery folds gives the figures a sense of three-dimensional form. Some of the apostles break away from the central crowd and rush off to the right. Their long, curvilinear planes have the quality of a graceful dance movement performed in unison. At the left, Saint Peter also turns from Christ, but, in a rage, he cuts off the ear of Malchus, the servant of the high priest.

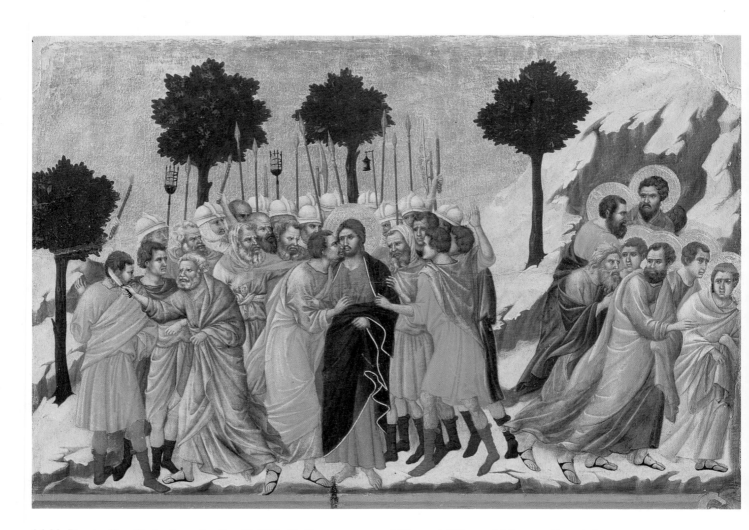

14.11 Duccio, *Kiss of Judas*, from the *Maestà*, 1308–11. Tempera on panel. Museo dell'Opera del Duomo, Siena, Italy.

Giotto's *Kiss of Judas* (fig. **14.12**) lives up to his reputation among Renaissance authors as having reintroduced naturalism to painting. The fresco is virtually devoid of landscape forms that might distract viewers from the central event. Nor do any of Giotto's figures face the picture plane. They turn freely in space like actors on a stage and are focused on the dramatic confrontation between Jesus and Judas. They, in turn, are locked in each other's gaze, surrounded ominously by the blackened helmets framing their heads. Over Jesus's head, the two hands holding stakes accentuate the rage of the mob against him; none of the stakes is vertical, as in the Duccio; in fact, those behind Jesus seem to radiate like a halo from an unseen point. In this convergence of forms, Giotto signals both the violence of Jesus's death and his ultimate triumph.

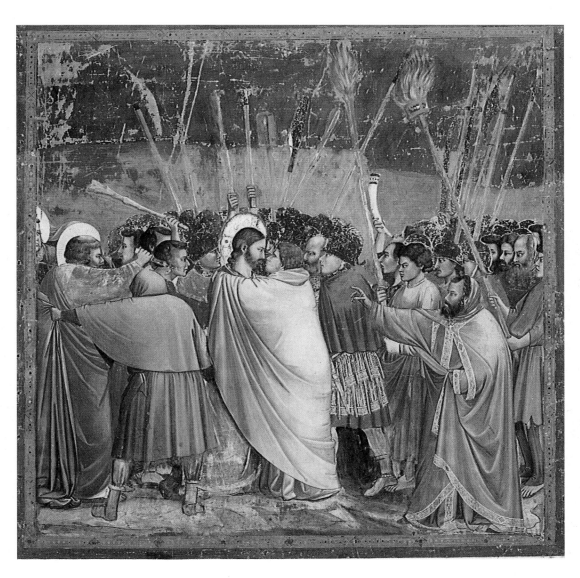

14.12 Giotto, *Kiss of Judas,* Arena Chapel, Padua, c. 1305. Fresco.

Ambrogio Lorenzetti and the *Effects of Good Government*

Twenty-seven years after the triumphal procession for Duccio's *Maestà,* the innovative Sienese artist Ambrogio Lorenzetti (active 1319–47) painted *Allegories of Good and Bad Government* for the Palazzo Pubblico (Town Hall) of Siena. Figure **14.13**, like Giotto's *Justice* (see fig. **14.8**), illustrates the effects of good government on a city—in this case Siena. In contrast to the *Maestà,* Ambrogio's *Allegory* is secular, and it reflects the new humanist interest in republican government. He depicts a broad civic panorama with remarkable realism. In the foreground (from left to right), women wearing the latest fashions dance and sing in celebration of the joys of good government; people ride on horseback among the buildings, whose open archways reveal a school, a cobbler's shop, and a tavern; farmers are shown entering the city to sell their produce. On the rooftops in the background, workers carry baskets and lay bricks. In this imagery, Lorenzetti shows that both agricultural prosperity and architectural construction are among the advantages of good government.

Just outside the city walls, people ride off to the country. Below, a group of peasants till the soil, and the cultivated landscape visible in the distance draws the viewer into an almost unprecedented degree of spatial depth. Floating above this tranquil scene, an allegorical figure of Security holds a scroll with an inscription reminding viewers that peace reigns under her aegis. And should one fail to heed the inscription, she provides a pictorial message in the form of a gallows. Swinging from the rope is a criminal executed for violating the laws of good government. Accompanying Ambrogio's vision of prosperity and tranquillity, therefore, is a clear warning of the consequences of social disruption.

Directly behind the left foot of Security, Ambrogio has included the statue of the legendary she-wolf who nursed Romulus and Remus. Projecting from the city's wall, she seems to survey the surrounding countryside. At the same time, the wolf makes explicit the link between ancient Rome and Siena, alluding to the legendary founding of Siena by Senius, the son of Remus.

A series of disasters in Western Europe disrupted the activities of the next generations of fourteenth-century artists. There was famine in 1329, an eclipse followed by a flood in 1333, and a smallpox epidemic in 1335 that killed thousands of children. In the early 1340s, the Bardi and Peruzzi banks failed, and in 1348 bubonic plague—known as the Black Death—devastated Europe. In Florence and Siena, between 50 and 70 percent of the residents died; this resulted in population shifts, economic depression, and radical changes in artistic patronage and style.

As a result of these disasters, artists became drawn to such subjects as the Triumph of Death. Andrea di Cione—known as Orcagna (active c. 1343–68)—painted a monu-

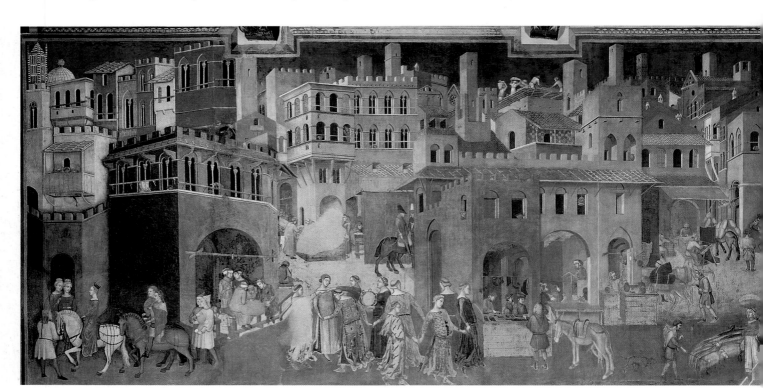

14.13 Ambrogio Lorenzetti, *Effects of Good Government in the City and the Country,* Sala della Pace, Palazzo Pubblico, Siena, 1338–39. Fresco, entire wall 46 ft. (14 m) long. Ambrogio was one of two artist brothers who were active in the first half of the 14th century. Both were born and worked in Siena, and they are believed to have died of the Black Death, since nothing is heard of them after 1348. Ambrogio also worked in Florence, where he was exposed to Giotto's style. The *Allegory of Good Government,* which has considerable documentary value as well as artistic merit, is considered his greatest surviving work.

mental fresco in the church of Santa Croce in Florence in which he combined the theme with depictions of hell and the Last Judgment. Although the work survives only in fragments, its message of impending doom remains clear.

The detail in figure **14.14** shows two cripples and two blind men invoking Death. The anxious gesture of one of the sightless men contrasts with the wide-eyed stares of the cripples, whose hands are needed for their crutches. The inscription reads: "Since prosperity has departed, Death, the medicine of all pain, come and give us our last supper."

Contemporary sermons document the resurgence of religious fervor following the Black Death. In the visual arts there was a revival of certain aspects of the Byzantine style. The increasingly humanistic style of the first half of the century yielded to a more pessimistic view of the world, with greater emphasis on death and damnation. The innovations of Giotto and other early-fourteenth-century artists remained in abeyance; they were revived by the first generation of Italian painters, sculptors, and architects of the fifteenth century.

14.14 (Above) Andrea Orcagna, detail from the *Triumph of Death*, showing figures invoking Death. 1360s. Fresco. Museo dell'Opera di Santa Croce, Florence, Italy.

The International Gothic Style

An entirely different mood characterized works commissioned by the courts in fourteenth-century Italy and France. Their wealth made it possible to import artists from different regions and to pay them well. The resulting convergence of styles, generally known as International Gothic, continued into the fifteenth century; the best fourteenth-century examples were executed under French patronage.

Toward the end of the fourteenth century, France was ruled by Charles V. Two of his brothers—Philip the Bold (1342–1404) and Jean, duc de Berry (1340–1416)—presided over lavish courts, which were enriched by their ambitious patronage. The sumptuousness of the works produced for them shows the degree to which the courts were removed from the real world. In actuality, France and other areas of Europe suffered continual upheaval from the ravages of the Hundred Years' War.

Philip's court was located at Dijon, in the Burgundy region of central France. His wife, Margaret of Flanders (modern Holland, Belgium, and parts of France), provided a link with the North. Reflecting the international character of his court and his patronage, Philip commissioned an architect from Paris and a sculptor from the Netherlands to design a Carthusian monastery—the Chartreuse de Champmol—near his Dijon palace; this building was to house the family tombs. Philip's competition with the king is suggested by the fact that his architect had worked for Charles in Paris, and that the monastery's portal followed Charles's lead in placing portrait sculptures of living people on the door jambs—a site formerly reserved for Old Testament kings, queens, and prophets, and for Christian saints.

Claus Sluter

Philip's sculptor, Claus Sluter (active 1379–1406), placed a figure of the Virgin Mary on the **trumeau** of the portal (fig. **14.15**). She is crowned, but her character is primarily maternal. Although the architectural feature above her is Gothic and Sluter worked in a Gothic tradition, he transformed the representation of human figures. Compared with the door jamb figures at Chartres, Sluter's Virgin turns freely to gaze on her son. She is animated by the sweep of her billowing draperies, and the folds emphasize her spatial flexibility, creating a sense of dynamic energy.

Mary's gaze, focused as it is on Jesus, is repeated by the door jamb figures. Philip (on the left) and Margaret (on the right) kneel in prayer, facing toward the Virgin. They adore the Queen of Heaven as she adores Jesus. Leaning over the noble pair and interceding on their behalf are Saints John the Baptist and Catherine. Sluter contrasts the rhythmic orchestration of deeply carved, elegant drapery curves with the fixed, arrested concentration of the door jamb figures on Mary and Jesus.

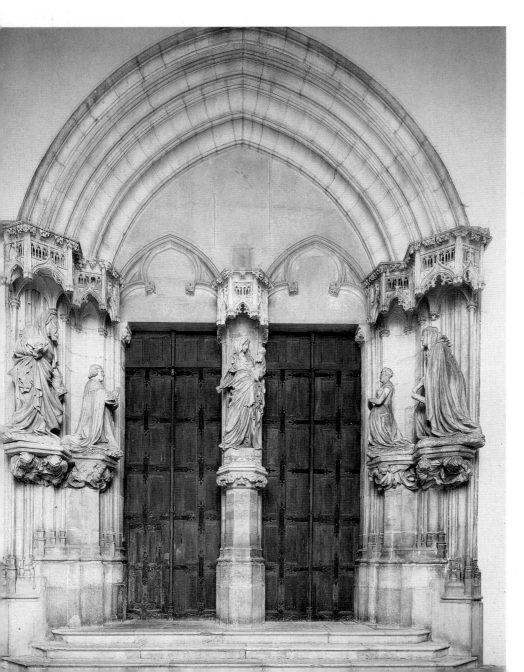

14.15 Claus Sluter, portal, Chartreuse de Champmol, Dijon, 1385–93. The sculptor Claus Sluter was born in Haarlem, the Netherlands. After he went to the court of Philip the Bold, he was quickly promoted to the position of *imagier* and *valet de chambre*.

Two years after completing the portal, Sluter began the Well of Moses, a monumental fountain for the Chartreuse (fig. **14.16**). It stands on a hexagonal base with an Old Testament figure on each side. Six small angels on colonnettes between the life-size figures lean over in the compressed space under the edge of the basin. They spread their wings to form an arch over each figure. The Crucifixion was originally represented by a great Cross (now lost) set in stone and carved in imitation of Golgotha. This was supported by the "well," just as the Old Testament was seen as the foundation of the New. Christ was thus the "fountain of life"—the *fons vitae.*

The figure of Moses is a powerful, thoughtful patriarch. His lined face, strong nose, and slight frown give the sculpture a portraitlike quality. But the features are overwhelmed by the swirling energy of the beard and by the stunted horns emerging from his head. These became an iconographic convention in representations of Moses, when his radiance on descending from Sinai with the Tables of the Law was mistranslated as "horned." The Ten Commandments were interpreted as a prefiguration of the new Christian order signified in the great Crucifix over the fountain. And it is to this event that the inscription of Moses's scroll refers: "The whole assembly of the congregation of Israel shall kill it [the lamb] in the evening" (Exodus 12:6).

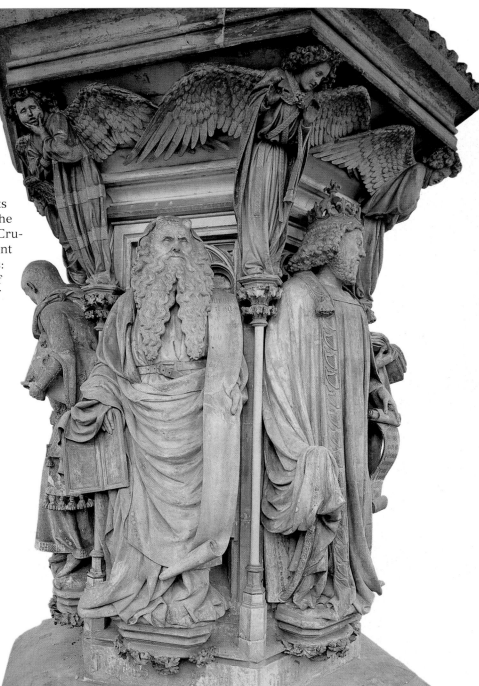

14.16 Claus Sluter, Well of Moses, Chartreuse de Champmol, Dijon, begun 1395. Painted stone, interior diameter of basin 23 ft. 6 in. × 23 ft. 7 in. (7.16 × 7.19 m).

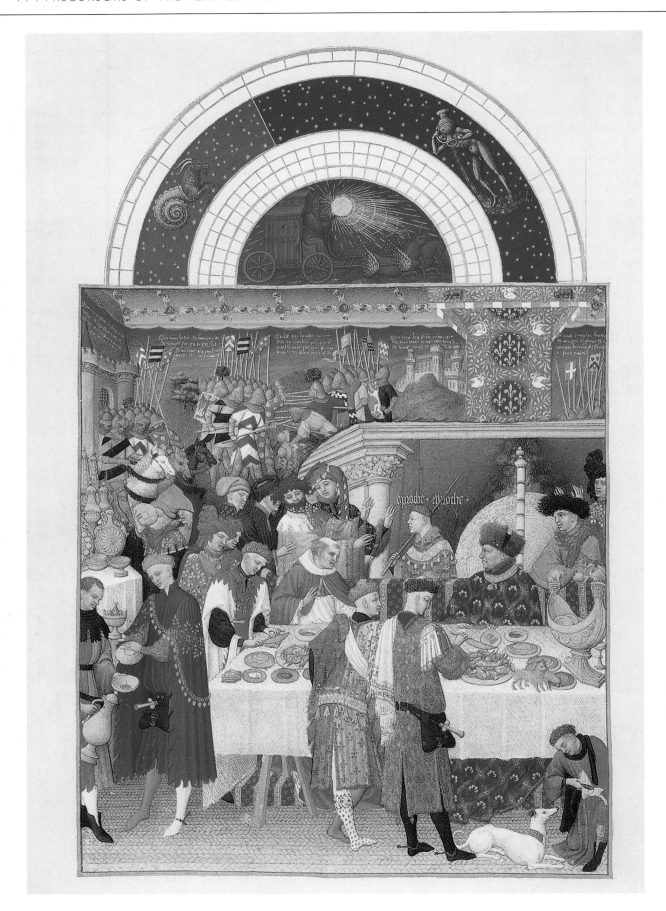

14.17 Limbourg brothers, *January*, from the *Très Riches Heures du Duc de Berry*, 1413–16. Illuminated manuscript, 8¾ × 5⁵⁄₁₆ in. (22.2 × 13.5 cm). Musée Condé, Chantilly, France.

The Limbourg Brothers

In northern Europe, manuscript illumination was the primary medium of painting at the turn of the century. The illuminated manuscripts of the Limbourg brothers were among the most impressive works of art produced at the court of Jean, duc de Berry. Jean was an ardent patron who collected jewels and books, tapestries and goldwork, and led a life of immense luxury. The three Limbourg brothers—Paul, Herman, and Jean—came from the Netherlands, first to the Burgundy court and then to Berry. They made **Books of Hours,** which are prayer books organized according to the liturgical calendar. The most famous of these is the *Très Riches Heures du Duc de Berry (Very Rich Hours of the Duke of Berry).*

The manuscript page illustrating the month of *January* (fig. **14.17**) shows the day on which gifts were exchanged at the court of Berry. The depiction of precise details is typical of the Limbourg brothers, here concentrating on rich material textures. The duke is seated at a table filled with plates of food, a gold saltcellar at the far right, and a pair of dogs nibbling from the dishes. He wears a fur cap and an elaborate blue-and-gold brocade robe. Behind him is a golden wicker fire screen, and the man in red on the duke's right is inviting visitors to enter. The words "approach, approach" are lettered in gold above his head. On the background tapestry, a battle from the Trojan War is fought by soldiers in medieval armor. The identity of the battle is indicated by lines of verse written across the sky. In the foreground, various courtiers in patterned robes partake of the feast, while a white dog waits eagerly for a morsel of food at the lower right corner. Perhaps the richest area of the page is the red canopy over the fireplace. It contains blue circles decorated with the *fleurs-de-lis* of French royalty, golden foliage, white swans, and two brown bears. Swans and bears were the duke's heraldic devices, and a gold statuette of each surmounts the tips of the saltcellar on the table. In the semicircle above the scene are the zodiac signs that correspond to the time of year.

Such representation of observed detail entered the vocabulary of painting in the course of the fourteenth century. The art of the courts seems to have ignored the effects of the disasters in western Europe during the first half of the century. The International Gothic style persisted into the fifteenth century, but the major innovations in art from 1400 resume the developments introduced by Giotto.

c. 1280 **c. 1420**

PRECURSORS OF THE RENAISSANCE

(14.2)	(14.3)	(14.7)	(14.14)	(14.9)	(14.13)	(14.16)	(14.17)	
End of the Crusades (1295)	Palazzo Vecchio in Florence (1299–1301)	Petrarch (1304–1374)	Dante, *Divine Comedy* (1307–1321)	Black Death arrives in Europe (1348)	Boccaccio, *Decameron* (begun 1348)	Peasant Revolt in England (1381)	Medici rise to power in Florence (c. 1400)	Invention of scientific perspective (c. 1400)

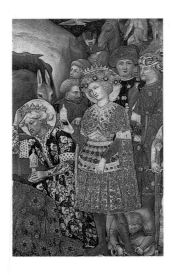

15

The Early Renaissance

Italy in the Fifteenth Century

For most of the Quattrocento (1400s) the city of Florence in Tuscany was the intellectual, financial, and artistic center of Renaissance Italy. Florence followed the lead of the fourteenth-century poet Petrarch in the pursuit of humanism (see Box) and the revival of Classical texts. Fifteenth-century writers, such as Leonardo Bruni, who was the chancellor of Florence, extolled the city as a new Athens and the heir of ancient Roman republicanism. A chair of Greek studies had been established at the University of Florence in the 1390s, and in the next few decades translations of Plato and other Greek authors would become available.

Renaissance Humanism

The Medici, the dominant Florentine banking family in the fifteenth century, were among the leading supporters of humanism. They encouraged the study of Plato and Neoplatonism, one goal of which was to reconcile Christianity with Platonic philosophy. They also collected Greek and Roman sculpture and gave contemporary artists access to it. The humanist interest in individual fame that had developed in the fourteenth century was associated not only with territorial, financial, and political power but also with the arts. Renaissance patrons understood the power of imagery and used it to extend their fame.

SOCIETY AND CULTURE
The Humanist Movement

The Renaissance is sometimes called the great age of humanism because it revived the ideals embodied in the ancient Greek maxim "Man is the measure of all things." Renaissance humanism, which flourished from about 1300 to 1600, was many-faceted. There was a movement away from medieval, specifically Aristotelian, logic and toward the study of original Greek and Roman texts. Beginning with Petrarch in the fourteenth century, educational reformers approached Classical studies independently, rather than linking them with Christianity. Scholars no longer used Gothic script or pursued intellectual inquiry in the service of the Church, but rather preferred the clarity of the Latin alphabet, standardized spelling and grammar, and skill in the art of rhetoric. Classical texts were translated, and history, literature, and mythology were studied along with Christian subjects. Professorships in Greek were established, humanist schools and libraries were founded, and art collectors sought out original Greek and Latin works. There was a new awareness of history and a fledgling interest in archaeology as a means

of uncovering ancient objects and resuming contact with the Classical past.

The pursuit of the literature of antiquity had a parallel in the visual arts. Now artists wanted to bypass the Middle Ages and recover Greek and Roman forms. Sometimes, because of faulty historical information, Renaissance artists mistook Romanesque for Roman, just as scholars believed the Carolingian script to be Latin. In literature, the anecdotal tradition led to full-length biographies and autobiographies, especially of artists; fewer lives of the saints were written. Above all, the philosophical idea that man was rational and capable of achieving dignity, intellectual excellence, and high ethical standards by means of a Classical education determined the character of Renaissance humanism. Several humanist authors wrote about the dignity of man. Gianozzo Manetti (1396–1459), for example, wrote: "How great and wonderful is the dignity of the human body; secondly, how lofty and sublime the human soul, and finally, how great and illustrious is the excellence of man himself made up of these two parts."[1]

Leading art centers in Renaissance Italy.

Courts throughout Italy were thriving centers of artistic activity and vied with each other for prominent humanist scientists, writers, architects, painters, and sculptors. They established libraries as collections of Classical and Christian manuscripts expanded. In Mantua, the Gonzaga court founded an innovative school, La Gioiosa, where promising students from less wealthy families were educated alongside the children of the nobility. In the most enlightened families, girls were taught together with boys, and both learned Latin and Greek as well as other humanist subjects. Such schools also stressed physical education and discipline. Girls and boys learned sports, including swimming, ball games, and horse riding, but boys were more likely than girls to study the martial arts.

By the time these students became rulers, they were skilled in politics, diplomacy, and rhetoric and were knowledgeable in the Classics. In some cases, women were sufficiently well educated to run the state while their husbands were away—either fighting as *condottieri* (see p. 258) or engaged in diplomatic missions abroad. A few women became important patrons of the arts. Painters and sculptors made portraits of patrons or, as in the Arena Chapel (see fig. **14.7**), included their portraits in monumental fresco cycles. The humanist writers praised their patrons in works of literature, which were generally based on ancient Greek and Roman models.

Artists gained stature as they absorbed the culture of Classical antiquity. Leon Battista Alberti, for example (see p. 256), recommended a humanist education for all artists and advised them to befriend poets, orators, and princes.

Artists and others who admired antiquity traveled to Rome to draw ancient ruins. Antiquarians went to Constantinople and Greece to collect Classical texts and Greek statuary. During the Renaissance this search for the Classical past was combined with an interest in empirical experience and a taste for intellectual and geographical discovery.

One of the energizing features of the Renaissance was its interdisciplinary nature. The most influential synthesis derived from the integration of antiquity, especially ancient history and art, with the ideas and attitudes of the Quattrocento. Far from treating the Classical revival as threatening, the most enlightened Renaissance popes encouraged the humanist assimilation of ancient Greek and Roman philosophies into their own Christian faith.

The Competition for the Florence Baptistery Doors

A good example of the increase in the range of patronage during the Renaissance was the competition of 1401 for a set of doors on the east side of the Florence Baptistery. (This was subsequently changed to the north side.) Two fourteenth-century doors were already in place, but two more were needed. Members of the wool refiners' guild supervised the contest and served as the jury. The subject chosen for the competition was the Sacrifice of Isaac. According to the account in Genesis 22, Isaac's father, Abraham, obeys God's command to sacrifice his only son as an act of faith. At the last moment, as Abraham is about to kill Isaac, an angel intervenes and Abraham, having proved his obedience to God, is instructed to substitute a ram for Isaac.

Of the seven contestants for the baptistery doors, the most important were Filippo Brunelleschi (1377–1446) and Lorenzo Ghiberti (c. 1381–1455). Ghiberti won the competition despite, or perhaps because of, his less monumental, more graceful style. Brunelleschi's figures (fig. **15.1**) are more direct and forceful than those of Ghiberti (fig. **15.2**). His Abraham grasps Isaac by the throat and is physically restrained by the angel. The thrust of Brunelleschi's Abraham, emphasized by his drapery folds, is also more energetic than Ghiberti's. The ambivalence of Ghiberti's figure is implicit in its pose; Abraham simultaneously leans toward Isaac and pulls away from him.

Another reason for Ghiberti's victory may have been the technical differences between the reliefs. Brunelleschi

15.1 Filippo Brunelleschi, *Sacrifice of Isaac,* competition panel for the east doors of the Florence Baptistery, 1401–2. Gilded bronze relief, 21 × 17 in. (53.3 × 43.2 cm). Museo Nazionale del Bargello, Florence, Italy.

15.2 Lorenzo Ghiberti, *Sacrifice of Isaac,* competition panel for the east doors of the Florence Baptistery, 1401–2. Gilded bronze relief, 21 × 17 in. (53.3 × 43.2 cm). Museo Nazionale del Bargello, Florence, Italy.

Both Brunelleschi and Ghiberti were born in or near Florence—Brunelleschi, the son of a lawyer, trained as a gold- and silversmith; Ghiberti, the stepson of a goldsmith. The scenes are framed by a **quatrefoil** and depict the moment when the angel appears just in time to prevent Abraham from cutting his son's throat.

cast his panel in several pieces, while Ghiberti cast his in only two. Ghiberti also used less bronze, which would have made his doors considerably less costly to produce than Brunelleschi's.

There are no surviving records of the judges' deliberations. From the perspective of historical hindsight, however, it is clear that both reliefs are indebted to the Classical revival. Ghiberti's Isaac is a Classical nude that reflects the artist's assimilation of Greek forms. Brunelleschi quotes a specific ancient sculpture in the seated figure at the lower left; it repeats the pose of the well-known Hellenistic statue known as the *Thorn Puller*, a boy removing a thorn from his foot (fig. **15.3**).

The depiction of nature in both reliefs continues in the tradition of Giotto. Landscape forms provide a narrow but convincing three-dimensional space, in which the surfaces rationally support the figures and architecture. In each case, the cubic altar on which Isaac kneels is set at an oblique angle to the relief surface so that, as with Giotto's architecture, the sides imply a recession in space.

This competition reverberated with political and civic meaning. Florence had recently been ravaged by a plague that killed at least 12,000 citizens, and the survivors probably identified with Isaac's rescue. Danger had also come from the powerful and tyrannical duke of Milan, who threatened the Florentine republic. With the duke's death in 1402, Florence must have felt that it, like Isaac, had been granted a reprieve.

Brunelleschi's Architecture

After losing the baptistery competition, Brunelleschi was said to have given up sculpture, only to become the seminal figure in Renaissance architecture. He moved for a few years to Rome, where he studied ancient monuments. The effect of Rome on Brunelleschi was recorded by the sixteenth-century biographer of the artists, Giorgio Vasari (see Box):

> Through the studies and diligence of Filippo Brunelleschi, architecture rediscovered the proportions and measurements of the antique. . . . Then it carefully distinguished the various orders, leaving no doubt about the difference between them; care was taken to follow the Classical rules and orders and the correct architectural proportions. . . .[2]

The roots of Brunelleschi's early architecture can be traced to Classical precedents. Compared with the complexity of Abbot Suger's search for perfect mathematical ratios based on musical harmonies, Brunelleschi's concept of architectural beauty lay in basic ratios and shapes. He preferred simple to irrational numbers, and ratios of 1:2 and 1:3. He used circles and squares in his building plans, and he constructed round, rather than pointed, arches, which were supported by Classical columns rather than Gothic piers.

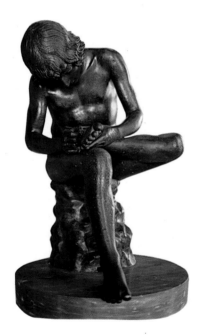

15.3 *Spinario (Boy Removing a Thorn from His Foot)*. Roman, c. 1st century B.C. Bronze, life-size. Musei Capitolini, Rome, Italy.

HISTORY
Vasari's *Lives*

Giorgio Vasari (1511–74) was an architect and painter. Born in Arezzo, he lived in Florence and worked there for the Medici family. Cosimo I commissioned him to design the Uffizi Palace in Florence, which was originally a building for the government and judiciary but is now the Uffizi Museum.

Vasari's architecture and painting are overshadowed by his writings. His major work, *The Lives of the Most Eminent Painters, Sculptors, and Architects*, is the earliest full account of Renaissance art. The first edition (1550) began with Cimabue and ended with Michelangelo, a friend and contemporary of Vasari. A second edition gave more prominence to painting and included Vasari's autobiography. Although Vasari's facts are not always accurate, he is a major source of information about art and artists in the fourteenth, fifteenth, and sixteenth centuries. Vasari believed that medieval art was an inferior product of the Dark Ages, which had been no more than an unfortunate interlude between Classical antiquity and the Italian Renaissance.

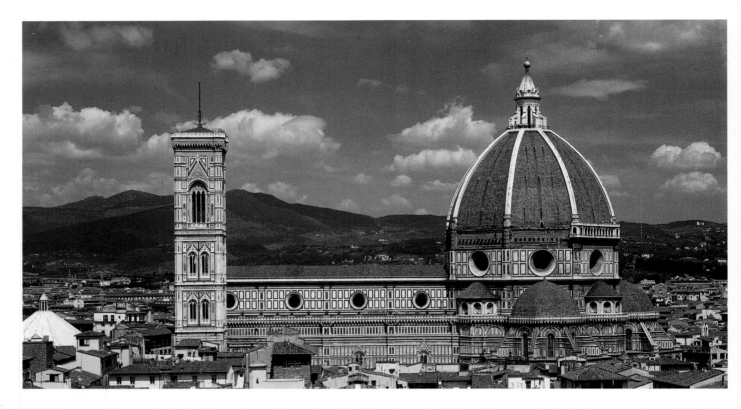

15.4 Exterior of Florence Cathedral. According to Vasari, Brunelleschi's rivalry with Ghiberti did not end with the baptistery doors. Ghiberti's political connections won him a commission to work with Brunelleschi on the dome of Florence Cathedral for equal credit and equal pay. Brunelleschi found fault with Ghiberti's work and ideas, but his protests fell on deaf ears. It was not until he took to his bed, feigning illness and refusing to advise on the project, that Ghiberti was removed—and even then Ghiberti was allowed to keep his salary.

The Dome of Florence Cathedral On returning to Florence about 1410, Brunelleschi became involved in constructing a dome for the cathedral (figs. **15.4** and **15.5**). This undertaking lasted until 1436, but Brunelleschi died in 1446 before the **lantern,** which he had also designed, could be completed. The dome had been a perennial problem for the city. As early as 1294 Florence had decided to rebuild the old cathedral, and in the course of the fourteenth century the original design was enlarged. By the fifteenth century, the cathedral required a dome to surmount an octagonal drum (already in place) measuring 138 feet (42.1 m) across.

In Rome, Brunelleschi learned from the example of the Pantheon—which had a hemispherical dome 142 feet (43.3 m) in diameter—that it was theoretically possible to span an opening of this width. However, the structure of Florence Cathedral did not lend itself to Roman building techniques, and the octagonal drum was too wide to be built with the wooden centering used in the Middle Ages.

In 1417–30 Brunelleschi proposed a solution, which he illustrated with a model on a 1:12 scale. He followed a horizontal construction plan based on a system of vertical ribs. Primary ribs were placed at each of the eight corners of the octagonal drum (fig. **15.5**). At their base, they were approximately 11 feet by 7 feet (3.35 × 2.13 m), tapering toward their apex and visible to the viewer from the outside. Between each two primary ribs were two secondary vertical ribs, not visible from the outside, making a total of twenty-four ribs. Around these ribs Brunelleschi

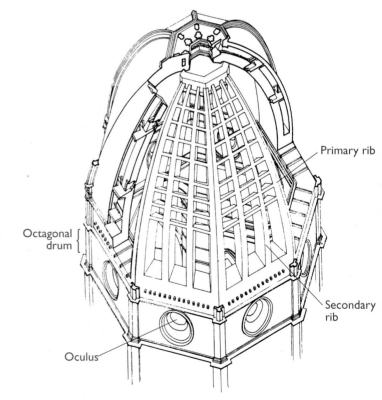

15.5 Axonometric section of the dome of Florence Cathedral. The overall height of the dome is slightly over 100 feet (30.48 m); the diameter is 138 feet (42 m). © Electa Archive, Milan.

Primary rib

Secondary rib

Octagonal drum

Oculus

constructed, in horizontal sections, two shells comprising a single dome and connected by horizontal ties placed at intervals. Building two thin shells instead of a single thicker one lessened the weight of the dome. Its thrust was further reduced by building the walls of the dome at a steep angle—they rose a full 58 feet (17.7 m) before needing support from below. As a result, the dome was slightly pointed rather than perfectly hemispherical.

Santo Spirito, Florence In his church architecture, Brunelleschi rejected Gothic style, preferring the design of the Early Christian basilica. The church of Santo Spirito, planned in 1434, one year before Brunelleschi's death, illustrates the basic principles of his architecture: simplicity, harmonious proportion, and symmetry. Spatial units are based on the square **module** formed by each bay of the aisles, and the whole geometry of the structure is based on a series of interrelated circles and squares.

The plan (fig. **15.6**) is a simple **Latin cross.** The depths of the choir and of the transept arms are the same. The perimeter forms a continuous ambulatory and, apart from the southern end, is ringed with forty semicircular chapels. Round arches in the nave and the aisles are supported by Corinthian columns (fig. **15.7**) and reduce the size and height of the church to human scale. As a result, there is much less space in the structure for stained glass or the luminous quality that had been characteristic of Gothic cathedrals.

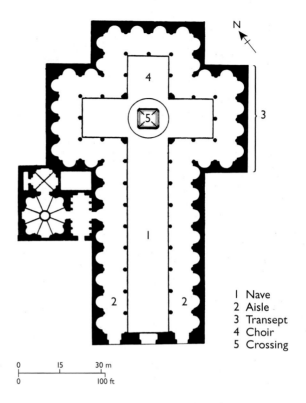

1 Nave
2 Aisle
3 Transept
4 Choir
5 Crossing

0 15 30 m
0 100 ft

15.6 (Above) Filippo Brunelleschi, plan of Santo Spirito, Florence (after R. Sturgis).

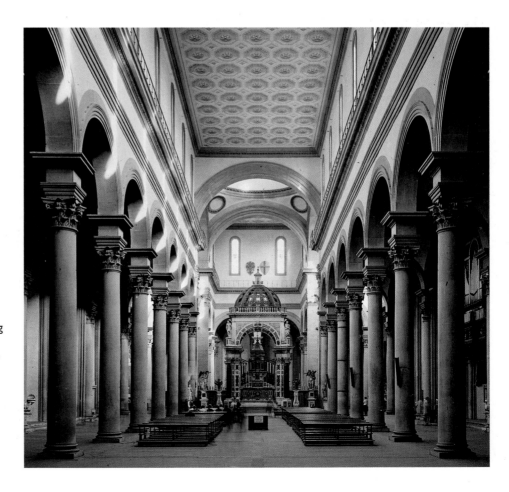

15.7 Filippo Brunelleschi, interior of Santo Spirito, Florence, designed 1434. Each double bay of the nave forms a large square equivalent to four modular squares. The larger square is repeated in the crossing bays, the transept arms, and the choir. The semicircle of each chapel is half the size of a circle that would fit exactly into the square module. If the larger squares were cubed and placed one on top of another, they would exactly match the height of the nave. The height of the side aisle is exactly half that of the nave.

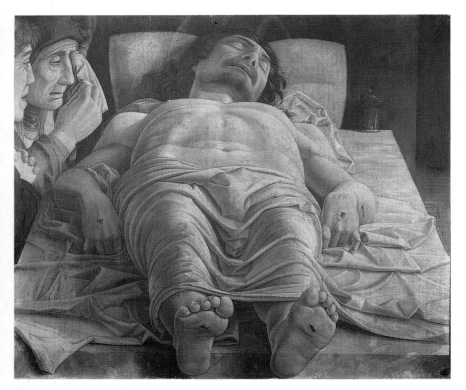

15.8 Andrea Mantegna, *Dead Christ,* c. 1500. Tempera on canvas, 26¾ × 31⅞ in. (67.9 × 81 cm). Pinacoteca di Brera, Milan, Italy.

the frame of the painting as the window frame. Through this "window" the viewer sees the scene to be depicted. The edges of architectural objects such as roofs and walls are extended along imaginary lines, known as **orthogonals**, to converge at a single point, the **vanishing point**, which generally corresponds to the viewer's eye level.

In his *De Pictura (On Painting),* written in 1435, Leon Battista Alberti refined Brunelleschi's system, although it is not clear to what extent he was proposing a new theory or merely describing current artistic practice. His method establishes relative proportions for every figure and object within a picture plane and transposes them onto a grid consisting of orthogonals and transverse lines parallel to the baseline.

Andrea Mantegna (c. 1430–1506) used perspectival theory to achieve radical foreshortening in his *Dead Christ* (fig. **15.8**). The body is shown feet foremost, with the stigmata—the wounds of the Crucifixion—clearly visible and the head slightly tilted forward by a pillow. Mantegna's idealization of the body and mastery of perspective create a haunting psychological effect.

Artists using linear perspective made preliminary studies in the planning stages of their work. Most of these studies were on paper and are now lost. One that survives is Leonardo da Vinci's study for *Adoration of the Magi* (fig. **15.9**), which allows us a rare look at an artist's working plans laid out in schematic form.

Linear Perspective

Brunelleschi is credited with the invention of **linear** or **one-point perspective** in Italy. This system is based on the observed fact that distant objects seem smaller than closer ones and that the far edges of uniformly shaped objects appear shorter than the near edges.

Brunelleschi conceived of the picture plane—the surface of a painting or relief sculpture—as a window and

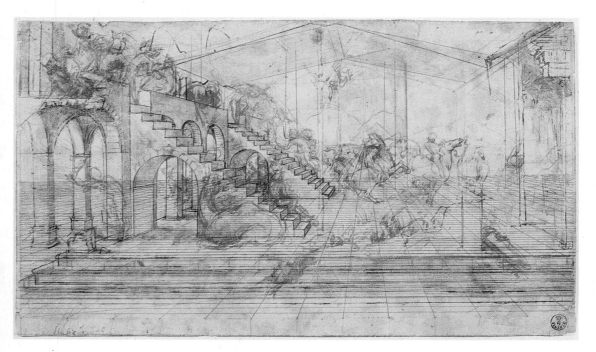

15.9 Leonardo da Vinci, perspective study for *Adoration of the Magi,* c. 1481. Pen, **bistre**, and wash, 6½ × 11½ in. (16.5 × 29.2 cm). Gabinetto dei Disegni e Stampe, Galleria degli Uffizi, Florence, Italy. Leonardo created a perspective grid by drawing a series of horizontal lines parallel to the picture plane. Then he drew a series of lines intersecting the horizontals and converging at the vanishing point, which is just to the left of the figure on a rearing horse. All architectural forms in the study are aligned with the grid so that the sides of the buildings are either parallel or perpendicular to the picture plane.

Ghiberti's East Baptistery Doors

A good example of one-point perspective (in which there is a single vanishing point) occurs in Ghiberti's relief of the *Meeting of Solomon and Sheba* on the east door of the Florence Baptistery (figs. **15.10** and **15.11**). As was true of the competition reliefs, the *Solomon and Sheba* also has political as well as Christian implications, for it illustrates the extension of traditional typology (the pairing of the Old and New Testaments) to include the contemporary era. Typologically, the Meeting was paired with the Adoration of the **Magi;** in both cases, Eastern personages (the queen of Sheba and the Magi, respectively) traveled to honor a king (Solomon and Christ). Politically, the biblical meeting of East and West was related to efforts in the fifteenth century to unite the Eastern (or Byzantine) branch of the Church with the Western branch in Rome.

15.10 (Above) Lorenzo Ghiberti, *Meeting of Solomon and Sheba,* east door, Florence Baptistery (single panel of fig. **15.11**), 1424–52. Gilded bronze relief, 31½ × 31½ in. (80 × 80 cm). This relief illustrates two techniques used by Ghiberti to create an illusion of depth. One is Brunelleschi's system of one-point perspective. The vanishing point is located above the meeting of Solomon and Sheba, on the central axis of the relief. The other combines the diminishing size of figures and objects with a decrease in the degree of relief. What is in lower relief appears more distant than what is in higher relief.

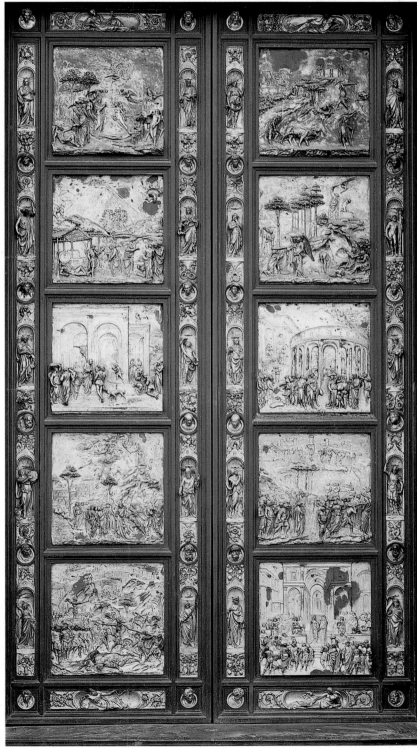

15.11 Lorenzo Ghiberti, *Gates of Paradise,* east door, Florence Baptistery, 1424–52. Gilded bronze relief, approx. 17 ft. (5.18 m) high. Here, Ghiberti has eliminated the medieval quatrefoil frame and used the square, which is better suited to the new perspective system. The door is divided into two sets of five Old Testament scenes, which were modeled in wax, cast in bronze, and faced with gold. The east door was nicknamed the *Gates of Paradise,* because the space between a cathedral and its baptistery is called a *paradiso.* According to another tradition, recorded by Vasari, Michelangelo said that Ghiberti's doors were "beautiful enough to grace the entrance of Paradise."

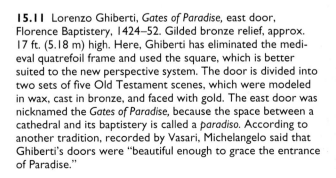

Early-Fifteenth-Century Painting

Masaccio

Of the first generation of fifteenth-century painters, it was Masaccio (1401–c. 1428) who most thoroughly assimilated the innovations of Giotto and developed them into a revolutionary new monumental style.

The *Holy Trinity* Masaccio's *Holy Trinity* (fig. **15.12**) in the church of Santa Maria Novella in Florence uses not only the new perspective system, but also the new architectural forms established by Brunelleschi. A single vanishing point is located at the center of the step, corresponding to the eye level of an observer standing in the church. Orthogonals, provided by the receding lines of the barrel-vaulted, coffered ceiling, create the illusion of an actual space extending behind the nave wall. This pictorial space is defined on the outside by two Corinthian pilasters supporting an architrave, above which is a projecting cornice. The pilasters frame a round arch supported by composite columns.

The interior is a rectangular room with a barrel vault and a ledge on the back wall. Below the illusionistic interior, a projecting step surmounts a ledge supported by Corinthian columns. Framed by the columns, a skeleton lies on a sarcophagus. The inscription above reads: "I was once what you are. And what I am you too will be." This kind of warning to the living from the dead, called a **memento mori** or "reminder of death," had been popular in the Middle Ages and continued as a motif in the Renaissance. One purpose of the warning was to remind viewers that their time on earth was finite and that faith in Christ offered the route to eternal salvation.

The spatial arrangement of the figures in the *Holy Trinity* is pyramidal so that the geometric organization of the image reflects its meaning. The three persons of the Trinity—Father, Son, and Holy Spirit—occupy the higher space. God stands on the foreshortened ledge, his head corresponding to the top of the pyramid. He faces the observer and supports the arms of the Cross. Between God's head and that of Christ floats the dove, symbol of the Holy Spirit. Masaccio has emphasized the pull of gravity on Christ's arms, which are stretched by the weight of his torso, causing his head to slump forward. His body is rendered organically, and his nearly transparent drapery defines his form.

Inside the sacred space are Mary—who looks out and gestures toward Christ—and Saint John, in an attitude of grief. Outside the sacred space, on the illusionistic step, kneel two donors, probably members of the politically influential Lenzi family, who commissioned the fresco. They form the base of the figural pyramid.

The Renaissance convention of including donors in Christian scenes served a twofold purpose. In paying for the work, the donors hoped for prayers of intercession on

15.12 Masaccio, *Holy Trinity*, c. 1425. Fresco, 21 ft. 9 in. × 9 ft. 4 in. (6.63 × 2.85 m). Santa Maria Novella, Florence. Tommaso di Ser Giovanni di Mone (1401–c. 1428) was nicknamed Masaccio ("Sloppy Tom") because, according to Vasari, he neglected everything, including his own appearance, in favor of his art. In 1422 he enrolled in the painters' guild, and in 1424 he joined the Company of Saint Luke, a lay confraternity consisting mostly of artists. By his death at age twenty-six or twenty-seven, Masaccio had become the most powerful and innovative painter of his generation.

their behalf. Their presence was the visual sign of their donation and of their wish to be associated with holy figures in a sacred space. The donors of the *Holy Trinity* occupy a transitional space between the natural world of the observer and the spiritual, timeless space of the painted room.

The Brancacci Chapel Masaccio's other major commission in Florence was the fresco cycle illustrating events from the life of Saint Peter in the Brancacci Chapel, in the church of Santa Maria del Carmine (figs. **15.13** and **15.14**). Masaccio, like Giotto, used **chiaroscuro** (from the Italian words *chiaro,* "light," and *scuro,* "dark"). This is a more natural means of conveying light and shade than line because

it allows artists to model forms and create an illusion of mass and volume.

Masaccio's Adam and Eve in the *Expulsion from Eden* (fig. **15.14**) are the two most powerful painted nudes since antiquity. Eve's pose is derived from the type of Greek Venus in figure **15.15**. But Masaccio transformed the figure of the modest goddess into an extroverted, wailing Eve, who realizes what she has lost and covers her nakedness in shame. The more introverted Adam hunches forward and covers his face as if reluctant to confront his destiny. Adam and Eve leave the gateway to paradise behind them at the command of the foreshortened, sword-bearing angel. The rays of light emerging from the gate represent the angry voice of God.

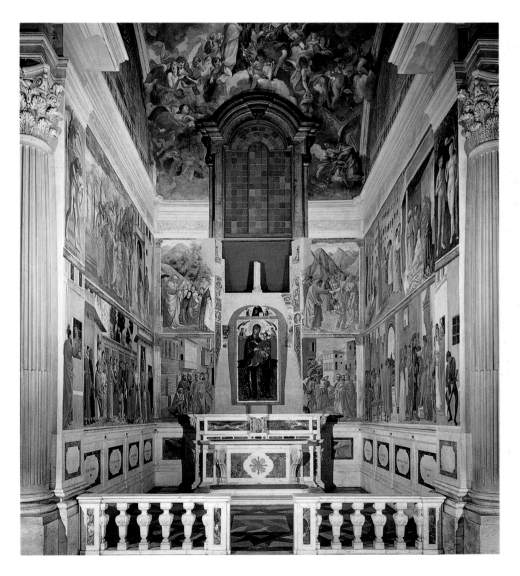

15.13 View of the Brancacci Chapel (after restoration), looking toward the altar, Santa Maria del Carmine, Florence. Masaccio worked on the Brancacci Chapel in the 1420s. He shared the commission with an older artist, Masolino, whose *Temptation of Adam and Eve* is on the right pilaster. When Masolino left Italy to work in Hungary, Masaccio continued on his own. After Masaccio's untimely death, the frescoes were completed in the 1480s by a third artist, Filippino Lippi. Lippi painted the *Saint Peter in Prison* and the remainder of the wall frescoes. The ceiling is later.

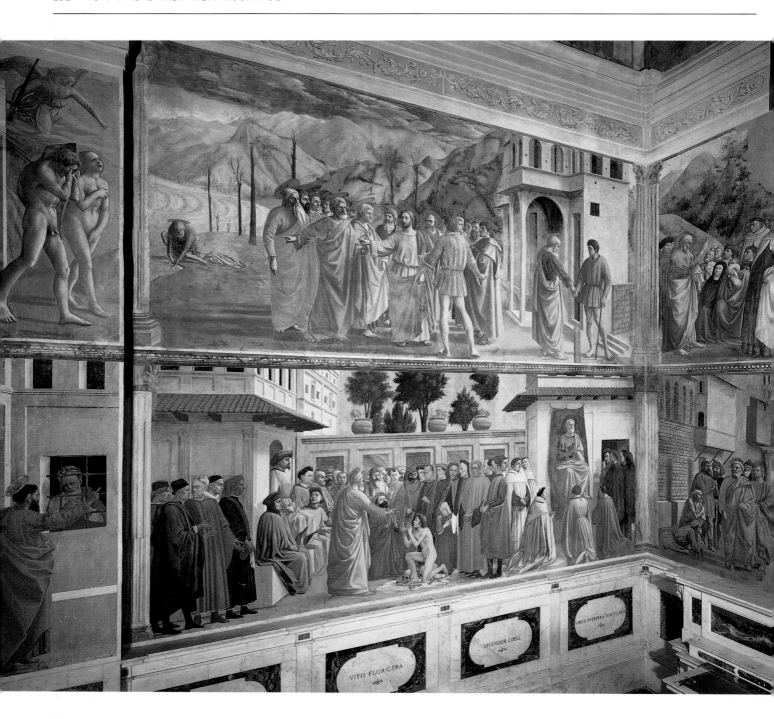

15.14 Left side of the Brancacci Chapel, Santa Maria del Carmine, Florence (after restoration, 1989). The scene on the upper left pilaster is the *Expulsion from Eden* (c. 1425), and below is *Saint Peter in Prison*. The large scene to the right of the *Expulsion* is from the New Testament Gospel of Matthew (17:24–27). In the *Tribute Money*, Jesus arrives at the Roman colony of Capernaum, in modern Israel, with his twelve apostles. A Roman tax collector asks Jesus to pay a tribute to Rome. This biblical event was topical in Florence in the 1420s because taxation was being considered as a way of financing the struggle against the imperialistic dukes of Milan. Below, Peter raises a boy from the dead in the center of the fresco and is enthroned at the right. The two scenes on the altar wall (far right) show *Saint Peter Preaching* (above) and *Saint Peter Curing by the Fall of His Shadow* (below). The latter is by Masaccio and takes place in a contemporary Florentine street. In it, Saint Peter purposefully keeps his right arm at his side and gazes straight ahead to emphasize that it is his shadow alone that has curative power. As he passes and his shadow falls on the cripples to his right, they are miraculously cured and stand upright. The figure with crossed arms—a reference to the Cross—is in the process of rising, while the kneeling figure has not yet benefited from Peter's passage. All the frescoes are illuminated as if from the window behind the altar. As a result, the light consistently hits the forms on the left wall from the right, gradually increasing the shading toward the left. So monumental were the forms created by Masaccio in these frescoes that Michelangelo (see p. 287) practiced drawing them in order to learn the style of his great Florentine predecessor.

15.15 *Medici Venus*, 1st century A.D. Marble, 5 ft. ¼ in. (1.53 m) high. Galleria degli Uffizi, Florence, Italy. The statue is named after the Medici Collection, where it was first documented in the 17th century.

Masaccio's characteristic use of massive draperies can be seen in the large horizontal fresco the *Tribute Money* (see fig. **15.14**), immediately to the right of the *Expulsion*. The fresco is divided into three scenes. Occupying the central section is Jesus. He faces the viewer, surrounded by a semicircle of apostles. They wear simple, heavy drapery, whose folds and surface gradations are rendered in *chiaroscuro*. Seen from the back, wearing a short tunic and formally continuing the circular group around Jesus, is the Roman tax collector. Horizontal unity in this central group is maintained by strict isocephaly. The foreshortened halos conform to the geometric harmony of Jesus and his circle of followers. They repeat the circular arrangement of figures and match their convincing three-dimensional quality.

The psychology of this scene is as convincing as its forms. Jesus has no money with which to pay the tax. He tells Saint Peter (the elderly bearded apostle in yellow and blue-green on his right)—through both word and gesture—to go to the Sea of Galilee, where he will find the money in the mouth of a fish. Peter's not unreasonable skepticism is conveyed by his angry expression and conflicted gesture. With his right hand he echoes Jesus's outstretched arm and pointing finger, but withdraws his left hand in protest.

At the far left of the scene, separated by space and distance from the central group, is a radically foreshortened Peter retrieving a coin from the fish. At the right, Peter, framed by an arch, pays the tax collector. Masaccio has thus organized the narrative so that the point of greatest dramatic conflict—between Jesus and Peter—occupies the largest and most central space, while the *dénouement* takes place on either side.

Masaccio used both linear and **aerial**, or **atmospheric**, **perspective** (see Box) in the Brancacci Chapel frescoes. That he set his figures in a boxlike, cubic space is clear from the horizontal ground, the trees, and the architecture. To find the vanishing point of the painting, extend the orthogonals at the right and the receding lines of the entrance to paradise in the *Expulsion*. The orthogonals meet at the head of Christ, who is also at the mathematical center of the combined scenes. Rather than provide the vanishing point within a single frame, as he had done in the *Holy Trinity*, in the Brancacci Chapel Masaccio unified several scenes through a shared perspective construction. The diminished figure of Saint Peter at the far left and the decreasing size of the trees also indicate linear perspective—in this case to create an illusion of spatial recession far into the distance, beyond the Sea of Galilee. The shaded contours and slightly blurred mountains and clouds are partly the result of damage caused by a fire in the chapel. They also, however, exemplify Masaccio's use of aerial perspective to suggest their distance in relation to the monumental figures in the foreground.

TECHNIQUE
Aerial Perspective

Aerial, or atmospheric, perspective is a painting technique based on the fact that objects in the distance appear to be less distinct and vivid than nearby objects. This is because of dust, moisture, and other impurities in the atmosphere. The artist may therefore use fainter, thinner lines and less detail for distant objects, while depicting foreground objects with bolder, darker lines and in greater detail. The artist may also create an illusion of distance by subduing the colors in order to imitate the bluish haze that tends to infuse distant views. In his advice to painters, Leonardo da Vinci (see p. 283) recommended that all horizons be blue, as his were. Atmospheric perspective was also employed by Masaccio. In the *Tribute Money* (see fig. **15.14**), for example, although the distant mountains are larger than the figures, they are less clearly defined.

International Style in Italy: Gentile da Fabriano

Masaccio's originality as a painter can be seen by comparing his work with that of an older contemporary, Gentile da Fabriano (c. 1370–1427). Gentile's greatest extant work is the large altarpiece in figure **15.16**, in which the *Procession and Adoration of the Magi* occupy the main panel.

In contrast to Masaccio's taste for simplicity, Gentile's frame is elaborately Gothic, and his gold sky continues Byzantine convention. A procession winds its way to and from distant fortified hill towns, ending at the foreground, where the three Magi worship Jesus. The crowded composition, elaborate gold drapery patterns, and exotic animals—birds and monkeys, for example—are typical features of International Gothic. In the foreground, though Gentile's use of linear perspective is not consistent, he has foreshortened the horses and the kneeling page removing the spurs from the youngest Magus. Gentile's elegance, like Ghiberti's, reflected popular, conservative tastes more so than the unadorned monumentality of Brunelleschi and Masaccio.

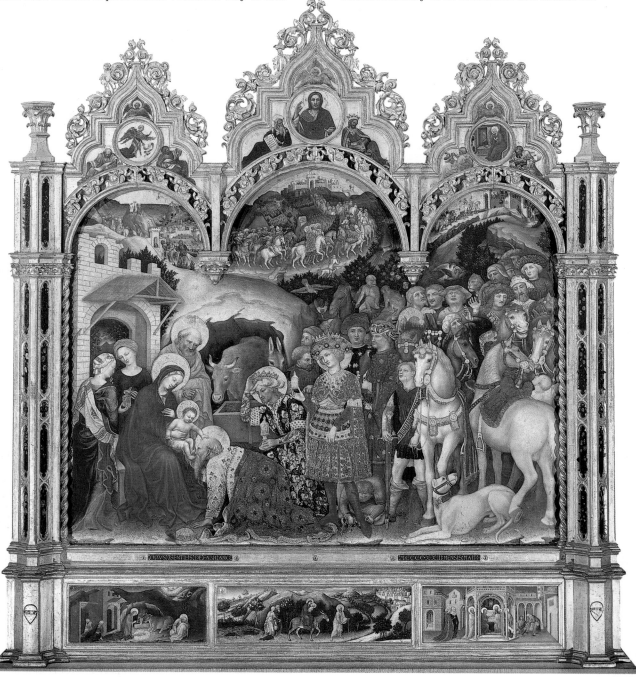

15.16 Gentile da Fabriano, *Procession and Adoration of the Magi*, altarpiece, 1423. Tempera on wood panel, approx. 9 ft. 11 in. × 9 ft. 3 in. (3.02 × 2.82 m). Galleria degli Uffizi, Florence, Italy. Gentile was born in Fabriano, in the Marches (a region of central Italy bordering on the Adriatic coast). He is first documented in Venice in 1408, and he established himself as a leading painter of the International Gothic style in northern Italy. *The Procession and Adoration of the Magi* was commissioned by Florence's richest merchant, Palla Strozzi, to decorate his family chapel in the sacristy of Santa Trinità, thereby reflecting his wealth in the panel's rich materials and abundance of gold.

Early-Fifteenth-Century Sculpture: Donatello's *David*

The most important sculptor of early-fifteenth-century Florence was Donatello (1386–1466). He outlived Masaccio by nearly forty years, continuing to develop his style beyond the next generation.

His bronze *David* (fig. **15.17**), probably commissioned by the Medici family for a pedestal in their palace courtyard, is a revolutionary depiction of the nude. Its pose recalls that of Polykleitos's *Spear Bearer* (see fig. **7.14**). David stands over Goliath's head, which he has severed with the giant's own sword. In his left hand, David holds the stone thrown from his sling. He wears boots and a shepherd's hat ringed with laurel, the ancient symbol of victory. His facial expression is one of complacency at having conquered so formidable an enemy.

The genius of this statue lies not only in its revival of antique forms but also in its enigmatic character and complex meaning. David and Goliath, whose encounter is described in the Old Testament (1 Samuel 17:28–51), were traditional Christian types for Christ and Satan, respectively, and David's victory over Goliath was paired with the moral triumph of Christ over the Devil. David was also an important symbol for the Florentine republic in its resistance against tyranny, for he represented the success of the apparent underdog against a more powerful aggressor.

The erotic aspect of the *David* is enhanced by the large lifelike wing sprouting from Goliath's helmet and rising up the inside of David's leg. It is accentuated by the casual way in which David's toe is caressed by Goliath's mustache. The elegance of the polished bronze, together with David's self-absorption, feminine pose, and slim, graceful, adolescent form, reinforces the narcissism and the homosexual quality of the statue. This aspect of the *David*'s iconography probably reflects a Platonic version of the ideal warrior, who fights to impress and defend his male lover. In an unusually personal Renaissance synthesis, Donatello has combined the adolescent friendship of David and King Saul's son Jonathan as described in the Bible with Plato's philosophy. (Plato argues that homosexuality is tolerated under republican forms of government and discouraged by tyrants.) It is also likely that Donatello drew on his own homosexuality—for such was his reputation in fifteenth-century Florence—in his characterization of David.

—— **CONNECTIONS** ——

See figure 7.14.
Polykleitos,
*Doryphoros
(Spear Bearer)*,
c. **440** B.C.

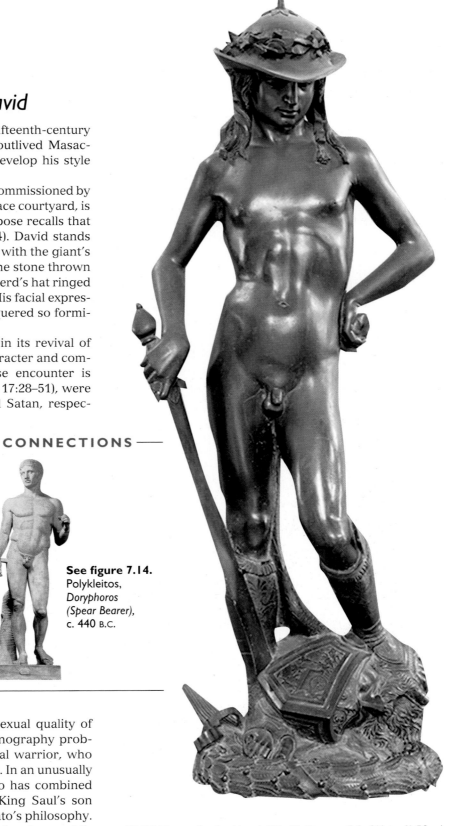

15.17 Donatello, *David*, c. 1430–40. Bronze, 5 ft. 2½ in. (1.58 m) high. Museo Nazionale del Bargello, Florence, Italy (after cleaning). The *David* is the first nearly life-size, naturalistic nude sculpture that we know of since antiquity. By 1430 to 1440, fragments of original Greek statues had been added to the collections of wealthy Florentine humanists, particularly the Medici. Like Masaccio and Brunelleschi, Donatello studied those works and also went to Rome to study ancient ruins. The pose of his *David* was influenced by Classical statues he had seen.

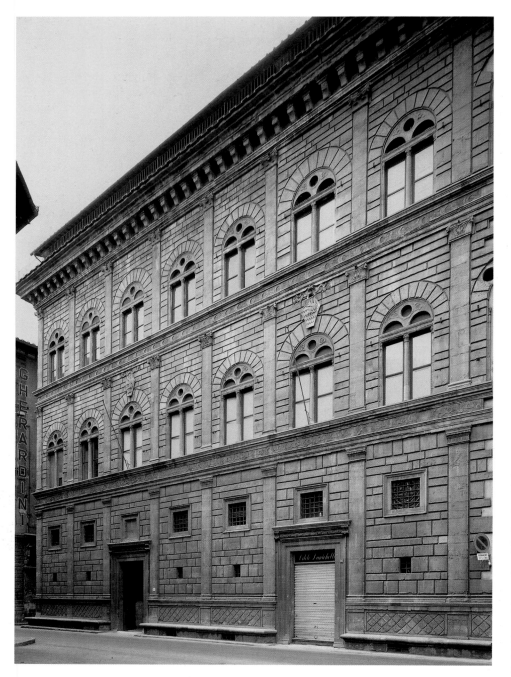

Leon Battista Alberti, Rucellai Palace, Florence, c. 1446–50. By way of a family signature, the Rucellai coat of arms appears above each second-story window that is over a ground-floor door. An upward glance from either of the main entrances would therefore have identified the owner of the palace.

family in Renaissance Florence was his most popular work, and its progressive precepts influenced child rearing in fifteenth-century humanist families. From the 1440s onward Alberti worked as an architect. His influential treatise *De Re Aedificatoria (On Architecture),* based on Vitruvius (see p. 118), emphasized the aesthetic importance of harmonious proportions.

The Rucellai Palace From about 1446 to 1450, Alberti designed the Rucellai Palace in Florence (fig. **15.18**). It belonged to the wealthy merchant Giovanni Rucellai, who had made a fortune manufacturing red dye. The façade, which is symmetrical and composed of Classical details, illustrates Alberti's interest in harmonious surface design. The second- and third-story windows contain round arches subdivided by two smaller arches on either side of a colonnette. The large window arches blend with the rest of the wall, and the stone wedges of which they are composed remain visible. Alberti thus retains the surface pattern of the individual stones, setting them in curves around the windows and in horizontals elsewhere. In contrast, the pilasters framing each bay on all three stories (the Tuscan Order for the first story, modified Ionic for the second, and Corinthian for the third) have a smooth surface and serve as vertical accents. The vertical progression follows the order of the Colosseum in Rome. Crowning the third story is a projecting cornice, which echoes the horizontal courses separating the lower stories and reinforces the unity of the façade.

Second-Generation Developments

Leon Battista Alberti

In his treatise *On Painting,* Leon Battista Alberti (1404–72) summed up the contributions of Brunelleschi, Masaccio, Ghiberti, and Donatello to the visual arts. But *On Painting* was more than a summation of what had already been done; it was the first Renaissance text of art theory. Alberti was a prolific humanist writer on many different subjects in both Latin and the vernacular. In addition to art theory, he wrote plays, satirical stories, a Tuscan grammar, a book on dogs, and an anonymous autobiography. His book on the

The Theme of David and Goliath

Because of David's role as a symbol of Florence, the theme of David and Goliath continued to preoccupy Italian artists—especially in Florence—throughout the Renaissance. A unique example is *The Youthful David* (fig. **15.19**) by Andrea del Castagno (c. 1417/19–57), which is painted on the curved surface of a leather shield. The shield itself was probably ceremonial, perhaps carried in civic processions. Castagno's sculpturesque style is evident in the figure of David, as well as in the rocky terrain. David is depicted in vigorous motion, with the wind blowing his hair and drapery to the right. He raises his foreshortened left arm and fixes his stare as if sighting Goliath. Whereas Donatello's *David* (fig. **15.17**) is relaxed, Castagno's participates in a narrative moment requiring action. The resulting tension of Castagno's *David* is indicated by his taut leg muscles and the bulging veins in his arms. He draws back his right arm, preparing to shoot the stone from his sling.

In a striking condensation of time, Castagno has simultaneously depicted two separate moments in the narrative. For although David is about to slay Goliath, the giant's severed head lies on the ground between his feet. The same stone that David launches from his sling is embedded in Goliath's head. Temporal condensation of this kind speeds up our vision and our grasp of the narrative so that we see the middle and end of the episode at the same time.

Andrea del Verrocchio (1435–88), the leading sculptor of the second half of the fifteenth century, cast a bronze *David* (fig. **15.20**), commissioned sometime in the early 1470s by Lorenzo de' Medici, known as *Il Magnifico* ("the Magnificent"). The work is at once more straightforward than Donatello's and a comment on it. Verrocchio has transformed the graceful curves and soft flesh of Donatello's effeminate *David* into a sinewy, angular adolescent. The modeling of the cuirass to resemble a torso with a rib cage and the bony arms of the later *David* express a different facet of adolescent arrogance. Here, Goliath's head lies at David's feet, without the erotic interplay of wings and legs or of toes and beard. Instead of a giant sword closing the space and enhancing David's self-absorption as in Donatello's version, Verrocchio's *David* carries a short sword. He also gazes out into space, rather than down at his victim. The general effect of the Verrocchio is that of a slightly gawky, outgoing, and energetic boy.

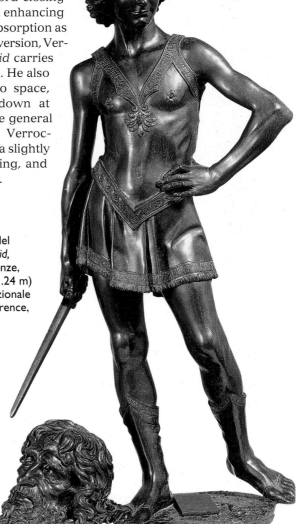

15.20 Andrea del Verrocchio, *David*, early 1470s. Bronze, approx. 49 in. (1.24 m) high. Museo Nazionale del Bargello, Florence, Italy.

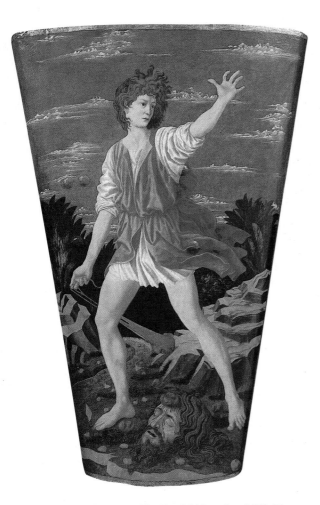

15.19 Andrea del Castagno, *The Youthful David*, c. 1450. Tempera on leather mounted on wood, 45½ × 30¼ in. (115.6 × 76.9 cm); lower end 16⅛ in. (41 cm) wide. National Gallery of Art, Widener Collection, Washington, D.C.

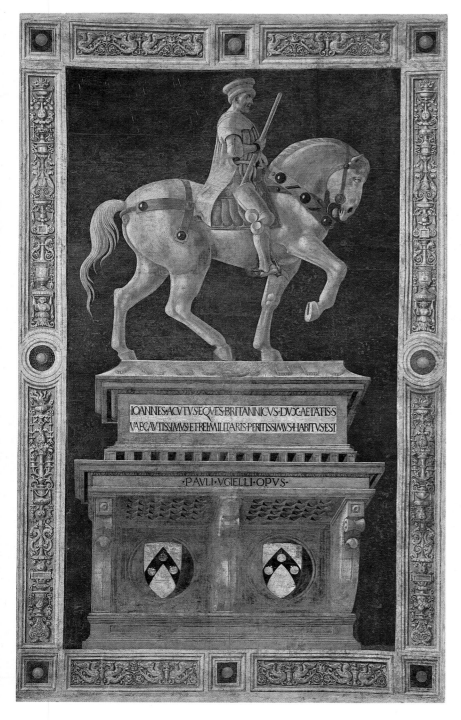

15.21 Paolo Uccello, *Sir John Hawkwood*, Florence Cathedral, 1436. Fresco transferred to canvas. Vasari criticized Uccello for his obsession with mathematics and perspective, which, he said, interfered with his art. According to a popular anecdote, they also interfered with his marital life. On being called to bed by his wife, Uccello allegedly extolled the beauty of *la prospettiva* (perspective) —a feminine noun in Italian. Uccello's interest in geometry is apparent in the spherical balls on the horse trappings, in Hawkwood's medieval armor, and in his hat. Although the horse's forms are rendered organically, they have a wooden, toylike character created by crisp edges separating areas of light and dark.

SOCIETY AND CULTURE
Soldiers of Fortune

Condottiere (*condottieri* in the plural) is the Italian word for a soldier of fortune. During the Renaissance, Italy was divided into separate states, and individual mercenaries led armies of one state against those of another, according to their loyalties, their pay, or both. A *condottiere* could be a ruler earning money for his state, as was Federico da Montefeltro (see fig. **15.23**), or a private citizen, such as Gattamelata (fig. **15.22**), who had trained as a soldier. Training to be a *condottiere* took place under a kind of apprentice system, usually through the tutelage of an experienced "master" *condottiere*. In the course of the fifteenth century, several *condottieri* were honored with portraits commissioned by the states for which they had fought.

Both the Latin inscription on the **pedestal** and two shields bearing Hawkwood's coat of arms were a means of securing his fame for posterity. Uccello's memory is preserved in the signature at the top of the base. Consistent with the Renaissance synthesis of secular and sacred is the very location of an image memorializing a military hero on the wall of a cathedral.

Uccello has constructed a double perspective system in the Hawkwood fresco in order to accommodate the viewpoint of the observer. The base and pedestal are rendered as if from the eye level of a person standing below the lower edge of the fresco. As a result, the underside of the top ledge is visible, while the sides of both base and pedestal are foreshortened. The horse and rider, however, are painted as if the viewer were higher up or the horse were lower down. This shift permits us to see the soldier and his horse in profile and the pedestal from below. Uccello thus condenses space by portraying a double viewpoint on one flat picture plane, whereas Castagno, in his *David*, condenses two narrative moments within one frame.

The Equestrian Portrait

Another type of image that became increasingly popular in fifteenth-century Italy was the equestrian portrait, typically commissioned to honor a *condottiere* (see Box). This, too, can be related to the notion of fame and the wish to preserve one's features in the cultural memory.

Uccello's *Sir John Hawkwood*　In 1436, the Florentine artist Paolo Uccello (1397–1475) painted an enormous fresco on the north wall of the cathedral (fig. **15.21**). It was to honor Sir John Hawkwood, an English soldier of fortune who had led the Florentine army in the fourteenth century.

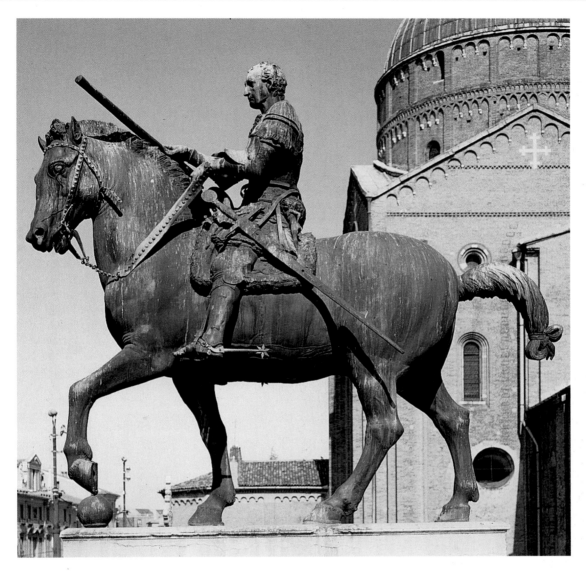

15.22 Donatello, *Gattamelata*, 1445–50. Bronze, approx. 11 × 13 ft. (3.35 × 3.96 m). Piazza del Santo, Padua.

Donatello's *Gattamelata* Donatello's monumental bronze equestrian portrait of Gattamelata stands on a high pedestal in front of the Church of Sant' Antonio in Padua (fig. **15.22**). It was inspired by the *Marcus Aurelius* (see fig. **9.33**), which Donatello had seen in Rome. Both horses raise one foreleg; their massive forms are rendered with a sense of weight and power. Donatello's rider, like the *Marcus Aurelius,* is assertive, extending his baton in the conventional gesture of command. Gattamelata's armor is also inspired by ancient Roman models and is decorated with figures from Greek and Roman mythology.

"Gattamelata," meaning "honeyed cat," was the nickname of the *condottiere* Erasmo da Narni. He had led the troops of Venice, which at that time controlled Padua. Even though the *condottiere*'s family had, according to the terms of his will, financed the sculpture, its prominent location would have needed approval from the Venetian government.

CONNECTIONS

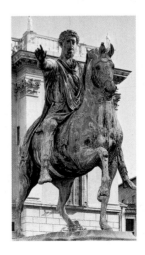

See figure 9.33.
Marcus Aurelius,
A.D. 164–166.

State Portraits

The official, or state, portrait of a ruler also became popular in fifteenth-century Italy. Portrait busts, a revival of the ancient Roman sculptural type, had been commissioned from the earliest years of the Renaissance, and Donatello is reputed to have cast portraits from death masks, just as the Romans had done.

Piero della Francesca (active c. 1439–died 1492) painted a double portrait of Battista Sforza and Federico da Montefeltro of Urbino (fig. **15.23a, b**) in oil and tempera on wood panels (see Box). The iconography is inspired by imperial Roman portraits, particularly by profile busts on ancient coins, and Federico's coat and hat are rendered in the red that had been conventional for portrait busts of Roman emperors (see p. 146).

Both figures are in strict profile (concealing the loss, in a tournament, of Federico's right eye). They dominate the landscape background and are formally related to it. Figures and landscapes are bathed in the white light that is characteristic of Piero's style. Battista Sforza's pearls repeat the diagonal plane of the white buildings in the distance, while the diamond shapes in her necklace and her brocade sleeve echo the rolling hills and distant mountains. The moles on Federico's face and the curls overlapping his ear create patterns of dark on light, just as the trees do against

MEDIA
Oil Painting

In oil painting, pigments are ground to a powder and mixed to a paste with oil, usually linseed or walnut. In Italy, oil first came into use as part of tempera paintings and was applied to panels coated with a gesso support. Although oil had been known and occasionally used in Italy since the fourteenth century, it was not prevalent before about 1500. In Northern Europe, on the other hand, oil was the most popular medium for painters from the early 1400s.

There are several advantages to using oil paint. It can be applied more thickly than fresco or tempera because the brush will hold more paint. Oil dries very slowly; this allows artists time to revise their work as they proceed. Oil also increases the possibilities for blending and mixing colors, opening up a much wider color range. Modeling in light and dark became easier because oil enabled artists to blend their shades more subtly. Since oil paint tends to retain marks made by the brush, artists began to emphasize their brush-strokes so that these became a kind of personal signature. Tempera, a brittle medium, required a rigid support. Oil, on the other hand, was flexible, so canvas became popular as a painting surface. This meant that artists did not have to worry so much about warping. The woven texture of canvas also held the paint better than wood.

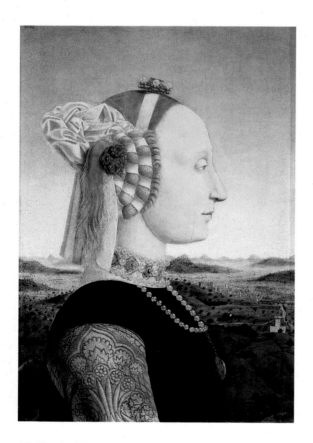

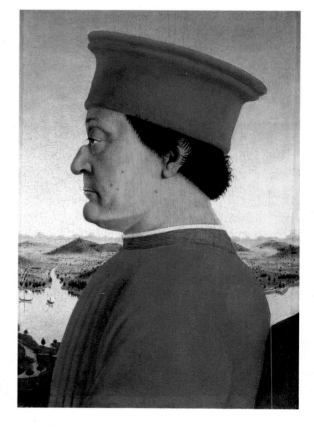

15.23a, b Piero della Francesca, *Battista Sforza* and *Federico da Montefeltro* (after cleaning), after 1475. Oil and tempera on panel, each 18½ × 13 in. (47 × 33 cm). Galleria degli Uffizi, Florence, Italy. Federico da Montefeltro, a successful *condottiere*, and his wife were leading patrons of the arts and presided over one of the most enlightened humanist courts in 15th-century Italy. Artists, scientists, and writers (including Alberti) came from various parts of Europe to work for Federico. The fact that Piero used oil in his painting was probably a result of his contacts with Flemish painters working at the court of Urbino.

the fields. The triangular shading under his chin repeats the triangular mountains. Such formal parallels between rulers and landscape signified the relationship between them and their territory. Piero's perspective construction, which makes the background forms radically smaller than the figures, denotes the greatness of the ruler and the expanse of his duchy.

Monumentality versus Spirituality in Fifteenth-Century Painting

A comparison of Piero's *Annunciation* (fig. **15.24**) with a painting of the same subject by Fra Angelico (fig. **15.25**) illustrates two of the leading stylistic trends in mid-fifteenth-century Italian Renaissance painting. Each picture must be understood in context. Piero's is part of a fresco cycle in the Church of San Francesco in Arezzo, while Fra Angelico's is one of many individual pictures in the Dominican monastery of San Marco (St. Mark) in Florence. In addition to different contexts, the paintings were commissioned by patrons—Franciscans and Dominicans—with differing attitudes to Christian imagery and church decoration.

The Dominican Order, to which Fra Angelico (c. 1400–1455) belonged, had been founded by Saint Dominic (1170–1221), who was born in Old Castile in Spain, and its mission was to defend the Church and convert heretics. (Since Dominican monks wore black mantles, they were also known as the Black Friars.) In their choice of church decoration, the Dominicans emphasized the spiritual qualities of Christian subject matter. Humanist artists such as Piero della Francesca, who worked in the tradition of Giotto, tended to attract Franciscan patronage. Piero's *Annunciation* is a good example of the artist's interest in combining Christian iconography with geometry and the Classical revival. The scene takes place in a white marble building with composite Corinthian and Ionic columns, an entablature, and a projecting cornice. Mary holds a book, Gabriel enters from the left, and God the Father hovers over a cloud at

the upper left. Mary is related to the architecture as both a form and a symbol. She fills the space of the portico, evoking the Christian convention equating Mary's monumental proportions with the Church building. The column swells slightly, even though it is not Doric and should not exhibit such marked *entasis*. It is thus an architectural metaphor

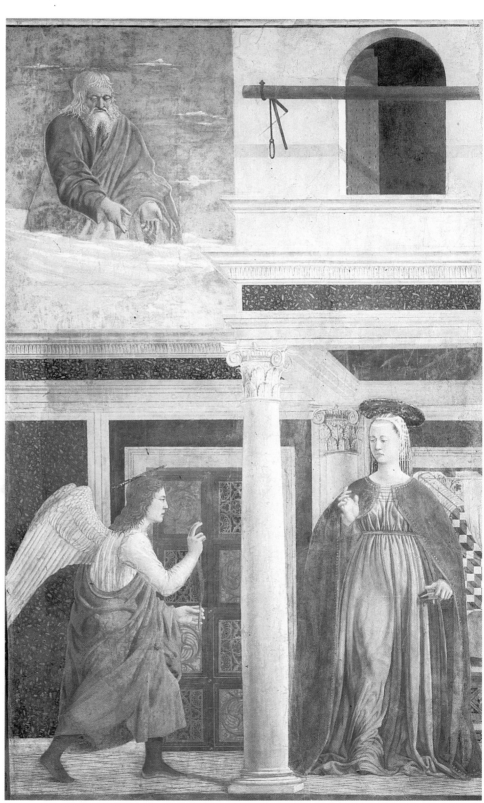

15.24 Piero della Francesca, *Annunciation* (after restoration), c. 1450. Fresco, 10 ft. 9½ in. × 6 ft. 4 in. (3.29 × 1.93 m). San Francesco, Arezzo, Italy.

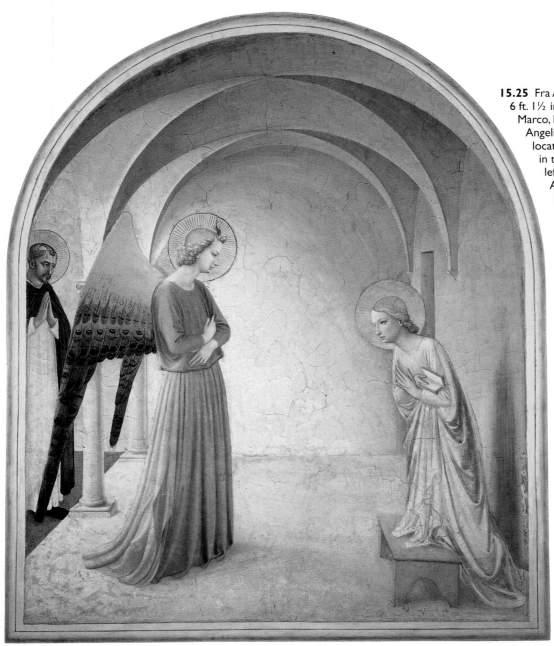

15.25 Fra Angelico, *Annunciation*, c. 1440. Fresco, 6 ft. 1½ in. × 5 ft. 1½ in. (1.87 × 1.56 m). San Marco, Florence, Italy. The purpose of Fra Angelico's *Annunciation* is related to its location—in the cell of a Dominican friar in the monastery of San Marco. On the far left, just outside the sacred space of the Annunciation, stands the 13th-century Dominican saint, Peter Martyr, who devoted his life to converting heretics to orthodox Christianity. A member of the Dominican Order who had evoked visions of the Annunciation through prayer and meditation, he was a daily inspiration to the friars of San Marco.

light, may be read as coming from God. Both shadow and light enter the building and, in a metaphor for conception, symbolically enter Mary. The maternal significance of these images is implicit in Mary's form. Her monumental presence allies her with Piero's classicizing architecture, with Christian liturgy, and with the mother goddesses of antiquity.

Fra Angelico's *Annunciation* (fig. **15.25**) of about 1440 offers an instructive contrast to Piero's. Although Fra Angelico was a Dominican friar who painted Christian subjects exclusively, his style reflects the new fifteenth-century painting techniques. His *Annunciation* takes place in a cubic space, and orthogonals indicate a vanishing point. However, compared with those in Piero's *Annunciation,* Fra Angelico's figures are thin and delicate. Their gently curving draperies echo the curve of the ceiling vaults. The halos, rather than being foreshortened as on Piero's God the Father, are flat circles placed on the far sides of the heads. The patterned rays in Gabriel's halo and the design on his wings reveal a taste for surface decoration more compatible with International Gothic than with the monumental artistic trends of fifteenth-century Florence.

Fra Angelico uses light to convey spirituality. Like Gabriel himself, the light enters from the left and falls on Mary's bowed form. More striking is the fact that the vanishing point lies on the plain back wall of the porch, where the light is at its most intense. In contemplating this event, therefore, one's line of sight is directed to pure light, which, in the context of the Annunciation, signifies the miraculous presence of Christ.

for Mary's pregnancy through the miraculous Incarnation of Christ. Mary's formal relationship with the architecture confirms her symbolic role as the "House of God."

Piero's *Annunciation* contains several allusions to the miraculous nature of Mary's impregnation. In the liturgy, Mary is the "closed door," or *porta clausa,* because she is a virgin. This is the connotation of the closed door behind Gabriel. But she also stands before an open door, which represents Mary as "open" to God's Word. The rays of light that God transmits toward Mary signify Jesus, "the light of the world."

The opposite of light—in nature, in painting, and in metaphor—is shadow. Piero uses shadow to create another allusion to impregnation in the *Annunciation.* The horizontal wooden bar that crosses the upper-story window casts a shadow that seems to pierce the metal ring hanging from it, turn the corner, and enter the window. Because in the West we read pictures from left to right, the shadow, like the

15.26 Filippo Lippi, *Madonna and Child with Scenes from the Life of Saint Anne (Pitti Tondo)*, 1450s. Diameter 4 ft. 5 in. (135 cm). Pitti Palace, Florence, Italy. Filippo was notorious for having several nuns living in his household. When one of them—Lucrezia Buti—became pregnant, she was permitted to leave her Order and marry Filippo. He, too, was released from his vows and, thanks to Medici influence, had his children legitimized by the humanist pope, Pius II. It has often been suggested that Filippo's delicate Madonnas were inspired by the features of Lucrezia. Their son, Filippino Lippi, became a painter and later completed the frescoes in the Brancacci Chapel.

Filippo Lippi

An artist who combined spirituality with the monumentality of Masaccio in a new way was Fra Filippo Lippi (c. 1406–69). Filippo was orphaned in 1421 and placed in the Carmelite monastery in Florence. There he studied Masaccio's Brancacci Chapel frescoes, which impressed him enormously. His **tondo** of the *Madonna and Child with Scenes from the Life of Saint Anne* (fig. **15.26**) shows his taste for Masacciesque blond figure types and weighty forms. The chubby infant Christ eats a pomegranate, an allusion to the Resurrection. Time is condensed in the image, as the scenes from Saint Anne's life—her meeting with Joachim on the right and the birth of the Virgin on the left—are depicted in the background. Here the past is rendered as literally "behind" Mary and Christ, while the future, denoted by the pomegranate and Mary's wistful gaze, is in the foreground.

References to antique forms are evident, particularly in the woman carrying a basket to the right of Christ. Her pose and flowing drapery seem derived from Classical sculpture and vase painting. The grid patterns of the floor tiles and ceiling beams reflect the artist's study of Brunelleschian perspective. Combined with Filippo's assimilation of monumental form, perspective, and the Classical revival is a taste for delicate, curvilinear draperies, transparent halos that filter light through gold, and rich textures. His fusion of spirituality, grace, and monumentality appealed to contemporary patrons—especially the Medici, who commissioned several of his most important works.

In the drawing study (fig. **15.27**) for the *Madonna and Child*, Filippo's use of light to create form is particularly evident. Whites are the source of the light, which is shown, as in the painting, entering from the left. Here, the artist's linear aesthetic enhances the delicacy of the features, as well as the graceful curves of the cloth. The whites in the drawing become light in the painting.

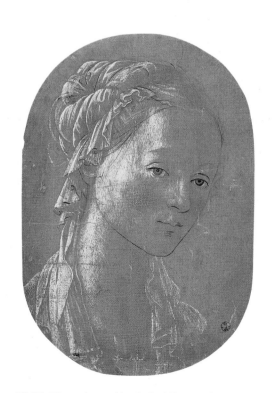

15.27 Filippo Lippi, *Head of a Woman*, drawing study for fig. **15.26**. Gabinetto dei Disegni e delle Stampe, Gallerie degli Uffizi, Florence, Italy.

Andrea Mantegna's Illusionism

In northern Italy, the leading painter after the middle of the Quattrocento was Andrea Mantegna (c. 1430–1506). From 1460 onward, he worked for Lodovico Gonzaga, the marquis of Mantua (see Box), who, like Federico da Montefeltro, ruled a humanist court. Mantegna decorated the state bedroom, or audience chamber, of the Ducal Palace in Mantua, using the new perspective techniques to create an illusionistic totality (fig. **15.28**).

In the painted wall above the fireplace, the room seems to open onto a balcony where the family sits with children, courtiers, household servants, and a dwarf. Lodovico has just been given a letter by a messenger. An illusionistic curtain appears to flutter out of the picture plane, over Lodovico's head, and overlap the pilaster on the left. To the right, figures come and go, as painted and real architecture merge.

15.28 Andrea Mantegna, *Camera Picta*, also known as the *Camera degli Sposi*, Ducal Palace, Mantua, finished 1474. Room approx. 26 ft. 6 in. × 26 ft. 6 in. (8.1 × 8.1 m). Two walls are covered with frescoes depicting members of the Gonzaga family, their court, horses, and dogs, together with decorative motifs and a distant landscape. The landscape view to the left of the door exemplifies the Renaissance notion of painting as a window.

The most dramatic instance of Mantegna's illusionism in the Ducal Palace is the ceiling tondo, painted to resemble an architectural oculus (fig. **15.29**). Visually, it is integrated with the ceiling so that it is difficult for the casual observer to identify the boundaries between reality and illusion. The portrait busts of Roman rulers on the ceiling (visible in figure **15.28**) simulate relief sculpture and associate the marquis of Mantua with imperial Rome. The tondo itself seems to open onto a cloudy sky above a round parapet, with figures peering down into the real space of the room. Mantegna's humor is given full rein in this tondo. A potted plant balances precariously on the edge of the wall. Three leering women lean over and stare, while two more engage in conversation. A group of playful ***putti*** are up to various pranks. One prepares to drop an apple over the edge, while three others have gotten their heads stuck in the round spaces of the parapet. In this scene of surreptitious looking, the artist plays on the dangers that await the observers as well as the observed. Mantegna's taste for radical foreshortening, also evident in the *Dead Christ* (see fig. **15.8**), can be seen here in the spatial compression of the parapet and the point of view from which the figures—particularly the *putti*—are depicted. Such illusionistic painted environments, which elaborate the fourteenth-century spatial innovations of Giotto, could not have developed without the invention of perspective.

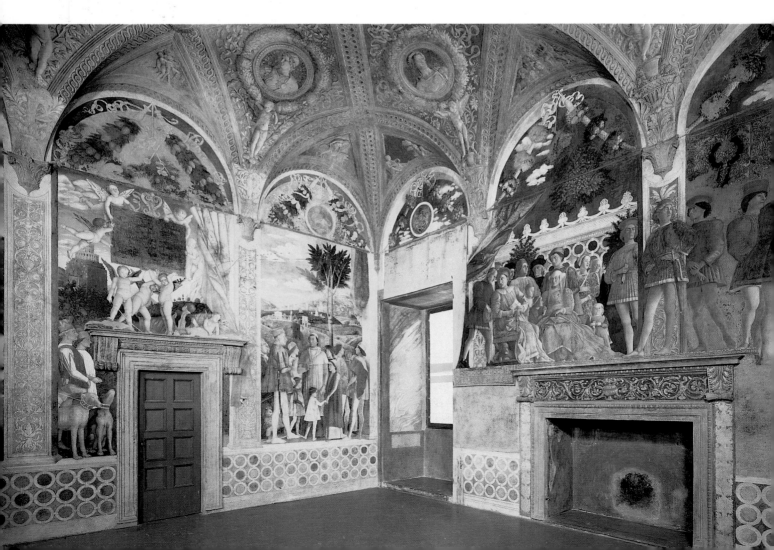

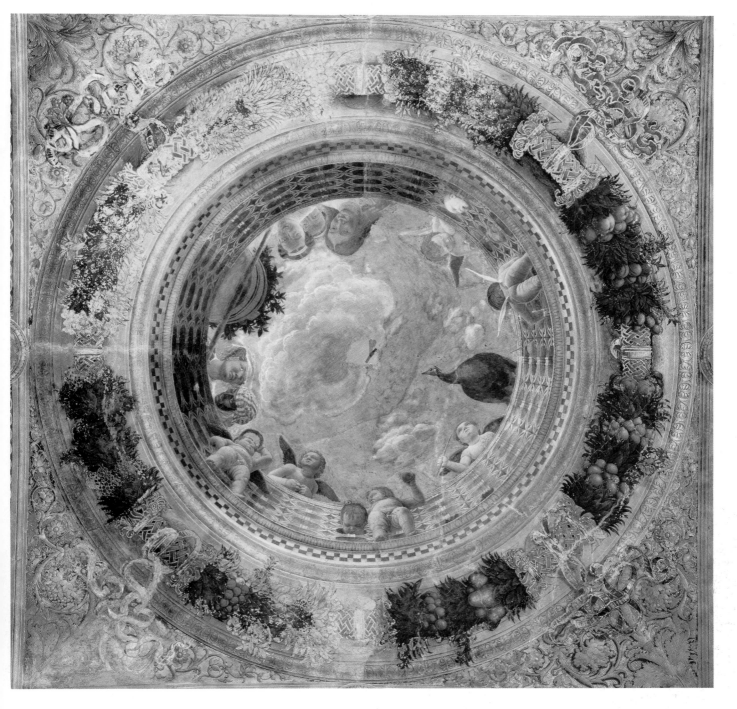

15.29 Andrea Mantegna, ceiling tondo of the *Camera Picta (Camera degli Sposi),* Ducal Palace, Mantua, finished 1474. Fresco, diameter of balcony 5 ft. (1.52 m).

Botticelli's Mythological Subject Matter

Slightly later than Mantegna's illusionistic *tour de force* at Mantua are the mythological paintings of Sandro Botticelli (1445–1510), which exemplify the Renaissance interest in pagan subject matter. His *Birth of Venus* (fig. **15.30**) is one of a series of mythological pictures executed for the Medici family. It was the Medici interest in Classical themes and the revival of Plato's philosophy that had led to the founding of the Platonic Academy in Florence in 1469 (see Box).

Botticelli's nude Venus, like Masaccio's Eve (fig. **15.14**), is derived from the type of the *Medici Venus* (fig. **15.15**). Unlike the Masaccio, however, Botticelli's Venus is somewhat elongated, elegant, even languid—as if just waking up. Her flowing hair, echoing the elegant drapery curves and translucent waves, conveys a linear quality characteristic of Botticelli's distinctive style.

15.30 Sandro Botticelli, *Birth of Venus*, c. 1482. Tempera on canvas, approx. 5 ft. 8 in. × 9 ft. 1 in. (1.73 × 2.77 m). Galleria degli Uffizi, Florence, Italy. According to Classical myth, Venus was born when the severed genitals of Uranus were cast into the sea. Botticelli's Venus floats ashore on a scallop shell, gently blown by a male wind god and a female breeze. On the right, a woman, perhaps a personification of spring, rushes to cover Venus with a pink floral cloak. As a goddess of love and fertility, Venus is appropriately surrounded by flowers.

PHILOSOPHY
The Platonic Academy

Cosimo de' Medici was an enthusiastic patron of humanism. From the 1460s, humanists met at the Medici Villa in Careggi, outside Florence. Their meetings were inspired by Plato's informal school of philosophy, established in Athens in 387 B.C. There, in a public garden, philosophical interchanges became the basis of Plato's *Dialogues*, a literary form revived in the Renaissance. After Cosimo's death, his grandson Lorenzo (1449–92) continued to support the humanists and founded the Platonic Academy of Florence in 1459.

Neoplatonism, a combination of Plato's philosophy with Christianity, prevailed at Lorenzo's academy. It was led by Marsilio Ficino, who lived at the villa, where philosophical discussion provided regular dinner-table entertainment. Artists as well as authors participated in these humanist gatherings, along with members of the Medici family.

Ficino translated all of Plato's *Dialogues*, and other Greek works, into Latin. In his *Commentary on Plato's Symposium*, Ficino notes the twofold nature of Venus—one divine, the other vulgar. The divine Venus is Mind and Intelligence, and loves spiritual beauty. The other Venus is procreative energy, fueled by the impulse to transform spiritual beauty into physical beauty. "On both sides, therefore," according to Ficino, "there is a love: there a desire to contemplate beauty, here a desire to propagate it. Each love is virtuous and praiseworthy, for each follows a divine image."[3]

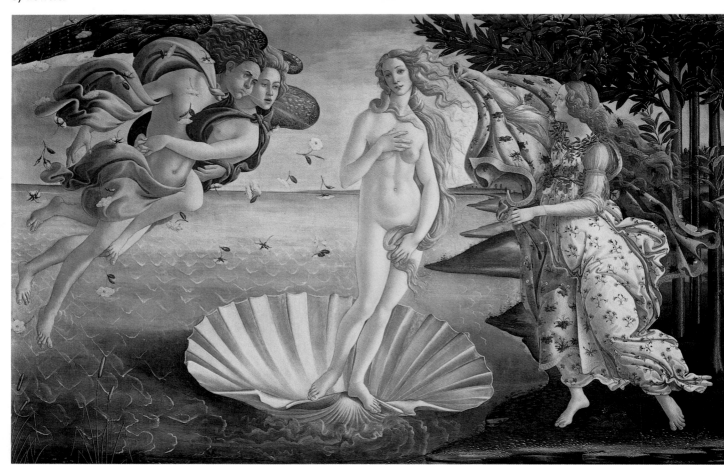

Fifteenth-Century Painting in the Netherlands

In the Netherlands, economic changes similar to those in Italy began to occur in the early fifteenth century. Medieval feudalism and court patronage gradually gave way to a more bourgeois society and a merchant economy based mainly on wool trading and banking. By the fifteenth century, commercial ties between Italy and the Netherlands were close, and business travel was quite common. Northern artists worked in Italian courts, and Italian princes and wealthy businessmen commissioned works of art from the Netherlands.

For the most part, Northern artists of the Renaissance were more innovative in painting than in sculpture or architecture. Whereas in Italy panel paintings were mainly executed in tempera until the sixteenth century, Netherlandish painters preferred oil paint and refined the technique for altarpieces. The use of oil satisfied the interest in meticulous, decorative, naturalistic detail, which characterizes much fifteenth-century Northern painting.

Although artists in the north of Europe shared the Italian preference for the representation of three-dimensional space and lifelike figures, they were less directly affected by the Classical revival than the Italians. Artists in the North continued to work in a Gothic tradition, which they nevertheless integrated into the Renaissance style.

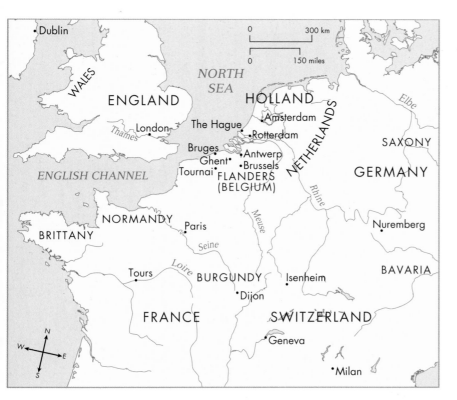

Northern and Central Europe during the Renaissance.

Campin's *Mérode Altarpiece*

A good example of a Northern altarpiece used for private devotions in a home rather than in a church is the triptych (fig. **15.31**) by Robert Campin, also called the Master of Flémalle (c. 1375–1444). The central panel depicts the Annunciation. In the right wing, Joseph makes mousetraps in his carpentry workshop; in the left, two donors kneel by an open door. As in contemporary Italian painting, Campin's figures occupy three-dimensional space and are modeled in light and dark. The light source is consistent and unified.

In contrast to contemporary Italian art, however, the Netherlandish painters preferred sharp, precise details, some of which are so small that magnification is necessary to see them clearly. Campin does not use one-point perspective to unify all three panels of the triptych, as Masaccio does in the *Tribute Money* (see fig. **15.14**). Instead, each panel is seen from a different viewpoint. Unlike floors in Italian perspective constructions, Campin's rise slightly, even though the ceilings are nearly horizontal. The gradual upward movement of the painted space, together with the attention to minute detail, has been attributed by some scholars to Late Gothic influence. Angular drapery folds also reflect Gothic taste.

This altarpiece contains a wealth of complex Christian symbols. In contrast to Italian Annunciations, Campin's takes place in a bourgeois home, whose everyday, secular objects are endowed with Christian meaning. The lilies represent the purity of the Virgin, and their triple aspect refers to the three persons of the Trinity. The brass basin and the towel are household objects but may also refer to Christ cleansing the sins of the world. At the same time, the niche corresponds to an altar niche, where the priest washed his hands, symbolically purifying himself before Mass.

Gabriel's dress, the white robe worn by priests at Mass, and other priestly accoutrements endow the central space with liturgical meaning. In such a context, the prominence given to the table identifies it as a reference to the altar. The candle, which on a naturalistic level has been blown out by a draft from the open door at the left, can also represent Christ's Incarnation. Entering the room from the round window, a tiny Christ carrying his Cross slides down rays of light (fig. **15.32**). Mary sits on the floor reading, her lowered position an allusion to her humility.

In the right panel, the attention to detail and the convincing variety of surface textures—for example, the wood, the metal tools, Joseph's fluffy beard, and his heavy simple drapery—reflect Campin's study of

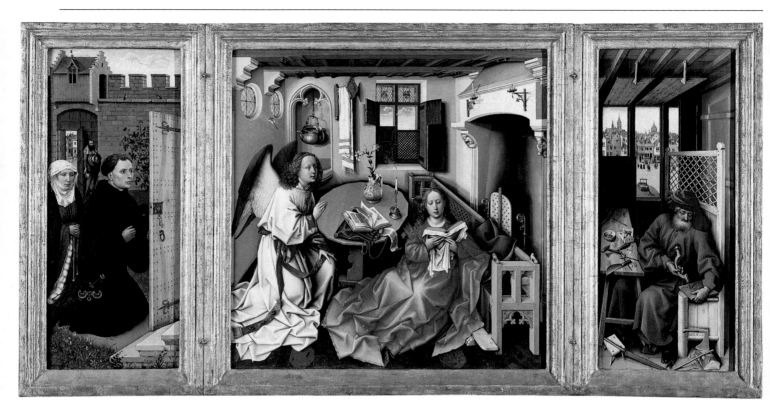

15.31 Robert Campin (Master of Flémalle), *Mérode Altarpiece* (open), c. 1425–30. Tempera and oil on wood, central panel 25 × 25 in. (63.5 × 63.5 cm). Each wing 25 × 10¾ in. (63.5 × 27.3 cm). Metropolitan Museum of Art, New York (Cloisters Collection, purchase). Campin was a master painter in the painters' guild in Tournai from 1406, as well as being active in local government. A married man, he was convicted of living openly with a mistress and was banished from Tournai, although his punishment was later commuted to a fine. This triptych is called the *Mérode Altarpiece* after the 19th-century family that owned it.

the natural world. The image of Joseph and the mousetrap signifies his symbolic role as a trap for the Devil: his marriage to Mary was interpreted as a divine plan to fool Satan into believing that Jesus's father was mortal. Joseph thus protects Mary and Jesus, and so guards the sanctity of the central panel. In working alone, isolated from the miraculous Annunciation, Joseph is both part of, and separate from, the central drama. His inclusion in Annunciation scenes was unusual and has been linked to a growing cult of Saint Joseph in Flanders. Joseph is depicted as a family man, reflecting the bourgeois character of the Netherlands.

The donor has been identified by the coat of arms at the top of the back-wall window of the *Annunciation* as belonging to the Ingelbrechts family from Mechelen. His wife, thought to have been added after their marriage, kneels behind him and holds a string of rosary beads. Husband and wife are privileged to witness the moment of the Incarnation through the slightly open door, but they remain outside the sacred space. Their presence reinforces the private, devotional function of Campin's triptych. The small figure in the background has been variously identified—from the artist himself to Isaiah, whose Old Testament prophecies are the source of several iconographic conventions used in Annunciation scenes.

15.32 Detail of fig. **15.31.** Here, Christ enters the sacred, though domestic, space of the Annunciation. He carries a small Cross, referring forward in time to his Crucifixion. Christ and the Cross leave the glass intact, illustrating the popular Christian metaphor that equates the entry of light through a window with the Virgin Conception and Birth.

Jan van Eyck

The most prominent painter of the early fifteenth century in the North was Jan van Eyck (c. 1380/90–1441), whose work combines Flemish interest in natural detail and tactile sensibility with Christian symbolism.

The *Ghent Altarpiece* Van Eyck's most elaborate and complex work is the *Altarpiece of the Lamb,* also called the *Ghent Altarpiece* because it is in the cathedral of Saint Bavon in the Belgian city of Ghent (figs. **15.33–15.35**). Jan worked on the altarpiece with his brother Hubert, who died in 1426. Six years later, Jan completed the altarpiece on his own. Although it is not entirely clear which brother was responsible for which parts, Jan may be credited with the final product. The altarpiece is a **polyptych** (many-paneled painting), its sections held together by hinges. There are twenty-four panels in all, twelve inside (visible when the altarpiece is open) and twelve outside (visible when it is closed).

Van Eyck refined the technique of oil painting to such a degree that the brilliant glow of his light and color took on symbolic character. He mixed pigment with linseed oil, which he built up through several layers into a rich but translucent paint surface. By using tiny brushes, he was able to apply minute dabs of paint that replicate details of the material world. Medium and content thus merge with technique.

Figure **15.33** shows the *Ghent Altarpiece* with the wings open. The *Adoration of the Lamb by All Saints,* the lower central scene, occupies the largest panel. Its literary source is the Book of Revelation, which was read on All Saints' Day (November 1). The Lamb, the symbol of Christ's sacrifice, stands on an altar, its blood dripping into a gold chalice. A fountain, the *fons vitae,* stands before the altar. Water pours forth from the font, symbolically washing away the sins of the worshiper attending Mass before the altar in Saint Bavon.

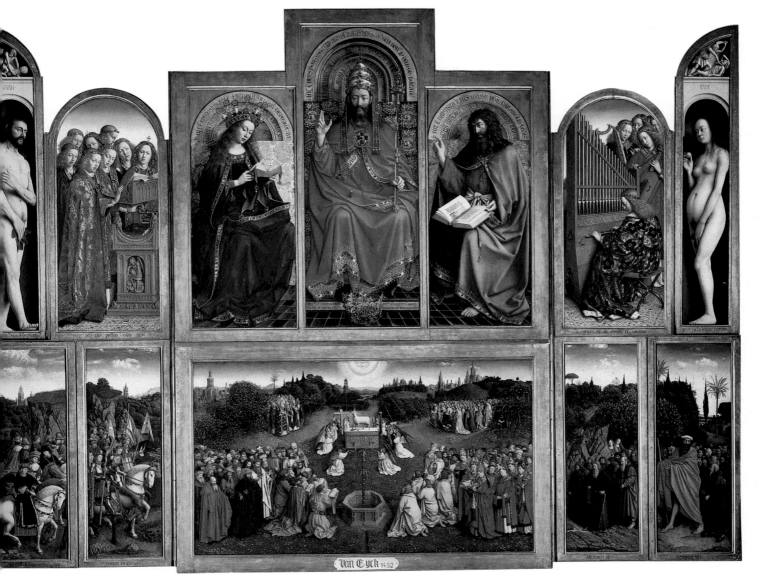

15.33 Jan van Eyck, *Ghent Altarpiece* (open), completed 1432. Oil on panel, approx. 11 ft. 6 in. × 14 ft. 5 in. (3.5 × 4.4 m). Cathedral of Saint Bavon, Ghent, Belgium.

15.34 Jan van Eyck, *Ghent Altarpiece*, detail of God's crown in fig. **15.33**.

Above the altar, rays of light emanate from the semicircle around the Holy Spirit and extend toward the crowds of worshipers. At the right are the twelve apostles and martyrs in red robes, and at the left are Old Testament and pagan figures considered by the Church to have merited salvation. In the background a group of confessors wearing blue robes congregates at the left, with virgin martyrs at the right. They carry palms, signifying the triumph of martyrdom over death. The far distance glows with minute landscape details and the skyline of a city (including a view of Saint Bavon Cathedral), evoking the Heavenly Jerusalem.

On the side panels, worshipers are shown traveling to the site of the altar. Just judges (representing the power of Christendom) and knights approach on horseback at the left, and holy hermits and pilgrims on foot at the right. The Altar of the Lamb is both the formal focus of the altarpiece and the destination of the travelers. When they arrive at the open field, they stop. When they reach the altar and the fountain, they kneel in adoration, their movement arrested by the holy sight.

The upper register contains seven panels. God the Father, merged with the Christ of the Last Judgment and the Deësis, occupies the largest space on this level. He sits in a frontal pose and raises his right hand in the manner of judgment but is flanked by the Virgin and John the Baptist as in the Deësis. The Virgin is crowned Queen of Heaven, and Saint John wears a green robe over his hair shirt. On either side of these figures are music-making angels in elaborate brocade cloaks juxtaposed with the nudity of Adam and Eve.

The figure of God/Christ is represented in hieratic scale. His importance is indicated by his central position, his height, his frontality, and his regal gestures and accoutrements. The elaborate crown at his feet, juxtaposed with the papal crown he is wearing, links him with the semicircle of light in the *Adoration of the Lamb*. Figure **15.34** shows the detail of the crown and the exquisite embroidery on the cloak. The minute depiction of the jewels in the crown and its gold tracery is characteristic of Northern taste. Here, however, the rich materials also have a symbolic meaning, for they belong to the personage who embodies the power of the Christian universe. Despite the frontality of the God/Christ figure, he is set in three-dimensional space. The grid pattern in the floor, like that in the panels of the Virgin and John the Baptist, is composed of orthogonals, although van Eyck's perspective is never as mathematically precise as in Italian paintings.

Adam and Eve stand in the narrow end panels, depicted illusionistically as stone niches. Above Adam and Eve are painted imitation sculptures (representing Cain's Offering and the Murder of Abel). Van Eyck's Adam and Eve provide an instructive contrast to those by Masaccio (see fig. **15.14**) in the Brancacci Chapel. The latter are derived from the more idealized forms of Classical antiquity, whereas van Eyck's are both more specific, as if painted from live models, and more Gothic. They are somewhat elongated, and their physiognomy is portraitlike.

Figure **15.35** shows the *Ghent Altarpiece* with the wings closed. The central lower panels represent John the Baptist holding a lamb (left), and John the Evangelist holding a chalice (right). Both, like the Cain and Abel, are painted in **grisaille**. Their prominence in the altarpiece is directly related to its commission and iconography. St. Bavon Cathedral was originally the church of St. John, dedicated to John the Baptist, and remained so in the fifteenth century. Kneeling on either side of the saints are the donors, Jodocus Vijd, an official of Ghent, and his wife, Isabel Borluut, who commissioned the altarpiece for their private chapel.

In the upper panels, the floor tiles and the distant cityscape reveal van Eyck's knowledge of linear perspective. But the pointed arch of the niche containing the wash basin betrays Gothic taste. In the *Annunciation*, Gabriel arrives carrying lilies, and his words are painted in gold. They extend across the picture plane from his mouth to

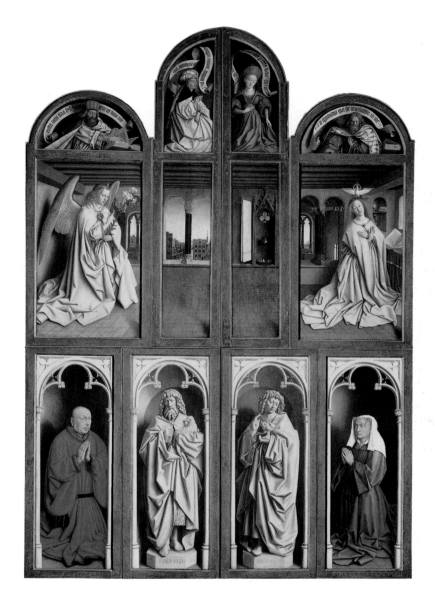

15.35 Jan van Eyck, *Ghent Altarpiece* (closed). Approx. 11 ft. 6 in. × 7 ft. 7 in. (3.5 × 2.33 m).

Mary's ear, illustrating the medieval tradition that Mary was impregnated through her ear by the Word of God. Her crossed arms and the cruciform shape of the Holy Spirit remind viewers of the Crucifixion.

The figures in the small panels at the top have typological meaning. At the ends are two Old Testament prophets, and in the center are two sibyls, the female seers of Classical antiquity. Taken as a whole, therefore, the iconography of the *Ghent Altarpiece* encompasses a vast time span. On the exterior, we are reminded that both the Old Testament prophets and the pagan seers were interpreted as having foretold the coming of Christ. The Annunciation marks the New Dispensation, while the two Saints John frame Christ's earthly mission—John the Baptist, who identified Jesus to the multitudes and baptized him, and John the

Evangelist, the author of the Gospel. The presence of the donors situates the time and place of the altarpiece itself in the fifteenth-century Netherlands.

The inner scenes encompass an even greater time span. Adam and Eve refer to the beginning of human time. Mary and John the Baptist mark the life and earthly mission of Christ, which is celebrated by the music-making angels. The lower scenes take Christ's temporal life into the realm of ritual—his sacrifice and rebirth—and therefore into timelessness. Although Christ himself never actually appears, except merged with the figure of God, every aspect of the iconography alludes to his presence. Even the little scenes of Cain and Abel refer to Jesus's death, for Abel was the first biblical victim, and thus typologically paired with Christ.

Man in a Red Turban A year after van Eyck completed the *Ghent Altarpiece,* he painted the *Man in a Red Turban* (fig. **15.36**). It is widely believed to represent himself, which would make it one of the first individual self-portraits of the Renaissance. The depiction of the turban reveals the artist's delight in the angular folds and their rich red color. In contrast to the expansive flourishes of the turban, van Eyck's features are meticulously defined. His lips are thin and drawn, while the corners of his piercing eyes are covered with slight wrinkles. At the top is a text in semi-Greek letters, painted to look as if carved into the picture frame. It reads "Als Ich Kan," which are the first words of a Dutch proverb meaning "As I can, but not as I would."

I5.36 Jan van Eyck, *Man in a Red Turban (Self-portrait?),* 1433. Tempera and oil on wood, approx. 13⅛ × 10⅛ in. (33.3 × 25.8 cm). National Gallery, London, England. Van Eyck worked in The Hague as painter to John of Bavaria and in Bruges for Philip the Good, duke of Burgundy. He also received commissions from private individuals. Jan was a master of the oil medium. He used alternating layers of transparent glaze and opaque tempera to produce his characteristic effects of light and shade.

The *Arnolfini Portrait* Jan van Eyck's so-called *Arnolfini Portrait* of 1434 (fig. **15.37**) is a unique subject in Western European art. A great deal has been written about this picture, and scholars have proposed numerous interpretations of it. There is, however, general agreement about the basic elements of the painting, if not about the overall intentions of the patron and artist.

The couple stand in a bedroom, holding hands, in formalized poses. In their clothing, each individual fabric and texture—for example, the fur, the lace, the gold and leather belt—is convincingly portrayed. The two pairs of shoes on the floor indicate that, while this is a bedroom, it is also a sacred space (compare this with the removal of the king's shoes on holy ground in the Egyptian Palette of Narmer, figs. **5.1** and **5.2**). At the same time, the scene contains several references to the woman's potential fertility. She holds her drapery in a way that suggests pregnancy. The seemingly casual positioning of pieces of fruit on the chest and windowsill denote natural abundance; and the little wooden statue on the chair back next to the bed represents Saint Margaret, patron of women in childbirth. The dog, whose prominence in the foreground is surely meaningful, signifies fidelity, although it can also have erotic associations.

As in Campin's *Annunciation,* almost every household detail in the *Arnolfini Portrait* has Christian significance. The single candle burning in the chandelier, for example, can refer to Christ's divine presence, and it also stands for the traditional marriage candle that brides brought to the bridal chamber. Once a marriage was consummated, the flame was snuffed. The most intriguing detail in this painting is the convex mirror on the back wall (fig. **15.38**). It is surrounded by ten small circles, each of which contains a scene of Christ's Passion. Reflected in the mirror are figures observing the scene from a door in front of the couple—the human witnesses. One of the figures may be Jan van Eyck, in which case he has documented his own presence twice, both as a reflection and by his signature. Above the mirror he has written on the wall in Latin, "Johannes de eyck fuit hic," or "Jan van Eyck was here," and added the date, 1434. Van Eyck's presence recalls the traditional parallel between God, as Creator of the universe, and the mortal artist, who imitates God's creations in making works of art.

15.38 (Above) Detail of the mirror in fig. **15.37.** Convex mirrors were popular in homes before the development of full-length mirrors in Europe around 1500. Because they reflect a large area, they were used by shopkeepers (as they still are today) to detect pilfering. As such, they were the "eyes" of owners who wanted to guard their possessions. Van Eyck's mirror has therefore been interpreted, in Christian terms, as the eye of God.

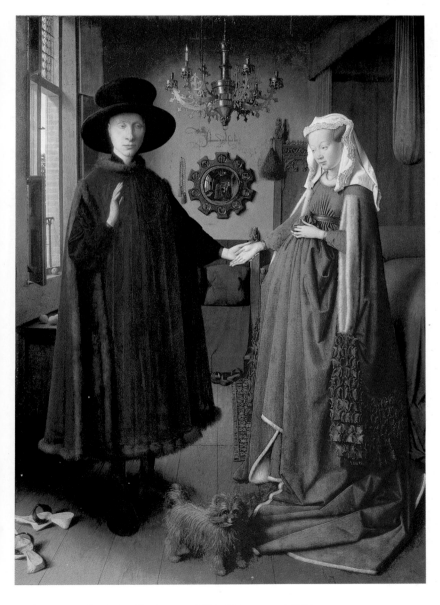

15.37 Jan van Eyck, *Arnolfini Portrait,* 1434. Oil on wood, 32¼ × 23½ in. (81.9 × 59.7 cm). National Gallery, London, England.

Rogier van der Weyden

The third great Netherlandish painter of the first half of the fifteenth century was Rogier van der Weyden (c. 1399–1463), the official painter of Brussels, who had been trained in the Tournai workshop of Robert Campin. His figures are typically larger in relation to their spatial setting than van Eyck's. They seem to enact monumental dramas as if on a narrow stage that brings them close to the picture plane.

Descent from the Cross Rogier's *Descent from the Cross* (fig. **15.39**) of around 1435 illustrates a theme imbued with emotional content that became popular in fifteenth-century Flemish art. The event takes place in a tight space containing ten harshly illuminated figures. The heavy, angular draperies of the fainting Virgin and Mary Magdalen (at Jesus's feet) and of Saint John (in red) are somewhat relieved by the figure in the brocade robe and the red stockings worn by Joseph of Arimathea (the patron saint of embalmers and grave diggers), who is directly behind

Jesus. A series of long, flowing curves unites the figures within the compressed setting. Jesus's horizontal S-shape form echoes the Virgin's. Both are supported by figures in countervailing S-shapes, which are arranged in vertical planes. The diagonal pull from Jesus's bowed head to Mary's limp right arm is anchored between Saint John's bare foot and Adam's skull—the latter a reminder that the Crucifixion takes place over his grave.

Mary's pose echoes Jesus's, indicating her emotional and physical identification with his suffering and death. Her empathic response reflects the power of contemporary religious movements, especially prominent in Northern Europe, that strove for mystical communion with Jesus's life and message. The most influential spokesman for this sentiment in the early fifteenth century was the German cleric Thomas à Kempis (1380–1471). He is credited as the author of *The Imitation of Christ,* written around 1414, which advocates a spiritual merger with Christ through self-denial and prayer.

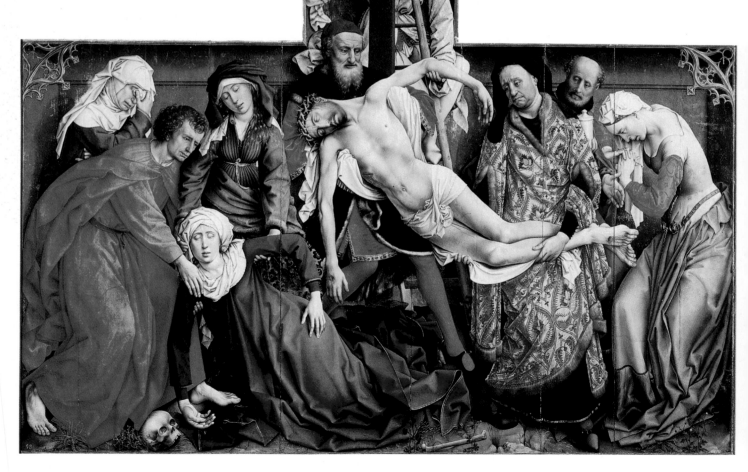

15.39 Rogier van der Weyden, *Descent from the Cross*, c. 1435. Oil on wood, 7 ft. 2⅝ in. × 8 ft. 7⅛ in. (2.19 × 2.65 m). Prado, Madrid, Spain.

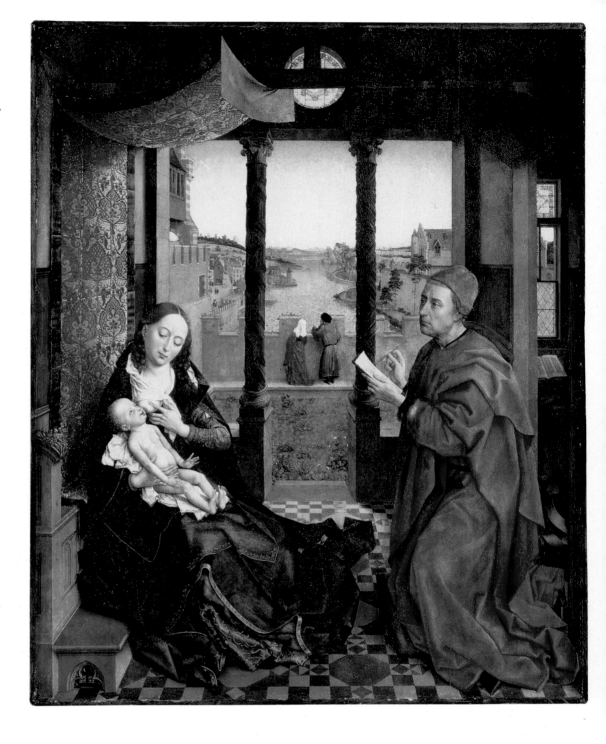

15.40 Rogier van der Weyden, *Saint Luke Depicting the Virgin*, c. 1435. Oil and tempera on panel, panel 4 ft. 6⅛ in. × 3 ft. 7⅝ in. (1.38 × 1.11 m). Courtesy of the Museum of Fine Arts, Boston. Gift of Mr. and Mrs. Henry Lee Higginson.

Saint Luke Depicting the Virgin Rogier creates an altogether different mood in *Saint Luke Depicting the Virgin* (fig. **15.40**). Through the open wall of the room, the observer joins the two figures seen in back view, in looking beyond the distant city toward the horizon. Figures, landscape, and architecture diminish abruptly in size, creating an illusion of great distance. At the same time, the elaborate patterns continue the tradition of International Gothic in the North.

Mary and Jesus, whose proportions depart more from the Classical ideal than their Italian counterparts, constitute an insightful psychological depiction of the mother-child relationship. Jesus is contained within Mary's voluminous form and framed by the white cloth. Mary looks down at the Christ Child, who gazes up at her. His physical pleasure in breast-feeding is revealed by his upturned toes and extended fingers.

The specific physiognomy of Saint Luke has led to the suggestion that he is a self-portrait of Rogier. His slightly wrinkled forehead, intense gaze, poised stylus, and posture reveal a physical tension that could well be autobiographical. There are no records of this painting's commission. However, it may have been painted for an artists' guild since Saint Luke was the patron saint of artists. Tradition had it that he had drawn the Virgin during her lifetime, making Rogier's identification with the saint, especially in this painting, a logical one.

Later Developments

Hugo's *Portinari Altarpiece* The Portinari Altarpiece, a triptych probably executed in the 1470s by Hugo van der Goes (c. 1435/40–82) is an example of later fifteenth-century painting in the North (fig. **15.41**). It was commissioned for the Church of Sant'Egidio in Florence by the Italian Tommaso Portinari, who was the Medici bank's representative in Bruges. The central panel represents Mary, Joseph, shepherds, and angels adoring the newborn Christ Child, who lies on the ground surrounded by a glow of light. In the distance, at the upper right, an angel announces Jesus's birth to the shepherds.

Hugo's colors are deeper and richer than those of van Eyck. Certain details, such as the vases of flowers in the foreground, express the Northern taste for endowing everyday objects with specific Christian meaning. The vase at the left, for example, contains flowers that denote Jesus's royal nature as well as his purity and passion. The grapes and vine scrolls on the surface of the vase allude to the wine of the Eucharist and to Christ as the Church (cf. "I am the vine"). Behind the vases is a sheaf of wheat, the placement of which nearly parallels that of the infant Christ and refers to the Eucharist.

The glass container at the right is penetrated by painted light as Mary was impregnated by God's divine light and became the vessel of Christ. It holds columbines, symbolizing Mary's suffering and humility. The vase on the left holds iris and red carnations, symbolizing pure love. Violets are strewn on the ground. The particular arrangement and iconography of the vases, wheat, and flowers and their formal relationship to Christ reveal the liturgical implications of Hugo's image and its relation to the enactment of the Eucharist in its actual setting in a church.

In the background, David's harp on his palace refers to Jesus's descent from the "house of David." In the shed, the ox looks up and observes the event taking place before him, while the ass keeps on munching. Just to the right of the ox and ass, gazing out from the shadows, is a demon whose presence has been identified as an allusion to the role of the Incarnation in foiling Satan's plans for the world.

Compared with van Eyck, Hugo's style, at least in this altarpiece, is fraught with tension. This is particularly true of the shepherds at the right in the central panel, whose grimacing faces and frantic gestures reflect their eagerness and wonder before Christ. In the side panels, members of the donor's family kneel in front of their patron saints. The children are among the first in Netherlandish art to have facial features suitable for their age. By depicting the family

members as so much smaller in scale than the saints, however, Hugo creates an oddly irrational juxtaposition.

Whether the tensions in this painting are a result of the artist's personal conflicts or a reflection of contemporary stylistic developments is difficult to determine. Most likely, a combination of factors was at work. In any case, it is Hugo's greatest surviving work. In 1483 it was sent to Florence, and its influence on Italian artists during the latter part of the fifteenth century was considerable.

Ghirlandaio's *Adoration of the Shepherds* Most of all, the *Portinari Altarpiece* impressed Domenico Ghirlandaio (1449–94), who was one of the leading Florentine painters at the close of the fifteenth century. His most important commissions were for the Tornabuoni (in-laws of the Medici) and the Sassetti, both wealthy banking families. The two fresco cycles he painted for them are unusual in the large number of family members taking part in the sacred events. His *Adoration of the Shepherds* (fig. **15.42**) was for the altar in the Sassetti Chapel, in Santa Trinità, which was decorated with scenes from the life of Saint Francis, the name saint of Francesco Sassetti.

Ghirlandaio's *Adoration* is clearly related to Hugo's, and it would attest to the commercial and artistic ties between

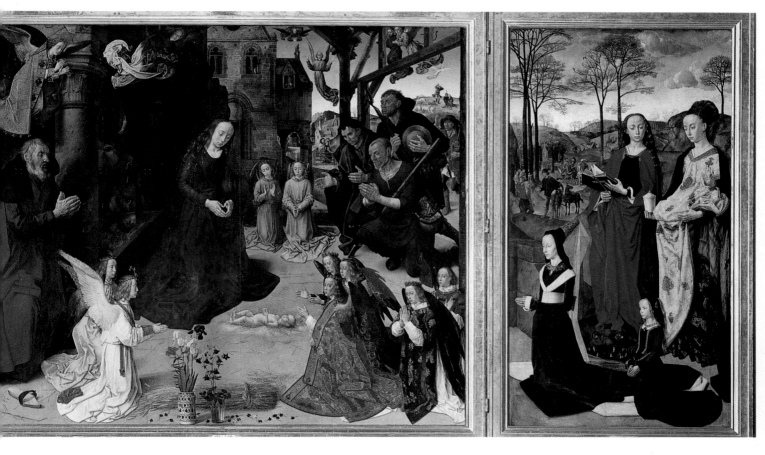

15.41 Hugo van der Goes, *Portinari Altarpiece* (open), 1470s. Oil on wood, central panel 8 ft. 3½ in. × 10 ft. (2.53 × 3.05 m). Galleria degli Uffizi, Florence, Italy. In 1475 Hugo entered the monastery of the Red Cloister near Brussels as a lay brother. But his fellow monks accused him of being too worldly because of his artistic success. He suffered several episodes of depression and in 1481 tried to commit suicide. Contemporary rumor attributed his depression to disappointment that he had failed to produce works as great as van Eyck's *Ghent Altarpiece.*

Italy and Northern Europe, even if they were not independently documented. Nevertheless, Ghirlandaio's mood is different from that of his Northern inspiration, and his proportions are more Classical. The shepherds are rustic individuals with craggy physiognomies like those in the *Portinari Altarpiece,* but they do not exhibit signs of agitation. Their nature corresponds to the relaxed atmosphere of the picture and to its naturalism. Both the ox and the ass gaze at Christ in a friendly manner. One of the shepherds points to Christ while turning to talk with the man praying.

In contrast to the tension exhibited in the *Portinari Altarpiece,* Ghirlandaio's painting is relaxed and seemingly casual. Joseph, for example, gazes at the angel appearing to the shepherds at the upper left. There is also, in the Ghirlandaio, an emphasis on physical, tactile warmth, which is lacking in the Hugo van der Goes. This can be seen in the way the lamb appears to touch the shepherd's head, the ox's horn to caress the ass's forehead, and Joseph's left hand to rest on the rim of the sarcophagus. Whereas the

Portinari Jesus lies flat on the ground, isolated and separated from human contact, Ghirlandaio's Jesus sucks his thumb and lies on his mother's extended drapery.

This painting is both a summation of certain fifteenth-century humanist concerns and a synthesis of Classical innovations. Ghirlandaio's attention to the details of landscape, the distant town, and the elegantly attired crowd traveling to adore the Christ Child appealed to popular taste. The rules of linear perspective are strictly followed in the diminishing size of figures and landscape. Finally, Ghirlandaio has incorporated a Classical sarcophagus and Classical architecture into the Christian scene. Two Corinthian pilasters rise behind the Adoration; the one on the left is inscribed with the date of the painting, 1485. The inscription on the sarcophagus identifies as its occupant a fictitious soothsayer, who died when Pompey besieged Jerusalem. The soothsayer predicts that his tomb will become the crib of a new deity (Christ). The Roman arch names Pompey as conqueror of Jerusalem and ironically alludes to the triumph of Christianity over pagan Rome.

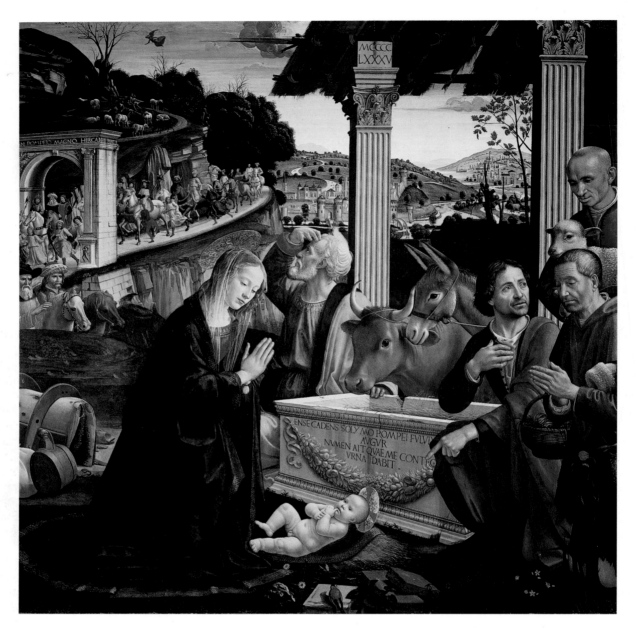

15.42 Domenico Ghirlandaio, *Adoration of the Shepherds*, 1485. Panel, 65¼ × 65¼ in. (165.7 × 165.7 cm). Sassetti Chapel, Santa Trinità, Florence, Italy.

c. 1400 **c. 1500**

THE EARLY RENAISSANCE

 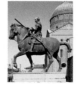 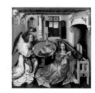 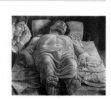

(15.1) (15.10) (15.36) (15.17) (15.22) (15.31) (15.8)

| Discovery of one-point linear perspective (c. 1400) | Henry V of England defeats France at Agincourt (1415) | Joan of Arc burned at the stake (1431) | Vatican Library founded (1450) | Turks capture Constantinople (1453) | Erasmus (1465–1536) | Lorenzo de' Medici, "the Magnificent," rules Florence (1469–1492) | Nicolaus Copernicus (1473–1543) | Savonarola burned at the stake (1498) | Vasco da Gama sails to India (1498) |

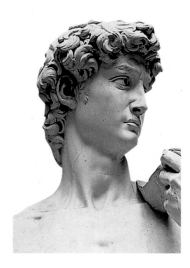

16

The High Renaissance in Italy

The High Renaissance in Italy was an age of great accomplishments in Western art that occurred in the late fifteenth century and the first decades of the sixteenth. The term *High,* which is used to designate this period, reflects the esteem in which it is generally held.

Politically, the High Renaissance was a time of tension and turbulence. The French invaded northern Italy and sacked Milan. The Medici were expelled from Florence in 1494, and the fervent Dominican, Savonarola, was executed four years later.

Under the control of ambitious popes, Rome succeeded Florence as the artistic center of Italy. Pope Julius II (papacy 1503–13), determined to expand his political and military power, was an enlightened humanist. In his patronage of the arts, Julius made perhaps the greatest contributions to the High Renaissance. His successor, Leo X (papacy 1513–21), continued to employ major painters, sculptors, and architects, but the artistic achievements of the period were not matched by political success. In 1527 the Holy Roman emperor, Charles V, invaded Italy and sacked Rome.

Although many important fifteenth-century artists helped to lay the foundations of the High Renaissance, the period is dominated by a relatively small number of powerful artistic personalities. Those considered in this chapter are Leonardo da Vinci, Bramante, Michelangelo, Raphael, Giorgione, and Titian. In the section on Venice, the Bellini are discussed as precursors of the High Renaissance.

Leonardo (1452–1519) succeeded Alberti as the embodiment of the "universal Renaissance man," or *uomo universale.* He painted only a small number of pictures, but worked as a sculptor and architect, and wrote on nearly every aspect of human endeavor, including the arts and sciences. Bramante (c. 1444–1514), Raphael (1483–1520), and Michelangelo (1475–1564), all of whom were influenced by Leonardo, achieved their greatest success in Rome. In Venice, the High Renaissance was dominated by Giorgione (c. 1477–1510) and above all by Titian (c. 1485–1576), whose life was long and productive. Of these six, only Titian and Michelangelo lived beyond the year 1520, when new artistic styles began to emerge and the short period of the High Renaissance came to an end.

Architecture

The Ideal of the Circle and Centrally Planned Churches

An important architectural ideal that preoccupied many artists and writers on art from the fifteenth century through the High Renaissance was the centrally planned church building. It was based on the ancient notion that the circle is the ideal shape. Plato considered the circle to be the perfect geometric form, associating it with divinity. In the Near East and Byzantium, belief in the divine property of the circle was reflected in churches and mosques, in which domed ceilings symbolized heaven. Churches whose plans are based on the **Greek cross** are centralized, in contrast to the longitudinal design of the Latin cross and the basilican plan of the Early Christian church. The divine associations of the circle persisted through the European Middle Ages, recurring in the huge rose windows of the Gothic cathedrals.

In fifteenth-century Italy, the circular ideal was an aspect of the humanist synthesis of Classical with Christian thought. It was also related to the new interest in the direct observation of nature. Alberti, for example, noted that in antiquity temples dedicated to certain gods were round, and he connected the divinity of the circle with round structures in nature. He wrote in his treatise on architecture that "Nature delights primarily in the circle," as well as in other centrally planned shapes such as the hexagon. In support of this view, Alberti observed that all insects create their living quarters in hexagonal shapes (the cells of bees, for example). Further, Alberti and other fifteenth-century architects followed Vitruvius in relating architectural harmony to human symmetry. Temples, according to Vitruvius, required symmetry and proportion in order to achieve the proper relation between parts that is found in a well-shaped man (fig. **16.1**).

Leonardo da Vinci followed these principles when devising his own projects for churches. These designs influenced the older architect Donato Bramante, who moved to Rome when the French invaded Milan in 1499.

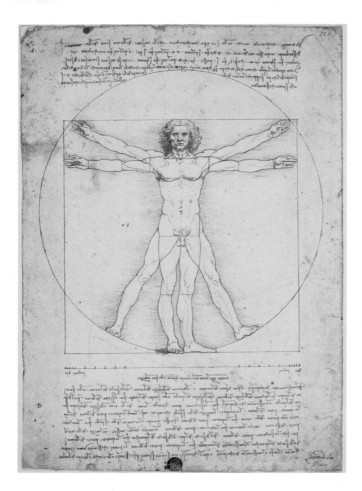

16.1 Leonardo da Vinci, *Vitruvian Man*, c. 1485–90. Pen and ink, 13½ × 9⅝ in. (34.3 × 24.5 cm). Gallerie dell'Accademia, Venice, Italy. This drawing illustrates the observation made by Vitruvius that if a man extends his four limbs so that his hands and feet touch the circumference of a circle, his navel will correspond to the center of that circle. Vitruvius also drew a square whose sides were touched by the head, feet, and outstretched arms of a man. Leonardo's script runs from right to left and must be read in a mirror. To date there is no generally accepted explanation for this curious "mirror writing."

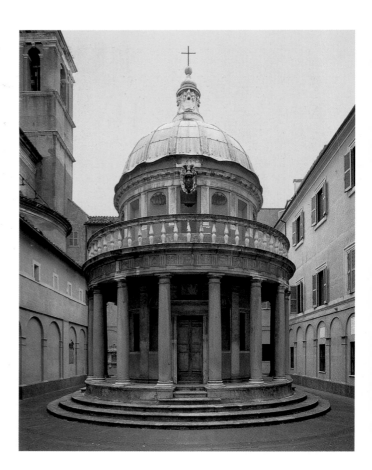

16.2 Donato Bramante, Tempietto, San Pietro in Montorio, Rome, c. 1502–3. The Tempietto ("Little Temple" in Italian) was a small martyrium commissioned by King Ferdinand and Queen Isabella of Spain and erected in Montorio, Rome, shortly after 1500. The hole in which Saint Peter's cross supposedly stood marked the center of a chamber below the round *cella*. In the *cella* itself, just above the hole, stood a single altar.

Bramante's Tempietto, situated on the traditional site of Saint Peter's crucifixion, fulfills the ideal of the round building (fig. 16.2). The exterior sixteen-column Doric peristyle supports a Doric frieze and a balustrade. Above the peristyle is a drum surmounted by a ribbed hemispherical dome. In selecting Doric columns and a Doric frieze, Bramante conformed to Vitruvius's view that an order should correspond to the god to whom the temple was dedicated. Doric, according to Vitruvius, was suitable for the active male gods—a category consistent with Saint Peter's hot-tempered nature. Finally, Bramante adopted the practice, also dating back to antiquity, of treating a building as one massive block of stone with openings and spaces carved out of it. This has been referred to as the **sculptured wall motif**.

The relatively small interior of the Tempietto meant that very few people could enter it at once, so it was probably intended to be appreciated more from the outside. It now stands in a rather constricted place, but Bramante's original ground plan is recorded in a sixteenth-century engraving (fig. **16.3**). This would have placed the structure in the

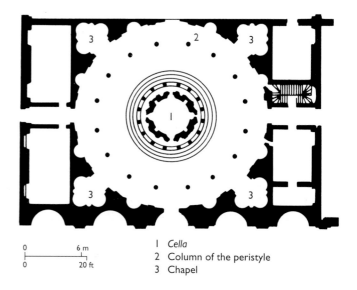

1	*Cella*
2	Column of the peristyle
3	Chapel

16.3 Donato Bramante, plan of the Tempietto with projected courtyard, after the 16th-century engraving by Sebastiano Serlio. From the geometrical center of the *cella*, equidistant lines can be drawn to each column of the peristyle, just as they can from the navel of Leonardo's Vitruvian man to the circumference of a circle.

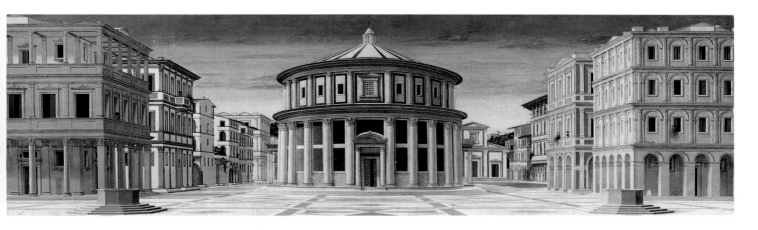

16.4 Anonymous, *Painting of an Ideal City*, mid-15th century. Panel painting, 79 × 23½ in. (200.7 × 59.7 cm). Palazzo Ducale, Urbino, Italy.

middle of a circular enclosure inscribed in a square with a tiny chapel in each corner.

Centrally planned buildings were regarded as key elements in Renaissance urban architecture, as can be seen in the *Painting of an Ideal City* (fig. **16.4**). A circular building occupies the center of the composition. By implication, it is the navel of the ideal city. The rectangular buildings surrounding it differ in size and type, but all have the symmetrical, geometrical quality that is a feature of Renaissance architecture.

St. Peter's and the Centralized Plan

Bramante and Raphael arrived in Rome within a few years of each other. The Tempietto established Bramante as Rome's leading architect, a position from which he acted as Raphael's mentor. In 1503 Julius II (see Box, p. 282) became pope and immediately set about re-creating the glory of imperial Rome. As part of his plan, Julius decided that the basilica of St. Peter's, by then over a thousand years old and in bad condition, would have to be rebuilt. He gave the commission to Bramante, who, by 1506, had designed a complex plan (fig. **16.5**). Bramante's design for the New St. Peter's was notable for its size. It was 550 feet (167.6 m) long, making it the largest church in history; in fact a sizable church could be accommodated in each of its four wings. Bramante also envisaged a large semicircular stepped dome above a relatively shallow drum.

In 1506 the foundation stone of the New St. Peter's was laid, and seven years later Pope Julius II died. Bramante himself died in 1514, but he had arranged for Raphael to succeed him as the new architect of St. Peter's. By the time of Raphael's death in 1520, little had been achieved beyond the demolition of the old basilica and the construction of the four great piers at the crossing.

In 1546, the task was entrusted to Michelangelo, then aged seventy-one. He retained the underlying concept of a huge dome on four piers but simplified Bramante's complex arrangements (fig. **16.6**). As a result of Michelangelo's

1 Domed space
2 Apse
3 Pier

16.5 Donato Bramante, plan for the New St. Peter's, Vatican, Rome, 1505. Bramante's central plan has four arms of a Greek cross ending in semicircular apses. A semicircular dome, larger than that of the Pantheon, would cover the central crossing. Between the arms of the cross would be four smaller, cross-shaped units, surmounted by smaller domes, and four tall towers. This plan is strictly symmetrical and follows the "sculptured wall" concept.

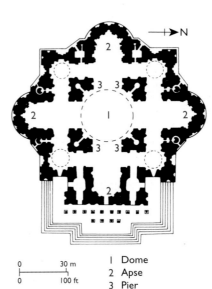

1 Dome
2 Apse
3 Pier

16.6 Michelangelo, plan for the New St. Peter's, Vatican, Rome, 1546. Michelangelo reduced the area of the floor by eliminating the smaller cruciform units (except for their domes) and the corner towers. He also simplified Bramante's proposed exterior by introducing a **colossal order** of pilasters topped by a cornice, and an attic high enough to conceal the smaller interior **cupolas**.

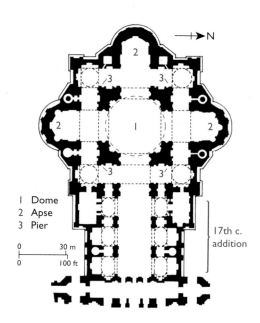

1 Dome
2 Apse
3 Pier

0 30 m
0 100 ft

17th c. addition

16.7 Plan for the New St. Peter's as built to Michelangelo's design with additions by Carlo Maderno, 1606–15 (see also fig. **19.3**).

changes, work proceeded quickly and, at his death in 1564, St. Peter's was nearly finished except for the dome. Despite the succession of architects who contributed to the New St. Peter's, the final result (figs. **16.7** and **16.8**) retained the original Greek cross plan, with the addition of a nave to form a Latin cross. The dome's profile is slightly pointed and small double columns soften the projection of the buttresses. Vertical ribs and a high lantern create a greater degree of verticality than in Bramante's original design.

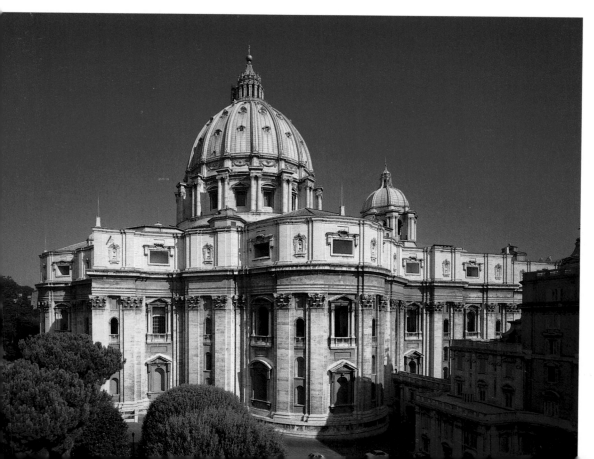

16.8 New St. Peter's, Vatican, Rome, view from the south flank.

Painting and Sculpture

Leonardo da Vinci

Scientific Drawings Leonardo da Vinci's numerous anatomical drawings illustrate the Renaissance synthesis of art and science. Among the most intriguing are his studies of fetuses in the womb (fig. **16.9**). In the main image, Leonardo depicts an opened uterus, a fetus in the breech position, and the umbilical cord. A smaller drawing to the right depicts the fetus as if seen through the amniotic membrane. Other drawings on the page illustrate the systems by which the fetus is linked to the mother's blood supply.

Apart from demonstrating his superb draftsmanship, such drawings reflect Leonardo's passionate interest in the origins of life and in discovering scientific explanations for natural phenomena. The thousands of studies, covering virtually every aspect of scientific and artistic endeavor, contrast strikingly with the small number of finished paintings by his hand. Leonardo's artistic nature may thus be characterized as investigative, preliminary, and experimental. Only rarely did he actually complete a work and deliver it to a patron.

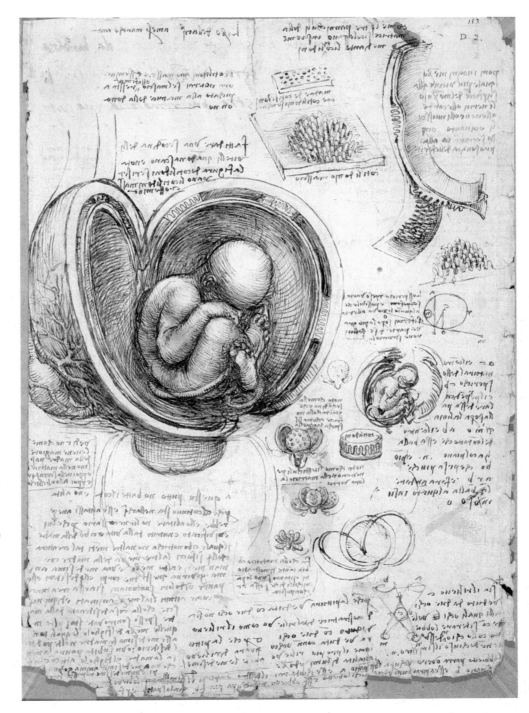

16.9 Leonardo da Vinci, *Embryo in the Womb*, c. 1510. Pen and brown ink, 11¾ × 8½ in. (29.8 × 21.6 cm). Royal Collection, Windsor Castle, Royal Library, England. The Royal Collection © 2011, Her Majesty Queen Elizabeth II RL19102r. Many Renaissance artists studied human anatomy, but Leonardo went far beyond the usual artistic concern with musculature and studied the digestive, reproductive, and respiratory systems. He apparently intended to collect his anatomical drawings into a treatise but never completed the project.

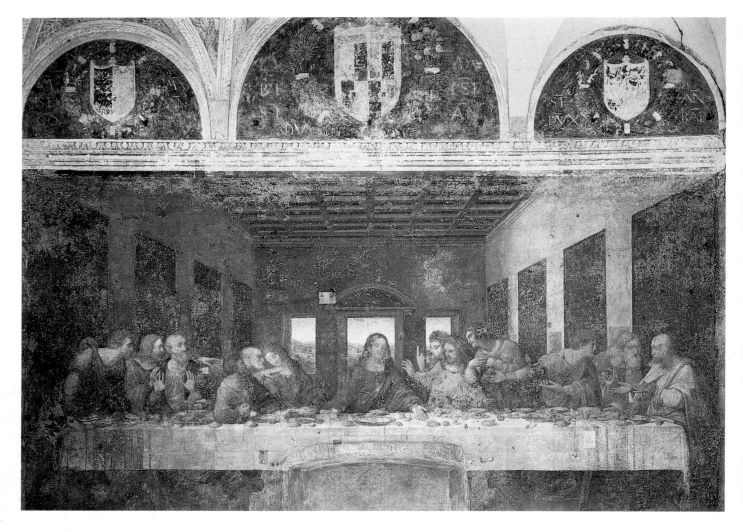

16.10 Leonardo da Vinci, *Last Supper,* refectory of Santa Maria delle Grazie, Milan, c. 1495–98. Fresco (oil and tempera on plaster), 15 ft. 1⅛ in. × 28 ft. 10½ in. (4.6 × 8.56 m). Leonardo's experimentation had negative as well as positive results. Because of his slow, deliberate working methods, he could not keep pace with the speed required by the *buon fresco* technique. Here, he seems to have applied a mixture of oil and tempera to the dry plaster. Unfortunately, the fusion between pigment and plaster was imperfect, and the paint soon began to flake off the wall. What we see today is a badly damaged painting, which has undergone several stages of restoration. The coats of arms in the lunettes formed by the arches are those of Lodovico Sforza and his wife, Beatrice d'Este. Lodovico ruled Milan and was one of Leonardo's most powerful patrons.

The *Last Supper* Leonardo's single most important mature work is his great mural of the Last Supper (fig. **16.10**) of around 1495 to 1498. Despite its poor condition, the *Last Supper* has become an icon of Christian painting and one of the most widely recognized images in Western art. Its success comes from Leonardo's genius in conveying character and dramatic tension, and integrating these qualities with an imposing and unified architectural setting.

The painting fills a short wall of what was the **refectory** of Santa Maria delle Grazie in Milan. The opposite wall had previously been decorated with a fresco of the Crucifixion to remind the monks of the connection between the Eucharist and Christ's Passion. Like Masaccio's *Holy Trinity* (see fig. **15.12**), Leonardo's *Last Supper* occupies an illusionistic room receding beyond the space of an existing wall and placed above the viewer's eye level.

Leonardo represents a series of moments following Jesus's announcement that one of his apostles will betray him. Each reacts according to his biblical personality.

Peter, whose head is fifth from the left, angrily grasps the knife with which he will later cut off the ear of the servant of Malchus. John, the youngest apostle, slumps toward Peter in a faint. Thomas, the doubter, on Jesus's left, points upward, his gesture highlighted by the dark wall behind his hand. Judas, to the left of Peter, is the villain of the piece. He leans back, forming the most vigorous diagonal away from Jesus. In placing Judas on the same side of the table as Jesus and the other apostles, Leonardo departs from convention, which distinguishes Judas by location, rather than by pose or gesture. Here, Judas is the only apostle whose face is in shadow—a symbol of the evil that comes from ignorance and sin.

The figures also play their part in the geometry of the composition. The apostles are arranged in four groups of three, echoing the four wall hangings on each side of the room and the three windows on the wall behind Jesus. Jesus forms a triangle, as he extends his arms forward. His triangular form corresponds to the triple windows, and

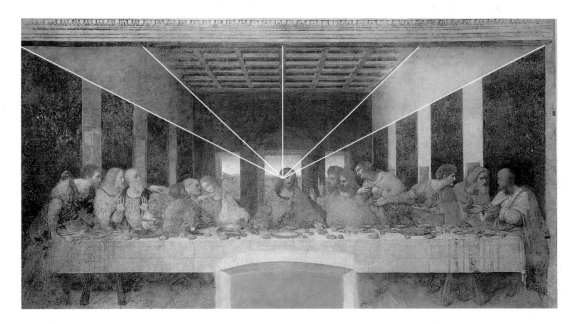

16.11 Leonardo da Vinci, *Last Supper* (after latest restoration). Superimposed orthogonals and the vanishing point illustrate the perspective system of the painting.

both allude to the three persons of the Trinity. The curved pediment over the central window functions as an architectural halo. Combined with the light background behind Christ's head, it is a reminder that Christ is the "light of the world." This aspect of Jesus is reinforced in the perspective construction. The orthogonals radiate outward from his head, so Christ becomes the sun, or literal "light of the world," extending his "rays" to the world outside the picture.

Figure **16.11** shows Leonardo's *Last Supper* after the most recent restoration, which took many years. The aim of the restorers was to remove everything that was not painted by Leonardo; when they had finished, very little of the original image remained. As a result, several of the figures were nearly blank and had to be repainted. The present appearance of the *Last Supper* is thus rather bland compared to its precleaned state. Its colors are paler, and much of the shading has been lost, giving the figures a flattened appearance.

Madonna and Child with Saint Anne Nature, as well as geometry, is an important aspect of Leonardo's paintings. In the unfinished *Madonna and Child with Saint Anne* (fig. **16.12**), Leonardo arranged the figures to form a pyramid set in a landscape. The three generations, represented by Anne (Mary's mother), Mary, and Jesus, correspond to the triangulation of their formal organization. The triple aspect of time—past, present, and future—is also a feature of Leonardo's integration of geometry with landscape and narrative. In this painting, past combines with future to

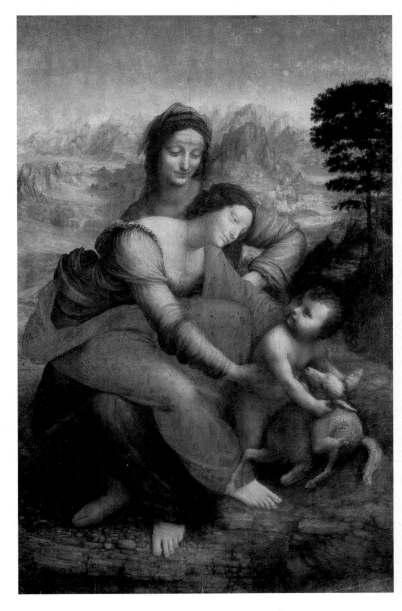

16.12 Leonardo da Vinci, *Madonna and Child with Saint Anne,* c. 1503–6. Oil on wood, 5 ft. 6⅛ in. × 3 ft. 8 in. (1.68 × 1.12 m). Musée du Louvre, Paris, France.

form the present image: the lamb and the tree refer forward in time to Jesus's sacrificial death on the Cross.

Leonardo's original handling of *chiaroscuro* is more evident in the *Saint Anne* than in the badly damaged and overrestored *Last Supper*. The soft, yellowish light bathing the figures and the gradual shading characteristic of Leonardo's style endow both flesh and drapery with a degree of softness unprecedented in Christian art. The landscape is also softened by the mists of Leonardo's *sfumato* (see Box), which filter through the atmosphere. Furthermore, just as the figures in the *Last Supper* echo the architectural composition, so in *Saint Anne* the figures and landscape are interrelated. In particular, the atmospheric mist in the background filters through the veil covering Anne's head. The angles of her veil and the strong zigzag thrust of her left arm repeat the rocky background. In this way, Leonardo depicts Anne as a metaphor for the landscape and perhaps also the symbolic architectural foundation of the three generations in the painting.

The *Mona Lisa* The painting that epitomizes Leonardo's synthesis of nature, architecture, human form, geometry, and character is the *Mona Lisa* (fig. **16.13**). Vasari says that the portrait depicts the wife of Francesco del Giocondo (hence its nickname, *La Gioconda,* meaning "the smiling one"). The figure forms a pyramidal shape in three-quarter view, seated within the cubic space of a **loggia.** The observer's point of view is made to shift from figure to landscape, and while Mona Lisa is seen from the same level as the observer, the viewpoint shifts upward in the landscape. The light also shifts, bathing the figure in subdued dark-yellow tones and the landscape in a blue-gray

sfumato. As a result, the rocky background, which is imaginary, has a misty atmosphere.

The contrasts of viewpoint and light serve to distinguish the landscape from the figure. At the same time, however, Leonardo has created formal parallels between figure and landscape. For example, the form of Mona Lisa repeats the triangular mountains, and her transparent veil echoes the filtered light of the mists. The curved aqueduct continues into the highlighted drapery fold over her left shoulder, and the spiral road on her right is repeated in the short curves on her sleeves. These, in turn, correspond to the line of her fingers.

Such formal parallels do not explain the mystery of the figure, whose expression has been the subject of songs, stories, poems, and other works of art. They do, however, illustrate Leonardo's own description, in his notebooks, of the human body as a metaphor for the earth. He compares flesh to the soil, bones to rocks, and blood to waterways. This metaphorical style of thinking, which recurs in visual form throughout his paintings and drawings, is characteristic of Leonardo's genius.

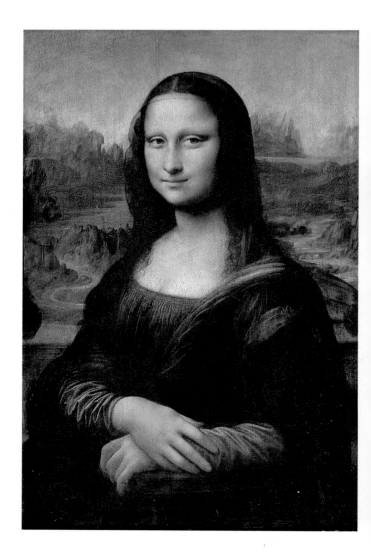

16.13 Leonardo da Vinci, *Mona Lisa*, c. 1503–5. Oil on wood, 30¼ × 21 in. (76.8 × 53.3 cm). Musée du Louvre, Paris, France. The enigmatic smile of the *Mona Lisa* is the subject of volumes of scholarly interpretation. Vasari says that Leonardo hired singers and jesters to keep the smile on her face while he painted. According to Freud, the smile evoked the dimly remembered smile of Leonardo's mother. Leonardo was unwilling to part with the picture and took it with him to the court of Francis I of France, where he died in 1519. It then became part of the French royal collection and was later trimmed by about an inch on either side.

Michelangelo Buonarroti

Michelangelo Buonarroti, born near Arezzo, lived to be eighty-nine; his life is documented in contemporary biographies, in comments on his personality and work, and from his own letters and sonnets. Like Leonardo, Michelangelo was an architect, painter, and writer, although he thought of himself primarily as a sculptor and considered sculpture a higher art form than painting.

Michelangelo's father opposed his wish to become a sculptor but, when his son was thirteen, apprenticed him to Domenico Ghirlandaio (see p. 276). Before Michelangelo was sixteen, his talent was recognized by Lorenzo de' Medici, under whose patronage he studied sculpture and was exposed to Classical art and humanist thought. His style was formed in Florence well before he went to Rome to work for Julius II. His attraction to the most monumental of his Florentine predecessors is evident from his habit of visiting the Brancacci Chapel and making drawings of Masaccio's frescoes (see figs. **15.13** and **15.14**).

Early Sculpture Michelangelo's first monumental work of sculpture is the marble *Pietà* of 1498–1500 (fig. **16.14**), now in St. Peter's, which he carved in Rome for the tomb chapel of a French cardinal. A youthful Mary mourns the dead Jesus, and both are contained in a pyramidal space on an oval base.

Mary and Jesus are formally and psychologically interrelated so that one hardly notices Jesus's relatively small size compared with Mary's massive form. The zigzag of Jesus's body blends harmoniously with Mary's legs and voluminous drapery folds. Mary's left hand repeats the movement of Jesus's left leg. She inclines her head forward as Jesus's tilts back, and the slow curve of her drapery on the left is repeated by Jesus's limp right arm. His right hand falls so that his fingers enclose and continue the prominent drapery curve between Mary's legs. In addition to the formal rhythms uniting Mary and Jesus, Michelangelo makes them appear to be about the same age. He thus creates an emotional and formal bond between the two figures who, though separated by

16.14 Michelangelo, *Pietà*, 1498–1500. Marble, 5 ft. 8½ in. (1.74 m) high. St. Peter's, Vatican, Rome. Michelangelo's favorite material was marble, and he spent much time in the quarries selecting the right stone for his sculptures. This **pietà** is his only signed work. The signature, carved in the band across Mary's chest, may be related to Michelangelo's comment that he imbibed the hammer and chisels of his trade with the milk of his wet nurse (the wife of a stonecutter).

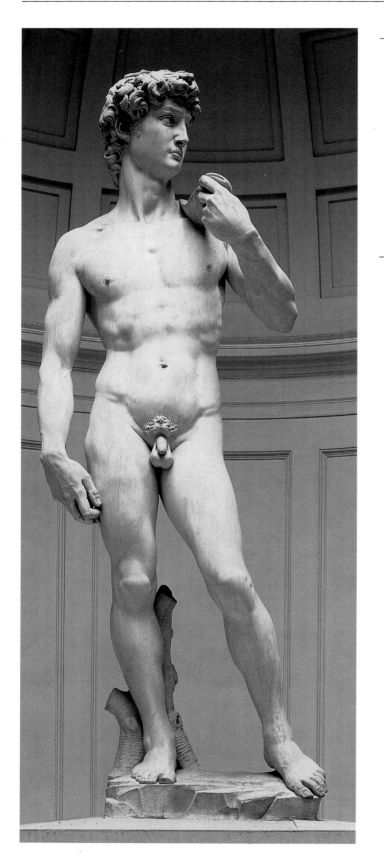

16.15 Michelangelo, *David*, 1501–4. Marble, approx. 13 ft. 5 in. (4.09 m) high. Galleria dell'Accademia, Florence, Italy.

CONNECTIONS

See figure 7.14. Polykleitos, *Doryphoros (Spear Bearer)*, c. 440 B.C.

See figure 15.17. Donatello, *David*, c. 1430–40.

death, will eventually be reunited as King and Queen of Heaven. According to one report, when Michelangelo was asked about the age of the Virgin, he replied that her youthfulness was a result of her chaste character.

In 1501 Florence commissioned a marble statue of David (fig. **16.15**), the symbol of Florentine republicanism. For three years Michelangelo worked secretly on a huge and difficult block of marble over 14 feet (4.27 m) high. Originally destined for the exterior of the cathedral, the *David* was placed in 1504 in front of the Palazzo Vecchio (the government seat of Florence)—a more suitable location for a political sculpture. In 1873 the original was removed to the Accademia, and a copy was put in its earlier place.

The little tree trunk supporting the *David* is a reminder of the ancient Roman copies of Greek statuary and evokes the Classical past. Although both Michelangelo's *David* and Donatello's (see fig. **15.17**) assume a *contrapposto* pose, the latter is relaxed whereas Michelangelo's is tense and watchful. He is represented at a moment before the battle and so does not stand on the head of the slain Goliath. His creased forehead and his strained neck and torso muscles betray apprehension as he sights his adversary. Michelangelo's *David* is the most monumental marble nude since antiquity, its proportions corresponding more to Hellenistic than to Classical style. David's hands, in particular, are large in relation to his overall size, and his veins and muscles seem to bulge from beneath his skin.

Shortly after completing the *David,* Michelangelo was summoned to Rome by Julius II to design his tomb. The project was interrupted when the pope commissioned him to paint the ceiling of the Sistine Chapel in the Vatican (see fig. **16.17**).

16.16 Diagram of scenes from the ceiling of the Sistine Chapel. The first three narrative scenes represent God's creation of the universe; the second three, Adam and Eve; and the last three, Noah and the Flood. Each small scene is surrounded by four nudes (called *ignudi*) in various poses. In each corner of the ceiling, the **spandrel** (a curved triangular section) contains an additional Old Testament scene. The spandrels and lunettes above the windows depict the ancestors of Christ.

Sistine Ceiling Frescoes The side walls of the Sistine Chapel had already been painted by fifteenth-century artists according to typological pairing, with Old and New Testament scenes on the left and right, respectively. Michelangelo was initially reluctant to undertake the frescoes. He finally agreed, however, designed the scaffold himself, and worked on the ceiling and the window lunettes from 1508 to 1512. Michelangelo's descriptions of the work dwell on the physical discomfort of having to contort his body in order to paint the ceiling.

Figure **16.16** shows the ceiling scenes in diagrammatic form. The nine main narratives occupy the center of the barrel vault. Michelangelo painted the scenes in reverse chronological order, ending with the three creation scenes, in which God organizes the universe. The three Adam and Eve scenes depict the Creation, Temptation, and Expulsion from Eden. The three Noah scenes show both God's destructive power and his willingness to save humanity from total annihilation. When viewers stand at the entrance opposite the altar wall, the ceiling scenes appear right-side up and are read beginning with the earliest creation scene at the greatest distance (fig. **16.17**).

Although none of the figures or scenes on the Sistine ceiling is from the New Testament, they nevertheless have a typological intent, all referring in some way to the Christian future. The Old Testament prophets and the sibyls of antiquity, who are portrayed between the window spandrels, were viewed as having foretold the coming of Christ. The inclusion of Jesus's ancestors in the spandrels and lunettes above the windows alludes to the divine plan, in which Christ and Mary redeem the sins of Adam and Eve.

16.17 Michelangelo, ceiling of the Sistine Chapel (after cleaning), Vatican, Rome, 1508–12. Fresco, 5,800 sq. ft. (538 m²).

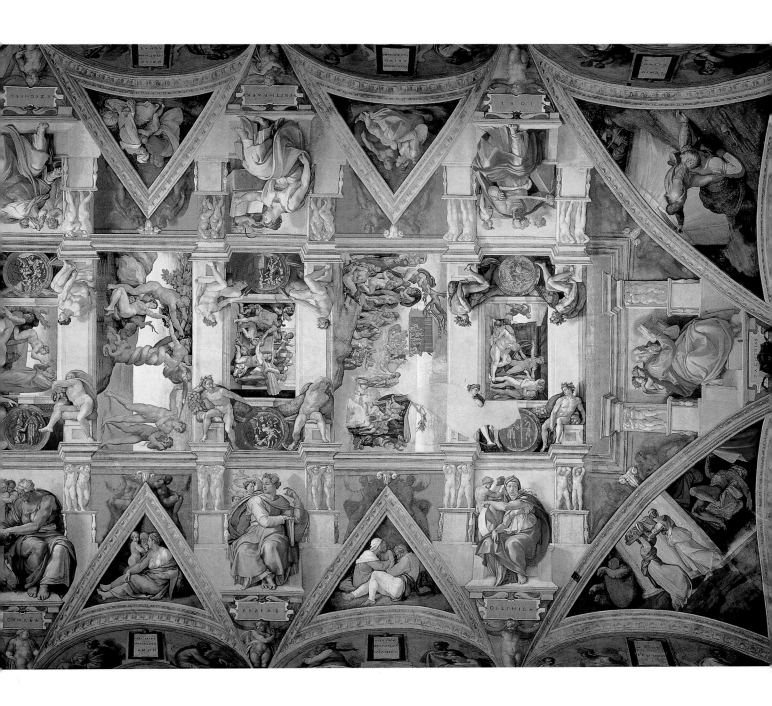

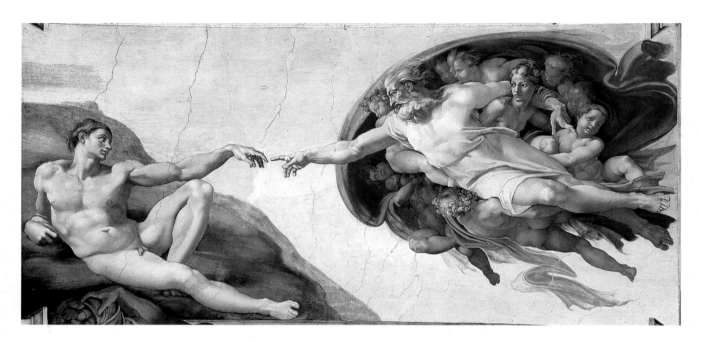

16.18 Michelangelo, *Creation of Adam* (after cleaning, 1989), c. 1510. © Nippon Television Network Corporation Tokyo 1991.

In the *Creation of Adam* (fig. **16.18**), a monumental patriarchal God extends dramatically across the picture plane. He is framed by a sweeping dark-red cloak containing a crowd of nude figures, including a woman (identified by some scholars as Eve), who looks expectantly over his left shoulder. In contrast to the vibrant energy of God, Adam reclines languidly on the newly created earth, for he has not yet received the spark of life from God's touch. Michelangelo's interest in landscape was minimal compared with his emphasis on the power inherent in the human body, especially the torso. Whether clothed or nude, Michelangelo's muscular figures, rendered in exaggerated *contrapposto,* are among the most monumental images in Western art.

The *Last Judgment* After Michelangelo completed the Sistine ceiling, he went back to Florence and worked for the Medici family. In 1534, on the order of Pope Paul III, he returned to Rome and began the *Last Judgment,* on the altar wall of the Sistine Chapel (fig. **16.19**). There has been a great deal of discussion about Michelangelo's late style. Some scholars consider that it marks the close of the Renaissance, while others prefer to see it as part of

new Mannerist developments (see Chapter 17). Both views contain some truth since Mannerist trends, which share certain characteristics of Michelangelo's late style, were well under way by the mid-sixteenth century. Nevertheless, the *Last Judgment* is considered here within the context of Michelangelo's style as it developed beyond the High Renaissance.

The picture is divided horizontally into three levels, which correspond roughly to three planes of existence. At the top is heaven; in the lunettes, angels carry the instruments of Christ's Passion—the crown of thorns, the column of the Flagellation, and the Cross. In the center, below the lunettes, Christ is surrounded by a glow of light. He raises his hand and turns toward the damned. Mary crouches beneath his upraised right arm, and crowds of saints and martyrs twist and turn in space, exhibiting the instruments of their martyrdom. In the middle level, at the sound of the Last Trump (blown by angels in the lower center), saved souls ascend toward heaven on Christ's right (our left), while the damned descend into hell on Christ's left. At the lowest level, the saved climb from their graves and are separated from the scene of hell on the lower right by a rocky riverbank.

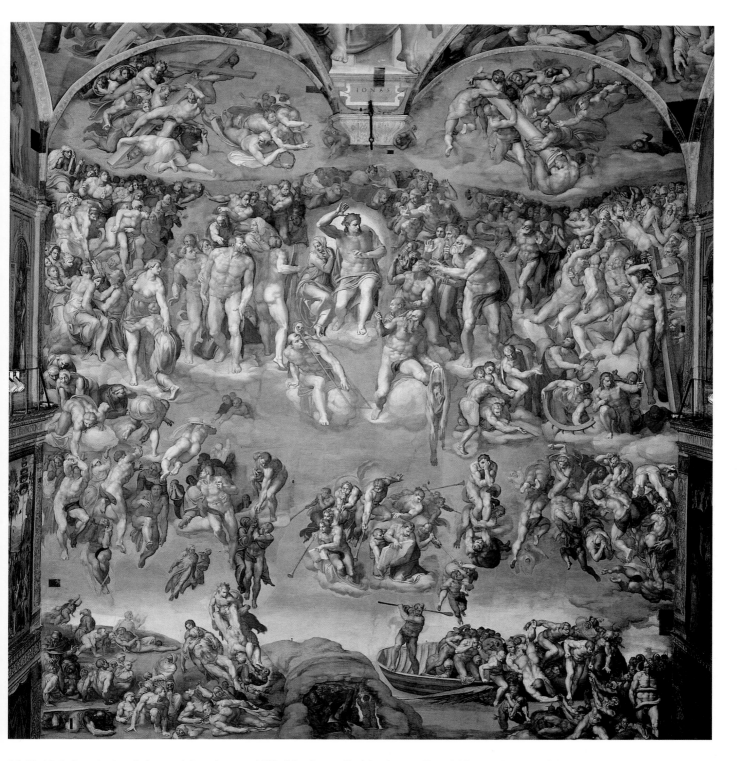

16.19 Michelangelo, *Last Judgment* (after cleaning, 1990–94), altar wall of the Sistine Chapel, Vatican, Rome, 1534–41. Commissioned in 1534, the *Last Judgment* was completed in 1541, when Michelangelo was sixty-six. The effect on contemporary viewers was strong—and not always favorable. During Michelangelo's lifetime Pope Paul IV wanted to erase it, and after Michelangelo's death loincloths and draperies were painted over the nude figures. Many of these were removed in the recent cleaning.

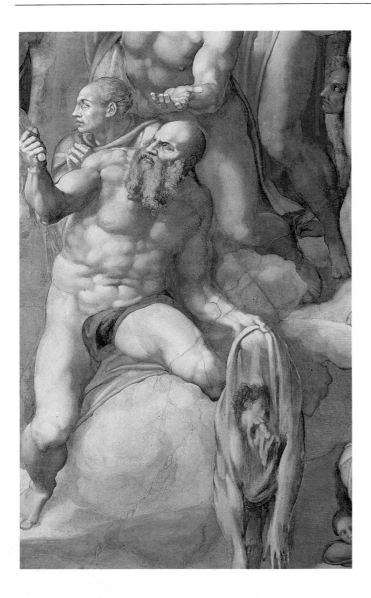

Raphael

Raffaello Sanzio ("Raphael") was born eight years after Michelangelo but died forty-four years before him. During his short life he came to embody the Classical character of High Renaissance style, assimilating the forms and philosophy of Classical antiquity and hiring scholars to translate Greek and Roman texts. Prolific and influential, he was primarily a painter, although it is clear from his appointment as overseer of the New St. Peter's that his skills included architecture.

At the beginning of his independent career, Raphael worked in Florence, where he painted many versions of the Virgin and Child. The *Madonna of the Meadow* of 1505 (fig. **16.21**) is a good example of his clear, straightforward, classicizing style. Figures are arranged in the pyramidal form favored by Leonardo, though the landscape lacks Leonardo's mysterious *sfumato*. Christ stands in the security of Mary's embrace, as John the Baptist, his second cousin and playmate, hands him the symbol of his earthly mission. Mary observes this exchange from above, recognizing that it means the future sacrifice of her son. In contrast to the ambiguities of Leonardo's iconography and the contorted, anxious figures of Michelangelo, Raphael's style is calm, harmonious, and restrained.

At the age of twenty-four or twenty-five, Raphael went to Rome, where, in addition to religious works, he painted portraits and mythological pictures. His patrons were among the political, social, and financial leaders of the High Renaissance.

Around 1511–12 Raphael painted a portrait of Julius II in figure **16.22**. He conveys the pope's personality, emphasizing the dark eye sockets and highlighting the forehead. The result—the first known independent portrait of an individual pope—shows a man of about seventy, dressed in everyday (rather than ceremonial) official garb. Raphael has captured a sense of Julius II's intellect and his capacity for deep introspection. The pope's portrait is a psychological portrayal rather than a conventional icon of power. Its oblique position and three-quarter-length view became typical of portraiture during the High Renaissance.

Julius II (1443–1513) was a forceful ruler and the greatest patron of his age. As pope, he restored the Papal States as the leading power in Italy. A fearless military leader, he drove out the French forces of Louis XII. He led a worldly life (he was the father of three illegitimate daughters) and had a reputation for being hot-tempered and *terribile* (awe-inspiring). The acorn motif on the pope's chair was an emblem of his family, the della Rovere. The rings on six of Julius's fingers confirm reports that he liked to spend money on jewels.

Michelangelo's hell is a new conception in Christian art. Unlike the medieval hell of Giotto's Arena Chapel (see fig. **14.6**), Michelangelo's draws on Classical imagery. The boatman of Greek mythology, Charon, ferries the damned across the River Styx into Hades. At the far right corner, the monstrous figure of Minos has replaced Satan and is entwined by a giant serpent. In contrast to Giotto's *Last Judgment,* which, except for hell, is orderly, restrained, and clear, Michelangelo's is filled with overlapping figures whose twisted poses, radical *contrapposto,* and sharp foreshortening energize the surface of the wall. In Giotto's conception, actual tortures are confined to hell. In Michelangelo's, tortuous movement pervades the whole work. That this mood reflects the artist himself, as well as the troubled times, is evident in the detail of Saint Bartholomew (fig. **16.20**), the Christian martyr who was flayed alive. He brandishes a knife and displays a flayed skin containing Michelangelo's self-portrait.

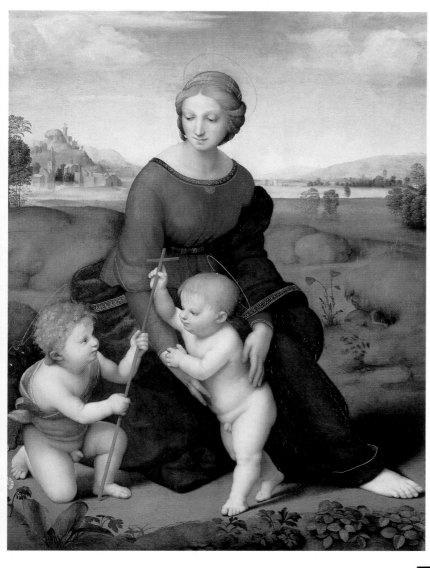

16.21 (Above) Raphael, *Madonna of the Meadow*, 1505. Oil on panel, 3 ft. 8½ in. × 2 ft. 10¼ in. (1.13 × 0.87 m). Kunsthistorisches Museum, Vienna, Austria.

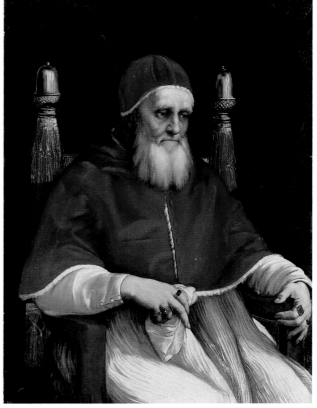

16.22 Raphael, *Pope Julius II*, 1511–12. Oil on panel, 3 ft. 6½ in. × 2 ft. 7½ in. (1.08 × 0.80 m). Uffizi, Florence, Italy.

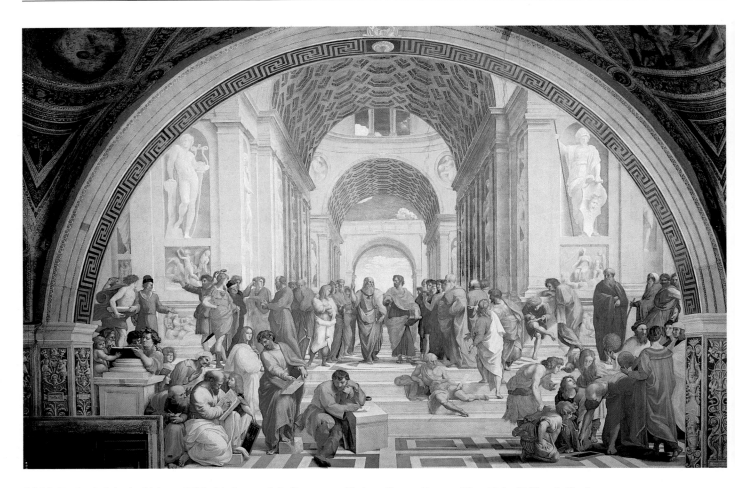

16.23 Raphael, *School of Athens*, 1509–11, Stanza della Segnatura, Vatican, Rome. Fresco, 26 × 18 ft. (7.92 × 5.49 m). This fresco covered one entire wall of the private library of Julius II. The room was known as the Stanza della Segnatura because it used to be the place where the Signatura Curiae, a division of the supreme papal tribunal, met. Raphael was commissioned by Julius II to decorate this vast room with frescoes of Classical and Christian subjects.

Raphael's monumental *School of Athens* (fig. **16.23**) is generally considered to represent the culmination of his Classical harmony. Philosophers representing the leading schools of ancient Greek philosophy are assembled in a single unified compositional space. The figures are lined up horizontally at the top of the steps, with distinct groups on either side. On the left, Pythagoras demonstrates his system of proportions to students. Diogenes, who proverbially carried a lantern through the streets of ancient Athens in search of an honest man, sprawls across the steps slightly to the right of center. On the right, the Greek mathematician Euclid discusses geometry and draws a geometric figure with the aid of a compass. At the center of the top step, framed by the round arches, are the two most famous Greek philosophers. At the left, Plato carries his *Timaeus,* and at the right is Aristotle with his *Ethics.*

Not only has Raphael integrated different philosophical schools; he has also included portraits of his contemporaries among the philosophers. Euclid, for example, is a portrait of Bramante. The architecture of the paint-

ing, which is a tribute by Raphael to his mentor, is itself influenced by Bramante's centralized buildings. Plato is a portrait of Leonardo, whose pointing finger is a characteristic gesture in Leonardo's own pictures—e.g., the doubting Thomas in the *Last Supper* (fig. **16.10**). Raphael pays tribute to Leonardo's central role as a thinker and artist in establishing the High Renaissance style. Plato points upward, alluding to the Platonic ideal and his notion of a realm of ideas beyond the human mind. Aristotle, the empiricist, points toward the earthly space of the viewer.

The brooding foreground figure to the left of center, presumed to be the philosopher Heraklitos, is a portrait of Michelangelo, who was working on the Sistine ceiling while Raphael was painting the papal apartments. On the far right, amid the crowd of geographers, is a self-portrait of Raphael (fig. **16.24**, second from the right), looking out of the picture. Raphael portrays Michelangelo and himself according to their respective personalities and styles. Michelangelo is brooding, isolated, and muscular. Raphael,

16.24 Raphael, self-portrait (detail of fig. **16.23**). The proverbial contrast between Raphael's sociability and Michelangelo's brooding isolation is captured by a 16th-century anecdote. The two artists run into each other on a street in Rome. Michelangelo, noting the crowd around Raphael, asks: "Where are you going, surrounded like a provost?" Raphael replies: "And you? Alone like the executioner?"

who was known for his easy, sociable manner, relates freely to his companions and to the observer and is painted in the soft, restrained style of his early works. By placing Leonardo at the top of the steps, Raphael sets him apart, as if above the competitive rivalry that existed between Michelangelo and himself.

Raphael's style became more complex after the *School of Athens,* expanding in scale, in range of movement, and in the use of light and dark. But his early death cut short his remarkable career. He, more than any other High Renaissance artist, combined Classical purity with the Christian tradition in painting. In contrast to Leonardo, who had enormous difficulty completing his works, Raphael worked quickly and efficiently. Michelangelo's difficult personality often interfered with his relationships with patrons and affected his ability to finish and deliver a work. Raphael, on the other hand, was an efficient worker who had good relationships with his patrons. In a final tribute to the Classical past and its relevance to present and future, Raphael was, at his own request, buried in the Pantheon.

Developments in Venice

Venice was a port city and an international center of trade throughout the Middle Ages and Renaissance. Because it was built on water, it had an effect on painters different from that of other Italian cities. Its soft light, at once muted and reflected by its waterways, has influenced painters up to the present day. During the Renaissance, Venice was a republic, which remained invulnerable to foreign attack. The Venetian constitution had lasted since the late thirteenth century, fostering relative political continuity despite upheavals in other Italian states. By 1500, the city had been free of foreign domination for about one thousand years, a fact that contributed to the so-called myth of Venice. Venice considered itself a harmonious blend of the best qualities of different types of government—the freedom of democracy; the elegant, aristocratic style of oligarchy; and the stability of monarchy. Under its constitution, Venice was ruled by patrician senators who formed the Great Council, which emphasized the rule of law. This led to greater stability, as well as to greater political repression, than in Florence.

In the early fifteenth century, the visual arts were somewhat more conservative in Venice than in Florence. They were rooted in Byzantine and Gothic tradition, and Venetian taste was more in tune with the rich colors and elaborate patterns of the International Style. More so than in Florence and Rome, Venetian artists tended to receive their training in family-run workshops maintained for several generations. A major reason for the durability of this tradition was the fact that visual art was still considered a manual craft in Venice—the profession of painting was closely controlled by the Painters' Guild, the *Arte dei Depentori.* In Florence, on the other hand, painting had attained the higher intellectual status of a liberal art.

One of the most successful examples of the family-workshop tradition in Venice is the Bellini family. The brothers Gentile (c. 1429–1507) and Giovanni (c. 1432–1516) were major artists of their time and influenced High Renaissance developments in Venice. Their sister married Andrea Mantegna, whose interest in Classical antiquity Gentile and Giovanni shared.

Gentile Bellini

From 1474, Gentile Bellini worked on frescoes for the Great Council Hall of Venice, and his reputation as a portraitist won him many official commissions. Most of these are lost, but his portrait of Sultan Mehmet II (fig. **16.25**) survives. After concluding a celebrated peace treaty with Venice, the sultan requested that a Venetian portrait painter be sent to his court. On September 3, 1479, Gentile left Venice to spend a year in Constantinople, where he was appointed a knight of the Ottoman Empire.

Gentile's portrait of the sultan shows his taste for textures created by gradual shading and for the illusion of

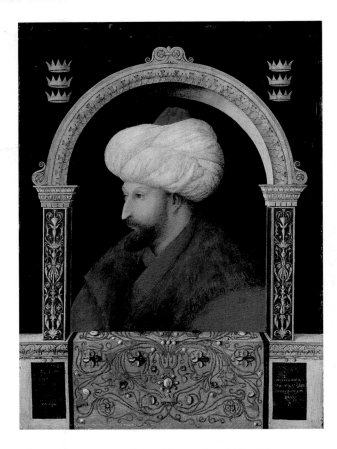

16.25 Gentile Bellini, *Sultan Mehmet II*, c. 1480. Oil on canvas, 27¾ × 20⅝ in. (70.5 × 52.4 cm). National Gallery, London, England.

distinctive materials. Mehmet II is framed by a decorative round arch, and a rich fabric with Islamic designs is draped over the balustrade. His heavy robe, beard, turban, and long pointed nose seem to weigh him down, accentuating his serious, thoughtful character.

Giovanni Bellini and the *Sacra Conversazione*

Giovanni Bellini, who was active for over sixty years, was the artist most instrumental in bringing the Renaissance style to Venice. His subjects are mainly Christian, although he produced many portraits and a few mythological pictures. His monumental *San Giobbe Altarpiece* (fig. **16.26**) is the first surviving example of the **sacra conversazione** (holy conversation) type in Venetian art. The painted space ends in a fictive apse, which is suffused with a rich yellow light. This is consistent with the Byzantine flavor of the gold mosaic in the half dome behind Mary and Jesus. At the same time, the classicizing pilasters and the relative precision of their surface carving are reminiscent of Mantegna. Enthroned in front of the apse, Mary and Jesus are the focal point of the painting, even though the viewer's eye level is at the center of the lower frame. As a result, we look up at Mary and Jesus, whose central importance is both literal (in their placement) and symbolic (in their significance).

This type of image is referred to as a *sacra conversazione* because of the postural and gestural communication between the painted figures. Mary and Jesus look out of the picture, but they are not as iconic as their more static, frontal counterparts in Byzantine art. Saint Francis stands at the left, his head tilted at an angle parallel to the cross of John the Baptist. Francis gestures toward the viewer

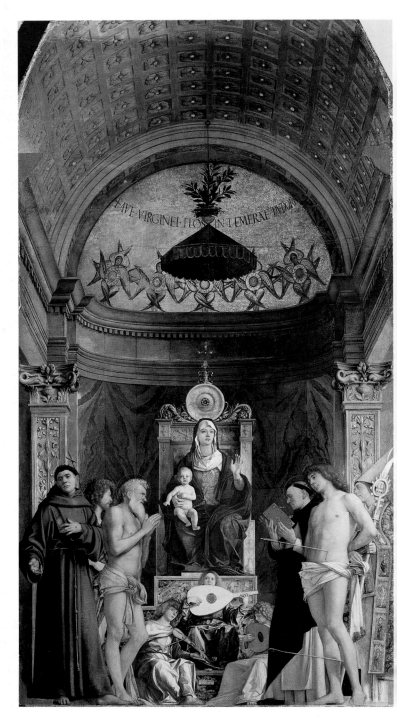

16.26 Giovanni Bellini, *San Giobbe Altarpiece*, 1480s. Oil on wood, 15 ft. 4 in. × 8 ft. 4 in. (4.67 × 2.54 m). Gallerie dell'Accademia, Venice, Italy.

and, in displaying the **stigmata**, invites us to participate, as he does, in Jesus's sacrifice. Reading from left to right, we follow Francis's left elbow to the right arm of Saint Job. His gesture of prayer, in turn, leads diagonally up toward Jesus's lowered right arm. At this point, we realize that the position of Jesus's arms echoes Francis's gesture and therefore also alludes to the Crucifixion.

Mary's raised left arm recedes toward the upward diagonal of Saint Dominic's book, which repeats the red of her garment. From here, we are led to Saint Sebastian, whose arrows link him with Jesus through martyrdom, with Saint Francis through his wounds, and with Job through his semi-nudity. At the same time, Sebastian's arms, crossed behind his back, lead to the young Saint Louis of Toulouse in his characteristically elaborate robe. The three music-making angels at the foot of the throne are at once a reference to the Trinity and a formal echo of the crucifix at the back of the throne.

In this altarpiece, Giovanni Bellini lays the groundwork for future developments in High Renaissance Venetian painting. The soft yellow light playing over the figures and the *chiaroscuro* create sensual flesh tones that recur in the work of Giorgione and Titian (see pp. 300–304). Intense colors—especially reds—and textural variations also develop as oil paint becomes the primary medium in Venice. The climate of Venice was not conducive to fresco because of dampness and salt air from the sea. Oil on stretched canvas proved more durable and allowed for richer, more **painterly** effects.

The same taste for rich textures and subtle shading is evident in Giovanni's portrait of Doge Leonardo Loredan (fig. **16.27**). Each gold thread of the buttons is visible. The gold embroidery of the cloak and the hatband reflects the influence of Flemish painting. Giovanni delineates Doge Loredan's expression by the play of light and dark across his features. His upright posture and precise physiognomy convey the impression of a stern but slightly pensive character. In the clarity of forms—the rectilinear space and the single, unified source of light—Giovanni Bellini is in the forefront of Renaissance innovation.

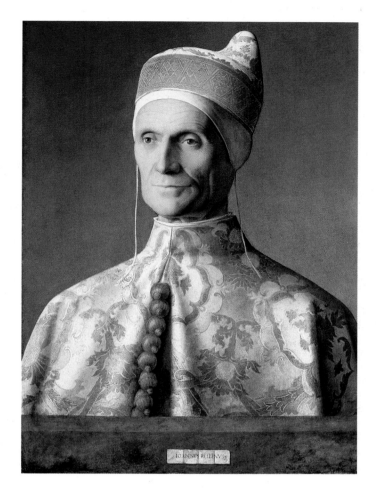

16.27 Giovanni Bellini, *Doge Leonardo Loredan,* soon after 1501. Oil on wood, 24¼ × 17¾ in. (61.5 × 45 cm). National Gallery, London, England. Leonardo Loredan (1438–1521) was a member of an influential Venetian family. He was doge from 1501, during a period of political defeat for Venice. The doges were chairmen of the ruling committees of Venice, and their position was permanent, even though the members of the committees often changed.

THEORY
Pietro Aretino on Color versus Drawing

Pietro Aretino (1492–1556) was a flamboyant Venetian personality, an author writing in the vernacular, and a scathing social critic. For this latter activity, he was dubbed the "Scourge of Princes." His *Dialogues* (1534–35) reflect his own variable sexual mores and comment pessimistically on those around him. The main character is Nanna, who converses in Volume 1 with a friend about the lives of nuns, married women, and courtesans. In Volume 2, she instructs her daughter on how to succeed as a prostitute.

Pietro's passionate sensibilities led him to take sides in the competition between Michelangelo and Titian, which embodied, among other things, the aesthetic quarrel between *disegno*

and *colorito*. Aretino came squarely down on the side of color. He championed the poetic effects of the oil medium applied directly to the canvas without preliminary drawing, in contrast to the more linear styles preferred in Florence and Rome. In particular, he responded to Titian's sensual use of paint, which enhanced the erotic character of his figures. He much preferred Titian's *chiaroscuro* and rich color to the sculpturesque figures of Michelangelo, which he believed failed to differentiate adequately between men, women, and children. Aretino's critical pen was aimed against Michelangelo, in defense of Titian, just as it was directed at the social and political corruption of his time.

Giorgione

The Venetian love of landscape, especially landscape softened by muted lighting, became an important feature in the work of Giorgio da Castelfranco, known as Giorgione. Very little of his life is documented, although he is believed to have studied with Giovanni Bellini. Giorgione lived only to the age of thirty-two or thirty-three, and few of his paintings survive. Because none was either signed or dated, and because Giorgione died while in the formative stage of his artistic development, there have been continual problems of attribution. Nevertheless, he emerges as a distinct personality, who created a stylistic link between Giovanni Bellini and Titian. His so-called *Tempesta,* or *Tempest* (fig. **16.28**), of around 1505–10, subordinates human figures to landscape. The viewer has the impression that there is an intimate relationship between landscape and figures, but scholars disagree on the precise meaning of Giorgione's picture.

The *Tempesta* is one of the persistent mysteries of Renaissance iconography. At the right, a nearly nude woman nurses a baby, and at the left a soldier seems to watch over them. Together they create a "dialogue" of glances—the soldier gazes at the woman, she gazes at us, and the infant focuses on the breast. The figures are con-

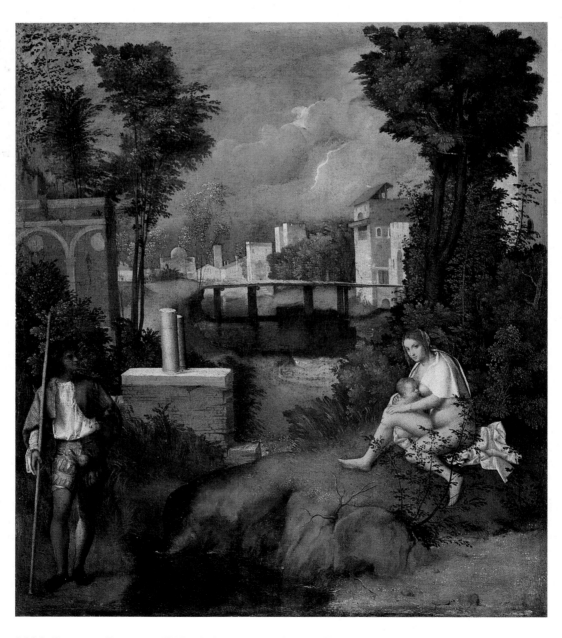

16.28 Giorgione, *Tempest,* c. 1505–10. Oil on canvas, 31¼ × 28¾ in. (79.4 × 73 cm). Gallerie dell'Accademia, Venice, Italy.

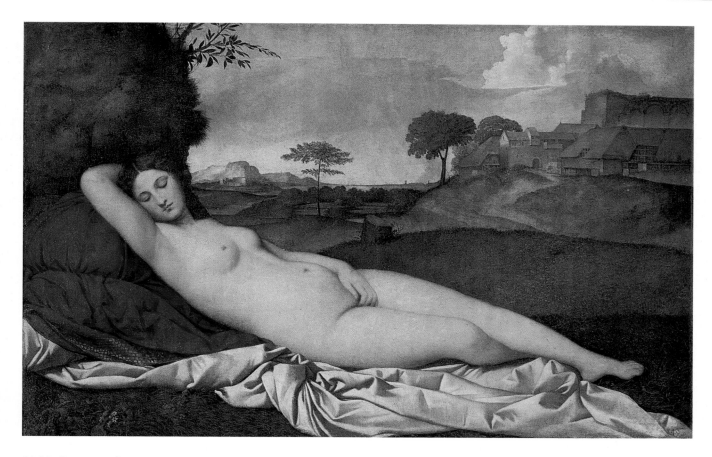

16.29 Giorgione, *Sleeping Venus*, c. 1509. Oil on canvas, 3 ft. 6¾ in. × 5 ft. 9 in. (1.08 × 1.75 m). Staatliche Kunstsammlungen, Dresden, Germany. The woman is identified as Venus by the presence of a Cupid at her feet. Cupid was later painted out but is visible with X-ray analysis.

nected but distanced from each other. This ambivalent relationship is reflected in the background landscape and architecture. Woman and child are distinguished from the soldier by their nudity and physically by the space between them. Their separation, bridged as it is by the soldier's gaze, is accentuated by open space. They are likewise connected by the painted bridge in the background. The woman and child are surrounded by the knoll on which they sit and by foliage, while the vertical plane of the soldier recurs in the lance, the trees on the left, and the truncated columns.

Giorgione enhances the figures' tension with the storm. A flash of lightning cuts through a darkened sky made turbulent by rolling clouds. Its atmospheric effects are accentuated by the artist's taste for layers of **glaze** and the visible texture of the brushstrokes. Whatever the real meaning of this picture, Giorgione had become an undisputed master of technique and psychology, which he expressed in the most advanced style of his time.

Giorgione's *Sleeping Venus* (fig. **16.29**) of around 1509 was unfinished at his death and was completed by Titian, but the basic style is Giorgione's. He shows the woman as a metaphor of landscape, which is a recurring theme in Western iconography. The long, slow curve of the left leg repeats the contour of the hill above, while the shorter curves formed by the outlines of the left arm, breast, and shoulder echo the landscape as it approaches the horizon.

Giorgione's Venus is perhaps dreaming; if so, her dream is erotic. This is made clear in the gesture of her left hand, as well as in the upraised right arm (in certain periods of Western art, an exposed armpit is associated with seduction). But the eroticism is also displaced onto the silver drapery, the folds and texture of which convey an energy that is absent from the calm pose and relaxed physiognomy of the nude. It is believed that the sky is primarily the work of Titian, and it is certainly typical of his taste for rich color and glowing but subdued lighting.

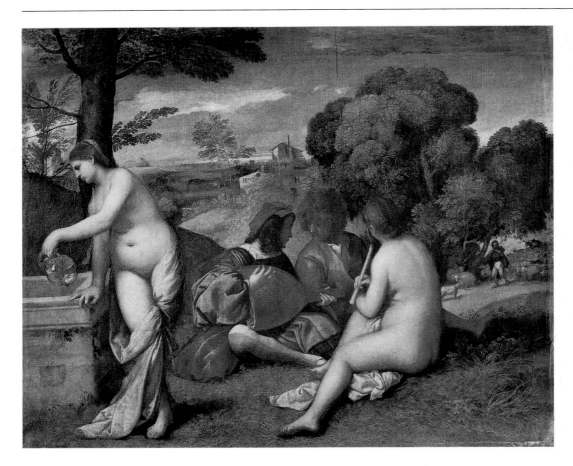

16.30 Giorgione, *Fête Champêtre*, c. 1510. Oil on canvas, 43¼ × 54⅜ in. (1.10 × 1.38 m). Louvre, Paris, France.

The enigmatic *Fête Champêtre,* or *Pastoral Concert* (fig. **16.30**), has been attributed to both Giorgione and Titian. Like the *Sleeping Venus,* it is pastoral in its setting and mood, but the meaning of its iconography has proved elusive. Two clothed musicians are seated opposite a nude woman, and all three seem about to play. At the left, a second nude pours water into a well, and in the background a shepherd tends his flock. The work is related to the *Tempest* in the fleshy character of the women and in the calm of the figures contrasted with the charged atmosphere of the landscape.

Because of their collaboration and stylistic affinities, the transition from Giorgione to Titian seems to be a natural development. In contrast to Giorgione, who died of plague in 1510, Titian had a long, productive life and became the undisputed master of the High Renaissance in Venice.

Titian

The paintings of Tiziano Vecellio (Titian, in English) cover a wide range of subject matter, including portraits and religious, mythological, and allegorical scenes. Particularly impressive are his warm colors, deepened by many layers of glaze; his insight into the character of his figures; and his daring compositional arrangements. Compared with the paintings of his Roman and Florentine contemporaries, Titian's are softly textured and richly material.

In an important early picture, the *Pesaro Madonna* (fig. **16.31**), painted for the Venetian church of Santa Maria Gloriosa dei Frari, Titian modified the pyramidal composition of Giovanni Bellini's *San Giobbe Altarpiece*. In contrast to the Bellini, Titian's Mary and Jesus are off-center, high up on the base of a column, and the asymmetrical architecture is positioned at an oblique angle. The painting was commissioned by Jacopo Pesaro, whose family acquired the chapel in 1518. Jacopo was bishop of Paphos, in Cyprus, and had been named commander of the papal fleet by the Borgia pope Alexander VI. Titian shows his patron in a devotional pose, kneeling before the Virgin and presented to her by Saint Peter. Prominently displayed on the step is Saint Peter's key; its diagonal plane, leading toward the Virgin, parallels that of Jacopo. The Virgin's position at the top of the steps alludes to her celestial role as Madonna della Scala (Madonna of the Stairs) and as the Stairway to Heaven.

The large red banner at the far left displays the papal arms in the center and those of Jacopo below. An unidentified knight has two prisoners in tow—a turbaned Turk and a Moor—probably a reference to Jacopo's victory over the Turks in 1502. At the right, Saint Francis links the five kneeling Pesaro family members to Jesus, suggesting that through his own route of identification with Christ salvation can be achieved.

The members of the donor's family are motionless. All the other figures gesture energetically and occupy diagonal

16.31 Titian, *Pesaro Madonna*, 1519–26. Oil on canvas, 16 ft. × 8 ft. 10 in. (4.88 × 2.69 m). Santa Maria Gloriosa dei Frari, Venice, Italy. Titian became the official painter of the Venetian republic in 1516 and raised the social position of the artist in Venice to the level achieved by Michelangelo and Raphael in Rome.

planes of space. The steps, surmounted by large columns cut off at the top, are thrust diagonally back into space. Infant angels appear on the cloud above. One seen from the rear holds the Cross. The back of this angel is juxtaposed with the infant Jesus, turning playfully on Mary's lap and looking down at Saint Francis, who gazes up at him. The fabrics are characteristically rich and textured, particularly the Pesaro flag and costumes. This attention to material textures is further enhanced by the variation of bright lights and dark accents in the sky. The light of Venice, sparkling in its waterways, in contrast to the darkened setting of the Bellini, seems to illuminate this painting.

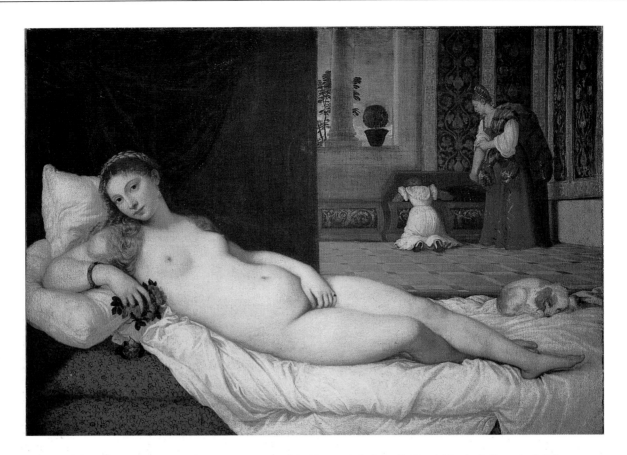

16.32 Titian, *Venus of Urbino*, c. 1538. Oil on canvas, 3 ft. 11 in. × 5 ft. 5 in. (1.19 × 1.65 m). Galleria degli Uffizi, Florence, Italy. The meaning of this painting has been the subject of much discussion. Some claim that the Venus is a Venetian courtesan and that the theme of the work is illicit love. Others, while admitting its sensuality, see it as representing marital love and fidelity. Recently, the gesture of Venus has been read as a prelude to sexual intercourse in the context of a marriage picture.

In the *Venus of Urbino* (fig. **16.32**) of c. 1538, Titian's debt to Giorgione is clear. But Titian's nude is awake, consciously observing and being observed. The relation of the figure to the drapery has also been reversed—here the drapery is arranged in fluid rhythms, but Venus is a more active participant in the "seduction" of the observer than Giorgione's sleeping figure. Titian's Venus reclines in a contemporary Venetian interior on a bed that is parallel to the picture plane. A relatively symmetrical, rectangular room occupies the background, where two maids remove garments from a chest. Titian's Venus is clearly descended from the Giorgione; as we shall see, the pose recurs in Western art up to the present day.

The rich red of Venus' long flowing hair is characteristic of Titian, as are the yellow light and the gradual shading that enhance the fleshy texture of her body. The roses, which languidly drop from her hand, and the myrtle in the flowerpot on the windowsill are attributes of Venus. The dog signifies both fidelity and erotic desire.

A late painting, the *Rape of Europa* (fig. **16.33**), reflects Titian's interest in mythology. But Titian portrays the event in the idiom of sixteenth-century Venice, delighting in the deeply glazed colors and the background mists of purple and gold. He endows the scene with erotic excitement by virtue of pose, gesture, and energetic curves and diagonals. Jupiter, in the guise of a white bull, plows the sea with Europa on his back. She, in turn, combines the receptive pose of the reclining nude with gestures of excited protest, accompanied by fluttering drapery. Two Cupids in the sky echo Europa's excitement, while a third rides a dolphin swimming after the bull. This Cupid gazes at the abduction like a child riveted by the erotic activity of adults. The dolphin, as well as the bull, echoes the child's gaze by staring back at the viewer out of one very prominent eye. In the distant background, Europa's companions wave helplessly from the shore.

Titian's long career, like Michelangelo's, chronologically overlapped the Mannerist style, which followed the High Renaissance. In their late styles, both artists went beyond the High Renaissance classicism of Raphael—Titian in his loose brushwork and Michelangelo in his elongated forms. This demonstrates the difficulty of confining dynamic artists to specific stylistic categories. Nevertheless, by virtue of their training and their impact on the history of art, both Titian and Michelangelo are considered to epitomize the High Renaissance.

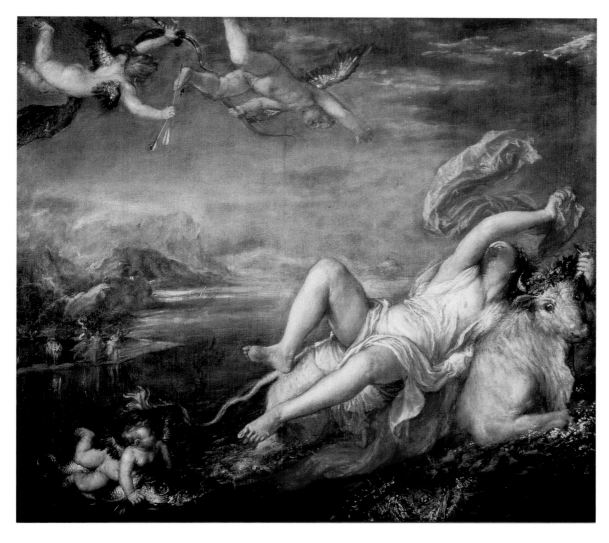

16.33 Titian, *Rape of Europa*, 1559–62. Oil on canvas, 73 × 81 in. (185 × 206 cm). Isabella Stewart Gardner Museum, Boston. This is one of a series of mythological scenes, known as *poesia*, that Titian painted from 1550 to 1560 for Philip II of Spain. Titian would have known the description of the episode in Ovid's *Metamorphoses* (lines 843–875), and possibly also in the 2nd-century novel by Achilles Tatius, who includes certain details depicted here.

1480 **1570**

THE HIGH RENAISSANCE IN ITALY

 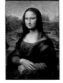

(16.2) (16.15) (16.10) (16.13) (16.25) (16.9) (16.26)

Columbus sails to the New World (1492) Famine in Florence (1497) Charles VIII of France invades Italy (1494–1498) African slave trade begins (c. 1500) Copernicus, heliocentrism (1512) Pope Julius II (papacy 1503–1513) Machiavelli, *The Prince* (1517) Henry VIII of England breaks with the pope (1534)

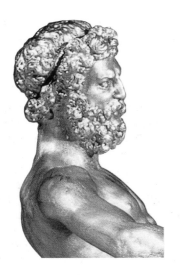

17

Mannerism and the Later Sixteenth Century in Italy

Politics and Religion

The sixteenth century was a period of intense political and military turmoil from which no Italian artist could remain completely insulated. Charles V extended his empire to Austria, Germany, and the Low Countries, culminating in the sack of Rome in 1527. The 1500s were also a period of religious change. The power of the Catholic Church was challenged—and finally fractured —by the Protestant Reformation (see Box).

The counter-challenge, or Counter-Reformation, went far in the opposite direction, and religious orthodoxy was strictly enforced by the Inquisition. Established in 1232 by the emperor Frederick II, the Inquisition was a group of state officials dedicated to identifying, converting, and punishing heretics. Pope Gregory IX (died 1241) appropriated

the Inquisition and instituted papal Inquisitors for the same purposes. Their power was increased by Pope Innocent IV (died 1254), who permitted the use of torture to force confessions from the accused.

During the sixteenth century, in the climate of upheaval within the Church and the Protestant challenges to its authority, humanism seemed to pose a greater threat than it had in the fifteenth century. Notions of the primacy of man were replaced by a harsh view of nature. Emphasis was placed on God's role as judge and on penalties for sin rather than on the possibility of redemption. Besides splitting Europe into two religious camps, the Reformation and Counter-Reformation (also called the Catholic Reformation) had fundamental effects on art, artists, and patrons.

HISTORY
The Reformation

By the second decade of the sixteenth century, after more than a thousand years of religious unity under the Roman Catholic Church, Western Christendom underwent a revolution known as the Reformation. This led to the emergence, in large parts of Europe, of the Protestant Church.

During the fifteenth century the Catholic Church had become increasingly materialistic and corrupt. Particularly offensive to some was the selling of "indulgences" (a kind of credit against one's sins), which allegedly enabled sinners to buy their way into heaven. In 1517 the German Augustinian monk Martin Luther protested. He nailed to a church door in Wittenberg, Saxony, a manifesto listing ninety-five arguments against indulgences. Luther criticized the basic tenets of the Roman Church. He advocated abolishing the monasteries and restoring the Bible as the sole source of Christian truth. Luther believed that human salvation depended on individual faith and not on the mediation of the clergy. In 1520 he was excommunicated.

In 1529 Charles V tried to stamp out dissension among German Catholics. Those who protested were called Protes-

tants. In the course of the next several years, most of northern and western Germany became Protestant. England, Scotland, Denmark, Norway, Sweden, the Netherlands, and Switzerland also espoused Protestantism. For the most part, France, Italy, and Spain remained Catholic. By the end of the sixteenth century, about one-fourth of Western Europe was Protestant.

King Henry VIII of England had been a steadfast Catholic, but his wish for a male heir led him to ask the pope to annul his marriage to Catherine of Aragon (in Spain), the first of his six wives. The pope refused, and Henry broke with the Catholic Church. In 1534 the Act of Supremacy made Henry, and all future English monarchs, head of the Church of England.

The Reformation dealt a decisive blow to the authority of the Roman Catholic Church, and the balance of power in Western Europe shifted from religious to secular authorities. As a result, the cultural and educational dominance of the Church waned, particularly in the sciences. In the visual arts, the Reformation had a far greater impact in northern Europe than in Italy or Spain, where the Counter-Reformation predominated.

Mannerism

After the death of Raphael in 1520, new developments in art began to emerge in Italy. The most significant of these has been called Mannerism. It coexisted with the later styles of Michelangelo and Titian, and it remained influential until the end of the sixteenth century.

The term *Mannerism* is ambiguous and has potentially conflicting meanings. Among the several derivations that have been proposed for Mannerism are the Latin word *manus* (meaning "hand"), the French term *manière* (meaning a style or way of doing things), and the Italian *maniera* (an elegant, stylish refinement). In English, too, the term is fraught with multiple interpretations. We speak of being "well-mannered" or "mannerly" when we mean that someone behaves according to social convention. "To the manner born" denotes that one is suited by birth to a certain social status. Being "mannered," on the other hand, suggests a stilted, unnatural style of behavior. "Mannerisms," or seemingly uncontrolled gestures, are considered exaggerated or affected. The nature of Mannerism also inspired the term "manneristic," used in clinical psychology, which refers to bizarre, stylized behavior of an individual nature.

All of these terms apply in some way to the sixteenth-century style called Mannerism. In contrast to the Renaissance interest in studying, imitating, and idealizing nature, Mannerist artists typically took as their models other works of art. The main subject of Mannerism is the human body, which is often elongated, exaggerated, elegant, and arranged in complex, twisted poses. Classical Renaissance symmetry is not used in Mannerism, which creates a sense of instability in figures and objects. Spaces tend to be compressed and crowded with figures in unlikely or provocative positions, and colors are sometimes jarring. Finally, Classical proportions are rejected, and odd juxtapositions of size, space, and color often occur.

In contrast to the dominance of papal patronage during the High Renaissance, Mannerism was a style of the courts. It appealed to an elite, sophisticated audience. Mannerist subjects are often difficult to decipher, and their iconography can be highly complex and obscure, except to the initiated. They may also be self-consciously erotic.

Mannerist Painting

Pontormo The sometimes disturbing quality of Mannerism is evident in the work of Jacopo da Pontormo (1494–1557). His *Entombment* of 1525–28 (fig. **17.1**) was painted for the Church of Santa Felicità in Florence: Christ has been taken down from the Cross, and his contorted body, with gray areas denoting the pallor of death, is being carried to his tomb. Michelangelo's influence can be seen in the sculptural, carved appearance of the drapery—especially that worn by the figure seen from the back at the right—as well as in Christ's pose (cf. fig. **16.14**). But the ambiguous space, the pink-and-blue **palette,** and the stony rather than fleshy forms create an entirely different effect.

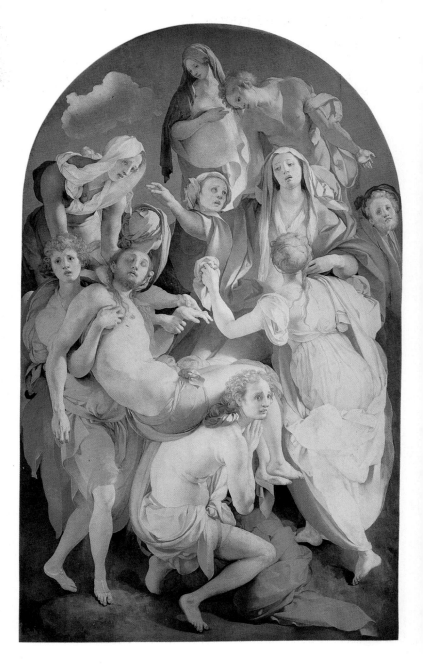

17.1 Jacopo da Pontormo, *Entombment,* 1525–28. Oil on panel, 10 ft. 3 in. × 6 ft. 4 in. (3.12 × 1.93 m). Capponi Chapel, Santa Felicità, Florence, Italy. The painting was commissioned for the altar, with an *Annunciation* on an adjacent wall. This pairs Christ's Incarnation and Death—the former event heralding his birth and the latter his rebirth. The image of the Entombment on an altar was also a visual reminder of the Eucharist.

In an uncanny juxtaposition, the activated forms and agitated poses contrast sharply with the fixed, terror-stricken gazes of the two youths holding Christ. Several gazes focus on the more languid figure of Mary (in blue), who seems withdrawn into herself, her relaxed, semiconscious state at odds with the dynamic pose of the woman in front of her. Mary's characterization corresponds to that of her dead son—both are removed from the frenzy of the moment. Likewise, the gray-black sky alludes to the tradition that the sky darkened at Christ's death. Another uncanny juxtaposition is thus the contrast between the gloomy chromatic setting and the pastel colors of the draperies.

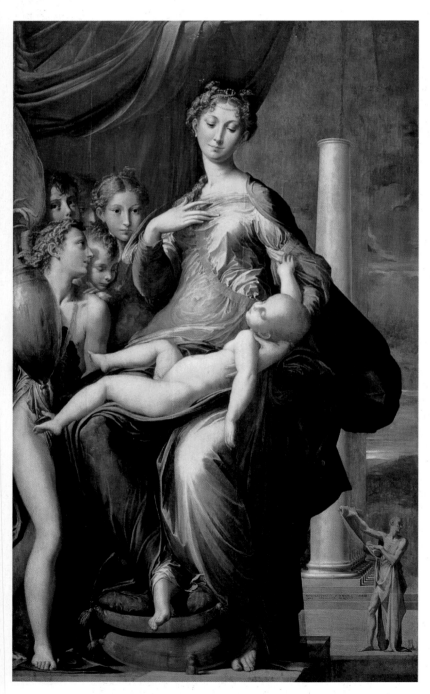

Parmigianino Parmigianino's *Madonna and Child with Angels* (fig. **17.2**), also called the *Madonna of the Long Neck*, illustrates the odd spatial juxtapositions and non-Classical proportions that are typical of Mannerism. The foreground figures are short from the waist up and long from the waist down. The Madonna, in particular, has an elongated neck and tilted head; their movement flows into the spatial twist of the torso and legs, creating a typically Mannerist *figura serpentinata*. Mary's dress, in contrast to the usual blue and red of earlier periods, is a cool metallic color. The man in the distance unrolling a scroll could be an Old Testament prophet. His position between the Madonna and the row of unfinished columns is a logical visual link between pagan antiquity and the Christian era. His improbably small size in relation to both the column and the Madonna, however, is illogical.

Il Parmigianino ("The Little Fellow from Parma") was the nickname of Francesco Mazzola, who worked in Parma, Rome, and Bologna. His career was fraught with conflicts and lawsuits, and his interest in pictorial illusionism can be related to his preoccupation with counterfeiting. He was obsessed with alchemy (the science of converting base metal to gold) and eventually abandoned painting altogether. Parmigianino's perverse nature is evident in this painting. Its undercurrent of sinister, lascivious eroticism is also consistent with Mannerist tastes.

Bronzino The allegorical painting of about 1545 by Agnolo Bronzino (1503–72), traditionally called *Venus, Cupid, Folly, and Time* (fig. **17.3**), illustrates the Mannerist taste for obscure iconography with erotic overtones. The attention to silky textures, jewels, and masks is consistent with Bronzino's courtly, aristocratic patronage. Crowded into a compressed space are several figures whose identities and purpose have been the subject of extensive scholarly discussion. Venus and her son Cupid are easily recognizable as the two figures in the left foreground. Both are nude, and bathed in a white light that creates a porcelain skin texture.

Cupid fondles his mother's breast and kisses her lips. To the right, a nude *putto* with a lascivious expression dances forward. All three twist in the Mannerist *serpentinata* pose. But only the *putto*'s pose seems consistent with his action. The undulating forms of Venus and Cupid are rendered for their own sake rather than to serve the logic of the narrative. A more purposeful gesture is that of

17.2 Parmigianino, *Madonna and Child with Angels (Madonna of the Long Neck)*, c. 1535. Oil on panel, approx. 7 ft. 1 in. × 4 ft. 4 in. (2.16 × 1.32 m). Galleria degli Uffizi, Florence, Italy. Vasari described Parmigianino as "unkempt . . . melancholy, and eccentric" at the time of his early death, and related that he was, at his own request, buried naked with a cypress cross standing upright on his breast—apparently an expression of his psychotic identification with Christ.

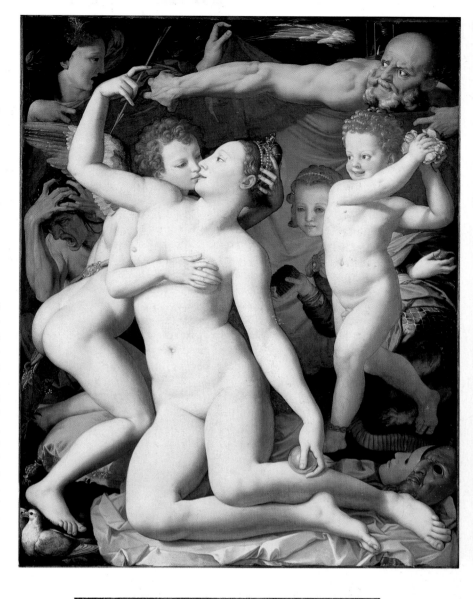

17.3 Agnolo Bronzino, allegory called *Venus, Cupid, Folly, and Time,* c. 1545. Oil on wood, 5 ft. 1 in. × 4 ft. 8¾ in. (1.55 × 1.44 m). National Gallery, London, England.

Time, the old man who angrily draws aside a curtain to reveal the incestuous transgressions of Venus and Cupid. The identity of the remaining figures is less certain. The hag tearing her own hair has been called Envy, and the creature behind the *putto,* with a serpent's tail, reversed right and left hands, and the rear legs of a lion, Fraud. There is, however, no consensus on their identification or even on the overall meaning of this painting. It was apparently commissioned by Cosimo I de' Medici as a gift for Francis I of France. Despite the strictures of the Counter-Reformation as codified by the Council of Trent (see Box, p. 312), court patronage clearly enjoyed playful and erotic, if somewhat enigmatic, imagery.

Anguissola Sofonisba Anguissola (1532/5–1625) was an accomplished portrait painter. Her portrait of her sister Minerva (fig. **17.4**) captures a rather wistful expression and emphasizes the textured variation of the dress. Minerva wears coral and gold jewelry, lace, and fur, which like her features, are delicately rendered. Her pendant depicts Minerva, the Roman goddess of weaving as well as of war and wisdom. By referring to the goddess Minerva, Sofonisba associates both herself and her sister with artistic creativity. In fact, all five of Sofonisba's sisters were artists. Her own success brought her to the attention of Philip II of Spain, at whose court she spent many years. She married twice—first to a Sicilian lord and then to a ship's captain.

17.4 Sofonisba Anguissola, *The Artist's Sister Minerva Anguissola,* c. 1564. Oil on canvas, 33½ × 26 in. (85 × 66 cm). Milwaukee Art Museum. Layton Art Collection, Gift of the family of Mrs. Frederick Vogel, Jr. L1952.1.

Mannerist Sculpture

Cellini Benvenuto Cellini (1500–1571) was trained as a goldsmith, but he was equally comfortable as a sculptor in marble, an architect, and an author. His celebrated autobiography was written when he was fifty-eight and under house arrest for sodomy. Cellini was restive, moving from place to place, often to avoid lawsuits. He was continually in trouble—he was charged with two murders in Rome in 1529—and had a reputation for violence. In 1558 he took preliminary vows for the priesthood but later renounced them and married the mother of his two children. His autobiography was published posthumously in 1728, and Berlioz based an opera on it.

Cellini's elaborate gold and enamel saltcellar (fig. **17.5**) illustrates the iconographic complexity and taste for mythological subject matter that appealed to Mannerist artists and their patrons. Cellini himself gave conflicting accounts of the object's meaning. Perhaps he simply forgot—but the ambiguity is nevertheless consistent with Cellini's flamboyant and unconventional lifestyle. What is clear is that the two main nude figures represent the bearded Neptune, holding a trident and surrounded by seahorses, next to a ship, and the Earth goddess, next to an Ionic triumphal arch. According to Cellini's description of the saltcellar, Neptune's ship was designed to contain the salt, and Earth's arch the pepper. Other figures include personifications of times of day and wind gods. The style and poses of the figures are clearly Mannerist, some appropriated from sculptures by Michelangelo. They are elegantly proportioned and arranged to form spatial twists that result in impossible poses. Both Neptune and Earth lean so far back that in reality they would topple over. The absence of any visible means of support reinforces their uneasy equilibrium, and the movement inherent in their poses and surface patterns is enhanced by the high polish of the gold itself.

17.5 Benvenuto Cellini, saltcellar of Francis I, finished 1543. Gold and enamel, 10¼ × 13⅛ in. (26 × 33.3 cm). Kunsthistorisches Museum, Vienna, Austria. Benvenuto Cellini (1500–1571), a versatile Mannerist artist, made this elaborate saltcellar while working in France as King Francis I's court goldsmith.

Giambologna Although Mannerism was primarily an Italian style, Jean de Boulogne (1529–1608)—known as Giovanni Bologna, or Giambologna, in Italy—who was born in Flanders, became a leading Mannerist sculptor. His bronze *Mercury* (fig. **17.6**) of around 1576 shows the increasing importance of open space in Mannerism. The god flies swiftly forward. His left foot is balanced on a breath of air blown by the detached head of a wind god. Mercury stretches upward, opening up a variety of spaces bounded by curves and diagonals, which enhance the sense of motion. The forms are thin and elongated, and the rippled surface of the bronze creates a pattern of reflected light.

Compared with the bronze *Davids* of Donatello and Verrocchio (see figs. **15.17** and **15.20**), the *Mercury* offers multiple viewpoints, for the difference between the front view and the side view is considerable. Not only do we see another aspect

of the figure itself, but the spaces around it change. The bronze *Davids* are more of a consistent piece—enclosing rather than opening space and exhibiting smooth, fleshy surfaces. The content also contributes to the differences between the figures. Whereas the *Davids* are self-satisfied and relaxed after victory, the *Mercury*'s winged cap, sandals, and caduceus identify him as the god of speed. Giambologna has used the expanded formal movement and taste for virtuosity that are characteristic of Mannerism to convey an impression of swiftness and flight.

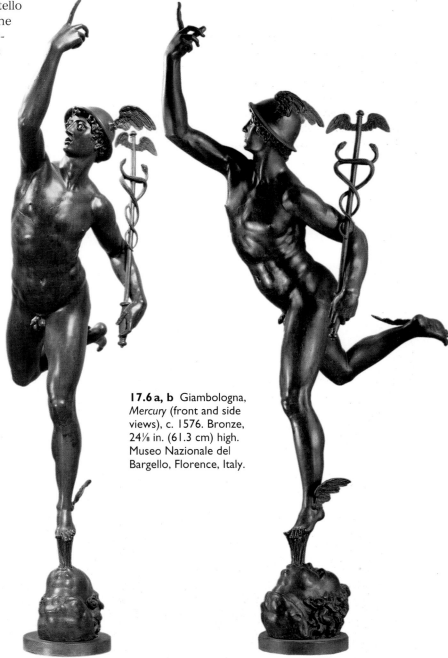

17.6 a, b Giambologna, *Mercury* (front and side views), c. 1576. Bronze, 24⅛ in. (61.3 cm) high. Museo Nazionale del Bargello, Florence, Italy.

CONNECTIONS

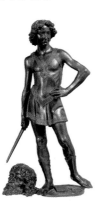

See figure 15.17.
Donatello, *David*, c. 1430–40.

See figure 15.20.
Andrea del Verrocchio, *David*, early 1470s.

In response to the Reformation, the Roman Catholic Church mounted the Counter-Reformation and tried to eliminate internal corruption. From 1545 to 1563 the Council of Trent was convened at Trento, in Italy. The Council denounced Lutheranism and reaffirmed Catholic doctrine. Measures were initiated to improve the education of priests and reassert papal authority beyond Italy. The council established an Inquisition in Rome to identify heretics and bring them to trial.

In its final session, the Council of Trent restated the Roman Church's view that art should be didactic, ethically correct, decent, and accurate in its treatment of religious subjects. Parallels between the Old and New Testaments were to be emphasized, rather than Classical events. The council directed that art should appeal to emotion rather than reason—an implicitly anti-humanist stance—and the Roman Inquisition was granted the power to censor works of art that failed to meet its requirements.

In 1573 the Venetian painter Paolo Veronese (1528–88) was summoned to appear before the Holy Tribunal to defend his monumental High Renaissance painting of the *Last Supper* (fig. **17.7**). The trial transcript, which has been preserved, makes it clear that the Inquisition objected to Veronese's naturalism. The Inquisitors asked Veronese to identify his profession and describe his painting.

"In this Supper," the prosecutor asked, "what is the significance of the man whose nose is bleeding?" "I intended to represent a servant whose nose was bleeding because of some accident," the artist replied.

The Inquisitor asked about the apostle next but one to Peter. "He has a toothpick and cleans his teeth," said Veronese.

The Inquisitor also objected to German soldiers eating and drinking on the stairs, and to the jesters and other figures in the picture. Germany, he declared—no doubt thinking of Martin Luther—was "infected with heresy." Veronese was contrite, admitting he had used artistic license. He said that Jesus's Last Supper had taken place in the house of a rich man who might be expected to have visitors, servants, and entertainment. The Inquisitor was not impressed.

"Does it seem fitting at the Last Supper of the Lord to paint buffoons, drunkards, Germans, dwarfs, and similar vulgarities?"

"No, milords."

Veronese was given three months to alter his picture. Instead, he changed its title to *Christ in the House of Levi*.

In Catholic countries the zeal of the Counter-Reformation led to intolerance, moralizing, and a taste for exaggerated religiosity. Michelangelo came under particular attack. In 1549 a copy of his *Pietà* (see fig. **16.14**) was unveiled in Florence. Because of Mary's depiction as an attractive figure, scarcely older than Christ himself, Michelangelo was called an "inventor of filth." In 1545 Pietro Aretino wrote to Michelangelo, criticizing his *Last Judgment* (see fig. **16.19**) as suitable for a bathroom but not for a chapel.

It was against this background of political and religious turmoil that sixteenth-century art developed after 1520. One cannot prove that this directly affected the development of Mannerism. Nevertheless, there is, in that style, an undercurrent of anxiety and tension—beneath the refinement and elegance—that is not inconsistent with the times.

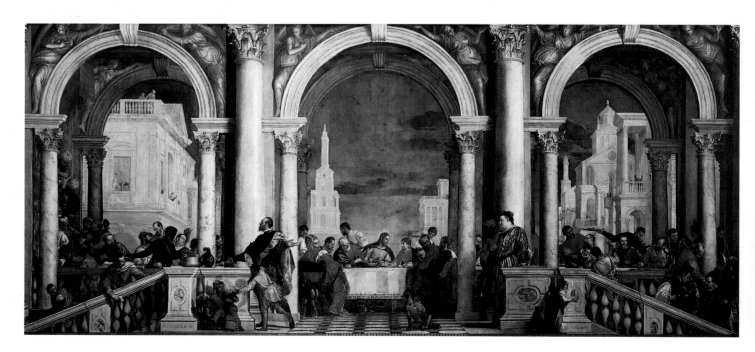

17.7 Paolo Veronese, *Last Supper,* renamed *Christ in the House of Levi,* 1573. Oil on canvas, 18 ft. 3 in. × 42 ft. (5.56 × 12.8 m). Gallerie dell'Accademia, Venice, Italy. Paolo Caliari was born in Verona, hence his name, Il Veronese. In 1553 he moved to Venice, where, with Titian and Tintoretto, he dominated 16th-century Venetian painting. Although Veronese liked to dress luxuriously—in keeping with the taste for pageantry evident in his paintings—he was known for his piety and financial acumen.

Counter-Reformation Painting

Tintoretto

The impact of the Council of Trent and the Counter-Reformation on the visual arts is most evident in the second half of the sixteenth century. Tintoretto (1518–94), for example, a leading Venetian painter and a contemporary of Veronese, painted a *Last Supper* (fig. **17.8**) in the 1590s that conformed well to Counter-Reformation requirements. The choice of the moment represented, when Jesus demonstrates the symbolic meaning of the bread as his body and the wine as his blood, lends itself to mystical interpretation.

In Tintoretto's *Last Supper,* in contrast to those by Veronese (see fig. **17.7**) and Leonardo (see fig. **16.10**), the picture space is divided diagonally. The table is no longer parallel to the picture plane, but recedes sharply into the background, and the figures are not evenly lit from a single direction. The humanist interest in psychology and observation of nature has been subordinated to mystical melodrama. To the right of the table, in deep shadow, are servants, going about their business, apparently unaware

CONNECTIONS

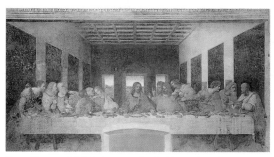

See figure 16.10. Leonardo da Vinci, *Last Supper,* c. 1495–98.

of the significant event taking place. On the left of the table are the apostles, some in exaggerated poses, illuminated by a mystical light that is consistent with official Counter-Reformation taste. Toward the center of the table, Christ distributes bread to the apostles. Light radiates from his head so that he is depicted as "the light of the world." On the other side of the table, brooding, isolated, and in relative darkness, sits Judas. At the upper right, outlined in glowing light, is a choir of angels.

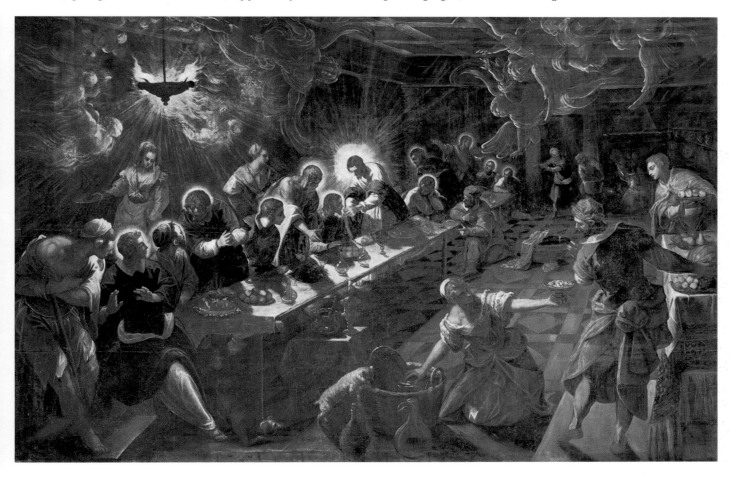

17.8 Jacopo Tintoretto, *Last Supper,* 1590s. Oil on canvas, 12 ft. × 18 ft. 8 in. (3.66 × 5.69 m). Choir, San Giorgio Maggiore, Venice, Italy. Jacopo Robusti (1518–94) was nicknamed Tintoretto ("Little Dyer" in Italian) because of his father's profession as a wool dyer. He worked for most of his life in Venice and succeeded Titian as official painter to the Republic. He was a prolific artist and employed many assistants, including two sons and a daughter, Marietta (see Box, p. 314).

painting, which is over 15 feet high, is divided into two levels: the earthly and the heavenly. Local tradition had it that the count of Orgaz was rewarded for his good works by the appearance of Saints Stephen and Augustine at his funeral. Here, the elderly Bishop Augustine (on our right) and the youthful Saint Stephen (on our left) lift the count into his grave. Lined up behind the burial scene are citizens of Toledo wearing black costumes and somber expressions. A small boy at the lower left, thought to be the artist's son, points us toward the miracle. At the right, the only figure seen in back view wears a luminous white robe and leads us heavenward with his upward gaze.

The scene taking place in heaven shows the count's nearly naked soul before Christ. The Virgin Mary, opposite the count, is clad in her traditional red and blue robes and acts as intercessor—her traditional role. Just behind the Virgin, Saint Peter dangles the keys to the gate of heaven. Receding upward and into the background, the heavenly host seems to swirl weightlessly, illuminated by variations of mystical, translucent light.

El Greco

Domenikos Theotokopoulos ("El Greco," 1541–1614) was even more directly a painter of the Counter-Reformation. He worked in Spain from 1577 onward, when Counter-Reformation influence was at its strongest. In his paintings virtually all traces of High Renaissance style and Classical subject matter have disappeared. Although he spent time in Titian's workshop, El Greco's style was affected more by the Byzantine influence he encountered in Venice than by Titian's humanism. He was also more in tune with the mystical fervor and religious zeal that predominated in Catholic Spain.

Once El Greco had settled in Spain, he spent most of his life in the small town of Toledo. There he painted his famous work in the Church of Santo Tomé for the burial chapel of Gonzalo Ruiz, count of Orgaz (fig. **17.9**). The

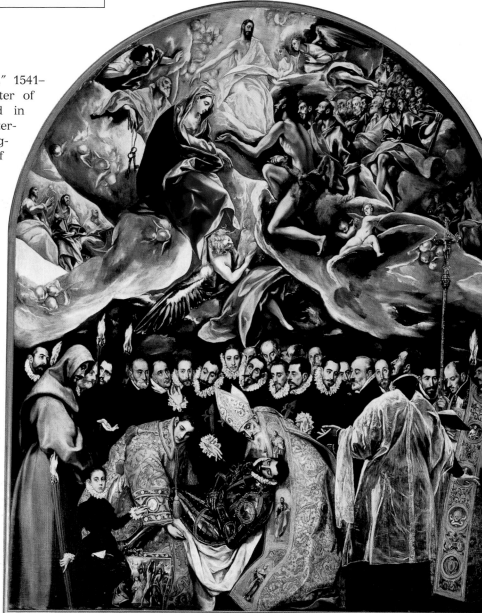

17.9 El Greco, *Burial of the Count of Orgaz*, 1586–88. Oil on canvas, 15 ft. 9 in. × 11 ft. 10 in. (4.80 × 3.61 m). Church of Santo Tomé, Toledo, Spain. Domenikos Theotokopoulos was born in Crete and was subsequently nicknamed El Greco (Spanish for "The Greek"). Most of his work was executed for the Church rather than the court and has a strongly spiritual quality. Of the leading Mannerist painters, El Greco was the most mystical and was therefore well suited to the fervent religious atmosphere of Counter-Reformation Catholic Spain.

Architecture: Andrea Palladio

The greatest architect of late-sixteenth-century Italy was Andrea Palladio (1508–80), who combined elements of Mannerism with the ideals of the High Renaissance. His use of ancient sources, particularly Vitruvius, was inspired by a humanist education (see Box).

From 1566 to 1570, Palladio built the Villa Rotonda (figs. **17.10** and **17.11**), near the northern Italian city of Vicenza, for a Venetian cleric. The façade replicates the Classical temple portico—Ionic columns supporting an entablature crowned by a pediment—in the context of domestic architecture. There are four porticoes, all in the same style and one on each side of the square plan. In Palladio's view, the Classical entrance endowed the building with an air of dignity and grandeur. The strict symmetry was both a Classical and a Renaissance characteristic. Such features recalled ancient Rome, where the villa had originated as an architectural type.

The square plan of the Villa Rotonda is typical of Palladio's villas. Passages radiate from a domed central chamber to each of the four exterior porticoes. They, in turn, offer views of the surrounding landscape in four different directions. At the sides, each portico is enclosed by a wall pierced by an arch, thereby providing shelter as well as ventilation.

In figure **17.11** some of the classically inspired statues at each angle of the pediments are visible. Others decorate the projecting walls flanking each side of the steps. Since the Villa Rotonda was a purely recreational building, used exclusively for entertaining, it did not have the functional additions found in Palladio's other villas.

From 1570 Palladio worked mainly in Venice, particularly on church design. His church of San Giorgio Maggiore

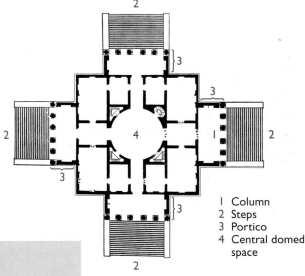

1 Column
2 Steps
3 Portico
4 Central domed space

17.10 (Above) Plan of the Villa Rotonda.

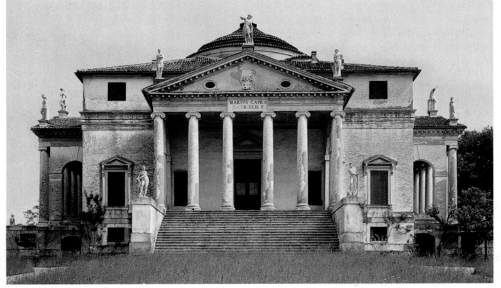

17.11 Andrea Palladio, Villa Rotonda, Vicenza, 1566–70. Andrea di Pietro della Gondola was renamed Palladio (after Pallas Athena) by Count Trissino, a humanist scholar and poet who supervised his education and career. Palladio is known to have been involved in over 140 building projects, of which no more than about 35 survive. He also published *L'Antichità di Roma*, one of the first Italian guidebooks, in 1554.

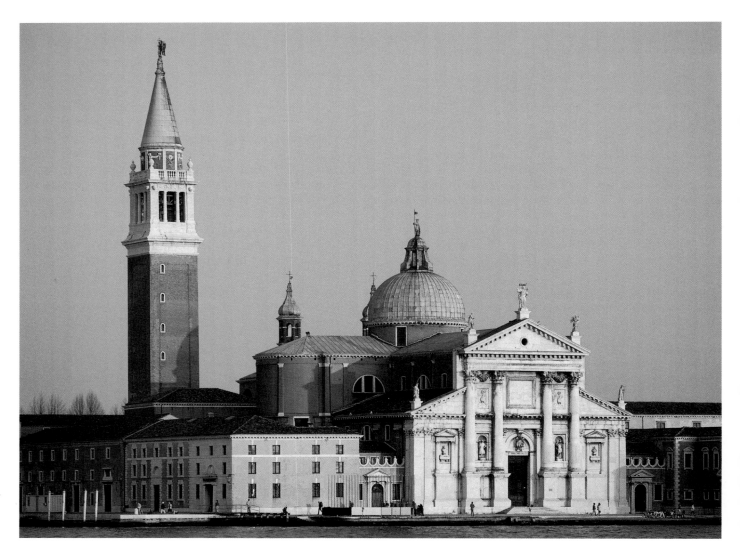

17.12 Andrea Palladio, San Giorgio Maggiore, Venice, begun 1565.

(figs. **17.12** and **17.13**), begun in 1565 but not completed until 1592, stands on the small Venetian island of San Giorgio. In this building, Palladio solved the problem of relating the façade to an interior with a high central nave and lower side aisles. He did so by superimposing a tall Classical façade with engaged Corinthian columns and a high pediment on a shorter, wider façade with shorter pilasters and a low pediment. The former corresponds to the elevation of the nave and the latter to that of the side aisles. This relationship between the façade and the nave and side aisles unified the exterior and interior of the church in a new way (although Alberti had achieved a similar solution in the later fifteenth century in Florence). They are further unified by the repetition of Corinthian columns along the nave and of the shorter pilasters on the side aisles.

In these solutions, Palladio incorporates Classical elements into religious as well as domestic architecture. Nevertheless, the order and the relationship of the elements are not strictly Classical. It would be difficult to demonstrate that his works are Mannerist, but they share with Mannerism the tendency to juxtapose form and space in a way that is inconsistent with Classical arrangements. For example, Palladio breaks, or interrupts, one pediment in imposing another over it. This feature, called a **broken pediment**, becomes a characteristic aspect of Baroque architecture in the seventeenth century (see Chapter 19). In superimposing larger and smaller façades, as in San Giorgio Maggiore, and combining a temple portico with a domestic villa, Palladio recalls certain unexpected juxtapositions and combinations found in Mannerist painting.

Palladio was the single most important architect of his generation, and his influence on subsequent generations of Western architects was extensive. His style was revived in England and America in the eighteenth century, and his palaces and villas are still imitated today.

Despite efforts to characterize Mannerism, it remains a style whose qualities are difficult to pin down. It coincides chronologically with the political and religious turmoil of the Protestant Reformation and the Catholic Counter-Reformation, and it expresses the extremes of the time. The subject matter of Mannerist paintings and sculptures ranges from the mystical to the lascivious, while the best of the architecture is a synthesis of new formal combinations.

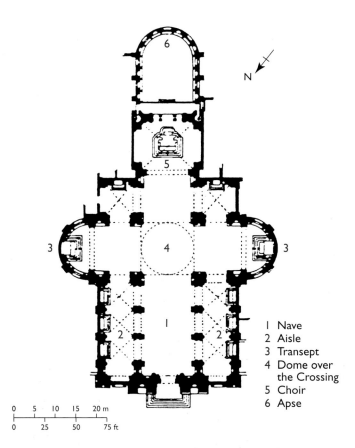

1 Nave
2 Aisle
3 Transept
4 Dome over the Crossing
5 Choir
6 Apse

0 5 10 15 20 m
0 25 50 75 ft

17.13 Plan of San Giorgio Maggiore, Venice.

c. 1520 **c. 1590**

MANNERISM AND THE LATER 16TH CENTURY IN ITALY

(17.4)

Ignatius Loyola
(1491–1582)

(17.6)

Martin Luther,
Ninety-five Theses
(1517)

(17.5)

Saint Teresa
(1515–1582)

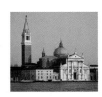

(17.12)

Council
of Trent
(1545–1563)

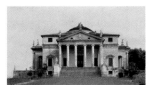

(17.11)

Vasari,
Lives of the Artists
(1550, 1568)

English fleet
defeats
Spanish Armada
(1588)

(17.9)

Shakespeare,
Hamlet
(1600)

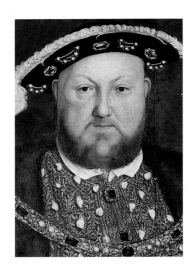

18

Sixteenth-Century Painting and Printmaking in Northern Europe

As in the fifteenth century, Northern Europe in the sixteenth century underwent many of the same developments as the South (see map). The most important Northern artists were the painters of Germany and the Netherlands, several of whom traveled to Italy and were influenced by humanism. Nevertheless, the North was always less comfortable with Classical form than was Italy. The elegant linear qualities, rich colors, and crisp edges of International Gothic persist in Netherlandish and German painting. Northern artists were also less interested than the Italians in the subtleties of *chiaroscuro* and modeling, and the textured, painterly qualities of the late Venetian Renaissance do not often appear in the North.

status of the artist. In 1604 Karel van Mander (1548–1606) of Haarlem, Holland, published *Het Schilderboeck (The Painter's Book),* describing the lives of Northern artists. Like Vasari's *Lives,* it has become an important source for the history of Renaissance art.

One of the most prevalent humanist expressions in the North was the proverb. Humanists such as Erasmus collected proverbs, many of which were Classical in origin, as a way of educating people and arousing interest in antiquity. Proverbs were explained and placed in historical context, and their relevance to contemporary life was demonstrated. This development was consistent with the Northern tradition of depicting bourgeois **genre** scenes (scenes of everyday life).

Humanism in the North

The North produced some of Europe's most distinguished humanists, including the prolific writer and scholar Erasmus of Rotterdam (see Box, p. 328). Germany was the home of Martin Luther (see Box), whose views launched the Protestant Reformation. Humanism, as well as Protestantism, clashed with the Inquisition, and religious strife continued to intensify from the late fifteenth century. The opposition of the Church to both the humanists and the Protestants was often virulent and excessive. One striking expression of the character of the Inquisition was its opposition to witchcraft. In 1487, two German Inquisitors— Heinrich Kramer (died 1500) and James Sprenger (died 1494), both of whom were members of the Dominican Order—had published *The Witches' Hammer,* in which they described the characteristics of witches and recommended methods of torture for extracting confessions from them.

In a more humanist vein, Northern Europe, like Italy, displayed an interest in artist biographies, which were revived as part of the Classical tradition and were consistent with the rise in the social

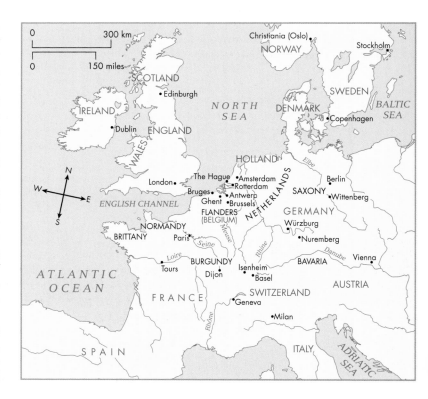

Northern and Central Europe during the Renaissance.

Martin Luther (1483–1546), as we have seen, initiated the Protestant Reformation, which divided Europe and broke the monopoly of the Catholic Church. He objected to the practice of selling indulgences, and particularly to Johann Tetzel (c. 1465–1519), the Dominican "pardoner." Luther saw Tetzel and the papacy as profiting from the fear and ignorance of his German compatriots. This view was confirmed by Tetzel's "Sermon on Indulgences," in which he compared indulgences to "letters of safe conduct" into heaven and pointed out that each mortal sin was punished by seven years of purgatory. Since people repeatedly commit mortal sins, Tetzel argued, they could save themselves many years of torture by buying indulgences.

Luther's Ninety-Five Theses included scathing attacks on the principle of buying one's way into heaven. Referring to the financial motives of the Church, Luther's thesis number 28 stated, "It is certain that, when the money rattles in the chest, avarice and gain may be increased, but the effect of the intercession of the Church depends on the will of God alone." Number 43 declares, "He who gives to the poor man, or lends to a needy man, does better than if he bought pardons." And number 50, "If the pope were acquainted with the exactions of the preachers of pardons, he would prefer that the basilica of Saint Peter [then being rebuilt] should be burnt to ashes rather than that it should be built up with the skin, flesh, and bones of his sheep."[1]

In these sentiments, Luther essentially attacked the pope's right to speak for God. His zeal for ecclesiastic reform spilled over into the socioeconomic arena. In 1524, following Luther's example, the peasants of southwest Germany rebelled against the increasing demands of the nobility. This time, however, Luther did not sanction the revolt. He published virulent attacks against the peasants on the ground that the Bible encourages suffering as a means to salvation. According to Luther, the rebels "cause uproar and sacrilegiously rob and pillage monasteries and castles that do not belong to them, for which, like public highwaymen and murderers, they deserve the twofold death of body and soul."[2]

The Netherlands

Hieronymus Bosch

The most important Netherlandish artist at the turn of the sixteenth century was Hieronymus Bosch (c. 1450–1516). Little is known of his artistic development, but he created some of the most original and puzzling imagery in Western art.

The meaning of Bosch's huge, complex, and controversial triptych known as *The Garden of Earthly Delights* (fig. **18.1**), now generally dated c. 1510–15, is difficult to decipher. Documents suggest that the *Garden* was a secular commission for the state room of the House of Nassau in Brussels, although this is debated by scholars. The work has been interpreted in a number of ways: as a satire on lust, as an alchemical vision, and as a dreamworld revealing unconscious impulses. But there are also a number of traditional Christian features in the triptych, suggesting a religious commission, and some scholars identify the primary source of the iconography as the Bible. The Garden of Eden is represented in the left panel. In the foreground, God presents the newly created Eve to Adam. The prickly tree behind Adam is the Tree of Life. In the middle ground, a curious fountain—the *fons vitae* (fountain of life)—stands in a pool of water, and in the background wild animals exist in a state of apparent tameness.

Even in paradise, Bosch's taste for biting satire is evident in certain details that prefigure the Fall. In the foreground, for example, a self-satisfied cat strolls off with a dead mouse in its mouth. At the upper right, a lion eats a deer and a boar pursues a fantastic animal. Ravens, which can symbolize death, perch on the fountain of life, and the owl in the opening of the fountain could denote the nocturnal activities of witches and devils. Eve's role as the primal seductress is clear from Adam's response to her. He is not the traditional languid or sleeping figure of Michelangelo (see fig. **16.18**), but is alert and wide awake. He literally "sits up and takes notice" of the creature to whom he is being introduced. His reaction is all the more significant in the presence of the serpent coiling itself around the Tree of Life.

The human figures in the large central panel seem engaged in sexual pursuits. The lovers enclosed in a transparent globe, a reference to the transience of lust, illustrate the proverb "Happiness and glass, how soon they pass." The upper section of the central panel depicts what is generally identified as a Tower of Adultresses in a Pool of Lust. It is decorated with horns and filled with figures that have been interpreted as cuckolded husbands. Four so-called castles of vanity stand at the pool's edge. In the middle ground, a procession of frenzied human figures mounted on animals endlessly circles a Pool of Youth. The human figures are small in relation to the strange plant and animal forms that populate the picture's space. Some are enclosed in transparent globes that suggest alchemical vessels. The illogical juxtapositions of size, together with the strange symbolic details, such as the enlarged strawberries, have led some scholars to think that Bosch is depicting a dreamlike inner world. Consistent with Christian tradition, however, is the conventional opposition of the era before the Fall on the left and hell on the right. The sinister aura of the central panels suggests moralizing on the artist's part, which may refer to the decadence of humanity that led God to unleash the Flood.

In hell, buildings burn in the distance. The scene is filled with elaborate tortures and dismembered body parts taking

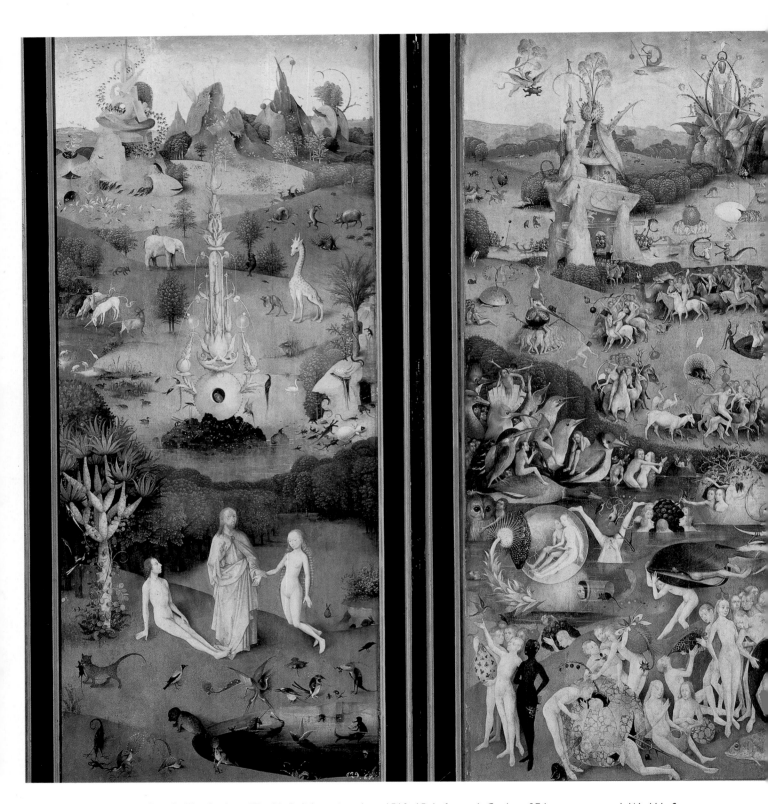

18.1 Hieronymus Bosch, *The Garden of Earthly Delights,* triptych, c. 1510–15. Left panel: *Garden of Eden;* center panel: *World before the Flood;* right panel: *Hell.* Oil on wood, left and right panels 7 ft. 2 in. × 3 ft. (2.18 × 0.91 m), center panel 7 ft. 2 in. × 6 ft. 4 in. (2.18 × 1.93 m). Museo del Prado, Madrid, Spain.

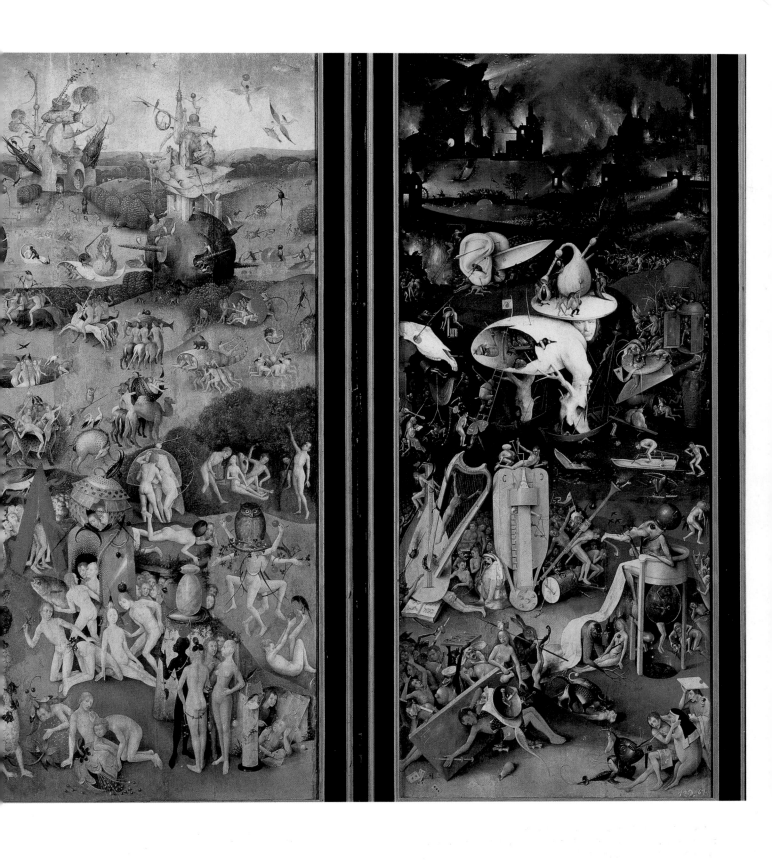

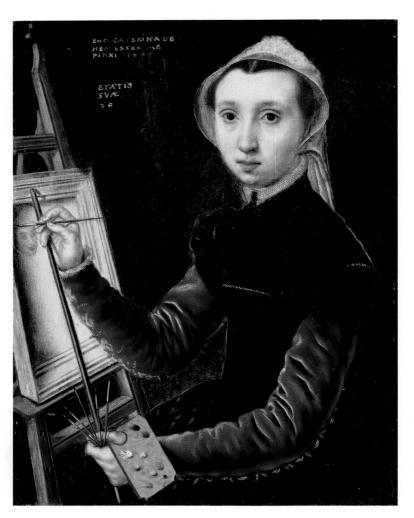

18.2 Caterina van Hemessen, *Self-Portrait*, 1548. Oil on panel, 12³⁄₁₆ × 9¹³⁄₁₆ in. (31.0 × 25.0 cm). Kunstmuseum Basel, Switzerland.

images in this work, however, the meaning of the face remains unexplained.

Caterina van Hemessen

Caterina van Hemessen (1528–87) lived in the port city of Antwerp, in modern Belgum, an international center of commerce and finance. Like many women artists of the period, she studied painting with her father and primarily painted portraits. She married the organist of Antwerp Cathedral and became a favorite court artist to Mary of Hungary, then the regent of the Netherlands. In her self-portrait of 1548 (fig. **18.2**) she sits in three-quarter view facing the observer and at the same time applies a brush to a framed canvas. Caterina used somber colors and rich textures that emphasize the seriousness with which she took her profession, even at a young age. Her identification with her work is shown by the colors on her palette, which match those of her costume. At the top of the picture she has written: "I Caterina van Hemessen painted myself in 1548." She adds that she was twenty years old at the time.

Pieter Bruegel the Elder

The foremost sixteenth-century painter of the Netherlands, and a follower of Bosch, was Pieter Bruegel the Elder (c. 1525–69). Early in his career, Bruegel worked in Antwerp. He trained in a printing concern, and in 1551 he became a master in the Painters' Guild. The following year he departed for Italy. His trip influenced his work considerably, in particular his taste for landscape. While in Italy he made many drawings of the landscape, especially the Alps and the southern seacoast, but he made virtually no sketches of the Roman sculpture and architecture that appealed to Italian Renaissance artists. Bruegel's passion for landscape reflects his belief that nature is the source of all life, a humanist idea that was related to the contemporary interest in exploration.

In *Landscape with the Fall of Icarus* (fig. **18.3**), Bruegel expresses his love of landscape for its own sake, for much of the picture plane is dominated by the sea and the surrounding land. Bruegel's vision of humanity in nature is shown by the intense relationship between the peasant pushing his plowshare and the land. The folds of the peasant's tunic repeat the furrows of the plowed earth, formally uniting him with the land. Below the peasant, a shepherd tends his flock, and a fisherman sits by the edge of the sea. The shepherd rests on his crook and gazes up at the sky. In the context of the myth (see caption), it is likely that he is watching the flight of Daedalos, but he does not notice the drowning Icarus. The other two figures are so absorbed in their tasks that they fail to observe the mythical event taking place. Bruegel's philosophy as expressed in this

on a life of their own. Musical instruments that cause pain rather than pleasure reflect the medieval notion that music was the work of Satan. One figure is crucified on the strings of a harp, and another is tied to a long flute. A seated monster, probably Satan himself, swallows one soul and simultaneously expels another through a transparent globe. Two ears with no head are pierced by an arrow.

At the center of this vision of hell is a monster whose body resembles a broken egg. This could refer to the alchemical egg, which was believed to be the source of spiritual rebirth. He is supported by tree-trunk legs, each of which stands in a boat. His egglike body is cracked open to reveal an old crone by a wine keg and a table of sinners. On his head, the egg man balances a disk with a bagpipe, which is a traditional symbol of lust in Western art. Peering out from under the disk, and seemingly weighed down by it, is an individualized face. Its self-conscious appeal to the observer is a convention of artists' self-portraits. Like the fantastic complexity and tantalizing obscurity of Bosch's

painting conforms to the German proverb "No plow stops for a dying man."

To the humanist integration of antiquity with contemporary concerns, Bruegel adds the Christian moralizing tradition of Northern Europe. The *Fall of Icarus* demonstrates that it is wiser to till the land than to brave the skies, which was also the message of his *Tower of Babel* (see fig. **1.5**). There, too, though in a biblical setting, Bruegel depicts the dangers of unrealistic ambition, as the tower seems to crumble and fall like Icarus. For Bruegel, therefore, what the Greeks called *hubris* (a concept encompassing "pride" and "unrealistic ambition") corresponds to the Netherlandish notion of human folly. Folly, in Bruegel's view, turns things upside down, just as Icarus has landed head first with his feet flailing in the air. To avoid such a fall, according to Bruegel's imagery, one is advised to concentrate on work. Even in our own age of air travel and space programs, popular wisdom considers it a virtue and a sign of mental stability to "have one's feet planted firmly on the ground." People who "fly too high" are considered overly ambitious and destined for a fall (see Box).

LITERATURE
W. H. Auden's *Icarus*

The twentieth-century poet W. H. Auden included a description of Bruegel's *Icarus* in his 1938 poem "Musée des Beaux-Arts":

> In Bruegel's *Icarus*, for instance: how everything
> turns away
> Quite leisurely from the disaster; the ploughman
> may
> Have heard the splash, the forsaken cry,
> But for him it was not an important failure; the
> sun shone
> As it had to on the white legs disappearing into
> the green
> Water; and the expensive delicate ship that must
> have seen
> Something amazing, a boy falling out of the sky,
> Had somewhere to get to and sailed calmly on.[3]

18.3 Pieter Bruegel the Elder, *Landscape with the Fall of Icarus*, c. 1554–55. Oil on panel (transferred to canvas), 2 ft. 5 in. × 3 ft. 8⅛ in. (0.74 × 1.12 m). Musées Royaux des Beaux-Arts de Belgique, Brussels, Belgium. Although famous for his peasant scenes and known as "Peasant Bruegel," Bruegel was a townsman and a humanist. Here he combines the theme of man's unity with landscape with the Classical myth of Icarus. Daedalos, the father of Icarus, fashioned a pair of wings out of feathers held together by wax and warned his son not to fly too near the sun. Icarus disobeyed, the sun melted his wings, and he drowned in the Aegean Sea. In the painting, Icarus can be seen flailing around in the water just below the large ship on the right.

18.4 Pieter Bruegel the Elder, *Netherlandish Proverbs*, 1559. Panel, 3 ft. 10 in. × 5 ft. 4½ in. (1.17 × 1.63 m). Staatliche Museen, Berlin, Germany.

In 1559 Bruegel painted *Netherlandish Proverbs* (fig. **18.4**), which is the visual equivalent of Erasmus's *Adagia* (see Box, p. 328). It is an outdoor scene filled with about one hundred figures, whose activities exemplify moral principles. But every instance fulfills the proverb in the negative, creating the "world upside down" that stood for Bruegel's view of human folly. The predominant colors are yellows and browns, which are accented throughout by blues and reds—blue denoting cheating and foolishness; red, sin and arrogance. The painting is also called *The Blue Cloak* from the detail in which a woman in a sinful red dress puts a blue cloak on her foolish husband. The pointed hood is an allusion to the horns of the cuckold.

The large number of scenes in this painting makes it difficult to discern the individual proverbs in the reproduction, but we can identify a few of them. A woman carries a bucket of water in her left hand and a burning fire poker in her right ("the right hand doesn't know what the left is doing"). At the left, a man sits on the ground between two stools ("to fall between two stools"). In the lower middle, a man whose calf has already drowned is filling the well ("closing the barn door after the horse has gone"), and roses are scattered around a pig ("to cast pearls before swine"). Gossip is represented as two women, one spinning and the other holding the distaff (they literally "spin tales"). Other proverbs illustrated in the picture include "to hold an eel by the tail" (the man at the right in the hut on the water is holding a large eel), "big fish eat little fish" (in the water), "jumping from ox to ass," or "from the frying pan into the fire" (the man by the door of the castle tower), and at the lower left another man "beats his head against a brick wall."

Bruegel lived during the tense years of the Reformation and the Counter-Reformation, which coincided with Spanish rule of the Netherlands. Nothing is known for certain of his political views, but it is clear that he was a humanist. In his art, Bruegel creates a synthesis of Christian genre and Classical imagery, which is at once moralizing and satirical.

Germany

Albrecht Dürer

The German taste for linear quality in painting is especially striking in the work of Albrecht Dürer (1471–1528). He was first apprenticed to his father, who ran a goldsmith's shop. Then he worked under a painter in Nuremberg, which was a center of humanism, and in 1494 and 1505 he traveled to Italy. He absorbed the revival of Classical form and copied Italian Renaissance paintings and sculptures, which he translated into a more rugged, linear style. He also drew the Italian landscape, studied Italian theories of proportion, and read Alberti. Like Piero della Francesca and Leonardo, Dürer wrote a book of advice to artists— *Vier Bücher von menschlichen Proportion (Four Books of Human Proportion)*.

The *Self-Portrait* (fig. **18.5**) of 1498 reveals the influence of Leonardo (see fig. **16.13**), whom Dürer greatly admired, in the figure's three-quarter view and the distant landscape. Although set in a three-dimensional cubic space, according to the laws of fifteenth-century perspective, and consistently illuminated from the left, Dürer's figure is painted with crisp contours that would be unusual in Italy. The attention to patterning in the long curls and in the costume also reveals Dürer's interest in line for its own sake. Particularly prominent in this and other works by the artist is his signature monogram, a *D* within an *A*, which is accompanied here by an inscription—the artist's statement of his own role in creating the image. Dürer's confident sense of himself is conveyed by his upright posture, firmly clasped hands, and elegant dress; it is also a reflection of the social status he achieved in Nuremberg.

— CONNECTIONS —

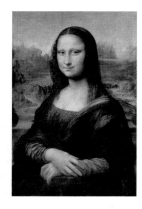

See figure 16.13.
Leonardo da Vinci,
Mona Lisa, c. 1503–5.

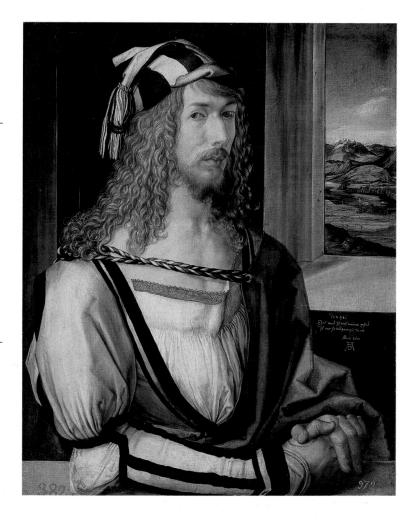

18.5 Albrecht Dürer, *Self-Portrait*, 1498. Oil on panel, 20½ × 16 in. (52 × 40.6 cm). Museo del Prado, Madrid, Spain. Dürer was trained as a metalworker and painter and in his twenties traveled in Italy. Young German artists traditionally spent a *Wanderjahr*, a year of travel, visiting different parts of Europe and studying art. From 1512, as court painter to the Holy Roman emperor, Dürer became the most important artist in the transition from Late Gothic to Renaissance style in Northern Europe.

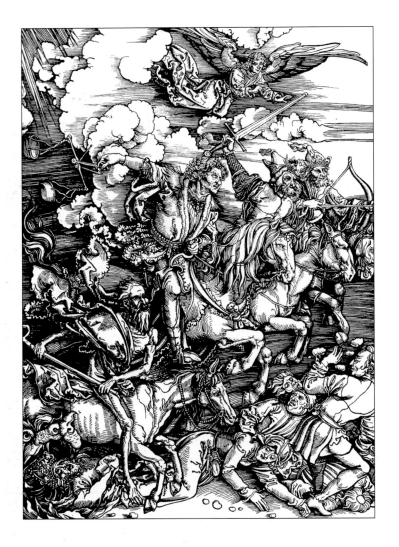

Prints Dürer's interest in line is most apparent in his work as a **woodcut** artist and engraver (see Box). His *Apocalypse* was the first book to be designed and published by a single artist. In it Dürer included the full text of the Book of Revelation in Latin and German editions, which he illustrated. In the *Four Horsemen of the Apocalypse* (fig. **18.6**), the aged and withered figure of Death rides the skeletal horse, trampling a bishop whose head is in the jaws of a monster. Cowering before the horse are figures awaiting destruction. Next to Death, and the most prominent of the four, rides Famine, carrying a scale. War brandishes a sword, which is parallel to the angel above. Plague, riding the background horse, draws his bow (the arrow's wounds were associated with the sores caused by the plague). Finally, the presence of God as the ultimate motivating force behind the four horsemen is indicated by rays of light entering the picture at the upper left corner.

In this image, Dürer took evident delight in the expressiveness of line. The powerful left-to-right motion of the horses and their riders is created by their diagonal

18.6 Albrecht Dürer, *Four Horsemen of the Apocalypse*, c. 1497–98. Woodcut, approx. 15¹¹⁄₁₆ × 11 in. (39.2 × 27.9 cm). This is one of a series of fifteen woodcuts from the late 1490s illustrating the Apocalypse.

MEDIA AND TECHNIQUE
Printmaking

Printmaking is the generic term for a number of processes, of which **engraving** and woodcut are two prime examples. **Prints** are made by pressing a sheet of paper (or other material) against an image-bearing surface (the **print matrix**) to which ink has been applied. When the paper is removed, the image adheres to it, but in reverse.

The woodcut had been used in China from the fifth century for applying patterns to textiles, but it was not introduced into Europe until the fourteenth century. It was used first for textile decoration and then for printing on paper. Woodcuts are created by a relief process. First, the artist takes a block of wood sawn parallel to the grain, covers it with a white ground, and draws the image in ink. The background is then carved away, leaving the design area slightly raised. The woodblock is inked, and the ink adheres to the raised image. It is then transferred to damp paper either by hand or with a printing press.

Engraving, which grew out of the goldsmith's art, originated in Germany in the middle of the fifteenth century. It is an intaglio process (from the Italian word *intagliare*, meaning "to carve"). The image is incised into a highly polished metal **plate,** usually of copper, with a cutting instrument, or **burin.**

The artist then inks the plate and wipes it clean so that some of the ink remains in the incised grooves. An impression is made on damp paper in a printing press, with sufficient pressure being applied so that the paper picks up the ink.

Both woodcut and engraving have distinctive characteristics. Dürer's engraving in figure **18.7**, for example, shows how this technique lends itself to subtle modeling and shading through the use of fine lines. Hatching and crosshatching determine the degree of light and shade in a print. Woodcuts, as in figure **18.6**, tend to be more linear, with sharper contrasts between light and dark, and hence more vigorous.

Printmaking is well suited to the production of multiple images. A set of multiples is called an **edition.** Both methods described here can yield several hundred good-quality prints before the original block or plate begins to show signs of wear. Mass production of prints in the sixteenth century made images available, at a lower cost, to a much broader public than before. Printmaking played a vital role in Northern Renaissance culture, particularly in disseminating knowledge, expanding social consciousness, and transmitting artistic styles.

sweep across the picture space. The less forceful zigzags of the cowering figures reveal their panic in the face of the unrelenting advance of the horsemen.

Dürer's copper engraving of Melencolia (fig. **18.7**), or Melancholy, signed and dated 1514, is an early example of the tradition of portraying artists as having a saturnine, or melancholic, personality (see Box). That the female winged genius is meant to represent Dürer himself is suggested by the location of his monogram underneath her bench. She leans on her elbow in the pose of melancholy that had been conventional since antiquity.

Dürer's Melancholy is an idle, uninspired creator, an unemployed "genius," looking inward for inspiration and not finding it. She is in the grip of obsessive thinking and therefore cannot act. Idle tools, including a bell that does not ring, empty scales, and a ladder leading nowhere, reflect her state of mind. The winged child conveys a sense of anxiety that probably mirrors the anxiety felt by the uninspired artist. Other details, such as the hourglass, refer to the passing of time. In the upper left, a squeaking bat displays a banner with MELENCOLIA I written on it. The bat, associated with melancholy because of its isolation in dark places, comes out only at night. By combining the bat with the darkened sky pierced by rays of light, Dürer seems to be making a visual play on the contrasting mental states of black melancholy and the light of inspiration.

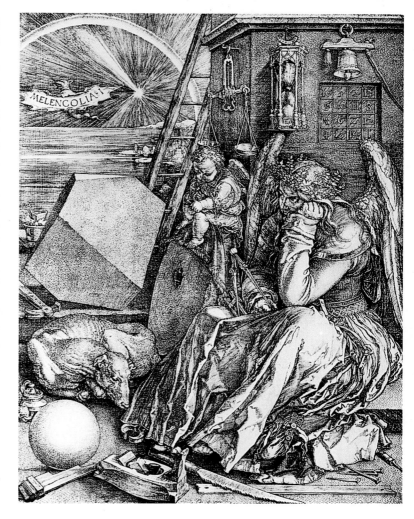

18.7 Albrecht Dürer, *Melencolia I*, 1514. Engraving, 9⅜ × 6⅝ in. (23.8 × 16.8 cm).

SOCIETY AND CULTURE
The Myth of the Mad Artist

Artists, particularly melancholic artists, have traditionally been considered "different" (from the general population) to the point of madness. Aristotle made the first known connection between melancholy—derived from the Greek words *melas*, meaning "black," and *cholos*, meaning "bile" or "wrath"—and genius. The melancholic was thought to have an excess of black bile (one of the four bodily humors) in his system, an idea revived in the Renaissance.

Marsilio Ficino believed that melancholics were born under the astrological sign of Saturn, the Roman god known for his moody temperament, and hence shared this particular aspect of Saturn's personality. Consistent with his Neoplatonic philosophy, Ficino combined astrology with Plato's notion that artistic genius was a gift from the gods, who inspired artists with a creative *mania* (Greek for "madness" or "frenzy"). Thus, from the Renaissance onward, artists and other creative people have been thought to be saturnine (in the sense of temperamental), melancholic, and eccentric.

Saturn, who was identified with Kronos, the Greek Titan, was a god of agriculture, which was associated with geometry (literally, "measurement of the earth"). Artists, farmers, and geometricians alike used measuring instruments in their work, as seen in the compass in the hand of Dürer's Melancholy (see fig. **18.7**).

The pose of Dürer's uninspired genius echoes that of Raphael's Heraklitos/Michelangelo in the *School of Athens* (see fig. **16.23**). But Dürer's engraving is the earliest representation of the *idea* of melancholy as an artistic image in its own right. It influenced the view of the artist as a divinely inspired melancholic genius who suffered bouts of creative frenzy and gloomy idleness. Both Dürer and Michelangelo identified with that image, which declined in popularity in the seventeenth century but was revived by the nineteenth-century Romantics (see Chapter 22).

In 1526, Dürer engraved a portrait of Erasmus writing in his study, surrounded by the books that denote his substantial intellect and scholarship (fig. **18.8**). The flowers refer to his love of beauty and modesty, while the prominent Classical inscriptions are signs of his humanism. The Latin reads: "This image of Erasmus of Rotterdam was drawn from life by Albrecht Dürer." The Greek, below, reads: "The better image will reveal his writings." Signed with Dürer's monogram and dated in Roman numerals, the engraving also reflects the humanist character of the artist.

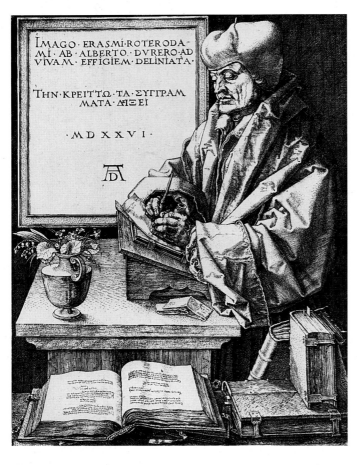

18.8 Albrecht Dürer, *Erasmus*, 1526. Engraving, 9⅞ × 7⅝ in. (24.9 × 19.3 cm). When Erasmus wrote about Dürer, he was inspired by Pliny's praise of Apelles. But Dürer, according to Erasmus, surpassed Apelles because he could do solely with line what his Classical predecessor had done with line plus color. And, indeed, the massive sleeves and their bulky, angular folds exemplify Renaissance naturalism.

HISTORY
Erasmus

Desiderius Erasmus of Rotterdam (c. 1466–1536) was a Roman Catholic reformer and one of the greatest Renaissance humanists in northern Europe. The illegitimate son of a priest, Erasmus was ordained in 1492 and then studied Classics in Paris. Among his most important works is *Moriae encomium* ("The Praise of Folly") of c. 1511, in which he satirizes greed, superstition, and the corruption and ignorance of the clergy. He argues that piety depends on spiritual substance rather than on the observance of religious ceremony.

Erasmus's satirical inclinations were well suited to the Northern interest in proverbs as a way of revealing human folly. His *Adagia* ("Adages"), published in 1500, is a compendium of sayings that contain hidden or double meanings. In 1513, he published a satire on Julius II in which the pope is barred from heaven. Julius announces himself to Saint Peter as "P. M." (meaning *Pontifex Maximus,* or "Highest Priest"), but Saint Peter takes "P. M." to mean *Pestis Maxima*—"the Biggest Plague." Through the personage of Saint Peter, Erasmus objects to Julius II as an arrogant lush tainted by political, financial, territorial, and military ambition.

Erasmus's knowledge of Classical languages is evident in his publication of the first edition of the New Testament in Greek (1516); he also published a Latin translation of it. He believed that Latin would bridge the gap between divergent cultures and thus be a force for unity.

Erasmus was a moderate in an age of extremism. But his tolerance and reason limited his influence as compared with that of Martin Luther. He opposed the Reformation, fearing the destructive effects of partisan religious strife. Attacked by Catholics and Protestants alike, Erasmus remained committed to reconciliation and unity.

Matthias Grünewald

Contemporary with Dürer's engraving of *Melencolia* is the Isenheim Altarpiece (figs. **18.9–18.11**), a monumental polyptych by the German artist Matthias Grünewald (died 1528). It was commissioned for the hospital chapel of the monastery of St. Anthony in Isenheim. The hospital specialized in the treatment of skin diseases, particularly ergotism, known as "St. Anthony's Fire." The altarpiece was a form popular in Germany between 1450 and 1525. It typically consisted of a central corpus, or body, containing sculptured figures and was enclosed by doors (wings) painted on the outside and carved in low relief inside. In the Isenheim Altarpiece, it is the base, not the corpus, that contains the sculptures; but sculptured figures of Saint Anthony, Saint Jerome, and Saint Augustine are located in the central corpus behind the *Virgin and Child with Angels* and are revealed when the two panels of this scene are opened (see fig. **18.10**).

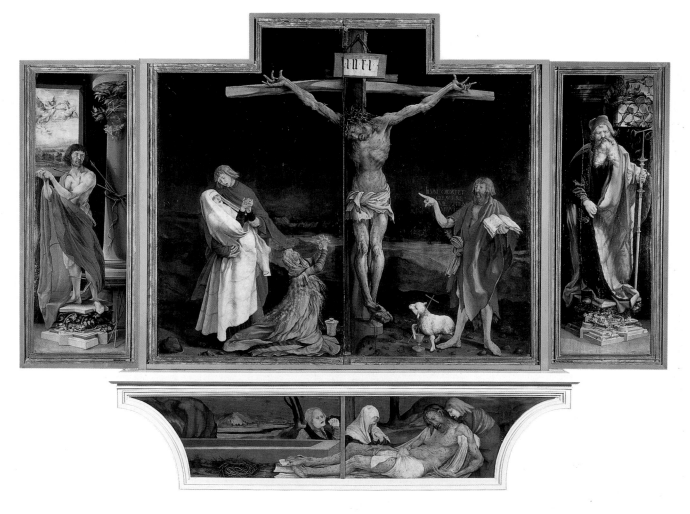

18.9 Matthias Grünewald, *Crucifixion with Saint Sebastian* (left), *Saint Anthony* (right), and *Lamentation* (below), the Isenheim Altarpiece, closed, c. 1510–15. Oil on panel (with frame), side panels 8 ft. 2½ in. × 3 ft. ½ in. (2.5 × 0.93 m), central panel 9 ft. 9½ in. × 10 ft. 9 in. (2.98 × 3.28 m), base 2 ft. 5½ in. × 11 ft. 2 in. (0.75 × 3.4 m). Musée d'Unterlinden, Colmar, France.

The exterior of the doors (fig. **18.9**) depicts the *Crucifixion;* its emphasis on physical suffering and the wounds of Jesus was related to healing. This is enhanced by Grünewald's revolutionary use of color—for example, the greenish flesh (suggesting gangrene), the gray-black sky, and the rich reds of the drapery that echo the red of Jesus's blood—to accentuate the overwhelming effect of the scene. The arms of the cross are bowed from Jesus's weight. In contrast to the idealized, relaxed Jesus of Michelangelo's *Pietà* in Rome (see fig. **16.14**), Grünewald's Jesus is contorted, blood drips from his scalp, and his loincloth is torn and ragged.

Grünewald's depiction of Jesus has been related to fourteenth-century mystical writings, notably the *Revelations* of the Swedish saint Bridget. "The crown of thorns," she wrote, "was impressed on his head; it was firmly pushed down covering half his forehead, the blood, gushing forth from the prickling of thorns. . . . The color

of death spread through his flesh. . . . His knees . . . contracted. . . . His feet were cramped and twisted. . . . The cramped fingers and arms were stretched out painfully."[4]

John the Baptist, on Jesus's left, points to Jesus. The Latin inscription, written in blood-red, which John seems to be speaking, reads "He must increase and I must decrease." At John's feet, holding a small cross, is the sacrificial Lamb, whose blood drips into a chalice that prefigures the Eucharist. On Jesus's right, Mary Magdalen wrings her hands in anguish. The curve of her arms continues backward toward the swooning Virgin and John the Evangelist supporting her. The darkening sky recalls the biblical account of the sun's eclipse and nature's death at the time of Jesus's Crucifixion. On the base of the closed altarpiece, Grünewald has depicted the *Lamentation,* or mourning over Jesus after he has been taken down from the Cross. It is set against a snowy, alpine background with barren trees, both being natural metaphors of Jesus's death.

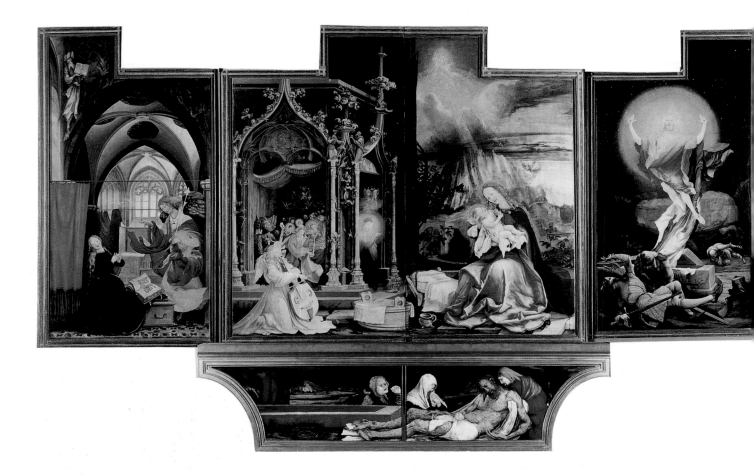

18.10 Matthias Grünewald, *Annunciation, Virgin and Child with Angels,* and *Resurrection,* the Isenheim Altarpiece, open.

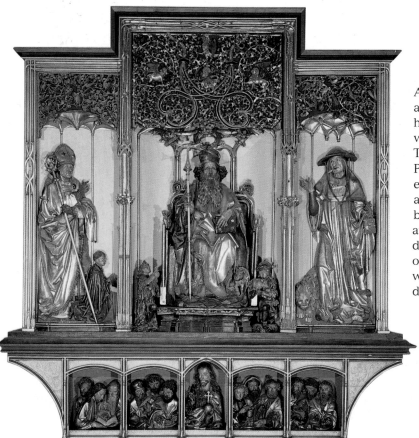

18.11 Nikolaus von Hagenau, central corpus and base of the Isenheim Altarpiece. The corpus sculptures depict Saints Augustine at the left, Jerome at the right with his lion attribute, and Anthony enthroned in the center. Represented on the base are Jesus and the twelve apostles. Two side panels by Grünewald depicting scenes from Saint Anthony's life are not illustrated. Polychrome wood sculpture, early 16th century.

The wings of the closed altarpiece depict Saint Anthony, who was associated with healing, on the right, and Saint Sebastian, known as a plague saint because his sores, caused by being shot through with arrows, were likened to those of the bubonic plague, on the left. The altarpiece was generally kept in the closed position. Patients prayed before it to atone for their sins and to effect a cure. On Sundays and feast days, however, the altarpiece was opened to reveal an interior transformed by bright colors (fig. **18.10**). In the right panel, Jesus attains a new, spiritual plane of existence. His body, defined by curvilinear forms, floats upward into a fiery orb. Christ-as-sun is juxtaposed with the Roman soldiers, whose sinful ignorance causes them to stumble in a rocky darkness.

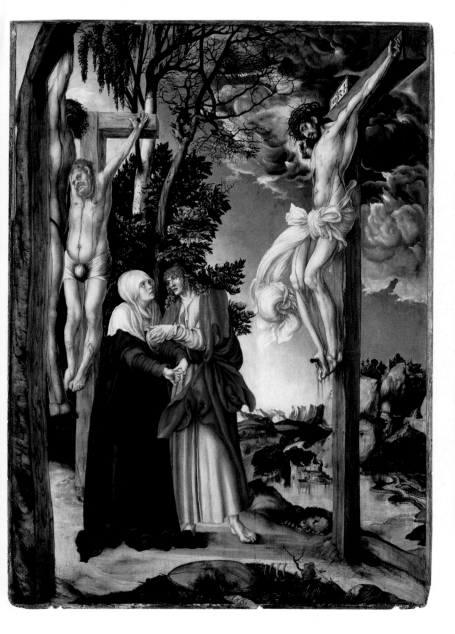

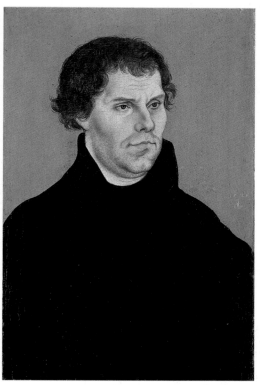

18.12 (Left) Lucas Cranach the Elder, *Crucifixion*, 1503. Panel, 54½ × 43 in. (138.4 × 109.2 cm). Alte Pinakothek, Munich, Germany.

18.13 (Above) Lucas Cranach the Elder, *Martin Luther,* 1525. Oil on canvas, 8 × 5¾ in. (20.5 × 14.5 cm). Nationalmuseum, Stockholm, Sweden.

Lucas Cranach

Lucas Cranach the Elder (1472–1553) was a German humanist and an admirer of Martin Luther. In his early work, he primarily depicted landscapes, an interest that continues in his large Crucifixion of 1503 (fig. **18.12**).

Cranach creates the effect of towering figures by showing us the event as if we are looking up at it from below. At the left are the two thieves, one partly hidden from view and the other grotesque in appearance. A more idealized Jesus hangs from the Cross at the right. Mary and John are united in mourning, their agitated gestures repeating Jesus's windblown loincloth and the turbulent sky. Behind them, a dead tree rises, pushing through the green tree and

denoting the death of God's son. The responsiveness of nature to human events is both part of Christian tradition —that the sky turned black when Jesus died—and a reflection of Cranach's humanism.

Cranach was best known for his portraits. His portrait of Martin Luther (fig. **18.13**), who was a close friend, is austere. The figure is set against a solid green background, eliminating the sense of a natural context. Luther's dark robe is also unmodulated so that the only three-dimensional form is the head. In the emphasis on the stubble of Luther's beard, Cranach makes his subject seem above the concerns of daily grooming. He is rendered as a man of vision, staring out of the picture with an air of inner resolution.

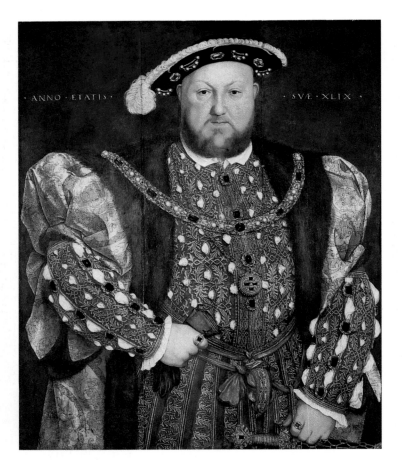

18.14 Hans Holbein the Younger, *Henry VIII*, c. 1540. Oil on panel, 34¾ × 29½ in. (88.3 × 74.9 cm). Galleria Nazionale d'Arte Antica, Rome, Italy.

Basel, where he met Erasmus and painted his portrait. Holbein left Basel in 1526 and, on the recommendation of Erasmus, sought the patronage of the humanist Sir Thomas More in England. On a second trip in 1532, Holbein became the court painter to Henry VIII.

Holbein's portrait of Henry (fig. **18.14**) of about 1540 conveys the overpowering force of the king's personality. Henry's proverbial bulk dominates the picture plane as he stares directly out at the observer. The king's forceful character is unrelieved by a spatial setting or by objects in the surrounding space. But the fine textures and minute patterns of his costume create a surface luster that is reminiscent of van Eyck. Henry's bent right arm is posed so that the elbow is thrust forward, showing off the elaborate sleeves. From the neck down, the king's body forms a rectangle filling the lower two-thirds of the picture. His head seems directly placed on his shoulders, creating a small, almost cubic shape. The hat, by contrast, forms a slightly curved diagonal, echoing the curved chain and also softening the monumental force of Henry's character.

The main source of variety in this picture is the material quality of the surface patterns. Their richness is calculated to remind viewers of Henry's wealth, just as his pose exudes power, self-confidence, and determination, while his face reflects his intelligence and political acumen. In this image, therefore, Holbein has fused style with content, creating a Henry VIII who is "every inch a king."

After Holbein's death, no major artists emerged in Germany during the sixteenth century. By 1600 the conflicts between Protestant and Catholic, Reformation and Counter-Reformation, mysticism and humanism, though hardly at an end, had at least become familiar. Their effects on art would continue, though to a lesser degree, into the seventeenth century.

Hans Holbein the Younger

The last great German painter of the High Renaissance was Hans Holbein the Younger (c. 1497–1543). He synthesized German linear technique with the fifteenth-century Netherlandish taste for elaborately detailed surface textures and rich color patterns. Perhaps his greatest achievements were his portraits.

Holbein's family came from the southern German city of Augsburg, which, like Antwerp, was a center of international trade. At the age of eighteen, Holbein traveled to

c. 1500 **c. 1600**

16TH-CENTURY PAINTING AND PRINTMAKING IN NORTHERN EUROPE

		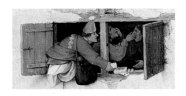			
(18.1)	(18.2)	(18.4)	(18.5)	(18.13)	(18.14)
The Witches' Hammer (1487)	Erasmus, *The Praise of Folly* (1514)	Martin Luther excommunicated (1521)	Henry VIII breaks with the pope (1534)	Elizabeth I queen of England (1558–1603)	Karel van Mander, *Het Schilderboeck* (*The Painter's Book*) (1604)

19

The Baroque Style
in Western Europe

The Baroque style corresponds roughly to the closing years of the sixteenth century, overlapping Mannerism and lasting, in some areas, until around 1750. Religious and political conflicts, especially between Catholics and Protestants, continued in the seventeenth century. The Thirty Years' War (1618–48) sapped the power of the Holy Roman emperor. Holland rebeled against the repressive Catholic domination of Spain. As a result, what had previously been the Netherlands was separated into Protestant Holland and Catholic Flanders (modern Belgium). From 1620 the Puritans fled religious persecution in Europe and sailed to New England. In 1649 England beheaded King Charles I and introduced parliamentary rule.

Religion, Politics, and Science

Building on the explorations of the 1500s, the seventeenth century was an age of geographical colonization and scientific development. European powers competed for control of the Far East and the Americas. In science and philosophy, the seventeenth century made great strides—though not without controversy. In England, William Harvey established the system of blood circulation. Isaac Newton discovered the laws of gravity, which brought him into conflict with the Catholic king, James II. René Descartes, the French philosopher, based his philosophy on a method of systematic doubt. He emphasized clear, rational thought, embodied by the humanist phrase "I think, therefore I am." Descartes avoided conflict with the Church only by acknowledging that God was the source of the original impulse to reason.

Perhaps the greatest threat to established theology came from the astronomers. The earth lost its traditional place as the center of the universe, and the sun, always a central image in the human imagination, now became the demonstrable center of the solar system. The discoveries of Nicolaus Copernicus in Poland, Johannes Kepler in Germany, and Galileo Galilei in Italy were vigorously opposed by the Church. In Rome, the Inquisition forced Galileo to recant and banned his book. Scientific advances were paradoxically accompanied by a rise in religious fundamentalism. Superstition and fear of the Devil and the Antichrist swept Europe. In America as well as in Europe, these fears led to devastating waves of witch hunts.

Baroque Style

The term *Baroque* is applied to diverse styles, a fact that highlights the approximate character of art-historical categories. Like Gothic, Baroque was originally a pejorative term. It is a French variant of the Portuguese *barroco*, meaning an irregular, and therefore imperfect, pearl. The Italians used the word *barocco* to describe a convoluted medieval style of academic logic. Although Classical themes and subject matter continued to appeal to artists and their patrons, Baroque tended to be relatively unrestrained, overtly emotional, and more energetic than earlier styles.

Baroque artists rejected aspects of Mannerist virtuosity and stylization, while absorbing the Mannerists' taste for *chiaroscuro* and theatrical effects. They were more likely than Mannerist artists to pursue the study of nature directly. As a result, Baroque art achieves a new kind of naturalism that reflects some of the scientific advances of the period. There is also a new taste for dramatic action and violent narrative scenes, and emotion is given a wide range of expression—a departure from the Renaissance adherence to Classical restraint. Baroque color and light are dramatically contrasted, and surfaces are richly textured. Baroque space is usually asymmetrical and lacks the appearance of controlled linear perspective; sharply diagonal planes generally replace the predominant verticals and horizontals of Renaissance compositions. Landscape, genre, and still life, which had originated as separate but minor categories of painting in the sixteenth century, gained new status in the seventeenth. **Allegory** also takes on a new significance in Baroque art and is no longer found primarily in a biblical context. Portraiture, too, develops in new directions, as artists depict character and mood along with the physical presence of their subjects.

The considerable variety within the Baroque style is partly a function of national and cultural distinctions. Baroque art began in Italy, particularly Rome, whose position as the center of Western European art had been established during the High Renaissance by papal patronage and Rome's links with antiquity.

At the end of the Baroque period Paris emerged as the artistic center of Europe, a position it would retain until World War II. Two major Baroque architectural achievements, the completion of St. Peter's in Rome and the sumptuous court of the French monarch Louis XIV, reflect the enormous resources that were devoted to the arts in seventeenth-century Europe.

In Italy, Spain, and Catholic Flanders, the influence of the Counter-Reformation remained strong. In France, the Baroque style had its greatest expression at the court of Versailles. Court patronage also prevailed in Spain and England, whereas in capitalist Holland the art market was primarily, though not entirely, secular.

Architecture

Italy

The rebuilding of Saint Peter's, which began when Julius II became pope in 1503, was finally completed during the Baroque period. Its interior decoration and spatial design, however, still required attention. Pope Urban VIII (papacy 1623–44) appointed Gianlorenzo Bernini (1598–1680) to the task, and he remained the official architect of St. Peter's until his death. Bernini reduced the space at the crossing so that worshipers would be drawn to the altar. He did so by erecting the bronze **baldachino** (fig. **19.1**), or canopy, over the high altar above St. Peter's tomb.

Four twisted columns, decorated with acanthus scrolls and surmounted by angels, support a bronze valance resembling the tasseled cloth canopy used in religious processions. At the top, a gilded cross stands on an orb. The twisted-column motif did not originate with Bernini. In the fourth century, Constantine was thought to have taken spiral columns from Solomon's Temple in Jerusalem and used them at Old St. Peter's. Eight of these columns were incorporated into the pier niches of New St. Peter's. Bernini's columns seem to pulsate, and the dark bronze, accented with gilt, stands out against the lighter marble of the nave and apse. Such contrasts of light and dark, like the organic quality of the undulating columns, are characteristic of Baroque.

Europe during the Baroque period.

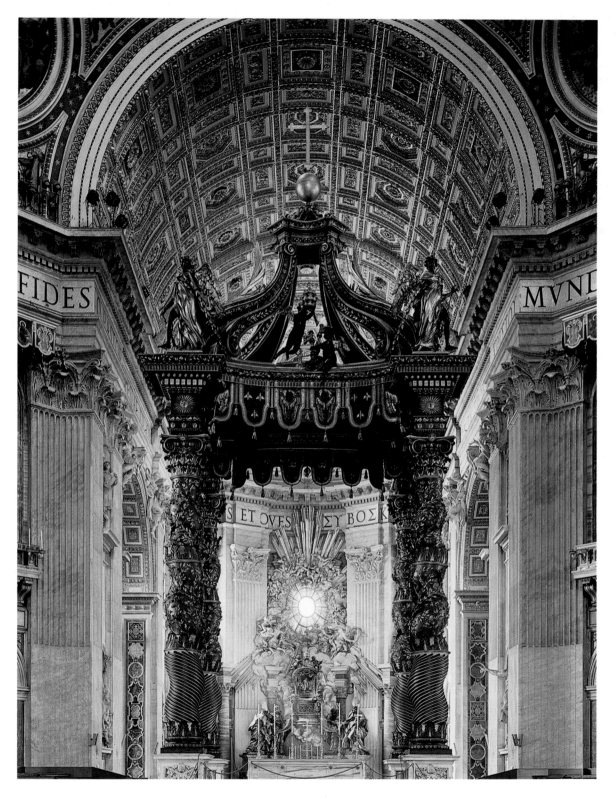

19.1 Gianlorenzo Bernini, baldachino, St. Peter's, Rome, 1624–33. Gilded bronze, approx. 95 ft. (28.96 m) high. The baldachino's height is about one-third the distance from the floor of St. Peter's to the base of its lantern. Although small in relation to the dome, it is the size of a modern nine-story building, and its foundations reach deep into the floor of the old Constantinian basilica.

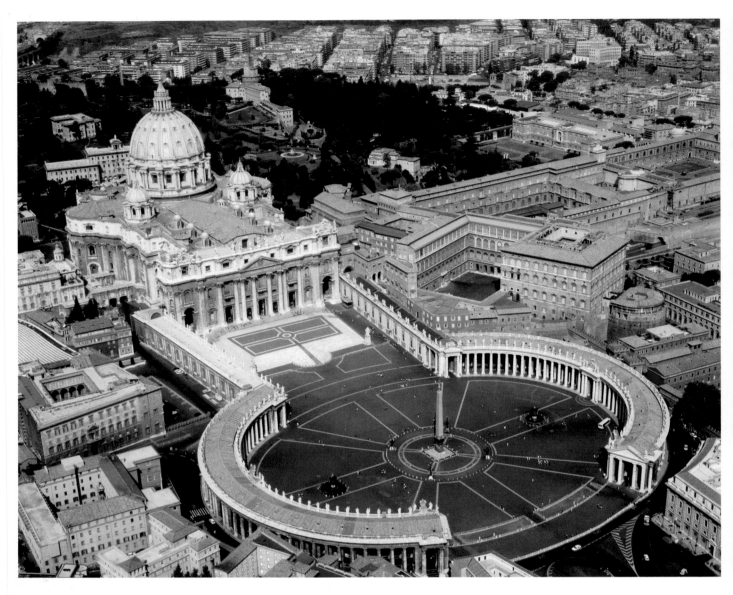

19.2 St. Peter's basilica and piazza, Vatican, Rome. Maderno, façade, 1607–26; Gianlorenzo Bernini, piazza design, c. 1656–57. The piazza is large enough to accommodate more than 250,000 people.

In 1656 Bernini began the exterior of St. Peter's. His goal was to provide an impressive approach to the church and to define the Piazza San Pietro. The piazza, or public square (fig. **19.2**), is where the faithful gather during Christian festivals to hear the pope's message and receive his blessing. Bernini conceived of the piazza as a large open space, organized into elliptical and trapezoidal shapes (in contrast to the Renaissance circle and square). He used Classical Orders and combined them with statues of Christian saints.

He divided the piazza into two parts (fig. **19.3**). The first section has the approximate shape of an oval, or ellipse, and at its center is an obelisk 83 feet (25.3 m) high, imported from Egypt during the Roman Empire. Around the curved sides of the oval, Bernini designed two colonnades, consisting of 284 travertine columns in the Tuscan Order, each one 39 feet (11.89 m) high. The columns are four deep, and the colonnades end in temple fronts on either side of a large opening. Crowds can thus convene and disperse easily;

they are enclosed but not confined. Bernini compared the curved colonnades to the arms of St. Peter's, the Mother Church, spread out to embrace the faithful.

The second part of the piazza is a trapezoidal area connecting the oval with the church façade. The trapezoid lies on an upward gradient, and the visitor approaches the portals of St. Peter's by a series of steps. As a result, the walls defining the north and south sides of the trapezoid become shorter toward the façade. This enhances the verticality of the façade and offsets the horizontal emphasis produced by the incomplete flanking towers. The two sections of the piazza are tied together by an Ionic entablature that extends all the way around the sides of both the oval and the trapezoid, and the entablature is crowned by a balustrade with marble statues of saints. The integration of the architecture with the participating crowds reflects the Baroque taste for involving audiences in a created space, in particular a processional space leading to a high altar.

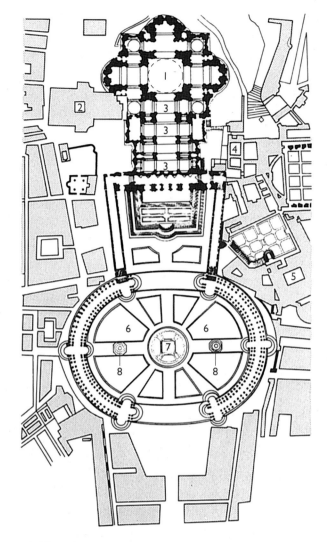

1 Domed space
2 Sacristy
3 Nave
4 Sistine Chapel
5 Papal palace
6 Piazza of Saint Peter
7 Obelisk
8 Fountain

→ N

0 50 100 m
0 200 400 ft

19.3 (Above) Plan of St. Peter's and the piazza, Rome. In the center of the oval a radial pattern converges at the obelisk. The shape and width of the oval—approx. 800 ft. (244 m)—and the location of a fountain within each of its semicircular sections help to establish a stronger north-south axis. That axis is perpendicular to the direction in which most visitors move: along the east-west axis of the nave and dome.

19.4 Francesco Borromini, façade of San Carlo alle Quattro Fontane, Rome, 1665–67. Born in Lombardy, Borromini was the son of an architect. In 1621 he moved to Rome and worked under both Maderno and Bernini. Borromini and Bernini were intense rivals with very different temperaments. Borromini resented living and working in Bernini's shadow. Moody and constantly dissatisfied, he eventually committed suicide.

Bernini's greatest professional rival in Rome was Francesco Borromini (1599–1667). They collaborated on the baldachino, but immediately afterward their interests diverged. From about 1634 to his death, Borromini worked on the Trinitarian monastery of San Carlo alle Quattro Fontane (St. Charles at the Four Fountains) in Rome (figs. **19.4–19.7**), named after the fountains at the four corners of the street intersection. The small monastery church is Borromini's best-known building, and it established his reputation for daring architectural innovation.

The alternation of convex and concave in the façade of San Carlo (fig. **19.4**) is repeated with variations in the walls (see plan, fig. **19.5**). At the ground level there are three bays—concave, convex, concave. At the upper level the bays are all concave, although a small **aedicule** (niche) and a balustrade fill the central bay, echoing the convex shape of the level below. Borromini's undulating walls, like the twisted columns of Bernini's baldachino, are characteristic of the plasticity of Italian Baroque architecture.

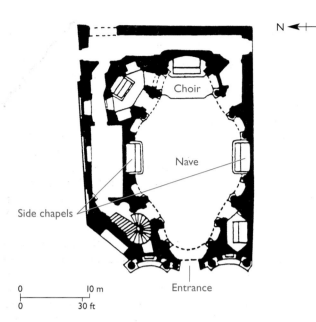

19.5 (Above) Francesco Borromini, plan of San Carlo alle Quattro Fontane, Rome, 1638–41. The plan is shaped like a pinched and distended oval. Its main altar and entrance are opposite each other on the short sides of the oval, and the walls are a series of convexities and concavities. Side chapels, which seem to be parts of smaller ovals, bulge out from the walls.

Above the door of the façade, a statue of San Carlo stands in a niche, surmounted by a pointed gable. A large painted medallion of the saint, crowned with a gable that echoes the lower one, has been placed above the top level, in alignment with the statue. The corner of the building is beveled and contains one of the four fountains. Above the entablature are pendentives supporting an oval ring at the base of the dome.

The interior view (fig. **19.6**) toward the high altar shows the use of large, smooth-shafted Corinthian columns to create a plastic effect in the walls. This is enhanced further by the undulating character of the walls as they approach the apse. Surmounting the relatively sharp curve of the apse's entablature is a pediment that seems to be stretching its lower corners outward.

In figure **19.7** we are looking up at the interior of the dome, which expresses the Baroque concern for lightening architectural volume. The appearance of increased height, and of actual upward motion, is enhanced by coffers that decrease in size as they approach the center of the dome.

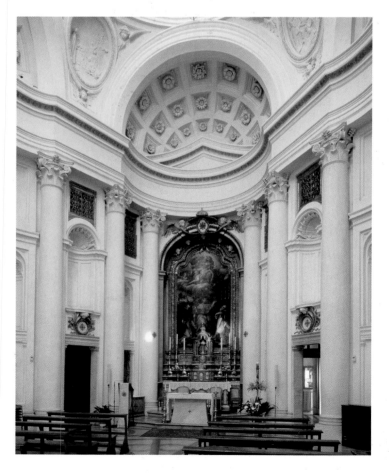

19.6 Francesco Borromini, San Carlo alle Quattro Fontane, Rome, view toward the high altar.

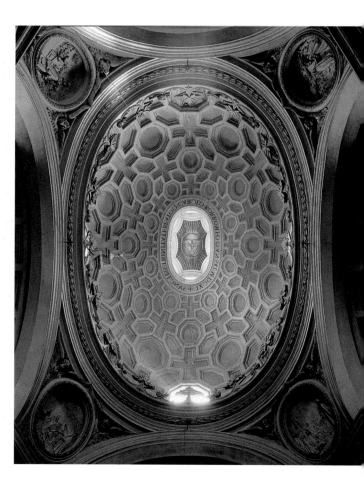

19.7 Francesco Borromini, interior dome of San Carlo alle Quattro Fontane, Rome. The dome is illuminated on the interior by windows at its base and contains coffers in the shape of hexagons, octagons, and crosses. At the center of the dome, an oval oculus contains a triangle: a geometric symbol of the Trinity and an emblem of the Trinitarian Order that commissioned the church.

France

Seventeenth-century French architecture was elegant, ordered, rational, and restrained, recalling the Classical aesthetic. France rejected the exuberance of Italian Baroque, preferring a strictly rectilinear approach to Borromini's curving walls or the open, activated spaces of Bernini. Geometric regularity was also more in keeping with the French political system—absolute monarchy personified by Louis XIV.

Louis ascended the throne in 1643 at the age of five and ruled from 1661, when he came of age, until his death in 1715. His shrewd policies and talented ministers made France the most powerful, and most populous, nation in Europe. His chief minister, Jean-Baptiste Colbert, organized the arts in the service of the monarchy. Their purpose was to glorify Louis' achievements and enhance his power and splendor in the eyes of the world. To this end, the building industry and the crafts guilds were subjected to a central authority. An **Academy** was established to create a national style which would reflect the glory of France and its king (see Box, p. 340).

The first task of Louis and Colbert was to complete the rebuilding of the Louvre (fig. **19.8**) in Paris. Now the city's largest art museum, the Louvre was then a royal palace. Bernini submitted a series of proposals and was summoned to work on the Louvre. His final proposal was rejected, however, on the grounds that it did not match the existing structure or conform to French taste. The eventual design for the east façade was the work of three men—the painter Charles Le Brun (director of the French Academy), the architect Louis Le Vau, and Claude Perrault, a physician. The restrained, classicizing symmetry of the façade, in contrast to Bernini's plan for a curved wall, occupies a long horizontal plane; it set the style for seventeenth-century French architecture.

In 1667 Louis XIV decided to move his court to Versailles, a small town about 15 miles (24 km) southwest of Paris. This involved moving not only the vast royal household but also the whole apparatus of government. Versailles was the site of a hunting lodge built in 1624 by Louis' father, Louis XIII, and enlarged from 1631 to 1636. His son had visited this modest twenty-room *château* as a child. The lodge was at the center of a radiating landscape design

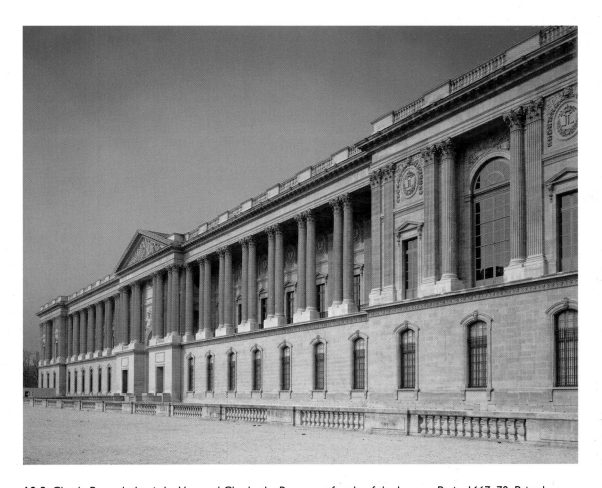

19.8 Claude Perrault, Louis Le Vau, and Charles Le Brun, east façade of the Louvre, Paris, 1667–70. Paired two-story columns separate the windows and are linked by a continuous entablature. The flat roof is hidden by a surrounding balustrade, which accents the horizontality of the building. The central pavilion, resembling a Roman temple front, is crowned by a pediment, which is echoed by the small individual pediments above the windows. The main floor rests on a ground floor presented as a **podium.** It is lightly **rusticated**—the blocks of masonry have roughened surfaces and sunken joints.

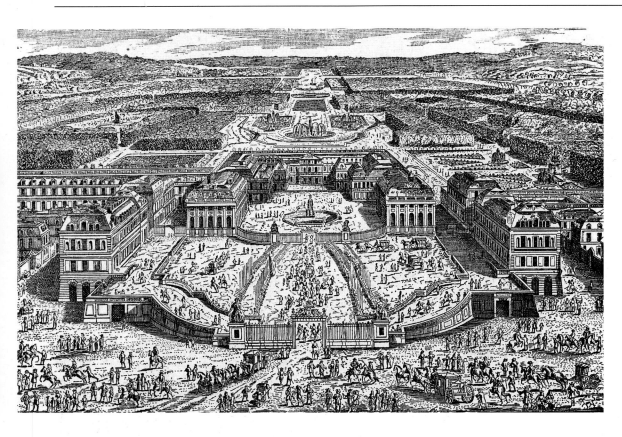

19.9 Aerial view of the park, palace, and town of Versailles, after a 17th-century engraving by G. Pérelle. Versailles was the epitome of the French *château* ("castle," "mansion," or "country house"), which had been established in the 16th century as the centerpiece of lavish country estates. A small town grew up at the eastern end of the palace, planned in grid formation around three broad boulevards. These radiated out from the palace and funneled visitors into the courtyard, or Court of Honor.

and formed the nucleus of the new palace, which was built under Louis XIV (fig. **19.9**). From 1661 to 1708 the building underwent a series of enlargements, the earlier ones under the direction of Le Brun and Le Vau. The landscape architect André Le Nôtre (1613–1700) designed elaborate gardens with pools and fountains—typical Baroque features. The palace itself contained hundreds of rooms and served more than twenty thousand people. Four thousand servants lived inside the palace and nine thousand soldiers were billeted nearby.

SOCIETY AND CULTURE
The French Academy (Académie Royale de Peinture et de Sculpture)

Louis XIV extended his notion of the monarch's absolute power to the arts. In 1648 his minister Jean-Baptiste Colbert founded the Royal Academy of Painting and Sculpture with a view to manipulating imagery for political advantage. The philosophy and organization of the Academy were as hierarchical as Louis' state. Artists were trained according to the principle that tradition and convention had to be studied and understood. Art students drew from plaster casts and copied the old masters. They were steeped in the history of art and of their own culture.

Another issue of philosophical importance to the Academy was the role of nature in the concept of the "ideal." Artists, if properly trained, should be able to produce the ideal in their work. The representation of emotion through physiognomy, expression, and gesture was also discussed at length by Charles Le Brun, who headed the Academy for twenty years. All such considerations were subjected to a system of rules, derived partly from Platonic and Renaissance theory and partly from the French interest in the creation of an aesthetic order.

The subject matter of art was also organized according to a hierarchy. At the top were the Christian Sacraments, followed by history painting. In these two categories, the philosophy of the Academy supported the religious and political hierarchy imposed by Louis XIV. Next in line were portraiture, genre, landscape (with or without animals), and, lowest on the scale, still life.

Despite the Academic emphasis on systems and rules, artistic "quarrels" were prevalent. High Renaissance arguments over the merits of line and color (*disegno* and *colorito*) continued in the Baroque period, now exemplified by Poussin and Rubens. The *Rubénistes* championed color, while the *Poussinistes* preferred line. A parallel quarrel between the "Ancients" and "Moderns" arose: this concerned the question of which group was the best authority for artists to follow. The Ancients were more traditional and tended to be allied with the proponents of *disegno* and Poussin. Line was considered rational, controlled, and Apollonian. Color, which was allied with Rubens and the Moderns, was emotional, exuberant, and related to Dionysiac expression.

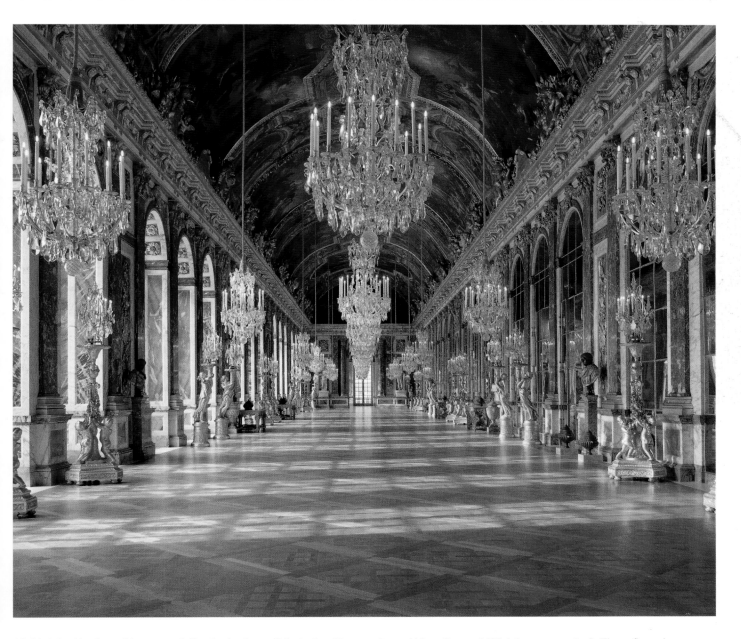

19.10 Jules Hardouin-Mansart and Charles Le Brun, Galerie des Glaces, palace of Versailles, c. 1680 (after restoration). The reflected sunlight in the Hall of Mirrors was only one of the many solar allusions at Versailles. The Salon d'Apollon, named after Apollo, was the throne room. The gardens are laid out along axes that radiate like the sun's rays from a central hub. They are adorned with sculptures illustrating Apollonian myths.

Unprecedented in scale and grandeur, the palace at Versailles was intended to glorify the power of the French monarch, and so was its iconography. The latter was supervised by Le Brun, who portrayed Louis as the *Roi Soleil* (Sun King), an appellation designed to bolster his divine right to rule. The unrivaled splendor and life-giving force of the king were proclaimed throughout the lavish interior of the palace, as well as in the gardens.

A second stage in the construction of Versailles lasted from 1678 to 1688, and included the great Galerie des Glaces, or Hall of Mirrors (fig. **19.10**), which was added by Jules Hardouin-Mansart. The Galerie has seventeen large arched mirrors, which constitute a literal wall of glass. At each end of the Hall of Mirrors are the Salons of War and Peace, decorated with the relevant symbols. Foreign ambassadors were received in the appropriate salon to learn Louis' political intentions.

Above the main entrance, at the center of the palace, was the king's bedroom. Here, Louis enacted his daily ceremonies of *lever* (rising) and *coucher* (going to bed), which identified him with the rising and setting sun.

England

Baroque was also the architectural style of seventeenth-century England. Its greatest exponent was Sir Christopher Wren (1632–1723). Following the Great Fire (1666), which destroyed more than two-thirds of the old walled City of London, Wren was appointed the King's Surveyor of Works. From 1670 to 1700 he took part in redesigning fifty-one of the churches that had burned down. Wren's priority during this period, however, was St. Paul's, the first cathedral to be built for the Protestant Church of England.

The longitudinal section and plan (fig. **19.11**) blended elements from several styles. The formal arrangement (although not the style) of the nave, side aisles, and clerestory is Early Christian. The western façade (fig. **19.12**), with its paired columns and central pediment, is reminiscent of the Louvre. Two flanking towers, although similar in conception to Gothic cathedral towers, are more Baroque in their execution. They combine round and triangular pediments on the two lower stories, while curved walls appear at the bases of the spires. On the two stories of the façade between the towers, like the façade of the Louvre, paired Corinthian columns support an entablature. Both are also crowned by a triangular pediment. The dome, which rises over the crossing and spans both nave and aisles, was originally a Renaissance feature.

It took forty years to complete St. Paul's under Wren's supervision. The result is a successful synthesis of French and Italian Baroque, with elements of Renaissance and Gothic style.

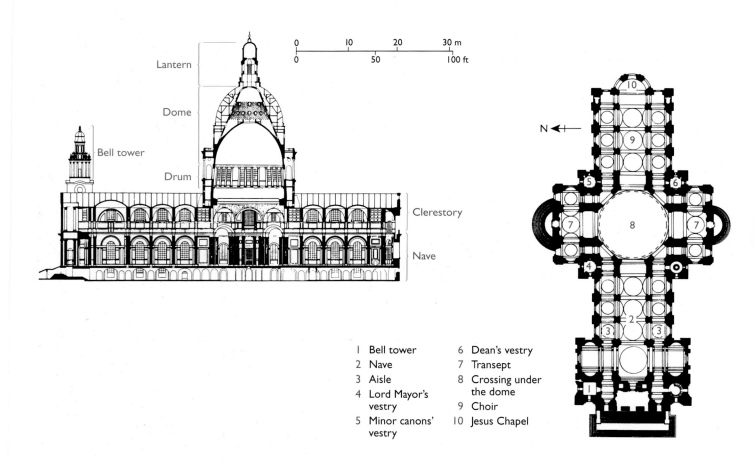

1 Bell tower
2 Nave
3 Aisle
4 Lord Mayor's vestry
5 Minor canons' vestry
6 Dean's vestry
7 Transept
8 Crossing under the dome
9 Choir
10 Jesus Chapel

19.11 Longitudinal section and plan of St. Paul's Cathedral, London. An invisible conical brick structure supports the lantern and the lead-faced wooden framework of the outer dome. Extra support is supplied by flying buttresses, which are masked by the upper parts of the side aisle walls.

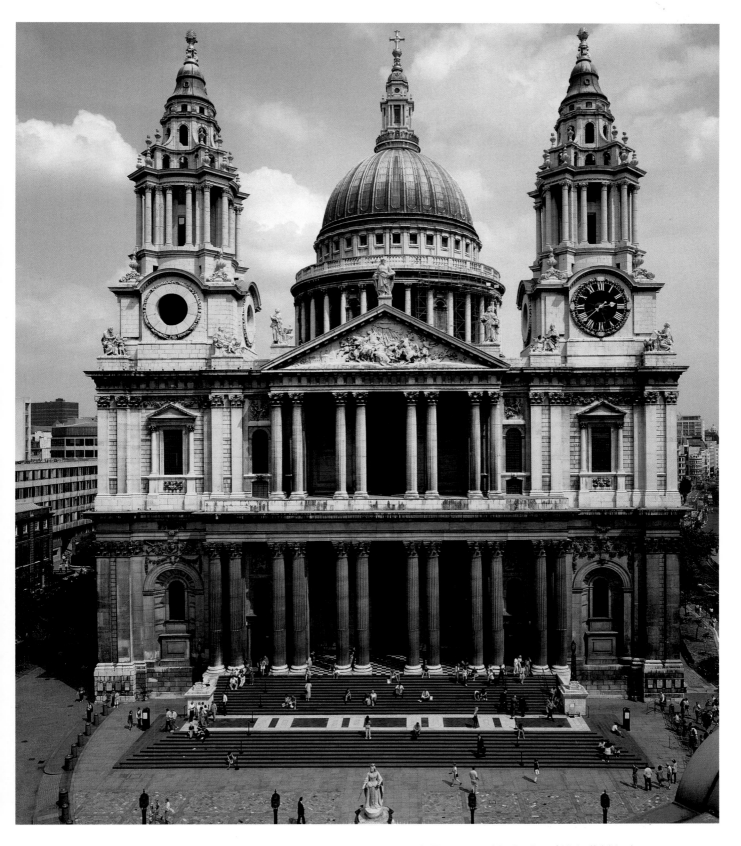

19.12 Christopher Wren, St. Paul's Cathedral, London, western façade, 1675–1710. The dome of St. Paul's is 112 ft. (34.14 m) in diameter and 300 ft. (91.44 m) high, second in size only to St. Peter's in Rome. Even today, the dome dominates the London skyline, although the lower façade is easily visible only from nearby.

Sculpture: Gianlorenzo Bernini

By far the most important sculptor of the Baroque style in Rome was Gianlorenzo Bernini. In his life-size marble sculpture *David* of 1623 (fig. **19.13**), all trace of Mannerism has disappeared. He represents a narrative moment requiring action. David leans to his right and stretches the sling, while turning his head to look over his shoulder at Goliath. In contrast to Donatello's relaxed, self-satisfied bronze *David* (see fig. **15.17**), who has already killed Goliath, and Michelangelo's (see fig. **16.15**), who tensely sights his adversary, Bernini's is in the midst of the action.

The vertical plane of the Renaissance *Davids* has become, in the Baroque style, a dynamic diagonal extending from the head to the left foot. That diagonal is countered by the left arm, the twist of the head, and the drapery. Although Bernini's *David* is a single figure, it assumes the presence of Goliath, thereby expanding the space—psychologically as well as formally—beyond the sculpture. This is a characteristic, theatrical Baroque technique for involving the spectator in the work.

Even more theatrical is Bernini's "environmental" approach to the chapel of the Cornaro family (fig. **19.14**) in the church of Santa Maria della Vittoria. The Cornaro Chapel illustrates Bernini's skill in integrating the arts in a single project. Here he uses the chapel as if it were a little theater. Directly opposite the worshiper, the altar wall opens onto the dramatic encounter between Saint Teresa and the angel. Joining the worshiper in witnessing the miracle are members of the Cornaro family, who are sculptured in illusionistic balconies on the side walls.

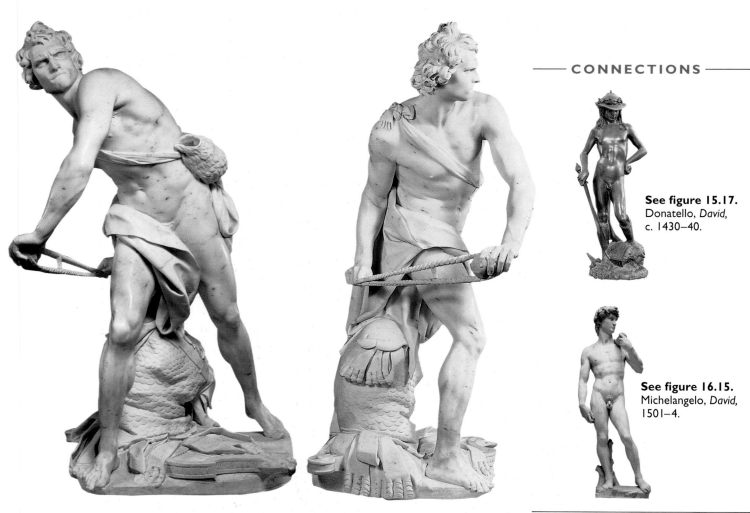

— **CONNECTIONS** —

See figure 15.17.
Donatello, *David*, c. 1430–40.

See figure 16.15.
Michelangelo, *David*, 1501–4.

19.13a Gianlorenzo Bernini, *David*, 1623. Marble, life-size. Galleria Borghese, Rome, Italy. According to Bernini's biographers, Cardinal Maffeo Barberini (elected pope in 1623) held up a mirror so that Bernini could carve the David's face as a self-portrait. Whether true or not, the story is consistent with Bernini's habit of studying his mirror reflection for the purpose of self-portraiture.

19.13b Gianlorenzo Bernini, *David*, side view (after cleaning).

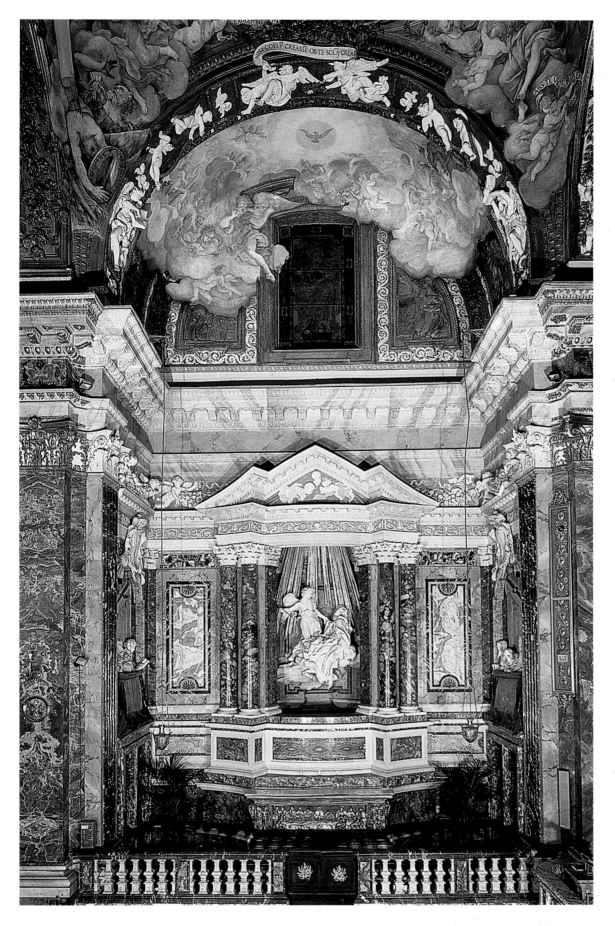

19.14 Gianlorenzo Bernini, Cornaro Chapel, Santa Maria della Vittoria, Rome, 1640s.

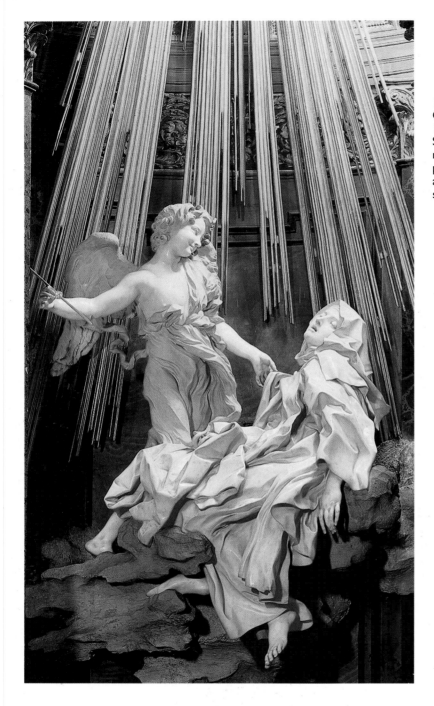

19.15 Gianlorenzo Bernini, *Ecstasy of Saint Teresa*, Cornaro Chapel, Santa Maria della Vittoria, Rome, Italy. Marble, 11 ft. 6 in. (3.51 m) high. Saint Teresa was born in Ávila, Spain, in 1515. She was a Carmelite nun who described the mystical experience depicted here. An angel from heaven pierced her heart with a flaming golden arrow. Pleasure and pain merged, and she felt as if God were "caressing her soul." She was canonized in 1622.

The Cornaro Chapel was the funerary chapel of Cardinal Federico Cornaro, who came to Rome from Venice in 1644. The main event over the altar is the *Ecstasy of Saint Teresa* (fig. **19.15**), representing the visionary world of the mystic saint. Life-size figures are set in a Baroque niche with paired Corinthian columns and a broken pediment over a curved entablature. As in the *David,* Bernini represents a moment of heightened emotion—in this case, the transport of ecstasy. The angel prepares to pierce Saint Teresa with an arrow as he gently pulls aside her drapery. His own delicate drapery flutters slightly as if he has just arrived. Although Teresa appears elevated from the ground, she is actually supported by a formation of billowing clouds. Leaning back in a long, slowly curving diagonal plane, she closes her eyes and opens her mouth slightly, as if in a trance. Her inner excitement contrasts with the relaxed state of her body and is revealed by the energetic drapery folds, which blend with the clouds. Behind Saint Teresa and the angel are gilded rods, representing rays of divine light descending from heaven.

This scene combines the Baroque taste for inner emotion with Counter-Reformation mysticism. Only a sculptor as great as Bernini could combine powerful religious content with erotic implications in a way that would satisfy the Church. Also characteristic of the Baroque style is Bernini's ability to draw the observer into the event, which is reinforced by the theatrical arrangement of the chapel itself. Sculptures of the Cornaro family on the side walls occupy an illusionistic architectural space combining the Ionic Order with a barrel-vaulted ceiling and a broken pediment. Some of the onlookers witness and discuss Saint Teresa's mystical experience just like theatergoers watching a play.

Italian Baroque Painting

Caravaggio

The leading Baroque painter in Rome was Michelangelo Merisi, called Caravaggio (1571–1610) because he was born in the small northern Italian town of Caravaggio. When he was eleven, his father apprenticed him to a painter in Milan. In about 1590 Caravaggio moved to Rome, where his propensity for violence landed him in repeated difficulties. During his relatively short life, despite the interruptions to his career caused by brushes with the law, Caravaggio worked in an innovative style that influenced painters in Italy and Northern Europe. He painted directly on the canvas, making no preliminary drawings. His depiction of religious themes was intended to appeal to the ordinary observer and was not aimed at a social or cultural elite. In his more private commissions, Caravaggio was equally direct in depicting subjects and themes of a homoerotic nature.

In his early *Boy with a Basket of Fruit* (fig. **19.16**), the convincing rendition of the fruit leaves no doubt about Caravaggio's close study of nature. Details such as the points of light on the grapes and the veins in the leaves contribute to the realistic effect. The boy stands out against a background divided by irregular illumination—a characteristic of the Baroque style. He may be a fruit vendor, but he offers himself as well as the fruit to the observer.

In contrast to the Renaissance view of painting as the natural world made visible through the window of the picture plane, Baroque artists draw the observer into the picture by means other than Brunelleschian linear perspective. In this painting, Caravaggio attracts us through the diagonals of the boy's right arm and the tilt of his head. His seductive nature is reinforced by the theatrical quality of his illumination. The fruit, which traditionally has erotic connotations, creates another transition between the observer and the boy. For example, the bright red and yellow peach at the front of the basket is a visual echo of the bare shoulder. Both have a slight cleft, repeated in the boy's chin, as if to suggest that the boy is as edible as the fruit. The wilting leaf at the right, which droops from the basket, is a reference to time. Together with the yellow piece of fruit turning brown in the center of the basket, the leaf calls on the viewer to enjoy life's pleasures—of the palate as well as of the flesh— before they become rotten with age.

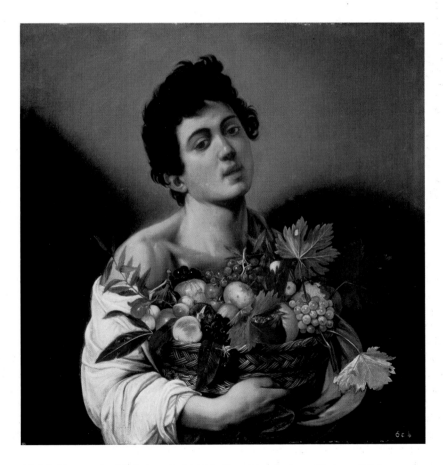

19.16 Caravaggio (Michelangelo Merisi), *Boy with a Basket of Fruit*, c. 1594. Oil on canvas, 27½ × 26⅜ in. (70 × 67 cm). Borghese Gallery, Rome, Italy.

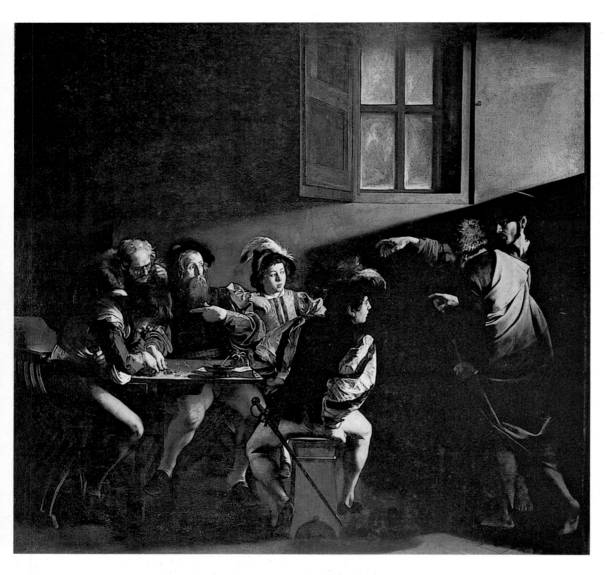

19.17 Caravaggio, *Calling of Saint Matthew*, 1599–1600. Oil on canvas, 10 ft. 6¾ in. × 11 ft. 1⅞ in. (3.2 × 3.4 m). Contarelli Chapel, San Luigi dei Francesi, Rome, Italy. Caravaggio's criminal behavior and acquaintance with Roman street life clearly contributed to the character of this picture. In 1606 he fled Rome after killing a man in a dispute over a tennis match. He died of a fever in 1610 before news of the pope's pardon reached him.

The *Calling of Saint Matthew* (fig. **19.17**) is a good example of Caravaggio's innovative approach to Christian subjects. Following the account in the Gospel, Jesus and an apostle approach a group of older men and youths who are counting money. Among them is Matthew, the tax collector. Jesus points to him with a gesture that is a visual quotation of Michelangelo's *Creation of Adam* (see fig. **16.18**), as if to say, "Follow me." This parallels Adam's original creation with Matthew's re-creation through Jesus. The coin set in Matthew's hatband underlines his preoccupation with money. His own gesture echoes that of Jesus, however, and indicates that his future will be dedicated to Jesus's service.

In the *Calling of Saint Matthew*, Caravaggio's **tenebrism** —the use of sharply contrasting light and dark—enhances the Christian message. Jesus enters the picture from the right, along with a miraculous shaft of light penetrating the darkness. Light is ironically juxtaposed with sight in the two figures on the far left. The young man who does not see Jesus because he is focusing intently on money is covered in shadow. The old man leaning over him peers through his spectacles. But, in his myopia, he sees only the money and remains oblivious to the significance of the event taking place right beside him.

CONNECTIONS

See figure 16.18.
Michelangelo, *Creation of Adam*, c. 1510.

Artemisia Gentileschi

Caravaggio's unstable lifestyle did not lend itself to maintaining a workshop or employing apprentices. Nevertheless, he had a major influence on Western art. Among his followers, known as the *Caravaggisti*, was Artemisia Gentileschi (1593–1652/3), one of the first women artists to emerge as a significant personality in Europe (see Box).

Artemisia's *Judith Slaying Holofernes* (fig. **19.18**), which exhibits the Baroque taste for violence, illustrates an event from the Book of Judith in the Old Testament Apocrypha. The Assyrian ruler Nebuchadnezzar has sent his general

Over the past forty years, largely as a result of the feminist movement, art historians have researched and reevaluated the role of women artists in Western art. Women's achievements in the visual arts and the obstacles they have had to overcome are now much better understood.

Pliny's *Natural History* lists the names of five women artists in ancient Greece and Rome, together with their works, although nothing else is known of them. From the Roman period through the end of the fourteenth century, there are relatively few records of any individual artists, men or women. During the Middle Ages, women played a major role in the production of embroidery and tapestry—though more so in Northern Europe than in Italy. They were also active in the illumination of manuscripts, although this was largely confined to the daughters of wealthier families. Until the late thirteenth century, illumination was done by nuns, and a woman needed a dowry to enter a convent.

The bylaws of the Company of Saint Luke, a confraternity of artists in Florence, founded in 1361, mention dues to be paid by women members. However, no women's names are found in the company's records. From the fifteenth century onward, beginning in Italy, women artists emerge from obscurity. There is evidence, for example, that a woman submitted a model for the lantern of Brunelleschi's dome over Florence Cathedral, but her name is unknown. Previously, women artists in Italy had usually been nuns—they were women of education and talent, but their work was limited because of their isolation from the wider artistic community. Exceptions include Sofonisba Anguissola (see Chapter 17), who worked for Philip II of Spain, Caterina van Hemessen (see Chapter 18), who was a court painter to Mary of Hungary, and Tintoretto's daughter Marietta (see Chapter 17).

Artemisia Gentileschi was the first woman to join the successor of the Company of Saint Luke, the Accademia del Disegno (Academy of Design), in 1616.

The elevated status of the artist in the Renaissance was largely the result of a new humanist educational curriculum. For the first time, artists mixed socially with the princes of the Church and the nobility as intellectual equals rather than as artisans and craftsmen. Gradually, the new educational standards were extended, especially among the ruling classes, to women. They were encouraged to engage in a wider range of activities, including poetry, music, and art (in that order). By the sixteenth century it was generally agreed that the daughters of the middle classes should be educated. Women who wanted to become artists had to be trained in the workshops of established masters; many were the daughters, sisters, or wives of artists. The courts of fifteenth- and sixteenth-century Italy produced women who were patrons as well as artists. Nevertheless, attributions are always a problem with women, for works by women were likely to have been delivered under the name of the male head of a workshop.

Despite advances made by women in the Renaissance, practical obstacles remained. Marriage, usually followed by continuous childbearing, interfered with some promising careers. Artemisia Gentileschi was unusual in being able to combine a successful career with marriage and motherhood. Women were also barred from drawing from live models, which prevented competition on equal terms with men. Artemisia Gentileschi drew from female models, but familiarity with the male nude was important for monumental works. It is thus no accident that, until recently, women's artistic achievements were generally confined to portraiture and still life.

19.18 Artemisia Gentileschi, *Judith Slaying Holofernes*, c. 1614–20. Oil on canvas, 6 ft. 6⅜ in. × 5 ft. 4 in. (1.99 × 1.63 m). Galleria degli Uffizi, Florence, Italy. Artemisia learned painting from her father, Orazio. In 1611 Orazio hired Agostino Tassi to teach her drawing and perspective. Tassi raped Artemisia and then refused to marry her. When Orazio sued Tassi, Artemisia was tortured with thumbscrews to test her veracity before Tassi was convicted. Undoubtedly affected by this experience, Artemisia is known for her pictures of heroic women and of violent scenes.

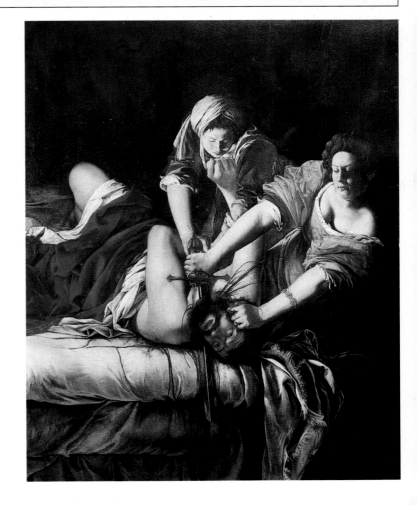

Holofernes to lay waste the land of Judah. A Hebrew widow of Bethulia, Judith, pretending to be a deserter, goes with her maidservant to the camp of Holofernes and flirts with him. Arranging to spend the evening alone with him, Judith plies him with liquor until he falls into a stupor, and then uses his own sword to cut off his head. She places the head in a bag and returns home; the head is exhibited from the city walls, and the Assyrians disperse. Artemisia depicts the moment at which Judith plunges the blade through Holofernes' neck. The violence of the scene is enhanced by the dramatic Caravaggesque shifts of light and dark and by the energetic draperies.

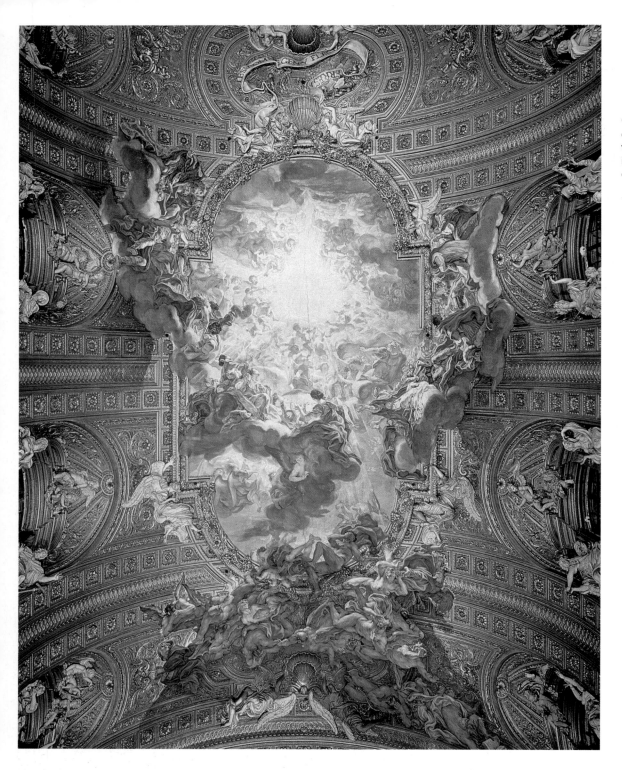

19.19 Giovanni Battista Gaulli, *Triumph of the Name of Jesus*, 1676–79. Ceiling fresco with **stucco** figures in the vault of the Church of Il Gesù, Rome, Italy.

Giovanni Battista Gaulli

A type of painting that reflected a new level of Counter-Reformation exaltation of Catholicism was the decoration of church ceilings. One of the most spectacular of the seventeenth-century ceiling paintings in Rome is Giovanni Battista Gaulli's fresco of the *Triumph of the Name of Jesus* in the vault of Il Gesù (fig. **19.19**). The artist had worked with the devoutly Catholic Bernini in Rome and eventually surpassed him in illusionistic effects.

In a large oval space framed by architectural features and writhing figures, Gaulli painted IHS, the first three let-ters of "Jesus" in Greek, as a dramatic source of formal and spiritual light. The scene resembles a Last Judgment, with the saved rising toward the white light of Christ's name. As they approach the IHS, they dissolve into light, thus creating a more mystical vision of salvation than Michelangelo's. The damned, in contrast, are weighty and depicted in shadow as they plummet toward the nave below. Worshipers thus appear to be on the same plane as the sinners, while the vault of heaven and of the mother church of the Jesuit Order merge in a blaze of light.

Baroque Painting in Northern Europe

In Flanders the Catholic Church was the primary patron of the arts. In Protestant Holland, on the other hand, the development of a bourgeois economy and a free commercial art market resulted in a significant change in the kind of art produced. For the first time, artists were able to support themselves by specializing in a category such as portraiture, still life of various kinds, genre, or landscape. Art dealers sold works to middle-class citizens, who often purchased as much for investment and resale as for aesthetic pleasure.

Flanders: Peter Paul Rubens

Peter Paul Rubens (1577–1640) was one of the most productive Flemish painters of the seventeenth century. He worked for the Church, the nobility, private citizens, and himself. Rubens ran a successful workshop with many apprentices and dealt shrewdly in the art market. He undertook important diplomatic missions for the Spanish Netherlands and was court painter to the governors of their territory. In the late 1620s, Rubens spent several months at the Spanish court of Philip IV, where he influenced Velázquez (see p. 363).

Rubens's mythological paintings, such as *Venus and Adonis* (fig. **19.20**), celebrate the sensual side of life and seem unaffected by the Counter-Reformation. They also reflect Rubens's Classical education. In this work, Venus tries to prevent her handsome mortal lover Adonis from departing. His hunting dogs wait impatiently as he tries to disengage from the goddess and her son Cupid, who has placed his bow and arrow on the ground and tugs at Adonis's leg. Venus clings to his arm as he turns back, allowing his right hand to linger on her thigh. The ambivalence of Adonis's pose, forming a long diagonal, reveals his conflict between staying and leaving.

Venus herself forms a counterdiagonal, her fleshy, highlighted body a variation on the traditional reclining nude. In contrast to Classical and Renaissance reclining nudes, Rubens's figure is actively, rather than passively, seductive. Venus's more active role in this scene is consistent both with the particular myth and with the moment represented, in which she attempts to control and dominate her lover. Her proportions have also ventured some distance from those of Classical antiquity, for Rubens has emphasized her generous breasts and rippling, dimpled flesh in a way that is frankly sensuous. It is likely that, for Rubens, such full figures reflected, among other things, the Flemish equation of fleshiness with prosperity.

In contrast to the *Venus and Adonis*, the central panel of the monumental triptych in Antwerp Cathedral depicting

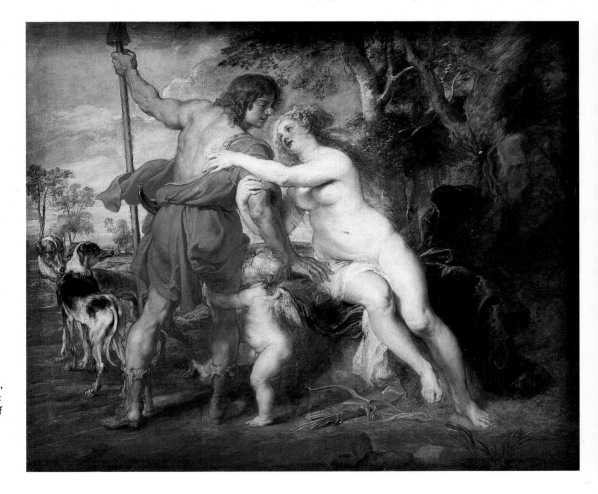

19.20 Peter Paul Rubens, *Venus and Adonis*, c. 1635. Oil on canvas, 6 ft. 5½ in. × 7 ft. 11¼ in. (1.97 × 2.42 m). Metropolitan Museum of Art, New York (Gift of Harry Payne Bingham, 1937).

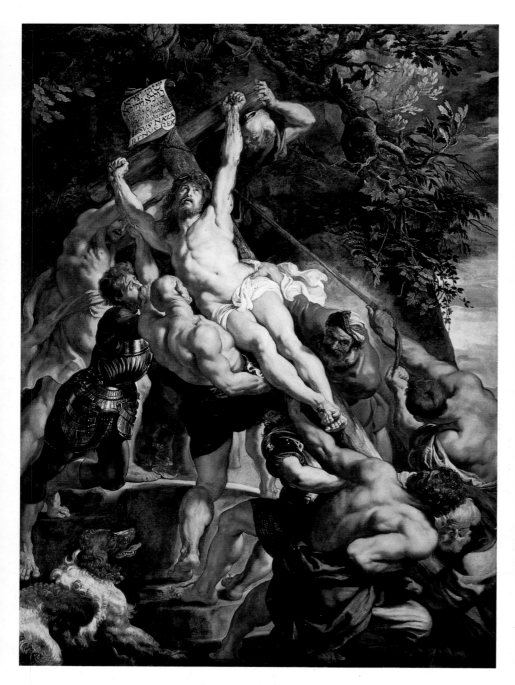

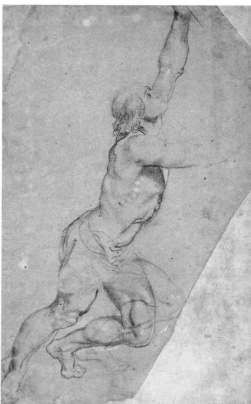

19.21 (Left) Peter Paul Rubens, *Raising of the Cross*, center panel of triptych, originally for the church of St. Walburgis and now in Antwerp Cathedral, 1610–11. Oil on canvas, 15 ft. 1⅞ in. × 11 ft. 1½ in. (4.62 × 3.39 m).

19.22 (Above) Peter Paul Rubens, *Nude Man with Arms Raised*, c. 1610. Black chalk heightened with white, 19¼ × 12⅜ in. (49.0 × 31.5 cm). Koninklijk Huisarchief, Collection of H.M. The Queen of the Netherlands.

the *Raising of the Cross* (fig. **19.21**) is very much affected by Counter-Reformation concerns. Formally and emotionally, viewers are drawn into the picture, and their identification with Jesus's suffering is powerfully evoked. The composition is based on the sharp diagonal of Jesus and the Cross, their weight accentuated by the muscular figures struggling to elevate them into an upright position. A touch of realism is introduced in the dog barking excitedly at the lower left—Rubens has meticulously depicted the texture of its curly coat.

The image juxtaposes the brute force of the executioners with Jesus's enlightened spirituality. In contrast to the pushing and pulling necessary to raise the Cross, Jesus seems to soar toward heaven, despite the suffering caused

by the nails and the crown of thorns. His form is the most extended highlight in the painting, which is a reminder of his role as the Light of the World. Fluttering weightlessly over his head are inscriptions in Latin, Greek, and Hebrew proclaiming Jesus "King of the Jews."

Rubens was a great draftsman as well as a major painter. In figure **19.22** we can see his use of drawing as a way of studying figural poses for a painting. Here *Nude Man with Arms Raised* is a study for the soldier at the left of figure **19.21** who helps to raise the Cross. Shading delineates the structure of the nude, while the double left leg reveals the experimental, preliminary character of the drawing. As is often the case with drawing studies, this one offers clues to the artist's working process.

Holland: Rembrandt van Rijn

Rembrandt van Rijn (1606–69) was born in Leiden, in Protestant Holland. He became a successful painter and moved to Amsterdam. Unlike Rubens, Rembrandt worked largely for Protestant patrons. However, he ran his own commercial enterprise, as free as possible from the influence of patronage, preferring that his works be valued as "Rembrandts" rather than as products of a contractual agreement. With this attitude Rembrandt virtually invented the modern art market. He also reflected the seventeenth-century rise in Dutch capitalism, which had become international in scope.

The subject matter of Rembrandt's paintings includes biblical and mythological scenes, landscapes, and portraits. Like Caravaggio, Rembrandt was attracted to the dramatic effects of light and dark, but he used them to create the character of his figures as much as their background.

In the Old Testament scene of *Belshazzar's Feast* (fig. **19.23**), Rembrandt emphasizes the mystical light required by the text. Belshazzar, the son of the regent of Babylon in the sixth century B.C., sees a great light on the wall during a feast. Beside the light a hand appears with a cryptic message, which Daniel interprets as "You have been weighed in the balance and found wanting." The same night, Belshazzar is killed, fulfilling the sense of menace that is still popularly associated with "handwriting on the wall."

Rembrandt's Belshazzar rises from the table and turns to face the mysterious light. He extends his arm, creating a sweeping diagonal and displaying the elaborate gold embroidery of his cloak. Light is also concentrated on his face, jewelry, turban, and crown, contrasting these reflections of his material wealth with the illumination of inner fear and awe in the faces of the two figures on Belshazzar's right (our left) and with the light from heaven appearing on the wall. This painting is primarily rendered in warm brown tones, with a prominent color shift in the red-orange of the woman at the lower right corner. She withdraws in fear from the light and spills her drink. In so doing, she helps to draw the observer into the picture plane through her forceful diagonal movement.

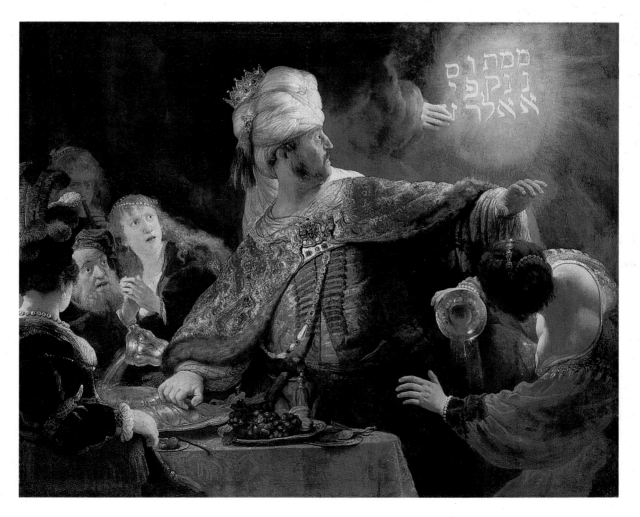

19.23 Rembrandt van Rijn, *Belshazzar's Feast*, c. 1635. Oil on canvas, 5 ft. 5¾ in. × 6 ft. 9½ in. (1.67 × 2.07 m). National Gallery, London, England. Rembrandt shared the Baroque interest in naturalism. For his Old Testament scenes, he liked to frequent the Jewish quarter of Amsterdam for inspiration and models.

By the middle of his career, Rembrandt was Amsterdam's most esteemed portrait painter. As Church patronage waned in the Protestant countries, secular groups began to commission works of art. Rembrandt's *Night Watch* (fig. **19.24**) is a group portrait that depicts a militia company, led by Captain Banning Cocq, leaving Amsterdam on a shooting expedition. The city wall, pierced by an arch in the background, evokes the triumphal arches of ancient Rome; it also reminded viewers that the Dutch had overthrown their Spanish conquerors and were now a free people.

The two men striding into the foreground form a diagonal link between the observer and the company. The captain extends his left hand as if to invite us into the scene. Light falls onto his hand from above and casts a shadow across the yellow jacket of his companion. As a result, the shadow continues the line of the captain's red sash, creating a typical Baroque interplay of lights, darks, and colors.

The facial features are defined by gradations of light and dark. Each figure appears to be a portrait. Included in the crowd is a young woman highlighted in yellow; hanging from her belt is a bird, whose claws were the emblem of the militia. Peering out over the shoulder of the flag-bearer is Rembrandt's own face—possibly his most unassuming self-portrait.

Rembrandt painted many portraits and more self-portraits than any other artist before the seventeenth century. Including paintings, etchings, and drawings, he produced at least seventy-five self-portraits, which constitute a visual autobiography. They chronicle Rembrandt's changing fortunes and moods and, above all, his journey through life from youth to old age.

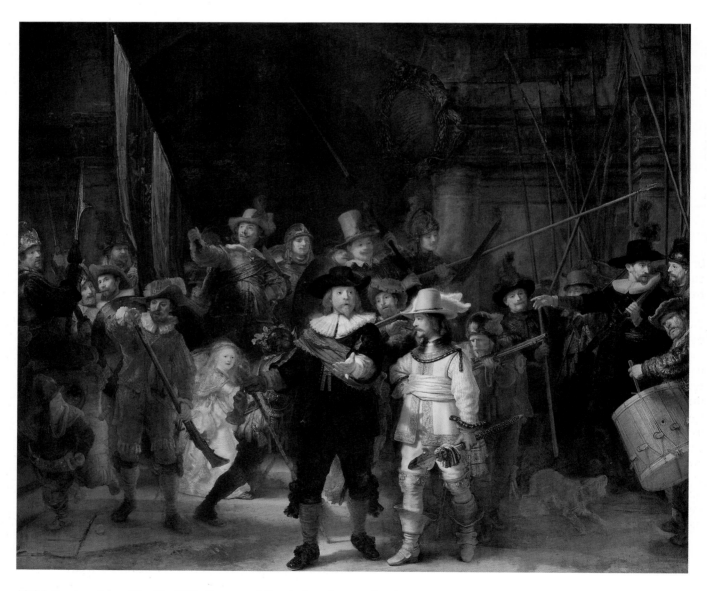

19.24 Rembrandt van Rijn, *The Militia Company of Captain Frans Banning Cocq* (known as *The Night Watch*), 1642. Oil on canvas, 12 ft. 2 in. × 14 ft. 4 in. (3.71 × 4.37 m). Rijksmuseum, Amsterdam, Netherlands. This was originally located in the headquarters of the Amsterdam Civic Guard. In 1975 a cook who had been fired from the Dutch navy slashed *The Night Watch*. This painting is so identified with the Dutch nation that the sailor believed he was taking revenge on the Dutch Republic itself.

TECHNIQUE
Etching

Etching, like engraving, is an intaglio method of producing multiple images from a metal (usually copper) plate. In etching, the artist covers the plate with a resinous acid-resistant substance (the **etching ground**). A pointed metal instrument, or stylus, is then used to scratch through the ground and create an image on the plate. When the plate is dipped in acid or some other corrosive chemical, the acid eats away the exposed metal. In so doing, it creates grooves where the ground was scratched through by the stylus. The ground is then wiped off, the plate is inked, and impressions are taken, just as in engraving. The result, however, is different. Whereas in engraving the artist pushes the burin to cut into the metal surface, the etching stylus moves more easily through the ground, allowing for more delicate marks and greater freedom of action. The result is a more convincing sense of spontaneity in the image and a blurred, atmospheric quality (see, for example, the sleeves in fig. **19.26**).

Rembrandt also used the intaglio **drypoint** method, in which the image is scratched directly onto the plate. "Dry" signifies that acid is not used. The incisions on the plate make metal grooves with raised edges, called the **burr.** When the drypoint plate is inked, the burr collects the ink and produces a soft, rich quality in the darker areas of the image.

In both etching and drypoint, the burin can be used for emphasis. It is possible to combine the two techniques in one image, as Rembrandt did. It is also possible to make alterations to an etched or engraved plate and then produce additional prints. One can see the artist's changes by studying in order the different **states,** or subsequent versions, of the same image.

19.25 (Above) Rembrandt van Rijn, *Self-Portrait in a Cap, Open-mouthed and Staring,* 1630. Etching, 2 × 1⅞ in. (5.1 × 4.6 cm). Rijksmuseum, Amsterdam, Netherlands.

The medium of etching (see Box) was suited to Rembrandt's genius for manipulating light and dark. Although etching had been invented in the sixteenth century, it was Rembrandt who perfected the technique during the seventeenth century. The two small self-portrait etchings reproduced here illustrate his use of black and white, or pure dark and pure light, to convey character.

Figure **19.25** shows the twenty-four-year-old Rembrandt in a cap. His youthful vigor is indicated by the short, wavy lines of hair and the sharp twist of the head. Something seems suddenly to have caught his attention, for his eyes are round with wonder and his mouth is slightly open as if he is about to speak. Rembrandt studied his own facial expressions in a mirror, which he used in self-portraits and biblical scenes. Figure **19.26** was executed in 1639 and shows a well-dressed Rembrandt, his hat perched rakishly on his head, exuding the self-confidence of success. His inner artistic energy seems to shine forth from the illumination of his face.

19.26 Rembrandt van Rijn, *Self-Portrait Leaning on a Stone Sill,* 1639. Etching and drypoint, state 2, 8⅛ × 6½ in. (20.5 × 16.4 cm). Rembrandt House Museum, Amsterdam, Netherlands.

By 1661, after several personal tragedies, Rembrandt is an older and sadder figure (fig. **19.27**). He is no longer the prosperous bourgeois artist, confident of his future. Now he is a "Saint Paul," humbled and saddened; his pose is less assertive, and he seems weighed down with care. Barely visible is the sword, which is Saint Paul's traditional attribute; it emerges in flecks of gold from under his left arm. Rather than endow Saint Paul with a conventional halo, Rembrandt weaves a yellow band into the cloth of his hat,

merging light, color, and the paint itself with content in a unique way. The figure looks up from the rather worn pages of an open book, as if shrugging his shoulders at the twists of fate. The slight tilt of his head and the loose brushwork emphasize the sagging cheeks. The raised eyebrows create a pattern of wrinkles on his forehead, and his hair has turned gray. As in the earlier pictures, Rembrandt highlights the face and hand, leaving a darkened surrounding space from which the figure seems to emerge.

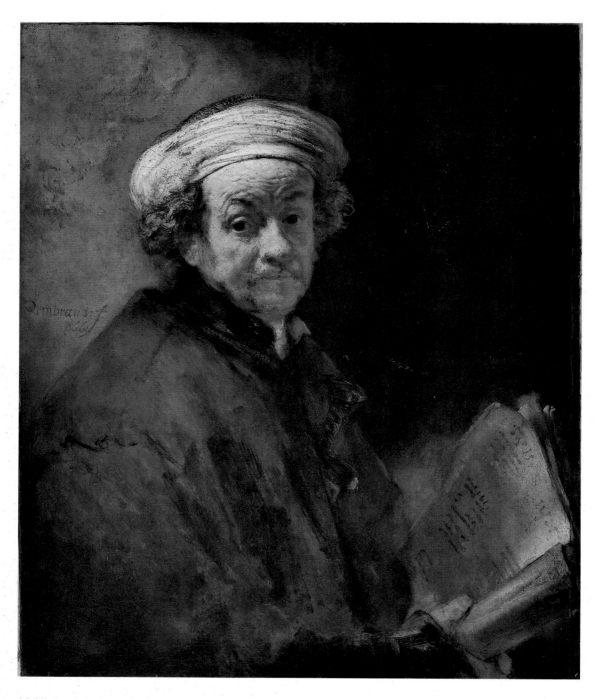

19.27 Rembrandt van Rijn, *Self-Portrait as Saint Paul* (age fifty-five), 1661. Oil on canvas, 35⅞ × 30⅜ in. (91 × 77 cm). Rijksmuseum Foundation, Amsterdam, Netherlands.

Frans Hals

Frans Hals (c. 1581–1666) worked mainly in Haarlem. Known primarily for his individual and group portraits, he did not have as wide a range of subject matter as Rembrandt. His portraits, such as *The Laughing Cavalier* (fig. **19.28**), convey a sense of exuberance, which in this case is enhanced by the sitter's pose, character, and proximity to the picture plane. The cavalier, a courtly soldier, is set at an oblique angle. His left arm forms two diagonals, simultaneously leading into and out of the picture space, and repeated in the torso and the tilted hat. He does not actually laugh, but the upturned curves of his mustache and his direct gaze create that impression. Hals's evident delight in the textural variations of the portrait add to its cheerful effect. The hat is nearly flat in contrast to the ruddy complexion and slightly fleshy face. The intricate lace and embroidery of the costume are interrupted, and relieved, by the broad brushstrokes defining the black silk sash.

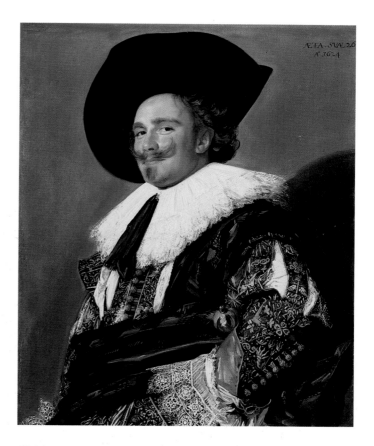

19.28 (Above) Frans Hals, *The Laughing Cavalier*, 1624. Oil on canvas, 33¾ × 27 in. (86 × 69 cm). Reproduced by permission of the Trustees, The Wallace Collection, London.

Judith Leyster

Judith Leyster (1609–90) also worked in Haarlem, where she was the only woman elected to the Painters' Guild. Her figures, like Hals's *Laughing Cavalier,* are vital and energetic. Her genre painting *The Last Drop* (formerly known as *The Gay Cavalier*) (fig. **19.29**) provides an instructive contrast to the Hals and shows the influence of Caravaggio's tenebrism. In *The Last Drop,* exuberance is created, as in the Hals, by broad, hearty gestures and strong diagonals. This is accentuated by Leyster's dramatic contrasts of light, dark, and color. Whereas Hals's figure is right up against the picture plane, Leyster's two youths are somewhat set back in space. They are less monumental in their impact, and they do not confront the viewer directly. Instead, the drinker engages us by his absorption in the wine cask, and the smoker by his graceful, dancelike motion. This iconography reflects the popularity of drinking, carousing, and smoking in the Dutch Republic. The skeleton and the hourglass allude to the passage of time and the inevitability of death, which were recurrent moralizing themes in seventeenth-century Dutch art.

19.29 Judith Leyster, *The Last Drop (The Gay Cavalier)* (after restoration), c. 1628–29. Oil on canvas, 35⅛ × 29 in. (89.3 × 73.7 cm). Philadelphia Museum of Art (The John G. Johnson Collection). Leyster was the daughter of a brewer in Haarlem. She married a painter of genre scenes and had five children. In 1635 she successfully sued Frans Hals for taking one of her students as his apprentice.

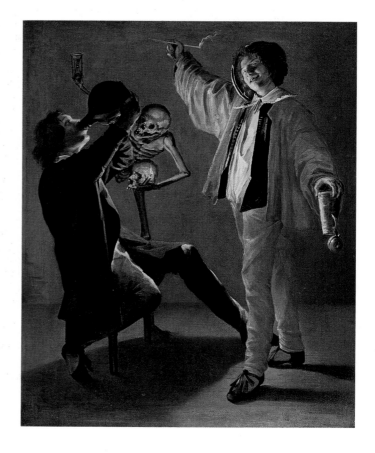

Jan Vermeer

Jan Vermeer (1632–75) left a very small number of pictures —no more than thirty-five in all. Like Rembrandt, he was a master of light, but in a completely different way. Most of his paintings are interior genre scenes, and many have allegorical meanings. His canvases are generally small, and his subjects, as well as their treatment, are intimate.

Vermeer's *Geographer* (fig. **19.30**) reflects both the Dutch interest in exploration and science, and the artist's meticulous depiction of interiors. It shows a scholarly geographer, surrounded by maps and charts. The globe above him refers to the exterior, which is contrasted with the enclosed space of the room. Reinforcing the sense of a vast world are the cropped map on the wall and the gaze of the geographer. He looks toward the window, whose light brightly illuminates his desk. Clearly preoccupied with the outside world, he holds a pair of dividers and rests his hand on a book. His intellectual energy is conveyed by his alertness and the sense that a sudden thought has arrested his movement.

Vermeer's characteristic use of light and color to convey texture is particularly evident in the wooden chest and rumpled tapestry. The areas of glistening, pearl-like light are typical of Vermeer and reflect contemporary advances in microscopic research. (The anatomist and microscopist Anton van Leeuwenhoek was appointed executor of Vermeer's estate.)

The juxtaposition of large spaces and minute detail characterizes Vermeer's largest canvas, the *View of Delft* (fig. **19.31**). It is a particularly striking example of Dutch taste for landscape, and it is unique among his known works. Vermeer has combined an atmospheric sky with houses and water in a way that illustrates his genius for conveying jewel-like areas of light. Despite the large size of the canvas, Vermeer's attention to meticulous detail creates a feeling of intimacy.

The shifting lights and darks of the clouds and the delicately colored buildings are reflected in the water. Standing on the shore in the foreground are a few small human figures, who seem insignificant compared with the vast sky and the implied continuation of the scene beyond the picture's frame. Their staunch verticals anchor the church spires, the towers of the drawbridge, and their reflections. Silvers, blues, and grays alternate in the sky, as yellow sunlight filters through the clouds. The sparkle of the sunlight, as it catches details of the houses or glimmers on the water, shows Vermeer's concern for naturalistic effects and creates a glowing, textured surface motion that was entirely new in Western European art.

19.30 Jan Vermeer, *The Geographer*, c. 1668. Oil on canvas, 20⅞ × 18¼ in. Städelsches Kunstinstitut, Frankfurt, Germany. Vermeer lived and worked in Delft, Holland. Little is known of his life and career, but it appears that he earned a good income from his paintings. After his death, his works were neglected by critics and collectors until the late 19th century. Today they are among the most highly valued in the world. The signature and date at the upper right are not original.

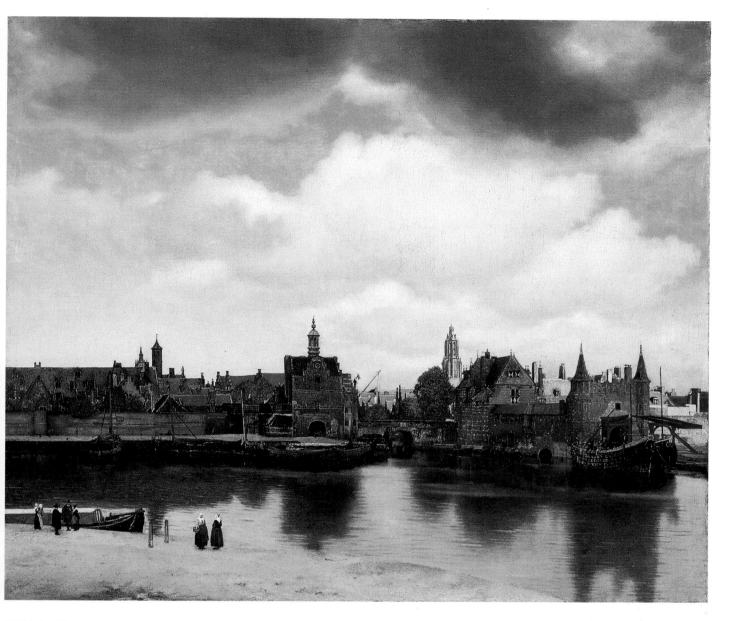

19.31 Jan Vermeer, *View of Delft* (after restoration), c. 1660–61. Oil on canvas, 3 ft. 2 in. × 3 ft. 9½ in. (0.97 × 1.16 m). Royal Cabinet of Paintings, Mauritshuis, The Hague, Netherlands.

Jacob van Ruisdael

The landscapes of Jacob van Ruisdael (c. 1628–82) are even more expansive than Vermeer's *View of Delft*. Much of Holland's landscape was artificially created by dikes, making Ruisdael's scenes resonate with the very survival of Holland. His panoramic view in the *Extensive Landscape with Ruins* (fig. **19.32**), for example, seems to encompass a vast space, which is expanded by the broad horizontal sweep of earth, water, and sky. Together these natural features produce a sense of atmospheric intensity enhanced by menacing clouds.

The strong vertical accent of the church tower anchors the painting and emphasizes the flatness of the landscape. Painterly atmospheric effects and imagery that shows the smallness of human creations (the church) in relation to the vastness of nature took on a moralizing quality in seventeenth-century Holland. The ruins show the deterioration over time of man-made works, in contrast to the seasonal renewal of nature.

19.32 Jacob van Ruisdael, *Extensive Landscape with Ruins,* 1660s. Oil on canvas, 13⅜ × 15¾ in. (34 × 40 cm). National Gallery, London, England.

Maria van Oosterwyck

The moralizing trends in Dutch art are perhaps clearest in Baroque **vanitas** still lifes. In contrast to the macrocosmic views of Dutch landscape, the still lifes reflect the microcosm. Both illustrate the scientific concerns of Northern Europe.

In the *Vanitas Still Life* of Maria van Oosterwyck (fig. **19.33**), each element contains a warning against folly. As such, it is well within the Northern tradition of Erasmus's *Adagia* (see p. 328). Flowers are transient and die—the tulip refers to the economic folly of the Dutch tulip craze, which collapsed in 1637. The skull, the stalk of grain being eaten by a mouse, and the ear of corn are images of transience and decay. An hourglass marks the passage of time, and the astrological globe contrasts the vastness of the universe and the notion that humanity is ruled by the stars with minute creatures such as flies and butterflies. Written texts accompanying the images reinforce their message: *Rekeningh* ("reckoning") alludes to the final accounting at the end of time, and *Self-Stryt* ("self-struggle") to the moral conflicts with which the human soul struggles. Visible in the carafe at the left are a window and the artist herself, continuing the Northern interest in reflective surfaces and in asserting the artist's presence in the work.

19.33 Maria van Oosterwyck, *Vanitas Still Life*, 1668. Oil on canvas, 29 × 35 in. (73.7 × 88.9 cm). Kunsthistorisches Museum, Vienna, Austria.

Mughal Art and the Baroque

The sixteenth-century age of exploration had led to colonization, missionary activity, and trade with the Americas and the Far East. In Holland, many Chinese and Japanese objects were imported through the Dutch East India Company. Although by and large any real understanding of these distant regions on the part of Europeans was minimal, Eastern motifs began to influence furniture design, and a general taste for the exotic emerged in Europe. These cultural exchanges were most meaningful in contacts with Mughal painters of seventeenth-century India. Rembrandt copied Mughal miniatures, and Rubens drew figures from the Mughal court.

The Mughal school of painting in India was known in Europe largely through the enlightened patronage of three emperors: Akbar (1555–1603), Jahangir (1603–27), and Shah Jehan (1627–66). Descended from Genghis Khan, Akbar's Persian grandfather founded the Mughal dynasty in India. Akbar himself endorsed the progressive notion that the divine status of a ruler depended on just and fair administration. His desire for political unity inspired him to collect European art.

Although orthodox Muslims in India objected to Akbar's patronage of figurative art, his son Jahangir encouraged artists to study nature and European painting. In the *Allegorical Representation of the Emperor Jahangir Seated on an Hourglass Throne* (fig. **19.34**), the Baroque interest in the theme of time (the hourglass) is incorporated into an Islamic setting. The border designs, the **calligraphic** lettering, and the elaborate carpet that flattens the space are a result of Persian influence. The figures and hourglass, on the other hand, are rendered three-dimensionally and are shaded. Jahangir, surrounded by a double sun and moon halo, greets four personages, who reveal his international outlook: a Muslim divine in a long white beard, a Muslim prince with a black beard, a European dressed as an envoy from the English court of King James, and an artist holding up a picture. Two little angels copied from a European painting play near the hourglass. Above and to the left, a Cupid carries a bow and arrow. To the right is another Cupid who covers his eyes, a reference to the Western notion of blind love.

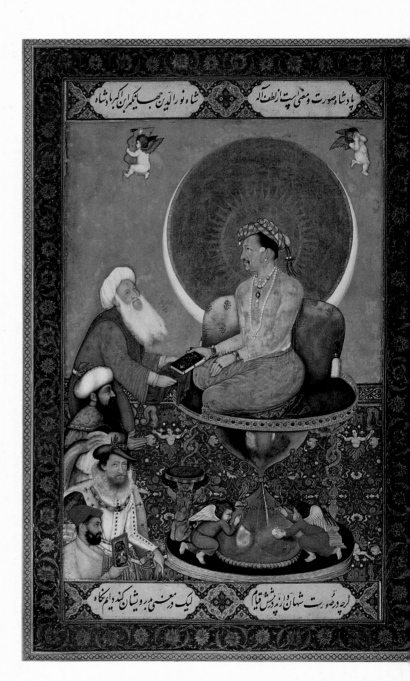

19.34 Bichtir, *Allegorical Representation of the Emperor Jahangir Seated on an Hourglass Throne*, early 17th century. Color and gold on paper, 10⅞ in. (27.6 cm) high. Courtesy of the Freer Gallery of Art and Arthur M. Sackler Gallery, Smithsonian Institution, Washington, D.C.

Spanish Baroque Painting

During the seventeenth century, Spain witnessed a so-called Golden Age in the visual arts. Early on, the influence of Caravaggio's tenebrism can be seen in the dark backgrounds and dramatic interest in naturalism. At the same time, the impact of the Counter-Reformation inspired scenes of martyrdom calculated to arouse the viewer's identification with Christian suffering.

Juan Sánchez Cotán

The still lifes of Juan Sánchez Cotán (1561–1627) reflect a new interest in the relationship of art and natural science at the turn of the seventeenth century. In *Still Life with Quince, Cabbage, Melon, and Cucumber* (fig. **19.35**), for example, the artist's fascination with precise natural detail and striking three-dimensional space is evident. The fruit and vegetables are rendered with an exactitude that is enhanced by the flat, dark background, in front of which is a perspectival setting. The cast shadows and illuminated wall to the right indicate a light source from the left. In this arrangement of light and dark, Cotán creates an intentional spatial ambiguity that forces the viewer to focus on the contrast between the curvilinear still-life details, in particular the *tour-de-force* of realism, and the angular, geometric quality of their setting.

Francesco de Zurbarán

Francesco de Zurbarán's (1598–1664) *Saint Serapion* of 1628 (fig. **19.36**) is a painting of martyrdom, in which the human suffering of the saint is also shown against a dark background. Serapion belonged to the Spanish Order of Mercedarians, dedicated to rescuing Christians captured by the Moors. He was martyred when he agreed, as the Order required, to die in place of Christian prisoners. His white habit, with its beautifully painted folds and his sagging head emphasize the downward pull of his body against the ropes digging into his wrists. Much of the color has drained from his face—the brightest color in the picture is the gold and orange insignia with the cross prominently displayed on it. This work, like Cotán's still life, sharply juxtaposes light and dark, but in this case, to emphasize the impact of death and suffering on behalf of the Christian faith. The transcendence of martyrdom is thus a main theme of this work and, as such, appealed to the power of religion in seventeenth-century Spain.

Diego Velázquez

The paintings of the leading Baroque artist in seventeenth-century Counter-Reformation Spain, Diego Velázquez (1599–1660), cover a broad spectrum of subject matter. His genius was nurtured by a Classical education, stimulated by his admiration for Titian, and spurred by his competition with Rubens.

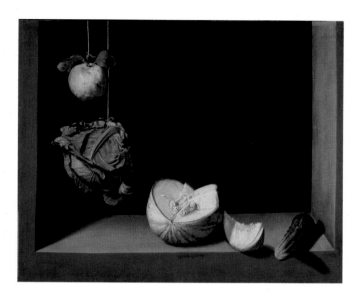

19.35 (Above) Juan Sánchez Cotán, *Still Life with Quince, Cabbage, Melon, and Cucumber*, c. 1602. Oil on canvas, 27⅛ × 33¼ in. (68.8 × 84.4 cm). San Diego Museum of Art, California.

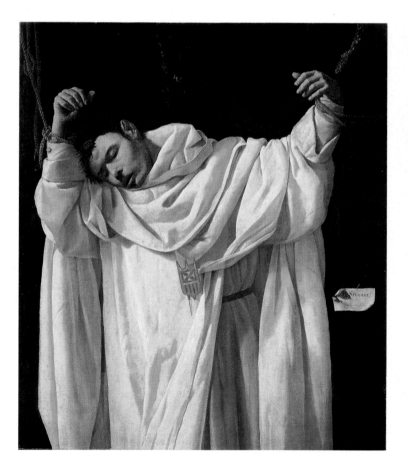

19.36 Francesco de Zurbarán, *Saint Serapion*, 1628. Oil on canvas, 47½ × 40¾ in. (120.7 × 103.5 cm). Wadsworth Atheneum, Hartford, Connecticut.

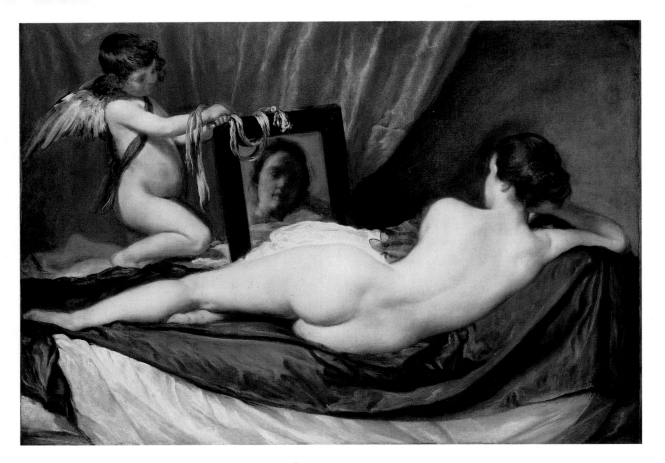

19.37 Diego Velázquez, *Venus with a Mirror (Rokeby Venus)*, c. 1648. Oil on canvas, 4 ft. ⅜ in. × 5 ft. 9⅝ in. (1.23 × 1.77 m). National Gallery, London, England.

Velázquez's *Venus with a Mirror* (fig. **19.37**), known as the *Rokeby Venus* after the nineteenth-century family that owned it, was designed for a private patron. This was probably the marquis of Eliche, who was well known as both a libertine and a collector of Velázquez's works. The painting obscures the identity of the model by turning her away from the viewer and blurring her features in the mirror. Cupid's presence hints at, but does not specifically identify, the amorous content of the scene, which is enhanced by the painterly textures and rich red. Seen in rear view, the nude is a long series of curves, which are repeated in the grand sweep of the silky curtain. The rarity of the female nude in seventeenth-century Spain, where the anti-humanist Counter-Reformation was a strong force, makes this painting all the more unusual. It clearly reflects the influence of reclining Venuses by Giorgione (see fig. **16.29**) and Titian (see fig. **16.32**), which Velázquez had studied during his two trips to Italy.

Velázquez's unqualified masterpiece is the monumental *Las Meninas* of 1656 (fig. **19.38**). This work not only is a tribute to the artist's genius as a painter, but is also about the very art of painting. The setting is a vast room in the palace of King Philip IV and Queen Mariana, parents of the five-year-old infanta Margharita, who is the focus of the picture. She is attended by her maids *(meninas)* and accompanied by a midget, a dwarf, and a dog. The elaborate costumes of the Spanish court are painted in such a way that the brushstrokes highlight the textures.

CONNECTIONS

See figure 16.29. Giorgione, *Sleeping Venus*, c. 1509.

See figure 16.32. Titian, *Venus of Urbino*, c. 1538.

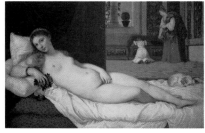

Certain forms, such as the infanta and the doorway, are emphasized by light. Other areas—the paintings on the side wall, for example—are unclear. Most obscure of all is the huge canvas at the left, on which Velázquez is working. It is seen, like *Venus with a Mirror* (see fig. **19.37**), from the back.

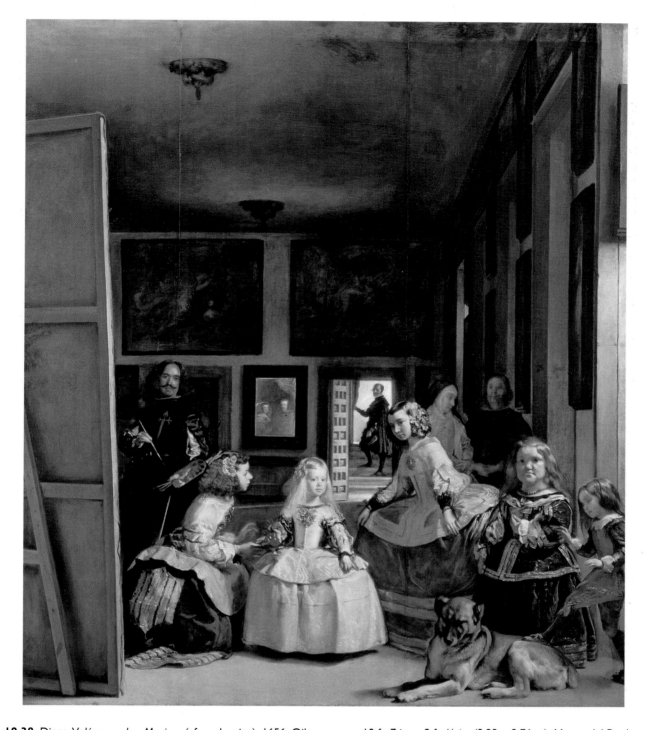

19.38 Diego Velázquez, *Las Meninas* (after cleaning), 1656. Oil on canvas, 10 ft. 7 in. × 9 ft. ½ in. (3.23 × 2.76 m). Museo del Prado, Madrid, Spain. Velázquez's personal pride in his own status—as a "divine" artist and a member of the royal circle—is evident in his self-confident stance and raised paintbrush. The red cross on his black tunic is the emblem of the Order of Santiago, of which Velázquez became a knight in 1659. Since the painting was completed in 1656, the cross must have been a later addition. Velázquez became court painter to Philip IV early in his career. He followed the humanist leanings of his teacher, Francisco Pacheco, who later became his father-in-law. Like Titian, Velázquez worked for the elevation of painting to the status of a liberal art, alongside music and astronomy. In Spain, painting and sculpture were still considered mere crafts because artists worked with their hands.

Below the mythological pictures on the back wall, depicting contests between gods and mortals (inevitably won by the gods), is a mirror, which has been the subject of extensive scholarly discussion. The king and queen are visible in the mirror. Does their image mean that they are actually standing in front of their daughter, or that they are the subjects of Velázquez's canvas? These are among the questions most often posed about the unusual iconography. The

mirror in *Las Meninas* may be intentionally ambiguous, which would not be inconsistent with Baroque taste.

Another issue to which Velázquez almost certainly refers in *Las Meninas* is the status of painting. It was not considered a liberal art in Spain, as it was in Italy, but rather was thought of as a handicraft. It is likely that by placing himself in royal company, Velázquez was arguing for elevating the status of painting as well as that of the artist (see caption).

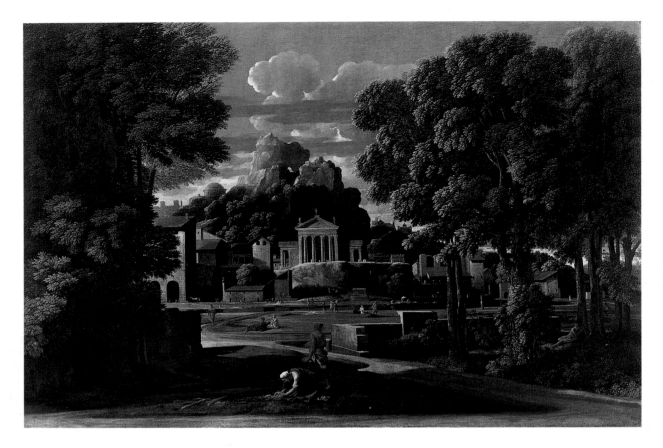

19.39 Nicolas Poussin, *Ashes of Phokion*, 1648. Oil on canvas, 3 ft. 9¾ in. × 5 ft. 9¼ in. (1.16 × 1.76 m). Walker Art Gallery, Liverpool, England. Phokion was a 4th-century-B.C. Athenian politician. Although elected general forty-five times, he consistently opposed the war against Macedon because he believed that Athenian military supremacy had come to an end. As a result, he was convicted of treason and executed, and his ashes were buried outside the city limits. The Greek author Plutarch included Phokion in his *Lives* as a model of Stoic virtue.

French Baroque Painting: Nicolas Poussin

Although Nicolas Poussin (1594–1665) was a French painter, born in Normandy, he spent most of his adult life in Rome. He studied the Italian Renaissance and was drawn to Classical as well as biblical subjects. In his later works, Poussin represents the most Classical phase of Baroque, particularly in scenes with Greek and Roman subject matter.

Exemplifying his classicism is the somber *Ashes of Phokion* (fig. **19.39**). Despite Baroque lighting, everything seems ordered and rational, in keeping with Classical restraint. The Classical temple façade is set off by dark landscape forms, as tiny figures stroll calmly in the clearing between foreground and background. Closest to the picture plane, and highlighted by a white head scarf and sleeve, is Phokion's widow. Ignored by the other figures, she collects her husband's ashes, evoking the *vanitas* theme of "ashes to ashes, and dust to dust." A related theme is evident in Poussin's combination of buildings from different historical periods. Buildings and nature, he suggests, may last; human beings do not.

c. 1600 **c. 1720**

THE BAROQUE STYLE IN WESTERN EUROPE

(19.13)
Galileo Galilei
(1564–1642)

(19.16)
Caravaggio
moves to
Rome
(1592)

(19.18)
Dutch
East India
Company
(1602)

Shakespeare,
King Lear
(1605)

Thirty Years
War
(1618–1648)

(19.2)
Puritans
reach
New England
(1620)

(19.4)
Louis XIV
becomes
king of France
(1643)

(19.10)
French
Royal Academy
founded
(1648)

Bernini
begins
Saint Peter's
Square
(1656)

(19.12)
Great
Fire of
London
(1666)

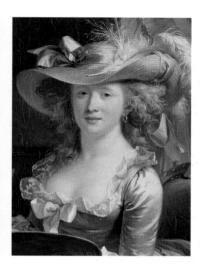

20

Rococo, the Eighteenth Century, and Revival Styles

The eighteenth century, particularly its latter half, was a complex patchwork of several different artistic trends. Two of these, Neoclassicism and Romanticism, overlap each other in time and often converge in a single work. They continue into the nineteenth century and are discussed in Chapters 21 and 22. The most distinctive eighteenth-century style, which flourished from about 1700 to 1775, is called Rococo, a term apparently coined from the French words *rocaille* and *coquille* (meaning, respectively, "rock" and "shell"—formations used to decorate Baroque gardens). Scholars are divided over whether Rococo was an independent style or a refinement of Baroque.

Rococo Style

The Rococo style is above all an expression of wit and frivolity, although at its best it has more somber, satirical undercurrents. On the surface, the typical Rococo picture depicts the aristocracy gathered in parks and gardens, while Cupids frolic among would-be lovers. Classical gods and goddesses engage in amorous pursuits. The world of Rococo is a world of fantasy and grace, which also includes a taste for the exotic. One expression of this taste was a fad for **chinoiserie.** From about 1720, an interest in Chinese imagery developed in France and England. This included garden design, architectural follies, costumes, and decorative motifs in general. In 1761 Sir William Chambers built a **pagoda** in Kew Gardens, Middlesex, on the outskirts of London (fig. **20.1**). The fanciful, unlikely appearance of a Chinese pagoda (fig. **20.2**) in an English garden appealed to the Rococo aesthetic. Chambers's pagoda has little connection with the meaning of the Chinese pagoda, which originally was both a Buddhist reliquary and a military watchtower. Nonetheless, the elegant forms of the pagoda and its Far Eastern associations enhanced the exotic character of Kew Gardens.

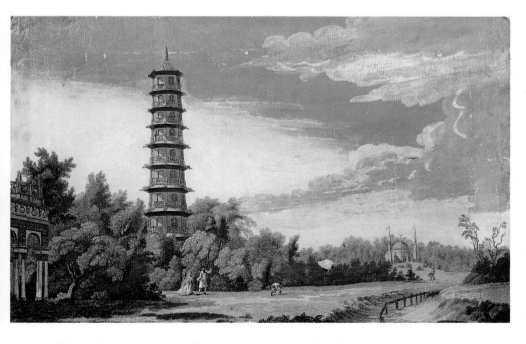

20.1 Sir William Chambers, *Pagoda*, Kew Gardens, England, 1761. Engraving by William Woollett after J. Kirby, hand-colored by Heath. Victoria and Albert Museum, London, England.

20.2 Pagoda, Kaifeng, Hunan Province, China, mid-11th century.

Cultural Developments

After the death of Louis XIV in 1715 and a subsequent decline in royal patronage, the center of taste shifted from the court to the Paris *hôtel* (an elegant townhouse) and to the **salon** (see Box). The source of patronage also shifted from the exclusive province of the French aristocracy to include the upper middle class and the bourgeoisie. In other capitals of Europe, especially in Germany, the Rococo style was quickly taken up in the courts.

In contrast to the apparent frivolity of Rococo, serious advances were taking place in music—with the works of Vivaldi, Bach, Haydn, and Mozart—and science. Gottfried Leibniz developed calculus, Joseph Priestley discovered oxygen, and Edmund Halley identified the comet that bears his name. Technological developments, such as mechanized spinning and James Watt's steam engine, laid the foundations for the Industrial Revolution. Satire had as its leading literary exponents Jonathan Swift in England and François-Marie Arouet (Voltaire) in France.

In politics, Frederick the Great turned Prussia into an aggressive military power, and France and Austria united against him. This new alignment resulted in the Seven Years' War (1756–63), which was won by the Prussians. England, whose international influence was based largely on the strength of its navy, consolidated its position in the eighteenth century and took the lead in European industrialization. England's position of economic and naval primacy extended to the New World and to India.

Developments in America mirrored shifts in European power. The North American colonies belonged mainly to England. The exceptions were in the South, in the Louisiana territory, and in Canada, where the English did not dislodge the French until 1763. Spain controlled all of Central and South America (except Brazil, which remained Portuguese), Mexico, Texas, parts of California, and most of Florida (which it ceded to England in 1763).

The Age of Enlightenment

The eighteenth century has been called the "Age of Enlightenment." This concept derives from philosophical ideas that were translated into political movements. The rationalism of the French philosopher René Descartes—*Cogito, ergo sum* ("I think, therefore I am")—in the previous century continued to appeal to European and American thinkers. In England, John Locke advanced "empiricism," the belief that all knowledge of matters of fact derives from experience. This became the basis of the scientific method. Improvements in microscopes and telescopes lent credence to Locke's ideas. And in France, Denis Diderot and the *encyclopédistes* classified the various branches of knowledge on a scientific basis. Diderot's pursuit of scientific observation carried over into his views on art training. In

SOCIETY AND CULTURE
Salons and *Salonnières*

In the eighteenth century, the salon became the center of Parisian society and taste. The typical salon was the creation of a charming, financially comfortable, well-educated, and witty hostess (the *salonnière*) in her forties. She provided good food, a well-set table, and music for people of achievement in different fields who visited her *hôtel*. The guests engaged in the art of conversation and in social and intellectual interchange. Among the *salonnières* were women of significant accomplishments in addition to hostessing. These included writers (Mesdames de La Fayette, de Sévigné, and de Staël, and Mademoiselle de Scudéry), a scientist (Madame de Châtelet), and the painter Élisabeth Vigée-Lebrun.

contrast to the study of tradition advocated by the French Academy, Diderot advised art students to leave the studio and observe real life.

Joseph Wright's (1734–97) *An Experiment on a Bird in the Air Pump* (fig. **20.3**) illustrates the use of scientific method. He put a bird into a glass container that was connected to a pump. The demonstrator then pumped out the air in order to show the effect on the bird, which is a white cockatoo. Since in reality such a bird is valuable, it was probably chosen for dramatic effect. In the picture, the air has already been pumped out and the bird has fallen to the bottom of the container. The left hand of the demonstrator is raised to the valve of the pump, which, if turned in time, will restore the air flow and save the bird.

On the table stands a large glass jar containing an opaque liquid and what appears to be a skull, **silhouetted** by a candle standing behind the jar. Both candle and skull are traditional components of a *vanitas* scene—the candle signifying the passage of time, the skull its inevitable result. The man seated in profile to the left of the pump holds a watch, ostensibly to clock the experiment but also as a further reminder that time is passing.

In political philosophy, the concept of a secular "social contract" developed. Locke's *Two Treatises of Civil Government,* published in 1690, argued against the divine right of kings. In Locke's view, government is based on a contract between the ruler and the ruled, who have a right to rebel when their freedom is threatened. In 1762, Jean-Jacques Rousseau went a step further in his *Social Contract*. For him, the "contract" was not between people and government, but between the people themselves. The outcome of such reasoning can be seen in Thomas Jefferson's Bill of Rights and the American Constitution (see p. 393). The American Revolution (1775–83) ended the oppression of the colonies by the English king George III, and it was followed a few years later by the French Revolution (1789–99). These two revolutions essentially broke the time-honored

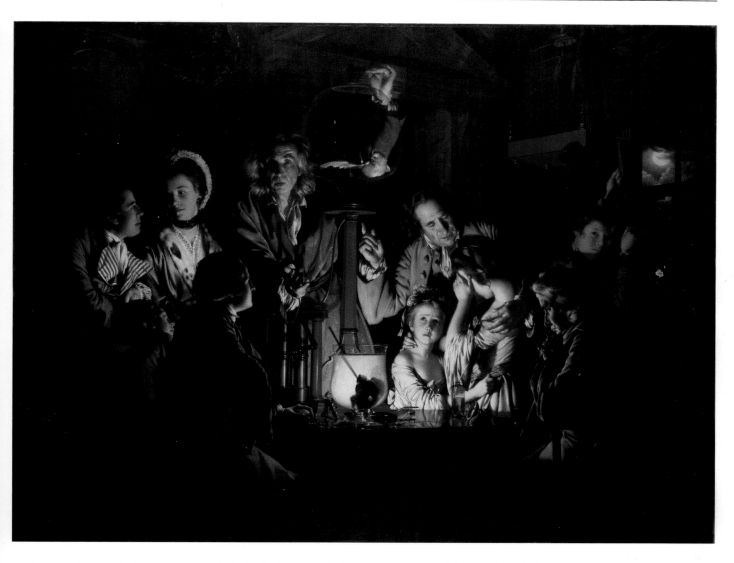

20.3 Joseph Wright, *An Experiment on a Bird in the Air Pump,* 1768. Oil on canvas, 28⅜ × 37¾ in. (72.0 × 95.9 cm). National Gallery, London, England. Wright was a British portraitist and landscape painter who spent most of his life in Derby, in the heartland of England. He became known as Wright of Derby to distinguish him from another contemporary artist of the same name.

belief throughout most of Western Europe in the divine right of kings.

Traditionally, the image of light, associated with the power of the sun, had been used for political ends. In ancient Egypt the pharaoh was thought of as the sun god, Ra, on earth; and the entire court of Louis XIV revolved around his self-image as the Sun King. Likewise, throughout the history of Christian art, Christ is paralleled with the sun as the "light of the world." In the eighteenth century, light became associated with a "rational," empirical outlook. The *light* in *Enlightenment* referred to the primacy of reason and intellect, in contrast to the unquestioning acceptance of divine power. This bias was profoundly optimistic because it encouraged a spirit of inquiry, a

belief in progress, and faith in the human ability to control nature.

Although these were the most dominant eighteenth-century views, countercurrents persisted. The prevalence of irony and satire, for example, implied an awareness that darker forces underlay the optimistic view of nature and the surface levity of Rococo. In Germany, the reaction was even more pronounced, particularly in the aesthetic of the so-called *Sturm und Drang* ("storm and stress") movement, which was a manifestation of early Romanticism. According to that more pessimistic outlook, nature had ultimate power over reason. As in Johann Wolfgang von Goethe's play *Faust,* human life was seen as a continual—and losing—battle for control over the evil forces of nature.

Painting in France

Antoine Watteau

The leading Rococo painter, Antoine Watteau (1684–1721), was born in Flanders but spent most of his professional life in France. He worked in the painterly, colorist tradition of his compatriot Rubens, whose interest in voluptuous nudes and richly textured materials he shared. Nevertheless, the thin, graceful proportions of Watteau's figures, and his subject matter, are more consistent with Rococo style. He is especially known for his *fêtes galantes,* paintings of festive gatherings, in which elegant aristocrats relax in outdoor settings.

The best known of these works is the *Pilgrimage to Cythera* (fig. **20.4**), depicting a group of amorous couples who have journeyed to the island of Venus. At the right, her statue is draped with flowers denoting love and fertility. Her presence in stone marks the enduring character of love as well as of the Classical tradition, in contrast to the frivolity and transience of the trysting lovers. The emphasis on silk textures that reflect light and the powder-pink Cupids frolicking in the sky are typical of Rococo. As the figures prepare to depart the magical island, they descend toward the scallop-shell boat at the left: the colors of their costumes become dulled as they begin their return to the world of reality.

Jean-Honoré Fragonard

In Jean-Honoré Fragonard's (1732–1806) *Swing* (fig. **20.5**), the picture is enlivened with frilly patterns. The lacy ruffles in the dress of the girl swinging are repeated in the illuminated leaves, twisting branches, and scalloped edges of the fluffy clouds.

At the right of the painting, an elderly cleric pushes the swing, while a voyeuristic suitor hides in the bushes and

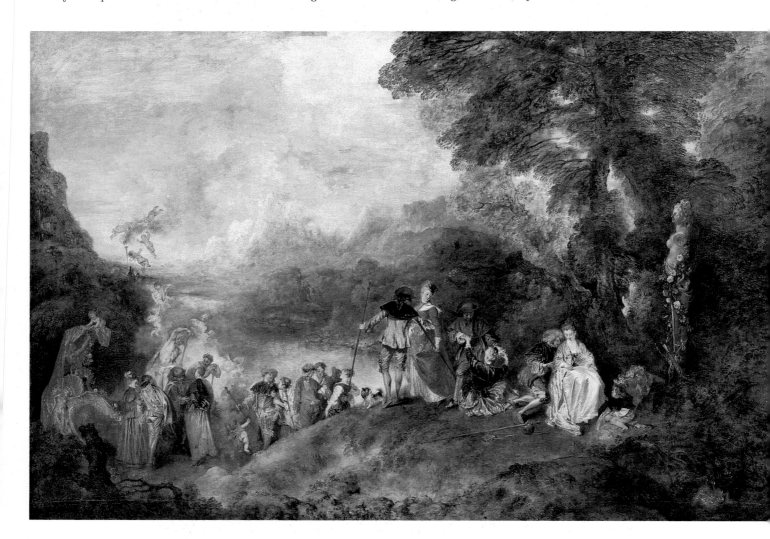

20.4 Antoine Watteau, *Pilgrimage to Cythera,* 1717. Oil on canvas, 4 ft. 3 in. × 6 ft. 4¼ in. (1.3 × 1.9 m). Musée du Louvre, Paris, France. This was Watteau's presentation painting for admission to the French Academy. Not only was he accepted, but the Academy added the category *fêtes galantes* to its hierarchy of genres. Watteau died of tuberculosis at age thirty-seven.

gazes under the girl's skirts. His hat and her shoe are sexual references in this context—the former a phallic symbol and the latter a vaginal one. They complement the setting: an enclosed yet open garden, where amorous games are played. The stone statues also deepen the erotic implications of the scene. On the left, Cupid calls for secrecy and silence by putting his finger to his lips. Between the swing and the old man, two more Cupids cling to a dolphin. Like Watteau, Fragonard calls on Classical imagery to provide a serious underpinning for frivolous erotic themes. His choice of such content was related to a widespread vogue for secular scenes of pleasure, especially in French aristocratic circles.

The Swing was commissioned by Baron de Saint-Julien, who specified that Fragonard paint the baron's mistress on a swing, with himself as her observer. Fragonard emphasizes the erotic associations of "swinging" by highlighting the shimmering texture and swirling curves of the dress. Swinging has some of the same connotations today—compare the "swinging sixties."

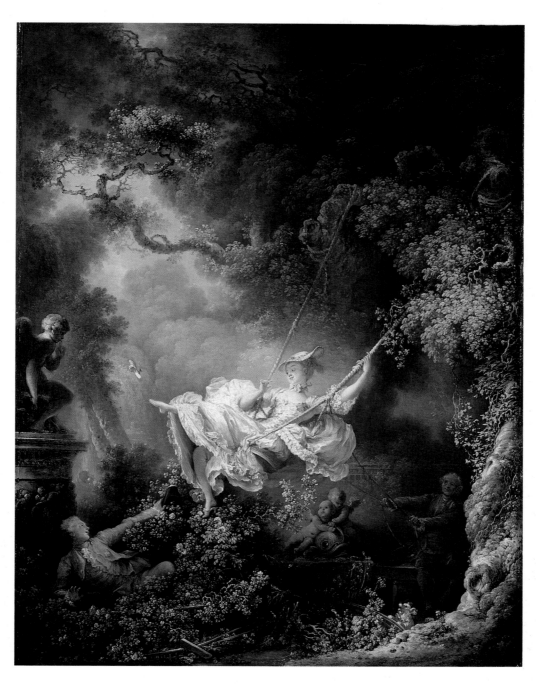

20.5 Jean-Honoré Fragonard, *The Swing*, 1766. Oil on canvas, 35 × 32 in. (88.9 × 81.3 cm). Wallace Collection, London, England.

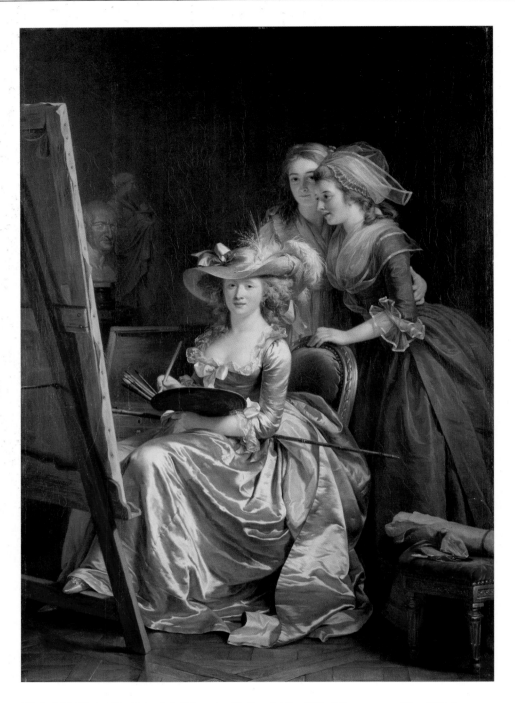

20.6 Adélaïde Labille-Guiard, *Self-Portrait with Two Pupils,* 1785. Oil on canvas, 83 × 59½ in. (210.82 × 151.13 cm). The Metropolitan Museum of Art, New York.

Adélaïde Labille-Guiard

Adélaïde Labille-Guiard's *Self-Portrait with Two Pupils* (fig. **20.6**) is both a quintessentially Rococo painting and a visual declaration of her talent as a female artist. She helped to improve the position of women in the arts and succeeded in having the four places reserved for women at the French Academy of Painting and Sculptures expanded. In this picture, which is more than six feet (2.1 m) high, she is seated before an **easel,** one hand taking up a brush and the other supporting a palette. Two female students pose behind her, and the marble bust of her father in the background is a homage to him as her teacher as well as to the classical tradition. The attention to shimmering silks and lace, the wide-brimmed feathered hat, and a variety of other textures is typical of Rococo surface elegance. At the same time, however, the painting contains a serious message about the role of women artists.

signify lust. The dangers of sexual excess, which Hogarth satirizes, are underscored by locating Cupid among ruins, foreshadowing the inevitable ruin of the marriage. As in French Rococo, Hogarth calls on traditional figures from Classical antiquity for the purpose of playful, but telling, satirical warnings. Also like French Rococo, which typically represents aristocrats, Hogarth's pictures deal with identifiable social and professional classes. But they lack the air of theatrical fantasy that pervades French examples of the style.

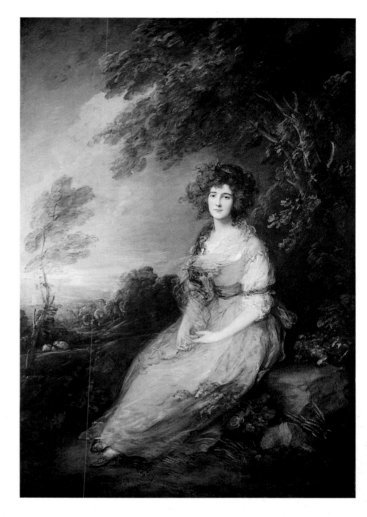

20.9 (Right) Thomas Gainsborough, *Mrs. Richard Brinsley Sheridan*, 1785–87. Oil on canvas, 7 ft. 2½ in. × 5 ft. ½ in. (2.2 × 1.54 m). National Gallery of Art (Andrew W. Mellon Collection), Washington, D.C. Gainsborough's patrons included English royalty and the aristocracy, but he also painted portraits of his musical and theatrical friends and their families. Mrs. Sheridan was the wife of Richard Brinsley Sheridan, author of the satirical comedies *The Rivals* and *School for Scandal.*

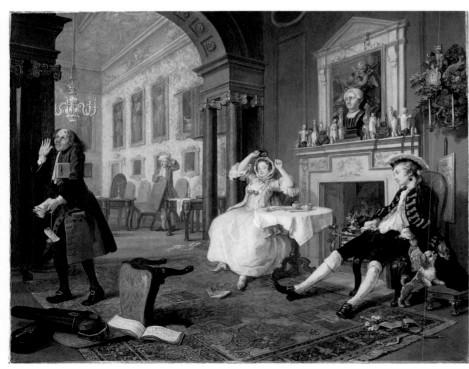

20.10 William Hogarth, *Marriage à la Mode II*, c. 1743. Oil on canvas. National Gallery, London, England.

Hogarth's satirical imagery included comments on taste and fraud in the art world. In 1761 he produced the etching in figure **20.11**, *Time Smoking a Picture,* in which the motif of the picture within a picture plays a central role. An aged Father Time literally "smokes" a painting in order to make it seem older than it is. He sits on a broken plaster cast, which denotes Hogarth's preference for new, clean, modern art rather than old-master paintings (see caption). Time's scythe cuts through the canvas, the top frame of which is inscribed in Greek: "Time is not a clever craftsman, for he makes everything more obscure." At the left, the jar marked VARNISH refers to the technique of varnishing pictures to age them artificially. The purpose of Time's activity is to increase the value of the painting, as is indicated by the phrase at the lower right: "As Statues moulder into Worth." Hogarth depicts Time as a fraudulent art dealer, more interested in profit than in paintings and willing to destroy art in order to make money.

Rococo Architecture in Germany

Several divergent architectural trends can be identified in the eighteenth century, but the most original new style was Rococo. In architecture, as in painting, Rococo emerged from late Baroque classicism, which it both elaborated and refined. In northern Italy and Central Europe, Baroque had been the preferred style for palaces and hunting lodges. Particularly in the countries along the Danube—Austria, Bohemia, and southern Germany—a distant regional style developed, which was a blend of Italian Baroque and French Rococo.

20.11 William Hogarth, *Time Smoking a Picture,* 1761. Etching and mezzotint, 8 × 6¹¹⁄₁₆ in. (20.3 × 17.0 cm). Guildhall Art Gallery, London, England. Hogarth's father was a teacher, from whom his son learned Latin and Greek (as is evident from this etching). His father opened a Latin-speaking coffeehouse that went bankrupt, and he spent three years in debtors' prison until Parliament passed an act freeing all debtors. This experience contributed to the artist's fierce opposition to social injustice and hypocrisy. In 1752 Hogarth published his views on art in *Analysis of Beauty,* which, like the etching, states his anti-Academic position. In the couplet at the bottom of the print, he urges people to look at nature and at themselves, rather than at the plaster casts of traditional art schools, for "what to feel."

Balthasar Neumann

A leading exponent of this movement was the German architect Balthasar Neumann (1687–1753). He created the ornate Rococo Residenz, or Episcopal Palace, in Würzburg, Bavaria, in southwest Germany. Begun in 1719 and not finished until 1753, the Residenz was an enormous building belonging to the hereditary prince-bishops of the Schönborn family.

The principal feature of the interior of the Residenz is its magnificent staircase, which ascends to a first landing. It then divides, reverses direction, and rises to the upper level (fig. **20.12**). The hall containing the staircase is the largest room—nearly 100 by 60 feet (30 by 18 meters)—in the Residenz. The banister and balustrade are decorated with statues and stone kraters, while Cupids lounge on entablatures over the doorways. Each door is framed by large triple Corinthian pilasters, which support another entablature that continues around the entire room. The ceiling fresco was painted by the Italian Rococo artist Giovanni Tiepolo (1696–1770) and is believed to be the largest in the world. Its portrayal of Apollo and the prince-bishop, the seasons, the zodiac, and the continents of Africa, America, Asia, and Europe is a grand statement of the far-reaching influence of the Schönborns.

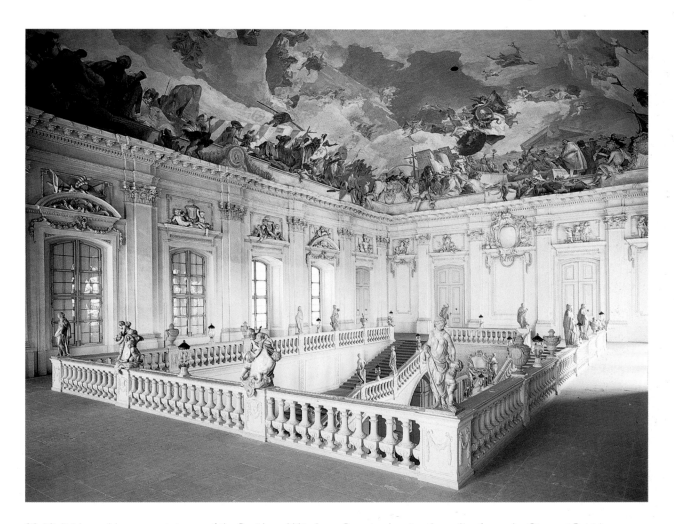

20.12 Balthasar Neumann, staircase of the Residenz, Würzburg, Bavaria, showing the ceiling fresco by Giovanni Battista Tiepolo, 1752–53. Born and trained in Venice, Tiepolo had by the 1730s established himself throughout northern Italy as a master of monumental fresco decoration. He was known for his technical skill, command of perspective, and fondness for illusionistic architecture. He spent three years in Würzburg decorating the Residenz, and in 1762 he was invited to Spain by Charles II to work on the royal palace.

Matthäus Daniel Pöppelmann

The ultimate in German Rococo architecture is the Zwinger, built in Dresden in 1711–22 (fig. **20.13**). The Zwinger (German for "enclosure," or "courtyard") is a series of galleries and pavilions commissioned by Augustus the Strong, king of Poland and elector of Saxony. Arranged around an enclosed courtyard, it serves as an open-air theater for tournaments and other spectacles. The section illustrated here is the Wallpavillon, one of the pavilions at the corners of the courtyard, to which it is connected by glass-covered arcades. All of these structures were designed to provide shelter for the spectators.

The architect, Matthäus Daniel Pöppelmann (1662–1736), included elements that are Classical in origin, such as the statue of Hercules with the world on his shoulders—a reference to Augustus himself—at the top, and satyrs emerging from the bunched pilasters. But the Classical elements are freely rearranged so that the overall intricate effect is far from Classical in spirit. So elaborate, in fact, is the surface decoration that the wall seems to dissolve into ornate detail.

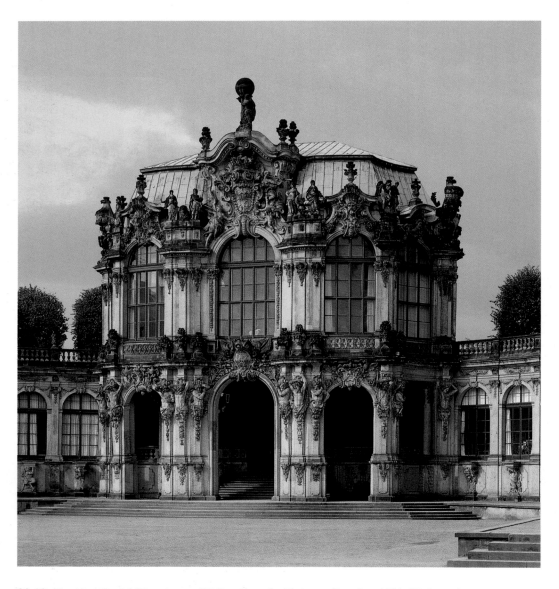

20.13 Matthäus Daniel Pöppelmann, Wallpavillon, the Zwinger, Dresden, 1711–22. Pöppelmann was trained as a sculptor but became court architect to Augustus the Strong. Augustus sent Pöppelmann to Rome, Vienna, Paris, and Versailles (the capitals of Rococo taste) to gather ideas for his palace in Dresden. Finally, only the Zwinger was built. It was gutted during World War II but has been accurately reconstructed.

Dominikus Zimmermann

Rococo church architecture is well illustrated by Dominikus Zimmermann's Wieskirche, or "Church of the Meadow" (fig. **20.14**), a pilgrimage church near Oberammergau in the foothills of the Bavarian Alps. From the interior view it is clear that Zimmermann was influenced by Borromini's elliptical architectural shapes. The exterior is relatively plain, but the interior is typical of German Rococo, designed to give visitors a sense of spiritual loftiness and a glimpse of heaven. The nave is mainly white, and the decoration (including the elaborate pulpit on the left) is largely gold, though there are accents of pink throughout. As one approaches the **chancel**, the colors deepen. Gilt and brown predominate, but the columns flanking the altar are of pink marble; the statues and other decorations are white. The ceiling decoration is entirely Rococo in that it unites the painted surfaces with the architecture through ornate illusionism.

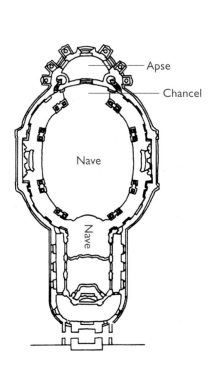

20.14a Dominikus Zimmermann, Wieskirche, Bavaria, 1745–54. The nave is a Rococo development of Borromini's oval church plans in Baroque Rome. The Wieskirche's longitudinal axis is emphasized by the deep oblong chancel. Eight freestanding pairs of columns with shadow edges (square corners or ridges that accentuate light and shadow) support the ceiling. The ambulatory, which continues the side aisles, lies outside the columns.

Apse
Chancel
Nave
Nave

20.14b Plan of the Wieskirche.

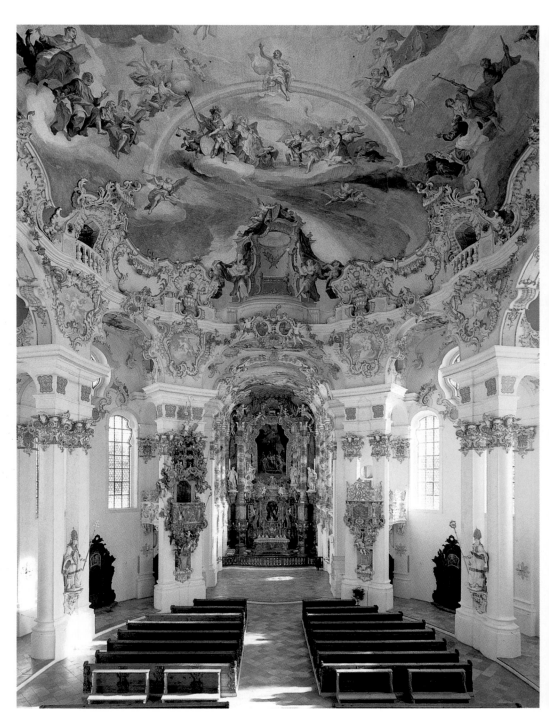

Architectural Revivals in England

Classicism: Lord Burlington and Robert Adam

In England in the eighteenth century, the Baroque style—and especially Rococo, with all its frills—was rejected in favor of renewed interest in the ordered, classicizing appearance of Palladian architecture. Palladio's *Four Books of Architecture* (see p. 315) was published in an English translation in 1715 and exerted widespread influence. An early example of English Palladian style is Chiswick House (fig. **20.15**) on the southwestern outskirts of London, which Lord Burlington (1695–1753) began in 1725 as a library and a place for entertainment.

Burlington based Chiswick House loosely on Palladio's Villa Rotonda (see fig. **17.11**), although it is on a smaller scale. It has only one portico, which is approached by lateral double staircases. The columns are Corinthian, there are no gable sculptures, and the dome is shallower than that of the Villa Rotonda. Despite such differences, however, the proportions and spirit of Chiswick are unmistakably Palladian.

Another leader of the Classical revival in England, particularly in interior design, was Robert Adam (1728–92). Interest in antiquity had been heightened by excavations at Herculaneum and Pompeii. Discoveries from these sites provided the first concrete examples of imperial Roman domestic architecture since the eruption of Mt. Vesuvius in A.D. 79. Publications about Classical archaeology followed. Not only was Adam influenced by these, but he was himself an enthusiastic amateur archaeologist. He had traveled to Rome and made drawings of the ruins, which informed much of his own work. In a fireplace niche in the entrance hall of Osterley Park House near London (fig. **20.16**), which Adam began to remodel in 1761, he re-created the atmosphere of a Roman villa. Although there is still an element of Rococo delicacy, especially in the pastel color schemes of certain rooms, it is now a much more austere setting. The main characteristics of this later style are axial symmetry and geometrical regularity, both of which reflect the taste of the Classical revival.

Gothic Revival: Horace Walpole

Contemporary with German Rococo architecture and the Palladian movement was a renewed interest in Gothic style. The revival of Gothic—which never completely died out in England—began around 1750. It must be seen in relation to the late-eighteenth-century Romantic movement, which is discussed in Chapter 22.

In its most general form, Romanticism rejected established beliefs, styles, and tastes—particularly the Classical ideals of clarity and perfection of form. It fostered the dominance of imagination over reason. In the context of eighteenth-century architecture, Romanticism was a reaction against Neoclassical trends (see Chapter 21), with their emphasis on order and symmetry. At the same time, however, to the extent that it evoked the Classical past, Romanticism shared certain aspects of the Neoclassical style.

CONNECTIONS

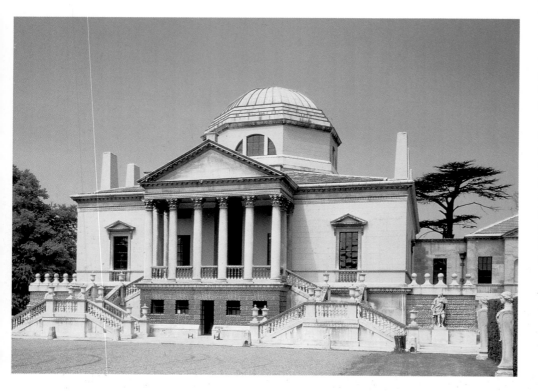

20.15 Richard Boyle (Earl of Burlington), Chiswick House, near London, begun 1725. Lord Burlington was one of a powerful coterie of Whigs and supporters of the House of Hanover (George I and his family). He took a grand tour of Europe in 1714 to 1715 and returned to Italy in 1719 to revisit Palladio's buildings. On his return to England, he became an accomplished architect in the tradition of Palladio.

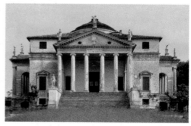

See figure 17.11. Andrea Palladio, Villa Rotonda, 1566–70.

One of the earliest non-Classical manifestations of Romanticism in England was the use (from the 1740s) of imitation Gothic ruins and other medievally inspired objects in garden design. This was followed by the more radical activity of Horace Walpole (1717–97), a prominent figure in politics and the arts. Walpole and a group of friends spent more than twenty-five years enlarging and "gothicizing" a small villa in Twickenham, just outside London. The result, renamed Strawberry Hill (fig. **20.17**), was widely admired at the time. It is a large, sprawling structure, without the soaring grandeur of traditional Gothic buildings. Nevertheless, Strawberry Hill contains an interesting jumble of Gothic features, including battlements, buttresses, and tracery. There are turrets on the outside and vaulting in the interior. Strawberry Hill also reflects the serious nostalgia with which the British viewed the Middle Ages, associated with a lost sense of community.

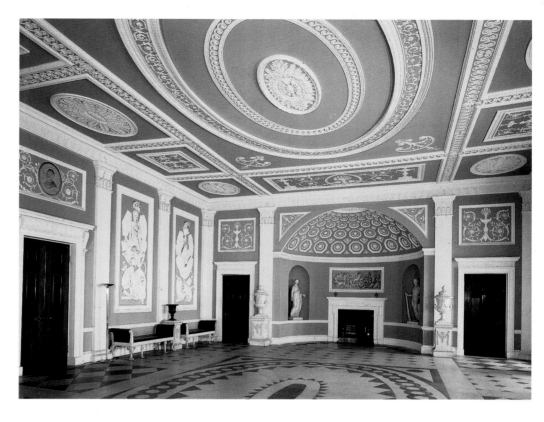

20.16 (Above) Robert Adam, fireplace niche, Osterley Park House, Middlesex, England, begun 1761. The ornamentation—including pilasters, entablature, **moldings,** relief over the fireplace, coffered semidome, and sculptures in the smaller niches—was all based on Classical precedents.

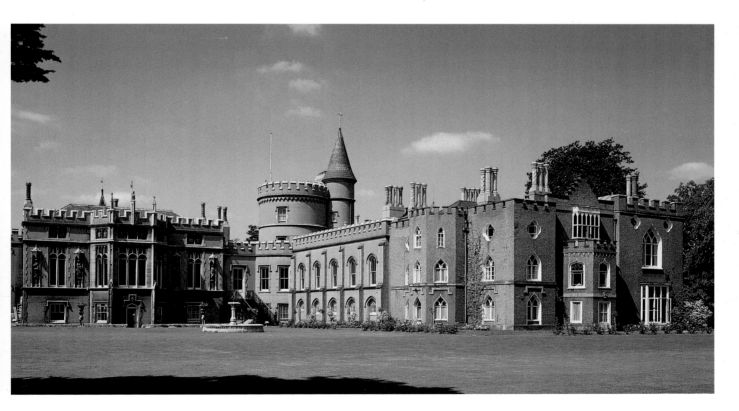

20.17 Horace Walpole, Strawberry Hill, Twickenham, near London, 1749–77. Like his father, Sir Robert Walpole, a Whig prime minister of England, Horace Walpole sat in Parliament as a Whig. His novel *The Castle of Otranto* started a fashion for Gothic tales of terror. Walpole's prolific correspondence is a valuable record of eighteenth-century manners and tastes, and through it he elevated letter writing to an art form.

The Classical Revival in Painting: Angelica Kauffmann

Angelica Kauffmann (1741–1807) was a child prodigy who became one of the most important and prolific Neoclassical painters. Her *Cornelia Pointing to Her Children as Her Treasures* (fig. **20.18**) illustrates the late-eighteenth-century interest in Classical form and content as well as the degree to which different styles can overlap each other within the same period. Although the content is Classical, the mood is Romantic. The figures wear costumes inspired by ancient Rome, and the profiles are reminiscent of Classical busts. But the pronounced gestures and the textured lighting that leaves areas hidden in shadow have a Romantic flavor. At the same time, such details as the jewels and the way they are handled reveal a taste for Rococo fussiness.

Cornelia was the daughter of the Republican-minded Roman leader Scipio Africanus. Her husband, Tiberius Sempronius Gracchus, was a distinguished Roman official known for his fairness. In this painting, Kauffmann depicts an event that took place in second-century-B.C. Rome, when Cornelia received a visit from a friend. Her friend is shown with an open jewelry box on her lap, displaying a necklace. When she asks to see Cornelia's jewels, her hostess points to her sons—the Gracchi (sons of Gracchus). They, in turn, grew up to be respected politicians, a reflection of their honorable parents. In the first century A.D., the Gracchi became the subject of a well-known biography by the moral philosopher Plutarch, according to whom the Romans honored Cornelia with a statue inscribed "Cornelia, mother of the Gracchi."

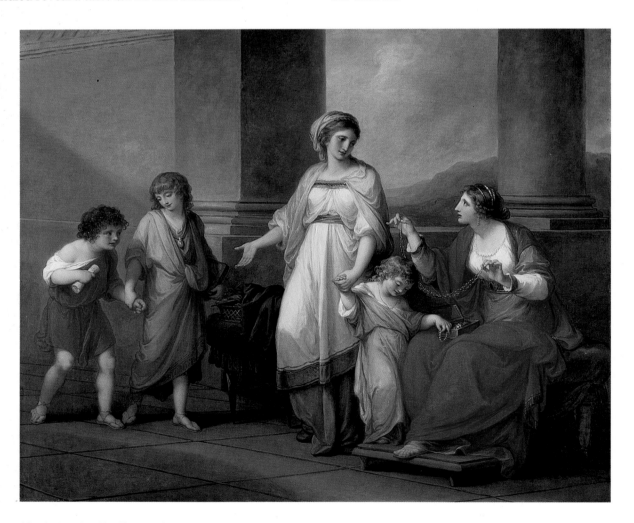

20.18 Angelica Kauffmann, *Cornelia Pointing to Her Children as Her Treasures*, 1785. Oil on canvas, 80 × 50 in. (203.2 × 127.0 cm). Virginia Museum of Fine Arts, Richmond. The Adolph D. and Wilkins C. Williams Fund. Kauffmann was born in Switzerland and studied art in Italy. Although a member of the Accademia di San Luca in Rome from 1765, as a woman she was barred from figure drawing. She also worked in England, where she was influenced by Reynolds, and became a founding member of the Royal Academy of Art. She married a man who pretended to be a Swedish count but turned out to be a bigamist. In 1781 she married a Venetian artist and returned to Italy, where her career continued to prosper.

American Painting

John Singleton Copley

In North America (see map), artists of the late eighteenth century were affected by European styles. John Singleton Copley (1738–1815) was a leading painter of the Colonial period. He grew up in Boston, the son of Irish emigrants. He was trained by his stepfather, an engraver of **mezzotint** portraits, and then became a portrait painter. Copley did not sympathize with the American Revolution and in 1775 emigrated to England, where, under the influence of European Rococo, his work became more ornate.

Before his departure, Copley painted a portrait of Paul Revere (fig. **20.19**), which is typical of his earlier, more realist style. Despite the apparent simplicity of the picture, however, there are elements of Baroque and Rococo. The figure looks directly out of the picture, inviting the viewer into his space, as Baroque figures do. The way in which the sharply focused, illuminated figure is set against a dark background is reminiscent of Baroque portraiture and the tenebrism of Caravaggio. Likewise, the attention to surface shine (the silver teapot and highly polished tabletop with engraving tools) occurs frequently in both Baroque and Rococo. In contrast to those styles, however—and

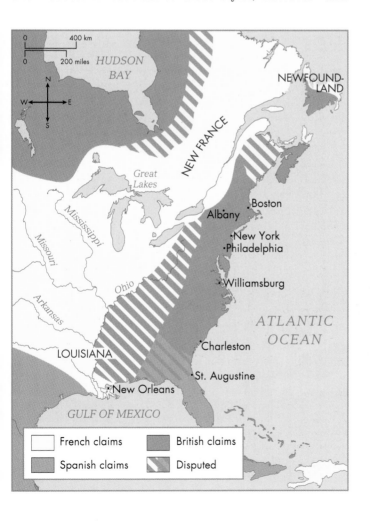

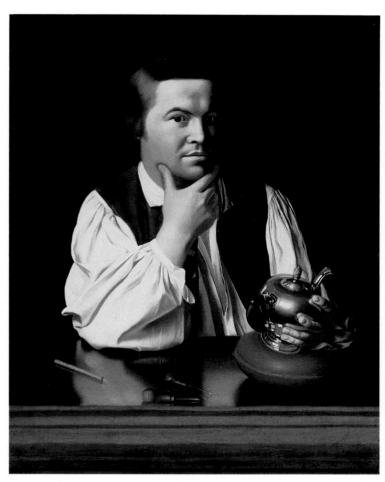

20.19 John Singleton Copley, *Paul Revere*, c. 1768–70. Oil on canvas, 35 × 28½ in. (88.9 × 72.3 cm). Museum of Fine Arts, Boston (Gift of Joseph W., William B., and Edward H. R. Revere).

particularly to the latter—Copley's Paul Revere is not idealized; he wears a simple shirt and a plain vest. His solid, squarish bulk is emphasized, and the weight of his head is indicated by his stern expression and the thumb pushing up against his jaw.

Benjamin West

Benjamin West (1738–1820), another important late-eighteenth-century American artist, came from Pennsylvania Quaker stock and began painting at the age of six. Like Copley, West settled in England, where he became known for his pictures of Classical and historical subjects. In 1772 he was appointed historical painter to King George III, and he was president of the Royal Academy from 1792 to 1805 and from 1807 to 1820. Many young American artists visiting London, including Copley, trained at his studio.

North American settlements in the 18th century.

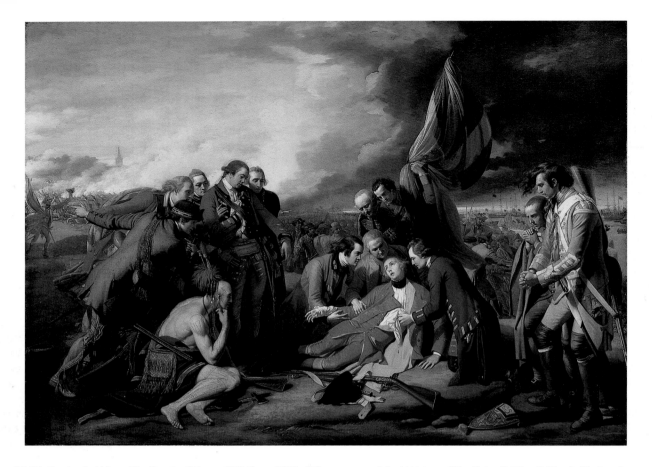

20.20 Benjamin West, *The Death of General Wolfe*, c. 1770. Oil on canvas, 4 ft. 11½ in. × 7 ft. ¼ in. (1.51 × 2.13 m). National Gallery of Canada, Ottawa (Gift of the 2nd Duke of Westminster, 1918). James Wolfe, the subject of this painting, was a young general who led the British troops to victory over a much larger French force in Quebec in 1759. His success obliged France to concede Canada to England. At the decisive moment of battle, Wolfe was wounded and died in the arms of his officers.

In *The Death of General Wolfe* (fig. **20.20**), West caused consternation among conservative elements by his choice of contemporary, rather than Classical, dress. It was generally thought that West's figures should have worn togas so that the picture would convey a universal message. But despite such criticism, the work was enormously popular. Its appeal to the past, with a suggestion of nostalgia, became characteristic of nineteenth-century Romanticism. Although West rejected Classical costume, his training in the Classical tradition is evident. The American Indian in the foreground assumes the traditional pose of mourning.

At the same time, however, the use of light and the melodramatic gestures are reminiscent of the Baroque style.

In eighteenth-century America and Europe, different trends in artistic style persisted alongside the Palladian movement, the Classical and Gothic revivals, and the beginnings of Romantic and Realist developments. By the end of the eighteenth century, Rococo was a style of the past. The Neoclassical, Romantic, and Realist movements would at various times emerge to dominate taste in the nineteenth century.

c. 1720 c. 1800

ROCOCO, THE 18TH CENTURY, AND REVIVAL STYLES

(20.5)

Louis XIV of France (ruled 1643–1715)

Jonathan Swift, *Gulliver's Travels* (1726)

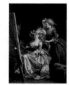

(20.13)

Discovery of Herculaneum and Pompeii (1738–1748)

(20.6)

Johann Winckelmann, *The History of Ancient Art* (1764)

(20.1)

James Watt's steam engine (1769)

Boston Tea Party (1773)

(20.18)

American Declaration of Independence (1776)

Beginning of the French Revolution (1789)

(20.8)

Execution of Louis XVI and Marie Antoinette (1793)

Napoleon Bonaparte becomes first consul of France (1799)

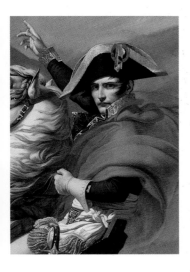

21

Neoclassicism: The Late Eighteenth and Early Nineteenth Centuries

During the late eighteenth and early nineteenth centuries in Western Europe, several artistic styles competed for primacy. Paris had become the undisputed center of the Western art world, but Rome was still a significant force. In France, the "True Style," later called the Neoclassical style, was a reaction against Rococo levity. French Baroque, especially under Louis XIV, had had a pronounced Classical flavor; from it evolved the Neoclassical style, which was adopted by the leaders of the French Revolution. Neoclassical then became the style most closely associated with the revolutionary movements of the period (see Box).

The Neoclassical Style in France

Jacques-Louis David

The political aspects of the Neoclassical style derived from its associations with heroic subject matter, its formal clarity, and its impression of stability and solidity. It also contained implicit references to Athenian democracy and the Roman Republic. In artistic terms, the Neoclassical style was a reaction against Rococo. However, the political preoccupations of the Neoclassical style arose directly from the questioning stance that had characterized eighteenth-century Enlightenment thought. Increasing popular resentment of the abuses of the monarchy was a logical development of the Enlightenment, which championed the rights of the individual. After the French Revolution, Napoleon Bonaparte adopted the Neoclassical style to enhance his political image—first as general and consul, and later as emperor.

The leading Neoclassical painter, Jacques-Louis David (1748–1825), appealed to republican sentiments associated with Classical antiquity. His *Oath of the Horatii* (fig. **21.1**), first exhibited in 1785, illustrates an event from Roman tradition in which honor and self-sacrifice prevailed (see caption). The figures wear Roman dress, and the scene takes place in a Roman architectural setting before three round arches resting on a type of Doric column. The triple

arch, clearly related to Roman triumphal arches, implies the victory of the ideas embodied in the painting. Framed by the center arch, Horatius raises his sons' three swords, on which they swear allegiance to Rome. Within a rectangular space composed of clear vertical and horizontal planes and subdued by muted color, the gestures of the soldiers are vigorous, determined, and somewhat theatrical. They express a fervor that links Roman patriotism of the past to the contemporary passions of the French—first

Chronology: The French Revolution and the Reign of Napoleon

1789	The storming of the Bastille prison in Paris, followed by the Reign of Terror. Many associated with the *ancien régime* ("old regime") and the hereditary monarchy are killed.
1793	Louis XVI and his wife, Marie Antoinette, are beheaded by the guillotine.
1795–99	*Directoire*, or Directory, period—rule by the middle class.
1799	Napoleon becomes First Consul.
1803	Napoleonic Law Code is issued.
1804	Napoleon is crowned emperor.
1806	Napoleon begins a building campaign in Paris with the intention of creating a new Rome. He takes Julius Caesar, who was also a consul before becoming dictator, as his model. Like Caesar, Napoleon adopts the eagle for his military emblem and the laurel wreath for his crown.
1812	Napoleon attacks Russia but is forced to retreat.
1814	Napoleon abdicates. The monarchy is restored under Louis XVIII.
1815	Napoleon is defeated in the Battle of Waterloo. The Congress of Vienna establishes the borders of European countries, which last until World War I (1914–18).
1821	Napoleon dies in exile.

21.1 Jacques-Louis David, *Oath of the Horatii,* first exhibited in 1785. Oil on canvas, approx. 11 × 14 ft. (3.35 × 4.27 m). Louvre, Paris, France. Although the event is not described in Classical sources, the story of the Horatii was known from a tragedy by Pierre Corneille, the 17th-century French dramatist. Rome and Alba Longa had agreed to settle their differences by "triple" combat between two sets of triplets—the Horatii of Rome and the Curiatii of Alba—rather than by all-out war.

for reform and later for revolution. The women and children, in contrast, collapse at the right in a series of fluid, rhythmic curves, which reflect the view that they are more emotional. They include the sisters of the Horatii, one of whom is engaged to an enemy combatant and is overcome by her tragic destiny. In the shadows, the wife of Horatius comforts her grandchildren.

The painting was commissioned by Louis XVI as part of a program aimed at the moral improvement of France. Although the modern viewer tends to see it as a piece of revolutionary propaganda, the ideals embodied in Neoclassical painting were in fact appealing to both the royalist establishment and its republican opponents. The irony of the political subtext was apparently lost on Louis' minister for the arts, who approved the painting.

In the *Death of Marat* (fig. **21.2**), commissioned during the Reign of Terror, David used the principles of Neoclassical style in the service of contemporary political events (see caption). Both David and Marat were Jacobins, a group of revolutionary extremists, and the patrons of David's painting. David himself was elected to the National Convention and voted to send Louis XVI to the guillotine. When Robespierre, the minister who presided over the Reign of Terror, fell, David was imprisoned twice. But he regained favor under Napoleon, who appointed him to be his imperial painter and granted him a barony. After Napoleon's exile, David left France and died in Brussels in 1825.

The painting, which is set in a cubic space, depicts a recent, rather than a Classical, event. David's *Marat* has affinities with Christian images of the dead Christ, empha-

21.2 Jacques-Louis David, *Death of Marat,* 1793. Oil on canvas, approx. 5 ft. 3 in. × 4 ft. 1 in. (1.6 × 1.25 m). Musées Royaux des Beaux-Arts de Belgique, Brussels, Belgium. On July 13, 1793, Marat was stabbed in his bathtub by Charlotte Corday, a supporter of the conservative Girondin group.

sizing Marat's role as a political martyr. The influence of Caravaggio can be seen in the darkened background, from which the figure emerges into light. In both form and content, therefore, David's *Marat* represents intellectual and political enlightenment.

Marat has been idealized in Classical fashion, but his body was in fact ravaged by a skin disease, from which he found relief by soaking in the bath. At the same time, though, the stab wound is visible, and the red bathwater has stained the sheet. Marat has placed a writing surface over the tub, and he holds the letter sent by his assassin, which reads: *"Il suffit que je sois bien malheureuse pour avoir droit à votre bienveillance,"* meaning "I just have to be unhappy to merit your goodwill."

The knife that Charlotte Corday has dropped on the floor beside the tub is contrasted ironically with the quill pen still in Marat's limp hand. The instrument of violence and death is thus opposed to the pen, which is associated in this picture with revolutionary political writing. That Marat the revolutionary was stabbed by a member of a more conservative party enhances the tragic irony of David's picture.

Inscribed on the crate supporting Marat's inkwell, pen, and papers is a combined personal and political message. David dedicates the painting À MARAT, DAVID ("To Marat, from David") and dates it L'AN DEUX ("the Year Two"), the second year of the French revolutionary calendar.

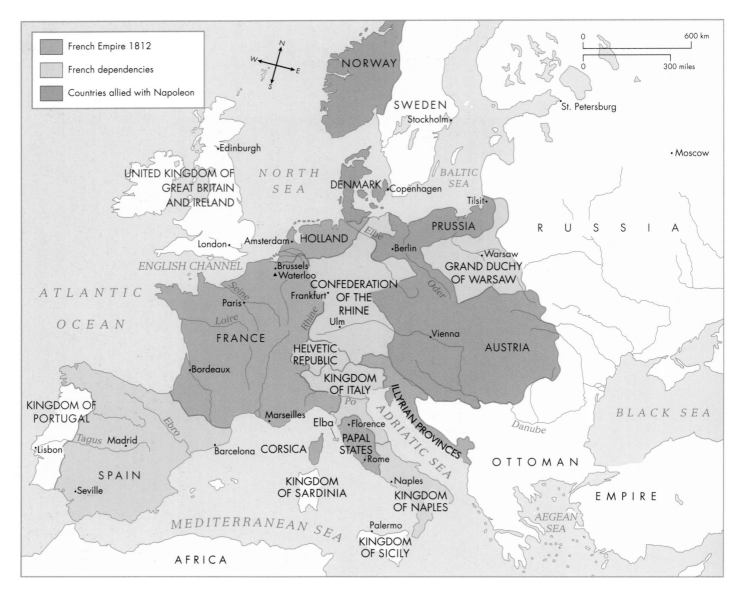

The Napoleonic empire, 1812.

Napoleon and the Arts

With the rise of Napoleon Bonaparte to political prominence in France, a new and powerful patron of the arts emerged. David worked for Napoleon from 1799, when he was First Consul of France. His *Napoleon at Saint Bernard Pass* of 1800 (fig. 21.3), which depicts Napoleon crossing the Alps, is clearly in the tradition of Roman equestrian portraits. Napoleon wears full military regalia and sits proudly astride a splendid rearing white charger. The textures of his uniform and the horse trappings are rendered in precise detail. The wind blows at their backs, whipping forward the horse's tail and mane. Napoleon points ahead, toward the peak of the mountain, and simultaneously looks down at the viewer. His dramatic gesture and the horse's pose are intimations of early Romanticism. David's glorification of his patron is evident from the fact that on this occasion Napoleon actually rode a mule.

David's Neoclassicism is used here in the interests of the new political regime in France. Napoleon's charger looms up and dominates the picture, in contrast to the distant soldiers, who struggle with their cannons and are obscured by the misty sky. David relates Napoleon to his illustrious imperial predecessors by the inscriptions "KAROLUS MAGNUS" (Charlemagne) and "ANNIBAL" (Hannibal) carved in stone under "BONAPARTE" in the left foreground.

When Napoleon became emperor in 1804, he set about using the arts to project the image of France as a new imperial Rome. To commemorate his military successes, Napoleon conceived the idea of constructing an arch of triumph (fig. 21.4), based on the triumphal arches of ancient Rome (see fig. 9.25). From these, the architect adopted the relief sculptures on the upper piers, the decorative cornices, and the row of metopes and triglyphs below the upper cornice. There were no columns or pilasters on the arch, and the design was enhanced later by adding sculptures to the lower parts of the piers. The arch was commissioned in 1806 but completed only in 1836, twenty-one years after Napoleon's defeat at Waterloo in 1815 (he was exiled to the island of St. Helena the following year). At 164 feet (50 m) high, it was the largest arch ever built.

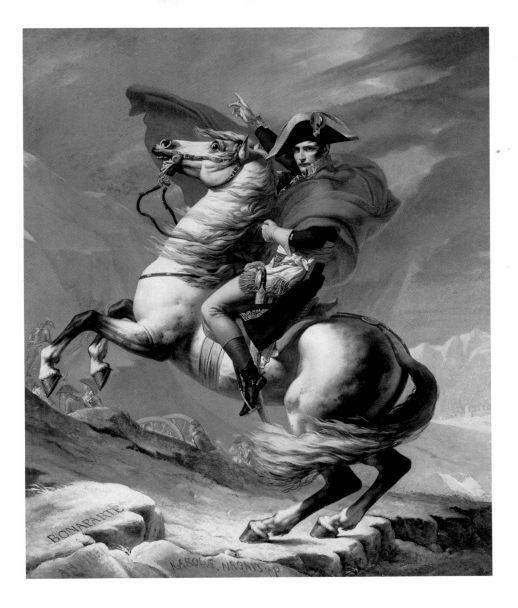

21.3 Jacques-Louis David, *Napoleon at Saint Bernard Pass,* 1800. Oil on canvas, 8 ft. × 7 ft. 7 in. (2.44 × 2.31 m). Musée National du Château de Versailles, France.

CONNECTIONS

See figure 9.25.
Arch of Titus,
A.D. 81.

21.4 Jean-François-Thérèse Chalgrin et al., Arc de Triomphe, Paris, 1806–36. 164 ft. (50 m) high.

Marie-Guillemine Benoist

Marie-Guillemine Benoist's (1768–1826) *Portrait of a Negress* of 1800 (fig. **21.5**) shows a figure who is partly nude from the waist up and in the tradition of the reclining nude female. She combines aspects of Classicism and Romanticism, reflecting the overlap of the two styles in the late eighteenth and early nineteenth centuries. The figure stands out against a plain background, and the dark brown skin contrasts sharply with the classicizing white drapery. At the same time, Benoist has added to the figure's exotic, Romantic character by providing a turban and a gold earring. But the clear edges, the smooth texture of the paint, and the Neoclassical drapery enhance the unexpected impact made by a black woman depicted within a conventional European tradition.

Benoist was the daughter of a government official. She studied with Élisabeth Vigée-Lebrun (see p. 373) and began her career as a portraitist in **pastel**. Later she studied with Jacques-Louis David (see p. 385), and in 1791 she exhibited two history paintings. When she married a royalist, her career declined, and she was in constant danger under the Reign of Terror. Napoleon awarded her an annual pension.

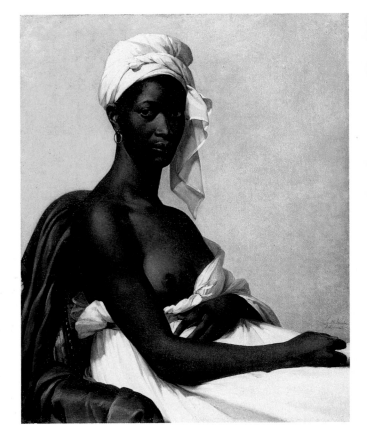

21.5 Marie-Guillemine Benoist, *Portrait of a Negress*, 1800. Oil on canvas, 31⅝ in. × 25⅝ in. (80.33 × 65.1 cm). Louvre, Paris, France.

Antonio Canova

Napoleon brought the Neoclassical sculptor Antonio Canova (1757–1822) to Paris from Rome, and in 1808 his sister Paolina Bonaparte Borghese commissioned him to carve a life-size marble portrait of herself (fig. **21.6**). Her idealized proportions are Classical, and she is also nude from the waist up. Although she lounges on an Empire-style divan, her pose recalls that of the traditional reclining Venus. The sculpture is a *tour de force* of carving, as the sheets, pillows, and drapes are all made of marble.

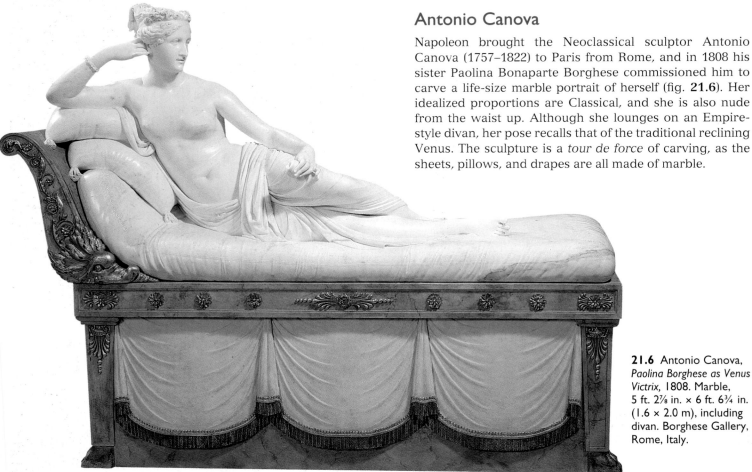

21.6 Antonio Canova, *Paolina Borghese as Venus Victrix*, 1808. Marble, 5 ft. 2⅞ in. × 6 ft. 6¾ in. (1.6 × 2.0 m), including divan. Borghese Gallery, Rome, Italy.

The title of Canova's sculpture refers to the mythological contest in which a golden apple was awarded to Venus, the Roman goddess of love and beauty. She had promised Paris, the Trojan prince, the world's most beautiful woman, who turned out to be Helen of Troy. Note that Paolina holds an apple in her left hand.

Jean-Auguste-Dominique Ingres

Jean-Auguste-Dominique Ingres' (1780–1867) career also embodies the interplay of Neoclassicism and Romanticism. There are hints of Romantic taste for the exotic in Benoist's *Negress,* but Ingres' work also retains traces of Mannerist elegance.

His portrait of 1806, depicting Napoleon as a deified Roman emperor in all his imperial splendor (fig. **21.7**), recalls the fussiness of Rococo and the exaggeration of Mannerism. On the other hand, the clarity and precision of the details are characteristic of the Neoclassical style. Napoleon exhibits the accoutrements of kingship and deity, his scepter and staff pointing heavenward and forming a large V. The grand, halolike golden arc of his throne echoes the arc of his laurel wreath and the curves of his collar, necklace, and ermine. Also denoting his imperial status are the predominance of red and

the eagles that adorn the columns of his throne. Another large eagle is outlined in the weave of the carpet. Everywhere, the brushstrokes are submerged to enhance the illusion of texture. Ingres' smooth, finished surfaces were characteristic of Academic painting rather than of Romanticism (see Chapter 22), which stressed the material quality of the media. His fondness for rich textures is expressed in the red velvet (red was the color of Roman emperors), ermine, and gold, all of which overwhelm the emperor.

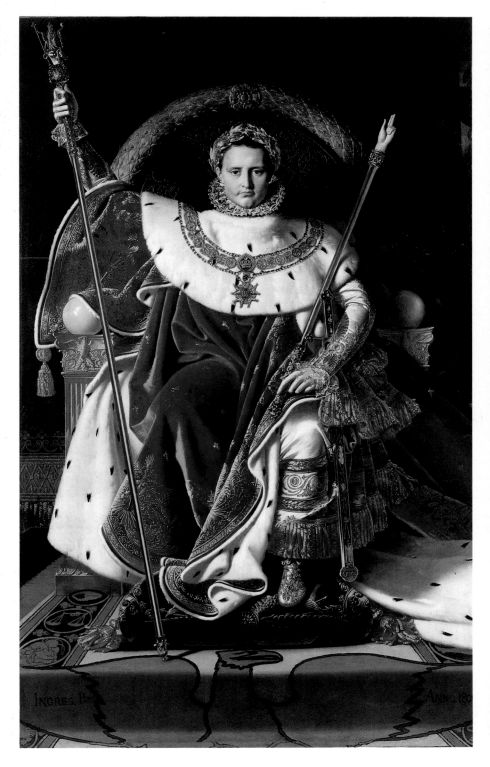

21.7 Jean-Auguste-Dominique Ingres, *Napoleon Enthroned,* 1806. Oil on canvas, 8 ft. 8 in. × 5 ft. 5¼ in. (2.59 × 1.55 m). Musée de l'Armée, Paris, France.

It was in his "Odalisques" that Ingres achieved his most successful synthesis of Neoclassical clarity; rich, aristocratic textures; and a Romantic taste for the exotic. (An odalisque is a harem girl, from *oda,* a room in a Turkish harem.) Ingres' *Grande Odalisque* (fig. **21.8**), commissioned by Napoleon's sister Caroline Bonaparte Morat and exhibited in 1817, depicts an idealized, reclining nude seen from the back, as is Vélazquez's *Venus with a Mirror* (see fig. **19.37**). But here the figure turns to gaze at the observer. In contrast to the painterliness that obscures the Venus, Ingres' nude has precise edges and a clear form. At the same time, however, the odalisque remains aloof and somewhat distant by comparison with the Baroque Venus. She is removed from everyday contemporary French experience by an exotic setting filled with illusionistic textures—the silk curtain and sheets, the peacock feathers of the fan, the fur bed covering, the headdress, and the hookah (a Turkish pipe in which the smoke is cooled by passing through water). This harem iconography reflects the popular contemporary craze for things "oriental" that followed Napoleon's failed military campaigns in Syria and North Africa. The *Grande Odalisque* also illustrates Ingres' love of clarity, which he associated with line—hence his Academic motto "Drawing is the probity of art." Nevertheless, he, more than the purely Neoclassical David, was attracted to the Romantic elements of sensuality and color.

CONNECTIONS

See figure 19.37. Diego Velázquez, *Venus with a Mirror (Rokeby Venus),* c. 1648.

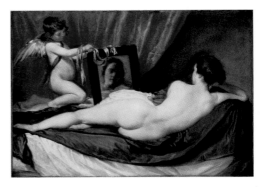

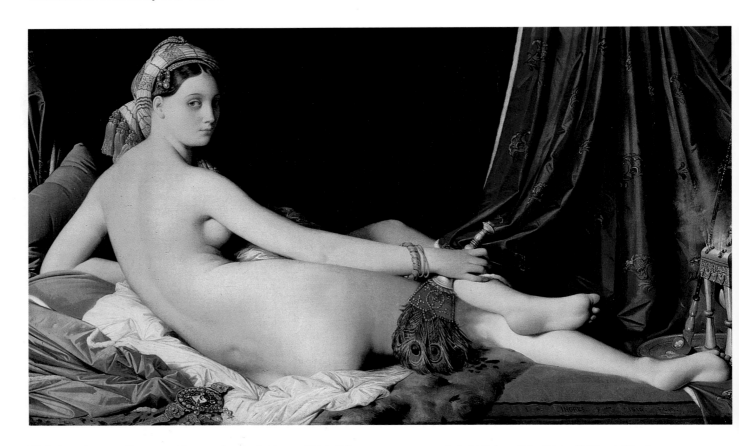

21.8 Jean-Auguste-Dominique Ingres, *Grande Odalisque,* 1814. Oil on canvas, approx. 2 ft. 11¼ in. × 5 ft. 4¾ in. (0.89 × 1.65 m). Louvre, Paris, France.

Developments in America

The American Revolution

The American Revolution preceded the French Revolution by only a few years (see Box). As in France, the intent of the American Revolution was liberation from monarchy. But the additional factor of throwing off the yoke of a foreign ruler made the revolution in America somewhat different from its French counterpart. Once liberated from the English throne, which at the time was occupied by King George III, America abandoned monarchy completely. The system designed by Jefferson and the other framers of the Constitution resulted in a smoother transition of power than in France and a more stable form of government (see Box).

In America, not only did the Revolution signify a political break with its colonial origins; it also marked a departure from the pre-Revolutionary "Colonial Georgian" style of architecture, named after the English king. Just as republican Rome was the political model to which the newly independent colonies aspired, so Roman architecture was more closely imitated in the early period of independence. Since this period (c. 1780–1810) coincided with the establishment of many United States government institutions, the style is referred to as the Federal style.

The Architecture of Thomas Jefferson

No single American embodied the principles of Neoclassicism more than Thomas Jefferson (1743–1826). In 1789 the French sculptor Jean-Antoine Houdon (1741–1828) carved a marble portrait bust of Jefferson (fig. **21.9**) during his stay in France as United States minister to that country (1785–89). Houdon captured an air of kindly self-confidence and suggested his sitter's profound intellect. The indentation at the side of Jefferson's jutting chin, his smile, and the slight furrow of his brow convey the impression of a composed, thoughtful individual. The portrait bust itself was a type derived from ancient Rome and therefore reflects the Neoclassical taste of both Houdon and Jefferson.

Jefferson's views on contemporary architecture also reveal his Classical education and humanist outlook. Although Jefferson was a native of Virginia, which was then the wealthiest and most populous of the states, he disliked the houses of Virginia and wrote that they were "very rarely constructed of stone and brick. . . . It is impossible

Chronology: The American Campaign for Independence	
1776	Declaration of Independence. The colonies declare independence from England, marking the beginning of the American Revolution.
1787	The Constitution of the United States is signed.
1789	George Washington is inaugurated as first president of the United States.
1790	Washington, D.C., is founded as the nation's capital.
1801	Thomas Jefferson is inaugurated as the third president.

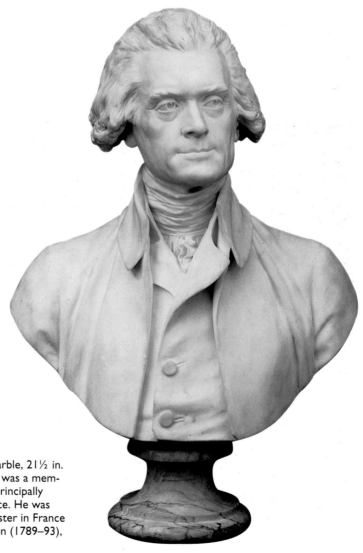

21.9 Jean-Antoine Houdon, *Thomas Jefferson*, 1789. Marble, 21½ in. (54.6 cm) high. Museum of Fine Arts, Boston. Jefferson was a member of the Continental Congress of 1775–76 and was principally responsible for drafting the Declaration of Independence. He was subsequently governor of Virginia (1779–81), U.S. minister in France (1785–89), secretary of state under George Washington (1789–93), vice president (1796–1801), and president (1801–9).

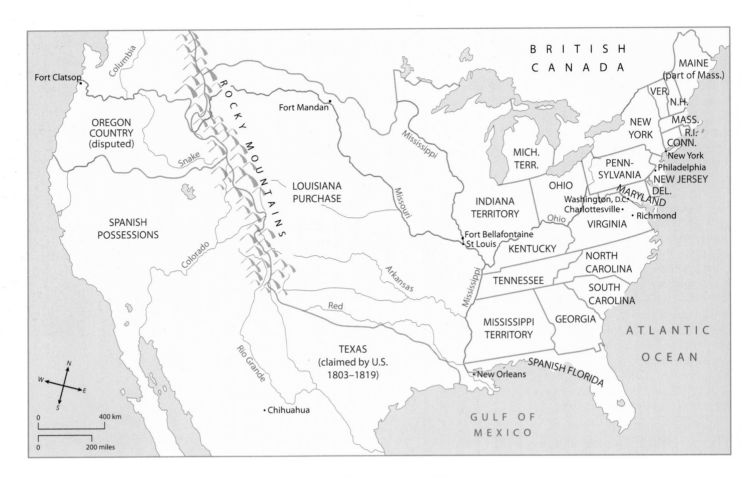

The United States, showing states and territories, during Jefferson's presidency, c. 1803.

to devise things more ugly, uncomfortable, and happily more perishable." He described the buildings of Colonial Williamsburg, which he knew from his student days at the College of William and Mary, as "rude, mis-shapen piles, which, but that they have roofs, would be taken for brick-kilns."[1] In addition to his other accomplishments, Jefferson studied Classical and Palladian architectural theory, and he owned the first copy in America of Palladio's *Four Books on Architecture*. His work as an architect produced two of the finest Neoclassical buildings in America.

While in France, Jefferson became familiar with the elegant *hôtels* of Paris and other French Neoclassical architecture. He visited the remains of Roman Gaul and saw the so-called Maison Carrée at Nîmes in southern France. This was a small, well-preserved Roman temple, similar to the Temple of Portunus (see fig. **9.15a**). Jefferson used it as the model for a new State Capitol of Virginia in Richmond. Figure **21.10** shows the projecting Ionic portico, surmounted by a Classical pediment. Both buildings were thus designed

in the context of representative government—the temple during the Roman Republic and Richmond's State Capitol during the early years of the American democracy.

The pride and joy of Jefferson's later years was the University of Virginia, the first state-supported educational establishment. Its centerpiece is the Rotunda (fig. **21.11**), originally the library. Although its proportions are somewhat taller, its inspiration is clearly the Pantheon in Rome (see fig. **9.16**). Among the purely Jeffersonian features are an entablature encircling the building and two layers of windows (pedimented on the ground floor, plain on the second).

Jefferson was the first rector of the university and described himself on his tombstone as "Father of the University." Both the curriculum and the architectural concept were a tribute to Jeffersonian humanist principles. In the quality of its individual parts and the harmony of the whole environment, Jefferson's "academical village," as he called it, is a masterpiece of the Federal style.

CONNECTIONS

See figure 9.15a. Temple of Portunus, late 2nd century B.C.

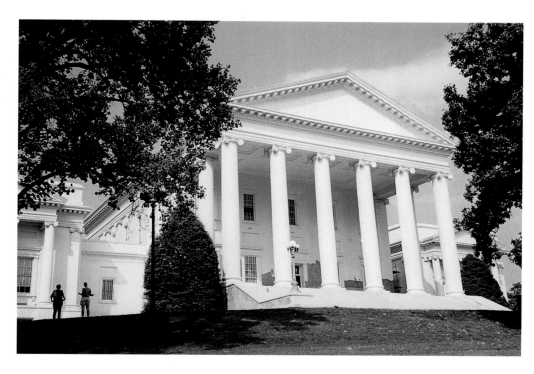

21.10 Thomas Jefferson, State Capitol, Richmond, Virginia, 1785–89.

CONNECTIONS

See figure 9.16. Pantheon, A.D. 117–125.

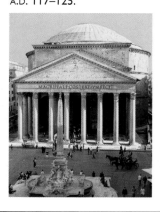

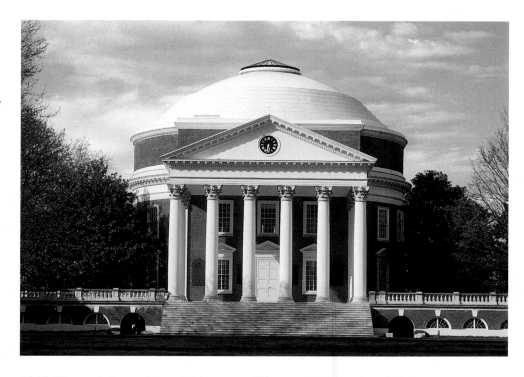

21.11 Thomas Jefferson, Rotunda, University of Virginia, Charlottesville, 1817–26.

John Trumbull's *Declaration of Independence*

In 1817 President James Madison commissioned John Trumbull to paint four pictures illustrating American Independence; they were to be displayed in the Rotunda of the Capitol building in Washington, D.C. One of these works was the *Declaration of Independence* (fig. **21.12**). The Declaration was a product of Enlightenment philosophy and of the belief that reason could impose an intelligent order on human society. According to Trumbull's autobiography, he was given advice on the composition by Jefferson himself.

All the signers are present in the painting, in which the solemn dignity of the occasion is portrayed. Formally, it is a construction of rectangular space, with simple doors and an unadorned Doric frieze. The furniture is austere, and the figures wear plain, contemporary American dress. Contrasting with the overall austerity are the sweeping—and more colorful—diagonals of the flags and the drum on the far wall. These refer to the battles that had made it possible to achieve the aims of the Declaration. Visually, the flags unite the long diagonal of mostly seated figures at

the left with the central group in front of the desk, and the seated figures at the right. The tallest figure, distinguished by a long red vest, is Jefferson. He hands a copy of the Declaration to John Hancock of Massachusetts. Standing to Jefferson's left is the stocky Benjamin Franklin of Pennsylvania, and at the left in the foreground is John Adams of Massachusetts. Between Adams and Jefferson are Roger Sherman of Connecticut and Philip Livingston of New Jersey.

Greenough's *George Washington*

Shortly after the University of Virginia was completed, the United States Congress decided to erect a statue to commemorate George Washington in a grand manner. In 1832 the commission was given to Horatio Greenough (1805–52), America's first professional sculptor, then living in Italy. The colossal marble statue that he produced (fig. **21.13**) was inspired by Phidias's Early Classical sculpture of Zeus in the temple at Olympia. Although this work, one of the Seven Wonders of the ancient world, was lost, it was known from ancient descriptions and from representations

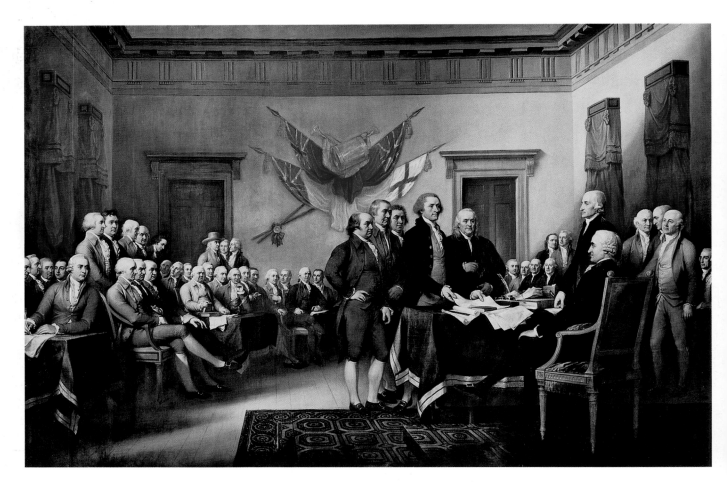

21.12 John Trumbull, *Declaration of Independence*, 1818. Oil on canvas, 12 × 18 ft. (3.66 × 5.49 m). U.S. Capitol Rotunda, Washington, D.C. Trumbull came from Connecticut, fought in the Revolution, and was educated at Harvard. In 1780 he went to London and studied with Benjamin West (see p. 383), who influenced his history paintings. He also painted many portraits.

on coins. The imposing presence, monumental scale, and grand gestures of the *Washington* also have a Romantic quality. Nude from the waist up, the figure points upward in the manner of Raphael's Plato (see fig. **16.23**). The left hand, extending forward and holding a sword, repeats the movement of the left leg. The statue embodies various aspects of Washington—man of action, political philosopher, ruler, and general. The frontal pose and the imposing presence, combined with a lion throne, create the impression of a powerful leader.

Unfortunately, the statue did not reach America until 1841, by which time taste had changed. The Neoclassical style was no longer in fashion, and the statue was criticized for its partial nudity. It was placed outside the Capitol building in Washington, D.C., where it began to erode; today it sits unceremoniously inside the Smithsonian American Art Museum.

In the United States, as in Western Europe, the purity of Neoclassicism gave way to Romanticism. In its own way, the Romantic movement, like the Neoclassical, had political, cultural, and literary significance, much of which is reflected in the visual arts.

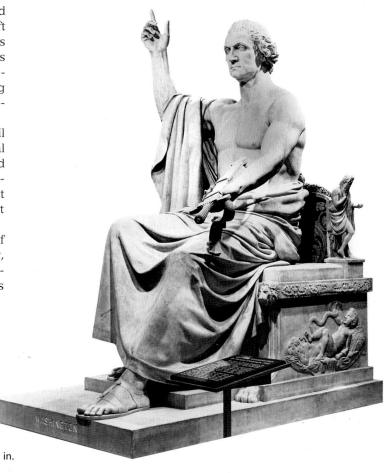

21.13 Horatio Greenough, *George Washington,* 1832–41. Marble, 11 ft. 4 in. × 8 ft. 6 in. × 6 ft. 10 in. (3.45 × 2.59 × 2.08 m). American Art Museum, Smithsonian, Washington, D.C.

c. 1780 **c. 1830**

NEOCLASSICISM: THE LATE 18TH AND EARLY 19TH CENTURIES

 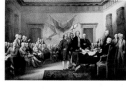 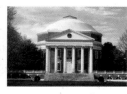

(21.5) (21.3) (21.4) (21.9) (21.13) (21.12) (21.11)

End of American Revolution (1784)

Thomas Paine, *Rights of Man* (1790)

Storming of the Bastille (1789)

Napoleon becomes emperor of France (1804)

Napoleon defeated, Battle of Waterloo (1815)

Thomas Jefferson founds University of Virginia (1817)

Charles Dickens, *Oliver Twist* (1838)

22

Romanticism: The Late Eighteenth and Early Nineteenth Centuries

The Romantic Movement

The Romantic movement, like Neoclassicism, swept through Western Europe and the United States in the late eighteenth and early nineteenth centuries. The term *Romantic* is derived from the Romance languages (French, Italian, Spanish, Portuguese, and Romanian) and from medieval tales of chivalry and adventure written in those languages. Romantic literature shares with the so-called Gothic novels and poems by English writers of the late eighteenth and early nineteenth centuries a haunting nostalgia for the past. The Romantic aesthetic of "long ago" and "far away" is conveyed in works with locales and settings that indicate the passage of time, such as ruined buildings and broken sculptures. To the extent that Neoclassicism expresses a nostalgia for antiquity, it too may be said to have a "Romantic" quality.

Whereas Neoclassicism has roots in antiquity, the origins of Romanticism are no older than the eighteenth century. They can be found especially in the work of the French philosopher Jean-Jacques Rousseau (1712–78). His writings inspired the French Revolution and provided the philosophical underpinning of the Romantic movement. Rousseau advocated a "return to nature" and believed in the concept of the "noble savage"—that humanity was born to live harmoniously with nature, free from vice, but had been corrupted by civilization and progress. Such ideas led to the political belief that people, rather than kings, should rule. The effect of the Romantic movement on early nineteenth-century culture is thus evident not only in the visual arts but also in politics, social philosophy, music, and literature (see Box).

In addition to their nostalgia for the past and their idealistic participation in current events, the Romantics were interested in the mind as the site of mysterious, unexplained, and possibly dangerous phenomena. For the first time in Western art, dreams and nightmares were depicted as internal events, with their source in the individual imagination, rather than as external, supernatural happenings. States of mind, including insanity, began to interest artists, whose imagery anticipated Freud's theories of psychoanalysis at the end of the nineteenth century and the development of modern psychology in the twentieth.

Architecture

In architecture, the Romantic movement was marked by revivals of historical styles. The Gothic revival had begun in the late eighteenth century with such buildings as Horace Walpole's Strawberry Hill (see fig. **20.17**) evoking the English past. Jefferson revived ancient Greek and Roman forms, which were ideologically appropriate for the newly founded American democracy.

The Romantic vision of the Far East as a distant, exotic locale also became a source for nineteenth-century art and architecture. The Royal Pavilion (fig. **22.1**) in Brighton, a fashionable English seaside resort, was constructed by John Nash (1752–1835) for the prince regent in the Indian Gothic style. A mixture of minarets and onion domes, borrowed from Islamic architecture such as the Taj Mahal (see Connection), covers a cast-iron framework. The Royal Pavilion echoes the eastern forms that attracted Coleridge, whose "Kubla Khan" incorporates the exotic sounds of faraway places and the characteristic Romantic taste for endless time and infinite spaces:

> In Xanadu did Kubla Khan
> A stately pleasure-dome decree;
> Where Alph, the sacred river, ran
> Through caverns measureless to man
> Down to a sunless sea. (lines 1–5)

The various strains of Romanticism evident in the visual arts are also found in nineteenth-century music and poetry. In Romantic music, the expression of mood and feeling takes precedence over form and structure.

Romantic music was often based on literary themes, and literary or geographical references evoked various moods. Some of Hector Berlioz's overtures, for example, are based on Sir Walter Scott's historical novels, which are set in the Middle Ages. Felix Mendelssohn's "Italian" and "Scottish" symphonies were inspired by the composer's travels in Italy and Scotland. The Polish mazurkas of Frédéric Chopin and the Hungarian rhapsodies of Franz Liszt reflect the strong nationalistic strain in Romanticism. In opera, the emotional and nationalistic intensity of the Romantic movement found its fullest expression in the works of the German composer Richard Wagner.

In English poetry, the leaders of Romanticism were William Wordsworth (1770–1850) and Samuel Taylor Coleridge (1772–1834). In 1798 they jointly published a collection of poems, *Lyrical Ballads,* the introduction to which served as a manifesto for the English Romantics.

Wordsworth's "Solitary Reaper" conveys a sense of the melancholy oneness of humanity with an all-encompassing nature. When seen by the poet, the reaper is alone in a vast expanse of land:

> Behold her, single in the field,
> Yon solitary Highland Lass!
> Reaping and singing by herself;
> Stop here, or gently pass!
> Alone she cuts and binds the grain,
> And sings a melancholy strain;
> O listen! for the Vale profound
> Is overflowing with the sound. (stanza I)

Other English poets of the Romantic movement included Lord Byron (1788–1824), Percy Bysshe Shelley (1792–1822), and John Keats (1795–1821). Byron's nostalgic yearning for ancient Greece is evident in much of his poetry:

> The isles of Greece, the isles of Greece!
> Where burning Sappho loved and sung,

> Where grew the arts of war and peace,
> Where Delos rose, and Phoebus sprung!
> Eternal summer gilds them yet,
> But all, except their sun, is set.
> ("Don Juan" III.lxxxvi)

Shelley's "Ozymandias" evokes the attraction of exotic locales and explores our ability to communicate with the past through time-worn artifacts:

> I met a traveller from an antique land
> Who said: Two vast and trunkless legs of stone
> Stand in the desert . . .
> And on the pedestal these words appear:
> "My name is Ozymandias, king of kings:
> Look on my works, ye Mighty, and despair!"
> Nothing beside remains. Round the decay
> Of that colossal wreck, boundless and bare
> The lone and level sands stretch far away.

In 1819 Shelley visited the Uffizi Gallery in Florence, where he saw a painting of Medusa's head, then attributed to Leonardo da Vinci. The head lies on the ground, crawling with lizards, insects, and snakes. Shelley's poem expresses the Romantic taste for the macabre, the appeal of death, and the theme of the aloof, unattainable woman:

> It lieth, gazing on the midnight sky,
> Upon the cloudy mountain-peak supine;
> Below, far lands are seen tremblingly;
> Its horror and its beauty are divine.
> ("On the Medusa of Leonardo da Vinci in the
> Florentine Gallery," lines 1–4)

The aloof and unattainable woman, seen by the Romantics as cold and deathlike but nevertheless fascinating, is celebrated with a medieval flavor in Keats's "La Belle Dame sans Merci":

> I saw pale kings and princes too,
> Pale warriors, death-pale were they all;
> Who cry'd—"La belle Dame sans merci
> Hath thee in thrall!" (lines 38–41)

22.1 John Nash, Royal Pavilion, Brighton, England, 1815–18.

CONNECTIONS

Taj Mahal, Agra, India, 1632–48.

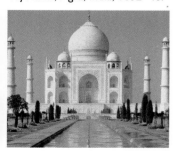

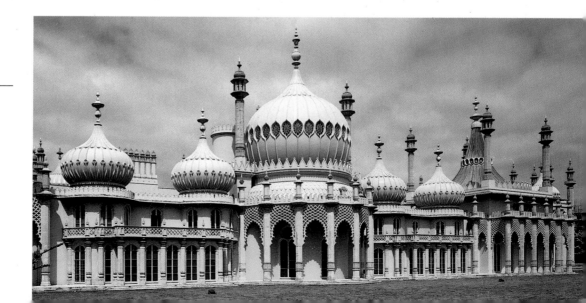

Sculpture: François Rude

Romantic sculptors were generally less prominent than poets, painters, and architects. One sculpture inspired by Romantic ideals is François Rude's (1784–1855) stone relief of 1833–36 (fig. **22.2**). Originally titled the *Departure of the Volunteers of 1792* but generally known as *La Marseillaise,* it was one of four reliefs added to the Arc de Triomphe in Paris (see fig. **21.4**).

The relief shows a group of volunteers answering the call to arms in defense of France against foreign enemies. They seem caught up in the "romance" of their enthusiasm, as the rhythmic energy of their motion echoes the imaginary beat of military music (see caption). Rude's soldiers range from youths to old men, who are either nude or equipped with Classical armor. But unlike the sedate, orderly imagery of Neoclassical patriotism, Rude's volunteers seem carried away by the force of the crowd. Vigorously striding above the volunteers, and driving them on, is an allegory of Liberty, a nineteenth-century revolutionary version of the traditional winged Victory (see fig. **7.38**).

22.2 François Rude, *Departure of the Volunteers of 1792 (La Marseillaise),* 1833–36. Limestone, approx. 42 ft. (12.8 m) high. Arc de Triomphe, Paris. The "Marseillaise," the French national anthem, was composed in 1792 by an army officer, Claude-Joseph Rouget de Lisle. Volunteers from the port of Marseille, who led the storming of the Tuilleries, brought the song to Paris.

CONNECTIONS

See figure 7.38. *Winged Nike (Winged Victory),* c. 190 B.C.

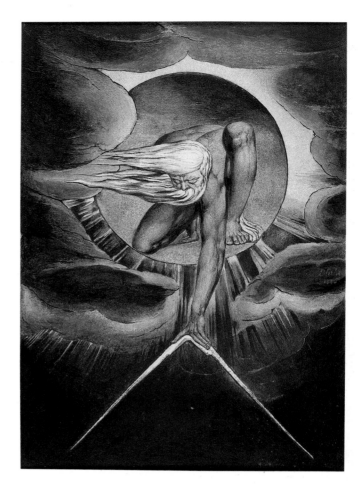

22.3 William Blake, *God Creating the Universe (Ancient of Days),* frontispiece of *Europe: A Prophecy,* 1794. Metal relief etching, hand-colored with watercolor and gouache, 12¼ × 9½ in. (31.1 × 24.1 cm). British Museum, London, England.

Painting in Europe

William Blake

There was a strong Christian strain in Romanticism. It was associated with a longing for a form of religious mysticism, which, from the Reformation onward, had been on the wane in Western Europe. This can be seen in the work of the English visionary artist and poet William Blake (1757–1827).

Blake was an engraver, painter, and poet whose work was little known until about a century after his death. From 1793 to 1796, Blake illuminated a group of so-called *Prophetic Books* dealing with visionary biblical themes. His watercolor and gouache (see Box) *God Creating the Universe* (fig. **22.3**), also called *Ancient of Days,* shows God organizing the world with a compass (see fig. **1.4**).

In this image, Blake's God is almost entirely enclosed in a circle. The light extending from each side of his hand forms the arms of a compass. The precision of the circle and triangle contrasts with the looser painting of clouds and light, and the frenetic quality of God's long white hair, blown sideways by an unseen wind.

Blake's nostalgic combination of medieval iconography and a Michelangelo-style God with a revival of mysticism is characteristic of the Romantic movement. His passionate yearning for a past (and largely imaginary) form of Christianity appears in his poems as well as in his pictures. It is exemplified by the opening lines of his hymn "Jerusalem":

> And did those feet in ancient time
> Walk upon England's mountains green?
> And was the holy Lamb of God
> On England's pleasant pastures seen?

MEDIA AND TECHNIQUE
Watercolor

In **watercolor,** powdered pigments are mixed with water, often with gum arabic used as a **binder** and drying agent. Watercolor is transparent, and so one color overlaid on another can create a **wash** effect. The most common **ground** for watercolor is paper. Because the medium is transparent, the natural color of the paper also contributes to the image.

Watercolor had been known in China as early as the third century, but it was used only occasionally in Europe before the late eighteenth and early nineteenth centuries. At that point it became popular, particularly with English artists such as Constable and Turner, for landscape paintings on a small scale. In the second half of the nineteenth century, watercolor also became popular among American artists. It was favored by those who preferred to paint directly from nature rather than in a studio and needed a more portable, quickly drying medium.

Gouache is a watercolor paint that becomes opaque when dry. It is commonly used on its own or in combination with transparent watercolor.

Théodore Géricault

Théodore Géricault (1791–1824) died at the age of only thirty-three, but his work was crucial to the development of Romantic painting, especially in France.

Géricault's commitment to social justice is reflected in his acknowledged masterpiece, the *Raft of the Medusa* (fig. **22.4**), which he began in 1818 and exhibited at the Salon (see Box) the following year. This picture commemorates a contemporary disaster at sea rather than a heroic example of Neoclassical patriotism. On July 2, 1816, the French frigate *Medusa* hit a reef off the west coast of Africa. The captain and senior officers boarded six lifeboats, saving themselves and some of the passengers. The 149 remaining passengers and crew were crammed onto a wooden raft, which the captain cut loose from a lifeboat. During the thirteen-day voyage that followed, the raft became a floating hell of death, disease, mutiny, starvation, and cannibalism. Only fifteen people survived.

The episode became a national scandal when it was discovered that the ship's captain owed his appointment to his

SOCIETY AND CULTURE
The Salon

The *Salon* refers to the official art exhibitions sponsored by the French authorities. The term is derived from the Salon d'Apollon in the Louvre. It was here, in 1667, that Louis XIV sponsored an exhibition of works by members of the Royal Academy of Painting and Sculpture. From 1737 the Salon was an annual event, and in 1748 selection by jury was introduced. Throughout the eighteenth century, the Salons were the only important exhibitions at which works of art could be shown. This made acceptance by the Salon jury crucial to an artist's career.

During the eighteenth century the influence of the Salon was largely beneficial and progressive. By the nineteenth century, however, despite the fact that during the Revolution the Salon was officially opened to all French artists, it was in effect controlled by Academicians, whose conservative taste resisted innovation.

22.4 Théodore Géricault, *Raft of the Medusa*, 1819. Oil on canvas, 16 ft. × 23 ft. 6 in. (4.88 × 7.16 m). Louvre, Paris, France. The mood of this painting is evoked by lines from "The Rime of the Ancient Mariner" by Coleridge, the English Romantic poet: "I looked upon the rotting deck and there the dead men lay." To ensure authenticity, Géricault spoke with survivors and made studies of the dead and dying in morgues and hospitals before executing the final painting.

monarchist sympathies rather than to merit. Furthermore, the French government had covered up the worst details of the incident. It was not until the ship's surgeon, one of the survivors from the raft, published his account of the disaster that the full extent of the tragedy became known. Géricault took up the cause of the individual against social injustice and translated it into a struggle of humanity against the elements.

The writhing forms, reminiscent of Michelangelo's Sistine ceiling figures from the Flood, echo the turbulence of sea and sky. In the foreground a father mourns his dead son. Other corpses hang over the edge of the raft, while in the background, to the right, frantic survivors wave hopefully at a distant ship. The raft itself tilts upward on the swell of a wave, and the sail billows in the wind. As a result, the viewer looks down on the raft, directly confronting the corpses. The gaze gradually moves upward, following the diagonals of the central figures, and finally reaches the waving drapery of the man standing upright. In this painting Géricault incorporates the Romantic taste for adventure and individual freedom into an actual event, in which victims of injustice fight to survive the primal forces of nature.

Figure **22.5** shows one of Géricault's many drawing studies for the *Raft*. It depicts the father mourning his son in a full-figure profile view and the head and arm in three-quarter view. The former is bearded, as is the painted version; the latter has a dark mustache. The strong hatching lines and bold anatomical structure of the kneeling father contribute to the forcefulness of his despair. In the other drawing, Géricault focuses on the shocked, wide-eyed horror registered by the father. There, the artist uses subtler tonal variations to create the facial expression and reveal character.

22.6 Théodore Géricault, *Madwoman with a Mania of Envy*, 1822–23. Oil on canvas, 28⅜ × 22⅞ in. (72 × 58 cm). Musée des Beaux-Arts, Lyon, France. Géricault was a man of paradoxes—a fashionable society figure and a political and social liberal who was active in exposing injustice. The subject of this portrait, which is also known as *L'Hyène de la Salpêtrière*, was a child murderer. La Salpêtrière was a mental hospital in Paris where Freud studied under the celebrated neuropathologist Jean-Martin Charcot and learned that hypnosis could temporarily relieve the symptoms of hysteria.

Géricault's interest in human psychology is evident in his studies of the insane, which he executed from 1822 to 1823. In these works he captured the mental disturbance of his subjects through pose and physiognomy. In the *Madwoman with a Mania of Envy* (fig. **22.6**), for example, the figure hunches forward and stares suspiciously off to the left, as if aware of some potential menace. The raising of one eyebrow and the lowering of the other, combined with the slight shift in the planes of her face, indicate the wariness of paranoia.

Géricault's loose brushstrokes create the textures of the woman's face, which is accentuated by light and framed by the ruffle of her cap. By the conscious organization of light and color, and the visibility of his brushwork, Géricault unifies the composition both formally and psychologically. The sweeping light-brown curve below the collar echoes the more tightly drawn curve of the mouth. Reds around the eyes and mouth are repeated in the collar, and the white of the cap ruffle recurs in the small triangle of the white undergarment. The untied cap laces and disheveled strands of hair are a metaphor for the woman's emotional state, as if she is "coming apart" and "unraveling" physically as well as mentally.

22.5 Théodore Géricault, figure study for *Raft of the Medusa*, 1819. Pen and pencil on paper, 9⅞ × 11¾ in. (25 × 30 cm). Palais des Beaux-Arts, Lille, France.

Eugène Delacroix

The most prominent figure in French Romantic painting was Eugène Delacroix (1798–1863), who outlived Géricault by nearly forty years. In painting, Delacroix stood for color, just as Ingres, his contemporary and rival, championed line. In this theoretical opposition, Delacroix and Ingres transformed the traditional aesthetic quarrel between *colorito* and *disegno*, the Rubenists and the Poussinists, the Moderns and the Ancients, into Romanticists versus Classicists. Delacroix's paintings are characterized by broad sweeps of color, lively patterns, and energetic figural groups. His thick brushstrokes, like Géricault's, are in direct contrast to the precise edges and smooth surfaces of Neoclassical painting.

In the *Massacre at Chios* (fig. **22.7**) of 1822–24, Delacroix satisfied the Romantic interest in distant places and political freedom. In this he shared the views of Byron (see p. 399), who died of disease in 1824 while aiding the Greeks in their struggle for freedom from the Turks. Delacroix enlists the viewer's sympathy for Greece by showing the suffering and death of its people in the foreground. They are individualized and thus elicit identification with their plight. At the same time, Delacroix has concentrated attention on the details of their exotic dress. Two Turks—one holding a gun and the other on a rearing horse—threaten the Greeks, while scenes of burning villages and massacre are depicted in the distance.

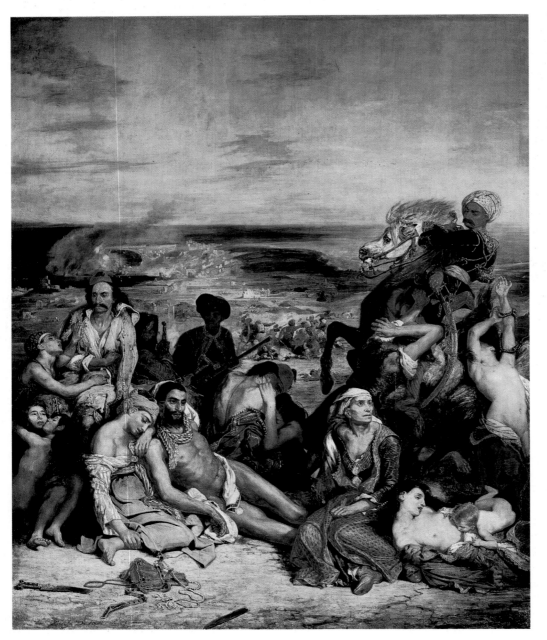

22.7 Eugène Delacroix, *Massacre at Chios*, 1822–24. Oil on canvas, 13 ft. 10 in. × 11 ft. 7 in. (4.22 × 3.53 m). Louvre, Paris, France. Delacroix was rumored to be the illegitimate son of the French statesman Charles Talleyrand (whom he resembled physically), but he was brought up in the family of a French government official. His celebrated *Journal* is a useful source of information on the social context of his life, as well as on his philosophy of art.

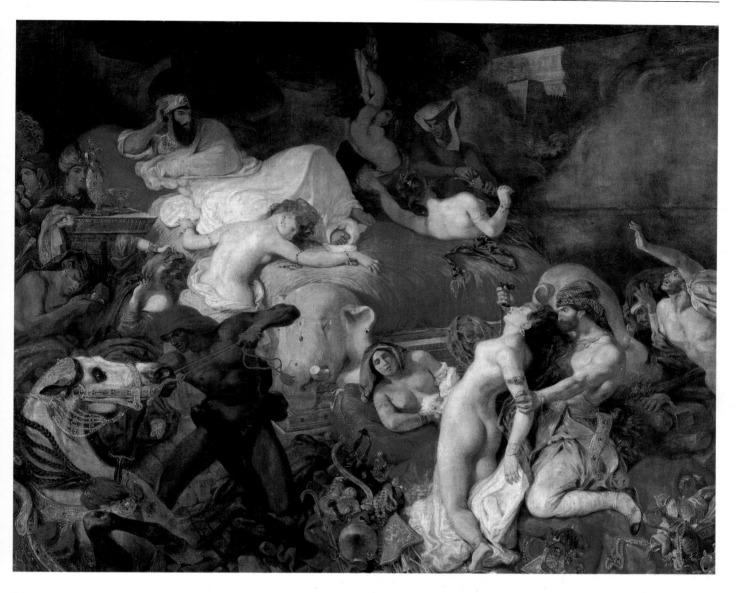

22.8 Eugène Delacroix, *Death of Sardanapalus*, 1827–28. Oil on canvas, 12 ft. 11½ in. × 16 ft. 3 in. (3.95 × 4.95 m). Louvre, Paris, France. When the painting was exhibited at the Salon in February 1828, it was widely criticized. Delacroix was unable to sell it until 1845, and then the buyer was an English collector. The Louvre purchased the work in 1921.

The enormous *Death of Sardanapalus* (fig. **22.8**) inspired by Byron's play of the same subject, also reflects Delacroix's affinities for the poet. Both Byron and Delacroix portray the Assyrian king as a meditative figure in the midst of violence and debauchery. In the play, Sardanapalus accepts that his empire has fallen because his officials betrayed him, and he kills himself on a pyre with his favorite Ionian concubine, Myrrha. Delacroix's figure reclines on a large bed with a rich red covering that accentuates the sensuality of the scene and echoes the multiple reds throughout the painting. The opulence associated with the East is shown in the jewels and objects of gold strewn

on the floor, and in the exotic costumes. Only Sardanapalus and Myrrha, lying at the king's feet, are calm. They are surrounded by vignettes of murderous rage and helpless victims. At the lower left, a black man pulls a fallen horse decked out in elaborate trappings, and at the upper right the city is engulfed in smoke.

Delacroix's *Liberty Leading the People* (fig. **22.9**), executed in 1830, applies Romantic principles to the revolutionary ideal. In contrast to Rude's *Marseillaise* on the Arc de Triomphe (see fig. **22.2**), whose figures are in side view, Delacroix's rebels march directly toward the viewer. Delacroix "romanticizes" the uprising by implying that

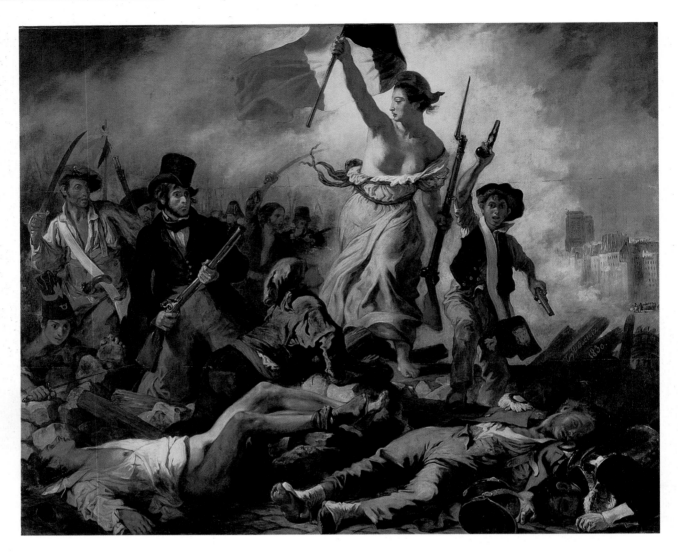

22.9 Eugène Delacroix, *Liberty Leading the People,* 1830. Oil on canvas, 8 ft. 6 in. × 10 ft. 7 in. (2.59 × 3.23 m). Louvre, Paris, France. This painting refers to the July 1830 uprising against the Bourbon king Charles X, which led to his abdication. Louis Philippe, the "citizen-king," was installed in his place, though his powers were strictly limited.

the populace has spontaneously taken up arms, united in yearning for liberty (see caption). The figures emerge from a haze of smoke—a symbol of France's political emergence from the shackles of tyranny. Visible in the distance is the Paris skyline and the towers of Notre-Dame Cathedral. From here the rebels will fly the tricolor (the red, white, and blue French flag).

As in the *Raft of the Medusa* (see fig. **22.4**), Delacroix's corpses lie in contorted poses in the foreground. The diagonal of the kneeling boy leads upward to Liberty, whose raised hand, holding the flag aloft, forms the apex of a pyramidal composition. Her Greek profile and bare breasts recall ancient statuary, while her towering form and costume confirm her allegorical role. By incorporating antiquity into his figure of Liberty, Delacroix makes a nostalgic, "Romantic" appeal to republican sentiment. Among Liberty's followers are representatives of differ-

ent social classes, who are united by their common cause. In their determined march forward, they trample the corpses beneath them. They are willing to die themselves, secure in the knowledge that others will arise to take their place.

A colorist in the tradition of Rubens, Delacroix integrates color with the painting's message. In an image that is primarily composed of brown tones and blacks, the colors that appear most vividly on the flag are repeated throughout the picture. Whites are more freely distributed. In the sky, reds and blues are muted. Denser blues are repeated in the stocking of the fallen man at the left and the shirt of the kneeling boy. His scarf and belt, like the small ribbon of the corpse at the right, are accents of red. In echoing the colors of the flag, which is at once a symbol of Liberty and of French republicanism, Delacroix paints a political manifesto.

Francisco de Goya y Lucientes

The leading Spanish painter of the late eighteenth and early nineteenth centuries, Francisco de Goya y Lucientes ("Goya"; 1746–1828) was attracted by several Romantic themes. His compelling images reflect his remarkable psychological insights, and many also display his support for the causes of intellectual and political freedom.

In 1799 Goya published *Los Caprichos* (Caprices), a series of etchings combined with the new medium of **aquatint** (see Box, p. 408). In this series, he depicts psychological phenomena, often juxtaposing them with an educational or social message. In plate 3 (fig. **22.10**), for example, the title of which may be translated as "The Bogeyman Is Coming," Goya illustrates the nighttime fears of childhood. The mother's gaze is riveted on the unseen face of the Bogeyman, while her children cringe in fear. Their terrified faces,

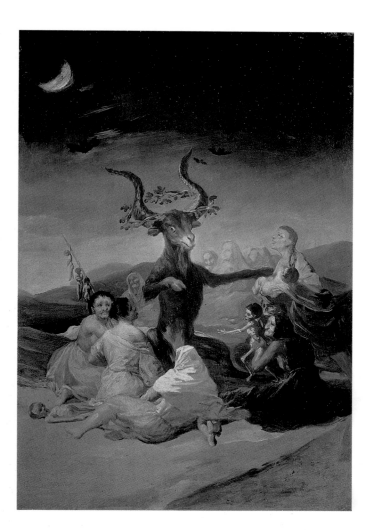

22.11 Francisco de Goya y Lucientes, *The Witches' Sabbath*, 1798–99. Oil on canvas, 17¼ × 12¼ in. (44 × 31 cm). Museo Lázaro Galdiano, Madrid, Spain.

22.10 Francisco de Goya y Lucientes, *Los Caprichos*, plate 3, published 1799. Etching and aquatint. Metropolitan Museum of Art, New York (Gift of M. Knoedler and Co., 1918). Inscribed on the plate (but not visible here) is Goya's warning against instilling needless fears in children: "Bad education. To bring up a child to fear a Bogeyman more than his own father is to make him afraid of something that does not exist."

contrasted with the anonymity of the apparition, accentuate the uncanny character of the Bogeyman. Goya takes full advantage of the dramatic possibilities of the blacks and whites that are characteristic of the medium. The Bogeyman's sharply contrasting light and dark—his "dark side" turned toward the children, whose white faces and black features accentuate their terror—is a metaphor for his two-sided nature. Goya's enlightened view of child development is consistent with the philosophy of Jean-Jacques Rousseau and was unusual in a country still haunted by the Inquisition.

The Witches' Sabbath (fig. **22.11**) of 1798–99 satirizes the irrational belief in witchcraft by exaggerating the primitive quality of such thinking. Here, Goya indirectly attacks the Inquisition, which opposed the Enlightenment. He depicts the widespread fantasy that witches were old, ugly, deformed women who sucked the blood of children and fed infants to Satan. Goya's witches form a circle around a devil in the guise of a goat, and one witch offers him a bloodless, skeletal infant. The lascivious implications of the goat and the bacchanalian grape leaves on his horns refer to popular notions of the witches' sabbath as an orgiastic, cannibalistic ritual.

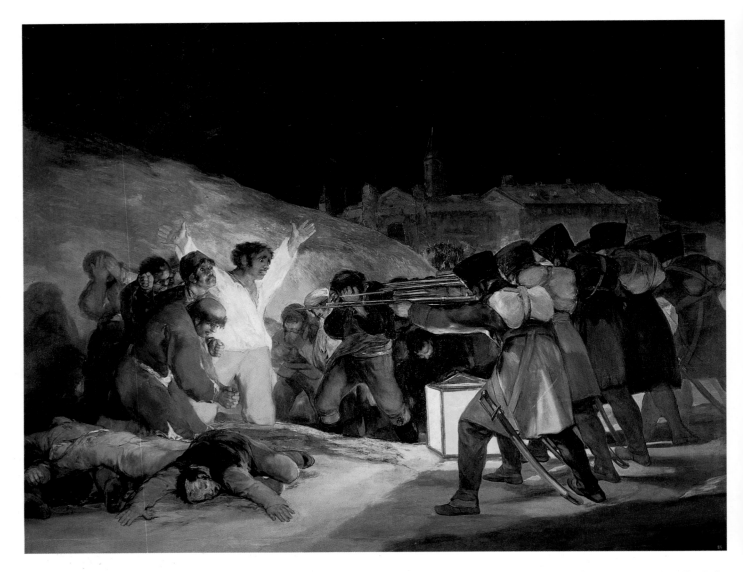

22.12 Francisco de Goya y Lucientes, *The Executions of the Third of May, 1808*, 1814. Oil on canvas, 8 ft. 9 in. × 11 ft. 4 in. (2.67 × 3.45 m). Prado, Madrid, Spain. This painting depicts the aftermath of events that occurred on May 2 and 3, 1808. Two Spanish rebels fired on fifteen French soldiers from Napoleon's army. In response, the French troops rounded up and executed close to a thousand inhabitants of Madrid and other Spanish towns. Six years later, after the French were ousted, the liberal government of Spain commissioned a pair of paintings, of which this is one, to commemorate the atrocity.

In his images of war, Goya champions Enlightenment views of individual freedom against political oppression. In *The Executions of the Third of May, 1808* (fig. **22.12**), he dramatically juxtaposes the visible faces of the victims with the covered faces of the executioners. The firing squad is an anonymous but deadly force whose regular, repeated rhythms and dark mass contrast with the highlighted, disorderly victims. The emotional poses and gestures, accentuated by thick brushstrokes, and the stress on individual reactions to the "blind" brute force of the firing squad are characteristic of Goya's Romanticism. The raised arms of the central, illuminated victim about to be shot recall the death of Jesus. His pose and gesture, in turn, are repeated by the foremost corpse lying in a pool of blood. The lessons of the Crucifixion, Goya seems to be saying, are still unlearned. By mingling reds and browns in this section of the picture, Goya creates the impression that blood is flowing into the earth and literally dyeing it red. Somewhat muted by the night sky, a church rises in the background and towers over the scene. The black sky alludes to the tradition that the sky turned dark at the moment of Jesus's death.

MEDIA AND TECHNIQUE
Aquatint

Although etching was not new to the nineteenth century, its use in combination with aquatint was. In aquatint, the artist covers the spaces between etched lines with a layer of **rosin** (a form of powdered resin). This partially protects against the effects of the acid bath. Since the rosin is porous, the acid can penetrate to the metal, but the artist controls the acid's effect on the plate by treating the plate with varnish. This technique expands the range of grainy tones in finished prints. Aquatint thus combines the principles of engraving with the effects of a watercolor or wash drawing.

Caspar David Friedrich

In Germany, Caspar David Friedrich's (1774–1840) poetic landscapes express these Romantic trends. His *Two Men Contemplating the Moon* from his famous series of *Moon-watchers* (fig. **22.13**) exemplifies the merging of human form and mood with nature. The two men have no individual identity beyond their relationship to the landscape and their old German dress, which reflects Romantic nostalgia for the past. Their forms are nearly silhouettes, and they seem riveted to the distant moon illuminating them and the ghoulish oak tree. We, as viewers, look past the men (Friedrich himself is on the right) and identify with their gaze. They are nearly lost in nature, enveloped by the animated branches reaching toward them. In being engulfed by nature's darkness, in the mysterious quality of the light, and in their ancient mode of dress, Friedrich's figures embody the Romantic aesthetic of the sublime (see Box).

> **THEORY**
> ## The Aesthetic of the Sublime
>
> In 1757 the British philosopher Edmund Burke (1729–97) published *A Philosophical Enquiry into the Origin of Our Ideas of the Sublime and the Beautiful.* Certain artists and writers of the late eighteenth and early nineteenth centuries took up his views on the sublime, which reflect the ambivalent character of the Romantic aesthetic. According to Burke, the passions and the irrational exert a powerful, awesome force on people. These, he believed, explain the subjective reaction to art. Burke's aesthetic system describes the "irrational" attraction to fear, pain, ugliness, loss, hatred, and death (all of which are elements of the sublime), along with beauty, pleasure, joy, and love.

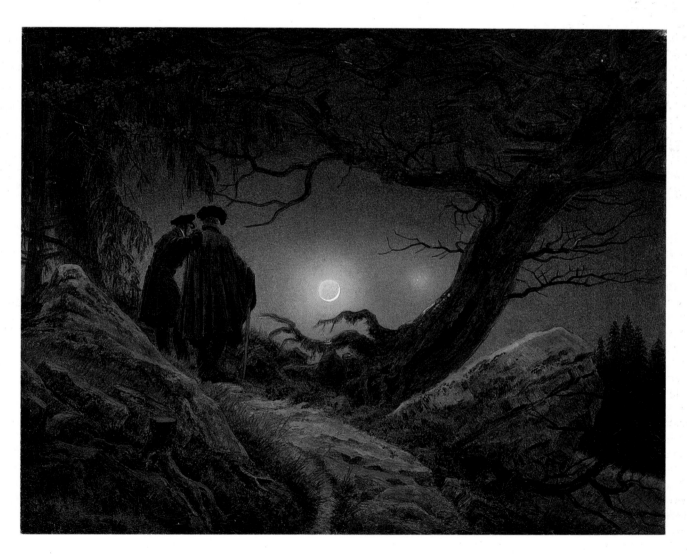

22.13 Caspar David Friedrich, *Two Men Contemplating the Moon,* 1819. Oil on canvas, 13¾ × 17½ in. (35.0 × 44.5 cm). Gemäldegalerie Neue Meister, Staatliche Kunstsammlungen, Dresden, Germany.

John Constable and
Joseph Mallord William Turner

In England, the two greatest Romantic landscape painters, John Constable (1776–1837) and Joseph Mallord William Turner (1775–1851), approached their subjects quite differently. Whereas Constable's images are clear and tend to focus on the details of English country life, Turner's are likely to become swept up in the paint.

In Constable's *Salisbury Cathedral from the Bishop's Garden* (fig. **22.14**), cows graze in the foreground as couples stroll calmly along pathways. The cathedral is framed by trees that echo its vertical spire. Nostalgia for the past is evident in the juxtaposition of the day-to-day activities of the present with the Gothic cathedral. Humanity, like the cathedral, is at one with nature, and there is no hint of the industrialization that in reality was encroaching on the pastoral landscape of nineteenth-century England. The atmosphere of this painting is echoed in the poems of Wordsworth, who wanted to break away from eighteenth-century literary forms and return to nature, to a "humble and rustic life." In "Tintern Abbey," Wordsworth evokes the Romantic sense of the sublime that is achieved by oneness with nature:

> . . . And I have felt
> A presence that disturbs me with the joy
> Of elevated thoughts; a sense sublime
> Of something far more deeply interfused,
> Whose dwelling is the light of setting suns,
> And the round ocean and the living air,
> And the blue sky, and in the mind of man. . . .
> (lines 93–99)

CONNECTIONS

See figure 13.26.
Salisbury Cathedral, England, begun 1220.

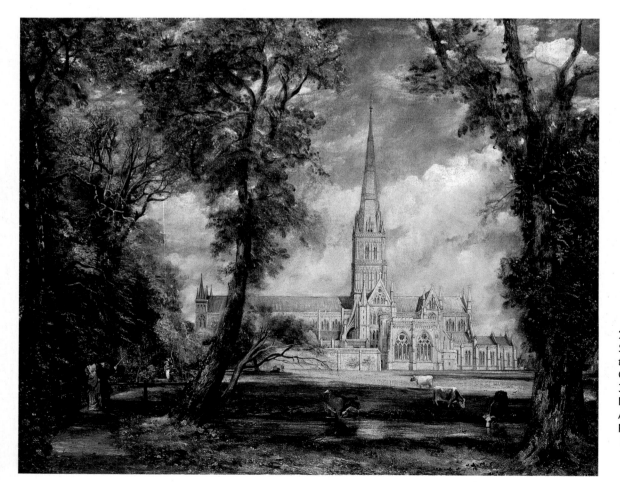

22.14 John Constable, *Salisbury Cathedral from the Bishop's Garden*, 1820. Oil on canvas, 2 ft. 10⅝ in. × 3 ft. 8 in. (0.91 × 1.12 m). Metropolitan Museum of Art, New York (Bequest of Mary Stillman Harkness, 1950).

In contrast to the calm landscapes of Constable, Turner's approach to Romanticism is characterized by dynamic, sweeping brushstrokes and vivid colors that blur the forms. His *Burning of the Houses of Lords and Commons* (fig. **22.15**) is a whirlwind of flame, water, and sky, structured mainly by the dark diagonal pier at the lower right, the bridge, and the barely visible towers of Parliament across the Thames. The luminous reds, yellows, and oranges of the fire dominate the sky and are reflected in the water below. In this work, architecture is in the process of dissolution, enveloped by the blazing lights and colors of the fire. The forces of nature let loose and their destruction of man-made structures are the primary theme of this painting. In Constable, on the other hand, nature is under control and in harmony with human creations.

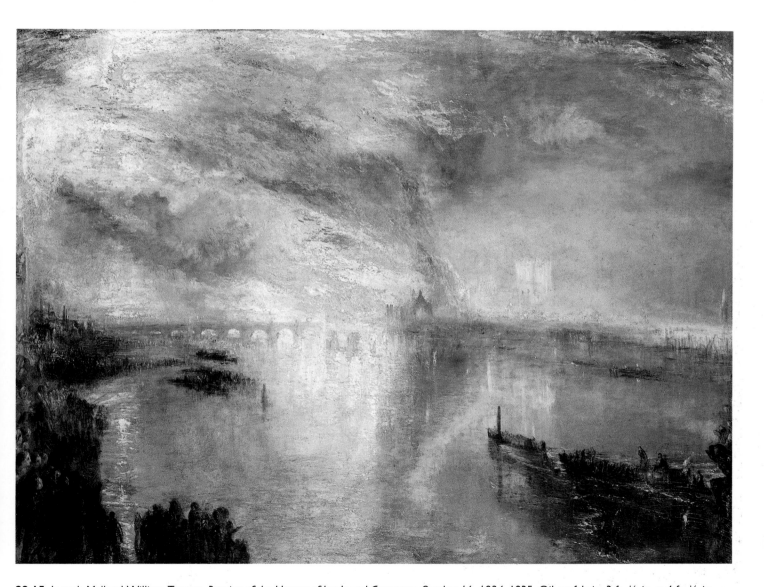

22.15 Joseph Mallord William Turner, *Burning of the Houses of Lords and Commons, October 16, 1834*, 1835. Oil on fabric, 3 ft. ¼ in. × 4 ft. ½ in. (0.92 × 1.23 m). Cleveland Museum of Art (Bequest of John L. Severance, 42.647). The painting is based on an actual fire of 1834. Turner spent the entire night sketching the scene. After the fire, the new Houses of Parliament (still standing today) were built in the Gothic revival style, which was inspired by Romantic nostalgia for a medieval Christian past.

Painting in the United States

In the United States as well as Europe, the Romantic movement infiltrated both art and literature. The landscape of different parts of the country inspired artists, individually and in groups, to produce works that were often monumental in size and breathtaking in effect.

Thomas Cole

One such painting is *The Oxbow* (fig. **22.16**) by Thomas Cole (1801–48), which depicts a bend in the Connecticut River, near Northampton. (*Oxbow* is the term used to describe the crescent-shaped, almost circular, course of a river caused by its meandering.) One is struck by the abrupt contrast between the two sides of the painting. On the left is wilderness, where two blasted trees in the foreground bear witness to the power of the elements. A thunderstorm, an example of nature's dramatic, changing moods characteristic of the Romantic aesthetic, is passing over. The direction of the rain indicates that the storm is moving away to the left and that it has already passed the farmland to the right, which now lies serene and sunlit. A landscape of neatly arranged fields, dotted with haystacks, sheep, and other signs of cultivation, extends into the distance. Boats ply the river, and plumes of smoke rise from farmhouses. Barely visible in the foreground, just right of center, is a single figure, the artist at work before his easel. On a jutting rock are his umbrella and folding stool; leaning against them is a portfolio with the name T. Cole on its cover. Both artist and viewer have a panoramic view from the top of the mountain, a feature that became typical of the Hudson River school of painting, of which Cole was the acknowledged leader.

It was Cole's habit to journey on foot through the northeastern states, making pencil sketches of the landscape. He would then develop these sketches into finished paintings during the winter, and this was the case with *The Oxbow*. It is likely that Cole never actually witnessed the storm in the way he depicts it and that there is a large element of the artist's imagination at work. If so, why did Cole choose

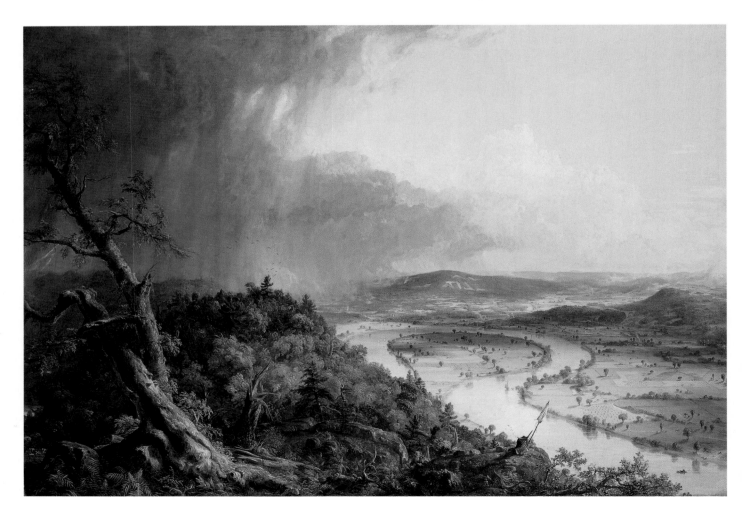

22.16 Thomas Cole, *View from Mount Holyoke, Northampton, Massachusetts, after a Thunderstorm (The Oxbow)*, 1836. Oil on canvas, 4 ft. 3½ in. × 6 ft. 4 in. (1.31 × 1.93 m). Metropolitan Museum of Art, New York (Gift of Mrs. Russell Sage, 1908). Cole was born in England and emigrated to America with his family at the age of seventeen. In 1825 his work came to the attention of John Trumbull (see p. 396), then president of the American Academy, who is quoted as saying: "This youth has done at once, and without instruction, what I cannot do after fifty years' practice." This story, whether accurate or not, places Cole squarely in the tradition of other "boy wonders" such as Giotto and Picasso.

this particular image? An untitled poem, which he wrote in January 1835, a year before he completed *The Oxbow,* begins as follows:

> I sigh not for a stormless clime,
> Where drowsy quiet ever dwells,
> Where purling waters changeless chime
> Through soft and green unwinter'd dells—
>
> For storms bring beauty in their train;
> The hills that roar'd beneath the blast,
> The woods that welter'd in the rain
> Rejoice whene'er the tempest's past.

Cole's affinity for storms has been interpreted by some scholars as a metaphor for his inner life. It is also possible to see the painting as an allegory of civilization (the right) versus savagery (the left), which is consistent with Cole's own outlook. For although he made his reputation primarily as a landscape artist, Cole always aspired to a "higher style of landscape," a mode of painting that contained some additional moral or religious significance.

Albert Bierstadt

The interest in American landscape pushed west from the Hudson River and inspired paintings of panoramic spaces with spectacular views of nature. Variations of light play over mountains, trees, and lakes, the colors softening and changing with the time of day. This emphasis on light led to the term **luminism,** an example of which can be seen in Albert Bierstadt's (1830–1902) *Sunrise, Yosemite Valley* (fig. **22.17**).

Bierstadt was born in Germany but raised in Massachusetts. He combined the German taste for Romanticism and the sublime with an enthusiasm for the American West. In 1859 Bierstadt traveled west with European landscape painters in mind and an ambition to create a new vision in America. In *Sunrise, Yosemite Valley,* his rich yellow lighting is gradually transformed into muted grays as it moves left. The still lake is a mirror of change as it captures the fleeting sensations of nature. As with Friedrich (see fig. **22.13**), Bierstadt emphasizes nature's vastness compared with humanity's smallness.

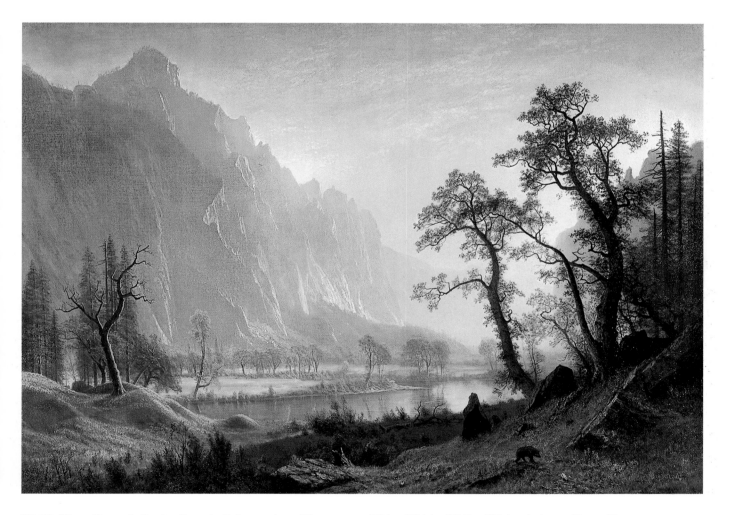

22.17 Albert Bierstadt, *Sunrise, Yosemite Valley,* no date. Oil on canvas, 36½ × 52½ in. (92.7 × 133.4 cm). Amon Carter Museum, Fort Worth, Texas.

Folk Art: Edward Hicks

Another view of nature in nineteenth-century American painting can be found in folk art. Typically folk artists are not academically trained; their forms are usually flattened, their proportions are unnatural, and their imagery is without reference to the Classical tradition. As a result, their works tend to have a spontaneous quality that can be refreshing compared with the more "finished" appearance of works by artists who have had formal training.

One example of this genre that embodies the Romantic ideal of a return to nature is *The Peaceable Kingdom* (fig. **22.18**) by Edward Hicks (1780–1849), who during his lifetime was celebrated more as a Quaker preacher than as an artist. Hicks based this painting on a passage from the Book of Isaiah (11:6–9): "The wolf also shall dwell with the lamb, and the leopard shall lie down with the kid; and the calf and the young lion and the fatling together; and a little child shall lead them." Rather than being drawn into

LITERATURE
American Romantic Writers

Nineteenth-century America produced many important Roman works of literature. The historical adventures of James Fenimo Cooper (1789–1851), particularly *The Last of the Mohicans* (182 extol the American Indian as an example of the "noble savage." T supernatural poems and tales of Edgar Allan Poe (1809–49) conta uncanny portrayals of death and terror. Likewise, the Gothic nov and short stories of Nathaniel Hawthorne (1804–64) create a haunte medieval atmosphere in which supernatural phenomena abound.

A characteristic American Romantic philosophy emerged in t Transcendentalism of Ralph Waldo Emerson (1803– 82) and Hen David Thoreau (1817–62), a doctrine that stressed the presence God within the human soul as a source of truth and a moral guid After a trip to England (where he met Coleridge and Wordsworth Emerson became a spokesman for Romantic individualism, which expressed in poems and essays. A more personal form of natu philosophy can be seen in Thoreau's experimental return to natu He lived alone for two years in a hut at the edge of Walden Pond Massachusetts and recorded his experience in *Walden; or, Life in t Woods* (1854).

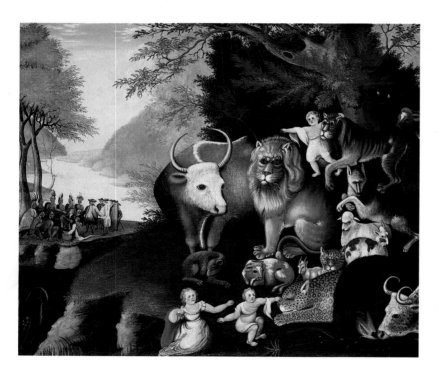

a vast space, the viewer experiences an immediate confrontation with the image, especially the wild cats. Its impact is enhanced by the close-up view of wild animals coexisting peacefully with humans. Their careful, almost staged arrangement and immobile frontality endow them with a static quality. *The Peaceable Kingdom* merges the natural landscape with a utopian ideal related to the notion of a Garden of Eden. The background scene, also utopian, is a visual quotation of a scene in Benjamin West's *Penn's Treaty with the Indians*. In contrast to the capricious, dangerous, and constantly changing eruptions of nature that are captured in the work of Turner and Cole, Hicks's conception seems frozen in time.

22.18 Edward Hicks, *The Peaceable Kingdom*, c. 1834. Oil on canvas, 29⅜ × 35½ in. (74.8 × 90.2 cm). National Gallery of Art, Washington, D.C. (Gift of Edgar William and Bernice Chrysler Garbisch.)

c. 1790

c. 1850

ROMANTICISM: THE LATE 18TH AND EARLY 19TH CENTURIES

(22.2)

Wordsworth and Coleridge, *Lyrical Ballads* (1798)

(22.12)

Napoleon abdicates (1814)

John Keats, *Endymion* (1818)

(22.1)

July Revolution in France (1830)

(22.9)

Charles Darwin begins voyage aboard the *Beagle* (1831)

(22.15)

Slavery ends in British Empire (1834)

Queen Victoria rules in England (1837–1901)

(22.17)

California gold rush begins (1848)

23

Nineteenth-Century Realism

Culture and Politics

The nineteenth century was an age of revolution. Contemporary ideas about human rights can be traced to the eighteenth-century Enlightenment. Resulting conflicts between different classes of society were often implicit in works of art—usually depicted from the viewpoint of those rebelling against political oppression.

England led the Industrial Revolution, which transformed the economies, first of Western Europe, then of the United States and other parts of the world, from an agricultural to a primarily industrial base. The process of industrialization continued at breakneck speed. Inventions such as the steam engine and new materials such as iron and steel made mass manufacturing possible.

Factories were established, mainly in urban areas, and people moved to the cities in search of work. New social class divisions arose between factory owners and workers. Demands for individual freedom and citizens' rights were accompanied in many European countries by social and political movements for workers' rights. In 1848 Karl Marx and Friedrich Engels (see Box) published the most influential of all political tracts on behalf of workers—*The Communist Manifesto*. The same year, the first convention for women's rights was held in New York.

English and French literature of the nineteenth century is imbued with the currents of reform inspired by a new social consciousness. Novelists described the broad panorama of society, as well as the psychological motivation of their characters (see Box, p. 416). In science, the observation of nature led to new theories about the human species and its origin. In 1859, for example, the naturalist Charles Darwin (1809–92) published *Origin of Species by Means of Natural Selection,* written after a five-year sea voyage aboard the *Beagle*.

Newspapers and magazines reported scientific discoveries and also carried **cartoons** and **caricatures** satirizing political leaders, the professions, actors, and artists. The

THEORY
Marx and Engels: *The Communist Manifesto*

The political theory of communism was set out by Karl Marx (1818–83) and Friedrich Engels (1820–95) in *The Communist Manifesto,* published in England in 1848.

Marxism views history as a struggle to master the laws of nature and apply them to humanity. The *Manifesto* outlines the stages of human evolution, from primitive society to feudalism and then to capitalism, each phase being superseded by a higher one.

Marxists believed that bourgeois society had reached a period of decline; it was now time for the working class (or "proletariat") to seize power from the capitalist class and organize society in the interests of the majority. The next stage would be socialism under the rule of the working-class majority ("dictatorship of the proletariat"). This, in turn, would be followed by true communism, in which the guiding principle "from each according to his ability, to each according to his needs" would be realized. Part analysis, part rhetoric, the *Manifesto* ends: "The proletarians have nothing to lose but their chains. They have a world to win. Working men of all countries, unite!"

In his *Introduction to the Critique of Political Economy* (1857–59), Marx argued that art is linked to its social context and should not be regarded in purely aesthetic terms. His primary interest was in the relationship of art production to the proletarian base of society and its exploitation by the superstructure (the bourgeoisie). For Marx, the arts were part of the superstructure, which comprises the patrons of art, while the artists were "workers." As a result, he believed that artists had become alienated from their own productions. His view of the class struggle has led to various so-called Marxist theories of art history, in which art is interpreted as a reflection of conflict between proletariat and bourgeoisie.

LITERATURE
Realism

The current of Realism and its related "-ism," Naturalism, flows through nineteenth-century literature, science, and the arts. In England, Charles Dickens (1812–70) described the dismal conditions of lower-class life. He drew on direct observation and personal experience, for as a boy he had worked in a factory while his father was in debtors' prison. His opening sentence in his novel of the French Revolution, *A Tale of Two Cities,* reflects his ambivalence toward contemporary society: "It was the best of times, it was the worst of times, it was the age of wisdom, it was the age of foolishness, it was the epoch of belief, it was the epoch of incredulity, it was the season of Light, it was the season of Darkness."

In France, Honoré de Balzac (1799–1850) wrote eighty novels, making up *La Comédie Humaine (The Human Comedy)*—a sweeping panorama of nineteenth-century French life. The novelists Gustave Flaubert (1821–80) and Émile Zola (1840–92) also focused on society and personality. In 1857 Flaubert published *Madame Bovary*, the story of the unfaithful wife of a French country doctor. The description of her suicide by arsenic poisoning is a classic example of naturalistic observation. Zola not only championed a Realist approach to the arts but was also a staunch defender of political and social justice.

proliferation of newspapers reflected the expanding communications technology, and advances in printing and photography made articles and images ever more accessible to a wider public. Inventions such as the telegraph (1837) and telephone (1876) increased the speed with which news could be delivered. Travel was also accelerated; the first passenger railroad, powered by steam, went into service in England in 1825.

Paralleling the more general social changes in the nineteenth century was the change in the social and economic structure of the art world that had begun in the previous century. Crafts were replaced by manufactured goods. Guilds were no longer important to an artist's training, status, or economic well-being. A new figure on the art scene was the critic, whose opinions, published in newspapers and journals, influenced buyers. Patronage became mainly the province of dealers, museums, and private collectors. Both the art gallery and the museum as they exist today originated in the nineteenth century.

In the visual arts, the style that corresponded best to the new social awareness is called Realism. The term was coined in 1840, although the style itself appeared well before that date. The primary concerns of the Realist movement in art were direct observation of society and nature, and political and social satire.

French Realism

Jean-François Millet

The Gleaners (fig. **23.1**), by Jean-François Millet (1814–75), illustrates the transition between Romanticism and Realism in painting. The heroic depiction of the three peasants in the foreground and their focus on their task recalls the Romantic sense of "oneness with nature." Two peasants in particular are monumentalized by their foreshortened forms, which convey a sense of powerful energy. Contrasted with the laborers gleaning the remains of the harvest is the prosperous farm in the background. The emphasis on class distinctions—the hard physical labor of the poor as opposed to the comfortable lifestyle of the wealthy—is characteristic of Realism. In addition to social observation, Millet uses light to highlight economic differences—the farm is illuminated in a golden glow of sunlight, while the three foreground figures and the earth from which they glean are in shadow.

Rosa Bonheur

Another approach to nature in which Realism and Romanticism are combined is found in the work of Rosa Bonheur (1822–99). Her painting *The Horse Fair* (fig. **23.2**) shows her close study of the anatomy and movement of horses galloping, rearing, and parading. Consistent with Realist interest in scientific observation, Bonheur dissected animals from butcher shops and slaughterhouses; she also visited horse fairs, such as this one, and cattle markets. In addition to the Realist qualities of *The Horse Fair,* the thundering energy of the horses and the efforts of their grooms to keep them under control have a Romantic character. Likewise, the turbulent sky echoes the dramatic (and Romantic) dynamism of the struggle between humanity and the untamed forces of nature.

23.1 Jean-François Millet, *The Gleaners,* 1857. Oil on canvas, approx. 2 ft. 9 in. × 3 ft. 8 in. (0.84 × 1.12 m). Musée d'Orsay, Paris, France. Because of their powerful paintings of rural labor, Millet and his contemporary Courbet were suspected of harboring anarchist views. Both were members of the Barbizon school, a group of French artists who settled in the village of that name in the Fontainebleau Forest. They painted directly from nature, producing landscapes tinged with nostalgia for the countryside, which was receding before the advance of the Industrial Revolution.

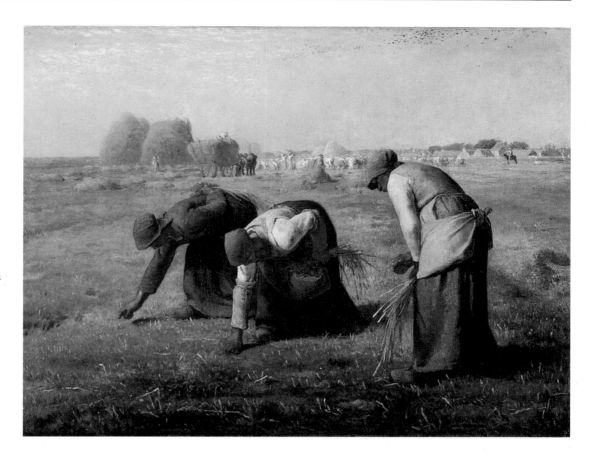

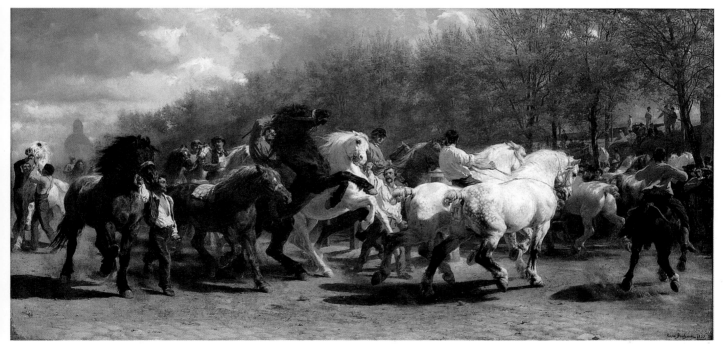

23.2 Rosa Bonheur, *The Horse Fair,* 1853. Oil on canvas, 8 ft. ¼ in. × 16 ft. 7½ in. (2.44 × 5.07 m). Metropolitan Museum of Art, New York (Gift of Cornelius Vanderbilt, 1887). Rosa Bonheur regularly exhibited in the Salons of the 1840s and achieved international renown as a painter of animals. In 1894 she was named the first woman artist of the Legion of Honor. Her father was a landscape painter, and a Saint-Simon socialist who favored women's rights and believed in a future female Messiah. Bonheur made a point of imitating the dress and behavior of men and lived only with women. In order to wear men's clothes in Paris—they were especially practical when she made sketches in slaughterhouses—she had to have a police permit, which was renewable every six months. *The Horse Fair* toured England and was privately exhibited in Windsor Castle at the behest of Queen Victoria. In 1887 Cornelius Vanderbilt donated it to the Metropolitan Museum of Art. When "Buffalo Bill" Cody took his Wild West show to France, he brought Bonheur a gift of two mustangs from Wyoming.

Gustave Courbet

The painter most directly associated with Realism was Gustave Courbet (1819–77), who believed that artists could accurately represent only their own experience. He rejected historical painting, as well as the Romantic depiction of exotic locales and revivals of the past. Although he had studied the history of art, he claimed to have drawn from it only a greater sense of himself and his own experience. In 1861 he wrote that art could not be taught. One needed individual inspiration, he believed, fueled by study and observation. Courbet's Realist approach to his subject matter is expressed in the statement "Show me an angel and I'll paint one."

Courbet's *Stone Breakers* of 1849 (fig. **23.3**) reflects the impact of socialist ideas on his iconography. It depicts two workers, one breaking up stones with a hammer and the other lifting a heavy rock. Like Millet's *Gleaners,* these figures evoke the Romantic nostalgia for a simple existence, but also show the mindless, repetitive character of physical labor born of poverty. Both the *Gleaners* and the *Stone Breakers* are rendered anonymously—their faces are lost in shadow—and this allies them with a class of work rather than accentuating their human individuality.

A similar emphasis on repetitive sameness as an aspect of French society can be seen in Courbet's enormous friezelike painting *Burial at Ornans* (fig. **23.4**). Turning to his native town of Ornans, Courbet depicted the local bourgeoisie attending a funeral. At the right, female mourners in black attract the gaze of the dog in the foreground. A circle formed by male relatives, a group of beadles (local officials) in red, and a priest frames the newly dug grave. Churchmen occupy the far left. The long horizontal plane of figures is interrupted only by the vertical crucifix penetrating the somber sky. The dark colors that predominate are varied only by the red costume of the beadles and the blue stockings on the man by the dog.

This intensely Catholic group, its compact arrangement, and its minimal variety reflect the monotonous reality of life in rural nineteenth-century France. It is also possible that by equalizing his figures through the use of isocephaly, Courbet was making a revolutionary political statement in favor of egalitarianism. When the *Burial* was first exhibited in 1850, critics found it boring. They also objected to monumentalizing such an everyday occurrence.

Honoré Daumier

Honoré Daumier (1808–79), one of the most direct portrayers of social injustice, has been called both a Romantic and a Realist. In this chapter he is discussed in the context of Realism. His *Third-Class Carriage* (fig. **23.5**) illustrates his attention to Realist concerns. A section of society seems to have been framed unawares. Strong contrasts of light and dark, notably in the silhouetted top hats, create clear edges, in opposition to the looser brushwork elsewhere. The very setting, the interior of a railroad car, exemplifies the new industrial subject matter of nineteenth-century painting.

Although Daumier had painted for much of his life, he was not recognized as a painter before his first one-man show at the age of seventy. He earned his living by selling satirical drawings and cartoons to the Paris press and reproducing them in large numbers by **lithography** (see Box, p. 420, and figure **23.7**). His works usually appeared in *La Caricature,* a weekly paper founded in 1830 and

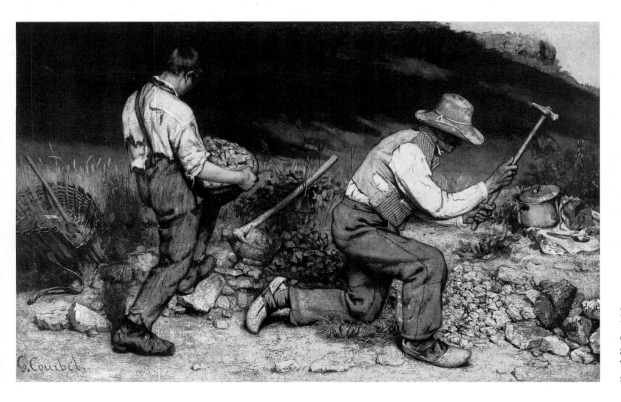

23.3 Gustave Courbet, *The Stone Breakers,* 1849. Oil on canvas, 5 ft. 3 in. × 8 ft. 6 in. (1.60 × 2.60 m). Whereabouts unknown since World War II.

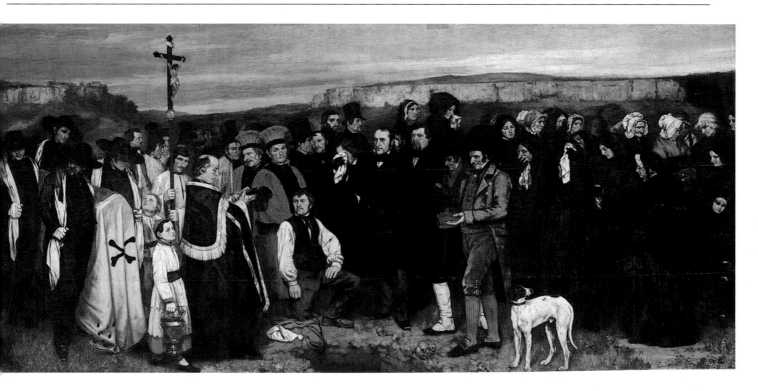

23.4 (Above) Gustave Courbet, *Burial at Ornans,* 1849. Oil on canvas, 10 ft. 4 in. × 21 ft. 11 in. (3.15 × 6.68 m). Musée d'Orsay, Paris, France.

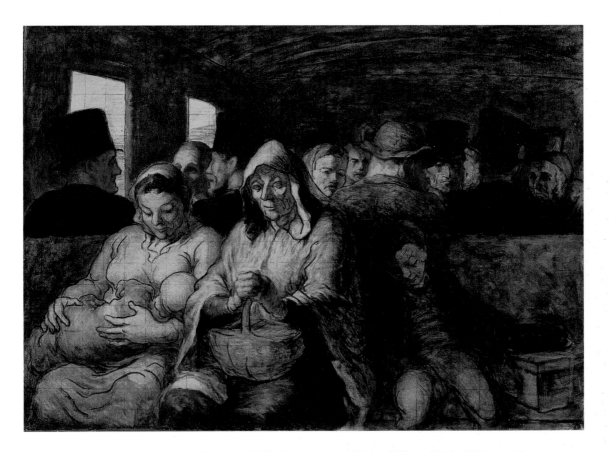

23.5 Honoré Daumier, *Third-Class Carriage,* c. 1862. Oil on canvas, 25¾ × 35½ in. (65.4 × 90.2 cm). Metropolitan Museum of Art, New York (Bequest of Mrs. H. O. Havemeyer, 1929). Lower-class figures crowd together in a dark, confined space. The three drably dressed passengers in the foreground slump slightly on a hard wooden bench. They seem resigned to their status and turn inward, as if to retreat from harsh economic reality. Their psychological isolation defends them from the crowded conditions in which they live.

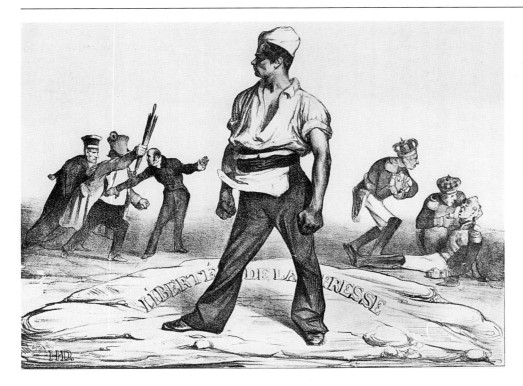

23.6 Honoré Daumier, *The Freedom of the Press: Don't Meddle with It (Ne Vous y Frottez Pas)*, 1834. Lithograph, 12 × 17 in. (30.5 × 43.2 cm). Private collection, France. The implication of this image is that the power of the press is ultimately greater than that of a king. Daumier's depiction of dress according to class distinctions is characteristic of 19th-century Realist social observation.

suppressed by the government in 1835, and *La Charivari*, a daily paper started in 1832. Daumier satirized corrupt politicians, judges, lawyers, doctors, businessmen, actors, and even the king himself (see fig. **23.8**).

In 1834 *La Caricature* published Daumier's protest against censorship, titled *The Freedom of the Press: Don't Meddle with It* (fig. **23.6**). The foreground figure in working-class dress is Daumier's hero. He stands firm, with clenched fists and a set, determined jaw. Behind him "FREEDOM OF THE PRESS" is inscribed like raised type on a rocky terrain. He is flanked in the background by two groups of three social and political characters, who are the targets of Daumier's caricature. On the left, members of the bourgeoisie feebly brandish an umbrella. On the right, the dethroned and crownless figure of Charles X receives ineffectual aid from two other monarchs.

MEDIA AND TECHNIQUE
Lithography

A lithograph, literally a "stone (lith) writing or drawing (graph)," is a print technique first used at the end of the eighteenth century in France. In the nineteenth century, lithography became the most widely used print medium for illustrating books, periodicals, and newspapers, and for reproducing posters.

To create a lithograph (fig. **23.7**), the artist makes a picture with a grease **crayon** on a limestone surface. Alternatively, a pen or brush is used to apply ink to the stone. Since limestone is porous, it "holds" the image. The artist then adds water, which adheres only to the nongreased areas of the stone because the greasy texture of the image repels the moisture. The entire stone is rolled with a greasy ink that sticks only to the image. When a layer of damp paper is placed over the stone and both are pressed together, the image is transferred from the stone to the paper, thereby creating the lithograph. This original print can then be reproduced relatively cheaply and quickly, making it suitable for mass distribution. Since the stone does not wear out in the printing process, a large number of impressions can be taken from it.

In transfer lithography, a variant used by Daumier, the artist draws the image on paper and fixes it to the stone before printing. This retains the texture of the paper in the print and is more convenient for mass production.

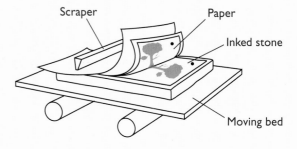

23.7 Creating a lithograph.

So great was the impact of Daumier's caricatures that in 1835 France passed a law limiting freedom of the press to verbal rather than pictorial expression. The French authorities apparently felt that drawings were more apt to incite rebellion than words. Such laws, which are remi- niscent of the ninth-century Iconoclastic Controversy (see p. 169), are another reflection of the power of images. Clearly, the nineteenth-century French censors felt more threatened by the proverbial "picture" than by the "thou- sand words."

SOCIETY AND CULTURE
Daumier and Satire

Gargantua, a good-natured giant in French folklore, became the main character in Rabelais' (c. 1494–1553) work on monastic and educational reform, *La Vie Très Horrifique du Grand Gargan- tua (The Very Horrific Life of the Great Gargantua)*. Rabelais' Gar- gantua is a gigantic prince with an equally enormous appetite. (The root word *garg* is related to "gargle" and "gorge," which is also French for "throat." In Greek, the word *gargar* means "a lot" or "heaps," and in English one who loves to eat is some- times referred to as having a "gargantuan" appetite.)

In Daumier's print (fig. **23.8**), a gigantic Louis Philippe, the French king (1830–48), is seated on a throne before a starving crowd. A poverty-stricken woman tries to feed her infant, and a man in rags is forced to drop his last few coins into a bas- ket. The coins are then carried up a ramp and fed to the king. Underneath the ramp, greedy but well-dressed figures grasp at falling coins. A group in front of the Chamber of Deputies, the French parliament, applauds Louis Philippe. The message of this caricature is clear: a never-satisfied king exploits his sub- jects and grows fat at their expense. Daumier explicitly identi- fied Louis Philippe as Gargantua in the title of the print. In 1832 Daumier, along with his publisher and printer, was charged with inciting contempt and hatred for the French government and with insulting the person of the king. He was sentenced to six months in jail and fined one hundred francs.

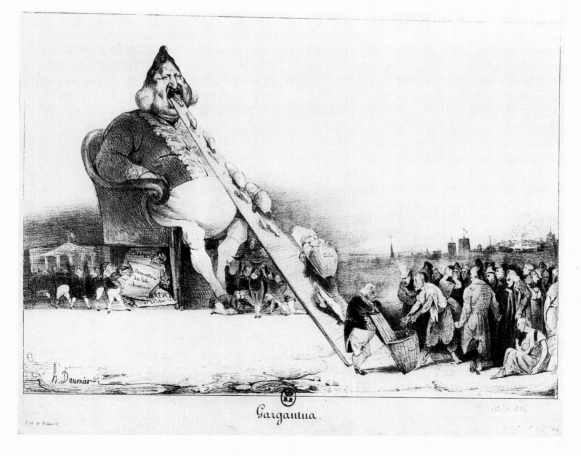

23.8 Honoré Daumier, *Louis Philippe as Gargantua*, 1831. Lithograph, 8⅜ × 12 in. (21.4 × 30.5 cm). Bibliothèque Nationale de France, Paris.

Photography

Another method of creating multiple images—and one that struggled to become an art form in its own right in the nineteenth century—was photography. It achieved great popularity, and its potential use for both portraiture and journalism was widely recognized. Many painters were also photographers, and from the nineteenth century the mutual influence of photography and painting has grown steadily.

Photography means literally "drawing with light" (from the Greek word *phos,* "light," and *graphe,* "drawing" or "writing"). The basic principles may have been known in China as early as the fifth century B.C. The first recorded account of the **camera obscura** (fig. **23.9**), literally a "dark room," is by Leonardo da Vinci. He described how, when light is admitted through a small hole into a darkened room, an inverted image appears on the opposite wall or on any surface (for example, a piece of paper) interposed between the wall and the opening. In the early seventeenth century, the astronomer Johannes Kepler devised a portable camera obscura, resembling a tent. It has since been refined and reduced to create the pre-digital camera, the operation of which matches the principles of the original "dark room."

From the eighteenth century, discoveries in photochemistry accelerated the development of modern photography. It was found that silver salts, for example, were sensitive to light, and that an image could therefore be made with light on a surface coated with silver. In the 1820s a Frenchman, Joseph-Nicéphore Niépce (1765–1833), discovered a way to make the image remain on the surface. This process was called **fixing** the image; however, the need for a long exposure time (eight hours) made it impractical.

In the late 1830s another Frenchman, Louis Daguerre (1789–1851), discovered a procedure that reduced the exposure time to fifteen minutes. He inserted a copperplate coated with silver and chemicals into a camera obscura and focused through a lens onto a subject. The plate was then placed in a chemical solution (or "bath"), which "fixed" the image. Daguerre's photographs, called **daguerreotypes,** could not be reproduced, and each one was therefore unique. The final image reversed the real subject, however, and also contained a glare from the reflected light. In 1839 the French state purchased Daguerre's process and made the technical details public.

Improvements and refinements quickly followed. Contemporaneously with the development of the daguerreotype, the English photographer William Henry Fox Talbot (1800–77) invented "negative" film, which permitted multiple prints. The negative also solved the problem of Daguerre's reversed print image: since the negative was reversed, reprinting the negative onto light-sensitive paper reversed the image back again. By 1858 a shortened exposure time made it possible to capture motion in a still picture.

During the twentieth century, color photography developed. Still photography inspired the invention of "movies," first in black-and-white and then in color. Today, photog-

23.9 Diagram of a camera obscura. Courtesy George Eastman House, Rochester, New York. Here the camera obscura has been reduced to a large box. Light reflected from the object (1) enters the camera through the lens (2) and is reflected by the mirror (3) onto the glass ground (4), where it is traced onto paper by the artist/photographer.

raphy and the cinema have achieved the status of art forms in their own right.

From its inception, photography has influenced artists. Italian Renaissance artists used the camera obscura to study perspective. Later artists, including Vermeer, are thought to have used it to enhance their treatment of light. In the mid-nineteenth century, artists such as Ingres and Delacroix used photographs to reduce the sitting time for portraits. Eakins was an expert photographer who used photographic experiments to clarify the nature of locomotion.

Black-and-white photography has an abstract character quite distinct from painting, which, like nature itself, usually has color. The black-and-white photograph creates an image with tonal ranges of gray rather than line or color. Certain photographic genres, such as the close-up, the candid shot, and the aerial view, have influenced painting considerably.

France: Nadar

In France, the photographic portraits taken by the novelist and caricaturist Gaspard-Félix Tournachon, known as Nadar (1820–1910), were particularly insightful. His portrait of Sarah Bernhardt (fig. **23.10**), the renowned French actress, illustrates the subtle gradations of light and dark that are possible in the photographic medium. Nadar has captured Bernhardt in a pensive mood. Her piercing eyes stare at nothing in particular but seem capable of deep penetration.

In addition to portraiture, Nadar was a pioneer of aerial photography. He took the first pictures from a balloon in 1856, which demonstrated the potential of photography for creating panoramic vistas and new viewpoints. Nadar

then built his own balloon, which he named *Le Géant* (The Giant). In 1870, when France declared war on Prussia, Nadar helped organize the Paris balloon service for military observation.

From 1850 a new "quarrel" arose in the French art world over the status of photography. "Is it ART?" became a controversial issue, with the "nays" arguing that its mechanical technology made it an automatic, rather than an artistic, process. Because the artist's hand did not create the image directly, it was not "ART." Many adherents of this point of view did not, however, object to the use of photography for commerce, industry, journalism, or science. The exhibition of photography also became an issue, which was exemplified by the International Exhibition of 1855 in Paris. On the one hand, photography was brought before a wide public, and its advantages were recognized. But on the other hand, because it was not shown in the Palais des Beaux-Arts (Palace of Fine Arts), photography was allied with industry and science rather than with the arts. In 1859 the French Photographic Society negotiated an exhibition scheduled at the same time, and in the same building, as

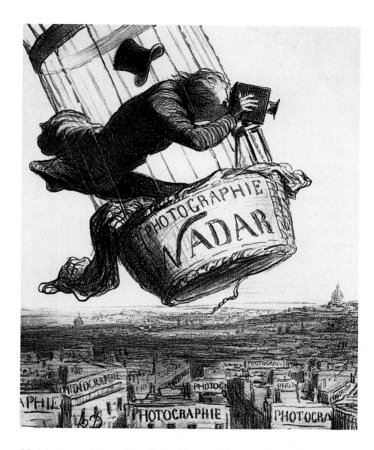

23.11 Honoré Daumier, *Nadar Elevating Photography to the Height of Art*, 1862. Lithograph, 10¾ × 8¾ in. (27.2 × 22.2 cm).

the Salon, but the two exhibitions were held in separate sections of the building.

In the 1860s several books were published that argued that photography should be accorded artistic status. To some extent, this debate continues even today. Its irony can be seen in the light of the sixteenth- and seventeenth-century quarrels—in Venice and Spain, respectively—over the status of painting as a Liberal Art. In those instances, because the artist's hand *did* create the work, it was considered a craft, and not an art. With photography, the *absence* of the hand is used as an argument against artistic status.

This ongoing quarrel did not escape Daumier's penchant for satire. In 1862 he executed the caricature of *Nadar Elevating Photography to the Height of Art* (fig. **23.11**), showing Nadar inside *Le Géant,* photographing the rooftops of Paris. Each roof is inscribed with the word "PHOTO-GRAPHIE." Daumier emphasizes Nadar's precarious position by a series of sharp diagonals—from his hat to his camera, which is parallel to his legs, and the line of his back, which repeats the basket and rim of the balloon. The force of the wind is indicated by the flying drapery, flowing hair, and hat about to be blown away. Height, in this image, is satirically equated with the lofty aspirations of photography to the status of ART.

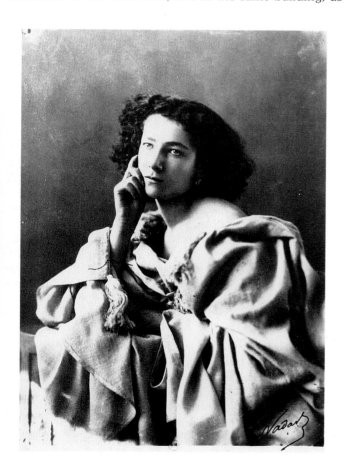

23.10 Gaspard-Félix Tournachon (Nadar), *Sarah Bernhardt,* c. 1864. Photograph from a collodion negative. Bibliothèque Nationale, Paris, France. In 1854 Nadar published *Le Panthéon Nadar,* a collection of his best works. The portrait of Bernhardt (at age nineteen) emphasizes her delicate features and quiet pose, in contrast to the large, voluminous, tasseled drapery folds.

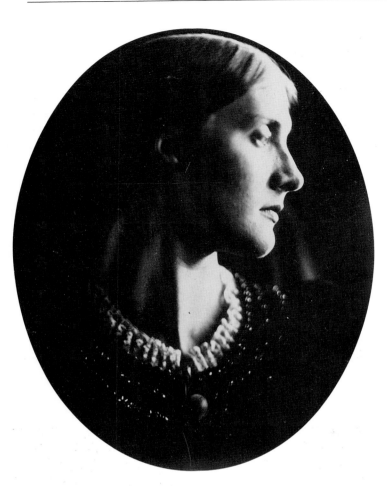

23.12 Julia Margaret Cameron, *Mrs. Herbert Duckworth*, 1867. Photograph. National Museum of Photography, Film & Television / Science & Society Picture Library. Mrs. Duckworth, later Mrs. Leslie Stephen, was the mother of the English author Virginia Woolf.

England: Julia Margaret Cameron

In England, the portrait photographer Julia Margaret Cameron (1815–79) insisted on the aesthetic qualities of photography. She manipulated techniques in order to achieve certain effects, preferring blurred edges and a dreamy atmosphere to precise outlines. Her 1867 portrait of Mrs. Herbert Duckworth (fig. **23.12**) illustrates these preferences. The softness of the face and collar, which emerge gradually from the darkness, seem literally "painted in light." Cameron conceived of photography almost with reverence, as a means to elicit the inner character of a talented sitter. She described this in her autobiography, *Annals of My Glass House,* as follows: "When I have had such men before my camera, my whole soul has endeavored to do its duty towards them in recording faithfully the greatness of the inner as well as the features of the outer man. The photograph thus taken has been almost the embodiment of a prayer."[1]

America: Mathew Brady

In the United States, the photographs of Mathew Brady (c. 1822–96) combine portraiture with on-the-spot journalistic reportage. Of the one hundred or so known photographs of Lincoln, more than a third were taken by Brady. In his "Cooper Union" portrait (fig. **23.13**), Brady depicts Lincoln as a thoughtful, determined man. Lincoln's straightforward stare, as if gazing firmly down on the viewer, creates a very different impression from the dreamy, introspective characters of Nadar's *Sarah Bernhardt* and Cameron's *Mrs. Herbert Duckworth*. Lincoln stands before a column, which is both a studio prop and an architectural allusion. To foster the union of North and South, Lincoln cited the biblical metaphor, "A house divided against itself cannot stand." His hand rests on a pile of books, evoking his profound commitment to literature and intellectual truth.

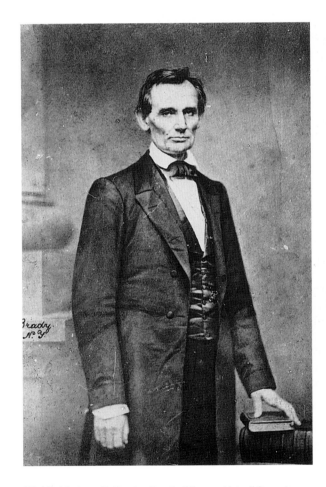

23.13 Mathew B. Brady, *Lincoln "Cooper Union" Portrait,* 1860. Photograph. Library of Congress. Brady took this photograph on February 27 at the Tenth Street Gallery in New York City. Lincoln had just delivered his Cooper Union Speech to the members of the Young Men's Republican Club.

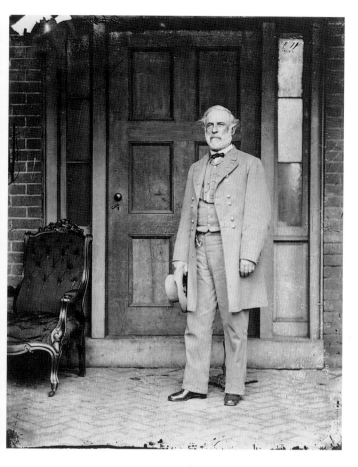

23.14 Mathew B. Brady, *Robert E. Lee*, 1865. Photograph. Library of Congress.

In April 1865 Brady photographed the Confederate general Robert E. Lee (fig. **23.14**). He portrayed the formally dressed and neatly groomed Lee as proud and dignified, despite defeat. Only a few creases in his clothing and under his eyes betray the years of suffering he has witnessed. His house in Richmond, like Lee himself, is shown still standing at the end of the war—he is framed by the rectangle of his back door. The elegant upholstered chair, half out of the picture, is a memento of the passing civilization for which he fought.

American Realist Painting

Thomas Eakins's *Gross Clinic*

One of the landmarks of Realist painting in America was *The Gross Clinic* (fig. **23.15**) by Thomas Eakins (1844–1916). It depicts a team of doctors led by Dr. Samuel D. Gross, an eminent surgeon at Jefferson Medical College in Philadelphia. They are performing an operation while dressed in street clothes, as was the custom in the nineteenth century. Dr. Gross holds a scalpel and comments on the operation to the audience in the amphitheater.

Eakins uses atmospheric perspective (see p. 253) and highlights the surgical procedure. In his choice of subject, as well as his lighting, Eakins echoes Rembrandt, who had painted a well-known scene of a doctor dissecting a cadaver. Here, however, the patient is alive, and a female relative, probably his mother, sits at the left and hides her face. In addition to using light to highlight the surgery, Eakins endows it with symbolic meaning. The illumination on Gross's forehead and hand accentuates his "enlightened" mind and his manual skill.

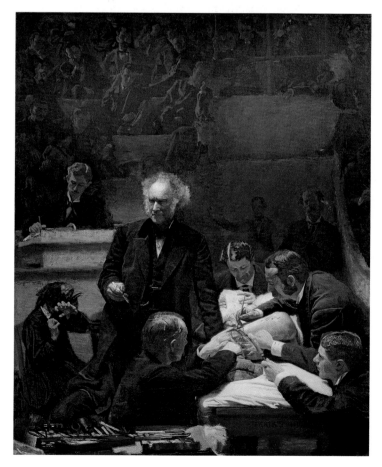

23.15 Thomas Cowperthwait Eakins, *The Gross Clinic*, 1875–76. Oil on canvas, 8 ft. × 6 ft. 6 in. (243.8 × 198.1 cm). Philadelphia Museum of Art and the Pennsylvania Academy of Fine Arts. As an art teacher, Eakins emphasized the study of anatomy, dissection, and scientific perspective. He clashed with the authorities of the Pennsylvania Academy over his policy that women students draw from the nude.

23.16 Henry Ossawa Tanner, *Annunciation*, 1898. Oil on canvas, 4 ft. 9 in. × 5 ft. 11½ in. (1.45 × 1.82 m). Philadelphia Museum of Art (W. P. Wilstach Collection). Tanner's mother was born a slave and remained so until her father was given his freedom. She moved to Pittsburgh, attended school, and eventually married the Reverend Benjamin Tucker Tanner, who became a bishop. Tanner's parents admired the abolitionist John Brown; they gave their son the middle name Ossawa after Osawatomie, Kansas, where John Brown killed several vigilantes who were fighting to preserve slavery.

Henry Ossawa Tanner

Eakins's student Henry Ossawa Tanner (1859–1937) moved to Paris, where he was the first African American to exhibit at the Paris Salon. Tanner painted Realist scenes of African American life in the United States. Later he used his religious faith to express what he believed were universal emotions—the essential reality—in biblical stories. He traveled to the Middle East in January 1897 and absorbed the atmosphere that would provide the setting for his biblical pictures.

The next year, Tanner exhibited his *Annunciation* (fig. **23.16**) at the Salon. He shows Mary having just awakened and sitting up in bed. She tilts her head to stare at the appearance of a gold rectangle of light, which signifies a divine presence. The attention to realistic details such as Mary's dress, the stone floor, and the Near Eastern rug, is combined with mystical qualities of light. At the same time, Tanner depicts Mary as an apprehensive participant in the miraculous event.

French Realism in the 1860s

Édouard Manet's *Déjeuner sur l'Herbe*

The work of Édouard Manet (1832–83) in Paris formed a transition from Realism to Impressionism (see Chapter 24). By and large, Manet's paintings of the 1860s are consistent with the principles of Realism, whereas in the 1870s and early 1880s he adopted a more Impressionist style.

In 1863 Manet shocked the French public by exhibiting his *Déjeuner sur l'Herbe* ("Luncheon on the Grass") (fig. **23.17**). It is not a Realist painting in the social or political sense of Daumier, but it is a statement in favor of the artist's individual freedom. The shock value of a nude woman casually lunching with two fully dressed men, which was an affront to the propriety of the time, was accentuated by the recognizability of the figures. The nude, Manet's model Victorine Meurend, stares directly at the viewer. The two men are Manet's brother Gustave and his future brother-in-law, Ferdinand Leenhoff. In the background, a lightly clad woman wades in a stream.

Although Manet's *Déjeuner* contains several art-historical references to well-known Renaissance pictures, in particular to Giorgione's *Fête Champêtre* (see fig. **16.30**), they have been transformed in a way that was unacceptable to the nineteenth-century French public. The figures were not sufficiently Classical, or even close enough to their Renaissance prototypes, to pass muster with the prevailing taste. Certain details, such as the bottom of Victorine's bare foot and the unidealized rolls of fat around her waist, aroused the hostility of the critics. The seemingly cavalier application of paint also annoyed viewers, with one complaining, "I see fingers without bones and heads without skulls. I see sideburns painted like two strips of black cloth glued on the cheeks."

CONNECTIONS

See figure 16.30. Giorgione, *Fête Champêtre*, c. 1510.

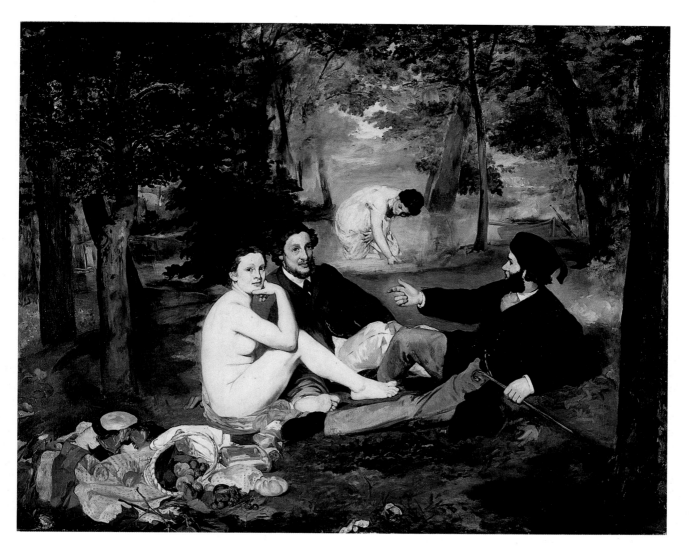

23.17 Édouard Manet, *Le Déjeuner sur l'Herbe*, 1863. Oil on canvas, 7 × 9 ft. (2.13 × 2.69 m). Musée d'Orsay, Paris, France. The visual impact of the painting is partly a result of the shallow perspective. Rather than creating the illusion of a distant space, Manet, like Courbet and Eakins, builds up areas of color so that the forms seem to advance toward the viewer. The final effect of this technique is a direct confrontation between viewer and image, allowing little of the relief, or "breathing space," that comes with distance.

Manet's *Olympia*

Manet created an even more direct visual impact in his *Olympia* (fig. **23.18**), which also caused a scandal when first exhibited in 1865. Here again, Manet is inspired by the past—most obviously by Giorgione's *Sleeping Venus* (see fig. **16.29**) and Titian's *Venus of Urbino* (see fig. **16.32**). But whereas the Italian Renaissance nudes are psychologically "distanced" from the viewer's everyday experience by their designation as Classical deities, Manet's figure (the same Victorine who posed for the *Déjeuner*) was widely assumed to represent a prostitute. As such, she raised the specter of venereal disease, which was rampant in Paris at the time. The reference to "Olympia" in such a context only served to accentuate the contrast between the social reality of nineteenth-century Paris and the more comfortably removed Classical ideal. Titian had also relieved the viewer's confrontation with his Venus by the spatial recession. In *Olympia,* however, the back wall of the room approaches the picture plane and is separated from it only by the bed and the black servant. Olympia is harshly illuminated, in contrast to the soft light and gradual, sensual shading of Titian's Venus.

Furthermore, Olympia shows none of the traditional signs of modesty but instead stares boldly at the viewer.

In 1863 the Salon rejected the *Déjeuner,* but two years later it accepted the *Olympia.* It is impossible to overestimate not only the depth of feeling that surrounded the decisions of the Salon juries, but also the hostile criticism that generally greeted **avant-garde,** or modernist, works. The subsequent outcry following the rejection of more than four thousand canvases by the Salon jury prompted Napoleon III to authorize a special exhibition, the "Salon des Refusés," for the rejected works. Among the rejected were many artists who later gained international recognition.

Manet's *Olympia* caused dissension even among the ranks of the so-called Realists. It offended Courbet, who pronounced it "as flat as a playing card."

—— **CONNECTIONS** ——

See figure 16.29. Giorgione, *Sleeping Venus*, c. 1509.

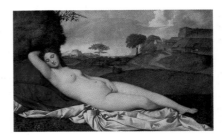

—— **CONNECTIONS** ——

See figure 16.32. Titian, *Venus of Urbino*, c. 1538.

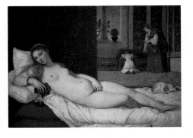

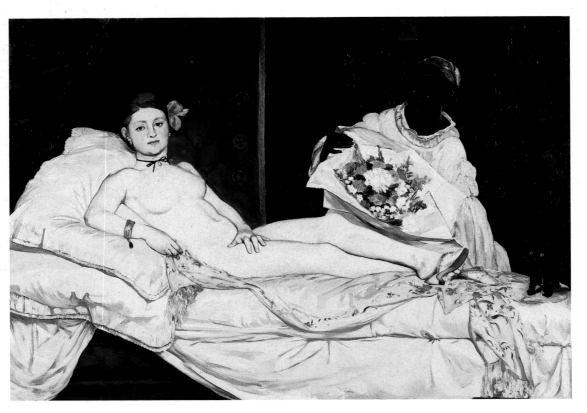

23.18 Édouard Manet, *Olympia*, 1865. Oil on canvas, 4 ft. 3 in. × 6 ft. 3 in. (1.3 × 1.9 m). Musée d'Orsay, Paris, France. Olympia is naked rather than nude, an impression emphasized by her bony, unclassical proportions. The sheets are slightly rumpled, and the flowers that her maid delivers have clearly been sent by a client. Olympia's shoes may refer to "streetwalking," and the alert black cat is a symbol of sexuality, no doubt because of the popular reputation of the alley cat. The term *cathouse* is commonly used for a brothel.

Architecture

By and large, nineteenth-century architects were not quick to adopt iron and steel, both of which had been recently developed, as building materials. At first they did not regard them as suitable for such use. The first major project making extensive use of iron was thus considered a utilitarian structure rather than a work of art.

Joseph Paxton: The Crystal Palace

In 1851 the "Great Exhibition of the Works of Industry of All Nations" was held in London. This was the first in a series of Universal, or International, Expositions ("Expos") and World's Fairs which continue to this day. Architects were invited to submit designs for a building in Hyde Park to house the exhibition.

When Joseph Paxton submitted his proposal, 245 designs had already been rejected. As a landscape gardener, Paxton had built large conservatories and greenhouses from iron and glass. Not only was his proposal less expensive than the others, but it could be completed within the nine-month deadline. The project was subdivided into a limited number of components and subcontracted out. Individual components were thus "prefabricated," made in advance and assembled on the actual site. Because of its extensive use of glass, the structure was dubbed the Crystal Palace (fig. **23.19**).

There were many advantages to this construction method. Above all, prefabrication meant that the structure could be treated as temporary. After the exhibition had ended, the building was taken apart and reassembled on a site in the south of London. But one alleged advantage of iron and glass—that they were fireproof—proved to be illusory. In 1936 the Crystal Palace was destroyed in a fire, the framework buckling and collapsing in the intense heat.

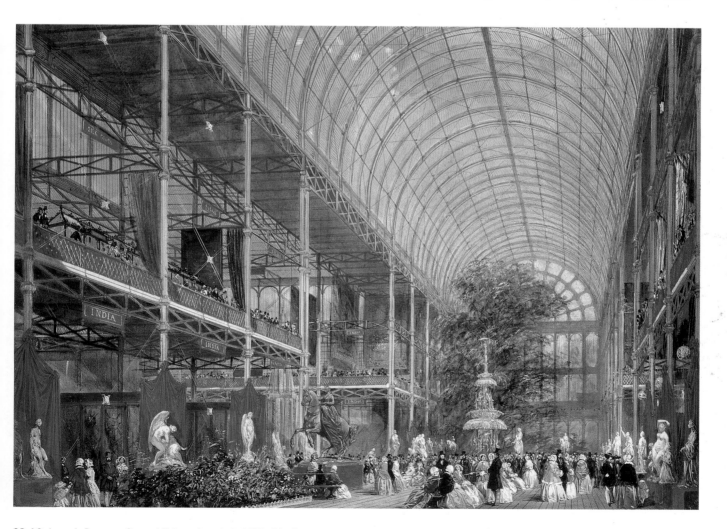

23.19 Joseph Paxton, Crystal Palace, London, 1850–51. Cast iron, wrought iron, and glass. Engraving (R. P. Cuff after W. B. Brounger). Victoria and Albert Museum, London, England. The Crystal Palace was 1,850 feet (564 m) long (perhaps an architect's pun on the year in which it was built) and 400 feet (122 m) wide. It covered an area of 18 acres (7.3 ha), enclosed 33 million cubic feet (934,000 m³) of space (the largest enclosed space up to that time), and contained more than ten thousand exhibits of technology and handicrafts from all over the world.

Bridges: The Roeblings

The industrializing countries, particularly the United States with its great distances, needed better systems of transportation to keep up with advances in communication and commerce. Rivers and ravines had to be crossed by roads and railroads, and this led to new developments in nineteenth-century bridge construction. Until the 1850s bridges had been designed according to the **truss** method of construction, which utilized short components joined together to form a longer, rigid framework. Wooden truss bridges used by the Romans to cross the river Danube, for example, are illustrated on Trajan's Column (see fig. **9.23**). By the 1840s metal began to replace wood as the preferred material for such bridges.

The principle of the **suspension bridge** had been known for centuries, from the bridges of twisted ropes or vines used to cross ravines in Asia and South America. The superior span and height of the suspension bridge were appropriate for deep chasms or wide stretches of navigable water. Modern suspension bridges were built from the early 1800s using iron chains, but by the middle of the century engineers had begun to see the advantages of using flexible cable made of steel wire.

The greatest American bridge builders of the nineteenth century, John A. Roebling (1806–65) and his son, Washington A. Roebling (1837–1926), were responsible for the Brooklyn Bridge, shown in the old photograph in figure **23.20**. Two massive towers of granite were constructed at either end of the bridge. They were linked by four huge parallel cables, each containing more than five thousand strands of steel wire. The steel, which was spun on the site, supported the roadways and pedestrian walkways. It was the first time that steel had been used for this purpose. But in deference to architectural tradition, the shape of the arches was a return to Gothic.

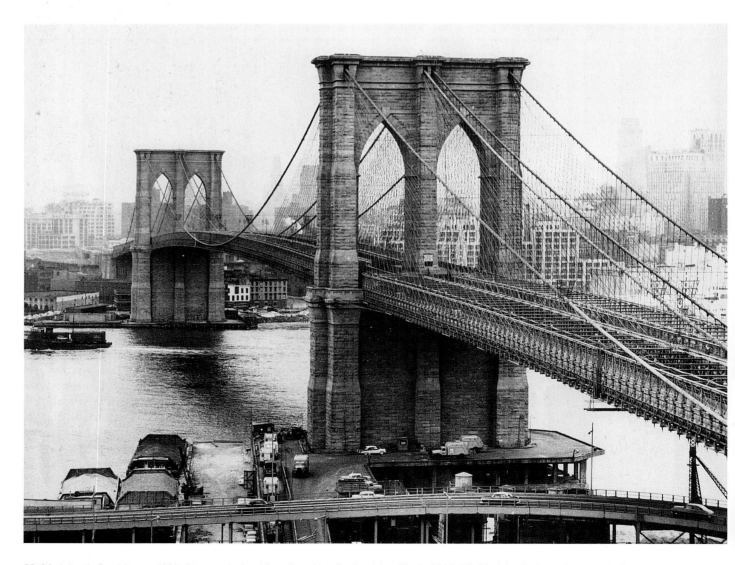

23.20 John A. Roebling and Washington A. Roebling, Brooklyn Bridge, New York, 1869–83. Black-and-white photograph. Stone piers with steel cables, 1,595 ft. (486 m) span. This suspension bridge spanned the East River to connect Manhattan (New York City) and Brooklyn. Like the Crystal Palace, the Brooklyn Bridge was regarded at the time as a work of engineering rather than architecture.

The Eiffel Tower

Like the Crystal Palace, the Eiffel Tower in Paris (fig. **23.21**) was built as a temporary structure. It was designed as a landmark for the Universal Exposition of 1889, celebrating the centenary of the French Revolution. From the third and highest platform of the tower, visitors could enjoy a spectacular panorama of Paris, covering a radius of about 50 miles (80 km).

Named for its designer, Gustave Eiffel, the tower was a metal truss construction on a base of reinforced concrete. Through the curves of the elevation and the four semi-circular curves of the base—all executed in open-lattice wrought iron—Eiffel transformed an engineering feat into an elegant architectural monument. An unusual feature of the Eiffel Tower was the design of its elevators (by the American Elisha Otis), which at the lowest level had to ascend in a curve.

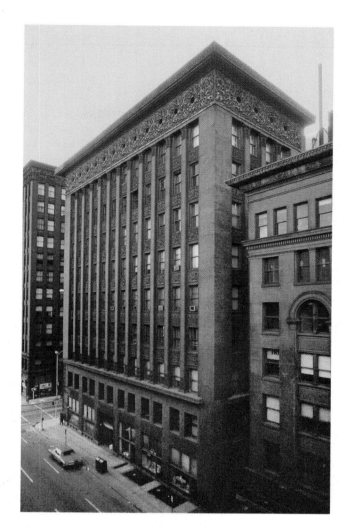

23.22 Louis Sullivan, Wainwright Building, St. Louis, Missouri, 1890–91.

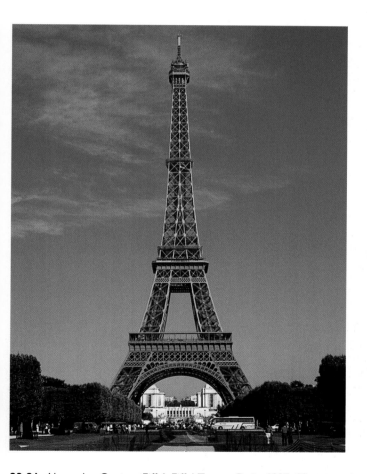

23.21 Alexandre-Gustave Eiffel, Eiffel Tower, Paris, 1887–89. Wrought-iron superstructure on a reinforced concrete base, 984 ft. (300 m) high; 1,052 ft. (320 m) including television mast. The Eiffel Tower was so controversial that a petition demanding its demolition was circulated. When the Exposition ended in 1909, the tower was saved because of its value as a radio antenna. Its original height, before the addition of a television mast, was twice that of the dome of St. Peter's or the Great Pyramid at Giza. Until the Empire State Building was built in New York in 1932, the Eiffel Tower was the highest man-made structure in the world.

Origins of the Skyscraper: Louis Sullivan

By the second half of the nineteenth century, a new type of construction was needed to make more economical use of land. One of the drawbacks of masonry or brick construction is that the higher the building, the thicker the supporting walls have to be at the base. This increases the cost of materials, the overall weight of the structure, and the area that it occupies. The new materials—structural steel and concrete reinforced with steel wire or mesh—were stronger than the traditional materials. Their **tensile strength** (ability to withstand longitudinal stress) was also much greater, allowing flexibility in reaction to wind and other pressures. The power-driven electric elevator was another necessity for high-rise construction. All of the ingredients for the skyscraper were now in place. Skyscrapers could be used as apartment houses, office buildings, multistory factories, department stores, auditoriums, and other facilities for mass entertainment.

The Wainwright Building in St. Louis (fig. **23.22**), a nine-story office building built in 1890–91, is one of the finest examples of early high-rise building. It is based on the

steel frame method of construction, in which steel girders are joined horizontally and vertically to form a grid. The framework is strong enough for the outer and inner walls to be suspended from it without themselves performing any supporting function. Architectural features that had been used since Classical antiquity and the Gothic era—post-and-lintel, arch, vault, buttress—were now functionally superfluous.

The architect, Louis Sullivan, used a Classical motif to stress the verticality of the building and to disguise the fact that it was basically a rectangular block with nine similar horizontals superimposed on one another. He treated the first and second floors as a horizontal base.

The next seven floors were punctuated vertically by transforming the wall areas between the windows into slender pilasters (every second one corresponding to a vertical steel beam), extending from the third to the ninth floor. The top floor, which contained the water tanks, elevator plant, and other functional units, was made into an overhanging cornice, with small circular windows blending into the ornamental reliefs. The Renaissance impression of the building is heightened by the brick, red granite, and terra-cotta facing. Although the Wainwright Building is not tall by contemporary standards, Sullivan's use of Classical features makes it seem taller than it actually is.

c. 1830 **c. 1900**

19TH-CENTURY REALISM

(23.6)	(23.3)	(23.13)	(23.17)	(23.14)	(23.21)	(23.22)
July Revolution in France (1830)	John Ruskin, *Modern Painters*, Volume I (1843)	Trade with Japan begins (1850s)	Gustave Flaubert, *Madame Bovary* (1857)	Charles Darwin, *On the Origin of Species* (1859)	American Civil War (1861–1865)	Franco-Prussian War (1870–1871)

Karl Marx and Friedrich Engels, Communist Manifesto (1848)

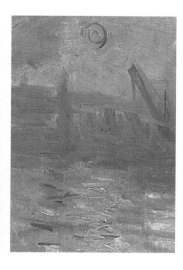

24

Nineteenth-Century Impressionism

Context and Style

The Impressionist style evolved in Paris in the 1860s and continued into the early twentieth century. Unlike Realism, Impressionism rarely responded to political events. The devastating effects of France's defeat in the Franco-Prussian War in 1871, for example, had virtually no impact on Impressionist imagery. Impressionist painters preferred genre subjects, especially leisure activi-

ties, entertainment, landscape, and cityscape. Impressionism was also more influenced by Japanese prints and new developments in photography than by politics.

Despite the changing focus of its content, Impressionism was in some ways a logical development of Realism. But Impressionists were more concerned with optical realism and the natural properties of light. They studied changes in light and color caused by weather conditions, times of day, and seasons, making shadows and reflections important features of their iconography. Impressionists also studied the effects of artificial interior lighting, such as theater spotlights and café lanterns. Nevertheless, these formal concerns did not entirely eliminate the interest in observing society and the changes brought about by growing industrialization; subject matter included canals and barges, factories with smoking chimneys, and railway stations.

Although many Impressionists were from bourgeois families, they liked to exchange ideas in more bohemian surroundings. They gathered at the Café Guerbois in the Montmartre district of Paris, and because their paintings were initially, and vociferously, rejected by the French Academy as well as by the French public, the Impressionists became a group apart. They held eight exhibitions of their own work between 1874 and 1886. Ironically, despite the contemporary rejection of Impressionism, it had a greater international impact in the long run than previous styles that France had readily accepted.

Painting in France

Édouard Manet: 1880s

At first Édouard Manet remained separate from the core of Impressionist painters who were his contemporaries. He did not adopt their interest in bright color and the study of light until the 1870s.

His *Bar at the Folies-Bergère* (fig. **24.1**) of 1881–82 depicts the figure close to the picture plane as in his *Olympia* (see fig. **23.18**), but he uses Impressionist color, light, and brushwork. By the device of the mirror in the

background, Manet simultaneously maintains a narrow space and expands it. The mirror reflects the back of the barmaid, her customer, and the interior of the music hall, which is in front of her and behind the viewer.

The bright oranges in the reflective glass bowl are the strongest color accent in the picture. Daubs of white paint create an impression of sparkling light. In contrast, the round lightbulbs on the pilasters seem flat because there is no tonal variation. Absorbing the light, on the other hand, is the smoke that rises from the audience, blocking out part of the pilaster's edge and obstructing our view. This detail exemplifies the Impressionist observation of the effect of atmospheric pollution—a feature of the industrial era—on light, color, and form.

A third kind of light can be seen in the chandeliers, whose blurred outlines create a sense of movement. The depiction of blurring is one aspect of Impressionism that can be related to photography as well as to the ways in which we see. When a photographic subject moves, a blur results. In Manet's painting, the figures reflected in the mirror are blurred, indicating that the members of the audience are milling around.

The formal opposite of blurred edges—the silhouette—is also an important feature of the Impressionist style. In its purest form, a silhouette is a flat, precisely outlined image, black on white or vice versa, as in the black ribbon around the barmaid's neck. Other, more muted silhouettes occur in the contrast of the round lightbulbs and the brown pilasters, the gold champagne foil against the dark green bottles, or the woman with the white blouse and yellow gloves in the audience on the left. Such juxtapositions, whether of pure black and white or of less contrasting lights and darks, also occur in certain Realist pictures, notably those by Daumier. They reflect the contrasts that are possible in black-and-white photography.

The impression that an image is one section of a larger scene—a "slice of life," or cropped view—is another characteristic of Impressionism that can be related to photography. Manet's customer is cut by the frame, as is the trapeze artist, whose legs and feet are visible in the upper left corner. The marble surface of the bar is also cut; it appears to continue indefinitely to the right and left of the observer.

In addition to the many formal innovations of Impressionism in Manet's *Bar,* the imagery of the painting is also

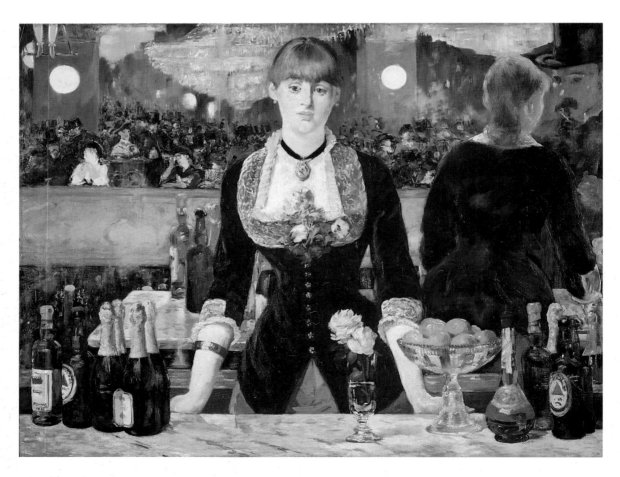

24.1 Édouard Manet, *A Bar at the Folies-Bergère,* 1881–82. Oil on canvas, 3 ft. 1½ in. × 4 ft. 3 in. (0.95 × 1.3 m). The Samuel Courtauld Trust, Courtauld Institute of Art Gallery, London, England. The Folies-Bergère is a Paris music hall, which opened in 1869. Today it is a tourist attraction, offering lavish spectacles. In Manet's day it featured light opera, pantomime, and similar forms of entertainment.

significant. The structural fragmentation of the picture corresponds to the mood of the barmaid. In contrast to the energy and motion in the audience, the members of which interact with each other—or the gazes of which are riveted on the trapeze artist—the barmaid stares dully into space. Her immobility is accentuated by the clarity and sharp focus of her edges compared with those of the audience. Nor does she seem interested in her customer; the viewpoint shifts, and the customer is seen as if from an angle, whereas the barmaid and the mirror are seen from the front.

This image has evoked art-historical interpretation from several methodological viewpoints. As a social comment, Manet makes a distinction between the monotony of serving at a bar and the bourgeoisie enjoying leisure time. This effect continues the concerns of Courbet and the Realists.

Another way of reading this image is through its sexual subtext. When seen from the back, the girl seems engaged in conversation with the man. But from the front she is alienated—bored and vacant—and aligned with the objects on the bar. She herself becomes an object to be consumed, along with the fruit and the alcoholic beverages. The flowers on her lace collar, like those on the counter, may be read as *vanitas* symbols. Her corsage is roughly triangular and is echoed by the more precise gray triangle below her jacket. The sexual connotations of this triangle are fairly straightforward, and they reinforce the implication that the customer is propositioning the barmaid.

Pierre-Auguste Renoir

Pierre-Auguste Renoir's *Moulin de la Galette* (fig. **24.2**) depicts a "slice of life," a scene of leisure in the courtyard of a Montmartre dance hall. In the foreground, a group of men and women gather around a table where their half-filled glasses reflect light. They are separated from the dancers by the strong diagonal of the bench, which blocks off a triangular space at the lower right. The dancers make up the background, along with the lamps and the architecture of the Moulin. Animating the scene are shifting shadows that create patterns of lights and darks. Characteristic of Renoir, even in this relatively early picture, is the soft, velvety texture of his brushstroke.

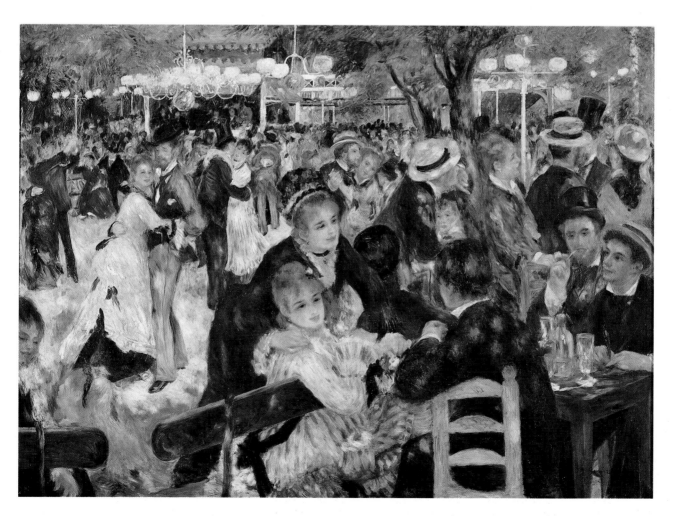

24.2 Pierre-Auguste Renoir, *Moulin de la Galette*, 1876. Oil on canvas, 4 ft. 3½ in. × 5 ft. 9 in. (1.31 × 1.75 m). Musée d'Orsay, Paris, France.

Edgar Degas

Absinthe (fig. **24.3**), by Edgar Degas (1834–1917), also represents a "slice of life," the boundaries of which are determined by the seemingly arbitrary placement of the frame. The zigzag construction of the composition creates a slanted viewpoint, rather like that of a candid photograph. It is as if the photographer had taken the picture without aligning the camera with the space being photographed. The two figures are "stoned"—the white liqueur in the woman's glass is absinthe—and, like Manet's barmaid, stare fixedly at nothing in particular. The poses and gestures convey psychological isolation and physical inertia.

By contrast, in his ballet pictures Degas expresses a wide range of movement. His dancers rest, stretch, exercise, and perform. In *Dancer with a Bouquet, Bowing* (fig. **24.4**), Degas shows a ballerina at the end of a performance. As in *Absinthe,* the floor tilts upward, and we view the figures from a lowered vantage point—in this case, that of the audience. The main dancer is illuminated from unseen floor lights below, giving her face a masklike appearance and accentuating the diaphanous quality of her costume. At the back of the stage and in the wings, dancers occupy various poses and create a sense of informal motion. Two static accents are provided by the vertical figures holding umbrellas. The flat orange triangles reflect the influence of Japanese prints (see Box, p. 444).

Degas was a devoted amateur photographer, and his passion for depicting forms moving through space can be related to his interest in photography. Other nineteenth-century photographers also explored the nature of motion. In 1878, for example, the American photographer Eadweard Muybridge (1830–1904) recorded for the first time the actual movements of a galloping horse (fig. **24.5**). To do so, he set up along the side of a racetrack twelve cameras, the shutters of which were triggered as the horses passed. Muybridge discovered that all four feet are off the ground only when they are directly underneath the horse (as in the second and third frames) and not when they are extended, as they are in the flying gallop pose in ancient art (see fig. **6.5**).

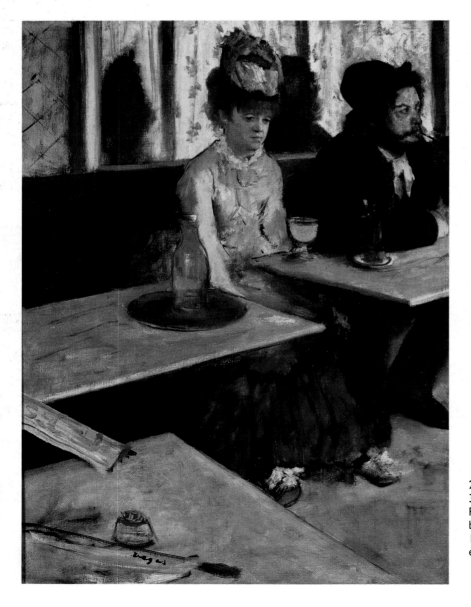

24.3 Edgar Degas, *Absinthe*, 1876. Oil on canvas, 36¼ × 26¾ in. (92.1 × 67.9 cm). Musée d'Orsay, Paris, France. Degas, the son of a wealthy Parisian banker, joined the Impressionists' circle around 1865 and exhibited in seven of their eight exhibitions between 1874 and 1886.

24.4 Edgar Degas, *Dancer with a Bouquet, Bowing,* c. 1877. Pastel and gouache on paper, 28⅜ × 30⅝ in. (72.0 × 77.5 cm). Musée d'Orsay, Paris, France. Degas sketched ballerinas from the wings of the theater and in dance classes. His interest in depicting forms moving through space led him to paint horse races as well as various types of entertainers.

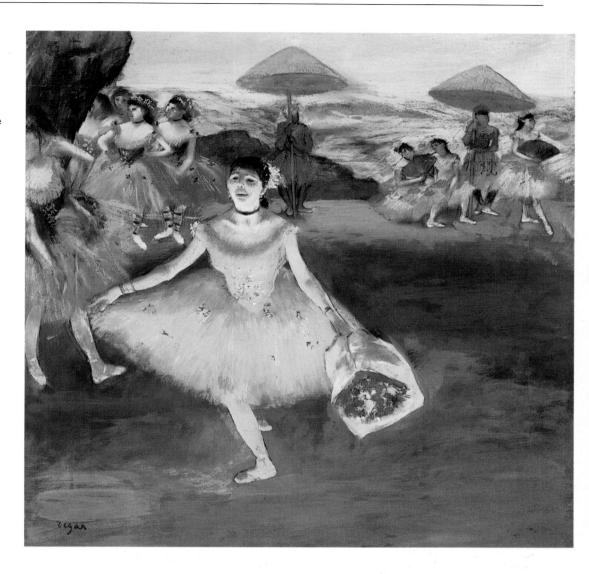

See figure 6.5. *Toreador Fresco* (also called the *Leaping Bull Fresco*), from Knossos, Crete, c. 1500 B.C.

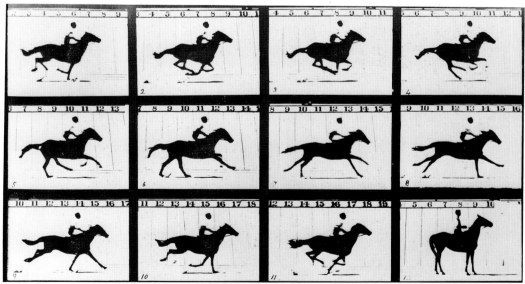

24.5 Eadweard Muybridge, *Galloping Horse,* 1878. Albumen print. Eadweard Muybridge Collection, Kingston Museum and Heritage Service, Kingston upon Thames, England.

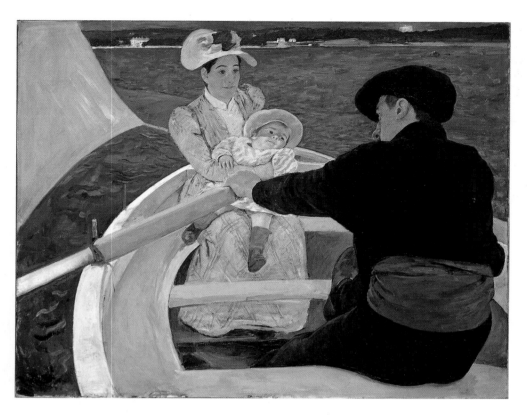

24.6 Mary Cassatt, *The Boating Party*, 1893–94. Oil on canvas, 35½ × 46⅛ in. (90 × 117 cm). National Gallery of Art, Washington, D.C. (Chester Dale Collection). Cassatt was from a well-to-do Pennsylvania family. For most of her career she lived in France, where she exhibited with the Impressionists and was a close friend of Degas. She fostered American interest in the Impressionists by urging her relatives and friends—particularly the Havemeyer family—to buy their works at a time when they were still unpopular.

Mary Cassatt

In *The Boating Party* (fig. **24.6**) of 1893–94, Mary Cassatt (1845–1926) uses the Impressionist "close-up," another pictorial device inspired by photography. She combines it with a slanting viewpoint to emphasize the intimacy between mother and child. The rower, on the other hand, is depicted in back view as a strong silhouette. More individualized are the mother and child, who gaze at the rower and are contrasted with his anonymity. Cassatt intensifies the tension among the three figures by flattening the space and foreshortening both child and rower. The compact forms create an image of powerful monumentality. Cassatt's bold planes of color, sharp outlines, and compressed spaces, as well as the *obi* (wide sash) worn by the rower, exemplify the influence of Japanese woodblocks on the Impressionist painters.

Berthe Morisot

Like the work of Cassatt, Berthe Morisot's (1841–95) *Cradle* of 1873 (fig. **24.7**) explores the theme of intimacy between mother and child through a close-up. Morisot does not, however, use oblique spatial shifts. Instead, she sets her figures on a horizontal surface within a rectangular composition. Curves and diagonals reinforce the relationship of the figures to each other. The mother's left arm connects her face with the baby's arm, which is bent back behind

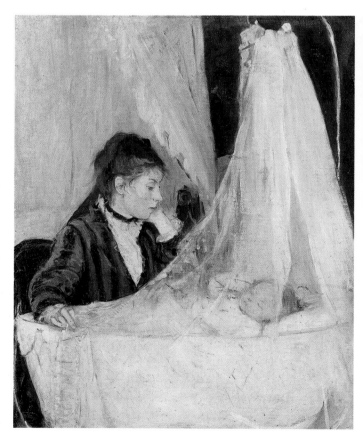

24.7 Berthe Morisot, *The Cradle*, 1873. Oil on canvas, 22½ × 18½ in. (57 × 47 cm). Louvre, Paris, France. Morisot was one of five sisters, all of whom learned to paint. She married Eugène Manet, the brother of the artist, and had one daughter, Julie, whom she frequently used as a model in her paintings.

its head. The line of the mother's gaze, intently focused on the baby, is repeated by the diagonal curtain. On the left, the mother's right arm curves toward the picture plane and is counteracted by the slow curve of the cradle covering from top right to lower left. The baby's left arm also curves so that the unity of mother and child is here indicated by a series of formal repetitions in which both participate.

The loose brushwork, for which Morisot and her Impressionist colleagues were often criticized, is particularly apparent in the lighter areas of the painting. The translucent muslin invites the viewer to "look through" the material at the infant. Looking is also implied by the window and curtain, although in fact nothing is visible through the window. In these lighter areas, as in the edges of the mother's dress, the individual white brushstrokes seem to catch the available light and reflect it. Contrasting with the whites are the dark, silhouetted areas such as the wall, the chair, and the ribbon around the mother's neck. A transitional area is provided by the mother's dress, which, though dark, contains light highlights that create a shiny surface texture.

Claude Monet

The work of Claude Monet (1840–1926), more than any other nineteenth-century artist, embodied the technical principles of Impressionism. He was above all a painter of landscape who studied light and color with great intensity. In contrast to the Academic artists, Monet did much of his painting outdoors. As a result, he and the Impressionists were sometimes called *plein air,* or "open air," painters.

The term *Impressionism* is derived from a critic's negative view of Monet's *Impression: Sunrise* (fig. **24.8**), which was painted in 1872 and exhibited two years later. The critic declared Monet's picture and others like it "Impressionisms." By that he meant that the paint was sketchily applied and the work unfinished in appearance. In fact, however, Monet was striving for the transient effects of shifts in nature. He used the technique of "broken color" to show that the clear circle of orange sun is "broken" into individual brushstrokes when reflected in the water. The same is true of the dark, silhouetted boat. Both reflections are composed of horizontal daubs of paint to convey the leisurely motion of the water and the blurred forms that we would actually see.

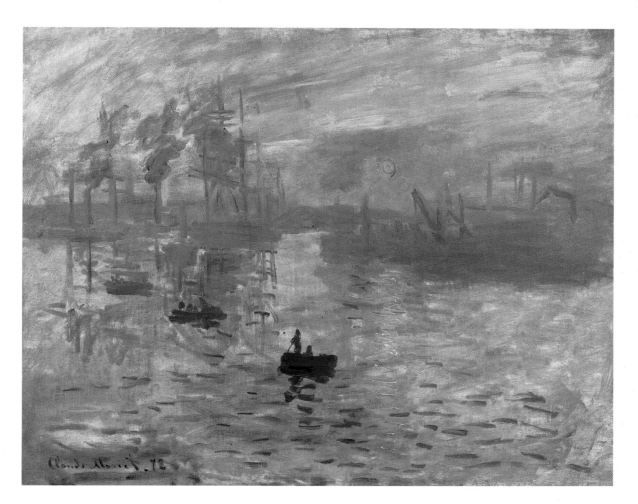

24.8 Claude Monet, *Impression: Sunrise*, 1872. Oil on canvas, 19½ × 25½ in. (49.5 × 64.8 cm). Musée Marmottan, Paris, France.

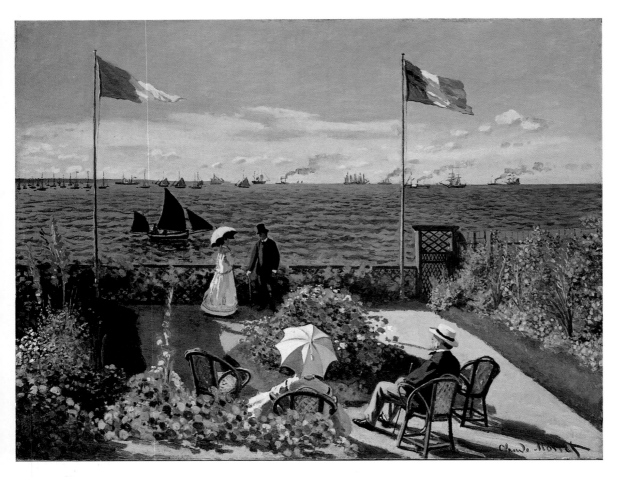

24.9 Claude Monet, *Terrace at Sainte-Adresse,* c. 1866–67. Oil on canvas, 38⅝ × 51⅛ in. (98 × 130 cm). Metropolitan Museum of Art, New York. In his youth Monet lived at Le Havre, a port town on the Normandy coast. It was here that he first became familiar with rapid changes in light and weather. In 1874 he exhibited in the show that launched the Impressionist movement. Until the 1880s his work was poorly received and he lived in extreme poverty.

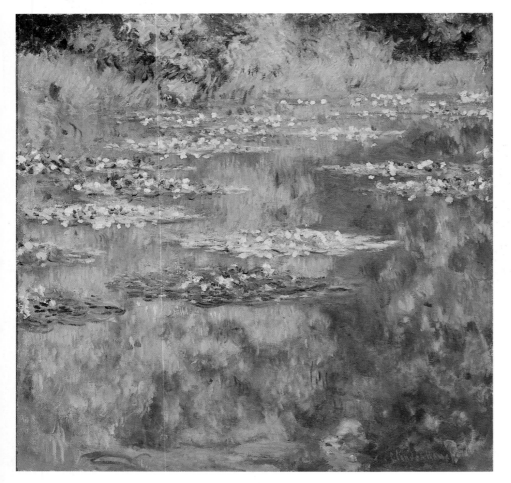

From the 1860s, early in his career, Monet worked with a wide range of color. A comparison of an early and a late work by Monet illustrates the development of the Impressionist style. The *Terrace at Sainte-Adresse* (fig. **24.9**) of about 1866–67 is a leisure genre scene. In the distance, sailboats and steamships hint at the Industrial Revolution and changing times. The *Bassin des Nymphéas,* or *Water Lily Pond,* of 1904 (fig. **24.10**) illustrates Monet's style nearly forty years later.

Both pictures reflect Monet's concern with the direct observation of nature, and both are the result of his habit of painting outdoors with nature itself as his "model." In the *Water Lily Pond,* the lack of motion is indicated by the more vertical arrangement of the broken colors—greens, blues, yellows, and purples—that make up the

24.10 Claude Monet, *Bassin des Nymphéas (Water Lily Pond),* 1904. Oil on canvas, 34½ × 35¾ in. (87.6 × 90.8 cm). Denver Art Museum. In 1883 Monet moved to Giverny, a village about 50 miles (80 km) west of Paris, where he spent his later years. He built a water garden that inspired numerous "waterscape" paintings, including this one and a series of large water lily murals.

water's surface. Monet's method here reflects the way light strikes the eye—in patterns of color rather than in the relatively sharp focus of the *Terrace*. In the *Water Lily Pond* the observer's point of view is the same as in the *Terrace*, but the field of vision is much narrower.

These paintings also illustrate Monet's fidelity to optical experience through the depiction of colored shadows and reflections. In the *Terrace*, shadows on the pavement are dark gray, and creases in the flags are darker tones of their actual colors—red, yellow, and blue. Likewise, the reflection of the large dark-gray sailboat is composed of more densely distributed dark-green brushstrokes than the rest of the water. In the *Water Lily Pond*, reflected foliage is transformed into relatively formless patches of color. Without the lily pads and the edge of the pond, there would be no recognizable objects at all, and no way for viewers to orient themselves in relation to the picture's space.

Although even in late Impressionism there is never a complete absence of recognizable content, the comparison of these two pictures indicates a progressive dissolution of edges. The brushstrokes and the paint begin to assume an unprecedented prominence. As a result, instead of accepting a canvas as a convincing representation of reality, the viewer is forced to take account of the technique and medium in experiencing the picture. This is consistent with Monet's recommendation that artists focus on the color,

form, and light of an object rather than its iconography. In that suggestion, Monet emphasized the essence of a painted object as an abstract form, not as a replica of the thing itself. In other words, a painted "tree" is not a tree at all but a vertical accent on a flat surface.

In studying the natural effects of light and color on surfaces, Monet painted several series of pictures representing one locale under different atmospheric conditions. In 1895 he exhibited eighteen canvases of Rouen Cathedral. *Rouen Cathedral, West Façade, Sunlight* of 1894 (fig. **24.11**) shows the myriad details of a Gothic cathedral dissolving into light and shadow, which are indicated by individual patches of color. The blue sky creates a cream-colored façade, the dark areas of which repeat the sky-blue combined with yellows and oranges. Here, as in the *Water Lily Pond*, viewers are made aware of the medium as much as of the subject matter. They are also reminded that our normal vision lacks sharp focus.

CONNECTIONS

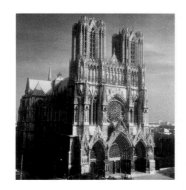

See figure 13.20. West façade, Reims Cathedral, France, begun 1211.

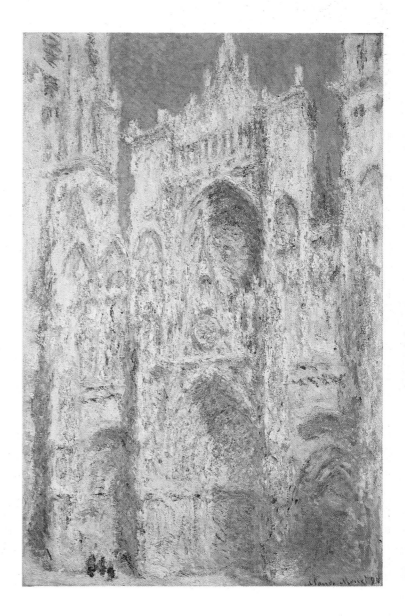

24.11 Claude Monet, *Rouen Cathedral, West Façade, Sunlight*, 1894. Oil on canvas, 39½ × 26 in. (1.00 × 0.66 m). National Gallery of Art, Washington, D.C. (Chester Dale Collection).

Views of Paris:
Renoir and Pissarro

In Renoir's *Pont-Neuf* (fig. **24.12**) of 1872, the influence of photography can be seen in the somewhat elevated vantage point. The rhythms of the city, which became a favorite Impressionist subject, are indicated by the variety of human activity. The scene is a "slice" of a city street, but Renoir also presents a condensed panorama of different social classes. Mothers stroll with children, youths lean against the side of the bridge, some people carry bundles and push carts, and others walk their dogs or ride in carriages. Soldiers and policemen are among the crowd. At the far side of the bridge the familiar buildings of the Left Bank are visible. Because the sky is blue, the forms—like the day—are relatively clear, and figures cast dark shadows on the pavement. Their patterns, as well as the general view of a busy street, are reminiscent of Hiroshige's *Night View, Saruwaka Street at Night* (see fig. **24.16**). Hiroshige's print, in turn, reflects the influence of Western one-point perspective.

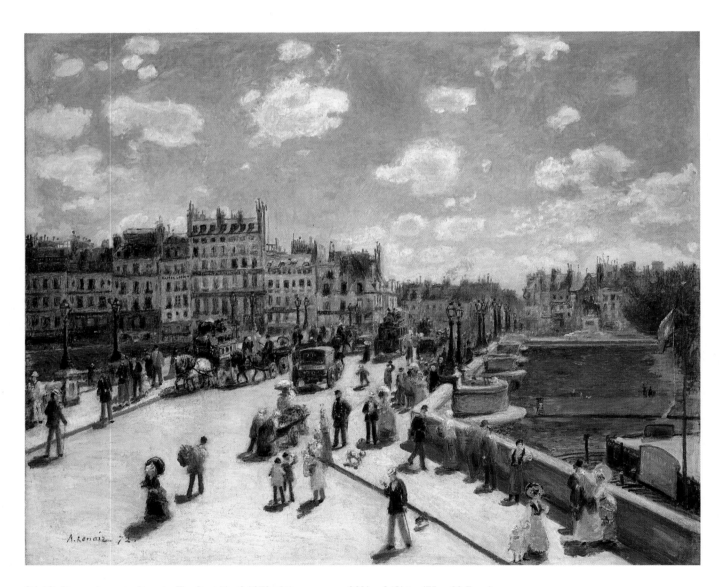

24.12 Pierre-Auguste Renoir, *The Pont-Neuf,* 1872. Oil on canvas, 29⅝ × 36⅞ in. (75 × 93.7 cm). National Gallery of Art, Washington, D.C. (Ailsa Mellon Bruce Collection).

The viewpoint of Camille Pissarro's (1830–1903) *Place du Théâtre Français* of 1898 (fig. **24.13**) is higher than that of Renoir's *Pont-Neuf*. In contrast to the Renoir, this picture depicts a rainy day, and the figures are in softer focus, which blurs their forms. Also blurred is the façade of the Paris Opéra at the end of the long Boulevard de l'Opéra. Both are rendered as patches of color and create dark accents against the lighter pavement. The effect of the gray sky is to drain the color from the street and dull it. At the same time, however, the street's surface is enlivened by visible brushstrokes and reflective shadows. Impressionist cityscapes offered artists an opportunity to explore the effects of outdoor light on the color and textures of the city. They also record the momentary and fugitive aspects of Haussmann's boulevards in ways that even photographs could not.

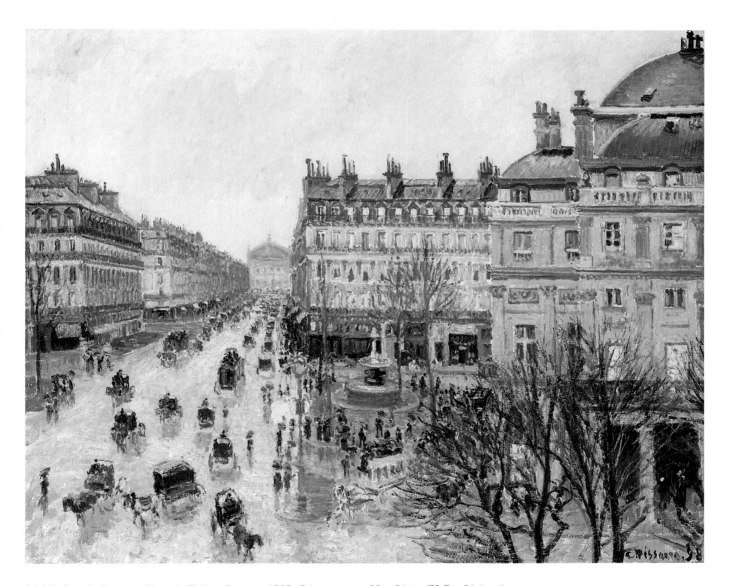

24.13 Camille Pissarro, *Place du Théâtre Français*, 1898. Oil on canvas, 29 × 36 in. (73.7 × 91.4 cm). Minneapolis Institute of Arts (William Hood Dunwoody Fund).

Japanese Woodblock Prints

From 1853 to 1854 Commodore Matthew Perry, a United States naval officer, led an expedition that forced Japan to end its policy of isolation. This opened up trade with the Far East and set the stage for cultural exchange. In the Paris Universal Exposition of 1867, many Japanese woodblock prints were on view. As a result, so-called *japonisme,* the French term for the Japanese aesthetic, became popular in fashionable Parisian circles. Japanese prints exerted considerable influence on Impressionist painters in France, the United States, and elsewhere.

Woodblock printing had begun in China in the fourth century. In the sixth century, Buddhist missionaries brought the technique to Japan. At first it was used for printing words, and only in the sixteenth century did artists begin to make woodblock images to illustrate texts. Originally the images were confined to black and white, but in the seventeenth century color was introduced. In order to create a woodblock print in color, the artist makes a separate block for each color and prints each block separately. The raised portions differ in each block and correspond to a different color in the final print. It is important, therefore, that the outlines of each block correspond exactly so that there is no unplanned overlapping or empty space between forms.

The prints that most influenced the Impressionist painters were made during the Edo period (1600–1868), when Edo (present-day Tokyo) became an urban center of feudalism in Japan. It was also the primary residence of the emperor. Nevertheless, a merchant class developed, which produced the main patrons of literature and the visual arts. Woodblock prints provided multiple images, which could be sold to a wide audience. As a result, publishers commissioned artists to prepare preliminary designs and then supervised the engraving, printing, and sale of the final works.

Japanese art students were apprenticed to master artists, just as in Western Europe during the Renaissance. The signatures on the prints reflect this system, for the artist had a chosen name (or *go*) as well as an apprentice name. The former was framed by a cartouche, while the latter was usually unframed and placed at the bottom of the page. A publisher's mark might also be stamped on the print. At the top of the page are the titles of the individual texts, or series of texts, that are illustrated. If the subject is an actor, his name or role is sometimes added.

Ukiyo-e The Golden Age of Japanese woodblock is identified with the Ukiyo-e school of painting. It was founded around the middle of the seventeenth century and lasted

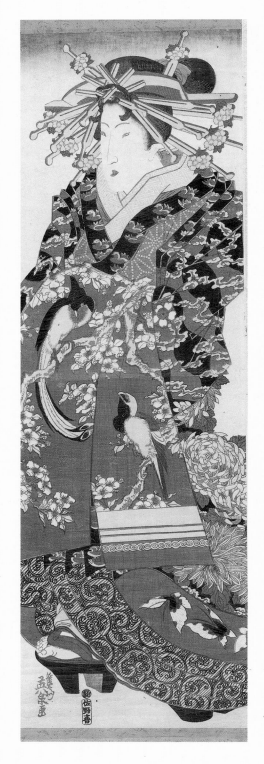

24.14 Keisei Eisen, *Oiran on Parade,* c. 1830. Woodblock print, 29 × 9¾ in. (73.7 × 24.8 cm). Victoria and Albert Museum, London, England. An *oiran* is the highest-ranking Japanese courtesan.

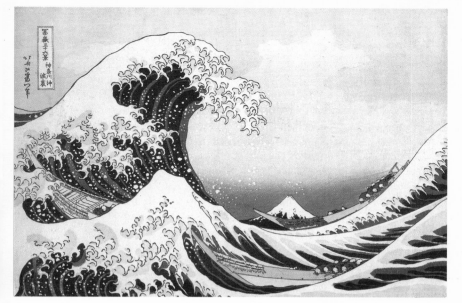

24.15 Katsushika Hokusai, *The Great Wave at Kanagawa,* from the series *Thirty-six Views of Mount Fuji,* ca. 1830–32. Polychrome woodblock print; ink and color on paper, 10⅛ × 14¹⁵⁄₁₆ in. (25.7 × 37.9 cm). Published by Eiudo. Metropolitan Museum of Art, New York (H. O. Havemeyer Collection, Bequest of Mrs. H. O. Havemeyer, 1929).

until the end of the Edo period in 1868. The term *ukiyo-e* means "floating world" and refers to the transience of material existence. The most popular subjects were theater, dance, and various kinds of female services ranging from outright erotica to the high-class courtesan. Respectable middle-class women performing daily tasks were also depicted, but mythological and historical scenes were less popular, and landscape was used only as background until the nineteenth century. Both the stylistic techniques used in woodblock prints and their subject matter—leisure genre scenes, entertainment, courtesans, landscape and cityscape, aerial views, and so forth—have close affinities with French Impressionism.

Keisei Eisen *Oiran on Parade* (fig. **24.14**) by Keisei Eisen (1790–1848) illustrates one of the Edo period's high-ranking courtesans, and she is decked out in full regalia for public viewing. Her lofty position is reflected by her height, her massive proportions, and the attention to the design of her costume. Two birds embroidered on the kimono echo the woman herself: the bird at the left repeats the kimono's lower curve, and the other echoes her strutting posture. The repetition of orange and blue, and the subject itself have affinities with the chromatic unity of Impressionism. Prussian blue, which is used here, was a recent import from the West and is evidence of contacts between the East and Europe even before 1853.

Katsushika Hokusai Katsushika Hokusai's (1760–1849) *The Great Wave at Kanagawa* (fig. **24.15**), which made a great impact on the Impressionists, is from a series titled *Thirty-six Views of Mount Fuji.* Such series of scenes, in

particular different views of the same place or similar views of the same place at different times of day and in different seasons, were also taken up by the Impressionists. The use of Prussian blue in this print enhances the wave's naturalism, but it is the dramatic rise of the wave and its nearness to the picture plane that create its impressive effect. It is a convincing portrayal of the rhythmic power of a swelling wave, even though the wave's flat, patternistic quality seems to arrest its movement. In the distance, the sacred Mount Fuji is small and insignificant by comparison.

Utagawa Hiroshige Utagawa Hiroshige's (1797–1858) last and most famous series of woodblock prints was titled *One Hundred Views of Edo. Night View, Saruwaka Street at Night* of 1856 (fig. **24.16**) shows a busy theater street at night. It is rendered in linear perspective, with the moon causing the figures to cast gray shadows. At the left, theater touts are trying to lure customers. The sense of a busy street, seen from an elevated vantage point, appeals to the same aesthetic as Renoir's *Pont-Neuf* (see fig. **24.12**) and Pissarro's *Place du Théâtre Français* (see fig. **24.13**). It thus reflects cross-cultural influences between Western Europe and the Far East.

24.16 Utagawa Hiroshige, *Night View, Saruwaka Street at Night,* 1856. Woodblock print, 14⅛ × 9¾ in. (35.9 × 24.8 cm). Whitworth Art Gallery, University of Manchester, England. Hiroshige was the son of a fire warden. Born in Edo, he was trained in the Ukiyo-e school and became one of the greatest masters of woodblock printing.

French Sculpture: Auguste Rodin

The acknowledged giant of nineteenth-century sculpture was Auguste Rodin (1840–1917). Rodin's influence on twentieth-century art parallels that of the Impressionist painters. Like Degas, Rodin built up forms in clay or wax before casting them. His characteristic medium was bronze, but he also made casts of plaster. *The Thinker* of 1879–89 (fig. **24.17**) reveals the influence of Italian Renaissance sculpture on Rodin's concept of the monumental human figure. The work actually evolved from what Rodin originally planned to be a representation of Dante. Its introspective power and large, muscular body are created by the figure's formal tension and sense of contained energy. Both are meditative figures, immobilized by thought.

In 1891 Zola asked Rodin to take over a commission from the French Society of Men of Letters for a monumental statue of the French novelist Honoré de Balzac. Rodin spent the last seven years of his life on the work, which was not cast until after his death. He called it the sum of his whole life.

The plaster version of Rodin's *Balzac* (fig. **24.18**) demonstrates his interest in conveying the dynamic, experimental *process* of sculpture, rather than in the finished work. The great novelist looms upward like a ghostly specter wrapped in a white robe.

Rodin's revolutionary working methods included the use of nonprofessional models in nontraditional poses. Apart from portrait busts, Rodin was the first major sculptor to create work consisting of less than the whole body—a headless torso, for example. In 1898, when the plaster *Balzac* was first exhibited, the public disliked it, and so did the Society of Men of Letters, which had commissioned it. Rodin never cast the work in bronze, and it is not known whether he ever intended to do so.

The *Balzac* has the Impressionist quality of pronounced surface texture, which in this case conveys the raw power and primal thrust characteristic of Rodin's style and also of Balzac's novels. Their surface motion creates a blurred effect similar to the prominence of Impressionist brushwork and mirrors Balzac's own dynamic spirit. The figure also seems to be in an unfinished state—a not-quite-human character in transition between unformed and formed. Since Balzac's literary output was prodigious, his representation as a monumental creative power evokes the timeless energy of his work.

24.17 Auguste Rodin, *The Thinker*, ca. 1904. Bronze, 28⅜ in. (72 cm) high. Nationalgalerie, Staatliche Museen, Berlin, Germany.

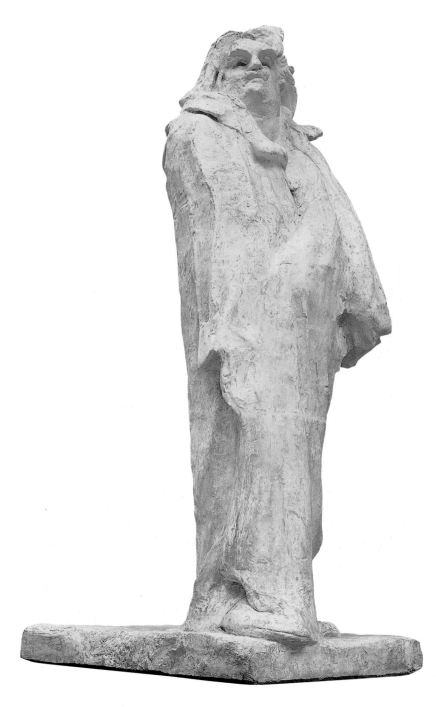

24.18 Auguste Rodin, *Balzac,* 1892–97. Plaster, 9 ft. 10 in. (3 m) high. Musée d'Orsay, Paris, France.

American Painting at the Turn of the Century

Several important late-nineteenth-century American artists correspond chronologically to French Impressionism. Some, such as Cassatt, lived as expatriates in Europe and worked in the Impressionist style. Others stayed in the United States and continued in a more Realist vein.

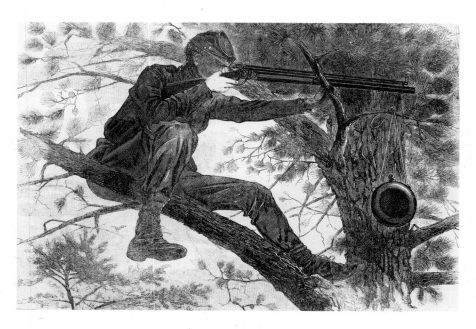

24.19 (Above) Winslow Homer, *The Army of the Potomac— A Sharpshooter on Picket Duty*, from *Harper's Weekly*, November 15, 1862. Engraving, 9⅛ × 13¾ in. (23.2 × 34.9 cm). Butler Institute of American Art, Youngstown, Ohio.

Winslow Homer

Winslow Homer (1836–1910) visited Paris before the heyday of Impressionism, and his work can be regarded as transitional between Realism and Impressionism. A largely self-taught artist from Boston, Homer first worked as a magazine illustrator. At the outbreak of the American Civil War in 1861, he was sent by *Harper's Weekly* to make drawings at the front.

Homer's *Army of the Potomac—A Sharpshooter on Picket Duty* of 1862 (fig. **24.19**) exemplifies his visual recording of the war. He shows a soldier aiming at a potential adversary, his precarious position reinforced by the repeated diagonals. The soldier's intense concentration as he gazes through the viewfinder of his rifle echoes our own gaze as we watch him watching his enemy. Homer thus creates a strong sense that we are there, present at a moment of tension and danger.

After the Civil War, Homer spent a year in France. He returned to the United States and lived much of his later life in Maine, where he painted in both watercolor and oil. In *Breezing Up* (fig. **24.20**) of 1873–76, Homer's interest in the American identity of his subjects and their place in society is evident. At the same time, however, he has been influenced by the Impressionist interest in weather conditions and their effect on light and color. The sea, churned up by the wind, is rendered as broken color with visible brushstrokes. By tilting the boat in the foreground, Homer creates a slanted "floor" that is related to Degas' compositional technique. The interruption of the diagonal sail by the frame, the oblique viewpoint, and the sailors' apparent indifference to the observer suggest a fleeting moment captured by a camera.

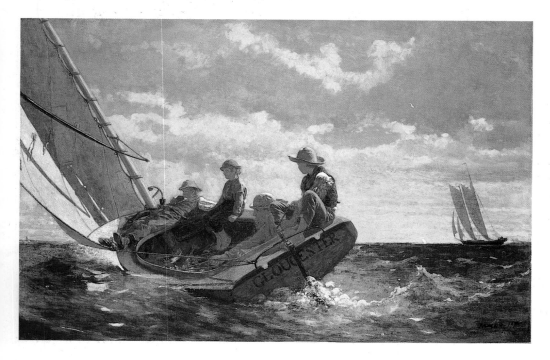

John Singer Sargent

John Singer Sargent (1856–1925), who lived in Paris in the early 1880s, espoused Impressionism wholeheartedly. But even though Sargent is sometimes considered an Impressionist, he did not allow form to dissolve into light, as did the French Impressionists. After his death, and with the advent of modernism, Sargent was dismissed, as a painter of elegant, superficial portraits, which

24.20 Winslow Homer, *Breezing Up (A Fair Wind)*, 1873–76. Oil on canvas, 24¼ × 38⅛ in. (61.5 × 97.0 cm). National Gallery of Art, Washington, D.C. (Gift of the W. L. and May T. Mellon Foundation).

emphasized the rich materials worn by his society patrons. However, *The Daughters of Edward Darley Boit* (fig. **24.21**), exhibited in the Salon of 1883, reveals the inner tensions of four young sisters, despite their comfortable lifestyle.

The girls occupy a fashionable room decorated with elements of *japonisme,* notably the large vases and the rug. The mirror, which recalls Diego Velázquez's *Las Meninas* (see fig. **19.38**), complicates the spatial relationships within the picture, while the oblique view sets the figures above the observer. The cropped rug and vase evoke the Impressionist "slice of life," and the subjects seem frozen in time. Three gaze at the viewer, and one leans introspectively against a vase. Two are close together, and two, echoing the vases, are apart. The spaces separating the figures convey a sense of tension and create the impression of an internal subtext. Enhancing the psychological effect of the work is the fact that as the girls become older, they are more in shadow.

CONNECTIONS

See figure 19.38. Diego Velázquez, *Las Meninas,* 1656.

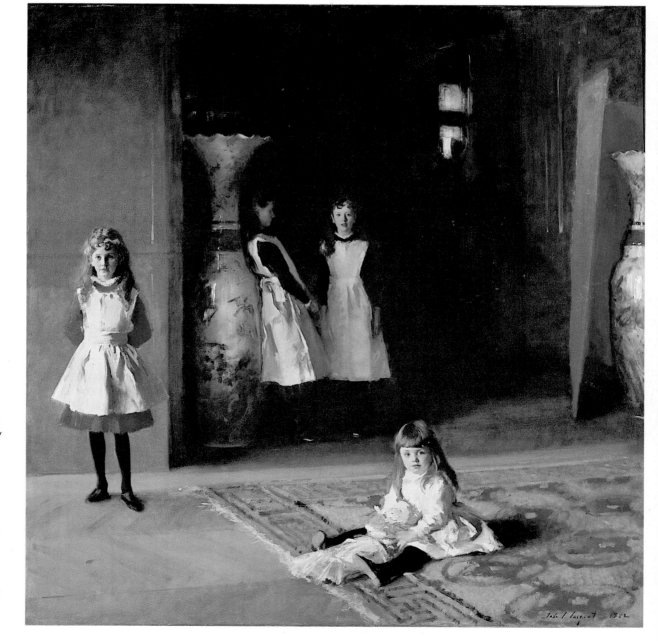

24.21 John Singer Sargent, *The Daughters of Edward Darley Boit,* 1882. Oil on canvas, 7 ft. 3 in. × 7 ft. 3 in. (2.21 × 2.21 m). Courtesy, Museum of Fine Arts, Boston (Gift of Mary Louisa Boit, Florence D. Boit, Jane Hubbard Boit, and Julia Overing Boit, in memory of their father, Edward Darley Boit).

"Art for Art's Sake"

Whistler versus Ruskin

In Paris, widespread condemnation made it difficult for the Impressionists to sell their work. In London as well, there were aesthetic quarrels. One of these erupted into the celebrated libel trial between the American painter James Abbott McNeill Whistler (1834–1903) and the reigning English art critic John Ruskin. In 1877 Ruskin published a scathing review of Whistler's *Nocturne in Black and Gold (The Falling Rocket)* (fig. **24.22**), painted about two years earlier. The picture was on view at London's Grosvenor Gallery, and it threw Ruskin into a rage. He accused Whistler of flinging "a pot of paint . . . in the public's face." Whistler himself, Ruskin added, was a "coxcomb," guilty of "Cockney impudence" and "willful imposture."

Whistler, born in Lowell, Massachusetts, moved with his family to Russia, where his father designed the Moscow–St. Petersburg railroad. He set up art studios in Paris and London, finally settling in Chelsea. The author of *The Gentle Art of Making Enemies,* Whistler was known for his distinctive personality and biting wit. He dressed as a dandy, wearing pink ribbons on tight patent leather shoes and carrying two umbrellas as a precaution against the rain in London.

Whistler responded to Ruskin's review by suing him for libel, and the case went to trial in November 1878. Ruskin, who was in the throes of a psychotic breakdown, could not appear in court, but his views were presented by his attorney. According to Ruskin, Whistler's picture was outrageously overpriced at 200 guineas, quickly and sloppily executed, technically "unfinished," and devoid of recognizable form. Ruskin also objected to Whistler's musical titles (in this case "Nocturne") as pandering to the contemporary fad for the incomprehensible. The paintings themselves were not, he insisted, serious works of art. In his opening statement, the attorney general, acting for Ruskin, had this to say about musical titles:

> In the present mania for art it had become a kind of fashion among some people to admire the incomprehensible, to look upon the fantastic conceits of an artist like Mr. Whistler, his "nocturnes," "symphonies," "arrangements," and "harmonies," with delight and admiration; but the fact was that such productions were not worthy of the name of great works of art.

On cross-examination, Whistler was questioned about his subject matter:

> "What is the subject of the *Nocturne in Black and Gold*?" "It is a night piece," Whistler replied, "and represents fireworks at Cremorne."
> "Not a view of Cremorne?"
> "If it were a view of Cremorne, it would certainly bring about nothing but disappointment on the part of the beholders. It is an artistic arrangement. . . . It is as impossible for me to explain to you the beauty of that picture as it would be for a musician to explain to you the beauty of a harmony in a particular piece of music if you have no ear for music."

Ironically, Ruskin had once used his critical genius to further the public reception of Turner, himself a rather "Impressionistic" artist. Equally ironic, Whistler was quite capable of producing clear and precise images as he did in his etchings, as well as in some of his portraits. The famous portrait of Whistler's mother (see fig. **1.6**)—*Arrangement in Black and Gray*—is a remarkable psychological portrait and also satisfies Ruskin's requirement that works appear "finished." It conveys her dour, puritanical character, reflected in the assertion by one of Whistler's friends that she lived on the top floor of his London house in order to be closer to God.

Whistler countered Ruskin's position by stating what was essentially the formalist "art for art's sake" view of art: that art did not necessarily serve a utilitarian purpose. Whistler's *Nocturne* was a study in light, color, and form. The atmospheric effects of the cloudy night sky are contrasted with gold spots of light from the exploded rocket. When questioned about the identity of the black patch in the lower right corner, Whistler replied that it was a vertical, placed there for purely formal reasons. On the subject of money, Whistler testified that he had spent only a day and a half painting *Nocturne,* but was charging for a lifetime of experience.

The jury followed the judge's instructions and decided in Whistler's favor but awarded him only a farthing in damages. When it was over, the trial was extensively ridiculed in the English and American press. A *New York Times* critic complained (December 15, 1878) that "the world has been much afflicted of late with these slapdash productions of the paint-pot." In his view, musical titles were "exasperating nomenclature," and the "shadowy and unseen presences" of modern art were confusing. "Ordinary men and women in a state of health," he concluded, "prefer to have their pictures made for them." Nearly seventy years later, *Art Digest* reported that the Detroit Institute of Arts paid $12,000 for the infamous "pot of paint."

The significance of this absurd trial is its function as a window on aesthetic conflict in the late nineteenth century. It also proves that one cannot legislate taste. Whistler later called the trial a conflict between the "brush" and the "pen." It exemplified the rise of the critic as a potent force in the nineteenth-century art world.

We have seen that the history of Western art is fraught with aesthetic quarrels, but passions rose to new heights during the latter half of the nineteenth century. For the first time, the material of art became a subject of art, and content yielded to style. More than anything else, it was the dissolution of form that seems to have caused the intense critical outrage. But this was the very development that would prove to have the most lasting impact on the development of Western art.

24.22 James Abbott McNeill Whistler, *Nocturne in Black and Gold (The Falling Rocket)*, c. 1875. Oil on oak panel, 23⅝ × 18½ in. (60 × 47 cm). Detroit Institute of Arts (Gift of Dexter M. Ferry, Jr.).

c. 1860

c. 1920

19TH-CENTURY IMPRESSIONISM

(24.1)

Paris Opéra
(1862–75)

(24.14)

End of
Edo period
in Japan
(1868)

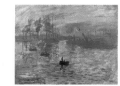

(24.8)

First Impressionist
exhibition in Paris
(1874)

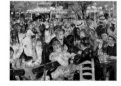

(24.2)

Alexander Graham
Bell invents
the telephone
(1876)

(24.18)

Gilbert and
Sullivan,
The Mikado
(1885)

(24.11)

Kodak
box camera
(1888)

(24.6)

Boxer
Rebellion
in China
(1899–1900)

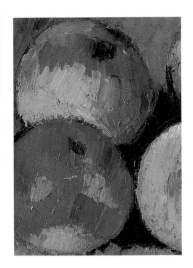

25

Post-Impressionism and the Late Nineteenth Century

The term *Post-Impressionism,* meaning "After Impressionism," designates the work of certain late-nineteenth-century painters, whose diverse styles were significantly influenced by Impressionism. Like the Impressionists, the Post-Impressionists were drawn to bright color and visible, distinctive brushstrokes. But Post-Impressionist forms do not dissolve, and their edges, whether outlined or defined by sharp color separations, are relatively clear.

Within Post-Impressionism two important trends evolved. These are exemplified on one hand by Cézanne and Seurat, who reassert formal and structural values, and on the other by Gauguin and van Gogh, who explore emotional content. Both trends set the stage for major trends in early-twentieth-century art. Certain Post-Impressionist artists were also influenced by the late-nineteenth-century Symbolist movement (see p. 463).

Post-Impressionist Painting

Henri de Toulouse-Lautrec

Henri de Toulouse-Lautrec (1864–1901), who was inspired by Degas, based his most characteristic imagery on Parisian nightlife. He frequented dance halls, nightclubs, cafés, and bordellos in search of subject matter. Loose, sketchy brushwork, contained within clearly defined color areas, contributes to a sense of dynamic motion in his paintings. In *Quadrille at the Moulin Rouge* (fig. **25.1**), the woman facing the viewer exudes an air of determined, barely contained energy about to erupt in dance. Her stance is the opening position of a quadrille, and a challenge to the other figures. Like Degas, Toulouse-Lautrec favored partial, oblique views, which suggest photographic cropping. He was also, like Degas, influenced by Japanese prints, using strong silhouettes to offset the more textured areas of his painted surfaces.

In contrast to the textured surfaces of his paintings, Toulouse-Lautrec's lithograph posters consist of flat, unmodeled areas of color. The poster—which Lautrec popularized at the end of the nineteenth century—was not only

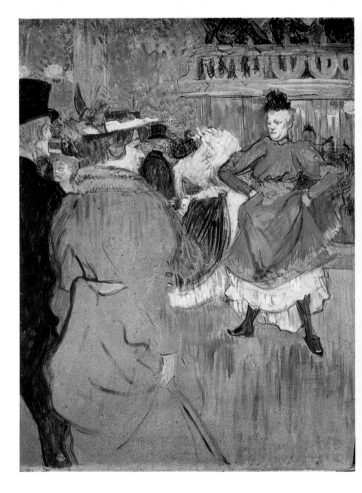

25.1 Henri de Toulouse-Lautrec, *Quadrille at the Moulin Rouge,* 1892. Oil on cardboard, 31⅜ × 23¾ in. (80 × 60.5 cm). National Gallery of Art, Washington, D.C. (Chester Dale Collection). The Moulin Rouge was (and still is) a popular music hall in Montmartre. It was here, in the artistic and entertainment center of Paris, that Toulouse-Lautrec lived and worked. He was descended from the counts of Toulouse, and although his family disapproved of his lifestyle, his wealth saved him from the poverty suffered by many artists of his generation. He died at age thirty-seven from the effects of alcoholism.

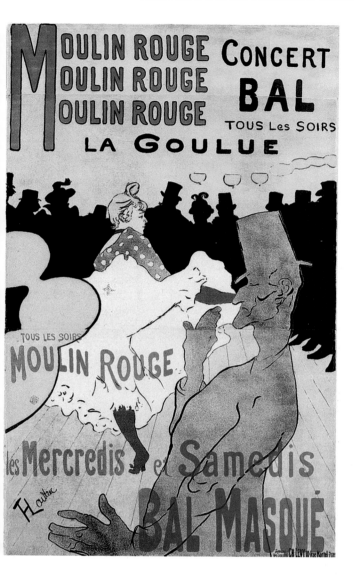

25.2 Henri de Toulouse-Lautrec, *La Goulue at the Moulin Rouge*, 1891. Poster, color lithograph, 74¾ × 45⅞ in. (190.0 × 116.5 cm). The Metropolitan Museum of Art, Harris Brisbane Dick Fund, 1932 (32.88.12). At age fifteen, Toulouse-Lautrec was left with permanently stunted legs as the result of two accidents. Perhaps because of this, dancers had a particular attraction for him. La Goulue was one of the professional dancers who, along with singers, circus performers, and prostitutes, were among his favorite subjects.

an art form. Like the print techniques used by the Realists for social and political ends, posters such as *La Goulue at the Moulin Rouge* (fig. **25.2**) disseminated information. Because the purpose of a poster is to advertise an event, words generally form part of the message. In *La Goulue*, the letters are integrated with the composition by repeating the lines and colors of the printed text in the image. The blacks of BAL ("dance") and LA GOULUE recur in the silhouetted background crowd and the stockings of the dancer. The flat red-orange of MOULIN ROUGE is echoed in the dress. And the thin, dark lines of TOUS LES SOIRS ("every evening") are repeated in the floorboards and the outlines of the figures.

Paul Cézanne

The Post-Impressionist who was to have the most powerful impact on the development of Western painting was Paul Cézanne (1839–1906). He, more than any artist before him, transformed paint into a visible structure. His early pictures were predominantly black and obsessed with erotic or violent themes.

Cézanne's *Self-Portrait* (fig. **25.3**) of around 1872 depicts a man of intense vitality. Although the colors are dark, the background landscape conveys Impressionist ideas. The thickly applied paint accentuates each brushstroke—short and determined—like the bricks of an architectural structure. The arched eyebrows frame diamond-shaped eye sockets, and the curved brushstrokes of the hair and beard create an impression of wavy, slightly unruly motion.

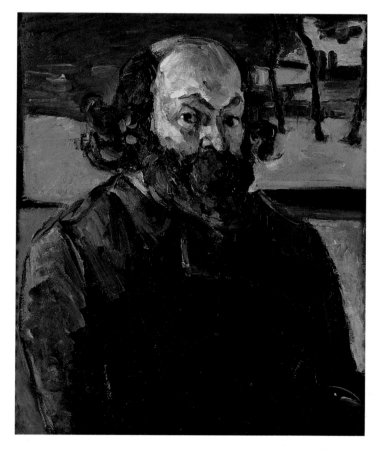

25.3 Paul Cézanne, *Self-Portrait*, c. 1872. Oil on canvas, 25¼ × 20½ in. (64 × 52 cm). Musée d'Orsay, Paris, France. Cézanne was born and lived most of his life in Provence, in the south of France. He studied law before becoming a painter. In 1869 he began living with Hortense Fiquet, by whom he had a son in 1872. They married in 1886, the year his father died.

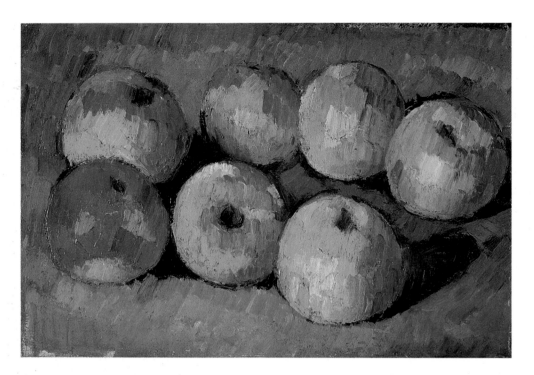

25.4 Paul Cézanne, *Still Life with Apples*, c. 1875–77. Oil on canvas, 7½ × 10¾ in. (19.1 × 27.3 cm). By kind permission of the Provost and Fellows of King's College, Cambridge, England (Keynes Collection).

Cézanne exhibited with the Impressionists in 1873 and 1877, and, under the influence of Pissarro, his palette became brighter and his subject matter more restricted. In *Still Life with Apples* (fig. **25.4**), of about 1875–77, painted at the height of his Impressionist period, Cézanne subordinates narrative to form. He condenses the rich thematic associations of the apple in Western imagery with a new, structured abstraction. Cézanne's punning assertion that he wanted to "astonish Paris with an apple" (see Box) is nowhere more evident than in this work. Seven brightly colored apples are set on a slightly darker surface. Each is a sphere, outlined in black and built up with patches of color—reds, greens, yellows, and oranges—like the many facets of a crystal. Light and dark, as well as color, are created by the arrangement of the brushstrokes in rectangular shapes. The structural quality of the apples seems to echo Cézanne's assertion that the natural world can be "reduced to a cone, a sphere, and a cylinder."

The apples are endowed with a life of their own. Each seems to be jockeying for position, as if it has not quite settled in relation to its neighbors. The shifting, animated

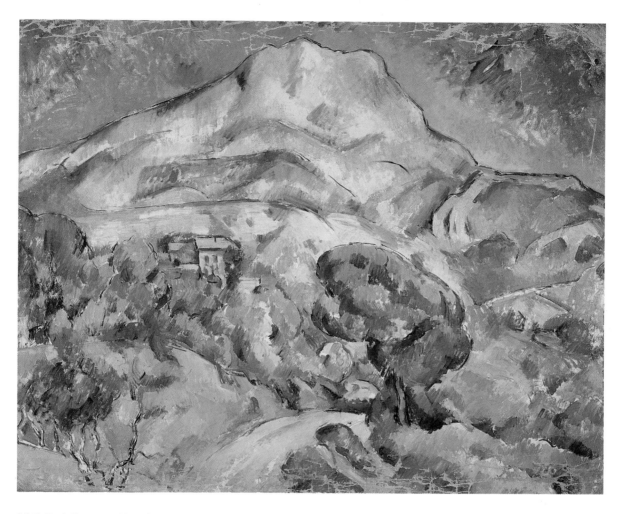

25.5 Paul Cézanne, *Mont Sainte-Victoire*, c. 1900. Oil on canvas, 30¾ × 39 in. (78 × 99 cm). Hermitage, St. Petersburg, Russia.

quality of these apples creates dynamic tension, as does the crystalline structure of the brushstrokes. Nor is it entirely clear just what the apples are resting on, for the unidentified surface beneath them also shifts. As a result, the very space of the picture is ambiguous, and the image has an abstract, iconic power.

In 1887 Cézanne's active involvement with the Impressionists in Paris ended, and he returned to his native Provence in the south of France. Having integrated Impressionism with his own objectives, he now focused most of his energy on the pursuit of a new way of representing space.

In *Mont Sainte-Victoire* of about 1900 (fig. **25.5**), Cézanne revisited a subject that had preoccupied him for years. His personal identification with the mountain is indicated by the anthropomorphism of the rich green tree in the right foreground—possibly a self-image. The landscape itself is a multifaceted patchwork of shifting color—greens, oranges, and blues. Geometry pervades the picture, not only in the cubic character of the brushstrokes but also in the trapezoidal mountain, the rectangular house in the middle ground, and the structured curve of the foreground road. Through Cézanne's faceted, crystalline forms, a breakdown and restructuring of Western spatial conventions are achieved. This was a revolution made possible by the Post-Impressionist synthesis of the prominent brushstrokes and the clarity of the edge.

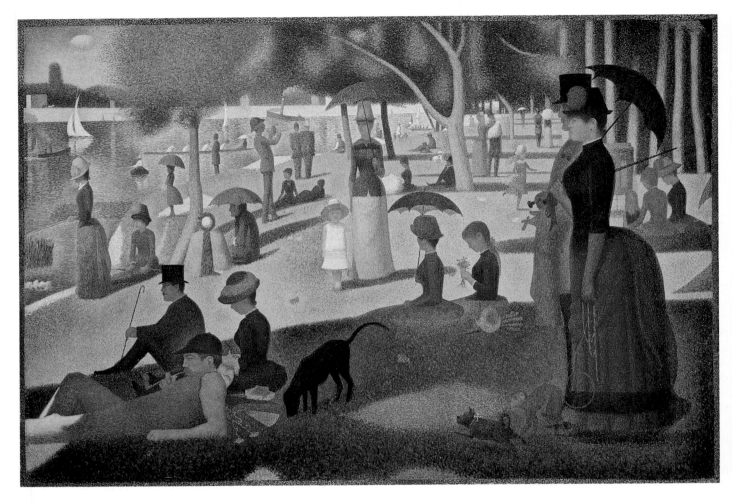

25.6 Georges Seurat, *Sunday Afternoon on the Island of La Grande Jatte*, 1884–86. Oil on canvas, 6 ft. 9¾ in. × 10 ft. 1⅜ in. (2.08 × 3.08 m). Art Institute of Chicago (Helen Birch Bartlett Memorial Collection). La Grande Jatte is an island in the river Seine that was popular with Parisians for weekend outings. Seurat's painstaking and systematic technique reflected his scientific approach to painting. For two years he made many small outdoor studies before painting the large final canvas of *La Grande Jatte* in his studio. In 1886 it was unveiled for the last Impressionist Exhibition.

Georges Seurat

In his own brand of Post-Impressionism, short-lived though it was, Georges Seurat (1851–91) combined Cézanne's interest in volume and structure with Impressionist subject matter. His most famous painting, *Sunday Afternoon on the Island of La Grande Jatte* (fig. **25.6**), monumentalizes a scene of leisure by filling the space with solid iconic forms. Human figures, animals, and trees are frozen in time and space. Motion is created formally, by contrasts of color, silhouettes, and repetition, rather than by the figures.

Seurat has been called a Neo-Impressionist and a Pointillist, after his process of building up color through dots, or points, of pure color; Seurat himself called this technique "divisionism." In contrast to Cézanne's outlined forms, Seurat's are separated from each other by the grouping of dots according to their color. In the detail of the girl holding the spray of flowers (fig. **25.7**), the individual dots are quite clear.

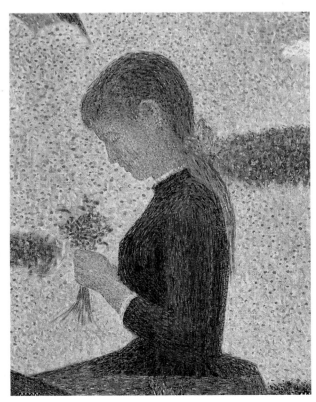

25.7 Detail of figure **25.6**.

25.8 Georges Seurat, *Monkey*, 1884. Conté crayon, 7 × 9¼ in. (17.7 × 23.7 cm). Metropolitan Museum of Art, New York (Bequest of Miss Adelaide Milton de Groot, 1967).

Seurat's attention to detail is apparent from the many studies he made in preparation for the final painting. The little monkey, for example, which stands by the woman at the right, was the subject of several studies. The drawing in figure **25.8** shows a monkey in a different pose from that in the painting. It is also quickly drawn rather than being built up with dots. Here the texture of the paper surface contributes to the tactile quality of the animal. It has a light edge and face, with the inner form darkened to show contour. Endowed with a sense of inherent energy, this monkey seems tense and alert.

Seurat's divisionism was based on two relatively new theories of color. The first was that placing two colors side by side intensified the hue of each. There is in *La Grande Jatte* a shimmering quality in the areas of light and bright color, which tends to support this theory. The other theory, which is only partly confirmed by experience, asserted that the eye causes contiguous dots to merge into their combined color. Blue dots next to yellow dots would thus merge and be perceived as vivid green. If the painting is viewed from a distance or through half-closed eyes, this may be true. It is certainly not true if the viewer examines the picture closely, as the illustration of the detail confirms. True or not, such theories are characteristic of the search by nineteenth-century artists for new approaches to light and color based on scientific analysis.

autobiographical character of his paintings. Figures who do not communicate are replaced by an absence of figures. The artist's existence, rather than the artist himself, is indicated by furnishings and clothing. Only the portraits on the wall, one of which is a self-portrait, contain human figures; they are arranged as a pair juxtaposed with a single landscape over the clothes rack. Likewise, two pillows lie side by side on a single bed. There are two chairs, but they are separated from each other. The same is true of the doors. There are two bottles on the table, and a double window next to a single mirror. Van Gogh's *Bedroom* is thus a psychological self-portrait, which records his efforts to achieve a fulfilling relationship with another person and his failure to do so.

Vincent van Gogh

Vincent van Gogh (1853–90), the greatest Dutch artist since the Baroque period, devoted only the last ten years of his short life to painting. He began with a dark palette and subjects that reflected a social consciousness reminiscent of nineteenth-century Realism. When he moved to Paris and met the Impressionists, however, his range of color expanded.

In 1888 van Gogh left Paris for Arles in the south of France. The following year he painted the famous *Bedroom at Arles* (fig. **25.9**), which is pervaded by isolation and tension and exemplifies the manifestly

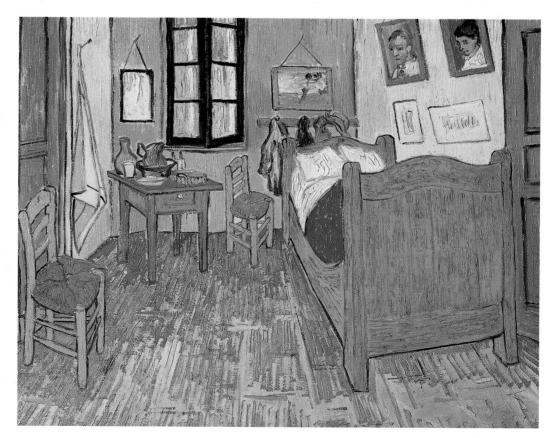

25.9 Vincent van Gogh, *Bedroom at Arles*, 1889. Oil on canvas, 28⅜ × 35⅜ in. (72 × 90 cm). Musée d'Orsay, Paris, France.

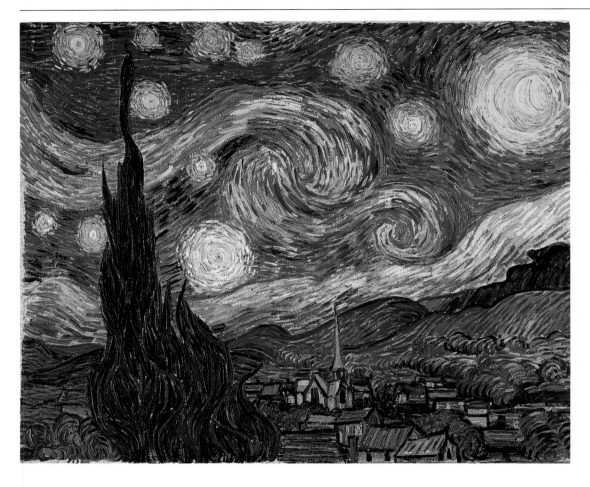

25.10 Vincent van Gogh, *The Starry Night*, 1889. Oil on canvas, 28¾ × 36½ in. (73 × 92 cm). Museum of Modern Art, New York. Acquired through the Lillie P. Bliss bequest.

The tension is reinforced by the color, particularly the intense hue of the red coverlet, which is the only pure color in the painting. In October 1888 Vincent described the colors in a letter to his younger brother, Theo:

> The walls are pale violet. The floor is of red tiles. The wood of the bed and chairs is the yellow of fresh butter, the sheets and pillows very light greenish citron. The coverlet scarlet. The window green. The toilet table orange, the basin blue. The doors lilac. And that is all—there is nothing in this room with its closed shutters.[1]

Van Gogh shared the Impressionist passion for landscape. *The Starry Night* (fig. **25.10**) illustrates his genius for intense, expressive color, his powerful imagery, and his strong sense of line. Line becomes color in the energetic curves spiraling across the night sky. Their movement from left to right is counteracted by hills cascading in the opposite direction. Stabilizing the animated surface are the verticals of the two foreground cypress trees and the church spire. The church itself, as well as the small village, has been identified as van Gogh's memory of Dutch villages, merged here with the French landscape of Provence. Because he painted *The Starry Night* while in a mental asylum, it has been seen as the reflection of a disturbed mind. Nothing, however, could be further from the truth, for van Gogh's characteristic control of formal elements, his

technical skill, and his intellectual clarity, radiate from every inch of the canvas.

Like Rembrandt, whom he studied in his native Holland, van Gogh painted many self-portraits. Whereas Rembrandt created physiognomy primarily by variations in lightness and darkness, van Gogh did so with color. Aside from the yellows and oranges of the face and hair, this *Self-Portrait* (fig. **25.11**) is very nearly monochromatic. The main color is a pale blue-green, varying from light to dark in accordance with the individual brushstrokes. The jacket remains distinct from its background by its darkened outline.

Although the figure itself is immobile, the pronounced spiraling, wavy brushstrokes undulate over the surface of the picture. Yellow predominates in the depiction of van Gogh's head and is a component of both the orange and the blue-green. The intense gaze is also achieved through color, for the whites of the eyes are not white at all but rather the same blue-green as the background. As a result, the viewer has the impression of looking through van Gogh's skull at eyes set far back inside his head.

The drawing studies in figure **25.12** illustrate van Gogh's efforts to arrive at an expression. Each of the three faces on the sheet is seen from a slightly different angle, but all appear serious and thoughtful. The vigorous brushstrokes in the final painting are apparent in the sharp drawing lines, especially of the hair, mustache, and beard.

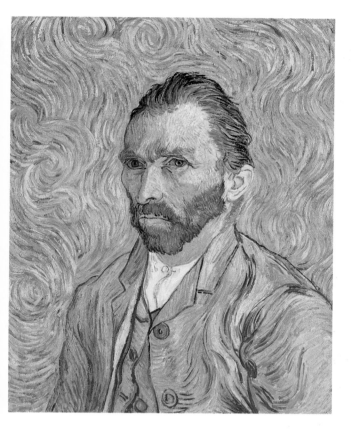

25.11 Vincent van Gogh, *Self-Portrait*, 1889. Oil on canvas, 25½ × 21¼ in. (64.8 × 54.0 cm). Musée d'Orsay, Paris, France.

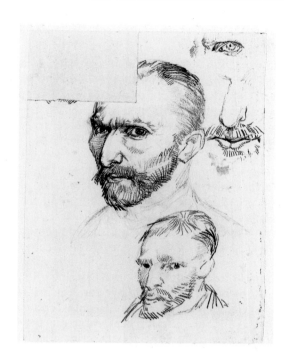

25.12 Vincent van Gogh, studies for *Self-Portrait*, 1889. Pencil and pen drawing, 12⅝ × 9½ in. (32.1 × 24.1 cm). Van Gogh Museum, Amsterdam (Vincent van Gogh Foundation).

PRIMARY SOURCE
"Dear Theo"—The Letters of Vincent van Gogh

Van Gogh's most penetrating exercise in self-portraiture was his correspondence with his younger brother, Theodorus van Gogh, known as Theo. The letters chronicle Vincent's life of poverty and despair, his efforts to find his life's calling, his tortured relationships with women, and his bouts of madness.

Van Gogh's father was a clergyman in Zundert, a small town in Holland. His mother was depressed by the death of her first son, after whom Vincent was named, and who was born on exactly the same day as the second Vincent. Van Gogh grew up with the grave of his older brother, which, located near the family house, was a constant presence. As an adult, he took several jobs before devoting himself exclusively to painting. At first, he aspired to follow his father as a minister in the Dutch Reform Church. He was sent by the Church to work with the coal miners in the Borinage district in the south of Belgium. Their poverty inspired *The Potato Eaters,* but van Gogh's religious zeal alarmed the church authorities and he was not ordained. He also worked in his uncle's art dealership (Goupil's) in Brussels and London, and taught school in England. He was a prodigious reader, fluent in English and French, as well as in Dutch.

Although van Gogh did not decide to be a painter until about 1884, he had—like most artists—begun drawing as a child. Once he settled on his career, he became dependent on Theo for money and emotional support. Virtually every letter details his expenditures on art supplies and complains about the cost of living. Often he went without food in order to paint. Aside from a few brief stints in formal art classes, van Gogh comes close to being a self-taught artist. His letters also describe his efforts to learn to draw, to capture a likeness, and his views on art and artists, particularly Delacroix, who exerted a major influence on his development.

After two years in Paris, van Gogh moved to Arles, in the south of France. There he hoped to found a society of artists who would live and work in a communal setting. Gauguin joined him, but these two difficult personalities were not destined to coexist for long. When van Gogh cut off his earlobe in a fit of jealous despair and was hospitalized, Gauguin left. Van Gogh then suffered several episodes of mental breakdown, and on July 27, 1890, he shot himself, dying two days later. Six months after Vincent's death, Theo also died.

Van Gogh's clinical diagnosis has never been satisfactorily identified. Theories abound, however, and they range from epilepsy to childhood depression to lead poisoning from paint fumes. As van Gogh was unable to sell his pictures during his lifetime, his legacy of paintings went to Theo and then to Theo's son, also named Vincent. The young Vincent bequeathed the bulk of the collection to Holland, and most are now permanently exhibited in the Van Gogh Museum, in Amsterdam.

Paul Gauguin

Compared with van Gogh, whose pictorial surfaces have a dynamic character, Paul Gauguin (1848–1903) applied his paint smoothly. Although Gauguin's colors are bright, they are arranged as flat shapes, usually outlined in black. The surfaces of his pictures seem soft and smooth in contrast to the energetic rhythms of van Gogh's thick brushstrokes.

Gauguin began his career under the aegis of the Impressionists—he exhibited with them from 1879 to 1886—and then went on to explore new approaches to style. In *The Yellow Christ* (fig. **25.13**) of 1889, Gauguin identifies with the Symbolist movement (see p. 463). He sets the Crucifixion in a Breton landscape and depicts Christ in flattened yellows. Three women in local costume encircle the Cross—a reference to traditional Christian symbolism, in which the circle signifies the Church. In fact, the women of Brittany often prayed at large stone crosses in the countryside. The juxtaposition of the Crucifixion with the late-nineteenth-century landscape of northern France is a temporal and spatial condensation that is characteristic of the dreamworld depicted by the Symbolists. It is also intended to convey the hallucinatory aspects of prayer, indicating that through meditating on the scene of the Crucifixion the Breton women have conjured up an image of the event.

25.13 Paul Gauguin, *The Yellow Christ*, 1889. Oil on canvas, 36¼ × 28⅞ in. (92.1 × 73.3 cm). Albright-Knox Art Gallery, Buffalo, New York.

25.14 Paul Gauguin, *Self-Portrait with Halo*, 1889. Oil on wood, 31¼ × 20¼ in. (79.5 × 51.4 cm). National Gallery of Art, Washington, D.C. (Chester Dale Collection). In 1873 Gauguin, then working as a stockbroker, married a Danish piano teacher, with whom he led a middle-class life and had five children. In 1882 he became a full-time painter and deserted his family. After a turbulent year with van Gogh in Arles, in the south of France, Gauguin returned in 1889 to Brittany, where he was influenced by the Symbolists, and his work assumed a spiritual, self-consciously symbolic quality.

In *Self-Portrait with Halo* (fig. **25.14**) of the same year, two apples are suspended behind Gauguin's head. They, like the serpent rising through his hand, allude to the Fall of Man. The flat, curved plant stems in the foreground repeat the motion of the serpent, the outline of Gauguin's lock of hair, and the painting's date and signature. The clear division of the picture plane into red and yellow depicts the artist's divided sense of himself; his head is caught between the two colors, implying that his soul wavers between the polarities of good and evil. Gauguin combines Symbolist color with traditional motifs to convey this struggle. He is at once the tempted and the tempter, a saint and a sinner, an angel and a devil. An important feature of this *Self-Portrait* is Gauguin's contrast between himself as a physical entity and the red and yellow background. His hand and face, as well as the apples, are modeled three-

dimensionally, whereas the red and yellow are flat. These methods by which the artist depicted animate and inanimate objects continued to be used throughout his career.

In 1891 Gauguin sold thirty paintings to finance a trip to Tahiti (see Box, p. 462). Apart from an eighteen-month stay in France in 1895–96, he spent the rest of his life in the South Sea Islands. In his Tahitian paintings, Gauguin synthesized the Symbolist taste for dreams and myths with native subjects and traditional Western themes. *Nevermore* (fig. **25.15**), for example, depicts a Tahitian version of the reclining nude. The brightly colored patterns and silhouettes indicate the influence both of Japanese prints and of native designs. They enliven the composition and contrast with the immobility of the figures.

Gauguin has infused the traditional reclining nude with a sense of danger and suspicion. She evidently knows of the danger, since she rolls her eyes as if aware of the two women talking in the background. The title of the picture, spelled out in the upper left corner, echoes the refrain of Edgar Allan Poe's "The Raven," which Gauguin knew from the French translation by the critic and poet Charles Baudelaire:

> Once upon a midnight dreary, while I pondered,
> weak and weary,
> Over many a quaint and curious volume of
> forgotten lore—

> While I nodded, nearly napping, suddenly there
> came a tapping,
> As of someone gently rapping, rapping at my
> chamber door.
> "'Tis some visitor," I muttered, "tapping at my
> chamber door—
> Only this and nothing more." . . .
> "Prophet!" said I,
> "thing of evil!—prophet still, if bird or devil!
> Whether Tempter sent, or whether tempest tossed
> thee here ashore,
> Desolate yet all undaunted, on this desert land
> enchanted—
> On this home by Horror haunted—tell me truly,
> I implore—
> Is there—is there balm in Gilead?—tell me—tell me,
> I implore!"
> Quoth the Raven, "Nevermore."

In Gauguin's painting, the raven perches on a shelf between the title and the whispering women, and stares at the nude. The juxtaposition of raven, nude, and talking women hints at a silent, but sinister, communication. In this combination of Tahitian imagery and Western themes, self-consciously imbued with a psychic dimension, Gauguin merges his personal brand of Post-Impressionism with a Symbolist quality.

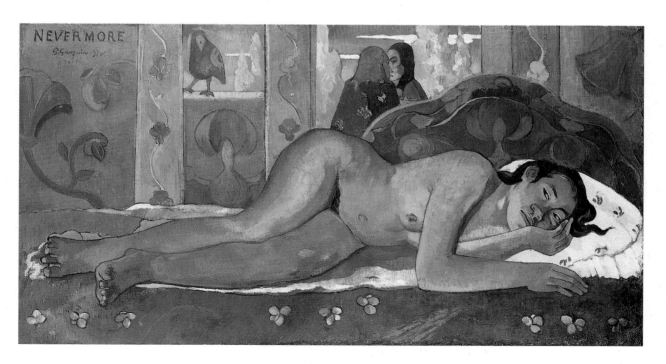

25.15 Paul Gauguin, *Nevermore*, 1897. Oil on canvas, 1 ft. 11⅞ in. × 3 ft. 9⅝ in. (61 × 116 cm). The Samuel Courtauld Trust, Courtauld Institute of Art Gallery, London, England. Although Gauguin's style changed little after he left France, Polynesian life and culture became the subject of his work. Gradually, poverty, alcoholism, and syphilis undermined his health, and he died at age fifty-five, after at least one suicide attempt.

Gauguin and Oceania

Following the eighteenth-century Enlightenment, there developed a new interest in Oceania, which includes Polynesia, Melanesia, and Micronesia. The possibility that man existed there in the utopian state of nature posited by Jean-Jacques Rousseau intrigued Western Europe. Between 1768 and 1778, Captain Cook made three voyages to the South Seas. Collectors began to focus on Oceanic objects that had been brought back by explorers. Descriptions and drawings of the native populations—their artifacts, dwellings, and costumes, and even their tattoos—achieved a certain popularity in Europe.

By the latter half of the nineteenth century, after the fashion for *japonisme* had been established, ethnology museums became more numerous and began to mount exhibits of Oceanic art. This was encouraged by French colonial expansion in Africa and the Far East (especially Indochina) in the 1880s. In 1882 the Musée d'Ethnographie (Musée de l'Homme) opened in Paris, and the arts of Polynesia were well represented. In an effort to provide "context," the Universal Exposition of 1889 exhibited Oceanic objects in reconstructed village settings.

Gauguin was one of the first major artists to become interested in Oceanic culture and to collect its art. The European fantasy of a "noble savage" appealed to him, and in 1891 he gave the following account of his intention to live and work in Tahiti:

> I am leaving in order to have peace and quiet, to be rid of the influence of civilization. I only want to do simple, very simple art, and to be able to do that, I have to immerse myself in virgin nature, see no one but savages, live their life, with no other thought in mind but to render, the way a child would, the concepts formed in my brain and to do this with the aid of nothing but the primitive means of art, the only means that are good and true.[2]

For Gauguin, Tahiti had many complex associations. It was one aspect of the ambivalent self he depicted in the *Self-Portrait* of 1889

(see fig. **25.14**). He saw Tahiti as a new Eden, an island paradise where nature took precedence over the corrupt, industrial, "civilized" West; and he described his trip as a return to the "childhood of mankind." The South Seas also fueled the eclectic character of his art. For he never renounced the Western tradition, in which he was deeply immersed. His affinity with late-nineteenth-century European abstraction is evident in his reply to a question about his "red dogs" and "pink skies":

> It's music, if you like! I borrow some subject or other from life or from nature as a pretext, I arrange lines and colors so as to obtain symphonies, harmonies that do not represent a thing that is real, in the vulgar sense of the word, and do not directly express any idea, but are supposed to make you think the way music is supposed to make you think, unaided by ideas or images, simply through the mysterious affinities that exist between our brains and such arrangements of colors and lines.[3]

Gauguin was a prodigious synthesizer of different artistic traditions, including those of Western Europe, Japanese woodblock, and the sculpture of Egypt, Oceania, Indonesia, and the Far East. For example, he combined Oceanic mythology with Christian and Buddhist iconography. In his *Idol with the Seashell* (fig. **25.16**) of about 1893, the figure represents Taaroa, who was worshiped on Easter Island as the divine creative force of the universe. The prominent teeth, made of inlaid bone, carry cannibalistic implications. But the idol occupies a traditional pose of Buddha, and the rounded, polished shell is reminiscent of the Christian halo. In such works as this, Gauguin helped to correct the popular misunderstanding of the tribal arts as primitive in the sense of regressive. For him, the incorporation of various non-Western forms and motifs into Western art expanded intellectual as well as aesthetic experience.

25.16 Paul Gauguin, *Idol with the Seashell*, c. 1893. Wood, 10⅝ in. (27 cm) high. Musée d'Orsay, Paris, France.

Symbolism was particularly strong in France and Belgium in the late nineteenth century. It began as a literary movement, emphasizing internal psychological phenomena rather than objective descriptions of nature.

The English word *symbol* comes from the Greek word *sumbolon*, meaning "token." It originally referred to a sign that had been divided in two and could therefore be identified because the two halves fit together. A symbol thus signifies the matching part or other half. It is something that stands for something else. Symbols derive from myth, folklore, allegory, dreams, and other manifestations of the unconscious. The Symbolists believed that by focusing on the internal world of dreams, it was possible to rise above the here and now and arrive at the universal. It is no coincidence that the Symbolist movement in art and literature was contemporary with advances in psychology and the development of psychoanalysis.

In literature, the poets' "Symbolist Manifesto" of 1886 rejected Zola's Naturalism in favor of the Idea and the Self. The French poets Charles Baudelaire, Stéphane Mallarmé, and Paul Verlaine became cult figures for the Symbolists, as did the American writer Edgar Allan Poe and the Swedish philosopher Emanuel Swedenborg. Their literature of decadence, disintegration, and the macabre shares many qualities with Symbolist painting. An erotic subtext, often containing perverse overtones, pervades and haunts the imagery.

Symbolism

The Symbolists (see Box) rejected both the social consciousness of Realism and the Impressionist interest in nature and the outdoors. They were attracted instead by the internal world of the imagination and by images that portrayed the irrational. They were also drawn to mythological subject matter because of its affinity with dreaming, but their rendition of myth was neither heroic in character nor Classical in style. Rather, it was disturbed and poetic, and it contained more than a hint of perversity.

Gustave Moreau

Gustave Moreau (1826–98) was the leader of the Symbolist movement in France. His *Galatea* (fig. **25.17**) depicts an imaginary scene from Greek myth in which the Cyclops Polyphemos gazes at the dozing, idealized nude figure of his mortal beloved. He holds the stone with which he has killed her lover, Acis, because of his primitive longing for her, which is reflected in the abundance of rich but bizarre foliage. Polyphemos's power over Galatea is conveyed by his giant size and the alert gaze of his single eye—uncannily juxtaposed with her two closed eyes. The scene depicts a tale of unrequited love and passion turned to murder and is pervaded by a disturbing calm. An eerie, unreal light transports the *Galatea* into the realm of imagination: the Cyclops is bathed in orange light, while Galatea is illuminated by white light. Her pose recalls the traditional reclining nude, which enhances the impression of her vulnerability in the presence of Polyphemos.

25.17 Gustave Moreau, *Galatea*, 1880–81. Oil on panel, 33½ × 26¾ in. (85 × 67 cm). Musée d'Orsay, Paris, France.

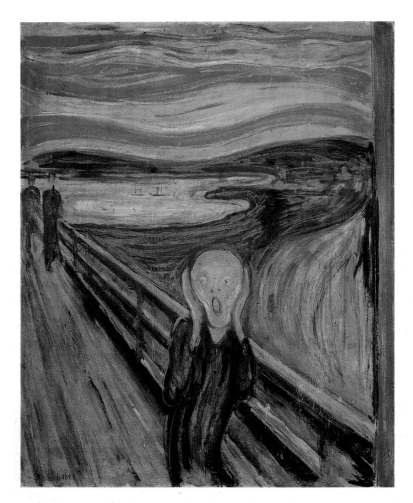

25.18 Edvard Munch, *The Scream*, 1893. Oil, pastel, and casein on cardboard, 35¾ × 29 in. (90.8 × 73.7 cm). National Gallery, Oslo, Norway.

Edvard Munch

The Norwegian artist Edvard Munch (1863–1944) went in 1889 to Paris, where he came into contact with Impressionism and Post-Impressionism. The combination of Symbolist content with Post-Impressionism was particularly suited to Munch's character. His mental suffering, like van Gogh's, was so openly acknowledged in his imagery and statements that it is unavoidable in considering his work. His pictures conform to Symbolist theory in that they depict states of mind, emotions, or ideas rather than observable physical reality. The style in which Munch's mental states are expressed, however, is Post-Impressionist in its expressive distortions of form and its use of nonlocal color.

In his best-known painting, *The Scream* (fig. **25.18**) of 1893, Munch represents his own sense of disintegration in a figure crossing the bridge over Oslo's Christiania-fjord. The bright colors—reds, oranges, and yellows—intensify the sunset, with darker blues and pinks defining the water. Both sky and water seem caught up in an endless swirl echoing the artist's anguish. His fellow pedestrians at the far end of the bridge continue on ahead, whereas he stops to face the picture plane, simultaneously screaming and holding his ears. The action of blocking out the sound pushes in the sides of his face so that his head

resembles a skull and repeats the landscape curves. Munch described the experience depicted in this painting as follows: "I felt as though a scream went through nature—I thought I heard a scream—I painted this picture—painted the clouds like real blood. The colors were screaming."[4] He thus joins the scream of nature as his form echoes the waving motion of the landscape.

The remainder of this text surveys the major styles of twentieth-century art, which derive from certain nineteenth-century developments. Realism had introduced a new social consciousness into the visual arts, and Impressionism had made artists and viewers alike aware of the expressive power of the medium. Post-Impressionists explored various ways in which the individual brushstrokes could enhance and construct images, even to the point where the paint intruded on the subject. At the same time, Symbolism took up the Romantic interest in giving visual form to states of mind. The nineteenth century ended and the twentieth century began with an artist in whose work the medium and the imagination were combined as new subjects in Western art.

Naïve Painting:
Henri Rousseau

Although Henri Rousseau (1844–1910) worked largely during the latter part of the nineteenth century, his impact on Western art history must be seen in the context of the first half of the twentieth century. He has been called a **naïve** painter because he had no formal training. He spent most of his working life as a customs inspector near Paris—hence his nickname "Le Douanier" ("customs officer"). He painted in his spare time, exhibited at the Salon des Indépendants, and in 1885 retired from his job to become a full-time painter. At first mocked by the critics, Rousseau was later much admired. In 1908 Pablo Picasso (see Chapter 26) held a banquet at his Montmartre studio in Rousseau's honor.

Rousseau's last great work, *The Dream* (fig. 25.19), was painted in 1910, shortly before his death and eleven years after the publication of Freud's *Interpretation of Dreams* (see Box, p. 466). The painting shows a nude, reclining but alert, in a pose related to the Classical reclining Venus (see figs. **16.32** and **23.18**). Rousseau's figure has been transported on a Victorian couch to a jungle setting, complete with wild animals and abundant flowers and foliage. Emerging from the jungle depths is a dark-gray creature, clothed in a colorful tunic, who stands upright. He is simultaneously animal and human and plays a musical instrument. The bizarre gray of his face and skin contrasts with the bright jungle colors. The daytime sky is at odds with the normal time for dreaming, which is night.

CONNECTIONS

See figure 16.32.
Titian, *Venus of
Urbino,* c. 1538.

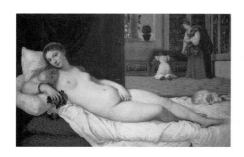

CONNECTIONS

See figure 23.18.
Édouard Manet,
Olympia, 1865.

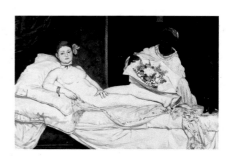

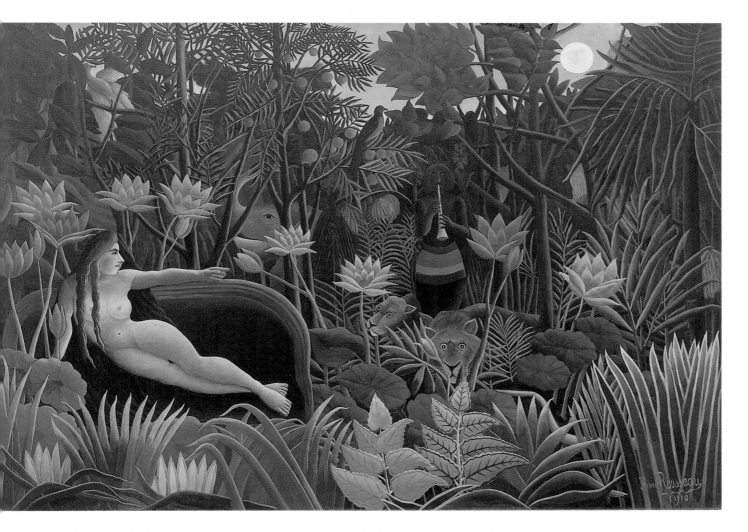

25.19 Henri Rousseau, *The Dream,* 1910. Oil on canvas, 6 ft. 8½ in. × 9 ft. 9½ in. (2.05 × 2.99 m). Museum of Modern Art,
New York (Gift of Nelson A. Rockefeller).

When asked about the unlikely juxtaposition of the couch with the jungle in *The Dream*, Rousseau provided two different answers. In the first, he said that the woman is the dreamer; she is sleeping on the couch, and both have been transported to the jungle. In the second, he said that the couch was there simply because of its red color. In the French journal *Soirées de Paris* (January 15, 1914), Rousseau published the following inscription for the painting:

> In a beautiful dream
> Yadwigha gently sleeps
> Heard the sounds of a pipe
> Played by a sympathetic charmer
> While the moon reflects
> On the rivers and the verdant trees
> The serpents attend
> The gay tunes of the instrument.

In one sense *The Dream* can be regarded as a synthesis of the two main trends in Western European art at the turn of the twentieth century. For lack of better terminology, these trends may be described as "subjectivity" (one of the primary characteristics of Romanticism and Symbolism) and "objectivity" (the ideal aspired to by the Realists and Impressionists). In *The Dream*, Rousseau merges the visionary world of dream and imagination with a detailed depiction of reality. To this end, he made a careful study of leaves and flowers before painting them, although their very "reality" in this painting has an eerie quality. However, *The Dream* is remarkably consistent with Freud's account of the mechanisms of dreaming and, as such, looks forward to twentieth-century Surrealism (see Chapter 28). Rousseau's image combines the dream (the picture) with the dreamer (the nude inside the picture). The precise, clear edges contain the wild character of the jungle, which symbolizes the primitive forces revealed in dreams.

HISTORY
Freud on the Mechanisms of Dreaming

In 1899 Sigmund Freud published *The Interpretation of Dreams*. Although initially only a few copies were sold, its impact on Western thought has been enormous. As defined by Freud, there are four mechanisms of dreaming:

1. **Representability** means that an idea or feeling can be changed into a picture. Dream pictures are unconscious regressions from words to images, whereas works of art are consciously controlled by the artist.

2. **Condensation** merges two or more elements into a new, disguised form. In Rousseau's *Dream*, for example, the jungle is condensed with a European drawing room, and day is condensed with night.

3. **Displacement** means moving an element from its usual setting to another place. The dark musician in *The Dream* is an example, for nonhuman features have been displaced onto him. Displacement can result in condensation. Geographical condensation is achieved by displacing the couch into the jungle.

4. **Symbolization** is the process of making symbols. A symbol is something that stands for something else. In *The Dream* the flowers, fruit, serpent, musician, jungle setting, and nude may be interpreted as symbols of the dreamer's sexual fantasies.

c. 1870 **c. 19**

POST-IMPRESSIONISM AND THE LATE 19TH CENTURY

 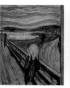 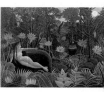

| (25.4) | (25.2) | (25.8) | (25.10) | (25.15) | (25.18) | (25.19) |

Mark Twain, *The Adventures of Tom Sawyer* (1875)

Henrik Ibsen, *A Doll's House* (1879)

Edison invents electric lightbulb (1879–80)

European colonization of Africa (1880s)

Brooklyn Bridge opens (1883)

Cinematograph invented (1894)

The Curies discover radium (1898)

Sigmund Freud, *The Interpretation of Dreams* (1899)

First Model Ford (1908

26

The Early Twentieth Century: Picasso, Fauvism, Expressionism, and Matisse

Culture and Context

Western history is traditionally divided into centuries, and historians tend to see significance in the "turn of a century." Given the span of human history from the Paleolithic era, in which the first known works of art were produced, a century represents a small, almost infinitesimal, fragment of time. Nevertheless, as we consider historical events that are closer to our own era, their significance seems to increase and time itself to expand. Although we measure the prehistoric era by millennia and later periods by centuries, we tend to measure our own century by decades—or less. Our perception of time depends upon its relation to ourselves.

From the perspective of the turn of the twenty-first century, it seems that rapid changes have occurred in many fields. Technological advances set in motion by the Industrial Revolution speeded up communication and travel to an unprecedented degree. Electric lights have been in use since the 1890s, radios since 1895, cars since the early 1900s, televisions and computers since the 1950s. The Wright brothers flew the first airplane in 1903. Sixty-six years later, in 1969, the United States put the first man on the moon. Great strides were made in medicine, Albert Einstein formulated the theory of relativity, and Sigmund Freud founded the psychoanalytic movement.

In politics, too, major changes took place. Lenin led the Russian Revolution in 1917; by 1991 the Soviet Union was dissolved. World War I (1914–18) decimated a generation of European men. Following the Great Depression of 1929, Europe witnessed the rise of Hitler and National Socialism in Germany, as well as Fascism in Italy and Spain, which culminated in World War II (1939–45). The end of that war ushered in the anxieties of the nuclear age and new concerns about the future of the environment.

In the arts as well, rapid changes are evident, as styles came and went, often merging into one another. For the purposes of this text, the twentieth century is divided by the marker of World War II. Up to that point, Paris had been the center of the Western art world. As Gertrude Stein (see p. 480) said, "Paris was where the twentieth century was." Paris exerted a strong pull on artists, who studied in its art schools, and on collectors and critics, who toured its studios, galleries, and museums. After the war, and partly because of it, many artists—indeed, entire schools of artists—were forced to flee Europe.

In 1900 works by Impressionist and Post-Impressionist artists were shown at the World's Fair, or International Exposition, in Paris. These styles had emphasized the primacy of the medium. Building on this innovation, twentieth-century artists expanded into new areas, influenced in part by non-Western cultures. The nineteenth century had developed a taste for *japonisme* as a result of contact with Japanese woodblock prints. In the early twentieth century, there was a growing interest in African art, the geometric abstraction of which appealed to artists, collectors, and critics (see Box, p. 469).

Whereas the Impressionists extended the range of subject matter by expanding the range of social classes depicted by Neoclassical artists, twentieth-century artists developed a new iconography of everyday objects. They also began to use new materials, such as plastics, which resulted from advances in technology. New techniques for making art were developed, especially in the second half of the century. Technological developments also encouraged new directions in architecture.

The very idea of "newness" became one of the tenets of modernism. The so-called avant-garde (literally the "vanguard," or leaders, of artistic change) became a prominent force in Western art. Continual striving for avant-garde status contributed to the rapidity with which styles changed in the twentieth century.

Pablo Picasso and Henri Matisse

In painting, two figures dominated the first half of the twentieth century: the Spanish artist Pablo Picasso (1881–1973) and the French artist Henri Matisse (1869–1954). Both made sculptures but were primarily painters. In contrast to the experience of the Impressionists and Post-Impressionists, the genius of Picasso and Matisse was recognized relatively

early in their careers. Their paths crossed at the Paris apartment of Gertrude Stein, the American expatriot author, who held regular gatherings of artists and intellectuals from Europe and the United States.

Picasso and Matisse began their careers in the nineteenth century under the influence of Impressionism, Post-Impressionism, and Symbolism. They soon branched out—Picasso earlier than Matisse—and spearheaded the avant-garde, although their styles were quite distinct. Matisse began and ended as a colorist, with important evolutions along the way. Picasso, on the other hand, shifted from one style to another, often working in more than one mode at the same time (see Chapter 27). His first individual style was actually Symbolist; it is referred to as his "Blue Period."

Symbolism: Picasso's Blue Period

Picasso was born in Málaga on the south coast of Spain. His father, José Ruíz Blasco, was an art teacher devoted to furthering his son's career. (Picasso took his mother's

26.1 Pablo Picasso, *The Old Guitarist*, 1903. Oil on panel, 4 ft. ⅝ in. × 2 ft. 8½ in. (1.23 × 0.83 m). Art Institute of Chicago (Helen Birch Bartlett Memorial Collection).

LITERATURE
Wallace Stevens: "The Man with the Blue Guitar"

The Symbolist quality of Picasso's *Old Guitarist* appealed to the American poet Wallace Stevens (1879–1955), who wrote "The Man with the Blue Guitar" in 1937 in response to it:

> The man bent over his guitar,
> A shearsman of sorts. The day was green.
> They said, "You have a blue guitar,
> You do not play things as they are."
> The man replied, "Things as they are
> Are changed upon the blue guitar." [stanza I]

> And the color, the overcast blue
> Of the air, in which the blue guitar
> Is a form, described but difficult,
> And I am merely a shadow hunched
> Above the arrowy, still strings,
> The maker of a thing yet to be made;
> The color like a thought that grows
> Out of a mood, the tragic robe
> Of the actor, half his gesture, half
> His speech, the dress of his meaning, silk
> Sodden with his melancholy words,
> The weather of his stage, himself. [stanza IX][1]

family name.) From 1901 to 1904 Picasso moved between Paris, Barcelona, and Madrid, settling permanently in Paris in 1904. The subjects of Picasso's Blue Period, which lasted from approximately 1901 to 1904, were primarily the poor and unfortunate. Consistent with the Symbolist aesthetic, Picasso's "Blue" paintings depict a mood or state of mind—in this case, melancholy and pessimism (note, for example, the expressions "to be in a blue mood," "blue Monday," "to have the blues"). The predominance of blue as the mood-creating element reflects the liberation of color that had been effected by nineteenth-century Post-Impressionism.

Picasso emphasizes the somber quality of *The Old Guitarist* (fig. **26.1**) with the all-pervasive blue color and the shimmering silver light (see Box). The guitarist's long, thin, bony form, tattered clothes, and downward curves convey dejection. His inward focus enhances the impression that he is listening intently, absorbed in his music, and also indicates that he is blind. The elongated forms and flickering silver light evoke the spirituality of El Greco.

African Art and the European Avant-Garde

With the increasing number of ethnological museums at the end of the nineteenth century, non-Western art was becoming an aesthetic force in Europe. Against the background of nineteenth-century *japonisme,* the influence of Oceanic art, revivals of interest in Egyptian and Iberian art, and the spatial revolution of Cézanne, the early-twentieth-century avant-garde was receptive to new formal ideas. One of the major sources for these ideas was the growing interest in African art. The interest in such cultures was known as "primitivism."

Most surviving African art is sculpture, which can be understood only in its cultural context. The cave paintings and glyptic arts of Africa were little known to nineteenth- and early-twentieth-century European artists, who rarely had contact with African architecture.

The Baule ancestor from the Ivory Coast (fig. **26.2**) typifies the African sculptures whose abstraction appealed to the Western avant-garde in the early twentieth century. Its surface is smooth and polished, with relief patterns of scarification on the face, neck, and torso. The hair is made of finely incised parallel lines. A mechanical effect is created by abrupt, nonorganic planar shifts, which contrast with Classical proportions. Compare figure **26.2** with figure **7.14**. Such objects offered Western artists new ways of approaching the human figure. At the same time, however, the proportions of African sculpture have meanings that vary from culture to culture, which were not understood by most Westerners in the early twentieth century.

The following quotations from European artists discussed in this text express the liberating effect of their encounter with African sculpture:

Kandinsky (statement, published 1930): "the shattering impression made on me by Negro art, which I saw in [1907] in the Ethnographic Museum in Berlin."[2]

Marc (1911): "I was finally caught up, astonished and shocked, by the carvings of the Cameroon people, carvings which can perhaps be surpassed only by the sublime works of the Incas. I find it so self-evident that we should seek the rebirth of our artistic feeling in this cold dawn of artistic intelligence, rather than in cultures that have already gone through a thousand-year cycle like the Japanese or the Italian Renaissance."[3]

Matisse (on African sculptures in a shop on the rue de Rennes in Paris; interview recorded in 1941): "I was astonished to see how they were conceived from the point of view of sculptural language; how it was close to the Egyptians. . . . Compared to European sculpture, which always took its point of departure from musculature and started from the description of the object, these Negro statues were made in terms of their material, according to invented planes and proportions."[4]

Picasso (on African masks): "For me the [tribal] masks were not just sculptures, they were magical objects . . . intercessors . . . against everything—against unknown, threatening spirits. . . . They were weapons—to keep people from being ruled by spirits, to help free themselves. . . . If we give a form to these spirits, we become free."[5]

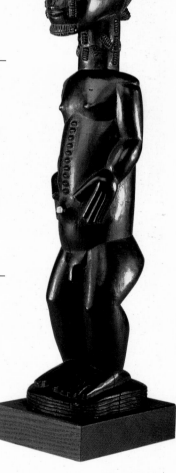

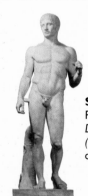

See figure 7.14.
Polykleitos,
*Doryphoros
(Spear Bearer),*
c. 440 B.C.

26.2 Baule ancestor, Ivory Coast. Wood, 20½ in. (52.1 cm) high. British Museum, London, England.

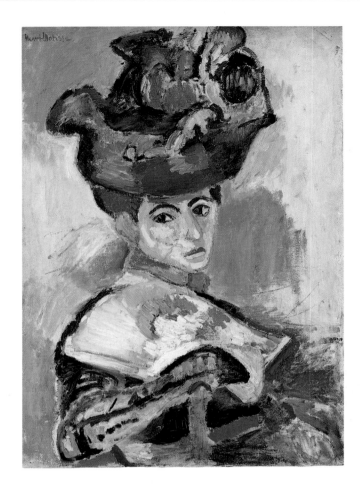

Fauvism: Matisse in 1905–6

In 1905 a new generation of artists exhibited their paintings in Paris at the Salon d'Automne. Bright, vivid colors seemed to burst from their canvases and dominate the exhibition space. Forms were built purely from color, and vigorous patterns and unusual color combinations created startling effects. To a large extent, the works were derived from Gauguin's Symbolist use of color. The critic Louis Vauxcelles noticed a single traditional sculpture in the room, and exclaimed, "Donatello parmi les fauves!" ("Donatello among the wild beasts!"), because the color and movement of the paintings reminded him of the jungle. His term stuck, and the style of those pictures is still referred to as "Fauve."

Vauxcelles's observation of a traditional sculpture juxtaposed with the works of the young artists exhibiting in 1905 signaled the latest skirmish in the traditional Western European dispute over the primacy of line versus color. Although there was plenty of "line" in Fauve painting, it was the brilliant, nonnaturalistic color and emotional exuberance that struck viewers. In contrast, Classical restraint and harmony, which were associated with line, appeared more controlled and, by implication, more civilized.

26.3 (Right) Henri Matisse, *Woman with the Hat*, 1905. Oil on canvas, 2 ft. 7¾ in. × 1 ft. 11½ in. (81 × 65 cm). Museum of Modern Art, San Francisco (Bequest of Elise S. Haas).

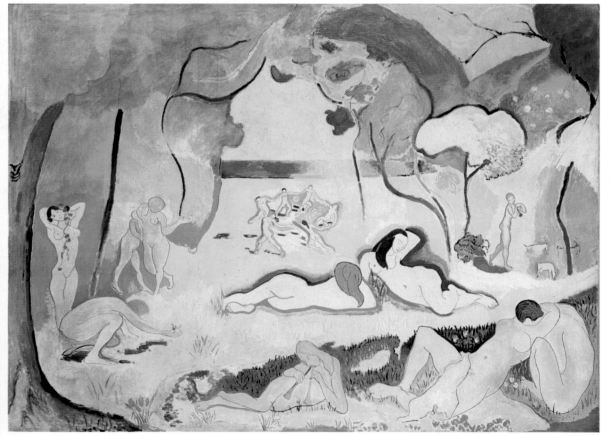

26.4 Henri Matisse, *The Joy of Life*, 1905–6. Oil on canvas, 5 ft. 8½ in. × 7 ft. 9¾ in. (1.74 × 2.38 m). The Barnes Foundation, Merion, Pennsylvania. Archives Matisse.

The leading Fauve artist in France was Henri Matisse. Matisse was born in northern France. He reportedly decided to become a painter when his mother gave him a set of *chromos* (colors) while he was recuperating from surgery. His *Woman with the Hat* (a portrait of his wife) of 1905 (fig. **26.3**) is a construction in color—a concept that Matisse had learned from Cézanne. Throughout the picture plane, shading, modeling, and perspective are subordinate to color, which creates the features. The result is a nonorganic masklike quality. The background of the painting is identified only as patches of color. To the right of Madame Matisse (our left) are greens, yellows, blues, and oranges. At the opposite side, the background is mainly green and lavender. Variations on these colors recur in the face, creating a chromatic unity between figure and background.

The painting caused a scandal in the Paris art world for its unconventional use of color. But when purchased by Michael Stein, Gertrude's brother, the painting's reputation was saved. From that point on, Matisse's prices began to rise.

Matisse's *Joy of Life* (fig. **26.4**) shows his use of Fauve color to create a mood of exuberant, creative eroticism. The entire picture undulates with passionate enjoyment as figures dance, play music, and embrace. The "non-realistic" colors, especially the warm reds, yellows, and oranges, are as uninhibited as the figures. And the continually curving lines seem to dance and pulsate in time to music. Despite the overt modernity of the work, however, Matisse refers to the idyllic pastoral tradition of antiquity in the shepherd, to dancers circling Greek vases in the background, and to Classical nudes reclining and stretching.

concerned than the Fauves with the formal and structural composition of color.

The Bridge (Die Brücke)

In 1905, the year of the Fauve exhibition in Paris, four German architecture students in Dresden formed a group called *Die Brücke* (The Bridge), which lasted until 1913. The name was inspired by the artists' intention to create a "bridge," or link, between their own art and modern revolutionary ideas, and between tradition and the avant-garde. The notion of "bridging" modernity and the past derived from the philosophy of Frederick Nietzsche, who believed that civilized society continually wavers between progress and decline. The artists of The Bridge modernized both the spiritual abstraction of medieval art and the geometric aesthetic of African and Oceanic art by integrating them with the mechanical forms of the city. Expressionist color was typically brilliant, vivid, and sometimes garish. Paintings by these artists can be further energized by harsh, angular shapes that reflect a pessimistic view of society.

Ernst Ludwig Kirchner

The most important founding artist of The Bridge was Ernst Ludwig Kirchner (1880–1938), who had been trained as an architect before becoming a painter. *The Street* of 1907 (fig. **26.5**) combines exuberant Expressionist color with undulating forms reminiscent of Munch. The flat color areas, on the other hand, can be related to Fauvism. Like Matisse's *Joy of Life, The Street* has a dreamlike quality created by unusual color and curvilinear, undulating forms.

Expressionism

In Germany, the artists most interested in the expressive possibilities of color—as derived from Post-Impressionism—were called Expressionists. They formed groups that outlasted the Fauves in France and styles that persisted until the outbreak of World War I in 1914. Expressionism, like Fauvism, used color to create mood and emotion but differed from Fauvism in its greater concern for the emotional and spiritual properties of color and form. Expressionists were also less

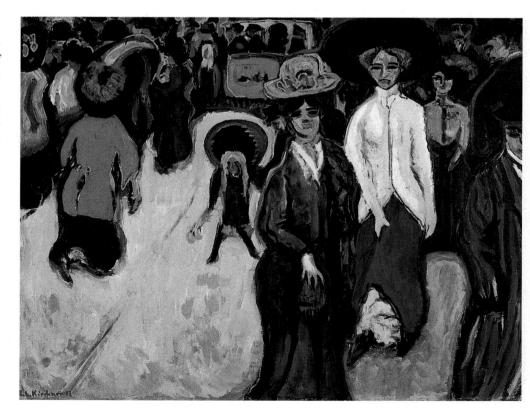

26.5 Ernst Ludwig Kirchner, *The Street*, 1907. Oil on canvas, 4 ft. 11¼ in. × 6 ft. 6⅞ in. (1.5 × 2 m). Museum of Modern Art, New York. During World War I, Kirchner was sent from the front for psychiatric treatment. Repeated panic attacks landed him in a Swiss sanitorium, and a deep depression resulted in his suicide in 1938.

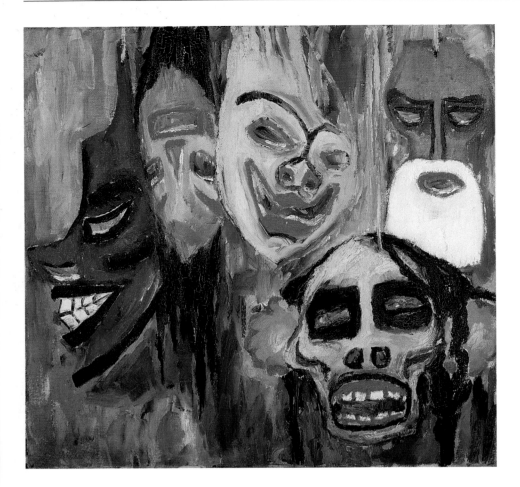

26.6b Emil Nolde, drawing of an Oceanic canoe prow, for left-hand mask in fig. **26.6a**, 1911. Pencil drawing, 11⅞ × 7⅛ in. (30 × 18 cm). Stiftung Seebüll Ada und Emil Nolde.

26.6a Emil Nolde, *Still Life with Masks*, 1911. Oil on canvas, 28¾ × 30½ in. (73.0 × 77.5 cm). Nelson-Atkins Museum of Art, Kansas City, Missouri. Nolde's interest in ethnology inspired trips to New Guinea and other South Pacific islands as well as to the Far East.

Emil Nolde

Another artist associated with German Expressionism, Emil Nolde (1867–1956), spent only a year as a member of The Bridge. His *Still Life with Masks* of 1911 (fig. **26.6a**) shows his combination of bright color with thickly applied paint to achieve intense, dynamic effects. The upside-down pink mask and the adjacent yellow one were inspired by northern European carnivals. But the red mask at the far left is based on Nolde's own drawing of an Oceanic canoe prow (fig. **26.6b**). The yellow skull is also derived from non-Western prototypes—in this case a shrunken head from Brazil, of which Nolde also made sketches. African examples probably inspired the green mask at the upper right, but the combination of a green surface with red outlining the features is an Expressionist use of color. Nolde's non-Western imagery served to express qualities that were finally more in tune with Expressionism than with the cultural or artistic intentions of the non-Western art he studied.

The Blue Rider (Der Blaue Reiter)

Another German Expressionist group, more drawn to non-figurative abstraction than the members of The Bridge, was *Der Blaue Reiter* (The Blue Rider), established in Munich in 1911. The name of the group, derived from the visionary language of the Book of Revelation, was inspired by the millennium and the notion that Moscow would be the new center of the world from 1900—as Rome had once been. "Blue Rider" referred to the emblem of the city of Moscow: Saint George (the "Rider") killing the dragon.

Vassily Kandinsky

The Russian artist Vassily Kandinsky (1866–1944) was among the first to eliminate recognizable objects from his paintings. He identified with The Blue Rider as the artist who would ride into the future of a spiritual, nonfigurative, and mystical art; for him the color blue signified the masculine aspect of spirituality (cf. fig. **26.9**). At the age of thirty, Kandinsky left Moscow, where he was a law student, and went to Munich to study painting. There he was a founder of the *Neue Künstler Vereinigung* (New Artists' Association), or NKV, whose aim was rebellion against tradition. A few artists split from the NKV to form The Blue Rider.

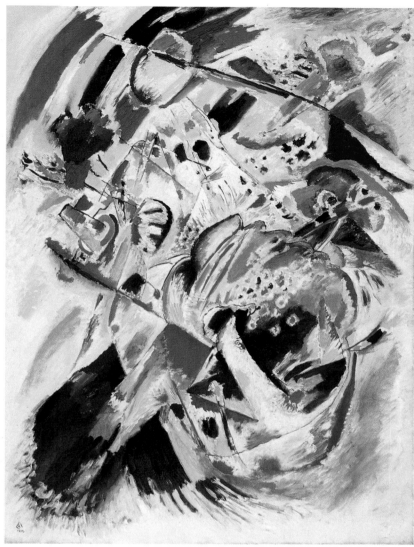

26.7 Vassily Kandinsky, *Panel for Edwin R. Campbell No. 4* (formerly *Painting Number 201, Winter*), 1914. Oil on canvas, 5 ft. 4¼ in. × 4 ft. ¼ in. (1.63 × 1.24 m). Museum of Modern Art, New York (Nelson A. Rockefeller Fund, by exchange).

For Kandinsky, art was a matter of rhythmic lines, colors, and shapes, rather than narrative. Like Whistler, Kandinsky gave his works musical titles intended to express their abstract qualities. By eliminating references to material reality, Kandinsky followed The Blue Rider's avoidance of the mundane in order to communicate the spiritual in art. Titles such as *Improvisation* evoked the dynamic spontaneity of creative activity, and the *Compositions* emphasized the organized abstraction of his lines, shapes, and colors.

In 1912 Kandinsky published *Concerning the Spiritual in Art,* in which he argued that music was intimately related to art. He was by temperament drawn to religious and philosophical thinking imbued with strains of mysticism and the occult, which can be related to the millennarian spirit reflected in The Blue Rider emblem. And he believed that art had a spiritual quality because it was the product of the artist's spirituality. The work of art, in turn, reflected this through musical harmonies created by form and color.

Panel for Edwin R. Campbell No. 4 (formerly *Painting Number 201, Winter*) of 1914 (fig. **26.7**) was one of four in a series representing the seasons—this one being winter. In it Kandinsky creates a swirling, curvilinear motion, within which there are varied lines and shapes. Lines range from thick to thin, color patches from plain to spotty, and hues from unmixed to blended. The most striking color is red, which is set off against yellows and softer blues and greens. The strongest accents are blacks with the sense of winter suggested by the whites, which occur in pure form and also blend with the colors. Blues become light blues and reds become pinks, creating an illusion of coldness associated with winter.

Later, in the 1920s, despite stylistic changes inspired by his association with the Moscow avant-garde, Kandinsky continued to pursue the notion of the spiritual in art. He did so by endowing delicate geometric shapes with a dynamic spatial tension. This is evident in *Several Circles, No. 323* (fig. **26.8**), in which translucent circles float in a swirling space. Some of the circles are isolated, others barely touch the edge of adjacent circles, while a few appear to skim over one another, their geometric purity contrasting with the textured background. Kandinsky's image has an "otherworldly" quality, evoking both the minutiae of the invisible molecular world and the vast distances of a solar system occupied by orbiting moons and planets.

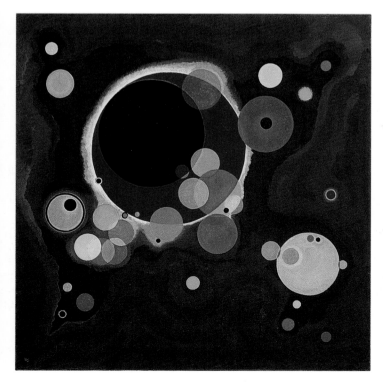

26.8 Vassily Kandinsky, *Several Circles, No. 323*, 1926. Oil on canvas, 55⅛ × 55⅛ in. (140.0 × 140.0 cm). Solomon R. Guggenheim Museum, New York (Gift, 1941).

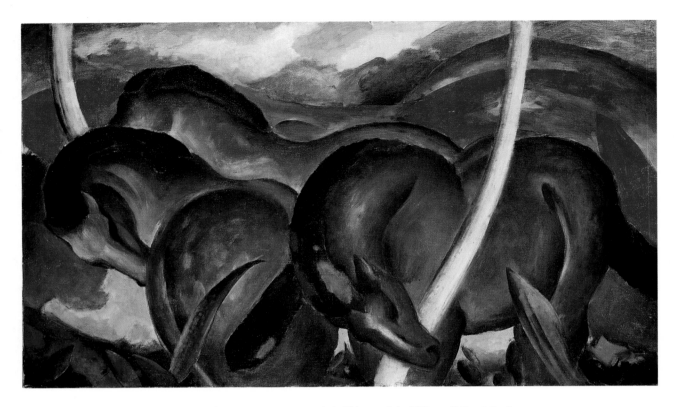

26.9 Franz Marc, *The Large Blue Horses*, 1911. Oil on canvas, 3 ft. 5⅝ in. × 5 ft. 11⁵⁄₁₆ in. (1.0 × 1.8 m). Walker Art Center, Minneapolis (Gift of the T. B. Walker Foundation, Gilbert Walker Fund, 1942).

Franz Marc

The other major Blue Rider artist was Franz Marc (1880–1916), who joined Kandinsky in editing *The Blue Rider Yearbook* of 1912. This contained discussions of Picasso, Matisse, The Bridge, The Blue Rider itself, and the new interest in expanding aesthetic experience through contact with non-Western art. In contrast to Kandinsky, however, Marc did not entirely eliminate recognizable objects from his work, except in preliminary drawings made shortly before his premature death.

Marc's *Large Blue Horses* of 1911 (fig. **26.9**) combines geometry with rich color. Like Gauguin's "red dogs" and "pink skies" (see p. 462), Marc's animals and their setting can be considered in the abstract terms of musical composition. They are an arrangement in foreshortened blue forms, harmonizing with the brightly colored curvilinear landscape. Marc's use of animals reflects his belief that they are better suited than humans to the expression of cosmological ideas. The two gray curves representing slender tree trunks serve as structural anchors. They also create a sense of confinement, which compresses the space and enhances the monumentality of the horses.

Marc shared Kandinsky's spiritual attitude toward the formal qualities of painting, especially color. Like Kandinsky,

he thought of blue as masculine; yellow, in Marc's view, has the calm sensuality of a woman, and red is aggressive. Mixed colors are endowed with additional meaning. For Marc, therefore, color functioned independently of narrative content.

Marc's *Small Yellow Horses* of 1912 (fig. **26.10**) lacks the structural elements of *The Large Blue Horses*, and the horses seem to flow into the landscape. The warm yellows, highlighted in places with oranges, correspond to the artist's association of yellow with female sensuality. The blues and greens of the horses' manes and contoured edges echo the landscape colors, whereas the blue horses contrast more sharply with the reds behind them. Marc thus juxtaposes the "masculine" blue with the "aggressive" reds, whereas the yellows are softer and have a more seductive character.

The Blue Rider, in contrast to The Bridge, was international in scope and had a greater impact on Western art. In particular, Kandinsky's nonfigurative imagery, which was among the first of its kind, was part of a revolutionary development that would remain an important current in twentieth-century art. Matisse and Picasso, for all their innovations, never completely renounced references to nature and to recognizable forms.

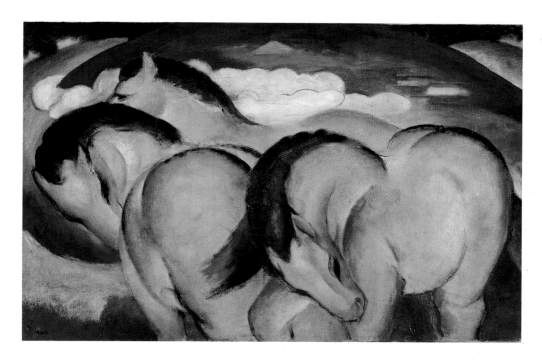

26.10 Franz Marc, *Small Yellow Horses,* 1912. Oil on canvas, 26 × 41 in. (66.0 × 104.0 cm). Staatsgalerie, Stuttgart, Germany.

Käthe Kollwitz

Although Käthe Kollwitz (1867–1945) was not a formal member of any artistic group, her *Whetting the Scythe* (fig. **26.11**) of 1904 conveys the direct emotional confrontation characteristic of Expressionism. Her harsh textures and preponderance of rich blacks enhance her typically depressive themes. The gnarled figure concentrating intently on her task is rendered in close-up, which accentuates the detailed depiction of the wrinkled hands and aged, slightly suspicious face. In the background, the cruciform arrangement of blacks reinforces the ominous associations of the image. The presence of the scythe, an attribute of the Grim Reaper, conforms to the woman's rather sinister quality and suggests impending death.

Although Kollwitz herself was financially comfortable, her imagery brings the viewer into contact with the emotional and material struggles of the working classes. This print is from a series published in 1904 to commemorate Germany's sixteenth-century peasant rebellion.

26.11 Käthe Kollwitz, *Whetting the Scythe,* 1904. Soft-ground 8th-state etching, 11¹¹⁄₁₆ × 11¹¹⁄₁₆ in. (29.7 × 29.7 cm). British Museum, London, England.

Matisse after Fauvism

Although Fauvism was short-lived, its impact, and that of Expressionism, laid the foundations of twentieth-century abstraction. Matisse reportedly said that "Fauvism is not everything, but it is the beginning of everything."

As Matisse developed, he was influenced by abstraction without embracing it completely. His sense of musical rhythm translated into line creates energetic, curvilinear biomorphic forms. On the other hand, the shapes and spaces of Matisse that are determined primarily by color and only secondarily by line are more static and geometric. These two tendencies—fluid line and flat color—create a dynamic tension that persists throughout his career.

Harmony in Red

In *Harmony in Red* of 1908–9 (fig. **26.12**), Matisse goes beyond the thick, constructive brushstrokes and unusual color juxtapositions of his Fauve period. The subject of the painting, a woman placing a bowl of fruit on a table, seems secondary to its formal arrangement. Within the room, the sense of perspective has been minimized because the table and wall are of the same red. The demarcation between them is indicated not by a constructed illusion of space but by a dark outline and by the bright still-life arrangements on the surface of the table. The effect is reinforced by the tilting plates and bowls. Linear perspective is confined to the chair at the left and the window frame behind it. But despite the flattening of the form by minimal modeling, Matisse endows the woman and the still-life objects with a sense of volume.

The landscape, visible through the open window, relieves the confined quality of the close-up interior view. It is related to the interior by the repetition of energetic black

26.12 Henri Matisse, *Harmony in Red*, 1908–9. Oil on canvas, 5 ft. 11 in. × 8 ft. 1 in. (1.80 × 2.46 m). State Hermitage Museum, St. Petersburg, Russia.

curves, which Matisse referred to as his "**arabesques**." The inside curves create branchlike forms that animate the table and wall, while those outside form branches and tree trunks. Smaller arabesques define the flower stems and the outline of the woman's hair.

The title *Harmony in Red* evokes the musical abstraction of Matisse's picture. It refers to the predominant color, the flat planes of which "harmonize" the wall and table into a shared space. Matisse builds a second, more animated "movement" in the fluid arabesques harmonizing interior with exterior. Finally, the bright patches on the woman, the still-life objects, and the floral designs create a more staccato rhythm composed of individual accented forms. Matisse's ability to harmonize these different formal modes within a static pictorial space represents a synthesis of three artistic currents: the Post-Impressionist liberation of color, the Symbolist creation of mood, and the twentieth-century trend toward abstraction.

Dance I

In *Dance I* of 1909 (fig. **26.13**), it is the figures, rather than the arabesques, that dance. The black outlines define the dancers, who twist and turn, jump and stretch. Their rhythmic, circular motion has been compared to dancers on the surface of a Greek vase, and their poses replicate those in the background of *The Joy of Life* (see fig. **26.4**). Although the blue and green background is composed of flat colors, Matisse creates a three-dimensional illusion in the dancers themselves. This is enhanced by the warm pinks that make the dancers appear to advance, while the cool background colors recede. Although the individual movements of the dancers vary, together they form a harmonious continuum.

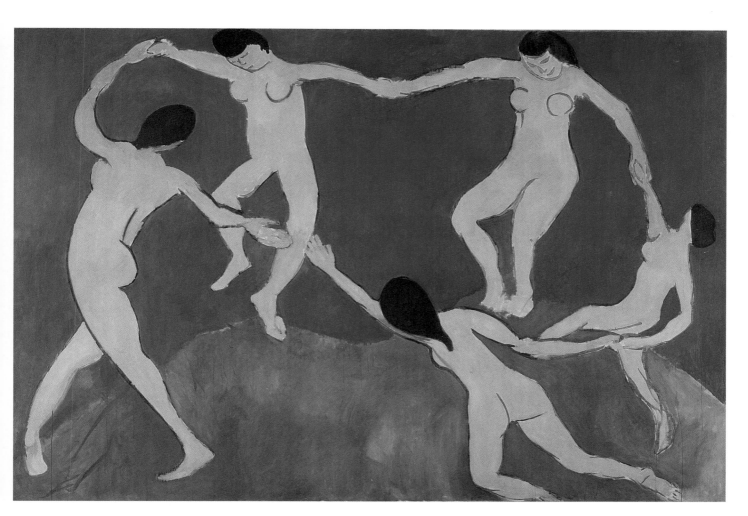

26.13 Henri Matisse, *Dance I*, 1909. Oil on canvas, 8 ft. 6½ in. × 12 ft. 9½ in. (2.6 × 3.9 m). Museum of Modern Art, New York (Gift of Nelson A. Rockefeller in honor of Alfred H. Barr, Jr.).

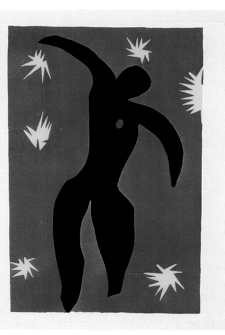

See figure 18.3. Pieter Bruegel the Elder, *Landscape with the Fall of Icarus*, c. 1554–55.

26.14 Henri Matisse, *Icarus*, plate 8 from *Jazz*, Paris, E. Tériade, 1947. Pochoir, printed in color, each double page 16⅝ × 25⅝ in. (42.2 × 65.1 cm). Museum of Modern Art, New York (Louis E. Stern Collection). The *Jazz* series is composed of individual book-size cutouts printed in book form to accompany Matisse's own text.

Icarus

During the last decade of his life, Matisse gave up painting, partly because of cancer. Instead, he grappled directly with the problem of creating a three-dimensional illusion from absolutely flat forms. His medium was the so-called *découpage,* or "cutout," an image created by pasting pieces of colored paper onto a flat surface. An early series of cutouts, titled *Jazz,* indicates Matisse's continuing interest in synthesizing musical with pictorial elements. His cutout of *Icarus* of 1947 (fig. 26.14), from the *Jazz* series, combines the Greek myth with modern style and technique. By curving the edges and expanding or narrowing the forms, Matisse gives the silhouetted Icarus (see Bruegel's *Landscape with the Fall of Icarus,* fig. 18.3) the illusion of three-dimensional volume. His outstretched, winglike arms and tilting head create an impression that, although he is falling

through space, he is not plummeting down to the sea as is Bruegel's Icarus but rather floats gracefully downward in slow motion.

Entirely different in character are the zigzagging bright-yellow stars that surround Icarus. Their points shoot off in various directions, and their vivid color is more energetic than the languid figure of Icarus. There are thus two musical "movements" in this cutout—the slower curvilinear motion of Icarus and the rapid angular motion of the stars. Staccato and adagio are combined against the deep, resonant blue sky.

The drive toward new techniques and media for image-making, which is evident in Matisse's cutouts, will be seen to characterize many of the innovations of twentieth-century art.

c. 1900

c. 1945

THE EARLY 20TH CENTURY: PICASSO, FAUVISM, EXPRESSIONISM, AND MATISSE

(26.1)

World's Fair (1900)

(26.3)

Theodore Roosevelt U.S. president (1901–9)

(26.6a)

Einstein's theory of relativity (1905)

Fauvism exhibition in Paris (1905)

(26.12)

Titanic sinks (1912)

World War I (1914–18)

(26.9)

Bolshevik Revolution in Russia (1917)

League of Nations established (1919)

The Jazz Age (1920s)

(26.8)

U.S. stock market crash (1929)

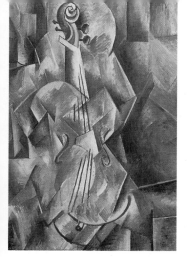

27

Cubism, Futurism, and Related Twentieth-Century Styles

The most influential style of the early twentieth century was Cubism, which, like Fauvism, developed in Paris. Cubism was essentially a revolution in the artist's approach to space, both on the flat surface of the picture and in sculpture. The nonnaturalistic colorism of the Fauves can be seen as synthesizing nineteenth-century Impressionism, Post-Impressionism, and Symbolism. Cubism, however, together with the nonfigurative innovations of Expressionism, soon became the wave of the artistic future.

The main European impetus for Cubism came from Cézanne's new spatial organization, in which he built up images from constructions of color. Other decisive currents of influence came from tribal and Iberian art. These offered European artists unfamiliar, non-Classical ways to represent the human figure.

Cubism

Precursors

Picasso's 1906 portrait of Gertrude Stein (fig. **27.1**; see Box, p. 480) is composed of the dark-red hues that mark the end of his Rose Period, which followed the Blue Period discussed in Chapter 26. The emphasis on color is consistent with contemporary Fauve interests, but a comparison with *The Old Guitarist* of the Blue Period (see fig. **26.1**) indicates that more than color has changed. In *Gertrude Stein*, there are new spatial and planar shifts that herald the beginning of the development of Cubism.

Stein's right arm and hand, for example, are organically shaded and contoured. But her left hand is flatter, and her arm looks as if it were constructed of cardboard. Picasso reportedly needed more than eighty sittings to finish the picture, the main stumbling block

See figure 26.1. Pablo Picasso, *The Old Guitarist*, 1903.

being the face. In the final result, Stein stares impassively as if from behind a mask. The hair does not grow organically from the scalp, and the ears are flat. The sharp separations between light and dark at the eyebrows, the black outlines around the eyes, and the disparity in the size of the eyes detract from the impression of a flesh-and-blood face.

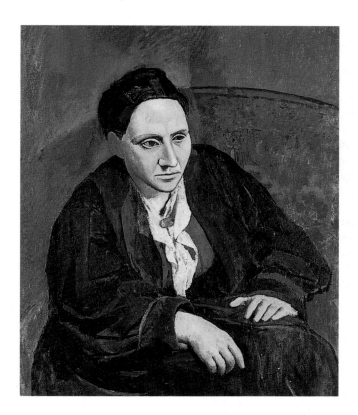

27.1 Pablo Picasso, *Gertrude Stein,* 1906. Oil on canvas, 39⅜ × 32 in. (100.0 × 81.3 cm). Metropolitan Museum of Art, New York (Bequest of Gertrude Stein, 1947). In 1909 Gertrude Stein wrote *Prose Portraits*, the literary parallel of Analytic Cubism. Her unpunctuated repetition reads like free association. The following is from her *Portrait* of Picasso: "One whom some were certainly following was one working and certain was one bringing something out of himself then and was one who had been all his living had been one having something coming out of him. . . . This one was one who was working."[1]



479

HISTORY
Gertrude Stein

Gertrude Stein (1874–1946) was an expatriate American art collector and writer. She moved to Paris in 1903, after studying psychology at Radcliffe and medicine at Johns Hopkins. Her Paris apartment became a salon for the leading intellectuals of the post–World War I era, whom she dubbed the "lost generation." Her most popular book, *The Autobiography of Alice B. Toklas* (Stein's companion), is actually her own autobiography.

Stein and her two brothers were among the earliest collectors of paintings by avant-garde artists. History has vindicated her judgment, for she left an art collection worth several million dollars. Ernest Hemingway, in *A Moveable Feast*, wrote that he had been mistaken not to heed Stein's advice to buy Picassos instead of clothes.

Even more like masks are the faces in Picasso's pivotal picture *Les Demoiselles d'Avignon (The Women of Avignon)* of 1907 (fig. **27.2**). With this representation of five nudes and a still life, Picasso launched a spatial revolution. The subject itself was hardly new, and Picasso had adapted traditional poses from earlier periods of Western art. On the far left, for example, the standing figure nearly replicates the pose of ancient Egyptian kings (see Chapter 5). The left leg is forward, the right arm is extended, and the fist is clenched. Also borrowed from Egypt is the pictorial convention of rendering the face in profile and the eye in front view. Picasso's two central figures, whose arms stretch behind their heads, are based on traditional poses of Venus. Of all the figures, the faces of the seated and standing nudes on the far right are most obviously based on African prototypes. The wooden mask from the Congo in figure 27.3, for example, shares an elongated, geometric quality with the face of the standing figure. Here Picasso has abandoned *chiaroscuro* in favor of the Fauve preference for bold strokes of color. The nose resembles the long, curved, solid wedge of the mask's nose.

Like the mask, Picasso's faces disrupt nature and defy the Classical ideal and are influenced by the contemporary vogue for so-called primitivism. The nose curves to one side, while the mouth shifts to the other. In

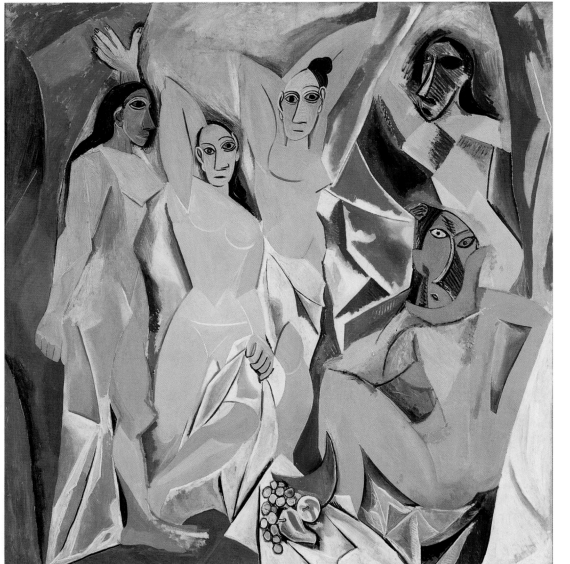

27.2 Pablo Picasso, *Les Demoiselles d'Avignon*, Paris, June–July 1907. Oil on canvas, 8 ft. × 7 ft. 8 in. (2.44 × 2.34 m). Museum of Modern Art, New York (acquired through the Lillie P. Bliss Bequest). This painting was named for a bordello in the Carrer d'Avinyo (Avignon Street), Barcelona's red-light district. Earlier versions had a seated sailor and a medical student carrying a skull. Both were aspects of Picasso himself. By removing them from the final painting, Picasso shifted from a personal narrative to a more powerful mythic image.

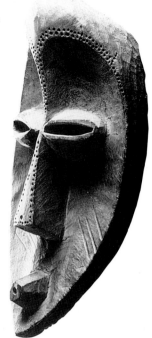

27.3 Mask from the Etoumbi region, Democratic Republic of the Congo. Wood, 14 in. (35.6 cm) high. Musée Barbier-Müller, Geneva, Switzerland.

observer in favor of multiple vantage points along the lines pioneered by Cézanne. The so-called simultaneous view was to become an important visual effect of Cubism.

In *Les Demoiselles,* Picasso fragments the figures into solid geometric constructions with sharp edges and angles. They interact spatially with the background shapes, blurring the distinction between foreground and background. Such distortion of the human figure is particularly startling because it assaults our bodily identity. Light, as well as form, is fragmented into multiple sources so that the observer's point of view is constantly shifting. Because of its revolutionary approach to space and its psychological power, *Les Demoiselles* represented the greatest expressive challenge to the traditional, Classical ideal of beauty and harmony since the Middle Ages.

As with his portrait of Gertrude Stein, Picasso struggled to arrive at the final iconography and figural poses in *Les Demoiselles.* He made many drawing studies, such as the one in figure **27.4**. Here, in a preliminary version of the image, Picasso depicted a man—in some drawings he is a medical student carrying a skull—entering the brothel from the left. Another figure, not present in the painting, is seated at the center in a dark jacket. The five nude women reappear in the final picture, where the other two have been eliminated. In addition, the nudes in the drawing turn to look at the man who enters. But that has changed in the painting, so that three nudes gaze out of the picture to face the viewer and two focus on the center. In these changes, Picasso has gone from a narrative to a more intense, iconic, even threatening image imbued with greater power and forcing us to confront the scene directly.

the two central nudes one eye is slightly above the other, the nose is no longer directly above the mouth, and the ears are asymmetrical. Still more radical is the depiction of the body of the seated figure, the so-called squatter. She looks toward the picture plane while simultaneously turning her body in the opposite direction so that her face and back are visible at the same time. In this figure, Picasso has broken from tradition by abandoning the single vantage point of the

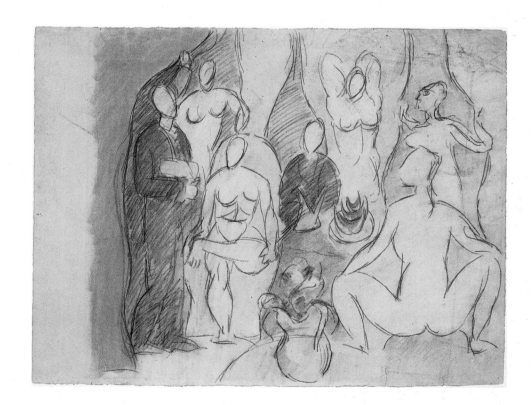

27.4 Pablo Picasso, study with seven figures for *Les Demoiselles d'Avignon,* March–April 1907. Pencil and pastel on paper, 18¾ × 25 in. (47.7 × 63.5 cm). Öffentliche Kunstmuseum Basel, Kupferstichkabinett, Switzerland.

Analytic Cubism:
Pablo Picasso and Georges Braque

In 1907 Picasso met the French painter Georges Braque (1882–1963), who had studied the works of Cézanne and had been overwhelmed by *Les Demoiselles*. Braque is reported to have declared, when he first saw it, that looking at it was like drinking kerosene. For several years Braque worked so closely with Picasso that it can be difficult to distinguish their pictures during the period known as Analytic Cubism. Braque's *Violin and Pitcher* (fig. **27.5**) of 1909–10 is very much like Picasso's works of that time and will serve as an example of the style.

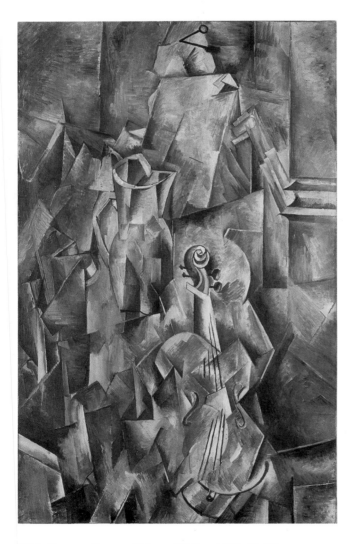

27.5 Georges Braque, *Violin and Pitcher*, 1909–10. Oil on canvas, 3 ft. 10 in. × 2 ft. 4¾ in. (1.17 × 0.73 m). Öffentliche Kunstsammlung Basel, Kunstmuseum Basel, Switzerland (Gift of Dr. H. C. Raoul La Roche, 1952). Braque was born in Argenteuil, France, and moved to Paris in 1900. There he joined the Fauves and established a collaborative friendship with Picasso. They worked closely together until World War I and were jointly responsible for the development of Cubism. In 1908, on seeing a painting by Braque, Matisse reportedly remarked that it had been painted "with little cubes." This is credited with being the origin of the term Cubism.

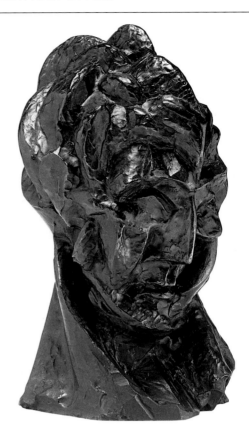

27.6 Pablo Picasso, *Head of a Woman*, 1909. Bronze (cast), 16³⁄₁₆ × 9⅝ × 10½ in. (41.1 × 24.5 × 26.7 cm). National Gallery of Art, Washington, D.C.

Both the subject matter and the expressive possibilities of color—here limited to dark greens and browns—are subordinated to a geometric exploration of three-dimensional space. The only reminders of natural space and of the objects that occupy it are the violin and pitcher, a brief reference to the horizontal surface of a table, and a vertical architectural support on the right. Most of the picture is a jumble of fragmented cubes and other solid geometric shapes. What would, in reality, be air space is filled up, in Cubism, with multiple lines, planes, and geometric solids. The sense of three-dimensional form is achieved by combining shading with bold strokes of color. Despite the crisp edges of the individual shapes in Analytic Cubist pictures such as this one, the painted images lose parts of their outlines. Whereas in Impressionism edges dissolve into prominent brushstrokes, in Cubism they dissolve into shared geometric shapes. No matter how closely the forms approach dissolution, however, they never dissolve completely.

In 1909 Picasso produced the first Cubist sculpture, the bronze *Head of a Woman* (fig. **27.6**), in which he shifted the natural relationship between head and neck, creating two diagonal planes. The hair, as in Analytic Cubist paintings, is multifaceted, and the facial features are geometric rather than organic.

In 1911 two Cubist exhibitions held in Paris brought the work of avant-garde artists to the attention of the general

public. The year 1911 also marked the culmination of Analytic Cubism. Although this phase of Cubism was brief, its impact on Western art was enormous. It stimulated the emergence of new and related styles, along with original techniques of image-making.

Collage

Picasso's Cubist *Man with a Hat* (fig. **27.7**) of 1912 is an early example of **collage** (see Box), which was a logical outgrowth of Analytic Cubism and marked the beginning of the shift to Synthetic Cubism. Pieces of colored paper and newspaper are pasted onto paper to form geometric representations of a head and neck; the remainder of the image is drawn in charcoal. The use of newspaper, which seems textured because of the newsprint, was a common feature of early collages. Words and letters, which are themselves abstract signs, often formed part of the overall design. Collage, like Cubism, involved disassembling aspects of the environment—just as one might take apart a machine, break up a piece of writing, or even divide a single word into letters—and then rearranging (or reassembling) the parts to form a new image.

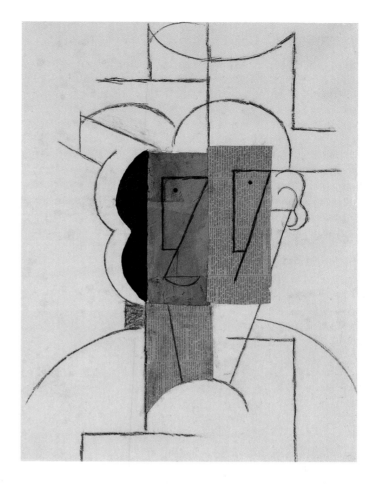

27.7 Pablo Picasso, *Man with a Hat*, after December 3, 1912. Pasted paper, charcoal, and ink, 24½ × 18⅝ in. (62.2 × 47.3 cm). Museum of Modern Art, New York (Purchase).

MEDIA AND TECHNIQUE
Collage and Assemblage

Collage (from the French word *coller*, meaning "to paste" or "to glue") developed in France from 1912. It is a technique that involves pasting lightweight materials or objects, such as newspaper and string, onto a flat surface. A technique related to collage, which developed slightly later, is **assemblage.** Here, heavier objects are brought together and arranged, or assembled, to form a three-dimensional image. Both techniques make use of **"found objects"** *(objets trouvés),* which are taken from everyday sources and incorporated into works of art.

Picasso's witty 1943 assemblage titled *Bull's Head* (fig. **27.8**) is a remarkable example of his genius for synthesis. He has fused the ancient motif of the bull and the traditional medium of bronze with modern steel and plastic. He has also conflated the bull's head with African masks and effected a new spatial juxtaposition by reversing the direction of the bicycle seat and eliminating the usual space between it and the handlebars. He cast the object in bronze and hung it on a wall. In this work, Picasso simultaneously explores the possibilities of new media, of conflated imagery, and of the spatial shifts introduced by Cubism.

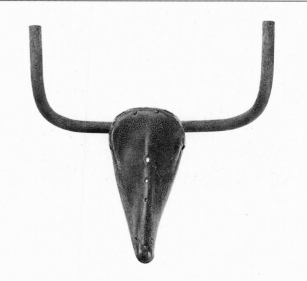

27.8 Pablo Picasso, *Bull's Head*, 1943. Assemblage of bicycle saddle and handlebars, 13¼ × 17⅛ × 7½ in. (33.7 × 43.5 × 19 cm). Musée Picasso, Paris, France.

Synthetic Cubism

Synthetic Cubism marked a return to bright colors. Whereas Analytic Cubism fragmented objects into abstract geometric forms, Synthetic Cubism arranged flat shapes of color to form objects. Picasso's *Three Musicians* (fig. **27.9**)—a clarinetist on the left, a Harlequin playing a guitar in the center, and a monk—is built up from unmodeled shapes of color arranged into tilted planes. In addition, the flat shapes—such as the dog lying under the table—occupy a more traditional space than those of Analytic Cubism. The painted shapes resemble the flat paper pasted to form a collage. Simultaneity of viewpoint is preserved—for example, in the sheet of music. It is held by the monk and turned toward the viewer, who sees both the musician and what he is reading.

Picasso's Surrealism

Another stylistic shift in Picasso's work that was influenced by Cubism has been called Surrealism. This term (see Chapter 28) literally means "above realism" and denotes a truer reality than that of the visible world. In *Girl before a Mirror* (fig. **27.10**) of 1932, Picasso aims at psychological reality. He uses the multiple viewpoint in the service of symbolism, although the precise meaning of this picture has remained elusive and has been the subject of many interpretive discussions. The girl at the left combines frontal and profile views, but her mirror reflection is in profile. It is also darker than the "real" girl outside the mirror, and the torsos do not match.

The device of the mirror to create multiple views is not new. Picasso was certainly familiar with Manet's *Bar at*

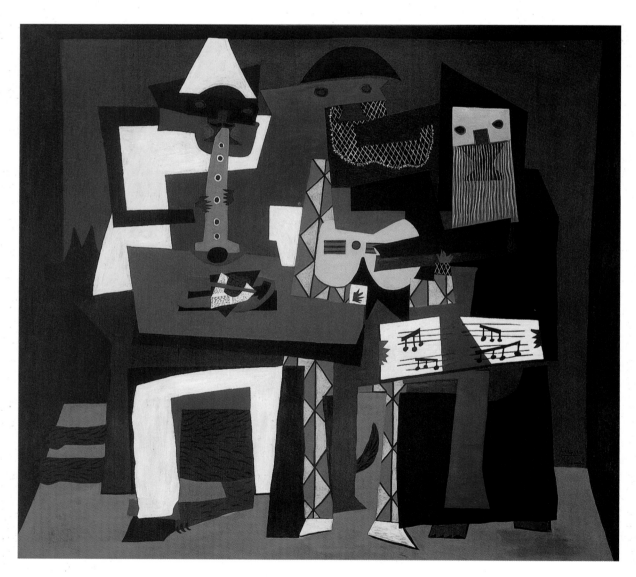

27.9 Pablo Picasso, *Three Musicians*, 1921. Oil on canvas, 6 ft. 7 in. × 7 ft. 3¾ in. (2.01 × 2.23 m). Museum of Modern Art, New York (Mrs. Simon Guggenheim Fund).

the *Folies-Bergère* (see fig. **24.1**), Velázquez's *Venus with a Mirror* (see fig. **19.37**) and *Las Meninas* (see fig. **19.38**), and Jan van Eyck's *Arnolfini Portrait* (see fig. **15.37**), all of which use mirrors to expand the viewer's range of vision. Here, however, the formal differences between the girl and her reflection suggest that outer appearances are contrasted with an inner psychological state. One French term for "mirror" is *psyché*, which means "soul," and this provides a clue to the picture's significance. It reinforces the notion that Picasso transformed the multiple views of Cubism into multiple psychological views, which simultaneously show the girl's interior psychic reality and her exterior appearance.

CONNECTIONS

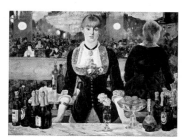

See figure 24.1. Édouard Manet, *A Bar at the Folies-Bergère,* 1881–82.

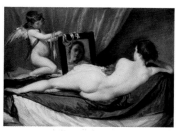

See figure 19.37. Diego Velázquez, *Venus with a Mirror (Rokeby Venus),* c. 1648.

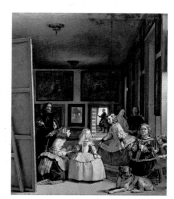

See figure 19.38. Diego Velázquez, *Las Meninas,* 1656.

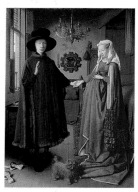

See figure 15.37. Jan van Eyck, *Arnolfini Portrait,* 1434.

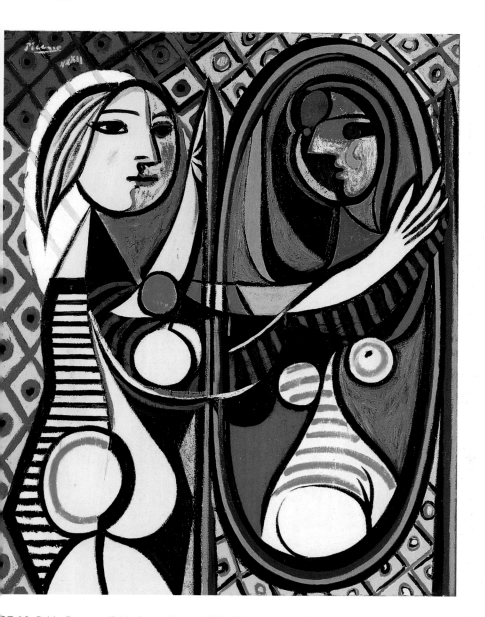

27.10 Pablo Picasso, *Girl before a Mirror,* 1932. Oil on canvas, 5 ft. 4 in. × 4 ft. 3¼ in. (1.62 × 1.30 m). Museum of Modern Art, New York (Gift of Mrs. Simon Guggenheim).

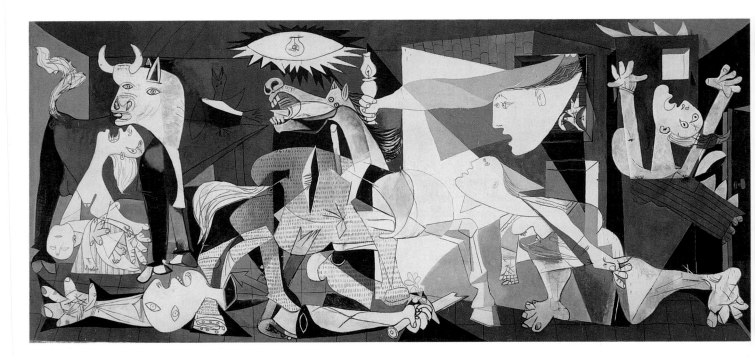

27.11 Pablo Picasso, *Guernica,* 1937. Oil on canvas, 11 ft. 5½ in. × 25 ft. 5¾ in. (3.49 × 7.77 m). Museo Nacional Centro de Arte Reina Sofía, Madrid, Spain. From 1936 to 1939 there was a civil war between Spanish Republicans and the Fascist army of General Franco. In April 1937 Franco's Nazi allies carried out saturation bombing over the town of Guernica. Picasso painted *Guernica* to protest this atrocity. He lent it to New York's Museum of Modern Art, stipulating that it remain there until democratic government was restored in Spain. In 1981 *Guernica* was returned to Madrid.

Picasso's *Guernica*

In his monumental work of 1937, *Guernica* (fig. **27.11**), Picasso combined both Analytic and Synthetic Cubist forms with several traditional motifs, which he juxtaposed in a new Surrealist way. The combination serves the political message of the painting—Picasso's powerful protest against the brutality of war and tyranny (see caption). Consistent with its theme of death and dying, the painting is nearly devoid of color, although there is considerable tonal variation within the range of black to white. The absence of color enhances the journalistic quality of the painting, relating it to the news accounts of the bombing.

Guernica is divided into three sections, a compositional structure that recalls the triptychs of the Middle Ages and Renaissance. There is a central triangle with an approximate rectangle on either side. The base of the triangle extends from the arm of the dismembered and decapitated soldier at the left to the foot of the running woman at the right. The dying horse represents the death of civilization, though it may be rescued by the woman with a lamp (Liberty) rushing toward it. Another expression of hope, as well as of the light of reason, appears in the motif combining the shape of an eye with the sun's rays and a lightbulb just above the horse's head. On the right, the pose and gesture of a falling woman suggest Christ's Crucifixion. On the left, a woman holds a dead baby on her lap in a pose reminiscent of Mary supporting the dead Christ in Michelangelo's *Pietà* in Rome

(see fig. **16.14**). Behind the woman looms the specter of the Minotaur, the monstrous tyrant of ancient Crete, whose only human qualities are the flattened face and eyes. For Picasso, the Minotaur came to represent modern tyranny, as embodied by the Spanish dictator General Francisco Franco, who collaborated with Adolf Hitler and Benito Mussolini.

These apparently disparate motifs are related by form and gesture, by their shared distortions, and by the power of their message. Cubist geometric shapes and sharp angles pervade the painting. Picasso's characteristic distortions emphasize the physical destruction of war. Eyes are twisted in and out of their sockets, ears and noses are slightly out of place, tongues are shaped like daggers, palms and feet are slashed. Although the integrity of the human form is maintained throughout, it is an object of attack and mutilation.

— **CONNECTIONS** —

See figure 16.14. Michelangelo, *Pietà,* 1498–1500.

Other Early-Twentieth-Century Developments

Futurism

Related to Expressionism was a contemporary movement called Futurism, which originated in Italy. The Futurists were inspired by the dynamic energy of industry and the machine age. They argued for a complete break with the past. In February 1909 a Futurist Manifesto, written by Filippo Marinetti, the editor of a literary magazine in Milan, appeared on the front page of the French newspaper *Le Figaro*. The Manifesto sought to inspire in the general public an enthusiasm for a new artistic language. In all the arts—the visual arts, music, literature, theater, and film—the old Academic traditions would be abandoned. Libraries and museums would be abolished, and creative energy would be focused on the present and future. Speed, travel, technology, and dynamism would be the subjects of Futurist art.

Futurism was given plastic form in a 1913 sculpture by Umberto Boccioni (1882–1916) titled *Unique Forms of Continuity in Space* (fig. **27.12**). It represents a man striding vigorously, as if with a definite goal in mind. The long diagonal from head to foot is thrust forward by the assertive angle of the bent knee. The layered surface planes, related to the fragmented planes of Analytic Cubism, convey an impression of flapping material. Organic flesh and blood are subjugated to a mechanical, robotlike appearance—a vision that corresponds to Boccioni's aims as stated in his *Technical Manifesto of Futurist Sculpture 1912*. Sculpture, he said, must "make objects live by showing their extensions in space" and by revealing the environment as part of the object.

In the Futurist Manifesto, Marinetti's language was apocalyptic in its determination to slash through the "millennial gloom" of the past. "Time and Space died yesterday," he declared. "We already live in the absolute, because we have created eternal, omnipresent speed."

27.12 Umberto Boccioni, *Unique Forms of Continuity in Space*, 1913. Bronze (cast 1931), 43⅞ × 34⅞ × 15¾ in. (111.2 × 88.5 × 40.0 cm). Museum of Modern Art, New York (acquired through the Lillie P. Bliss Bequest). Boccioni fought for Italy in World War I and was killed by a fall from a horse in 1916.

27.13 Fernand Léger, *The City*, 1919. Oil on canvas, 7 ft. 7 in. × 14 ft. 9½ in. (2.30 × 4.50 m). Philadelphia Museum of Art (A. E. Gallatin Collection). Léger described the kinship between modern art and the city as follows: "The thing that is imaged does not stay as still . . . as it formerly did. . . . A modern man registers a hundred times more sensory impressions than an 18th-century artist. . . . The condensation of the modern picture . . . [and] its breaking up of forms, are the result of all this. It is certain that the evolution of means of loco- motion, and their speed, have something to do with the new way of seeing."[2]

Fernand Léger's *City*

The work of Fernand Léger (1881–1955) is more directly derived from Cubism than is Boccioni's sculpture. Léger's *City* of 1919 (fig. **27.13**) captures the cold steel surfaces of the urban landscape that reflected the new artistic aware- ness of the city. Harsh forms, especially cubes and cylin- ders, evoke the metallic textures of industry. The jumbled girders, poles, high walls, and steps, together with the human silhouettes, create a sense of the anonymous, mechanical movement associated with the fast pace of city life. In *The City,* Léger has taken from Analytic Cubism the multiple viewpoint and superimposed solid geometry. His shapes, however, are colorful and recognizable, and there is a greater illusion of distance within the picture plane.

Piet Mondrian

In 1911, the year of the two Cubist exhibitions, Piet Mon- drian (1872–1944) came to Paris from Holland. He had begun as a painter of nature, but under the influence of Cubism he gradually transformed his imagery to flat rect- angles of color bordered by black edges.

In his early pictures he plays on the tension, as well as the harmony, between vertical and horizontal. He rejects curves and diagonals altogether and expresses his belief in the purity of primary colors. According to Mondrian, chromatic purity, like the simplicity of the rectangle, had a universal character. To illustrate this, he wrote that since paintings are made of line and color, they must be liberated from the slavish imitation of nature.

Later, while living in New York in the 1940s as a refugee from World War II, Mondrian painted *Broadway Boogie Woogie* (fig. **27.14**). This was one of a series of pictures that he executed in small squares and rectangles of color, which replaced the large rectangles outlined in black. The grid pattern of the New York streets, the flashing lights of Broadway, and the vertical and horizontal motion of cars and pedestrians are conveyed as flat, colorful shapes. Fast shifts of color and their repetition recall the strong, accented rhythm of boogie-woogie, a popular form of music. In combining musical references with the beat of city life and suggesting these qualities through color and shape, Mondrian synthesized Expressionist exuberance with Cubist order and control.

The Armory Show

The burgeoning styles of the early twentieth century in Western Europe did not reach the general American public until 1913. In February of that year, the Armory of the Sixty- ninth Regiment, National Guard, on Lexington Avenue at 25th Street in New York was the site of an international exhibition of modern art. A total of twelve hundred works by Post-Impressionists, Fauves, and Cubists, as well as by

27.14 Piet Mondrian, *Broadway Boogie Woogie*, 1942–43. Oil on canvas, 4 ft. 2 in. × 4 ft. 2 in. (1.27 × 1.27 m). Museum of Modern Art, New York (Given anonymously, 73.1943). © 2010 Mondrian/Holtzman Trust c/o HCR International, Virginia, USA.

American artists, filled eighteen rooms. This event marked the first widespread American exposure to the European avant-garde.

The Armory Show caused an uproar. Marcel Duchamp (1887–1968) submitted *Nude Descending a Staircase, No. 2* (fig. **27.15**), which was the most scandalous work of all. It was a humorous attack on Futurist proscriptions against traditional Academic nudity. The image has a kinetic quality consistent with Futurist speed and motion. At the same time, the figure is a combination of Cubist form and multiple images that indicate the influence of photography. She is shown at different points in her descent, so the painting resembles a series of consecutive movie stills, unframed and superimposed.

Various accounts published at the time ridiculed the *Nude*'s début in the United States. Descriptions by outraged viewers included "disused golf clubs and bags," an "elevated railroad stairway in ruins after an earthquake," "a dynamited suit of Japanese armor," an "orderly heap of broken violins," an "explosion in a shingle factory," and "Rude Descending a Staircase (Rush Hour in the Subway)." Duchamp recorded his own version of the *Nude*'s place in the history of art: "My aim was a static representation of movement—a static composition of indications of various positions taken by a form in movement—with no attempt to give cinema effects through painting."[3]

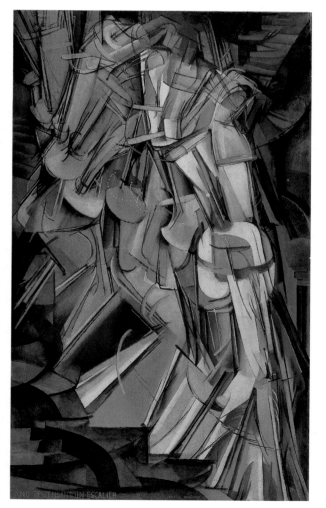

27.15 Marcel Duchamp, *Nude Descending a Staircase, No. 2*, 1912. Oil on canvas, 4 ft. 10 in. × 2 ft. 11 in. (1.47 × 0.89 m). Philadelphia Museum of Art (Louise and Walter Arensberg Collection).

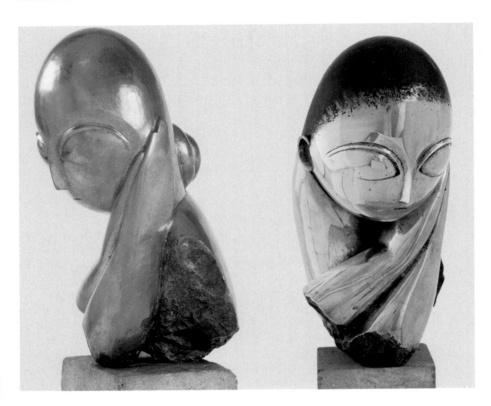

27.16a (Left) Constantin Brancusi, *Mademoiselle Pogany*, Version I (1913) after a marble of 1912. Polished bronze, 17½ in. (44.8 cm) high. Private collection.

27.16b (Right) Constantin Brancusi, *Mademoiselle Pogany*, Version I (1913) after a marble of 1912. Bronze, on limestone base: bronze, 17¼ × 8½ × 12½ in. (43.8 × 21.5 × 31.7 cm); base, 5¾ × 6⅛ × 7⅜ in. (14.6 × 15.6 × 18.7 cm). Museum of Modern Art, New York (acquired through the Lillie P. Bliss Bequest).

These two versions of Mademoiselle Pogany show how different viewpoints can change the effect of certain sculptures.

The influence of Futurism, Cubism, and African sculpture is evident in the style of the Romanian sculptor Constantin Brancusi (1876–1957), who was also represented in the Armory Show. A version of his *Mademoiselle Pogany* (fig. **27.16**), listed for sale at $540, created a stir of its own. Her reductive, essential form was described as a "hard-boiled egg balanced on a cube of sugar." The last stanza of "Lines to a Lady Egg," which appeared in the *New York Evening Sun,* went as follows:

> Ladies built like a bottle,
> Carrot, beet, or sweet potato—
> Quaint designs that Aristotle
> Idly drew to tickle Plato—
> Ladies sculptured thus, I beg
> You will save your tense emotion;
> I am constant in devotion,
> O my egg![4]

In Chapter 1 we discussed Brancusi's bronze *Bird in Space* (see fig. **1.2**), which achieved notoriety in a legal debate over whether it was a work of art or a "lump of manufactured metal." In *Mademoiselle Pogany,* the emphasis on quasi-geometrical form allies the work with Cubism and related styles. Brancusi's high degree of polish conveys the increased prominence of the medium itself as artistic "subject."

However, the roughness of the unpolished bronze at the top of the head in figure **27.16b**, which contrasts with the polish of the face, creates an impression of hair. In the detachment of Mademoiselle Pogany's hands and head from her torso, she becomes a partial body image that is characteristic of Brancusi's human figures and reflects the influence of Rodin, with whom Brancusi studied briefly in Paris. The partial aspect of Brancusi's sculptures is related to his search for a truthful, Platonic "essence" of nature, rather than a literal depiction.

Stuart Davis

The Armory Show, which traveled to Chicago and Boston, had a lasting impact on American art. The American artist Stuart Davis (1894–1964), for example, had exhibited several watercolors in the Armory Show while still an art student. Later, in 1921, he painted *Lucky Strike* (fig. **27.17**), in which the flattened cigarette box was clearly influenced by collage. The colorful, unmodeled shapes are reminiscent of Synthetic Cubism, while the words and numbers recall early newspaper collages. The subject itself reflects American consumerism, which advertises a product by its package; the painting was thus an important early forerunner of Pop Art (see Chapter 30).

See figure I.2. Constantin Brancusi, *Bird in Space,* 1928.

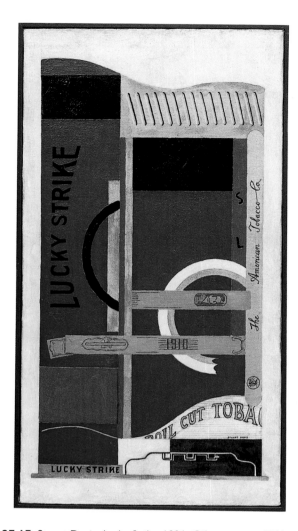

27.17 Stuart Davis, *Lucky Strike*, 1921. Oil on canvas, 33¼ × 18 in. (84.5 × 45.7 cm). Museum of Modern Art, New York (Gift of American Tobacco Company, Inc.). Davis designed the first abstract postage stamp for the United States in 1964. He gravitated to abstract forms from objects such as eggbeaters and electric fans. As a lifelong smoker, Davis had a particular fondness for the imagery of smoking.

Aaron Douglas and the Harlem Renaissance

The African American painter Aaron Douglas (1898–1979) used the principles of Synthetic Cubism to depict the history of his people. Douglas was a leading figure in the Harlem Renaissance of the 1920s. Centered in Harlem, a district of New York City, this was a significant Black American cultural movement. It was primarily a literary movement, but it also included philosophers, performers, political activists, and photographers, as well as painters and sculptors.

Douglas was born in Kansas and studied art in Paris, where he was exposed to the avant-garde. He became interested in the affinities between Cubism and African art and combined these concerns with the Black experience in America. In 1934 Douglas painted four murals, titled *Aspects of Negro Life,* for the New York Public Library. The second in the series—*From Slavery through Reconstruction* (fig. 27.18)—depicts three events following the American Civil War. At the right, there is rejoicing at the news of the Emancipation Proclamation (January 1, 1863), which freed the slaves. The man on the soapbox in the center represents the success of the black man, whose voice is now being heard. In the background, the Union army leaves the South, and Reconstruction with its anti-Black backlash follows.

The exuberance of the figures recalls the dynamic energy of jazz, which also appealed to Matisse. Music appears in the subject matter of the mural—the trumpet and the drums—as well as in the rhythms of its design. The main colors are variations on rose, while concentric circles of yellow suggest sound traveling through space. At the same time, the unmodeled character of the color allies the work with Synthetic Cubism. The green-and-white cotton plants in the foreground refer to the work of the American slaves and create an additional pattern superimposed over the light reds.

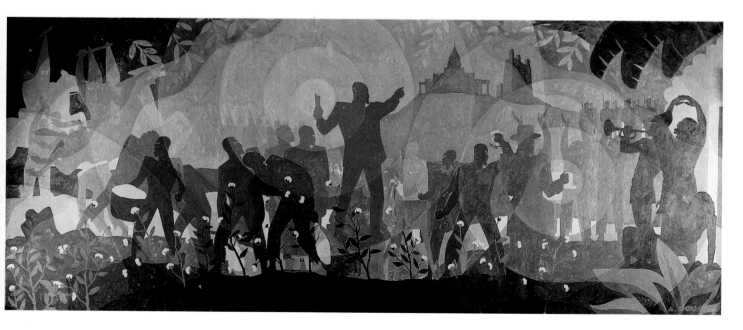

27.18 Aaron Douglas, *From Slavery through Reconstruction* (from the series *Aspects of Negro Life*), 1934. Oil on canvas, 5 ft. × 10 ft. 8 in. (1.50 × 3.25 m). Schomburg Center for Research in Black Culture, New York Public Library, Astor, Lenox and Tilden Foundations.

Kazimir Malevich: Suprematism

One of the most geometric developments that grew out of Cubism took place in Russia. Kazimir Malevich (1878–1933) was born in Kiev, and in 1904 he went to Moscow to study art. Although as a student he did not travel outside Russia, he was exposed to the European avant-garde through important collections in Moscow, and in 1908 he saw works exhibited by Cézanne, Gauguin, Matisse, and Braque. As a mature artist, Malevich combined Cubism with Futurism. He considered the proto-Cubism of Cézanne to have been rooted in village life, whereas the later development of the style was urban in character. For Malevich, it was Futurism that expressed the fast pace of city life.

Following his Cubist-Futurist phase, Malevich created the style he called Suprematism. His first Suprematist painting, exhibited in 1915 in St. Petersburg, Russia, consisted of a black square centered in a white background. The original became damaged, and he subsequently made several additional versions (fig. **27.19**). According to Malevich, the black square was an expression of the cosmic, of pure feeling, and the white was the void beyond feeling. His aim was to achieve the mystical through pure form, which embodied pure feeling, instead of depicting what is visible and natural. In his book *The Non-objective World,* Malevich summed up his philosophy of Suprematism as follows:

Artists have always been partial to the use of the human face in their representations, for they have seen in it (the versatile, mobile, expressive mimic) the best vehicle with which to convey their feelings. The Suprematists have nevertheless abandoned the representation of the human face (and of natural objects in general) and have found new symbols with which to render direct feelings (rather than externalized reflections of feelings), for *the Suprematist does not observe and does not touch—he feels.*[5]

After the Communist Revolution of 1917, Malevich was appointed Commissar for the Preservation of Monuments and Antiquities. By the late 1920s, the Soviet government under Stalin (died 1953) was suppressing avant-garde art and asserting state control over all the arts. Sensing that further oppression was to come, Malevich traveled in 1927 to Poland and Germany, where the Bauhaus (see p. 496) published his book in German. In 1930 he was arrested by the Soviets for artistic "deviation."

When Malevich died, his white coffin was decorated with one black circle and one black square, and a white cube with a black square on it marked the place where his ashes were buried. In 1936 the Soviets confiscated his remaining pictures; they were not shown publicly again until 1977.

27.19 Kazimir Malevich, *Black Square,* 1929. Oil on canvas, 31¼ × 31¼ in. (79.4 × 79.4 cm). State Tretiakov Gallery, Moscow, Russia.

27.20 Installation view, "Brancusi + Mondrian" exhibition at the Sidney Janis Gallery, New York, December 1982–January 1983. Painting on left: Piet Mondrian, *Lozenge Composition with 8 lines and Red / Picture No. III*, 1938. Oil on canvas, diagonal measurement 55¼ in. (140 cm). Painting on right: Piet Mondrian, *Lozenge Composition with 2 lines*, 1931. Oil on canvas, diagonal measurement 44⅛ in. (112 cm). Photo courtesy of Carroll Janis, New York. © 2010 Mondrian/Holtzman Trust c/o HCR International, Virginia, USA. © 2011 Artists Rights Society (ARS), New York/ADAGP, Paris. The art critic Sidney Geist wrote of this show, "If the century's Modernist struggle seems to have been called in question by recent developments, 'Brancusi + Mondrian' banished all doubt. . . . We have to do here with two saintly figures—for whom art was a devotion. Their lives and art evolved under the sign of inevitability."[6]

Postscript

Figure **27.20**, an installation photograph, shows the main space of the Sidney Janis Gallery in New York during a landmark exhibition titled "Brancusi + Mondrian" in the early 1980s. Mounted nearly seventy years after the Armory Show and more than fifty years after Malevich's detention for so-called deviant art, the Janis exhibition conveyed the importance of the avante-garde. It also emphasized the formal and historical relationship between Brancusi and Mondrian. In the left corner, a group of highly polished bronzes

by Brancusi includes two versions of *Mademoiselle Pogany*. Flanked by Mondrians are a marble and a bronze version of *Bird in Space*. Brancusi's "essences," here composed of graceful curves and rounded, volumetric shapes, are contrasted with Mondrian's pure verticals and horizontals on a flat surface. In this juxtaposition, the viewer confronts the work of two major early-twentieth-century artists. Despite their apparent differences, these artists have a remarkable affinity in their pursuit of an "idea," which they render in modern, abstract form.

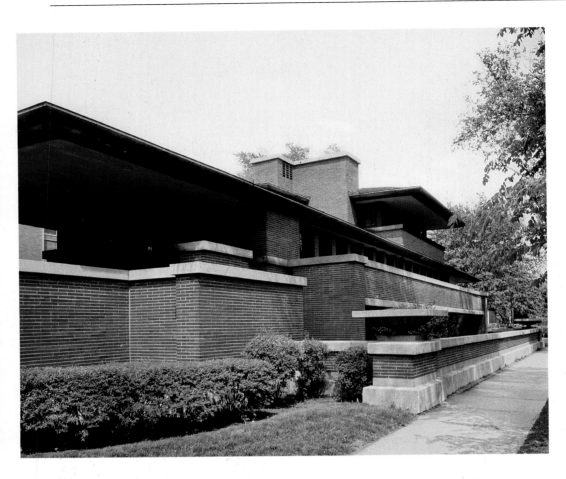

27.21 Frank Lloyd Wright, Robie House, Chicago, 1909. Wright's insistence on creating a total environment inspired him, sometimes against the wishes of his clients, to design the furniture and interior fixtures of his houses. In the case of the Robie House, Wright designed outfits for Mrs. Robie to wear on formal occasions so that she would blend with his architecture.

Architecture

In the late nineteenth and early twentieth centuries, the most innovative developments in architecture took place in the United States. Following Louis Sullivan, who developed the skyscraper, the next major American architect was Frank Lloyd Wright (1869–1959). Wright had worked in Chicago as Sullivan's assistant before building private houses, mainly in Illinois, in the 1890s and early 1900s. But whereas Sullivan's skyscrapers addressed the urban need to provide offices and apartment blocks on relatively small areas of land, Wright launched the Prairie Style, which sought to integrate architecture with the natural landscape.

Frank Lloyd Wright and the Prairie Style

The best-known example of Wright's early Prairie Style is the Robie House of 1909 (fig. **27.21**) in South Chicago. Its horizontal emphasis, low-pitched roofs with large overhangs, and low boundary walls are related to the flat prairie landscape of the American West and Middle West. At the same time, the predominance of rectangular shapes and shifting, asymmetrically arranged horizontal planes is reminiscent of the Cubist aesthetic.

ARCHITECTURE
Cantilever

The system of **cantilever construction** (fig. **27.22**) is one in which a horizontal architectural element, projected in space, has vertical support at one end only. Equilibrium is maintained by a support and counterbalancing weight inside the building. The cantilever requires materials with considerable tensile strength. Wright pioneered the use of **reinforced concrete** and steel girders for cantilever construction in large buildings. In a small house, wooden beams provide adequate support.

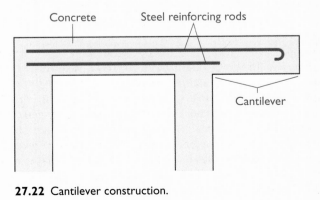

27.22 Cantilever construction.

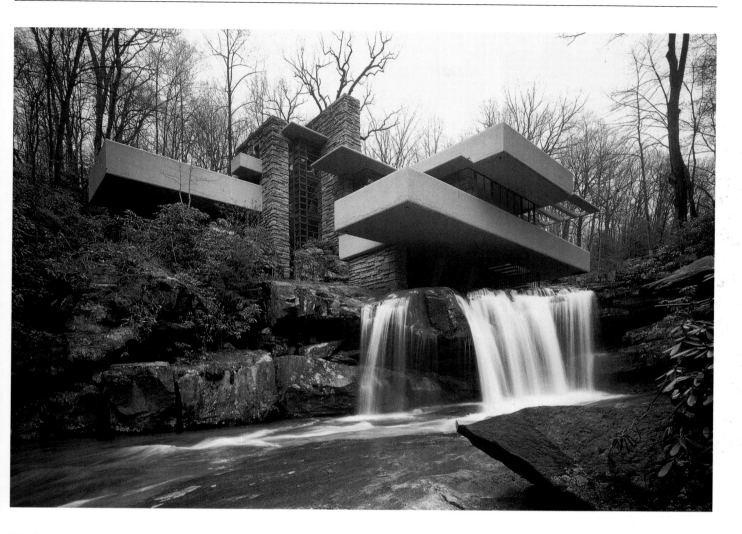

27.23 Frank Lloyd Wright, Fallingwater, Bear Run, Pennsylvania, 1936.

In 1936, on a wooded site in Bear Run, Pennsylvania, Wright built a weekend house (fig. **27.23**) for the Edgar Kaufmann family. This house was a synthesis of the International Style (see below) and the Prairie Style; it is called Fallingwater because it is perched over a small waterfall. As in the Robie House, there is a large central core, composed here of local masonry. Fallingwater is surrounded by reinforced concrete terraces, which are related to the International Style. Their beige color attempts to blend with the landscape, and their cantilevered horizontals (see Box) repeat the horizontals of the rocky ledges below. Although the smooth texture and light hue of the terraces contrast with the darker natural colors of the woods, the natural stone of the chimneys resembles the rocks in the surrounding landscape. In keeping with the Prairie Style, parts of the house are integrated with the landscape and seem to "grow" from it. Glass walls, which make nature a constant visible presence inside the house, further reinforce the association of architecture with landscape. To some extent, therefore, Fallingwater fulfills Wright's pursuit of "organic" architecture.

The International Style

From the end of World War I, a new architectural style developed in Western Europe. Since it apparently originated in several countries at about the same time, it is known as the International Style.

Holland: De Stijl

In Holland, the International Style of architecture began as the De Stijl (The Style) movement, of which Mondrian was a founder. The primary leader, however, was the artist Theo van Doesburg (1883–1931), whose transformation of a cow into abstract geometric shapes is illustrated in figure **2.12**. Several Dutch architects, attracted by Frank Lloyd Wright's work, joined Mondrian and van Doesburg in the De Stijl movement. They were idealists searching for a universal style that would satisfy human needs through mass production. The spiritual goal of world peace, they believed, would also be fostered by the "equilibrium of opposites" that was part of De Stijl's credo.

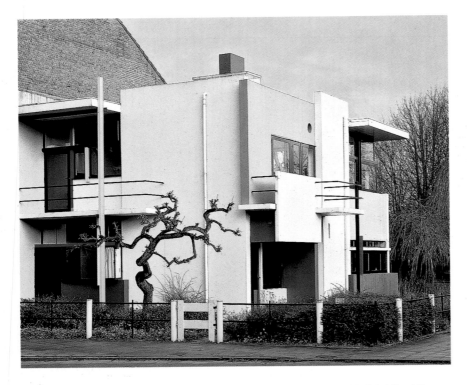

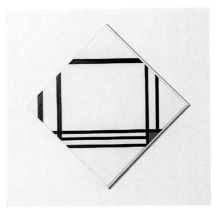

Piet Mondrian, *Lozenge Composition with 8 Lines and Red/Picture No. III*, 1938. Oil on canvas, diagonal measurement 55¼ in. (140 cm). Photo courtesy of Carroll Janis, New York. © 2010 Mondrian/Holtzman Trust, c/o HCR International, Virginia, USA.

27.24 Gerrit Rietveld, Schroeder House, Utrecht, Netherlands, 1923–24. Alfred Barr, Jr., curator of New York's Museum of Modern Art, defined the International Style as follows: ". . . emphasis upon volume . . . thin planes . . . as opposed to . . . mass and solidity; . . . regularity as opposed to symmetry . . . and . . . dependence upon the intrinsic elegance of materials, perfection, and fine proportions, as opposed to applied ornament." These goals are fulfilled in the Schroeder House.

Typical of this new architecture is the Schroeder House in Utrecht (fig. **27.24**), designed by Gerrit Rietveld (1888–1964). The flat roof and cantilevered balconies are similar to those in Wright's private houses. Whereas Wright emphasized horizontals, however, Rietveld preferred oppositions of horizontals and verticals derived from Cubism, which he integrated with a **skeletal construction.** There is no surface decoration interrupting the exterior simplicity of the building. The many windows and balconies, with attached rectangular panels that seem to float in midair, create a sense of tension paradoxically combined with weightlessness. Composed of predominantly white flat planes and right angles, the Schroeder House is reminiscent of Mondrian's paintings.

Germany: The Bauhaus

The German version of the International Style centered on the Bauhaus. In the first decade of the twentieth century, the Deutscher Werkbund (German Craft Association) was formed. Its aim was to improve the aesthetic quality of manufactured goods and industrial architecture, to produce them more cheaply, and to make them more widely available. This produced a number of important architects and designers who had enormous international influence through the 1960s. Many who had worked together in Europe later emigrated to the United States during World War II.

The leader of this community was Walter Gropius (1883–1969), who in 1919 became the first director of the Bauhaus, in Weimar. The Bauhaus (from the German *Bau,* "structure" or "building," and *Haus,* "house") combined an arts and crafts college with a school of fine arts. Gropius believed in the integration of art and industry. With that in mind, he set out to create a new institution that would offer courses in design, architecture, and industry.

Vassily Kandinsky was a prominent member of the Bauhaus faculty from 1922, and he remained until 1933, when the Bauhaus was closed by the Nazis. His paintings of that period reflect the geometric angularity he espoused as part of the Russian avant-garde in Moscow at the beginning of World War I. Such forms, which were also characteristic of the Bauhaus aesthetic, can be seen, for example, in *Composition 8* (fig. **27.25**). Compared with the exuberant curvilinear forms of his Expressionist *Panel for Edwin R. Campbell No. 4* (see fig. **26.7**), this painting is measured, constructed, and dominated by dynamic diagonal planes. While he was at the Bauhaus, Kandinsky published a textbook on composition, *Point and Line to Plane: Contribution to the Analysis of the Pictorial Elements* (1926), in which he combined spirituality and mysticism with strict **formal analysis.**

In 1926 Gropius relocated the Bauhaus from Weimar to Dessau, planning its new quarters according to International Style philosophy. The workshop wing of the Bauhaus (fig. **27.26**) is entirely rectilinear, with verticals and horizontals meeting at right angles. The primary material is

CONNECTIONS

See figure 26.7. Vassily Kandinsky, *Panel for Edwin R. Campbell No. 4* (formerly *Painting Number 201, Winter*), 1914.

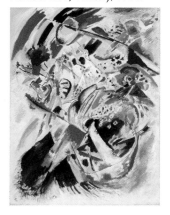

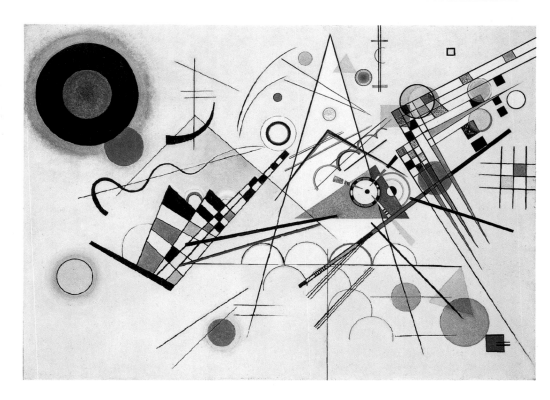

27.25 Vassily Kandinsky, *Composition 8,* 1923. Oil on canvas, 55⅛ in. × 79⅛ in. (140 × 200 cm). Solomon R. Guggenheim Museum, New York (Gift, 1937).

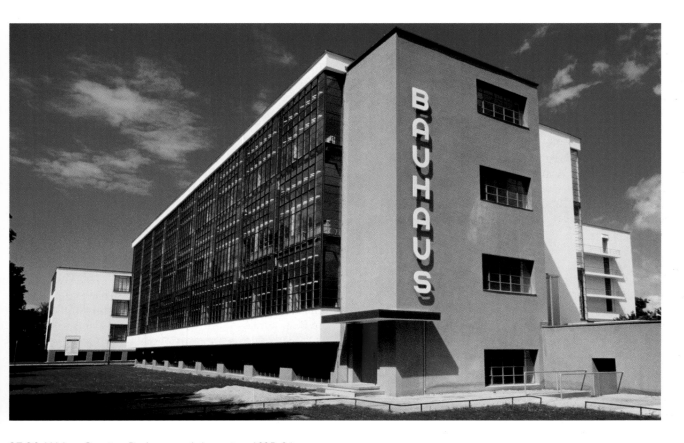

27.26 Walter Gropius, Bauhaus workshop wing, 1925–26.

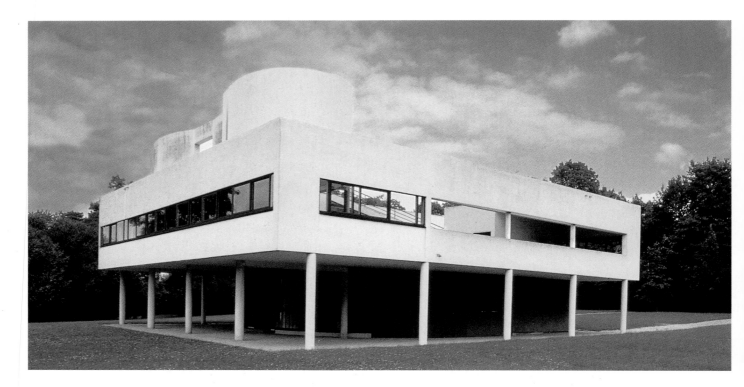

27.27 Le Corbusier, Villa Savoye, Poissy-sur-Seine, France, 1928–30. Le Corbusier believed that houses should be mass-produced. To this end, he reduced architectural components to simple forms—concrete slabs for floors, concrete pillars for vertical support, stairs linking the floors, and a flat roof. In *Towards a New Architecture* (1931), Le Corbusier wrote, "If we eliminate from our hearts and minds all dead concepts in regard to houses . . . we shall arrive at the 'House-Machine,' the mass-production house, healthy (and morally so too) and beautiful in the same way that the working tools and instruments which accompany our existence are beautiful."

reinforced concrete, but, apart from two thin white bands at the top and bottom, the viewers see only sheet-glass walls from the outside. Structurally, this was a logical extension of the steel-skeleton system of construction, which, as in the Wainwright Building (see fig. **23.22**), relieves the outer walls of any support function. Formal affinities with Cubism are inescapable, although Gropius, like the members of De Stijl, was motivated primarily by a philosophy of simplicity and harmony intended to integrate art and architecture with society. The Bauhaus exteriors, devoid of any regional identity, were an international concept translated into architectural form.

France: Le Corbusier

The best-known exponent of the International Style in France during the 1920s and early 1930s was the Swiss-born architect Charles-Édouard Jeanneret, known as Le Corbusier (1887–1969). The Villa Savoye (fig. **27.27**), a weekend residence built from 1928 to 1930 at Poissy, near Paris, is the last in a series of International Style houses by Le Corbusier. It is regarded as his masterpiece.

The Villa Savoye is a grand version of what Le Corbusier described as a "machine for living." It rests on very slender

reinforced concrete pillars, which divide the second-floor windows. The second floor contains the main living area, and it is connected to the ground floor and the open terrace on the third floor by a staircase and a ramp. The driveway extends under the house and ends in a three-car carport. This part of the ground floor is deeply recessed under the second-floor overhang and contains an entrance hall and servants' quarters. All four elevations of the house are virtually identical, each having the same ribbon windows running the length of the wall.

The United States

The architectural principles of the International Style were brought to the United States by Bauhaus artists who were forced to leave Germany in the late 1930s. Ludwig Mies van der Rohe (1886–1969), the director of the Bauhaus from 1930, designed the glass and steel Lake Shore Drive Apartment Houses in Chicago (fig. **27.28**) with the principles of **functionalism** in mind. The influence of Cubism in their geometric repetitions is inescapable. These vertical, cubic structures, which are reminiscent of Mondrian's late paintings, inspired many similar skyscrapers throughout America's large cities.

27.28 Ludwig Mies van der Rohe, Lake Shore Drive Apartment Houses, Chicago, 1950–52.

c. 1900 **c. 1950**

CUBISM, FUTURISM, AND RELATED 20TH-CENTURY STYLES

 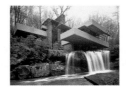

(27.2) (27.5) (27.12) (27.16a) (27.23) (27.26) (27.28)

Futurist
Manifesto
(1909)

De Stijl
movement
in the
Netherlands
(1910–20)

World War I
(1914–18)

League
of Nations
established
(1919)

James Joyce,
Ulysses
(1922)

Harlem
Renaissance
(1920s)

Museum of
Modern Art
opens in
New York
(1929)

Bauhaus
artists
emigrate
to the U.S.
(late 1930s)

Spanish
Civil War
(1936–39)

World War II
(1939–45)

28

Dada, Surrealism, Social Realism, Regionalism, and Abstraction

The devastation of World War I affected the arts as well as other aspects of Western civilization. For the first time in history, armies used trench warfare, barbed wire, machine guns firing along fixed lines, and chemical weapons. After treating the victims of gassing and shell shock in World War I, Freud and other medical researchers published accounts of the long-term psychological traumas of the new warfare. "The lost generation," a phrase coined by Gertrude Stein, captured the overwhelming sense of desolation experienced by the post–World War I intellectuals. In the visual arts of that era, the same pessimism and despair emerged as Dada.

Dada

The term *Dada* refers to an international artistic and literary movement that began during World War I in the relative safety of neutral Switzerland. Artists, writers, and performers gathered at the Cabaret Voltaire, a café in Zurich, for discussion, entertainment, and creative exploration. Dada was thus not an artistic style in the sense of shared formal qualities that are easily recognized. Rather, it was an idea, a kind of "antiart," predicated on a nihilist (from the Latin word *nihil*, meaning "nothing") philosophy of negation. By 1916 the term *Dada* had appeared in print—a new addition to the parade of aesthetic "manifestos" that developed in the nineteenth century. Dada lasted as a cohesive European movement until about 1920. It also achieved a foothold in New York, where it flourished from about 1915 to 1923.

According to the 1916 Manifesto, *Dada* is French for a child's wooden horse. *Da-da* are also the first two syllables spoken by children learning to talk, and thus suggest a regression to early childhood. The implication was that artists wished to "start life over." Likewise, Dada's iconoclastic force challenged traditional assumptions about art and had an enormous impact on later twentieth-century **conceptual art.** Despite the despair that gave rise to Dada, however, a taste for the playful and the experimental was an important, creative, and ultimately hopeful aspect of the

movement. This, in turn, is reflected in the Russian meaning of *da, da,* which is "yes, yes."

Marcel Duchamp

One of the major proponents of Dada was Marcel Duchamp (1887–1968), whose *Nude Descending a Staircase* (see fig. **27.15**) had caused a sensation at the 1913 Armory Show. He shared the Dadaists' taste for wordplay and punning, which he combined with visual images. Delighting, like a child, in nonsensical repetition, Duchamp entitled his art magazine *Wrong Rong*. The most famous instance of visual and verbal punning in Duchamp's work is *L.H.O.O.Q.* (fig. **28.1**), whose title is a bilingual pun. Read phonetically in English, the title sounds like "look," which, on one level, is the artist's command to the viewer. If each letter is pronounced according to its individual sound in French, the title reads "Elle *(L)* a ch *(H)* aud *(O)* au *(O)* cul *(Q),*" meaning in English "She has a hot ass." Read backward, on the other hand, "look" spells "kool," which counters the forward message.

When viewers do, in fact, look, they see that Duchamp has penciled a beard and mustache onto a reproduction of Leonardo's *Mona Lisa* (see fig. **16.13**), turning her into a bearded lady. One might ask whether Duchamp has "defaced" the *Mona Lisa*—perhaps a prefiguration of graffiti art (see p. 564)—or merely "touched her up." This question plays with the sometimes fine line between creation and destruction. (The modern expression "You have to break eggs to make an omelet" illustrates the connection between creating and destroying that is made explicit by the Dada movement.)

Duchamp called the kind of work exemplified by *L.H.O.O.Q.* a "ready-made aided." When he merely added a title to an object, he called the result a "ready-made." Duchamp's most outrageous ready-made was a urinal (fig. **28.2**) that he submitted as a sculpture to a New York exhibition mounted by the Society of Independent Artists in 1917. He turned it upside down, signed it "R. Mutt," and called it *Fountain.* The work was rejected by the society, and Duchamp resigned his membership.

CONNECTIONS

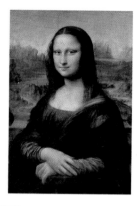

See figure 16.13.
Leonardo da Vinci,
Mona Lisa, c. 1503–5.

Despite the iconoclastic qualities of his ready-mades and his ready-mades aided, it must be said that both *L.H.O.O.Q.* and *Fountain* have a place in the history of imagery. In the former, the connection with the past is obvious, for the work reproduces a classic icon. It comments on Leonardo's homosexuality and on the sexual ambiguity of the *Mona Lisa* herself, and it reflects Duchamp's interest in creating his own alter ego as a woman, whom he named Rose Sélavy (a pun on "C'est la vie," meaning "That's life"). The *Fountain* makes a connection between the idea of a fountain and a urinating male, which in fact has been the subject of actual and painted fountains in many works of Western art.

28.1 Marcel Duchamp, replica of *L.H.O.O.Q.*, from "Boîte-en-Valise," 1919. Color reproduction of the *Mona Lisa* altered with a pencil, 7¾ × 5 in. (19.7 × 12.7 cm). Philadelphia Museum of Art (Louise and Walter Arensberg Collection). Duchamp was born in Blainville, France, the third of three sons who were all artists. In 1915 he moved to New York, and in 1955 he became an American citizen. After painting only twenty works, Duchamp announced his retirement in 1923 in order to devote the rest of his life to chess.

28.2 Marcel Duchamp, *Fountain (Urinal)*, 1917. "Ready-made," 24 in. (61 cm) high. Photo courtesy of Carroll Janis, New York. Duchamp declared that it was the artist's conscious choice that made a "ready-made" into a work of art. In 1915 he bought a shovel in a New York hardware store and wrote on it "In advance of a broken arm." "It was around that time," he said, "that the word 'ready-made' came to my mind. . . . Since the tubes of paint used by an artist are manufactured and ready-made products, we must conclude that all the paintings in the world are ready-made aided."[1]

28.3 Jean (Hans) Arp, *Collage Arranged According to the Laws of Chance*, 1916–17. Torn and pasted paper, 19⅛ × 13⅝ in. (48.6 × 34.6 cm). Museum of Modern Art, New York (purchase).

Jean (Hans) Arp

A quality of playfulness pervades the work of the Swiss artist Jean Arp (1887–1966), who was one of the founders of European Dada. In 1916–17, in a famous act of Dada "chance," Arp cut up rectangles of blue, white, and gray paper and dropped them onto a surface. He claimed to have pasted them where they fell and called the result *Collage Arranged According to the Laws of Chance* (fig. **28.3**). In fact, however, as the title indicates he arranged the papers so as not to overlap. By tilting the rectangles slightly and leaving the edges ragged, Arp animated the image and created the impression that the shapes are trying to arrange themselves.

Arp's cord collage titled *The Dancer* of 1928 (fig. **28.4**) was created by arranging a string on a flat surface. The string is equivalent to the draftsman's "line"—it defines the form and its character. By moving the string to achieve the desired shapes, Arp "played" creatively and arrived at a humorous image—a small head on a bulky torso with a circle in the center. The figure's slight tilt, the position of its left leg, and the upward curve of the right leg create a convincing impression of forward motion. The dancer literally seems to "kick up her heel," which, together with the flowing hair evoked by a single strand of string, conveys an impression of movement through space.

In moving the string, Arp also engaged in a form of visual free association, which was part of Dada and appealed to its interest in the spontaneous quality of chance. Dada artists and writers attempted a creative process designed to minimize the overlay of tradition and conscious control. Instead, they emphasized the expression of unconscious material through play, chance, and rapid execution. This approach was used in wordplay as well as in visual punning. The connection of both with unconscious processes had been explicated in Freud's 1911 publication *Jokes and Their Relation to the Unconscious*.

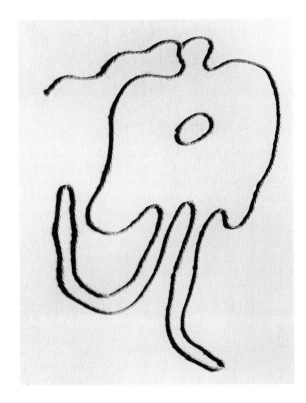

28.4 Jean Arp, *The Dancer*, 1928. Cord collage, 20 × 15½ in. (50.8 × 39.4 cm). Photo courtesy of Carroll Janis, New York.

Surrealism

Many members of the Dada movement also became interested in the Surrealist style that supplanted it. The writer André Breton bridged the gap between Dada and Surrealism with his First Surrealist Manifesto of 1924. He advocated art and literature based on Freud's psychoanalytic technique of free association as a means of exploring the imagination and entering the world of myth, fear, fantasy, and dream. The very term *surreal* connotes a higher reality—a state of being that is more real than mere appearance.

28.5 Man Ray, *Le Violon d'Ingres*, 1924. Photograph, reworked with pencil and ink. Musée National d'Art Moderne, Centre Georges Pompidou, Paris, France. The artist's real name was Emanuel Rudnitsky (1890–1976). His choice of the name Man Ray, although derived from his real name, illustrates the fondness for punning and word games that he shared with other Dada artists. He reportedly chose "Man" because he was male and "Ray" because of his interest in light.

CONNECTIONS

See figure 21.8. Jean-Auguste-Dominique Ingres, *Grande Odalisque*, 1814.

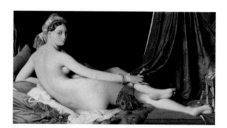

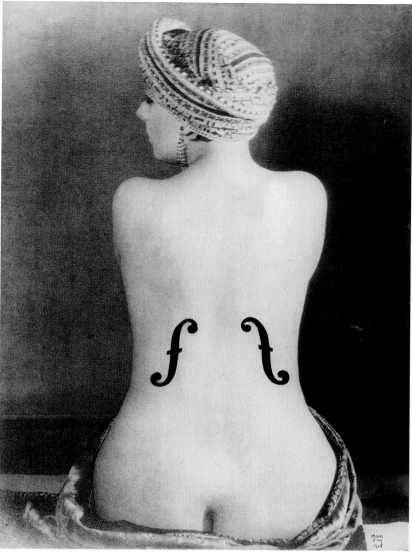

Breton had studied medicine and, like Freud, had encountered the traumas experienced by victims of shell shock in World War I. This led both Breton and Freud to recognize the power that trauma had over logical, conscious thinking. As a result, Breton wished to gain access to the unconscious mind, where, he believed, the source of creativity lay. He recommended writing in a state of free-floating association in order to achieve spontaneous, unedited expression. This "automatic writing" influenced European Abstract Surrealists and later, in the 1940s, had a significant impact on the Abstract Expressionists in New York City (see Chapter 29). The Surrealists' interest in gaining access to unconscious phenomena led to images that seem unreal or unlikely, as dream images often are, and to odd juxtapositions of time, place, and iconography.

Man Ray

Among the Surrealists who had also been part of the Dada movement was Man Ray (1890–1976). In 1921 he moved to Paris, where he showed his paintings in the first Surrealist exhibition of 1925. He worked as a fashion and portrait photographer and an avant-garde filmmaker. His experiments with photographic techniques included the **Rayograph**, made without a camera by placing objects on light-sensitive paper. Man Ray's most famous photograph, *Le Violon d'Ingres* (fig. **28.5**), combines Dada wordplay with Surrealist imagery. The nude recalls the odalisques of Ingres (see fig. **21.8**), while the title refers to Ingres' hobby—playing the violin (which led to the French phrase *violon d'Ingres,* meaning "hobby"). By adding sound holes, Man Ray puns on the similarity between the nude's back and the shape of a violin. The combination of the nude and the holes exemplifies the dreamlike imagery of Surrealism.

Man Ray defended the art of photography and argued against those unwilling to treat it as an art form. In "Photography Can Be Art," he wrote:

> When the automobile arrived, there were those that declared the horse to be the most perfect form of locomotion. All these attitudes result from a fear that the one will replace the other. Nothing of the kind has happened. We have simply increased our vocabulary. I see no one trying to abolish the automobile because we have the airplane.[2]

In characteristic Dada fashion, Man Ray also published *Photography Is Not Art* and *Art Is Not Photography.*

Paul Klee

Fantasy characterizes the Surrealism of the Swiss artist Paul Klee (1879–1940), who had been a member of The Blue Rider. He made many pencil drawings that reveal his attraction to linear, childlike imagery, as well as the influence of Surrealist "automatic writing." His *Mask of Fear* of 1932 (fig. **28.6**) reflects all these qualities, including the recollection of a painted wooden sculpture by the Zuni carvers of the American Southwest (fig. **28.7**). Such allusions

28.7 Zuni war god from Arizona or New Mexico. Painted wood and mixed media, 30½ in. (77.5 cm) high. Museum für Volkerkunde, Berlin, Germany.

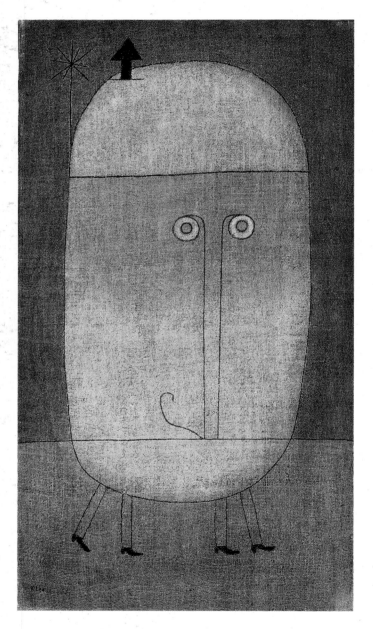

28.6 Paul Klee, *Mask of Fear*, 1932. Oil on burlap, 3 ft. 3½ in. × 1 ft. 10½ in. (1.0 × 0.57 m). Museum of Modern Art, New York (Nelson A. Rockefeller Fund). Klee described the creative process as follows: "Art does not reproduce the visible; rather, it makes visible."[3] Klee himself was enormously productive, recording a total of nearly nine thousand works.

exemplify the Surrealists' search for new sources of imagery, especially those with dreamlike and mythological content. As a young man, Klee visited the folk-art museum in Berlin, which had acquired the Zuni statue in 1880. In addition to formal correspondences, it is also possible that there are iconographic parallels. The Zuni figure represents a war god and thus might have been associated in Klee's mind with Nazi storm troopers. They, too, wore zigzag insignia reminiscent of lightning, and they aroused fear of the kind suggested by the men behind the mask.

In any event, Klee has transformed the Zuni sculpture into an image that plays with the boundaries between two- and three-dimensionality. The horizontal line defining the tip of the mask's nose is also the horizon line of the painting. Two pairs of legs either support the mask, whose size does not correspond naturally to theirs, or walk behind it. As a result, the viewer is somewhat startled by unlikely juxtapositions.

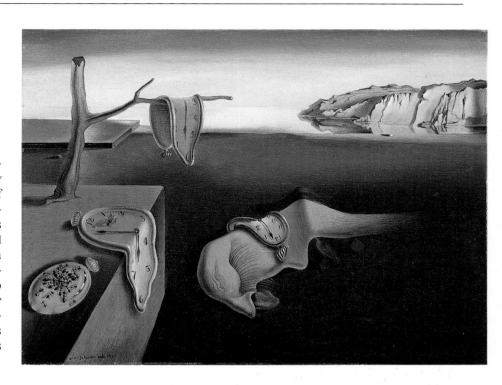

28.8 Salvador Dalí, *The Persistence of Memory*, 1931. Oil on canvas, 9½ × 13 in. (24 × 33 cm). Museum of Modern Art, New York (given anonymously).

Salvador Dalí

Salvador Dalí's (1904–89) famous "melting clocks" in *The Persistence of Memory* (fig. **28.8**) portray the uncanny quality of certain dreams. In a stark, oddly illuminated landscape, a number of elements referring to time—watches, eggs, a dead fish, a dead tree—are juxtaposed with a single living fly and swarming ants. Displaced from an unidentified location onto the eerie landscape are the two rectangular platforms at the left. The one in the foreground impossibly supports a tree, just as an impossible system of lighting produces strange color combinations.

Joan Miró

The Surrealist pictures of Joan Miró (1893–1983) are composed of imaginary motifs that are often reminiscent of childhood. In that way, they too are about the "persistence of memory." His paintings of the 1940s are characterized by biomorphic, sexually suggestive abstract forms as well as primary colors, vigorous linear movement, and complex design.

Miró's *Spanish Dancer* of 1945 (fig. **28.9**), for example, captures the rapid rhythms of Spanish dancing by juxtaposing thin curves, diagonal planes, and flat shapes that shift abruptly from one color to another. The red-and-green curve on the red-and-black shape at the lower right seems to turn in space like a dancer's torso. Two legs kick energetically to the left, while a hand is poised above the torso. Surrounding the hand is a shape with two curved points—one black, one red—which resemble breasts. At the top, the large head tilts upward as a nose and mouth (two black eyes hang from the nose) project from it to the left. Two eyes—one red, one blue, each with two black circles within it—also occupy the large head. A corresponding eye shape is lodged in the lower leg. The exuberance of Miró's dancing figure and the illusion of speed created by curved lines and shifting planes reflect his interest in Surrealist "automatic writing."

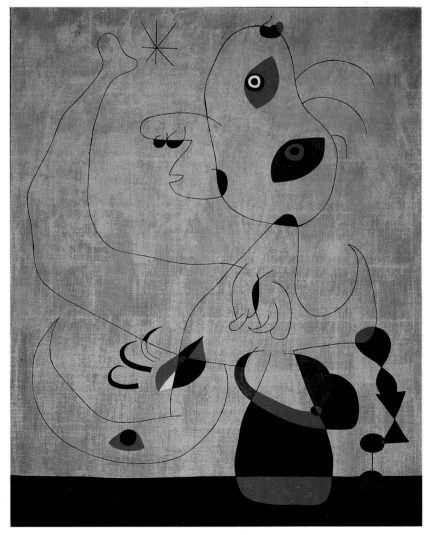

28.9 Joan Miró, *Spanish Dancer*, 1945. Oil on canvas, 4 ft. 9½ in. × 3 ft. 8⅞ in. (1.46 × 1.14 m). Fondation Beyeler, Riehen/Basel, Switzerland.

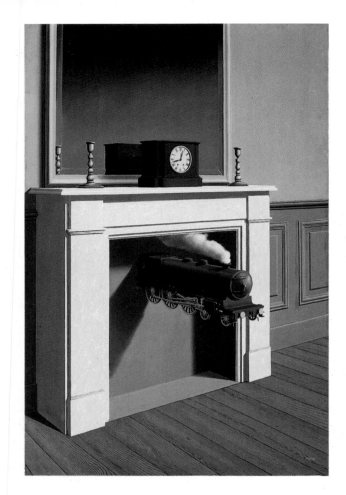

28.10 René Magritte, *Time Transfixed (La Durée poignardée)*, 1938. Oil on canvas, 4 ft. 9⅝ in. × 3 ft. 2⅜ in. (1.46 × 0.98 m). Art Institute of Chicago (Joseph Winterbotham Collection). Freud's observation that time does not exist in the unconscious accounts for certain unlikely condensations in dreams. The uncanniness of temporal condensation contributes to the eerie quality of this painting, as does the impossible juxtaposition of objects that appear realistic.

René Magritte

The Belgian artist René Magritte (1898–1967) painted Surrealist images of a more veristic kind. Individually they are realistic, often to the point of creating an illusion. However, their context, their size, or the juxtaposition of objects is unrealistic or possible only in a world of dreams.

In *Time Transfixed* (*La Durée poignardée* in French) of 1938 (fig. **28.10**), Magritte juxtaposed two familiar objects in order to evoke the unfamiliar. Various motifs in this work are clearly depicted and easily identifiable, but their relation to each other is odd, and they convey an impression of immobility and timelessness. The clock is fixed at a specific hour, and the candlesticks are empty. The cold, sterile room, composed entirely of rectangular forms, is devoid of human figures. A steam engine has burst through the fireplace, but without disrupting the wall. A shadow cast by the train is unexplained because there is no light source to account for it. The smoke, which indicates that the train is moving although it looks static, disappears up the chimney. *Poignardée* in the French title, literally meaning "stabbed" with a dagger or sword, expresses the "transfixed," frozen quality of both the train and the time.

Sculpture Derived from Surrealism

Surrealism influenced sculptors as well as painters and photographers in Europe and America. The Surrealist interest in depicting dream images contributed to the twentieth-century break with certain traditional forms and techniques.

Max Ernst

Max Ernst (1891–1976) began his artistic career in Germany as a Dadaist. He moved to France after World War I and eventually settled in the United States. *The King Playing with the Queen* (fig. **28.11**) of 1944 combines Surrealism with Cubism, a knowledge of Freud's theories, and the playful qualities of Picasso and Duchamp. A geometric king looms up from a chessboard, which is also a table. His horns are related to the role of the bull as a symbol of male fertility and kingship. He dominates the board by his large size and extended arms. The king is a player sitting at the table, as well as a chess piece on the board. He literally "plays" with the queen, who is represented as a smaller geometric construction at the left. On the right, a few tiny chess pieces seem detached from whatever "game" is taking place between the king and queen.

28.11 Max Ernst, *The King Playing with the Queen*, 1944. Bronze (cast 1954, from original plaster), 38½ in. (97.8 cm) high; 18¾ × 20½ in. (47.7 × 52.1 cm) at the base. Museum of Modern Art, New York (Gift of D. and J. de Menil).

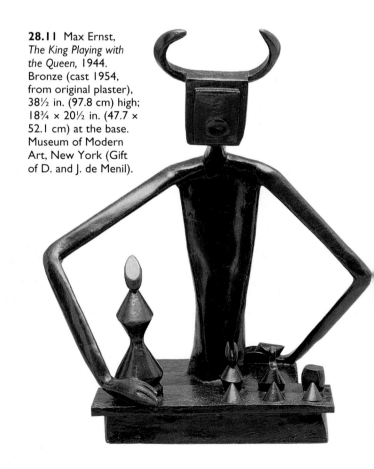

506

Alberto Giacometti

In the 1930s Alberto Giacometti (1901–66) had been involved with the Surrealists in Paris, and from the 1940s he began exploring the paradoxical power of the emaciated human form. The tall, thin, anti-Classical proportions of *Large Standing Woman III* (fig. **28.12**), one of his most imposing works, hark back to the rigid standing royal figures of ancient Egypt (see fig. **5.16**), which exerted a significant influence on Giacometti's development as a sculptor. In figures such as this, whether large or small, Giacometti explores the idea of extinction. His obsession with existence and nonexistence is evident in the fact that he made these sculptures as thin as they can be without collapsing. Ironically, the thinner they become, the more their presence is felt. By confronting the observer with the potential for disappearance, Giacometti evokes existential anxiety and takes the viewer to the very threshold of being. The sculpture is shown here as installed at the Sidney Janis Gallery in New York. On the wall is Mondrian's *Composition A (No. 1)/Composition with Blue, Red, and Yellow* of 1935–42; the juxtaposition shows the relationship of both artists to the avant-garde.

CONNECTIONS

See figure 5.16.
Statue of Hatshepsut as pharaoh, c. 1473–1458 B.C.

28.12 Alberto Giacometti, *Large Standing Woman III*, 1960, and Piet Mondrian, *Composition A (No. 1)/Composition with Blue, Red, and Yellow*, 1935–42, from the 1989 exhibition "40th Anniversary of Sidney Janis Gallery," curated by Carroll Janis. Giacometti: bronze, 7 ft. 8½ in. (2.35 m) high. © 2011 Succession Giacometti/Artists Rights Society (ARS), New York/ADAGP. Mondrian: oil on canvas, 3 ft. 3¼ in. × 1 ft. 8¼ in. (0.99 × 0.51 m). Photo courtesy of Carroll Janis, New York. © 2010 Mondrian/Holtzman Trust c/o HCR International, Virginia, USA. Born in Switzerland, Giacometti spent a formative period in the 1930s as a Surrealist. He met the Futurists in Italy and the Cubists in Paris and finally developed a distinctive way of representing the human figure that has become his trademark.

Henry Moore

In contrast to Giacometti, the British sculptor Henry Moore (1898–1986) was drawn to massive biomorphic forms. The traditional motif of the reclining figure was one of his favorite subjects. Moore himself related the image to the "mother earth" theme and to his fascination with the mysterious holes of nature. From the 1930s Moore began making sculptures with hollowed-out spaces and openings, thereby playing with the transition between inside and outside, interior and exterior. Many of his reclining figures are intended as outdoor landscape sculptures and are related to the traditional theme of the reclining Venus (cf. fig. **16.29**). Their holes permit viewers to see through the work as well as around it, and thus to include the surrounding landscape in their experience of the sculpture.

Reclining Figure, in front of the main UNESCO building in Paris (fig. **28.13**), is in an architectural setting. Its curvilinear masses and open spaces contrast with the stark rectangularity of the wall. The white marble, with its pronounced grain, gleams in the natural outdoor light. Moore considered the mountainous quality of the forms and the majestic character of the upright head and torso a fitting metaphor for the noble aims of the United Nations.

--- **CONNECTIONS** ---

See figure 16.29. Giorgione, *Sleeping Venus,* c. 1509.

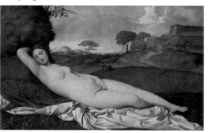

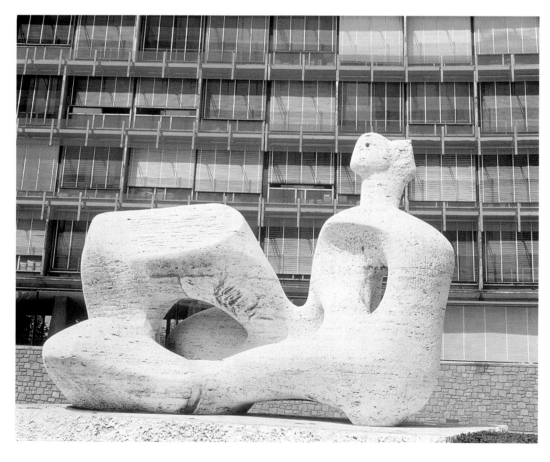

28.13 Henry Moore, *Reclining Figure,* 1957–58. Roman travertine, 16 ft. 8 in. (5.08 m) long. UNESCO Building, Paris, France. Moore's habit of collecting the chance objects of nature, such as dried wood, bone, and smooth stones from beaches, recalls the use of "found objects" in collage and assemblage. Unlike Dada and Surrealist artists, however, he used found objects as his inspiration rather than his medium, preferring the more traditional media of stone, wood, and bronze.

Alexander Calder

From the 1930s, the American artist Alexander Calder (1898–1976) developed **mobiles,** hanging sculptures set in motion by air currents. The catalyst for these works came from experiments with kinetic sculpture in Paris in the late 1920s and early 1930s. *Big Red* of 1959 (fig. **28.14**) is made from a series of curved wires arranged in a sequence of horizontal, vertical, and diagonal planes. Flat, red metal shapes are attached to the wires. Because they hang from the ceiling, mobiles challenge the traditional viewpoint of sculpture. Their playful quality and the chance nature of air currents are reminiscent of Dada and Surrealism, although Calder is more abstract (in the nonfigurative sense) than many Dada and Surrealist artists. On the role of the color red in his sculpture, Calder is quoted as saying, "I love red so much that I almost want to paint everything red."⁴

The United States: Regionalism and Social Realism

In spite of the variety of expression produced by the European avant-garde and exhibited at the 1913 Armory Show, painting in the United States of the 1920s and 1930s was, above all, affected by economic and political events, particularly the Depression and the rise of Fascism in Europe. Two different types of response to the times —responses that had political overtones of their own— can be seen in the work of American Regionalists and Social Realists.

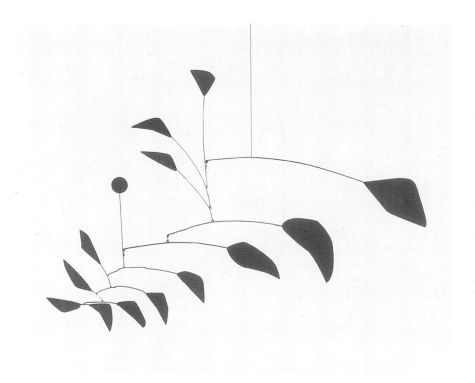

28.14 Alexander Calder, *Big Red*, 1959. Painted sheet metal and steel wire, 6 ft. 1 in. × 9 ft. 6 in. (1.88 × 2.9 m). Whitney Museum of American Art, New York (Purchase).

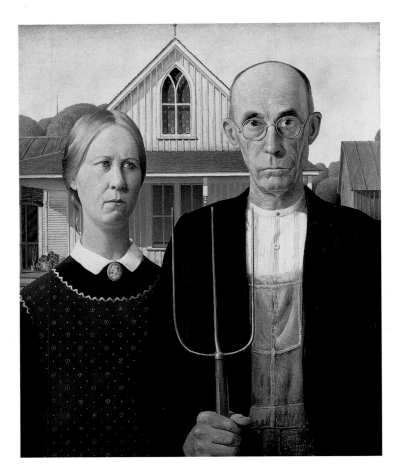

28.15 Grant Wood, *American Gothic*, 1930. Oil on **beaverboard,** 29¼ × 24½ in. (74.3 × 62.4 cm). Art Institute of Chicago (Friends of American Art Collection). Wood studied in Europe but returned to his native Iowa to paint the region with which he was most familiar. In this work, the two sober paragons of the American work ethic depicted as Iowa farmers are actually the artist's sister and dentist.

Grant Wood

American Gothic (fig. **28.15**) by Grant Wood (1892–1942) reflects the Regionalists' interest in provincial America and their isolation from the European avant-garde. Although the influence of Gothic is evident in the vertical planes and the pointed arch of the farmhouse window (see fig. **13.16**), the figures and their environment are unmistakably those of the American Midwest. Wood's meticulous attention to detail and the linear quality of his forms recall the early-fifteenth-century Flemish painters. All such European references, however, are subordinated to a distinctly regional American character.

Jacob Lawrence

The African American artist Jacob Lawrence (1917–2000), who was influenced by the Harlem Renaissance, dealt with issues of racial inequality and social injustice. Figure **28.16** reveals the influence of European Expressionist and Cubist trends, although the subject and theme are purely American. By a combination of flattened planes and abrupt foreshortening, Lawrence creates a powerful image of the abolitionist Harriet Tubman sawing a log. Tubman's

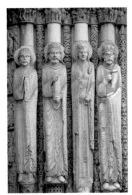

See figure 13.16. Door jamb statues, west façade, Chartres Cathedral, c. 1145–70.

single-minded concentration engages the observer directly in her activity. The geometric abstraction of certain forms, such as her raised right shoulder, contrasts with three-dimensional forms—the shaded left sleeve, for example—to produce shifts in tension. The result of such shifts is a formal instability that is stabilized psychologically by Tubman's determination.

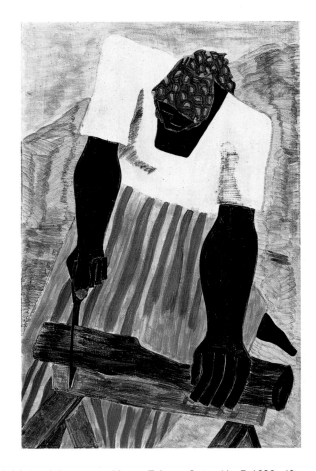

28.16 Jacob Lawrence, *Harriet Tubman Series, No. 7*, 1939–40. **Casein** tempera on hardboard, 17⅛ × 12 in. (43.5 × 30.5 cm). Hampton University Museum, Hampton, Virginia. From the age of ten, Lawrence lived in Harlem; in 1990 he was awarded the National Medal of Arts. This painting is from his 1939–40 series celebrating Harriet Tubman (c. 1820–1913). She was an active abolitionist and champion of women's rights who helped southern slaves to escape. From 1850 to 1860, as a "conductor" on the "underground railroad," she freed more than three hundred slaves.

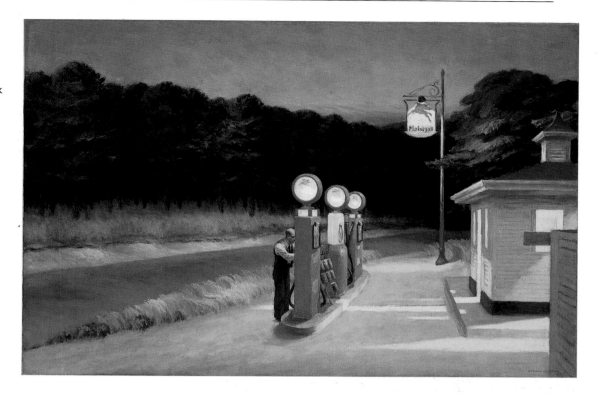

28.17 Edward Hopper, *Gas*, 1940. Oil on canvas, 2 ft. 2¼ in. × 3 ft. 4¼ in. (0.67 × 1.02 m). Museum of Modern Art, New York (Mrs. Simon Guggenheim Fund).

Edward Hopper

Edward Hopper (1882–1967), also a painter of the American scene, cannot be identified strictly as either a Regionalist or a Social Realist. His work combines aspects of both styles, to which he adds a sense of psychological isolation and loneliness. His settings, whether urban or rural, are uniquely American, often containing self-absorbed human figures whose interior focus matches the still, timeless quality of their surroundings. In *Gas* of 1940 (fig. **28.17**), a lone figure stands by a gas pump, the form of which echoes his own. The road, for Hopper a symbol of travel and time, seems to continue beyond the frame. Juxtaposed with the road are the figure and station that "go nowhere," as if frozen within the space of the picture.

James VanDerZee

Photography served the aims of social documentation in America as well as in Europe. The Harlem Renaissance photographer James VanDerZee (1886–1983) took pictures in his Lenox Avenue studio and also recorded African American life in New York City. His *Portrait of Couple, Man with Walking Stick* of 1929 (fig. **28.18**) was taken in the studio against a landscape backdrop. The figures seem self-consciously well-dressed in an urban style that is slightly at odds with the scenery. Their attire places them in the 1920s, and their poses convey a sense of self-assurance.

28.18 James VanDerZee, *Portrait of Couple, Man with Walking Stick*, 1929. Silver print. James VanDerZee Collection. © Donna M. VanDerZee.

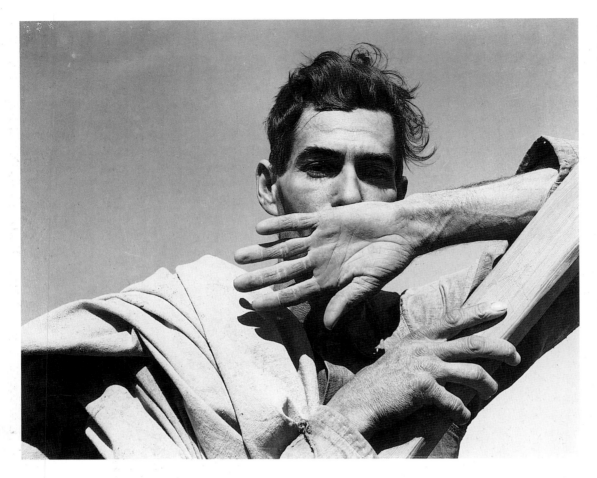

28.19 Dorothea Lange, *Migratory Cotton Picker, Eloy, Arizona,* 1940. Gelatin-silver print, 10½ × 13½ in. (26.8 × 34.3 cm). The Dorothea Lange Collection, Oakland Museum of California, City of Oakland. Gift of Paul S. Taylor.

Dorothea Lange

During the Depression, Dorothea Lange (1895–1965) took pictures for the Resettlement Administration—later the Farm Security Administration (FSA). This organization hired photographers to illustrate rural poverty. Lange was herself committed to conveying the desired social message. Her *Migratory Cotton Picker* of 1940 (fig. **28.19**) is typical of the way she ennobled the poor and the working class. The man is physically worn by laboring in the fields and toughened by the hot sun. The earth clings to his hands, and the lines and veins of the hands create abstract patterns by virtue of the close-up view. Arizona's arid climate is reflected in the clear, crisp sky and the precise outlines of the worker. In such images, Lange succeeded in evoking sympathy for, and identification with, her subjects, thereby achieving her political goals.

Mexico

Diego Rivera

Another approach to social concerns can be seen in the murals of the Mexican artist Diego Rivera (1886–1957). From 1909 to 1921 he lived in Europe, where he painted in a Cubist style. On returning to Mexico, however, he renounced the avant-garde in favor of Mexican nationalism. The government commissioned him to create a series of large murals for the National Palace, which he used as a vehicle for depicting Mexican history. In this approach Rivera was influenced by Socialist Realism.

Figure **28.20** shows the first mural in the series. At the left, the Spanish conquerors fight the native population, who perform ancient ceremonies at the far right. References to Quetzalcoatl, the pre-Columbian feathered-serpent god, appear on either side of the sun, which is above a Mesoamerican pyramid. The seated figure in front of the pyramid resembles Lenin, leaving no doubt about Rivera's political message. Rivera has thus combined a kind of historical imperative with contemporary issues; and even though he has diverged from the avant-garde, there are unmistakable Cubist forms in his imagery.

Frida Kahlo

Diego Rivera's third wife, Frida Kahlo (1907–54), shared her husband's Marxist sentiments and his Surrealist style. She joined the Communist party in the 1940s to fight Hitler and befriended Leon Trotsky, the Russian revolutionary exiled to Mexico and later assassinated.

28.20 Diego Rivera, *Ancient Mexico,* from the *History of Mexico* fresco murals, 1929–35. National Palace, Mexico City.

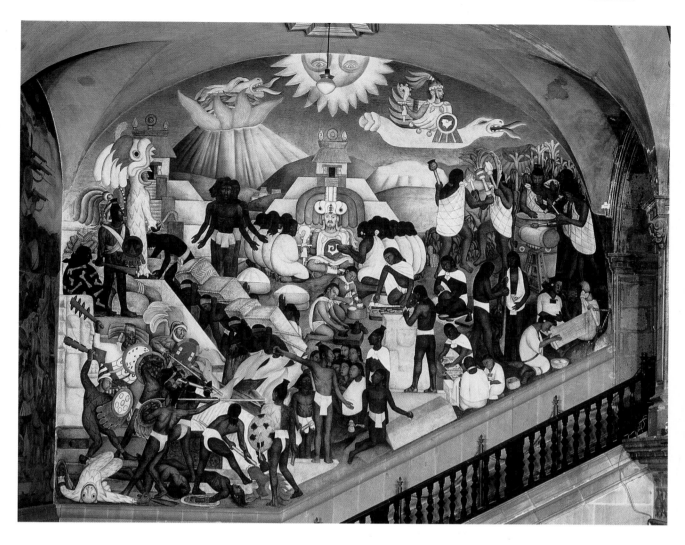

Despite a turbulent marriage, Kahlo remained in love with Rivera until her death. She shared the Surrealist interest in childhood memory and in using imagery to reveal the unconscious mind. Having suffered a serious accident as an adolescent that required repeated surgery and forced her to wear an uncomfortable back brace, Kahlo was in constant pain. This she depicted in many of her paintings, but she also portrayed the mental suffering caused by her relationship with Rivera.

In figure **28.21**, Kahlo uses the Surrealist technique of painting thoughts and ideas. She depicts herself against a background of green and yellowing leaves and thorns that seem about to engulf her. The abundance of foliage, juxtaposed with the death's head in the landscape tondo on Kahlo's forehead, alludes to Mexican mythology in which life and death are seen as integral aspects of nature's continuum.

28.21 Frida Kahlo, *Thinking about Death,* 1943. Oil on canvas, mounted on Masonite, 17½ × 14¼ in. (44.5 × 36.3 cm). Private collection.

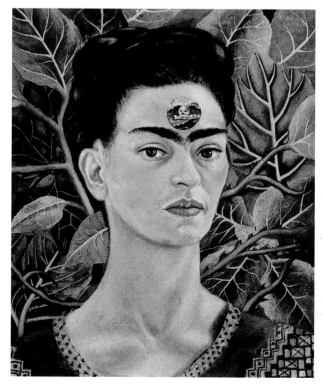

Toward American Abstraction

Countering the Regional and Social Realist currents of American art between the wars was the influence of the European avant-garde. A few private New York galleries, run by dealers who understood the significance of the new styles, began to exhibit "modern" art. In 1905 the American photographer Alfred Stieglitz (1864–1946) opened the 291 Art Gallery at 291 Fifth Avenue in New York, where he exhibited work by Rodin, Cézanne, the Cubists, and Brancusi, along with work by progressive American artists. The Museum of Modern Art, under the direction of Alfred Barr, Jr., opened in 1929, the year of the stock market crash. In 1930, Stieglitz opened the American Place Gallery to exhibit abstract art. Also during this period, government support for the arts was provided by the Federal Arts Project, which operated under the aegis of Franklin Roosevelt's social programs. The Arts Project employed thousands of artists and in so doing granted some measure of official status to abstract art.

Alfred Stieglitz

Alfred Stieglitz's photographs straddle the concerns of American Social Realism and avant-garde abstraction. Many of his pictures document contemporary society, while others are formal studies in abstraction. In 1922 he began a series of abstract photographs titled *Equivalent* (fig. **28.22**), in which cloud formations create various moods and textures. Stieglitz believed in what is called "straight photography," as opposed to unusual visual effects achieved, among other means, by the manipulation of negatives and chemicals.

Georgia O'Keeffe

Georgia O'Keeffe (1887–1986), who was married to Stieglitz, is difficult to place within a specific stylistic category. But it is clear that she was influenced by photography and early-twentieth-century abstraction, as well as by the landscape of the American Southwest. She, along with other abstractionists, had exhibited at Stieglitz's 291 in the 1920s. Her *Black and White* of 1930 (fig. **28.23**) is an abstract depiction of various textures, motion, and form, without any reference to recognizable objects. By eliminating color, O'Keeffe further distances the image from nature and makes use of the same tonal range that is available to the black-and-white photographer.

In her *Cow's Skull with Calico Roses* of 1931 (fig. **28.24**), O'Keeffe depicts one of the desiccated skulls found in the deserts of Arizona and New Mexico. The close-up view abstracts the forms. With the accent of the black vertical and the horizontal of the horns, the image evokes the Crucifixion. At the same time, the death content of O'Keeffe's subject is softened by the roses, which are still alive. This juxtaposition of living and dead forms recalls the death and resurrection themes of Christian art, as well as being a feature of the desert itself. It also has a Surrealist quality.

28.22 Alfred Stieglitz, *Equivalent*, 1923. Chloride print, 4⅝ × 3⅝ in. (11.8 × 9.2 cm). Art Institute of Chicago (Alfred Stieglitz Collection). Stieglitz was born in Hoboken, New Jersey. He organized the 1902 exhibition that led to Photo-Secession, an informal group that held exhibitions all over the world and whose objective was to gain the status of a fine art for pictorial photography. In 1903 he founded the quarterly journal *Camera Work*, which encouraged modern aesthetic principles in photography.

28.23 (Left) Georgia O'Keeffe, *Black and White*, 1930. Oil on canvas, 36 × 24 in. (91.4 × 61.0 cm). Collection, Whitney Museum of American Art, New York (Gift of Mr. and Mrs. R. Crosby Kemper). O'Keeffe was born in Sun Prairie, Wisconsin. In 1917 Stieglitz gave O'Keeffe her first one-woman show at "291." She married Stieglitz in 1924, and after his death moved permanently to New Mexico, where desert objects—animal bones, rocks, flowers—became favorite motifs in her work.

28.24 (Right) Georgia O'Keeffe, *Cow's Skull with Calico Roses*, 1931. Oil on canvas, 36⁵⁄₁₆ × 24⅛ in. (92.2 × 61.3 cm). Art Institute of Chicago (Gift of Georgia O'Keeffe). In July 1931, O'Keeffe wrote from New Mexico to the art critic Henry McBride: "Attempting to paint landscape—I must think it important or I wouldn't work so hard at it—Then I see that the end of my studio is a large pile of bones— a horse's head—a cow's head—a calf's head—long bones—all sorts of funny little bones and big ones too—a beautiful ram's head has the center of the table—with a stone with a cross on it and an extra curly horn."[5]

The United States has had a strong ongoing folk-art tradition. In the nineteenth century, folk sculpture included shop signs, carousel horses, weather vanes, ships' figureheads, carved gravestones, and cigar-store Indians. Folk art also includes quilts and embroidery as well as painting. These have continued into the twentieth century—in some cases up to the present.

One of the best-known folk artists is Anna Mary Robertson ("Grandma") Moses (1860–1961). She worked mainly in embroidery until she was in her seventies, when she turned to painting. Scenes such as *The Old Checkered House* of 1944 (fig. **28.25**) show the persistent appeal of styles that have not been modified by formal training.

Although Grandma Moses was self-taught, it is clear that the lively designs of embroidery provided her with a training of their own. Small patterns, particularly in the red and white squares of the house, recall those made by embroidered threads. Here they are flattened, as are the silhouetted horses, creating an impression of naiveté. But there is a convincing sense of three-dimensional space. The hills diminish in clarity as well as in size compared with the foreground forms, indicating a familiarity with both aerial and linear perspective. There is no suggestion here of the momentous international events of the period, no reference to American participation in World War II (then in its third year), or to industrialization. Instead, the scene evokes a past era of rural life, horse-drawn carriages, and soldiers of the American Civil War. The painting thus has a romantic, nostalgic quality.

The self-taught African American artist Horace Pippin (1888–1946) is best known for his domestic interiors, often evoking memories of his childhood. In *Domino Players* of 1943 (fig. **28.26**), he depicts three figures seated at a table playing dominoes. The two women seem intent on the game, but the boy—Pippin himself—is clearly bored. He gazes directly out of the picture, inviting viewers to identify with a child stuck in an adult setting. Behind the table, a grandmotherly figure sews a quilt. As in the work of Grandma Moses, Pippin's imagery has the appeal of folk art, emphasizing flat patterns—the dominoes, the polka-dot blouse, and the quilt. Likewise, seemingly casual details, such as the stove and the oil lamp, are reminiscent of another era.

28.25 Anna Mary Robertson ("Grandma") Moses, *The Old Checkered House,* 1944. Oil on pressed wood, 24 × 43 in. (0.61 × 1.09 m). The Seiji Togo Memorial Sompo Japan Museum of Art.

28.26 Horace Pippin, *Domino Players,* 1943. Oil on composition board, 12¾ × 22 in. (32.4 × 55.9 cm). Phillips Collection, Washington, D.C. Pippin lived in Pennsylvania. A veteran of World War I, in which he suffered a shoulder wound, he exercised his right arm by decorating cigar boxes with charcoal. In 1928, at the age of forty, he began working in oil paints, although he described himself as having been interested in pictures from his youth.

Transcendental Painting

From 1938 to 1941 a unique group of avant-garde painters dedicated to the principles of abstraction was formed in New Mexico. These artists were inspired by the expanses of the southwestern landscape and by Kandinsky's *Concerning the Spiritual in Art*. In a brochure published by the group, they stated:

> Transcendental has been chosen as a name for this group because it best expresses its aim, which is to carry painting beyond the appearance of the physical world, through new concepts of space, color, light, and design, to imaginative realms that are idealistic and spiritual. The work does not concern itself with political, economic, or other social problems.[6]

The execution of these goals can be seen in the work of Agnes Pelton, who had participated in the Armory Show and had exhibited at Stieglitz's gallery in New York. Her *Blest* of 1941 (fig. **28.27**) is typical of the expanding biomorphic forms depicted by the Transcendental painters. In this case, a large floral form rises and stretches like an explosion in slow motion. It seems to dissolve as it expands, creating a mystical, floating effect that is related to elusive notions of Transcendental spirituality.

Along with Stieglitz, O'Keeffe, and other abstractionists, the Transcendental painters were among the most avant-garde artists of the early twentieth century in America. At that time, despite the Armory Show and other inroads made by the new European styles, art in the United States was still primarily conservative. It was not until the 1950s that American art finally emerged as the most innovative on an international scale.

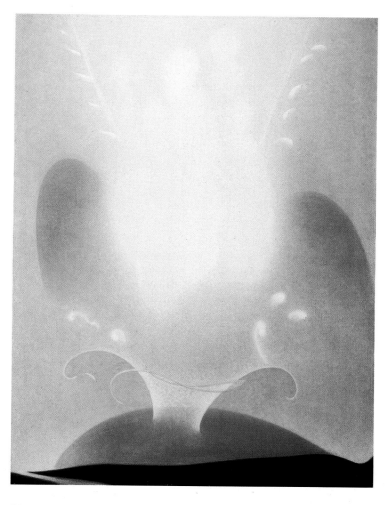

28.27 Agnes Pelton, *The Blest*, 1941. Oil on canvas, 38 × 29 in. (96.5 × 73.6 cm). Georgia Riley de Havenon Collection, New York.

c. 1910 **c. 1960**

DADA, SURREALISM, SOCIAL REALISM, REGIONALISM, AND ABSTRACTION

(28.2)	(28.3)	(28.5)	(28.6)	(28.10)	(28.16)	(28.14)	
World War I (1914–18)	Dada movement begins in Zurich (c. 1915)	Harlem Renaissance (1920s)	E. E. Cummings, *The Enormous Room* (1922)	First Surrealist exhibition in Paris (1925)	Ernest Hemingway, *For Whom the Bell Tolls* (1940)	World War II (1939–45)	Guggenheim Museum opens in New York (1959)

29

Mid-Century American Abstraction

B y the middle of the 1930s, American abstraction had, paradoxically, emerged from the background of Regionalism and Social Realism. Equally influential, however, was the influx of artists and intellectuals from Europe. By 1940, when Paris fell to the Nazis, the center of the art world had shifted to New York, whose cultural life was enriched by émigré artists. Among the dealers and collectors who fled Europe was Peggy Guggenheim, who, in 1942, opened the Art of This Century Gallery in New York, which exhibited avant-garde work.

The Teachers: Hans Hofmann and Josef Albers

Two of the most influential emigrants from Germany were Hans Hofmann (1880–1966) and Josef Albers (1888–1976). They taught at the Art Students League in New York and at Black Mountain College in North Carolina, respectively, and from 1950 to 1960 Albers chaired the Department of Architecture and Design at Yale. Both Hofmann and Albers influenced a generation of American painters.

Hofmann's *Gate* (fig. **29.1**) is an architectural construction in paint. The intense, thickly applied color is arranged in squares and rectangles. It ranges from relatively pure hues, such as the yellow and red, to more muted greens and blues. For Hofmann, as for the Impressionists, it was the color in a picture that created light. In nature, the reverse is true; light makes color visible. In *The Gate,* edges vary from precise to textured. Everywhere, the paint is structured, combining bold, expressive color with the **tectonic** qualities of Cubism and related styles.

29.1 Hans Hofmann, *The Gate,* 1959–60. Oil on canvas, 6 ft. 3⅛ in. × 4 ft. ½ in. (1.90 × 1.23 m). Solomon R. Guggenheim Museum, New York. For Hofmann, nature was the source of inspiration, and the artist's mind transformed nature into a new creation. "To me," he said, "a work is finished when all parts involved communicate themselves, so that they don't need me."[1]

29.2 Josef Albers, *Study for Homage to the Square*, 1968. Oil on Masonite, 32 × 32 in. (81.3 × 81.3 cm). Photo courtesy of Carroll Janis, New York.

Albers's series of paintings titled *Homage to the Square* (fig. **29.2**) also explores color and geometry. But his surfaces are smooth, and the medium is subordinate to the color relationships among the squares. In his investigation of light and color perception, Albers concentrated on the square because he believed that it was the shape furthest removed from nature. "Art," he said, "should not represent, but present."[2]

Abstract Expressionism

The New York School

Abstract Expressionism was a term used in 1929 by Alfred Barr Jr. to refer to Kandinsky's nonfigurative, non-representational paintings. The style was to put the United States on the map of the international art world. In the 1950s it was generally used to categorize the New York school of painters, which, despite its name, actually comprised artists from many parts of the United States and Europe.

Nearly all the Abstract Expressionists had passed through a Surrealist phase. From this they had absorbed an interest in myths and dreams, and in the effect of the unconscious on creativity. From Expressionism they inherited an affinity for the expressive qualities of paint. This aspect emerged particularly in the so-called action or gesture painters of Abstract Expressionism.

Arshile Gorky

The Abstract Expressionist painter who was most instrumental in creating a transition from European Abstract Surrealism to American Abstract Expressionism was the Armenian Arshile Gorky (1904–48). After absorbing several European styles, including Impressionism and Surrealism, he developed his own pictorial "voice" in the 1940s.

Sometime between about 1926 and 1936, Gorky painted his famous work *The Artist and His Mother* (fig. **29.3**). The slightly geometric character of the faces suggests the influence of early Cubism. Flattened planes of color—the mother's lap, for example—and visible brushstrokes reveal affinities with Fauvism and Expressionism. To the left stands the rather wistful young Gorky. His more dominant mother recalls the mythic enthroned mother goddesses of antiquity.

29.3 Arshile Gorky, *The Artist and His Mother*, c. 1926–36. Oil on canvas, 5 ft. × 4 ft. 2 in. (1.52 × 1.27 m). Collection, Whitney Museum of American Art, New York (Gift of Julien Levy for Maro and Natasha Gorky). Gorky was born Vosdanig Manoog Adoian in Turkish Armenia and emigrated to the United States in 1920. At the height of his career, a series of misfortunes—a fire that burned most of his recent work, a cancer operation, a car crash that fractured his neck—led to his suicide in 1948. This painting was based on an old photograph.

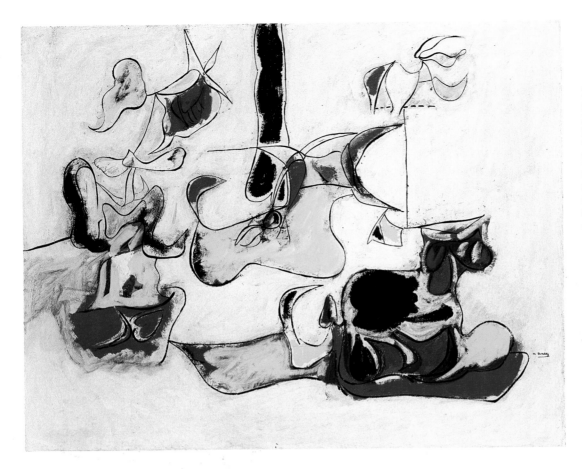

29.4 Arshile Gorky, *Garden in Sochi*, c. 1943. Oil on canvas, 31 × 39 in. (78.7 × 99.0 cm). Museum of Modern Art, New York (Acquired through the Lillie P. Bliss Bequest). Gorky related this series to a garden at Sochi on the Black Sea. He recalled porcupines and carrots, and a blue rock buried in black earth with moss patches resembling fallen clouds. Village women rubbed their breasts on the rock—probably a fertility rite. Passersby tied colorful strips of clothing to a leafless tree. The strips blew in the wind like banners and rustled like leaves.

Entirely different in form, though it shares the nostalgic quality of *The Artist and His Mother*, is *Garden in Sochi* of about 1943 (fig. **29.4**). The third of a series depicting childhood recollections, this painting exemplifies Gorky's most characteristic innovations. Paint is applied thinly, and colorful shapes are bounded by delicate curvilinear outlines, which create a sense of fluid motion.

Both the title and the abstract biomorphic shapes suggest natural, organic protozoan or vegetable life. Gorky studied nature closely, sketching flowers, leaves, and grass from life before transforming the drawings into abstract forms. The suggestive, elusive identity of Gorky's shapes is reminiscent of Miró, who had influenced Gorky's Surrealist phase.

THEORY
Critics and the Avant-Garde

Harold Rosenberg (1906–78) and Clement Greenberg (1909–94) were the two leading critics most closely associated with American Abstract Expressionism. In 1952 Rosenberg coined the term *action painting* to describe the new techniques of applying paint. For American artists, he said, the canvas became "an arena in which to act—rather than . . . a space in which to reproduce. . . . What was to go on the canvas was not a picture but an event." Rather than begin a painting with a preconceived image, the Abstract Expressionists approached their canvases with the idea of doing something *to* it. "The image," wrote Rosenberg, "would be the result of this encounter."[3]

Greenberg took issue with Rosenberg's assessment on the grounds that painting thus became a private myth. Because such work did not resonate with a larger cultural audience, according to Greenberg, it could not be considered art. But he was nevertheless a staunch defender of abstraction, noting

that subject matter had nothing to do with intrinsic value. "The explicit comment on a historical event offered in Picasso's *Guernica*," he wrote in 1961, "does not make it necessarily a better or richer work than an utterly 'non-objective' painting by Mondrian."[4]

Greenberg described the shift in the artists' view of pictorial space as having "lost its 'inside' and become all 'outside.'" He surveyed this shift from the fourteenth century as follows:

From Giotto to Courbet, the painter's first task had been to hollow out an illusion of three-dimensional space on a flat surface. One looked through this surface as through a proscenium into a stage. Modernism has rendered this stage shallower and shallower until now its backdrop has become the same as its curtain, which has now become all that the painter has left to work on.[5]

Action Painting

Just as brushstrokes are a significant aspect of Impressionism and Post-Impressionism, so the action painters developed characteristic methods of applying paint. They dripped, splattered, sprayed, rolled, and threw paint onto their canvases, with the result that the final image reflects the artist's activity in the creative process.

Jackson Pollock

Of the "action" or "gesture" painters who were part of the New York school, the best known is Jackson Pollock (1912–56). He began as a Regionalist and turned to Surrealism in the late 1930s and early 1940s.

From 1947 onward, Pollock used a **drip technique** to produce his most celebrated pictures, in which he engaged his whole body in the act of painting. From cans of commercial housepainter's paint, enamel, and aluminum, Pollock dripped paint from the end of a stick or brush directly onto a canvas spread on the ground. In so doing, he achieved some of the chance effects sought by the Dada and Surrealist artists. At the same time, however, he controlled the placement of the drips and splatters through the motion of his arm and body (fig. **29.5**). He described this process as follows: "On the floor I am more at ease. I feel nearer, more a part of the painting, since this way I can walk around it, work from the four sides and literally be *in* the painting. This is akin to the Indian sand painters of the West" (see Box, p. 522). Pollock also declared that, when actually painting, he was unaware of his actions: "When I am *in* my painting, I'm not aware of what I'm doing . . . because the painting has a life of its own."[6]

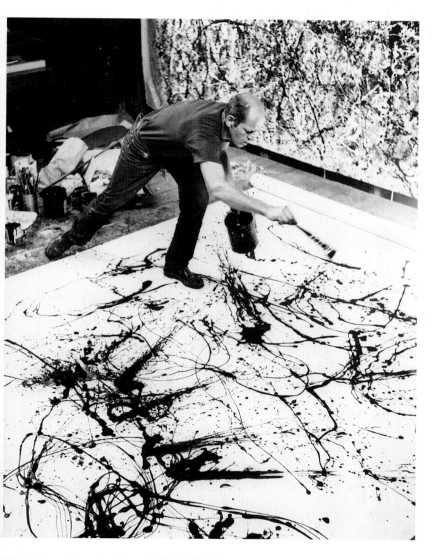

29.5a Hans Namuth, *Jackson Pollock*, 1950. Photograph. Courtesy Center for Creative Photography, University of Arizona.

29.5b Hans Namuth, *Jackson Pollock*, 1950. Three color stills from a film strip. Courtesy Pollock-Krasner House and Study Center, East Hampton, NY.

MEDIA AND TECHNIQUE
Navajo Sand Painting

Pollock's "Indian sand painters" were the Navajo, who led a nomadic existence in the American Southwest. They made paintings out of crushed colored rocks, which were ground to the consistency of sand. These were the sacred products of a medicine man, or shaman, who created images in order to exorcise the evil spirits of disease from a sick person. He continued to make the pictures until the patient either died or recovered. Then the image was destroyed, usually at night, and its effect dissipated.

According to Navajo belief, humans had been preceded by Holy People who created sacred images in nature. These images became a medium of communication between the human and spirit worlds. For the Navajo, sand paintings provide a means of summoning the assistance of the Holy People in order to restore the spiritual and physical balance of a sick person. Typically the patient sits inside the painting and faces east, the direction from which the Holy People enter the image. As a result, the Navajo refer to sand paintings as *iikaah*, or "the place to which gods come and from which they go."

Figure **29.6a** shows a modern sand painter at work, his image not yet complete. Figure **29.6b** is a sand painting of a *yei* god (a lesser Navajo deity). Its frontal stance, stylized, figurative character, geometric forms, and clear outlines are unlike anything in Pollock's work. Figure **29.6a** also differs from Pollock's all-over drips in its flattened perspective and discrete zones of color. His interest was in energetic execution and the artist's movement around the image on the ground. It is also likely that Pollock was drawn to the shamanistic character of the medicine man, and that he identified with the notion that images have curative power.

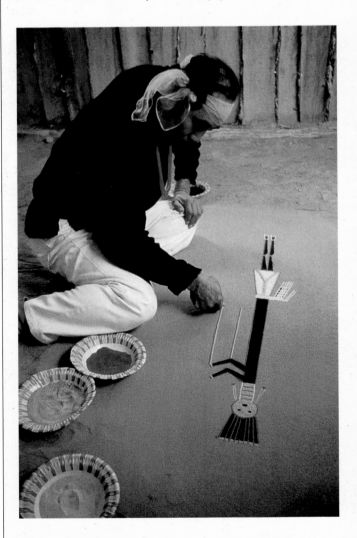

29.6a Michael Heron, *Navajo Crafts,* creating a sand painting.

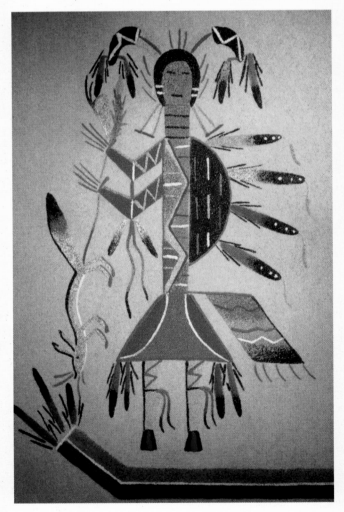

29.6b *Yei* god, sand painting, 20th century. Navajo Indian Reservation, western New Mexico.

Pollock's *White Light* of 1954 (fig. **29.7**) eliminates all reference to recognizable objects. Lines of different widths and textures swirl through the picture space and are slashed diagonally at various points. There is an underlying chromatic organization of yellows and oranges blending with, and crisscrossed by, thick blacks and whites.

The white, as indicated by the title, is what predominates, and the intensity of Pollock's light is everywhere present. His habit of trimming finished canvases enhances their dynamic quality, for the lines appear to move rhythmically in and out of the picture plane, unbound by either an edge or a frame, as if self-propelled.

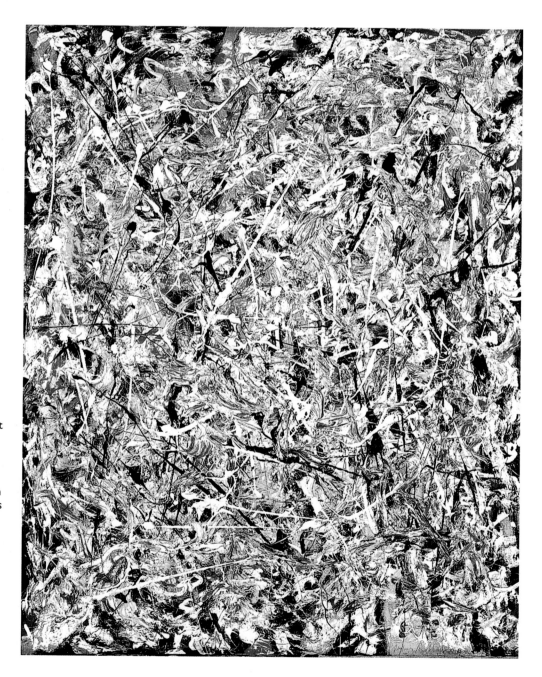

29.7 Jackson Pollock, *White Light,* 1954. Oil, enamel, and aluminum paint on canvas, 48¼ × 38¼ in. (122.4 × 96.9 cm). Museum of Modern Art, New York (Sidney and Harriet Janis Collection). Pollock was born in Wyoming and moved to New York in 1929. He worked for the Federal Arts Project and had his first one-man show in 1943 at Peggy Guggenheim's Art of This Century Gallery. Pollock first exhibited paintings such as this in 1948 to a shocked public. A critic for *Time* magazine dubbed him "Jack the Dripper," but avant-garde critics came to his defense. Within a few years of his death, he was the most widely exhibited of all the artists of the New York school.

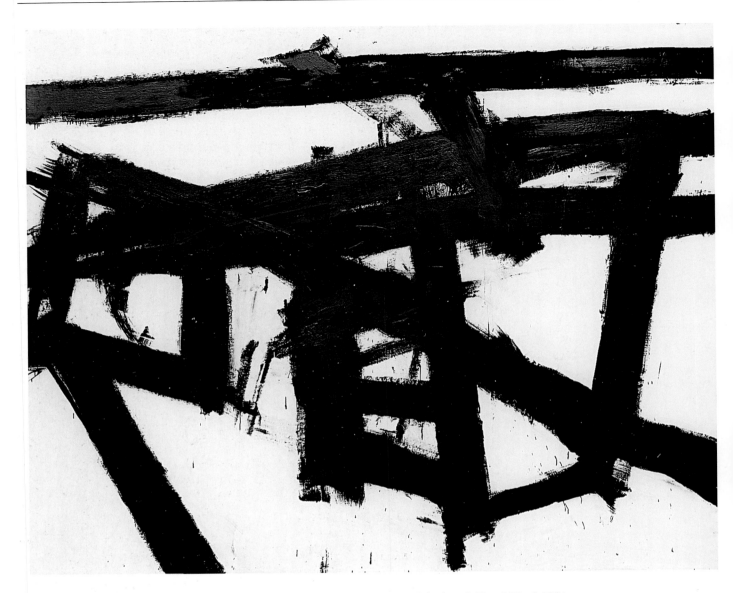

29.8 Franz Kline, *Mahoning*, 1956. Oil and paper collage on canvas, 6 ft. 8 in. × 8 ft. 4 in. (2.03 × 2.54 m). Whitney Museum of American Art, New York (Purchase, funds from friends of Whitney Museum of American Art).

Franz Kline

The dynamic energy of Pollock's monumental drip paintings is virtually unmatched, even among the Abstract Expressionist action painters. But Franz Kline (1910–62) achieved dynamic imagery through thick, bold strokes of paint slashing across the picture plane. He had his first one-man show in New York in 1950, by which time he had renounced figuration and begun working on his characteristic black-and-white canvases. *Mahoning* of 1956 (fig. **29.8**) is a typical example. Strong black diagonals are created by the wide brush of a housepainter and form a kind of "structured" calligraphy. The edges are too rough and the blacks too angular for Classical calligraphy, while the architectural appearance tilts, as if beams are about to collapse. Drips and splatters enhance the textured quality of the surface.

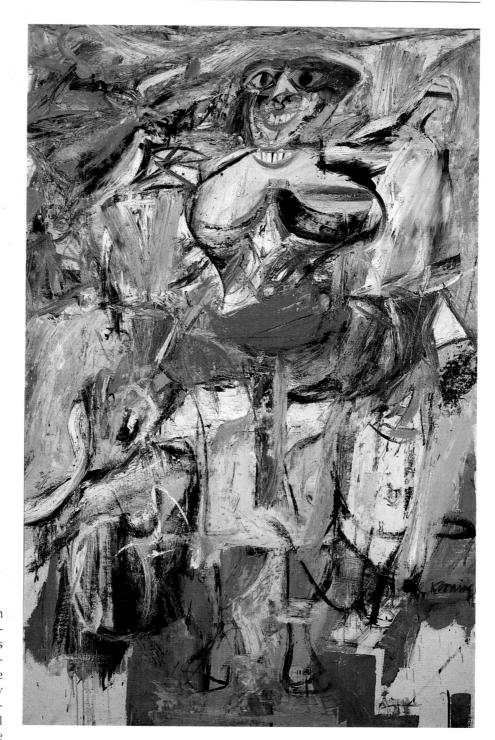

Willem de Kooning

Willem de Kooning (1904–97) used action painting in the service of explicit aggression. This is particularly true of the series of pictures of women that de Kooning painted in the early 1950s. Unlike Pollock and Kline, de Kooning only partially eliminated recognizable subject matter from his iconography until late in his career. *Woman and Bicycle* of 1952–53 (fig. **29.9**), for example, combines the frontal image of a large, frightening woman with violent brushstrokes tearing through the figure's outline. The anxiety created by the woman's appearance—huge staring eyes, a double set of menacing teeth, and platform-like breasts, which reveal the influence of Cubist geometry —matches the frenzy of the brushstrokes. The assault on the figure, which seems to disintegrate into unformed paint, is also an attack on the idealized Classical image of female beauty.

29.9 Willem de Kooning, *Woman and Bicycle*, 1952–53. Oil on canvas, 6 ft. 4½ in. × 4 ft. 1 in. (1.94 × 1.25 m). Collection, Whitney Museum of American Art, New York (Purchase). De Kooning was born in the Dutch port of Rotterdam and emigrated to the United States in 1926, but did not have his first one-man show until 1948. He described his relationship to 20th-century art as follows: "Of all movements, I like Cubism most. It had that wonderful unsure atmosphere of reflection. . . . And then there is that one-man movement: Marcel Duchamp—for me a truly modern movement because it implies that each artist can do what he thinks he ought to—a movement for each person and open for everybody."[7]

Mark Rothko

One of the most important Abstract Expressionist artists was Mark Rothko (1903–70). Like Pollock, he had gone through a Surrealist period and was engaged in the search for universal symbols, which he believed were accessible through myths and dreams. By the 1950s, Rothko had developed his most original style. Nonfigurative and non-representational, Rothko's paintings are images of rectangles hovering in fields of color.

In *Number 15* of 1957 (fig. **29.10**), two black-green rectangles occupy an intense, vibrant blue. Above and below the larger rectangle is a thinner bar of green. The blue background appears to be suffused into the greens and blacks, producing a shimmering, textured quality that infiltrates the overall impression of darkness. By muting the colors and blurring the edges of the rectangles, Rothko softens the potential contrast between them. He likewise mutes the observer's attention to the "process" of painting by virtually eliminating the presence of the artist's hand.

By eliminating references to the natural world as well as to the creative process, Rothko attempted to transcend material reality. His pictures seem to have no context in time or space. The weightless quality of his rectangles is enhanced by their blurred edges and thin textures, which allow the underlying blue to filter through them. Whereas Pollock's light moves exuberantly across the picture plane, weaving in and out of the colors in the form of white drips, Rothko's light is luminescent. It flickers at the edges of the rectangles and shifts mysteriously from behind and in front of them. His large canvases, with their broad fields of color, can be seen as a kind of transition to Color Field painting.

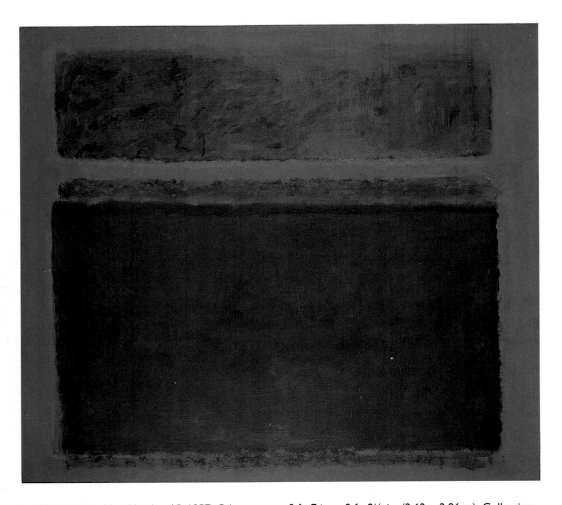

29.10 Mark Rothko, *Number 15*, 1957. Oil on canvas, 8 ft. 7 in. × 9 ft. 8½ in. (2.62 × 2.96 m). Collection of Christopher Rothko. Rothko was born in Latvia. In 1913 his family emigrated to Portland, Oregon, and in 1923 he moved to New York. Rothko suffered from depression and committed suicide in 1970. He expressed his alienation from society as follows: "The unfriendliness of society to his [the artist's] activity is difficult . . . to accept. Yet this very hostility can act as a lever for true liberation. . . . The sense of community and of security depends on the familiar. Free of them, transcendental experiences become possible."[8] Rothko's striving for freedom from the familiar is evident in the absence of recognizable forms in paintings such as this one.

Color Field Painting

At the opposite pole from the action painters are the artists who applied paint in a more traditional way. This has been variously referred to as "Chromatic Abstraction" and "Color Field painting." The latter term refers to the preference for expanses of color applied to a flat surface in contrast to the domination of line in action painting. The imagery of action painting is more in tune with Picasso and Expressionism. Color Field painters, by contrast, were influenced by Matisse's broad planes of color. Compared with action paintings, Color Field imagery is typically calm and inwardly directed, and is capable of evoking a meditative, even spiritual, response.

Helen Frankenthaler

Helen Frankenthaler (born 1928) used synthetic media (see Box) to "stain" her canvas by pouring paint directly onto it. In 1952 she visited Pollock in his studio in the Springs section of eastern Long Island. There she saw the effect of Pollock's paint on unprimed canvas, which revealed the staining process—a method that is basic to Color Field painting. *The Bay* of 1963 (fig. **29.11**) is made of thinned paint poured onto the canvas in layers of color, engulfing the picture plane. The colors are delicate and, for the most part, pastel. The blue expands over the canvas, like water filling the recess in the yellow and green areas of color. We seem to be looking down on a body of water in a landscape.

MEDIA AND TECHNIQUE
Acrylic

One of the most popular of the modern synthetic media is **acrylic,** a water-based paint. Acrylic comes in bright colors, dries quickly, and does not fade. It can be applied to paper, canvas, and board with either traditional brushes or **airbrushes.** It can be poured, dripped, and splattered. When thick, acrylic approaches the texture of oils. When thinned, it is fluid like water paint. However, in contrast to water paint, which mixes when more than one wet color is applied, acrylic can be applied in layers that do not blend even when wet. It is possible to build up several layers of paint which retain their individual hues, and thus to create a structure of pure color—as Frankenthaler does in *The Bay* (see fig. **29.11**).

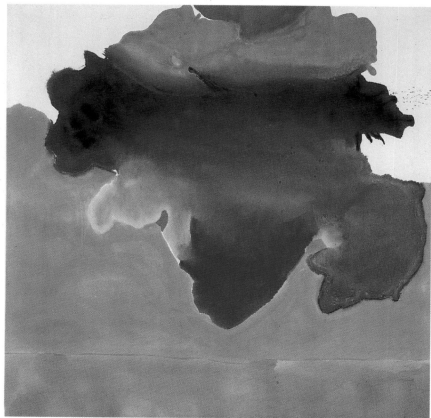

29.11 Helen Frankenthaler, *The Bay*, 1963. Acrylic on canvas, 6 ft. 8¾ in. × 6 ft. 9¾ in. (2.05 × 2.08 m). Detroit Institute of Arts (Founders Society Purchase with funds from Dr. and Mrs. Hilbert H. DeLawter).

Frank Stella

Frank Stella (born 1936) was trained in art during the heyday of the New York school of Abstract Expressionism, but he paints with a new vision of color and form. His early pictures are somber and largely monochrome. They are fitted into triangular, star-shaped, zigzag, and open rectangular frames. By varying the shape of the canvas, Stella focused on the quality of a picture as an object in itself. Within the picture, he painted stripes of flat color, separated from each other and bordered by a precise edge. This technique is sometimes referred to as Hard-Edge painting.

Tahkt-i-Sulayman I of 1967 (fig. **29.12**) belongs to Stella's "Protractor Series," in which arcs intersect as if drawn with a compass. Here, a central circle is divided into two semicircles, which are repeated symmetrically on either side by flanking semicircles. These forms are related by sweeping curves, which interlace with all three sections in a continuous, interlocking motion. The intense, bright color strips in Stella's paintings of the 1960s combine dynamic exuberance with geometric control. Since the 1960s, Stella has continued to expand his formal repertoire, evolving from reductive clarity to complex, often highly colorful three-dimensional wall sculptures of varying textures and materials.

29.12 Frank Stella, *Tahkt-i-Sulayman I*, 1967. Polymer and fluorescent paint on canvas, 10 ft. ¼ in. × 20 ft. 2¼ in. (3.05 × 6.15 m). Menil Collection, Houston, Texas. Stella has lived and worked in New York since 1958. The Near Eastern title of this painting indicates his interest in colorful Islamic patterns (which also influenced Matisse). The interlaced color strips reflect his study of Hiberno-Saxon designs (see fig. **11.6**).

Ellsworth Kelly

Ellsworth Kelly (born 1923) is another leading Hard-Edge Color Field painter, who works in the tradition of Josef Albers. His color is vibrant and arranged in large, flattened planes that sometimes seem to expand organically. In other instances—as in *Spectrum III* (fig. **29.13**)—bands of color create a temporal sequence of visual movement through the spectrum. By aligning the colors in this way, Kelly produces a tactile effect, despite the absence of modeling. The sequential arrangement of the rich hues causes a buildup of tension that proceeds through a progression of color.

In 1990 the Sidney Janis Gallery in New York mounted an exhibition titled "Classic Modernism: Six Generations." Figure **29.14** is a view of the installation with Mondrian's *Trafalgar Square* of 1939–43 on the left and Ellsworth Kelly's *Red, Yellow, Blue* of 1965 on the right. This juxtaposition illustrates the relationship between Kelly's pure primary colors, unframed and juxtaposed with Mondrian's rectangles of color bounded by firm black verticals and horizontals. Kelly has enlarged the rectangles by comparison with Mondrian and has liberated the color from Mondrian's black "frames." By organizing the two paintings in this way, the installation shows Mondrian's historical role as a link between Cubism and Color Field painting.

29.13 (Above) Ellsworth Kelly, *Spectrum III,* 1967. Oil on canvas, in 13 parts, 2 ft. 9¼ in. × 9 ft. ⅜ in. (0.84 × 2.76 m). Private collection.

29.14 Installation view of "Classic Modernism: Six Generations." On right: Ellsworth Kelly, *Red, Yellow, Blue,* 1965. Oil on canvas, 6 ft. 10 in. × 15 ft. 5 in. (2.08 × 4.70 m). On left: Piet Mondrian, *Trafalgar Square,* 1939–43. Oil on canvas, 4 ft. 9¼ in. × 3 ft. 11¼ in. (1.45 × 1.20 m). Exhibition held Nov. 15–Dec. 29, 1990, at the Sidney Janis Gallery, New York, curated by Carroll Janis. Photo courtesy of Carroll Janis, New York. © Ellsworth Kelly. © 2010 Mondrian/Holtzman Trust c/o HCR International, Virginia, USA.

West Coast Abstraction: Richard Diebenkorn

An important group of abstract painters also developed on the West Coast. It includes Richard Diebenkorn (1922–93), whose early pictures were of landscapes, often based on views of the San Francisco Bay area, and of anonymous, isolated figures reminiscent of Hopper in mysterious, rectangular settings. By the end of the 1960s, however, Diebenkorn had replaced figuration with nonrepresentational abstraction, building up layers of textured geometric shapes defined by straight lines. His monumental *Ocean Park* series (1970s–1980s) is reminiscent of the open spaces of the American West and the vast expanse of the Pacific Ocean. Most of his paintings contain a dominant horizontal, suggestive of landscape. The colors of *Ocean Park No. 129* of 1984 (fig. **29.15**), for example, evoke the blue sea, while above the horizon is a narrow strip of abstract patches of color bounded by horizontals and diagonals. Despite the evident influence of Matisse and Cubism on Diebenkorn's vision, the strict geometry of the forms is relieved by the drips and the emphasis on the paint texture, which relate his work to Abstract Expressionism.

Sculpture

Contemporary with the above developments in American and European painting were several sculptors whose work conveys a dynamic abstraction akin to both Abstract and Figurative Expressionism.

29.15 Richard Diebenkorn, *Ocean Park No. 129*, 1984. Oil on canvas, 5 ft. 6 in. × 6 ft. 9 in. (1.68 × 2.06 m). Private collection. © Estate of Richard Diebenkorn.

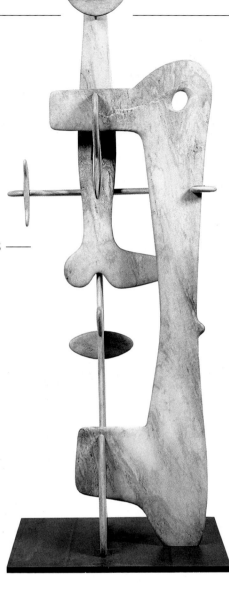

29.16 Isamu Noguchi, *Kouros*, 1944–45. Pink marble, slate base, 9 ft. 9 in. (2.97 m) high. Metropolitan Museum of Art, New York (Fletcher Fund, 1953).

ONNECTIONS

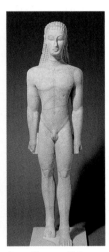

See figure 7.8. Statue of a *Kouros*, c. 590–580 B.C.

Isamu Noguchi

Kouros (fig. **29.16**), by the Japanese-American Isamu Noguchi (1904–88), contains biomorphic shapes that evoke those of Miró and Gorky. Flat, protozoan forms are arranged in interlocking horizontal and vertical planes, creating a configuration that, the artist claimed, "defies gravity." Although it conforms to the principles of twentieth-century abstraction, Noguchi's figure shares a vertical stance—softened by curvilinear stylization—with the Archaic Greek *kouros* (see fig. **7.8**).

Noguchi was born in Los Angeles in 1904 to an American mother and a Japanese father. He grew up in Japan and was a premedical student at Columbia University (1921–24). He decided to become a sculptor and worked with Brancusi, whose influence can be seen in the smooth surfaces and elegant forms of the *Kouros*. In addition to sculpture, Noguchi has produced furniture and stage designs, public sculptural gardens, and playgrounds.

David Smith

Shapes and lines combine with open space in the sculpture of David Smith (1906–65). Smith welded iron and steel to produce a dynamic form of sculptural abstraction. His last great series of work, titled *Cubi* (fig. **29.17**), is composed of cylinders, cubes, and solid rectangles. As both the title and the shapes indicate, Smith was influenced by Cubism. The works were intended to be installed outdoors (as in the illustration), their open spaces making it possible to experience the landscape through and around them. The surface, enlivened by variations of texture, contributes to the sense of planar motion in the individual shapes. Each sculpture is set against another and often at an angle to it so that the sculptures seem to move and stretch, though still firmly anchored by their pedestals.

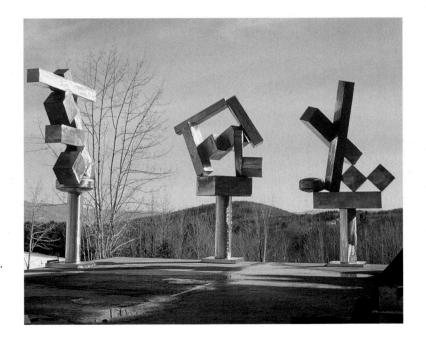

29.17 (Right) David Smith, *Cubi XVIII, Cubi XVII,* and *Cubi XIX,* 1963–64. Polished stainless steel, 9 ft. 7¾ in., 9 ft., and 9 ft 4¾ in. (2.94, 2.74, and 2.87 m) high. Courtesy, Museum of Fine Arts, Boston (Gift of Susan W. and Stephen D. Paine), Dallas Museum of Fine Arts, and Tate London, England.

Louise Nevelson

Louise Nevelson (1900–88) made assemblages consisting of "found objects"—especially furniture parts and carpentry tools—placed inside open boxes. The boxes are piled on top of each other and arranged along a wall, much like bookshelves, so that they are seen, like paintings, from only one side. Typical of these works is *Black Wall* of 1959 (fig. **29.18**), in which the framing device of the boxes orders the assembled objects. Although originally utilitarian in nature, the objects become abstractions by virtue of their arrangement. Further abstracting the assemblage from everyday experience is the fact that it is monochrome. As a result, the variety of shape and line takes precedence over the absence of color.

Many American Abstract Expressionists—some have been illustrated in this chapter—worked beyond the 1950s, when the novelty and excitement of the style was at its height. In painting, Abstract Expressionism can be seen as a logical development of the Impressionists' attention to the medium of paint. Brushstrokes became part of the critical vocabulary of Impressionism, Post-Impressionism, Fauvism, and the different forms of Expressionism. With the gestural Abstract Expressionists, paint and the way it behaved sometimes replaced narrative content entirely, emerging finally as the "subject" of painting. In sculpture as well, the texture of the medium became an increasingly significant feature of the work.

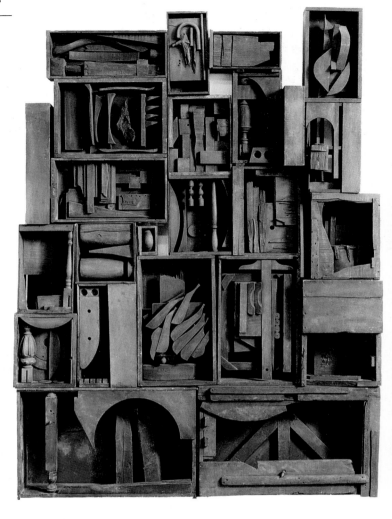

29.18 Louise Nevelson, *Black Wall,* 1959. Wood, 9 ft. 4 in. × 7 ft. 1¼ in. × 2 ft. 1½ in. (2.64 × 2.16 × 0.65 m). Tate Gallery, London, England.

c. 1930 **c. 1965**

MID-CENTURY AMERICAN ABSTRACTION

(29.3)

World War II (1939–45)

(29.16)

Albert Camus, *The Stranger* (1942)

(29.13)

Rodgers and Hammerstein, *Oklahoma!* (1943)

Atomic bomb dropped on Hiroshima (1945)

(29.5a)

Tennessee Williams, *A Streetcar Named Desire* (1947)

(29.7)

Korean War (1950–53)

(29.10)

U.S. enters Vietnam War (1962)

(29.17)

President John F. Kennedy assassinated (1963)

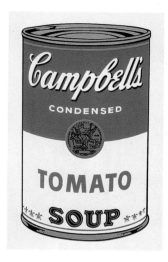

30

Pop Art, Op Art, Minimalism, and Conceptualism

In the late 1950s and 1960s, a reaction against the non-figurative and seemingly subjective character of Abstract Expressionism took the form of a return to the object. The most prominent style to emerge in America in the 1960s was "Pop," although the origins of the style are to be found in England in the 1950s. The imagery of Pop Art was derived from commercial sources, the mass media, and everyday life. In contrast to Abstract Expressionism—which viewed works of art as revelations of the artist's inner, unconscious mind—the Pop artists strove for "objectivity" embodied by an imagery of objects. The impact of Pop Art was enhanced by the mundane character of the objects selected. As a result, Pop Art was regarded by many as an assault on accepted conventions and aesthetic standards.

Despite the 1960s emphasis on the objective "here and now," however, the artists of that period were not completely detached from historical influences or psychological expression. The elevation of everyday objects to the status of artistic imagery can be traced to the early-twentieth-century taste for "found objects" and assemblage. Likewise, the widespread incorporation of letters and numbers into the new iconography of Pop Art reflects the influence of the newspaper collages produced by Picasso and Braque.

Another artistic expression of the 1960s, the so-called **happenings,** probably derived from the Dada performances at the Café Voltaire in Zurich during World War I. Happenings, in which many Pop artists participated, were multimedia events that took place in specially created environments. They included painting, assemblage, television, radio, film, and artificial lighting. Improvisation and audience participation encouraged a spontaneous, ahistorical atmosphere that called for self-expression in the here and now. Happenings were also a response to consumerism and the fact that works of art were valued as commodities. In a Happening, there is no commodity, for nothing about it—unless it is recorded or videotaped—is permanent.

Additional art movements that developed during the 1960s, which are discussed in this chapter include Op Art, which explored the kinetic effects of optical illusion; Minimalism, which attempted to eliminate the presence of the artist and focus on pure form and industrial materials; and Conceptualism, in which the idea (the concept) is theoretically more important than the work itself.

Pop Art in England: Richard Hamilton

The small collage *Just what is it that makes today's homes so different, so appealing?* (fig. **30.1**), by the English artist Richard Hamilton (born 1922), was originally intended for reproduction on a poster. It can be considered a visual manifesto of what was to become the Pop Art movement. First exhibited in London in a 1956 show titled "This Is Tomorrow," Hamilton's collage inspired an English critic to coin the term "Pop."

The muscleman in the middle of the room is a conflation of the Classical *Spear Bearer* (see fig. **7.14**) by Polykleitos and the *Medici Venus* (see fig. **15.15**). The giant Tootsie Pop directed toward the woman on the couch is at once a sexual, visual, and verbal pun. Advertising images occur in the sign pointing to the vacuum hose, the Ford car emblem, and the label on the tin of ham. Mass-media imagery is explicit in the tape recorder, television set, newspaper, and movie theater. The framed cover of *Young Romance* magazine reflects popular teenage reading of the 1950s.

Despite the iconographic insistence on what was contemporary, however, Hamilton's collage contains traditional historical references. The image of a white-gloved Al Jolson on the billboard advertising *The Jazz Singer* recalls an earlier era of American entertainment. The old-fashioned portrait on the wall evokes an artistic past, and the silicon pinup on the couch is a plasticized version of the traditional reclining nude. Hamilton's detailed attention to the depiction of objects, especially those associated with domestic interiors, reveals his respect for fifteenth-century Flemish painters, as well as his stated admiration for Duchamp.

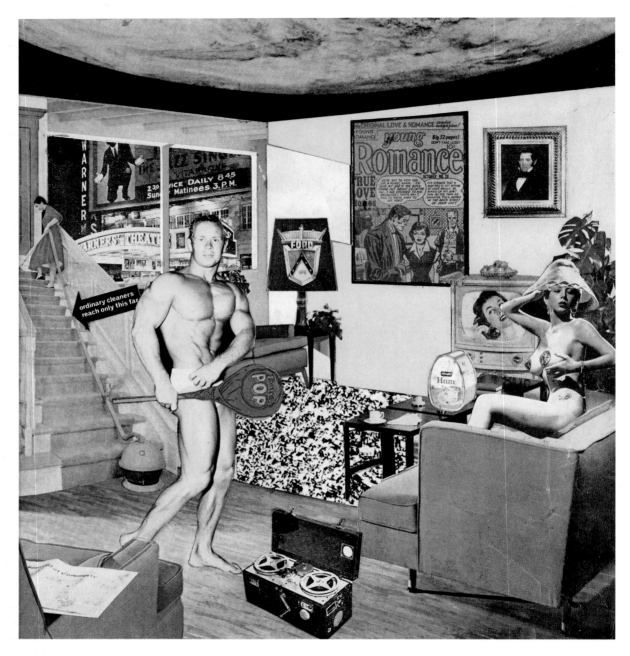

30.1 Richard Hamilton, *Just what is it that makes today's homes so different, so appealing?* 1956. Collage on paper, 10¼ × 9¼ in. (26.0 × 23.5 cm). Kunsthalle, Tübingen, Germany (Collection Zundel). As a guide for subsequent Pop artists, Hamilton compiled a checklist of Pop Art subject matter: "Popular (designed for a mass audience), transient (short-term solution), expendable (easily forgotten), low-cost, mass-produced, young (aimed at youth), witty, sexy, gimmicky, glamorous, big business."

CONNECTIONS

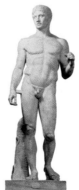

See figure 7.14.
Polykleitos, *Doryphoros (Spear Bearer),* c. 440 B.C.

See figure 15.15.
Medici Venus,
1st century A.D.

534

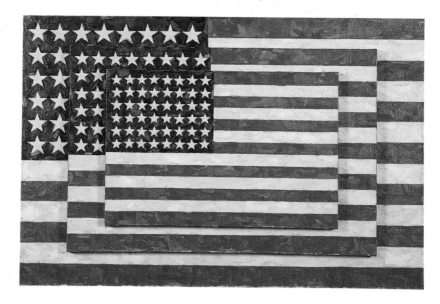

30.2 Jasper Johns, *Three Flags*, 1958. Encaustic on canvas, 30⅞ × 45½ × 5 in. (78.4 × 115.6 × 12.7 cm). Collection, Whitney Museum of American Art, New York (50th Anniversary Gift of Gilman Foundation, Lauder Foundation, A. Alfred Taubman, anonymous donor, purchase).

Pop Art in the United States

Although Pop Art made its debut in London in 1956 and continued in England throughout the 1960s, it reached its fullest development in New York. In 1962 an exhibition of the New Realists at the Sidney Janis Gallery gave Pop artists official status in the New York art world. Pop Art, however, was never a homogeneous style, and within this classification are many artists whose imagery and technique differ significantly. The first two artists discussed here—Jasper Johns and Robert Rauschenberg—are actually transitional between Abstract Expressionism and Pop Art, for they combine textured, painterly brushwork with a return to the object.

Jasper Johns

One of the constant themes of Jasper Johns (born 1930) is the boundary between everyday objects and the work of art. In the late 1950s he chose a number of objects whose representation he explored in different ways, including the map and flag of the United States, targets, and stenciled numbers and words. In *Three Flags* of 1958 (fig. **30.2**), Johns depicts a popular image that is also a national emblem. His flags are built up with superimposed canvas strips covered with wax **encaustic**—a combination that creates a pronounced sense of surface texture. "Using the design of the American flag," Johns has been quoted as saying, "took care of a great deal for me because I didn't have to design it." The flag is abstract insofar as it consists of pure geometric shapes (stars and rectangles), but it is also an instantly recognizable, familiar object. The American flag

has its own history, and the encaustic medium that Johns used to paint it dates back to antiquity (see Chapter 7). It thus combines the painterly qualities of Abstract Expressionism with the representation of a well-known and popular object. One question raised by Johns's treatment of this subject is: "When does the flag cease to be a patriotic sign or symbol and become an artistic image?"

In Johns's painted bronze casts of cans of Ballantine Ale (fig. **30.3**), he retains the painterly texture of the *Three Flags*. As a Pop artist, Johns deals with themes of commercialism and repeated imagery versus the unique work of art. In this case, he draws commercial objects into the realm of art but, in contrast to Duchamp (see Chapter 28), Johns makes the artist's presence visible in the artistic process. In repeating the ale cans, Johns has created an imposing pair of cylinders. The more we look at them, the more we have the impression that they are standing up and looking back at us.

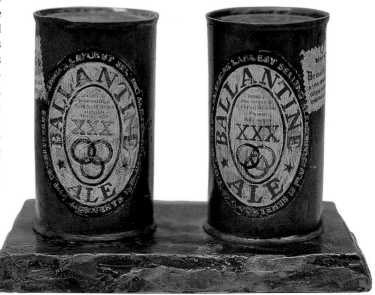

30.3 Jasper Johns, *Painted Bronze (Ale Cans)*, 1960. Painted bronze, 5½ × 8 × 4¾ in. (14.0 × 20.3 × 12.1 cm). Museum Ludwig, Cologne. Photo: Rheinisches Bildarchiv Köln, ML 1439.

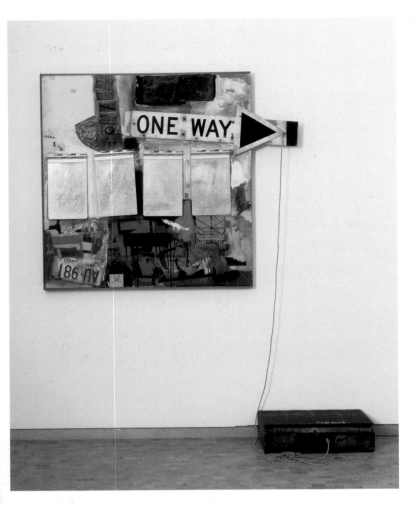

30.4 Robert Rauschenberg, *Black Market*, 1961. Canvas, wood, metal, and oil paint, 59¾ × 50 × 4 in. (152 × 127 × 10 cm). Museum Ludwig, Cologne, Germany. Photo: Reinisches Bildarchiv Köln, rba_c007677.

The **silk-screen** print of 1964, *Retroactive I* (fig. **30.5**), is an arrangement of cutouts resembling a collage. It illustrates the artist's expressed wish to "unfocus" the mind of the viewer by presenting simultaneous images that are open to multiple interpretations. The newspaper imagery evokes current events, reflecting the contemporary emphasis of Pop Art. A returning astronaut parachutes to earth in the upper left frame, while in the center President Kennedy, who had been assassinated the previous year, extends his finger as if to underline a point. The frame at the lower right reveals a historical thread behind Rauschenberg's "current events" iconography. It contains a blowup of a stroboscopic photograph of a takeoff on Duchamp's *Nude Descending a Staircase* (see fig. **27.15**).

Despite the presence of media images in this print, Rauschenberg seems to have covered it with a thin veil of paint. Brushstrokes and drips running down the picture's surface are particularly apparent at the top. The dripping motion of paint parallels the fall of the astronaut, while one drip lands humorously in a glass of liquid embedded in the green patch on the right. More hidden, or "veiled," is the iconographic parallel between the falling paint, the astronaut, and the "Fall of Man."

Robert Rauschenberg

Robert Rauschenberg (1925–2008) was as liberal in his choice of imagery as Johns was frugal. His sculptures and "combines"—descendants of Duchamp's ready-mades and Picasso's assemblages—include stuffed animals, quilts, pillows, and rubber tires. His paintings contain images from a wide variety of sources, such as newspapers, television, billboards, and old masters.

The combine titled *Black Market* of 1961 (fig. **30.4**) combines elements of painting, photography, and sculpture. A canvas hanging on the wall is attached by a cord to a wooden box marked "OPEN" on the floor. The canvas contains a variety of objects, as well as thickly painted brushstrokes. Dominating the center are four notebooks with metal covers, and above them a slightly diagonal "ONE WAY" sign points to the cord, leading our gaze to the box on the floor. An upside-down Ohio license plate tilts in the lower left and a photograph of the U.S. capitol dome is visible under the right notebook. The iconograpy of this combine points to features of American travel, while the technique and media combine collage with assemblage. On the one hand, Rauschenberg's brushwork is related to Abstract Expressionist gesture painting and, on the other, his use of everyday objects is a feature of Pop Art.

30.5 Robert Rauschenberg, *Retroactive I*, 1963. Silk-screen print with oil on canvas, 7 × 5 ft. (2.13 × 1.52 m). Wadsworth Athenaeum, Hartford, Connecticut (Gift of Susan Morse Hilles).

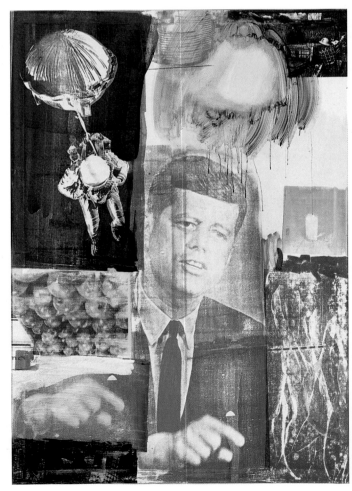

Andy Warhol

Andy Warhol (1928–87) was the chief example of the Pop Art lifestyle, as well as the creator of highly individual works of art. With his flair for multimedia events and self-promotion, Warhol turned himself into a work of Pop Art and became the central figure of a controversial cult. One of his most characteristic works, *Campbell's Soup I (Tomato)* of 1968 (fig. **30.6**), illustrates his taste for commercial images. The clear precision of his forms and the absence of any visible reference to paint texture intensify the confrontation with the object represented—with the object as object. Warhol's famous assertion "I want to be a machine" expresses his obsession with mass production and his personal identification with the mechanical, mindless, repetitive qualities of mass consumption.

Warhol's iconography is wide-ranging. In addition to labels advertising products, he created works that monumentalize commercial American icons. These include Coca-Cola bottles, Brillo and Heinz boxes, comic books, matchbook covers, green stamps, dollar bills, and so forth. He also produced portraits of iconic American heroes and heroines—John F. Kennedy, Jackie Kennedy, Marilyn Monroe, Elvis Presley, Elizabeth Taylor, Marlon Brando, and Troy Donahue. Icons have a mythic quality, and Warhol did a myth series that included Superman, Howdy Doody, Mickey Mouse, Uncle Sam, Dracula, and the Wicked Witch of Oz.

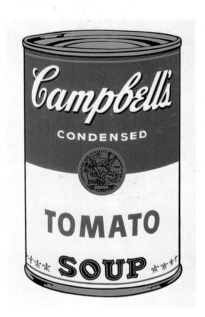

30.6 Andy Warhol, *Campbell's Soup (Tomato).* 1968. One from a portfolio of screenprints on paper, 35 × 23 in. (88.9 × 59.4 cm). The Andy Warhol Foundation, Inc./Art Resource, NY. © 2011 Andy Warhol Foundation/Artists Rights Society (ARS), New York/Trademarks, Campbell's Soup Company. All rights reserved.

In *Elvis I & II* (fig. **30.7**), Warhol depicts an icon of American pop culture in the traditional diptych format. He juxtaposes a black-and-white pair of images with a colored pair, creating the impression of photographic repetition. Elvis himself is shown in an aggressive stance with gun drawn, transforming the conventional cowboy image into that of a pop star.

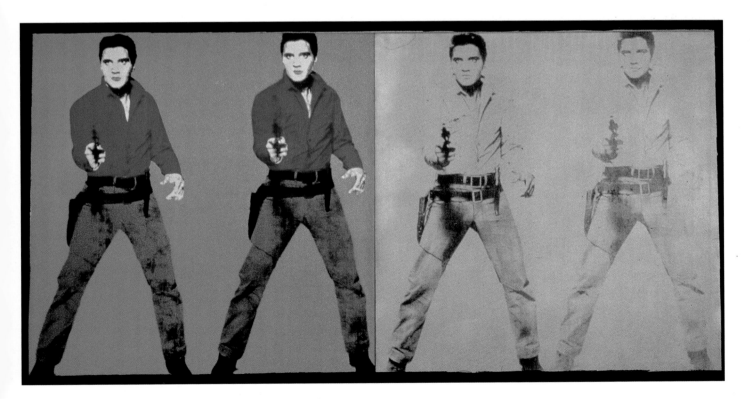

30.7 Andy Warhol, *Elvis I & II*, 1964. Two panels. Synthetic polymer paint and silk-screen ink on canvas, aluminum paint and silk-screen ink on canvas, each panel 6 ft. 10 in. × 6 ft. 10 in. (2.10 × 2.10 m). The Andy Warhol Foundation, Inc./Art Resource, NY. © 2011 The Andy Warhol Foundation for the Visual Arts, Inc./Artists Rights Society (ARS), New York.

30.8 Roy Lichtenstein, *Torpedo . . . Los!* 1963. Oil on canvas, 5 ft. 8 in. × 6 ft. 8 in. (1.73 × 2.03 m). © Estate of Roy Lichtenstein.

Roy Lichtenstein

Comic books provided the source for some of the best-known images by Roy Lichtenstein (1923–97). He monumentalized the flat, clear comic-book drawings with "balloons" containing dialogue. *Torpedo . . . Los!* (fig. **30.8**) is a blowup inspired by a war comic, illustrating a U-boat captain launching a torpedo. The impression of violence is enhanced by the close-up of the figure's open mouth and scarred cheek. The absence of shading, except for some rudimentary hatching, and the clear, outlined forms replicate the character of comic-book imagery.

Tom Wesselmann

The *Great American Nude* series by Tom Wesselmann (1931–2004) combines Hollywood pinups with the traditional reclining nude. In *No. 57* (fig. **30.9**) the nude is a symbol of American vulgarity. She lies on a leopard-skin couch, and two stars on the back wall evoke the American flag. She is faceless except for her open mouth, and her body bears the suntan traces of a bikini. Her pose is related to traditional reclining nudes such as Giorgione's *Sleeping Venus* (see fig. **16.29**), but Wesselmann's surfaces are unmodeled, although they still appear to have volume. The partly drawn curtain reveals a distant landscape, and the oranges and flowers refer to the woman's traditional role as a fertile earth goddess. This metaphor is reinforced by the formal parallels between the mouth, the nipples, and the interior of the flowers. In this work, Wesselmann combines three-dimensional forms with flattened geometric abstraction, the interior bedroom with exterior landscape, and specificity with universal themes.

Wayne Thiebaud

The West Coast artist Wayne Thiebaud (born 1920) arranges objects in a self-consciously ordered manner. Although identified with Pop Art, he emphasizes the texture of paint. In the 1960s Thiebaud focused on cafeteria-style food arrangements, but his content in the following decades includes a wide range of objects, portraits, and atmospheric images of cloud formations and landscape.

His *Thirteen Books* of 1992 (fig. **30.10**) depicts a neat pile of books, which has a constructed, architectural quality that is enhanced by the oblique angle. Each book functions

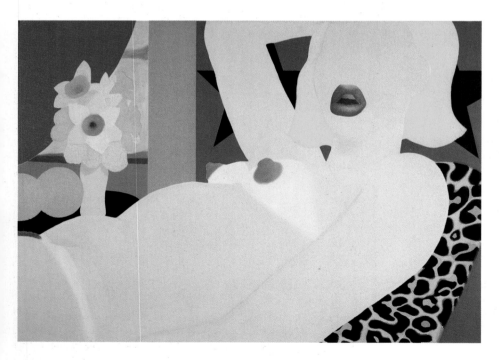

CONNECTIONS

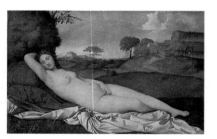

See figure 16.29. Giorgione, *Sleeping Venus*, c. 1509.

30.9 Tom Wesselmann, *Great American Nude No. 57*, 1964. Synthetic polymer on composition board, 4 ft. × 5 ft. 5 in. (1.22 × 1.65 m). Whitney Museum of American Art, New York (Purchase).

as an individual structural element that nevertheless contributes to the effect of the whole. The textured edges of the books and the bright colors of their spines contrast with the stark, white background. The titles are blurred and unreadable, thereby suggesting the hidden, secret content of the proverbial "closed book."

To the right of the stack, there is no distinction between the surface supporting the books and the background space. This leaves the viewer uncertain of their exact placement in space—they seem to float in a plane of white. At the left, on the other hand, the books cast a gray, trapezoidal shadow edged in orange, which identifies a source of light and confirms the presence of a supporting surface. The predominance of white is characteristic of the artist's paintings of objects. White was of particular interest to Thiebaud because it combines all colors while simultaneously absorbing and reflecting light.

30.10 (Above) Wayne Thiebaud, *Thirteen Books*, 1992. Oil on panel, 13 × 10 in. (33.0 × 25.4 cm). Allan Stone Gallery, New York.

Sculpture

Generally included among the leading New York Pop artists are the sculptors Claes Oldenburg (born 1929) and George Segal (1924–2000). Although both can be considered Pop artists in the sense that their subject matter is derived from everyday objects and the media, their work is distinctive in maintaining a sense of the textural reality of their materials.

George Segal

The sculptures of George Segal are literally "figurative." Segal creates environments in which he sets figures, singly or in groups, that appear isolated and self-absorbed. He also uses his technique of "wrapping" living people in plaster for portraiture. His *Portrait of Sidney Janis with Mondrian Painting* (fig. **30.11**) is about looking and seeing, as well as the development of twentieth-century abstraction. His own figuration is combined with the nonfigural, geometric abstraction of Mondrian. Segal has described Janis's gesture as a caress, expressing his kinship with the Mondrian. In 1932, before becoming an art dealer, Janis bought the painting for seventy-five dollars for his private collection. Thirty years later, when Segal did the portrait, he suggested including the Mondrian, which is

30.11 George Segal, *Portrait of Sidney Janis with Mondrian Painting*, 1967. Plaster figure with Mondrian's *Composition*, 1933, on an easel. Figure: 66 in. (167.6 cm) high; easel: 67 in. (170 cm) high; overall: 69⅞ × 56¼ × 27¼ in. (177.5 × 142.9 × 69.2 cm). The Sidney and Harriet Janis Collection (653.1967.a–b). Museum of Modern Art, New York. © 2010 Mondrian/Holtzman Trust c/o HCR International, Virginia, USA. Art © The George and Helen Segal Foundation/Licensed by VAGA, New York, NY. Janis was Segal's dealer and a champion of the avant-garde. He mounted exhibitions of Duchamp, Mondrian, Brancusi, and the Abstract Expressionists before the "New Realists" show of 1962.

removable and has been exhibited separately. In contemplating the Mondrian, Janis symbolically gazes on the art of the past, on the work of a seminal artist of the twentieth century, while also participating in Segal's expression of the contemporary.

Claes Oldenburg

Like Warhol, Claes Oldenburg has produced an enormous, innovative body of imagery, ranging from clothing, light switches, food displays, and furniture sets to tea bags. His giant *Clothespin* of 1976 in Philadelphia (fig. **30.12**) illustrates his enlargement of objects that are small in everyday experience. *Clothespin* has an anthropomorphic quality.

It resembles a tall man, standing with his legs apart, as if striding forward. The wire spring suggests an arm, and the curved top with its two semicircular openings, a head and face. Despite the hard texture of this work, Oldenburg manages to arouse a tactile response by association with actual clothespins. Pressing together the "legs," for example, would cause the spring to open up the spaces at the center of the "head." The tactile urge aroused by the clothespin, together with its anthropomorphic character, reflects Oldenburg's talent for conveying paradox and metaphor. The clothespin thus assumes the quality of a visual pun, which is reminiscent of Picasso's *Bull's Head* (see fig. **27.8**) and of the unlikely, surprising juxtapositions of the Surrealist aesthetic that were calculated to raise the consciousness of the viewer.

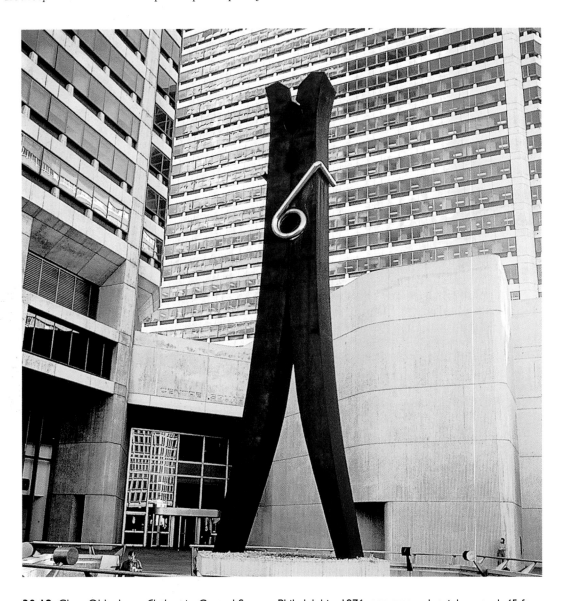

30.12 Claes Oldenburg, *Clothespin*, Central Square, Philadelphia, 1976. COR-TEN and stainless steel, 45 ft. × 6 ft. 3¾ in. × 4 ft. 4 in. (13.7 × 1.92 × 1.32 m). This is one of several "projects for colossal monuments," based on everyday objects, that Oldenburg proposed for various cities. Others include a giant *Teddy Bear* for New York, a *Drainpipe* for Toronto, and a *Lipstick* for London (presented to Yale University in 1969). Oldenburg says that he has always been "fascinated by the values attached to size."

Niki de Saint-Phalle

Niki de Saint-Phalle (1930–2002) was born in Paris, grew up in New York, and returned to Paris in 1951. There she began painting and making combinations of reliefs and assemblages, using toys as a primary medium. She was originally part of the French *nouveaux réalistes,* a group of artists that was formed in 1960. In New York, these artists were termed the New Realists, which was also the title of the exhibition held in 1962 at the Sidney Janis Gallery.

De Saint-Phalle's most characteristic works are her so-called *Nanas,* which are polyester sculptures of large women. Generally, as with her *Black Venus* of 1965–67 (fig. **30.13**), the *Nanas* are painted in bright, unshaded colors that are reminiscent of folk imagery. The torso of this figure looks inflated, ironically even more so than the beach ball, which seems to be losing its air. De Saint-Phalle's *Venus* shares exaggerated breasts and hips with the Paleolithic *Venus of Willendorf* (see fig. **3.1**), but the head is small by comparison, a device that has a Mannerist quality. The figure seems engaged in an energetic dance movement, which, together with its "blackness," allies it with the exuberance and modernism of jazz.

──────── **CONNECTIONS** ────────

See figure 3.1.
Venus of Willendorf,
c. 25,000–21,000 B.C.

30.13 Niki de Saint-Phalle, *Black Venus,* 1965–67. Painted polyester, 110 × 35 × 24 in. (279.0 × 88.5 × 61.0 cm). Whitney Museum of American Art, New York (Gift of Howard and Jean Lipman Foundation).

Marisol Escobar

Marisol Escobar's (born 1930) brand of Pop Art combines Cubist-inspired blocks of wood with figuration. In her monumental sculptural **installation** of *The Last Supper* (fig. **30.14**), she re-creates Leonardo's fresco (see fig. **16.10**) in a modern idiom. The architectural setting replicates the Leonardo, with four rectangular panels on either side that recede toward a back wall, a triple window, and a curved pediment. The apostles, like Leonardo's, are arranged in four groups of three, with corresponding poses. An image of Marisol herself sits opposite the scene, playing the role of viewer as well as artist. As viewer, Marisol contemplates the past, which she appropriates.

CONNECTIONS

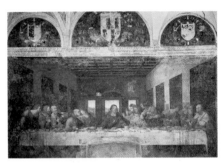

See figure 16.10. Leonardo da Vinci, *Last Supper*, c. 1495–98.

Op Art

Another artistic movement that flourished during the 1960s has been called Optical, or Op, Art. In 1965 the Museum of Modern Art contributed to the vogue for the style by including it in an exhibition titled "The Responsive Eye." But Op Art is akin to Pop Art in rhyme only, for the recognizable object is totally eliminated from Op Art in favor of geometric abstraction, and the experience is exclusively retinal. The Op artists produced kinetic effects using arrangements of color, lines, and shapes, or some combination of these elements.

In *Aubade (Dawn)* of 1975 (fig. **30.15**), by the British painter Bridget Riley (born 1931), there are evident affinities with Albers and the Color Field painters. Riley has arranged pinks, greens, and blues in undulating vertical curves of varying widths, evoking the vibrancy of dawn itself. The changing width of each line, combined with the changing hues, makes her picture plane pulsate with movement.

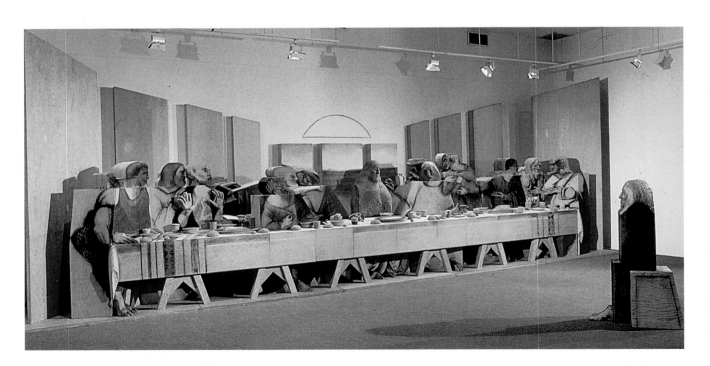

30.14 Marisol Escobar, *The Last Supper* (installed at the Sidney Janis Gallery), 1982. Wood, brownstone, plaster, paint, and charcoal, 10 ft. 1 in. × 29 ft. 10 in. × 5 ft. 7 in. (3.07 × 9.09 × 1.70 m). Photo courtesy of Carroll Janis, New York. Art © Marisol Escobar / Licensed by VAGA, New York, NY.

30.15 (Left) Bridget Riley, *Aubade (Dawn)*, 1975. Acrylic on linen, 6 ft. 10 in. × 8 ft. 1½ in. (2.08 × 2.73 m). Private collection. © Bridget Riley 2010. All rights reserved. Courtesy Karsten Schubert, London. Riley's work generally relies on two effects—producing a hallucinatory illusion of movement (as here) or encouraging the viewer to focus on a particular area before using secondary shapes and patterns to intrude and disturb the original perception. Riley's early Op Art pictures were in black and white and shades of gray. In the mid-1960s she turned to color compositions such as this one.

Minimalism

Sculptures of the 1960s "objectless" movement were called "minimal," or "primary," structures because they were direct statements of solid geometric form. In contrast to the personalized process of Abstract Expressionism, Minimalism, like Color Field painting, tries to eliminate all sense of the artist's role in the work, leaving only the medium for viewers to contemplate. There is no reference to narrative or to nature, and no content beyond the medium itself. The impersonal character of Minimalist sculptures is intended to convey the idea that a work of art is a pure object having only shape and texture in relation to space.

Donald Judd

Untitled (fig. **30.16**) by Donald Judd (1928–94) is a set of rectangular "boxes" derived from the solid geometric shapes of David Smith's *Cubi* series (see fig. **29.17**). Judd's boxes, however, do not stand on a pedestal. Instead, they hang from the wall. They are made of galvanized iron and painted with green lacquer, reflecting the Minimalist preference for industrial materials. Judd has arranged the boxes vertically, with each one placed exactly above another at regular intervals, to create a harmonious balance. The shadows cast on the wall, which vary according to the interior lighting, participate in the design. They break the monotony of the repeated modules by forming trapezoids between boxes and between the lowest box and the floor. The shadows also emphasize the vertical character of the boxes by linking them visually and creating an impression of a nonstructural pilaster.

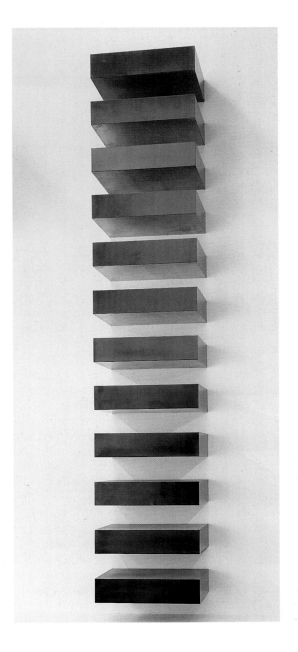

30.16 Donald Judd, *Untitled*, 1967. Green lacquer on galvanized iron, each unit 9 × 40 × 31 in. (23 × 102 × 79 cm). Museum of Modern Art, New York (Helen Achen Bequest and gift of Joseph A. Helman).

See figure 13.21.
Nave, Reims Cathedral,
1211–c. 1290.

30.17 Dan Flavin, *Untitled (in Honor of Harold Joachim), 3,* 1977. Pink, yellow, blue, and green fluorescent light, 8 ft. (2.44 m) square across a corner. Photo: Florian Holzherr. Courtesy Dia Art Foundation. Collection Dia Art Foundation, New York.

Dan Flavin

Light is the primary medium of the Minimalist fluorescent sculptures of Dan Flavin (1933–96). As store-bought objects transformed into "art" by virtue of the artist's intervention, they can be related to Duchamp's ready-mades. Flavin defines interior architectural spaces with tubes of fluorescent lights arranged in geometric patterns or shapes. Light spreads from the tubes and infiltrates the environment. The technological character of the medium and its impersonal geometry are typical of the Minimalist aesthetic. Sometimes, as in *Untitled (in Honor of Harold Joachim)* (fig. **30.17**), the color combinations are unexpected. Flavin's merging of light and color, dependent as it is on technology and twentieth-century nonrepresentation, nevertheless has a spiritual quality that, ironically, allies his work with stained-glass windows and the play of light and color inside Gothic cathedrals (see fig. **13.21**).

Flavin described this work as a "corner installation . . . intended to be beautiful, to produce the color mix of a lovely illusion. . . . [He] did not expect the change from the slightly blue daylight tint on the red rose pink near the paired tubes to the light yellow midway between tubes and the wall juncture to yellow amber over the corner itself."[1]

Agnes Martin

The early work of Agnes Martin (1912–2004) was an inspiration to the Minimalists, but she developed in a more painterly direction. She was born in Saskatchewan, Canada, and moved to the United States in the 1930s. Her first one-woman show was held at the Betty Parsons Gallery in New York City. Martin's early all-over grid paintings consisted of grids penciled by hand that crisscrossed the canvas, which appeared, like Minimalist sculpture, to "minimalize" the presence of the artist. In contrast to the Minimalists, however, Martin filled the picture plane with glowing color that seems to radiate from an inner mental landscape projected beneath the material surface of the work. In so doing, she revealed affinities with the vast—because they were conceptually vast—pictorial spaces of Mark Rothko.

From 1967 to 1974, Martin took a "sabbatical" from painting and traveled through Canada and the American West, finally settling into an isolated existence in New Mexico. When she returned to painting in the 1970s, her work had changed, progressing even further beyond the material world—possibly influenced by her interest in Far Eastern philosophy. *Untitled #9* (fig. **30.18**) is an example

of her work in 1990. The all-over grid has been replaced by gray horizontal bands that potentially extend beyond the confines of the frame. Their geometry and the fact that the grays lighten as they rise present an image that combines the structure of architecture with the changing, cyclical quality of nature.

The following are excerpts from Martin's writings that were selected to accompany her exhibition of 1992–93 at the Whitney Museum of American Art in New York:

> I didn't paint the plane
> I just drew this horizontal line
> Then I found out about all the other lines
> But I realized what I liked was the horizontal line
>
> Art restimulates inspirations and awakens sensibilities
> That's the function of art
>
> Any thing is a mirror.
> There are two endless directions. In and out.[2]

30.18 (Above) Agnes Martin, *Untitled #9*, 1990. Synthetic polymer and graphite on canvas, 6 × 6 ft. (1.83 × 1.83 m). Whitney Museum of American Art, New York (Gift of the American Art Foundation 92.60).

Eva Hesse

The American sculptor Eva Hesse (1936–70) took Minimalism in a new direction by consciously "writing" her autobiography into her work. As a result, she is sometimes referred to as a Post-Minimalist. Hesse's *Metronomic Irregularity I* of 1966 (fig. **30.19**), the first in a series of three, explores the relationship of line to plane in a literal way. The surfaces of the rectangles are inscribed with a grid pattern; there is a small hole in the corner of each square of the grid. White cotton-covered wires are threaded from holes in one rectangle through holes in another. Formally, Hesse has juxtaposed actual, three-dimensional lines (the threads) with the flat planes of the two vertical plaques. The space between them participates in the image, creating a nonrepresentational triptych in which medium and content converge. From an autobiographical point of view, one can read the threads as attachments, binding together the plaques across a space, as a metaphor for Hesse's fear of separation and abandonment, and also as links between her two identities, German and American. Her lifelong sense of anxiety is perhaps reflected in the frantic, though lyrical, quality of the connecting threads.

30.19 Eva Hesse, *Metronomic Irregularity I*, 1966. Painted wood, Sculp-Metal, and cotton-covered wire, 12 × 18 × 1 in. (30.5 × 45.7 × 2.5 cm). Museum Wiesbaden, Germany. © The Estate of Eva Hesse. Hauser & Wirth Zürich London. Hesse was born a Jew in Hamburg, Germany, and was taken to Amsterdam to escape Nazi persecution. After a few traumatic years, she went with her family to New York, where her mother committed suicide. Hesse's psychological difficulties and sense of abandonment found expression in an art that was rooted in the forms and materials of Minimalism. She studied at the Yale School of Art, where she came under the influence of Josef Albers, and after graduation returned to Germany. She had her first solo exhibition in Düsseldorf in 1965, and, by the time of her own early death at the age of thirty-four, she had produced an influential body of work.

30.20 Joseph Kosuth, *Art as Idea as Idea*, 1966. Mounted photostat, 4 × 4 ft. (1.22 × 1.22 m).

pāint'ing, *n.* **1.** the act or occupation of covering surfaces with paint.
2. the act, art, or occupation of picturing scenes, objects, persons, etc. in paint.
3. a picture in paint, as an oil, water color, etc.
4. colors laid on. [Obs.]
5. delineation that raises a vivid image in the mind; as, word-*painting*. [Obs.]

Conceptualism

The Conceptual artists of the 1960s wanted to extend Minimalism so that even the materials of art would be eliminated, leaving only the idea, or concept, of the art. Like Duchamp and the Dadaists, for the Conceptualists the mental concept takes precedence over the object. This is also related to the Minimalist rejection of the object as a consumer product. Although the term itself was coined in the 1960s, Conceptual art attained official status through the 1970 exhibition at the Museum of Modern Art, in New York. The show's title—*Information*—reflected the emphasis of Conceptual art on language and text, rather than on imagery.

Joseph Kosuth

Some Conceptual works combine objects with text, and others, such as Joseph Kosuth's (born 1945) *Art as Idea as Idea* of 1966 (fig. **30.20**), consist only of text. The "text" in this instance is composed of five dictionary definitions of the noun *painting*. Definition numbers 4 and 5, which are marked "Obs.," or "obsolete," describe the term in its most painterly ("colors laid on") and pictorial ("vivid image") sense. Their "obsolescence," therefore, is consistent with the takeover by the idea and with the presumed demise of the object. At the same time, however, Kosuth presents the text as a photographic enlargement within a pictorial field. As a result, the text is as much an "object" as it is the expression of an idea.

30.21 Sol LeWitt, *Serial Project, I (ABCD)*, 1966. Baked enamel on steel units over baked enamel on aluminum, 1 ft. 8 in. × 13 ft. 7 in. × 13 ft. 7 in. (50.8 × 398.9 × 398.9 cm). Museum of Modern Art, New York.

Sol LeWitt

Sol LeWitt (1928–2007) worked as a Minimalist in the early 1960s, using industrial materials to create geometric, often serial constructions placed on the floor. For example, he might start with a cube, as shown in figure **30.21**, and explore its various possible combinations. Some are open cubes, others are closed; some are tall and slim; others are shorter and wider. All are made of aluminum and painted in glossy white on a gray surface.

In 1967 LeWitt published what is considered a "manifesto" of Conceptualism—*Paragraphs on Conceptual Art.*

He summed up his approach as follows: "When an artist uses a conceptual form of art, it means that all of the planning and decisions are made beforehand and the execution is a perfunctory affair."[3] To this effect, LeWitt made a series of "wall drawings," for which he sold the instructions rather than the finished work. The first installation of *Wall Drawing No. 681 C,* for example, was done in 1993 at the National Gallery in Washington, D.C. (fig. **30.22**). The instructions accompanying the caption are also a description of the work, which has enormous aesthetic appeal despite the artist's insistence that the concept takes precedence over the final product.

30.22 Sol LeWitt, *Wall Drawing No. 681 C. A wall divided vertically into four equal squares separated and bordered by black bands. Within each square, bands in one of four directions, each with color ink washes superimposed,* first installation, 1993. Color ink washes (wall installation), 10 × 37 ft. (3.0 × 11.2 m). National Gallery of Art, Washington, D.C. (The Dorothy and Herbert Vogel Collection, Gift of Dorothy Vogel and Herbert Vogel, Trustees 1993.41.1).

Action Sculpture: Joseph Beuys

The German artist Joseph Beuys (1921–86), like Eva Hesse, was significantly affected by World War II, although in an entirely different way. He flew a Stuka for the Luftwaffe and was shot down by the Russians in 1943. This led Beuys to construct an autobiographical myth that continually informed his art and has become a staple of art-world mythology. According to Beuys, he was rescued by Tartars (a Mongolian people of central Asia) and wrapped in animal fat and felt, which kept him alive. Beuys viewed this event as a kind of resurrection through which he identified with Christ. Influenced by German Romanticism and Germanic myth, and impelled to atone for the German atrocities in the war, Beuys was drawn to mysticism and spirituality, and projected the self-image of a shaman on an international scale. He set out to cure the social, economic, and political ills of the world, and to this purpose he dedicated thousands of drawings, sculptures, and, above all, a series of carefully choreographed so-called action sculptures with moving figures and music, conceived of as neither happenings nor performances, but containing elements of both.

Like Marc (see p. 474), Beuys believed in the spirituality of animals and, like Kandinsky (see p. 472), in the spiritual in art. As a shaman, he played with the boundary between human and animal, just as politically he worked toward peace between nations and cultures by crossing borders and merging boundaries.

In 1974 Beuys performed one of his most famous action sculptures, *Coyote, I Like America and America Likes Me* (fig. **30.23**). He arrived in New York and was taken, wrapped in felt, by ambulance to the René Block Gallery. For a week he and a live coyote performed the sculpture on the floor of the gallery, which had a pile of felt for the coyote to sit on. Fifty copies of the *Wall Street Journal* were placed on the floor every day as a sign of the financial values overwhelming modern culture. Beuys was wrapped up in a tentlike felt blanket with a Tartar's crook emerging from the top. As he moved, the coyote moved, and vice versa. Tied together by their gazes, at once uniting them and signifying their mutual suspicion, Beuys and the coyote engaged in a dance calculated, shamanlike, to blur the boundaries between man and animal.

30.23 Joseph Beuys, *Coyote, I Like America and America Likes Me*, 1974. Action sculpture, New York, one view of a weeklong sequence.

Many meanings have been read into this performance, most based on Beuys's autobiographical myth. The Tartar's felt that kept him alive protects him from the wild animal, while the crook has associations with Christ as the Good Shepherd. To celebrate the plane crash and his rescue at the Eurasian border of two continents, Beuys tries to bridge the borders of human and animal, of the Native American worship of the coyote and the white man's fear and hatred of it, and of modern commercial society and the values of a less technological age.

The aesthetic quality of this action sculpture is in the planned and unplanned movements and positions of the two performers, and the lighting and setting as captured by the camera. Figure **30.23** shows the coyote gazing fixedly at the triangular felt "tent," with the crook protruding at the top in the manner of a Native American tepee. The close-up camera angle captures the simultaneity of movement as both figures turn in space, and the diagonal of the coyote's head and neck parallels that of the crook. The nature of the relationship, Beuys seems to be saying, moves dynamically from enmity to suspicious contemplation to mutual assessment to harmony. Such was his program for world peace.

The 1960s were a decade of social and political upheaval both in the United States and in Western Europe. This upheaval culminated in the Paris riots of May 1968, campus takeovers by college students, and radical changes in educational curricula. The burgeoning women's movement, advances in civil rights—especially in the United States—

and, above all, the Vietnam War contributed to the cultural turmoil. In the arts, these currents were expressed in the here-and-now character of happenings and other types of artistic performances, in the protests against commercialism implied by some Pop Art, in the withdrawal from figuration by the Minimalists, and in the exaltation of the idea by the Conceptualists.

The contradictory aspect of the 1960s, in which two generations clashed over social and political issues, was reflected in the arts. On the one hand, Pop artists imposed the "object" by making it a central image; on the other hand, they protested against the abuses of materialism and the profit motives of industry. Minimalists avoided the "figurative" object in favor of geometric form but used industrial materials to do so, and many Conceptual artists gave preference to the idea of a work over the work itself. In Chapter 31, the final chapter, we shall see that it is in the nature of art to evolve dynamically by continually responding to the past while also "pushing the envelope" into the future.

c. 1950

c. 1990

POP ART, OP ART, MINIMALISM, AND CONCEPTUALISM

 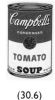

(30.2) (30.4) (30.6) (30.8) (30.13) (30.22)

Samuel Beckett, *Waiting for Godot* (1952)

Fidel Castro becomes premier of Cuba (1959)

Cuban missile crisis (1962)

Betty Friedan, *The Feminine Mystique* (1963)

The Autobiography of Malcolm X (1963)

Hair, first rock musical (1967)

Martin Luther King Jr. assassinated (1968)

Apollo II lands on the moon (1969)

End of Vietnam War (1973)

Communist governments fall in Eastern Europe (1989)

31

Continuity, Innovation, and Globalization

As we respond to contemporary art, our sense of historical perspective inevitably diminishes. The more recent the date, the more necessary is the passage of time before one can properly evaluate a work of art and assess whether or not it will last. Accordingly, of all the chapters in this survey, this is the most subject to reevaluation.

In recent works of art, age-old themes are expressed in new ways, through modern as well as traditional media. Portraits and self-portraits, for example, have claimed the attention of artists from the Neolithic era to the present. The belief in the power of portraiture, which inspired people to reconstitute skulls (see p. 34) and create death masks to keep alive a likeness (see pp. 81 and 120), persists today. Political and social subtexts, and environmental considerations, which have informed works of art throughout Western history, also persist in contemporary art. In addition, as modern technology and speed of communication shrink the globe, artists and their work reflect contacts between different cultures to a greater degree than in the past. Artists travel more than ever before, exhibitions are held throughout the world, and iconography begins to merge East with West.

Return to Realism

With the development of photography, artists found a new medium for capturing a likeness. Many painters and sculptors have used photographs to decrease the posing time of their sitters. In the late 1960s, the popularity of photography, its relationship to Pop Art, and the belief that it permits an objective record of reality led to the development of Super Realism.

Chuck Close

Chuck Close (born 1940) uses grids to convert photographic images into paintings. Up until 1970 it was Close's habit to paint mainly in black and white, and to use an airbrush to create a smooth surface. The result is work that resembles photographic enlargements and, in a sense, forms a transition between painting and photography.

From the 1970s, Close created portraits of people in the art world. He is the first artist in history to produce a large body of work consisting of portraits of artists, including himself. His 1997 *Self-Portrait* as a close-up (fig. **31.1**) is based in photography but is painstakingly painted, colored square by colored square. He combined the crystalline structure of Cubism with the illusion of a computer-derived image and assembled the building blocks of paint as if each were a mosaic tessera. The result is a rugged, monumental head emerging in a blaze of light and color from the black edge of the picture plane.

31.1 Chuck Close, *Self-Portrait*, 1997. Oil on canvas, 8 ft. 6 in. × 7 ft. (2.59 × 2.13 m). Museum of Modern Art, New York.

Richard Estes

One of the most prominent Super-Realist painters is Richard Estes (born 1932). His oil paintings resemble color photographs, although they are on a larger scale and are more crisply defined than a photograph of similar size would be. His *Solomon R. Guggenheim Museum* of 1979 (fig. **31.2**) combines an urban landscape with the reflections of steel, chrome, and glass. As in the Renaissance, Estes' illusionistic effects are enhanced by the use of linear perspective.

In this painting, as in reality, Frank Lloyd Wright's imposing structure dominates the space. Its purpose was to house the Guggenheim Collection and to provide space for exhibitions of twentieth-century art. Built between 1956 and 1959, somewhat earlier than other works in this chapter, the Guggenheim embodies the climax of Wright's interest in curvilinear form. Its most imposing feature is the large inverted cone, which encloses a six-story ramp coiling around a hollow interior. Natural light enters from a flat skylight. Viewers inside the Guggenheim Museum look at paintings and sculptures as they descend the ramp so that they are always slightly tilted in relation to the works of art.

Despite a design that is inconvenient for viewing art, the Guggenheim is itself a monumental work of art. Unlike Wright's Prairie Style architecture, it cannot be said to blend into its surroundings. Located on Fifth Avenue, directly across from Central Park, the spiral cone can be conceived of organically as growing upward and outward, toward the sky, like the trees opposite. Most observers, however, experience the museum in relation to the neighboring rectangular buildings, which generally tend to become smaller toward the top. These formal anomalies between the Guggenheim and its environment were, for a while, a source of considerable controversy. They are made clear by the "photographic" quality of Estes' painting.

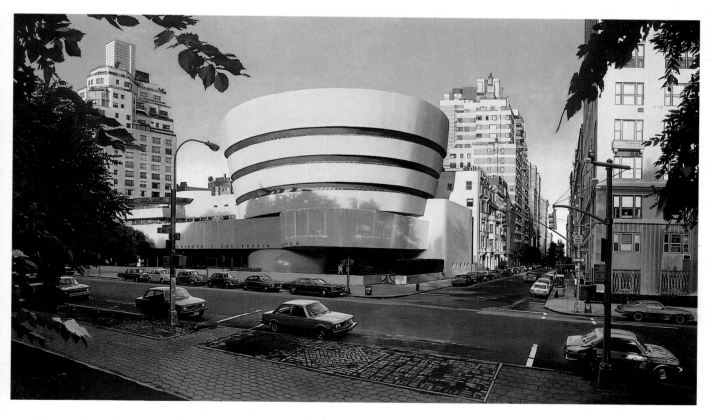

31.2 Richard Estes, *The Solomon R. Guggenheim Museum*, 1979. Oil on canvas, 2 ft. 7⅛ in. × 4 ft. 7⅛ in. (0.79 × 1.40 m). Solomon R. Guggenheim Museum, New York. Estes assembles color photographs and re-creates the scene with brushes and oil on canvas. "The incorporation of the photograph into the means of painting," he wrote, "is the direct way in which the media have affected the type of painting. That's what makes New Realism new."[1]

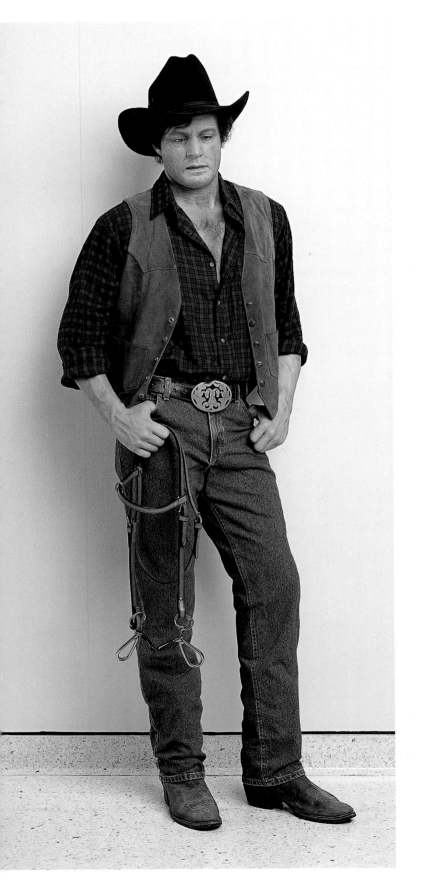

Duane Hanson

The Super-Realist sculptor Duane Hanson (1925–96) made sculptures that are often taken for real people. His sculptures are created directly from models, and his convincing *trompe-l'oeil* illusionism is reminiscent of ancient Greek legends about the artist Daedalos, who rivaled the gods by making living sculptures. In clothing his figures, Hanson also evokes Ovid's tale of Pygmalion, the sculptor who dressed and attended to his statue of Galatea as if she were a real woman.

Combined with a contemporary aesthetic and dependence on modern materials, Hanson's *Cowboy* of 1995 (fig. **31.3**) assumes a traditional *contrapposto* pose. The figure is meditative, gazing downward and forming a closed space within the boundaries of the sculpture. He holds a bridle in his right hand and wears the costume of a canonical American cowboy. His hat, checked shirt, suede vest, dungarees, and leather boots identify the type, whereas the "five o'clock shadow" and the chest hair contribute to the illusion that he is also a specific individual.

Hanson molded each section of the model's body and assembled the sections. Flesh-colored polyester resin was then poured into the mold and reinforced with fiberglass. When the mold was broken, the figure was painted and dressed in actual clothing.

31.3 Duane Hanson, *The Cowboy*, 1995. Polyester resin polychromed in oil, life-size.

31.4 Ron Mueck, *Mask II*, 2001–2. Mixed media, 30⅜ × 33½ in. (77.2 × 85.1 cm). © Ron Mueck. Courtesy Anthony d'Offay, London. Mueck began his career working for children's television and then went into advertising and film. He turned from photographing objects to making the object, rather than the photograph, the end product.

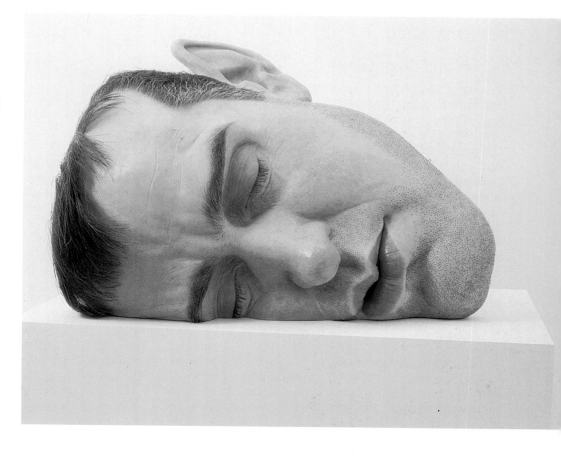

Ron Mueck and Constantin Brancusi

More recent examples of Super-Realism can be seen in works by the Australian-born Ron Mueck (born 1958), who now lives in London. His intriguing *Mask II* of 2001–2 (fig. **31.4**), like Hanson's sculptures, is made of modern materials such as fiberglass resin. *Mask II* also seems uncannily alive, despite the absence of a body. The head lies sideways; the eyes are closed, and the lips are parted as if breathing through the mouth. The head thus appears to be sleeping, with the slight creases in the forehead suggesting mental activity—as if in a dream.

In this work, Mueck continues the theme of partial form that characterized the human figures of Rodin and Brancusi (see Chapters 24 and 27). Brancusi produced several versions in bronze and marble of *Sleeping Muse,* which also shows a detached head lying sideways, with closed eyes and an open mouth. But *Sleeping Muse I* (fig. **31.5**) has an abstract, curvilinear quality and a smooth contour that create an impression of elegance. As with *Bird in Space* (see fig. **1.2**), Brancusi has captured the essence of a figure—in this case, a physically detached head replicating the psychological detachment of sleep. Mueck's head, in contrast, is very much present by virtue of its "in your face" realism.

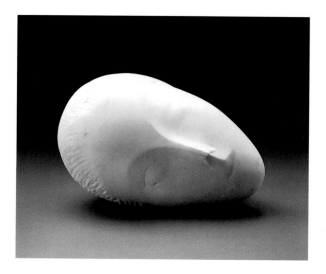

31.5 Constantin Brancusi, *Sleeping Muse I*, 1909–10. Marble, 6¾ × 10⅞ × 8⅜ in. (17.2 × 27.6 × 21.2 cm). Hirshhorn Museum and Sculpture Garden, Smithsonian Institution, Washington, D.C. (Gift of Joseph H. Hirshhorn, 1966, 66.610).

Performance

Gilbert and George

The work of two English performing artists, Gilbert (born 1943) and George (born 1942), is related to the "happenings" of the 1960s. Gilbert and George, like Joseph Beuys, became their own works of art. Figure **31.6** illustrates a 1969 performance of their much-repeated piece *The Singing Sculpture,* in which they mimed in slow motion to a recording of an old English music-hall song while standing on a low platform. They gilded their faces and hands and wore business suits. Their only props were Gilbert's cane and George's gloves. This and similar performances raised the issue of the boundary between artists and their work. By describing themselves as "living sculptures," Gilbert and George explored the ambiguous transitional areas between living and nonliving, between illusion and reality, and between art and life.

Laurie Anderson

The multimedia performance art of Laurie Anderson (born 1947) uses photography, video, film, and music. Her message, which is typically delivered in spoken narrative, is political and social. Figure **31.7** is a still from *Home of the Brave,* shown in July 1985 at the Park Theater in Union City, New Jersey. Anderson describes her performances as being "about a collaboration between people and technology." Like Marisol in *The Last Supper* (fig. **30.14**), Anderson is an actor in her own work of art. As such, she explores the boundary between artist and art, subject and object, and the natural and the technological worlds.

31.6 (Above) Gilbert and George, *The Singing Sculpture,* 1971. Presented at Sonnabend Gallery, New York.

31.7 Laurie Anderson, playing the violin. From a performance of *Home of the Brave,* 1986. Courtesy of Canal Street Communications, Inc.

Architecture

The Geodesic Dome: R. Buckminster Fuller

One of the more interesting personalities of twentieth-century design was R. Buckminster Fuller (1895–1983), philosopher, poet, architect, and engineer, as well as a cult figure among American college students. His architecture expresses his belief that the world's problems can be solved through technology. One of his first designs (1927–28) was a house he called Dymaxion, a name conflating "dynamic" and "maximum." These were key concepts for Fuller, who aimed at achieving the maximum output with the minimum energy consumption. The Dymaxion house was a prefabricated factory-assembled structure that hung from a central mast and cost no more to build than a car. A later invention was a three-wheeled Dymaxion car, but, like the house, it was never produced commercially.

Buckminster Fuller is best known for the **geodesic dome.** It is composed of polyhedral units (from the Greek words *poly,* "many," and *hedron,* "side")—usually either tetrahedrons (four-sided figures) or octahedrons (eight-sided figures). The units are assembled in the shape of a sphere. This structure offers four main advantages. First, because it is a sphere, it encloses the maximum volume per unit of surface area. Second, the strength of the framework increases logarithmically in proportion to its size. This fulfills Fuller's aim of combining units to create greater strength than the units have individually. Third, the dome can be constructed of any material at very low cost. And fourth, it is easy to build. Apart from purely functional structures such as greenhouses and hangars, however, the geodesic dome has been used very little. Fuller's design for the American Pavilion at the Montreal Expo of 1967 (fig. **31.8**) reveals both its utility and its curious aesthetic attraction. (The architectural principle underlying the geodesic dome is shared by a class of carbon molecules named "fullerenes," after Buckminster Fuller. They were discovered in the late 1980s, and they possess unique qualities of stability and symmetry.)

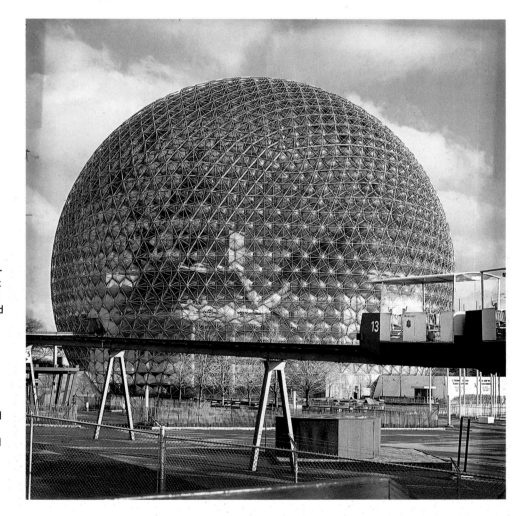

31.8 R. Buckminster Fuller, American Pavilion, Expo '67, Montreal, 1967. Buckminster Fuller was descended from eight generations of New England lawyers and ministers. He was expelled from Harvard twice, served in the U.S. Navy in World War I, and worked in the construction business. In 1959 he became a professor of design science at Southern Illinois University. Buckminster Fuller's abiding interest in education is revealed by his belief that all children are born geniuses. "It is my conviction from having watched a great many babies grow up," he said, "that all of humanity is born a genius and then becomes de-geniused very rapidly by unfavourable circumstances and by the frustration of all their extraordinary built-in capabilities."[2]

Post-Modern Architecture

Buckminster Fuller's architectural ideas remained isolated from the stylistic mainstream of the late twentieth century. Post-Modernism, on the other hand, has developed into a widespread movement. Post-Modern architecture is eclectic; it combines different styles from the past to produce a new vision, which is enhanced but not determined by modern technology. Post-Modernism rejects the International Style philosophy that "form follows function" and instead juxtaposes traditional architectural features without regard for their historical contexts.

Charles Moore A good example of Post-Modernism is Charles Moore's (1925–93) Piazza d'Italia (fig. **31.9**), or Italy Square, in New Orleans. In this illustration, the piazza is shown at night, illuminated by colored neon lights. The lights define space and accentuate architectural form—an effect that relates the piazza to Flavin's fluorescent light sculptures (see fig. **30.17**). Color conforms to each particular architectural element; the central entablature and its round arch are green, and the supporting Corinthian columns are red. Curved colonnades on either side are alternately red and yellow, while the inner Corinthian capitals are predominantly blue. The pool of water between the colonnades reflects the lights in broad patches of color.

Piazza d'Italia is a Post-Modern rearrangement of Classical, Renaissance, and Baroque architectural forms, enlivened by the light and color possibilities of twentieth-century technology. Whereas Flavin's light sculptures are designed for interiors and are intimate in scale, those in the Piazza d'Italia contribute to its expansive relationship with the surrounding area.

31.9 Charles W. Moore and William Hersey, Piazza d'Italia, New Orleans, 1978–79. The piazza was built to celebrate the contributions made to New Orleans by Italian immigrants. Its eclecticism is characteristic of the Post-Modern style.

Michael Graves The massive, blocklike Post-Modern buildings of Michael Graves (born 1934) assimilate elements of Cubism and Classical architecture. His striking Portland Municipal Services Building (fig. **31.10**) in Portland, Oregon, built from 1980 to 1982, also uses color as a significant architectural feature. He defined the stepped base in green and the upper cube in a cream color. Planned mainly for offices, the Portland Building is decorated on the exterior with multiple square windows piercing the wall surfaces. The side most visible in figure **31.10** incorporates two sets of six dark verticals accented like fluted columns against a glass rectangle. Capping these are projecting, inverted trapezoidal blocks that are a visual—not structural—equivalent of Classical capitals. Above these is a large, flat, inverted trapezoid enclosing horizontal strips of windows separated by dark cream-colored horizontal sections.

Although the building does not conform to the surrounding architecture, it is "color-coded" with the blue sky and green trees. It looms upward from a green base, with the cream block framed above and below by green. Since green combines cream with blue, the building is unified with its natural, if not with its architectural, surroundings. Architecturally it is an amalgam of the Mesopotamian ziggurat, the Egyptian pylon, the Greek temple, and the American office building.

31.10 Michael Graves, Portland Municipal Services Building, Portland, Oregon, 1980–82.

I. M. Pei Glass and steel form the prevailing aesthetic in I. M. Pei's (born 1917) Louvre Pyramid (fig. **31.11**). In 1983 the French government commissioned Pei to redesign parts of the Louvre in Paris. Completed in 1988, the pyramid includes an underground complex of reception areas, stores, conference rooms, information desks, and other facilities, all located below the vast courtyard. To serve as a shelter, skylight, and museum entrance for the underground area, Pei built a large glass pyramid between the wings of the sixteenth-century building.

Paris had not witnessed such architectural controversy since the construction of the Eiffel Tower in 1889. Not only was the architect not a Frenchman, but the imposing façade of the Louvre, former residence of French kings, was to be blocked by a pyramid—and a glass one at that. Pei's pyramid has an undeniable presence, with transparent glass that allows a fairly clear view of the traditional buildings beyond. Broad expanses of pools of water around the pyramid create a reflective interplay with the glass, literally mirroring the old in the new. The view in figure **31.11** illustrates the dramatic possibilities of the pyramid as a pure geometric form juxtaposed with a Baroque environment.

─────── **CONNECTIONS** ───────

See figure 5.5. Pyramids at Giza, Egypt, 2551–2472 B.C.

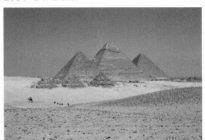

31.11 I. M. Pei, Louvre Pyramid, Paris, 1988. The pyramid is 65 ft. (19.80 m) high at its apex and 108 ft. (32.90 m) wide; it contains 105 tons (107,000 kg) of glass.

Richard Rogers By 1977 Lloyd's of London, the international insurance market, needed new quarters. In addition to accommodating the more than five thousand people who use the building every day, the new Lloyd's had to adapt to technological advances in communications that were revolutionizing the insurance and other financial markets.

The commission for the new Lloyd's building went to the firm of Richard Rogers (born 1933), an English architect who had been jointly responsible for the Pompidou Center in Paris in the 1970s. The irregular triangular space that Rogers had to work with in London was large, but not large enough to accommodate all of the underwriting staff on one floor. Rogers solved the problem in two ways. First, he created an atrium—the original central court of Etruscan and Roman houses—and wrapped all the floors around it. The atrium, an architectural feature that was widely revived in the 1970s, is a rectangle rising the entire height

of the building (twelve floors) and culminating in a barrel-vaulted glass and steel roof (fig. **31.12**). The three lower floors form galleries around the atrium. Together, they make up the approximately 115,000 square feet (10,700 m²) where underwriters sit and negotiate terms with brokers. This solution visually unified the working areas of the building and illuminated them from above.

Second, Rogers left the atrium space as flexible and open as possible by housing all the ancillary services—air-conditioning ducts, elevators, staircases, toilet facilities, and so forth—in satellite towers built apart from the main structure. At the top of the towers are boxlike "plant rooms," which dominate distant views of the building. Each room is three stories high and contains elevator motors, tanks, and an air-handling plant. On the roofs, bright yellow cradles for carrying maintenance crews are suspended from blue cranes.

31.12 Richard Rogers, Lloyd's Building, London, 1986. Rogers wrote that "esthetically one can do what one likes with technology . . . but we ignore it at our peril. To our practice, its natural functionalism has an intrinsic beauty." In the Lloyd's Building, Rogers has fulfilled his philosophical view of uniting technology with aesthetic appeal.

Frank Gehry In 1997 the Solomon R. Guggenheim Museum Bilbao opened in Bilbao, on the Bay of Biscay, in Spanish Basque country (fig. **31.13**). The architect, Frank Gehry (born 1929), originally from Toronto, Canada, came to the United States in 1974, living and working mainly in Los Angeles. He is known for his ability to integrate striking new forms into existing spaces and for his interest in merging sculptural with architectural form. In the 1980s, for example, he assisted in the placement of a giant pair of binoculars by Oldenburg at the entrance to the city of Venice, California.

The Bilbao Guggenheim, begun in 1993, is situated on the Nervion River, across from a bridge and a thriving port, and surrounded by a water garden. Its striking curvilinear roof forms, referred to as a "metallic flower," are made of titanium, which is durable in the salty atmosphere of Bilbao, and the main structural elements are of limestone-covered blocks. The unusual variety of shapes is arranged to create an impression of animation so that the building seems to grow and expand upward from its site.

31.13 Frank Gehry, Solomon R. Guggenheim Museum Bilbao, Bilbao, Spain, 1993–97. The museum is 260,000 square feet (24,290 m²), with 112,000 square feet (10,560 m²) of gallery space, and stands on the site of an old factory and parking lot. Its construction was part of an urban-renewal project for Bilbao and cost $100 million.

Zaha Hadid The Iraqi-born architect Zaha Hadid (born 1950) creates Post-Modern buildings that reflect a new approach to the city. In 1994 she designed the IBA (Internationale Bauausstellung) housing complex in Berlin (fig. **31.14**). The building is sheathed in reflective sheet metal and is composed of curved walls and unusual angles. Hadid has been called a "Deconstructivist" architect for her challenges to the traditional retangularity of urban structures—especially in Germany, where the Bauhaus influence has been strong. This particular housing complex, like Gehry's Bilbao Guggenheim, appears to expand organically. Located on a corner, the IBA building seems not quite settled, as if trying to adjust itself to its site.

31.14 Zaha Hadid, IBA housing complex, Stressemannstrasse 109, Berlin, Germany, 1994. Since 1987 Hadid has taught in major American universities. Her architectural firm is presently in London, England, and she is also a professor in Vienna, Austria.

Environmental Art

All works of art affect the environment in some way. In its broadest sense, the environment encompasses any indoor or outdoor space. Today, the term tends to refer more to the outdoors—the rural and urban landscape—than to indoor spaces. Artists whose work has had a startling, though usually temporary, impact on the environment include Robert Smithson and the Christos.

Robert Smithson

Robert Smithson's (1938–73) *Spiral Jetty* (fig. **31.15**), a single huge spiral that jutted 400 yards (366 m) out into the Great Salt Lake of Utah, is his best-known **earthwork.** As an isolated form, set against a background—in this case, water—*Spiral Jetty* was rooted in 1960s Minimalism, but its concept and actuality are related to the gesture painting of Abstract Expressionism. The philosophy of Smithson's earthworks, however, which is extensively described in his writings, has many levels of meaning. In some of his gallery exhibits, he placed rocks and earth—reflecting his interest in the natural landscape—in boxes and bins indoors (the "nonsite," in Smithson's terminology). Crystals, in particular, appealed to him as examples of the earth's geometry, and he used them, along with earth, as an artistic medium.

Ecology, as one might expect, was one of Smithson's primary concerns. *Spiral Jetty* and his other earthworks are all degradable and will eventually succumb to the natural elements. Smithson's interest in the earth has a primeval character. He was inspired by the Neolithic stone structures of Great Britain and their mythic association with the land. Although he created his own earthworks with modern construction equipment, his affinity for the prehistoric earth mounds of the United States and Mexico also influenced the shape of his monuments and their integration with the landscape.

Andy Goldsworthy

For the British artist Andy Goldsworthy (born 1956), nature is the primary medium. He creates dazzling works by arranging foliage, stones, and twigs on the earth's surface. He also forms snow and ice into temporary sculptures, which he photographs in their natural setting before they disappear. Goldsworthy's main themes involve the changing character of nature, its sense of process and energy. In the sculpture illustrated in figure **31.16**, he has created a starlike burst of icicles radiating from a central point and balanced on natural rock. The variations in the icicles emit different degrees of translucency. This was created in Scotland and photographed in January 1987.

Christo and Jeanne-Claude

Another approach to shaping the environment can be seen in the work of Christo (born 1935) and Jeanne-Claude (1935–2009). They evoke a sense of mystery by "wrapping up" buildings or sections of landscape, paradoxically covering something from view while accentuating its external contour.

In contrast to artists who intend their works to last, the Christos always remove their projects from their sites,

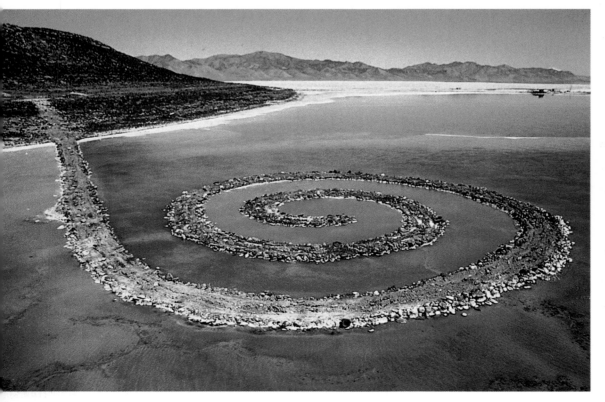

31.15 Robert Smithson, *Spiral Jetty*, Great Salt Lake, Utah, April 1970. Mud, precipitated salt crystals, rocks, water; coil: 1,500 ft. (457.00 m) long, 15 ft. (4.57 m) wide. Photo: Gianfranco Gorgoni. Collection: DIA Center for the Arts, New York. Financed by two art galleries, Smithson took a twenty-year lease on 10 acres (4 ha) of land. He hired a contractor to bulldoze some 6,000 tons of earth. The resulting spiral consists of black rock, earth, and salt crystals. The algae inside the spiral change the water's color to red. Smithson wrote an essay on this work and photographed and filmed it from a helicopter.

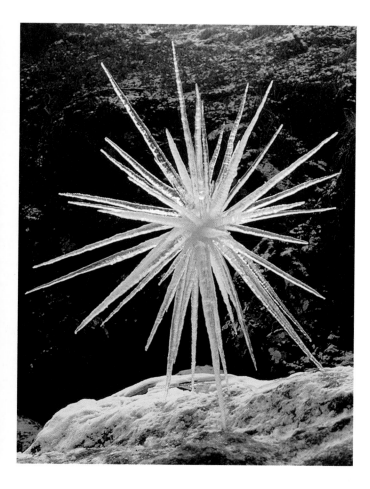

31.16
Andy Goldsworthy,
Icicles
thick ends dipped in snow then water
held until frozen to the work
pouring on water until solid
occasionally using forked sticks as support until stuck
a tense moment when taking them away
breathing on the stick first to release it
sun catching the work for a dangerous half hour
but always intensely cold,
1987. © Andy Goldsworthy.
Courtesy Galerie Lelong, New York.

leaving the environment intact. The temporary nature of their large-scale works is part of their aesthetic identity. The continued existence of the work depends on film, photographs, drawings, and models. It endures as a series of visual concepts, temporarily realized on a monumental scale. Another feature distinguishes the Christos from many artists—a unique view of patronage. They accept no financial sponsorship or commissions for large-scale projects and personally provide the funding for construction. Money is raised by selling drawings, collages, and scale models for the projects as well as early work from the 1950s and 1960s.

In 1980 Christo and Jeanne-Claude proposed a two-week project titled *The Gates, Project for Central Park, New York City* (fig. **31.17**). As is often the case, the project initially met with vigorous local resis-

tance. A 185-page report by the Parks Department originally rejected the idea. Eventually, however, New York's Mayor Bloomberg supported the project, which became a reality in February 2005.

Christo and Jeanne-Claude envisioned steel gates with rectangles of orange or saffron fabric extending from the top of each gate to some 6 feet over the ground. In 1979 the first drawing was titled *Ten Thousand Gates;* in 2005 there were 7,500 gates. The gates were 12 feet tall in 1979; they were 16 feet tall in 2005. In 1979 the poles were considered only as a means of suspending fabric panels, while in 2005 the poles were made of a thick saffron-colored vinyl and had a commanding profile, 5 × 5 inches. They were no longer simply structural, but an important part of the sculpture. The top of the fabric panel in 1979 was attached by loops to a horizontal steel cable; in 2005 the upper parts of the fabric panels were secured inside the bottom parts of the horizontal poles in a "sail tunnel."

31.17 Christo and Jeanne-Claude, *The Gates, Project for Central Park, New York City,* 1979–2005.

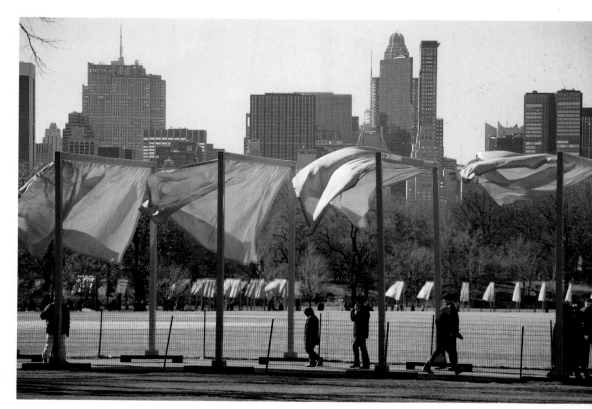

Urban Environment

A recent development in painting that has been inspired by an aspect of the modern urban environment is work with imagery derived from graffiti. Graffiti—which are visual statements and often a personal affirmation—call into question the boundary between the creative and destructive impulses.

Jean-Michel Basquiat Rendered in a harsh, linear style derived from graffiti, *CARBON/OXYGEN* of 1984 (fig. **31.18**) by Jean-Michel Basquiat (1960–88) conveys the frenetic pace and mortal dangers of the city. The childlike drawing of the buildings is ironically contrasted with scenes of explosion and death. Various methods of transportation —cars, planes, and rocket ships—create a sense of the speed and technology that pollute the environment. The black face at the center of the picture plane stares blankly at the viewer as if warning of threatened destruction. The words of the title implicitly pose the question whether we are going to poison the air we breathe or ensure that it remains clean.

31.18 Jean-Michel Basquiat, *CARBON/OXYGEN*, 1984. Acrylic, oilstick, and silkscreen on canvas, 66 × 60 in. (167.6 × 152.4 cm). Private collection, Switzerland.

31.19 Andres Serrano, *Nomads (Sir Leonard)*, 1990. Cibachrome, silicone, Plexiglas, wood frame, 60 × 49½ in. (152 × 126 cm). Edition of four. Courtesy of the artist and Yvon Lambert, Paris.

CONNECTIONS

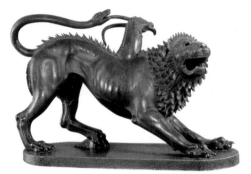

See figure 8.3. *Wounded Chimera*, second quarter of the 4th century B.C.

Andres Serrano Another modern expression of the urban environment in works of art is reflected in Andres Serrano's (born 1950) series of thirty photographs titled *Nomads*. These large Cibachromes represent the homeless of America's cities. But the images do not show the suffering, poverty, or anonymity of the figures. Instead, as in *Sir Leonard* (fig. **31.19**), Serrano disrupts expectations by ennobling and individualizing his subjects. He also monumentalizes them by combining a close-up viewpoint with an enlarged scale. Sir Leonard, for example, is relatively well groomed. His beard and mustache are neatly trimmed, and he wears a felt hat, a jacket, and gloves. The only suggestions of his actual status (contradicted by the epithet "Sir") are the torn fabric by his white scarf and the fact that he wears two jackets and two scarves.

Sir Leonard also holds a belt buckle as if it were a medal; it appears to have been taken from a pair of jeans, for it is inscribed "IN DENIM WE TRUST" and "QUALITY GARMENTS FOR QUALITY PEOPLE." The former is a pun on the United States currency inscription "IN GOD WE TRUST," an ironic allusion to Sir Leonard's indigence. At the same time, the central image on the buckle is a relief of the famous fourth-century-B.C. Etruscan bronze statue *Wounded Chimera* (see fig. **8.3**). In this detail, Serrano allies Sir Leonard with the mythic Greek hero Bellerophon, who rode the winged horse, Pegasus, and slew the Chimera.

Serrano has been a controversial figure in the United States. In 1989 he exhibited his famous *Piss Christ,* a photograph of a plastic crucifix immersed in his own urine. Outraged conservative groups protested the $15,000 government grant to the NEA (National Endowment for the Arts) that had supported the artist and succeeded in having congressional funding for the arts reduced (see Box, p. 566).

SOCIETY AND CULTURE
Government Funding and Censorship

The visual arts have, at various times in Western history, appeared to threaten established social, political, or religious order and values. On some occasions official retribution has been swift. In the ninth century, for example, the Iconoclasts felt that images of saints would result in viewers' worshiping the image instead of the saint. In the sixteenth century, the Inquisition brought Veronese to trial because his *Last Supper* included dogs, dwarfs, jesters, Germans, and Saint Peter picking his teeth. The Inquisition also ordered draperies painted over Michelangelo's figures in the Sistine Chapel *Last Judgment*. In the nineteenth century, Daumier was jailed for publishing caricatures of the king.

The United States in the twentieth century has had its share of artistic controversies. Since the 1980s the main concerns seem to be government funding for the arts and censorship—the latter raising First Amendment issues. In 1989 Robert Mapplethorpe received federal funding for an exhibition of photographs, some of which dealt with sexual, and specifically homosexual, themes.

Figure **31.20** is Mapplethorpe's photo self-portrait of 1980, published ten years later by *Newsweek* when the Cincinnati Contemporary Arts Center, which was exhibiting his work,

was sued by the Cincinnati Citizens for Community Values. Although this *Self-Portrait* is not as graphic as some works in the show, it reveals Mapplethorpe's homosexual identification. Here he represents himself partly as a transvestite and partly as an androgynous male-female figure. He plays with the boundaries of gender and with the limits of sexual identity. The image itself is beautifully printed, and, as with all his black-and-white photographs, the forms are imbued with a soft, silver glow.

Conservative politicians and some religious leaders mounted a campaign against federal funding for the arts, arguing that the government should not guarantee freedom of expression if it is offensive. Others countered that the arts should not only be funded but also defended against censorship on the grounds of First Amendment protection of free expression. They further pointed out that time and history—rather than moral outrage—is the best long-term judge of aesthetic value. The jury deliberated for two hours and acquitted the museum.

In 1999 the mayor of New York City sued to close the Brooklyn Museum over an exhibit of young British artists titled "Sensation." In that case, the mayor had not seen the show, but he professed outrage at a painting of the Virgin with a small lump of dried elephant dung on one breast. Unfortunately the impulsiveness of the mayor's rush to judgment exposed his own lack of contextual knowledge, for in parts of Africa—where the artist had been raised—elephant dung was endowed with magic properties. Whatever the aesthetic value of the work turns out to be, it was neither pornographic nor an offense in the context of the history of Christian art. In any case, the media attention given to the uproar and the money spent on lawyers show that debates over censorship of the arts, as well as government funding, are likely to continue.

31.20 Robert Mapplethorpe, *Self-Portrait,* 1980. Unique gelatin silver print, 30 × 30 in. (76.2 × 76.2 cm). Collection, Howard and Suzanne Feldman.

Installations

Valerie Jaudon The urban environment has also been affected by artistic installation "projects." *Long Division* of 1988 (fig. **31.21**) by Valerie Jaudon (born 1945) is a painted steel barrier commissioned by the Metropolitan Transportation Authority in New York City. Located in a subway station, *Long Division* is an "open wall" enlivened by curves and diagonals that seem to dance across the vertical bars. The surrounding neon lights and broad areas of color create a sharp contrast to the dark accents of the barrier.

The Guggenheim Museum as Installation Space The interior of the Guggenheim Museum has provided a unique context for many innovative installation exhibitions devoted to a single artist. In 1989, for example, Jenny Holzer (born 1950) installed a program lasting 105 minutes and consisting of some 330 verbal messages conveyed through vivid colored lights (fig. **31.22**). The view shown here looks toward the skylight at the top of the inverted cone.

Holzer is a Conceptual artist who uses the power of words and texts—carved in stone or signed in neon lights—and combines them with impressive visual form. Among her groups of messages are *Laments, Truisms, Inflammatory Essays, The Living Series,* and *The Survival Series,* all of which were represented in the Guggenheim installation. She used the circular format of the ramp in a unique way, aligning its spiraling plane with the viewer's sequential reading of texts. Below the skylight on the ground floor of the museum, Holzer arranged in a circle seventeen red granite benches inscribed with verbal messages. She thus juxtaposed the age-old tradition of inscribing texts in stone with the more transitory electronic media of the modern era.

31.21 (Above) Valerie Jaudon, *Long Division,* 23rd Street and Park Avenue Station, IRT Subway Line, New York, 1988. Painted steel, 12 × 60 ft. (3.66 × 18.29 m). Photo courtesy of Carroll Janis, New York.

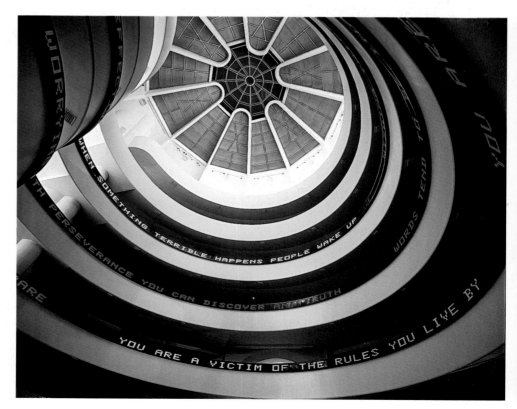

31.22 Jenny Holzer, *Untitled* (Selections from *Truisms, Inflammatory Essays, The Living Series, The Survival Series, Under a Rock, Laments,* and *Mother and Child Text*), 1989–90. Extended helical tricolor LED electronic-display signboard; site-specific dimensions: 16½ in. × 162 ft. × 6 in. (41.9 cm × 49.4 m × 15.2 cm). Solomon R. Guggenheim Museum, New York. Partial gift of the artist, 1989.

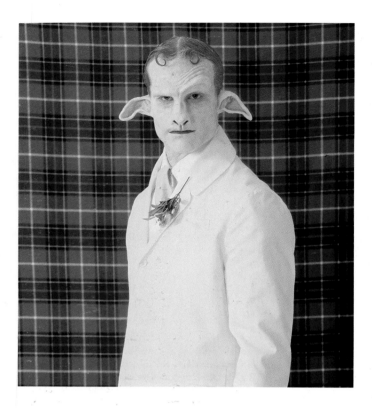

31.23 Matthew Barney, *Cremaster 4: The Loughton Candidate,* 1994. Color photograph in cast plastic frame, 19½ × 17⅝ × 1 in. (7.60 × 6.95 × 2.54 cm). © Matthew Barney. Courtesy Gladstone Gallery, New York.

In 2003 the Guggenheim Museum became the context for a complex installation by Matthew Barney (born 1967) titled *The Cremaster Cycle.* This was an elaborate combination of sculptures, drawings, still photographs, videos, and music that drew on a wide range of media and iconographic sources. Media ranged from film to Astroturf, and imagery from myth and surreal fantasy to biogenetics. The term *cremaster* refers to the muscle of the testicles and reflects the artist's preoccupation with sexuality and body parts. The cycle has five parts, adding up to an epic display of imagery that encompasses the history of the human race.

Barney created a number of sculptures depicting mutating species and shifting genders. Nearly all his work is based on the human figure and is influenced by issues in modern biology. Figure **31.23** is a video still from *Cremaster 4.* A male figure, formally dressed in a white jacket, is represented against a blue-plaid background. The head, like certain facial configurations of Picasso, is arresting because it distorts and disrupts our expectations of how a face should look. It attacks our narcissism by challenging Classical idealization and threatens our sense of being human. The pointed ears assume an animal quality, whereas the curls recall old-fashioned hair styles for men. At the same time, the folds of flesh in the forehead and the flattened nose seem in the very process of mutating into some unknown and unknowable future species.

Feminist Art

Although women have made significant contributions to the history of Western art, the iconography of feminism *per se* was a twentieth-century phenomenon.

Judy Chicago

In 1979 Judy Chicago (née Cohen; born 1939) created her monumental installation *The Dinner Party* (fig. **31.24**) with the assistance of hundreds of female coworkers. The result is a triangular feminist version of Leonardo's *Last Supper* (see fig. **16.10**), with strong diagonals that are reminiscent of Tintoretto's *Last Supper* (see fig. **17.8**). We saw in Marisol's *Last Supper* (see fig. **30.14**) that the artist introduced herself as both viewer and participant in the work. Here, on the other hand, Jesus and his apostles have been replaced by place settings of thirty-nine distinguished women, such as Queen Hatshepsut of Egypt, Georgia O'Keeffe, and the author Virginia Woolf. The settings are designed to commemorate the achievements of such women, even though the women themselves are not actually represented. The plates are decorated with designs that are intentionally vaginal because, according to the artist, that was the one feature all the women at the table had in common.

Thirty-nine is three times thirteen, the number of Jesus plus his twelve apostles. The tiled floor contains 999 names of famous women not referred to in the place settings. Traditional female crafts, such as embroidery, appliqué, needlepoint, painting on china, and so forth, are used for details. In part, this is to emphasize the value of these skills, which feminists believe to have been undervalued by a male-dominated society.

The artist established a foundation to send *The Dinner Party* on tour and later published a monograph on it that included the biographies of the women it celebrated. Despite the originality of Chicago's conception and the new iconographic content of her piece, the work would have less impact without its historical relevance. For although the triangle can be read as a female symbol, it also refers to the Trinity and is thus rooted in Christian art and culture. Likewise, the numerical regularity and symmetry of the design link the formal arrangement of *The Dinner Party* with Leonardo's *Last Supper.*

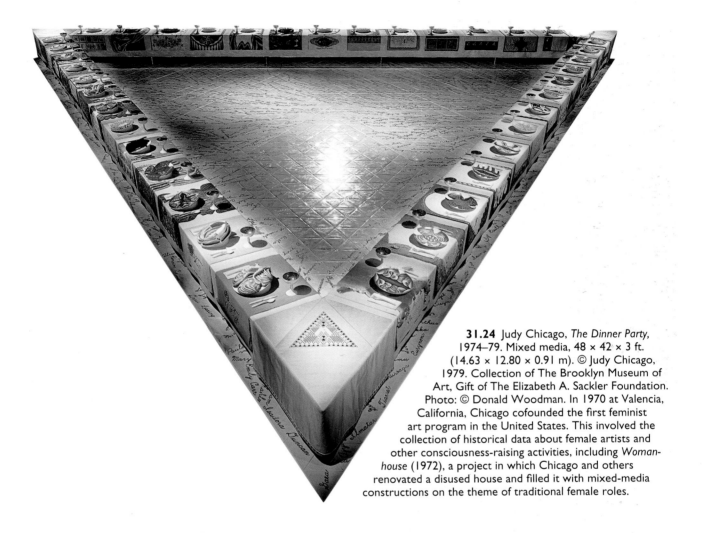

31.24 Judy Chicago, *The Dinner Party,* 1974–79. Mixed media, 48 × 42 × 3 ft. (14.63 × 12.80 × 0.91 m). © Judy Chicago, 1979. Collection of The Brooklyn Museum of Art, Gift of The Elizabeth A. Sackler Foundation. Photo: © Donald Woodman. In 1970 at Valencia, California, Chicago cofounded the first feminist art program in the United States. This involved the collection of historical data about female artists and other consciousness-raising activities, including *Woman-house* (1972), a project in which Chicago and others renovated a disused house and filled it with mixed-media constructions on the theme of traditional female roles.

CONNECTIONS

See figure 16.10. Leonardo da Vinci, *Last Supper,* c. 1495–98.

CONNECTIONS

See figure 17.8. Jacopo Tintoretto, *Last Supper,* 1590s.

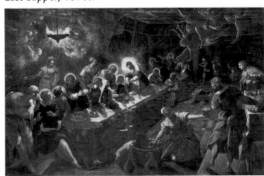

Kiki Smith

A recent development, particularly in sculpture, that is derived from the feminist movement is so-called Body Art. In general, Body Art signals a return to interest in the human form, which in some artists focuses primarily on the female body.

The Body Art of Kiki Smith (born 1954) challenges viewers by refusing to be "pretty." Smith has developed an iconography of body parts, in particular those that reveal the interior functions of the female. There is a political significance for Smith in the metaphor of the body and the "body politic," with the hidden body systems as signs of hidden social issues. She has been engaged with contemporary controversies over AIDS, gender, race, and battered women.

Smith's *Mary Magdalene* of 1994 (fig. **31.25**) is a traditional Christian subject rendered in a new light. The bronze body is covered with incised lines, except for the smooth breasts and navel area. The lines are reminiscent of the Magdalene's hair, grown long after the Crucifixion as penance for her sins. The figure represents the penitent Magdalene, whose long hair, combined with the ankle chain, endow the figure with a subhuman quality. This iconography places her at the borderline between human and animal, saint and sinner, chastity and lust.

Smith has related this sculpture to French folktales about the Magdalene's life after Christ's death. According to these stories, Mary Magdalene lived in the wilderness for seven years. When, on one occasion, she happened to catch sight of her reflection in a pool, she was punished for her narcissism and condemned to do further penance. Her flowing tears created the seven rivers of Provence, in the South of France.

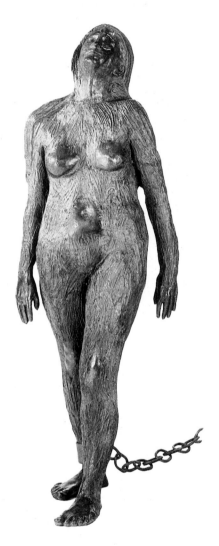

31.25 Kiki Smith, *Mary Magdalene*, 1994. Cast silicon bronze and forged steel, edition 2 of 3 plus 1 artist proof, 60 × 20½ × 21½ in. (152.4 × 52.1 × 54.6 cm). © Kiki Smith, courtesy The Pace Gallery. Photograph by Herbert Lotz, courtesy The Pace Gallery.

Elizabeth Murray

The shaped canvases of Elizabeth Murray (1940–2007) are composed of vivid color and dynamic shapes that seem to be in constant motion. She combines abstraction—often suggestive of female forms—with an iconography of household objects. In *The Lowdown* of 2001 (fig. **31.26**), a pair of detached, red lips is visible in the upper right and a distorted orange face is contained by green and blue diagonals to the left. Her shapes range from biomorphic to angular, from shaded to flat, from abstract to figurative. Their "cut-out" quality combines assemblage and collage, as well as painting and sculpture.

31.26 Elizabeth Murray, *The Lowdown,* 2001. Oil on canvas and wood, 7 ft. 8½ in. × 8 ft. 2 1/16 in. (2.35 × 2.49 m). Instituto Valenciano de Arte Moderno, Generalitat Valenciana, Spain.

Race and Gender

Issues of race and gender in twentieth- and twenty-first-century art often overlap with feminism and other movements. They reflect social and political developments in the United States—notably the feminist and Civil Rights movements—as well as increasing globalization. In the work of Bob Thompson, Kara Walker, and Yasumasa Morimura, we can see three distinct, though related, approaches to these issues.

Bob Thompson

The African American artist Bob Thompson (1937–66) died in Rome before the age of thirty. His powerful images, which heralded a promising artistic future, reflect some of the ways in which artists assimilate the past and rework it. Thompson's *Crucifixion* of 1963–64 (fig. **31.27**) shows the influence of Symbolist color combined with Renaissance iconography and the racial turmoil of the American Civil Rights movement of the 1960s. He was influenced by monumental Italian Renaissance painters such as Masaccio and Piero della Francesca, and by the sixteenth-century Northern humanist artists Bruegel and Cranach.

Thompson's *Crucifixion* was inspired by Cranach's *Crucifixion* (see fig. **18.12**)—in the arrangement of the figures and in the iconography. The foreshortened red, crucified Jesus on the right corresponds to Cranach's placement of the same figure; the swirling sky, also similar to Cranach's, alludes to nature's ominous response to the death of Jesus. Thompson's Jesus, shown in three-quarter view, is the artist's self-portrait. The yellow figure—the good thief (on Jesus's right)—is seen in front view. The unrepentant thief, depicted in orange, is on Jesus's left (as well as ours) and is turned away from the viewer, which accentuates his anonymity. The blue, red-haired Mary resembles Thompson's Caucasian wife who, as in the Cranach, seems to be conversing with Saint John. The "colored" people in the painting reflect both Thompson's interest in contemporary racial issues and the correlation between his personal artistic identity as a man of color and of colors.

31.27 Bob Thompson, *Crucifixion*, 1963–64. Oil on canvas, 5 × 4 ft. (1.52 × 1.22 m). Private collection.

CONNECTIONS

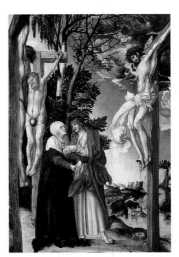

See figure 18.12. Lucas Cranach the Elder, *Crucifixion*, 1503.

Romare Bearden

Romare Bearden (1912–88) was born in North Carolina. He worked in several art media, including oil and stained glass. He created large murals and book illustrations but is best known for collages that reflect the Black experience in mid-century America. He worked in Harlem during the Harlem Renaissance and used a wide variety of iconographic themes.

In *Empress of the Blues* (fig. **31.28**) Bearden captures the power of Bessie Smith, who dominates the foreground in a bright yellow skirt and a patterned white top as she sings the Blues. Echoing the Blues's rhythms are the diagonals of the musicians at the right, while the strong beat of drums, piano, and bass anchor the left. By virtue of using collage, Bearden creates broad, flat areas of color that reinforce the dynamism of Bessie Smith's performance.

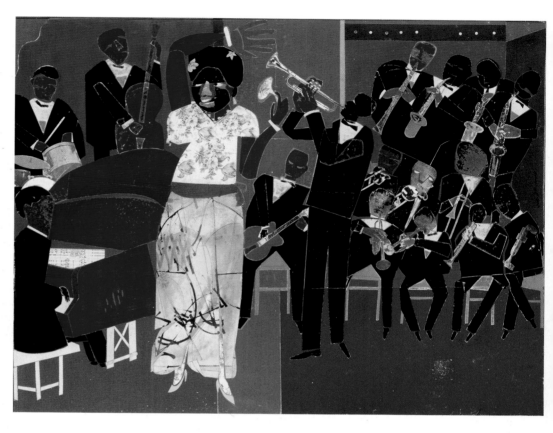

31.28 (Above) Romare Bearden, *Empress of the Blues*, 1974. Acrylic and pencil on paper and printed paper on paperboard, 36 × 48 in. (91.4 × 121.9 cm). Smithsonian American Art Museum (Museum purchase in part through the Luisita L. and Franz H. Denghausen Endowment, 1996.71).

Kara Walker

The black silhouettes of Kara Walker (born 1969), often installed directly on a white wall, address the history of Blacks in America as well as present-day issues. In the detail of *Slavery! Slavery!* shown here (fig. **31.29**), Walker portrays a Black woman who is simultaneously anchored and exuberant. She is depicted as a fountain, spouting water from her mouth, breasts, and bladder, supported by a monkey crouching on a skull. In the Western iconographic tradition, the skull is a *vanitas* symbol and the monkey represents the artist as the "ape of nature." There is thus a dark undercurrent literally beneath the apparent freedom of the woman who remains tied to her past but strives for liberation. The cottonball in her right hand alludes to the era of slavery, whereas the use of the silhouettte is derived from Victorian decorative design.

31.29 Kara Walker, *Slavery! Slavery!* (detail), 1997. Cut paper and adhesive on wall, 11 × 85 ft. (3.4 × 25.9 m). © Kara Walker. Image courtesy of the artist and Sikkema Jenkins & Co.

Yasumasa Morimura

The Post-Modern Japanese artist Yasumasa Morimura (born 1951) remakes European paintings, using himself as the model. He also photographs himself as movie stars, regardless of whether the actual person is male or female. He thus crosses the boundaries of race, gender, and nationality, and uses computers to make digital alterations to the original photograph.

In *Self-Portrait (Actress)/White Marilyn* (fig. **31.30**), Morimura shows himself in three provocative poses, all in imitation of Marilyn Monroe, who is self-consciously aware of being looked at by an audience. "She" stands in silver high heels on large cylindrical pedestals, her blowing white skirt based on a scene from *The Seven Year Itch*. We also recognize Marilyn Monroe's signature dyed blonde hair and prominent red lipstick, and yet the face is the narrow face of the artist, rather than hers.

31.30 Yasumasa Morimura, *Self-Portrait (Actress)/White Marilyn*, 1996. Ilfochrome and acrylic sheet, 37¼ × 47¼ in. (94.6 × 120.0 cm). Courtesy of the artist and Luhring Augustine, New York.

Plus ça change . . .

At times, history seems to repeat itself. The French expression *Plus ça change, plus c'est la même chose* ("The more things change, the more they remain the same") well describes this historical paradox. In the visual arts, it is possible to witness this phenomenon unfolding before our very eyes. Themes persist; styles change and are revived. New themes appear; old themes reappear. The media of art also persist; artists still use bronze and marble, oil paint, and encaustic. Nevertheless, modern technology is constantly expanding the media available to artists, as well as introducing new subjects and inspiring stylistic developments. This can be illustrated by four trends of the early twentieth century that continue to emerge in contemporary art—Expressionism, the preeminence of the object, the rejection of the object by Conceptual artists, and Surrealism. Technology has also influenced artistic media, and this has given rise to new art forms—among them, video art—although traditional themes continue to be represented.

Anselm Kiefer

Anselm Kiefer (born 1945), a prominent German Neo-Expressionist and a student of Joseph Beuys, creates powerful canvases using aggressive lines and harsh textures. His *To the Unknown Painter* of 1983 (fig. **31.31**) protests the Fascist persecution of artists in Europe and tyranny of all kinds. It also evokes one of the primary impulses to make art: the wish to keep alive the memory of the deceased. The somber colors and jagged surface evoke the devastation of war. From beneath the scorched picture plane a large, rectangular structure comes into focus, looming forward to memorialize those who stand for the forces of creativity and to defeat the forces of war and destruction. It seems to be engaged in its own process of becoming, forming itself from the formlessness of what has been destroyed.

31.31 Anselm Kiefer, *To the Unknown Painter*, 1983. Oil, emulsion, woodcut, shellac, latex, and straw on canvas, 9 ft. 2 in. × 9 ft. 2 in. (2.79 × 2.79 m). Carnegie Museum of Art, Pittsburgh (Richard M. Scaife Fund and A. W. Mellon Acquisition Endowment Fund, 83.53).

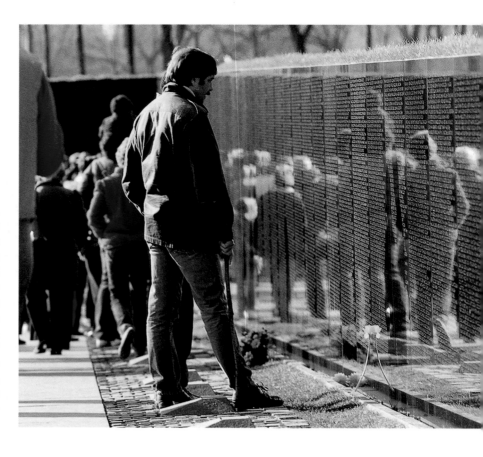

31.32 Maya Lin, Vietnam Veterans Memorial, The Mall, Washington, D.C., 1981–83. Lin designed this monument while she was a student at the Yale School of Architecture.

Maya Lin

The Vietnam Veterans Memorial (fig. **31.32**) of Maya Lin (born 1959) is a more understated though equally impressive form of memorial than Kiefer's. On two wings of polished granite, each 246 feet (75 m) long, seventy slabs display the names of every American killed in the war. A total of 58,183 names are inscribed in the order of their deaths. Viewers become engaged in reading the names as the reflective nature of the wall mirrors the world of the living. In this work, therefore, it is the name of the deceased, rather than the image or likeness, that conveys immortality.

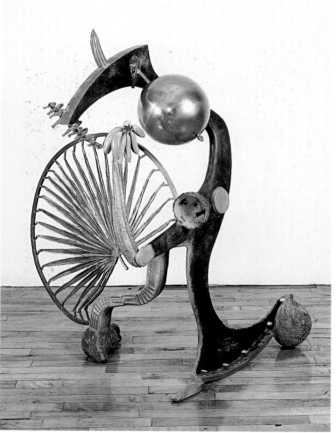

31.33 Nancy Graves, *Morphose*, 1986. Bronze and copper with polychrome patina and baked enamel, 4 ft. 6 in. × 3 ft. 3 in. × 3 ft. 3 in. (1.37 × 0.99 × 0.99 m).

Nancy Graves

The influence of Dada and Surrealism, in which content and objects are often playfully infused with ideas, can be seen in *Morphose* (fig. **31.33**) by Nancy Graves (1940–95). Among Graves's earlier works are a series of freestanding abstract forms based on the objects and rituals of Native Americans and other tribal societies. From the late 1970s, she added three-dimensional *objets trouvés* to her paintings and surface colors to her sculptures. Her linear abstractions of natural form are reminiscent of Calder's witty mobiles. The central part is a turbine rotor from a ship, which integrates the "object" into a sculptural assemblage, as Picasso did in his *Bull's Head* of 1943

— **CONNECTIONS** —

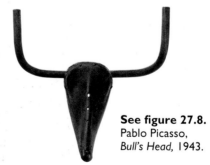

See figure 27.8. Pablo Picasso, *Bull's Head*, 1943.

(see fig. **27.8**). Anthropomorphic quality is created by Graves in a series of visual metaphors—ball for head, sardines for hair, bronze bananas for fingers. At the same time, however, the sculpture as a whole resembles a sea animal rotating slowly in space. Graves's title is itself a kind of Surrealist pun, suggesting the words *metamorphosis, anthropomorphism,* and *metaphor.* All are related to the Greek word *morphe,* meaning "shape" or "form," which is a foundation of every work of art.

Bruce Nauman and Marcel Duchamp

For Bruce Nauman (born 1941), figuration is part of a more general return to the object. His wide range of media includes neon lighting, holography, video, and audio effects, as well as the more traditional forms of painting and sculpture. He has filmed himself in a variety of performance sequences, using dance, music, and language. His attraction to the object is consistent with Dada, especially the multimedia of Man Ray and the wordplay of Marcel Duchamp. "My interest in Duchamp," Nauman has said, "has to do with his use of objects to stand for ideas. I like Man Ray better: there's less 'tied-upness' in his work, more unreasonableness."[3]

Nauman's relationship to Duchamp is evident in his *Self-Portrait as a Fountain* (fig. **31.34**). Illuminated from the right by an eerie green light and from the left by a yellow light, he emerges from a dark background reminiscent of Caravaggio's tenebrism (see Chapter 19). Nauman reflects the twentieth-century trend in which the artist is present in his own work. He spouts water from his mouth, holding up his hands as if to balance himself.

Echoing the visual pun of Duchamp's *Urinal* (see fig. **28.2**), Nauman himself is the ready-made in this photograph, which has been "aided" by the artist's action. In addition to visual punning, Nauman is fascinated by philosophical and literary language as well as wordplay— especially of certain modern French writers. He is quoted as saying, "I think the point where language starts to break down as a useful tool for communication is the same edge where poetry or art occurs. . . . If you only deal with what is known, you'll have redundancy; on the other hand, if you only deal with the unknown, you cannot communicate at all. There's always some combination of the two, and it is how they touch each other that makes communication interesting."[4]

CONNECTIONS

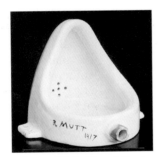

See figure 28.2. Marcel Duchamp, *Fountain (Urinal)*, 1917.

31.34 Bruce Nauman, *Self-Portrait as a Fountain*, 1966–67/1970. Portfolio of eleven color photographs. Edition of 8. 19⅞ × 22¾ in. (50.96 × 57.80 cm). Courtesy of Sperone Westwater, New York.

Cindy Sherman

The theme of innovation and continuity is expressed in some of the work of Cindy Sherman (born 1954). Her medium is photography, and she is her own model. She has photographed herself in various guises from fashion model to cadaver. Her *Untitled* of 1989 (fig. **31.35**) is a photograph of herself as Raphael's *Fornarina* (fig. **31.36**). In what is apparently a satire on its Renaissance inspiration, Sherman attaches a pair of false breasts and shows herself as pregnant. Her left hand replicates the traditional gesture signifying both modesty and seduction (see figs. **15.15** and **15.30**). With her right hand she holds up heavy mesh drapery resembling a household curtain, which contrasts with Raphael's lighter, more diaphanous material. This gesture recalls that of Arnolfini's bride (see fig. **15.37**). Instead of the orderly embroidered headscarf of the Fornarina, Sherman wears a ragged cloth. In such transformations of the Renaissance work, Sherman creates a pregnant, housewifely version of Raphael's idealized Classical muse.

The Fornarina ("baker's wife" in Italian) was reputed to have been one of Raphael's mistresses, a reading that is reinforced by the background leaves of laurel, myrtle, and quince. All are attributes of Venus and are therefore associated with love. This work is also one of Raphael's very few signed paintings—the neatly jeweled armband is inscribed "Raphael of Urbino," suggesting his possession of the woman. Cindy Sherman, on the other hand, wears a garter on her arm, as if to declare her independence from men. At the same time, however, she plays on various aspects of the woman's role in society, including the sense that she is weighed down by childbearing and household chores. Sherman's humor lies in her visual punning, and in the fine line between aspects of her own role, which shifts between artist and model, self and other.

31.35 Cindy Sherman, *Untitled*, 1989. Color photograph, 5 ft. 1½ in. × 4 ft. ¼ in. (1.56 × 1.22 m). Metro Pictures, New York. One of Sherman's best-known projects of the late 1970s was a series of black-and-white film stills in which she dressed as a stereotypical female character—the heroine, the ingenue, the vamp—in grade-B Hollywood movies.

31.36 Raphael, *The Fornarina*, c. 1518. Oil on panel, 33½ × 23½ in. (85 × 60 cm). Galleria Nazionale (Palazzo Barberini), Rome, Italy.

Video Art

Nam June Paik The medium of video has offered artists new ways of conveying old as well as contemporary themes. One of the leading exponents of video art is the Korean-born composer, performer, and visual artist Nam June Paik (1932–2006). He studied philosophy, aesthetics, and music at the University of Tokyo and in 1956 went to Munich to study music. In Germany, Paik met the avant-garde musician John Cage and worked with Joseph Beuys. In the late 1960s Paik began to create video sculptures consisting of television monitors arranged in significant shapes and projecting specific, controlled images. He developed a philosophy of cybernetics (the study of communication processes) that he translated into works, merging the transitory character of performance art with the durability of the created object. In a pamphlet titled *Manifestos* of 1966, Paik wrote: "As the Happening is the fusion of various arts, so cybernetics is the exploitation of boundary regions between and across various existing sciences."[5]

In 1996, inspired by a trip to Denmark, Paik produced the *Robot* series. In these portraits of six famous Danes, a traditional genre is portrayed using modern media. Figure **31.37** is *Hamlet Robot,* composed of radios, televisions, and laser disc players. Paik's *Hamlet,* like Shakespeare's, is a man who would be king but bows his crowned head as if weighed down by despair. The artist conveys Hamlet's proverbial ambivalence by the contrast of the lowered right arm holding the staff of rule with the raised left arm. The skull of Yorick posed on Hamlet's left hand is reminiscent of the warnings inherent in *vanitas* iconography, and its juxtaposition with Hamlet's head seems to foreshadow his tragic end. "The Buddhists also say," according to Paik, that "karma is samsara. Relationship is metempsychosis. We are in open circuits."[6]

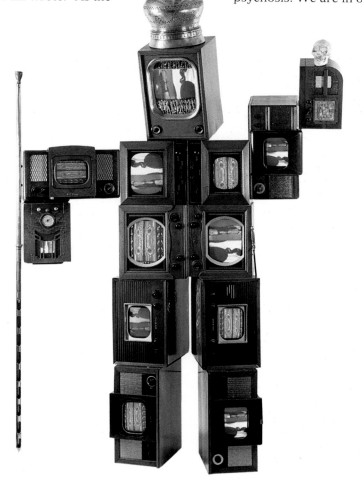

31.37 Nam June Paik, *Hamlet Robot,* 1996. 2 radios, 24 TVs, transformer, 2 laser disc players, laser discs, crown, scepter, sword, and skull, 12 ft. 1 in. × 7 ft. 4¼ in. × 2 ft. 7⅞ in. (3.66 × 2.24 × 0.81 m).

Bill Viola The same year that Paik created *Hamlet Robot* out of radios and television monitors, Bill Viola (born 1951) presented his video installation *The Crossing*. Using sound as well as video, Viola combined the ancient dualism of fire and water with modern media. He projected two sequences, one on either side of a screen, in which a man is consumed and destroyed by the elemental power of nature. Influenced by Eastern religions (including Buddhism and Islam) and interested in the relationship of light and color to form, Viola shows a rapid evolution (a crossing over) from human to nonhuman—and implicitly from physicality to spirituality—as his man disappears into fire or water.

Both sequences are shown simultaneously and begin with a man walking toward the viewer. In the fire sequence (fig. **31.38**), a votive candle at the man's feet becomes a raging fire (accompanied by a roar) and swallows him up. The same sequence occurs on the opposite side of the screen, but with water (fig. **31.39**). At first a few drops fall on the man, but then they become a flood and, accompanied by a roar, engulf him. In contrast to traditional works, found in nearly every culture, that represent various religious and mythical accounts of human creation, Viola reverses the process and undoes the creation of human form. His man thus stands for humanity as a whole, which is destroyed by the elemental forces of fire and water.

In the context of twentieth-century art history, Viola's video can also be seen as a metaphor for the dissolution of the figure with the rise of abstraction. He begins with figuration—the man—which dissolves into images of unformed light and color. By projecting the sequences onto opposite sides of a screen, Viola creates an anxiety in viewers who cannot apprehend both at once. They must either watch first one sequence and then the other or move back and forth between the two. Thus there is always something happening that the viewer cannot see. The resulting anxiety echoes the panic that results from contemplating one's own physical dissolution.

31.38 Bill Viola, *The Crossing*, fire still, 1996. Video/sound installation. Collection: Edition 1, Collection of the Solomon R. Guggenheim Museum, New York (Gift of The Bohen Foundation). Edition 2, Collection of Pamela and Richard Kramlich, San Francisco. Edition 3, Dallas Museum of Art, Texas. Photo: Kira Perov.

31.39 Bill Viola, *The Crossing*, water still, 1996. Video/sound installation. Collection: Edition 1, Collection of the Solomon R. Guggenheim Museum, New York (Gift of The Bohen Foundation). Edition 2, Collection of Pamela and Richard Kramlich, San Francisco. Edition 3, Dallas Museum of Art, Texas. Photo: Kira Perov.

31.40 Shirin Neshat, *Fervor*, 2000. Production still. Video/sound installation, black and white. Duration: 10 minutes. © Shirin Neshat. Courtesy Gladstone Gallery, New York. Neshat was studying in the United States in 1979 when the shah of Iran was overthrown by Islamic fundamentalists. Appalled by conditions in her native country upon her return in 1990, she has devoted herself to making videos that show the oppression of women and other conditions that resulted from Islamic rule.

Shirin Neshat The Iranian-born artist Shirin Neshat (born 1957), like Nam June Paik, combines Eastern and Western themes. Like Viola, she projects videos. But her sequences face each other so that viewers can stand between them and turn from side to side to see them. The shifts required of viewers replicate the social and gender-based oppositions of Neshat's native Iran. They also reinforce the sense of difference between East and West, while at the same time calling for their reconciliation.

The still illustrated here is from her 2000 video *Fervor* (fig. **31.40**) and shows a group of Muslim worshipers listening to a religious leader. They are separated by a black curtain, reflecting the gender divide between men and women as well as between the Islamic custom of covering women and allowing men to wear Western dress. The men are more differentiated, for they wear white shirts, black pants, and their heads are uncovered. The women, on the other hand, are silhouettes with covered heads. As if to protest these imposed distinctions, Neshat shows a single woman looking over the curtain at the men. She alone is given an individual identity.

Having entered the twenty-first century, we are presented with a proliferation of artistic styles and expanding definitions of what constitutes art. The pace of technological change, particularly in communications and the media, spawns new concepts and styles at an increasing rate. Taste as well as style change, and it will be for future generations to look back at our era and to separate the permanent from the impermanent. How long a work of art must endure for it to claim a place in the artistic pantheon is a matter of dispute. The little *Venus of Willendorf* has existed for more than 25,000 years, the Sistine ceiling for more than 450. And yet some of the modern art discussed in this chapter is intentionally transitory. Performance art, for example, lasts no longer than the performance itself, except in memory or on film.

In this survey we have considered some of the artists whose works have stood the test of time. Artists, the "children" of preceding generations of artists, are influenced by their predecessors. This survey will have fulfilled its purpose if readers are affected by some of the best of what has survived.

1970 **c. 2009**

CONTINUITY, INNOVATION, AND GLOBALIZATION

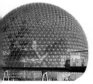 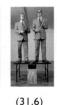 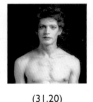

(31.8) (31.1) (31.6) (31.20) (31.19) (31.28) (31.29) (31.26) (31.17)

Birth of genetic engineering (1973) End of Vietnam War (1973) Alex Haley, *Roots* (1976) Mother Teresa wins Nobel Peace Prize (1979) Ronald Reagan elected U.S. president (1980) Operation Desert Shield (1990–91) Bill Clinton elected U.S. president (1992) Barack Obama elected U.S. president (2008)

Notes

Chapter 4

1. Cited by Diane Wolkstein and Samuel Noah Kramer, *Inanna, Queen of Heaven and Earth: Her Stories and Hymns from Sumer* (New York, 1983), p. 105.
2. Quotes from the *Epic of Gilgamesh* are from John Gardner and John Maier, *Gilgamesh* (New York, 1984), p. 57.

Chapter 5

1. British Museum, *An Introduction to Ancient Egypt*, rev. ed. (London, 1979).

Chapter 7

1. Plutarch, *Lives*, trans. Bernadotte Perrin, 11 vols., Loeb Edition (Cambridge, MA, 1984–1997), III (1984), p. 36.

Chapter 9

1. Virgil, *The Aeneid* VI.ii. 847–53, trans. Robert Fitzgerald (New York, 1983).
2. Josephus, *Jewish Wars* VII.5, 132; cited in J. J. Pollitt, *The Art of Rome c. 753 B.C.–A.D. 337: Sources and Documents* (New York: Cambridge University Press, 1983), p. 159.
3. Marcus Aurelius, *Meditations* V.1, 2; cited in Pollitt, ibid., p. 185.

Chapter 11

1. *Beowulf: A Verse Translation*, trans. Frederick Rebsamen (New York, 1991), p. 2.

Chapter 13

1. Cited by Erwin Panofsky, ed., *Abbot Suger on the Abbey Church of St.-Denis and Its Art Treasures*, 2nd ed. (Princeton, 1979), p. 43.
2. Cited by Panofsky, ibid., p. 51.

Chapter 14

1. Cited by Laurie M. Schneider, ed., *Giotto in Perspective* (Englewood Cliffs, NJ, 1974), p. 29.
2. Dante, *Purgatory* II.91–95, in Millard Meiss, *Painting in Florence and Siena after the Black Death* (Princeton, 1951), p. 5.

Chapter 15

1. Cited by Linnea H. Wren and David J. Wren, eds., in *Perspectives on Western Art*, 2 vols. (New York, 1994), II, p. 33.
2. Cited by Wren, ibid., pp. 36–37.
3. Marsilio Ficino, *Commentary on Plato's Symposium on Love*, trans. Sears Jayne (Dallas, 1985), pp. 53–54; cited by Linnea H. Wren, ibid., pp. 34–36.

Chapter 18

1. Cited by Linnea H. Wren, in *Perspectives on Western Art*, ed. Linnea H. Wren and David J. Wren, 2 vols. (New York, 1994), II, p. 105.
2. Cited by Wren, ibid., p. 109.
3. W. H. Auden, *Collected Poems*, ed. Edward Mendelson (London, 1976), p. 146.
4. Saint Bridget, *Revelations*, Bk IV; cited by James Snyder, *Northern Renaissance Art: Painting, Sculpture, the Graphic Arts from 1350 to 1575* (New York, 1985), pp. 349–50.

Chapter 21

1. Cited by William Howard Adams, *Jefferson's Monticello* (New York, 1983), p. 16.

Chapter 23

1. Julia Margaret Cameron, *Annals of My Glass House* (Claremont, CA: Ruth Chandler Williamson Gallery, 1996).

Chapter 25

1. Vincent van Gogh, letter 554, reprinted from *The Complete Letters of Vincent van Gogh* (Boston, 1991).
2. Paul Gauguin, *L'Echo de Paris*, Feb. 23, 1891; cited by Daniel Guérin, ed., in *The Writings of a Noble Savage* (New York, 1990), p. 48.
3. Paul Gauguin, *L'Echo de Paris*, May 13, 1895; cited by Daniel Guérin, ed., in *The Writings of a Noble Savage* (New York, 1990), p. 109.
4. Cited by Arne Eggum, *Edvard Munch: Symbols and Images* (Washington, DC: National Gallery of Art, 1978), p. 391.

Chapter 26

1. Wallace Stevens, *Collected Poems* (New York, 1964), pp. 165–84.
2. Vassily Kandinsky, "Der Blau Reiter (Rück blick)," *Das Kunstblatt*, 1930, as trans. in *Kandinsky, Complete Writings on Art*, ed. Kenneth C. Lindsay and Peter Vergo, 2 vols. (Boston, 1982), II, p. 746; cited by Robert Goldwater, in *Primitivism in Modern Art*, rev. ed. (New York, 1967), p. 127 and in *"Primitivism" in Twentieth Century Art: Affinity of the Tribal and Modern*, ed. William Rubin, 2 vols. (New York, 1984), II, p. 375.
3. Franz Marc, in *August Macke, Franz Marc, Briefwechsel* (Cologne, 1964), pp. 39–44.
4. Cited by D.-H. Kahnweiler, *Juan Gris, sa vie, son oeuvre, ses écrits*, 4th ed. (Paris, 1946), pp. 155–56; also cited in *"Primitivism" in Twentieth Century Art*, I, p. 216.
5. Pablo Picasso, *La Tête d'obsidienne*, in André Malraux, *Picasso's Mask*, trans. June Guicharnaud and Jacques Guicharnaud (New York, 1976), p. 18; also cited in *"Primitivism" in Twentieth Century Art*, I, p. 255.

Chapter 27

1. Gertrude Stein, in *Camera Work* (Aug. 1912): 29–30.
2. Fernand Léger, *Contemporary Achievements in Painting* (Paris, 1914); cited in Edward F. Fry, *Cubism* (New York, 1978), pp. 135–39.
3. Marcel Duchamp, interview with James Johnson Sweeney, in "Eleven Europeans in America," *Bulletin of the Museum of Modern Art* 13, nos. 4–5 (1946): 19–21.
4. From "Lines to a Lady Egg," *New York Evening Sun* (1913); cited by Milton W. Brown, in *The Story of the Armory Show* (Greenwich, CT, 1963), p. 113.
5. Kazimir Malevich, *The World as Non-objectivity: Unpublished Writings 1922–25*, ed. Troels Andersen, trans. Xenia Glowacki-Prus (Copenhagen, 1976).
6. Sidney Geist, in *Artforum* (Feb. 1983): 69.

Chapter 28

1. Marcel Duchamp, cited by Hans Richter, in *Dada: Art and Anti-Art*, trans. David Britt (New York, 1997), p. 89.
2. Man Ray, "Photography Can Be Art," in *Man Ray: Photographs* (New York, 1982), p. 34.
3. Paul Klee, "Creative Credo" (1920), originally published as *Schöpferische Konfession*, ed. K. Edschmid (Berlin, 1920); cited by Herschel B. Chipp, in *Theories of Modern Art: A Source Book by Artists and Critics* (Berkeley: University of California Press, 1968), p. 182.
4. Alexander Calder, cited in Katharine Kuh, *The Artist's Voice: Talks with Seventeen Artists* (New York and Evanston, IL: Harper & Row, 1962), p. 41.
5. Georgia O'Keeffe, letter to Henry McBride, July 1931; cited by Jack Cowart, Juan Hamilton, Sarah Greenough, eds., *Georgia O'Keeffe, Art and Letters* (Washington, DC, 1987), p. 203.
6. Cited by Alfred Morang, in *Transcendental Painting* (Santa Fe, N.Mex.: American Foundation for Transcendental Painting, 1940).

Chapter 29

1. Cited by Herschel B. Chipp, *Theories of Modern Art: A Source Book by Artists and Critics* (Berkeley, 1968), pp. 536–44.
2. Excerpt from a transcript of an artists' session held in New York, 1948; cited by Chipp, ibid.
3. Harold Rosenberg, "Getting inside the Canvas," *Art News* (Dec. 1952): 22–23; repro. in Harold Rosenberg, *The Tradition of the New* (New York, 1959); cited by Chipp, p. 580.
4. Clement Greenberg, "Abstract, Representational, and So Forth," in *Art and Culture: Critical Essays* (Boston, 1961), pp. 137–38; cited by Chipp, p. 580.
5. Greenberg, pp. 137–38; cited by Chipp, p. 580.
6. Jackson Pollock, in *Arts and Architecture* 61 (Feb. 1944): 193; cited by Chipp, p. 546.
7. Willem de Kooning, from the symposium "What Abstract Art Means to Me," held at the Museum of Modern Art, New York, 1951.
8. Mark Rothko, "The Romantics Were Prompted," in *Possibilities I* (Winter 1947/48): 84.

Chapter 30

1. Cited by Brydon Smith, *etc. from Dan Flavin*, exh. cat. (Ottawa: The National Gallery of Canada, 1969), p. 206.
2. Cited by Barbara Haskell, *Agnes Martin*, exh. cat. (New York: Whitney Museum of American Art, 1992), pp. 16, 17, 24.
3. Cited in Gary Garrels, ed., *Sol LeWitt: A Retrospective* (New Haven, CT: Yale University Press, 2000), p. 369.

Chapter 31

1. Cited by Linda Chase and Tom McBurnett, "Tom Blackwell," in "The Photo-Realists: Twelve Interviews," *Art in America* (Nov.–Dec. 1972): 76.
2. Cited in the *New York Times* (July 3, 1983).
3. Cited by Robert Storr, *Bruce Nauman*, exh. cat. (New York: Museum of Modern Art, 1995), p. 59.
4. Cited by Storr, ibid., p. 55.
5. Nam June Paik, *Manifestos* (New York, 1966).
6. Paik, ibid.

Glossary

Abacus: the flat slab that forms the topmost unit of a Doric **column** and on which the **architrave** rests (see pp. 100–101).

Abstract: in painting and sculpture, having a generalized or essential form with only a symbolic resemblance to natural objects.

Abutment: the part of a building intended to receive and counteract the thrust, or pressure, exerted by **vaults** and **arches**.

Academy: (a) the gymnasium near Athens where Plato taught; (b) from the eighteenth century, the cultural and artistic establishment and the standards that it represents.

Acanthus: a Mediterranean plant with prickly leaves, supposedly the source of foliage-like ornamentation on **Corinthian** columns.

Achromatic: free of color.

Acrylic: a fast-drying water-based synthetic paint **medium**.

Aedicule: (a) a small building used as a shrine; (b) a niche designed to hold a statue, both formed by two **columns** or **pilasters** supporting a **gable** or **pediment**.

Aerial (or atmospheric) perspective: a technique for creating an illusion of distance by the use of less distinct contours and a reduction in color **intensity** (see p. 253).

Aesthetic: the theory and vocabulary of an individual artistic style.

Aesthetics: the philosophy and science of art and artistic phenomena.

Agora: the open space in an ancient Greek town used as a marketplace or for general meetings.

Airbrush: a device for applying a fine spray of paint or other substance by means of compressed air.

Aisle: a passageway flanking a central area (e.g., the corridors flanking the **nave** of a **basilica** or **cathedral**).

Alabaster: a dense variety of fine-textured gypsum, usually white and translucent, but sometimes gray, red, yellow, or banded, used for carving on a small scale.

Allegory: the expression (artistic, oral, or written) of a generalized moral statement or truth by means of symbolic actions or figures.

Altar: (a) any structure used as a place of sacrifice or worship; (b) a tablelike structure used in a Christian church to celebrate the **Eucharist**.

Altarpiece: a painted or sculptured work of art designed to stand above and behind an **altar** (see p. 226).

Ambulatory: a vaulted passageway, usually surrounding the **apse** or **choir** of a church (figs. **10.7, 12.3**).

Amphitheater: an oval or circular space surrounded by rising tiers of seats, used by the ancient Greeks and Romans for plays and other spectacles.

Amphora: an ancient Greek two-handled vessel for storing grain, honey, oil, or wine (figs. **7.1–7.3**).

Analogous hues: **hues** containing a common color, though in different proportions.

Anthropomorphism: ascription of human characteristics to nonhuman objects.

Apocalypse: (a) the last book of the New Testament, containing revelations of the future by Saint John the Divine; (b) a prophetic revelation.

Apocrypha: certain books of the Bible, the authority and authenticity of which are in doubt.

Apostle: in Christianity, one of the twelve followers chosen by Christ to spread his Gospel.

Apse: a projecting part of a building (especially a church), usually semicircular and topped by a half **dome** or **vault**.

Aquatint: a **print** from a metal **plate** on which certain areas have been "stopped out" to prevent the action of the acid (see p. 408).

Aqueduct: a man-made conduit for transporting water (fig. **9.14**).

Arabesque: literally meaning "in the Arabian fashion"; an intricate pattern of interlaced or knotted lines consisting of stylized floral, foliage, and other **motifs**.

Arcade: a **gallery** formed by a series of **arches** with supporting **columns** or **piers** (fig. **13.5**), either freestanding or blind (i.e., attached to a wall).

Arch: a curved architectural member, generally consisting of wedge-shaped blocks (**voussoirs**), that is used to span an opening; it transmits the downward pressure laterally (see pp. 46, 127).

Architrave: the lowest unit of an **entablature**, resting directly on the **capital** of a **column** (see pp. 100–101).

Archivolt: the ornamental band or **molding** surrounding the **tympanum** of a Romanesque or Gothic church.

Arena: the central area in a Roman **amphitheater** where gladiatorial and other spectacles took place.

Armature: (a) a metal framework for a **stained-glass** window; (b) a fixed inner framework supporting a sculpture made of a more flexible material.

Arriccio: the rough first coat of plaster in a fresco.

Assemblage: a group of **three-dimensional** objects brought together to form a work of art.

Asymmetrical: characterized by asymmetry, or lack of **balance**, in the arrangement of parts or components.

Atmospheric perspective: see **Aerial perspective**.

Atrium: (a) an open courtyard leading to, or within, a house or other building, usually surrounded on three or four sides by a **colonnade**; (b) in a modern building, a rectangular space off which other rooms open.

Attic: in Classical architecture, a low story placed above the main **entablature**.

Avant-garde: literally the "advanced guard"; a term used to denote innovators or nontraditionalists in a particular field.

Axis: an imaginary straight line that passes through the center of a figure, form, or structure and about which that figure is imagined to rotate.

Axonometric projection: the depiction on a single plane of a **three-dimensional** object by placing it at an angle to the **picture plane** so that three faces are visible (fig. **10.14**).

Balance: an aesthetically pleasing equilibrium in the combination or arrangement of elements.

Baldachino: a canopy or canopylike structure above an **altar** or throne (fig. **19.1**).

Balustrade: a series of balusters, or upright pillars, supporting a rail (as along the edge of a balcony or bridge).

Baptistery: a building, usually round or polygonal, used for Christian baptismal services.

Barrel (or tunnel) vault: a semicylindrical **vault**, with parallel **abutments** and an identical cross section throughout, covering an oblong space (see p. 127).

Base: (a) that on which something rests; (b) the lowest part of a wall or **column**, considered as a separate architectural feature.

Basilica: (a) in Roman architecture, an oblong building used for tribunals and other public functions (see p. 131); (b) in Christian architecture, an early church with features similar to the Roman prototype (fig. **10.3**).

Bas-relief: see **Low relief**.

Bay: a unit of space in a building, usually defined by **piers**, **vaults**, or other elements in a structural system.

Beaverboard: a type of fiberboard used for partitions and ceilings.

Belfry: a bell tower.

Binder, binding medium: a substance used in paint and other **media** to bind particles of pigment together and enable them to adhere to the **support**.

Biomorphic: Lifelike in shape.

Bistre (or bister): a brown artistic **medium** made from the soot of burnt wood.

Black-figure: a style of pottery painting found in sixth-century-B.C. Greece in which the decoration is black on a red background.

Book of Hours: a prayer book, intended for lay use, containing the devotions, or acts of worship, for the hours of the Roman Catholic Church (i.e., the times appointed for prayer, such as Matins and Vespers).

Broken pediment: a **pediment** in which the **cornice** is discontinuous or interrupted by another element.

Buon fresco: see **Fresco**.

Burin: a metal tool with a sharp point used to incise designs on pottery and **etching plates**, for example.

Burr: in etching, the rough ridge left projecting above the surface of an engraved **plate** where the design has been incised.

Bust: a sculptural or pictorial representation of the upper part of the human figure, including the head and neck (and sometimes part of the shoulders and chest).

Buttress: an external architectural support that counteracts the lateral thrust of an **arch** or wall.

Caduceus: the symbol of a herald or physician, consisting of a staff with two snakes twined around it and two wings at the top.

Calligraphy, calligraphic: the art of fine (literally "beautiful") handwriting.

Camera obscura: a dark enclosure or box into which light is admitted through a small hole, enabling images to be projected onto a wall or screen placed opposite that hole; the forerunner of the photographic camera.

Canon: a set of rules, principles, or standards used to establish scales or **proportions**.

Canopic: relating to the city of Canopus in ancient Egypt; used to denote a vessel in which ancient Egyptians preserved the viscera of the dead.

Cantilever construction: an architectural system in which a beam or member, supported at only one end, projects horizontally from a wall or **pier** to which it is fixed (fig. **27.22**).

Capital: the decorated top of a **column** or **pilaster**, providing a transition from the **shaft** to the **entablature**.

Cardo: the north-south axis of a **castrum**.

Caricature: a representation in art or literature that distorts, exaggerates, or oversimplifies certain features.

Cartoon: (a) a full-scale preparatory drawing for a painting, which is transferred to the **support** before the final work is executed; (b) in more modern usage, a comical or satirical drawing.

Cartouche: an oval or **scroll**-shaped design or ornament, usually containing an inscription, a heraldic device, or (as in Egypt) a ruler's name.

Carving: a subtractive sculptural technique in which the artist removes material from a hard surface with a sharp instrument.

Caryatid: a supporting **column** in **post-and-lintel** construction carved to represent a human (generally female) figure.

Casein: a light-colored protein-based substance derived from milk, used in the making of paint, adhesives, etc.

Casting: a sculptural process in which liquid metal or plaster is poured into a mold to create a copy of the original model.

Castrum (pl. *castra*): an ancient Roman fortress; a Roman encampment.

Catacomb: an underground complex of passageways and **vaults**, such as those used by Jews and early Christians to bury their dead.

Cathedral: the principal church of a diocese (the ecclesiastical district supervised by a bishop).

Cella: the main inner room of a temple, often containing the cult image of the deity.

Centering: the temporary wooden framework used in the construction of **arches**, **vaults**, and **domes** (see p. 127).

Centrally planned: radiating from a central point.

Ceramics: (a) the art of making objects from clay or other substances (such as **enamel** and porcelain) that require **firing** at high temperatures; (b) the objects themselves.

Chancel: that part of a Christian church, reserved for the clergy and choir, in which the **altar** is placed.

Chapter house: a meeting place for the discussion of business in a **cathedral** or **monastery**.

Château: French word for a castle or large country house.

Chevet: French term for the eastern end of a Gothic church, comprising the **choir**, **ambulatory**, and **radiating chapels**.

Chiaroscuro: the subtle gradation of light and shadow used to create the effect of **three-dimensionality**.

Chinoiserie: a style in art, developed in France and England during the eighteenth century, in which Chinese imagery was adapted to garden design, architectural follies, costumes, and decorative motifs.

Choir: part of a Christian church, near the **altar**, set aside for those chanting the services (fig. **12.3**); usually part of the **chancel**.

Chroma: see **Intensity**.

Chromatic: colored.

Chryselephantine: consisting of gold and ivory.

Circus: in ancient Rome, an oblong space, surrounded by seats, used for chariot races, games, and other spectacles.

Cire-perdue: see **Lost-wax bronze casting**.

Citadel: a fortress or other fortified area placed in an elevated or commanding position.

Clerestory: the upper part of the main outer wall of a building, located above an adjoining roof and admitting light through a row of windows (fig. **10.4**).

Cloisonné: a multicolored surface made by pouring **enamels** into compartments outlined by bent wire fillets, or strips.

Cloister: in a **monastery**, a covered passage or **ambulatory**, usually with one side walled and the other open to a courtyard.

Close: an enclosed space, or precinct, usually next to a building such as a **cathedral** or castle.

Cluster (or compound) pier: a **pier** composed of a group, or cluster, of **engaged column** shafts, often used in Gothic architecture.

Codex: sheets or **parchment** or **vellum** bound together—the precursor of the modern book.

Coffer, coffering: a recessed geometrical panel in a ceiling (fig. **9.19**).

Collage: a work of art formed by pasting fragments of printed matter, cloth, and other materials to a flat surface.

Colonnade: a series of **columns** set at regular intervals, usually supporting **arches** or an **entablature** (see p. 99).

Colonnette: a small, slender **column**.

Color wheel: a circular, two-dimensional model illustrating the relationships of the various **hues** (fig. **2.8**).

Colossal Order: an architectural **Order** with the **columns** or **pilasters** extending in height above one story (fig. **16.6**).

Column: a cylindrical support, usually with three parts—**base**, **shaft**, and **capital** (see pp. 100–101).

Complementary colors: **hues** that lie directly opposite each other on the **color wheel**.

Composition: the arrangement of formal elements in a work of art.

Compound pier: see **Cluster pier**.

Conceptual art: art in which the idea is more important than the **form** or style.

Content: the themes or ideas in a work of art, as distinct from its **form**.

Contour: the outline of a figure or form.

Contrapposto (or **counterpoise**): a stance of the human body in which one leg bears the weight while the other is relaxed, creating an **asymmetry** in the hip-shoulder axis (fig. **7.35**).

Convention: a custom, practice, or principle that is generally recognized and accepted.

Corbeling: brick or masonry courses, each projecting beyond, and supported by, the one below it; the meeting of two corbels would create an **arch** or a **vault**.

Corinthian: see **Order**.

Cornice: the projecting horizontal unit, usually molded, that surmounts an **arch** or a wall; the topmost member of a Classical **entablature** (see pp. 100–101).

Cornucopia: a curved horn overflowing with fruit and produce, symbolic of abundance.

Counterpoise: see *Contrapposto*.

Courses: horizontal layers of brick or masonry in a wall.

Crayon: a stick for drawing formed from powdered **pigment** mixed with wax.

Cromlech: a prehistoric monument consisting of a circle of **monoliths** (fig. **3.10**).

Crosshatching: pattern of superimposed parallel lines **(hatching)** on a two-dimensional surface used to create shadows and suggest **three-dimensionality** (fig. **2.4**).

Crossing: the area in a Christian church where the **transepts** intersect the **nave**.

Cross section: a diagram showing a building cut by a vertical **plane**, usually at right angles to an **axis**.

Cross vault: see **Groin vault**.

Cruciform: shaped or arranged like a cross (fig. **10.3**).

Crypt: a chamber or **vault** beneath the main body of a church.

Cuneiform: a form of writing, consisting of wedge-shaped characters, used in ancient Mesopotamia.

Cupola: a small domed structure crowning a roof or **dome**, usually added to provide interior lighting.

Curvilinear: composed of, or bounded by, curved lines.

Cyclopean masonry: stone construction using large, irregular blocks without mortar.

Cylinder seal: a small cylinder of stone or other material engraved in **intaglio** on its outer surface and used (especially in Mesopotamia) to roll an impression on wet clay.

Daguerreotype: mid-nineteenth-century photographic process for **fixing** positive images on silver-coated metal **plates**.

Decumanus: the east-west axis of a **castrum**.

Deësis: an image showing Christ enthroned between the Virgin Mary and Saint John the Baptist.

Diorite: a type of dark (black or gray) crystalline rock.

Diptych: a writing tablet or work of art consisting of two panels side-by-side and connected by hinges.

Dolmen: a prehistoric structure consisting of two or more **megaliths** capped with a horizontal slab (fig. **3.9**).

Dome: a **vaulted** (frequently hemispherical) roof or ceiling, erected on a circular base, which may be envisaged as the result of rotating an **arch** 180 degrees about a central **axis** (see p. 127).

Doric: see **Order**.

Dressed stone: blocks of stone that have been cut and shaped to fit in a particular place for a particular purpose.

Drip technique: a painting technique in which paint is dripped from a brush or stick onto a horizontal canvas or another **ground**.

Drum: (a) one of the cylindrical blocks of stone from which the **shaft** of a **column** is made (see pp. 100–101); (b) the circular or polygonal wall of a building surmounted by a **dome** or **cupola**.

Drypoint: an **engraving** in which the image is scratched directly into the surface of a metal **plate** with a pointed instrument.

Earthwork: a construction made of earth, such as an embankment.

Easel: a frame for supporting a canvas or wooden panel.

Easel painting: a movable painting, as opposed to one executed on a wall or another architectural surface.

Echinos: in the Doric **Order**, the rounded **molding** between the **necking** and the *abacus* (see pp. 100–101).

Edition: a batch of **prints** made from a single **plate** or **print** form.

Elevation: an architectural diagram showing the exterior (or, less often, interior) surface of a building as if projected onto a vertical plane.

Emulsion: a light-sensitive chemical coating used to transfer photographic images onto metal **plates** or other surfaces.

Enamel: a vitreous coating applied by heat-fusion to the surface of metal, glass, or pottery. See also **Cloisonné**.

Encaustic: a painting technique in which **pigment** is mixed with a **binder** of hot wax and fixed by heat after application.

Engaged column: a **column**, decorative in purpose, attached to a supporting wall.

Engraving: (a) the process of incising an image on a hard material, such as wood, stone, or a copper **plate**; (b) a **print** or impression made by such a process.

Entablature: the portion of a Classical architectural **Order** above the **capital** of a **column** (see pp. 100–101).

Entasis: the slight bulging of a Doric **column**, which is at its greatest about one-third of the distance from the **base**.

Etching: (a) a printmaking process in which an impression is taken from a metal plate on which the image has been etched, or eaten away by acid; (b) a **print** produced by such a process.

Etching ground: a resinous acid-resistant substance used to cover a copper **plate** before an image is etched on it.

Eucharist: (a) the Christian Sacrament of Holy Communion, commemorating the Last Supper; (b) the consecrated bread and wine used at the Sacrament.

Expressive content: the emotions and feelings communicated by a work of art.

Façade: the front or "face" of a building.

Facing: an outer covering or sheathing.

Faïence: earthenware or pottery decorated with brightly colored **glazes** (originally from Faenza, in northern Italy).

Fenestration: the arrangement of windows and doors in a building.

Figura serpentinata: a snakelike twisting of the body, typical of Mannerist art.

Figurative: representing the likeness of a recognizable human (or animal) figure.

Figurine: a small figure

Fire (verb): to prepare (especially **ceramics**) by baking in a **kiln** or otherwise applying heat.

Fixing: the use of a chemical process to make an image (a photograph, for example) more permanent.

Fleur-de-lis: (a) a white iris, the royal emblem of France; (b) a **stylized** representation of an iris, common in artistic design and heraldry.

Flutes, fluting: a series of vertical grooves used to decorate the **shafts** of **columns** in Classical architecture (see pp. 100–101).

Flying buttress, or **flyer:** a **buttress** in the form of a strut or open half-**arch** (fig. **13.5**).

Focal point: the point or area of a work of art to which the viewer's eye is most compellingly drawn.

Foreground: the area of a picture, usually at the bottom of the **picture plane**, that appears nearest to the viewer.

Foreshortening: the use of **perspective** to represent a single object extending back in space at an angle to the **picture plane**.

Form: the overall plan or structure of a work of art.

Formal analysis: analysis of a work of art to determine how its integral parts, or **formal elements**, are combined to produce the overall style and effect.

Formal elements: the elements of style (line, shape, color, etc.) used by an artist in the **composition** of a work of art.

Formalism: the doctrine or practice of strict adherence to **stylized** shapes or other external forms.

Forum: the civic center of an ancient Roman city, containing temple, marketplace, and official buildings (see p. 130).

Found object (or *objet trouvé*): an object not originally intended as a work of art but presented as one.

Fresco: a technique of painting on the plaster surface of a wall or ceiling (see p. 228). In *buon fresco*, the paint is applied while the plaster is still damp so that the **pigments** bond with the wall (see p. 72).

Fresco secco: a variant technique of **fresco** painting in which the paint is applied to dry plaster; this is often combined with *buon fresco*, or "true" fresco painting.

Frieze: (a) the central section of the **entablature** in the Classical **Orders**; (b) any horizontal decorative band.

Functionalism: a philosophy of design (in architecture, for example) holding that **form** should be consistent with material, structure, and use.

Gable (or **pitched**) **roof:** a roof formed by the intersection of two **planes** sloping down from a central beam (fig. **10.4**).

Gallery: the second story of a church, placed over the side **aisles** and below the **clerestory** (see fig. **10.7a**).

Genre: a category of art representing scenes of everyday life.

Geodesic dome: a **dome**-shaped framework consisting of small interlocking polygonal units (fig. **31.8**).

Geometric: (a) based on mathematical shapes such as the circle, square, or rectangle; (b) a style of Greek pottery made between c. 1000 and 700 B.C., characterized by geometric decoration; (c) a kind of **perspective:** see **Linear perspective.**

Gesso: a white coating made of chalk, plaster, and **size** that is spread over a surface to make it more receptive to paint.

Gilding: the covering of all or part of a work of art with gold leaf or some other gold-colored substance.

Giornata: a day's work (in Italian); a term used particularly in the context of **fresco** to describe each area of fresh plaster applied to a wall before painting.

Glaze: (a) in **oil painting**, a layer of translucent paint or varnish, sometimes applied over another color or **ground** so that light passing through it is reflected back by the lower surface and modified by the glaze; (b) in pottery, a material applied in a thin layer that, when **fired**, fuses with the surface to produce a glossy, nonporous effect (see p. 46).

Glyptic art: the art of carving or **engraving**, especially on small objects such as seals or precious stones.

Gospel: one of the first four books of the New Testament, which recount the life of Christ (see p. 154).

Gouache: an opaque, water-soluble painting **medium.**

Greek cross: a cross in which all four arms are of equal length.

Grisaille: a **monochromatic** painting (usually in shades of black and gray, to simulate stone sculpture).

Groin (or **cross**) **vault:** the ceiling configuration formed by the intersection of two **barrel vaults** (see p. 127).

Ground: in painting, the prepared surface of the **support** to which the paint is applied.

Ground plan: a plan of the ground floor of a building, seen from above (as distinguished from an **elevation**).

Guild: an organization of craftsmen (see p. 202).

Half-barrel vaulting: see **Quadrant vaulting.**

Halo: a circle or disk of golden light surrounding the head of a holy figure.

Happening: an event in which artists give an unrehearsed performance, sometimes with the participation of the audience.

Hatching: close parallel lines used in drawings and prints to create the effect of shadow on **three-dimensional** forms. See also **Crosshatching.**

Hierarchical proportion or **scale:** the representation of more important figures as larger than less important ones.

Hieroglyph: a picture or symbol of an object standing for a word or syllable, developed by the ancient Egyptians into a writing system.

Highlight: in painting, an area of high **value** color.

High relief: relief sculpture in which the figures project substantially (e.g., more than half of their natural depth) from the background surface.

Hôtel: in eighteenth-century France, a private house in a city.

Hue: a pure color with a specific wavelength (see p. 17).

Hydria: an ancient Greek or Roman water jar (fig. **7.3**).

Hypostyle: a hall with a roof supported by rows of **columns.**

Icon: a sacred image.

Iconography: the meaning of the subject matter.

Iconology: the study of the meaning or content of a larger **program** to which individual works of art belong.

Idealized, idealization: the representation of objects and figures according to ideal standards of beauty rather than to real life.

Ignudi (pl.): nude figures (in Italian).

Illuminated manuscript: see **Manuscript.**

Illusionism, illusionistic: a type of art in which the objects are intended to appear real.

Impasto: the thick application of paint, usually **oil** or **acrylic**, to a canvas or panel.

Incise: to cut designs or letters into a hard surface with a sharp instrument.

Incised relief: see **Sunken relief.**

Installation: a **three-dimensional** environment or ensemble of objects, presented as a work of art.

Insula (pl. *insulae*): an ancient Roman apartment block.

Intaglio: a printmaking process in which lines are incised into the surface of a **plate** or **print** form (e.g., engraving and etching).

Intensity: the degree of purity of a color; also known as **chroma** or **saturation.**

Interlace: a form of decoration composed of intertwined strips or ribbons.

Intermediate colors: see **Tertiary colors.**

Intonaco: in **fresco** painting, the top coat of fine plaster to which the final design is applied.

Ionic: see **Order.**

Isocephaly, isocephalic: the horizontal alignment of heads in a composition.

Isometric projection: an architectural diagram combining a **ground plan** of a building with a view from an exterior point above and slightly to one side.

Jamb: an upright surface forming the side of a doorway or window, often decorated with sculptures in Romanesque and Gothic churches (fig. **13.16**).

Japonisme: the adoption of features characteristic of Japanese art and culture.

Keystone: the wedge-shaped stone at the center of an **arch**, **rib**, or **vault** that is inserted last, locking the other stones into place (see p. 127).

Kiln: an oven used to bake (or **fire**) clay.

Kore (pl. *korai*): Greek word for "maiden"; an Archaic Greek statue of a standing female, usually clothed (fig. **7.9**).

Kouros (pl. *kouroi*): Greek word for "youth"; an Archaic Greek statue of a standing nude male (fig. **7.8**).

Krater: a wide-mouthed bowl for mixing wine and water in ancient Greece (fig. **7.3**).

Kylix: an ancient Greek drinking cup with a wide, shallow bowl (fig. **7.3**).

Lamassu: in Assyrian art, a figure of a bull or lion with wings and human head (fig. **4.20**).

Lancet: a tall, narrow, arched window without **tracery** (fig. **13.19**).

Landscape: a pictorial representation of natural scenery.

Lantern: the structure crowning a **dome** or tower, often pierced to admit light to the interior.

Lapis lazuli: a semiprecious blue stone, used to prepare the blue **pigment** known as ultramarine.

Lares and **Penates:** (a) in ancient Rome, the tutelary gods of the household; (b) figuratively, one's most valued household possessions.

Latin cross: a cross in which the vertical arm is longer than the horizontal arm, through the midpoint of which it passes (fig. **15.6**).

Lekythos: an ancient Greek vessel with a long, narrow neck, used primarily for pouring oil (fig. **7.3**).

Linear: a style in which lines are used to depict figures with precise, fully indicated outlines.

Linear (or **scientific** or **geometric** or **one-point**) **perspective:** a mathematical system devised during the Renaissance to create an illusion of depth in a two-dimensional image, through the use of straight lines converging toward a **vanishing point** in the distance (see p. 16).

Lintel: the horizontal cross-beam spanning an opening in the **post-and-lintel** system (fig. **3.12**).

Lithography: a printmaking process in which the printing surface is a smooth stone or **plate** on which an image is drawn with a **crayon** or some other oily substance.

Load-bearing construction: a system of construction in which solid forms are superimposed on one another to form a tapering structure.

Loggia: a roofed **gallery** open on one or more sides, often with **arches** or **columns**.

Longitudinal section: an architectural diagram giving an inside view of a building intersected by a vertical **plane** from front to back (fig. **19.11**).

Lost-wax bronze casting (also called *cire-perdue*): a technique for **casting** bronze and other metals (see p. 94).

Low relief (also known as **bas-relief**): relief sculpture in which figures and forms project only slightly from the background **plane**.

Luminism: an American nineteenth-century art style emphasizing the effect of light on **landscape**.

Lunette: (a) a semicircular area formed by the intersection of a wall and a **vault**; (b) a painting, **relief** sculpture, or window of the same shape.

Maestà: the Italian word for "majesty"; the name given to pictures of the Madonna and Child enthroned in majesty (i.e., surrounded by saints and angels).

Magus (pl. **Magi**): in the New Testament, one of the three Wise Men who traveled from the East to pay homage to the infant Christ.

Mandorla: an oval or almond-shaped aureola, or radiance, surrounding the body of a holy person.

Manuscript: a handwritten book produced in the Middle Ages or Renaissance. If it has painted illustrations, it is known as an illuminated manuscript (see p. 176).

Martyrium: a structure built over the tomb or relics of a martyr (fig. **10.3**).

Masonite: a type of fiberboard used in insulation and paneling.

Mastaba: a rectangular burial monument in ancient Egypt.

Masterpiece: a piece of work that a craftsman presented to his **guild** in order to qualify for the rank of master.

Mausoleum (pl. **mausolea**): an elaborate tomb (named for Mausolus, a fourth-century-B.C. ruler commemorated by a magnificent tomb at Halicarnassus).

Meander pattern: a fret or key pattern originating in the Greek **Geometric** period.

Medium (pl. **media**): (a) the material with which an artist works (e.g., **watercolor** on paper); (b) the liquid substance in which **pigment** is suspended, such as oil or water.

Megalith: a large, undressed stone used in the construction of prehistoric monuments.

Megaron: Greek for "large room"; used principally to denote a rectangular hall, usually supported by **columns** and fronted by a porch, traditional in ancient Greece since Mycenaean times.

Memento mori: an image, often in the form of a skull, to remind the living of the inevitability of death.

Menhir: a prehistoric **monolith** standing alone or grouped with other stones (fig. **3.8**).

Metope: the square area, often decorated with **relief** sculpture, between the **triglyphs** of a Doric **frieze** (see pp. 100–101).

Mezzanine: in architecture, an intermediate, low-ceilinged story between two main stories.

Mezzotint: a method of **engraving** by burnishing parts of a roughened surface to produce an effect of light and shade.

Mihrab: a niche or chamber in a **mosque** indicating the direction of Mecca (fig. **11.3**).

Minaret: a tall, slender tower attached to a **mosque**, from which the *muezzin* calls the Muslim faithful to prayer (fig. **10.13**).

Miniature: a representation executed on a much smaller scale than the original object.

Mixed media: a term used to describe a single work of art executed in a variety of **media** or techniques.

Mobile: a delicately balanced sculpture with movable parts that are set in motion by air currents or mechanical propulsion.

Modeling: (a) in two-dimensional art, the use of **value** to suggest light and shadow, and thus create an effect of mass and weight; (b) in sculpture, the creation of form by manipulating a pliable material such as clay.

Module: a unit of measurement on which the **proportions** of a building or work of art are based.

Molding: a continuous contoured surface, either recessed or projecting, used for decorative effect on an architectural surface.

Monastery: a religious establishment housing a community of people living in accordance with religious vows (see p. 180).

Monochromatic: having a color scheme based on shades of black and white, or on **values** of a single **hue**.

Monolith: a large block of stone that is all in one piece (i.e., not composed of smaller blocks), used in **megalithic** structures.

Montage: a pictorial technique in which cutout illustrations (often from heterogeneous sources —**prints**, photographs, etc.) are combined to form a single, composite image.

Monumental: being, or appearing to be, larger than life-size.

Mosaic: the use of small pieces of glass, stone, or tile (**tesserae**), or pebbles, to create an image on a flat surface such as a floor, wall, or ceiling (see p. 163).

Mosque: an Islamic place of worship.

Motif: a recurrent element or theme in a work of art.

Multipoint perspective: a **perspective** system involving more than two **vanishing points**.

Mural: a wall decoration.

Naïve art: art created by artists with no formal training.

Naos: the inner sanctuary of an ancient Greek temple.

Narthex: a porch or vestibule in early Christian churches (fig. **10.3**).

Naturalism, naturalistic: a style of art seeking to represent objects as they actually appear in nature.

Nave: in **basilicas** and churches, the long, narrow, central area used to house the congregation.

Necking: a groove or **molding** at the top of a **column** or **pilaster** forming the transition from **shaft** to **capital**.

Necropolis (pl. **necropoleis**): an ancient or prehistoric burial ground (literally, "city of the dead").

Neutral: lacking color; white, gray, or black.

Nike: a winged statue representing Nike, the goddess of victory.

Nonrepresentational (or **nonfigurative**): not representing any known object in nature.

Obelisk: a tall, four-sided stone, usually **monolithic**, that tapers toward the top and is capped by a **pyramidion** (fig. **5.15**).

Objet trouvé: see Found object.

Oculus: a round opening in a wall or at the apex of a **dome**.

Oenochoe: an ancient Greek wine jug (fig. **7.3**).

Oil paint: slow-drying and flexible paint formed by mixing **pigments** with the **medium** of oil (see p. 260).

One-point perspective: a **perspective** system involving a single **vanishing point**.

Orchestra: in an ancient Greek theater, a circular space used by the chorus (fig. **7.32**).

Order: one of the architectural systems (Corinthian, Ionic, Doric) used by the Greeks and Romans to decorate and define the **post-and-lintel** system of construction (see pp. 100–101).

Organic: having the quality of living matter.

Orthogonals: the converging lines that meet at the **vanishing point** in the system of **linear perspective**.

Pagoda: a multistoried Buddhist reliquary tower, tapering toward the top and characterized by projecting eaves (fig. **20.2**).

Painterly: in painting, using the qualities of color and **texture**, rather than line, to define form.

Palette: (a) the range of colors used by an artist; (b) an oval or rectangular tablet used to hold and mix **pigments**.

Palette knife: a knife with a flat, flexible blade and no cutting edge, used to mix and spread paint.

Papyrus: (a) a plant found in Egypt and neighboring countries; (b) a paperlike writing material made from the pith of the plant.

Parchment: a paperlike material made from bleached and stretched animal hides, used in the Middle Ages for **manuscripts** (see p. 167).

Pastel: a **crayon** made of ground **pigments** and a gum **binder**, used as a drawing **medium**.

Patina: (a) the colored surface, often green, that forms on bronze and copper either naturally (as a result of oxidation) or artificially (through treatment with acid); (b) in general, the surface appearance of old objects.

Patron: the person or group that commissions a work of art from an artist.

Pedestal: the base of a **column**, statue, vase, or other upright work of art.

Pediment: (a) in Classical architecture, the triangular section at the end of a **gable** roof, often decorated with sculpture (fig. **7.25**); (b) a triangular feature placed as a decoration over doors and windows.

Pendentive: in a domed building, an inwardly curving triangular section of the **vaulting** that provides a transition from the round base of the **dome** to the supporting piers (fig. **10.14**).

Peplos: in ancient Greece, a woolen outer garment worn by women, wrapped in folds about the body (fig. **7.9**).

Peripteral: surrounded by a row of **columns** or **peristyle**.

Peristyle: a **colonnade** surrounding a structure (fig. **7.19**); in Roman houses, the courtyard surrounded by **columns**.

Perspective: the illusion of depth in a two-dimensional work of art.

Picture plane: the flat surface of a drawing or painting.

Pier: a vertical support used to bear loads in an **arched** or **vaulted** structure (fig. **13.5**).

Pietà: an image of the Virgin Mary holding and mourning over the dead Christ (fig. **16.14**).

Pigment: a powdered substance that is used to give color to paints, inks, and dyes.

Pilaster: a flattened, rectangular version of a **column**, sometimes load-bearing, but often purely decorative.

Pillar: a large vertical architectural element, usually freestanding and **load-bearing**.

Pitched roof: see **Gable roof.**

Plane: a surface on which a straight line joining any two of its points lies on that surface; in general, a flat surface having a direction in space.

Plate: (a) in **engraving** and **etching,** a flat piece of metal into which the image to be printed is cut; (b) in photography, a sheet of glass, metal, etc., coated with a light-sensitive **emulsion.**

Podium: (a) the masonry forming the base of a temple; (b) a raised platform or **pedestal.**

Polychrome: consisting of several colors.

Polyptych: a painting or **relief,** usually an **altarpiece,** composed of more than three sections.

Portal: the doorway of a church and the architectural composition surrounding it.

Portico: (a) a **colonnade;** (b) a porch with a roof supported by **columns,** usually at the entrance to a building.

Portrait: a representation of a specific person; a likeness.

Portraiture: the art of making **portraits.**

Post-and-lintel construction: an architectural system in which upright members, or posts, support horizontal members, or **lintels** (see p. 31).

Predella: the lower part of an **altarpiece,** often decorated with small scenes that are related to the subject of the main panel.

Primary color: the pure **hues**—blue, red, yellow—from which all other colors can be mixed.

Print: a work of art produced by one of the printmaking processes—**engraving, etching, woodcut** (see p. 326).

Print matrix: an image-bearing surface to which ink is applied before a **print** is taken from it.

Program: the arrangement of a series of images into a coherent whole.

Pronaos: the vestibule of a Greek temple in front of the *cella* or *naos.*

Proportion: the relation of one part to another, and of parts to the whole, with respect to size, height, and width.

Propylaeum (pl. **propylaea**): (a) an entrance to a temple or another enclosure; (b) the entry gate at the western end of the Acropolis, in Athens.

Provenience: origin; the act of coming from a particular source.

Psalter: a copy of the Book of Psalms in the Old Testament, often illuminated.

Pseudo-peripteral: appearing to have a **peristyle,** though some of the **columns** may be **engaged columns** or **pilasters** (fig. **9.15**).

Pulpit: in church architecture, an elevated stand, surrounded by a parapet and often richly decorated, from which the preacher addresses the congregation.

Putto (pl. **putti**): a chubby male infant, often naked and sometimes depicted as a Cupid, popular in Renaissance art (fig. **15.28**).

Pylon: a pair of truncated pyramidal towers flanking the entrance to an Egyptian temple.

Pyramidion: a small pyramid as at the top of an **obelisk.**

Qibla: a wall in a **mosque** that indicates the direction of Mecca.

Quadrant (or **half-barrel**) **vaulting:** vaulting whose arc is one-quarter of a circle, or 90 degrees (fig. **12.5**).

Quatrefoil: an ornamental "four-leaf clover" shape—i.e., with four lobes radiating from a common center.

Radiating chapels: chapels placed around the **ambulatory** (and sometimes the **transepts**) of a medieval church.

Rayograph: an image made by placing an object directly on light-sensitive paper, using a technique developed by Man Ray.

Realism, realistic: attempting to portray objects from everyday life as they actually are; not to be confused with the nineteenth-century movement called Realism (see p. 20).

Rebus: the representation of words or syllables by pictures or symbols, the names of which sound the same as the intended words or syllables.

Rectilinear: consisting of, bounded by, or moving in a straight line or lines.

Red-figure: style of pottery painting in sixth- or fifth-century-B.C. Greece in which the decoration is red on a black background.

Refectory: a dining hall in a **monastery.**

Register: a range or row, especially one of a series.

Reinforced concrete: concrete strengthened by embedding an internal structure or wire mesh or rods.

Relief: (a) a mode of sculpture in which an image is developed outward (**high** or **low relief**) or inward (**sunken relief**) from a basic plane; (b) a printmaking process in which the areas not to be printed are carved away, leaving the desired image projecting from the **plate.**

Reliquary: a casket or container for sacred relics.

Repoussé: in metalwork, decorated with patterns in **relief** made by hammering on the reverse side (fig. **6.22**).

Representational: representing natural objects in recognizable form.

Rib: an arched diagonal element in a **vault** system that defines and supports a **rib vault.**

Rib vault: a **vault** constructed of arched diagonal **ribs,** with a **web** of lighter masonry in between (fig. **13.4**).

Romanticize: to glamorize or portray in a romantic, as opposed to a **realistic,** manner.

Rose window: a large, circular window decorated with **stained glass** and **tracery** (fig. **13.19**).

Rosin: a crumbly resin used in making varnishes and lacquers.

Rotunda: a circular building, usually covered by a **dome.**

Rusticate: to give a rustic appearance to masonry blocks by roughening their surface and beveling their edges so that the joints are indented.

Sacra conversazione: Italian for "sacred conversation"—a Madonna and Child in the company of saints, conversing by means of pose and gesture.

Sahn: an enclosed courtyard in a **mosque.**

Salon: (a) a large reception room in an elegant private house; (b) an officially sponsored exhibition of works of art (see p. 402).

Sanctuary: (a) the most holy part of a place of worship, the inner sanctum; (b) the part of a Christian church containing the **altar.**

Sarcophagus: a stone coffin, sometimes decorated with **relief** sculpture.

Sarsen: a large sandstone block used in prehistoric monuments.

Saturation: see **Intensity.**

Scientific perspective: see **Linear perspective.**

Screen wall: a nonsupporting wall, often pierced by windows.

Scriptorium (pl. **scriptoria**): the room (or rooms) in a **monastery** in which **manuscripts** were produced.

Scroll: (a) a length of writing material, such as **papyrus** or **parchment,** rolled up into a cylinder; (b) a curved **molding** resembling a scroll (e.g., the **volute** or an Ionic or Corinthian **capital**) (fig. **7.20**).

Sculpture in relief: see **Relief.**

Sculpture in the round: freestanding sculptural figures carved or modeled in **three dimensions.**

Sculptured wall motif: the concept of a building as a massive block of stone with openings and spaces carved out of it.

Secondary colors: hues produced by combining two **primary colors.**

Section: a diagrammatic representation of a building intersected by a vertical **plane.**

Self-portrait: a visual representation of an artist depicted by him- or herself.

Serapaeum: a bulding or shrine sacred to the Egyptian god Serapis.

Serekh: a rectangular outline containing the name of a king in the Early Dynastic period of ancient Egypt.

Sfumato: the definition of form by delicate gradations of light and shadow.

Shading: decreases in the **value** or **intensity** of colors to imitate the fall of shadow when light strikes an object.

Shadow: darkness within a space from which the source of light has been blocked.

Shaft: the vertical, cylindrical part of a **column** that supports the **entablature** (see pp. 100–101).

Silhouette: the outline of an object, usually filled in with black or some other uniform color.

Silk screen: a printmaking process in which **pigment** is forced through the mesh of a silk screen, parts of which have been masked to make them impervious.

Sinopia (pl. **sinopie**): in **fresco** painting, a full-size preliminary sketch executed in a red **pigment** on the first, rough coat of plaster.

Size, sizing: a mixture of glue or resin that is used to make a **ground** such as canvas less porous so that paint will not be absorbed into it.

Skeletal (or **steel-frame**) **construction:** a method of construction in which the walls are supported at floor level by a steel frame consisting of vertical and horizontal members.

Skene: in a Greek theater, the stone structure behind the **orchestra** that served as a backdrop or stage wall (fig. **7.32**).

Slip: a mixture of clay and water used to decorate pottery.

Spandrel: the triangular area between (a) the side of an **arch** and the right angle that encloses it, and (b) two adjacent arches.

Sphinx: in ancient Egypt, a creature with the body of a lion and the head of a human, an animal, or a bird (fig. **5.7**).

Spolia: materials taken from an earlier building for reuse in a new one.

Springing: (a) the architectural member of an **arch** that is the first to curve inward from the vertical; (b) the point at which this curvature begins (see p. 127).

Stained glass: windows composed of pieces of colored glass held in place by strips of lead (see p. 202).

State: one of the successive printed stages of a **print,** distinguished from other stages by the greater or lesser amount of work carried out on the image.

Steel-frame construction: see **Skeletal construction.**

Stele: an upright stone slab or pillar, usually carved or inscribed for commemorative purposes (figs. **4.11, 4.16**).

Stereobate: a substructure or foundation of masonry visible above ground level (fig. **7.20**).

Stigmata (pl.): marks resembling the wounds on the crucified body of Christ (from *stigma,* a "mark" or "scar").

Still life: a picture consisting principally of inanimate objects such as fruit, flowers, or pottery.

Stucco: (a) a type of cement used to coat the walls of a building; (b) a fine plaster used for **moldings** and other architectural decorations.

Style: in the visual arts, a manner of execution that is characteristic of an individual, a school, a period, or some other identifiable group.

Stylization, stylized: the distortion of a **representational** image to conform to certain artistic conventions or to emphasize particular qualities.

Stylobate: the top step of a **stereobate**, forming a foundation for a **column**, **peristyle**, temple, or other structure (fig. **7.20**).

Stylus: a pointed instrument used in antiquity for writing on clay, wax, **papyrus**, and **parchment**. Also used with tempera in the Renaissance, and for etching.

Sunken (or **incised**) **relief:** a style of **relief** sculpture in which the image is recessed into the surface.

Support: in painting, the surface to which the **pigment** is applied.

Suspension bridge: a bridge in which the roadway is suspended from two or more steel cables, which usually pass over towers and are then anchored at their ends.

Symmetry: the aesthetic balance that is achieved when parts of an object are arranged about a real or imaginary central line, or **axis**, so that the parts on one side correspond in some respect (shape, size, color) with those on the other.

Synthesis: the combination of parts or elements to form a coherent, more complex whole.

Tectonic: of, or pertaining to, building or construction.

Tell: an archaeological term for a mound composed of the remains of successive settlements in the Near East.

Tempera: a paint in which the **pigments** are mixed with egg yolk and water (see p. 226).

Tenebrism: a style of painting used by Caravaggio and his followers in which most objects are in shadow, while a few are brightly illuminated.

Tenon: a projecting member in a block of stone or other building material that fits into a groove or hole to form a joint.

Tensile strength: the internal strength of a material that enables it to support itself without rupturing.

Terra-cotta: (a) an earthenware material, with or without a **glaze**; (b) an object made of this material.

Tertiary (or **intermediate**) **colors: hues** made from mixing **primary** and **secondary** colors that are adjacent to each other on the **color wheel**.

Tessera (pl. **tesserae**): a small piece of colored glass, marble, or stone used in a **mosaic**.

Texture: the visual or tactile surface quality of an object.

Tholos: (a) a circular tomb of beehive shape approached by a long horizontal passage; (b) in Classical times, a round building modeled on ancient tombs.

Three-dimensional: having height, length, and width.

Thrust: the lateral force exerted by an **arch**, **dome**, or **vault**, that must be counteracted by some form of **buttressing**.

Tondo: (a) a circular painting; (b) a medallion with **relief** sculpture.

Tracery: a decorative **interlaced** design (as in the stonework in Gothic windows).

Transept: a cross arm in a Christian church placed at right angles to the **nave**.

Transverse rib: a **rib** in a **vault** that crosses the **nave** or **aisle** at right angles to the **axis** of the building.

Travertine: a hard limestone used as a building material by the Etruscans and Romans.

Tribune: (a) the **apse** of a **basilica** or basilican church; (b) a **gallery** in a Romanesque or Gothic church.

Triforium: in Gothic architecture, part of the **nave** wall above the **arcade** and below the **clerestory**.

Triglyph: in a Doric **frieze**, the rectangular area between the **metopes**, decorated with three vertical grooves (glyphs) (see pp. 100–101).

Trilithon: an ancient monument consisting of two vertical **megaliths** supporting a third as a **lintel**.

Triptych: an **altarpiece** or painting consisting of one central panel and two **wings**.

Trompe l'oeil: illusionistic painting that "deceives the eye" with its appearance of reality.

Trumeau: in Romanesque and Gothic architecture, the central post supporting the **lintel** in a double doorway.

Truss construction: a system of construction in which the architectural members (such as bars and beams) are combined, often in triangles, to form a rigid framework.

Tufa: a porous volcanic rock that hardens on exposure to air, used as a building material.

Tumulus (pl. **tumuli**): an artificial mound, typically found over a grave.

Tunnel vault: see Barrel vault.

Two-point perspective: a **perspective** system involving two **vanishing points**.

Tympanum: a **lunette** over the doorway of a church, often decorated with sculpture (fig. **12.7**).

Typology: the Christian theory of types, in which characters and events in the New Testament (i.e., after the birth of Christ) are prefigured by counterparts in the Old Testament.

Underdrawing: a preparatory drawing applied directly to the **ground** and over which the artist paints the final work.

Underpainting: a preliminary painting subsequently covered by the final layer(s) of paint.

Value: the degree of lightness (high value) or darkness (low value) in a **hue** (fig. **2.9**).

Value scale: a graded scale of **value**.

Vanishing point: in the **linear perspective** system, the point at which the **orthogonals**, if extended, would intersect (fig. **2.5**).

Vanitas: a category of painting, often a **still life**, the theme of which is the transitory nature of earthly things and the inevitability of death.

Vault, vaulting: a roof or ceiling of masonry, constructed on the **arch** principle (see p. 127); see also **Barrel vault, Groin vault, Rib vault**.

Vehicle: the liquid in which **pigments** are suspended and which, as it dries, binds the color to the surface of the painting.

Vellum: a smooth cream-colored surface for painting or writing, prepared from calfskin.

Villa: (a) in antiquity and the Renaissance, a large country house; (b) in modern times, a detached house in the country or suburbs.

Visible spectrum: the colors, visible to the human eye, that are produced when white light is dispersed by a prism (fig. **2.7**).

Volute: in the Ionic **Order**, the spiral **scroll** motif decorating the **capital** (see pp. 100–101).

Voussoir: one of the individual wedge-shaped blocks of stone that make up an **arch** (see p. 127).

Wash: a thin, translucent coat of paint (e.g., in **watercolor**).

Watercolor: (a) paint made of **pigments** suspended in water; (b) a painting executed in this **medium**.

Wattle and daub: a technique of wall construction using woven branches or twigs plastered with clay or mud.

Web: in Gothic architecture, the portion of a **rib vault** between the **ribs** (fig **13.4**).

Westwork: from the German *Westwerk,* the western front of a church, containing an entrance and vestibule below and a chapel or **gallery** above, and flanked by two towers.

White-ground: a style of pottery painting in fifth-century-B.C. Greece, in which the decoration is usually black on a white background.

Wing: a side panel of an **altarpiece** or screen.

Woodcut: a **relief** printmaking process in which an image is carved on the surface of a wooden block by cutting away those parts that are not to be printed.

Ziggurat: a trapezoidal stepped structure representing a mountain in ancient Mesopotamia (fig. **4.4**).

Suggestions for Further Reading

General

Adams, Laurie. *Art on Trial: From Whistler to Rothko*. New York: Walker, 1976.
———. *Art and Psychoanalysis*. New York: HarperCollins, 1993.
———. *Methodologies of Art: An Introduction*. New York: Westview Press, 2010.
Barasch, Moshe. *Theories of Art: From Plato to Winckelmann*. New York: New York University Press, 1985.
———. *Modern Theories of Art, I: From Winckelmann to Baudelaire*. New York: New York University Press, 1990.
Barolsky, Paul. *A Brief History of the Artist from God to Picasso*. University Park: Pennsylvania State University Press, 2010.
Baxandall, Michael. *Patterns of Intention: On the Historical Explanation of Pictures*. New Haven, CT, CT: Yale University Press, 1985.
Bois, Yve-Alain. *Painting as Model*. Cambridge, MA: MIT Press, 1990.
Broude, Norma, and Mary D. Garrard, eds. *Feminism and Art History: Questioning the Litany*. New York: Harper & Row, 1982.
———, eds. *The Expanding Discourse: Feminism and Art History*. New York: HarperCollins, 1992.
Bryson, Norman. *Vision and Painting: The Logic of the Gaze*. New Haven, CT: Yale University Press, 1983.
Bryson, Norman, Michael Ann Holly, and Keith Moxey, eds. *Visual Theory: Painting and Interpretation*. New York: Cambridge University Press, 1991.
Cahn, Walter. *Masterpieces: Chapters on the History of an Idea*. Princeton, NJ: Princeton University Press, 1979.
Chadwick, Whitney. *Women, Art, and Society*. 3rd ed. New York: Thames & Hudson, 2002.
Clark, Kenneth M. *The Nude: A Study in Ideal Form*. Garden City, NY: Doubleday, 1959.
Derrida, Jacques. *The Truth in Painting*. Trans. Geoff Bennington and Ian McLeod. Chicago and London: University of Chicago Press, 1987.
Eliade, Mircea. *A History of Religious Ideas*. 2 vols. Trans. W. R. Trask. Chicago: University of Chicago Press, 1978.
Fine, Elsa Honig. *Women and Art: A History of Women Painters and Sculptors from the Renaissance to the Twentieth Century*. Montclair, NJ: Allanheld & Schram, 1978.
Flynn, Tom. *The Body in Three Dimensions*. New York: Abrams, 1998.
Freedberg, David. *The Power of Images: Studies in the History and Theory of Response*. Chicago: University of Chicago Press, 1989.
Gombrich, Ernst. *Art and Illusion: A Study in the Psychology of Pictorial Representation*. 5th ed. New York: Pantheon, 1977.
———. *The Image and the Eye: Further Studies in the Psychology of Pictorial Representation*. Ithaca, NY: Cornell University Press, 1982.
———. *Meditations on a Hobby Horse: And Other Essays on the Theory of Art*. 4th ed. Chicago: University of Chicago Press, 1985.
———. *Shadows: The Depiction of Cast Shadows in Western Art*. London: National Gallery, 1995.
Harris, Ann S., and Linda Nochlin. *Women Artists, 1550–1950*. Los Angeles: Los Angeles County Museum of Art, 1976.
Harrison, Charles, and Paul Woods, eds. *Art in Theory, 1900–1990: An Anthology of Changing Ideas*. Cambridge, MA: Blackwell, 1993.
Hauser, Arnold. *The Philosophy of Art History*. Cleveland: World, 1963.

———. *The Social History of Art*. 3rd ed. 4 vols. New York: Routledge, 1999.
Heller, Nancy G. *Women Artists: An Illustrated History*. 3rd ed. New York: Abbeville, 1991.
Holt, Elizabeth G., ed. *A Documentary History of Art*. 2 vols. Garden City, NY: Doubleday, 1981.
Kemp, Martin. *The Science of Art: Optical Themes in Western Art from Brunelleschi to Seurat*. New Haven, CT: Yale University Press, 1990.
Kostof, Spiro. *A History of Architecture: Settings and Rituals*. 2nd ed. New York: Oxford University Press, 1995.
Kris, Ernst, and Otto Kurz. *Legend, Myth, and Magic in the Image of the Artist: A Historical Experiment*. New Haven, CT: Yale University Press, 1979.
Levine, Lawrence W. *Highbrow/Lowbrow: The Emergence of Cultural Hierarchy in America*. Cambridge, MA: Harvard University Press, 1988.
McCoubrey, John W., ed. *American Art, 1700–1960: Sources and Documents*. Englewood Cliffs, NJ: Prentice-Hall, 1965.
Mitchell, W. J. Thomas. *Picture Theory: Essays on Verbal and Visual Representation*. Chicago: University of Chicago Press, 1994.
Nochlin, Linda. *Women, Art, and Power: And Other Essays*. New York: Harper & Row, 1988.
Panofsky, Erwin. *Meaning in the Visual Arts: Papers in and on Art History*. Garden City, NY: Doubleday, 1955.
———. *Idea: A Concept in Art Theory*. Trans. Joseph J. S. Peake. Columbia: University of South Carolina Press, 1968.
———. *Perspective as Symbolic Form*. Trans. Christopher S. Wood. New York: Zone Books, 1991.
Praz, Mario, *Mnemosyne: The Parallel between Literature and the Visual Arts*. Princeton, NJ: Princeton University Press, 1970.
Roth, Leland M. *Understanding Architecture: Its Elements, History, and Meaning*. New York: HarperCollins, 1993.
Saxl, Fritz. *A Heritage of Images: A Selection of Lectures*. Harmondsworth, UK: Penguin, 1970.
Stephenson, Jonathan. *The Materials and Techniques of Painting*. New York: Watson-Guptill, 1989.
Trachtenberg, Marvin, and Isabelle Hyman. *Architecture, from Prehistory to Post-Modernism*. New York: Abrams, 1986.
Verhelst, Wilbert. *Sculpture: Tools, Materials, and Techniques*. 2nd ed. Englewood Cliffs, NJ: Prentice-Hall, 1988.
Winternitz, Emanuel. *Musical Instruments and Their Symbolism in Western Art*. New York: Norton, 1967.
Wittkower, Rudolf. *Allegory and the Migration of Symbols*. London: Thames & Hudson, 1977.
Wittkower, Rudolf, and Margot Wittkower. *Born under Saturn: The Character and Conduct of Artists*. New York: Norton, 1969.
Wodehouse, Lawrence, and Marian Moffet. *A History of Western Architecture*. Mountain View, CA: Mayfield, 1989.
Wolff, Janet. *The Social Production of Art*. 2nd ed. New York: New York University Press, 1993.
Wölfflin, Heinrich. *Principles of Art History: The Problem of the Development of Style in Later Art*. 7th ed. New York: Dover, 1950.
———. *Classic Art: An Introduction to the Italian Renaissance*. New York: Phaidon, 1952.
———. *The Sense of Form in Art: A Comparative Psychological Study*. Trans. Alice Muehsam and Norma A. Shatan. New York: Chelsea, 1958.

Wollheim, Richard. *Painting as an Art*. Princeton, NJ: Princeton University Press, 1987.
Wren, Linnea H., and David J. Wren, eds. *Perspectives on Western Art, I: Source Documents and Readings from the Ancient Near East through the Middle Ages*. New York: Harper & Row, 1987.
———. *Perspectives on Western Art, II: Source Documents and Readings from the Renaissance to the 1970s*. New York: HarperCollins, 1994.
Yates, Frances A. *The Art of Memory*. Chicago: University of Chicago Press, 1966.

The Art of Prehistory

Amiet, Pierre, ed. *Art in the Ancient World: A Handbook of Styles and Forms*. Trans. Valerie Bynner. New York: Rizzoli, 1981.
Bandi, Hans-Georg, and Henri Breuil. *The Art of the Stone Age: Forty Thousand Years of Rock Art*. 2nd ed. London: Methuen, 1970.
Bataille, Georges. *Lascaux; or, The Birth of Art: Prehistoric Painting*. Trans. Austryn Wainhouse. Lausanne, Switz.: Skira, 1980.
Breuil, Henri. *Four Hundred Centuries of Cave Art*. Trans. Mary E. Boyle. Montignac, 1952; repr. New York: Hacker, 1979.
Castleden, Rodney. *The Making of Stonehenge*. New York: Routledge, 1993.
Chauvet, Jean-Marie, Eliette Brunel Deschamps, and Christian Hillaire. *Dawn of Art: The Chauvet Cave*. New York: Abrams, 1996.
Clottes, Jean, and Jean Courtin. *The Cave beneath the Sea: Paleolithic Images at Cosquer*. Trans. Marilyn Garner. New York: Abrams, 1996.
Finegan, Jack. *Light from the Ancient Past: The Archeological Background of Judaism and Christianity*. 2nd ed. 2 vols. Princeton, NJ: Princeton University Press, 1974.
Gimbutas, Marija A. *The Gods and Goddesses of Old Europe, 7000–3500 B.C.: Myths, Legends, and Cult Images*. Berkeley: University of California Press, 1974.
James, Edwin O. *From Cave to Cathedral: Temples and Shrines of Prehistoric, Classical, and Early Christian Times*. London: Thames & Hudson, 1965.
Leroi-Gourhan, André. *The Dawn of European Art: An Introduction to Palaeolithic Cave Painting*. New York: Cambridge University Press, 1982.
Sandars, Nancy K. *Prehistoric Art in Europe*. 2nd ed. Pelican History of Art series. New York: Penguin, 1985.
Sieveking, Ann. *The Cave Artists*. London: Thames & Hudson, 1979.
Twohig, Elizabeth Shee. *The Megalithic Art of Western Europe*. New York: Oxford University Press, 1981.
Wainwright, Geoffrey. *The Henge Monuments: Ceremony and Society in Prehistoric Britain*. New York: Thames & Hudson, 1990.

The Art of the Ancient Near East

Akurgal, Ekrem. *Art of the Hittites*. New York: Abrams, 1962.
Bottéro, Jean. *Mesopotamia: Writing, Reasoning, and the Gods*. Trans. Z. Bahrani and M. Van De Mieroop. Chicago: University of Chicago Press, 1992.
Collon, Dominique. *First Impressions: Cylinder Seals in the Ancient Near East*. London: British Museum, 1987.

Crawford, Harriet E. W. *Sumer and the Sumerians.* New York: Cambridge University Press, 1991.

Frankfort, Henri. *The Art and Architecture of the Ancient Orient.* 5th ed. Pelican History of Art series. New Haven, CT: Yale University Press, 1996.

Gilgamesh. Trans. James Gardner and John Maier. New York: Knopf, 1984.

Groenewegen-Frankfort, Henriette A. *Arrest and Movement: An Essay on Space and Time in the Representational Art of the Ancient Near East.* Cambridge, MA: Belknap Press, 1987.

Kramer, Samuel N. *History Begins at Sumer.* Garden City, NY: Doubleday, 1959.

———. *The Sumerians: Their History, Culture, and Character.* Chicago: University of Chicago Press, 1963.

Lloyd, Seton. *The Archaeology of Mesopotamia: From the Old Stone Age to the Persian Conquest.* Rev. ed. New York: Thames & Hudson, 1978.

Lloyd, Seton, and Hans W. Müller. *Ancient Architecture.* New York: Electa/Rizzoli, 1986.

Mellaart, James. *Çatal Hüyük: A Neolithic Town in Anatolia.* New York: McGraw-Hill, 1967.

Moscati, Sabatino, ed. *The Phoenicians.* New York: Abbeville, 1988.

Muscarella, Oscar W. *Bronze and Iron: Ancient Near Eastern Artifacts in the Metropolitan Museum of Art.* New York: Metropolitan Museum of Art, 1988.

———. *The Lie Became Great: The Forgery of Ancient Near Eastern Cultures.* Groningen, Neth.: Styx, 2000.

Oppenheim, A. Leo. *Ancient Mesopotamia: Portrait of a Dead Civilization.* Rev. ed. Chicago: University of Chicago Press, 1977.

Porada, Edith, and Robert H. Dyson. *The Art of Ancient Iran: Pre-Islamic Cultures.* Rev. ed. New York: Greystone Press, 1967.

Reade, Julian. *Mesopotamia.* 2nd ed. London: British Museum Press, 2000.

Saggs, Henry W. F. *The Greatness That Was Babylon: A Survey of the Ancient Civilization of the Tigris-Euphrates Valley.* Rev. ed. London: Sidgwick & Jackson, 1988.

Woolley, Charles L. *The Art of the Middle East, including Persia, Mesopotamia, and Palestine.* New York: Crown, 1961.

———. *The Development of Sumerian Art.* Westport, CT: Greenwood Press, 1981.

The Art of Ancient Egypt

Aldred, Cyril. *Akhenaten and Nefertiti.* Exh. cat. New York: Viking, 1973.

———. *Egyptian Art in the Days of the Pharaohs, 3100–320 B.C.* New York: Oxford University Press, 1980.

Davis, Whitney. *The Canonical Tradition in Ancient Egyptian Art.* New York: Cambridge University Press, 1989.

Edwards, I. E. S. *The Pyramids of Egypt.* Rev. ed. Harmondsworth, UK: Penguin, 1991.

El Mahdy, Christine, ed. *The World of the Pharaohs: A Complete Guide to Ancient Egypt.* London: Thames & Hudson, 1990.

Gardiner, Alan H. *Egypt of the Pharaohs.* New York: Oxford University Press, 1978.

Hayes, William C. *The Scepter of Egypt.* 2 vols. New York: Metropolitan Museum of Art, 1953–59.

Lange, Kurt, and Max Hirmer. *Egypt: Architecture, Sculpture, Painting in Three Thousand Years.* 4th ed. Trans. Judith Filson and Barbara Taylor. London: Phaidon, 1968.

Lurker, Manfred. *The Gods and Symbols of Ancient Egypt: An Illustrated Dictionary.* Trans. Barbara Cummings. London: Thames & Hudson, 1982.

Panofsky, Erwin. *Tomb Sculpture: Four Lectures on Its Changing Aspects from Ancient Egypt to Bernini.* New York: Abrams, 1992.

Redford, Donald B. *Akhenaten, the Heretic King.* Princeton, NJ: Princeton University Press, 1984.

Reeves, Carl Nicholas. *The Complete Tutankhamun: The King, the Tomb, the Royal Treasure.* New York: Thames & Hudson, 1990.

Schaefer, Heinrich. *Principles of Egyptian Art.* Trans. John Baines. Oxford, UK: Griffith Institute, 1986.

Smith, William Stevenson, and W. Kelly Simpson. *The Art and Architecture of Ancient Egypt.* Rev. ed. New Haven, CT: Yale University Press, 1998.

Strouhal, Eugen. *Life of the Ancient Egyptians.* Norman: University of Oklahoma Press, 1992.

Taylor, John H. *Egypt and Nubia.* Cambridge, MA: Harvard University Press, 1991.

Aegean Art

Boardman, John. *Pre-Classical: From Crete to Archaic Greece.* Baltimore: Penguin, 1967.

Doumas, Christos. *The Wall-Paintings of Thera.* Trans. Alex Doumas. Athens: Thera Foundation, 1992.

Hampe, Roland, and Erika Simon. *The Birth of Greek Art from the Mycenaean to the Archaic Period.* New York: Oxford University Press, 1981.

Higgins, Reynold A. *Minoan and Mycenaean Art.* New rev. ed. New York: Thames & Hudson, 1997.

Hurwit, Jeffrey M. *The Art and Culture of Early Greece, 1100–480 B.C.* Ithaca, NY: Cornell University Press, 1985.

Immerwahr, Sara A. *Aegean Painting in the Bronze Age.* University Park: Pennsylvania State University Press, 1990.

Jenkins, Ian. *The Parthenon Frieze.* Austin: University of Texas Press, 1994.

Marinatos, Spyridon N., and Max Hirmer. *Crete and Mycenae.* New York: Abrams, 1960.

McDonald, William A. *Progress into the Past: The Rediscovery of Mycenaean Civilization.* 2nd ed. Bloomington: Indiana University Press, 1990.

Mylonas, George E. *Mycenae and the Mycenaean Age.* Princeton, NJ: Princeton University Press, 1966.

Nilsson, Martin P. *The Minoan-Mycenaean Religion and Its Survival in Greek Religion.* 2nd rev. ed. New York: Biblo and Tannen, 1971.

Palmer, Leonard R. *Mycenaeans and Minoans: Aegean Prehistory in the Light of the Linear B Tablets.* 2nd rev. ed. Westport, CT: Greenwood Press, 1980.

The Art of Ancient Greece

Ashmole, Bernard. *Architect and Sculptor in Classical Greece.* New York: New York University Press, 1972.

Beazley, John D. *Attic Red-Figure Vase-Painters.* 2nd ed. 3 vols. Oxford, 1963; repr. New York: Hacker, 1984.

———. *The Development of Attic Black-Figure.* Rev. ed. Berkeley: University of California Press, 1986.

Boardman, John. *Athenian Black-Figure Vases.* New York: Oxford University Press, 1974.

———. *The Parthenon and Its Sculptures.* Austin: University of Texas Press, 1985.

———. *Greek Sculpture—the Archaic Period: A Handbook.* New York: Thames & Hudson, 1985.

———. *Greek Sculpture—the Classical Period: A Handbook.* New York: Thames & Hudson, 1985.

———. *Athenian Red-Figure Vases—the Classical Period: A Handbook.* New York: Thames & Hudson, 1989.

———. *Athenian Red-Figure Vases—the Archaic Period: A Handbook.* New York: Thames & Hudson, 1991.

———. *Greek Art.* 4th ed. New York: Thames & Hudson, 1996.

Brilliant, Richard. *Arts of the Ancient Greeks.* New York: McGraw-Hill, 1973.

Carpenter, Rhys. *The Esthetic Basis of Greek Art of the Fifth and Fourth Centuries B.C.* Rev. ed. Bloomington: Indiana University Press, 1959.

———. *Greek Sculpture: A Critical Review.* Chicago: University of Chicago Press, 1960.

———. *The Architects of the Parthenon.* Baltimore: Penguin, 1970.

Carpenter, Thomas H. *Art and Myth in Ancient Greece: A Handbook.* New York: Thames & Hudson, 1991.

Cook, Robert M. *Greek Art: Its Development, Character, and Influence.* New York: Farrar, Penguin, 1991.

Dinsmoor, William B. *The Architecture of Ancient Greece: An Account of Its Historic Development.* 3rd ed. New York: Norton, 1975.

Francis, Eric David. *Image and Idea in Fifth-Century Greece: Art and Literature after the Persian Wars.* London: Routledge, 1990.

Havelock, Christine M. *Hellenistic Art: The Art of the Classical World from the Death of Alexander the Great to the Battle of Actium.* 2nd ed. New York: Norton, 1981.

Kampen, Natalie Boymel. *Sexuality in Ancient Art: Near East, Egypt, Greece, and Italy.* New York: Cambridge University Press, 1996.

Koloski-Ostrow, Ann Olga, and Claire L. Lyons, eds. *Naked Truths: Women, Sexuality, and Gender in Classical Art and Archaeology.* London: Routledge, 1997.

Lawrence, Arnold W. *Greek Architecture.* 5th ed. New Haven, CT: Yale University Press, 1996.

Onians, John. *Art and Thought in the Hellenistic Age: The Greek World View, 350–50 B.C.* London: Thames & Hudson, 1979.

———. *Bearers of Meaning: The Classical Orders in Antiquity, the Middle Ages, and the Renaissance.* Princeton, NJ: Princeton University Press, 1988.

———. *Classical Art and the Cultures of Greece and Rome.* New Haven, CT: Yale University Press, 1999.

Osborne, Robin. *Archaic and Classical Greek Art.* New York: Oxford University Press, 1998.

Pedley, John Griffiths. *Greek Art and Archaeology.* 2nd ed. New York: Abrams, 1998.

Pollitt, J. J. *The Art of Greece, 1400–31 B.C.: Sources and Documents.* Englewood Cliffs, NJ: Prentice-Hall, 1965.

———. *Art and Experience in Classical Greece.* Cambridge, UK: Cambridge University Press, 1972.

———. *The Ancient View of Greek Art: Criticism, History, and Terminology.* New Haven, CT: Yale University Press, 1974.

———. *Art in the Hellenistic Age.* New York: Cambridge University Press, 1986.

Ridgway, Brunilde Sismondo. *The Severe Style in Greek Sculpture.* Princeton, NJ: Princeton University Press, 1970.

———. *Fifth-Century Styles in Greek Sculpture.* Princeton, NJ: Princeton University Press, 1981.

———. *The Archaic Style in Greek Sculpture.* 2nd ed. Chicago: Ares, 1993.

Scully, Vincent. *The Earth, the Temple, and the Gods: Greek Sacred Architecture.* Rev. ed. New Haven, CT: Yale University Press, 1979.

Smith, R. R. R. *Hellenistic Sculpture: A Handbook.* New York: Thames & Hudson, 1991.

Stewart, Andrew F. *Greek Sculpture: An Exploration.* 2 vols. New Haven, CT: Yale University Press, 1990.

———. *Art, Desire, and the Body in Ancient Greece.* New York: Cambridge University Press, 1997.

Vermeule, Emily. *Greece in the Bronze Age.* Chicago: University of Chicago Press, 1972.

———. *Aspects of Death in Early Greek Art and Poetry.* Berkeley: University of California Press, 1979.

The Art of the Etruscans

Boëthius, Axel, and John B. Ward-Perkins. *Etruscan and Roman Architecture.* Pelican History of Art series. Baltimore: Penguin, 1970.

Bonfante, Larissa, ed. *Etruscan Life and Afterlife: A Handbook of Etruscan Studies.* Detroit: Wayne State University Press, 1986.

———. *Etruscan: Reading the Past.* Berkeley: University of California Press/British Museum, 1990.

Brendel, Otto J. *Etruscan Art.* 2nd ed. New Haven, CT: Yale University Press, 1995.

de Grummond, Nancy T., ed. *A Guide to Etruscan Mirrors.* Tallahassee, Fla.: Archaeological News, 1982.

Etruscan Mirrors. New York: The Metropolitan Museum of Art, 1997.

Macnamara, Ellen. *Everyday Life of the Etruscans.* Cambridge, MA: Harvard University Press, 1991.

Richardson, Emeline H. *The Etruscans: Their Art and Civilization.* Chicago: University of Chicago Press, 1976.

Spivey, Nigel, and Simon Stoddart. *Etruscan Italy: An Archaeological History.* London: Batsford, 1992.

Sprenger, Maja, Gilda Bartoloni, and Max Hirmer. *The Etruscans: Their History, Art, and Architecture.* New York: Abrams, 1983.

The Art of Ancient Rome

Anderson, L. Maxwell, and Leila Nista, eds. *Radiance in Stone: Sculptures in Colored Marble from the Museo Nazionale Romano.* Rome: De Luca, 1989.

Brendel, Otto J. *Prolegomena to the Study of Roman Art.* New Haven, CT: Yale University Press, 1979.

Brilliant, Richard. *Roman Art from the Republic to Constantine.* London: Phaidon, 1974.

———. *Pompeii A.D. 79.* New York: Clarkson N. Potter/Museum of Natural History Publications, 1979.

D'Ambra, Eve. *Roman Art.* New York: Cambridge University Press, 1998.

Feder, Theodore. *Great Treasures of Pompeii and Herculaneum.* New York: Abbeville, 1978.

Heintze, Helga von. *Roman Art.* New York: Universe, 1990.

Jenkyns, Richard., ed. *The Legacy of Rome: A New Appraisal.* New York: Oxford University Press, 1992.

Krautheimer, Richard. *Rome: Profile of a City, 312–1308.* Princeton, NJ: Princeton University Press, 1980.

Ling, Roger. *Roman Painting.* New York: Cambridge University Press, 1991.

MacDonald, William L. *The Architecture of the Roman Empire.* Rev. ed. 2 vols. New Haven, CT: Yale University Press, 1982.

———. *The Pantheon: Design, Meaning, and Progeny.* Cambridge, MA: Harvard University Press, 2002.

Pollitt, J. J. *The Art of Rome c. 753 B.C.–A.D. 337: Sources and Documents.* New York: Cambridge University Press, 1983.

Ramage, Nancy H., and Andrew Ramage. *The Cambridge Illustrated History of Roman Art.* Cambridge, UK: Cambridge University Press, 1991.

———. *Roman Art: Romulus to Constantine.* 2nd ed. Englewood Cliffs, NJ: Prentice-Hall, 1996.

Sear, Frank. *Roman Architecture.* Ithaca, NY: Cornell University Press, 1982.

Vermeule, Cornelius. *European Art and the Classical Past.* Cambridge, MA: Harvard University Press, 1964.

Vitruvius. *The Ten Books on Architecture.* Trans. M. H. Morgan. 1914 Repr. New York: Dover, 1960.

Wells, Colin M. *The Roman Empire.* 2nd ed. Cambridge, MA: Harvard University Press, 1995.

Zanker, Paul. *The Power of Images in the Age of Augustus.* Trans. Alan Shapiro. Ann Arbor: University of Michigan Press, 1988.

Early Christian and Byzantine Art

Beckwith, John. *The Art of Constantinople: An Introduction to Byzantine Art (330–1453).* 2nd ed. New York: Phaidon, 1968.

———. *Early Christian and Byzantine Art.* 2nd ed. New York: Penguin, 1979.

Demus, Otto. *Byzantine Art and the West.* New York: New York University Press, 1970.

Elsner, Jaś *Imperial Rome and Christian Triumph: The Art of the Roman Empire A.D. 100–450.* New York: Oxford University Press, 1998.

Grabar, André. *Byzantium: Byzantine Art in the Middle Ages.* Trans. B. Forster. London: Methuen, 1966.

———. *The Beginnings of Christian Art, 200–395.* Trans. Stuart Gilbert and James Emmons. London: Thames & Hudson, 1967.

———. *Christian Iconography: A Study of Its Origins.* Princeton, NJ: Princeton University Press, 1968.

———. *The Golden Age of Justinian, from the Death of Theodosius to the Rise of Islam.* Trans. Stuart Gilbert and James Emmons. New York: Braziller, 1971.

Kitzinger, Ernst. *Byzantine Art in the Making: Main Lines of Stylistic Development in Mediterranean Art, 3rd–7th Century.* Cambridge, MA: Harvard University Press, 1978.

Krautheimer, Richard. *Studies in Early Christian, Medieval, and Renaissance Art.* New York: New York University Press, 1969.

———. *Early Christian and Byzantine Architecture.* 4th ed. Pelican History of Art series. New York: Penguin, 1986.

Lane Fox, Robin. *Pagans and Christians.* New York: Knopf, 1987.

Mainstone, Rowland J. *Hagia Sophia: Architecture, Structure and Liturgy of Justinian's Great Church.* New York: Thames & Hudson, 1988.

Mango, Cyril. *The Art of the Byzantine Empire, 312–1453: Sources and Documents.* Englewood Cliffs, NJ: Prentice-Hall, 1972.

———. *Byzantine Architecture.* New York: Rizzoli, 1985.

Mathews, Thomas F. *Byzantium: From Antiquity to the Renaissance.* New York: Abrams, 1998.

Morey, Charles Rufus. *Early Christian Art.* 2nd ed. Princeton, NJ: Princeton University Press, 1953.

Rice, David T. *The Appreciation of Byzantine Art.* London: Oxford University Press, 1972.

Schapiro, Meyer. *Late Antique, Early Christian, and Mediaeval Art.* New York: Braziller, 1979.

von Simson, Otto G. *Sacred Fortress: Byzantine Art and Statecraft in Ravenna.* Princeton, NJ: Princeton University Press, 1987.

Weitzmann, Kurt. *Studies in Classical and Byzantine Manuscript Illustration.* Chicago: University of Chicago Press, 1971.

———. *Art in the Medieval West and Its Contacts with Byzantium.* London: Variorum, 1982.

Weitzmann, Kurt, et al. *The Icon.* New York: Knopf, 1982.

The Early Middle Ages

Aldhouse-Green, Miranda. *Celtic Art: Symbols and Imagery.* New York: Sterling, 1997.

Alexander, Jonathan J. G. *Medieval Illuminators and Their Methods of Work.* New Haven, CT: Yale University Press, 1992.

Backhouse, Janet, ed. *The Lindisfarne Gospels.* Oxford, UK: Phaidon, 1981.

Backhouse, Janet, D. H. Turner, and Leslie Webster. *The Golden Age of Anglo-Saxon Art, 966–1066.* Bloomington: Indiana University Press, 1984.

Barasch, Moshe. *Gestures of Despair in Medieval and Early Renaissance Art.* New York: New York University Press, 1976.

Basing, Patricia. *Trades and Crafts in Medieval Manuscripts.* London: British Library, 1990.

Beckwith, John. *Early Medieval Art: Carolingian, Ottonian, Romanesque.* New York: Thames & Hudson, 1985.

Blair, Sheila S., and Jonathan M. Bloom. *The Art and Architecture of Islam, 1250–1800.* New Haven, CT: Yale University Press, 1994.

Braunfels, Wolfgang. *Monasteries of Western Europe.* Trans. Alastair Laing. London: Thames & Hudson, 1993.

Brown, Peter. *The Book of Kells.* New York: Knopf, 1980.

Conant, Kenneth J. *Carolingian and Romanesque Architecture, 800–1200.* 3rd ed. Pelican History of Art series. Harmondsworth, UK: Penguin, 1973.

Davis-Weyer, Caecilia. *Early Medieval Art, 300–1150: Sources and Documents.* Englewood Cliffs, NJ, 1971; repr. Toronto: University of Toronto Press, 1986.

Diebold, William J. *World and Image: An Introduction to Early Medieval Art.* Boulder, CO: Westview, 2000.

Dodwell, Charles Reginald. *Pictorial Arts of the West, 800–1200.* Pelican History of Art series. New Haven, CT: Yale University Press, 1993.

Frishman, Martin, and Hasan-Uddin Khan. *The Mosque: History, Architectural Development and Regional Diversity.* New York: Thames & Hudson, 1994.

Grabar, André, and Carl Nordenfalk. *Early Medieval Painting from the Fourth to the Eleventh Century: Mosaics and Mural Painting.* New York: Skira, 1957.

Grabar, Oleg. *The Formation of Islamic Art.* Rev. and enl. ed. New Haven, CT: Yale University Press, 1987.

Henderson, George. *Early Medieval.* Harmondsworth, UK: Penguin, 1972.

———. *From Durrow to Kells: The Insular Gospel-Books, 650–800.* London: Thames & Hudson, 1987.

Hubert, Jean, J. Porcher, and W. F. Volbach. *The Carolingian Renaissance.* New York: Braziller, 1970.

Irwin, Robert. *Islamic Art in Context: Art, Architecture, and the Literary World.* New York: Abrams, 1997.

Kendrick, Thomas D. *Anglo-Saxon Art to A.D. 900.* New York: Barnes & Noble, 1972.

Laing, Lloyd. *Art of the Celts.* New York: Thames & Hudson, 1992.

Lasko, Peter. *Ars Sacra, 800–1200.* 2nd ed. Pelican History of Art series. New Haven, CT: Yale University Press, 1994.

Martindale, Andrew. *The Rise of the Artist in the Middle Ages and Early Renaissance.* New York: McGraw-Hill, 1972.

Megaw, Ruth, and Vincent Megaw. *Celtic Art: From Its Beginnings to the Book of Kells.* Rev. and exp. ed. New York: Thames & Hudson, 2001.

Mütherich, Florentine, and Joachim E. Gaehde. *Carolingian Painting.* New York: Braziller, 1976.

Nordenfalk, Carl. *Celtic and Anglo-Saxon Painting: Book Illumination in the British Isles, 600–800.* New York: Braziller, 1977.

———. *Early Medieval Book Illumination.* New York: Rizzoli, 1988.

Pevsner, Nikolaus. *An Outline of European Architecture.* 7th ed. Baltimore: Penguin, 1974.

———. *Islamic Art.* London: Thames & Hudson, 1975.

Saalman, Howard. *Medieval Architecture: European Architecture, 600–1200.* New York: Braziller, 1962.

Snyder, James. *Medieval Art: Painting—Sculpture —Architecture, 4th–14th Century.* New York: Abrams, 1989.

Stalley, Roger. *Early Medieval Architecture.* New York: Oxford University Press, 1999.

Stokstad, Marilyn. *Medieval Art.* 2nd ed. Boulder, CO: Westview, 2004.

Zarnecki, George. *Art of the Medieval World: Architecture, Sculpture, Painting, the Sacred Arts.* New York: Abrams, 1975.

Romanesque Art

Cahn, Walter. *Romanesque Bible Illumination.* Ithaca, NY: Cornell University Press, 1982.

Demus, Otto. *Romanesque Mural Painting.* New York: Abrams, 1970.

Evans, Joan. *Art in Mediaeval France, 987–1498.* New York: Oxford University Press, 1952.

Focillon, Henri. *The Art of the West in the Middle Ages.* Ed. J. Bony. Trans. D. King. 2nd ed. 2 vols. New York: Phaidon, 1969.

Grabar, André, and Carl Nordenfalk. *Romanesque Painting from the Eleventh to the Thirteenth Century.* New York: Skira, 1958.

Grape, Wolfgang. *The Bayeux Tapestry: Monument to a Norman Triumph.* New York: Prestel, 1994.

Hearn, Millard F. *Romanesque Sculpture: The Revival of Monumental Stone Sculpture in the Eleventh and Twelfth Centuries.* Ithaca, NY: Cornell University Press, 1981.

Jacobs, Michael. *Northern Spain: The Road to Santiago de Compostela.* San Francisco: Chronicle, 1991.

Mâle, Émile. *Religious Art in France, the Twelfth Century: A Study of the Origins of Medieval Iconography.* Bollingen Series 90:1. Princeton, NJ: Princeton University Press, 1978.

———. *Art and Artists of the Middle Ages.* Redding Ridge, CT: Black Swan Books, 1986.

Nichols, Stephen G. *Romanesque Signs: Early Medieval Narrative and Iconography.* New Haven, CT: Yale University Press, 1983.

Petzold, Andreas. *Romanesque Art.* New York: Abrams, 1995.

Radding, Charles M., and William W. Clark. *Medieval Architecture, Medieval Learning: Builders and Masters in the Age of Romanesque and Gothic.* New Haven, CT: Yale University Press, 1992.

Schapiro, Meyer. *Romanesque Art.* New York: Braziller, 1977.

Tate, Brian, and Marcus Tate. *The Pilgrim Route to Santiago.* Oxford, UK: Phaidon, 1987.

Thompson, Daniel V. *The Materials and Techniques of Medieval Painting.* New York: Dover, 1956.

Voelkle, William. *The Stavelot Triptych: Mosan Art and the Legend of the True Cross.* New York: The Pierpont Morgan Library, 1980.

The Year 1200. 2 vols. New York: Metropolitan Museum of Art, 1970.

Zarnecki, George. *Romanesque Art.* New York: Universe Books, 1971.

Gothic Art

Andrews, Francis B. *The Medieval Builder and His Methods.* New York: Barnes & Noble, 1993.

Armi, C. Edson. *The "Headmaster" of Chartres and the Origins of "Gothic" Sculpture.* University Park: Pennsylvania State University Press, 1994.

Blum, Pamela Z. *Early Gothic Saint-Denis: Restorations and Survivals.* Berkeley: University of California Press, 1992.

Branner, Robert. *St. Louis and the Court Style in Gothic Architecture.* London: Zwemmer, 1965.

———. *Chartres Cathedral.* New York: Norton, 1969.

Camille, Michael. *The Gothic Idol: Ideology and Image-Making in Medieval Art.* New York: Cambridge University Press, 1989.

———. *Gothic Art: Glorious Visions.* New York: Abrams, 1996.

Favier, Jean. *The World of Chartres.* Trans. F. Garvie. New York: Abrams, 1990.

Frisch, Teresa G. *Gothic Art, 1140–c. 1450: Sources and Documents.* Englewood Cliffs, NJ, 1971; repr. Toronto: University of Toronto Press, 1987.

Grodecki, Louis. *Gothic Architecture.* Trans. I. Mark Paris. New York: Abrams, 1977.

Grodecki, Louis, and Catherine Brisac. *Gothic Stained Glass, 1200–1300.* Ithaca, NY: Cornell University Press, 1985.

Jantzen, Hans. *High Gothic: The Classic Cathedrals of Chartres, Reims, Amiens.* Trans. James Palmes. New York, 1962; repr. Princeton, NJ: Princeton University Press, 1984.

Henderson, George. *Gothic.* Baltimore: Penguin, 1967.

———. *Chartres.* Baltimore: Penguin, 1968.

Katzenellenbogen, Adolf. *The Sculptural Programs of Chartres Cathedral: Christ, Mary, Ecclesia.* Baltimore: Johns Hopkins Press, 1959.

Lord, Carla. *Royal French Patronage of Art in the Fourteenth Century: An Annotated Bibliography.* Boston: Hall, 1985.

Mâle, Émile. *The Gothic Image: Religious Art in France of the 13th Century.* Rev. ed. Princeton, NJ: Princeton University Press, 1978.

———. *Religious Art in France, the 13th Century: A Study of Medieval Iconography and Its Sources.* Princeton, NJ: Princeton University Press, 1984.

———. *Religious Art in France, the Late Middle Ages: A Study of Medieval Iconography and Its Sources.* Princeton, NJ: Princeton University Press, 1986.

Meulen, Jan van der. *Chartres—Sources and Literary Interpretation: A Critical Bibliography.* Boston: Hall, 1989.

Panofsky, Erwin. *Gothic Architecture and Scholasticism.* Latrobe, Pa.: Archabbey Press, 1951.

Panofsky, Erwin, and Gerda Panofsky-Soergel, eds. *Abbot Suger on the Abbey Church of St.-Denis and Its Art Treasures.* 2nd ed. Princeton, NJ: Princeton University Press, 1979.

von Simson, Otto G. *The Gothic Cathedral: Origins of Gothic Architecture and the Medieval Concept of Order.* 3rd ed. Princeton, NJ: Princeton University Press, 1988.

Watson, Percy. *Building the Medieval Cathedrals.* New York: Cambridge University Press, 1976.

Williamson, Paul. *Gothic Sculpture, 1140–1300.* New Haven, CT: Yale University Press, 1995.

Wilson, Christopher. *The Gothic Cathedral: The Architecture of the Great Church, 1130–1530.* New York: Thames & Hudson, 1990.

Precursors of the Renaissance

Barasch, Moshe. *Giotto and the Language of Gesture.* New York: Cambridge University Press, 1987.

Barolsky, Paul. *Giotto's Father and the Family of Vasari's Lives.* University Park: Pennsylvania State University Press, 1992.

Baxandall, Michael. *Giotto and the Orators: Humanist Observers of Painting in Italy and the Discovery of Pictorial Composition, 1350–1450.* Oxford, UK: Clarendon, 1971.

Bomford, David. *Italian Painting before 1400.* Art in the Making series. London: National Gallery, 1989.

Borsook, Eve. *The Mural Painters of Tuscany: From Cimabue to Andrea del Sarto.* 2nd ed. Oxford, UK: Clarendon, 1980.

Borsook, Eve, and Fiorella Superbi Gioffredi. *Italian Altarpieces, 1250–1550: Function and Design.* Oxford, UK: Clarendon, 1994.

Burckhardt, Jakob C. *The Civilization of the Renaissance in Italy.* Trans. S. G. C. Middlemore. 3rd rev. ed. London: Phaidon, 1950.

Campbell, Lorne. *Renaissance Portraits: European Portrait-Painting in the 14th, 15th, and 16th Centuries.* New Haven, CT: Yale University Press, 1990.

———. *The Fifteenth-Century Netherlandish Schools.* London: National Gallery, 1998.

Cennini, Cennino. *The Craftsman's Handbook (Il Libro dell'Arte).* Trans. Daniel V. Thompson Jr. New York: Dover, 1954.

Chiellini, Monica. *Cimabue.* Trans. Lisa Pelletti. Florence: Scala, 1988.

Cole, Bruce. *Giotto and Florentine Painting, 1280–1375.* New York: Harper & Row, 1976.

———. *Sienese Painting: From Its Origins to the 15th Century.* New York: Harper & Row, 1980.

———. *The Renaissance Artist at Work: From Pisano to Titian.* New York: Harper & Row, 1983.

Martindale, Andrew. *The Rise of the Artist in the Middle Ages and Early Renaissance.* New York: McGraw-Hill, 1972.

Meiss, Millard. *Painting in Florence and Siena after the Black Death.* Princeton, NJ: Princeton University Press, 1951.

———. *French Painting in the Time of Jean de Berry: The Late Fourteenth Century and the Patronage of the Duke.* New York: Braziller, 1967.

Meiss, Millard, and E. H. Beatson. *The Belles Heures of Jean, Duke of Berry.* New York: Braziller, 1974.

Schneider, Laurie M., ed. *Giotto in Perspective.* Englewood Cliffs, NJ: Prentice-Hall, 1974.

Smart, Alastair. *The Dawn of Italian Painting, 1250–1400.* Ithaca, NY: Cornell University Press, 1978.

Stubblebine, James H., ed. *Giotto: The Arena Chapel Frescoes.* New York: Norton, 1969.

———. *Assisi and the Rise of Vernacular Art.* New York: Harper & Row, 1985.

Vasari, Giorgio. *Lives of the Most Eminent Painters, Sculptors, and Architects.* Trans. Gaston du C. de Vere. New York: Abrams, 1979.

White, John. *Duccio: Tuscan Art and the Medieval Workshop.* New York: Thames & Hudson, 1979.

———. *The Birth and Rebirth of Pictorial Space.* 3rd ed. Cambridge, MA: Belknap Press, 1987.

The Early Renaissance

Adams, Laurie Schneider. *Key Monuments of the Italian Renaissance.* Boulder, CO: Westview, 1999.

———. *Italian Renaissance Art.* Boulder, CO: Westview, 2001.

Alazard, Jean. *The Florentine Portrait.* New York: Schocken, 1968.

Alberti, Leon Battista. *Ten Books on Architecture.* Ed. J. Rykwert. Trans. J. Leoni. London: Tiranti, 1955.

———. *On Painting.* Rev. ed. Trans. J. R. Spencer. New Haven, CT: Yale University Press, 1966.

Ames-Lewis, Francis. *Drawing in Early Renaissance Italy.* 2nd ed. New Haven, CT: Yale University Press, 2000.

Antal, Frederick. *Florentine Painting and Its Social Background: The Bourgeois Republic before Cosimo de' Medici's Advent to Power—XIV and Early XV Centuries.* Boston: Boston Book and Art Shop, 1965.

Barolsky, Paul. *Infinite Jest: Wit and Humor in Italian Renaissance Art.* Columbia: University of Missouri Press, 1978.

———. *Walter Pater's Renaissance.* University Park: Pennsylvania State University Press, 1987.

Baxandall, Michael. *Painting and Experience in Fifteenth-Century Italy.* 2nd ed. New York: Oxford University Press, 1988.

Beck, James. *Italian Renaissance Painting.* New York: Harper & Row, 1981.

Bennett, Bonnie A., and David G. Wilkins. *Donatello.* Oxford, UK: Phaidon, 1984.

Berenson, Bernard. *Italian Pictures of the Renaissance: Florentine School.* 2 vols. London: Phaidon, 1963.

———. *Italian Painters of the Renaissance.* Rev. ed. London: Phaidon, 1967.

———. *Italian Painters of the Renaissance: Central and Northern Italian Schools.* 3 vols. London: Phaidon, 1968.

———. *The Drawings of the Florentine Painters.* 3 vols. Chicago, 1938; repr. Chicago: University of Chicago Press, 1973.

Blunt, Anthony. *Artistic Theory in Italy, 1450–1600.* New York: Oxford University Press, 1956.

Bober, Phyllis P., and Ruth O. Rubinstein. *Renaissance Artists and Antique Sculpture: A Handbook of Sources.* New York: Oxford University Press, 1986.

Butterfield, Andrew. *The Sculptures of Andrea del Verrocchio.* New Haven, CT: Yale University Press, 1997.

Campbell, Lorne. *Renaissance Portraits: European Portrait-Painting in the 14th, 15th, and 16th Centuries.* New Haven, CT: Yale University Press, 1990.

Christiansen, Keith. *Gentile da Fabriano.* Ithaca, NY: Cornell University Press, 1982.

Clark, Kenneth. *The Art of Humanism.* New York: Harper & Row, 1981.

Cole, Alison. *Virtue and Magnificence: Art of the Italian Renaissance Courts.* New York: Abrams, 1995.

Edgerton, Samuel Y., Jr. *The Renaissance Rediscovery of Linear Perspective.* New York: Basic, 1976.

Friedländer, Max J. *Early Netherlandish Painting.* 14 vols. Trans. Heinz Norden. New York: Praeger, 1967–73.

Gilbert, Creighton E., ed. *Renaissance Art.* New York: Harper & Row, 1970.

———. *Italian Art, 1400–1500: Sources and Documents.* Englewood Cliffs, NJ: Prentice-Hall, 1980.

Goffen, Rona, ed. *Masaccio's Trinity.* New York: Cambridge University Press, 1998.

Goldthwaite, Richard A. *The Building of Renaissance Florence: An Economic and Social History.* Baltimore: Johns Hopkins University Press, 1980.

Gombrich, Ernst H. *Norm and Form: Studies in the Art of the Renaissance.* London: Phaidon, 1966.

———. *Symbolic Images.* London: Phaidon, 1972.

———. *The Heritage of Apelles: Studies in the Art of the Renaissance.* Ithaca, NY: Cornell University Press, 1976.

———. *New Light on Old Masters.* Chicago: University of Chicago Press, 1986.

Greenstein, Jack M. *Mantegna and Painting as Historical Narrative.* Chicago: University of Chicago Press, 1992.

Grendler, Paul F. *Schooling in Renaissance Italy: Literacy and Learning, 1300–1600.* Baltimore: Johns Hopkins University Press, 1989.

Hale, J. R. *Artists and Warfare in the Renaissance.* New Haven, CT: Yale University Press, 1990.

Hall, Edwin. *The Arnolfini Betrothal: Medieval Marriage and the Enigma of Van Eyck's Double Portrait.* Berkeley: University of California Press, 1994.

Harbison, Craig. *The Mirror of the Artist: Northern Renaissance Art in Its Historical Context.* New York: Abrams, 1995.

Hartt, Frederick. *A History of Italian Renaissance Art: Painting, Sculpture, Architecture.* 5th ed. New York: Abrams, 2002.

Heydenreich, Ludwig H., and Wolfgang Lotz. *Architecture in Italy, 1400 to 1600.* Trans. Mary Hottinger. Harmondsworth, Penguin, 1974.

Hibbert, Christopher. *The House of Medici: Its Rise and Fall.* New York: Morrow Quill, 1980.

Horster, Marita. *Andrea del Castagno.* Ithaca, NY: Cornell University Press, 1980.

Jacks, Philip. *The Antiquarian and the Myth of Antiquity: The Origins of Rome in Renaissance Thought.* New York: Cambridge University Press, 1993.

Janson, Horst W. *The Sculpture of Donatello.* 2 vols. Princeton, NJ: Princeton University Press, 1957.

Kemp, Martin. *Behind the Picture: Art and Evidence in the Italian Renaissance.* New Haven, CT: Yale University Press, 1997.

Krautheimer, Richard, and Trude Krautheimer-Hess. *Lorenzo Ghiberti.* 2nd ed. Princeton, NJ: Princeton University Press, 1970.

Lee, Rensselaer W. *Ut Pictura Poesis: The Humanistic Theory of Painting.* New York: Norton, 1967.

Lightbown, Ronald W. *Sandro Botticelli.* 2 vols. Berkeley: University of California Press, 1978.

Machiavelli, Niccolò. *Florentine Histories.* Trans. Laura F. Banfield and Harvey C. Mansfield Jr. Princeton, NJ: Princeton University Press, 1988.

Murray, Peter. *Renaissance Architecture.* New York: Abrams, 1976.

Panofsky, Erwin. *Studies in Iconology: Humanistic Themes in the Art of the Renaissance.* New York: Oxford University Press, 1939.

———. *Renaissance and Renascences in Western Art.* New York: Harper & Row, 1969.

Panofsky, Erwin, and Dora Panofsky. *Pandora's Box: The Changing Aspects of a Mythical Symbol.* New York: Harper & Row, 1965.

Pater, Walter. *The Renaissance: Studies in Art and Poetry.* Ed. Donald L. Hill. Berkeley: University of California Press, 1980.

Philip, Lotte Brand. *The Ghent Altarpiece and the Art of Jan van Eyck.* Princeton, NJ: Princeton University Press, 1971.

Pope-Hennessy, John. *The Portrait in the Renaissance.* Princeton, NJ: Princeton University Press, 1966.

———. *An Introduction to Italian Sculpture.* 3rd ed. 3 vols. New York: Phaidon, 1986.

Rabil, Albert, Jr. *Renaissance Humanism: Foundations, Forms and Legacy.* 3 vols. Philadelphia: University of Pennsylvania Press, 1988.

Ruggiero, Guido. *Violence in Early Renaissance Venice.* New Brunswick, NJ: Rutgers University Press, 1980.

Saxl, Fritz. *A Heritage of Images.* Harmondsworth, UK: Penguin, 1970.

Seidel, Linda. *Jan van Eyck's Arnolfini Portrait: Stories of an Icon.* New York: Cambridge University Press, 1993.

Seymour, Charles, Jr. *The Sculpture of Verrocchio.* Greenwich, CT: New York Graphic Society, 1971.

Seznec, Jean. *The Survival of the Pagan Gods: The Mythological Tradition and Its Place in Renaissance Humanism and Art.* Trans. B. F. Sessions. New York, 1953; repr. Princeton, NJ: Princeton University Press, 1972.

Snyder, James. *Northern Renaissance Art: Painting, Sculpture, the Graphic Arts from 1350 to 1575.* New York: Abrams, 1985.

Stechow, Wolfgang. *Northern Renaissance Art, 1400–1600: Sources and Documents.* Englewood Cliffs, NJ: Prentice-Hall, 1966.

Steinberg, Leo. *The Sexuality of Christ in Renaissance Art and in Modern Oblivion.* 2nd ed. Chicago: University of Chicago Press, 1996.

Thomson, David. *Renaissance Architecture: Critics, Patrons, Luxury.* Manchester, UK: Manchester University Press, 1993.

Turner, A. Richard. *Renaissance Florence: The Invention of a New Art.* New York: Abrams, 1997.

Wackernagel, Martin. *The World of the Florentine Renaissance Artist: Projects and Patrons, Workshop and Art Market.* Princeton, NJ: Princeton University Press, 1981.

Weiss, Roberto. *The Renaissance Discovery of Classical Antiquity.* 2nd ed. Oxford, UK: Blackwell, 1988.

Wind, Edgar. *Pagan Mysteries in the Renaissance.* Rev. ed. New York: Norton, 1969.

Wittkower, Rudolf. *Idea and Image: Studies in the Italian Renaissance.* New York: Thames & Hudson, 1978.

———. *Architectural Principles in the Age of Humanism.* 5th ed. Chichester, UK: Academy, 1998.

Wölfflin, Heinrich. *Renaissance and Baroque.* Trans. Kathrin Simon. Ithaca, NY: Cornell University Press, 1966.

———. *Classic Art: An Introduction to the Italian Renaissance.* Trans. L. and P. Murray. 5th ed. London: Phaidon, 1994.

The High Renaissance in Italy

Ackerman, James S. *The Architecture of Michelangelo.* 2nd ed. Chicago: University of Chicago Press, 1986.

Barolsky, Paul. *Michelangelo's Nose: A Myth and Its Maker.* University Park: Pennsylvania State University Press, 1990.

———. *Why Mona Lisa Smiles and Other Tales by Vasari.* University Park: Pennsylvania State University Press, 1991.

———. *The Faun in the Garden: Michelangelo and the Poetic Origins of Italian Renaissance Art.* University Park: Pennsylvania State University Press, 1994.

Brown, D. *Leonardo's Last Supper: The Restoration.* Washington, DC: National Gallery of Art, 1983.

Brown, Patricia Fortini. *Venetian Narrative Painting in the Age of Carpaccio.* New Haven, CT: Yale University Press, 1988.

———. *Art and Life in Renaissance Venice.* New York: Abrams, 1997.

Castiglione, Baldesar. *The Book of the Courtier* (1528). Trans. G. Bull. New York: Penguin, 1967.

Chastel, André. *The Sack of Rome, 1527.* Trans. Beth Archer. Princeton, NJ: Princeton University Press, 1983.

Clark, Kenneth M. *Leonardo da Vinci.* Rev. ed. New York: Viking, 1988.

Cole, Bruce. *Titian and Venetian Painting, 1450–1590.* Boulder, CO: Westview, 1999.

Collins, Bradley I. *Leonardo, Psychoanalysis and Art History: A Critical Study of Psychobiographical Approaches to Leonardo da Vinci.* Evanston, IL: Northwestern University Press, 1997.

De Tolnay, Charles. *Michelangelo.* 2nd rev. ed. 5 vols. Princeton, NJ: Princeton University Press, 1969–71.

Freedberg, Sidney J. *Painting of the High Renaissance in Rome and Florence.* Rev. ed. 2 vols. New York: Hacker, 1985.

———. *Painting in Italy, 1500–1600.* 3rd ed. Pelican History of Art series. New Haven, CT: Yale University Press, 1993.

Gilbert, Creighton E. *Michelangelo on and off the Sistine Ceiling.* New York: Braziller, 1994.

Goffen, Rona. *Piety and Patronage: Bellini, Titian, and the Franciscans.* New Haven, CT: Yale University Press, 1986.

———. *Giovanni Bellini.* New Haven, CT: Yale University Press, 1989.

———. *Titian's Women.* New Haven, CT: Yale University Press, 1997.

———, ed. *Masaccio's Trinity.* Cambridge University Press, 1998.

———, ed. *Titian's "Venus of Urbino."* New York: Cambridge University Press, 1998.

Hall, Marcia, ed. *Raphael's "School of Athens."* New York: Cambridge University Press, 1997.

Heydenreich, Ludwig H. *Leonardo: "The Last Supper."* New York: Viking, 1974.

Hibbard, Howard. *Michelangelo.* 2nd ed. New York: HarperCollins, 1983.

Humfrey, Peter. *Painting in Renaissance Venice.* New Haven, CT: Yale University Press, 1995.

Huse, Norbert, and Wolfgang Wolters. *The Art of Renaissance Venice: Architecture, Sculpture, and Painting, 1460–1590.* Trans. E. Jephcott. Chicago: University of Chicago Press, 1990.

Kemp, Martin, ed. *Leonardo on Painting: An Anthology of Writings.* Trans. Martin Kemp and Margaret Walker. New Haven, CT: Yale University Press, 1989.

Leonardo da Vinci. *The Notebooks.* Trans. E. MacCurdy. 2 vols. New York: Reynal & Hitchcock, 1938.

Meilman, Patricia, ed. *The Cambridge Companion to Titian.* New York: Cambridge University Press, 2004.

Murray, Linda. *The High Renaissance and Mannerism.* New York: Thames & Hudson, 1985.

Panofsky, Erwin. *Problems in Titian, Mostly Iconographic.* New York: New York University Press, 1969.

Partridge, Loren. *The Art of Renaissance Rome, 1400–1600.* New York: Abrams, 1996.

Partridge, Loren, and Randolph Starn. *A Renaissance Likeness: Art and Culture in Raphael's Julius II.* Berkeley: University of California Press, 1980.

Pedretti, Carlo. *Leonardo Da Vinci on Painting: A Lost Book.* Berkeley: University of California Press, 1964.

———. *Leonardo: Studies for the Last Supper from the Royal Library at Windsor Castle.* Cambridge, UK: Cambridge University Press, 1983.

Pope-Hennessy, John. *Raphael.* New York: New York University Press, 1970.

———. *Italian High Renaissance and Baroque Sculpture.* 4th ed. 3 vols. New York: Phaidon, 2000.

Rosand, David. *Painting in Cinquecento Venice: Titian, Veronese, Tintoretto.* New Haven, CT: Yale University Press, 1982.

Ruggiero, Guido. *The Boundaries of Eros: Sex Crime and Sexuality in Renaissance Venice.* New York: Oxford University Press, 1985.

———. *Binding Passions: Tales of Magic, Marriage, and Power at the End of the Renaissance.* New York: Oxford University Press, 1993.

Saslow, James M. *Ganymede in the Renaissance: Homosexuality in Art and Society.* New Haven, CT: Yale University Press, 1986.

———. *The Poetry of Michelangelo.* New Haven, CT: Yale University Press, 1991.

Settis, Salvatore. *Giorgione's Tempest: Interpreting the Hidden Subject.* Chicago: University of Chicago Press, 1990.

Tafuri, Manfredo. *Venice and the Renaissance.* Trans. Jessica Levine. Cambridge, MA: MIT Press, 1989.

Turner, A. Richard. *Inventing Leonardo.* Berkeley: University of California Press, 1992.

Vasari, Giorgio. *Vasari on Technique.* Ed. G. Baldwin Brown. Trans. L. Maclehose. New York: Dover, 1960.

Wethey, Harold E. *The Paintings of Titian.* 3 vols. London: Phaidon, 1969.

Wilde, Johannes. *Venetian Art from Bellini to Titian.* Oxford, UK: Clarendon, 1981.

Mannerism and the Later Sixteenth Century in Italy

Ackerman, James S. *Palladio.* New York: Penguin, 1978.

Cellini, Benvenuto. *Autobiography.* Ed. John Pope-Hennessy. Trans. J. A. Symonds. London: Phaidon, 1960.

Cox-Rearick, Janet. *The Drawings of Pontormo.* 2 vols. Cambridge, MA: Harvard University Press, 1964.

———. *Dynasty and Destiny in Medici Art: Pontormo, Leo X, and the Two Cosimos.* Princeton, NJ: Princeton University Press, 1984.

———. *Bronzino's Chapel of Eleonora in the Palazzo Vecchio.* Berkeley: University of California Press, 1993.

Freedberg, Sidney J. *Parmigianino: His Works in Painting.* Cambridge, MA: Harvard University Press, 1950.

Hauser, Arnold. *Mannerism: The Crisis of the Renaissance and the Origin of Modern Art.* Cambridge, MA: Belknap Press, 1986.

Holt, Elizabeth Gilmore, ed. *A Documentary History of Art,* vol. 2: *Michelangelo and the Mannerists: The Baroque and the 18th Century.* 2nd ed. Garden City, NY: Doubleday, 1957.

Pope-Hennessy, John. *Cellini.* New York: Abbeville, 1985.

Shearman, John K. G. *Mannerism.* Baltimore: Penguin, 1967.

Smyth, Craig H. *Mannerism and Maniera.* Locust Valley, NY: Augustin, 1963.

Tomlinson, Janis. *From El Greco to Goya: Painting in Spain, 1561–1828.* New York: Abrams, 1997.

Sixteenth-Century Painting and Printmaking in Northern Europe

Cuttler, Charles P. *Northern Painting from Pucelle to Bruegel: Fourteenth, Fifteenth, and Sixteenth Centuries.* New York: Holt, Rinehart & Winston, 1968.

Davies, Martin. *Rogier van der Weyden: An Essay with a Critical Catalogue of Paintings.* New York: Phaidon, 1972.

Friedländer, Max J. *From Van Eyck to Bruegel.* Ed. F. Grossman. Trans. M. Kay. 3rd ed. New York: Phaidon, 1969.

Gilbert, Creighton E. *History of Renaissance Art: Painting, Sculpture, Architecture throughout Europe.* New York: Abrams, 1973.

Harbison, Craig. *The Mirror of the Artist: Northern Renaissance Art in Its Historical Context.* New York: Abrams, 1995.

Hayum, Andrée. *The Isenheim Altarpiece: God's Medicine and the Painter's Vision.* Princeton, NJ: Princeton University Press, 1989.

Hind, Arthur M. *A History of Engraving and Etching from the 15th Century to the Year 1914.* 3rd rev. ed. New York: Dover, 1963.

———. *An Introduction to a History of Woodcut, with a Detailed Survey of Work Done in the Fifteenth Century.* New York: Dover, 1963.

Koerner, Joseph. *The Moment of Self-Portraiture in German Renaissance Art.* Chicago: University of Chicago Press, 1993.

Lane, Barbara G. *The Altar and the Altarpiece: Sacramental Themes in Early Netherlandish Painting.* New York: Harper & Row, 1984.

Mellinkoff, Ruth. *The Devil at Isenheim: Reflections of Popular Belief in Grünewald's Altarpiece.* Berkeley: University of California Press, 1988.

Panofsky, Erwin. *Albrecht Dürer.* 3rd ed. 2 vols. Princeton, NJ: Princeton University Press, 1948.

———. *Early Netherlandish Painting, Its Origins and Character.* 2 vols. Cambridge, MA: Harvard University Press, 1958.

The Baroque Style in Western Europe

Adams, Ann Jensen, ed. *Rembrandt's Bathsheba Reading King David's Letter.* New York: Cambridge University Press, 1998.

Adams, Laurie Schneider. *Key Monuments of the Baroque.* Boulder, CO: Westview, 1999.

Alpers, Svetlana. *The Art of Describing: Dutch Art in the Seventeenth Century.* Chicago: University of Chicago Press, 1983.

———. *Rembrandt's Enterprise: The Studio and the Market.* Chicago: University of Chicago Press, 1988.

———. *The Making of Rubens.* New Haven, CT: Yale University Press, 1995.

———. *The Vexations of Art: Velázquez and Others.* New Haven, CT: Yale University Press, 2005.

Avery, Charles. *Bernini: Genius of the Baroque.* London: Thames & Hudson, 1998.

Berger, Robert W. *Versailles: The Chateau of Louis XIV.* University Park: Pennsylvania State University Press, 1985.

———. *The Palace of the Sun: The Louvre of Louis XIV.* University Park: Pennsylvania State University Press, 1993.

Blunt, Anthony. *Art and Architecture in France, 1500–1700.* 5th ed. New Haven, CT: Yale University Press, 1999.

Blunt, Anthony, et al. *Baroque and Rococo, Architecture and Decoration.* New York: Harper & Row, 1982.

Brown, Jonathan. *Velázquez: Painter and Courtier.* New Haven, CT: Yale University Press, 1986.

———. *The Golden Age of Painting in Spain.* New Haven, CT: Yale University Press, 1991.

Canby, Sheila. *Persian Painting.* New York: Thames & Hudson, 1993.

Carrier, David. *Poussin's Paintings: A Study in Art-Historical Methodology.* University Park: Pennsylvania State University Press, 1993.

Clark, Kenneth. *Rembrandt and the Italian Renaissance.* New York: New York University Press, 1966.

Enggass, Robert, and Jonathan Brown. *Italy and Spain, 1600–1750: Sources and Documents.* Englewood Cliffs, NJ: Prentice-Hall, 1970.

Friedländer, Walter F. *Caravaggio Studies.* Princeton, NJ: Princeton University Press, 1955.

Garrard, Mary D. *Artemisia Gentileschi.* Princeton, NJ: Princeton University Press, 1989.

Grimm, Claus. *Frans Hals: The Complete Work.* Trans. Jürgen Riehle. New York: Abrams, 1990.

Haskell, Francis. *Patrons and Painters: A Study in the Relations between Italian Art and Society in the Age of the Baroque.* Rev. ed. New Haven, CT: Yale University Press, 1980.

Haverkamp-Begemann, E. *Rembrandt: The Nightwatch.* Princeton, NJ: Princeton University Press, 1982.

Held, Julius, and Donald Posner. *17th- and 18th-Century Art: Baroque Painting, Sculpture, Architecture.* New York: Abrams, 1971.

Hibbard, Howard. *Bernini.* Baltimore: Penguin, 1966.

———. *Caravaggio.* New York: Harper & Row, 1983.

Kahr, Madlyn M. *Dutch Painting in the Seventeenth Century.* 2nd ed. New York: Harper & Row, 1993.

Kitson, Michael. *The Age of Baroque.* London: Hamlyn, 1967.

Martin, John R. *Baroque.* New York: Harper & Row, 1977.

Norberg-Schulz, Christian. *Baroque Architecture.* New York: Abrams, 1985.

———. *Late Baroque and Rococo Architecture.* New York: Rizzoli, 1986.

Orso, Steven N. *Velázquez, Los Borrachos, and Painting at the Court of Philip IV.* New York: Cambridge University Press, 1993.

Rosenberg, Jakob. *Rembrandt: Life and Work.* 3rd ed. London: Phaidon, 1968.

Rosenberg, Jakob, Seymour Slive, and E. H. ter Kuile. *Dutch Art and Architecture, 1600–1800.* 3rd ed. Pelican History of Art series. New York: Penguin, 1977.

Schwartz, Gary. *Rembrandt, His Life, His Paintings.* New York: Penguin, 1991.

Slive, Seymour. *Rembrandt and His Critics, 1630–1730.* New York: Hacker, 1988.

Slive, Seymour, et al. *Frans Hals.* London: Royal Academy of Arts, 1989.

Snow, Edward. *A Study of Vermeer.* Rev. and enl. ed. Berkeley: University of California Press, 1994.

Stechow, Wolfgang. *Dutch Landscape Painting of the 17th Century.* 2nd ed. London: Phaidon, 1968.

Stratton-Pruitt, Suzanne L., ed. *Velázquez's Las Meninas.* New York: Cambridge University Press, 2003.

Sutton, Peter. *The Age of Rubens.* Boston: Museum of Fine Arts, 1993.

Varriano, John. *Italian Baroque and Rococo Architecture.* New York: Oxford University Press, 1986.

Welu, James A., and Pieter Biesboer, eds. *Judith Leyster: A Dutch Master and Her World.* New Haven, CT: Yale University Press, 1993.

Wheelock, Arthur K. Jr. *Jan Vermeer.* New York: Abrams, 1988.

White, Christopher. *Peter Paul Rubens: Man and Artist.* New Haven, CT: Yale University Press, 1987.

Wittkower, Rudolf. *Art and Architecture in Italy, 1600 to 1750.* 3rd ed. Pelican History of Art series. New York: Penguin, 1980.

———. *Bernini, The Sculptor of the Roman Baroque.* 4th ed. London: Phaidon, 1997.

Wright, Christopher. *The French Painters of the 17th Century.* Greenwich, CT: New York Graphic Society, 1986.

Rococo, the Eighteenth Century, and Revival Styles

Alpers, Svetlana, and Michael Baxandall. *Tiepolo and the Pictorial Intelligence.* New Haven, CT: Yale University Press, 1994.

Antal, Frederick. *Hogarth and His Place in European Art.* New York: Basic, 1962.

Bryson, Norman. *Word and Image: French Painting of the Ancien Régime.* New York: Cambridge University Press, 1981.

Burke, Joseph. *English Art, 1714–1800.* Oxford History of English Art series, 9. New York: Oxford University Press, 1976.

Conisbee, Philip. *Painting in Eighteenth-Century France.* Ithaca, NY: Cornell University Press, 1981.

Crow, Thomas E. *Painters and Public Life in Eighteenth-Century Paris.* New Haven, CT: Yale University Press, 1985.

Duncan, Carol. *The Pursuit of Pleasure: The Rococo Revival in French Romantic Art.* New York: Garland, 1976.

Einberg, Elizabeth. *Manners and Morals: Hogarth and British Painting 1700–1760.* London: Tate Gallery, 1987.

Hitchcock, Henry R. *Rococo Architecture in Southern Germany.* London: Phaidon, 1968.

Kalnein, Wend von, and Michael Levey. *Art and Architecture of the Eighteenth Century in France.* Harmondsworth, UK: Penguin, 1972.

Kimball, Sidney F. *The Creation of the Rococo.* New York: Norton, 1964.

Levey, Michael. *Rococo to Revolution: Major Trends in Eighteenth-Century Painting.* New York: Thames & Hudson, 1985.

Palladio, Andrea. *The Four Books of Architecture.* Reprint of the Isaac Ware edition, 1738. New York: Dover, 1965.

Paulson, Ronald. *The Art of Hogarth.* London: Phaidon, 1975.

Rosenberg, Pierre. *Chardin, 1699–1779.* Ed. Sally W. Goodfellow. Trans. Emilie P. Kadish and Ursula Korneitchouk. Cleveland: Cleveland Museum of Art, 1979.

Rosenblum, Robert. *Transformations in Late Eighteenth-Century Art.* Princeton, NJ: Princeton University Press, 1967.

Summerson, John. *The Architecture of the Eighteenth Century.* New York: Thames & Hudson, 1986.

Wittkower, Rudolf. *Palladio and Palladianism.* New York: Braziller, 1974.

Neoclassicism: The Late Eighteenth and Early Nineteenth Centuries

Arnason, Hjorvardur H. *The Sculptures of Houdon.* New York: Oxford University Press, 1975.

Boime, Albert. *Art in an Age of Revolution, 1750–1800.* Chicago: University of Chicago Press, 1987.

———. *Art in an Age of Bonapartism, 1800–1815.* Chicago: University of Chicago Press, 1990.

Bryson, Norman. *Tradition and Desire: From David to Delacroix.* New York: Cambridge University Press, 1984.

Chu, Petra ten-Doesschate. *Nineteenth-Century European Art.* New York: Abrams, 2003.

Cooper, Wendy A. *Classical Taste in America 1800–1840.* Baltimore: Baltimore Museum of Art, 1993.

Craske, Matthew. *Art in Europe, 1700–1830: A History of the Visual Arts in an Era of Unprecedented Urban Economic Growth.* New York: Oxford University Press, 1997.

Eitner, Lorenz. *Neoclassicism and Romanticism, 1750–1850: An Anthology of Sources and Documents.* New York: Harper & Row, 1989.

———. *An Outline of 19th-Century European Painting: From David through Cézanne.* New York: HarperCollins, 1996.

Friedländer, Walter F. *David to Delacroix.* Trans. Robert Goldwater. Cambridge, MA: Harvard University Press, 1952.

Honour, Hugh. *Neo-Classicism.* Harmondsworth, UK: Penguin, 1987.

Jaffe, Irma B. *Trumbull: The Declaration of Independence.* New York: Viking, 1976.

McLaughlin, Jack. *Jefferson and Monticello: The Biography of a Builder.* New York: Henry Holt, 1988.

Middleton, Robin, and David Watkin. *Neoclassical and 19th-Century Architecture.* 2 vols. New York: Electa/Rizzoli, 1987.

Novotny, Fritz. *Painting and Sculpture in Europe, 1780–1880.* Pelican History of Art series. Harmondsworth, UK: Penguin, 1980.

Roberts, Warren. *Jacques-Louis David, Revolutionary Artist: Art, Politics, and the French Revolution.* Chapel Hill: University of North Carolina Press, 1989.

Rosenblum, Robert. *Jean-Auguste-Dominique Ingres.* New York: Abrams, 1967.

———. *Transformations in Late Eighteenth-Century Art.* Princeton, NJ: Princeton University Press, 1970.

Roworth, Wendy Wassyng, ed. *Angelica Kauffman: A Continental Artist in Georgian England.* London: Reaktion, 1992.

Stillman, Damie. *English Neo-Classical Architecture.* 2 vols. London: Zwemmer, 1988.

Vaughan, William, and Helen Weston, ed. *David's Marat.* New York: Cambridge University Press, 2000.

Romanticism: The Late Eighteenth and Early Nineteenth Centuries

Athanassoglou-Kallmyer, Nina M. *Eugène Delacroix: Prints, Politics and Satire, 1814–1822.* New Haven, CT: Yale University Press, 1991.

Bindman, David. *William Blake: His Art and Time.* New Haven, CT: Yale Center for British Art, 1982.

Börsch-Supan, Helmut. *Caspar David Friedrich.* Trans. Sarah Twohig. New York: Braziller, 1974.

Clark, Kenneth. *The Romantic Rebellion: Romantic versus Classic Art.* New York: Harper & Row, 1973.

Eitner, Lorenz. *Géricault's "Raft of the Medusa."* London: Phaidon, 1972.

———. *Géricault: His Life and Work.* Ithaca, NY: Cornell University Press, 1982.

Harris, Enriqueta. *Goya.* Rev. ed. London: Phaidon, 1994.

Hilton, Timothy. *Pre-Raphaelites.* London: Thames & Hudson, 1970.

Honour, Hugh. *Romanticism.* New York: Harper & Row, 1979.

Licht, Fred. *Goya: The Origins of the Modern Temper in Art.* New York: Harper & Row, 1983.

Murphy, Alexandra R. *Jean-François Millet.* Boston: Museum of Fine Arts, 1984.

Pérez Sánchez, Alfonso E., and Eleanor A. Sayre. *Goya and the Spirit of Enlightenment.* Boston: Museum of Fine Arts, 1989.

Powell, Earl A. *Thomas Cole.* New York: Abrams, 1990.

Praz, Mario. *The Romantic Agony.* New York: Oxford University Press, 1983.

Rosenblum, Robert, and Horst W. Janson. *19th-Century Art.* New York: Abrams, 1984.

Truettner, William H., and Alan Wallach, eds. *Thomas Cole: Landscape into History.* New Haven, CT: Yale University Press, 1994.

Vaughan, William. *German Romantic Painting.* New Haven, CT: Yale University Press, 1980.

———. *Romanticism and Art.* New York: Thames & Hudson, 1994.

Walker, John. *John Constable.* New York: Abrams, 1991.

Wilton, Andrew. *Turner and the Sublime.* Chicago: University of Chicago Press, 1980.

———. *Turner in His Time.* New York: Abrams, 1987.

Wolf, Bryan Jay. *Romantic Re-vision: Culture and Consciousness in Nineteenth-Century American Painting and Literature.* Chicago: University of Chicago Press, 1986.

Nineteenth-Century Realism

Ashton, Dore. *Rosa Bonheur: A Life and a Legend.* New York: Viking, 1981.

Barger, M. Susan, and William B. White. *The Daguerreotype: Nineteenth-Century Technology and Modern Science.* Baltimore: Johns Hopkins University Press, 2000.

Boime, Albert. *A Social History of Modern Art.* Chicago: University of Chicago Press, 1987.

Carrier, David. *High Art: Charles Baudelaire and the Origins of Modernist Painting.* University Park: Pennsylvania State University Press, 1996.

Clark, T. J. *The Absolute Bourgeois: Artists and Politics in France, 1848–1851.* London: Thames & Hudson, 1973.

———. *Image of the People: Gustave Courbet and the 1848 Revolution.* London: Thames & Hudson, 1982.

Eisenman, Stephen F. *Nineteenth-Century Art: A Critical History.* 2nd ed. New York: Thames & Hudson, 2002.

Farwell, Beatrice. *Manet and the Nude: A Study of Iconography in the Second Empire.* New York: Garland Press, 1981.

Fried, Michael. *Courbet's Realism.* Chicago: University of Chicago Press, 1990.

Gosling, N. *Nadar.* New York: Knopf, 1976.

Homer, William Innes. *Thomas Eakins: His Life and Art.* 2nd ed. New York: Abbeville, 2002.

Isaacson, Joel. *Manet: Le Déjeuner sur l'Herbe.* New York: Viking, 1972.

Janson, Horst W. *19th-Century Sculpture.* New York: Abrams, 1985.

Johns, Elizabeth. *Thomas Eakins: The Heroism of Modern Life.* Princeton, NJ: Princeton University Press, 1983.

Krell, Alan. *Manet and the Painters of Contemporary Life.* New York: Thames & Hudson, 1996.

Lindsay, Jack. *Gustave Courbet: His Life and Art.* New York: State Mutual Reprints, 1981.

McKean, John. *Crystal Palace: Joseph Paxton and Charles Fox.* London: Phaidon, 1994.

Meredith, Roy. *Mr. Lincoln's Camera Man, Mathew B. Brady.* 2nd rev. ed. New York: Dover, 1974.

Needham, Gerald. *19th-Century Realist Art.* New York: Harper & Row, 1984.

Newhall, Beaumont. *The History of Photography from 1839 to the Present.* Rev. ed. New York: Museum of Modern Art, 1982.

Nicolson, Benedict. *Courbet: The Studio of the Painter.* New York: Viking, 1973.

Nochlin, Linda. *Realism and Tradition in Art, 1848–1900: Sources and Documents.* Englewood Cliffs, NJ: Prentice-Hall, 1966.

———. *Realism.* Harmondsworth, UK: Penguin, 1971.

———. *Gustave Courbet: A Study of Style and Society.* New York: Garland, 1976.

———. *Courbet.* New York: Thames and Hudson, 2007.

Novak, Barbara. *American Painting of the Nineteenth Century: Realism, Idealism, and the American Experience.* 2nd ed. New York: Harper & Row, 1969.

O'Gorman, James F. *Three American Architects: Richardson, Sullivan, and Wright, 1865–1915.* Chicago: University of Chicago Press, 1991.

Passeron, Roger. *Daumier.* Trans. Helga Harrison. New York: Rizzoli, 1981.

Reff, Theodore. *Manet: Olympia.* New York: Viking, 1977.

Sullivan, Louis. *The Autobiography of an Idea.* New York: Dover, 1956.

Tucker, Paul H., ed. *Manet's Le Déjeuner sur l'Herbe.* New York: Cambridge University Press, 1998.

Weisberg, Gabriel P., ed. *The European Realist Tradition.* Bloomington: Indiana University Press, 1982.

Nineteenth-Century Impressionism

Bell, Quentin. *Ruskin.* New York: Braziller, 1978.

Boggs, Jean Sutherland, et al. *Degas.* Exh. cat. New York: Metropolitan Museum of Art, 1988.

Clark, T. J. *The Painting of Modern Life: Paris in the Art of Manet and His Followers.* Rev. ed. Princeton, NJ: Princeton University Press, 1999.

Gerdts, William H. *American Impressionism.* 2nd ed. New York: Abbeville, 2001.

Guth, Christine. *Art of Edo Japan: The Artist and the City, 1615–1868.* New York: Abrams, 1996.

Hanson, Anne C. *Manet and the Modern Tradition.* New Haven, CT: Yale University Press, 1977.

Hanson, Lawrence. *Renoir: The Man, the Painter, and His World.* London: Frewin, 1972.

Herbert, Robert L. *Impressionism: Art, Leisure and Parisian Society.* New Haven, CT: Yale University Press, 1988.

Higonnet, Anne. *Berthe Morisot's Images of Women.* Cambridge, MA: Harvard University Press, 1992.

Kendall, Richard. *Degas: Beyond Impressionism.* London: National Gallery Publications, 1996.

Mathews, Nancy Mowll. *Mary Cassatt.* New York: Abrams, 1987.

Nochlin, Linda. *Impressionism and Post-Impressionism, 1874–1904: Sources and Documents.* Englewood Cliffs, NJ: Prentice-Hall, 1966.

Pissarro, Joachim. *Camille Pissarro.* New York: Abrams, 1993.

Rewald, John. *The History of Impressionism.* 4th rev. ed. Greenwich, CT: New York Graphic Society, 1973.

———. *Studies in Impressionism.* New York: Abrams, 1986.

Smith, Paul. *Impressionism: Beneath the Surface.* New York: Abrams, 1995.

Spate, Virginia. *Claude Monet: Life and Work.* New York: Rizzoli, 1992.

Tucker, Paul Hayes. *Claude Monet: Life and Art.* New Haven, CT: Yale University Press, 1995.

Walker, John. *James McNeill Whistler.* New York: Abrams, 1987.

Post-Impressionism and the Late Nineteenth Century

Andersen, Wayne. *Gauguin's Paradise Lost.* New York: Viking, 1971.

Badt, Kurt. *The Art of Cézanne.* Trans. S. A. Ogilvie. Berkeley: University of California Press, 1965.

Collins, Bradley, Jr. *Van Gogh and Gauguin: Electric Arguments and Utopian Dreams.* Boulder, CO: Westview Press, 2001.

D'Alleva, Anne. *Arts of the Pacific Islands.* New York: Abrams, 1998.

Denvir, Bernard. *Toulouse-Lautrec.* New York: Thames & Hudson, 1991.

———. *Post-Impressionism.* New York: Thames & Hudson, 1992.

Eggum, Arne. *Edvard Munch: Paintings, Sketches, and Studies.* Trans. Ragnar Christophersen. New York: Potter, 1984.

Geist, Sidney. *Interpreting Cézanne.* Cambridge, MA: Harvard University Press, 1988.

Gogh, Vincent van. *The Complete Letters of Vincent van Gogh.* Trans. J. van Gogh-Bonger and C. de Dood. 2nd ed. 3 vols. Greenwich, CT: New York Graphic Society, 1978.

Gordon, Robert, and Andrew Forge. *Degas.* Trans. Richard Howard. New York: Abrams, 1988.

Gowing, Lawrence, ed. *Cézanne: The Early Years, 1859–1872.* New York: Abrams, 1988.

Hamilton, George H. *Painting and Sculpture in Europe, 1880–1940.* 6th ed. Pelican History of Art series. New Haven, CT: Yale University Press, 1993.

Heller, Reinhold. *Edvard Munch: The Scream.* New York: Viking, 1973.

Holt, Elizabeth Gilmore, ed. *The Expanding World of Art, 1874–1902.* New Haven, CT: Yale University Press, 1988.

Jullian, Philippe. *The Symbolists.* Trans. M. A. Stevens. New York: Phaidon, 1973.

Pickvance, Ronald. *Van Gogh in Arles.* New York: Metropolitan Museum of Art/Abrams, 1984.

———. *Van Gogh in Saint-Rémy and Auvers.* New York: Metropolitan Museum of Art/Abrams, 1986.

Post-Impressionism: Cross-Currents in European and American Painting, 1880–1906. Washington, DC: National Gallery of Art, 1980.

Rewald, John. *Post-Impressionism from Van Gogh to Gauguin.* 3rd ed. New York: Museum of Modern Art, 1978.

———. *Studies in Post-Impressionism.* New York: Abrams, 1986.

Rubin, William, ed. *Cézanne: The Late Work.* New York: Museum of Modern Art, 1977.

Schapiro, Meyer. *Paul Cézanne.* 3rd ed. New York: Abrams, 1969.

———. *Vincent van Gogh.* New York: Abrams, 1969.

Shiff, Richard. *Cézanne and the End of Impressionism: A Study of the Theory, Technique, and Critical Evaluation of Modern Art.* Chicago: University of Chicago Press, 1984.

Smith, Paul. *Seurat and the Avant-Garde.* New Haven, CT: Yale University Press, 1997.

Stang, Ragna. *Edvard Munch: The Man and His Art.* Trans. Geoffrey Culverwell. New York: Abbeville, 1988.

Thomson, Belinda. *Gauguin.* New York: Thames & Hudson, 1987.

Thomson, Richard, et al. *Toulouse-Lautrec.* New Haven, CT: Yale University Press, 1991.

Ukiyo-e: The Art of Japanese Woodblock Prints. Ed. Amy Newland and Chris Uhlenbeck. New York: Smithmark, 1994.

Wood, Mara-Helen, ed. *Edvard Munch: The Frieze of Life.* London: National Gallery Publications, 1992.

The Early Twentieth Century: Picasso, Fauvism, Expressionism, and Matisse

Barr, Alfred H., Jr. *Matisse, His Art, and His Public.* New York, 1951; repr. New York: Museum of Modern Art, 1974.

Blier, Suzanne. *The Royal Arts of Africa: The Majesty of Form.* New York: Abrams, 1998.

Brettell, Richard. *Modern Art, 1851–1929: Capitalism and Representation.* New York: Oxford University Press, 1999.

Chipp, Herschel B. *Theories of Modern Art: A Source Book by Artists and Critics.* Berkeley: University of California Press, 1968.

Corbin, George A. *Native Arts of North America, Africa, and the South Pacific: An Introduction.* New York: Harper & Row, 1988.

Elderfield, John. *The Cut-Outs of Henri Matisse.* New York: Braziller, 1978.

Flam, Jack D. *Matisse: The Man and His Art, 1869–1918.* Ithaca, NY: Cornell University Press, 1986.

———. *Matisse on Art.* Rev. ed. Berkeley: University of California Press, 1995.

———. *Matisse and Picasso: The Story of Their Rivalry and Friendship.* Boulder, CO: Westview Press, 2003.

Gordon, Donald E. *Expressionism: Art and Idea.* New Haven, CT: Yale University Press, 1987.

Hahl-Koch, Jelena. *Kandinsky.* New York: Rizzoli, 1993.

Herbert, James D. *Fauve Painting: The Making of Cultural Politics.* New Haven, CT: Yale University Press, 1992.

Kerchache, Jacques, Jean-Louis Paudrat, and Lucien Stéphan. *Art of Africa.* New York: Abrams, 1993.

Lloyd, Jill. *German Expressionism: Primitivism and Modernity.* New Haven, CT: Yale University Press, 1991.

Messer, Thomas M. *Vasily Kandinsky.* New York: Abrams, 1997.

Prelinger, Elizabeth. *Käthe Kollwitz.* Washington, DC: National Gallery of Art, 1992.

Richardson, John. *A Life of Picasso,* vol. I: *1881–1906.* New York: Random House, 1991.

Steinberg, Leo. *Other Criteria: Confrontations with Twentieth-Century Art.* New York: Oxford University Press, 1972.

Taylor, Brandon. *Avant-Garde and After: Rethinking Art Now.* New York: Abrams, 1995.

Vogt, Paul. *Expressionism: German Painting, 1905–1920.* Trans. Antony Vivis. New York: Abrams, 1980.

Cubism, Futurism, and Related Twentieth-Century Styles

Ashton, Dore. *Twentieth-Century Artists on Art.* New York: Pantheon, 1985.

Barr, Alfred H., Jr. *Cubism and Abstract Art: Painting, Sculpture, Constructions, Photography, Architecture, Industrial Art, Theatre, Films, Posters, Typography.* Cambridge, MA: Belknap Press, 1986.

Bayer, Herbert, Walter Gropius, and Ise Gropius, eds. *Bauhaus, 1919–1928.* New York: Museum of Modern Art, 1975.

Brown, Milton. *The Story of the Armory Show: The 1913 Exhibition That Changed American Art.* 2nd ed. New York: Abbeville, 1988.

Chipp, Herschel B. *Picasso's Guernica: History, Transformations, Meanings.* Berkeley: University of California Press, 1988.

Cooper, Douglas. *The Cubist Epoch.* New York: Phaidon, 1971.

Cowling, Elizabeth, and John Golding. *Picasso: Sculptor/Painter.* London: Tate Gallery, 1994.

Curtis, Penelope. *Sculpture, 1900–1945.* New York: Oxford University Press, 1999.

Curtis, William J. R. *Le Corbusier: Ideas and Forms.* New York: Rizzoli, 1986.

Elsen, Albert E. *Origins of Modern Sculpture: Pioneers and Premises.* New York: Braziller, 1974.

Fry, Edward F. *Cubism.* New York: Oxford University Press, 1978.

Geist, Sidney. *Brancusi: The Sculpture and Drawings.* New York: Abrams, 1975.

Golding, John. *Cubism: A History and an Analysis, 1907–1914.* Cambridge, MA: Belknap Press, 1988.

Gray, Camilla. *The Russian Experiment in Art, 1863–1922.* New York: Abrams, 1971.

Green, Christopher, ed. *Picasso's Demoiselles d'Avignon.* New York: Cambridge University Press, 2001.

Harrison, Charles, Francis Frascina, and Gill Perry. *Primitivism, Cubism, Abstraction: The Early Twentieth Century.* New Haven, CT: Yale University Press, 1993.

Hultén, Pontus. *Futurism and Futurisms.* New York: Abbeville, 1986.

Hunter, Sam, and John Jacobus. *Modern Art: Painting, Sculpture, Architecture.* 3rd rev. ed. New York: Abrams, 2000.

Kuenzli, Rudolf, and Francis M. Naumann, eds. *Marcel Duchamp: Artist of the Century.* Cambridge, MA: MIT Press, 1989.

Larkin, David, and Bruce Brooks Pfeiffer, eds. *Frank Lloyd Wright: The Masterworks.* New York: Rizzoli, 1993.

Mondrian, Piet C. *Plastic Art and Pure Plastic Art.* New York: Wittenborn, 1945.

Overy, Paul. *De Stijl.* New York: Thames & Hudson, 1991.

Pfeiffer, Bruce Brooks, and Gerald Nordland, eds. *Frank Lloyd Wright in the Realm of Ideas.* Carbondale: Southern Illinois University Press, 1988.

Richardson, John. *A Life of Picasso,* vol. II: *1907–1917.* New York: Random House, 1996.

Rosenblum, Robert. *Cubism and Twentieth-Century Art.* New York: Abrams, 2001.

Rubin, William, ed. *Pablo Picasso: A Retrospective.* New York: Museum of Modern Art, 1980.

———. *Picasso and Braque: Pioneering Cubism.* New York: Museum of Modern Art, 1989.

Schiff, Gert, ed. *Picasso in Perspective.* Englewood Cliffs, NJ: Prentice-Hall, 1976.

Silver, Kenneth E. *Esprit de Corps: The Art of the Parisian Avant-Garde and the First World War, 1914–1925.* Princeton, NJ: Princeton University Press, 1989.

Tomkins, Calvin. *Duchamp: A Biography.* New York: Henry Holt, 1996.

van Doesburg, Theo. *Principles of Neo-Plastic Art.* Trans. Janet Seligman. Greenwich, CT: New York Graphic Society, 1968.

Weiss, Jeffrey S. *The Popular Culture of Modern Art: Picasso, Duchamp, and Avant-Gardism.* New Haven, CT: Yale University Press, 1994.

Whitford, Frank. *Bauhaus.* London: Thames & Hudson, 1984.

Wilkin, Karen. *Georges Braque.* New York: Abbeville, 1991.

Wright, Frank Lloyd. *American Architecture.* Ed. E. Kaufmann. New York: Horizon, 1955.

Dada, Surrealism, Social Realism, Regionalism, and Abstraction

Alexandrian, Sarane. *Surrealist Art.* Trans. Gordon Clough. New York: Praeger, 1970.

Arp, Hans. *Arp on Arp: Poems, Essays, Memories.* Ed. Marcel Jean. Trans. Joachim Neugroschel. New York: Viking, 1972.

Baigell, Matthew. *The American Scene: American Painting of the 1930s.* New York: Praeger, 1974.

Barr, Alfred H., Jr., ed. *Fantastic Art, Dada, Surrealism.* New York, 1936; repr. New York: Arno Press, 1969.

Bearden, Romare, and Harry Henderson. *A History of African-American Artists from 1792 to the Present.* New York: Pantheon Books, 1993.

Dachy, Marc. *The Dada Movement, 1915–1923.* New York: Skira/Rizzoli, 1990.

Eldredge, Charles C. *Georgia O'Keeffe.* New York: Abrams, 1991.

Foucault, Michel. *This Is Not a Pipe.* Trans. J. Harkness. Berkeley: University of California Press, 1983.

Franciscono, Marcel. *Paul Klee: His Work and Thought.* Chicago: University of Chicago Press, 1991.

Herrera, Hayden. *Frida Kahlo: The Paintings.* New York: HarperCollins, 1991.

Levin, Gail. *Edward Hopper: An Intimate Biography.* New York: Knopf, 1995.

Lippard, Lucy R., ed. *Surrealists on Art.* Englewood Cliffs, NJ: Prentice-Hall. 1970.

Lynes, Barbara B. *O'Keeffe, Stieglitz, and the Critics, 1916–1929.* Chicago: University of Chicago Press, 1991.

Masheck, Joseph, ed. *Marcel Duchamp in Perspective.* Englewood Cliffs, NJ: Prentice-Hall, 1975.

Powell, Richard J. *Black Art and Culture in the 20th Century.* New York: Thames & Hudson, 1997.

Richter, Hans. *Dada: Art and Anti-Art.* Trans. David Britt. New York: Thames & Hudson, 1997.

Rubin, William S. *Dada and Surrealist Art.* New York: Abrams, 1968.

Schwarz, Arturo, ed. *The Complete Works of Marcel Duchamp.* London: Thames & Hudson, 1969.

———. *Man Ray: The Rigour of Imagination.* New York: Rizzoli, 1977.

Stich, Sidra. *Anxious Visions: Surrealist Art.* New York: Abbeville, 1990.

Sylvester, David. *Magritte: The Silence of the World.* New York: The Menil Foundation/Abrams, 1992.

Wheat, Ellen Harkins. *Jacob Lawrence: American Painter.* Seattle: University of Washington Press, 1986.

Mid-Century American Abstraction

Albright, Thomas. *Art in the San Francisco Bay Area, 1945–1980.* Berkeley: University of California Press, 1985.

Alloway, Lawrence. *Topics in American Art since 1945.* New York: Norton, 1975.

Ashton, Dore. *About Rothko.* New York: Oxford University Press, 1983.

———. *American Art Since 1945.* New York: Oxford University Press, 1983.

Doss, Erika. *Benton, Pollock, and the Politics of Modernism: From Regionalism to Abstract Expressionism.* Chicago: University of Chicago Press, 1991.

Francis, Richard H. *Jasper Johns.* New York: Abbeville, 1984.

Frascina, Francis, ed. *Pollock and After: The Critical Debate.* 2nd ed. New York: Routledge, 2000.

Gordon, John. *Louise Nevelson.* New York: Praeger, 1967.

Gray, Cleve, ed. *David Smith—Sculpture and Writings.* New York: Thames & Hudson, 1988.

Herbert, Robert L. *Modern Artists on Art.* 2nd ed. Mineola, NY: Dover, 2000.

Hertz, Richard, ed. *Theories of Contemporary Art.* Englewood Cliffs, NJ: Prentice-Hall, 1985.

Hess, Thomas B. *Willem de Kooning.* New York: Museum of Modern Art, 1968.

Howell, John, ed. *Breakthroughs: Avant-Garde Artists in Europe and America, 1950–1960.* New York: Rizzoli, 1991.

Hughes, Robert. *The Shock of the New.* Rev. ed. New York: Knopf, 1991.

Krauss, Rosalind E. *The Originality of the Avant-Garde and Other Modernist Myths.* Cambridge, MA: MIT Press, 1985.

Lipman, Jean. *Calder's Universe.* Philadelphia: Running Press, 1989.

Lucie-Smith, Edward. *Movements in Art since 1945.* New ed. New York: Thames & Hudson, 2001.

O'Connor, Francis V. *Jackson Pollock.* New York: Museum of Modern Art, 1967.

Reinhardt, Ad. *Art-as-Art: The Selected Writings of Ad Reinhardt.* Ed. Barbara Rose. New York: Viking, 1975.

Rosenberg, Harold. *The De-Definition of Art: Action Art to Pop to Earthworks.* New York: Museum of Modern Art, 1980.

Rosenblum, Robert. *Frank Stella.* Harmondsworth, UK: Penguin, 1971.

Rubin, William, ed. *"Primitivism" in 20th-Century Art.* 2 vols. New York: Museum of Modern Art, 1984.

Sandler, Irving. *The Triumph of American Painting: A History of Abstract Expressionism.* New York: Praeger, 1970.

———. *American Art of the 1960s.* New York: Harper & Row, 1989.

Wheeler, Daniel. *Art Since Mid-Century: 1945 to the Present.* New York: Vendome, 1991.

Pop Art, Op Art, Minimalism, and Conceptualism

Alloway, Lawrence. *American Pop Art.* New York: Collier, 1974.

———. *Robert Rauschenberg.* Washington, DC: Smithsonian Institution, 1976.

Baker, Kenneth. *Minimalism: Art of Circumstance.* New York: Abbeville, 1990.

Batchelor, David. *Minimalism.* New York: Cambridge University Press, 1997.

Battcock, Gregory, ed. *Minimal Art: A Critical Anthology.* Berkeley: University of California Press, 1995.

Bourdon, David. *Warhol.* New York: Abrams, 1989.

Crow, Thomas. *The Rise of the Sixties: American and European Art in the Era of Dissent.* New York: Abrams, 1996.

Geldzahler, Henry, and Robert Rosenblum. *Andy Warhol: Portraits of the Seventies and Eighties.* London: Anthony d'Offay Gallery/Thames & Hudson, 1993.

Livingstone, Marco. *Pop Art: A Continuing History.* New York: Thames & Hudson, 2000.

Lucie-Smith, Edward. *Art in the Seventies.* Ithaca, NY: Cornell University Press, 1980.

———. *American Art Now.* New York: William Morrow, 1990.

———. *Art in the Eighties.* New York: Phaidon, 1990.

Varnedoe, Kirk. *Jasper Johns: A Retrospective.* New York: Museum of Modern Art, 1996.

Varnedoe, Kirk, and Adam Gopnik, eds. *Modern Art and Popular Culture: Readings in High and Low.* New York: Museum of Modern Art, 1990.

Warhol, Andy. *America.* New York: Harper & Row, 1985.

Continuity, Innovation, and Globalization

Auping, Michael. *Susan Rothenberg: Paintings and Drawings.* New York: Rizzoli, 1992.

Baal-Teshuva, Jacob, ed. *Christo: The Reichstag and Urban Projects.* Munich: Prestel, 1993.

Barrette, Bill. *Eva Hesse—Sculpture: Catalogue Raisonné.* New York: Timken, 1989.

Battcock, Gregory. *Super Realism: A Critical Anthology.* New York: Dutton, 1975.

Beardsley, Richard. *Earthworks and Beyond: Contemporary Art in the Landscape.* 3rd ed. New York: Abbeville, 1998.

Bourdon, David. *Christo.* New York: Abrams, 1972.

Bruggen, Coosje van. *Bruce Nauman.* New York: Rizzoli, 1988.

Carrier, David. *The Aesthete in the City: The Philosophy and Practice of American Abstract Painting in the 1980s.* University Park: Pennsylvania State University Press, 1994.

Chicago, Judy. *The Dinner Party: A Symbol of Our Heritage.* Garden City, NY: Anchor Books/Doubleday, 1979.

Cruz, Amanda, Elizabeth A. T. Smith, and Amelia Jones. *Cindy Sherman: Retrospective.* New York: Thames & Hudson, 1997.

Danto, Arthur C. *History Portraits/Cindy Sherman.* New York: Rizzoli, 1991.

Farrington, Lisa E. *Creating Their Own Image: The History of African-American Women Artists.* New York: Oxford University Press, 2005.

Flam, Jack D., ed. *Robert Smithson: The Collected Writings.* Berkeley: University of California Press, 1996.

Gilmour, John C. *Fire on the Earth: Anselm Kiefer and the Postmodern World.* Philadelphia: Temple University Press, 1990.

Godfrey, Tony. *The New Image: Painting in the 1980s.* New York: McGraw-Hill, 1986.

Goldberg, RoseLee. *Performance Art: From Futurism to the Present.* Rev. ed. New York: Thames & Hudson, 2001.

Haskell, Barbara. *Agnes Martin.* New York: Whitney Museum of American Art, 1992.

Hobbs, Robert. *Robert Smithson: Sculpture.* Ithaca, NY: Cornell University Press, 1981.

Laporte, Dominique G. *Christo.* New York: Pantheon, 1986.

Marshall, Richard, et al. *Robert Mapplethorpe.* New York: Whitney Museum of American Art, 1988.

———. *Jean-Michel Basquiat.* New York: Whitney Museum of American Art, 1992.

Rosen, Randy, and Catherine C. Brawer, eds. *Making Their Mark: Women Artists Move into the Mainstream, 1970–85.* New York: Abbeville, 1989.

Sandler, Irving. *Art of the Postmodern Era: From the Late 1960s to the Early 1990s.* New York: HarperCollins, 1996.

Smithson, Robert. *The Writings of Robert Smithson.* Ed. N. Holt. New York: New York University Press, 1979.

Stachelhaus, Heiner. *Joseph Beuys.* Trans. David Britt. New York: Abbeville, 1991.

Storr, Robert. *Chuck Close.* New York: Museum of Modern Art, 1998.

Tisdall, Caroline. *Joseph Beuys.* New York: Solomon R. Guggenheim Museum, 1979.

Literary Acknowledgments

Ch. 9, p. 126 From *The Aeneid* by Virgil, translated by Robert Fitzgerald, translation copyright © 1980, 1982, 1983 by Robert Fitzgerald. Used by permission of Random House, Inc.

Ch. 11, p. 174 Ten lines ("…ring-prowed…/… to the mounting waves…") from *Beowulf: A Verse Translation* by Frederick Rebsamen. Copyright © 1991 by Frederick Rebsamen. Reprinted by permission of HarperCollins Publishers.

Ch. 18, p. 323 "Musée des Beaux-Arts" copyright 1940 and renewed 1968 by W. H. Auden, from *Collected Poems of W. H. Auden* by W. H. Auden. Used by permission of Random House, Inc.

Ch. 26, p. 468 "The Man with the Blue Guitar," from *The Collected Poems of Wallace Stevens* by Wallace Stevens, copyright 1954 by Wallace Stevens and renewed 1982 by Holly Stevens. Used by permission of Alfred A. Knopf, a division of Random House, Inc.

Ch. 30, p. 545 Agnes Martin, selections in Barbara Haskell, Agnes Martin (New York: Whitney Museum of American Art, (1992). Reprinted by permission of Pace Wildenstein for the artist.

Picture Credits

7.34 © akg-images/Nimatallah
7.37 Erich Lessing/Art Resource, NY
7.39a,b The Metropolitan Museum of Art, Rogers Fund, 1943 (43.11.4). MMA/AR
7.40 © Araldo de Luca
7.41 Alinari/Art Resource, NY
7.42, 7.43 BPK/AR

Chapter 8 Opener and 8.4, 8.5a,b, 8.6, 8.8–8.10a,b S/AR
8.1 akg-images/Pirozzi
8.2 Erich Lessing/Art Resource
8.3 © Museo Archeologico, Florence, Italy/BAL
8.7 Scala/Art Resource, NY
8.11 The Art Archive
8.12 Ancient Art & Architecture Collection, Pinner, UK

Chapter 9 Opener and 9.3, 9.31a,b © Araldo de Luca
9.4, 9.9, 9.12, 9.23, 9.27, 9.32–9.34, 9.38 S/AR
9.5 Photo Peter A. Clayton
9.7, 9.13, 9.18 akg-images/Peter Connolly
9.11 © Mary Evans Picture Library, London/ The Image Works
9.14 © D&J Heaton/Spectrum Colour Library/ imagestate media
9.15a © Gustavo Tomsich/Corbis
9.16, 9.22 © akg-images/Pirozzi
9.19 Image courtesy of the Board of Trustees, National Gallery of Art, Washington, Samuel H. Kress Collection. 1939.1.24.(135)/PA
9.20 © akg-images/Hilbich
9.21 © akg-images/Nimatallah
9.24 © Scala, Florence—courtesy of the Ministero Beni e Att. Culturali/Art Resource, NY
9.25 SEF/Art Resource, NY
9.26 Werner Forman/Art Resource, NY
9.28 The Metropolitan Museum of Art, Purchase, Joseph Pulitzer Bequest, 1955 (55.11.5). MMA/AR
9.29 © Araldo de Luca/Corbis
9.30 Museo Archeologico Nazionale
9.35 The Art Archive/Musée Archéologique Naples/Alfredo Dagli Orti
9.36 © Canali Photobank
9.37 The Metropolitan Museum of Art, Rogers Fund, 1920 (20.192.1). MMA/AR
9.39 The Art Archive/Gianni Dagli Orti

Chapter 10 Opener and 10.5, 10.8–10.12 S/AR
10.1 Alinari/Art Resource, NY
10.2 © Canali Photobank
10.4b © akg-images/Peter Connolly
10.6 © akg-images/Heiner Heine
10.13 Getty Images/Harvey Lloyd
10.15 © Historical Picture Archive/Corbis
10.16 © Marvin Trachtenberg
10.17 Osterreichische Nationalbibliothek, Vienna
10.18 The Art Archive/Kharbine-Tapabor/ Boistesselin
10.19 EL/AR

Chapter 11 Opener and 11.7 Library of Trinity College, Dublin, The Board of Trinity College, Dublin. TCD MS 58 (Book of Kells) fol. 124r
11.2 S/AR
11.3 Institut Amatller d'Art Hispanic
11.4 Raffaello Bencini, Florence
11.5 © BM/AR
11.6 Library of Trinity College, Dublin, The Board of Trinity College, Dublin, TCD MS. 57 (Book of Durrow) fol. 191v
11.8 Erich Lessing/Art Resource, NY
11.9 © akg-images/Hilbich
11.12 © akg-images
11.13 Bibliothèque Nationale de France, Paris Ms. Lat. 1, fol. 329v
11.15 EL/AR
11.17 Foto Marburg/Art Resource, NY

Chapter 12 Opener and 12.14 Bibliothèque Nationale de France, Paris. Ms. 2293, fol. 19v, initial
12.1 EL/AR
12.2 Erich Lessing/Art Resource, NY
12.4, 12.7 S/AR
12.8, 12.10 © Paul M. R. Maeyaert
12.9, 12.11 RMN/AR
12.12 The Pierpont Morgan Library/Art Resource, NY
12.13 Bibliothèque Nationale de France, Paris. Ms. Lat. 254, fol. 10
12.15 © Hirmer Foto Archiv, Munich
12.16, 12.17 Tapisserie de Bayeux, by special permission of the City of Bayeux

Chapter 13 Opener and 13.13 John Elk III/ Bruce Coleman, Inc./Photoshot
13.1 © Bibliothèque Nationale, Paris, France/ BAL. Ms. Fr. 2091 v. II fol. 125
13.2, 13.8 Anthony Scibilia/Art Resource, NY
13.6 Sonia Halliday and Laura Lushington/ Sonia Halliday Photographs
13.7 © John Elk III/Alamy
13.9 © Bill Wassman
13.10 Adam Woolfitt/Woodfin Camp & Associates
13.14 Vanni/Art Resource, NY
13.15 EL/AR
13.16 akg-images/Schütze/Rodemann
13.17, 13.21, 13.23 © Peter Willi/BAL
13.18 Bob Burch/Bruce Coleman, Inc./Photoshot
13.19, 13.20 © Roger-Viollet/The Image Works
13.24 RMN/AR
13.25 Bibliotheque Nationale, Paris, MS lat.10525, fol. 85 verso
13.26 © London Aerial Photo Library/Corbis
13.28 © Florian Monheim/Bildarchiv Monheim GmbH/Alamy
13.29, 13.31 Bildagentur Huber/Friedmar Damm

Chapter 14 Opener and 14.4–14.9, 14.11–14.13a,b S/AR
14.1 Alinari/Art Resource, NY
14.2 © Galleria degli Uffizi, Florence, Italy/BAL
14.3 © Canali Photobank
14.10 Scala/Art Resource NY
14.14 © Santa Croce, Florence, Italy/BAL
14.15 © Paul M.R. Maeyaert
14.16 EL/AR
14.17 Bridgeman-G/AR

Chapter 15 Opener and 15.16 Scala/Ministero per i Beni e le Attività culturali/Art Resource, NY
15.1, 15.2, 15.9–15.13, 15.18, 15.21–15.23a,b, 15.25–15.28, 15.30, 15.33, 15.34, 15.39, 15.41, 15.42 S/AR
15.3 Timothy McCarthy/Art Resource, NY
15.4 © akg-images/Rabatti-Domingie
15.7 Alinari/Art Resource, NY
15.8 Nimatallah/Art Resource, NY
15.14 Studio Fotografico Quattrone
15.15 The Art Archive/Galleria degli Uffizi Florence/Alfredo Dagli Orti
15.17 Erich Lessing/Art Resource, NY
15.19 Image courtesy of the Board of Trustees, National Gallery of Art, Washington, Widener Collection. 1942.9.8 (604)/PA
15.20, 15.29 Scala/Art Resource, NY
15.24 Scala/Ministero per i Beni e le Attività culturali/Art Resource, NY
15.31, 15.32 The Metropolitan Museum of Art, The Cloisters Collection, 1956 (56.70). MMA/AR
15.35 © Paul M.R. Maeyaert/© St. Baafskathedraal Gent
15.36, 15.37 © NG,L/AR
15.38 © National Gallery, London
15.40 Museum of Fine Arts, Boston. Gift of Mr. and Mrs. Henry Lee Higginson, 93.153. Photograph © 2011 Museum of Fine Arts, Boston

Chapter 16 Opener and 16.1, 16.4, 16.14. 16.15, 16.28, 16.31, 16.32 S/AR
16.2 © Canali Photobank
16.8 Photo by James Morris, London. Courtesy of Axiom, London
16.9 The Royal Collection © 2011, Her Majesty Queen Elizabeth II
16.10 © akg-images
16.11 Scala/Ministero per i Beni e le Attività culturali/Art Resource, NY
16.12, 16.21 EL/AR
16.13, 16.30 RMN/AR
16.17 Photo Vatican Museums/A. Bracchetti – P. Zigrossi © 2000 38016D
16.18–16.20 Photo Vatican Museums/ A. Bracchetti – P. Zigrossi © 2000
16.22 Scala/Art Resource,NY
16.23–16.24 Photo Vatican Museums/P. Zigrossi © 2000
16.25, 16.27 © NG,L/AR
16.26 Cameraphoto/Art Resource, NY
16.29 BPK/AR
16.33 © Isabella Stewart Gardner Museum, Boston, MA, USA/BAL

Chapter 17 Opener and 17.5 EL/AR
17.1, 17.2, 17.6a,b–17.9, 17.11 S/AR
17.3 © NG,L/AR
17.4 Milwaukee Art Museum, Layton Art Collection, Gift of the Family of Mrs. Fred Vogel Jr. L1952.1. Photo by P. Richard Eells
17.12 © Angelo Hornak Photograph Library

Chapter 18 Opener and 18.1, 18.5, 18.6, 18.14 S/AR
18.2 Kunstmuseum Basel, Martin P. Bühler
18.3 © akg-images
18.4 Bildarchiv Preussischer Kulturbesitz/ Art Resource, NY
18.7, 18.8 Foto Marburg/Art Resource, NY
18.9, 18.11 G/AR
18.10 © Musee d'Unterlinden, Colmar
18.12 © Artothek
18.13 © Nationalmuseum, Stockholm, Sweden/ BAL

Chapter 19 Opener and 19.1, 19.4, 19.13a,b, 19.15–19.19 S/AR
19.2 © Alinari Archives/Corbis
19.6 © Angelo Hornak/Alamy
19.7 Alinari/Art Resource, NY
19.8 © akg-images/Erich Lessing
19.9 © Fotomas Index/ The Bridgeman Art Library International
19.10 RMN/AR
19.12 © Angelo Hornak Photograph Library
19.14 akg-images/Pirozzi
19.20 The Metropolitan Museum of Art, Gift of Harry Payne Bingham, 1937 (37.162). MMA/AR
19.21 © Peter Willi/BAL
19.22 Royal Collection, The Hague (AT/0248)
19.23, 19.32, 19.37 © NG,L/AR
19.24, 19.25, 19.27 Rijksmuseum, Amsterdam
19.26 The Rembrandt House Museum, Amsterdam
19.28 © Wallace Collection, London, UK /BAL
19.29 Philadelphia Museum of Art, John G. Johnson Collection. The Philadelphia Museum of Art/Art Resource, NY
19.30 Stadelsches Kunstinstitut, Frankfurt and Artothek-Blauel/Gnamm
19.31 Photograph © Mauritshuis, The Hague. Royal Cabinet of Paintings Mauritshuis The Hague
19.33 Kunsthistorisches Museum, Vienna
19.34 Freer Gallery of Art and Arthur M. Sackler Gallery, Smithsonian Institution, Washington, DC. Purchase. F1942.15a
19.35 © San Diego Museum of Art, USA/Gift of Anne R. and Amy Putnam/BAL

Index

Page numbers in **boldface** refer to illustrations. Captions and maps are indicated by *c* and *m* following the page numbers.

A

Abdar-Rahm-n I, ruler of Spain, 172
Aboriginal art, 28, **28**
Abraham, 244, **244**
Absinthe (Degas), 436, **436**
abstract art, 3, 21. *See also* Abstract Expressionism; American abstraction
Abstract Expressionism: action painting, 520, 521, **521**, 523–26, **523–26**; "automatic writing" influencing, 503; Color Field painting, **527**, 527–29, **528**, **529**; critical response to, 520; early painting innovations, **519**, 519–20, **520**; political/cultural context, 518; style origins, 519
Abu, 39
Abu Simbel, **67**, 67–68
Académie Royal de Peinture et de Sculpture, 339, 340, 372, 433
acanthus-leaf designs, 100, **100**, 101, 334
Accademia del Disegno, 349
Accademia di San Luca, 382c
Achaemenid (Persian) art, **48**, 48–50, **49**, **50**
Achilles and Ajax Playing a Board Game (Exekias), 88, **88**
Acis, 463
Acropolis, 96–106, **97**, **105**, **106**, **107**. *See also* Parthenon
acrylic painting, 527
Act of Supremacy, 306
action painting, 520, 521, **521**, **523**, 523–26, **524**, **525**, **526**
action sculpture, **548**, 548–49
Adagia (Erasmus), 324, 328, 361
Adam, Robert: Osterley Park House, 380, **381**
Adam and Eve, 154, 251, **252**, **269**, 270, 289, 292, **292**, 319, **320**
Adams, John, 396, **396**
Adonis, 351, **351**
Adoration of the Lamb by All Saints (Eyck), 269, **269**
Adoration of the Magi (Leonardo da Vinci), 248
Adoration of the Shepherds (Ghirlandaio), 276–77, **278**
advertising, 5, 490, 533
Aegean art, 70–82, **71–82**
Aegisthos, 77
Aeneid (Virgil), 115, 126, 223
Aeneas, 11, 126, 127, 146
aerial perspective, 253, 425
aerial photography, 422–23
Aeschylos, 77, 85, 86
African American artists, 426, 491, 510, 511, 516, 572–73
African art, 467, 469, **469**, 480, **481**
Agamemnon, king of Mycenae, 77
Age of Enlightenment, 368–69, 394, 408
Age of Perikles, 96–97
agora, 130
Agrippa, Marcus, 136, 138, 141
Ahmose, queen of Egypt, 61
airbrush, 527
Ajax, 88, **88**
Akbar, Mughal emperor, 362
Akhenaten (Amenhotep IV), pharaoh of Egypt, **61**, 64–65, **65**
Akkadian art, **40**, 40–41, 43
Akkadian language, 37
Albers, Josef, 1, 518, 529, 546c; *Study for Homage to the Square*, **519**, 519
Alberti, Leon Battista, 1, 6, 243, 248, 256, 279; Rucellai Palace, 256, **256**
Alcuin of York, 178, 208
"Alexander Mosaic," 90, **90**

Alexander the Great: court artists of, 15, 89, 110, 112; death of, 125; Greek art style of, 112; in Greek history, 108; mosaics featuring, 90, **90**; and Nubia, 69; and Persian Empire, 50, 51; sculptural portraits of, 112, **112**; teachers of, 84
Alkmene, 120, 150
Alkyoneus, 116, **116**
Allegorical Representation of the Emperor Jahangir Seated on an Hourglass Throne (Bichtir), 362, **362**
Allegories of Good and Bad Government (Lorenzetti), 236
allegory, 358, 400
Altar of Peace, **140**, 140–41, **141**
Altar of Zeus, 114, **115**, 116, **116**, 167
Altarpiece of the Lamb (Eyck), **269**, 269–71, **270**, **271**
altarpieces: fifteenth-century Netherlandish, 267–71, **268**, **269**, **270**, **271**, 276–77, **276–77**; Late Gothic/pre-Renaissance, 224, **224**, 225, 225–26, 232, **232**; media and technique, 226; Renaissance, Italian, 254, **254**, **298**, 298–99; sixteenth-century German, 328–30, **329**, **330**
altars, monumental: Greek, 114, **115**, 116, **116**, 167; Roman, **140**, 140–41, **141**
alter deus, 6
Amanishakheto, queen of Nubia, tomb of, **68**, 68–69, **69**
Amarna period (Egypt), 64–65
Amazons, 102
ambulatories, 158, 159, **159**, 179, **179**, 186–87, 199, **200**, **215**, 221, 247, 379
Amenhotep III, pharaoh of Egypt, **60**
Amenhotep IV (Akhenaten), pharaoh of Egypt, **64**, 64–65, **65**
American abstraction: museums and galleries exhibiting, 514; painting, 476, 477, **477**, 514, **515**, 517, **517**, **518**, 518–19, **519**, 530, **530**; photography, 514, **514**; sculpture, 509, **509**, **531**, 531–32, **532**. *See also* Abstract Expressionism
American art. *See* Abstract Expressionism; American abstraction; United States
American Constitution, 368
American Gothic (Wood), 510, **510**
American Pavilion (Fuller), 555, **555**
American Place Gallery, 514
American Revolution, 368–69, 383, 393
American Southwest art, 504, **504**, 522, **522**
Amon, 56, 68
Amon-Mut-Khonsu, temple of, **59**, 59–60, **60**
Amon-Ra, 61
Amor, 86
amphitheaters, **134**, 134–35, **135**
Amphitryon, 150, 151
amphorae, 87, **87**, 88, **88**
Analysis of Beauty (Hogarth), 376
Analytic Cubism, **482**, 482–83, 486, **486**, 487, 488
ancestor cults, 34
Ancient Mexico (Rivera), 512, **513**
Ancient of Days (Blake), 401, **401**
Ancients, 340, 404
Anderson, Laurie: *Home of the Brave*, 554, **554**
Angelico, Fra: *Annunciation*, 261–62, **262**
Angles, 174
Anglo-Saxon art, **174**, 174–75
Anguissola, Sofonisba, 349; *Artist's Sister Minerva Anguissola, The*, 309, **309**
ankh, 61, 65
Annals of My Glass House (Cameron), 424
Anne, Saint, 212, 228, 263, **263**, **285**, 285–86
Annunciation (Fra Angelico), 261–62, **262**
Annunciation (Giotto), **227**, 228
Annunciation (Grünewald), **330**
Annunciation (Piero della Francesca), **261**, 261–62, **262**
Annunciation (Tanner), 426, **426**

Annunciation and Visitation (Reims Cathedral), 215–16, **216**
Annunciation to Mary (Pisano), 222, **222**
Annunciation to the Shepherds (Pisano), 222, **222**
Anthemius of Tralles, 164
Anthony, Saint, 328, 330, **330**
anthropomorphism, 85, 455, 540, 576
Antichità di Roma, L' (Palladio), 315c
Antiochus Epiphanes, 143
Anu, 36
Anubis, 56, 62
Apadana of Darius (Persepolis), **48**, 48–49, **49**
Apelles, 15, 89, 224, 328c
Aphrodite, 85, 86, 454. *See also* Venus
Aphrodite of Knidos (Praxiteles), 109, **109**
Aplu, 120, **120**
Apocrypha, 6, 348
Apollo, 86, 89, **89**, **102**, 118, **118**, 119, **119**, 120, **120**, 377
Apollo of Veii, 119, **119**
Apoxyomenos (Athlete with a Strigil) (Lysippos of Sikyon), 110, **110**
apples, symbolism of, 454
apprenticeship, 202, 222–23, 226, 258, 444
aquatint, 408
aqueducts, 136, **136**
Ara Pacis, **140**, 140–41, **141**
arabesques, 477
Arc de Triomphe (Chalgrin), 388, **389**, 400, **400**
Arch of Constantine, 144, **144**
Arch of Titus, **142**, 142–43, **143**
archaeology, 4, 9–10, 39, 66, 68, 71, 77, 128, 380
Archaic style, 89, **89**, 90–92, **91**, **92**, 119, 122, **123**
architectural urns, 122, **122**
architecture: Bauhaus, 496, **497**, 498; Byzantine, **159**, 159–61, **160**, 164–67, **165**, **166**, **167**; definition, 1; Early Christian, **156**, 156–58, **157**, **158**; early medieval Europe, 179, **179**, 181, 181–82, **182**; eighteenth-century revivals, 380, 380–81, **381**, 398; Etruscan, 118, **118**; and identification, 8–9; International Style, **495**, 495–96, **496**, **497**, 498, **498**; Islamic (early medieval), 171–73, **172**, **173**; Mannerism, **315**, 315–17, **316**, **317**; Minoan, 71–73, **72**, **73**; Mycenaean, 77, **77**, 78–80, **79**, **80**; Neoclassical American (Federal style), 393–95, **395**; Neoclassical French, 388, **389**; nineteenth-century Realism, **429**, 429–32, **430**, **431**; Post-Modern, **556**, 556–61, **557**, **558**, **559**, **560**, **565**; Prairie Style, **494**, 494–95, **495**; and religious value, 3–4; Renaissance, early Italian, 245–47, **246**, **247**, 256, **256**; Renaissance, High Italian, 279–82, **280**, **281**, **282**; Rococo, 376–79, **377**, **378**, **379**; Romanesque, **186**, 186–91, **187**, **188**; Romanticism, 398, **399**; and space, 16; Theran, 75; twentieth-century, late, 551, **551**, 555, **555**. *See also* Baroque architecture; Gothic architecture; Greek architecture; Near Eastern architecture, ancient; Roman architecture
Arena Chapel frescoes (Giotto), 226–31, **227**, **229**, **230**, **231**, 235, **235**, 294
Ares, 86
Aretino, Pietro, 299, 312
Ariadne, 150
Aristophanes, 85
Aristotle, 84–85, 108, 296, **296**, 326
Armory Show (exhibition), 488–89, 490, 509, 517
Army of the Potomac—A Sharpshooter on Picket Duty, The (Winslow Homer), 448, **448**
Arnolfini Portrait (Eyck), 272, **273**, 485, 578
Arp, Jean: *Collage Arranged According to the Laws of Chance*, 502, **502**; *Dancer, The*, 502, **502**
Arrangement in Black and Gray (Portrait of the Artist's Mother) (Whistler), 7, **8**, 11, 12, 450
arriccio, 228